DICTIONARY OF
CONTEMPORARY AMERICAN ARTISTS

DICTIONARY OF CONTEMPORARY AMERICAN ARTISTS

THIRD EDITION

PAUL CUMMINGS

St. Martin's Press New York
St. James Press London

25669

Copyright © 1977 by Paul Cummings
All rights reserved. For information, write:
St. Martin's Press, Inc., 175 Fifth Ave., New York, N.Y. 10010.
Manufactured in the United States of America
Library of Congress Catalog Card Number: 76-10548

ISBN: 0-312-20090-0

Library of Congress Cataloging in Publication Data

Cummings, Paul.
Dictionary of contemporary American artists.

Bibliography: p.
Includes index.
1. Artists—United States—Biography.
I. Title.
[N6536.C8 1976] 709'.22 76-10548

Published simultaneously in U.K. by St. James Press
For information, write:
St. James Press Ltd.
3 Percy Street
London W1P 9FA

Contents

Acknowledgments

To all the artists who so graciously took time to complete the questionnaires I should again like to express my gratitude. Without their assistance this revised edition could not have been completed.

In addition I wish to thank the many art dealers and their gallery staffs for their always generous help in providing information and photographs. The following people and institutions also deserve a particular word of thanks: Mary Joan Hall, the Solomon R. Guggenheim Museum; the librarians, the Museum of Modern Art; the Frick Art Reference Library; and the Metropolitan Museum of Art Library. William E. Woolfenden and Butler Coleman, the Archives of American Art, Smithsonian Institution, were unfailing in their encouragement and support. Nancy Grove and Cherene Holland undertook the laborious task of checking facts.

A special note of acknowledgment is due Joan Sumner Ohrstrom for the vital editorial assistance she has rendered with patience and exceeding good humor. She so often salvaged us from chaos in an ever-increasing welter of information. To Louise E. Halsey thanks for her exquisitely accurate typing.

To the artists, collectors, museums, and art dealers for permission to illustrate works of art in their possession, my sincere appreciation.

PC

February 1976
New York City

How to Use This Book

This extensively revised edition of the Dictionary, first published in 1966, includes 85 new artist entries and a new selection of illustrations. The annotated Bibliography, considerably enlarged, is the most diverse bibliography available on contemporary American art.

Questionnaires, personal interviews, and intensive research have brought together significant data regarding the careers of 872 artists, chosen essentially on the basis of the following criteria: representation in museum, public, and private collections; representation in major American and international exhibitions; influence as teachers; recognition received from fellow-artists, dealers, critics, and others with a professional interest in the fine arts. January 1976 was chosen as the cut-off date for all data, except for obituary notices through May 1976.

The artists' entries are organized on the following plan: where they studied art, and with whom; teaching experience; participation in the Federal Art Project; commissions executed; scholarships and/or awards won (**P.P.** in this category denotes "purchase prize" or "purchase award"); spouse (if prominent in art); address and dealer(s) of record; important one-man, retrospective, and group exhibitions (circ. in this category indicates that the exhibition circulated among various institutions); and bibliography. Archives, appearing at the end of some of the entries, indicates that the artist's papers and/or taped, in-depth interviews with the artist are available at the Archives of American Art. The Archives maintains complete microfilm files in their Boston, New York, Washington, D.C., Detroit, and San Francisco offices.

Naturally many artists have won the same awards, been represented in the same exhibitions and collections, and are mentioned in the same books. Repetition of the complete data in each case would have made this volume far too large. Therefore the data have been compressed into a

series of keys, found in the front of the book; the keyed, annotated bibliography is located at the back. Any abbreviations used in the body of the book are explained in those keys. The often long and complex names of museums and public collections have generally been abbreviated and codified in the Key to Museums and Institutions. Common-sense methods have been used, most often acronyms (MOMA for The Museum of Modern Art) and reductions, either to the name of the city (Mons for the Musee des Beaux-Arts, Mons, Belgium), to a combination of city and key word (Albany/Institute for the Albany Institute of History and Art), or to city and acronym (Akron/AI for the Akron Art Institute).

In the listing entitled Galleries, addresses are given for those dealers representing the artists listed in this volume; other galleries cited in the Exhibitions portions of the entries are identified therein by city.

The use of boldface type in the Bibliography sections of the entries distinguishes the writings of the artist himself, comprehensive exhibition catalogues, or monographs.

The Index of Artists in the front of this volume offers both a pronunciation guide and breakdown of the types of work for which each artist is best known.

Example:
...**One-man Exhibitions**: (first) The Babcock Gallery, 1946; Blank Gallery, Washington, D.C., 1949. **Group**: Toledo/MA; Corcoran, 1950; NAD, 1951; Venice Biennials. **Collections**: Springfield, Mass./MFA; Montclair/AM. **Bibliography**: Baur 1, 5, **6**, 7.

Explanation:
Because it functions as a dealer, the address of The Babcock Gallery is given in the Gallery list at the front of this book; the Blank Gallery was located in Washington, D.C., at the time of this exhibition and may still be there, but it does not represent any of the artists listed. Toledo/MA stands for the Toledo Museum of Art, and its full name may be found under T in the Key to Museums; the names of all coded institutions are listed alphabetically in the Key. The bibliographic notation indicates that this artist, among others, is referred to in the four similarly numbered books among the seven by Baur listed in the Bibliography, with boldface number **6** being a monograph.

DICTIONARY OF
CONTEMPORARY AMERICAN ARTISTS

Illustrations

(All dimensions are in inches unless otherwise indicated. Height precedes width.)

John Anderson
 Untitled. 1969
 7' 11" x 13'. wood
 Courtesy Allan Stone Gallery

Stephen Antonakos
 ELG Green Square on the Floor.
 1973
 4' x 4'. neon
 Courtesy John Weber Gallery
 Photograph by John A. Ferrari

Arakawa
 Untitled. 1968
 78 x 48. acrylic/canvas
 Courtesy Ronald Feldman Fine Arts
 Inc.
 Photograph by Eeva-Inkeri

William Bailey
 Still Life with Kitchen Objects. 1970
 30 x 36. oil/canvas
 Courtesy Robert Schoelkopf Gallery
 Photograph by John D. Schiff

William Baziotes
 Two Suns. 1952
 16¼ x 12½. pastel and charcoal
 Courtesy Marlborough Gallery, Inc.
 Photograph by O. E. Nelson

Jack Beal
 The Fisherman. 1974-75
 67 x 62. oil/canvas
 Courtesy Allan Frumkin Gallery
 Photograph by Eeva-Inkeri

Romare Bearden
 Show Time. 1974
 50 x 40. collage with acrylic and
 lacquer
 Courtesy Cordier & Ekstrom, Inc.
 Photograph by Geoffrey Clements

Robert Birmelin
 Apartment Living: A Recently Emp-
 tied Room. 1972-73
 72 x 66. acrylic and oil
 Courtesy Terry Dintenfass, Inc.
 Photograph by Barney Burstein

Varujan Boghosian
 Archon. 1975
 63 x 11½ x 9½. wood and metal
 Courtesy Cordier & Ekstrom, Inc.

Ilya Bolotowsky
 Black Diamond with Pale Blue. 1973
 42 x 42. acrylic
 Courtesy Grace Borgenicht Gallery
 Inc.
 Photograph by Bob Rogers

1

Joe Brainard
Untitled collage. 1975
14 x 11. mixed media
Courtesy Fischbach Gallery

James Brooks
Asnawa. 1970
22 x 29¾. lithograph
Courtesy Martha Jackson Gallery
Photograph by John D. Schiff

Charles Burchfield
Summer. 1920
24 x 30. watercolor
Courtesy Rehn Galleries
Photograph by Geoffrey Clements

John Button
SoHo Sunset: Cerulean, Rose. 1973
58 x 32. oil/canvas
Courtesy The Kornblee Gallery

Georgio Cavallon
Untitled. 1974-75
72 x 84. oil/canvas
Courtesy A. M. Sachs Gallery
Photograph by Eeva-Inkeri

Christo
Running Fence. 1973-76
18' x 24.5 miles. drawing
Courtesy the artist
Photograph by Eeva-Inkeri

John Clem Clarke
Plywood with Roller Marks #4. 1974
95 x 59½. oil/canvas
Courtesy OK Harris Works of Art
Photograph by Eric Pollitzer

Ross Coates
Pine Mesa. 1975
60 x 70. oil/canvas
Courtesy the artist

Andrew Dasburg
Landscape—New Mexico. 1932
14½ x 21. watercolor
Courtesy Gerald P. Peters
Photograph by Eeva-Inkeri

Robert Dash
Dull Spring No. 1. 1972

50 x 40. acrylic/canvas
Courtesy Fishbach Gallery

John DeAndrea
Woman on Foam Mattress. 1974
life size. polyester and fiberglas
Courtesy OK Harris Works of Art
Photograph by Eric Pollitzer

George Deem
Eight Women. 1967
50 x 40. oil/canvas
Courtesy Allan Stone Gallery

Avel DeKnight
Guardian of the Night (Mirage
Series). 1973
7¼ x 9¼. gouache/board
Courtesy The Babcock Galleries
Photograph by Carleton Sarver

Jose de Rivera
Construction #158. 1974-75
36 x 67 x 49. stainless steel
Courtesy Grace Borgenicht Gallery
Inc.
Photograph by David Lee Brown

Arthur G. Dove
A Cross in the Tree. 1935
28 x 20. oil/canvas
Courtesy Terry Dintenfass, Inc.
Photograph by Geoffrey Clements

Jimmy Ernst
Across a Wall. 1964
21 x 15. oil/canvas
Courtesy Grace Borgenicht Gallery
Inc.
Photograph by Walter Rosenblum

Richard Estes
Bus Reflection. 1972
38½ x 50½. canvas
Photograph Courtesy Allan Stone
Gallery

John Ferren
Eucalyptus. 1955
48 x 36. oil/canvas
Courtesy A. M. Sachs Gallery
Photograph by Eeva-Inkeri

Janet Fish
 Painted Water Glasses. 1974
 53¾ x 60. oil/canvas
 Collection The Whitney Museum of
 American Art
 Gift of Sue and David Workman
 Photograph by Eeva-Inkeri

Sam Francis
 Untitled. 1971
 25 x 35. lithograph
 Private collection
 Photograph O. E. Nelson

Helen Frankenthaler
 Inplace. 1975
 37 x 69. acrylic/canvas
 Courtesy Andre Emmerich Gallery
 Photograph by Geoffrey Clements

Ralph Goings
 Market. 1973
 36 x 52. oil/canvas
 Courtesy OK Harris Works of Art
 Photograph by Eric Pollitzer

Sidney Goodman
 Portrait of Five Figures. 1974
 52 x 72. oil/canvas
 Courtesy Terry Dintenfass, Inc.

Joseph Goto
 #12. 1963
 h. 13. welded steel
 Courtesy The Zabriskie Gallery
 Photograph by Nathan Rabin

Chaim Gross
 Mother and Children on a Unicycle.
 n.d.
 26 x 24. bronze
 Courtesy The Forum Gallery
 Photograph by Walter Russell

Nancy Grossman
 Head. 1968
 16¼ x 6½ x 8½. epoxy, leather, and
 wood
 Collection The Whitney Museum of
 American Art
 Gift of the Howard and Jean Lipman
 Foundation, Inc.
 Photograph by Geoffrey Clements

Roy Gussow
 Two Forms. 1973
 8½ x 10½ x 13½. stainless steel
 Courtesy Grace Borgenicht Gallery
 Inc.

Richard Haas
 Flatiron Building. 1973
 41¼ x 17½. etching
 Courtesy Brooke Alexander
 Photograph by Eric Pollitzer

Dimitri Hadzi
 Thermopylae. n.d.
 h. 16'. bronze
 Courtesy the artist

Duane Hanson
 Man against Wall. 1974
 life size. polyester and fiberglas
 Courtesy OK Harris Works of Art
 Photograph by Eric Pollitzer

Al Held
 Flemish X. 1975
 5' x 5'. acrylic/canvas
 Courtesy Andre Emmerich Gallery
 Photograph by Geoffrey Clements

Hans Hofmann
 Pre-Dawn. 1960
 72 x 60. oil/canvas
 Courtesy Andre Emmerich Gallery
 Photograph by Geoffrey Clements

Budd Hopkins
 Mahler's Castle. 1972
 98 x 140. oil/canvas
 Courtesy William Zierler Inc.
 Photograph by Geoffrey Clements

Will Insley
 Wall Fragment. 1975
 80 x 55¼ x 62 x 84¾. acrylic/masonite
 Courtesy Fischbach Gallery

Paul Jenkins
 Phenomena Winds of Trance. 1974
 77 x 149. acrylic/canvas
 Courtesy Gimpel & Weitzenhoffer
 Ltd.
 Photograph by Geoffrey Clements

metal grommets
Courtesy Leo Castelli Inc.
Photograph by Eric Pollitzer

Robert Motherwell
Elegy to the Spanish Republic No.
128. 1974
96 x 120. acrylic/canvas
Courtesy Knoedler Contemporary
Art.
Photograph by Steven Sloman

Louise Nevelson
Night Zug Wall. 1973
168 x 144 x 10½. black-painted wood
Courtesy The Pace Gallery, New
York
Photograph Al Mozell

Isamu Noguchi
Humpty Dumpty. 1959-73
67 x 39¾ x 8. stainless steel
Courtesy The Pace Gallery, New
York
Photograph by Al Mozell

Wayne Nowack
Theoretical Instrument for the Extra-
dition of Anemie. 1969
13½ x 19⅛ x 4½. mixed media
Courtesy Allan Stone Gallery
Photograph by John D. Schiff

Claes Oldenburg
Geometric Mouse, Scale X. 1971
steel
Courtesy Lippincott Inc.
Photograph by Roxanne Everett

George Ortman
Badge. 1969
24 x 38. acrylic/canvas and aluminum
Courtesy Gimpel & Weitzenhoffer
Ltd.

Philip Pearlstein
Female Model, Legs Up against Wall.
1975
72 x 59. oil/canvas
Courtesy Allan Frumkin Gallery
Photograph by Eeva-Inkeri

Jackson Pollock
Number 9. 1951
57⅛ x 38½. duco on canvas
Collection Lee Krasner Pollack
Photograph by O. E. Nelson

Larry Poons
Goodbye Vinnie. 1975
101 x 70. acrylic/canvas
Courtesy Knoedler Contemporary
Art

Joseph Raffael
City of Refuge. 1975
78 x 126. oil/canvas
Courtesy Nancy Hoffman Gallery
Photograph by Bevan Davies

Larry Rivers
Kinko the Nymph Bringing Happy
Tidings. 1974
78 x 108. acrylic/canvas
Courtesy Marlborough Gallery, Inc.
Photograph by Robert E. Mates and
Paul Katz

Theodore Roszak
Flight. 1970-71
48 x 60. steel
Courtesy Pierre Matisse Gallery

Lucas Samaras
Large Word Drawing #32. 1975
23⅝ x 17⅞. ink/paper
Courtesy The Pace Gallery, New
York
Photograph by Al Mozell

Ludwig Sander
Adirondack II. 1971
54 x 60. oil/canvas
Courtesy Knoedler Contemporary
Art
Photograph by Eric Pollitzer

Peter Saul
Cowboy. 1974
72 x 56. acrylic/canvas
Courtesy Allan Frumkin Gallery
Photograph by Eeva-Inkeri

Salvatore Scarpitta
Settlement and Pouch Sled. 1974

canvas: 7' 9" x 7' ½"
sled: 9' 4" x c. 25". wood, canvas, and
 resin
Courtesy Leo Castelli Inc.
Photograph by Bruce C. Jones

George Segal
 Bas-Relief: Girl with Hands above
 Her Head. 1973
 42½ x 28 x 11. plaster
 Courtesy Sidney Janis Gallery
 Photograph by O. E. Nelson

Charles Shaw
 Sketch for Shaped Canvas. 1936
 pencil/paper
 Courtesy Archives of American Art
 Charles Shaw Papers

David Smith
 Untitled. 1953
 85½ x 32 x 21½. rusted steel and acid-
 treated steel
 Courtesy Knoedler Contemporary
 Art

Keith Sonnier
 Untitled. 1971
 74½ x 81½ x 45. neon
 Courtesy Leo Castelli Inc.
 Photograph by Eric Pollitzer

Richard Stankiewicz
 Untitled. 1974
 23 x 19 x 17. welded steel
 Courtesy The Zabriskie Gallery
 Photograph by John A. Ferrari

Saul Steinberg
 Villa Maria. 1972
 19½ x 25½. ink and crayon/paper
 Courtesy Sidney Janis Gallery
 Photograph by O. E. Nelson

George Sugarman
 Kite Castle. 1974
 polychromed steel
 Courtesy Lippincott Inc.
 Photograph by Roxanne Everett

Paul Suttman
 Fruit Table I. 1967

19 x 20. bronze
Courtesy Terry Dintefass, Inc.

Michael Todd
 Lasso. 1973
 c. 14 x 17. steel
 Courtesy The Zabriskie Gallery

Richard Tuttle
 Rust-Colored Triangle with Parallel-
 ogram Added an Apex. 1967
 66 x 52½. cloth
 Courtesy Betty Parsons Gallery
 Photograph by Gwyn Metz

Jack Tworkov
 Knight Series OC #3, Q3-75-#4. 1975
 90 x 75. oil/canvas
 Courtesy Nancy Hoffman Gallery
 Photograph by Bevan Davies

Steve Urry
 Mini Blat II. 1971
 h. c. 12. aluminum
 Courtesy The Zabriskie Gallery
 Photograph by John A. Ferrari

Ruth Vollmer
 Archimedean Screw. 1973
 h. 15—dia. 3. acrylic rod
 Courtesy Betty Parsons Gallery
 Photograph by H. Landshoff

David Von Schlegell
 Model for Gate. 1974
 8' x 8' x 5', each element. stainless
 steel
 Courtesy The Pace Gallery
 Photograph by Al Mozell

Andy Warhol
 Portrait of Dorothy. 1974
 two panels: 40 x 40 each. oil and
 silkscreen/canvas
 Courtesy Leo Castelli Inc.

John Wesley
 Pet. 1972
 23½ x 39¼. acrylic/canvas
 Courtesy Robert Elkon Gallery
 Photograph by Eeva-Inkeri

Tom Wesselmann
 1970 Nude. 1975
 17⅜ x 28¾. pencil and liquatex/rag-
 board
 Courtesy Sidney Janis Gallery, N.Y.
 Photograph by Eric Pollitzer

H. C. Westermann
 A New Piece of Land. 1973
 30½ x 25½ x 24. vermilion wood,
 ebony, maple, pine tar
 Courtesy Allan Frumkin Gallery
 Photograph by Eric Pollitzer

John Willenbecher
 The Table (I). 1975
 16½ x 96 x 96. wood, plexiglass,
 acrylic paint
 Courtesy A. M. Sachs Gallery
 Photograph by Eeva-Inkeri

Jean Xceron
 No. 239A. 1937
 51 x 35. oil/canvas
 Courtesy Washburn Gallery Inc.
 Photograph by Geoffrey Clements

Jack Youngerman
 Centaurus. 1975
 68 x 74 x 41. fiberglas and polyester
 resin
 Courtesy The Pace Gallery, New
 York
 Photograph by Hans Namuth

Index of Artists

and Pronunciation Guide

(A) Painter; (A^1) Watercolorist; (B) Sculptor; (C) Printmaker; (D) Assemblagist; (E) Teacher; (F) Happenings; (G) Mosaicist; (H) Draftsman; (I) Conceptualist

A
1. Aach, Herb (A)
2. Acconci, Vito (B)
 Ah con she
3. Acton, Arlo C. (B)
4. Adams, Clinton (A,C)
5. Adams, Pat (A)
6. Adler, Samuel M. (A)
7. Agostini, Peter (B)
8. Albers, Josef (A,C,E)
9. Albert, Calvin (B)
10. Albright, Ivan Le Lorraine (A)
11. Alcalay, Albert (A)
12. Alston, Charles Henry (A)
13. Altman, Harold (C,A)
14. Altoon, John (A)
15. Amen, Irving (C)
16. Anderson, Guy Irving (A)
17. Anderson, Jeremy R. (B)
18. Anderson, John S. (B)
19. Anderson, Lennart (A)
20. Andre, Carl (B)
21. Andrejevic, Milet (A)
 An **dre** avic, Millet
22. Andrews, Oliver (B)
23. Antonakos, Stephen (B)
24. Antreasian, Garo (C)
 An **tray** sian
25. Anuszkiewicz, Richard (A)
 Anu **skay** vitch
26. Arakawa, Shusaku (A,C)
27. Archipenko, Alexander (B,E)

28. Arman (B,D)
29. Arnold, Anne (B)
30. Aronson, David (A)
31. Artschwager, Richard (A,B)
32. Atherton, John C. (A)
33. Ault, George, C. (A)
34. Austin, Darrel (A)
35. Avedisian, Edward (A)
36. Avery, Milton (A)
37. Azuma, Norio (C)

B
38. Baber, Alice (A)
39. Baer, Jo (A)
 Bear
40. Bailey, William (A,E)
41. Baizerman, Saul (B)
42. Baldessari, John (I)
43. Bang, Thomas (B)
44. Bannard, Darby (A)
45. Baringer, Richard E. (A)
46. Barnes, Robert (A)
47. Barnet, Will (A,C,E)
48. Barry, Robert (B,I)
49. Baskin, Leonard (B,C,E)
50. Bauermeister, Mary (A,D)
51. Bayer, Herbert (A)
52. Baylinson, A. S. (A)
53. Baziotes, William A. (A,E)
54. Beal, Gifford (A)
55. Beal, Jack (A)
56. Bearden, Romare (A)

8

Key to Museums
and Institutions and
Their Schools — reflecting ownership of art collections in which are represented works of the artists in this book

A

AAAL. American Academy of Arts and Letters, NYC

A.F.A. American Federation of Arts, NYC

ASL. Art Students League, NYC

AT&T. American Telephone & Telegraph Co.

Aachen. Museen der Stadt Aachen, Germany

Aachen/Kunstverein. Kunstverein, Aachen, Germany

Aachen/NG. Neue Galerie im der Stadt Aachen, Aachen, Germany

Abbot Academy, Andover, Mass.

Abbott Laboratories

Abilene Christian College

Abraham Lincoln High School, Brooklyn, N.Y.

Academy of Fine Arts, Warsaw—*see* Warsaw

Academy of Natural Sciences, Philadelphia—*see* PMA

Achenbach Foundation for Graphic Arts, San Francisco, Calif.

Ackland. William Hays Ackland Memorial Art Center, Chapel Hill, N.C.

Addison Gallery of Art—*see* Andover /Phillips

Adelaide. The Art Gallery of South Australia, Adelaide, Australia

Adelphi U.

Aetna Oil Co.

Agricultural and Mechanical College of Texas

Ain Harod. Mishkan Le'omanuth Museum of Art, Ain Harod, Israel

Akron/AI. Akron Art Institute, Akron, Ohio

Alabama Institute of Technology

Alabama Polytechnic Institute, Auburn, N.Y.

U. of Alabama

Albany/Institute. Albany Institute of History and Art, Albany, N.Y.

Albany Mall—*see* South Mall, Albany

Albany/SUNY. State University of New York, at Albany

U. of Alberta, Edmondton (Alta.), Canada

Albertina (Vienna)—*see* Graphische Sammlung Albertina

Albion College

Albrecht Gallery Museum of Art—*see* St. Joseph/Albrecht

Albright-Knox Art Gallery—*see* Buffalo/Albright

Alcoa. Aluminum Company of America

Larry Aldrich Museum—*see* Ridgefield/Aldrich

Alfred/SUNY. State University of New York, at Alfred

Allegheny College

Allen-Bradley Co. Inc.

Allen Memorial Art Museum—*see* Oberlin College

Allentown/AM. Allentown Art Museum, Allentown, Pa.

Lyman Allyn Museum—*see* New London

Alverthorpe Gallery, Jenkintown, Pa.
American Academy, Rome
American Academy of Arts and
 Letters—see AAAL
American Airlines
American Association of University
 Women
American Broadcasting Co.
American Can Corp.
American Car and Foundry Co.
American Export Isbrandtsen Lines Inc.
American Federation of Arts—see A.F.A.
American Life and Casualty Insurance
 Co.
American Locomotive Co.
American Museum of Immigration,
 NYC
American National Fire Insurance Co.
 Collection
American Republic Insurance Co.
American Swedish Historical Museum,
 Philadelphia, Pa.
American Swedish Institute, Minne-
 apolis, Minn.
American Telephone & Telegraph
 Co.—see AT&T
American Tobacco Co.
American U.
Amherst College
Amsterdam/Stedelijk. Stedelijk Mu-
 seum, Amsterdam, Holland
Amstar Corp.
Anchorage. Anchorage Historical and
 Fine Arts, Anchorage, Alaska
Arthur Anderson & Co.
Anderson Clayton Company
Andover/Phillips. Phillips Academy,
 Addison Gallery of American Art,
 Mass. Phillips Academy
The M.L. Annenberg Foundation,
 Philadelphia, Pa.
Anthology Film Archives
Antwerp. Musee Royal des Beaux-Art,
 Antwerp, Belgium
Argentina/Nacional. Museo Nacional
 de Bellas Artes, Buenos Aires, Argen-
 tina
Arizona State College
Arizona State U.
U. of Arizona
U. of Arkansas (incl. Arkansas Art
 Center)
Arnot Art Museum, Elmira, N.Y.

Art Council of Pakistan—see Karachi
Art Gallery of New South Wales—see
 Sydney/AG
Art Gallery of South Australia,
 Adelaide—see Adelaide
Art Students League—see ASL
Art of This Century (Peggy Guggen-
 heim), Venice, Italy
Arts Club of Chicago, Illinois
Arts Council of Great Britain, London,
 England
Ashland Oil Inc., NYC
Aspen Institute for Humanistic Studies,
 Aspen, Colo.
Associated Coin Amusement Company
Astor Place, NYC
Atlanta/AA. Atlanta Art Association,
 Atlanta, Ga.
Atlanta Corp., Atlanta, Ga.
Atlanta U.
Atlantic Richfield Co.
Atwater Kent Museum, Philadelphia,
 Pa.
Auburn U.
Aubusson. College de la Manufacture
 d'Aubusson, Aubusson, France
Auckland. Auckland City Art Gallery,
 Auckland, New Zealand
Augusta, Me./State. Maine State Mu-
 seum, Augusta, Me.
Austin. Texas Fine Arts Association,
 Austin, Tex.
Australian National Gallery,
 Canberra—see Canberra/National
Avco Corp.
Avon Products, NYC
L. S. Ayres & Co.

B
Baker U.
Ball State U. (formerly Teachers Col-
 lege), Muncie, Ind.
Baltimore/MA. Baltimore Museum of
 Art, Baltimore, Md.
U. of Baltimore
Baltimore/Walters. Walters Art Gal-
 lery, Baltimore, Md.
Bangor Public Library, Bangor, Me.
Bank of America
Bank of California
The Bank of California N.A., Portland,
 Ore.
Bank of Chicago

The Bank of New York (NYC)
Bank of Omaha (Neb.)
Bankers Trust Company, NYC
Barat College of the Sacred Heart
Barcelona. Museo de Arte Moderno, Barcelona, Spain
Barnard College
Barnes Foundation, Merion, Pa.
Baseball Museum, Baltimore, Md.
Basel. Kunstmuseum Basel, Switzerland
Bat-Yam Museum—see Rybak
Baton-Rouge. State of Louisiana Art Commission, Baton Rouge, La.
Bauhaus-Archiv, Darmstadt, Germany
Beach Public School, Portland, Ore.
Belgian Ministry of National Education, Brussels, Belgium
Belgrade/National. Narodni Muzej (National Museum), Belgrade, Yugoslavia
Bellevue Hospital, NYC
Bellevue, Wash. Bellevue Arts & Crafts Association
Beloit College (incl. Wright Art Center)
Belvedere. Osterreichische Galerie im Belvedere in Wein, Vienna, Austria
Bennington College
Berea College
Bergen Community College, Paramus, N.J.
John Nelson Bergstrom Art Center and Museum—see Neenah/Bergstrom
Berkshire Atheneum—see Pittsfield /Berkshire
Berlin. Staatliche Museen, Berlin, West Germany
Berlin/National. Nationalgalerie, Berlin, West Germany
Berne. Kunsthalle Berne, Switzerland
Betcar Corp.
Bethlehem Steel Corp.
Bezalel Museum, Jerusalem, Israel. Bezalel Art School
Bibliotheque Nationale, Paris, France
Bibliotheque Royale de Belgique, Brussels, Belgium
Bielefeld. Stadtisches Kunsthaus, Bielefeld, Germany
Birla Academy of Art and Culture—see Calcutta
Birmingham, Ala./MA. Birmingham Museum of Art, Birmingham, Ala.

Black Mountain College, Beria, N.C.
Blanden Memorial Art Gallery—see Fort Dodge/Blanden
Block Drug Co., Jersey City, N.J.
Boise-Cascade Corp.
Bordighera. Galleria d'Arte Moderna, Bordighera, Italy
Borgon Associates
Borg-Warner International Corporation
Boston/MFA. Museum of Fine Arts, Boston, Mass. Boston Museum School
Boston Public Library, Boston, Mass.
Boston U.
Boulogne. Musee des Beaux-Arts, Boulogne, France
Bowdoin College
Bowling Green State U., Bowling Green, Ohio
Bradford Junior College, Bradford, Mass.
Bradley U.
Brandeis U. (incl. Rose Art Museum)
Archie Bray Foundation, Helena, Mont.
Bremen. Kunsthalle Bremen, Germany
Brenton Bank, Des Moines, Iowa
Bridgeport. Museum of Art, Science and Industry, Bridgeport, Conn.
Bridgestone Museum, Tokyo, Japan
Brigham Young U.
Bristol-Meyers Co.
Britannica. Encyclopaedia Britannica
U. of British Columbia, Vancouver (B.C.), Canada
British Museum, London, England
Brockton/Fuller. Fuller Memorial Art Center, Brockton, Mass
Brookgreen Gardens, Georgetown, S.C.
Brookings Institute, Washington, D.C.
Brooklyn College of the City University of New York
Brooklyn Museum, Brooklyn, N.Y. Brooklyn Museum School
Bobbie Brooks Inc.
Brooks Memorial Art Gallery—see Memphis/Brooks
Brown U.
Bruce Museum, Greenwich, Conn.
Brunswick.Stadtisches Museum, Brunswick, Germany
Brussels/Beaux Arts. Palais des Beaux-

Arts, Brussels, Belgium

Brussels/Moderne. Musee d'Art Moderne, Brussels, Belgium

Brussels/Royaux. Musees Royaux des Beaux-Arts de Belgium

Bryn Mawr College

Buckingham Palace, London, England

Budapest/National. Hungarian National Gallery, Budapest, Hungary

The Budd Co.

Buenos Aires/Moderno. Museo de Arte Moderno, Buenos Aires, Argentina

Buenos Aires/Municipal. Museo Munipal de Bellas Artes y Arte Nacional, Buenos Aires, Argentina

Buffalo/Albright. Albright-Knox Art Gallery, Buffalo, N.Y. **Albright Art School** (prior to 1962)

Buffalo/SUNY. State University of New York, at Buffalo

Bundy Art Gallery—*see* Waitsfield/Bundy

Burlington Industries

Burlington Mills Collection

Harry and Della Burpee Gallery—*see* Rockford/Burpee

Busch-Reisinger Museum, Cambridge, Mass.

Business Card, Inc.

The Butler Institute of American Art—*see* Youngstown/Butler

C

CIA. Central Intelligence Agency, Washington, D.C.

CIT Corporation

CSCS. California State College System (when known, individual campuses are listed in the artists' entries)

CSFA (California School of Fine Arts)—*see* SFAI

Calcutta. Birla Academy of Art and Culture, Calcutta, India

U. of Calgary, Alberta, Canada

California Academy of Science, Museum and Library, San Francisco, Calif.

California College of Arts and Crafts

California Federal Savings and Loan Association, Los Angeles

California Palace of The Legion of Honor, San Francisco, Calif.

California School of Fine Arts—*see* SFAI

California State College System—*see* CSCS

California State Fair

California State Library

California State U.

California Watercolor Society

U. of California

The Cambridge School, Weston, Mass.

Cambridge, University of, Cambridge, England

The Canada Council, Ottawa (Ont.), Canada

Canadian Industries Ltd., Montreal (Que.), Canada

Canadian Society of Graphic Art

Canajoharie Library and Art Gallery, Canajoharie, N.Y.

Canberra/National. Australian National Gallery, Canberra, Australia

Canton Art Institute, Canton, Ohio

Capehart Corp.

Cape Town. South African National Gallery, Cape Town, Union of South Africa

Capitol Records, Inc.

Caracas. Museo de Bellas Artes de Caracas, Venezuela

Caracas/Contemporaneo. Museo de Arte Contemporaneo, Caracas, Venezuela

Carborundum Company

Cardiff—*see* National Museum of Wales

Carleton College

Carnegie Institute of Technology, Pittsburgh, Pa.

Carolina Art Association—*see* Charleston/Carolina

Amon Carter Museum of Western Art, Fort Worth, Tex.

La Casa del Libro, San Juan, Puerto Rico

Case Institute of Technology

The Catholic U. of America

Cedar Rapids/AA. Cedar Rapids Art Association, Cedar Rapids, Iowa

Central Florida Museum—*see* Orlando

Centraal Museum, Utrecht—*see* Utrecht

Central Research Corp., NYC

Centre National d'Art Contemporain—*see* CNAC

Centro Artistico de Barranquilla, Barranquilla, Colombia

Century Association, NYC

Ceret. Musee d'Art Moderne, Ceret,

France
Chaffey College
Charleston/Carolina. Carolina Art Association, Charleston, S.C.
Charleston, W. Va. Charleston Art Gallery, Charleston, W. Va.
Charlotte/Mint. Mint Museum of Art, Charlotte, N.C.
Chase Manhattan Bank
Chateau de Rohan, Strasbourg, France
Chattanooga/AA. Chattanooga Art Association, Chattanooga, Tenn.
Chattanooga/Hunter. Hunter Museum of Art, Chattanooga, Tenn.
Chautauqua Institute, Chautauqua, N.Y.
Cheekwood, Nashville, Tenn.
Chicago/AI. The Art Institute of Chicago, Ill. **Chicago Art Institute School** (and **Junior School**)
Chicago Arts Club—*see* Arts Club of Chicago
Chicago/Contemporary. Museum of Contemporary Art, Chicago, Ill.
Chicago Public Schools, Chicago, Ill.
The U. of Chicago (incl. Renaissance Society)
Chico State College (incl. Chico Art Center)
Choate Rosemary Hall School, Wallingford, Conn.
Chouinard Art Institute, Los Angeles, Calif.
Christian Theological Seminary, Indianapolis, Ind.
Chrysler Corp.
Walter P. Chrysler Museum of Art—*see* Norfolk/Chrysler
Ciba-Geigy Corp., Ardsley, N.Y.
Cincinnati/AM. The Cincinnati Art Museum, Cincinnati, Ohio. **Cincinnati Museum School**
Cincinnati/Contemporary. Contemporary Arts Center, Cincinnati, Ohio.
U. of Cincinnati
Cinematheque de Belgique, Brussels, Belgium
Cinematheque Francaise, Paris, France
Citizens Fidelity Bank, Louisville, Ky.
City of Chalon-sur-Soane, France
City of Claremont, Calif.
City College of the City University of New York

City of Fresno, Calif.
City of Hamburg, Germany
City of Hannover, Germany
City Investing Corp., NYC
City of Mill Valley, Calif.
City of Oakland, Calif.
City of San Francisco, Calif.
City of Tilburg, Holland
City of Toronto (Ont.), Canada
Civic Center Synagogue, NYC
Clairol Inc.
Claremont College
Clearwater/Gulf Coast. Florida Gulf Coast Art Center, Inc., Clearwater, Fla.
Cleveland/MA. The Cleveland Museum of Art, Cleveland, Ohio
Cleveland Trust Co.
The Coca-Cola Co.
Cochran Memorial Park, St. Paul, Minn.
Coe College
Colby College
Colgate U.
Collection de l'Etat, Paris, France
College des Musees Nationaux de France, Paris, France
College of St. Benedict
Cologne. Wallraf-Richartz-Museum, Cologne, Germany
Cologne/Kunstverein. Kolnischer Kunstverein, Cologne, Germany
Cologne/NG. Neue Galerie im Alten Kurhaus, Cologne, Germany
Colonial Bank & Trust Co., Waterbury, Conn.
Colonial Williamsburg. Williamsburg, Va.
Colorado College
Colorado Springs/FA. Colorado Springs Fine Arts Center, Colorado Springs, Colo.
Colorado State U.
U. of Colorado
Columbia, Mo. State Historical Society of Missouri, Columbia, Mo.
Columbia, S.C./MA. Columbia Museum of Art, Columbia, S.C.
Columbia Banking, Savings and Loan Association, Rochester, N.Y.
Columbia Broadcasting System
Columbia U.
Columbus. Columbus Gallery of Fine

Arts, Columbus, Ohio

Columbus, Ga. Columbus Museum of Arts and Crafts, Columbus, Ga.

Commerce Bank of Kansas City

Commerce Bank of St. Louis

Commerce Trust Co., Kansas City, Mo.

Community Arts Foundation, Los Angeles, Calif.

Concordia Teachers College (Ill.)

Concordia Teachers College (Neb.)

Connecticut Community College

Connecticut Life Insurance Company

Connecticut College

U. of Connecticut

Conover-Mast Publications Inc.

Container Corp. of America

Continental Grain Company

Cooperative Insurance Society, Manchester, England

Cooper Union. The Cooper Union Museum, NYC

Coos Bay Art Museum, Ore.

Copenhagen. Statens Museum fur Kunst, Copenhagen, Denmark

Corcoran. The Corcoran Gallery of Art, Washington, D.C. **The Corcoran School of Art**

Cordoba/Municipal. Museo Municipal de Cordoba, Argentina

Cordoba/Provincial. Museo Provincial de Bellas Artes, Cordoba, Argentina

Cornell College, Mt. Vernon, Iowa

Cornell U. (incl. Herbert F. Johnson Museum)

Cortland/SUNY. State University of New York, at Cortland

Corvallis (Ore.) First Federal Savings and Loan

Courtlauld Institute, London, England

Craig Elwood Associates

Cranbrook. Cranbrook Academy of Art, Bloomfield Hills, Mich.

E.B. Crocker Art Gallery—*see* Sacramento/Crocker

Crown Zellerbach Foundation, San Francisco, Calif.

Cuenca. Museo Municipal de Arte, Cuenca, Spain

Cummer Gallery of Art—*see* Jacksonville/Cummer

Currier. Currier Gallery of Art, Manchester, N.H. **Currier Gallery School**

D

Dallas Museum for Contemporary Arts, Dallas, Tex.—*see* Dallas/MFA

Dallas/MFA. Dallas Museum of Fine Arts, Dallas, Tex. **Dallas Museum School**

Dallas Public Library, Dallas, Tex.

Dalton School, NYC

Darmstadt/Hessisches. Hessisches Landesmuseum, Darmstadt, Germany

Darmstadt/Kunsthalle Kunsthalle, Darmstadt, Germany

Dartmouth College (incl. Hopkins Art Center)

Davenport/Municipal. Davenport Municipal Art Gallery, Davenport, Iowa

Davidson, N.C. Davidson Art Center, Davidson, N.C.

Davison Art Center—*see* Wesleyan U. (Conn.)

Dayton/AI. Dayton Art Institute, Dayton, Ohio. **Dayton Art Institute School**

De Beers Collection, Johannesburg, South Africa

Debevoise, Plimpton, Lyons and Gates, NYC

Decatur. Decatur Art Center, Decatur, Ill.

De Cordova and Dana Museum—*see* Lincoln, Mass./De Cordova

DeKalb. Northern Illinois U., DeKalb, Ill.

Delaware Art Center—*see* Wilmington

Delaware Art Museum, Wilmington, Del.

U. of Delaware

Isaac Delgado Museum of Art—*see* New Orleans/Delgado

Denison U.

Denver/AM. Denver Art Museum, Denver, Colo.

De Pauw U.

Des Moines. The Des Moines Art Center, Des Moines, Iowa

Des Moines Register & Tribune, Des Moines, Iowas

Detroit/Institute. The Detroit Institute of Arts, Detroit, Mich.

de Young. M. H. de Young Memorial Museum, San Francisco, Calif.

Diablo Valley College
Didrichsen Foundation, Helsinki, Finland
Dillard U.
Djakarta Museum, Djakarta, Indonesia
Doane College
Donaldson, Lufkin, & Jenrette, Inc.
Jay Dorf, Inc.
Downey Museum of Art, Downey, Calif.
Downtown Community School, NYC
Drake U.
Dresdener Bank, Los Angeles, Calif.
Dublin/Municipal. Municipal Gallery of Modern Art, Dublin, Ireland
U. of Dublin, Dublin, Ireland
Dubuque/AA. Dubuque Art Association, Dubuque, Iowa
Duisburg. Wilhelm-Lehmbruck-Museum der Stadt Duisburg, Germany
Duke U.
Dulin Gallery of Art, Knoxville, Tenn.
Dusseldorf. Kunstmuseum der Stadt Dusseldorf, Germany
Dusseldorf/KN-W. Kunstsammlung Nordrhein-Westfalen, Dusseldorf, Germany
Dusseldorf/Kunsthalle. Stadtische Kunsthalle, Dusseldorf, Germany

E
Earlham College
U. of East Anglia, Norwich, England
East Tennessee State College Museum of Art, Johnson City, Tenn.
Eastern Michigan U.
Eastern Oregon College
Eastland Shopping Center, Detroit, Mich.
Eaton Paper Corp.
Edinburgh/Modern. Scottish National Gallery of Modern Art, Edinburgh, Scotland
Edinburgh/National. National Gallery of Scotland, Edinburgh, Scotland
Eilat. Museum of Modern Art, Eilat, Israel
Eindhoven. Stedelijk van Abbe-Museum, Eindhoven, Holland
Ellerby Associates
Elmira College (N.Y.)

Emory U., Atlanta, Ga.
Equitable Life Assurance Society of the U.S.
Escuela Nacional de Artes Plasticas, Mexico City, Mexico
Essen. Museum Folkwang, Essen, Germany
Essen/NG. Neue Galerie, Essen, Germany
Esslingen. Stadtische Museum, Esslingen, Germany
Evansville. Evansville Museum of Arts and Sciences, Evansville, Ind. Evansville Museum School
Everett Junior College, Everett, Wash.
Everhart Museum—see Scranton/Everhart
Everson Museum of Art—see Syracuse /Everson
Exchange National Bank, Chicago, Ill.
Exeter. Phillips Exeter Academy, The Lamont Art Gallery, Exeter, N.H.

F
F.T.D. Association (Florists Transworld Delivery Association)
Fairleigh Dickinson U.
Fairmont Park Association, Philadelphia, Pa.
Farmers Elevator Insurance Co.
William A. Farnsworth Library and Art Museum—see Rockland/Farnsworth
Father Judge Mission Seminary, Lynchburg, Va.
Federal Deposit Insurance Corporation
Fidelity Bank, Philadelphia, Pa.
Hamilton Easter Field Foundation, Portland, Me.
57th Madison Corp., NYC
First City National Bank, Houston, Tex.
First National Bank of Boston
First National Bank of Chicago
First National Bank of Dallas
First National Bank, Iowa City, Iowa
First National Bank, Madison, Wisc.
First National Bank of Memphis, Tenn.
First National Bank, Minneapolis Minn.
First National Bank of Nevada, Reno, Nev.
First National Bank of Oregon

First National Bank of Seattle, Wash.
First National Bank, Tampa, Fla.
First National City Bank
Fisk U.
Fitchburg/AM. Fitchburg Art Museum, Fitchburg, Mass.
525 William Penn Plaza, Philadelphia, Pa.
Robert Hull Fleming Museum—*see* U. of Vermont
Flint/Institute. Flint Institute of Arts, Flint, Mich.
Florence, Italy. Galleria dell'Accademia, Florence, Italy
Florence (Italy)/Modern. Galleria d'Arte Moderna, Florence, Italy
Florence, S.C., Museum. Florence Museum, Florence, S.C.
Florida Gulf Coast Art Center, Inc.—*see* Clearwater/Gulf Coast
Florida Southern College
Florida State U.
U. of Florida
Florsheim Foundation, Chicago, Ill.
Fogg Art Museum—*see* Harvard U.
Fontana-Hollywood Corp.
Ford Foundation
Fordham U.
Ford Motor Company
Fort Dodge/Blanden. Blanden Memorial Art Gallery, Fort Dodge, Iowa
Fort Lauderdale. Fort Lauderdale Museum of Art, Fort Lauderdale, Fla.
Fort Wayne/AM. Fort Wayne Art Museum, Fort Wayne, Ind.
Fort Worth. Fort Worth Art Center, Fort Worth, Tex.
Fort Wright College, Spokane, Wash.
Foundation Maeght, St. Paul-de-Vence, France
405 Park Avenue, NYC
Four Seasons Restaurant, NYC
Fourth National Bank and Trust, Wichita, Kansas
France/National. Musee National d'Art Moderne, Paris, France (*see also* Paris-/Moderne)
Franchard Corp.
Frank Construction Company
Frankfurt am Main. Stadelsches Kunstinstitut, Frankfurt am Main, Germany
Franklin Institute, Philadelphia, Pa.

Simon Frazer U.
Fredonia/SUNY. State University of New York, at Fredonia
Free Library of Philadelphia, Pa.
French Ministry of National Education, Paris, France
Fresno State College
Friends of Art, Uniontown, Pa.
Fuller Memorial Art Center—*see* Brockton/Fuller
Fullerton Junior College (Calif.)

G

Galerie des 20. Jahrhunderts, Berlin, Germany
Galleria Comunale d'Arte Contemporanea, Arezzo, Italy
Gallery of Modern Art, NYC—*see* New York Cultural Center
Gallery of Modern Art, Washington, D.C.—*see* WGMA
Galveston. Galveston Historical Foundation Inc., Galveston, Tex.
Garcia Corp.
Garnett Public Library, Garnett, Kans.
Geigy Chemical Corp.—*see* Ciba-Geigy Corp.
Gelsenkirchen. Stadtische Kunstsammlung, Gelsenkirchen, Germany
General Electric Corp.
General Mills Inc.
General Motors Corp.
General Reinsurance Corp.
Geneseo/SUNY. State University of New York, at Geneseo
George Washington U.
George Washington Carver Junior College, Rockville, Md.
Georgia Institute of Technology
Georgia State U.
U. of Georgia (incl. Georgia Museum of Art)
Gettysburg College
Ghent. Musee des Beaux-Arts, Ghent, Belgium
Ghent/Moderne. Musee d'Art Moderne, Ghent, Belgium
Gibraltar Savings & Loan Association
Gimbel Bros.
U. of Glasgow, Glasgow, Scotland

Glen Alden Corp.
Goddard Art Center, Ardmore, Okla.
Goddard College
Golden Gateway Center, San Francisco, Calif.
Golden State Mutual Life Insurance Co.
Goldring International
Gothenburg—see Sweden/Goteborgs
Goucher College
Govett-Brewster Art Gallery, New Plymouth, New Zealand
The Grace Line
Grand Rapids. Grand Rapids Art Gallery, Grand Rapids, Mich.
Graphische Sammlung Albertina, Vienna, Austria
Graphische Sammlung der E. T. H. (Eidg. Technischen Hochschule), Zurich, Switzerland
Great Southwest Industrial Park, Atlanta, Ga.
Great Western Savings and Loan Association of South California, Los Angeles
Greece/National. National Picture Gallery, Athens, Greece
Greenville County Museum of Art, S.C.
Grenchen. Sammlungen der Museumgesellschaft, Grenchen, Switzerland
Grenoble. Musee des Beaux-Arts de Grenoble, France
Griffiths Art Center—see St. Lawrence U.
Grinnell College
Grolier Club, NYC
Grunewald Foundation for Graphic Arts, Los Angeles, Calif.
Guadalajara. Museo de Bellas Artes, Guadalajara, Mexico
The Solomon R. Guggenheim Museum—see SRGM
Guild Hall, East Hampton, N.Y.
Guild Plastics Co.
Gulf Coast Art Center—see Clearwater /Gulf Coast
Gulf Life Insurance Co., Jacksonville, Fla.
Gulf Oil Corp.
Gulf and Western Industries Inc.
A. V. Gumuchian, Inc.

H
Hackley Art Center—see Muskegon /Hackley
Hagen. Karl-Ernst-Osthaus-Museum, Hagen, Germany
Hagerstown/County MFA. Washington County Museum of Fine Arts, Hagerstown, Md.
The Hague. Haags Gemeentemuseum, The Hague, Holland
Haifa. Museum of Modern Art, Haifa, Israel
Hall of Justice, San Francisco, Calif.
Hallmark Collection
Hamburg. Hamburger Kunsthalle, Hamburg, Germany
Hamburg/Kunstverein. Kunstverein in Hamburg, Hamburg, Germany
Hamilton College
Hamline U.
Hampton Institute
Hampton School, Towson, Md.
Hannover. Stadtische Galerie, Hannover, Germany
Hannover/K-G. Kestner-Gesellschaft, Hannover, Germany (see also Kestner-Museum, Hannover)
Hannover/Kunstverein. Kunstverein Hannover, Hannover, Germany
Harcourt Brace Jovanovich Inc.
Harlem Hospital, NYC
Harmon Foundation Inc., NYC
Harrisburg/Pa. State Museum. Pennsylvania State Museum, Harrisburg, Pa. (incl. William Penn Memorial Museum)
Hartford (Conn.) State Library
Hartford/Wadsworth. The Wadsworth Atheneum, Hartford, Conn.
U. of Hartford
Harvard U. (incl. Fogg Art Museum)
Havana/Nacional. Museo Nacional, Havana, Cuba
Le Havre/Municipal. Musee Municipal, Le Havre, France (see also Musee du Havre)
Hawaii State Foundation
U. of Hawaii
Health and Hospital Corp., NYC
Hebron Academy, Hebron, Me.
Heckscher Museum—see Huntington, N.Y./Heckscher
H. J. Heinz Co., Pittsburgh, Pa.

Hellerup Commune, Copenhagen, Denmark

Helsinki. Ateneumin Taidemuseo, Helsinki, Finland

Hemisphere Club, NYC

Hempstead Bank, Hempstead, N.Y.

Henies-Onstadts Stiftelser, Hovikodden, Norway

John Herron Art Institute—see Indianapolis/Herron

Hershey Foods Corp.

Hessisches Landesmuseum, Darmstadt—see Darmstadt/Hessisches

The Hertz Corp.

Hickory, N.C. Hickory Museum of Art, Hickory, N.C.

High Museum of Art, Atlanta, Ga.

Hiroshima State Museum of Art (Japan)

Hirshhorn. The Hirshhorn Museum and Sculpture Garden, Smithsonian Institution, Washington D. C.

Historical Society of Montana, Helena, Mont.

Hoffman-La Roche Inc.

Hofstra U.

Hollins College

Holyoke Public Library, Holyoke, Mass.

Home Savings and Loan Association, Los Angeles, Calif.

Honolulu Academy of Arts, Honolulu, Hawaii. Honolulu Academy School

Hope College, Holland, Mich.

Hopkins Art Center—see Dartmouth College

Hospital Corp. of America

Hotel Corp. of America, NYC

Housatonic Community College, Stratford, Conn.

Houston/Contemporary. Contemporary Arts Museum, Houston, Tex.

Houston/MFA. Museum of Fine Arts of Houston, Texas. Houston Museum School

U. of Houston

Howard College

Howard U.

J. L. Hudson Co.

Hudson River Museum, Yonkers, N.Y.

Humlebaek/Louisiana. Louisiana Museum of Art, Humlebaek, Denmark

Hunt Foods & Industries

Hunter College of the City University of New York

Hunter Museum of Art—see Chattanooga/Hunter

Huntington, N.Y./Heckscher. Heckscher Museum, Huntington, N.Y.

Huntington, W. Va. Huntington Galleries, Huntington, W. Va.

Hyde Collection, Glens Falls, N.Y.

I

IBM. International Business Machines

ICA, Boston. Institute of Contemporary Art, Boston, Mass.

ICA, U. of Pennsylvania

ICA, Washington, D.C. Institute of Contemporary Arts, Washington, D.C.

IIE. International Institute of Education

ILGWU. International Ladies' Garment Workers Union

Idaho, College of

Idemitsu Museum, Tokyo, Japan

Illinois Bell Telephone Company

Illinois State Museum of Natural History and Art—see Springfield, Ill./State

Illinois State Normal U.

U. of Illinois (incl. Krannert Art Museum)

Illinois Wesleyan U.

Immaculate Heart College, Los Angeles, Calif.

Imperial Household, Tokyo, Japan

Indian Head Mills, Inc.

Indiana National Bank, Indianapolis, Ind.

Indiana State U. (formerly College), Terre Haute, Ind.

Indiana (Pa.) State Teachers College

Indiana U.

Indianapolis/Herron. John Herron Art Institute, Indianapolis, Ind.

Indianapolis Museum of Art, Indianapolis, Ind.

Industrial Electronics Engineers, Inc.

Industrial Museum, Barcelona, Spain

Inland Steel Co.

Inmont Corporation

Institut fur Moderne Kunst Nurnberg (Germany)

Institute of Contemporary Art(s)—see ICA, various cities

Institute of International Education—see

IIE
Institute for Policy Studies, Washington, D.C.
Interchemical Corporation
Interchurch Center, NYC
International Institute for Aesthetic Research, Turin, Italy
International Minerals & Chemicals Corp.
International Monetary Fund, Washington, D.C.
International Nickel Co.
Iowa State Education Association, Des Moines, Iowa
Iowa State Fair, Des Moines, Iowa
Iowa State Teachers College
Iowa State U. of Science and Technology
U. of Iowa
Iowa Wesleyan College
Ithaca College
Ivest-Wellington Corp.

J
Jacksonville/AM. Jacksonville Art Museum, Jacksonville, Fla.
Jacksonville/Cummer. Cummer Gallery of Art, Jacksonville, Fla.
Jacksonville U.
Jamestown/Prendergast. James Prendergast Free Library Art Gallery, Jamestown, N.Y.
Japanese Craft Museum, Tokyo, Japan
Jay Mfg. Co.
Jerusalem/National. National Museum, Jerusalem, Israel
Jesus College (Cambridge U.), Cambridge, England
Jewish Museum, NYC
Jewish Theological Seminary of America
Johannesburg/Municipal. Municipal Art Gallery, Johannesburg, South Africa
Johns Hopkins U.
Johnson College
Herbert F. Johnson Museum—see Cornell U.
Johnson Publishing Co., Chicago, Ill.
S. C. Johnson & Son, Inc.—see NCFA
Johnson Wax Co.
J. Turner Jones, Inc.
Jones & Laughlin Steel Corp.

Joslyn Art Museum—see Omaha/Joslyn
James Joyce Museum, Dublin, Ireland
Juilliard School, The, NYC

K
Kaiserslautern Museum, Kaiserslautern, Germany
Kalamazoo College
Kalamazoo/Institute. The Kalamazoo Institute of Arts, Kalamazoo, Mich. (incl. Kalamazoo Art Center)
Kamakura. Modern Art Museum of Kanagawa Prefecture, Kamakura, Japan
Kansas City/AI. Kansas City Art Institute and School of Design, Kansas City, Mo.
Kansas City/Nelson. William Rockhill Nelson Gallery of Art, Kansas City, Mo.
U. of Kansas City
Kansas State College
U. of Kansas
Karachi. Art Council of Pakistan, Karachi, Pakistan
Karamu House, Cleveland, Ohio
Karlsruhe. Staatliche Kunsthalle, Karlsruhe, Germany
Kassel. Stadtische Kunstsammlungen, Kassel, Germany
Kemper Insurance Co.
Kennedy Library, Cambridge, Mass.
Kent State U.
Kentucky Southern College, Louisville, Ky.
U. of Kentucky
Kenyon College
Kestner-Museum, Hannover, Germany (see also Hannover/K-G.)
Kingsborough Community College
Kirkland College, Clinton, N.Y.
Knoll Associates Inc.
Knox College, Galesburg, Ill.
Kolnisher Kunstverein, Cologne—see Cologne/Kunstverein
Krakow/National. National Museum, Krakow, Poland
Krannert Art Museum—see U. of Illinois
Krefeld/Haus Lange. Museum Haus Lange Wilhelmshofallee, Krefeld, Germany
Krefeld/Kaiser Wilhelm. Kaiser Wilhelm Museum, Krefeld, Germany

Kresge Art Center—*see* Michigan State U.
Kultusministerium, Hannover, Germany
Kultusministerium Baden-Wurttemberg, Stuttgart, Germany
Kunsthalle, Basel, Basel, Switzerland
Kunstkredit, Basel, Switzerland
Kunstverein in Hamburg—*see* Hamburg/Kunstverein
Kunstverein Hannover—*see* Hannover/Kunstverein
Kupferstichkabinett, Berlin, Germany
Kutztown State College

L
La France Art Institute, Philadelphia, Pa.
La Jolla. Museum of Art (formerly Art Center in La Jolla, La Jolla, Calif.)
Lakeview Center for Arts and Sciences, Peoria, Ill.
The Lamont Art Gallery—*see* Exeter
Lane Foundation, Leominster, Mass.
Lannan Foundation, NYC/Palm Beach, Fla./Chicago, Ill.
Lansing Sound Corp.
La Plata. Museo de La Plata, Argentina
H. E. Laufer Co.
Lawrence College
Layton School of Art, Milwaukee, Wisc.
League of Nations, Geneva, Switzerland
Lehigh U.
Leicester Education Committee, London, England
Leipzig. Museum der Bildenden Kunste Leipzig, Germany
Lembke Construction Co.
Lenox School, Lenox, Mass.
Leverkusen. Stadtisches Museum Leverkusen, Germany
Levin Townsend Computer Corp.
Lewiston (Me.) Public Library
Liaison Films, Inc.
Library of Congress, Washington, D.C.
Liege. Musee des Beaux Arts, Liege, Belgium
Lille. Palais des Beaux-Arts, Lille, France
Eli Lilly & Co.
Lima, Peru. Instituto de Arte Contemporaneo, Lima, Peru

Lincoln, Mass./De Cordova. De Cordova and Dana Museum, Lincoln, Mass.
Lincoln Center for the Performing Arts, NYC
Lincoln Life Insurance Co.
Lindenwood College
Linz. Oberosterreichisches Landesmuseum, Linz, Austria
Lipschultz Foundation
Little Rock/MFA. Museum of Fine Arts, Little Rock, Ark.
Litton Industries
Liverpool/Walker. Walker Art Gallery, Liverpool, England
Loch Haven Art Center, Orlando, Fla. (*see also* Orlando)
Lodz. Muzeum Sztuki w Lodzi, Lodz, Poland
London Film Society
Long Beach/MA. Long Beach Museum of Art, Long Beach, Calif.
Long Beach State College
Long Island U.
Longview Foundation
Longwood College
Los Angeles County Fair Association, Los Angeles, Calif.
Los Angeles/County MA. Los Angeles County Museum of Art, Los Angeles, Calif.
Los Angeles Public Library, Los Angeles, Calif.
Los Angeles State College, Los Angeles, Calif.
Lotus Club, NYC
Louisiana Museum of Art, Denmark—*see* Humlebaek/Louisiana
Louisiana State U. and Agricultural and Mechanical College
Louisville/Speed. J. B. Speed Art Museum, Louisville, Ky.
U. of Louisville
The Joe and Emily Lowe Art Gallery—*see* U. of Miami
The Joe and Emily Lowe Foundation, NYC
Lucerne. Kunstmuseum Luzern, Lucerne, Switzerland
Lugano. Museo Civico di Belle Arti, Lugano, Switzerland
Luther College
Lynchburg Art Gallery—*see* Randolph-Macon Women's College

Lytton Savings and Loan Association

M

MIT. Massachusetts Institute of Technology, Cambridge, Mass.

MMA. The Metropolitan Museum of Art, NYC

MOMA. The Museum of Modern Art, NYC. MOMA School

Norman MacKenzie Art Gallery—*see* Regina/MacKenzie

MacMurray College

MacNider Museum, Mason City, Iowa

Macomb County Community College, Warren, Mich.

R. H. Macy & Co.

Madison Art Center, Madison, Wisc.

Madison College

Madison Square Garden, NYC

Madrid/Nacional. Museo Nacional de Arte Contemporaneo, Madrid, Spain

Maeght—*see* Foundation Maeght

Maine State Museum—*see* Augusta, Me./State

U. of Maine

Malmo Museum, Malmo, Sweden

Manchester, England. City of Manchester Art Galleries, Manchester, England

Manila. Ateneo de Manila, P. I.

Mannheim. Stadtische Kunsthalle, Mannheim, Germany

Mansfield State College

Mansion House Project, St. Louis, Mo.

Manufacturers Hanover Trust Co.

Manufacturers and Traders Trust Co., Buffalo, N.Y.

Marbach Galerie, Berne, Switzerland

Marin Art and Garden Center, Ross, Calif.

Marine Midland Bank and Trust Co.

Marist College, Poughkeepsie, N.Y.

Mark Twain Bankshares, St. Louis, Mo.

Mark Twain South County Bank, St. Louis, Mo.

Marquette U.

Marshall Field & Co.

Marshall U.

Martha Washington U.

U. of Maryland

Marylhurst College

Mary Washington College of the U. of Virginia

U. of Massachusetts

Massillon Museum, Massillon, Ohio

McCann-Erickson, Inc.

McCrory Corporation

McDonald & Company

McDonnell & Co. Inc.

Marion Koogler McNay Art Institute—*see* San Antonio/McNay

Mead Corporation

Melbourne/National. National Gallery of Victoria, Melbourne (Victoria), Australia

Memphis/Brooks. Brooks Memorial Art Gallery, Memphis, Tenn.

Memphis State U.

Mendoza. Museo de Historia Natural, Mendoza, Argentina

Mestrovic Gallery, Split, Yugoslavia

Mestrovic Museum, Zagreb, Yugoslavia

Metalcraft Corp.

Meta-Mold Aluminum Co.

The Metropolitan Museum of Art, NYC—*see* MMA

Mexico City/Nacional. Museo Nacional de Arte Moderno, Mexico City, Mexico

Miami-Dade Junior College

Miami/Modern. Miami Museum of Modern Art, Miami, Fla.

U. of Miami (incl. The Joe and Emily Lowe Art Gallery)

James A. Michener Foundation—*see* U. of Texas

Michigan Consolidated Gas Co.

Michigan State U. (incl. Kresge Art Center)

U. of Michigan

Middlebury College, Middlebury, Vt.

Middle Tennessee State U.

Milan. Civica Galleria d'Arte Moderna, Milan, Italy

Miles College, Birmingham, Ala.

Miles Laboratories Inc.

Miles Metal Corp., NYC

The Miller Co.

Millikin U.

Mills College

Mills College of Education

Milton Academy, Milton, Mass.

Milwaukee. Milwaukee Art Center, Milwaukee, Wisc.

Milwaukee-Downer College

Milwaukee Journal
Minneapolis College of Art & Design
Minneapolis/Institute. Minneapolis Institute of Arts, Minneapolis, Minn.
Minneapolis Institute School
Minnesota/MA. Minnesota Museum of Art, St. Paul, Minn.
Minnesota State Historical Society, St. Paul, Minn.
U. of Minnesota (Duluth campus incl. Tweed Gallery)
Mint Museum of Art—*see* Charlotte /Mint
U. of Missouri
Mitsui Bank of Japan
Mobil Oil Co.
Moderna Museet—*see* Stockholm/National
Monchengladbach. Stadtisches Museum, Monchengladbach, Germany
Mons. Musee des Beaux-Arts, Mons, Belgium
Montana State College
Montana State U.
U. of Montana
Montclair/AM. Montclair Art Museum, Montclair, N.J.
Montclair State College
Montevideo/Municipal. Museo Municipal de Bellas Artes, Montevideo, Uruguay
Montgomery Museum of Fine Art, Montgomery, Ala.
Montpelier/Wood. Thomas W. Wood Art Gallery, Montpelier, Vt.
Montreal/Contemporain. Musee d'Art Contemporain, Montreal (Que.), Canada
Montreal/MFA. Montreal Museum of Fine Arts, Montreal (Que.), Canada
Montreal Trust Co.
Moorpark College, Moorpark, Calif.
Moravian College, Bethlehem, Pa.
The Morgan Library, NYC
Morgan State College
Moriarty Brothers, Manchester, Conn.
Morristown/Junior. Morris Junior Museum, Morristown, N.J.
Moscow/Western. Museum of Western Art, Moscow, USSR
Mount Holyoke College
Mt. Vernon High School, Mt. Vernon, Wash.

Muhlenberg College
Mulvane Art Museum—*see* Washburn U. of Topeka
Munich/Modern. Modern Art Museum, Munich, Germany
Munich/SG. Stadtische Galerie, Munich, Germany
Munich/State. Munchner Stadtmuseum, Munich, Germany
Municipal U. of Omaha
Munson-Williams-Proctor Institute—*see* Utica
Munster. Landesmuseum fur Kunst un Kulturgeschichte, Munster, Germany
Munster/WK. Westfalischer Kunstverein, Munster, Germany
Murray State U., Murray, Kentucky
Musee d'Art Contemporain, Montreal—*see* Montreal/Contemporain
Musee des Arts Decoratifs, Paris, France
Musee Cantonal des Beaux-Arts, Lausanne, Switzerland
Musee Guimet, Paris, France
Musee du Havre, Le Havre, France (*see also* Le Havre/Municipal)
Musee du Jeu de Paume, Paris, France
Musee Municipal, Brest, France
Musee de Quebec—*see* Quebec
Musee de Verviers, Verviers, Belgium
Musee du Vin, Pauillac (Gironde), France
Museo de Arte Contemporaneo, Caracas—*see* Caracas/Contemporaneo
Museo de Arte Contemporaneo R. Tamayo, Mexico City, Mexico
Museo de Arte Moderno, Barcelona—*see* Barcelona
Museo de Arte Moderno, Buenos Aires—*see* Buenos Aires/Moderno
Museo Dr. Genaro Perez, Cordoba, Argentina
Museo Emilio A. Caraffa, Cordoba, Argentina
Museo Juan B. Castagnino, Rosario, Argentina
Museo Municipal de Bellas Artes, Montevideo—*see* Montevideo/Municipal
Museo Municipal de Bellas Artes y Arte

Nacional, Buenos Aires—*see* Buenos Aires/Municipal

Museo Nacional de Bellas Artes, Buenos Aires—*see* Argentina/Nacional

Museo Nacional de Bellas Artes, Montevideo—*see* Uruguay/Nacional

Museo Nacional de Historia, Mexico City, Mexico

Museo Rosario, Santa Fe, Argentina

Museu de Arte Contemporanea, Sao Paulo—*see* Sao Paulo/Contemporanea

Museum of the City of New York

Museum of Contemporary Crafts, NYC

Museum of Living Art—*see* PMA

Museum of Military History, Washington, D.C.

Museum of Modern Art, Haifa—*see* Haifa

The Museum of Modern Art, NYC—*see* MOMA

Museum of Modern Art, Skopje—*see* Skopje/Modern

Museum of New Mexico Art Gallery—*see* Santa Fe, N.M.

Museum Schloss Marberg, Leverkusen, Germany

Museum of Science and Industry, Chicago, Ill.

Museum des 20. Jahrhunderts, Vienna, Austria

Muskegon/Hackley. Hackley Art Center, Muskegon, Mich.

Mutual Life Insurance Building, Chicago, Ill.

N

NAACP. National Association for the Advancement of Colored People

NAD. The National Academy of Design, NYC

NCFA. National Collection of Fine Arts, Washington, D.C.

NIAL. National Institute of Arts and Letters, NYC

NPG. National Portrait Gallery, Washington, D.C.

NYPL. The New York Public Library, NYC

NYU. New York University

Nagaoka City Hall, Nagaoka, Japan

Nagaoka, Japan. Museum of Contemporary Art, Nagaoka, Japan

Nantucket. Artists' Association of Nan-tucket, Nantucket, Mass.

Nashville. Tennessee Fine Arts Center, Nashville, Tenn.

The National Academy of Design—*see* NAD

National Academy of Sciences, Washington, D.C.

National Arts Foundation, NYC

National Bank of Des Moines

National Economics Research Association

National Gallery of Canada—*see* Ottawa/National

National Gallery, Reykjavik—*see* Reykjavik

National Gallery of Scotland—*see* Edinburgh/National

National Gallery, Washington, D.C. (incl. Rosenwald Collection)

National Institute of Arts and Letters—*see* NIAL

National Life Insurance Co.

National Museum, Athens—*see* Greece (National

National Museum, Jerusalem—*see* Jerusalem/National

National Museum, Sofia—*see* Sofia

National Museum of Wales, Cardiff, Wales

National Museum of Western Art, Tokyo, Japan

National Orange Show, San Bernardino, Calif.

National Portrait Gallery—*see* NPG

National U.—*see* George Washington U.

Nebraska State Teachers College

U. of Nebraska (incl. Sheldon Memorial Art Gallery)

Needham Harper & Steers Inc.

Neenah/Bergstrom. John Nelson Bergstrom Art Center and Museum, Neenah, Wisc.

Neiman-Marcus Co.

William Rockhill Nelson Gallery of Art—*see* Kansas City/Nelson

Netherlands Film Museum, Amsterdam, Holland

Neue Galerie, Essen—*see* Essen/NG

U. of Nevada

Newark Museum, Newark, N.J.

Newark Public Library, Newark, N.J.

Newberry Library, Chicago, Ill.

New Britain. Art Museum of the New

Britain Institute, New Britain, Conn.

New Britain/American. New Britain Museum of American Art, New Britain, Conn.

New Brunswick Museum—see St. John, N.B.

New College, Sarasota, Fla.

New England Merchants National Bank, Boston

U. of New Hampshire (incl. Paul Creative Arts Center)

New Haven Public Library, New Haven, Conn.

New Jersey State Cultural Center, Trenton, N.J.

New Jersey State Museum—see Trenton/State

New London. Lyman Allyn Museum, New London, Conn.

New Mexico State U.

U. of New Mexico

New Orleans/Delgado. Isaac Delgado Museum of Art, New Orleans, La.

New Orleans Museum of Art, New Orleans, La.

New Paltz/SUNY. State University of New York, at New Paltz

Newport Harbor. Newport Harbor Art Museum, Newport Beach, Calif.

New School for Social Research, NYC

Newsweek Magazine

New Trier High School, Winnetka, Ill.

The New York Bank for Savings, NYC

New York Coliseum, NYC

New York Cultural Center (formerly Gallery of Modern Art, NYC)

New York Hilton Hotel

New York Hospital, NYC

The New York Public Library—see NYPL

New York School of Interior Design

New York State Art Commission, Albany, N.Y.

New York State Health and Hospitals Corp.

New York, State University of—see under names of individual campuses

The New York Times

New York University—see NYU

Niigata Museum, Japan

Norfolk. Norfolk Museum of Arts and Sciences, Norfolk, Va.

Norfolk/Chrysler. Walter P. Chrysler Museum of Art, Norfolk, Va.

North Carolina Museum of Art—see Raleigh/NCMA

North Carolina National Bank

North Carolina/State. North Carolina State Museum, Raleigh, N.C. (see also Raleigh/NCMA)

North Carolina State U.

U. of North Carolina (incl. Weatherspoon Art Gallery of The Women's College at Greensboro)

North Central Bronx Hospital, Bronx N.Y.

U. of North Dakota

Northeast Missouri State Teachers College

Northern Illinois U.—see DeKalb

U. of Northern Iowa

Northern Trust Co., Chicago, Il.

Northland College

North Shore State Bank, Milwaukee, Wisc.

North Texas State U.

Northwest Missouri State College

Northwestern National Life Insurance Co.

Northwestern U.

Northwood Institute, Dallas, Tex.

Norton Gallery and School of Art—see West Palm Beach/Norton

U. of Notre Dame

Nurnberg. Stadtische Kunstsammlungen, Nurnberg, Germany

O

OBD/Basel. Offentliche Basler Denkmalpflege, Basel, Switzerland

Oak Cliff Savings and Loan, Dallas, Tex.

Oakland/AM. Oakland Art Museum, Oakland, Calif.

Oakland Public Library, Oakland, Calif.

Oberlin College (incl. Allen Memorial Art Museum)

Ogunquit. Museum of Art of Ogunquit, Me.

Ohara Art Museum, Kurashiki, Japan

The Ohio State U.

Ohio Wesleyan U.

Ohio U.

Oklahoma. Oklahoma Art Center, Oklahoma City, Okla.

Oklahoma City U.

Oklahoma State Art Collection
U. of Oklahoma
Oldenburg. Oldenburger Stadtmuseum, Oldenburg, Germany
Olivet College
The Olsen Foundation Inc.,New Haven, Conn.
Omaha/Joslyn. Joslyn Art Museum, Omaha, Neb.
The 180 Beacon Collection of Contemporary Art, Boston, Mass.
Oran. Musee Demaeght, Oran, Algeria
Orange Coast College, Costa Mesa, Calif.
Oregon State U.
U. of Oregon
Orlando. Central Florida Museum, Orlando, Fla. (*see also* Loch Haven Art Center)
Osaka/Municipal. Osaka Municipal Art Museum, Osaka, Japan
Oslo/National.Nasjonalgalleriet, Oslo, Norway
Oswego/SUNY. State University of New York, at Oswego
Otis Art Institute, Los Angeles, Calif.
Ottawa/National. National Gallery of Canada, Ottawa, Canada
Otterbein College
Outre-Mer—*see* Paris/Outre-Mer
Owens-Corning Fiberglas Corp.
Oxford, University of, Oxford, England

P
PAFA. The Pennsylvania Academy of the Fine Arts, Philadelphia, Pa.
PCA. Print Council of America, NYC
PMA. The Philadelphia Museum of Art, Philadelphia, Pa. (incl. the Museum of Living Art, the Academy of Natural Sciences, and the Rodin Museum).
Philadelphia College of Art (formerly the **Philadelphia Museum School**)
P.S. 144, NYC
Pacific, University of the
Pacific Indemnity Co.
Palais des Beaux-Arts, Brussels—*see* Brussels/Beaux-Arts
Palm Beach—*see* Society of the Four Arts
Palm Beach Company, NYC
Palm Springs Desert Museum, Palm Springs, Calif.

Palomar College, San Marcos, Calif.
Palos Verdes. Palos Verdes Art Gallery, Palos Verdes, Calif. **Palos Verdes Community Arts Association**
Paris/Moderne. Musee d'Art Moderne de la Ville de Paris, Paris, France (*see also* France/National)
Paris/Outre-Mer. Musee de la France d'Outre-Mer, Paris, France
Park College
The Parrish Museum—*see* Southampton/Parrish
Pasadena/AM. The Pasadena Art Museum, Pasadena, Calif. **Pasadena Museum School**
Paul Creative Arts Center—*see* U. of New Hampshire
Peabody College, Memphis, Tenn.
Peabody Institute of the City of Baltimore
Peabody Museum, Salem, Mass.
Pendleton High School, Pendleton, Ore.
William Penn Memorial Museum—*see* Harrisburg/Pa. State Museum
The Pennsylvania Academy of the Fine Arts—*see* PAFA
The Pennsylvania State U.
U. of Pennsylvania
J. C. Penny Corp.
Pensacola. Pensacola Art Center, Pensacola, Fla.
The Pentagon, Washington, D.C.
Pepsi-Cola Co.
Philadelphia Art Alliance, Philadelphia, Pa.
The Philadelphia Museum of Art—*see* PMA
Philadelphia Zoological Gardens
Philbrook Art Center—*see* Tulsa/Philbrook
Philip Morris Collection, NYC
Phillips. The Phillips Gallery, Washington, D.C. **The Phillips Gallery School**
Phillips Academy, Addison Gallery of American Art—*see* Andover/Phillips
Phillips Exeter Academy, The Lamont Art Gallery—*see* Exeter
Phoenix. Phoenix Art Museum, Phoenix, Ariz.
Pinacotheca Museum, Osaka, Japan
Pinacotheque National Museum, Athens, Greece

Pioneer Aerodynamic Systems

Pittsfield/Berkshire. Berkshire Atheneum, Pittsfield, Mass.

Pitzer College

Pomona College

Ponce. Ponce Museum of Art, Ponce, Puerto Rico

Poole Technical College, Dorset, England

Port Authority of New York & New Jersey

Portland, Me./MA. Portland Museum of Art, Portland, Me.

Portland, Ore./AM. Portland Art Museum, Portland, Ore. Portland (Ore.) Museum School

Portland State College (Ore.)

Potsdam/SUNY. State University of New York, at Potsdam

Power Gallery of Contemporary Art—see U. of Sydney

Prague/National. Norodni (National) Galerie, Prague, Czechoslovakia

Pratt Institute

Prendergast Free Library Art Gallery—see Jamestown/Prendergast

Prentice-Hall Inc.

Princeton Print Club, Princeton, N.J.

Princeton U.

The Print Club, Philadelphia, Pa.

Print Club of Rochester, Rochester, N.Y.

Print Council of America—see PCA

Pro-Civitate-Christiana, Assisi, Italy

Provincetown/Chrysler—see Norfolk/Chrysler

Prudential Insurance Co. of America, Newark, N.J.

Prudential Lines Inc.

Publishers Printing Co.

U. of Puerto Rico

Purchase/SUNY. State University of New York, at Purchase (incl. The Neuberger Museum)

Purdue U.

The Pure Oil Co.

Q

Quaker Oats Co.

Quaker Ridge School, Scarsdale, N.Y.

Quebec. Musee de Quebec (Que.), Canada

Queens College of the City University of New York

Queens U., Kingston (Ont.), Canada

Quimica Argentia, Buenos Aires, Argentina

R

RAC. Richmond Art Center, Richmond, Calif.

RISD. Rhode Island School of Design

Radcliffe College, Cambridge, Mass.

Radio Corporation of America

Raleigh/NCMA. North Carolina Museum of Art, Raleigh, N.C. (see also North Carolina/State)

Randolph-Macon College

Randolph-Macon Women's College (incl. Lynchburg Art Gallery)

Ration Mfg. Co.

Raycom Industries

Readers Digest

Reading/Public. Reading Public Museum and Art Gallery, Reading, Pa.

Recklinghausen. Stadtische Kunsthalle, Recklinghausen, Germany

U. of Redlands

Red Wing. Interstate Clinic, Red Wing, Minn.

Reed College

Regina/MacKenzie. Norman Mackenzie Art Gallery, Regina (Sask.), Canada

Remington-Rand Corp.

Renaissance Society—see The U. of Chicago

Rennes. Musee des Beaux-Arts (of the Musee de Rennes), Rennes, France

Rensselaer Polytechnic Institute

Revere Copper & Brass, Inc.

Revlon Inc.

Reykjavik. National Gallery, Reykjavik, Iceland

Reynolds Metals Co.

Rhode Island School of Design—see RISD

U. of Rhode Island

Rice U., Houston, Tex.

Rich-Lan Corp.

Richmond (Calif.) Art Center—see RAC

Ridgefield/Aldrich. Larry Aldrich Museum of Contemporary Art, Ridgefield, Conn.

Rijksmuseum Amsterdam, Amsterdam, Holland

Rijksmuseum Kroller-Muller, Otterlo, Holland

Ringling. John and Mable Ringling Museum of Art, Sarasota, Fla. **Ringling School of Art**

Rio Cuarto. Museo Municipal de Bellas Artes, Rio Cuarto, Argentina

Rio Hondo College, Whittier, Calif.

Rio de Janeiro. Museu de Arte Moderna, Rio de Janeiro, Brazil

Ripon College

Riverside Museum, NYC—*see* Brandeis U.

Roanoke Fine Arts Center, Roanoke, Va.

Sara Roby Foundation, NYC

Rochester Institute of Technology, Rochester, N.Y.

U. of Rochester (incl. Rochester Memorial Art Gallery)

Rockefeller Brothers Fund, NYC

Rockefeller Center, NYC

Rockefeller Institute—*see* Rockefeller U.

Rockefeller U., NYC

Rockford/Burpee. Harry and Della Burpee Gallery, Rockford, Ill.

Rockland/Farnsworth. William A. Farnsworth Library and Art Museum. Rockland, Me.

Rock River (Wyo.) High School

Rodin Museum, Philadelphia—*see* PMA

Nicholas Roerich Museum, NYC

Will Rogers Shrine, Colorado Springs, Colo.

Rohan, Chateau de—*see* Chateau de Rohan

Rome/Nazionale. Galleria Nazionale d'Arte Moderno, Rome, Italy

U. of Rome, Rome, Italy

Edward Root Collection—*see* Utica

Rose Art Museum—*see* Brandeis U.

Rosenthal China Co.

Rosenwald Collection—*see* National Gallery, Washington, D.C.

Roswell. Roswell Museum and Art Center, Roswell, N.M.

Rotterdam. Museum Boymans-van Beuningen, Rotterdam, Holland

Rouen. Musee des Beaux-Arts et de Ceramique, Rouen, France

Rumsey Hall School, Washington, Conn.

Russell Sage College

Rutgers U.

Rybak. Rybak Art Museum, Bat Yam, Israel

S

SAGA. The Society of American Graphic Artists, NYC

SFAI. San Francisco Art Institute, San Francisco, Calif.

SFMA. San Francisco Museum of Art, San Francisco, Calif.

SFPL. San Francisco Public Library, San Francisco, Calif.

SRGM. The Solomon R. Guggenheim Museum, NYC

Saarlandmuseum, Saarbrucken, Germany

Sacramento/Crocker. E. B. Crocker Art Gallery, Sacramento, Calif.

Sacramento State U. (formerly **College**)

Sacred Heart Seminary, Detroit, Mich.

Safad. Glicenstein Museum, Safad, Israel

Safeco Building

Saginaw Art Museum, Saginaw, Mich.

St. Albans School, Washington, D.C.

St. Antony's College (Oxford U.), Oxford, England

St. Benedict, College of—*see* College of St. Benedict

St. Bernard's Church, Hazardville, Conn.

St. Cloud State College

St.-Etienne. Musee Municipal d'Art et d'Industrie, St.-Etienne, France

St. George's Episcopal Church, NYC

St. John, N. B. New Brunswick Museum, St. John (N. B.), Canada

St. John's Abbey, Collegeville, Minn.

St. Joseph/Albrecht. Albrecht Gallery Museum of Art, St. Joseph, Mo.

St. Lawrence U. (incl. Griffiths Art Center)

St. Louis/City. The City Art Museum of St. Louis, Mo.

St. Mary's College (Ind.)

St. Patrick's, Menasha, Wisc.

St. Paul Gallery and School of Art—*see* Minnesota/MA

St. Petersburg, Fla. Art Club of St. Petersburg, Fla.

U. of St. Thomas (Tex.)

Salk Institute, La Jolla, Calif.

Salt Lake City Public Library, Salt Lake City, Utah

Salzburg. Salzburger Museum Carolino Augusteum, Salzburg, Austria

San Antonio/McNay. Marion Koogler McNay Art Institute, San Antonio, Tex.

Carl Sandburg Memorial Library, S.C.

San Diego. The Fine Arts Gallery of San Diego, Calif. San Diego Fine Arts School

San Fernando Valley State U.

San Francisco Art Association—see SFAI

San Francisco Municipal Art Commission, San Francisco, Calif.

San Francisco Museum of Art—see SFMA

San Francisco Public Library—see SFPL

San Francisco State College

San Joaquin Pioneer Museum and Haggin Art Galleries—see Stockton

San Jose Library, San Jose, Calif.

San Jose State College

Santa Barbara/MA. Santa Barbara Museum of Art, Santa Barbara, Calif.

Santa Barbara Museum School

Santa Fe, N.M. Museum of New Mexico Art Gallery, Santa Fe, N.M.

Santiago, Chile. Museo Nacional de Bellas Artes, Santiago, Chile

Sao Paulo. Museu de Arte Moderna, Sao Paulo, Brazil

Sao Paulo/Contemporanea. Museu de Arte Contemporanea, Sao Paulo, Brazil

Sarah Lawrence College

U. of Saskatchewan, Saskatoon (Sask.), Canada

City of Saskatoon (Sask.), Canada

Savannah/Telfair. Telfair Academy of Arts and Sciences, Inc., Savannah, Ga.

Savings Bank Association of New York State

Schaeffer School of Design, San Francisco, Calif.

Michael Schiavone & Sons Inc., North Haven, Conn.

Schiedam/Stedelijk. Stedelijk Museum, Schiedam, Holland

J. Henry Schroder Banking Corp.

Schwebber Electronics

Scientific American Inc.

Scottish National Gallery of Modern Art, Edinburgh—see Edinburgh/Modern

Scranton/Everhart. Everhart Museum, Scranton, Pa.

Scripps College

Seagram Collection

Seaton Hall Inc., NYC

Seattle/AM. Seattle Art Museum, Seattle, Wash.

Seattle Civic Center, Seattle, Wash.

Seattle Public Library, Seattle, Wash.

Seattle U.

Security Pacific National Bank, Los Angeles, Calif.

Shasta College, Redding, Calif.

Shelburne. Shelburne Museum Inc., Shelburne, Vt.

Sheldon Memorial Art Gallery—see U. of Nebraska

Shell Oil Co.

E. Sherry Truck Company

Shuttleworth Carton Co.

Silvermine Guild of Artists, New Canaan, Conn. Silvermine Guild School of Art

Simmons College

The Singer Company Inc.

Sioux City Art Center, Sioux City, Iowa

Skidmore College

Skidmore, Owings & Merrill

Skopje/Modern. Museum of Modern Art, Skopje, Yugoslavia

Skowhegan School of Painting and Sculpture, Skowhegan, Me.

Slater Memorial Museum, Norwich, Conn.

W. & J. Sloane, Inc.

Smith College

Smithsonian Institution, Washington, D.C.

Societe National des Arts Contemporains, Paris, France

The Society of American Graphic Artists—see SAGA

Society of the Four Arts, Palm Beach, Fla.

Society of New York Hospitals

Sofia. National Museum, Sofia, Bulgaria

Sofu School of Flower Arrangement, Tokyo, Japan

Southampton/Parrish. The Parrish Museum, Southampton, N.Y.

South County Bank, St. Louis, Mo.
U. of Southern California
Southern Idaho College, Twin Falls, Idaho
Southern Illinois U.
Southern Methodist U.
Southern Oregon College
Southern Vermont Art Center, Manchester, Vt.
U. of South Florida
South Mall, Albany, Albany, N.Y.
Southwestern College, Chula Vista, Calif.
Southwestern (College) at Memphis
Southwest Missouri State College
J. B. Speed Art Museum—see Louisville-/Speed
Spelman College
Spokane Coliseum, Spokane, Wash.
Sports Museum, NYC
Springfield Art Center, Springfield, Ohio
Springfield College (Mass.)
Springfield, Ill./State. Illinois State Museum of Natural History and Art, Springfield, Ill.
Springfield, Mass./MFA. Museum of Fine Arts, Springfield, Mass.
Springfield, Mo./AM. Springfield Art Museum, Springfield, Mo.
Staatliche Graphische Sammlung Munchen, Munich, Germany
Stadtische Galerie im Lenbachhaus, Munich, Germany
Stadtische Galerie, Munich—see Munich/SG
Stadtische Kunsthalle, Dusseldorf—see Dusseldorf/Kunsthalle
Stamford Museum, Stamford, Conn.
Standard Oil Co. of California
Standard Oil Co. of New Jersey
Stanford U.
Starr King School for the Ministry, Berkeley, Calif.
State Art Collection, Oklahoma City
State of California
State College of Iowa
State College at Salem, Salem, Mass.
State of Hawaii
State Historical Society of Missouri—see Columbia, Mo.
State of Iowa
State U. of Iowa

State of Louisiana Art Commission—see Baton Rouge
Staten Island. Staten Island Institute of Arts and Sciences, St. George, S. I., N.Y.
State Street Bank and Trust Co., Boston, Mass.
Steel Service Institute, Cleveland, Ohio
Stephens College
Steuben Glass
Stockholm/National. Moderna Museet (Nationalmuseum), Stockholm, Sweden
Stockholm/SFK. Svenska-Franska Konstgalliert, Stockholm, Sweden
Stockton. San Joaquin Pioneer Museum and Haggin Art Galleries, Stockton, Calif.
Stony Brook/SUNY. State University of New York, at Stony Brook
Storm King Art Center, Mountainville, N.Y.
Stratford College, Danville, Va.
Stuttgart. Staatsgalerie Stuttgart, Stuttgart, Germany
Stuttgart/WK. Wurttembergischer Kunstverein, Stuttgart, Germany
Peter Stuyvesant Collection, Amsterdam, Holland
Stuyvesant Foundation, Brussels, Belgium
Suffolk County National Bank, Riverhead, N.Y.
Sunflower Corp.
Svenska Handelsbanken, Stockholm, Sweden
Svenska-Franska Konstgalliert—see Stockholm/SFK
Svest, Germany
Swarthmore College (incl. Wilcox Gallery)
Sweden/Goteborgs. Goteborgs Konstmuseum, Gothenburg, Sweden
Sweet Briar College
Sheldon Swope Art Gallery—see Terre Haute/Swope
Sydney/AG. The Art Gallery of New South Wales, Sydney, Australia
U. of Sydney (incl. Power Gallery of Contemporary Art)
Syracuse/Everson. Everson Museum of Art, Syracuse, N.Y. Syracuse Museum School

Syracuse U.

T

Tacoma. Tacoma Art Museum, Tacoma, Wash.

Taconic Foundation, Inc., NYC

Taft Museum, Cincinnati, Ohio

Talavara. Museo Talavara, Ciudad Bolivar, Venezuela

Tampa/AI. Tampa Art Institute Gallery, Tampa, Fla.

Taos (N.M.) County Court House

Tate Gallery, London, England

Taubman Corp., Ann Arbor, Mich.

Tel Aviv. Tel Aviv Museum of Art, Tel Aviv, Israel

Telfair Academy of Arts and Sciences, Inc.—*see* Savannah/Telfair

Temple Beth El, Detroit, Mich.

Temple Israel, St. Louis, Mo.

Temple U.

Tennessee Fine Arts Center—*see* Nashville

Tennessee State Museum, Nashville, Tenn.

U. of Tennessee

Terre Haute/Swope. Sheldon Swope Art Gallery, Terre Haute, Ind.

Terry Art Institute, Miami, Fla.

Texas Fine Arts Association—*see* Austin

Texas Technological College, Lubbock, Tex.

Texas Tech U., Lubbock, Tex.

Texas Wesleyan College

Texas Western College

U. of Texas (incl. James A. Michener Foundation)

J. Walter Thompson Co., NYC

3M Company, St. Paul, Minn.

Louis Comfort Tiffany Foundation, NYC

Time Inc.

Tishman Realty & Construction Co. Inc.

Tokyo Folk Art Museum

Tokyo/Modern. National Museum of Modern Art, Tokyo, Japan (*see also* National Museum of Western Art, Tokyo)

Tokyo U. of Arts, Tokyo, Japan

Toledo/MA. Toledo Museum of Art, Toledo, Ohio

Topeka Public Library, Topeka, Kans.

Topeka U.—*see* Washburn U. of Topeka

Toronto. Art Gallery of Toronto, Toronto (Ont.), Canada

Torrington Mfg. Corp.

Tougaloo College

Tourcoing. Musee Municipal, Tourcoing, France

Towner Art Gallery, Eastbourne, England

Towson State College, Baltimore, Md.

Trade Bank and Trust Company, NYC

Transamerica Corp.

Treadwell Corp., NYC

Trenton/State. New Jersey State Museum, Trenton, N.J.

Tretyakov Art Gallery, Moscow, USSR

Trinity College, Dublin, Ireland

Harry S. Truman Library, Independence, Mo.

U. of Tucson

Tufts Dental College, Boston, Mass.

Tulane U. of Louisiana

Tulsa/Philbrook. Philbrook Art Center, Tulsa, Okla.

Tupperware Museum, Orlando, Fla.

Turin/Civico. Museo Civico di Torino, Turin, Italy (incl. Galleria Civica d'Arte Moderna)

Turku Museum, Finland

Tusculum College, Greenville, Tenn.

Tweed Gallery—*see* U. of Minnesota

Twentieth Century Fox Film Corp.

Two Trees, NYC

U

UCLA. U. of California, Los Angeles

USIA. United States Information Agency

US Coast Guard

US Department of the Interior

US Labor Department

US Maritime Commission

US Military Academy, West Point, N.Y.

US Navy

U.S. Rubber Co.

US State Department

U.S. Steel Corp.

US Treasury Department

Uffizi Gallery, Florence, Italy

Ulster Museum, Belfast, Northern Ireland

Underwood-Neuhaus Corp.

Union Carbide Corp.

Union College (N.Y.)
Union of Plastic Artists, Bucharest, Romania
Unitarian Church, Princeton, N.J.
United Aircraft Corp.
United Mutual Savings Bank
United Nations
United Tanker Ltd.
Upjohn Co.
Uris Buildings Corp.
Uris-Hilton Hotels
Uruguay/Nacional. Museo Nacional de Bellas Artes, Montevideo, Uruguay
Utah. Utah Museum of Fine Arts, Salt Lake City, Utah
Utah State U.
U. of Utah
Utica. Munson-Williams-Proctor Institute, Utica, N.Y. (incl. Edward Root Collection)
Utica Public Library, Utica, N.Y.
Utrecht. Centraal Museum, Utrecht, Holland

V

VMFA. Virginia Museum of Fine Arts, Richmond, Va.
Valley Bank of Springfield, Springfield, Mass.
Valparaiso U. (Ind.)
Vancouver. Vancouver Art Gallery, Vancouver (B.C.), Canada
Vanderbilt U.
Vassar College, Poughkeepsie, N.Y.
Venice/Contemporaneo. Museo dell' Arte Contemporaneo, Venice, Italy
U. of Vermont (incl. Robert Hull Fleming Museum)
Victoria (B.C.). Art Gallery of Greater Victoria, Victoria (B.C.), Canada
Victoria and Albert Museum, London, England
Vienna/Stadt. Museen der Stadt Wien, Vienna, Austria
Virginia Museum of Fine Arts—see VMFA
Virginia National Bank, Norfolk, Va.
Virginia State College
U. of Virginia

W

WDAY, Fargo, N.D.
WGMA. Washington Gallery of Modern Art, Washington, D.C.
WMAA. The Whitney Museum of American Art, NYC
The Wadsworth Atheneum—see Hartford/Wadsworth
Wagner College
Waitsfield/Bundy. Bundy Art Gallery, Waitsfield, Vt.
Wake Forest U. (formerly College)
Wales—see National Museum of Wales
Walker. The Walker Art Center, Minneapolis, Minn.
Walker Art Gallery, Liverpool, England—see Liverpool/Walker
Wallraf-Richartz-Museum—see Cologne
Walnut Creek Municipal Collection, Walnut Creek, Calif.
Walters Art Gallery—see Baltimore /Walters
Warsaw. Academy of Fine Arts, Warsaw, Poland
Warsaw/National. Muzeum Narodwe (National Museum), Warsaw, Poland
Washburn U. of Topeka (incl. Mulvane Art Museum)
Washington County Museum of Fine Arts—see Hagerstown/County MFA
Washington Federal Bank, Miami, Fla.
Washington Gallery of Modern Art—see WGMA
Washington Post
Washington State U. (incl. Spokane Art Center)
Washington U. (St. Louis)
U. of Washington
Wasserman Development Corp.
Waterloo. Waterloo Municipal Galleries, Waterloo, Iowa
Wayne State U., Detroit, Mich.
Weatherspoon Art Gallery—see U. of North Carolina
Wellesley College, Wellesley, Mass.
Wellington Management Co.
Wells College
Wesleyan College (Ga.)
Wesleyan U. (Conn.) (incl. Davison Art Center)
Western Art Museum, Tokyo—see National Museum of Western Art, Tokyo
Western Art Museum, USSR—see Moscow/Western

Western Michigan U.
Western New Mexico U.
Western Washington State College
Westfalischer Kunstverein, Munster—
see Munster/WK
Westfield, Mass., State College at
Westinghouse Electric Corp.
Westminster Academy, Salisbury,
Conn.
Westminster Foundation, Iowa City,
Iowa
Westmoreland County/MA. West-
moreland County Museum of Art,
Greensburg, Pa.
West Palm Beach/Norton. Norton
Gallery and School of Art, West Palm
Beach, Fla.
West Point—see US Military Academy
Westport Art Education Society, West-
port, Conn.
Westport Savings Bank, Westport,
Conn.
West Virginia State College
Whatcom Museum of History and Art,
Bellingham, Wash.
Wheaton College
The White House, Washington, D.C.
Whitney Communications Corp., NYC
The Whitney Museum of American
Art—see WMAA
Whitworth Art Gallery, U. of Manches-
ter, Manchester, England
Wichita/AM. The Wichita Art Mu-
seum, Wichita, Kans.
Wichita State U.
Wiesbaden. Stadtisches Museum Wies-
baden, Wiesbaden, Germany
Wilberfeld. Stadtische Museum, Wil-
berfeld, Germany
Wilcox Gallery—see Swarthmore Col-
lege
College of William and Mary, Williams-
burg, Va.
Williams College (incl. Williamstown
Museum), Williamstown, Mass.
Willowbrook High School, Villa Park,
Ill.
Wilmington. Delaware Art Center,
Wilmington, Del.

Windsor. Windsor Art Museum, Wind-
sor (Ont.), Canada
Winston-Salem Public Library,
Winston-Salem, N.C.
Wisconsin State U.
U. of Wisconsin
Witte. Witte Memorial Museum, San
Antonio, Tex.
Thomas W. Wood Art Gallery—see
Montpelier/Wood
Woodward Foundation, Washington,
D.C.
College of Wooster, Wooster, Ohio
Worcester/AM. The Worcester Art
Museum, Worcester, Mass. **Worces-
ter Museum School**
Wrexham Foundation, New Haven,
Conn.
Wright Art Center—see Beloit College
Wright State U., Dayton, Ohio
Wuppertal. Stadtisches Museum, Wup-
pertal, Germany
Wuppertal/von der Heydt. Von der
Heydt-Museum der Stadt Wuppertal,
Wuppertal, Germany
Wurttembergischer Kunstverein,
Stuttgart—see Stuttgart/WK
U. of Wyoming, Laramie, Wyo.

X
Xerox Corp.

Y
Yaddo, Saratoga Springs, N.Y.
Yale U., New Haven, Conn.
Yellowstone Art Center, Billings,
Mont.
York U., Toronto (Ont.), Canada
Youngstown/Butler. The Butler Insti-
tute of American Art, Youngstown,
Ohio
Youngstown U.

Z
Zanesville/AI. Art Institute of Zanes-
ville, Zanesville, Ohio
Zurich. Kunsthaus Zurich, Zurich,
Switzerland

Galleries
representing the artists
in this book

A.A.A. Gallery
663 Fifth Avenue
New York, N.Y. 10022

ACA Gallery
25 East 73 Street
New York, N.Y. 10021

Brooke Alexander
20 West 57 Street
New York, N.Y. 10019

Gallery Allen
213 Carroll
Vancouver, B.C.

Alpha Gallery
12 Newbury Street
Boston, Mass. 02116

Jacqueline Anhalt Gallery
750 N. La Cienega Boulevard
Los Angeles, Calif. 90069

Ankrum Gallery
657 N. La Cienega Boulevard
Los Angeles, Calif. 90069

Galerie Arnaud
212, boulevard Saint-Germain
Paris 7, France

Arras Gallery
29 West 57 Street
New York, N.Y. 10019

Arte Borgogna
Via Borgogna 7
Milan, Italy 20122

Lee Ault & Co.
25 East 77 Street
New York, N.Y. 10021

The Babcock Gallery
805 Madison Avenue
New York, N.Y. 10021

Galerie Baecker
Berggate 69
Bochum, Germany

Esther Baer Gallery
1125 High Road
Santa Barbara, Calif. 93108

Jacques Baruch Gallery
920 N. Michigan Avenue
Chicago, Ill. 60611

Hank Baum Gallery
1 Embarcadero Center
San Francisco, Calif. 94111

The Bay Window Gallery
604 Main Street
Mendocino, Calif. 95460

Adele Bednarz Gallery
920 N. La Cienega Boulevard
Los Angeles, Calif. 90069

Beilin Gallery
1018 Madison Avenue
New York, N.Y. 10028

Richard Bellamy
333 Park Avenue South
New York, N.Y. 10010

Benson Gallery
Bridgehampton, N.Y. 11932

The Berenson Gallery
1128 Kane Concourse
Bay Harbor Islands
Miami Beach, Fla. 33154

John Berggruen Gallery
228 Grant Avenue
San Francisco, Calif. 94108

Galerie Beyeler
Baumleingasse 9
Basel, Switzerland

Galerie Paul Bianchini
18, rue du Dragon
75006 Paris, France

Bienville Gallery
539 Bienville Street
New Orleans, La. 70130

Rene Block Gallery Ltd.
409 W. Broadway
New York, N.Y. 10012

Galerie Bonnier
Grand'Rue 12
Geneva 1200, Switzerland

Galeria Bonino Ltd.
48 Great Jones Street
New York, N.Y. 10012

Grace Borgenicht Gallery
1018 Madison Avenue
New York, N.Y. 10028

Du Bose Gallery
2950 Kirby Drive
Houston, Tex. 77006

Brandywine Ltd.
120 Morningside Drive
Albuquerque, N.M.

Brena Gallery
313 Detroit
Denver, Colo. 80406

Brentano's
586 Fifth Avenue
New York, N.Y. 10036

Bykert Gallery
24 East 81 Street
New York, N.Y. 10028

Galleria Cadario
Via della Spiga 7
Milan, Italy

Galerie des Cahiers d'Art
14, rue du Dragon
75006 Paris, France

Susan Caldwell Inc.
383 W. Broadway
New York, N.Y. 10012

Charles Campbell Gallery
647 Chestnut
San Francisco, Calif. 94133

Capricorn Gallery
8003 Woodmont Avenue
Bethesda, Md. 20014

Galleria A. Castelli
9 Via Brera
20121 Milan, Italy

Leo Castelli Inc.
4 East 77 Street
New York, N.Y. 10021

Galerie Chalette
9 East 77 Street
New York, N.Y. 10021

Merrill Chase Galleries
620 N. Michigan Avenue
Chicago, Ill. 60611

Cherry Stone Gallery
Wellfleet, Mass. 02667

Cirrus Editions Ltd.
209 N. Manhattan Pl.
Los Angeles, Calif. 90038

Iris Clert Gallery
28, faubourg Saint-Honore
Paris 8, France

Comara Gallery
8475 Melrose Place
Los Angeles, Calif. 90069

Cynthia Comsky Gallery
9489 Dayton Way
Beverly Hills, Calif. 90210

Gallery of Contemporary Art
Ledoux Placita
Taos, N.M. 87571

Paula Cooper Gallery
155 Wooster Street
New York, N.Y. 10012

Rebecca Cooper Gallery
2130 P. Street, N.W.
Washington, D.C. 20037

Cordier & Ekstrom, Inc.
980 Madison Avenue
New York, N.Y. 10021

Cramer Gallery
7 Main Street
Glen Rock, N.J. 07452

Andrew Crispo Gallery
41 East 57 Street
New York, N.Y. 10022

Cunningham Ward Inc.
94 Prince Street
New York, N.Y. 10013

M. L. D'Arc Gallery
15 East 57 Street
New York, N.Y. 10022

Peter M. David Gallery
920 Nicollet Mall
Minneapolis, Minn. 55402

Davis & Long Company
746 Madison Avenue
New York, N.Y. 10021

La Demeure
128, avenue Emile Zola
Paris, France

Terry Dintenfass, Inc.
50 West 57 Street
New York, N.Y. 10019

Discovery Art Galleries
1191 Valley Road
Clifton, N.J.

Estelle Dodge Associates
301 East 47 Street
New York, N.Y. 10017

Dorsky Gallery
111 Fourth Avenue
New York, N.Y. 10003

Galerie du Dragon
19, rue du Dragon
75006 Paris, France

Robert Elkon Gallery
1063 Madison Avenue
New York, N.Y. 10028

Andre Emmerich Gallery
41 East 57 Street
New York, N.Y. 10022

Galerie Andre Emmerich
Todista. 40
8002 Zurich, Switzerland

Harold Ernst Gallery
161 Newbury Street
Boston, Mass. 02116

Rosa Esman Gallery
29 West 57 Street
New York, N.Y. 10019

FAR Gallery
746 Madison Avenue
New York, N.Y. 10021

Galerie Paul Fachetti
17, rue de Lille
Paris, France

Fairweather-Hardin Gallery
101 E. Ontario Street
Chicago, Ill. 60611

Feingarten Gallery
736 N. La Cienega Boulevard
Los Angeles, Calif. 90069

Ronald Feldman Fine Arts Inc.
33 East 74 Street
New York, N.Y. 10021

Fendrick Gallery
3059 M. Street, N.W.
Washington, D.C. 20007

Fischbach Gallery
29 West 57 Street
New York, N.Y. 10019

Galerie Konrad Fischer
Andreasstr. 15
Dusseldorf, Germany

Galerie Karl Flinker
25, rue de Tournon
75017 Paris, France

The Forum Gallery
1018 Madison Avenue
New York, N.Y. 10021

Foster-White Gallery
311½ Occidental Street
Seattle, Wash. 98109

Fountain Gallery
115 S.W. Fourth Avenue
Portland, Ore. 97200

Fourcade, Droll Inc.
36 East 75 Street
New York, N.Y. 10021

Polly Friedlander Gallery
95 Yesler Way
Seattle, Wash. 98104

Frost Gully Gallery
Freeport, Me. 04032

Allan Frumkin Gallery
620 N. Michigan Avenue
Chicago, Ill. 60611

Allan Frumkin Gallery
50 West 57 Street
New York, N.Y. 10019

Galerie de Gestlo
Sophienterrasse 20
D2000 Hamburg 13, Germany

Gimpel Fils
30 Davies Street
London, W.1, England

Gimpel & Hanover
Claridenstrasse 35
8002 Zurich, Switzerland

Gimpel & Weitzenhoffer Ltd.
1040 Madison Avenue
New York, N.Y. 10028

Noah Goldowsky
1078 Madison Avenue
New York, N.Y. 10028

The Graham Gallery
1014 Madison Avenue
New York, N.Y. 10021

Grand Central Galleries
15 Vanderbilt Avenue
New York, N.Y. 10017

Graphics Gallery
1 Embarcadero Center
San Francisco, Calif. 94111

Graphics I & Graphics II
168 Newbury Street
Boston, Mass. 02116

Richard Gray Gallery
620 N. Michigan Avenue
Chicago, Ill. 60611

Green Mountain Gallery
17 Perry Street
New York, N.Y. 10014

Harriet Griffin Gallery
850 Madison Avenue
New York, N.Y. 10021

Grippi Gallery
344 East 59 Street
New York, N.Y. 10022

Gump's Gallery
250 Post Street
San Francisco, Calif. 94108

Hanover Gallery
32A St. George Street
London, W.1, England

Hansen-Fuller Gallery
228 Grant Avenue
San Francisco, Calif. 94108

Harcus Krakow Rosen Sonnabend
7 Newbury Street
Boston, Mass. 02116

Harmon Gallery
1258 Third Street South
Naples, Fla. 33940

OK Harris Works of Art
383 W. Broadway
New York, N.Y. 10013

Haslem Fine Arts, Inc.
2121 P. Street, N.W.
Washington, D.C. 20037

Dalzell Hatfield Gallery
3400 Wilshire Boulevard
Los Angeles, Calif.

Ben Heller Inc.
121 East 73 Street
New York, N.Y. 10021

Henri Gallery
1500 21st Street, N.W.
Washington, D.C. 20036

Heritage Galleries
718 N. La Cienega Boulevard
Los Angeles, Calif. 90069

Wendy Hilty Gallery
St. Croix, Virgin Islands

Hirschl & Adler Galleries
21 East 67 Street
New York, N.Y. 10021

Nancy Hoffman Gallery
429 W. Broadway
New York, N.Y. 10012

Hokin Gallery
200 E. Ontario Street
Chicago, Ill. 60611

Hokin Gallery
245 Worth Avenue
Palm Beach, Fla. 33480

Hundred Acres Gallery Ltd.
456 W. Broadway
New York, N.Y. 10012

Hunter-Meek Gallery
Taos, N.M. 87571

Max Hutchinson Gallery
127 Greene Street
New York, N.Y. 10012

I.F.A. Gallery
155 E. Ontario Street
Chicago, Ill.

Impressions Workshop, Inc.
27 Stanhope Street
Boston, Mass. 02116

Ingber Art Gallery
3 East 78 Street
New York, N.Y. 10021

Alexandre Iolas Gallery
52 East 57 Street
New York, N.Y. 10022

Alexandre Iolas Gallery
196, boulevard Saint-Germain
75007 Paris, France

Island Art Gallery
Manteo, N.C. 27954

Martha Jackson Gallery
32 East 69 Street
New York, N.Y. 10021

Sidney Janis Gallery
6 West 57 Street
New York, N.Y. 10019

Crane Kalman Gallery
178 Brompton Road
London, S.W.3, England

Kama Studio
Via Guilia 105
Rome, Italy

Tirca Karlis Gallery
353 Commercial Street
Provincetown, Mass. 02657

Gertrude Kasle Gallery
310 Fischer Building
Detroit, Mich. 48202

Kasmin Ltd.
118 New Bond Street
London W.1, England

Marjorie Kauffman Gallery
5015 Westheimer
Houston, Tex. 77027

Marjorie Kauffman Graphics
2330 Westward Boulevard
Los Angeles, Calif. 90064

Walter Kelly Gallery
620 N. Michigan Avenue
Chicago, Ill. 60611

Kendall Gallery
Route 6
Welfleet, Mass. 02607

Kennedy Gallery
40 West 57th Street
New York, N.Y. 10019

Coe Kerr Gallery
49 East 82 Street
New York, N.Y. 10028

Knoedler Contemporary Art
21 East 70 Street
New York, N.Y. 10021

The Kornblee Gallery
20 West 57 Street
New York, N.Y. 10019

The Krasner Gallery
1043 Madison Avenue
New York, N.Y. 10028

Kraushaar Galleries
1055 Madison Avenue
New York, N.Y. 10028

Kunst Kabinett Klihm
Franz-Josef-Strasse 9
Munich 13, Germany

Yvon Lambert
15, rue de l'Echaude
75006 Paris, France

Felix Landau Gallery
702 N. La Cienega Boulevard
Los Angeles, Calif. 90069

Mitzi Landau Gallery
1625 Thayer Avenue
Los Angeles, Calif. 90024

La Lanterna
Via S. Niccolo 6/A
Trieste, Italy

The Lanyon Gallery
700 Welch Road
Palo Alto, Calif. 94304

Richard Larcada Gallery
23 East 67 Street
New York, N.Y. 10021

Margo Leavin Gallery
812 N. Robertson Blvd.
Los Angeles, Calif. 90069

Janie C. Lee Gallery
2304 Bissonnet
Houston, Tex. 77005

Lerner-Heller Gallery
789 Madison Avenue
New York, N.Y. 10021

Arlene Lind Gallery
435 Jackson Street
San Francisco, Calif.

Lippincott Inc.
400 Sackett Point Road
North Haven, Conn. 06473

Lisson Gallery
66 & 68 Bell Street
London N.W. 1, England

Locksley-Shea Gallery
1300 Mount Curve Avenue
Minneapolis, Minn. 55403

Meredith Long Gallery
2323 San Felipe Road
Houston, Tex. 77019

Loring Gallery
661 Central Avenue
Cedarhurst, N.Y. 11516

Gloria Luria Gallery
14700 Biscayne Boulevard
Miami, Fla. 33161

Luz Gallery
448 Edelos Santos Avenue
Manila, Philippines

Galerie Maeght
13, rue de Teheran
Paris, France

Paul Maenz Gallery
Lindenstrasse 32
Cologne, Germany

Makler Gallery
1716 Locust Street
Philadelphia, Pa. 19103

Gallery Malacke
Malaga, Spain

Royal Marks Gallery
29 East 64 Street
New York, N.Y. 10021

Marlborough Fine Art Ltd.
39 Old Bond Street
London W.1, England

Marlborough Gallery, Inc.
40 West 57 Street
New York, N.Y. 10019

Pierre Matisse Gallery
41 East 57 Street
New York, N.Y. 10022

David McKee Gallery
140 East 63 Street
New York, N.Y. 10021

Louis K. Meisel Gallery
141 Prince Street
New York, N.Y. 10012

Mickelson Gallery
707 G. Street, N.W.
Washington, D.C. 20001

The Midtown Galleries
11 East 57 Street
New York, N.Y. 10022

Minami Gallery
3-3 Chome Nihonbashi dori-Chuo ku
Tokyo, Japan

David Mirvish Gallery
596 Markham Street
Toronto (Ont.), Canada

Mission Gallery
Old Kit Carson Road
Box 1575, Taos, N.M. 87571

Mizuno Gallery
669 N. La Cienega Boulevard
Los Angeles, Calif. 90069

Galeria Juana Mordo
Villanueva 7
Madrid, Spain

Donald Morris Gallery
20082 Livernois Avenue
Detroit, Mich. 48221

Multipla
3 Piazza Martini
20137 Milan, Italy

Munson Gallery
275 Orange Street
New Haven, Conn. 06511

Tibor de Nagy
29 West 57 Street
New York, N.Y. 10019

Nielsen Gallery
179 Newbury Street
Boston, Mass. 02116

Nordness Galleries
140 East 81 Street
New York, N.Y. 10028

Galleria d'Arte l'Obelisco
146 Via Sistina
Rome, Italy

Odyssia Gallery
41 East 57 Street
New York, N.Y. 10022

Frank Oehlschlaeger Gallery
107 East Oak
Chicago, Ill.

Frank Oehlschlaeger Gallery
28 Boulevard of the Presidents
St. Armands Key
Sarasota, Fla.

The Pace Gallery
32 East 57 Street
New York, N.Y. 10022

Betty Parsons Gallery
24 West 57 Street
New York, N.Y. 10019

Perls Galleries
1016 Madison Avenue
New York, N.Y. 10028

Joan Peterson Gallery
216 Newbury Street
Boston, Mass. 02116

Peter Plone Associates
1108 N. Tamarind Avenue
Los Angeles, Calif. 90038

Poindexter Gallery
24 East 84 Street
New York, N.Y. 10028

Princeton Gallery of Fine Art
9 Spring Street
Princeton, N.J. 08540

Prints on Prince Street
410 W. Broadway
New York, N.Y. 10014

Pucker-Safrai Gallery
171 Newbury Street
Boston, Mass. 02116

Pyramid Art Galleries Ltd.
2121 P. Street, N.W.
Washington, D.C. 20037

Quay Gallery
521 Pacific Avenue
San Francisco, Calif. 94133

Rankow Gallery
108 East 78 Street
New York, N.Y. 10021

Rehn Galleries
655 Madison Avenue
New York, N.Y. 10021

Galerie Denise Rene
6 West 57 Street
New York, N.Y. 10019

Galerie Denise Rene
24, rue La Boetie
75008 Paris, France

Galerie Denise Rene
196, boulevard Saint-Germain
75007 Paris, France

Galerie Denise Rene/Hans Mayer
Grabbeplatz 2
D-4000 Dusseldorf, Germany

Galerie Rolfe Ricke
Lindenstrasse 22
Cologne 5, Germany

Robinson Galleries
1100 Bissonnet
Houston, Tex. 77005

Esther Robles Gallery
655 N. La Cienega Boulevard
Los Angeles, Calif. 90069

Roko Gallery
90 East 10 Street
New York, N.Y. 10003

Rolly-Michaux Gallery
125 Newbury Street
Boston, Mass. 02116

Rolly-Michaux Gallery
943 Madison Avenue
New York, N.Y. 10021

Peter Rose Gallery
340 East 52 Street
New York, N.Y. 10022

Rudolph Gallery
Woodstock, N.Y. 12498

A.M. Sachs Gallery
29 West 57 Street
New York, N.Y. 10019

Saidenberg Gallery
16 East 79 Street
New York, N.Y. 10021

Sunne Savage Gallery
398a Beacon Street
Boston, Mass. 02167

William Sawyer Gallery
3045 Clay Street
San Francisco, Calif. 94115

The New Bertha Schaefer Gallery
41 East 57 Street
New York, N.Y. 10019

Ruth S. Schaffner Gallery
8406 Melrose Avenue
Los Angeles, Calif. 90069

Robert Schoelkopf Gallery
825 Madison Avenue
New York, N.Y. 10021

Martin Schweig Gallery
4657 Maryland Avenue
St. Louis, Mo. 63108

Jodi Scully Gallery
651 N. La Cienega Boulevard
Los Angeles, Calif. 90069

Sculptors Guild
75 Rockefeller Plaza
New York, N.Y. 10020

Sculpture Center
167 East 69 Street
New York, N.Y. 10021

Francine Seders Gallery
6701 Greenwood Avenue North
Seattle, Wash. 98103

J. Seligmann & Co.
5 East 57 Street
New York, N.Y. 10022

Serisawa Gallery
633 N. La Cienega Boulevard
Los Angeles, Calif. 90069

Shore Gallery
8 Newbury Street
Boston, Mass. 02116

Silvan Simone Gallery
11579 Olympic Boulevard
Los Angeles, Calif. 90031

Gallery 1640
1445 Crescent Street
Montreal (Que.), Canada

Smith Andersen Gallery
200 Homer Street
Palo Alto, Calif. 94301

Smith Andersen Gallery
228 Grant Avenue
San Francisco, Calif. 94108

Sneed-Hillman Gallery
2024 Harlem Boulevard
Rockford, Ill. 61103

Ileana Sonnabend Gallery
420 W. Broadway
New York, N.Y. 10012

Ileana Sonnabend Gallery
12, rue Mazarine
Paris, France

Gian Enzo Sperone
Corso S. Maurizo 27
Turin, Italy

Gian Enzo Sperone
Via Quatro Fontana 21A
Rome, Italy

Sperone Westwater Fisher Inc.
142 Greene Street
New York, N.Y. 10012

Darthea Speyer Gallery
6, rue Jacques Callot
Paris 6, France

Staempfli Gallery
47 East 77 Street
New York, N.Y. 10021

David Stuart Gallery
807 N. La Cienega Boulevard
Los Angeles, Calif. 90069

Allan Stone Gallery
48 East 86 Street
New York, N.Y. 10028

Terrain Gallery
141 Greene Street
New York, N.Y. 10012

The Texas Gallery
2439 Bissonnet
Houston, Tex. 77005

M. E. Thelen
Lindenstrasse 20
Cologne, Germany

Triangle Art Gallery
578 Sutter Street
San Francisco, Calif. 94102

Van Doren Gallery
1830 Union Street
San Francisco, Calif. 94123

Van Straaten Gallery
646 N. Michigan Avenue
Chicago, Ill. 60611

Galeria Van der Voort
633 Battery Street
San Francisco, Calif. 94111

Veldman Galleries
330 East Mason
Milwaukee, Wisc. 53202

Catherine Viviano Gallery
250 East 65 Street
New York. N.Y. 10022

Washburn Gallery Inc.
820 Madison Avenue
New York, N.Y. 10021

Watson/De Nagy
1106 Bertha
Houston, Tex.

Frank Watters Gallery
109 Riley Street
Sydney, N.S.W., Australia

John Weber Gallery
420 W. Broadway
New York, N.Y. 10012

Weyhe Gallery
794 Lexington Avenue
New York, N.Y. 10021

Nicholas Wilder Gallery
814 N. La Cienega Boulevard
Los Angeles, Calif. 90069

The Willard Gallery
29 East 72 Street
New York, N.Y. 10021

Sandra Wilson Galleries
1756 Broadway
Denver, Colo. 80202

Sandra Wilson Galleries
201 Canyon Road
Santa Fe, N.M. 87501

Wolfe Street Gallery
420 S. Washington
Alexandria, Va. 22314

Gordon Woodside Gallery
803 E. Union Street
Seattle, Wash. 98122

The Zabriskie Gallery
29 West 57 Street
New York, N.Y. 10019

William Zierler Inc.
956 Madison Avenue
New York, N.Y. 10021

Galerie Rudolf Zwirner
Albertusstrasse 16
Cologne, Germany

AACH, HERB. b. March 24, 1923, Cologne, Germany. **Studied:** Stanford U.; Brooklyn Museum School; Pratt Institute; School of Fine Arts, Cologne; Escuela de Pintura y Escultura, Mexico City (with John Ferren, Rufino Tamayo, Max Beckmann, Edwin Dickinson, Arthur Osver, Xavier Gonzalez). Traveled Europe, USA, Central America, Middle East. **Taught:** Brooklyn Museum School, 1947-51; Hazleton Art League; Kingsbridge Community Center, Bronx, N.Y.; Pratt Institute, 1966-69; Queens College, 1966-. **Member:** College Art Association; National Art Education Association. Technical consultant on colors. **Awards:** Hazleton Art League, First Prize, 1956, 63. **Address:** 523 East 14 Street, NYC 10009. **Dealer:** Martha Jackson Gallery. **One-man Exhibitions:** (first) Creative Gallery, NYC, 1952; Stroudsberg Gallery; Hazleton Art League; The Pennsylvania State U.; Scranton/Everhart; Albert Landry, NYC; J. Seligmann and Co., 1964; Martha Jackson Gallery, 1974; Buffalo/Albright, 1975. **Group:** WMAA; PAFA; U. of Illinois, 1961; ART:USA, NYC; Scranton/Everhart; Riverside Museum, NYC; Lehigh U., 1965, 67; Cranbrook, 5th Biennial, National Religious Art Exhibition, 1966; U. of Texas, Color Forum, 1972. **Collections:** Boston/MFA; Calcutta; Harris-

burg/Pa. State Museum; Scranton/ Everhart.

ACCONCI, VITO. b. January 24, 1940, Bronx, N.Y. **Studied:** College of the Holy Cross, Worcester, Mass., 1958-62, BA; U. of Iowa, Iowa City, 1962-64, MFA. Traveled Europe. **Taught:** School of Visual Arts, NYC, 1968-71. **Address:** 131 Chrystie Street, NYC 10002. **Dealer:** Ileana Sonnabend Gallery, NYC and Paris. **One-man Exhibitions:** John Gibson Gallery, 1971; Ileana Sonnabend Gallery, Paris, 1972, NYC, 1972, 73, 75; Galleria l'Attico, Rome, 1972; Modern Art Agency, Naples, Italy, 1973; Galerie D., Brussels, 1973; Galleria Schema, Florence, 1973; Galleria Forma, Genoa, 1974; Galleria A. Castelli, Milan, 1974, 75. **Group:** Jewish Museum, Software, 1970; MOMA, Information, 1971; Dusseldorf/Kunsthalle, Prospect '71, 1971; VII Paris Biennial, 1971; Documenta V, Kassel, 1972; MOMA, Some Recent American Art, circ., 1973; Parcheggio di Villa Borghese, Rome, Contemporanea, 1974; MOMA, Eight Contemporary Artists, 1974; Cologne, Project '74, 1974; Chicago/AI, Idea and Image in Recent Art, 1974. **Collections:** MOMA. **Bibliography:** *Contemporanea*; Meyer.

ACTON, ARLO C. b. May 11, 1933, Knoxville, Iowa. **Studied:** Washington State U., 1958, BA; California Institute of Arts, 1959, MFA. US Army Medical Corps, 1955-57. Traveled France, Italy. **Taught:** U. of California, Berkeley, 1963, 67, 68. **Awards:** SFMA, Edgar Walter Memorial Prize, 1961; California State Fair, 1961; Richmond (Calif.) Art Association Annual, Second Prize, 1961; San Francisco Art Association, cash award, 1964. **Address:** c/o General Delivery, North San Juan, Calif. 95960; studio: 63 Bluxome Street, San Francisco, Calif. 94107. **One-man Exhibitions:** (first) Bolles Gallery, San Francisco, 1962; The Lanyon Gallery, 1965; Nicholas Wilder Gallery, 1965, 66; Esther Robles Gallery, 1969. **Group:** SFMA Annuals, 1960, 61, 62, 63, 64, 65; RAC, 1961, 62; Los Angeles/County MA, Cross-section LA-SF, 1961; Oakland/

AM, 1960, 61; SFMA, Arts of San Francisco, 1962; Stanford U., Some Points of View for '62, 1962; Fort Worth, The Artist's Environment: The West Coast, 1962; WMAA, Fifty California Artists, 1962-63; Kaiser Center, Oakland, California Sculpture, 1963; III Paris Biennial, 1963; U. of Arkansas, Contemporary Americans, 1966; U. of California, Berkeley, Funk, 1967; Los Angeles/County MA, American Sculpture of the Sixties, circ., 1967; Portland, Ore. AM, the West Coast Now, 1968. **Collections:** U. of Nevada; Oakland/AM; SFMA; SFPL. **Bibliography:** Selz, P. 2; Tuchman 1.

ADAMS, CLINTON. b. December 11, 1918, Glendale, Calif. **Studied:** UCLA, 1940, BA, 1942, MFA US Army, World War II. Traveled USA and Europe extensively. **Taught:** UCLA, 1946-54; U. of Kentucky, 1954-57; U. of Florida, 1957-60; U. of New Mexico, 1961. Associate Director, Tamarind Lithography Workshop, 1960-61; Director, Tamarind Institute, 1970- . **Address:** 1917 Morningside Drive, Albuquerque, N.M. 87110. **One-man Exhibitions:** (first) UCLA, 1950; Felix Landau Gallery, 1952, 56, 58, 61, 63, 65; Pasadena/AM, 1954; Louisville/Speed, 1956; U. of Texas, 1957; U. of Florida, 1957; Galleria Mazzuchelli, Florence, Italy; Jonson Gallery, Albuquerque, N.M., 1961, 63, 68; Roswell, 1972. **Retrospective:** U. of New Mexico, 1973; U. of Iowa; U. of Georgia. **Group:** MOMA; MMA; Brooklyn Museum; Library of Congress; Carnegie; PAFA; Cincinnati/AM; Ringling; Oakland/AM; De Kalb, National Print and Drawing Exhibition, 1968; MOMA, Tamarind: Homage to Lithography, 1969; Honolulu Academy, First Hawaiian National Print Exhibition, 1971. **Collections:** Achenbach Foundation; Amon Carter Museum; Bibliotheque Nationale; Bradley U.; Brooklyn Museum; Chicago/AI; Dallas/MFA; De Kalb; De Pauw U.; Florida State U.; Grunwald Foundation; U. of Illinois; La Jolla; Los Angeles/County MA; MOMA; U. of New Mexico; NYPL; Otis Art Institute;

Pasadena/AM; San Diego; Santa Fe, N.M.; Seattle/AM; UCLA; Victoria and Albert Museum. Archives.

ADAMS, PAT. b. July 8, 1928, Stockton, Calif. **Studied:** U. of California (with Glenn Wessels, John Haley, Margaret O'Hagan, Erle Loran), 1949, BA, PBK; Brooklyn Museum School (with Max Beckmann, Reuben Tam, John Ferren). Traveled Europe, Middle East. **Taught:** Bennington College, 1967- ; Yale U., 1971-72; Queens College, 1972. **Awards:** Yaddo Fellowship, 1954, 64, 69, 70; Fulbright Fellowship (France), 1956; National Council on the Arts, $5000 Award, 1968; MacDowell Colony Fellowship, 1968, 72. **Address:** Bennington College, Bennington, Vt. 05201. **Dealer:** The Zabriskie Gallery. **One-man Exhibitions:** (first) Stockton, 1950; Korman Gallery, NYC, 1954; The Zabriskie Gallery, 1954, 56, 57, 60, 62, 64, 70, 72, 74; Kanegis Gallery, 1959; Wheaton College, 1959; Bennett College, 1959; Green Mountain College, 1962; Arts and Crafts Gallery, Wellfleet, Mass., 1963; Hotchkiss School, Lakeville, Conn., 1960; Windham College. **Group:** Bordighera, Americans in Europe, 1952; WMAA Annuals, 1956, 58, 61; A.F.A., Collage in America, circ., 1957-58; MOMA, 41 Watercolorists, circ. Europe, 1957; U. of Nebraska, 1958; A.F.A., The New Landscape in Art and Science, circ., 1958-59; WMAA, Fulbright Artists, 1958; Hirschl & Adler Galleries, Inc., NYC, Experiences in Art, I & II, 1959, 60; Tanager Gallery, NYC, The Private Myth, 1961; A.F.A., Lyricism in Abstract Art, circ., 1962-63; PAFA, Watercolor Annual, 1959; U. of Michigan, One Hundred Contemporary American Drawings, 1965; U. of Texas, Color Forum, 1972; New York Cultural Center, Women Choose Women, 1973; Hirshhorn, Inaugural Exhibitions, 1974, **Collections:** Bordighera; Hirshhorn; U. of Michigan; U. of North Carolina; Williams College; WMAA. **Bibliography:** *Art: A Woman's Sensibility*; Chaet.

ADLER, SAMUEL M. b. July 30, 1898, NYC. **Studied:** NAD, 1911. Traveled

North and Central America, Europe, Africa. A professional violinist through student years. **Taught**: Privately, 1934-48; NYU, 1948-72; U. of Illinois, 1959-60; Associate Member, Institute of Advanced Study, U. of Illinois, 1964; U. of Notre Dame, 1965; U. of Georgia, 1967-69. Ex-member, Artists Equity, formerly vice president and president of the New York Chapter. **Awards**: PAFA, J. Henry Schiedt Memorial Prize, 1951; U. of Illinois, **P.P.**, 1952; WMAA, **P.P.**, 1952, 63; Audubon Artists, 1956, First Hon. Men., 1957, 59, Gold Medal of Honor, 1960; Staten Island, **P.P.**, 1962; Ford Foundation Artist-in-Residence, 1965; American Society of Contemporary Artists, Second Prize, 1967, First Prize, 1968. **Address**: 45 Christopher Street, NYC 10014; **Studio**: 27 East 22 Street, NYC 10010. **Dealer**: Rehn Galleries. **One-man Exhibitions**: (first) Joseph Luyber Galleries, NYC, 1948; Indiana U., 1950; Louisville Art Center Association, 1950; Charlotte/Mint, 1951; Grace Borgenicht Gallery Inc., 1952, 54; Philadelphia Art Alliance, 1954; U. of Illinois, 1959, 60, 64; Grand Central Moderns, NYC, 1960; The Babcock Gallery, 1962; U. of Notre Dame, 1965; Rose Fried Gallery, 1965 (2); U. of Iowa, 1966; U. of Georgia, 1967, 68; Ripon College, 1968; Rehn Galleries, 1971, 72, 76; Andover/Phillips, 1972; Wichita State U., 1976. **Group**: AAAL; Chicago/AI; ART: USA, NYC; Atlanta/AA; Audubon Artists; Birmingham, Ala./MA; Youngstown/Butler; California Palace; Cincinnati/AM; St. Louis/City; Columbia, S.C./MA; Columbus; Corcoran; Dallas/MFA; Dayton/AI; Lincoln, Mass./De Cordova; Denver/AM; Honolulu Academy; Howard U.; Jewish Museum; Omaha/Joslyn; Los Angeles/County MA; MMA; Milwaukee; Cranbrook; Boston/MFA; Santa Barbara/MA; NAD; PAFA; Stanford U.; WMAA; Royal Academy, London. **Collections**: Brooklyn Museum; Clearwater/Gulf Coast; Cornell U., Fourth National Bank and Trust, Wichita; U. of Georgia; Hirshhorn; Illinois Wesleyan U.; Michigan State U.; NCFA; NYU; U. of Nebraska; Norfolk; U. of Notre Dame; Safad; St. Lawrence U.; Slater; Staten Island; Utica; WMAA; Wichita State U.; Youngstown/Butler. **Bibliography**: Biddle 4; Nordness, ed.; Pearson 2; Pousette-Dart, ed.; Weller. Archives.

AGOSTINI, PETER. b. 1913, NYC. **Studied**: Leonardo da Vinci Art School, NYC. **Commissions**: New York World's Fair, 1964-65. **Awards**: Longview Foundation Grant, 1960, 61, 62; Brandeis U., Creative Arts Award, 1964. **Address**: 151 Avenue B, NYC. **Dealer**: The Zabriskie Gallery. **One-man Exhibitions**: Galerie Grimaud, NYC, 1959; Stephen Radich Gallery, 1960, 62-65, 67, 68; Richard Gray Gallery, 1965; U. of North Carolina, 1969; The Zabriskie Gallery, 1971, 73. **Group**: New School for Social Research; Jewish Museum, Recent American Sculpture, 1964; WMAA; MOMA; Claude Bernard, Paris, 1960; Chicago/AI, 1962; Hartford/Wadsworth, 1962; Battersea Park, London, International Sculpture Exhibition, 1963. **Collections**: Brandeis U.; Hartford/Wadsworth; ILGWU; Kalamazoo/Institute; MIT; MOMA; U. of Southern California; U. of Texas; Union Carbide Corp.; Walter. **Bibliography**: Hunter, ed.; Lippard 5; Read 3; Rose, B. 1. Archives.

ALBERS, JOSEF. b. March 19, 1888, Bottrop, Westphalia, Germany; **d.** March 26, 1976, New Haven, Conn. **Studied**: Royal Art School, Berlin, 1913-15; School of Applied Art, Essen, 1916-19; Academy of Fine Arts, Munich, 1919-20; Bauhaus, Weimar, 1920-23, where he became an instructor (Weimar-Dessau-Berlin), 1923-33. To USA 1933 to teach and head Art Department at Black Mountain College, to 1949. US citizen 1939. Headed Department of Design at Yale U., 1950-58; Visiting Critic, 1958-60. **Taught**: Design, drawing, color and painting. Presented courses, seminars, lecture series in many European and North and South American universities, until his retirement, 1960. **Member**: American Abstract Artists; PCA. **Commissions**

(murals): Harvard U.; Corning Glass Building, NYC. **Awards:** German Federal Republic, Officers Cross First Class of the Order of Merit; Corcoran, William A. Clark Prize, 1954; Chicago/AI, Ada S. Garrett Prize, 1954; Hon. DFA, U. of Hartford, 1957; Ford Foundation Fellowship, 1959; PMA, Citation, 1962; Hon. DFA, Yale U., 1962; American Institute of Graphic Art, Medal of the Year, 1964; Carnegie, 1967; Hon. DFA, California College of Arts and Crafts, 1964; Bridgeport U., 1966; U. of North Carolina, 1967; U. of Illinois, 1969; Kenyon College, 1969; Minnesota College of Art and Design, 1969; AAAL, Award, 1970; Royal Society, 1971; Maryland Institute, 1972; York U., 1973; Pratt Institute, 1975.**One-man Exhibitions:** (first) Goltz Gallery, Munich, 1919; Sidney Janis Gallery, 1949, 52, 55, 58, 59, 61, 64, 68, 70; Cincinnati/AM, 1949; Yale U., 1956; Galerie Denise Rene, Paris, 1957, 58; Kunstverein Freiburg im Breisgau, 1958; Zurich, 1960; Amsterdam/Stedelijk, 1961; Raleigh/NCMA, 1962; MOMA, Josef Albers, circ. Latin America, 1964; WGMA, 1965; Gimpel & Hanover Galerie, Zurich, 1965; Kestner-Gesellschaft, Hannover, 1968; Landesmuseum fur Kunst und Kulturgeschichte, Munster, 1968; Bielefeld, 1968; Dusseldorf/Kunsthalle, 1970; MMA, 1971; Princeton U., 1971; Pollock Gallery, Toronto, 1972; Galerie Gmurzymska & Bargera, Cologne, 1973; Galerie Melki, Paris, 1973; and some 100 others. **Retrospective:** Yale U., 1956; WGMA, Josef Albers, The American Years, 1965; Josef Albers, circ. Germany and Switzerland. **Group:** American Abstract Artists, 1939; Herbert Hermann Gallery, Brooklyn, 1949; Galerie Stuttgart, 1948; U. of Illinois, 1951, 52, 53; Hartford/Wadsworth, Josef and Annie Albers, 1953; Zurich, 1956; WMAA, Geometric Abstraction in America, circ., 1962; SRGM, Cezanne and Structure in Modern Painting, 1963; SRGM, Abstract Expressionists and Imagists, 1961; Smithsonian, Paintings from the Museum of Modern Art, New York, 1963; MOMA, The Responsive Eye, 1965; MOMA, Two Decades of American Painting, circ. Japan, India, Australia, 1967; and some 500 others. **Collections:** Amsterdam/Stedelijk; Baltimore/MA; Basel; Bennington College; Berea College; Brown U.; Buffalo/Albright; Carnegie; Chicago/AI; Corcoran; Currier; Denver/AM; Detroit/Institute; Duke U.; Essen; Hagen; Hartford/Wadsworth; Harvard U.; Hollins College; Leverkusen; Los Angeles/County MA; U. of Louisville; MIT; MMA; MOMA; Mills College; U. of Minnesota; Morgan State College; Muhlenberg College; Munster; New London; U. of New Mexico; North Texas State U.; Park College; Portland, Ore./AM; Rio de Janeiro; SFMA; SRGM; Smith College; Smithsonian; Springfield, Mass./MFA; Stockholm/National; Svest; Toronto; Utica; VMFA; WMAA; Wesleyan U.; U. of Wisconsin; Yale U.; Zurich. **Bibliography:** MOMA, the Albers Archive-1. "Documentation in Manuscript" (photocopy, artist's personal record of his professional chronology); 2. Writings on Art (photocopies of typescripts); 3. Scrapbooks, clippings, catalogues, photographs, etc. Additional and overlapping data may be found at the Bauhaus-Archiv, Darmstadt, Germany, The Busch-Reisinger Museum, Cambridge, Mass., and the Yale U. Library, New Haven, Conn. **Albers 1, 2, 3, 4, 5, 6, 7;** American Abstract Artists, ed.; Battcock, ed.; Baur 7; Bihalji-Merin; Blanchard; Blesh 1; Calas, N. and E.; Chaet; Cheney; Christensen; Coplans 3; Davis, D.; Dorner; Eliot; Frost; Gaunt; Gerstner; Gomringer; Goodrich and Baur 1; Haftman; **Hamilton, G.H.;** Henning; Hess, T.B. 1; Hunter, ed.; Janis and Blesh 1; Janis, S.; Kepes, ed.; Kuh 2; Lynton; MacAgy 2; McCurdy, ed.; Mendelowitz; *Metro;* Morris; Motherwell 1; Neumeyer; Nordness, ed.; Pearson 2; Ponente; Pousette-Dart, ed.; Read 2, 3; Rickey; Ritchie 1; Rodman 2, 3; Rose, B. 1, 4; Roters; Seuphor 1; Tomkins; Trier 1; Tyler, K. E.; Weller; Wingler, ed. Archives.

ALBERT, CALVIN. b. November 19, 1918, Grand Rapids, Mich. **Studied:** Institute of Design, Chicago, with Lazlo Moholy-Nagy, Gyorgy Kepes, Alexander Archipenko. Traveled Europe. **Taught:** Institute of Design, Chicago; NYU; Brooklyn College; Pratt Institute. Federal A.P.: Painting, sculpture, design exhibitions. **Member:** College Art Association; AAUP (1969 president, Pratt chapter). **Commissions:** St. Paul's Episcopal Church, Peoria, Ill.; Temple Israel, Bridgeport, Conn.; Temple Israel, Tulsa, Okla.; Park Avenue Synagogue, NYC; Temple Emmanuel, Grand Rapids, Mich., 1973, 74. **Awards;** Detroit/Institute, The Haass Prize, 1944; ICA, London/Tate, International Unknown Political Prisoner Competition, Hon. Men., 1953; Audubon Artists, First Prize, 1954; Fulbright Fellowship, 1961; L. C. Tiffany Grant, 1963, 65; Guggenheim Foundation Fellowship, 1966; NIAL, **P.P.,** 1975. **Address:** 16 Kent Place, East Hampton, N.Y. 11937. **One-man Exhibitions:** Paul Theobald Gallery, Chicago, 1941; Puma Gallery, NYC, 1944; Chicago/AI, 1945; California Palace, 1947; Grand Rapids, 1948; Laurel Gallery, NYC, 1950; Grace Borgenicht Gallery Inc., 1952, 54, 56, 57; MMA, 1952; Walker, 1954; U. of Nebraska, 1955; The Stable Gallery, NYC, 1959, 64; U. of Georgia, 1970; Free Public Library, Fair Lawn, N.J., 1973; Landmark Gallery Inc., NYC, 1974; Benson Gallery, 1975. **Retrospective:** Jewish Museum, 1960. **Group:** Andover/Phillips, The American Line-100 Years of Drawing, 1959; Chicago/AI, Contemporary Drawings from 12 Countries, 1952; MMA, American Watercolors, Drawings and Prints, 1952; A.F.A., The Embellished Surface, circ., 1953-54; Contemporary Drawing from the United States, circ. France, 1954; MOMA, Recent Drawings, USA, 1956; U. of Illinois, 1957, 65; WMAA Annuals, 1954, 55, 56, 58, 60, 62, 66, 68; A.F.A., God and Man in Art, circ., 1958-59; Brooklyn Museum, Golden Year of American Drawing, 1956; Chicago/AI, 1962; PAFA, 1949, 53, 64; Flint/Institute, American Sculpture: 1900-1965, 1965; PAFA Annual, 1967; U. of Nebraska, American Sculpture, 1970; AAL, 1975. **Collections:** Brooklyn Museum; Chicago/AI; Detroit/Institute; Guild Hall; Jewish Museum; Kansas City/Nelson; MMA; U. of Nebraska; Norfolk/Chrysler; U. of North Carolina. **Bibliography:** Weller. Archives.

ALBRIGHT, IVAN LE LORRAINE. b. February 20, 1897, North Harvey, Ill. Studied: Chicago Art Institute School, 1920-23; PAFA, 1923; NAD, 1924; Northwestern U., 1915-16; Illinois School of Architecture, 1916-17; Ecole Regionale des Beaux-Arts, Nantes, 1919. US Army, 1918-19. Traveled Venezuela, USA, Europe. **Member:** NAD; Chicago Society of Arts, Inc. **Commissions** (paintings): "The Portrait of Dorian Gray" for the film, 1943; "The Temptation" of St. Anthony" for the film, 1943. **Awards:** Chicago/AI, Faculty Hon. Men., 1923; Chicago/AI, Hon. Men., 1926; Chicago/AI, John C. Shaffer Prize, 1928; Chicago/AI, Norman Wait Harris Medal, 1941, 43; Society for Contemporary American Art, Silver Medal, 1930, Gold Medal, 1931; Chicago/AI, First Prize, 1948; PAFA, Joseph E. Temple Gold Medal, 1942; MMA, Artists for Victory, First Prize, 1942; NAD, Benjamin Altman Prize, 1961; Corcoran, Silver Medal, 1955; Northwestern U., Centennial Award, 1951; Tate, $5,000 Dunn International Prize, 1963; NIAL, 1957. **Address:** Woodstock, Vt. 05091. **One-man Exhibitions:** Walden Book Shop, Chicago, 1930; Chicago/AI, 1931; A.A.A. Gallery, NYC (two-man), 1945; Chicago (two-man), 1946; Kennedy Gallery. **Retrospective:** Chicago/AI, 1964. **Group:** Chicago/AI, 1918, 23, 26, 28, 41, 43, 48; PAFA, 1924, 42; Brussels World's Fair, 1958; WMAA; Corcoran, 1955; NAD. **Collections:** Brooklyn Museum; Carnegie; Chicago/AI; Dallas/MFA; Hartford/Wadsworth; Library of Congress; MMA; MOMA; PMA; Phoenix; US Labor Department. **Bibliography:** Barker 1; Baur 7; Blesh 1;

Canaday; Cheney; Eliot; Flanagan; Flexner; Haftman; Hall; Jacobson, ed.; Kuh 1, 2, 3; McCurdy, ed.; Mendelowitz; Newmeyer; Pearson 1, 2; Pousette-Dart, ed.; Reese; Richardson, E. P.; Rose, B. 1, 4; **Sweet**; Weller. Archives.

ALCALAY, ALBERT. b. 1917, Paris, France. To USA 1951. Traveled France, England, Italy, Yugoslavia, Israel, 1970-71. **Taught:** Harvard U., 1959- ; U. of Maryland, 1971. **Awards:** Guggenheim Foundation Fellowship, 1959; Boston Arts Festival, First Prize, 1960. **Address:** 66 Powell Street, Brookline, Mass. 02146. **Dealers:** Pucker-Safrai Gallery; Du Bose Gallery. **One-man Exhibitions:** Cortile Gallery, Rome, 1947; Gaetano Chiurazzi, Rome, 1950; Boston Museum School, 1951; Lincoln, Mass./De Cordova, 1954; Philadelphia Arts Club, 1951; The Krasner Gallery, 1959, 61, 62, 64, 66; The Swetzoff Gallery, Boston, 1952-54, 56, 58; Wittenborn Gallery, NYC, 1958; The Pace Gallery, Boston, 1961, 62; Mickelson's Gallery, Washington, D.C., 1964, 67; Ward-Nasse Gallery, Boston, 1965, 67; Pucker-Safrai Gallery, 1971, 73; Smith-Andersen Gallery, Palo Alto, 1973. **Retrospective:** Lincoln, Mass./De Cordova, 1968. **Group:** Rome National Art Quadriennial, 1947; U. of Illinois, 1955, 57, 59; WMAA, 1956, 58, 60; ICA, Boston, View, 1960; PAFA, 1960; MOMA, 1955; AAAL. **Collections:** Andover/Phillips; Boston/MFA; Brandeis U.; Colby College; First National Bank of Boston; Harvard U.; Lincoln, Mass./De Cordova; MOMA; Rome/Nazionale; U. of Rome; Simmons College; State Street Bank and Trust Co., Boston; Wellesley College.

ALSTON, CHARLES HENRY. b. November 28, 1907, Charlotte, N.C. **Studied:** Columbia U., BA; 1931, MA; Pratt Institute (with Alexander Kostellow). Traveled Europe, Caribbean. **Taught:** Joe and Emily Lowe Art School, NYC, 1949-57; ASL, 1950- ; City College; MOMA School; New School for Social Research. Federal A.P.: Mural

and Lithography Supervisor; murals for Harlem Hospital, NYC; Golden State Mutual Life Insurance Co. **Commissions:** Murals, City College; American Museum of Natural History; P.S. 154, NYC; Harlem Hospital; Family Criminal Court Building, Bronx, N.Y., 1975. **Awards:** Columbia U., Dow Fellow, 1930; Lessing J. Rosenwald Fund Fellowship, 1939, 40; NIAL Grant, 1958; Atlanta U., First Prize, 1941; Dillard U., **P.P.,** 1942; Joe and Emily Lowe Foundation Award, 1960; National Council on the Arts, 1967. **Address:** 1270 Fifth Avenue, NYC 10029. **Dealer:** Kennedy Gallery. **One-man Exhibitions:** (first) Seymour Oppenheimer Gallery, Chicago, 1950; John Heller Gallery, NYC, 1953-57; Dunbarton Gallery, Boston, 1959; Feingarten Gallery, NYC, 1960. **Retrospective:** New York Cultural Center, Selective Retrospective, 1950-1969. **Group:** MMA, 1950; Boston/MFA; MOMA (several); Brussels World's Fair, 1958; Corcoran; WMAA; Detroit/Institute; Baltimore/MA; City College; U. of California, 1967; New York Cultural Center, 1969. **Collections:** Abraham Lincoln High School; Atlanta U.; City College; Detroit/Institute; Ford Motor Company; Golden State Mutual Life Insurance Co.; Harlem Hospital; Howard U.; IBM; U. of Illinois; MMA; NAACP; U. of Nebraska; WMAA; Youngstown/Butler. **Bibliography:** Dover. Archives.

ALTMAN, HAROLD. b. April 20, 1924, NYC. **Studied:** ASL (with George Bridgeman, Stefan Hirsch), 1941-42; Cooper Union (with Morris Kantor, Byron Thomas, Will Barnet), 1941-43, 1946-47; New School for Social Research (with Abraham Rattner), 1947-49; Black Mountain College (with Josef Albers), 1946; Academie de la Grande Chaumiere (with McAvoy), 1949-52. US Army, 1943-46. Traveled Europe, Mexico. **Taught:** N.Y. State College of Ceramics; U. of North Carolina; Indiana U.; U. of Wisconsin, 1956-62; The Pennsylvania State U., 1962- . **Member:** SAGA; California Society of Printmak-

ers; PCA. **Commissions** (print editions): MOMA; Jewish Museum; New York Hilton Hotel; SAGA; Container Corp. of America "Great Ideas of Western Man" advertising series. **Awards:** Guggenheim Foundation Fellowship, 1961, 63; NIAL Grant, 1963; Chicago/AI, John Taylor Arms Medal; SAGA; PAFA; Tamarind Fellowship; Silvermine Guild; Fulbright-Hayes Research Scholar to France, 1964-65; The Pennsylvania State U., 1968, 69; Oklahoma, 1969; and some 200 others. **Address:** P.O. Box 57, Lemont, Pa. 16851. **Dealers:** A.A.A. Gallery; Impressions Workshop, Inc.; Haslem Fine Arts, Inc.; Marjorie Kauffman Gallery, Houston. **One-man Exhibitions:** (first) Galerie Huit, Paris, 1951; Martha Jackson Gallery, 1958; Philadelphia Art Alliance, 1959; The Contemporaries, NYC, 1959, 63; Peter H. Deitsch Gallery, 1960; Chicago/AI, 1961; SFMA, 1961; Santa Barbara/MA, 1961; Escuela Nacional de Artes Plasticas, Mexico City, 1961; The Goodman Gallery, Buffalo, 1961; Kasha Heman, Chicago, 1961, 63; Felix Landau Gallery, 1962; Gump's Gallery, 1962, 64; Irving Galleries, Inc., Milwaukee, 1962, 64, 66; Kenmore Galleries, Inc., Philadelphia, 1963; The Pennsylvania State U. 1963; Kovler Gallery, 1963, 66; A. B. Closson Gallery, Cincinnati, 1965; Weyhe Gallery, 1966; Oklahoma, 1966; Ohio State U., 1966; Franklin Siden Gallery, Detroit, 1966; Sagot-Le Garrec Gallery, Paris, 1968, 74; Graphis Gallery, NYC, 1969, 71; Haslem Fine Arts, Inc., 1970, 71; David Barnett Gallery, Milwaukee, 1972; Gloria Luria Gallery, 1973; Gallery 1640, 1973; Marjorie Kauffman Gallery, Houston, 1973, 74; Wustum Museum of Art, 1974; Impressions Workshop, Inc., 1975. **Group:** WMAA Annuals; I Paris Biennial, 1959; PCA, American Prints Today, circ., 1959-62; SAGA, 1960-74; MOMA, Recent Painting USA: The Figure, circ., 1962-63; Festival of Two World, Spoleto; St. Paul Gallery, Drawing USA, 1962, 64, 66, 71; PAFA Annuals, 1963, 66, 67, 69; MMA, Walter C. Baker Master Drawings Collection; Basel, Five

American Printmakers, 1965; Santiago, Chile, II Interamerican Biennial of Printmaking, 1965; WMAA, A Decade of American Drawings, 1965. **Collections:** Achenbach Foundation; Amsterdam/Stedelijk; Auburn U.; Basel; Bibliotheque Nationale; Bibliotheque Royale de Belgique; Boston Public Library; Boston U.; Buffalo/Albright; Chicago/AI; Clairol Inc.; Cleveland/MA; The Coca-Cola Co.; Container Corp. of America; Copenhagen; Detroit/Institute; Escuela Nacional de Artes Plasticas, Mexico City; First National Bank of Dallas; First National Bank, Minneapolis; U. of Georgia; U. of Glasgow; Grinnell College; Grunwald Foundation; Haifa; Hartford/Wadsworth; Hershey Foods Corp.; IBM; U. of Illinois; U. of Kentucky; Library of Congress; Lincoln Mass./De Cordova; Los Angeles/County MA; Lytton Savings and Loan Association; MMA; MOMA; Malmo; Milwaukee; Milwaukee *Journal*; NYPL; NYU; National Gallery; Newark Museum; New York Hilton Hotel; Norfolk; PAFA; PMA; The Pennsylvania State U.; Philip Morris Collection; Princeton U.; Raleigh/NCMA; SFAI; Smithsonian; Syracuse U.; Victoria (B.C.); WMAA; Walker; Woodward Foundation; Yale U.; Youngstown/Butler.

ALTOON, JOHN. b. 1925, Los Angeles, Calif.; **d.** February 8, 1969, Los Angeles, Calif. **Studied:** Otis Art Institute; Art Center School, Los Angeles; Chouinard Art Institute. US Navy, World War II. Traveled France, Spain. **Taught:** Otis Art Institute, 1951-62; Art Center School, Los Angeles, 1956-60; UCLA, 1962-63; Chouinard Art Institute, 1962-63; La Jolla, summer, 1962; Pasadena/AM, 1965-68. **Awards:** SFMA, Stacy Award, 1950; Joe and Emily Lowe Foundation Award, 1955; Pasadena/AM, **P.P.,** 1959; SFMA, James D. Phelan Award, 1961; Los Angeles/County MA, **P.P.,** 1962; William and Noma Copley Foundation Grant, 1964. **One-man Exhibitions:** (first) Santa Barbara/MA, 1951, also 1965; Artists'

Gallery, NYC, 1953; Ganso Gallery, NYC, 1954; Ferus Gallery, Los Angeles, 1958-62; La Jolla, 1960; de Young, 1963; David Stuart Gallery, 1964, 65; Phoenix, Hack-Light, 1965; Quay Gallery, 1966, 68, 73; Fischbach Gallery, 1967; SFMA, 1967; Stanford U., 1967; Tibor de Nagy Gallery, NYC, 1970, 71, 73; WMAA, 1971; Galerie Hans R. Neuendorf, Cologne, 1972; Felicity Samuel Gallery, London, 1973; Nicholas Wilder Gallery, 1973, 75; Seder/Creigh Gallery, Coronado, 1975. **Group:** Carnegie, 1959; Santa Barbara Invitational, 1962; WMAA, Fifty California Artists, 1962-63; SRGM, American Drawings, 1964; SFMA, 1964, 65; U. of Texas, 1966; WMAA, 1967. **Collections:** La Jolla; Los Angeles/County MA; MOMA; Pasadena/AM; SFMA; Stanford U.; WMAA. **Bibliography:** John Altoon; Lippard 5; *The State of California Painting.*

AMEN, IRVING. b. July 25, 1918, NYC. **Studied:** ASL, with Vaclav Vytlacil, William Zorach, John Hovannes; Pratt Institute; Leonardo da Vinci Art School, NYC; Academie de la Grande Chaumiere, 1950; Florence and Rome, Italy. US Air Force, 1942-45. Traveled Europe extensively, Russia, Mexico. **Taught:** Pratt Institute, 1961; U. of Notre Dame, 1962. **Member:** Artists Equity; Audubon Artists; Boston Printmakers; SAGA; Fellow of the International Institute of Arts and Letters, 1960. **Address:** 1049 Madison Avenue, NYC 10028. **Dealers:** A.A.A. Gallery; Brentano's. **One-man Exhibitions:** (first) New School for Social Research, 1948; Smithsonian, 1949; The Krasner Gallery, 1948; Nebraska Wesleyan U., Lincoln, 1969. **Group:** USIA, Contemporary American Prints, circ. France, 1954; USIA, 20th Century American Graphics, circ., 1959-61; MOMA, Master Prints from the Museum Collection, 1949; MOMA, Young American Printmakers, 1953; MMA; Graphic Arts, 1955; U. of Illinois, 50 Contemporary American Printmakers, 1956; ART: USA:59, NYC, 1959; Library of Congress; Brooklyn Museum; IV Bordighe-ra Biennial, 1957; PAFA; NAD; Silvermine Guild; Audubon Artists; SAGA; American Color Print Society. **Collections:** Bezalel Museum; Bibliotheque Nationale; Bibliotheque Royale de Belgique; Boston/MFA; Cincinnati/AM; Graphische Sammlung Albertina; Harvard U.; Library of Congress; MMA; MOMA; NYPL; PMA; Smithsonian; Victoria and Albert Museum; Wilberfeld. Archives.

ANDERSON, GUY IRVING. b. November 20, 1906, Edmonds, Wash. Traveled USA, Mexico, Canada, Europe. Federal A.P.: Spokane (Wash.) Art Center, 1938-39; Staff member, Seattle/AM, 1944; Helen Bush School, Seattle, 1954-55; Fidalgo Allied Arts, La Conner, Wash.,1957-59. **Commissions:** Tacoma Art League, 1960; murals for: Hilton Inn, Seattle-Tacoma Airport; Seattle Opera House; Bank of California, Seattle; 1973; stone mosaic for First National Bank of Seattle; Seattle World's Fair, 1962. **Awards:** L. C. Tiffany Grant, 1929; Seattle/AM, Art Award; Seattle/AM, Margaret E. Fuller, **P.P.**; State of Washington Governor's Award, Man of the Year, 1969; Guggenheim Foundation Fellowship, 1975. **Address:** Box 217, LaConner, Wash. 98257. **Dealer:** Francine Seders Gallery. **One-man Exhibitions:** (first) Seattle/AM, 1936, also 1945, 1953 (four-man), 1960; Zoé Dusanne Gallery, Seattle, 1952; Otto Seligman Gallery, 1954, 59, 63, 65; College of Puget Sound, 1954; Tacoma, 1960; Smolin Gallery, NYC, 1962; Michel Thomas Gallery, Beverly Hills, Calif., 1962; Orris Gallery, San Diego, 1962; Kenmore Galleries, Inc., Philadelphia, 1963; Francine Seders Gallery, 1970, 73, 75. **Retrospective:** Seattle/AM; Tacoma. **Group:** Seattle/AM, Northwest Annual, 1929-68, with four exceptions; MMA, American Watercolors, Drawings and Prints, 1952; USIA, Eight American Artists, circ. Europe and Asia, 1957-58; Seattle World's Fair, 1962; Olympia, Wash., I Governor's Invita-

tional, 1963; A.F.A., Drawing Society National Exhibiton, 1970; NCFA, Art of the Pacific Northwest, 1974. **Collections:** Brooklyn Museum; Dublin/Municipal; Long Beach/MA; Melbourne/National; Mt. Vernon High School; NCFA; U. of Oregon; Santa Barbara/MA; Seattle/AM; Seattle Public Library; Tacoma; Utica; Victoria (B.C.); Washington State U.; Whatcom; Wichita/AM.

ANDERSON, JEREMY R. b. October 28, 1921, Palo Alto, Calif. **Studied:** San Francisco Art Institute (with David Park, Clyfford Still, Robert Howard, Mark Rothko, S. W. Hayter, Clay Spohn), 1946-50. US Navy, 1941-45. Traveled France. **Taught:** U. of California, 1955-56; SFAI, 1958-74; U. of California, Davis, 1974-75. **Awards:** SFAI, I. N. Walter Memorial Sculpture Prize, 1948; Abraham Rosenberg Foundation Traveling Fellowship, 1950; San Francisco Art Association, Sculpture Prize, 1959. **Address:** 534 Northern Avenue, Mill Valley, Calif. 94941. **One-man Exhibitions:** (first) Metart Gallery, San Francisco, 1949; Allan Frumkin Gallery, Chicago, 1954; The Stable Gallery, 1954; Dilexi Gallery, San Francisco, 1960-62, 1964, 66; Dilexi Gallery, Los Angeles, 1962; SFMA, 1966; Quay Gallery, 1970, 75. **Retrospectives:** SFMA and Pasadena/AM, 1966-67. **Group:** SFMA Annual, 1948, 49, 51-53, 58, 59, 63; U. of Illinois, 1955, 57; WMAA Annual, 1956, 62, 64; Stanford U., Some Points of View for '62, 1962; WMAA, Fifty California Artists, 1962-63; Kaiser Center, Oakland, California Sculpture, 1963; Musee Cantonal des Beaux-Arts, Lausanne, II Salon International de Galeries Pilotes, 1966; U. of California, Berkeley, Funk, 1967; Los Angeles/County MA, American Sculpture of the Sixties, 1967; Portland, Ore./AM, 1968; Expo '70, Osaka, 1970; Oakland/AM, 1973. **Collections:** U. of California; MOMA; Oakland/AM; Pasadena/AM; SFMA. **Bibliography:** Jeremy Anderson; McChesney; **Nordland 3;** Selz, P. 2; Seuphor 3; Tuchman 1.

ANDERSON, JOHN S. b. April 29, 1928, Seattle, Wash. **Studied:** Art Center School, Los Angeles, 1953-54; Pratt Institute, 1954-57, with Calvin Albert. US Army, 1951-53. Traveled Europe, Mexico, USA. **Taught:** Pratt Institute, 1959-62; School of Visual Arts, NYC, 1968-69; U. of New Mexico, 1969; Cooper Union, 1971-75. **Awards:** Guggenheim Foundation Fellowship, 1966, 67; New Jersey State Council on the Arts Grant, 1972. **Address:** Box 59, School Street, Asbury, N.J. 08802. **Dealer:** Allan Stone Gallery. **One-man Exhibitons:** (first) Allan Stone Gallery, 1962, also 1964, 65, 67, 69, 71, 75. **Group:** Waitsfield/Bundy, 1963; United States Plywood Corp., 1964; WMAA, 1964, Sculpture Annuals, 1965, 67, 69; World House Galleries, NYC, 1965. **Collections:** MOMA; WMAA. **Bibliography:** Atkinson.

ANDERSON, LENNART. b. August 22, 1928, Detroit, Mich. **Studied:** Chicago Art Institute School, 1946-50, BFA; Cranbrook Academy of Art, 1950-52, MFA; ASL, 1954, with Edwin Dickinson. Traveled Europe; resided Rome, 1958-61. **Taught:** Chatham College, 1961-62; Pratt Institute, 1962-64; Swain School, New Bedford, Mass., summers, 1963, 64; ASL; Yale U., 1967; Skowhegan School, 1968; Finch College, NYC; Brooklyn College. **Awards:** L. C. Tiffany Grant, 1957, 61; Prix de Rome, 1958-60; Silvermine Guild, Quinto Maganini Award, 1963; Ingram Merrill Foundation Grant, 1965; PAFA, Raymond A. Speiser Memorial Prize, 1966; National Council on the Arts, 1966. **Address:** 877 Union Street, Brooklyn, N.Y. 11215. **Dealer:** Davis & Long Company. **One-man Exhibitions:** (first) Tanager Gallery, NYC, 1962; The Graham Gallery, 1963, 67; Kansas City/Nelson (two-man, with Edwin Dickinson), 1964. **Group:** American Academy, Rome, 1958-60; Kansas City/Nelson, 1962, 64; IBM Gallery of Arts and Sciences, NYC, American Heritage, 1963; Silvermine Guild, 1963; WMAA Annual, 1963, 64; Gallery of Modern

Art, NYC, 1964; Boston U., 9 Realist Painters, 1964; Corcoran, 1964, and Biennial, 1965; Carnegie, 1964, 67; Norfolk, Contemporary Art USA, 1966; Vassar College, 1968; Ravinia Festival, Highland Park, Ill., 1968. **Collections:** Bowdoin College; Brooklyn Museum; Minneapolis/Institute; U. of North Carolina; WMAA.

ANDRE, CARL. b. September 16, 1935, Quincy, Mass. **Studied:** with Patrick Morgan, 1953, Frank Stella, 1958. US Army Intelligence Analyst. Employed by the Pennsylvania Railroad, 1960-64. Traveled England, France, Germany, Holland, Belgium. **Awards:** National Council on the Arts, 1968. **Address:** Box 540, Cooper Station, NYC 10003. **Dealer:** John Weber Gallery; Konrad Fischer Gallery, Dusseldorf. **One-man Exhibitions:** (first) Tibor de Nagy

Gallery, NYC, 1965, also 1966; Dwan Gallery, Los Angeles, 1967; Dwan Gallery, NYC, 1967, 69, 71; Konrad Fischer Gallery, Dusseldorf, 1967, 69, 71, 72, 73, 74; Monchengladbach, 1968; Galerie Heiner Friedrich, Munich, 1968, 71, Cologne, 73; Irving Blum Gallery, Los Angeles, 1969; Wide White Space Gallery, Antwerp, 1969, 71, 74; Galleria Sperone, Turin, 1969, 73; The Hague, 1969; ACE Gallery, Los Angeles, 1970; St. Louis/City, 1971; Yvon Lambert, Paris, 1971; Lisson Gallery, London, 1972; Janie C. Lee Gallery, Dallas, 1972; Galerie Annemarie Verna, Zurich, 1972; Max Protetch Gallery, Washington, D. C., 1973; Portland (Ore.) Center for the Visual Arts, 1973; Andover/ Phillips, 1973; MOMA, 1973; Wide White Space Gallery, Brussels, 1974; John Weber Gallery, 1974, 75; ACE Gallery, Vancouver, 1974; Cusack Gall-

John Anderson *Untitled* 1969

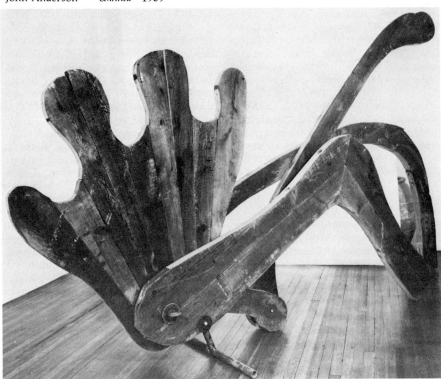

ery, Houston, 1975. **Retrospective:** SRGM, 1970. **Group:** Jewish Museum, Primary Structure Sculptures, 1966; Los Angeles/County MA, American Sculpture of the Sixties, 1967; Documenta IV, Kassel, 1968; The Hague, Minimal Art, 1968; MOMA, The Art of the Real, 1968; Amsterdam/Stedelijk, Op Losse Schroeven, 1969; Berne, When Attitudes Become Form, 1969; WMAA, Anti-Illusion: Procedures/Materials, 1969; Chicago/AI, 69th American Exhibition, 1970; Tokyo Biennial, 1970; Foundation Maeght, 1970; SFMA, Unitary Forms: Minimal Sculptures, 1970; Seattle/AM, 557, 087, 1969; WMAA Sculpture Annuals, 1970, 73; MOMA, Information, 1970; SRGM, Guggenheim International, 1971; Arnhem, Sonsbeek '71, 1971; ICA, U. of Pennsylvania, Grids, 1972; New York Cultural Center, 3**D** into 2**D**, 1973; Basel, Diagrams and Drawings, 1973; MOMA, Some Recent American Art, circ., 1973; Cologne/Kunstverein, Kunst uber Kunst, 1974; Indianapolis, 1974. **Collections:** Basel; Brandeis U.; Buffalo/Albright; Chicago/Contemporary; Cologne; Columbus; Darmstadt/ Hessisches; Dayton/AI; Krefeld/Haus Lange; La Jolla; MOMA; Milwaukee; Monchengladbach; Ottawa/National; Pasadena/AM; Ridgefield/Aldrich; Stuttgart; Tate; Toronto; Walker. **Bibliography:** *Art Now 74;* Battcock, ed.; Calas, N. and E.; **Carl Andre Sculpture;** Celant; *Contemporanea;* De Vries, ed.; Goossen 1; Honnef; Lippard 4; Lippard, ed.; Monte and Tucker; Muller; Tuchman 1; **Waldman 1;** *When Attitudes Become Form.* Archives

ANDREJEVIC, MILET. b. September 25, 1925, Zrenjanin, Yugoslavia. **Studied:** School of Applied Arts, Belgrade, 1939-42; Academy of Fine Arts, Belgrade, 1942-47, BA. Traveled Europe; resided Paris, 1953-58. To USA 1958. **Taught:** NYU, 1966. **Address:** c/o Dealer. **Dealer:** Noah Goldowsky. **One-man Exhibitions:** (first) Belgrade/National, 1948; Green Gallery, NYC, 1961, 63; Noah Goldowsky, 1970. **Group:** Galerie Creuze, Paris, 1956-57; Dallas/MFA, 1962; Corcoran, 1963; WGMA, The Formalists, 1963; WMAA Annual, 1963, 65; Chicago/AI, 1964. **Collections:** Allentown/AM; WMAA. **Bibliography:** Lippard 4.

ANDREWS, OLIVER. b. June 21, 1925, Berkeley, Calif. **Studied:** U. of Southern California, 1942; Stanford U., 1942-43, 1946-48, BA; U. of California, Santa Barbara, 1950-51; with Jean Helion, Paris, 1948-49. US Army, 1943-46. Traveled Europe, the Orient. Designed stage sets, 1951-52; began public events utilizing helium-filled balloons, 1969- **Taught:** UCLA, 1957- ; San Fernando Valley State College, 1962-63. **Commissions:** sculptural lighting fixtures for Yale U.; the David S. Ingalls Rink, 1958, Stiles and Morse Colleges, 1962; fountain for West Valley Professional Center, San Jose, Calif., 1963; I. Magnin Co., Los Angeles, 1965; UCLA, 1965; U. of California, Riverside, 1967; Metromedia Television Co., Los Angeles, 1969; Los Angeles Times-Mirror Co., 1970; Federal Reserve Bank of Cleveland, 1972. **Awards:** Los Angeles/County MA, Junior Art Council **P.P.** for Sculpture, 1957, 61; U. of California Institute for Creative Work in the Arts, Travel Fellowship, 1963. **Address:** 408 Sycamore Rd., Santa Monica, Calif. 90402. **Dealer:** David Stuart Gallery. **One-man Exhibitions:** Santa Barbara/MA, 1950, 56, 63; Stanford U., 1952, 60 (three-man); The Alan Gallery, NYC, 1955, 59, 61, 66; Frank Perls Gallery, Beverly Hills, 1960, 61; Gallery Eight, Santa Barbara, 1961; Los Angeles Municipal Art Gallery (two-man), 1963; David Stuart Gallery, 1967, 70; Palomar College, 1967; UCLA, 1970; Nordness Galleries, 1971; A. B. Closson Co., Cincinnati, 1971; California State U., Fullerton, 1971; U. of Rochester, 1971; Northwest Craft Center, Seattle, 1974; Leslie Wenger Gallery, San Francisco, 1974. **Group:** Los Angeles/County MA, 1953, 56, 57, 59, 61; U. of Minnesota, Contemporary American Sculpture, 1955; WMAA Annual, 1956; Chicago/

AI Annual, 1957; U. of California, Riverside, Four Sculptors, 1958; MOMA, Recent Sculpture USA, 1959; UCLA, 1959; Hartford/Wadsworth, Smallscale Sculpture, 1960; La Jolla, 1960, 61; SFMA Annual, 1960, 61, 63, 66; SRGM, The Joseph H. Hirshhorn Collection, 1962; WMAA, Fifty California Artists, 1962-63; Long Beach State College, 1963; Buffalo/Albright, Contemporary Sculpture, 1963; Municipal Art Gallery, Los Angeles, 1965; U. of Hawaii, 1965; Southern Sculpture '67, circ., 1967; Century City Sculpture Park, Los Angeles, Sculpture in the City, 1968; UCLA, Electric Art, 1969; Columbus, Art in Public Places, 1973. **Collections:** U. of California, Riverside; Hirshhorn; Johnson Wax Co.; Los Angeles/County MA; SFMA; Santa Barbara/MA; Storm King Art Center; UCLA.

ANTONAKOS, STEPHEN. b. November 1, 1926, Greece. To USA 1930. **Studied:** Brooklyn (N.Y.) Community College. Traveled Europe. **Taught:** Brooklyn Museum School. **Awards:** CAPS, 1972; National Endowment for the Arts, 1973. **Address:** 435 West Broadway, NYC 10012. **Dealer:** John Weber Gallery. **One-man Exhibitions:** Avant Garde Gallery, NYC, 1958; The Bryon Gallery, 1964; Miami Modern, 1964; Schramm Galleries, Fort Lauderdale, Fla., 1964; Fischbach Gallery, 1967-69, 1970, 71, 72; Madison Art Center, 1971; Wisconsin State U., Oshkosh, 1971; Houston/Contemporary, 1971; Fresno State College, 1972; CAPS, 1973; Rosa Esman Gallery, 1974; John Weber Gallery, 1974; Buffalo/Albright, 1974; The Clocktower, NYC, 1974; Cusack Gallery, Houston, 1974; Fort Worth, 1974; Galleria Marilena Bonomo, Bari, Italy, 1975; Galerie 27, Paris, 1975; Wright State U., 1975. **Group:** Martha Jackson Gallery, New Media—New Forms, I & II, 1960, 61; Van Bovenkamp Gallery, NYC, 1965; Eindhoven, Kunst-Licht-Kunst, 1966; Kansas City/Nelson, Sound, Light, Silence, 1966; WMAA, 1966, 68-69;

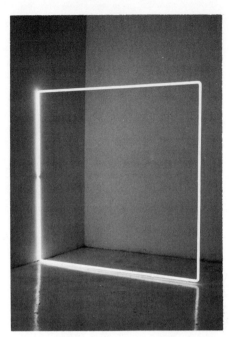

Stephen Antonakos
ELG Green Square on the Floor 1973

Carnegie, 1967; Worcester/AM, 1967; Los Angeles/County MA and PMA, American Sculpture of the Sixties, 1967; Trenton/State, Focus on Light, 1967; Milwaukee, Light Motion Space, 1967; A.F.A., 1968; Kansas City/Nelson, The Magic Theatre, 1968; WMAA, Light: Object and Image, 1968; UCLA, Electric Art, 1969; Newark Museum, Light in Contemporary Art, 1969; WMAA, Human Concern/Personal Torment, 1969, Annual, 1970; Jacksonville/Cummer, Light Art, 1970; Hayward Gallery, London, Kinetics, 1970; Portland, Me./MA, Light, 1971; U. of North Carolina, Works on Paper, 1971, 72; U. of Maryland, What's Happening in Soho, 1971; U. of Nebraska, Light and Motion, 1972; Katonah (N.Y.) Art Gallery, Drawing in Space, 1972; WMAA, American Drawings: 1963-1973, 1973; SFMA, Works in Spaces, 1973; Indianapolis, 1974; Webster College, Webster Groves, Mo., 4 Dimensions in 2, 1975; Ackland, Light/Sculpture, 1975. **Collections:** Brandeis U.;

Chase Manhattan Bank; Ciba-Geigy Corp.; Hartford/Wadsworth; La Jolla; MOMA; U. of Maine; Miami/Modern; Milwaukee; Newark Museum; U. of North Carolina; Phoenix; Ridgefield/ Aldrich; U. of Utah; WMAA. **Bibliography:** Battock, ed.; *Report;* Tuchman 1. Archives.

ANTREASIAN, GARO. b. February 16, 1922, Indianapolis, Ind. **Studied:** John Herron Art Institute, B.F.A. **Taught:** John Herron Art Institute, 1948-64; U. of New Mexico, 1964- . Technical Director, Tamarind Lithography Workshop, 1960-61; Technical Director, Tamarind Institute, 1970-72. **Awards:** Hoosier Salon, 1944, 49; MOMA, 1953; The Print Club, Philadelphia, 1958, 61; Albion College, 1968; Northern Illinois U., 1968. **Address:** 379 Juniper Hill Road, N.E., Albuquerque, N.M. 87122. **Dealers:** Martha Jackson Gallery; A.A.A. Gallery; Margo Leavin Gallery; Smith Andersen Gallery, San Francisco; Marjorie Kauffman Graphics, Houston and Los Angeles. **One-man Exhibitions:** Tulane U.; U. of Notre Dame; Stephens College; Wabash College; Kalamazoo/ Institute; Martha Jackson Gallery, 1969; Maluina Miller Gallery, San Francisco; Marjorie Kauffman Gallery, Houston; Cottonwood Gallery, Albuquerque; Lantern Gallery, Ann Arbor. **Retrospective:** Ohio State U.; Washburn U.; U. of Nebraska; Miami U. Oxford, Ohio; Kansas State U.; U. of Georgia; U. of New Mexico. **Group:** SFMA, 1942; NAD, 1943; Library of Congress, 1949, 66, 68; MMA, 1950; Boston/MFA; PMA; NYPL; USIA; ART: USA:59, NYC, 1959; PCA, 1959; Brooklyn Museum Print Biennials; SAGA, 1964; Florida State U., 1965, 67, 69; Seattle/AM, 1966, 68; Smithsonian, 1968; Potsdam/SUNY, 1968; Albany/ SUNY, 1968; Tokyo Print Biennial, 1972; U. of Kentucky, Graphics Now: USA, 1972; Bradford, England, III British Print Biennial, 1972; Honolulu Academy Print Biennial, 1973; California State U., Sacramento, Print Invitational, 1974. **Collections:** Albion College; L. S. Ayres & Co.; Boston/MFA; Bradley U.; Brooklyn Museum; Chicago/AI; Cleveland/MA; Coos Bay; Dallas/MFA; Grand Rapids; Indiana National Bank; Indiana U.; Indianapolis; Los Angeles/County MA; MMA; MOMA; U. of Michigan; U. of Minnesota; NCFA; National Gallery; U. of Notre Dame; Olivet College; PMA; The Print Club, Philadelphia; Roswell; SRGM; San Jose State College; Santa Fe, N.M.; Smith College; Southern Illinois U.; Stephens College; Terre Haute/Swope; USIA; US Coast Guard; U. of Wisconsin. Archives.

ANUSZKIEWICZ, RICHARD. b. May 23, 1930, Erie, Pa. **Studied:** Cleveland Institute of Art, 1948-53; Kent State U., 1955-56, BS.Ed.; Yale U., 1953-55, MFA. Traveled Western Europe, North Africa. **Taught:** Dartmouth College, Artist-in-Residence, 1967; U. of Wisconsin, 1968; Cornell U., 1968; Kent State U., 1968. **Awards:** Silvermine Guild, Philosophers Stone Prize, 1963, First Prize, 1964; Flint/Institute, **P.P.,** 1966. **Address:** 76 Chestnut Street, Englewood, N.J. 07631. **Dealer:** Andrew Crispo Gallery. **One-man Exhibitions:** Youngstown/Butler, 1955; The Contemporaries, NYC, 1960, 61, 63; Sidney Janis Gallery, 1965, 67, 69, 71, 73; Cleveland/MA, 1966; Dartmouth College, 1967; U. of Wisconsin, 1968; Kent State U., 1968; J. L. Hudson Art Gallery, Detroit, 1968; Free Public Library, Fair Lawn, N.J., 1969; Trenton/State (two-man), 1971; A. A. A. Gallery, 1973; Andrew Crispo Gallery, 1974. **Group:** U. of Illinois, 1961, 63; NYU, 1961; PAFA, 1962, 67; WMAA, Geometric Abstraction in America, circ., 1962; U. of Minnesota, 1962; Silvermine Guild, 1962, 63; Allentown/AM, 1963; Lincoln, Mass./De Cordova, New Experiments in Art, 1963; MOMA, Americans 1963, circ., 1963-64; WGMA, The Formalists, 1963; WMAA Annual, 1963, 67; Chicago/AI, 1964; Tate, Painting and Sculpture of a Decade, 1954-64, 1964; Carnegie, 1964, 67; MOMA, The Responsive Eye, 1965; Corcoran Bienni-

al, 1965; WMAA, A Decade of American Drawings, 1965; Buffalo/Albright, 1965, also Plus by Minus, 1968; Flint/Institute, I Flint Invitational, 1966; WMAA, Art of the U.S. 1670-1966, 1966; Detroit/Institute, Color, Image and Form, 1967; Trenton/State, Focus on Light, 1967; Expo '67, Montreal, 1967; Documenta IV, Kassel, 1968; WMAA, Artists Under 40, 1968; Corcoran Biennial, 1975. **Collections:** Akron/AI; Allentown/AM; Buffalo/Albright; Chicago/AI; Cleveland/MA; Corcoran; MOMA; WMAA; Yale U.; Youngstown/Butler. **Bibliography:** Battcock, ed.; Hunter, ed.; MacAgy 2; Rickey; Weller. Archives.

ARAKAWA, SHUSAKU. b. 1936, Nagoya City, Japan. **Studied:** U. of Tokyo, 1954-58; Massachusetts College of Art, Boston. To USA, 1961. **Address:** 124 West Houston Street, NYC 10012. **Dealer:** Ronald Feldman Fine Arts Inc.

Arakawa *Untitled* 1968

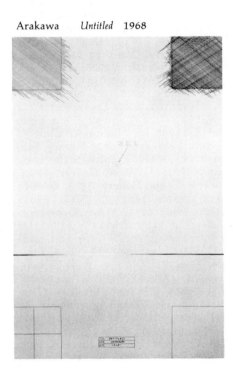

One-man Exhibitions: Mudo Gallery, Tokyo, 1961; Galerie Schmela, 1963, 65, 66; Dwan Gallery, Los Angeles, 1964, 66; Brussels/Beaux Arts, 1964; Minami Gallery, 1965; Galleria dell'Ariete, 1965; Dwan Gallery, NYC, 1966, 68, 69; Wide White Space Gallery, Antwerp, 1966; Stuttgart/WK, 1966; Eindhoven, 1966; Wuppertal/von der Heydt, 1967; Galeria Schwarz, 1967, 71; Yvon Lambert, Paris, 1969; Paris/Moderne, 1970; Hannover/Kunsterverein, 1970; Badischer Kunstverein, Karlsruhe, 1970; Fendrick Gallery, 1971; Harcus-Krakow Gallery, 1971; Angela Flowers Gallery, London, 1971; Hamburg, circ., 1972; Galerie Art in Progress, Zurich, 1972; Galerie van der Loo, Munich, 1972; Ronald Feldman Fine Arts Inc., 1972, 74; Dayton's Gallery 12, Minneapolis, 1973; Galleria A. Castelli, Milan, 1974; MOMA, 1974; U. of Wisconsin, circ., 1974; Multiples Inc., NYC, 1974; Galerie Art in Progress, Munich, 1974. **Group:** U. of Illinois, 1965, 67; MOMA, New Japanese Paintings and Sculpture, 1966; Documenta IV, Kassel, 1968; XXXV Venice Biennial, 1970; Indianapolis, 1974; Cologne, Project '74, 1974; Brooklyn Museum Print Biennial, 1974. **Collections:** Amsterdam/Stedelijk; Basel; Berlin; Brussels/Beaux-Arts; Dayton/AI; Des Moines; Dusseldorf; Hirshhorn; MOMA; Paris/Moderne; Walker. **Bibliography:** *Art Now 74;* Calas, N. and E.; *Contemporanea; Kunst um 1970.*

ARCHIPENKO, ALEXANDER. b. May 30, 1887, Kiev, Ukraine; **d.** February 25, 1964, NYC. **Studied:** Kiev, an art school, 1902-05; Academie des Beaux-Arts, Paris, 1908. To USA 1923; citizen 1928. Traveled Europe and USA extensively. **Taught:** U. of Washington, 1935-36; U. of Kansas; Allegheny College; opened school in Paris, 1910; opened school in NYC, 1939. **One-man Exhibitions:** Hagen, 1910, 60; X Venice Biennial, 1920; Andover/Phillips, 1928; Karl Nierendorf Gallery, NYC, 1944; Dallas/MFA, 100th One-Man, 1952; A.A.A. Gallery, NYC, 110th One-Man, 1954; Darmstadt/Kunsthalle, circ. Ger-

many, 1955; Perls Galleries, 1957, 59; Grosvenor (Gallery), London, 1961; Mannheim, 1962; Palazzo Barberini, Rome, 1963; Auckland, 1964; Finch College, NYC, 1967; UCLA, 1967; NCFA, 1968; Musee Rodin, Paris, 1969; Toronto, 1971; Paine Art Center and Arboretum, Oshkosh, 1971; The Pace Gallery, NYC, 1973. **Retrospective:** Smithsonian, 1968. **Group:** Major international exhibitions. **Collections:** Amherst College; Andover/Phillips; Belvedere; Brandeis U.; Chicago/AI; Cleveland/MA; Cranbrook; Darmstadt/Kunsthalle; U. of Delaware; Denver/AM; Detroit/Institute; Dusseldorf; Essen; Hagen; Hannover; Honolulu Academy; U. of Kansas City; Leipzig; MOMA; Mannheim; Miami/Modern; U. of Michigan; U. of Minnesota; Municipal U. of Omaha; Northwestern U.; Omaha/Joslyn; U. of Oregon; Osaka/Municipal; Phillips; Phoenix; Rotterdam; SFMA; SRGM; San Antonio/McNay; Seattle/AM; Tel Aviv; WMAA; Yale U. **Bibliography: Alexander Archipenko, A Memorial Exhibition; Archipenko 1, 2;** Barr 1; Baur 7; Biddle 4; Bihalji-Merin; Blesh 1; Brown; Brumme; Bulliet 1; Cassou; Cheney; Draven, W.; Christensen; **Daubler and Goll;** Dorner; Dreier 2; Gertz; Giedion-Welcker 1, 2; Goodrich and Baur 1; Guggenheim, ed.; Haftman; **Hildebrandt;** Huyghe; *Index of 20th Century Artists;* Janis and Blesh 1; Janis, S.; **Karshan;** Kuh 3; Langui; Lee and Burchwood; Licht, F.; Lynton; McCurdy, ed.; Mellquist; Mendelowitz; Neumeyer; Poore; Ramsden 2; **Raynal 1;** Read 3; Rickey; Ritchie 3; Rose, B. 1; Rosenblum 1; Salvini; Selz, J.; Seuphor 3; Trier 1, 2; Valentine 2; Verkauf; Wingler, ed.; Zaidenberg, ed.; Zervos. Archives.

ARMAN. b. November 17, 1928, Nice, France. **Studied:** Ecole du Louvre; Ecole Nationale des Arts Decoratifs. US citizen, 1972. Traveled Europe, Asia, Africa, North America. **Taught:** UCLA, 1967-68. Co-founder, Groupe des Nouveaux Realistes, 1960, and L'Ecole de Nice, 1961. **Awards:** IV International Biennial Exhibition of Prints, Tokyo, 1964, Second Prize; Premio Marzotto, 1966. **Address:** 380 West Broadway, NYC 10012. **Dealers:** Andrew Crispo Gallery; Galerie Bonnier; Arte Borgogna. **One-man Exhibitions:** (first) Galerie du Haut Pave, Paris, 1956; Iris Clert Gallery, 1958, 60; Galleria Apollinaire, Milan, 1959; Galerie Schmela, Dusseldorf, 1960, 63; Galleria Schwarz, Milan, 1961, 63, 68; Cordier and Warren, NYC, 1961; Galerie Saqqarah, Gstaad, Switzerland, 1962, 66; Dwan Gallery, Los Angeles, 1962; Galerie Lawrence, Paris, 1962, 63, 65; Sidney Janis Gallery, 1963, 64, 68; Walker, 1964; Richard Feigen Gallery, Chicago, 1965; Galerie Bonnier, Lausanne, 1965, 66, 69; Galerie de Leone, Venice, 1965; Galerie Svensk-Franska, Stockholm, 1966, 69; Ileana Sonnabend Gallery, Paris, 1967, 69; Il Punto, Turin, 1967; Galerie Francoise Meyer, Brussels, 1967; Galerie Mathias Fels, Paris, 1969; Musee des Arts Decoratifs, 1969; Humlebaek/Louisiana, 1969; Kunsthalle, Berlin, 1969; Dusseldorf/Kunsthalle, 1969; Stockholm/National, 1970; Zurich, 1970; Ileana Sonnabend Gallery, Paris, 1970; ACE Gallery, Los Angeles, 1970; ACE Gallery, Vancouver, 1970; Galerie der Spiegel, Cologne, 1970; Galerie Lambert-Monet, Geneva, 1970; Galerie Bonnier, 1970, 71; Lawrence Rubin Gallery, NYC, 1970, 71; Galerie de la Salle, Vence, 1971; Galerie Bischofberger, Zurich, 1971; Galerie Michel Couturier & Cie., Paris, 1971; Galleria del Leone, Venice, 1972; Galerie Guillaume Campo, Antwerp, 1972; Galerie de l'Oeil, Paris, 1972; White Gallery, Lutry, 1973; John Gibson Gallery, 1973; Andrew Crispo Gallery, 1973, 74; Musee d'Arles, 1974. **Retrospectives:** Amsterdam/Stedelijk, 1964; Krefeld/Haus Lange, 1964; Brussels/Beaux-Arts, 1966; La Jolla, circ., 1974. **Group:** XXXIV Venice Biennial, 1968; Documenta IV, Kassel, 1968; Tokyo Biennial, 1969; Expo '70, Osaka, 1970. **Collections:** Amsterdam/Stedelijk; Antwerp; Brussels/Royaux; Buffalo/Albright;

Cologne; Eindhoven; France/National; Ghent/Moderne; Helsinki; Humlebaek/Louisiana; Krefeld/Haus Lange; MOMA; Munich/Modern; Musee des Arts Decoratifs; Rome/Nazionale; U. of St. Thomas (Tex.); Societe Nationale des Artes Contemporains; Stockholm / National; Stuyvesant Foundation; Sweden/Gotegorgs; Talavera; Turin/ Civico; Venice/Contemporaneo; Walker. **Bibliography: Arman;** *Contemporanea;* **Hahn;** *Happening & Fluxus;* **Martin, H.** Archives.

ARNOLD, ANNE. b. May 2, 1925, Melrose, Mass. **Studied:** U. of New Hampshire, 1946, BA; The Ohio State U., 1947, MA; U. of Guadalajara, 1949; ASL, 1949-53. **Taught:** Geneseo/ SUNY, 1947-49; Wagner College, 1951-52; Philadelphia College of Art, 1965-68; Brooklyn College. **Address:** c/o Dealer. **Dealer:** Fischbach Gallery. **One-man Exhibitions:** Tanager Gallery, NYC, 1960; Fischbach Gallery, 1964, 67, 69, 71, 72, 74; Bard College, 1971; Galerie Dieter Brusberg, Hanover, 1972. **Retrospective:** Moore College of Art, Philadelphia, 1971. **Group:** Riverside Museum, NYC, Twelve Sculptors, 1962; Chicago/AI Annual, 1964; Milwaukee, Pop Art and the American Tradition, 1965; Sculptors Guild, 1967, 68; PAFA Annual, 1968; Finch College, NYC, The Dominant Woman, 1968; City Hall, Rockport, Me., Maine Coast Artists, 1969; Roko Gallery, Homage to Tanager: 1952-1962, 1971; U. of North Carolina, 1971, 72, 73; New York Cultural Center, Women Choose Women, 1973; Indianapolis, 1974; PMA/Museum of the Philadelphia Civic Center, Focus, 1974. **Collections:** Buffalo/Albright; Ciba-Geigy Corp.; U. of North Carolina.

ARONSON, DAVID. b. October 28, 1923, Shilova, Lithuania. To USA 1929. **Studied:** Boston Museum School, with Karl Zerbe; Hebrew Teachers College, Boston. Traveled Europe, Near East. **Taught:** Boston U., 1954- ; Boston Museum School, 1942-55. **Commis-**

sions: Container Corp. of America, 1962. **Awards:** ICA, Boston, First Prize, 1944; ICA, Boston, First Popular Prize, 1955; VMFA, 1946; Boston Museum School, Traveling Fellowship, 1946; Boston Arts Festival, Grand Prize, 1952, 54; Boston Arts Festival, Second Prize, 1953; Tupperware Annual, First Prize, 1954; NIAL Grant, 1958; J.S. Guggenheim Fellowship, 1960; NIAL, **P.P.,** 1961. **Address:** 137 Brimstone Lane, Sudbury, Mass. 01776. **One-man Exhibitions:** (first) Niveau Gallery, NYC, 1945, also 1956; Boris Mirski Gallery, Boston, 1951, 59, 64, 69; The Downtown Gallery, 1953; Lee Nordness Gallery, 1960, 61, 63, 69; Rex Evans Gallery, 1961; Westhampton Gallery, NYC, 1961; J. Thomas Gallery, Provincetown, Mass., 1964; Zora Gallery, Los Angeles, 1965; Hunter Gallery, Chattanooga, 1965; Kovler Gallery, 1965; Verle Gallery, Hartford, 1967; Danenberg Gallery, 1969, 72; Pucker-Safrai Gallery. **Group:** MOMA, Fourteen Americans, circ., 1946; Chicago/ AI; U. of Illinois; MMA; ICA, Boston; WMAA; Boston/MFA; Bridgestone Museum; Palazzo di Venezia, Rome. **Collections:** Atlanta/AA; Atlanta U.; Boston/MFA; Brandeis U.; Bryn Mawr College; Carnegie; Chicago/AI; Colby College; U. of Illinois; Lincoln, Mass./De Cordova; MOMA; Milwaukee; NCFA; U. of Nebraska; U. of New Hampshire; PAFA; Portland, Me./MA; Tupperware Museum; VMFA; WMAA; Worcester/ AM. **Bibliography:** Baur 7; Genauer; Miller, ed. 2; Nordness, ed.; Pearson 2; Soby 5; Weller.

ARTSCHWAGER, RICHARD. b. December 26, 1924, Washington, D.C. **Studied:** Privately with Amedee Ozenfant; Cornell U., BA. Traveled Mexico. **Address:** Box 23, Charlotteville, N.Y. 12036. **Dealer:** Leo Castelli Inc., NYC. **One-man Exhibitions:** Leo Castelli Inc., NYC, 1965, 67, 72, 73, 75; Galerie Rolf Ricke, 1969, 72; Eugenia Butler, 1970; Onnasch Galerie, Berlin, 1970; LoGiudice, Chicago, 1970; Chicago/Contemporary, 1973; Dunkleman Gallery,

Toronto, 1973; Weinberg Gallery, San Francisco, 1974. **Group:** Buffalo/Albright, 1964; Dwan Gallery, Boxes, 1964; SRGM, 1966; Jewish Museum, Primary Structures, 1966; WMAA, Contemporary American Sculpture, Selection I, 1966; Finch College, 1966; WMAA Sculpture Annuals, 1966, 68, 70, 72; MOMA, The 1960s, 1967; Ridgefield/Aldrich, 1968; Documenta IV, Kassel, 1968; Milwaukee, Directions I: Options, circ., 1968; Trenton/State, Soft Art, 1969; Berne, When Attitudes Become Form, 1969; U. of Notre Dame, 1969; Indianapolis/Herron, 1969; York U., Toronto, 1969; Hayward Gallery, London, 1969; Milwaukee, Aspects of a New Realism, 1969; Buffalo/Albright, Kid Stuff, 1971; MOMA, Information, 1971; Galerie des 4 Mouvements, Paris, Hyperrealistes Americains, 1972; Documenta V, Kassel, 1972; Oakland U., American Realism—Post Pop, 1973; WMAA, American Pop Art, 1974. **Collections:** Aachen/NG; Basel; Cologne; Kansas City/Nelson; MOMA; Milwaukee; Ridgefield/Aldrich; Rotterdam; WMAA. **Bibliography:** Alloway 1; Atkinson; Battcock, ed.; *Kunst um 1970;* Lippard 5; Lippard, ed.; Sager; *When Attitudes Become Form.*

ATHERTON, JOHN C. b. June 7, 1900, Brainerd, Minn.; **d.** 1952, New Brunswick, Canada. **Studied:** College of the Pacific; California School of Fine Arts, 1922-25. US Navy, 1918-19. Painter, illustrator and poster artist. **Awards:** MMA, Artists for Victory, Fourth Prize, 1942; Bohemia Club, San Francisco, First Prize, 1928; Hartford/Wadsworth, First Prize, 1922. **One-man Exhibitions:** Julien Levy Galleries, NYC, 1938, 39, 42, 44, 46; A.A.A. Gallery, NYC, 1951. **Group:** U. of Illinois, 1950; MOMA; WMAA; PAFA; Chicago/AI. **Collections:** Buffalo/Albright; Chicago/AI; Hartford/Wadsworth; MMA; MOMA; PAFA; WMAA. **Bibliography:** Baur 7; Pousette-Dart, ed.

AULT, GEORGE C. b. October 11, 1891, Cleveland, Ohio; **d.** December 30, 1948, Woodstock, N.Y. **Studied:** U. of London, Slade School; St. John's Wood Art School. Resided Great Britain, 1899-1911. **One-man Exhibitions:** Sea Chest Gallery, Provincetown, 1922; Whitney Studio Club, NYC; Bourgeois Gallery, NYC, 1923; The Downtown Gallery 1926, 28; J. B. Neumann's New Art Circle, NYC, 1927; The Little Gallery, Woodstock, N.Y., 1943; Woodstock (N.Y.) Art Gallery, 1949; The Milch Gallery, 1950; Charlotte/Mint, 1951; WMAA, 1973; The Zabriskie Gallery, 1973, 74. **Retrospective:** The Zabriskie Gallery, 1957, 63, 69. **Group:** Independents, NYC, 1920; WMAA. **Collections:** Albany/Institute; Andover/Phillips; Brooklyn Museum; California Palace; Columbus; Cleveland/MA; Dartmouth College; Los Angeles/County MA; MMA; MOMA; Montclair/AM; U. of Nebraska; Newark Museum; U. of New Mexico; Omaha/Joslyn; PAFA; PMA; Syracuse U.; WMAA; Walker; Worcester/AM; Yale U.; Youngstown/Butler. **Bibliography:** Baur 7; Brown; Bulliet 1; Cahill and Barr, eds. Archives.

AUSTIN, DARREL. b. June 25, 1907, Raymond, Wash. **Studied:** U. of Oregon; U. of Notre Dame and Columbia U., 1926-29; and with Emile Jacques. **Commissions:** Medical College of the U. of Oregon, 1933 (mural). **Awards:** PAFA, Walter Lippincott Prize, 1950. **Address:** Saw Mill Hill Road, RFD #4, New Fairfield, Conn. 06810. **Dealers:** ACA Gallery; Harmon Gallery. **One-man Exhibitions:** (first) Howard Putzell Gallery, Los Angeles, 1938; MOMA, 1942; James Vigeveno Gallery, Los Angeles (two-man), 1949; Perls Galleries, 1940, 42, 43, 44, 45, 47, 48, 50, 55, 57, 59, 64; Harmon Gallery, 1964, 67, 69, 70, 73, 74; ACA Gallery, 1970. **Group:** WMAA Annual, 1945; Carnegie, 1947, 48, 49, 50. **Collections:** Boston/MFA; Britannica; Detroit/Institute; U. of Georgia; Hartford/Wadsworth; IBM; Kansas City/Nelson; Los Angeles/County MA; MMA; MOMA; Montclair/AM; U. of Nebraska; PAFA;

Phillips; Portland, Ore./AM; U. of Rochester; Smith College. **Bibliography:** Baur 7; Bazin; Flanagan; Frost; Miller, ed. 1; Newmeyer.

AVEDISIAN, EDWARD. b. 1936, Lowell, Mass. **Studied:** Boston Museum School. **Taught:** U. of Kansas, 1969; School of Visual Arts, NYC, 1970; U. of California, Irvine, 1972; U. of Louisiana, 1973. **Awards:** Guggenheim Foundation Fellowship, 1967; National Council on the Arts Award, 1968. **Address:** c/o Dealer. **Dealer:** Robert Elkon Gallery. **One-man Exhibitions:** Boylston Print Center Gallery, Cambridge, Mass., 1957; Hansa Gallery, NYC, 1958; Tibor de Nagy Gallery, 1959, 60; Robert Elkon Gallery, 1962, 1964-68, 1970-74; Ziegler Gallery, 1964; Nicholas Wilder Gallery, 1966, 68, 69; Kasmin Ltd., 1966, 67; Bucknell U., 1970; Jack Glenn Gallery, Corona del Mar, 1971; Gallery Moos, Toronto, 1971; Janie C. Lee Gallery, Houston, 1974. **Group:** WMAA Annual, 1963, 65, 67; Dayton/AI, 1964; WMAA, Young America, 1965; MOMA, The Responsive Eye, 1965; Corcoran, 1966; SFMA, 1967; Expo '67, Montreal, 1967; Indianapolis, 1970; Buffalo/Albright, Six Painters, 1971. **Collections:** Hartford/Wadsworth; Los Angeles/County MA; MMA; Minneapolis/Institute; Norfolk/Chrysler; Pasadena/AM; Purchase/SUNY; Ridgefield/Aldrich; SRGM; WMAA. **Bibliography:** Wood.

AVERY, MILTON. b. March 7, 1893, Altmar, N.Y.; **d.** January 3, 1965, NYC. **Studied:** Connecticut Leage of Art Students, briefly 1913, with C. N. Flagg. Traveled Europe, USA. **Awards:** Chicago/AI, The Mr. & Mrs. Frank G. Logan Prize, 1929; Connecticut Academy of Fine Arts, Atheneum Prize, 1930; Baltimore Watercolor Club, First Prize, 1949; Boston Arts Festival, Second Prize, 1948; ART: USA:59, NYC, $1,000 Award, 1959. "A Painter's World," a 14-min., 16mm color sound film, shows him at work. **One-man Exhibitions:** (first) Opportunity Gallery, NYC, 1928;

Gallery 144, NYC, 1932; Curt Valentine Gallery, NYC, 1935, 36, 38, 41; Phillips, 1943, 44; P. Rosenberg and Co., 1943, 44, 45, 46, 47, 50; Arts Club of Chicago, 1944; The Bertha Schaefer Gallery, 1944; Durand-Ruel Gallery, NYC, 1945, 46, 47, 49; Colorado Springs/FA, 1946; Portland, Me./MA; 1946; Laurel Gallery, NYC, 1950; M. Knoedler & Co., NYC, 1950; Grace Borgenicht Gallery Inc., 1951, 52, 54, 56, 57, 58, 59, 68, 70, 72, 73; Baltimore/MA, 1952; Boston/MFA, circ., 1952; Mills College, circ., 1956; U. of Nebraska, 1956, 66; Felix Landau Gallery, 1956; HCE Gallery, Provincetown, Mass., 1956, 58, 59; Otto Seligman Gallery, 1958; Philadelphia Art Alliance, 1959; Waddington Gallery, London, 1962, 66; MOMA, circ., 1965-66; Richard Gray Gallery, 1966, 70; Makler Gallery, Philadelphia, 1966; Esther Suttman Gallery, Washington, D.C., 1966; David Mirvish Gallery, 1966, 67, 69; Donald Morris Gallery, 1966, 67, 69; New Britain, 1968; Reese Palley Gallery, San Francisco, 1969; NCFA, circ., 1969; Alpha Gallery, 1969, 70; Waddington Gallery, Montreal, 1970; Brooklyn Museum, 1970; U. of California, Irvine, 1971; Cynthia Comsky Gallery, 1972; A. A. A. Gallery, 1973; Andre Emmerich Gallery, NYC, 1973; Lunn Inc., Washington, D.C., 1973, 74. **Retrospective:** A.F.A./Ford Foundation, circ., 1960. **Group:** Carnegie, 1944; PAFA, 1945; Chicago/AI; Corcoran; WMAA; U. of Illinois; Buffalo/Albright. **Collections:** Andover/Phillips; Atlanta/AA; Baltimore/MA; Barnes Foundation; Brandeis U.; Brooklyn Museum; Bryn Mawr College; Buffalo/Albright; Chase Manhattan Bank; Dayton/AI; Evansville; Exeter; Honolulu Academy; Houston/MFA; U. of Illinois; MMA; MOMA; U. of Minnesota; U. of Nebraska; Newark Museum; PAFA; PMA; Phillips; Santa Barbara/MA; Smith College; Tel Aviv; Utica; WMAA; Walker; West Palm Beach/Norton; Witte; Yale U. **Bibliography:** Bazin; Blesh 1; Eliot; Frost; Goodrich and Baur 1; Greenberg 1; Kootz 2; **Kramer 2;** Mellquist; Nordness, ed.; Pousette-

Dart, ed.; Rose, B. 1; Sandler; **Wight 2, 3.** Archives.

AZUMA, NORIO. b. November 23, 1928, Japan. **Studied:** Kanazawa Art College, Kanazawa City, Japan; Chouinard Art Institute; ASL (with Will Barnet). **Commissions:** IBM. **Awards:** Seattle/AM; Boston Printmakers; American Color Print Society. **Address:** 142 Greene Street, NYC 10012. **Dealers:** A.A.A. Gallery; Weyhe Gallery; Fendrick Gallery. **One-man Exhibitions:** (first) A.A.A. Gallery, NYC, 1964, also 1969; The Print Club, Philadelphia, 1964; Tulsa/Philbrook, 1965; Benjamin Gallery, Chicago, 1965; International Monetary Fund, Washington, D.C., 1965; WGMA, 1967; Nashville, 1968; East Tennessee State U., 1969; Berman-Medalie Gallery, Massachusetts, 1969; Roanoke (Va.) Fine Arts Center 1969. **Group:** American Color Print Society; Corcoran; Boston Printmakers; New York World's Fair, 1964-65; Brooklyn Museum Print Biennial; WMAA Sculpture Annual, 1966; SAGA. **Collections:** American Republic Insurance Co.; Boston Public Library; Brooklyn Museum; U. of California; Chase Manhattan Bank; Chicago/AI; Chouinard Art Institute; Cleveland/MA; Library of Congress; MIT; National Gallery; PAFA; PMA; Seattle/AM; Smithsonian; Trenton/State; USIA; The White House; Youngstown/Butler.

BABER, ALICE. b. August 22, 1928, Charleston, Ill. **Studied:** Lindenwood College; Indiana U., BA; Ecole des Beaux-Arts, Fontainebleau. Traveled Europe, Russia, Japan, Thailand, India, Middle East. **Taught:** Queens College; U. of Minnesota; Purchase/SUNY; C. W. Post College; U. of California, Santa Barbara; U. of California, Berkeley; School of Visual Arts, NYC, 1973-75. **Member:** Women's InterArt Center. **Awards:** Yaddo Fellowship, 1958. Organized the exhibition Color Forum, U. of Texas, 1972. **Address:** 73 Bedford Mews, NYC 10014. **Dealer:** A. M. Sachs Gallery. **One-man Exhibitions:** (first), March Gallery, NYC, 1958; Galerie de la Librairie Anglaise, Paris, 1963; New Vision Center, London, 1963; Pinacotheca Museum (two-man), 1964; A. M. Sachs Gallery, 1965, 66, 69, 71, 73, 75; Kolnischer Kunstverein, Cologne, 1966; Bernard Baruch College, NYC, 1968; Galerie Lambert, Paris, 1970; U. of Minnesota, 1971; Galerie fur Zeitgenossische Kunst, Hamburg, 1971; Tom Bortolazzo Gallery, Santa Barbara, 1972; Benson Gallery, 1973; Ingber Art Gallery, 1973; EuRo-Kunstgalerie, Saarbrucken, 1974; Chanakya Gallery, New Delhi, 1974; Iran-American Society, Teheran, 1974; Palm Beach Gallery, Palm Beach, 1975; American Library, Brussels, 1975; U. of Alabama, 1975.

Group: The Stable Gallery Annual, 1957; II Paris Biennial, 1961; Whitechapel Art Gallery, London, 1966; Maison de la Culture du Havre, 1966-67; Musee des Arts Decoratifs, 1966; U. of Texas, Color Forum, 1972; New York Cultural Center, Women Choose Women, 1973; Fordham U., IX Painters—IX Styles, 1973. **Collections:** Bezalel Museum; Brandeis U.; U. of California; Ciba-Geigy Corp.; Corcoran; Cornell U.; Fordham U.; MOMA; Manchester, England; NCFA; NYU; U. of Notre Dame; Peter Stuyvesant Collection; Pinacotheca Museum; SFMA; Terre Haute/Swope; United Tanker Ltd.; Worcester/AM. **Bibliography:** *Art: A Woman's Sensibility.* Archives.

BAER, JO. b. August 7, 1929, Seattle, Wash. **Studied:** U. of Washington, 1946-49; New School for Social Research, 1952. **Taught:** School of Visual Arts, NYC, 1969-70. **Awards:** National Endowment for the Arts Grant, 1969. **Address:** c/o Dealer. **Dealer:** Richard Bellamy. **One-man Exhibitions:** Fischbach Gallery, 1966; Galerie Rolf Ricke, 1969, 70, 73; Locksley-Shea Gallery, 1970; Noah Goldowsky, 1970; School of Visual Arts, NYC, 1970; LoGiudice Gallery, NYC, 1972; Nicholas Wilder Gallery, 1973; Galleria Toselli, Milan, 1974; Weinberg Gallery, San Francisco, 1974. **Retrospective:** WMAA, 1975. **Group:** SRGM, Systemic Painting, 1966; Finch College, NYC, Art in Series, 1967; WMAA Annuals, 1967, 69, 73; Documenta IV, Kassel, 1968; Cologne/Kunstverein, Eine Tendenz Zeitgenossischer Maleri, 1969; Detroit/Institute, Other Ideas, 1969; Ars 69, Helsinki, 1969; Seattle/AM, Artists of the Sixties, 1969; Corcoran Biennial, 1969; Chicago/AI, Drawings, 1971; Yale U., Options and Alternatives, 1973; Chicago/Contemporary, Five Artists: A Logic of Vision, 1974; Baltimore/MA, 14 Artists, 1975. **Collections:** Aachen/NG; MOMA; SRGM. **Bibliography:** *Kunst um 1970; Options and Alternatives.*

BAILEY, WILLIAM. b. November 17, 1930, Council Bluffs, Iowa. **Studied:** U. of Kansas, 1948-51; Yale U., 1955, BFA, 1957, MFA, with Josef Albers. U.S. Army, 1951-53, Korea, Japan. Traveled Europe, Far East; resided Paris, Rome. **Taught:** Yale U., 1957-62, 69- ; Indiana U., 1962-69. **Awards:** Alice Kimball English Traveling Fellow, 1955; US State Department Grant, 1960; Guggenheim Foundation Fellowship, 1965. **Address:** 344 Willow Street, New Haven, Conn. 06511. **Dealer:** Robert Schoelkopf Gallery. **One-man Exhibitions:** Kanegis Gallery, 1957, 58, 61; Indiana U., 1963; U. of Vermont, 1965; Kansas City/AI, 1967; Robert Schoelkopf Gallery, 1968, 71, 75; Galleria dei Lanzi, Milan, 1973; Galleria Il Fante di Spade, Rome, 1973; La Parisina, Turin, 1974. **Group:** U. of Illinois, 1961; Vassar College, Realism Now, 1968; Cincinnati/AM, American Paintings on the Market Today V, 1968; Swarthmore College, The Big Figure, 1969; WMAA, 22 Realists, 1970; Florida State U., Realist Painters, 1971; Cleveland/MA, 32 Realists, 1972; A.F.A., Realist Revival, 1972; Kansas City/AI, Five Figurative Artists, 1972; Yale U., Seven Realists, 1973. **Collections:** Aachen/NG; Duke U.; Hirshhorn; Indiana U.; Kalamazoo/Institute; Louisville/Speed; U. of Massachusetts; Michigan State U.; Minneapolis/Institute; U. of New Mexico; U. of North Carolina; Ogunquit; Yale U. **Bibliography:** *Kunst um 1970;* Sager.

BAIZERMAN, SAUL. b. December 25, 1889, Vitebsk, Russia; **d.** August 30, 1957, NYC. **Studied:** Imperial Art School, Odessa; NAD; Beaux-Arts Institute of Design, NYC. To USA 1910. Traveled England, Russia, Italy. Fire demolished New York studio 1931,

William Bailey *Still Life with Kitchen Objects* 1970

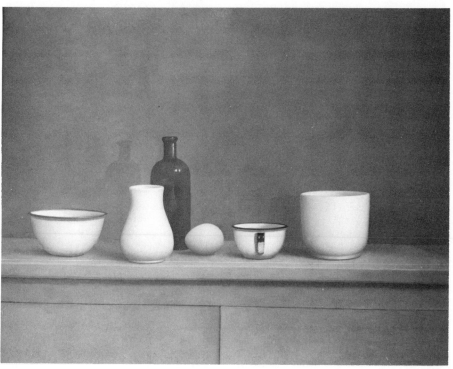

destroying almost all his work. **Taught:** American Artists School, NYC; U. of Southern California, summer, 1949; Baizerman Art School, 1934-40. **Awards:** PAFA, Hon. Men., 1949; AAAL Grant, 1951; Guggenheim Foundation Fellowship, 1952; PAFA, Alfred G. B. Steel Memorial Prize, 1952. **One-man Exhibitions:** (first) Dorien Leigh Galleries, London, 1924; Eighth Street Gallery, NYC, 1933; Artists' Gallery, NYC, 1938, 48, 57; Philadelphia Art Alliance, 1949; The New Gallery, NYC, 1952, 54; World House Galleries, NYC, 1963; The Zabriskie Gallery, 1967, 70, 72, 75. **Retrospective:** Walker, circ., 1953; ICA, Boston, 1958; Huntington, N.Y./Heckscher, 1961. **Collections:** Andover/Phillips; Hirshhorn; U. of Minnesota; U. of Nebraska; U. of New Mexico; U. of North Carolina; PAFA; WMAA; Walker. **Bibliography:** Baur 7; Brumme; Chipp; Goodrich and Baur 1; Pearson 2. Archives.

BALDESSARI, JOHN. b. June 17, 1931, National City, Calif. **Studied:** Otis Art Institute; Chouinard Art Institute; UCLA; U. of California, Berkeley; San Diego State College, 1953, BA, 1957, MA. Traveled Europe, Mexico, Canada, Middle East. **Taught:** San Diego Fine Arts School, 1953-54; San Diego city schools, 1956-57; San Diego State College, 1956, 59-61; Southwestern College, Chula Vista, 1962-68; U. of California, San Diego, 1962-70; La Jolla, 1966-70; California Institute of the Arts, Valencia, 1970- ; Hunter College, 1971. **Awards:** National Endowment for the Arts, 1973, 74-75. **Address:** 2405 Third Street, Santa Monica, Calif. 90405. **Dealer:** Ileana Sonnabend Gallery, NYC. **One-man Exhibitions:** La Jolla, 1960, 66, 68; Southwestern College, Chula Vista, 1962-64; Molly Barnes Gallery, Los Angeles, 1968; Eugenia Butler, 1970; Richard Feigen Gallery, 1970; Nova Scotia College of Art and Design, Halifax, 1971, 72; Art & Project, Amsterdam, 1971, 72, 75; Galerie Konrad Fischer, Dusseldorf, 1971, 73; Jack Wendler Gallery, London,

1972, 74; Galleria Toselli, Milan, 1972, 74; Galerie MTL, Brussels, 1972, 74, 75; Ileana Sonnabend Gallery, NYC, 1973; Ileana Sonnabend Gallery, Paris, 1973; Galleria Schema, Florence, 1973; Galerie Folker Skulima, Berlin, 1974; Felix Handschin Gallery, Basel, 1975; Galeria Saman, Genoa, 1975. **Group:** La Jolla, The Uncommon Denominator—13 San Diego Painters, circ., 1960; Long Beach/ MA, Arts of Southern California VIII: Drawing, circ., 1960; SFMA Annuals, 1961, 62; San Diego State College, Seven-Man Show, 1962; Long Beach/ MA, Arts of Southern California: Painting, circ., 1963; La Jolla, Some Aspects of California Painting and Sculpture, 1965; U. of California, San Diego, New Work Southern California, 1968; Hayward Gallery, London, Pop Art, 1969; Leverkusen, Konzeption-Conception, 1969; Seattle/AM, 557, 087, 1969; California College of Arts and Crafts, Space, 1969; Chicago/Contemporary, Art by Telephone, 1969; WMAA Annuals 1969, 72; Jewish Museum, Software, 1970; Oberlin College, Art in the Mind, 1970; Turin/ Civico, Conceptual Art, Arte Povera, Land Art, 1970; Kyoto Municipal Museum of Art, Nirvana, 1970; MOMA, Information, 1971; Buenos Aires/Moderno, Art Systems, 1971; Dusseldorf/ Kunsthalle, Prospect '71, 1971; Festival of Two Worlds, Spoleto, 1972; Documenta V, Kassel, 1972; Basel, Twelve-Man Show, 1972; Venice Biennial, 1972; VI International Theater Festival: Aspects, Belgrade, 1972; Houston/Contemporary, Five-Man Show, 1972; Minnesota College of Art and Design, I National Videotape Festival, 1972; Houston/Contemporary, Videotapes, 1972; Basel, Konzept Kunst, 1972; Pasadena/AM, Southern California Attitudes, 1972; Syracuse/Everson, Circuit, circ., 1973; Musee Galliera, Paris, Festival d'Automne, 1973; Dusseldorf/Kunsthalle, Prospect '73, 1973; Parcheggio di Villa Borghese, Rome, Contemporanea, 1974; Cologne, Project '74, 1974; Eindhoven, Kunst Informatie Centrum, 1974; Malmo,

New Media, 1975. **Collections:** Basel; Cologne; Eindhoven; Institut fur Moderne Kunst; La Jolla; Los Angeles/County MA; MOMA; Transamerica Corp. **Bibliography:** *Art Now 74; Contemporanea;* Meyer; *Report.*

BANG, THOMAS. b. 1938, Denmark. **Studied:** Cleveland Institute of Art, 1957-60; Yale U., 1962, BFA; U. of Southern California, Los Angeles, 1964, MFA. **Taught:** U. of California, Santa Barbara, 1967; Rice U., 1968; U. of Rochester. **Awards:** Fulbright Fellowship, 1964; La Jolla, **P.P.**, 1965; CSCS, **P.P.**, 1967. **Address:** c/o Dealer. **Dealer:** OK Harris Works of Art. **One-man Exhibitions:** La Jolla, 1964; Santa Barbara/MA, 1965; Esther Baer Gallery, 1965; Esther Robles Gallery, 1966, 67, 69; Rice U., 1968; OK Harris Works of Art, 1970, 71, 72, 74. **Group:** California State U., Long Beach, California Drawings, 1967; Western Mighigan U., The Growing Edge, circ., 1967; Scripps College, The Mathematical Muse, 1967; U. of Colorado, New York—Los Angeles, Drawings of the 1960s, 1967; WMAA Annuals, 1967, 73; Tampa Bay Art Center, Forty California Sculptors, 1968; Trenton/State, Soft Art, 1969; ICA, U. of Pennsylvania, Between Object and Environment, 1969; Berne, When Attitudes Become Form, 1969; Vassar College, Twenty-six by Twenty-six, 1971; Duke U., Real Cool—Cool Real, 1973. **Collections:** La Jolla; Western Michigan U. **Bibliography:** *When Attitudes Become Form.*

BANNARD, DARBY. b. 1934, New Haven, Conn. **Studied:** Princeton U., BA. **Awards:** Guggenheim Foundation Fellowship, 1968; National Council on the Arts, 1968. **Address:** P.O. Box 1157, Princeton, N.J. 08540. **Dealer:** Knoedler Contemporary Art. **One-man Exhibitions:** (first) Tibor de Nagy Gallery, NYC, 1965, also 1966, 67, 68, 69; Kasmin Ltd., 1965, 68, 69, 70, 72; Richard Feigen Gallery, Chicago, 1966; Nicholas Wilder Gallery, 1967; Bennington College, 1969; David Mirvish

Gallery, 1969; Lawrence Rubin Gallery, NYC, 1970, 73; Joseph Helman Gallery, St. Louis, 1970; Galerie Hans R. Neuendorf, Cologne, 1971; Newport Harbor, 1972; Pasadena/AM, 1973; Tibor de Nagy Gallery, Houston, 1973, 75; Knoedler Contemporary Art, 1974 (twice), 75; Laguna Gloria Art Museum, Austin, Tex., 1975. **Retrospective:** Baltimore/MA, circ., 1973. **Group:** Los Angeles/County MA, Post Painterly Abstraction, 1964; MOMA, The Responsive Eye, 1965; Chicago/Contemporary, 1965; Smithsonian, 1966; U. of Pennsylvania, 1966; WMAA Annual, 1967; Detroit/Institute, Color, Image and Form, 1967; MOMA, The Art of the Real, 1968; New Delhi, First World Triennial, 1968; Dusseldorf/Kunsthalle, Prospect '68, 1968; Corcoran Biennial, 1969; XXXV Venice Biennial, 1970; Buffalo/Albright, Color and Field: 1890-1970, 1970; Toledo/MA, The Form of Color, 1970; WMAA, The Structure of Color, 1971; Illinois State U. Biennial, 1971; Buffalo/Albright, Six Painters, 1971; Houston/MFA, Toward Color and Field, 1971; WMAA Annual, 1972; Boston/MFA, Abstract Painting in the '70s, 1972; Winnepeg (Canada) Art Gallery, Masters of the Sixties, 1972; Montreal/Contemporain, 11 Artistes Americains, 1973; Houston/MFA, The Great Decade of American Abstraction: Modernist Art 1960 to 1970, 1974; Cleveland/MA, Contemporary American Artists, 1974; WMAA (downtown), Continuing, Abstraction in American Art, 1974. **Collections:** Brandeis U.; Baltimore/MA; Boston/MFA; Buffalo/Albright; Cleveland/MA; Dayton/AI; Harvard U.; Honolulu Academy; Houston/MFA; MOMA; Melbourne/National; Newark Museum; Oberlin College; Princeton U.; Ridgefield/Aldrich; Storm King Art Center; Toledo/MA; Trenton/State; WMAA. **Bibliography:** Battcock, ed.; **Cone 2;** *The Great Decade;* Goossen 1; Rose, B. 1; Wood.

BARINGER, RICHARD E. b. December 3, 1921, Elkhart, Ind. **Studied:** Southwestern U.; Institute of Design, Chica-

go, with Lazlo Moholy-Nagy, Emerson Woelffer, B.Arch.; Harvard U. Graduate School, with Walter Gropius, B.Arch., M.Arch. US Air Force, World War II. Traveled Europe, Russia, North Africa, Caribbean. **Taught:** Institute of Design, Chicago; Columbia U.; U. of Pennsylvania, 1965-66; Institute of Design, Chicago, Artist-in-Residence, 1966-67. **Member:** American Institute of Architects. **Awards:** Prix de Rome; Harvard U., Sheldon Traveling Fellowship; American Institute of Architects, 1958 (Residential Design); *Progressive Architecture* Magazine, 1957; *Architectural Record* Magazine, 1958. **Address:** 18 Mahogany, Estate Welcome, Christiansted, St. Croix, U.S.V.I. 00820. **Dealer:** Wendy Hilty Gallery. **One-man Exhibitions:** (first) Ovington Gallery, Los Angeles, 1945; South Bend (Ind.) Art Center, 1946; Margaret Brown Gallery, Boston, 1949; MIT, 1950; Cambridge (Mass.) School of Design, 1950; Segno Gallery, Chicago, 1956; Nelson Taylor Gallery, East Hampton, N.Y., 1962; The Bertha Schaefer Gallery, 1962, 63, 65; Columbia U., 1963; Dwan Gallery, 1967; U. of Notre Dame, 1967; Institute of Design, Chicago, 1967; 10 Downtown, NYC, 1968; Island Center, St. Croix. **Group:** Johns Hopkins U., 1941; California Palace, 1948; U. of Illinois, 1949, 62, 63; ICA, Boston, 5 Young Americans, 1950; Arts Club of Chicago, 1955-57, 1961; WGMA, The Formalists, 1963; U. of Massachusetts, 1967; Colgate U., 1968. **Collections:** Busch-Reisinger Museum; Choate Rosemary Hall School; Cooperative Insurance Society; Farmers Elevator Insurance Co.; Fort Worth; MOMA; U. of Massachusetts; Pacific Indemnity Co.; Prudential Lines Inc.

BARNES, ROBERT. b. September 24, 1934, Washington, D.C. **Studied:** Chicago Art Institute School, 1952-56; The U. of Chicago, 1952-56, BFA; Columbia U., 1956; Hunter College, 1957-61; U. of London, Slade School, 1961-63. Traveled Great Britain, France, USA. **Taught:** Indiana U., summers, 1960, 61; Kansas

City Art Institute and School of Design, 1963-64; Indiana U., 1964- . **Commissions:** New York Hilton Hotel, 1962 (edition of lithographs). **Awards:** William and Noma Copley Foundation Grant, 1961; Fulbright Fellowship, 1961, renewed 1962; Chicago/AI, 67th Annual; AAAL, **P.P.**, 1970. **Address:** c/o Dealer. **Dealer:** Allan Frumkin Gallery, NYC and Chicago. **One-man Exhibitions:** (first) Allan Frumkin Gallery, NYC, 1963, also 1968; Allan Frumkin Gallery, Chicago, 1964, 67; Galerie du Dragon, Paris, 1967; Coe College, 1967; Indianapolis/Herron, 1968; Quincy (Ill.) Art Club, 1971; Il Fante di Spade, Rome, 1973. **Group:** Chicago/AI, Exhibition Monumentum, 1952-55; Chicago/AI, Prints from the Graphic Workshop, 1955; Boston Arts Festival, 1958; Chicago/AI Annuals, 1958, 60, 61, 64; State U. of Iowa, Main Current of Contemporary American Painting, 1960; Ravinia Festival, Highland Park, Ill., 1961; WMAA Annual, 1962; Yale U., 1962; Kansas City/Nelson, 1962; SFMA, 1963; MOMA, 60 Modern Drawings, 1963; Chicago/AI, Drawings, 1963; WMAA, Young America, 1965; Salon des Jeunes Peintres, Paris, 1965; Museo Civico, Bologna, 1965; PAFA, 1966; RISD, Recent Still Life, 1966; U. of Illinois, 1967; Richard Feigen Gallery, Chicago, 1969; VMFA, Works on Paper, 1970; Indianapolis, 1972; Chicago/Contemporary, Chicago Imagist Art, 1972; Galleria Comunale d'Arte Contemporanea, Una Tendenza Americana, 1973. **Collections:** Chicago/AI/MOMA; Pasadena/AM; St. Joseph/Albrecht; WMAA. **Bibliography:** Rose, B. 1.

BARNET, WILL. b. May 25, 1911, Beverly, Mass. **Studied:** Boston Museum School, with Phillip Hale; ASL, with Charles Locke. Traveled USA, Europe. **Taught:** ASL, 1936- ; Cooper Union, 1945- ; U. of Washington, Summer, 1963; Boston Museum School, 1963; Famous Artists Schools, Inc., Guiding Faculty, 1954-64; PAFA, 1967- ; Cornell U., summers, 1968, 69. **Member:** American Abstract Artists; Federa-

tion of Modern Painters and Sculptors; Century Association; NAD. Federal A.P.: Technical advisor in lithography. **Awards:** Corcoran, William A. Clark Prize; Ford Foundation/A.F.A. Artist-in-Residence; PAFA, Walter Lippincott Prize, 1968; Library of Congress, **P.P.**, 1974. **Address:** 43 West 90 Street, NYC 10024. **Dealers:** Hirschl & Adler Galleries; A.A.A. Gallery. **One-man Exhibitions:** (first) Hudson D. Walker Gallery, NYC, 1939; Gallery St. Etienne, NYC, 1943; The Bertha Schaefer Gallery, 1947, 49, 51, 53, 55, 60, 62; Peter H. Deitsch Gallery, 1960, 63; Mary Harriman Gallery Inc., Boston, 1963; Galleria Trastevere di Topazia Alliata, Rome, 1960; Waddell Gallery, 1965, 66, 68; Fairweather-Hardin Gallery, 1971; David/David Inc., Philadelphia, 1972; Hirschl & Adler Galleries, 1973; Century Association, 1974; Harmon Gallery, 1974; Meredith Long Gallery, 1974. **Retrospective:** U. of Minnesota, Duluth, 1958; ICA, Boston, 1961; Albany/ Institute, 1962; PAFA, 1970; A.A.A. Gallery, 1972. **Group:** American Abstract Artists since mid-1940's; MMA, American Paintings Today, 1950; Yale U., 1955; Corcoran, 1960; International Biennial Exhibition of Prints, Tokyo, 1960; PAFA, 1962, 68, 69; WMAA, Geometric Abstraction in America, circ., 1962; Brooklyn Museum; Carnegie; ICA, Boston; MOMA; U. of California, 1968; U. of Illinois, 1969; Spokane World's Fair, 1974; NAD, 1975. **Collections:** Boston/MFA; Brooklyn Museum; U. of California; Carnegie; Cincinnati/AM; Columbus; Corcoran; Harvard U.; Honolulu Academy; Library of Congress; MMA; MOMA; Montana State College; NYPL; NYU; PAFA; PMA; Phillips; SRGM; Seattle/AM; Sara Roby Foundation; U. of Texas; Utica; WMAA. **Bibliography:** American Artists Congress, Inc.; Farrell; Hayter 1; Janis and Blesh 1; Nordness, ed.; Reese; Smith, A. Archives.

BARRY, ROBERT. b. March 9, 1936, NYC. **Studied:** Hunter College, BFA, MA. **Address:** c/o Dealer. **Dealer:** Leo Castelli Inc., NYC. **One-man Exhibitions:** Westerly Gallery, NYC, 1964; Seth Siegelaub, Los Angeles, 1969; Art & Project, Amsterdam, 1969, 71, 72, 74; Gian Enzo Sperone, Turin, 1969, 70, 73, 74; Eugenia Butler, 1970, 71; Yvon Lambert, Paris, 1971, 73, 74; Paul Maenz Gallery, Cologne, 1971, 72, 73, 74; Leo Castelli Inc., 1971, 72, 74; Galerie MTL, Brussels, 1972; Jack Wendler Gallery, London, 1972, 73, 74; Galleria Toselli, Milan, 1972, 73; Tate, 1972; Gian Enzo Sperone, Rome, 1973; Galeria Foksal, Warsaw, 1973; Kabinett fur Actuelle Kunst, Bremerhaven, 1973; Kunstmuseum, Lucerne, 1974; Rolf Preisig Gallery, Basel, 1974; Amsterdam/Stedelijk, 1974. **Group:** Hudson River Museum, Eight Young Artists, 1964; SRGM, Systemic Painting, 1966; A.F.A., The Square in Painting, 1968; Berne, When Attitudes Become Form, 1969; Amsterdam/Stedelijk, Op Losse Schroeven, 1969; Seattle/AM, 557,087, 1969; Dusseldorf/Kunsthalle, Prospect '69, 1969; Leverkusen, Konzeption— Conception, 1969; Oberlin College, Art in the Mind, 1970; La Jolla, Projections: Anti-Materialism, 1970; New York Cultural Center, Conceptual Art and Conceptual Aspects, 1970; MOMA, Information, 1971; Kyoto Municipal Museum of Fine Art, Nirvana, 1970; Jewish Museum, Software, 1970; Kunsthalle, Nurnberg, Artist, Theory and Work, 1971; Munster/WK, Concept Art, 1971; Paris Biennial, 1971; Mills College, Notes and Scores for Sound, 1972; Documenta V, Kassel, 1972; Venice Biennial, 1972; Amsterdam / Stedelijk, Kunst Als Boek, 1972; Munster/WK, Das Konzept ist die Form, 1972; Parcheggio di Villa Borghese, Rome, Contemporanea, 1974. **Bibliography:** *ART Now 74;* Celant; *Contemporanea;* Honnef; Lippard, ed.; Meyer; *When Attitudes Become Form.*

BASKIN, LEONARD. b. August 15, 1922, New Brunswick, N.J. **Studied:** NYU, 1939-41; Yale U., 1941-43; New School for Social Research, MA, 1949; Academie de la Grande Chaumiere,

1950; Academy of Fine Arts, Florence, Italy, 1951; privately with Maurice Glickman. US Navy, 1943-46. **Taught:** Worcester Museum School, 1952-53; Smith College, 1953-74. Operates the Gehenna Press. **Awards:** Prix de Rome, Hon. Men., 1940; L. C. Tiffany Grant, 1947; Library of Congress, Pennell **P.P.**, 1952; Guggenheim Foundation Fellowship, 1953; SAGA, Mrs. A. W. Erickson Prize, 1953; Tokyo/Modern, O'Hara Museum Prize, 1954; U. of Illinois, **P.P.**, 1954; Chicago/AI, Alonzo C. Mather Prize, 1961; VI Sao Paulo Biennial, 1961; American Institute of Graphic Art, Medal of Merit, 1965; PAFA, Gold Medal, 1965; NIAL, Gold Medal, 1969. **Address:** c/o Dealer. **Dealer:** Kennedy Gallery. **One-man Exhibitions:** Glickman Studio, 1939; Numero Galleria d'Arte, Florence, Italy, 1951; The Little Gallery, Provincetown, Mass., 1952; Mount Holyoke College, 1952; Fitchburg/AM, 1952; Boris Mirski Gallery, Boston, 1954, 55, 56, 64, 65; Grace Borgenicht Gallery Inc., 1954, 60, 64, 66, 69; The Print Club, Philadelphia, 1956; Portland, Me./MA, 1956; Wesleyan U., 1956; U. of Minnesota, 1961; U. of Louisville, 1961; Rotterdam, 1961; Amerika Haus, Berlin, 1961; American Cultural Center, Paris, 1961; Royal Watercolor Society, London, 1962; Peale House, Philadelphia, 1966; FAR Gallery, 1970; NCFA, 1970; A. Lublin, Inc., NYC, 1970; Kennedy Gallery, 1971, 73, 74, 75; Amon Carter Museum, 1972; Jewish Museum, 1974. **Retrospective:** Bowdoin College, 1962; Rotterdam, 1961; Smith College, 1963; Worcester/AM, 1957. **Group:** MOMA; WMAA; Brooklyn Museum, 1949, 52, 53, 54, 55; Library of Congress; The Print Club, Philadelphia; SAGA, 1952, 53; Sao Paulo; Brandeis U.; Seattle/AM. **Collections:** Allegheny College; Auburn U.; Baltimore/MA; Bezalel Museum; Boston/MFA; Bowdoin College; Brandeis U.; Brooklyn Museum; Buffalo/Albright; Amon Carter Museum; Chase Manhattan Bank; Chicago/AI; U. of Delaware; Detroit/Institute; Fitchburg/AM; Harvard U.; Holyoke Public Library; U. of Illinois; Library of Congress; MMA; MOMA; Mount Holyoke College; NYPL; National Academy of Sciences; National Gallery; U. of Nebraska; Newark Museum; New School for Social Research; Omaha/Joslyn; PAFA; PMA; Princeton U.; The Print Club, Philadelphia; St. John's Abbey, Collegeville, Minn.; St. Louis/City; Seattle/AM; Skidmore College; Smith College; Utica; WMAA; Wesleyan U.; Worcester/AM. **Bibliography: Baskin;** Chaet; Craven, W.; **Fern;** Goodrich and Baur 1; Peterdi; Read 3; Rodman 1, 3; Sachs; Soyer, R.1. Archives.

BAUERMEISTER, MARY. b. September 7, 1934, Frankfurt, Germany. Traveled throughout the world. **Address:** c/o Dealer. **Dealer:** Galeria Bonino Ltd. **One-man Exhibitions:** (first) Amsterdam/Stedelijk, 1962; The Hague, 1963; Galeria Bonino Ltd., 1964, 65, 67, 70; Galerie der Spiegel, Cologne, 1971; Gallery Judith Weingarten, Amsterdam, 1971; Galerie Atelier 67, Ulm, 1971; Galeria Bonino Ltd., Buenos Aires, 1972; Staempfli Gallery, 1972; Galleria Schwarz, 1972. Mittelrhein-Museum, Coblenz, 1972; Petschek Arts, London, 1972; Jodi Scully Gallery, 1974. **Group:** Kunstverein, Oldenburg, Germany, 1962; Amsterdam/Stedelijk, 1962-63; WMAA Sculpture Annual, 1964-65; Buffalo/Albright, 1965; U. of Texas, 1965; WMAA, Young America, 1965; Newark Museum, 1965-66; VMFA, 1966; SRGM, 1966; Musee Cantonal des Beaux-Arts, Lausanne, II Salon International de Galeries Pilotes, 1966; The Ohio State U., 1967; U. of Illinois, 1974. **Collections:** Amsterdam/Stedelijk; Baltimore/MA; Brooklyn Museum; Buffalo/Albright; Chase Manhattan Bank; Flint/Institute; Hirshhorn; Inmont Corporation; MOMA; Minnesota/MA; NCFA; Ridgefield/Aldrich; SRGM; Trenton/State; WMAA.

BAYER, HERBERT. b. April 5, 1900, Haag, Austria. **Studied:** Real-Gymnasium, Linz, Austria; architecture with Prof. Schmidthammer, Linz, 1919;

Bauhaus, Weimar, 1921, with Vassily Kandinsky. Traveled Europe, Central America, Japan, North Africa. To USA 1938. **Taught:** Bauhaus, Dessau, 1925-28; New York Advertising Guild, 1939-40. Designs and plans exhibitions for museums throughout the world. Typographer and designer of type faces, packages, posters, books and charts. Registered Architect. **Member:** American Abstract Artists; Alliance Graphique Internationale; American Institute of Architects; Aspen Institute for Humanistic Studies; International Institute of Arts and Letters. **Commissions** (architectural): Seminar Building, Aspen Institute for Humanistic Studies; factories, Container Corp. of America; private residences; (murals): Harvard U.; Seminar Building, Aspen Institute; Colonial Williamsburg; Elementary School, West Bridgewater, Mass.; Container Corp. of America; sculpture for Arco Plaza, Los Angeles, 1973. **Awards:** Poster competitions; art director awards and medals; Milan Triennial, 1930; Medal of the City of Salzburg; Oklahoma, 4th Annual Southwest Abstract Art, First Prize; AIGA, Gold Medal for Excellence, 1970; Hon. DFA, Philadelphia College of Art, 1974. **Address:** P.O. Box B, Aspen, Colo. 81611. **Dealers:** Marlborough Fine Art Ltd.; Marlborough Gallery, Inc.; Kunst Kabinett Klihm. **One-man Exhibitions:** (first) Galerie Povolotzki, Paris, 1929; Kunstverein, Linz, 1929; Bauhaus, Dessau, 1931; Kunstlerhaus, Salzburg, 1936; The London Gallery, London, 1937; PM Gallery, NYC, 1939; Black Mountain College, 1939; Yale U., 1940; The Willard Gallery, 1943; Art Headquarters Gallery, NYC, 1943; North Texas State Teachers College, 1943; Outline Gallery, Pittsburgh, 1944; Cleveland/MA, 1952; H. Schaeffer Galleries, Inc., NYC, 1953; Galleria Il Milione, Milan, 1954; Kunst Kabinett Klihm, 1954, 57, 59, 62, 67; Aspen Institute, 1955, 64; Fort Worth, 1958; Walker, 1958; Dusseldorf, 1960; Bauhaus-Archiv, 1961; Andrew-Morris Gallery, NYC, 1963; The Byron Gallery, 1965; Esther Robles Gallery, 1965; Boise (Idaho) Art Association, 1965; U. of New Hampshire, 1966; Conzen Gallery, Dusseldorf, 1967; Kunst-Amendt, Aachen, 1967; Marlborough Fine Art Ltd., 1968; Dunkelman Gallery, Toronto, 1970; Marlborough Gallery, Inc., 1971; Marlborough Godard Ltd., Montreal, 1972; Marlborough Galerie AG, Zurich, 1974; Arte/Contacto, Caracas, 1974; Marlborough Godard Ltd., Toronto, 1975. **Retrospectives:** Brown U., The Way Beyond Art, circ. USA, 1947-49; Germanisches National Museum, Nurnberg, 33 Years of Herbert Bayer's Work, circ. Germany and Austria, 1956-57; Denver/AM, 1973; Haus Deutscher Ring, Hamburg, circ., 1974. **Group:** Julien Levy Galleries, NYC, 1931, 40; MOMA, Fantastic Art, DADA, Surrealism, 1936; MOMA, Bauhaus: 1919-28, 1938; MOMA, Art and Advertising Art, circ., 1943; ART: USA:58, NYC, 1958; American Abstract Artists Annuals, 1959-64; Marlborough Fine Art Ltd., Bauhaus, 1962; Arts Club of Chicago, 1962; Musee des Arts Decoratifs, 1966; Kunstverein Hannover, Germany, 1967; Bauhaus Exhibition, circ. Stuttgart, London, Amsterdam, Paris, 1967-71. **Collections:** Bauhaus-Archiv; Brandeis U.; Busch-Reisinger Museum; Cologne; Denver/AM; Duisburg; Dusseldorf; Essen; Evansville; Fort Worth; Graphische Sammlung Albertina; Hagen; Hannover; Harvard U.; Hudson River Museum; Kaiserslautern; Leverkusen; Linz; MOMA; U. of Michigan; Museum des 20. Jahrhunderts; Nurnberg; Oklahoma; Oldenburg; Omaha/Joslyn; Roswell; Rome/Nazionale; SFMA; SRGM; Saarlandmuseum; Smith College; Stuttgart; Vassar College; Wiesbaden. **Bibliography:** Barr 1; Baur 7; **Bayer 1, 2;** Blanchard; Blesh 1; Dorner; Gaunt; Haftman; Janis; McCurdy, ed.; Rickey; Rotors; Wingler, ed.

BAYLINSON, A.S. b. 1882, Moscow, Russia; **d.** May, 1950, NYC. **Studied** with Lattard, and privately with Robert Henri, Homer Boss. **Taught:** ASL.

Secretary of Society of Independent Artists, NYC, for 17 years. Fire destroyed studio 1930. Federal A.P.: Supervisor of Painting, 1937-39. **One-man Exhibitions:** Kraushaar Galleries, 1931; Uptown Gallery, NYC, 1940; Laurel Gallery, NYC, 1946, 49; Mount Holyoke College, 1934; ASL, Memorial Exhibition, 1951; Joseph Brummer Gallery, NYC (two-man), 1929; Mortimer Brandt, NYC (four-man), 1944. **Group:** WMAA. **Collections:** Ain Harod; Boston/MFA; MMA; MOMA; Newark Museum; PMA. **Bibliography:** Baur 7; Brown; Cheney; Dreier 2; Huyghe; *Index of 20th Century Artists;* Janis; Pach 3; Smith, S. C. K. Archives.

BAZIOTES, WILLIAM A. b. June 11, 1912, Pittsburgh, Pa.; **d.** June 4, 1963, NYC. **Studied:** NAD, 1933-36, with Leon Kroll. Federal A.P.: Teacher, 1936-38; easel painting, 1938-41. **Taught:** NYU, 1949-53; Brooklyn Museum School, 1949-52; Peoples Art Center (MOMA), 1951-53; Hunter College, 1952-63. Co-founder of a school, "Subject of the Artist," with Robert Motherwell, Barnett Newman, and Mark Rothko, NYC, 1948. **Awards:** Chicago/AI, Abstract and Surrealist Art, First Prize, 1948; U. of Illinois, **P.P.**; 1951; Chicago/AI, The Mr. & Mrs. Frank G. Logan Medal, 1961. **One-man Exhibitions:** (first) Art of This Century, NYC, 1944; The Kootz Gallery, NYC, 1946-48, 1950-54, 1956, 58, 61; Galerie Maeght, 1947; Sidney Janis Gallery, 1961; Milwaukee, 1965; Malborough Gallery, Inc., 1971; PAFA, 1971. **Retrospective:** SRGM, 1965. **Group:** California Palace, 1948; Chicago/AI, Abstract and Surrealist Art, 1948; WMAA Annuals, 1948, 50, 1952-57; U. of Illinois, 1949-51, 1953, 55, 61; Los Angeles/County MA, 1951; U. of Minnesota, 40 American Painters, 1940-50, 1951; I & II Sao Paulo Biennials, 1951, 53; MOMA, Fifteen Americans, circ., 1952; U. of Nebraska, 1952, 54; SRGM, Younger American Painters, 1954; WMAA, The New Decade, 1954-55; Brussels World's Fair, 1958; MOMA, The New American

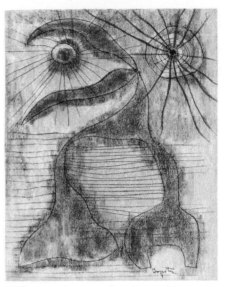

William Baziotes *Two Suns* 1952

Painting, circ. Europe, 1958-59; Documenta II, Kassel, 1959; Walker, 60 American Painters, 1960; Galerie de France, Paris, 1961; MOMA, The New American Painting and Sculpture, 1969. **Collections:** Baltimore/MA; Brandeis U.; Buffalo/Albright; Chicago/AI; Detroit/Institute; Harvard U.; U. of Illinois; MMA; MOMA; Newark Museum; New Orleans/Delgado; U. of Rochester; SRGM; San Francisco Art Association; Seattle/AM; Smith College; Tel Aviv; Vassar College; WMAA; Walker; Washington U. **Bibliography:** Alloway 4; Ashton 5; Baur 5, 7; Bazin; Biddle 4; Blesh 1; Dorner; Eliot; Finkelstein; Flanagan; Goodrich and Baur 1; Haftman; Hunter 6; Hunter, ed.; Janis and Blesh 1; Janis; McCurdy, ed.; Mendelowitz; *Metro;* Motherwell, ed.; Motherwell and Reinhardt, eds.; Neumeyer; Nordness, ed.; Paalen; Ponente; Pousette-Dart, ed.; Read 2; Richardson, E. P.; Ritchie 1; Rodman 2; Rose, B. 1, 4; Rubin 1; Sandler; Soby 5; Tuchman, ed.; Weller. Archives.

BEAL, GIFFORD. b. January 24, 1879, NYC; **d.** February 5, 1956, NYC. **Studied:** Princeton U., 1900; privately

with William M. Chase; ASL, with Frank V. DuMond. Traveled eastern USA. **Member:** NAD, 1914; President, ASL, 1914-29. **Commissions** (murals): Interior Department Building, Washington, D.C.; US Post Office, Allentown, Pa. **Awards:** Worcester/AM, Third Prize, 1903; St. Louis Exposition, 1904, Bronze Medal; NAD, Hallgarten Prize, 1910; NAD, The Thomas B. Clarke Prize, 1913; Chicago/AI, Hon. Men., 1913; Corcoran, Third Prize, 1914; Panama-Pacific Exposition, San Francisco, 1915, Gold Medal; PMA, 1917; National Arts Club, Gold Medal, 1918; NAD, Benjamin Altman Prize, 1919, 31; Chicago/AI, Watson F. Blair Prize, 1930; Corcoran, Second William A. Clark Prize, 1930; NAD Annual, Andrew Carnegie Prize, 1932; Paris World's Fair, 1937, Silver Medal; NAD, Saltus Gold Medal for Merit, 1948; NAD, Samuel F. B. Morse Gold Medal, 1954; NAD, Edwin Palmer Memorial Prize, 1955. **One-man Exhibitions:** Kraushaar Galleries, 1920-23, 1925-27, 29, 31, 33, 34, 36, 38, 41, 45, 48, 50, 56, 65, 71, 75; AAAL, Memorial Exhibition, 1957; Fitchburg/AM, 1960; Storm King Art Center, 1968, 71. **Retrospective:** Century Association, 1950; Cowie Galleries, Los Angeles, circ., 1953; Phillips, 1971; Montclair/AM, 1972. **Group:** Chicago/AI, 1928, 34, 37, 40, 44; Whitney Studio Club, NYC, 1929; PAFA, 1929, 30, 39, 44, 47, 51; St. Louis/City, 1930, 32; MOMA, 1930; Carnegie, 1931, 36, 51; U. of Rochester, 1932, 62; Phillips, 1932, 40, 54; WMAA, 1935, 45; New York World's Fair, 1939; NAD, 1942, 49, 51, 55; MMA, 1943; California Palace, 1945, 59; Youngstown/Butler, 1953; Hartford/Wadsworth, 1955. **Collections:** ASL; Andover/Phillips; Arizona State College; Brooklyn Museum; Chicago/AI; Detroit/Institute; Indiana U.; Kansas City/Nelson; Lehigh U.; Los Angeles/County MA; MMA; NAD; Newark Museum; New Britain; Omaha/Joslyn; The Pennsylvania State U.; Phillips; Randolph-Macon Women's College; Southampton/Parrish; Syracuse U.;

Utica; WMAA; Washington State U. **Bibliography:** Baur 7; Bryant, L.; Cahill and Barr, eds.; Hall; Jackman; Kent, N.; Mather 1; McCurdy, ed.; Mellquist; Neuhaus; Pagano; Phillips 1; Reese. Archives.

BEAL, JACK. b. June 25, 1931, Richmond, Va. **Studied:** College of William and Mary; Virginia Polytechnic Institute; Chicago/AI School (with Kathleen Blackshear). **Taught:** U. of Indiana, 1966; Purdue U., 1967; U. of Wisconsin, 1967, 69; Cooper Union, 1968; Wagner College; Cornell U.; Skowhegan School; San Francisco Art Association; Stanford U.; Fort Wright College; Miami-Dade. **Awards:** Chicago/AI, Emilie L. Wild Prize, 1972; National Endowment for the Arts Grant, 1972. **Address:** 101 Prince Street, NYC 10012; 83A Delhi Stage, Oneonta, N.Y. 13820. **Dealer:** Allan Frumkin Gallery, NYC and Chicago. **One-man Exhibitions:** (first) Allan Frumkin Gallery, NYC, 1965, also 1967, 68, 70, 72, 73, 75; Allan Frumkin Gallery, Chicago, 1966, 69, 74; Miami-Dade, 1972; Galerie Claude Bernard, Paris, 1973. **Retrospective:** VMFA, circ., 1973. **Group:** Chicago/AI, 1965; WMAA, Young America, 1965; A.F.A., 1965; RISD, Recent Still Life, 1966; Bennington College, 1967; Vassar College, 1968; SFMA, 1968; WMAA Annuals, 1968, 69; Milwaukee, Aspects of a New Realism, 1969; WMAA, 22 Realists, 1970; Boston U., The American Landscape, 1972; A.F.A., Realist Revival, 1972; Chicago/AI, 70th American Exhibition, 1972; Cleveland/MA, Aspects of the Figure, 1974. **Collections:** Bruce Museum; Chicago/AI; Delaware Art Museum; MOMA; Minneapolis/Institute; U. of North Carolina; U. of Notre Dame; Purchase/SUNY; Ringling; Sara Roby Foundation; SFMA; Valparaiso U. (Ind.); U. of Vermont; WMAA; Walker. **Bibliography:** Rose, B. 1; Sager. Archives.

BEARDEN, ROMARE. b. September 2, 1914, Charlotte, N.C. **Studied:** NYU, BA; ASL (with George Grosz), 1938.

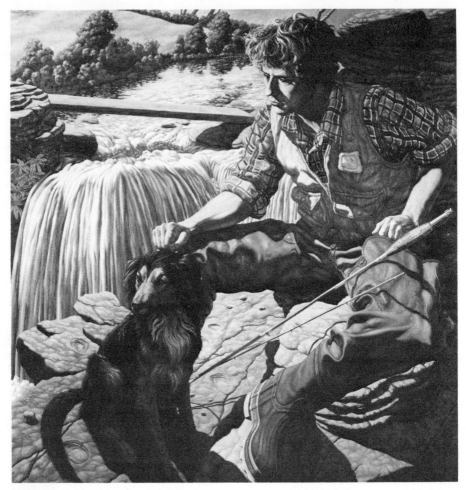

Jack Beal *The Fisherman* 1974-75

Traveled Europe, North Africa. US Army, 1942-45. **Memberships:** NIAL; Board of New York State Council on the Arts. Designed environment for the Ed Bullins' play, *House Rent Party,* at The American Place Theater, NYC, 1973. **Commissions:** murals for New Lincoln Hospital, NYC, and City Hall, Berkeley, Calif. **Awards:** AAAL, Painting Award, 1966; Guggenheim Foundation Fellowship, 1969; Ford Foundation Grant, 1973. **Address:** 357 Canal Street, NYC 10013. **Dealer:** Cordier & Ekstrom, Inc. **One-man Exhibitions:** (first) "G" Place Gallery, Washington, D.C., 1945; The Kootz Gallery, NYC, 1945, 46, 47; Duvuloy Gallery, Paris, 1945; Niveau Gallery, NYC, 1948; Barone Gallery, NYC, 1955; Michel Warren Gallery, NYC,1960; Cordier & Ekstrom, Inc., 1961, 64, 67, 70, 73, 74, 75; Corcoran, 1966; Waitsfield/Bundy, 1966. **Retrospective:** Albany/SUNY, 1968; MOMA, circ., 1971. **Group:** Carnegie; WMAA; Galerie Maeght, 6 American Painters, 1948; MMA, Survey of American Art, 1951; Chicago/AI; Dallas/MFA; Boston/MFA; MOMA, The New

Romare Bearden *Show Time* 1974

American Painting and Sculpture, 1969. **Collections:** Akron/AI; Atlanta U.; Boston/MFA; Brooklyn Museum; Buffalo/Albright; Flint/Institute; Howard U.; MMA; MOMA; Madison Art Center; Newark Museum; PMA; Princeton U.; St. Louis/City; U. of Rochester; WMAA. **Bibliography:** Dover. Archives.

BEASLEY, BRUCE. b. May 20, 1939, Los Angeles, Calif. **Studied:** Dartmouth College, 1957-59; U. of California, 1959-62. Traveled Europe, Japan, South Pacific, Central America, Mexico. **Commissions:** State of California; Oakland/. AM; Southland Center, Hayward, Calif.; City of San Francisco. **Awards:** Oakland/AM, Adele Morrison Memorial Medal, 1960; SFAI Annual, Hon. Men., 1961; Andre Malraux, **P.P.**, Paris Biennial, 1962; Marin, Frank Lloyd Wright Memorial, **P.P.**, 1965; San Francisco Arts Festival, **P.P.**, 1967. **Address:** 322 Lewis Street, Oakland, Calif. 94607. **Dealers:** Andre Emmerich Gallery, NYC; Hansen-Fuller Gallery; Darthea Speyer. **One-man Exhibitions:** RAC, 1961; Everett Ellin Gallery, Los Angeles, 1963; The Kornblee Gallery, 1964; Hansen-Fuller Gallery, 1965; David Stuart Gallery, 1966; Andre Emmerich Gallery, NYC, 1971; de Young, 1972; Santa Barbara/MA, 1973.

Group: RAC Annual, 1960; Oakland/AM Annual, 1960; MOMA, The Art of Assemblage, circ., 1961; III Paris Biennial, 1963; U. of California, Berkeley, Eleven American Sculptors, 1964; La Jolla, Some Aspects of California Painting and Sculpture, 1965; San Fernando Valley State College, Twenty-two Sculptors, 1966; U. of Illinois, 1969, 74; ICA, U. of Pennsylvania, Plastics and New Art, 1969; Jewish Museum, A Plastic Presence, 1969; Expo '70, Osaka, 1970; Stanford U., Sculpture Here and Now, 1970; Omaha/Joslyn, Looking West, 1970; Oakland/AM, Pierres de Fantaisie, 1970; U. of Nebraska, American Sculpture, 1970; Sacramento/Crocker Biennial, 1970; Stanford U., Sculpture 72, 1972. **Collections:** U. of California, Berkeley; U. of Kansas; Los Angeles/County MA; MOMA; Marin; Oakland/AM; Paris/Moderne; SRGM; UCLA; Wichita/AM.

BEATTIE, GEORGE. b. August 2, 1919, Cleveland, Ohio. **Studied:** Cleveland Institute of Art. **Taught:** Georgia Institute of Technology, Architectural School; Atlanta Art Institute. **Member:** Audubon Artists. **Commissions:** State of Georgia Agricultural Building (mural). **Awards:** NIAL Grant, 1955; Fulbright Fellowship (Italy), 1956; Atlanta/AA, Southeastern Annual, 1949; Mead Painting of the Year, 1959; Audubon Artists, Minnie R. Stern Memorial Medal, 1955. **Address:** 857 Woodley Drive, N.W., Atlanta 18, Ga. **One-man Exhibitions:** Grand Central Moderns, NYC, 1954; Hirschl & Adler Galleries, Inc., NYC, 1961; Atlanta/AA, 1950, 61; Georgia Institute of Technology, 1954; Columbus, 1956; U. of Virginia, 1956. **Group:** MMA, 1952; Utica, 1955; Uffizi Loggia, Florence, Italy, International Drawing Annual, 1957; Smithsonian, 1955, 1958-59, 61; ART: USA:59, NYC, 1959; Atlanta/AA, Southeastern Annual, 1949; Mead-Southeast Annual, 1955-61. **Collections:** Atlanta/AA; Atlanta U.; Columbus; Mead Corp.; Montclair/AM; WMAA. **Bibliography:** Pousette-Dart, ed.

BEAUCHAMP, ROBERT. b. November 19, 1923, Denver, Colo. **Studied:** U. of Denver; Cranbrook Academy of Art, BFA; Colorado Springs Fine Arts Center, with Boardman Robinson; Hofmann School. US Navy 1943-46. Traveled Italy, 1973. **Taught:** U. of Wisconsin, 1968; Cooper Union, 1969-70; Louisiana State U., 1971; U. of Illinois, 1972; Brooklyn College, 1973; School of Visual Arts, NYC, 1974-75. **Member:** Artists Equity. **Awards:** Fulbright Fellowship (Italy); Walter K. Gutman Foundation Grant; National Council on the Arts, 1966; Guggenheim Foundation Grant, 1974. **Address:** 463 West Street, NYC 10014. **One-man Exhibitions:** (first) Tanager Gallery, NYC, 1953; Great Jones Gallery, NYC, 1960, 61; Sun Gallery, Provincetown, 1961, 62, 63; Green Gallery, NYC, 1961, 63; Richard Gray Gallery, 1963; Felix Landau Gallery, 1963; East End Gallery, Provincetown, 1964, 65; The American Gallery, NYC, 1965; The Graham Gallery, 1965, 67, 69; Obelisk Gallery, 1966; U. of Utah, 1967; Tirca Karlis Gallery, 1967, 68, 71, 72; Louisiana State U., 1971; Galerie Simone Stern, New Orleans, 1971; French & Co. Inc., NYC, 1972; Robert Dain Gallery, NYC, 1972, 73; U. of Southern Florida, 1974. **Group:** Bernault Commission, circ. Asia; Carnegie, 1958, 61; WMAA Annual, 1961, 63, 65, 67, 69; Corcoran; Chicago/AI; MOMA, Recent American Painting and Sculpture, circ. USA and Canada, 1961-62; MOMA, Recent Painting USA; The Figure, circ., 1962-63; U. of Illinois, 1963; SRGM, 10 Independents, 1972. **Collections:** U. of California; Carnegie; Denver/AM; Hartford/Wadsworth; MOMA; U. of Massachusetts; Norfolk/Chrysler; Ridgefield/Aldrich; U. of Texas; WMAA. Archives.

BECHTLE, ROBERT. b. May 14, 1932, San Francisco, Calif. **Studied:** California College of Arts and Crafts, 1954, BA, 1958, MFA; U. of California, Berkeley. Traveled Europe, Mexico. **Taught:** California College of Arts and Crafts,

1957- ; U. of California, Berkeley, 1965-66, Davis, 1967-68; San Francisco State College, 1968- ; SFAI, 1975. **Awards:** Oakland/AM, **P.P.**, 1957, 59; RAC, 1958, 61, 64; Bay Printmakers Society, Oakland, Adell Hyde Morrison Memorial Medal, 1959, 61; SFMA, James D. Phelan Award, 1965. **Address:** 850 Mendocino Avenue, Berkeley, Calif. 94707. **Dealers:** OK Harris Works of Art; John Berggruen Gallery. **One-man Exhibitions:** (first) SFMA, 1959, also 1964, 67; Berkeley Gallery, Berkeley, 1965, San Francisco, 1967; RAC, 1965; Sacramento/Crocker, 1966; U. of California, Davis, 1967; Achenbach Foundation, 1969; OK Harris Works of Art, 1971, 74; John Berggruen Gallery, 1973; Jack Glenn Gallery, San Diego, 1973. **Retrospective:** Sacramento/Crocker, 1973; San Diego, 1973. **Group:** Witte, 1965; USIA, 1965-67; WMAA Annual, 1967; MOMA, The Artist as His Subject, 1967; California Palace, Painters behind Painters, 1967; U. of Illinois, 1967, 69; West Coast Now, 1968; Vassar College, 1968; Milwaukee, Aspects of a New Realism, 1969; WMAA, 22 Realists, 1970; Indianapolis, 1970; Omaha/Joslyn, Looking West, 1970; Syracuse/Everson, Cool Realism, 1970; Indiana U., American Scene: 1900-1970, 1970; Chicago/Contemporary, Radical Realism, 1971; Govett-Brewster, The State of California Painting, 1971; Documenta V, Kassel, 1972; Stuttgart/WK, Amerikanischer Fotorealismus, circ., 1972; WMAA Biennial, 1973; Hartford/Wadsworth, New/Photo Realism, 1974; Tokyo Biennial, 1974. **Collections:** Aachen/NG; Achenbach Foundation; U. of California, Berkeley; Chase Manhattan Bank; Concordia Teachers College (Ill.); Diablo Valley College; Govett-Brewster; Indiana National Bank; Library of Congress; MOMA; U. of Miami; Mills College; U. of Nebraska; Oakland/MA; SFMA; Sacramento/Crocker; San Francisco Municipal Art Commission; San Jose State College; Starr King School for the Ministry; USIA; Valparaiso U. (Ind.); WMAA. **Bibliography:** *Amerikanischer Fotorealis-*

mus; Kunst um 1970; Sager; *The State of California Painting.*

BECK, ROSEMARIE. b. July 8, 1923, NYC. **Studied:** Oberlin College, AB; Columbia U.; NYU. Traveled Europe. **Taught:** Vassar College, 1957-58, 61-62, 64-65; Middlebury College, 1958, 59, 63; Parsons School of Design, 1965-68; Queens College, 1968- . **Commissions:** Ration Mfg. Co., 1956. **Awards:** Ingram Merrill Foundation Grant, 1966; Yaddo Fellowship; MacDowell Colony Fellowship. **Address:** 6 East 12 Street, NYC 10003. **Dealer:** Poindexter Gallery. **One-man Exhibitions:** (first) The Peridot Gallery, 1953, also 1955, 56, 59, 60, 63, 64, 66, 68, 70, 72; Oberlin College, 1957; Vassar College, 1957, 61; New Paltz/SUNY, 1962; Duke U., 1971; Kirkland College, 1971; Zachary Waller Gallery, Los Angeles, 1971. **Retrospective:** Wesleyan U., 1960. **Group:** PAFA, 1954; U. of Nottingham (England), 1954, 57; WMAA Annual, 1955, 57; U. of Michigan, 1956; Chicago/AI; Brooklyn Museum; Tate; Youngstown/Butler; Arts Club of Chicago; NIAL, 1969, 70, 71, 72, 73; NAD, 1973. **Collections:** Fort Wright College; U. of Nebraska; New Paltz/SUNY; Ration Mfg. Co.; Vassar College; WMAA; Yaddo. **Bibliography:** Baur 5.

BEHL, WOLFGANG. b. April 13, 1918, Berlin, Germany. **Studied:** Academy of Fine Arts, Berlin, 1936-39; RISD, 1939-40. US citizen. Traveled Europe, Mexico, USA, Middle East. **Taught:** Perkiomen School, 1940-42; Lake Forest Academy, 1942-44; Layton School of Art, 1944-45; College of William and Mary, 1945-52; Silvermine Guild, 1955-57; U. of Hartford, 1955- . **Member:** Sculptors Guild. **Commissions:** Temple Beth El Sholom, Manchester, Conn.; St. Louis Priory, Creve Coeur, Miss.; Church of St. Timothy, West Hartford, Conn.; U. of Hartford; Willow Lawn Shopping Center, Richmond, Va.; St. Joseph's Cathedral, Hartford, Conn.; Church of the Resurrection, Wallingford, Conn.; Connecticut General In-surance Co. **Awards:** Chicago/AI, Joseph N. Eisendrath Prize, 1944; Milwaukee, Wisconsin Prize for Sculpture, 1945; Connecticut Academy of Fine Arts, First Prize for Sculpture, 1961; NIAL Grant, 1963; Ford Foundation, **P.P.**, 1964. **Address:** South Heath Road, Charlemont, Mass. 01339. **Dealer:** The New Bertha Schaefer Gallery; Bienville Gallery. **One-man Exhibitions:** Charlotte/Mint, 1949, 50; The Bertha Schaefer Gallery, 1950, also 1955, 63, 65, 68; Hollins College, 1951; Randolph-Macon Woman's College, 1951; Sweet Briar College, 1951; Amerika Haus, Schweinfurt, Wurzberg, and Munich; Bucknell U., 1965; U. of Connecticut, 1965; New Britain/American, 1969; Bienville Gallery, 1974; U. of New Hampshire, 1974. **Group:** Chicago/AI, 1943, 44; Milwaukee, 1945; Boston Arts Festival, 1946, 47; Silvermine Guild, 1946, 47; VMFA, 1946-49, 1951; U. of Illinois, 1957; Hartford/Wadsworth, 1957; Carnegie, 1962, 64; PAFA, 1964; Harvard U., 1966; Cranbrook, 6th Biennial, National Religious Art Exhibition, 1968. **Collections:** Andover/Phillips; Cornell U.; U. of Hartford; U. of Massachusetts; U. of Miami; New Britain; New Britain/American; PAFA; Slater.

BELL, LARRY. b. 1939, Chicago, Ill. **Studied:** Chouinard Art Institute, 1957-59. **Awards:** Guggenheim Foundation Fellowship, 1969. **Address:** Ranchos de Taos, New Mexico. **Dealer:** The Pace Gallery. **One-man Exhibitions:** Ferus Gallery, Los Angeles, 1962, 63, 65; The Pace Gallery, 1965, 67, 70, 71, 72, 73; Ileana Sonnabend Gallery, Paris, 1967, 68; Amsterdam/Stedelijk, 1967; Walker, 1968; Buffalo/Albright, 1968; Mizuno Gallery, 1969, 71, 75; Galerie Rudolf Zwirner, 1970; Joseph Helman Gallery, St. Louis, 1971; ACE Gallery, Los Angeles, 1972; Felicity Samuel Gallery, London, 1972; Pasadena/AM, 1972; Wilmaro Gallery, Denver, 1972; Oakland/AM, 1973; Fort Worth, 1975; Galleria del Cavallino, Venice, 1975; Marlborough Galleria d'Arte, Rome,

1975. **Group:** Pavilion Art Gallery, Balboa, Calif., 1964; MOMA, The Responsive Eye, 1965; VIII Sao Paulo Biennial, 1965; WMAA Sculpture Annual, 1966; WMAA, Contemporary American Sculpture, Selection I, 1966; U. of California, Irvine, 5 Los Angeles Sculptors, 1966; Jewish Museum, Primary Structures, 1966; La Jolla, 1966; Seattle/AM, 1966; MOMA, The 1960's, 1967; WGMA, A New Aesthetic, 1967; Los Angeles/County MA, American Sculpture of the Sixties, 1967; SRGM, Sculpture International, 1967; Documenta IV, Kassel, 1968; Vancouver, 1968; Eindhoven, Kompas IV, 1969; Walker, 14 Sculptors: The Industrial Edge, 1969; Princeton U., American Art since 1960, 1970; MOMA, Spaces, 1969; Tate (three-man), 1970; Hayward Gallery, London, 11 Los Angeles Artists, 1971; Detroit/Institute, Art in Space, 1973; Kennedy Center, Washington, D.C., Art Now '74, 1974. **Collections:** Buffalo/Albright; Chicago/AI; Denver/AM; Des Moines; Fort Worth; Hartford/Wadsworth; Los Angeles/County MA; MOMA; Oakland/AM; Pasadena/AM; Sydney/AG; Tate; WMAA; Walker. **Bibliography:** *Art Now 74;* Calas, N. and E.; Coplans 3; Davis, D.; Friedman, M. 2; Kozloff 3; *Report;* Rose, B. 1; *Transparency;* Tuchman 1; *USA West Coast.*

BENGSTON, BILLY AL. b. June 7, 1934, Dodge City, Kans. **Studied:** Los Angeles City College; Los Angeles State College; California College of Arts and Crafts; Los Angeles County Art Institute. **Taught:** Chouinard Art Institute, 1961; UCLA, 1962-63; U. of Oklahoma, 1967; U. of Colorado, 1969; U. of California, Irvine, 1973. **Awards:** National Council on the Arts, 1967; Tamarind Fellowship, 1968. **Address:** 110 Mildred Avenue, Venice, Calif. 90291. **Dealer:** Nicholas Wilder Gallery. **One-man Exhibitions:** (first) Ferus Gallery, Los Angeles, 1957, also 1958, 1960, 61, 62, 63; Martha Jackson Gallery, 1962; SFMA, 1968; Pasadena/AM, 1969; Utah, 1969; Santa Barbara/MA, 1970; Mizuno Gallery, 1970;

Galerie Hans R. Neuendorf, Cologne, 1970, 71; Galerie Hans R. Neuendorf, Hamburg, 1970, 72; Margo Leavin Gallery, 1971; La Jolla, 1971; Contract Graphics Associates, Houston, 1971; Felicity Samuel Gallery, London, 1972; Corcoran & Greenberg Inc., Coral Gables, 1973; Nicholas Wilder Gallery, 1973 (2), 1974; Southern Methodist U., 1973; Houston/Contemporary, 1973; The Texas Gallery, 1974, 75; John Berggruen Gallery, 1974; Jared Sable Gallery, Toronto, 1974; Pyramid Art Galleries Ltd., 1975; Seder/Creigh Gallery, Coronado, 1975. **Retrospective:** Los Angeles/County MA, circ. Vancouver, Corcoran, 1968. **Group:** Los Angeles/County MA Annual, 1957; Pasadena/AM, Pacific Profile of Young West Coast Artists, 1961; WMAA, Fifty California Artists, 1962-63; Oakland/AM, Pop Art USA, 1963; Milwaukee, Pop Art and the American Tradition, 1965; VIII Sao Paulo Biennial, 1965; Seattle/AM, Ten from Los Angeles, 1966; WMAA Annuals, 1967, 69; U. of California, San Diego, Los Angeles to New York, 1968; Palazzo Strozzi, Florence, Italy, I Biennale Internazionale della Grafica, 1968; MOMA, New Media: New Methods, circ., 1969; Jewish Museum, Superlimited: Books, Boxes, and Things, 1969; MOMA, Tamarind: Homage to Lithography, 1969; Eindhoven, Kompas IV, 1969-70; Pasadena/AM, West Coast: 1945-1969, 1969; Minnesota/MA, Drawings USA, 1971; Govett-Brewster, The State of California Painting, 1971; Kunstverein, Hamburg, USA: West Coast, circ., 1972; Akron/AI, Four Artists, 1972; Corcoran Biennial, 1973; Santa Barbara/MA, Fifteen Abstract Artists, 1974; U. of Illinois, 1974; WMAA, American Pop Art, 1974; Scripps College, Painting: Color, Form and Surface, 1974; U. of California, Santa Barbara, 4 from the East/4 from the West, 1975. **Collections:** A.F.A.; Amon Carter Museum; Chicago/AI; Community Arts Foundation; Fort Worth; La Jolla; Los Angeles/County MA; MOMA; Oakland/AM; Pasadena/AM; Ridgefield/Aldrich;

UCLA; WMAA. **Bibliography:** Alloway 1; Kozloff 3; Lippard 5; *The State of California Painting; USA West Coast.*

BENJAMIN, KARL. b. December 29, 1925, Chicago, Ill. **Studied:** Northwestern U.; U. of Redlands, 1949, BA; Claremont Graduate School, with Jean Ames, 1960, M.A. US Navy, 1943-46. **Taught:** General elementary school, Southern California, 1949- . **Address:** 675 West Eighth Street, Claremont, Calif. 91711. **One-man Exhibitions:** U. of Redlands, 1953, 56, 62; Pasadena/AM, 1954; Jack Carr Gallery, Pasadena, 1955, 56; Occidental College, 1958; Long Beach/MA, 1958; Esther Robles Gallery, 1959, 60, 62, 64, 65; Scripps College, 1960; La Jolla, 1961, 70; Bolles Gallery, 1961; Santa Barbara/AM, 1962, 68; Hollis Gallery, San Francisco, 1964, 66; Jefferson Gallery, 1965; Henri Gallery, 1968; Utah, 1971; William Sawyer Gallery, 1972. **Group:** Los Angeles/County MA Annuals; A.F.A., New Talent, circ., 1959; UCLA, California Painters Under 35, 1959; Los Angeles/County MA, Four Abstract Classicists, circ., 1959-61; ICA, London, West Coast Hard-Edge, 1960; Carnegie, California Artists, 1961; Pasadena/AM, Pacific Profile, 1961; WMAA, Geometric Abstraction in America, circ., 1962; Fort Worth, The Artist's Environment: The West Coast, 1962; Amon Carter Museum, circ., 1962-63; WMAA, Fifty California Artists, 1962-63; Colorado Springs/FA Annual, 1964; Denver/AM, 1965; MOMA, The Responsive Eye, 1965; SFMA, The Colorists, 1965; M. Knoedler & Co., Art Across America, circ., 1965-67; Corcoran Biennial, 1967. **Collections:** U. of California; City of Claremont; Haifa; La Jolla; Long Beach/MA; Los Angeles/County MA; NCFA; Pasadena/AM; Pepsi-Cola Co.; Pitzer College; Pomona College; U. of Redlands; SFMA; Salk Institute; San Diego; Santa Barbara/MA; Scripps College; Utah; WMAA. **Bibliography:** Rickey.

BENTON, FLETCHER. b. February 25, 1931, Jackson, Ohio. **Studied:** Miami U.,

BFA. Traveled Northern Europe, Mediterranean, parts of Africa and Asia, 1968. **Taught:** California College of Arts and Crafts, 1959; SFAI, 1964-67; California State U., San Jose, 1967- . **Commissions:** Atlantic Richfield Co. **Address:** 1072 Bryant Street, San Francisco, Calif. 94103. **One-man Exhibitions:** (first) Gump's Gallery, 1957; California Palace, 1964; SFMA, 1965; Hansen Gallery, San Francisco, 1965, 66; Esther Robles Gallery, 1966, 67; San Francisco Art Institute, 1967; Sonoma State College, 1967; Galeria Bonino Ltd., 1967, 69; Humboldt State College, 1968; Galerie Françoise Mayer, Brussels, 1969; SFMA, 1970; Buffalo/Albright, 1970; Chico State College, 1970; London Arts, Detroit, 1970; Berkeley (Calif.) Art Center, 1970; Reed College, 1970; Galeria Bonino Ltd., Buenos Aires, 1970; Estudio Actual, Caracas, 1970; Stanford U., 1971; La Jolla, 1972; Esther Robles Gallery, 1971, 72; Danenberg Gallery, 1972; Landry-Bonino Gallery, NYC, 1972; Phoenix, 1973; U. of California, Davis, 1973; Galeria Bonino Ltd., Rio de Janeiro, 1973; Elaine Horwich Gallery, Scottsdale, 1974; U. of Santa Clara, 1975. **Group:** Santa Barbara/MA, 1962, 66; San Francisco Art Association, 1964; La Jolla, 1965; New York World's Fair, 1964-65; U. of California, Berkeley, Directions in Kinetic Sculpture, 1966; SFMA, 1966; U. of Illinois, 1967, 69; Los Angeles/County MA and PMA, American Sculpture of the Sixties, 1967; U. of Hawaii, 1967; Carnegie, 1967; Flint/Institute, 1967; HemisFair '68, San Antonio, Tex., 1968; Milwaukee, Directions I: Options, circ., 1968; WMAA Sculpture Annual, 1968; Lytton Art Center, Los Angeles, 1968; UCLA, Electric Art, 1969; U. of Illinois, 1969; Expo '70, Osaka, 1970; Kent State U. Annual, 1970; Indianapolis, 1970; Hayward Gallery, London, Kinetics, 1970; Omaha/Joslyn, Looking West, 1970; U. of California, Santa Barbara, Constructivist Tendencies, circ., 1970; Hudson River Museum, Kinetic Art, 1971; Stanford U., A Decade in the West, 1971; WMAA Annual, 1973; U. of

California, Berkeley, Kinetic Exhibition, 1973; Philadelphia Art Alliance, Sculpture of the Sixties, 1974; Hirshhorn, Inaugural Exhibition, 1974. **Collections:** Atlantic Richfield Co.; U. of California; Denver/AM; First National City Bank of Dallas; Hirshhorn; IBM; Interchemical Corporation; La Jolla; Neiman-Marcus Co.; The New York Bank for Savings; Oakland/AM; Purchase/SUNY; Ridgefield/Aldrich; SFMA; Sacramento/Crocker; The Singer Company Inc.; Stanford U.; Taubman Corp.; WMAA. **Bibliography:** Atkinson; Davis, D.; Rickey; Selz, P. 1; Tuchman 1.

BENTON, THOMAS HART. b. April 15, 1889, Neosho, Mo.; **d.** January 19, 1975, Kansas City, Mo. **Studied:** Western Military Academy, 1906-07; Chicago Art Institute School, 1907; Academie Julian, Paris, 1908-11. Gallery director and art teacher for Chelsea Neighborhood Association, NYC, 1917. US Navy, 1918-19. Traveled Europe, USA, Canada. **Taught:** ASL, 1926-36; Kansas City Art Institute and School of Design, 1935-40; lectured at many colleges and universities. **Commissions** (murals): New School for Social Research, with Jose Clemente Orozco, 1928; WMAA, 1932; State of Indiana, 1933 (mural now located at U. of Indiana); Missouri State Capitol, 1935-36; "Achelous and Hercules" for Harzfeld Department Store, Kansas City, 1947 (Encyclopaedia Britannica filmed his progress on this mural); Lincoln U., 1952-53; Kansas City River Club, 1947; New York State Power Authority, Massena, 1957-61; Truman Library, Independence, Mo., 1958-61. **Awards:** Architectural League of New York, Gold Medal, 1933; Academia Argentina de Bellas Artes, Buenos Aires, Hon. Men., 1945; Accademia Fiorentina dell'Arte del Disegno, Hon. Men., 1949; Accademia Senese degli Intronati, Siena, 1949; Hon. D.Litt., Lincoln U., 1957; Hon. DFA, U. of Missouri, 1948; Hon. PBK, 1948; Hon. DFA, New School for Social Research, 1968. **One-man Exhibitions:** Lakeside Press Gallery, Chicago, 1927; Ferargil Galleries, NYC, 1934, 35; Des Moines (two-man), 1939; A.A.A. Gallery, NYC, 1939, 41, 65; A.A.A. Gallery, Chicago, 1946; U. of Arizona, circ., 1962; The Graham Gallery, 1968, 70; Madison (Wisc.) Art Center, 1971. **Retrospective:** Kansas City/Nelson, 1939; Omaha/Joslyn, 1951; New Britain, 1954; U. of Kansas, 1958; Cranbrook, 1966; The Graham Gallery, 1968; A.A.A. Gallery, 1969. **Group:** Anderson Galleries, NYC, Forum Exhibition, 1916; The Daniel Gallery, NYC, 1919; PMA, Modern Americans, 1922; Architectural League of New York, 1924; Delphic Studios, NYC, 1928, 29; WMAA, The 1930's; A.A.A. Gallery, NYC, 1939, 40, 42. **Collections:** Andover/Phillips; Brooklyn Museum; California Palace; Canajoharie; Columbia, Mo.; Kansas City/Nelson; U. of Kansas City; MMA; MOMA; U. of Nebraska; New Britain; Omaha/Joslyn; PAFA; St. Louis/City; Terre Haute/Swope. **Bibliography:** *Avant-Garde Painting and Sculpture;* **Baigell 1, 2;** Baur 7; Bazin; **Benton 1, 2, 3, 4;** Biddle 4; Biederman 1; Blesh 1; Boswell 1; Brown; Bruce and Watson; Bryant, L.; Cahill and Barr, eds., Canaday; Cheney; Christensen; **Craven, T.** 1, 2, 3; Eliot; **Fath, ed.;** Flanagan; Flexner; Goodrich and Baur 1; Haftman; Hall; Hunter 6; Huyghe; *Index of 20th Century Artists;* Kent, N.; Kootz 2; Lee and Burchwood; McCoubrey 1; McCurdy, ed.; Mellquist; Mendelowitz; Myers 2; Neuhaus; Newmeyer; Pagano; Pearson 1; Poore; Reese; Richardson, E.P.; Ringel, ed.; Rodman 2; Rose, B. 1, 4; Smith, S. C. K.; Soby 6; Tomkins and Time-Life Books; Wight 2; Wright 1; Zigrosser 1. Archives.

BEN-ZION. b. July 8, 1897, Old Constantin, Ukraine. Self-taught. Traveled Europe, Mexico, USA. To USA 1920; citizen 1936. **Taught:** Cooper Union, 1946-53; Ball State Teachers College, 1956; State U. of Iowa, 1959; Municipal U. of Omaha, 1959. Federal A.P.: Teacher. A co-founder of the Expressionist group The Ten, 1935. **Commissions:** Drawings for *Wisdom of the Fathers,*

Limited Editions Club (1960) and Heritage Press (1962). **Address:** 329 West 20 Street, NYC 10011. **One-man Exhibitions:** (first) Artists' Gallery, NYC, 1936; The Willard Gallery, 1937; Buchholz Gallery, NYC; The Bertha Schaefer Gallery; Jewish Museum, 1948, 52; Curt Valentine Gallery, NYC, 1952; A.F.A., circ., 1953-54; Duveen-Graham Gallery, NYC, 1955-56; Baltimore/MA; Taft Museum; SFMA; State U. of Iowa; St. Louis/City; Bezalel Museum; Brandeis U., 1969. **Retrospective:** Jewish Museum, circ., 1959. **Group:** PAFA; NYU; Carnegie, 1945; WMAA, 1946. **Collections:** Ball State U.; Bezalel Museum; Chicago/AI; Jewish Museum; Kansas City/Nelson; MOMA; NYPL; Newark Museum; Phillips; St. Louis/City; Tel Aviv; WMAA; U. of Washington. **Bibliography:** Baur 7; Pearson 2. Archives.

BERGER, JASON. b. January 22, 1924, Malden, Mass. **Studied:** Boston Museum School, 1942-43, 1946-49; U. of Alabama, 1943-44; Zadkine School of Sculpture, Paris, 1950-52. Traveled France, Mexico. **Taught:** Boston Museum School, 1955-69; Mount Holyoke College; Wellesley College; Buffalo/SUNY, 1969- . **Awards:** Boston/MFA, James William Paige Fellowship, 1957; Boston Arts Festival, Grand Prize, 1956; Boston Arts Festival, First Prize, 1961. **Address:** c/o Dealer. **Dealer:** Joan Peterson Gallery. **One-man Exhibitions:** The Swetzoff Gallery, Boston, 1952, 56; Deerfield (Mass.) Academy, 1954; Fitchburg/AM, 1955; The Peridot Gallery, 1956, 57, 58, 61; Nova Gallery, Boston, 1960; The Pace Gallery, Boston, 1961; Joan Peterson Gallery, 1962, 67. **Group:** Institute of Modern Art, Boston, 1943; Chicago/AI, 1952, 54; Salon de la Jeune Sculpture, Paris, 1952; ICA, Boston, 1952, 56, 60, 61; Boston Arts Festival, 1952-57, 1961; Boston/MFA, 1953-57; MOMA, Young American Printmakers, 1953; Library of Congress, 1954; Carnegie, 1954, 55; MOMA, Recent Drawings USA, 1956; PAFA, 1962; Silvermine Guild; Providence (R.I.) Art Festival, 1969. **Collections:** Brandeis U.; Chase Manhattan Bank; MOMA; Rockefeller Institute; SRGM; Smith College.

BERMAN, EUGENE. b. November 4, 1899, St. Petersburg, Russia; **d.** December 15, 1972, Rome. Studied privately in St. Petersburg with P. S. Naumoff, S. Grusenberg, 1915-18; Academie Ranson, Paris, with Edouard Vuillard, Maurice Denis, Pierre Bonnard, Felix Vallaton, 1920-22; with the architect Emilio Terry, 1920. Traveled Europe. To USA 1935; first citizenship papers 1937. Became active in designing for ballet, opera, 1937. **Member:** AAAL. **Commissions:** (murals) Wright Ludington, 1938, John Yeon, 1951; (theatre) Hartford Music Festival, 1936; *L'Opera de Quatre Sous*, Paris, 1936; "Icare" (ballet), NYC, 1939; "Concerto Barocco" (ballet), by George Balanchine, NYC, 1951. **Awards:** Guggenheim Foundation Fellowship, 1947, 49. **One-man Exhibitions:** (first) Galerie Granoff, Paris, 1927; Galerie de l'Etoile, Paris, 1928; Galerie Bonjean, Paris, 1929; Balzac Gallery, NYC, 1929; Galerie des Quatre Chemins, Paris, 1929; Julien Levy Galleries, NYC, 1932, 33, 35, 36, 37, 39, 41, 43, 46, 47; Galerie Pierre Colle, Paris, 1933; Zwemmer Gallery, London, 1935; Renoir and Lolle, Paris, 1937; Galerie Montaigne, Paris, 1939; Courvoisier Gallery, San Francisco, 1941; Princeton U., 1947; Kraushaar Galleries, 1948, 49, 54, 60; MOMA, 1945; Hanover Gallery, 1949; M. Knoedler & Co., 1965; Richard Larcada Gallery, 1969, 70, 72, 73; Utah, 1969; Maxwell Galleries, Ltd., San Francisco, 1970; La Medusa Gallery. **Retrospective:** Institute of Modern Art, Boston, circ., 1941. **Group:** Galerie Drouant, Paris, 1924; MOMA; Chicago/AI; WMAA; Hartford/Wadsworth, 1931; Musee du Petit Palais, Paris, 1934; New York Cultural Center, Leonid and His Friends, 1974. **Collections:** Baltimore/MA; Boston/MFA; Cincinnati/AM; Cleveland/MA; Denver/AM; Graphische Sammlung Albertina; Hartford/Wadsworth;

Harvard U.; U. of Illinois; State U. of Iowa; Los Angeles/County MA; MMA; MOMA; PMA; Paris/Moderne; Phillips; St. Louis/City; Santa Barbara/MA; Smith College; Tate; Vassar College; Venice/Contemporaneo; Washington U. **Bibliography:** Bazin; **Berman;** Canaday; Flanagan; Frost; Genauer; Holme 1, 2; Hunter 6; Huyghe; Kent, N.; **Levy 2;** McCurdy, ed.; Mendelowitz; Myers 2; Pearson 1, 2; Phillips 1; Richardson, E. P.; Rubin 1; Soby 1; Waldberg 4; Wight. Archives.

BERTHOT, JAKE. b. 1939, Niagara Falls, N.Y. **Studied:** New School for Social Research, 1960-61; Pratt Institute, 1960-62. **Address:** 66 Grand Street, NYC 10013. **Dealer:** David McKee Gallery. **One-man Exhibitions:** OK Harris Works of Art, 1970, 72, 75; Michael Walls Gallery, 1971, 72; Portland (Ore.) Center for the Visual Arts, 1973; Galerie de Gestlo, 1973; Cunningham-Ward Gallery, 1973; Locksley-Shea Gallery, 1974. **Group:** WMAA Annuals, 1969, 73; Indianapolis, 1970; Jewish Museum, Beautiful Painting & Sculpture, 1970; Foundation Maeght, 1970; Akron/AI, Watercolors and Drawings by Young Americans, 1970; Chicago/AI, Contemporary Drawings, 1971; U. of Rochester, Aspects of Current Painting, 1971; U. of Utah, Drawings by New York Artists, 1972; U. of California, Berkeley, Eight New York Painters, 1972; Paris Biennial, 1973; U. of Rhode Island, Drawings, 1974. **Collections:** Brandeis U.; Caracas; Ridgefield/Aldrich; VMFA; WMAA.

BERTOIA, HARRY. b. March 10, 1915, San Lorenzo, Italy. To USA 1930; became a citizen 1946. **Studied:** Society of Arts and Crafts, Detroit; Cranbrook. Traveled Norway. **Taught:** Cranbrook, 1937-41. **Commissions:** General Motors Technical Center, Detroit; MIT Chapel; Manufacturers Trust Co.; Dayton Co., Minneapolis; First National Bank of Miami; First National Bank of Tulsa; Dulles International Airport, Washington, D.C.; Northwestern National Life Insurance Bldg., Minneapolis, 1964; Kodak Pavilion, New York World's Fair, 1964-65; Philadelphia Civic Center, 1967; Marshall U., 1973; Woodward Price Park, Wichita, Kan., 1974; Standard Oil Plaza, Chicago, 1974. **Awards:** Architectural League of New York, Gold Medal; Graham Foundation Grant ($10,000), 1957; American Institute of Architects, Gold Medal, 1973; AAAL Award, 1975. **Address:** 644 Main Street, Bally, Pa. 19503. **Dealers:** Staempfli Gallery; Fairweather-Hardin Gallery. **One-man Exhibitions:** (first) Karl Nierendorf Gallery, NYC, 1940; Staempfli Gallery, 1961, 1963, 1968; Fairweather-Hardin Gallery; Museum of Non-Objective Art, NYC; Smithsonian, circ. **Group:** WMAA; MOMA; Battersea Park, London, International Sculpture Exhibition, 1963. **Collections:** Buffalo/Albright; Colorado Springs/FA; Dallas Public Library; Denver/AM; Des Moines; MIT; MOMA; Omaha/Joslyn; SFMA; Utica; VMFA; WMAA. **Bibliography:** Atkinson; Baur 7; Blesh 1; Craven, W.; Janis; *Metro*; **Nelson;** Ragon 2; Seuphor 3; Trier 1. Archives.

BESS, FOREST CLEMENGER. b. October 5, 1911, Bay City, Tex. **Studied:** Agricultural and Mechanical College of Texas, 1929-32; U. of Texas, 1932-33. Traveled Mexico, 1934-40, and USA, Corps of Army Engineers, 1940-45. **Awards:** Mark Rothko Foundation Grant, 1973. **Address:** 1701 Avenue E, Bay City, Tex. 77414. **Dealer:** Betty Parsons Gallery. **One-man Exhibitions:** Houston/MFA, 1938; Witte, 1939; Texas Technological College, 1939; Betty Parsons Gallery, 1949, 54, 57, 59, 62, 67; Andre Emmerich Gallery, Houston, 1958; Syracuse/Everson, 1974; Agricultural and Mechanical College of Texas; New Arts Gallery, Houston. **Group:** Corcoran, 1938; Dallas/MFA; Tulsa/Philbrook; A.F.A., Wit and Whimsey in 20th Century Art, 1962; de Young; Stanford U. **Collections:** Boston/MFA; Brandeis U.; Houston/MFA; Witte.

BIDDLE, GEORGE. b. January 24, 1885, Philadelphia, Pa.; **d.** November 6, 1973, Croton-on-Hudson, N.Y. **Studied:** Groton School, 1904; Harvard U., 1908, AB with honors, 1911, LLB; Academie Julian, Paris, 1911. Traveled Europe, Asia, Africa, Latin America, USA. **Taught:** Columbia U.; U. of California; Colorado Springs Fine Arts Center; Artist-in-Residence, American Academy, Rome. **Member:** American Society of Painters, Sculptors and Gravuers; National Society of Mural Painters; NIAL. **Commissions** (murals): Justice Department, Washington, D.C.; Supreme Court Building, Mexico City; National Library, Rio de Janeiro. **Awards:** Yaddo, MacDowell Colony, and Huntington Hartford Foundation Fellowships. **One-man Exhibitions:** (first) The Milch Gallery, 1919; more than 100 in USA, Europe, Japan, India. **Retrospective:** PAFA, 1947; USIA, Prints, circ., 1950. **Collections:** Berlin/National; Corcoran; MMA; Mexico City/Nacional; National Gallery; Norfolk/Chrysler; Tokyo/Modern; WMAA; Youngstown/Butler. **Bibliography:** American Artists Congress, Inc.; American Artists Group Inc., **Biddle 1, 2, 3, 4;** Birchman; Boswell 1; Brown; Bruce and Watson; Cheney; *Index of 20th Century Artists;* Mayerson, ed.; Nordmark; Pagano; Parkes; Pearson 2; Poore; Reese; Rose, B. 1; Sachs; Zigrosser 1. Archives.

BIEDERMAN, CHARLES (Karel) JO-SEPH. b. August 23, 1906, Cleveland, Ohio. **Studied:** Chicago Art Institute School, 1926-29, with Henry Poole, van Papelandam, John W. Norton. Resided Prague, Paris, New York. Traveled England. **Awards:** Amsterdam/Stedelijk, Sikkens Award, 1962; Ford Foundation, **P.P.**, 1964; National Council on the Arts, 1966; Walker Biennial, Donors Award, 1966; Minnesota State Arts Council, 1969; Hon. DFA, Minneapolis College of Art and Design, 1973; National Endowment for the Arts, 1973. **Address:** Route 2, Red Wing, Minn. 55066. **One-man Exhibitions:** (first) Chicago Art Institute School; a movie theater lobby in Chicago, 1930; Pierre Matisse Gallery, 1936; Arts Club of Chicago, 1941; Katharine Kuh Gallery, Chicago, 1941; St. Paul Gallery, 1954; Columbia U. School of Architecture, 1962; Georgia Institute of Technology, 1962; Rochester (Minn.) Art Center, 1967; Dayton's Gallery 12, Minneapolis, 1971. **Retrospective:** Walker, 1965; Hayward Gallery, London, 1969; Minneapolis/Institute, 1976. **Group:** Buffalo/Albright, 1936; Reinhardt Galleries, NYC, 1936; Galerie Pierre, Paris, 1936; Amsterdam/Stedelijk, 1962; Kunstgewerbemuseum, Zurich, 1962; Marlborough-Gerson Gallery Inc., 1964; Chicago/Contemporary, Relief/Construction/Relief, 1968; Akron/AI, Celebrate Ohio, 1971; Dallas/MFA, Geometric Abstraction: 1926-1942, 1972; Annely Juda Fine Art, London, The Non-Objective World: 1914-1955, 1972. **Collections:** Chicago/AI; Chicago Public Schools; Des Moines; U. of East Anglia; MOMA; McCrory Corporation; Minneapolis/Institute; PMA; Red Wing; Rijksmuseum Kroller-Muller; U. of Saskatchewan; Tate; Walker. **Bibliography:** Biederman 1, 2, 3; *Celebrate Ohio;* **Charles Bierderman;** Hill, ed.; Rickey; Seuphor 3.

BIRELINE, GEORGE. b. August 12, 1923, Peoria, Ill. **Studied:** Bradley U., BA; U. of North Carolina, MA. **Taught:** North Carolina State U., 1957-75. **Awards:** Guggenheim Foundation Fellowship, 1967; National Council on the Arts Grant ($5000), 1968. **Address:** 228 East Park Drive, Raleigh, N.C. 27605. **Dealer:** Andre Emmerich Gallery, NYC. **One-man Exhibitions:** U. of North Carolina, 1959, 63; Winston-Salem (N.C.) Gallery of Fine Arts, 1960, 62; Andre Emmerich Gallery, NYC, 1964, 65, 67; Gallery of Contemporary Art, Winston-Salem, 1969; Meredith College, 1973. **Retrospective:** Raleigh/NCMA, 1976. **Group:** PAFA Annual, 1950; Youngstown/Butler, 1958; Raleigh/NCMA, 1959, 61, 63; High Museum, 1960; Birmingham, Ala./MA,

1960; Columbia, S.C./MA, 1960; Los Angeles/County MA, Post Painterly Abstraction, 1964; Rockford/Burpee, 1965; U. of Illinois, 1965; Philadelphia Art Alliance, Optical Paintings, 1965; A.F.A., Fifty Artists from Fifty States, circ., 1966-68; North Carolina Annual Artists' Exhibition, 1965-67, 1969-74; Buffalo/Albright, Color and Field: 1890-1970, 1970. **Collections:** Charlotte/Mint; East Tennessee State; Hunter Museum; North Carolina National Bank; North Carolina State U.; Prentice Hall Inc.; Raleigh/NCMA; Syracuse/Everson.

BIRMELIN, A. ROBERT. b. November 7, 1933, Newark, N.J. **Studied:** Cooper Union, 1951-54; Yale U., 1954-56, BFA, 1959-60, MFA. US Army, 1957-59. Traveled England, Italy. **Taught:** Queens College, 1964- . **Awards:** Fulbright Fellowship, 1960-61; American Academy, Rome, Fellowship, 1961-64; PAFA, J. Henry Schiedt Memorial Prize, 1962; NIAL Grant, 1968; L. C. Tiffany Grant, 1973. **Address:** 547 Riverside Drive, NYC 10027. **Dealer:** Terry Dintenfass, Inc. **One-man Exhibitions:** Kanegis Gallery, 1960, 64, 66; Ross-Talalam Gallery, New Haven, 1960; The Stable Gallery, NYC, 1960, 64, 67;

Robert Birmelin *Apartment Living: A Recently Emptied Room* 1972-73

Esther Baer .Gallery, 1962; USIS Gallery, Milan, 1962; Florida State U., 1965; Jason-Teff Gallery, Montreal, 1965; Antioch College, 1965; Alpha Gallery, 1968; Terry Dintenfass, Inc., 1970, 72, 75; Queens College Art Library, N.Y., 1970; Kirkland College, 1971. **Group:** Corcoran Biennial, 1965; XXXV Venice Biennial, 1970; Indianapolis/Herron, 1972; Omaha/Joslyn, A Sense of Place, 1973; Ball State U., XX Annual, 1974; Kalamazoo/Institute, Fifty Works, 1974. **Collections:** Andover/Phillips; Brooklyn Museum; First National Bank of Chicago; U. of Florida; Hirshhorn; Indianapolis/Herron; MOMA; U. of Massachusetts; Nagaoka, Japan; U. of Nebraska; Newark Museum; Oklahoma; SFMA; Terre Haute/Swope; Worcester/AM; WMAA.

BISCHOFF, ELMER. b. July 9, 1916, Berkeley, Calif. **Studied:** U. of California, Berkeley, with Margaret Peterson, Erle Loran, John Haley, 1939, MA. US Air Force, 1942-46. Traveled Europe, Morocco, Great Britain. **Taught:** San Francisco Art Institute, 1946-52, 1956-63; Skowhegan School, 1961; U. of California, Berkeley, 1963- . Yuba College, 1964. **Awards:** RAC, First Prize, 1955; Oakland/AM, **P.P.**, 1957; Ford Foundation Grant, 1959; NIAL Grant, 1963; Chicago/AI, Norman Wait Harris Medal, 1964. **Address:** 109 Strathmoor Drive, Berkeley, Calif. 94705. **Dealers:** Staempfli Gallery; Charles Campbell Gallery. **One-man Exhibitions:** (first) California Palace, 1947; King Ubu Gallery, San Francisco, 1953; Paul Kantor Gallery, Beverly Hills, Calif., 1955; SFMA, 1956, 71; Staempfli Gallery, 1960, 62, 64, 69; de Young, 1961; Achenbach Foundation (three-man drawing show), 1963; Sacramento/Crocker, 1964; U. of Washington, 1968; RAC, 1969; SFAI, 1975; U. of California, Berkeley, 1975. **Group:** San Francisco Art Association Annuals, 1942, 46, 52, 57, 59, 63; Chicago/AI, 1947, 59, 64; California Palace, 1948, 50, 1960-63; Los Angeles/County MA, 1951; RAC, 1955, 56; Oakland/AM,

1957; Minneapolis/Institute, American Painting, 1945-57, 1957; A.F.A., New Talent, circ., 1958; ART: USA:59, NYC, 1959; U. of Illinois, 1959, 61; WMAA, 1959, 61, 63; A.F.A., West Coast Artists, circ., 1959-60; Denver/AM, 1960; Youngstown/Butler, 1960; Auckland, Painting from the Pacific, 1961; PAFA, 1962; Fort Worth, The Artist's Environment: The West Coast, 1962; SFMA, Fifty California Artists, circ., 1962; MOMA, Recent Painting USA; The Figure, circ., 1962-63; Art: USA:Now, circ., 1962-67; NIAL, 1963; Corcoran, 1963; Carnegie, 1967; Expo '70, Osaka, 1970; U. of Nebraska, 1973; U. of Illinois, 1974. **Collections:** Chase Manhattan Bank; Chicago/AI; MOMA; NCFA; Oakland/AM; Rockefeller Institute; SFMA; Sacramento/Crocker; U. of Texas; VMFA; WMAA. **Bibliography:** Goodrich and Baur 1; Nordness, ed.; Rose, B. 1. Archives.

BISHOP, ISABEL. b. March 3, 1902, Cincinnati, Ohio. **Studied:** New York School of Applied Design; ASL, with Kenneth Hayes Miller. **Taught:** ASL, 1937; Skowhegan School. **Member:** AAAL; NAD; NIAL; SAGA; Audubon Artists. Federal A.P.: US Post Office, New Lexington, Ohio (mural). **Awards:** NAD, Isaac N. Maynard Prize; NAD, The Adolph and Clara Obrig Prize, 1942; NAD Annual, Andrew Carnegie Prize, 1945; Corcoran, Second William A. Clark Prize, 1945; AAAL Grant, 1943; PAFA, Walter Lippincott Prize, 1953; NAD, Benjamin Altman Prize, 1955; Library of Congress, Pennell **P.P.**, 1946; NAD, Joseph S. Isidora Gold Medal, 1957; Hon. DFA, Moore Institute; Brandeis U., Creative Arts Award and $1000, 1975. **Address:** 857 Broadway, NYC 10003. **Dealer:** The Midtown Galleries. **One-man Exhibitions:** The Midtown Galleries, 1932, 35, 36, 39, 49, 55, 60, 67, 74; Pittsfield/Berkshire, 1957; VMFA (two-man), 1960. **Retrospective:** U. of Arizona, circ., 1974. **Group:** Carnegie; VMFA; Corcoran; PAFA; New York World's Fair; 1939; Chicago/AI; WMAA; MOMA; St.

Louis/City; NAD. **Collections:** Andover/Phillips; Atlanta U.; Baltimore/MA; Boston/MFA; Brooklyn Museum; California Palace; Clearwater/Gulf Coast; Colorado Springs/FA; Columbus; Corcoran; Cranbrook; Dallas/MFA; Des Moines; Hartford/Wadsworth; Harvard U.; Kansas City/Nelson; Library of Congress; Los Angeles/County MA; MMA; Memphis/Brooks; NAD; NYPL; U. of Nebraska; Newark Museum; New Britain; PAFA; PMA; Phillips; St. Louis/City; Southampton/Parrish; Springfield, Mass./MFA; Tel Aviv; Terre Haute/Swope; Utica; VMFA; WMAA; Washburn U. of Topeka; Youngstown/Butler. **Bibliography:** Baur 7; Boswell 1; Brown; *Celebrate Ohio*; Cheney; Goodrich and Baur 1; Isabel **Bishop**; Johnson 2; Kent, N.; **Lunde;** McCurdy, ed.; Mellquist; Mendelowitz; Nordness, ed.; Pagano; Richardson, E. P.; Rose, B. 1. Archives.

BISHOP, JAMES. b. October 7, 1927, Neosho, Mo. **Studied:** Syracuse U., 1950, BA; Washington U., 1951-54; Black Mountain College, 1953, with Esteban Vicente; Columbia U., 1955-56. Traveled France, 1957-66. **Taught:** Cooper Union, 1969-70; U. of California, Irvine, 1970; Carnegie-Mellon Institute, 1971; School of Visual Arts, NYC, 1972. **Awards:** Guggenheim Foundation Fellowship, 1970. Editorial associate, *Art News*, 1969-72. **Address:** 5 Lispenard Street, NYC 10013. **Dealer:** Fourcade, Droll Inc. **One-man Exhibitions:** (first) Galerie Lucien Durand, Paris, 1963; Galerie Smith, Brussels, 1963; Galerie Lawrence, Paris, 1964; Fischbach Gallery, 1966, 68, 70, 72; Galerie Fournier, Paris, 1966, 71, 73; the Clocktower, NYC, 1973; Rosa Esman Gallery, 1974. **Group:** Salon des Realites Nouvelles, Paris, 1962-65; Salon du Mai, Paris, 1964, 65; Musee Galliera, Paris, Promesses Tenues, 1965; Amerika Haus, Berlin, Ten Americans, 1966; WMAA, 1967; Corcoran, 1967; Expo '67, Montreal, 1967; Jewish Museum, Large Scale American Painting, 1967; Foundation Maeght, 1968,

70; U. of California, Riverside, Recent Direction, 1968; NIAL, 1971; U. of North Carolina, 1971; Yale U., Options and Alternatives, 1973; Indianapolis, 1974. **Collections:** SFMA. **Bibliography:** *Options and Alternatives.*

BISTTRAM, EMIL. b. April 7, 1895, Hungary. **Studied:** NAD; Cooper Union; New York School of Fine and Applied Art (with Ivan Olinsky, Leon Kroll, William Dodge, Jay Hambridge, Howard Giles). **Taught:** New York School of Fine and Applied Art; Master Institute of United Arts, Inc., NYC; Bisttram School, Taos, N.M. **Commissions** (murals): Justice Department, Washington, D.C.; US Post Office, Ranger, Tex. **Awards:** Philadelphia Watercolor Club, First Prize, Gold Medal, 1926; Guggenheim Foundation Fellowship, 1931; California Palace, Hon. Men., 1936. **Address:** Box 46, Taos, N.M. **One-man Exhibitions:** Philadelphia Watercolor Club; Delphic Gallery, NYC; Stendahl Gallery, Los Angeles, 1945. **Group:** PAFA; Chicago/ AI; XV Venice Biennial, 1930; WMAA, 1933. **Collections:** Buffalo/Albright; Nicholas Roerich Museum; Taos (N.M.) County Court House. **Bibliography:** Allen, ed.; Bruce and Watson; Cheney; Coke 2; *Index of 20th Century Artists;* Pearson 1, 2. Archives.

BLACKBURN, MORRIS. b. October 13, 1902, Philadelphia, Pa. **Studied:** PAFA, with Arthur B. Carles, Jr., Henry McCarter, Daniel Garber. Traveled Europe, Canada, Ireland, Caribbean. **Taught:** Philadelphia College of Art, 1933-73; Bryn Mawr College, 1947-48; Stella Elkins Tyler School of Fine Arts, Temple U., 1945- ; PAFA, 1952- . Federal A.P.: Mural and easel painting. **Member:** Philadelphia Watercolor Club; Audubon Artists; The Print Club, Philadelphia; American Watercolor Society. Subject of a 16mm film, "Portrait of a Painter," by Emilio Angelo. **Awards:** Guggenheim Foundation Fellowship, 1952; PAFA, Cresson Fellowship, 1928, 29; PAFA, Gold Medal, 1946; PAFA, H.

S. Morris Prize, 1951; PAFA, Thornton Oakley Prize, 1955. **Address:** 2104 Spring Street, Philadelphia, Pa. 19103. **One-man Exhibitons:** (first) Warwick Gallery, Philadelphia, 1930; PAFA; The Print Club, Philadelphia; Woodmere Art Gallery, Philadelphia; Philadelphia Art Alliance; Newman Gallery, Philadelphia; Joseph Luyber Galleries, NYC; National Serigraph Society, NYC; Pennsylvania Art Center; Rutgers U.; Peirce Junior College. **Retrospective:** Woodmere Art Gallery, Philadelphia, 1956; Provident National Bank, Philadelphia, 1969. **Group:** PAFA Annuals since 1937; NAD; Audubon Artists; New York World's Fair, 1939; Chicago/ AI; Carnegie; Brooklyn Museum; WMAA; Library of Congress; USIA traveling print exhibitions; Youngstown/Butler; Santa Fe, N.M.; New Orleans/Delgado; Santa Barbara/MA; US State Department, circ. **Collections:** Clearwater/Gulf Coast; Delaware Art Museum; Free Library of Philadelphia; Library of Congress; Memphis/Brooks; Montana State U.; PAFA; PMA; The Pennsylvania State U.; Santa Fe, N.M.; Trenton/State; USIA; US State Department; Youngstown/Butler. **Bibliography:** Bethers.

BLADEN, RONALD. b. July 13, 1918, Vancouver, B.C., Canada. **Studied:** Vancouver School of Art; CSFA. **Awards:** SFAI, Rosenberg Fellowship; National Council on the Arts; Guggenheim Foundation Fellowship, 1970. **Address:** 5 West 21 Street, NYC 10010. **Dealer:** Fischbach Gallery. **One-man Exhibitions:** Brata Gallery, NYC, 1953; U. of British Columbia (two-man), 1955; Six Gallery, San Francisco, 1956; Green Gallery, NYC, 1962; NYU (three-man), 1967; Fischbach Gallery, 1967, 70, 71, 72; Hofstra U., 1967; Vancouver (two-man), 1970; Pasadena/AM, 1972; Tyler School of Art, Philadelphia, 1972; U. of Wisconsin, Madison, 1972. **Group:** NYU, Concrete Expressionism, 1965; WMAA Annuals, 1966, 68, 73; Chicago/ AI Annual 1966; Jewish Museum, Primary Structure Sculptures, 1966;

Los Angeles/County MA, Sculpture of the Sixties, 1967; A.F.A., Rejective Art, 1967; Corcoran, Scale as Content, 1967; Documenta IV, Kassel, 1968; Walker, 14 Sculptors: The Industrial Edge, 1969; U. of Nebraska, American Sculpture, 1970; Arnhem, Sonsbeek '71, 1971; SFMA, Works in Spaces, 1973; Detroit/Institute, Art in Space, 1973; U. of Miami, Less is More: The Influence of the Bauhaus on American Art, 1974. **Collections:** La Jolla; MOMA, Marine Midland Bank and Trust Co.; South Mall, Albany. **Bibliography:** Calas, N. and E.; Friedman, M. 2; *Report.*

BLAINE, NELL. b. July 10, 1922, Richmond, Va. **Studied:** Richmond (Va.) School of Art, 1939-43; Hofmann School, 1943-44; Atelier 17,, NYC, with S. W. Hayter; New School for Social Research, 1952-53. Traveled Europe, Near East, West Indies, Mexico. **Taught:** Great Neck (N.Y.) Public Schools, 1943-1956, and privately. **Member:** American Abstract Artists, 1944-57; Jane Street Group, 1945-49; Artists Equity. **Commissions:** Revlon Inc. (murals); New York Hilton Hotel (lithographs). **Awards:** Norfolk, First Prize, Watercolor, 1945; MacDowell Colony Fellowship, 1957; Yaddo Fellowship, 1957, 58, 64; Ingram Merrill Grants, 1962, 64, 66; Longview Foundation Grant, 1964, 1970; CAPS, 1972; Mark Rothko Foundation Grant, 1972; Guggenheim Foundation Fellowship, 1974. **Address:** 210 Riverside Drive, NYC 10025. **Dealer:** Poindexter Gallery. **One-man Exhibitions:** (first) Jane Street Gallery, NYC, 1945, also 1948; VMFA, 1947, 54, 73; Southern Illinois U., 1949; Tibor de Nagy Gallery, 1953, 54; Poindexter Gallery, 1956, 58, 60, 66, 68, 70, 72; New Paltz/SUNY, 1959; Stewart Richard Gallery, San Antonio, 1961; Philadelphia Art Alliance, 1961; Yaddo, 1961; Longwood College, 1962; U. of Connecticut, 1973; Webb and Parsons, Bedford Village, N.Y., 1973. **Retrospective:** Southampton/Parrish, 1974. **Group:** Art of This Century, NYC, The Women, 1944; Salon des Realites Nouvelles, Paris, 1950; Chicago/AI; Baltimore/MA; WMAA; PAFA; Corcoran; VMFA; ART:USA:59, NYC, 1959; MOMA, Abstract Watercolors and Drawings: USA, circ. Latin America and Europe, 1961-62; Festival of Two Worlds, Spoleto; MOMA, Hans Hofmann and His Students, circ., 1963-64; Hartford/Wadsworth, Figures, 1964; MOMA, Contemporary Still Life, circ., 1967-68; New School for Social Research, Humanist Tradition, 1968; NIAL, 1970, 74, 75; A.F.A., Painterly Realism, 1970; WMAA, Frank O'Hara: A Poet among Painters, 1974. **Collections:** Brandeis U.; Brooklyn Museum; U. of California; Chase Manhattan Bank; Ciba-Geigy Corp.; Colgate U.; U. of Georgia; Hallmark Collection; Hirshhorn; State U. of Iowa; Longwood College; MOMA; U. of Massachusetts; Michigan State U.; New Paltz/SUNY; U. of North Carolina; *Readers Digest;* Revlon Inc.; Southern Illinois U.; Taconic Foundation; Union Carbide Corp.; VMFA; WMAA. **Bibliography:** *Art: A Woman's Sensibility;* Bryant, E. Archives.

BLANCH, ARNOLD. b. June 4, 1896, Mantorville, Minn.; **d.** October 23, 1968, Kingston, N.Y. **Studied:** Minneapolis Institute School; ASL (with Kenneth Hayes Miller, Boardman Robinson, John Sloan), 1916-17. Traveled USA. **Taught:** ASL, 1915-21, 1935-39, 1947-68; California School of Fine Arts, 1930-31; Colorado Springs Fine Arts Center, summers, 1939-41; U. of Minnesota, 1949, 52; Rollins College, 1950; Florida Gulf Coast Art Center, Inc., 1950-51; Woodstock, N.Y., 1950-61; Ohio U., summers, 1952, 56; Minneapolis Institute School, 1954; U. of Hawaii, 1955; Norton Gallery and School of Art, 1961-62; Michigan State U., 1964. **Commissions:** US Post Offices, Fredonia, N.Y., Norwalk, Conn., and Columbus, Wisc. (murals). **Awards:** Chicago/AI, Norman Wait Harris Prize, 1929; SFMA, **P.P.,** 1931; California Palace, 1931; Guggenheim Foundation Fellowship, 1933; PAFA, Medal, 1938; Carnegie, Medal, 1938; Syracuse/Everson, National Cer-

amic Exhibition, 1949, 51; Silvermine Guild. **One-man Exhibitions:** Rehn Galleries, 1923, 25; Philadelphia Art Alliance; Dudensing Gallery, NYC, 1928, 30; Walden-Dudensing Gallery, Chicago, 1930; Ulrich Gallery, Minneapolis, 1930; Beaux Arts Gallery, San Francisco, 1930; A.A.A. Gallery, NYC, 1943, 55, 63; Des Moines, 1952; Walker, 1952; The Krasner Gallery, 1954, 58, 59, 61, 62, 69; West Palm Beach/Norton, 1961. **Retrospective:** U. of Minnesota, 1949. **Group:** Chicago/AI, 1930-43; Corcoran, 1931-45; WMAA, 1931-46, 1948-52; PAFA, 1931-45, 1948-52; New York World's Fair, 1939; MOMA; Carnegie; VMFA; MMA; Library of Congress; ART:USA, NYC. **Collections:** Abbott Laboratories; U. of Arizona; Britannica; Brooklyn Museum; California Palace; Carnegie; Cincinnati/AM; Clearwater/Gulf Coast; Cleveland/MA; Colorado Springs/FA; Cranbrook; Denver/AM; Detroit/Institute; Library of Congress; MMA; U. of Minnesota, Duluth; U. of Nebraska; U. of Oklahoma; PAFA; St. Louis/City; Utica; WMAA; Youngstown/Butler. **Bibliography:** American Artists Congress, Inc.; Baur 7; **Blanch 1, 2, 3;** Boswell 1; Cheney; *Index of 20th Century Artists;* Jewell 2; Pagano; Pearson 1; Reese; Richardson, E. P.; Zaidenberg, ed. Archives.

BLAUSTEIN, AL. b. January 23, 1924, NYC. **Studied:** Cooper Union, with Morris Kantor; Skowhegan School. US Air Force, 3 years. Traveled Mexico, Africa, the Orient; resided Rome, 1954-57. **Taught:** Pratt Institute; Yale U. **Commissions:** Drawings for *Life* Magazine and British Overseas Food Corporation, 1948-49; fresco mural for South Solon (Me.) Meeting House, 1953. **Awards:** Prix de Rome, 1954-57; Guggenheim Foundation Fellowship, 1958, 61; AAAL Grant, 1958; Childe Hassam Award, 1962-68, and **P.P.**, 1969; PAFA, Alice McFadden Eyre Medal, 1959; ART:USA:59, NYC, Graphic Prize, 1959; Youngstown/Butler, First Prize, 1961; SAGA, First Prize, 1962; Audu-

bon Artists, Gold Medal of Honor, 1962. **Address:** 141 East 17 Street, NYC 10003. **Dealer:** Terry Dintenfass, Inc. **One-man Exhibitions:** (first) Lee Nordness Gallery, NYC, 1959, also 1961, 62; U. of Nevada, 1961; Philadelphia Art Alliance, 1962; Walter Laubli Gallery, Zurich, 1962; Philadelphia Print Club, 1964; Franklin Siden Gallery, Detroit, 1965, 66; Randolph-Macon College, 1967; C. Troup Gallery, Dallas, 1968; Terry Dintenfass, Inc., 1969, 72. **Group:** MMA, 1950; A.F.A., 1951; Buffalo/Albright, Expressionism in American Painting, 1952; Carnegie, 1952; WMAA Annuals, 1953, 57; The Downtown Gallery, 1958; SAGA, 1962. **Collections:** Albany/Institute; Boston/MFA; Brooklyn Museum; Chicago/AI; Hartford/Wadsworth; Library of Congress; MMA; U. of Nebraska; Norfolk; PAFA; Scranton/Everhart; Syracuse U.; WMAA; Washington U.; Youngstown/Butler. **Bibliography:** Chaet; Nordness, ed.

BLEIFELD, STANLEY. b. August 28, 1924, Brooklyn, N.Y. US Navy, 1944-46. **Studied:** Stella Elkins Tyler School of Fine Arts, Temple U., with Raphael Sabatini, 1949, BFA, BS.Ed., 1950, MFA. Traveled Israel, Mexico, and extensively in Italy; resided Rome, 1962-63. **Taught:** Weston (Conn.) Public Schools, 1950-53; New Haven State Teachers College, 1953-55; Danbury State College, 1955-63; Silvermine Guild, 1963-66; Bleifeld Studio Group, 1966- . **Member:** National Sculpture Society. **Commissions:** Vatican Pavilion, New York World's Fair, 1964-65; Kokomo (Ind.) Public Library, 1969. **Awards:** Tyler Annual, First Prize, 1951; National Sculpture Society, John Gregory Award, 1964, Bronze Medal, 1970; elected Tyler Fellow, 1964; L. C. Tiffany Grants, 1965, 67. **Address:** 27 Spring Valley Road, Weston, Conn. 06880. **Dealers:** FAR Gallery; I.F.A. Gallery; Sandra Wilson Galleries, Denver and Santa Fe. **One-man Exhibitions:** The Peridot Gallery, 1963, 68; Hoffman Fuel Co., Danbury, Conn., 1962; Kenmore Gal-

leries, Inc., Philadelphia, 1967; New Canaan (Conn.) Public Library, 1967; Fairfield U., 1967; I.F.A. Gallery, 1968, 71; FAR Gallery, 1971, 73; New Britain/American, 1974. **Group:** Silvermine Guild; Stella Elkins Tyler School of Fine Arts, Temple U.; International Arts Festival, Chetwode, Newport, R.I., 1964; A.F.A., 1966-67; Temple Emanuel, Houston, Tex., 1964; Indiana U., 1966. **Collections:** New Britain/American; Tampa/AI; Temple U.

BLOCH, ALBERT. b. August 2, 1882, St. Louis, Mo.; **d.** December 9, 1961, Lawrence, Kans. **Studied:** Washington U. School of Fine Arts, 1898-1900; New York and Europe. **Taught:** Chicago Art Institute School, 1922-23; U. of Kansas School of Fine Arts, 1941-47 (Prof. Emeritus). **One-man Exhibitions:** Chicago/AI, 1915; St. Louis/City, 1915; The Daniel Gallery, NYC, 1921, 26; Kansas City/Nelson (three-man), 1927; Arts Club of Chicago, 1927; Germany; Switzerland; Sweden; Renaissance Society, Chicago; The Willow Gallery, NYC, 1948; The U. of Chicago, 1956. **Retrospective:** U. of Kansas, 1955; Tulsa/Philbrook, 1961-62; Utica, 1974. **Group:** Der Blaue Reiter, Munich, 1911-14; Der Sturm, Berlin, 1913, 18; Neue Sezession, Munich, 1916; Cologne; A Century of Progress, Chicago, 1933-34; New York World's Fair, 1939. **Collections:** Baker U.; Chicago/AI; Columbus; Kansas State College; U. of Kansas; Phillips; Stadtische Galerie im Lenbachhaus; Yale U. **Bibliography:** Albert Bloch: **1882-1961;** Baur 7; Brown; Cheney; Selz, P. 3.

BLOOM, HYMAN. b. April, 1913, near Riga, Latvia. To USA 1920. **Studied:** West End Community Center, Boston, with Harold Zimmerman; Harvard U., with Denman W. Ross. **Taught:** Wellesley College, 1949-51; Harvard U., 1951-53. Federal A.P.: Easel Painting. **Address:** 1426 Cambridge Street, Cambridge, Mass. 02139. **Dealer:** Terry Dintenfass, Inc. **One-man Exhibitions:** Stuart Gallery, Boston, 1945; Durlacher

Brothers, NYC, 1946, 48, 54; ICA, Boston; Boris Mirski Gallery, Boston, 1949; The Swetzoff Gallery, Boston, 1957; WMAA, 1968; U. of Connecticut, 1969; Terry Dintenfass, Inc., 1972, 75; UCLA (two-man). **Retrospective:** Buffalo/Albright, circ., 1954. **Group:** MOMA, Americans 1942, circ., 1942; Boston/MFA; WMAA. **Collections:** Andover/Phillips; First National Bank of Boston; Harvard U.; Hirshhorn; Kalamazoo/Institute; MOMA; St. Louis/City; Smith College; WMAA. **Bibliography:** Barker 1; Baur 7; Biddle 4; Chaet; Eliot; Goodrich 1; Hess, T. B. 1; Hunter 6; Kootz 2; Kuh 3; Miller, ed. 1; Newmeyer; Pousette-Dart, ed.; Richardson, E.P.; Rodman 2, 3; Rose, B. 1; Soby 5; Wight 2; **Wight and Goodrich.**

BLUEMNER, OSCAR. b. 1867, Hannover, Germany; **d.** 1938, South Braintree, Mass. **Studied:** Academy of Fine Arts, Berlin. To USA 1892. Practicing architect, 1894-1912. **One-man Exhibitions:** Berlin, 1885, 1912; Stieglitz Gallery, NYC, 1915; Mrs. Liebman's Art Room, NYC, 1926; Stieglitz's Intimate Gallery, NYC, 1928; Whitney Studio Club, NYC, 1929; Marie Harriman Gallery, NYC, 1935; U. of Minnesota, 1939; Today's Gallery, Boston, 1945; The Graham Gallery, 1956, 60, 67, 72; Harvard U , 1967; New York Cultural Center, 1969; Davis Gallery, 1971; Danenberg Gallery, 1972. **Group:** Anderson Galleries, NYC, Forum Exhibition, 1916; Bourgeois Gallery, NYC, 1917-23; J. B. Neumann Gallery, NYC, 1924-36; WMAA, Pioneers of Modern Art in America, 1946; WMAA, Juliana Force Memorial Exhibition, 1949. **Collections:** Boston/MFA; MOMA; Phillips; WMAA. **Bibliography:** *Avant-Garde Painting and Sculpture;* Baur 7; Brown; Cheney; Frank, ed.; Goodrich and Baur 1; Hunter 6; Janis; Mellquist; **Oscar Bluemner: American Colorist;** Rose, B. 1, 4; Wright 1. Archives.

BLUHM, NORMAN. b. March 28, 1920; Chicago, Ill. **Studied:** Illinois Institute of Technology, 1936; 1945-47,

with Mies van der Rohe. US Air Force, 1941-45. Resided Paris, 1947-56. **Address:** P.O. Box 729, Millbrook, N.Y. 12545. **One-man Exhibitions:** (first) Leo Castelli Inc., 1957, also 1960; Galleria d'Arte del Naviglio, Milan, 1959; Notizie Gallery, Turin, 1961; David Anderson Gallery, NYC, 1962, Paris, 1965; Galerie Semiha Huber, Zurich, 1963; The American Gallery, NYC, 1963; Galerie Anderson-Mayer, Paris, 1963; Galerie Smith, Brussels, 1964; Galerie Stadler, Paris, 1968, 70, 72; Corcoran, 1969; Martha Jackson Gallery, 1970, 71, 74; J. L. Hudson Art Gallery, Detroit, 1971; Syracuse/Everson, 1973; Vassar College, 1974; Galleria Venezia, Venice, 1974; Carlo Rubboli, Milan, 1974. **Group:** Carnegie, 1958; Documenta II, Kassel, 1959; ICA, Boston, 100 Works on Paper, circ. Europe, 1959; Walker, 60 American Painters, 1960; WMAA Annual, 1960; Chicago/AI Annual, 1961; SRGM, The G. David Thompson Collection; SRGM, Abstract Expressionists and Imagists, 1961; Salon du Mai, Paris, 1964; MOMA, Two Decades of American Painting, circ., 1966; Jewish Museum, Large Scale American Painting, 1967; MOMA, Dada, Surrealism, and Their Heritage, 1968; Galleria d'Arte, Cortina, Espaces Abstraits, 1969; WMAA Annual, 1972; MOMA, Color as Language, circ., 1975. **Collections:** Baltimore/MA; Buffalo/Albright; CNAC; Dallas/MFA; Dayton/AI; Kansas City/Nelson; MIT; MOMA; U. of Massachusetts; Melbourne/National; NYU; National Museum of Wales; Phillips; Reed College; Stony Brook/SUNY; Vassar College; WMAA. **Bibliography:** *Metro; O'Hara 1; Rubin 1. Archives.

BLUME, PETER. b. October 27, 1906, Russia. To USA 1911. **Studied:** Educational Alliance, NYC; ASL; Beaux Arts Academy, NYC. Federal A.P.: US Post Offices, Cannonsburg, Pa., Rome, Ga., and Geneva, N.Y. (murals). **Awards:** Guggenheim Foundation Fellowship, 1932, 36; Carnegie, First Prize, 1934; MMA, Artists for Victory, 1942; NIAL

Grant, 1947. **Address:** Sherman, Conn. **Dealer:** Coe Kerr Gallery. **One-man Exhibitions:** (first) The Daniel Gallery, NYC, 1930; Julien Levy Galleries, NYC, 1937; The Downtown Gallery, 1941, 47; Durlacher Brothers, NYC, 1949, 54, 58; Kennedy Gallery, 1968; Danenberg Gallery, 1970; Coe Kerr Gallery, 1975. **Collections:** Boston/MFA; Columbus; Hartford/Wadsworth; MMA; Newark Museum; Randolph-Macon College; Williams College. **Bibliography:** Barker 1; Barr 3; Baur 7; Boswell 1; Brown; Cahill and Barr, eds.; Canaday; Cheney; Eliot; Flanagan; **Getlein 3;** Goodrich and Baur 1; Haftman; Hunter 6; *Index of 20th Century Artists;* Janis; Jewell 2; Kootz 1, 2; Kuh 1; McCurdy, ed.; Mellquist; Mendelowitz; Neumeyer; Nordness, ed.; Pearson 2; Poore; Pousette-Dart, ed.; Richardson, E.P.; Ringel, ed.; Rose, B. 1; Sachs; Smith, S. C. K.; Soby 5, 6; Wight 2. Archives.

BOARDMAN, SEYMOUR. b. December 29, 1921, Brooklyn, N.Y. **Studied:** City College of New York, 1942, BS; Academie des Beaux-Arts, Academie de la Grande Chaumiere, and Atelier Fernand Leger, Paris, 1946-52. US Army, 1942-46. **Taught:** Wagner College, 1957-58. **Awards:** Longview Foundation Grant, 1963. **Address:** 334 East 30 Street, NYC 10016. **Dealer:** Dorsky Gallery. **One-man Exhibitions:** (first) Salon du Mai, Paris, 1951; Martha Jackson Gallery, 1955, 56; Dwan Gallery, NYC, 1960; Stephen Radich Gallery, NYC, 1960-62; Esther Robles Gallery, 1965; A. M. Sachs Gallery, 1965, 67, 68; Dorsky Gallery, 1972; Cornell U., 1971. **Group:** WMAA, 1955, 61, 67; Youngstown/Butler, 1955; SFMA, 1955; Carnegie, 1955; U. of Nebraska, 1956; Santa Barbara/MA, 1964; Kunsthalle, Basel, 1964. **Collections:** Brandeis U.; Cornell U.; Geigy Chemical Corp; NYU; Newark Museum; SRGM; Santa Barbara/MA; Union Carbide Corp.; WMAA; Wagner College; Walker.

BOCHNER, MEL. b. 1940, Pittsburgh, Pa. **Studied:** Carnegie, 1962, BFA.

Taught: School of Visual Arts, NYC, 1965- . **Address:** 35 White Street, NYC 10013. **Dealer:** Ileana Sonnabend Gallery, NYC. **One-man Exhibitions:** Visual Arts Gallery, NYC, 1966; ACE Gallery, Los Angeles, 1969; Galerie Konrad Fischer, Dusseldorf, 1969; Galerie Heiner Friedrich, Munich, 1969; Galleria Toselli, Milan, 1969, 72; MOMA, 1971; 112 Greene Street Gallery, NYC, 1971; Galerie MTL, Brussels, 1972; Galleria Marilena Bonomo, Bari, Italy, 1972; Lisson Gallery, London, 1972; Ileana Sonnabend Gallery, NYC, 1972, 73, 74; Ileana Sonnabend Gallery, Paris, 1972, 73, 74; Galleria Schema, Florence, Italy, 1974; Weinberg Gallery, San Francisco, 1974; U. of California, Berkeley, 1975. **Group:** Finch College, NYC, Art in Series, 1967; Art in Process, 1969; Leverkusen, Konzeption—Conception, 1969; Seattle/AM, 557,087, 1969; Chicago/Contemporary, Art by Telephone, 1969; Turin/Civico, Conceptual Art, Arte Povera, Land Art, 1970; New York Cultural Center, Conceptual Art and Conceptual Aspects, 1970; Oberlin College, Art in the Mind, 1970; MOMA, Information, 1971; Chicago/Contemporary, White on White, 1972; Documenta V, Kassel, 1972; Basel, Konzept Kunst, 1972; Musee Galliera, Paris, Festival d'Automne, 1973; Seattle/AM, American art: Third Quarter Century, 1973; WMAA, American Drawings: 1963-1973, 1973; New York Cultural Center, 3**D** into 2**D**, 1973; Parcheggio di Villa Borghese, Rome, Contemporanea, 1974; Princeton U., Line as Language, 1974; Cologne, Project '74, 1974; Leverkusen, Drawings 3: American Drawings, 1975. **Bibliography:** *Contemporanea;* Lippard, ed.; Meyer; *When Attitudes Become Form.*

BODIN, PAUL. b. October 30, 1910, NYC. **Studied:** NAD; ASL, with Boardman Robinson. Traveled USA extensively. Federal A.P.: Easel painting and art teacher. **Awards:** Longview Foundation Grant, 1959; ART:USA:58, NYC, Special Distinction Award, 1958. **Address:** 207 West 86 Street, NYC 10024.

One-man Exhibitions: (first) Playhouse Gallery, NYC, 1936; Theodore A. Kohn Gallery, NYC, 1937; Artists' Gallery, NYC, 1942; Laurel Gallery, NYC, 1948, 50; The New Gallery, NYC, 1952; Betty Parsons Gallery, 1959, 61. **Group:** New York World's Fair, 1939; American-British Art Center, NYC, 1943, 44, 45; Yale U., 1949; Santa Barbara/MA, 1949; Philadelphia Art Alliance, 1949; Brooklyn Museum, 1949, 59; MMA, American Watercolors, Drawings and Prints, 1952; NAD, 1954; ART:USA:58, NYC, 1958; ART:USA:59, NYC, 1959. **Collections:** Buffalo/Albright; Dallas/MFA.

BOGHOSIAN, VARUJAN. b. June 26, 1926, New Britain, Conn. **Studied:** Yale U., 1956-59, BFA, MFA (with Josef Albers); Vesper George School of Art, 1946-48; US Navy, 1944-46. **Taught:** U.

Varujan Boghosian *Archon* 1975

of Florida, 1958-59; Cooper Union, 1959-64; Pratt Institute, 1961; Yale U., 1962-64; Brown U., 1964-68; American Academy, Rome, 1967; Dartmouth College, 1968- . **Awards:** Fulbright Fellowship (Italy), 1953; Brown U., Howard Foundation Grant for Painting, 1966; New Haven Arts Festival, First Prize, 1958; Portland (Me.) Arts Festival, 1958; Boston Arts Festival, 1961; Providence Art Club, First Prize, 1967; Hon. MA, Brown U.; AAAL; NIAL. **Address:** Dartmouth College, Hanover, N.H. 03755. **Dealer:** Cordier & Ekstrom, Inc. **One-man Exhibitions:** (first) The Swetzoff Gallery, Boston, 1949, also 1950, 51, 53, 54, 55, 59, 63, 65; R. M. Light & Co., Boston, 1962; The Stable Gallery, 1963-66; HCE Gallery, Provincetown, Mass., 1966; U. of Massachusetts, 1968; Dartmouth College, 1968; Currier, 1968; Cordier & Ekstrom, Inc., 1969, 70, 71, 73; Arts Club of Chicago, 1970; Alpha Gallery, 1972; U. of Connecticut, 1972; Keene (N.H.) State College, 1972. **Group:** MOMA, Young American Printmakers, 1953; MOMA, Recent Drawings USA, 1956; U. of Illinois, 1961; Chicago/AI Annual, 1961; WMAA Annual, 1963, 64, 66, 68; Yale U., 1965; ICA, Boston, As Found, 1966; WMAA, Contemporary American Sculpture, Selection I, 1966; Grand Rapids, Sculpture of the 60s, 1969. **Collections:** Andover/Phillips; Brandeis U.; U. of California; Dartmouth College; Indianapolis/Herron; MOMA; U. of Massachusetts; NYPL; New Britain/American; Phoenix; RISD; WMAA; Wesleyan U. (Conn.); Worcester/AM.

BOHROD, AARON. b. November 21, 1907, Chicago, Ill. **Studied:** Crane Junior College, 1925-26; Chicago Art Institute School, 1927-29; ASL, 1930-32, with Boardman Robinson, John Sloan, Richard Lahey. Traveled USA, Europe, South Pacific. **Taught:** Illinois State Normal U., 1941-42; Ohio U., summers, 1949, 54; U. of Wisconsin, 1948-73. **Member:** NAD, Academician, 1952. Federal A.P.: Easel painting. Artist War Correspondent for *Life* Magazine, 1942-45. **Commissions:** Eli Lilly & Co. (7 paintings, Medical Disciplines); *Look* Magazine (14 paintings, Great Religions of America). **Awards:** Corcoran, William A. Clark Prize and Corcoran Silver Medal ($1,500); MMA, Artists for Victory, $1,000 Prize; Guggenheim Foundation Fellowship, 1936, renewed, 1937; Chicago/AI, The Mr. & Mrs. Frank G. Logan Prize, 1937, 45; PAFA, First Watercolor Prize, 1942; Illinois State Fair, First Award, 1955; Carnegie; NAD, Saltus Gold Medal for Merit, 1961; AAAL, Childe Hassam Award, 1962; Hon. DFA, Ripon College, 1960. **Address:** 4811 Tonyawatha Trail, Madison, Wisc. 53716. **Dealers:** ACA Gallery; Frank Oehlschlaeger Gallery, Chicago and Sarasota, Fla. **One-man Exhibitions:** (first) Rehn Galleries, ca. 1935; A.A.A. Gallery, NYC, 1939, 41, 43, 45, 46, 49, 52, 55; The Milch Gallery, 1957, 59, 61, 65; Agra Gallery, 1966; The Banfer Gallery, 1967; Irving Galleries, Inc., Milwaukee, 1968; Hammer Gallery, 1969; Danenberg Gallery, 1971. **Retrospectives:** Madison Art Center, 1966; Memphis/Brooks, 1975. **Group:** WMAA; Milwaukee; MMA; Boston/MFA; PAFA; Chicago/AI; Corcoran; Brooklyn Museum. **Collections:** Abbott Laboratories; U. of Arizona; Beloit College; Boston/MFA; Britannica; Brooklyn Museum; Chicago/AI; Corcoran; Cranbrook; Davenport/Municipal; Detroit/Institute; Finch College; New York Cultural Center; Lawrence College; MMA; MacNider Museum; Madison Art Center; Neenah/Bergstrom; New Britain; Ohio U.; PAFA; St. Lawrence U.; San Antonio/McNay; Savannah/Telfair; Springfield, Mass./MFA; Terre Haute/Swope; Syracuse U.; WMAA; •Walker; West Palm Beach/Norton; U. of Wisconsin; U. of Wyoming; Youngstown/Butler. **Bibliography:** American Artists Group Inc. 2; Baur 7; Bethers; Bruce and Watson; Cheney; Christensen; Flanagan; McCurdy, ed.; Mendelowitz; Pagano; Pearson 1; Reese; Richardson, E. P.; Rose, B. 1; Wight 2. Archives.

BOLLINGER, WILLIAM. b. July 15, 1939, Brooklyn, N.Y. **Studied:** Brown U., 1961. **Address:** c/o Dealer. **Dealer:** OK Harris Works of Art. **One-man Exhibitions:** Paul Bianchini Gallery, NYC, 1966; Bykert Gallery, 1967, 69; Galerie Rolf Ricke, 1967, 69; Galerie Joachim Ernst, Hannover, 1969; Gian Enzo Sperone, Turin, 1969; Starrett Lehigh Building, NYC, 1970; OK Harris Works of Art, 1972, 73, 74; Bard College, 1973. **Retrospective:** Bennington College, 1973. **Group:** WMAA, Anti-Illusion: Procedures/Materials, 1969; WMAA Annuals, 1969, 73; MOMA, Information, 1971; Storm King Art Center, Sculpture in the Fields, 1974; U. of Rhode Island, Drawings, 1974. **Collections:** Four Seasons Restaurant; Mark Twain Bankshares; Mark Twain South County Bank; U. of Rhode Island; Skidmore College. **Bibliography:** *When Attitudes Become Form.*

BOLOMEY, ROGER. b. October 19, 1918, Torrington, Conn. **Studied:** Vevey, Switzerland, 1934-38; U. of Lausanne, 1947; Academy of Fine Arts, Florence, Italy, 1948-50; privately with Alfredo Cini, Switzerland. **Taught:** San Mateo Arts and Crafts, 1954-55; Dutchess Community College, Poughkeepsie, N.Y., 1965-66; Barlow School, Amenia, N.Y., 1967; Hunter College, 1968; Herbert H. Lehman College, Bronx, N.Y., 1968, Chairman, Department of Art, 1974- . **Commissions:** San Jose State College Art Building; South Mall, Albany (sculptures), 1967; Southridge Shopping Center, Milwaukee, 1968; Lehman High School, Bronx, N.Y., 1969; Eastridge Mall, San Jose, Calif., 1970; New York State Office Building, Hauppauge, 1973; Mt. Hood Community College, Gresham, Ore., 1974. **Awards:** SFMA, **P.P.,** 1960, Sculpture Prize, 1965; Walnut Creek (Calif.) Pageant, First Prize, 1962; Waitsfield/ Bundy, Bundy Sculpture Competition, First Prize, 1963. **Address:** Wingdale, N.Y. 12594. **Dealer:** Estelle Dodge Assoc. **One-man Exhibitions:** (first) SFMA, 1950; Sacramento/Crocker,

1950; Passedoit Gallery, NYC, 1951; Santa Barbara/MA, 1953; de Young, 1954; California Palace, 1958; Royal Marks Gallery, 1964. **Group:** SFMA Annuals, 1950, 1960-63, 65; ICA, Boston, 100 Works on Paper, circ. Europe, 1959; Chicago/AI, 1963; Salon du Mai, Paris, 1964; Carnegie, 1964; WMAA Sculpture Annual, 1964, 66; New York World's Fair, 1964-65; WMAA, Contemporary American Sculpture, Selection I, 1966; Quatrieme Exposition Suisse de Sculpture, Bienne, Switzerland, 1966; U. of Illinois, 1967; Southern Illinois U., 1967; Ridgefield/Aldrich, 1968; HemisFair '68, San Antonio, Tex., 1968; U. of Nebraska, American Sculpture, 1970; Storm King Art Center, Outdoor Sculpture Indoors, 1972; Society of the Four Arts, Contemporary American Sculpture, 1974; Van Saun Park, Paramus, N.J., Sculpture in the Park, 1974. **Collections:** U. of California; Chase Manhattan Bank; Corcoran; Fontana-Hollywood Corp.; Los Angeles/County MA; MOMA; Oakland/ AM; Ridgefield/Aldrich; San Francisco Art Association; San Jose State College; WMAA; Waitsfield/Bundy. Archives.

BOLOTOWSKY, ILYA. b. July 1, 1907, Petrograd, Russia. To USA 1923; citizen 1929. **Studied:** College St. Joseph, Istanbul; NAD, with Ivan Olinsky, 1924-30. US Air Force, 1942. Traveled Russia, Europe, North America. **Taught:** Black Mountain College, 1946-48; U. of Wyoming, 1948-57; Brooklyn College, 1954-56; Hunter College, 1954-56, 1963-64; New Paltz/SUNY, 1957-65; Long Island U.; 1965-71; Wisconsin State College, summer, 1968; U. of New Mexico, spring, 1969; Queens College, 1973. Federal A.P.: Master easel and mural artist, teacher. **Member:** Co-founder, charter member and former president of American Abstract Artists; co-founder and charter member of Federation of Modern Painters and Sculptors; AAAL. Produced 16mm experimental films. Began constructivist painted columns 1961. **Commissions** (murals): Williamsburgh Housing Pro-

ject, NYC, 1936 (one of the first abstract murals); New York World's Fair, 1939; Hospital for Chronic Diseases, NYC, 1941; Theodore Roosevelt High School, NYC, 1941; Cinema I, NYC, 1962; Southampton College, Long Island U., 1968; North Central Bronx Hospital, 1973; First National City Bank, NYC, 1974; P. S. 72, Brooklyn, N.Y., 1974, (tile mosaic mural). **Awards:** Sharon (Conn.) Art Foundation, First Prize for Painting, 1959; Guggenheim Foundation Fellowship, 1941, 73; Yaddo Fellowship, 1935; L. C. Tiffany Grant, 1930, 31; NAD, Hallgarten Prize for Painting, 1929, 30; NAD, First Prize Medal for Drawing, 1924, 25; The U. of Chicago, Midwest

Film Festival, First Prize (for *Metanois*); State U. of New York Grant, for film research, 1959, 60; NIAL Grant, 1971. **Address:** P.O. Box 744, Cooper Station, NYC 10003; studio: 80 Fourth Avenue, NYC 10003. **Dealer:** Grace Borgenicht Gallery Inc. **One-man Exhibitions:** (first) G.R.D. Studios, NYC, 1930; J. B. Neumann's New Art Circle, NYC, 1946, 52; Rose Fried Gallery, 1947, 49; Pratt Institute, 1949; Grace Borgenicht Gallery Inc., 1954, 56, 58, 59, 61, 63, 66, 68, 70, 72, 74; New Paltz/SUNY, 1960; Dickinson College, 1960; Elmira College 1962; Southampton/Parrish, 1965; Long Island U., 1965; East Hampton Gallery, East Hampton, N.Y., 1965;

Ilya Bolotowsky *Black Diamond with Pale Blue* 1973

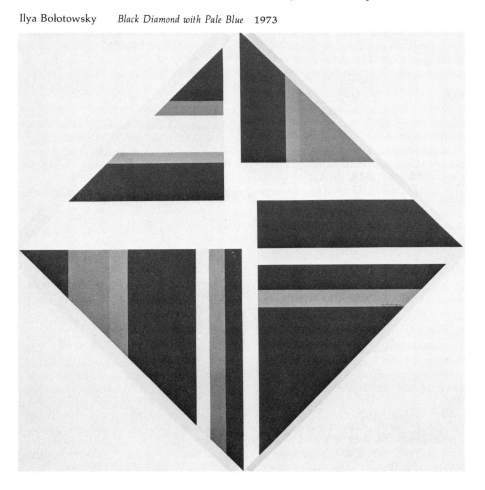

Buffalo/SUNY, 1965 (two-man), 1966; Gorham State College, 1967; Wisconsin State College, 1968; Stony Brook/SUNY, 1968; London Arts, London and Detroit, 1971; David Barnett Gallery, Milwaukee, 1972; Reed College, 1973. **Retrospectives:** U. of New Mexico, circ., 1970; SRGM, 1974; NCFA, circ., 1975. **Group:** American Abstract Artists Annuals; Federation of Modern Painters and Sculptors Annuals; WMAA Annuals; New York World's Fairs, 1939 and 1964-65; Seattle World's Fair, 1962; WMAA, Geometric Abstraction in America, circ., 1962; Corcoran, 1963; SRGM; Buffalo/Albright, Plus by Minus, 1968; Dallas/MFA, Geometric Abstraction: 1926-1942, 1972; Chicago/Contemporary, Post-Mondrian Abstraction in America, 1973. **Collections:** AAAL; American Republic Insurance Co.; Andover/Phillips; Atlantic Richfield Co.; Bezalel Museum; Brandeis U.; Brooklyn Museum; Buffalo/Albright; Burlington Industries; Calcutta; Ceret; Chase Manhattan Bank; Ciba-Geigy Corp.; Cleveland/MA; Continental Grain Company; Harcourt Brace Jovanovich Inc.; Hirshhorn; Housatonic Community College; Indianapolis; U. of Iowa; MMA; MOMA; Manufacturer's Hanover Trust Co.; U. of Michigan; The Miller Co.; Montclair/AM; NCFA; NYU; U. of Nebraska; New London; U. of New Mexico; New Paltz/SUNY; Norfolk/Chrysler; U. of North Carolina; Oklahoma; PMA; Phillips; RISD; Raleigh/NCMA; Ridgefield/Aldrich; Rock River (Wyo.) High School; SFMA; SRGM; Slater; Sweden/Goteborgs; U. of Texas; Union Carbide Corp.; Utica; U. of Vermont; WMAA; Walker; U. of Wyoming; Yale U. **Bibliography:** Blanchard; **Breeskin 2;** Goodrich and Baur 1; MacAgy 2; Rickey; Rose, B. 1. Archives.

BONEVARDI, MARCELO. b. 1929, Buenos Aires, Argentina. **Studied:** U. of Cordoba, 1948-51. Traveled Italy, USA. To USA 1958. **Taught:** National U. of Cordoba, 1956. **Awards:** Salon Anual de Santa Fe, **P.P.,** 1956; Premio de Honor J. Pellanda, Cordoba, 1957; XXXVI Salon Anual de Rosario, **P.P.,** 1957; Salon Ministerio de Obras Publicas de la Nacion, Buenos Aires, First Prize, 1957; Guggenheim Foundation Fellowship, 1958; New School for Social Research, Research Fellowship, 1963, 64; X Sao Paulo Biennial, International Award, 1969. **Address:** 799 Greenwich Street, NYC 10014. **Dealer:** Galeria Bonino Ltd. **One-man Exhibitions:** Museo Dr. Genario Perez, Cordoba, 1956; Galeria O. Rosario, 1956; Galeria Antigona, Buenos Aires, 1957; Amigos del Arte, Rosario, 1958; Radio Nacional de Cordoba, 1958; Gallery 4, Detroit, 1959; Roland de Anelle, NYC, 1960; Latow Gallery, NYC, 1961; Galeria Bonino Ltd., NYC, 1965, 67, 69, 73; J. L. Hudson Art Gallery, Detroit, 1966; Arts Club of Chicago, 1968; Galeria Bonino Ltd., Buenos Aires, 1969, 70; Museo Emilio A. Caraffa, Cordoba, 1969. **Group:** Birmingham, Ala./MA, Pan American Art, 1960; Riverside Museum, NYC, 30 Latin American Artists, 1960; ICA, Washington, D.C., Latin American Painters, 1964; U. of Illinois, 1965; Indianapolis, 1966; SRGM, The Emergent Decade, 1966; Cornell U., Latin American Art—Eight Argentines, 1966; Finch College, NYC, Art in Process, 1967. **Collections:** Atlantic Richfield Co.; Baltimore/MA; Buenos Aires/Moderno; Buffalo/Albright; Caracas; Centro Artistico de Barranquilla; Chase Manhattan Bank; Ciba-Geigy Corp.; MIT; MOMA; Museo de Arte Contemporaneo R. Tamayo; Museo Dr. Genaro Perez; Museo Emilio A. Caraffa; Museo Juan B. Castagnino; NYU; PMA; Quimica Argentia; RISD; Ridgefield/Aldrich; Southern Illinois U.; Sao Paulo/Contemporary; Tel Aviv; J. Walter Thompson Co.

BONTECOU, LEE. b. January 15, 1931, Providence, R. I. **Studied:** Bradford Junior College, with Robert Wade; ASL, 1952-55, with William Zorach, John Hovannes. Traveled Europe. **Taught:** Brooklyn College, 1971-75. **Commissions:** New York State Theater, Lincoln Center for the Performing Arts, NYC.

Awards: Fulbright Fellowship (Rome), 1957, 58; L. C. Tiffany Grant, 1959; Corcoran, 1963. **Address:** P. O. Box 1290, East Hampton, N.Y. 11937. **Dealer:** Leo Castelli Inc. **One-man Exhibitions:** (first) "G" Gallery, NYC, 1959; Leo Castelli Inc., 1960, 62, 66, 71; Ileana Sonnabend Gallery, Paris, 1965; Leverkusen, 1968; Rotterdam, 1968; Kunstverein, Berlin, 1968; Chicago/ Contemporary, 1972. **Retrospective:** Rotterdam, 1958. **Group:** Festival of Two Worlds, Spoleto, 1958; Martha Jackson Gallery, New Media—New Forms I & II, 1960, 61; WMAA Annuals, 1961, 63, 64, 66; Carnegie, 1961, 67; MOMA, The Art of Assemblage, circ., 1961; VI Sao Paulo Biennial, 1961; Seattle World's Fair, 1962; Chicago/AI, 1962, 63, Sculpture—A Generation of Innovation, 1967; Corcoran, 1963; MOMA, Americans 1963, circ., 1963-64; Buffalo/Albright, Mixed Media and Pop Art, 1963; Documenta III, Kassel, 1964; Brandeis U., Recent American Drawings, 1964; Jewish Museum, Recent American Sculpture, 1964; U.' of Texas, Drawings and . . . , 1966; Flint/Institute, I Flint Invitational, 1966; MOMA, The 1960s, 1967; WMAA Sculpture Annual, 1968; Denver/AM, Report on the Sixties, 1969; Foundation Maeght, L'Art Vivant, 1970; Carnegie, 1970; U. of North Carolina, Works on Paper, 1971; Yale U., American Drawing: 1970-1973, 1973. **Collections:** Amsterdam/Stedelijk; Buffalo/Albright; Chase Manhattan Bank; Chicago/AI; Corcoran; Cornell U.; Dallas/ MFA; Houston/MFA; MOMA; PAFA; The Singer Company Inc.; Smith College; WGMA; WMAA. **Bibliography:** Battcock, ed.; Hunter, ed.; Janis and Blesh 1; Licht, F.; *Metro;* Rose, B. 1; Seitz 3; Trier 1; Weller.

BOOTH, CAMERON. b. March 11, 1892, Erie, Pa. **Studied:** Fargo College, 1912; Chicago Art Institute School, 1912-17; Hofmann School, Munich and Capri, 1927-28; Academie Andre Lhote, Paris, 1927. Traveled Europe extensively. **Taught:** Minneapolis School of Art, 1922-28; St. Paul School of Art, 1929-40; Chicago/AI School, 1940; ASL, 1944-48; Queens College, 1946-47; U. of Minnesota, 1948-60; U. of California, Berkeley, 1957-58. **Member:** Federation of Modern Painters and Sculptors. **Awards:** Chicago/AI, J. Q. Adams Traveling Scholarship, 1917; J. S. Guggenheim Fellowship, 1942; Hon. Ph.D., Hamline U. **Address:** 3408 Park Terrace, Minneapolis, Minn. 55406. **One-man Exhibitions:** Paul Elder Gallery, San Francisco, 1935; Howard Putzell Gallery, San Francisco, 1946; Denver/ AM 1936; Chicago/AI, 1942; Mortimer Brandt, NYC, 1943; The Bertha Schaefer Gallery, 1950; The Howard Wise Gallery, NYC, 1962; Wisconsin State U., 1967; Paul Kramer Gallery, St. Paul, 1968. **Retrospective:** A.F.A./Ford Foundation, circ. USA, 1961-64. **Group:** Many in 1920's and 1930's; WMAA, 1958; Carnegie. **Collections:** U. of California; Denver/AM; MMA; MOMA; Minneapolis/Institute; Newark Museum; PAFA; Phillips; SFMA; SRGM; Walker; Youngstown/Butler. **Bibliography:** Cheney; Hall; Pousette-Dart, ed.

BOSA, LOUIS. b. April 2, 1905, Codroipo, Italy. To USA 1923; became a citizen. **Studied:** Academy of Fine Arts, Venice, with Mazotti; ASL, with John Sloan. Traveled Europe extensively. **Taught:** ASL, 1942-53; Parsons School of Design, 1950-53; Parsons School of Design, 1950-53; Syracuse U.; U. of Notre Dame, summer, 1960; Cleveland Institute of Art, 1954-69. **Member:** NAD; ASL; Audubon Artists. Federal A.P.: Easel painting. **Awards:** Portrait of America, NYC, $1,500 Prize, 1944; NAD, Hon. Men., 1944; Rockport (Mass.) Art Association, $100 Award, 1945; Mead Painting of the Year ($500), 1947; AAAL, $1,000 Award, 1948; Los Angeles County Fair, First Prize ($700), 1948; Pepsi-Cola $500 Award, 1948; U. of Illinois, **P.P.**, ($900), 1949; Audubon Artists, Gold Medal of Honor, 1949; Hallmark International Competition, $750 Award, 1949; NAD, Gold Medal,

1957; Hallmark International Competition, $900 Award, 1958; New Hope, Pa., First Prize, 1959, 62; Legionnaires of Pennsylvania, First Prize and Gold Medal, 1959; Youngstown/Butler, First Prize ($1,000); NAD, $400 Prize, 1961. **Address:** Upper Black Eddy, Bucks County, Pa. 18972. **Dealers:** Frank Oehlschlaeger Gallery, Chicago and Sarasota; Harmon Gallery. **One-man Exhibitions:** (first) Contemporary Arts Gallery, NYC, 1930; Springfield, Mass./MFA; Coy Gallery, Miami; Cleveland Institute of Art; Kleemann Gallery, NYC; Frank Oehlschlaeger Gallery, Chicago, 1954, 59, 65; The Milch Gallery, 1958, 60, 63, 65; Frank Oehlschlaeger Gallery, Sarasota, Fla., 1975. **Group:** MMA; MOMA; WMAA; Carnegie; Corcoran; PMA; Boston/MFA; Toledo/MA; Buffalo/Albright; New Orleans/Delgado; Worcester/AM; Montclair/AM; Wilmington; Audubon Artists; Atlanta/AA; Cleveland/MA; Chicago/AI; Kansas City/Nelson; Argentina/Nacional; PAFA; NAD. **Collections:** AAL; Atlanta/AA; Britannica; Clearwater/Gulf Coast; Columbus, Ga; Hartford/Wadsworth; IBM; U. of Illinois; Indianapolis/Herron; MMA; Montclair/AM; New Orleans/Delgado; U. of Notre Dame; PMA; U. of Rochester; San Diego; Springfield, Mass./MFA; Syracuse U.; Toronto; VMFA; WMAA; Wilmington; Worcester/AM; Youngstown/Butler. **Bibliography:** Kent, N.; Pagano; Watson, E. W. 2.

BOTHWELL, DORR. b. May 3, 1902, San Francisco, Calif. **Studied:** U. of Oregon; California School of Fine Arts; Rudolph Schaeffer School of Design, San Francisco. Traveled Europe, American Samoa, Africa, Indonesia, Malaysia. **Taught:** California School of Fine Arts, 1945-61; Parsons School of Design, 1952; Rudolph Schaeffer School of Design, San Francisco, 1958-61; Mendocino (Calif.) Art Center, 1961- ; Ansel Adams Workshop, Yosemite, Calif.; Inner London Education Authority, 1971. Federal A.P.: Painter; also designed murals for Visual Education,

State Exhibition Building, Los Angeles, Calif.; Pomona (Calif.) High School, 1934. **Awards:** National Serigraph Society, First Prize, 1948; Abraham Rosenberg Foundation Traveling Fellowship, 1949. **Address:** P.O. Box 27, Mendocino, Calif. 95460. **Dealer:** The Bay Window Gallery. **One-man Exhibitions:** (first) The Modern Gallery, San Francisco, 1927; El Prado Gallery, San Diego, 1929; San Diego, 1930; San Francisco Art Association, 1940, 41; Albatross Bookshop Gallery, San Francisco, 1942; Art in Action Gallery, San Francisco, 1943; Rotunda Gallery, San Francisco, 1946, 52; California Palace, 1947; National Serigraph Society, NYC, 1948, 52, 54; Sacramento/Crocker, 1948; Smithsonian, 1952; de Young, 1957, 63; Doris Meltzer Gallery, NYC, 1958; Mendocino Art Center, 1963; The Bay Window Gallery, 1966, 68, 70, 71, 73; Bolles Gallery, San Francisco, 1972. **Group:** San Francisco Art Association, 1925; California Palace, California Artists, 1930; San Diego Annuals, 1927-40; Golden Gate International Exposition, San Francisco, 1939; San Francisco Art Association Annuals, 1941- ; Denver/AM Annual, 1945; National Serigraph Society, NYC, Serigraph Annuals; WMAA Annual, 1950; SFMA, The New Decade, 1955; III Sao Paulo Biennial, 1955; Oakland/AM, 100 Years of California Art, 1971; Oakland/AM, A Period of Exploration, 1973; Mills College, Selections from the American Print Collection, 1975. **Collections:** Achenbach Foundation; Bibliotheque Nationale; Brooklyn Museum; Harvard U.; MMA; MOMA; SFMA; Sacramento/Crocker; San Diego; Santa Barbara/MA; Victoria and Albert Museum; WMMA; U. of Wisconsin. **Bibliography:** McChesney.

BOTKIN, HENRY. b. April 5, 1896, Boston, Mass. **Studied:** Massachusetts School of Art, 1915-19, with Joseph de Camp, Ernest Major; ASL, with George Bridgeman. Traveled Europe, USA; resided Paris, eight years. **Taught** privately. Active as a lecturer, writer,

and organizer of exhibitions. **Member:** Artists Equity (President, 1951-52); American Abstract Artists (President, 1954-55); Federation of Modern Painters and Sculptors (President, 1957-61, 1968-69); Fellow of the International Institute of Arts and Letters; Audubon Artists; International Association of Plastic Arts. **Awards:** Audubon Artists, First Prize (2); Mead Painting of the Year, $500 Prize; AAAL, **P.P.**, 1967, 74, 75. **Address:** 56 West 11 Street, NYC 10011. **Dealer:** Rehn Galleries. **One-man Exhibitions:** (first) Billiet Gallery, Paris, 1927; The Downtown Gallery; Marie Harriman Gallery, NYC; Carstairs Gallery, NYC; J. Seligmann & Co.; A.A.A. Gallery, NYC; Otto Gerson Gallery, NYC; Riverside Museum; Denver/AM; Phillips; Arts Club of Chicago; Tirca Karlis Gallery; Rehn Galleries, 1974. **Retrospectives:** Riverside Museum, NYC, 1962; Syracuse U., 1971. **Group:** Tate; Cleveland/MA; de Young; Carnegie; Chicago/AI; SFMA; MMA; WMAA; Boston/MFA; Brooklyn Museum; NIAL; PAFA; Detroit/Institute; Corcoran; Stadtische Kunstsammlungen, Bonn; Munich/State. **Collections:** Abbott Laboratories; Ain Harod; Akron/AI; Bath-Yam Museum; Boston/MFA; Brandeis U.; Brooklyn Museum; Colby College; Dallas/MFA; Denver/AM; Hagerstown/County MFA; Hartford/Wadsworth; La Jolla; Library of Congress; MMA; MOMA; Mount Holyoke College; Munich/State; NIAL; NYU; U. of Nebraska; Newark Museum; Norfolk; Norfolk/Chrysler; U. of Oklahoma; Phillips; U. of Rochester; Smith College; Syracuse U.; Tel Aviv; WMAA; Walker; Washington State U.; West Palm Beach/Norton; Youngstown/Butler. Archives.

BOUCHE, LOUIS. b. March 18, 1896, NYC; **d.** August 7, 1969, Pittsfield, Mass. **Studied:** Academie Colarossi; Academie de la Grande Chaumiere; Academie des Beaux-Arts, Paris, 1910-15, with Jules Bernard, Frank V. DuMond, Bernard Naudin; ASL, 1915-16. **Taught:** ASL; NAD, 1951-69. **Commis-**

sions (murals): New Interior Department Building, Washington, D.C.; Justice Department Building, Washington, D.C.; US Post Office, Ellenville, N.Y.; Radio City Music Hall, NYC; Bar Lounge cars, Pennsylvania Railroad (4); Eisenhower Center, Abilene, Kans. **Awards:** NAD, Saltus Gold Medal for Merit, 1915; Guggenheim Foundation Fellowship, 1933; PAFA, Carol H. Beck Gold Medal, 1944; MMA, Artists for Victory, Third Prize, 1944; NAD, The Adolph and Clara Obrig Prize, 1951; NAD, Benjamin Altman Prize, 1955, 62. **One-man Exhibitions:** Kraushaar Galleries, 1936, 38, 40, 42, 44, 46, 49, 51, 54, 58, 62, 64, 70; Des Moines; St. Gaudens Museum, 1966. **Retrospective:** Temple U. **Group:** Independents, NYC, 1917; The Daniel Gallery, NYC, 1918-31; Carnegie, 1937, 39; NAD; PAFA, 1941, 42, 45; Cincinnati/AM, 1948; MMA, Two Hundred Years of American Painting, 1965; WMAA, Art of the U.S. 1670-1966, 1966. **Collections:** AAAL; ASL; Britannica; Cincinnati/AM; Colorado College; Columbus; Cranbrook; Des Moines; Fort Dodge/Blanden; U. of Kansas; Lehigh U.; Los Angeles/County MA; MMA; U. of Nebraska; New Britain; U. of Oklahoma; PAFA; PMA; Phillips; Southampton/Parrish; US State Department; WMAA; Walker; Wichita/AM; Worcester/AM; Youngstown/Butler. **Bibliography:** Bethers; Bruce and Watson; Goodrich and Baur 1; Kent, N.; Pousette-Dart, ed.; Richardson, E. P.; Watson, E. W. 2. Archives.

BOURGEOIS, LOUISE. b. December 25, 1911, Paris, France. **Studied:** Lycee Fenelon, 1932, baccalaureate; Sorbonne, 1932-35; Ecole du Louvre, 1936-37; Academie des Beaux-Arts, Paris, 1936-38; Atelier Bissiere, Paris, 1936-37; Academie de la Grande Chaumiere, 1937-38; Academie Julian, Paris, 1938; Atelier Fernand Leger, Paris, 1938. Traveled Europe extensively. To USA 1938. **Taught:** Docent at the Louvre, 1937-38; Academie de la Grande Chaumiere, 1937, 38; Great Neck (N.Y.) Public Schools, 1960; Brooklyn College,

1963, 68; Pratt Institute, 1965-67. **Address:** 347 West 20 Street, NYC. **Dealer:** Fourcade, Droll Inc. **One-man Exhibitions:** The Bertha Schaefer Gallery, 1945; Norlyst Gallery, NYC, 1947; The Peridot Gallery, 1949, 50, 53; Allan Frumkin Gallery, Chicago, 1953; Cornell U., 1959; The Stable Gallery, 1964; Rose Fried Gallery, 1964; 112 Greene Street, NYC, 1974. **Group:** MOMA, 1943, 49, 51, 62; MMA, 1943; SFMA, 1944; Los Angeles/County MA, 1945; U. of Rochester, 1945; Brooklyn Museum, 1945; WMAA, 1945, 46, 53, 55, 57, 60, 62, 63, 68; Walker, 1954; U. of Illinois, 1957; Dallas/MFA, 1960; Claude Bernard, Paris, 1960; Salon de la Jeune Sculpture, Paris, 1965, 69; RISD, 1966; International Sculpture Biennial, Carrara, Italy, 1969; Baltimore/MA, 1969; MOMA, The New American Painting and Sculpture, 1969; WMAA, 1970, 72; Foundation Maeght, 1970; Lakeview Center, American Women: 20th Century, 1972; Storm King Art Center, The Emerging Real, 1973; PMA/Museum of the Philadelphia Civic Center, Focus, 1974. **Collections:** Calcutta; Ciba-Geigy Corp.; MOMA; NYU; Paris/Moderne; RISD; WMAA. **Bibliography:** Baur 5; Giedion-Welcker 1; Goodrich and Baur 1; Motherwell and Reinhardt, eds.; Seuphor 3; Trier 1. Archives.

BOWMAN, GEOFFREY. b. December 29, 1928, San Francisco, Calif. **Studied:** City College of San Francisco, 1951, AA; San Francisco State College, with John Ihle, Seymour Locks, Alexander Nepote, John Gutman, Waldermar Johanssen, 1945, BA, 1957, MA; San Francisco Art Institute, graduate study with Henry Takemoto, 1960. US Navy, 1946-48. **Taught:** California State Prison, San Quentin, 1957-60 full time, 1960- , part time. **Member:** California Society of Printmakers. **Address:** c/o Dealer. **Dealer:** The Lanyon Gallery. **One-man Exhibitions:** (first) The East-West Gallery, San Francisco, 1957; Yakima Valley Junior College, 1959; David Cole Gallery, San Francisco,

1962; The Lanyon Gallery, 1963; RAC, 1964. **Group:** California Palace, James D. Phelan Art Awards, 1959; California Society of Printmakers Annuals, 1960-64; California Palace Annuals, 1961, 62, 64; SFMA, 1961; Santa Barbara Invitational, 1962; SFMA, Small Format, 1963; U. of Illinois, 1963; Brooklyn Museum, Print Biennial; California Palace, 50th Anniversary of the California Society of Printmakers, 1964; Denver/AM Annual, 1964. **Collections:** Lannan Foundation; SFMA.

BOWMAN, RICHARD. b. March 15, 1918, Rockford, Ill. **Studied:** Chicago Art Institute School, 1938-42, BFA; State U. of Iowa, 1947-49, MFA. Traveled Mexico, USA. **Taught:** Chicago Art Institute School, 1944-47, including summer school, 1944, 45; North Park College, 1944-46; State U. of Iowa, 1947-49; Stanford U., 1949-50, 57, 58, 63; U. of Manitoba, 1950-54; Washburn-White Art Center, Palo Alto, Calif., 1954. **Awards:** Chicago/AI, Scholarship, 1939-41; Rockford/Burpee Annual, First Prize, 1940; Edward L. Reyerson Traveling Fellowship, 1942; Chicago/AI, William R. French Memorial Gold Medal, 1945; Iowa State Fair, Second Prize, 1948; Montreal/MFA Annual, 1952; Oakland/AM, Hon. Men., 1955. **Address:** 178 Springdale Way, Redwood City, Calif. 94062. **One-man Exhibitions:** Beloit College, 1941; Rockford/Burpee, 1941, 47; Ras-Martin Gallery, Mexico City, 1943; The Pinacotheca, NYC, 1945; Chicago/AI, 1945; Milwaukee, 1946; U. of Illinois, 1946 (two-man, with Joan Mitchell), 1947; The Swetzoff Gallery, Boston, 1949; Pen and Palette Gallery, St. Louis, 1949; Contemporary Gallery, Sausalito, Calif., 1949, 50; Stanford U., 1950, 56; Bordelon Gallery, Chicago, 1950; Kelly Gallery, Vancouver, B.C., 1954; The Rose Rabow Gallery, San Francisco, 1959, 61, 64, 68, 70, 72, 74; SFMA, 1959 (two-man, with Gordon Onslow-Ford), 1951, 70. **Retrospectives:** Stanford U., 1956; Washington State U., circ., 1957; SFMA, 1961; Roswell, 1972. **Group:** Chicago/AI,

1940, 44, 45; SFMA, 1941, 49, 50, 55, 60; Cincinnati/AM, 1941; Art of This Century, NYC, 1945; Chicago/AI, Abstract and Surrealist Art, 1948; Chicago/ AI, Exhibition Momentum, 1948; Omaha/Joslyn, 1948, 49; Iowa State Fair, 1948; Philadelphia Print Club Annual, 1949; Walker, 1949; Brooklyn Museum, 1949; Canadian Society of Graphic Art Annual, Toronto, 1952; Ottawa/National, Canadian Painters 1953, 1953; II Sao Paulo Biennial, 1953; Royal Ontario Museum, 1954; Oakland/ AM, 1955; Stanford U., 50 Contemporary American Painters, 1956; SFMA, After Surrealism, circ., 1959; USIA, Contemporary American Prints, circ. Latin America, 1959-60; California Palace, 1960, 61, 62, 63, 64; Carnegie, 1961, 64; WMAA, Fifty California Artists, 1962-63; Stanford U., Some Points of View for '62, 1962; A.F.A., circ., 1966-68. **Collections:** de Young; New Britain/American; Oakland/AM; SFMA; Santa Barbara/AM; U. of Texas.

BOYCE, RICHARD. b. June 11, 1920, NYC. US Army, 1940-44. **Studied:** Boston Museum School, 1945-49, with Karl Zerbe (highest honors in painting), Assistant to O. Kokoschka, summer, 1948, Pittsfield, Mass. Traveled Europe, southern Mexico. **Taught:** Boston Museum School, 1946-49; Wellesley College, 1953-62; Boston U., 1959-61; UCLA, 1963- . **Member:** Artists Equity. **Awards:** Boston/MFA, James William Paige Fellowship, 1949-51; Boston/ MFA, Bartlett Grant, 1959, 60. **Address:** 1419 W. Washington Boulevard, Venice, Calif. **Dealer:** Silvan Simone Gallery. **One-man Exhibitions:** Boris Mirski Gallery, Boston, 1952; The Swetzoff Gallery, Boston, 1956, 59, 61, 62; Brattle Gallery, Cambridge, 1956; The Zabriskie Gallery, 1961; The Alan Gallery, NYC, 1963, 65; Felix Landau Gallery, 1966, 69; The Landau-Alan Gallery, NYC, 1968. **Group:** John Hopkins U., Three Young Americans, 1948; ICA, Boston, 1948, 52, 56, 62, 64; U. of Illinois, 1957, 65; Worcester/AM, 1959; Chicago/AI Annual, 1960;

WMAA, 1963; PAFA Annual, 1964. **Collections:** Andover/Phillips; Harvard U.; Lincoln, Mass./De Cordova; RISD; WMAA; Wellesley College; Worcester/ AM.

BOYLE, KEITH. b. February 15, 1930, Defiance, Ohio. **Studied:** State U. of Iowa, with James Lechay, BFA; Ringling School of Art, with Fred Sweet, Andrew Sanders. Traveled Europe; resided Rome. **Taught:** Lake Forest College, 1956; Barat College, 1957, 59; Sacramento State College, 1960; Stanford U., 1962- . **Commissions:** St. Thomas Episcopal Church, Sunnyvale, Calif. **Awards:** State of Iowa, Department of Education, **P.P.**, 1952; Indiana (Pa.) State Teachers College, 1953; Springfield, Mo./AM, 1955; The Pennsylvania State U., 1955; Chicago/AI, The Mr. & Mrs. Frank G. Logan Medal ($1,500), 1958; California Palace, Patrons of Art and Music Award, 1964. **Address:** 515 Newell Road, Palo Alto, Calif. 94303. **Dealers:** Martha Jackson Gallery; Smith Andersen Gallery, Palo Alto. **One-man Exhibitions:** (first) Feingarten Gallery, Chicago, 1958, also 1959; Feingarten Gallery, San Francisco, 1960; Triangle Art Gallery, 1960; The Lanyon Gallery, 1963; de Young, 1964; SFMA, 1964; Stanford U., 1964, 67; Hollis Gallery, San Francisco, 1967; Hanson-Fuller Gallery, 1968; Smith Andersen Gallery, Palo Alto, 1971, 72; St. Mary's College, Moraga, Calif., 1972; Linda Farris Gallery, Seattle, 1973; Martha Jackson Gallery, 1974. **Group:** Springfield, Mo./AM, 1952-55; Des Moines, 1953; Denver/AM, 1953; Walker, 1954; Washburn U. of Topeka, 1955; Youngstown/Butler, 1955, 56, 58; Omaha/Joslyn, 1956; Chicago/AI, 1957-60; Ravinia Festival, Highland Park, Ill., 1957; Chicago/AI, 53 Chicago Artists, circ. France and Germany, 1957; PAFA, 1958; 60, 62; Buffalo/Albright, 1960; SFMA, 1960, 62, 64; California Palace, 1964, Painters behind Painters, 1967; U. of Michigan, 1965; SFMA, The Colorists, 1965; M. Knoedler & Co., Art Across America, circ., 1965-67; Califor-

nia Palace, A Century of California Painting, 1970; Omaha/Joslyn, Looking West, 1970). **Collections:**Barat College; Indiana (Pa.) State Teachers College; Mead Corporation; NCFA; Oakland/AM; The Pennsylvania State U.; SFMA; Springfield, Mo./AM; Stanford U.; State of Iowa.

BOYNTON, JAMES W. b. January 12, 1928, Fort Worth, Tex. **Studied:** Texas Christian U., BFA, MFA. **Taught:** U. of Houston, 1955-57; San Francisco Art Institute, 1960-62; U. of New Mexico, 1963; Houston Museum School, 1968-69; Northwood Institute, Dallas, 1968-69; U. of St. Thomas (Tex.), 1969-70. **Awards:** Fort Worth, **P.P.**, 1951, 52, 54, 55; Texas Watercolor Society, First **P.P.**, 1951, 1953-55; Denver/AM, **P.P.**, 1952, 54, 58; Texas State Fair, **P.P.**, 1953; Houston/MFA, **P.P.**, 1955; Underwood-Neuhaus Corp., 1957; Youngstown/Butler, 1957; ART:USA:59, NYC, Hon. Men., 1959; SFMA, First Prize, 1962; Longview Foundation Grant, 1966; Tamarind Fellowship, 1967; Beaumont (Tex.) Art Museum, Second Prize, 1968. **Address:** 3723 Albans, Houston, Tex. 77005. **Dealers:** Margo Leavin Gallery; Du Bose Gallery. **One-man Exhibitions:** Fort Worth, 1955; La Escondida, Taos, N.M., 1956; Andre Emmerich Gallery, Houston, 1957; New Arts Gallery, Houston, 1957; Fairweather-Hardin Gallery, 1958; Barone Gallery, NYC, 1958; Dord Fitz Gallery, Amarillo, 1959; Bolles Gallery, San Frnacisco, 1959-62; Dallas Museum for Contemporary Arts, 1959; Lynchburg Art Gallery, Lynchburg, Va., 1960; Downtown Gallery, New Orleans, 1960; Haydon Calhoun Gallery, Dallas, 1960-62; Staempfli Gallery, 1961; Louisiana Gallery, Houston, 1964; David Gallery, 1966; Louise Ferrari Gallery, 1967; Chapman Kelly Gallery, 1968; Beaumont (Tex.) Art Museum, 1969; Galerie Simone Stern, New Orleans, 1970; New Orleans/Delgado, 1970; U. of St. Thomas (Tex.), 1971; Du Bose Gallery, 1975. **Group:** Fort Worth, 1950-55; WMAA, Young America and others; Denver/

AM, 1952, 54, 56, 58; Yale U.; Corcoran; Colorado Springs/FA, 1953, 54, 57; SRGM, Younger American Painters, 1954; Carnegie, 1955; Houston/MFA, 1955, 57; MOMA, Recent Drawings USA, 1956; Santa Fe, N.M., 1957; Youngstown/Butler, 1957; Chicago/AI, 1957, 58; Brussels World's Fair, 1958; SFMA, After Surrealism, circ., 1959; MOMA, 1962; SFMA, 1962, 69; Hemis-Fair '68, San Antonio, Tex., 1968; WMAA Annual, 1967; MOMA, Tamarind: Homage to Lithography, 1969; SFMA, Tamarind, 1969; International Exhibitions Foundation, Washington, D.C., Tamarind: A Renaissance of Lithography, circ., 1971-72. **Collections:** Austin; Brooklyn Museum; Amon Carter Museum; Dallas/MFA; Denver/AM; Fort Worth; Hartford/Wadsworth; Houston/Contemporary; Houston/MFA; Inland Steel Co.; La Jolla; Los Angeles/County MA; MOMA; New Orleans/Delgado; Oak Cliff Savings and Loan; PMA; Pasadena/AM; SRGM; U. of Texas; UCLA; Underwood-Neuhaus Corp.; WMAA; Witte; Youngstown/Butler. **Bibliography:** MacAgy 1.

BRACH, PAUL. b. March 13, 1924, NYC. **Studied:** Fieldston School, NYC; State U. of Iowa (with Philip Guston, Mauricio Lasansky), 1941-42, 1945-48, BFA, 1967-69, MFA. US Army, 1942-45. **Taught:** U. of Missouri, 1949-51; New School for Social Research, 1952-55; Parsons School of Design, 1956-67; Cooper Union, 1960-62; U. of New Mexico, A.F.A. Visiting Artist, 1965; U. of California, San Diego, 1967-69; California Institute of the Arts, 1969-75; Fordham U., Lincoln Center Campus, 1975. **Awards:** Tamarind Fellowship, 1964. m. Miriam Schapiro. **Address:** 393 W. Broadway, NYC 10013; Montauk Highway, East Hampton, N.Y. 11037. **Dealers:** Andre Emmerich Gallery, NYC; Cirrus Editions Ltd. **One-man Exhibitions:** (first) Leo Castelli Inc., 1957, also 1959; Union College (N.Y.), 1958; Dwan Gallery, 1960; Cordier and Warren, NYC, 1962;

Cordier & Ekstrom Inc., 1964; U. of New Mexico, 1965; NYU, 1966; The Kornblee Gallery, 1968; Andre Emmerich Gallery, NYC, 1974; Cirrus Editions Ltd., 1975; Benson Gallery, 1975. **Retrospective:** Newport Harbor and La Jolla/MA, Paul Brach and Miriam Schapiro, 1969. **Group:** WMAA; Chicago/AI; Corcoran; Baltimore/MA; St. Louis/City; Jewish Museum; Brandeis U., 1964; MOMA, The Responsive Eye, 1965; SFMA, 1965; Los Angeles/County MA, 1970; MOMA, Tamarind: Homage to Lithography, 1969; Newport Harbor, 1974. **Collections:** Albion College; U. of Arizona; Avco Corp.; U. of California, San Diego; Los Angeles-/County MA; NYPL; NYU; U. of Nebraska; U. of New Mexico; St. Louis/City; Smith College; WMAA. **Bibliography:** Blesh 1; Weller.

BRACKMAN, ROBERT. b. September 25, 1898, Odessa, Russia. **Studied:** Ferrer School, San Francisco; NAD; and with George Bellows, Robert Henri. **Taught:** ASL, 1934- ; American Art School, NYC, 1951- ; Brooklyn Museum School, 1936-38. **Member:** Royal Society of Arts. Consultant on the motion picture, *A Portrait of Jennie*, 1950. **Awards:** Chicago/AI, 1929; NAD: The Thomas B. Clarke Prize, 1932; Saltus Gold Medal for Merit, 1941; Andrew Carnegie Prize, 1965; Gold Medal of Honor, 1966; Noel Flagg Prize, 1936; Connecticut Academy of Fine Arts, First Award, 1947; Carnegie, Hon. Men., 1949; PAFA, Carol H. Beck Gold Medal, 1958; Audubon Artists, **P.P.**, 1960; elected to Royal Society of Arts, London, 1962; Ford Foundation Grant, 1965. **Address:** 27 Smith Court, Noank, Conn. 06340. **One-man Exhibitions:** Macbeth Gallery, NYC, 1930, 31, 33, 34, 36, 40, 44; Grand Central, NYC, 1946. **Group:** NAD; Connecticut Academy of Fine Arts; PAFA; Audubon Artists; Montclair/AM. **Collections:** Atlanta-/AA; Britannica; Brooklyn Museum; Bryn Mawr College; Canajoharie; The U. of Chicago; Colonial Williamsburg; Connecticut Life Insurance Company;

U. of Connecticut; Davenport/Municipal; U. of Georgia; Harvard U.; Honolulu Academy; Houston/MFA; IBM; MMA; Memphis/Brooks; Milton Academy; Minneapolis/Institute; Montclair/AM; Newark Museum; New Britain; New Haven Public Library; Norfolk/Chrysler; Pasadena/AM; The Pentagon; Princeton U.; RISD; Radio Corporation of America; U. of Rochester; Rockford/Burpee; Toledo/MA; US Military Academy; US State Department; West Palm Beach/Norton; Wilmington; Yale U. **Bibliography:** Bates; Bazin; Boswell 1; Cheney; Hall; Jewell 2, 3; Watson, E. W. 1. Archives.

BRAINARD, JOE. b. March 11, 1942, Salem, Ark. **Taught:** Cooper Union, 1967-68. **Awards:** Copley Foundation Grant. **Address:** c/o Dealer. **Dealer:** Fischbach Gallery. **One-man Exhibitions:** The Alan Gallery, NYC, 1965; The Landau-Alan Gallery, NYC, 1967, 69; Gotham Book Mart, NYC, 1968; Jerrold Morris Gallery, Toronto, 1968; Benson Gallery, 1970; Phyllis Kind Gallery, Chicago, 1970; Fischbach Gallery, 1971, 72, 74; School of Visual Arts, NYC, 1972; New York Cultural Center, 1972; Utah, 1973. **Group:** U. of North

Joe Brainard *Untitled collage* 1975

Carolina, 1967; MOMA, In Memory of My Feelings: Frank O'Hara, 1967; U. of Illinois, 1969; VMFA, 1968; Chicago-/Contemporary, White on White, 1972; Corcoran, Seven Young Artists, 1972; Moore College of Art, Philadelphia, Artists' Books, 1973; Harvard U., New American Graphic Art, 1973; Yale U., American Drawing: 1970-1973, 1973; Tyler School of Art, Philadelphia, American Drawings, 1973. **Collections:** Colorado Springs/FA; Harvard U.; Liason Films, Inc.; MOMA; Utah.

BRANDT, WARREN. b. February 26, 1918, Greensboro, N.C. **Studied:** Pratt Institute, 1935-37; ASL, 1946, with Yasuo Kuniyoshi; Washington U., with Philip Guston, Max Beckmann, 1947-48, BFA with honors; U. of North Carolina, 1953, MFA. Traveled Mexico, Europe. **Taught:** Salem College, 1949-50; Pratt Institute, 1950-52; Guilford College, 1952-56; U. of Mississippi, 1957-59; Southern Illinois U., 1959-61; School of Visual Arts, NYC, 1962-63. **Awards:** John T. Milliken Traveling Fellowship. **m.** Grace Borgenicht. **Address:** 138 East 95 Street, NYC 10028. **Dealer:** A. M. Sachs Gallery. **One-man Exhibitons:** (first) Sacramento State College, 1943; Nonagon Gallery, NYC, 1959; Memphis State U., 1960; New Gallery, Province-town, 1960; Michigan State U., 1961; The American Gallery, NYC, 1961; Esther Stuttman Gallery, Provincetown, 1962; Grippi Gallery, NYC, 1963, 64; Obelisk Gallery, Washington, D.C., 1963; Grippi and Waddell Gallery, NYC, 1964; A. M. Sachs Gallery, 1966, 67, 68, 70, 72, 73, 74; U. of North Carolina, 1967; Reed College, 1967; Benson Gallery, 1967; Easten Illinois U., 1968; Salem College, 1968; Molly Barnes Gallery, Los Angeles, 1968; Cord Gallery, Southampton, N.Y., 1968; Allentown/AM, 1969; Agra Gallery, 1969; Grand Avenue Galleries, Milwaukee, 1969; Mercury Gallery, London, 1969; David Barnett Gallery, Milwaukee, 1969, 71, 74; Allentown-/MA, 1969; Agra Gallery, Washington, D.C., 1969, 70; Pratt Manhattan Cen-

ter, NYC, 1970. **Retrospective:** Allentown/AM, 1962-1968. **Group:** MMA, American Watercolors, Drawings and Prints, 1952; WMAA; Brooklyn Museum, Print Biennials; VMFA, Virginia Artists Biennial; PAFA; A.F.A. **Collections:** Chase Manhattan Bank; Ciba-Geigy Corp.; Guild Hall; Hirshhorn; Michigan State U.; NCFA; Norfolk/Chrysler; U. of North Carolina; New Mexico State U.; U. of Rochester; Southern Illinois U.; WGMA. Archives.

BRECHT, GEORGE. b. 1925, NYC. **Studied:** Philadelphia College of Pharmacy and Science, BSc.; Rutgers U.; New School for Social Research, with John Cage, 1958-59; Samuel S. Fleisher Art Memorial, Philadelphia. Traveled Western Europe, Mexico. **Taught:** Leeds (England) College of Art, 1968-69. Founder, Sight Unseen, a journal on research science and speculative art, 1968-69. **Commissions:** Music and sets for James Waring Dance Company, NYC. **Address:** Wildenburgstrasse 9, 5 Cologne 41, West Germany. **Dealer:** Multipla. **One-man Exhibitions:** (first) Reuben Gallery, NYC, 1959; Fischbach Gallery, 1965; Galleria Schwarz, 1967, 69; Galerie Rudolf Zwirner, 1969; Mayer Gallery, Stuttgart, 1969; Los Angeles/County MA, 1969; Onnasch Gallery, 1973. **Group:** Martha Jackson Gallery, New Media—New Forms, I & II, 1960, 61; Stockholm/National, Art in Motion, 1961; MOMA, The Art of Assemblage, circ., 1961; Buffalo/Albright, Mixed Media and Pop Art, 1963; Oakland/AM, Pop Art USA, 1963; Hartford/Wadsworth, Black, White, and Gray, 1964; Smith College, Sight and Sound; Jewish Museum, Superlimited, 1969; Tate, Pop Art, 1969; SRGM, Eleven from the Reuben Gallery, 1965; Chicago/Contemporary, Art by Telephone, 1969; Berne, Art after Plans, 1969; Documenta V, Kassel, 1972; Rijksuniversiteit, Utrecht, Toeval, 1972. Theater Pieces: Fluxus International Festival, NYC, 1962-63; Smolin Gallery, NYC, Yam Festival: A Series of Events, 1963; Arman's Key Event, NYC,

1965. **Collections:** CNAC; MOMA; Monchengladbach. **Bibliography:** Becker and Vostell; *Contemporanea;* Gerdts; Hansen; *Happening & Fluxus;* Hunter, ed.; Kaprow; Lippard, ed.; *Report;* Russell and Gablik.

BREER, ROBERT C. b. September 20, 1926, Detroit, Mich. **Studied:** Stanford U., BA. Resided Paris, 1949-59. Traveled Japan, 1969, Europe. **Taught:** Cooper Union, 1972-75; Film Study Center, Cambridge, Mass.; Hampshire College, Amherst, Mass., 1974-75. **Commissions:** Expo 70, Osaka, Pepsi-Cola Pavilion, 1970. **Awards:** Stanford U., Annual Painting Award, 1949; Creative Film Foundation Awards, 1957-60; Bergamo, Diplome Speciale, 1962; Oberhausen Film Festival, Max Ernst Prize, 1969; Film Culture Award, 1973; CAPS, NYC, 1975. **Address:** Palisades, N.Y., 10964. **One-man Exhibitions:** (first) Palais des Beaux-Arts, Brussels, 1955; Galeria Bonino Ltd., NYC, 1965, 66, 67, 70; Galerie Rolf Ricke, 1968; J. L. Hudson Art Gallery, Detroit, 1972; Dag Hammarskjold Plaza, NYC, 1973; Michael Berger Gallery, Pittsburgh, 1974; IBM Plaza, Pittsburgh, 1974; MOMA (films), 1975. **Retrospectives:** Montreux Film Festival, 1974; Film Forum, NYC, 1975. **Group:** WGMA, The Popular Image, 1963; MOMA, 1963; ICA, Boston, 1965; Stockholm/National, 1965; U. of California, Berkeley, Directions in Kinetic Sculpture, 1966; Jewish Museum, 1967; VI International Art Biennial, San Marino (Europe), 1967; Experimental Film Festival, Brussels, 1967; A.F.A., 1968; MOMA, The Machine as Seen at the End of the Mechanical Age, 1968; UCLA, Electric Art, 1969; MOMA, New Media: New Methods, circ., 1969; Hayward Gallery, London, Kinetics, 1970; Buffalo/Albright, Kid Stuff, 1971; Yale U., Options and Alternatives, 1973; Cannes Film Festival, 1974. **Collections:** Anthology Film Archives; CNAC; Cinematheque de Belgique: Cinematheque Francaise; Krefeld/Kaiser Wilhelm; MOMA; NYPL; Stockholm/National. **Bibliography:** *Art Now 74;* Battcock, ed.; Davis, D.; Hulten; *Options and Alternatives;* Rickey; Selz, P. 1; Tomkins. Archives.

BREININ, RAYMOND. b. November 30, 1910, Vitebsk, Russia. **Studied:** Chicago Academy of Fine Arts, with Uri Penn. **Taught:** Southern Illinois U.; U. of Minnesota; Breinin School of Art, Chicago; ASL. Costumes and settings for Ballet Theater's "Undertow." **Awards:** U. of Illinois; ART:USA:58, NYC, 1958; Chicago/AI, Watson F. Blair Prize, 1942; Chicago/AI, Norman Wait Harris Silver Medal, 1942; MMA, **P.P.,** 1942. **Address:** 121 Inwood Road, Scarsdale, N.Y. 10583. **One-man Exhibitions:** (first) The Downtown Gallery, 1939, also 1943; Indiana U., 1942; Chicago/AI, 1942. **Group:** MOMA, Twelve Americans, circ., 1956; WMAA. **Collections:** AAAL; Boston/MFA; Britannica; Brooklyn Museum; Capehart Corp.; Chicago/AI; Cranbrook; Edinburgh/National; Harvard U.; U. of Illinois; Indianapolis/Herron; Eli Lilly & Co.; MMA; MOMA; Newark Museum; Phillips; SFMA; San Diego; Williams College; Zanesville/AI. **Bibliography:** Baur 7; Frost; Genauer; Halpert; Miller, ed. 1. Archives.

BRICE, WILLIAM. b. April 23, 1921, NYC. **Studied:** ASL; Chouinard Art Institute, Los Angeles. Traveled England, Spain, Greece. **Taught:** Jepson Art Institute, Los Angeles; UCLA, 1953- . **Address:** 427 Beloit Street, Los Angeles, Calif. 90049. **Dealer:** Felix Landau Gallery. **One-man Exhibitions:** The Downtown Gallery, 1949; Frank Perls Gallery, 1952, 55, 56, 62; The Alan Gallery, NYC, 1955, 56, 64; Santa Barbara/MA, 1958; Felix Landau Gallery, 1966; U. of California, San Diego, 1967; Colorado Springs/FA, 1967; Dallas/MFA, 1967; SFMA, 1967; The Landau-Alan Gallery, NYC, 1968; Hancock College, Santa Maria, Calif., 1975; Orange Coast College, 1975. **Group:** Santa Barbara/MA, 1945; WMAA, 1947, 50, 51; Los Angeles/County MA,

1947-50, 1951; Sao Paulo; Carnegie, 1948, 49, 54; U. of Illinois; MMA, 1952; MOMA, 1952, 56; Chicago/AI, 1952, 56; Paris/Moderne, 1954; California Palace, 1951, 52; SFMA; de Young; VMFA, 1966; Des Moines, 1967. **Collections:** AAAL; Andover/Phillips; Chicago/AI; U. of Illinois; Los Angeles-/County MA; MMA; MOMA; U. of Nebraska; Santa Barbara/MA; Utica; WMAA; Wichita/AM. **Bibliography:** Pousette-Dart, ed. Archives.

BRIGGS, ERNEST. b. 1923, San Diego, Calif. **Studied:** California School of Fine Arts, with Clyfford Still, David Park, Mark Rothko. US Army, 1943-45. A cofounder of Metart Gallery, San Francisco, 1949. **Taught:** U. of Florida, 1958; Pratt Institute, 1961- ; Yale U., 1967-68. **Awards:** CSFA, Albert M. Bender Fellowship, 1951; SFMA, Anne Bremer Memorial Prize, 1953. **Address:** 128 West 26 Street, NYC 10001. **One-man Exhibitions:** (first) Metart Gallery, San Francisco, 1949; The Stable Gallery, NYC, 1954, 55; CSFA, 1956; The Howard Wise Gallery, NYC, 1960, 62, 63; Yale U., 1968; Alonzo Gallery, NYC, 1969; Green Mountain Gallery, 1973; Susan Caldwell Inc., 1975. **Group:** San Francisco Art Association Annuals, 1948, 49, 53; WMAA Annuals, 1955, 56, 61; California Palace, Five Bay Area Artists, 1953; MOMA, Twelve Americans, circ., 1956; Corcoran, 1961; Carnegie, 1961; Dallas/MFA, "1961," 1962; SFMA, 1962, 63; Jewish Museum, Large Scale American Painting, 1967; AAAL, 1969, 70; Oakland/AM, San Francisco: 1945-1950, 1973. **Collections:** Carnegie; Ciba-Geigy Corp.; Housatonic Community College; Michigan State U.; Oakland/AM; Rockefeller Institute; SFMA; WMAA; Walker. **Bibliography:** McChesney.

BRODERSON, MORRIS (Gaylord). b. November 4, 1928, Los Angeles, Calif. **Studied:** Pasadena Museum School; U. of Southern California, with Francis De Erdely; Jepson Art Institute, Los Angeles. Traveled Europe, Japan, India, Far East. **Awards:** Pasadena Museum School, Scholarship, 1943; Los Angeles/County MA, **P.P.**, *Art In America* (Magazine), New Talent, 1959; Los Angeles Art Festival, 1961; Carnegie, 1961. **Address:** c/o Ankrum Gallery. **Dealers:** Ankrum Gallery; Staempfli Gallery. **One-man Exhibitions:** Dixi Hall Studio, Laguna Beach, Calif., 1954; Stanford U., 1958; Santa Barbara/MA, 1958; U. of California, Riverside, 1959; Bertha Lewinson Gallery, Los Angeles, 1959, 60; Ankrum Gallery, 1961, 62, 70; The Downtown Gallery, 1963, 66; Los Angeles/County MA, 1966, 68; San Diego, 1969; Staempfli Gallery, 1971. **Retrospective:** San Diego, 1969; U. of Arizona. **Group:** Santa Barbara/MA, 1958; Los Angeles/MA, 1958, 59; PAFA, 1959; Youngstown/Butler, 1959, 60; Ringling, 1960; WMAA, 1960; de Young, 1960; California Palace; San Diego, 1961; Carnegie, 1961, 62, 64, 67; U. of Illinois, 1963; NIAL, 1967; Hirshhorn, Inaugural Exhibition, 1974. **Collections:** Boston/MFA; Container Corp. of America; Hirshhorn; Home Savings and Loan Association; Honolulu Academy; Kalamazoo/Institute; La Jolla; Los Angeles/County MA; NIAL; Palm Springs Desert Museum; Phoenix; SFMA; San Antonio/McNay; San Diego; Santa Barbara/MA; U. of South Florida; Stanford U.; U. of Texas; WMAA; Yale U. **Bibliography:** Weller.

BRODERSON, ROBERT M. b. July 6, 1920, West Haven, Conn. **Studied:** Duke U., 1947-50, AB; State U. of Iowa, 1952, MFA, with Mauricio Lasansky, James Lechay, Stuart Edie. US Air Force, 1941-45. Traveled Europe, USA. **Taught:** Duke U., 1957-64. **Awards:** AAAL, 1962, Childe Hassam Award, also **P.P.**, 1968; Ford Foundation, **P.P.**, 1962; Guggenheim Foundation Fellowship, 1964. **Address:** 304 Woodhaven Road, Chapel Hill, N.C. 27514. **Dealer:** Terry Dintenfass, Inc. **One-man Exhibitions:** (first) Charlotte/Mint, 1951; Raleigh/NCMA, 1957, 60; Catherine Viviano Gallery, 1961, 1963-65; Terry Dintenfass, Inc., 1965-68; Harpur Col-

lege, 1967, 68; Binghampton/SUNY, 1969. **Group:** Southwestern Annual, 1950, 54, 60; PAFA, 1951, 53, 62, 67; MMA, 1952; Corcoran Biennials, 1953, 57, 61; WMAA, 1961; U. of Illinois, 1963. **Collections:** Carnegie; Charlotte/Mint; Colorado Springs/FA; Des Moines; Hartford/Wadsworth; NIAL; Princeton U.; Raleigh/NCMA; WMAA.

BRODIE, GANDY. b. May 20, 1924, NYC; **d.** October 22, 1975, NYC. **Studied:** Art history courses with Meyer Schapiro; self-taught as artist. Traveled Mexico, Europe. **Taught:** privately; Carnegie-Mellon U., 1969-70; U. of Pennsylvania, 1970-71; Elmira College. **Awards:** Mark Twain Contest ($1,000), 1959; Ingram Merrill Foundation Grant, 1961; Hollins College, Artist-in-Residence, 1968; State of Washington, Title III Cultural Enrichment Grant, 1969; National Council on the Arts; Guggenheim Foundation Fellowship, 1969. **One-man Exhibitions:** (first) Urban Gallery, NYC, 1954; Durlacher Brothers, NYC, 1955, 57, 59, 61, 63; Saidenberg Gallery, 1964; Obelisk Gallery, Boston, 1965; Richard Gray Gallery, 1966; The Zabriskie Gallery, 1967; Andover/Phillips; Windham College; Williams College. **Group:** WMAA, Recent Acquisitions, 1957; MOMA 1957, 61; Phillips; Hirshhorn, Inaugural Exhibition, 1974. **Collections:** Baltimore/MA; Charlotte/Mint; MIT; MMA; MOMA; Norfolk/Chrysler; Phillips; Sarah Lawrence College; WMAA; Williams College.

BRONER, ROBERT. b. March 10, 1922, Detroit, Mich. **Studied:** Wayne State U., 1940-46, BFA, MA; UCLA, 1946-47; Society of Arts and Crafts, Detroit, 1942-45; Atelier 17, NYC, 1949-52, with S. W. Hayter; New School for Social Research, 1949-50, with Stuart Davis. **Taught:** City U. of New York, 1963-64; Society of Arts and Crafts, Detroit; Wayne State U., 1964- ; Haystack Mountain School of Crafts, 1964, 66, 68, 70, 75; U. of Haifa, 1975. Detroit

Times, 1958-60 (art critic); *Art in America* Magazine, 1958-63 (correspondent); *Craft Horizons* Magazine, 1961-68 (correspondent); Birmingham *Eccentric*, 1962-63 (art critic); *Pictures on Exhibit* Magazine, 1963-64 (reviewer). **Member:** SAGA; Philadelphia Print Club; British Printmakers Council. **Awards:** Brooklyn Museum, Print Biennial, **P.P.**, 1964; Los Angeles Art Festival, Bronze Medal, 1948; Detroit/Institute, Michigan Artist, **P.P.**, 1961, 66; SAGA, 50th Annual Print Exhibition, $1000 **P.P.**, 1969; Wayne State U., Faculty Research Fellowship, 1965, 69; Probus Club, Achievement Award ($500), 1969. **Address:** 18244 Parkside, Detroit, Mich. 48221. **One-man Exhibitions:** (first) Anna Werbe Gallery, Detroit, 1953; Wellons Gallery, NYC, 1954; Philadelphia Art Alliance, 1956; Garelick's Gallery, Detroit, 1956, 61; Michigan State U., 1957; Drake Gallery, Carmel, Calif., 1960; Society of Arts and Crafts, Detroit, 1962; Feingarten Gallery, Los Angeles, 1961; Raven Gallery, Birmingham, Mich., 1963; The Ohio State U., 1969; J. L. Hudson Art Gallery, Detroit, 1971; Rina Gallery, NYC, 1973; Klein-Vogel Gallery, Royal Oak, Mich.; Delson-Richter Gallery, Tel Aviv, 1975. **Group:** MMA, American Watercolors, Drawings and Prints, 1952; MOMA, Young American Printmakers, 1953; Brooklyn Museum, Print Biennials; USIA, circ. Europe, 1959-60 (prints); PCA, circ. Europe and France, 1959-60; PAFA, 1959, 60; Pasadena/AM, 1962; SAGA, 1962, 63; ICA, London; Salon du Mai, Paris, 1969; British International Print Biennials, 1968, 70, 72; MOMA, Pop Art Prints, Drawings and Multiples, 1970; Paris/Moderne, La Jeune Gravure, 1970; Bibliotheque Nationale, L'Estampe Contemporaine, 1973; Walker, Printmakers, 1973. **Collections:** Bibliotheque Nationale; Boston Public Library; Brooklyn Museum; Chicago/AI; Cincinnati/AM; Detroit/Institute; Harvard U.; Jerusalem/National; Los Angeles/County MA; MMA; MOMA; NYPL; National Gallery; PMA; SRGM; Smithsonian; Walker. Archives.

BROOK, ALEXANDER. b. July 14, 1898, Brooklyn, N.Y. **Studied:** ASL, 1913-17, with R. W. Johnson, Frank V. DuMond, George Bridgeman, Dimitri Romanovsky, Kenneth Hayes Miller. Assistant Director, Whitney Studio Club, NYC. **Commissions:** US Post Office, Washington, D.C. (mural). **Awards:** Chicago/AI, The Mr. & Mrs. Frank G. Logan Medal, 1929; Carnegie, Second Prize, 1930; PAFA, Joseph E. Temple Gold Medal, 1931; Guggenheim Foundation Fellowship, 1931; Carnegie, Frist Prize, 1939; Los Angeles/County MA, First Prize, 1934; Paris World's Fair, 1937, Gold Medal; SFMA, Medal of Award, 1938. **Address:** Point House, Sag Harbor, N.Y. 11963. **Dealer:** Richard Larcada Gallery. **One-man Exhibitions:** ACA Gallery; Curt Valentine Gallery, NYC, 1930; The Downtown Gallery, 1934, 37; Dayton/AI, 1942; Rehn Galleries, 1947, 60; M. Knoedler & Co., NYC, 1952; Richard Larcada Gallery, 1969, 74. **Retrospective:** Chicago/AI, 1929. **Group:** U. of Rochester,

1937; Brooklyn Museum; Carnegie; MMA; Toledo/MA; Buffalo/Albright; Chicago/AI; Newark Museum. **Collections:** Boston/MFA; Britannica; Brooklyn Museum; Buffalo/Albright; California Palace; Carnegie; Chicago/AI; Columbus; Corcoran; Detroit/Institute; de Young; Hartford/Wadsworth; IBM; Kansas City/Nelson; MMA; MOMA; Michigan State U.; U. of Nebraska; Newark Museum; SFMA; St. Louis/City; Toledo/MA; WMAA. **Bibliography:** Baur 7; Bethers; Biddle 4; Boswell 1; **Brook;** Cahill and Barr, eds.; Cheney; Eliot; Flexner; Goodrich and Baur 1; Hall; *Index of 20th Century Artists;* **Jewell 1,** 2; Kent, N.; Mellquist; Mendelowitz; Pagano; Pearson 1; Pousette-Dart, ed.; Richardson, E. P. Archives.

BROOKS, JAMES. b. October 18, 1906, St. Louis, Mo. **Studied:** Southern Methodist U., 1923-25; Dallas Art Institute, 1925-26, with Martha Simkins; ASL, 1927-31, with Kimon Nicolaides, Boardman Robinson; privately with

James Brooks *Asnawa* 1970

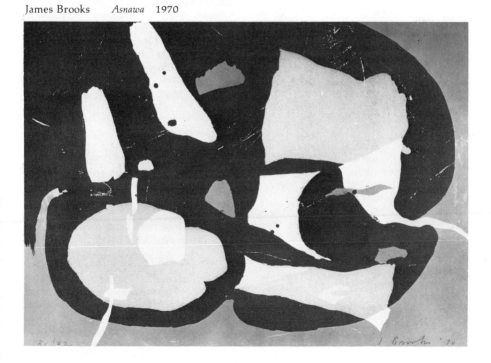

Wallace Harrison. Federal A.P.: 1937-42. US Army in Middle East, 1942-45. Traveled Italy. **Taught:** Columbia U., 1947-48; Pratt Institute, 1947-59; Yale U., 1955-60; American Academy, Rome, Artist-in-Residence, 1963; New College, Sarasota, Fla., 1965-67; Miami Beach (Fla.) Art Center, 1966; Queens College, 1966-67, 1968-69; U. of Pennsylvania, 1971, 72. **Member:** Century Association; NIAL. **Commissions** (murals): Woodside, N.Y., Library; La Guardia Airport; US Post Office, Little Falls, N.Y. **Awards:** Carnegie, Fifth Prize, 1952; Chicago/AI, The Mr. & Mrs. Frank G. Logan Medal, 1957; Chicago/AI, Norman Wait Harris Silver Medal and Prize, 1961; Ford Foundation, **P.P.**, 1962; Guggenheim Foundation Fellowship, 1967-68. **Address:** 128 Neck Path, The Springs, East Hampton, N.Y. 11937. **Dealer:** Martha Jackson Gallery. **One-man Exhibitions:** The Peridot Gallery, 1950, also 1951-53; Grace Borgenicht Gallery Inc., 1954; The Stable Gallery, 1957, 59; The Kootz Gallery, NYC, 1961, 62; Philadelphia Art Alliance, 1966; Martha Jackson Gallery, 1968, 71, 73, 75; The Berenson Gallery, 1969. **Retrospectives:** WMAA, circ., 1963-64; Dallas/MFA, 1972; Finch College, NYC, circ., 1975. **Group:** WMAA Annuals from 1950's; Galerie de France, American Vanguard, 1952; Carnegie, 1952, 55, 58, 61; SRGM, Younger American Painters, 1954; WMAA, The New Decade, 1954-55; MOMA, Twelve Americans, circ., 1956; IV Sao Paulo Biennial, 1957; MOMA, The New American Painting, circ. Europe, 1958-59; Documenta II, Kassel, 1959; II Inter-American Paintings and Prints Biennial, Mexico City, 1960; SRGM, Abstract Expressionists and Imagists, 1961; Seattle World's Fair, 1962; Cleveland/MA, 1963; SFMA, 1963; Tate, Dunn International, 1964; MOMA, The New American Painting and Sculpture, 1969; WMAA Annuals, 1970, 72; U. of Illinois, 1971; Ball State U., Collages by American Artists, 1971; Cranbrook, Drawings by Contemporary American Artists, 1975; Corcoran Biennial, 1975. **Collections:** Boston/MFA; Brandeis U.; Brooklyn Museum; Buffalo/Albright; U. of California, Berkeley; Carnegie; Chase Manhattan Bank; Chicago/AI; Ciba-Geigy Corp.; The Coca-Cola Co.; Dallas/MFA; Detroit/Institute; Fordham U.; Hartford/Wadsworth; Houston/MFA; U. of Illinois; International Minerals & Chemicals Corp.; MMA; MOMA; U. of Michigan; Miles Metal Corp.; NYU; U. of Nebraska; Owens-Corning Fiberglas Corp.; PAFA; Pepsi-Cola Co.; Philip Morris; Rockefeller U.; SRGM; The Singer Company Inc.; Southern Methodist U.; Tate; U. of Texas; Toledo/MA; Tulsa/Philbrook; Union Carbide Corp.; Utica; VMFA; WMAA; Walker; Yale U. **Bibliography:** Chaet; Flanagan; Goodrich and Baur 1; Haftman; Hess, T. B. 1; **Hunter** 1, 3, 6; Hunter, ed.; McCurdy, ed.; *Metro;* Motherwell and Reinhardt, eds.; Ponente; Pousette-Dart, ed.; Ritchie 1; Rodman 2; Sandler. Archives.

BROWN, CARLYLE. b. 1919, Los Angeles, Calif.; **d.** December 21, 1964. **Studied:** Rudolph Schaeffer School of Design, San Francisco, 1939-40. US Navy, 1942-46. **Awards:** U. of Illinois, **P.P.**, 1952. **One-man Exhibitions:** Durlacher Brothers, NYC, 1947; de Young, 1947; Catherine Viviano Gallery, 1950, 51, 53, 55, 57, 59; L'Obelisco, Rome, 1954; The Banfer Gallery, 1964, 65. **Group:** WMAA; Detroit/Institute; U. of Illinois; Carnegie, 1950. **Collections:** California Palace; U. of Illinois; MMA; PAFA; WMAA. **Bibliography:** Goodrich and Baur 1; McCurdy, ed.; Newmeyer; Pousette-Dart, ed.

BROWN, JOAN. b. 1938, San Francisco, Calif. **Studied:** California School of Fine Arts, 1955; with Elmer Bischoff, Frank Lobdell, Sonia Gechtoff, Richard Diebenkorn, Manuel Neri, Robert Howard, 1957-62. **Taught:** Raymond Wilkins High School, San Francisco, 1959; SFAI, 1961- . **Awards:** SFAI, Adaline Kent Award, 1973. **Address:** 37 Cameo Way, San Francisco, Calif. **One-man Exhibi-**

tions: Spasta Gallery, San Francisco, 1958; Staempfli Gallery, 1960 (two-man), 1961, 64; Batman Gallery, San Francisco, 1961; Ferus Gallery, Los Angeles, 1962; Hanson-Fuller Gallery, 1968; Lawson Galleries, San Francisco, 1970; SFMA, 1971; SFAI, 1973. **Retrospective:** U. of California, Berkeley, 1974. **Group:** Oakland/AM; RAC; SFMA; PAFA; SFAI, Drawing Invitational, 1969; WMAA, 1972. **Collections:** U. of California; MOMA; Oakland/AM; WMAA; Williams College. **Bibliography:** *Art as a Muscular Principle; Art: A Woman's Sensibility;* McChesney; **Richardson, B. 1;** Selz, P. 2. Archives.

BROWN, WILLIAM THEO. b. April 7, 1919, Moline, Ill. **Studied:** Yale U., 1941, BA; U. of California, Berkeley, 1952, MA. Traveled Europe. **Taught:** U. of California, Berkeley and Davis; California School of Fine Arts. **Address:** 1151 Keeler, Berkeley, Calif. 94708. **Dealer:** Felix Landau Gallery. **One-man Exhibitions:** SFMA, 1957; Felix Landau Gallery, 1958, 60, 63, 65, 67, 71; Barone Gallery, NYC, 1961; The Kornblee Gallery, 1962; Esther Baer Gallery, 1964 (two-man, with Paul Wonner); Hollis Gallery, San Francisco, 1965; Sacramento/Crocker, 1965; The Landau-Alan Gallery, NYC, 1968. **Group:** Oakland/AM Annuals, 1952-58; RAC Annuals, 1952-58; SFMA Annuals, 1952-58; Minneapolis/Institute, American Painting, 1945-57, 1957; Oakland/AM, Contemporary Bay Area Figurative Painting, 1957; Santa Barbara/MA, II & III Pacific Coast Beinnials, 1957, 59; SFMA, West Coast Artists, circ., 1957, 59; California Palace, 1959; The Zabriskie Gallery, East-West, 1960; U. of New Mexico, circ., 1964-67; Louisville/Speed, 1965; VMFA, 1966; U. of Illinois, 1969. **Collections:** California Palace; Capitol Records, Inc.; Commerce Trust Co., Kansas City, Mo.; Davenport/Municipal; U. of Kansas; U. of Nebraska; Oakland/AM; *Readers Digest;* SFMA. Archives.

BROWNE, BYRON. b. 1907, Yonkers, N.Y.; **d.** December 25, 1961. **Studied:** NAD, 1924-28, with C. W. Hawthorne, Ivan Olinsky. **Taught:** ASL, 1948-61. Charter Member, American Abstract Artists. **Awards:** U. of Illinois, **P.P.;** PAFA, **P.P.;** NAD, Hallgarten Prize, 1928; La Tausca Competition, Third Prize. **One-man Exhibitions:** (first) New School for Social Research, 1936, also 1937; Artists' Gallery, NYC, 1939; The Pinacotheca, NYC, 1943, 44; The Kootz Gallery, NYC, 1946-48; Grand Central, NYC, 1949, 50, 53; Grand Central Moderns, NYC, 1950, 51, 52, 54, 55, 57, 58, 61, 62; Syracuse U., 1952; Tirca Karlis Gallery, 1960; ASL, Memorial Exhibition, 1962; Washburn Gallery Inc., 1975. **Group:** Chicago/AI; Carnegie; WMAA; Corcoran; MOMA; MMA; ART:USA, NYC; U. of Illinois; PAFA. **Collections:** Brown U., Dallas/MFA; U. of Georgia; NIAL; U. of Nebraska; Newark Museum; U. of Oklahoma; PAFA; Rio de Janeiro; Roswell; San Antonio/McNay; Tel Aviv; VMFA; WMAA; Youngstown/Butler. **Bibliography:** Baur 7; Blesh 1; Cheney; Janis; Kootz 2; Pousette-Dart, ed.; Ritchie 1. Archives.

BROWNING, COLLEEN. b. May 18, 1929, Fermoy, County Cork, Ireland. **Studied:** Privately, and U. of London, Slade School. Traveled the world extensively. **Taught:** City College of New York, 1962-75. Illustrated many children's books. **Member:** NAD; Carnegie International; Edwin Austin Abbey Fellowship; Tupperware National Competition; Yaddo Fellowship; Los Angeles County Fair, 1956; Columbia, S.C./MA, Biennial, 1957; MacDowell Colony Fellowship. **Address:** 100 La Salle Street, NYC 10027. **Dealer:** Kennedy Gallery. **One-man Exhibitions:** Robert Isaacson Gallery, NYC; Little Gallery, London, 1949; Hewitt Gallery, NYC, 1951, 52, 54; J. Seligmann and Co., 1965, 67; Lehigh U., 1966; Lane Gallery, Los Angeles, 1968; Kennedy Gallery, 1968-72. **Group:** A.F.A., 20th Century Realists; WMAA Annual;

Chicago/AI; PAFA; NAD; NIAL; ART: USA, NYC; Walker; Carnegie; Festival of Two Worlds, Spoleto; Youngstown/Butler; Brandeis U.; U. of Rochester; U. of Illinois. **Collections:** California Palace; Columbia, S.C./MA; Corcoran; Detroit/Institute; U. of Miami; Milwaukee; NAD; U. of Rochester; Wichita/AM; Williams College; Youngstown/Butler.

BRUCE, PATRICK HENRY. b. April 2, 1880, Long Island, Va.; **d.** November 12, 1937, NYC. **Studied:** Richmond (Va.) Art School; New York School of Art, with Robert Henri, W. M. Chase, 1901-03; with Henri Matisse in Paris, 1909. Traveled Europe; resided Paris, 1904-36. **One-man Exhibitions:** Rose Fried Gallery (three-man), 1950; Coe Kerr Gallery, 1970. **Group:** Salon d'Automne, Paris, 1907-10; The Armory Show, 1913; Herbstsalon, 1913; Montross Gallery, NYC, 1916, 17; Societe Anonyme, 1920; Worcester, Mass., 1921; MacDowell Club, NYC, 1922; Vassar College, 1923; WMAA, The Decade of the Armory Show, 1963; U. of New Mexico, Cubism; its impact in the USA, 1967; Utica, Armory Show 50th Anniversary Exhibit, 1963; NAD; Hirshhorn, Inaugural Exhibition, 1974. **Collections:** U. of Nebraska; Yale U. **Bibliography:** *Avant-Garde Painting and Sculpture;* Baur 7; Dreier 2; Du Bois 1; Hunter 6; MacAgy 2; Ritchie 1; Rose, B. 1; Seuphor 1; Wright 2. Archives.

BULTMAN, FRITZ. b. April 4, 1919, New Orleans, La. **Studied:** Privately with Morris Graves, 1931; New Orleans Arts and Crafts School; Munich Preparatory School; New Bauhaus, Chicago, 1937-38; Hofmann School, NYC and Provincetown, 1938-41. **Taught:** Pratt Institute, 1958-63; Hunter College, 1959-64; Fine Arts Work Center, Provincetown, Mass., 1968-70. **Awards:** Italian Government Scholarship, 1950; Fulbright Fellowship, 1951, 1964-65 (Paris); Guggenheim Foundation Fellowship, 1975. **Address:** 176 East 95 Street, NYC 10028. **Dealer:** Martha

Jackson Gallery. **One-man Exhibitions:** (first) Hugo Gallery, NYC, 1947, also 1950; The Kootz Gallery, NYC, 1952; The Stable Gallery, NYC, 1958; Martha Jackson Gallery, 1959, 73, 74; New Orleans/Delgado, 1959, 74; Galerie Stadler, Paris, 1960; Michel Warren Gallery, NYC, 1960; Gallery Mayer, NYC, 1960; Tibor de Nagy Gallery, 1963, 64; Oklahoma, 1974; Newport (R.I.) Art Association, 1974. **Group:** WMAA, 1950, 53; Chicago/AI; MOMA, Hans Hofmann and His Students, circ., 1963-64; IIE, 20 American Fulbright Artists, 1975. **Collections:** Brandeis U.; Ciba-Geigy Corp.; Grinnell College; U. of Minnesota; U. of Nebraska; New Orleans/Delgado; Norfolk/Chrysler; U. of North Carolina; RISD; U. of Texas; Tougaloo College; WMAA; Williams College. **Bibliography:** Pousette-Dart, ed. Archives.

BUNCE, LOUIS. b. August 13, 1907, Lander, Wyo. **Studied:** Portland (Ore.) Museum School, 1925-26; ASL, 1927-30, with Boardman Robinson, William Von Schlegell. Traveled USA, Mexico, Europe extensively. **Taught:** Salem (Ore.) Art Museum, 1937-38; Portland (Ore.) Museum School; U. of California, Berkeley; U. of British Columbia; U. of Washington; U. of Illinois; U. of Oregon. Federal A.P.: Mural Division, NYC, 1940-41. **Commissions:** Federal Building, Grants Pass, Ore., 1936-37 (mural); Portland (Ore.) International Airport, 1958 (mural); Portland (Ore.) Hilton Hotel, 1963 (637 serigraphs). **Awards:** Seattle/AM, **P.P.**, 1936, 62; Northwest Printmakers Annual, 1948; U. of Washington, **P.P.**, 1950; Portland, Ore./AM, **P.P.**, 1952; SFMA, Emanuel Walter Bequest and Purchase Award, 1961; Ford Foundation, **P.P.**, 1964; Tamarind Fellowship. **Address:** 1800 S.E. Harold Street, Portland, Ore. 97202. **Dealers:** Fountain Gallery; Gordon Woodside Gallery; Comara Gallery. **One-man Exhibitions:** Seattle/AM, 1936, 63; Washburn U. of Topeka, 1937; Hollins College, 1941, 58; Portland, Ore./AM, 1945, 47, 56; U. of Washington, 1947;

Harvey Welch Gallery, Portland, Ore., 1947; National Serigraph Society, NYC, 1947; Reed College, 1947, 51; Willamette U., 1948; Santa Barbara/MA, 1948; Kharouba Gallery, Portland, Ore., 1950, 52; Cincinnati/AM, 1952; John Heller Gallery, NYC, 1953; Grants Pass (Ore.) Art League, 1953, 54; Salem (Ore.) Art Association, 1955; Morrison Street Gallery, Portland, Ore., 1955; Doris Meltzer Gallery, NYC, 1956, 57, 59, 60; Artists Gallery, Seattle, 1958; U. of California, Berkeley, 1960; Fountain Gallery, 1962, 64, 66, 72; Comara Gallery, 1964; Gordon Woodside Gallery, 1964; U. of Illinois, 1967. **Retrospective:** Portland, Ore./AM, 1955. **Group:** Golden Gate International Exposition, San Francisco, 1939; New York World's Fair, 1939; Chicago/AI, Abstract and Surrealist Art, 1948; Worcester/AM, 1949; MMA, American Paintings Today, 1950; Colorado Springs/FA, Artists West of the Mississippi, 1951, 53, 56, 59; WMAA Annuals, 1951, 53, 54, 59, 60; Corcoran, 1953; U. of Colorado, 1953; Los Angeles/County MA, 1953; VMFA, 1954; Des Moines, 1954; U. of Nebraska, 1954, 57; Carnegie Annual, 1955; Sao Paulo, 1955, 56; Denver/AM Annuals, 1955, 56, 59, 62; Santa Barbara/MA, 1957; PAFA, 1958; Detroit/Institute, 1958; Stanford U., Fresh Paint, 1958; Grand Rapids, 1961; Seattle World's Fair, 1962. **Collections:** AAAL; American Association of University Women; Auburn U.; Colorado Springs/FA; Hollins College; Library of Congress; MMA; U. of Michigan; National Gallery; PMA; Portland, Ore./AM; Reed College; SFMA; Seattle/AM; Springfield, Mo./AM; US State Department; Utica; WMAA; U. of Washington; Youngstown/Butler. **Bibliography:** Bunce.

BURCHFIELD, CHARLES. b. April 9, 1893, Ashtabula Harbor, Ohio; **d.** January 10, 1967, West Seneca, N.Y. **Studied:** Cleveland Institute of Art, 1912, with Henry G. Keller, F. N. Wilcox, William J. Eastman; NAD. US Army, 1918-19. **Taught:** U. of Minnesota, Duluth, 1949; Art Institute of Buffalo, 1949-52; Ohio U., summer, 1950; U. of Buffalo, summers, 1950, 51; Buffalo Fine Arts School, 1951-52. **Member:** American Academy of Arts and Sciences; NIAL; NAD. **Commissions:** *Fortune* Magazine, 1936, 37. **Awards:** Cleveland/MA, First Prize and Penton Medal, 1921; PAFA, Jennie Sesnan Gold Medal, 1929; Carnegie, Second Prize, 1935; International Arts Festival, Newport, R.I., First Prize, 1936; PAFA, Dana Watercolor Medal, 1940; Chicago/AI, Watson F. Blair Prize, 1941; NIAL, Award of Merit Medal, 1942; U. of Buffalo, Chancellor's Medal, 1944; Carnegie, Second Hon. Men., 1946; PAFA, Dawson Memorial Medal, 1947, Special Award, 1950; MMA, 1952 ($500); Buffalo/Albright, J. C. Evans Memorial Prize, 1952; Buffalo/Albright, Satter's Prize, 1955; Buffalo Historical Society, Red Jacket Medal, 1958; Hon. LHD, Kenyon College, 1944; Hon. DFA, Harvard U., 1948; Hon. DFA, Hamilton College, 1948; Hon. LLD, Valparaiso U., 1951. **One-man Exhibitions:** (first) Sunwise Turn Bookshop, NYC, 1916; Cleveland Institute of Art, 1916, 17, 21, 44; Laukhuff's Bookstore, Cleveland, 1918; Garrick Theater Library, NYC, 1919; Little Theatre, Cleveland, 1919; H. Kevorkian, NYC, 1920; Chicago/AI, 1921; Grosvenor (Gallery), London, 1923; Montross Gallery, NYC, 1924, 26, 28; Eastman-Bolton Co., Cleveland, 1928; Rehn Galleries, 1930, 31, 34-36, 39, 41, 43, 46, 47, 50, 52, 54-64, 66, 71, 73; U. of Rochester, 1932; Phillips, 1934; Philadelphia Art Alliance, 1937; Town and Country Gallery, Cleveland, 1948; MOMA, 1954; Buffalo/SUNY, 1963, 71; Cleveland/MA, 1966; Danenberg Gallery, 1970; Utica, 1970; Raydon Gallery, NYC, 1972; Kennedy Gallery, 1974. **Retrospectives:** Carnegie, 1938; Buffalo/Albright, 1944, 63; Cleveland/MA, 1953 (drawings); WMAA, 1956; AAAL, 1968. **Group:** WMAA Annuals; Chicago/AI; U. of Illinois; MOMA; MMA; Carnegie. **Collections:** Bos-

ton/MFA; Brooklyn Museum; Buffalo/Albright; Carnegie; Chase Manhattan Bank; Chicago/AI; Cleveland/MA; Detroit/Institute; Harvard U.; IBM; U. of Illinois; Indianapolis/Herron; Kalamazoo/Institute; Kansas City/Nelson; MMA; MOMA; Muskegon/Hackley; Newark Museum; New Britain; PAFA; Phillips; RISD; St. Louis/City; San Diego; Santa Barbara/MA; Sweet Briar College; Syracuse/Everson; Terre Haute/ Swope; Utica; VMFA; Valparaiso U.; WMAA; Wichita/AM; Wilmington; Youngstown/Butler. **Bibliography:** Barr 3; **Baur 1,** 7; Bazin; Beam; Blesh 1; Boswell 1; Brown; **Burchfield 1, 2, 3;** Cahill and Barr, eds.; Canaday; *Celebrate Ohio;* Cheney; Christensen; Craven 1, 2; **The Drawings of Charles E. Burchfield;** *8 American Masters of Watercolor;* Eliot; Flanagan; Flexner; Gallatin 1; Goodrich 1; Goodrich and Baur 1; Haftman; Hall;

Hunter 6; *Index of 20th Century Artists;* Jewell 2; **Jones, ed.;** Lee and Burchwood; McCurdy, ed.; Mellquist; Mendelowitz; Newmeyer; Nordness, ed.; Pagano; Pearson 1; Phillips 1; Poore; Pousette-Dart, ed.; Richardson, E. P.; Ringel, ed.; Rose, B. 1, 4; Sachs; Soby 5; Sutton; Watson, E. W. 1; Weller; Wight 2. Archives.

BURKHARDT, HANS GUSTAV. b. December 20, 1904, Basel, Switzerland. To USA 1924. **Studied:** Cooper Union, 1924-25; Grand Central School, NYC, 1928-29, with Arshile Gorky; and privately with Gorky, 1930-35. Resided Mexico, 1950-52. Traveled Europe, Mexico, USA. **Taught:** Long Beach State College, summer, 1959; U. of Southern California, 1959-60; UCLA, 1962-63; California Institute of the Arts, 1962-64; Laguna Beach (Calif.) School of Art

Charles Burchfield *Summer* 1920

and Design, 1962-64; San Fernando Valley State College, 1963-73; Otis Art Institute, summer, 1963; California State U., Northridge, 1973. **Member:** Artists Equity. **Awards:** Los Angeles/ County MA, First **P.P.**, 1946; California State Fair, **P.P.**, 1954, Second Prize, 1962; Santa Barbara/MA, Ala Story Purchase Fund, 1957; Los Angeles All-City Show, **P.P.**, 1957, 60, 61; California Watercolor Society, **P.P.**, 1962. **Address:** 1914 Jewett Drive, Los Angeles, Calif. 90046. **One-man Exhibitions:** (first) Stendahl Gallery, Los Angeles, 1939; Open Circle Gallery, 1943, 44; Chabot Gallery, Los Angeles, 1946, 47, 49; Los Angeles/County MA, 1946, 62; U. of Oregon, 1947; Hall of Art, Beverly Hills, 1948; Guadalajara, 1951; Fraymont Gallery, Los Angeles, 1951, 52; Paul Kantor Gallery, Beverly Hills, 1953; Escuela de Bellas Artes, San Miguel de Allende, Mexico, 1956, 61; Esther Robles Gallery, 1957-59; Comara Gallery, 1959; Long Beach State College, 1959; Glendale (Calif.) Public Gallery, 1960; Whittier (Calif.) Art Association, 1960; SFMA, 1961; Ankrum Gallery, 1961, 63; La Jolla, 1962; Fresno Art Center, 1962; Palm Springs Desert Museum, 1964; Freie Schule, Basel, Switzerland, 1965; San Fernando Valley State College, 1965; Bay City Jewish Community Center, San Francisco, 1966; Laguna Beach (Calif.) Art Gallery, 1966; San Diego, 1968; Michael Smith Gallery, Los Angeles, 1972; Four Oaks Gallery, South Pasadena, 1972; Moorpark College, 1974. **Retrospectives:** Falk-Raboff Gallery, Los Angeles, 1954; Pasadena/AM (10-year), 1957; Santa Barbara/MA (30-year), 1961; San Diego (40-year), 1966; Long Beach/MA, 1972; California State U., Northridge, 1973. **Group:** Los Angeles/County MA Annuals, 1940, 45, 46, 53, 54, 57, 59; Los Angeles Art Association Annuals, 1940-63; Corcoran, 1947, 51, 53; Denver/ AM, 1949, 53, 54; U. of Illinois, 1951; MMA, 1951; PAFA, 1951-53; WMAA Annuals, 1951, 55, 58; III Sao Paulo Biennial, 1955; Long Beach/MA, 1958, 60, 64; Kunsthalle, Basel, 1966; Trinity

U., San Antonio, Tex., 1967; ICA, Los Angeles, 1974; Los Angeles Municipal Art Gallery, 1975. **Collections:** Basel; California State U., Northridge; The Coca-Cola Co.; Columbia, S.C./MA; Downey Museum; Guadalajara; Hirshhorn; Home Savings and Loan Association; La Jolla; Long Beach/MA; Los Angeles/County MA; Lucerne; U. of Miami; Moorpark College; Omaha/Joslyn; Pasadena/AM; San Diego; Santa Barbara/MA; State of California; Stockholm/National. Archives.

BURLIN, PAUL. b. September 10, 1886, NYC; **d.** March 13, 1969, NYC. Self-taught in art. Traveled Europe, North Africa, USA; resided Paris, 1921-32. **Taught:** U. of Minnesota, 1949; Washington U., 1949-54; U. of Colorado, 1951; U. of Wyoming, 1952; UCLA, 1954; Union College (N.Y.), 1954-55; Chicago Art Institute School, 1960. Federal A.P.: Easel painting. **Awards:** Portrait of America, First Prize ($2,500), 1945; ART: USA:59, NYC, First Prize, 1959; Chicago/AI, Watson F. Blair Prize ($2,000), 1960; PAFA, J. Henry Schiedt Memorial Prize, 1963. **One-man Exhibitions:** (first) The Daniel Gallery, NYC, 1913, also 1914-20; Kraushaar Galleries, 1926, 27; Westheim Gallery, Berlin, 1927; de Hauke Gallery, NYC, 1942; A.A.A. Gallery, NYC, 1942, 43, 44; Vincent Price Gallery, Los Angeles, 1944; The Downtown Gallery, 1946, 49, 52, 53; U. of Minnesota, 1949; Southern Illinois U., 1950, 60; U. of Wyoming, 1952; Washington U., circ., 1954; The Stable Gallery, 1954; Poindexter Gallery, 1958, 59; The Alan Gallery, NYC, 1959; Chicago/AI, 1960; Holland-Goldowsky Gallery, Chicago, 1960; Grace Borgenicht Gallery Inc., 1963-66, 1970, 71, 73; Boston U., 1964. **Retrospective:** A.F.A., circ., 1962. **Group:** The Armory Show, 1913; WMAA Annuals; Carnegie; PAFA; WMAA, Pioneers of American Art, 1946; Walker; Corcoran; U. of Nebraska; nationally since 1913. **Collections:** Auburn U.; Britannica; Brooklyn Museum; Carleton College; Exeter; Hartford/Wads-

worth; IBM; S.C. Johnson & Son, Inc.; MOMA; U. of Minnesota; Newark Museum; Southern Illinois U.; Tel Aviv; WMAA; Washington U.; Wichita/AM. **Bibliography:** Baur 7; Biddle 4; Cheney; Coke 2; Genauer; Goodrich and Baur 1; Kootz 2; Nordness, ed.; Pagano; Passloff; Pearson 1, 2; Pousette-Dart, ed.; Richardson, E.P.; Rose, B. 1; Zaidenberg, ed. Archives.

BURLIUK, DAVID. b. July 22, 1882, Kharkov, Ukraine; **d.** January 15, 1967, Southampton, N.Y. **Studied:** Art schools in: Kazan, 1898-1902, Odessa, 1911, Munich, Moscow, 1914; Bayerische Akademie der Schonen Kunst, Munich; Academie des Beaux-Arts, Paris. To USA 1922; citizen 1930. Traveled Europe, the Orient, USA. **Taught:** Painting, art history. Federal A.P.: Easel painting. A founder (with W. Mayakovsky and W. Kamiensky) of Futurist art movement in Russia, 1911. A founder-member of Der Blaue Reiter and Der Sturm groups, 1910-14. Cofounder (1930) and publisher (with Marussia Burliuk) of art magazine *Color Rhyme.* Owned and operated Burliuk Gallery, Hampton Bays, N.Y. **Awards:** Pepsi-Cola, 1946. **One-man Exhibitions:** (first) Cherson, South Russia, 1904; galleries in Moscow and St. Petersburg, 1907; Societe Anonyme, NYC, 1924; J. B. Neumann Gallery, NYC, 1927; Morton Gallery, NYC, 1928; California Palace, 1931; Dorothy Paris Gallery, NYC, 1933-35; Boyer Gallery, NYC, 1935-39; Phillips, 1937; ACA Gallery, 1941-50, 1952-54, 1956, 58, 60, 63, 67, 69; Havana/Nacional, 1955; Galerie Maeght, Der Blaue Reiter, 1962; Galerie Stangl, Munich, 1962; Leonard Hutton Gallery, NYC, Der Blaue Reiter, 1963. **Group:** Brooklyn Museum, 1923, 26; PMA, 1962. **Collections:** Boston/MFA; Brooklyn Museum; MMA; Phillips; WMAA; Yale U. **Bibliography:** Baur 7; **Dreier 1;** Richardson, E. P.; Selz, P. 3; Soyer, R. 1. Archives.

BUTTON, JOHN. b. 1929, San Francisco. **Studied:** U. of California, Berkeley;

John Button
SoHo Sunset: Cerulean, Rose 1973

CSFA. **Taught:** Skowhegan School, 1964, 65; School of Visual Arts, NYC, 1965-67, 70-73, 74; Cornell U., 1967-68; Swarthmore College, 1969-70. **Address:** c/o Dealer. **Dealer:** The Kornblee Gallery. **One-man Exhibitions:** Tibor de Nagy Gallery, NYC, 1956, 57; The Kornblee Gallery, 1963, 65, 67, 68, 70, 72, 73; Franklin Siden Gallery, Detroit, 1967; J. L. Hudson Gallery, Detroit, 1970. **Group:** U. of North Carolina, 1966; Vassar College, Realism Now, 1968; A.F.A., Painterly Realism, 1970; MOMA, Eight Landscape Painters, circ., 1972; Boston U., The American Landscape, 1972; School of Visual Arts, NYC, The Male Nude, 1973; Omaha-/Joslyn, A Sense of Place, 1973; Hofstra U., The Male Nude, 1973. **Collections:** Chase Mahattan Bank; Chicago/AI; Columbia U.; Debevoise, Plimpton, Lyons and Gates; First National City Bank; Hirshhorn; MOMA; U. of North Carolina; Port Authority of New York.

CADMUS, PAUL. b. December 17, 1904, NYC. **Studied:** NAD, 1919-26; ASL, 1929-31, with Joseph Pennell, Charles Locke. Traveled Europe, the Mediterranean. Federal A.P.: Easel painting, 1934. Designed sets and costumes for Ballet Caravan, 1938. **Member:** NIAL. **Commissions** (mural): US Post Office, Richmond, Va., 1938. **Awards:** NIAL Grant, 1961; Norfolk, **P.P.,** 1967. **Address:** 128 Remsen Street, Brooklyn, NY. 11201. **Dealer:** The Midtown Galleries. **One-man Exhibitions:** The Midtown Galleries, 1937, 49; Baltimore/MA (three-man), 1942. **Retrospective:** The Midtown Galleries, 1968. **Group:** MOMA; MMA; WMAA, 1934, 36, 37, 38, 40, 41, 45; Chicago/AI, 1935; Hartford/Wadsworth; Williams College; Golden Gate International Exposition, San Francisco, 1939; PAFA, 1941; Carnegie, 1944, 45; Corcoran; NPG, American Self-Portraits: 1670-1973, 1974. **Collections:** Andover/Phillips; Baltimore/MA; Cranbrook; Hartford/Wadsworth; Library of Congress; MMA; MOMA; Milwaukee; NCFA; Sweet Briar College; WMAA; Williams College. **Bibliography:** American Artists Congress, Inc. 3; American Artists Group Inc. 3; Baur 7; Bazin; Boswell 1; Goodrich and Baur 1; Hall; **Johnson 3;** Kent, N.; McCurdy, ed.; Nordness, ed.; Pagano; Reese; Rose, B. 1. Archives.

CAESAR, DORIS. b. November 8, 1892, NYC; **d.** September 8, 1971. **Studied:** ASL; Archipenko School of Art; privately with Rudolph Belling. **Member:** Federation of Modern Painters and Sculptors; Sculptors Guild; Architectural League of New York; New York Society of Women Artists; National Association of Women Artists; Audubon Artists. **One-man Exhibitions:** Weyhe Gallery, 1933, 35, 37, 47, 53, 57, 59, 61, 64, 67, 69; Gallery Fifteen, NYC, 1940; Curt Valentine Gallery, NYC, 1943; Argent Gallery, NYC, 1948; Musee du Petit Palais, Paris, 1950; Katonah (N.Y.) Art Gallery, 1955; Margaret Brown Gallery, Boston, 1956; WMAA, 1959; Hartford/Wadsworth, 1960. **Group:** City of Philadelphia, Sculpture International, 1940-50; A.F.A., circ., 1953-54; MMA, 1955; New Burlington Galleries, London, 1956; I International Religious Art Biennial, Salzburg, 1958; WMAA, circ., 1959; Memphis/Brooks, 1960. **Collections:** Albion College; Andover/Phillips; Atlanta/AA; Busch-Reisinger Museum; La Casa del Libro; Cleveland/MA; Colby College; Colorado Springs/FA; Connecticut College; Dayton/AI; U. of Delaware; Father Judge Mission Seminary; Fort Worth; Grand Rapids; Hartford/Wadsworth; Harvard U.; Howard U.; Indiana U.; State U. of Iowa; Kansas City/Nelson; Memphis/Brooks; Minneapolis/Institute; U. of Minnesota; NYU; Newark Museum; PAFA; Pasadena/AM; Phoenix; Portland, Me./MA; Rockland/Farnsworth; St. Bernard's Church, Hazardville, Conn.; St. John's Abbey, Collegeville, Minn.; Syracuse U.; Utica Public Library; WMAA; Williams College. **Bibliography:** Brumme; **Bush 2; Goodrich and Baur 2.**

CAJORI, CHARLES. b. March 9, 1921, Palo Alto, Calif. **Studied:** Colorado College, 1939-40, with Boardman Robinson; Cleveland Institute of Art, 1940-42; Columbia U., 1946-48, with John Heliker, Henry Poor; Skowhegan School, summers, 1947, 48. US Air Force, 1942-46. A co-organizer of the

Tanager Gallery, NYC, 1952. Traveled Europe. **Taught:** College of Notre Dame of Maryland, 1950-56; American U., 1955-56; Cooper Union, 1956- ; Philadelphia Museum School, 1956-57; U. of California, Berkeley, 1959-60; Pratt Institute, 1961-62; Cornell U., summers, 1961, 63; Yale U., 1963-64; U. of Washington, 1964; New York Studio School, 1964- ; Queens College, 1965- **Awards:** Fulbright Fellowship (Italy), 1952; Yale U., Distinction in Arts Award, 1959; Longview Foundation Grant, 1962; Ford Foundation, **P.P.**, 1962; NIAL, 1970. **Address:** Litchfield Road, Watertown, Conn. 06795. **Dealer:** Ingber Art Gallery. **One-man Exhibitions:** (first) Tanager Gallery, NYC, 1956, also 1961; Watkins Gallery, Washington, D.C., 1956; The Bertha Schaefer Gallery, 1958; Oakland/AM, 1959; Cornell U., 1961; The Howard Wise Gallery, NYC, 1963; U. of Washington, 1964; Bennington College, 1969; Kirkland College, 1972; Landmark Gallery Inc., NYC, 1974. **Group:** Walker, Vanguard, 1955; WMAA, 1957, Annuals, 1957, 62; U. of Kentucky, 1957, 61; U. of Nebraska, 1958; Festival of Two Worlds, Spoleto, 1958; Corcoran, 1959; Brooklyn Museum, 1959; ICA, Boston, 100 Works on Paper, circ. Europe., 1959; MOMA, Abstract Watercolors and Drawings: USA, circ. Latin America and Europe, 1961-62; Chicago/AI, 1964; Santa Barbara/MA, 1964; U. of Texas, 1966, 68; U. of Washington, 1967; New School for Social Research, Protest and Hope, 1967, Humanist Tradition, 1968. **Collections:** Ciba-Geigy Corp.; Kalamazoo/Institute; U. of Kentucky; NYU; U. of Texas; WMAA; Wake Forest College; Walker; Wilmington.

CALCAGNO, LAWRENCE. b. March 23, 1913, San Francisco, Calif. US Air Force, 1941-45. **Studied:** California School of Fine Arts, 1947-50. Traveled Mexico, 1945-47; Europe, North Africa, 1950-55; Peru, Yucatan. **Taught:** U. of Alabama, 1955-56; Buffalo/SUNY, 1956-58; U. of Illinois, 1958-59; NYU,

1960; Carnegie-Mellon U., 1965-68; Honolulu Academy School, 1968. **Awards:** Yaddo Fellowship, 1961-64, 1965-68; Ford Foundation Grant, 1965-68; MacDowell Colony Fellowship, 1965-68. **Address:** 215 Bowery, NYC 10002. **One-man Exhibitions:** (first) The Little Gallery, New Orleans, 1945; College of the Pacific, 1948; Lucien Labaudt Gallery, San Francisco, 1948, 54; Numero Galleria d'Arte, Florence, Italy, 1951-52; Galeria Clan, Madrid, 1955; Studio Paul Facchetti, Paris, 1955; Martha Jackson Gallery, 1955, 58, 60, 62; U. of Alabama, 1956; Howard College, 1956; Macon (Ga.) Art Association, 1956; Buffalo/Albright, 1956; Lima, Peru, 1957; U. of Illinois, 1959; Fairweather-Hardin Gallery, 1959; Philadelphia Art Alliance, 1960; New Arts Gallery, Houston, 1960; Mexico City U., 1961; Tirca Karlis Gallery, 1961, 62, 64; McRoberts & Tunnard Gallery, London, 1961; Galerie Kobenhavn, Denmark, 1962; Gallery 31, Birmingham, Ala., 1964; The Osborne Gallery, NYC, 1964; Carnegie, 1965; Houston/MFA, 1965; Franklin Siden Gallery, Detroit, 1965, 66; Esther Robles Gallery, 1966; Meredith Long Galleries, Houston, Tex., 1968; U. of New Mexico, 1973; Yares Gallery, Scottsdale, 1975. **Retrospective:** Westmoreland County/MA, 1967. **Group:** Art: USA: Now, circ., 1962-67; WMAA Annuals, 1963, 65, 67; Smithsonian, 1966; Flint/Institute, I Flint Invitational, 1966. **Collections:** U. of Alabama; Allentown/AM; Baltimore/MA; Boston/MFA; Buffalo/Albright; California Palace; Carnegie; Chase Manhattan Bank; Dayton/AI; Denver/AM; Honolulu Academy; Houston/MFA; ICA, Boston; U. of Illinois; Lima, Peru; Los Angeles/County MA; MOMA; McCann-Erickson, Inc.; NCFA; NYU; U. of Nebraska; New York State Art Commission, Albany; Norfolk; Norfolk/Chrysler; Phoenix; RISD; Reynolds Metals Co.; U. of Rochester; SFMA; Santa Barbara/MA; Santa Fe, N.M.; Slater; Smithsonian; Union Carbide Corp.; WGMA; WMAA; Walker; Westmoreland County/MA. **Bibliography:** Baur 5; Blesh 1; McChesney;

Nordness, ed. Archives.

CALDER, ALEXANDER. b. July 22, 1898, Philadelphia, Pa. **d.** November 11, 1976. **Studied:** Stevens Institute of Technology, 1915-19; ASL, 1923-26, with George Luks, Guy Du Bois, Boardman Robinson, John Sloan. Traveled Europe, USA, Latin America, India. To Paris 1928. The subject of three films: "Alexander Calder: Sculpture and Constructions" (MOMA, 1944); "Alexander Calder" (Burgess Meredith and Herbert Matter, 1951); "Calder's Circus" (Pathé, 1961). Two Calder sequences are in the film "Dreams That Money Can Buy" (Hans Richter, 1948). Designed sets for: "Horizons" and "Four Movements" (by Martha Graham, NYC, 1936); "Socrates" (by Eric Satie, 1936); *Happy as Larry* (by Donagh MacDonagh, NYC, 1946); *Balloons* (by Padraic Colum, Boston, 1946); "Symphonic Variations" (by Tatiana Leskova, 1949). **Commissions:** Spanish Pavilion, Paris World's Fair, 1937; New York World's Fair, 1939; Hotel Avila, Caracas, 1940; Terrace Plaza Hotel, Cincinnati, 1945; Aula Magna, University City, Caracas, 1952; General Motors Corp., 1954; New York International Airport, 1958; UNESCO, Paris, 1958. **Awards:** MOMA, Plexiglas Sculpture Competition, First Prize, 1939; XXVI Venice Biennial, First Prize, 1952; Sao Paulo, 1953; City of Philadelphia, Outstanding Citizen Award, 1955; Stevens Institute of Technology, Medal, 1956; Carnegie, First Prize, 1958; Architectural League of New York, Gold Medal, 1960; Brandeis U., Creative Arts Award, 1962. **Address:** Roxbury, Conn.; Sache (Indre-et-Loire), France. **Dealers:** Perls Galleries; Galerie Maeght. **One-man Exhibitions:** (first) Weyhe Gallery, 1928 (wire sculpture); Billiet Gallery, Paris, 1929; Neumann-Nierendorf Gallery, Berlin, 1929; 56th Street Gallery, NYC, 1930; Galerie Percier, Paris 1931; Galerie Vignon, Paris, 1932 (first mobiles exhibited); Julien Levy Galleries, NYC, 1932; Galerie Pierre Colle, Paris, 1933; Pierre Matisse Gallery, 1934, 36, 37, 1939-43;

The U. of Chicago, 1935; Arts Club of Chicago, 1935; Honolulu Academy, 1937; Mayor Gallery, London, 1937; The Willard Gallery, 1940 (first jewelry exhibited), 1941, 42; Arts and Crafts Club, New Orleans, 1941; SFMA, 1942; Andover/Phillips, 1943; Buchholz Gallery, NYC, 1944, 45, 47, 49; The Kootz Gallery, NYC, 1945; Galerie Louis Carre, Paris, 1946; Cincinnati/AM, 1946; Berne, 1947 (two-man); Amsterdam/Stedelijk, 1947 (two-man), 1950, 59, 69; Brazilian Ministry of Education, Rio de Janeiro, 1948; Sao Paulo, 1948; Margaret Brown Gallery, Boston, 1949; Galerie Maeght, 1949, 64, 66, 71, 73, 75; Galerie Blanche, Stockholm, 1950; MIT, 1950; Lefevre Gallery, London, 1951; Gallery R. Hoffman, Hamburg, 1954; Palais des Beaux-Arts, Brussels, 1960; Kunstgewerbemuseum, Zurich, 1960; Galerie d'Art Moderne, Basel, 1962; Galleria d'Arte del Naviglio, Milan, 1964; Perls Galleries, 1966-68; Obelisk Gallery, 1967; Kiko Gallery, Houston, 1968; Wittenborn Gallery, NYC, 1968; Dayton's Gallery 12, Minneapolis, 1968; Perls Galleries, 1968, 71, 72, 73, 74; Gimpel Fils, 1969, 71; Grand Rapids, 1969; Musee d'Art Moderne, Geneva, 1969; Fundacion Eugenio Mendoza, Caracas, 1969; Leonard Hutton Gallery, NYC, 1972; Corcoran, 1972; Parker Street 470 Gallery, Boston, 1972; Sala Pelaires, Palma, Majorca, 1972; Source Gallery, San Francisco, 1974; Deson-Zaks Gallery, Chicago, 1975. **Retrospectives:** Springfield, Mass./MFA, 1938; MOMA, 1943; Tate, 1962; SRGM, 1964; Akademie der Kunst, Berlin, 1967; Foundation Maeght, 1969; Long Beach/MA, 1970; Chicago/Contemporary, 1974. **Group:** Artists' Gallery, NYC, 1926 (first paintings exhibited); Salon des Humoristes, Paris, 1927; Salon des Artistes Independants, Paris, 1929, 30; MOMA, Painting and Sculpture, 1930; Salon des Surindependants, Paris, 1930; WMAA; Chicago/AI; SFMA; Cincinnati/AM, 1942; Berne, 1947; Yale U., 1950; Kestner-Gesellschaft, Hannover, 1954; Documenta III, Kassel, 1964. **Collections:** Amsterdam/Stedelijk; Andover/Phil-

lips; U. of Arkansas; Arts Club of Chicago; Basel; Chicago/AI; Dallas/MFA; Frankfurt am Main; Hartford/Wadsworth; Honolulu Academy; Lodz; MMA; MOMA; Mannheim; Marshall Field & Co.; Montreal/MFA; Moscow/Western; Museum of Science and Industry, Chicago; PAFA; Phillips; Pittsfield/Berkshire; SRGM; St. Louis/City; U. of St. Thomas (Tex.); Sao Paulo; Smith College; Stockholm/National; Toronto; VMFA; WMAA; Washington U.; Yale U. **Bibliography: Alexander Calder**, 1967; **Alexander Calder**, 1971; Baldinger; Barr 1; Battcock, ed.; Baur 5, 7; Beam; Biederman 1; Bihalji-Merin; Blesh 1; Breton 3; Brion 1; Brumme; Calas, N. and E.; **Calder 1, 2; Calder and Liedl;** Canaday; Cheney; Christensen; Craven, W.; Davis, D.; Evans, ed.; Flanagan; Gaunt; Gertz; Giedion-Welcker 1, 2; Goodrich and Baur 1; Guggenheim, ed.; Haftman; Hayter 2; Henning; Hess, T. B. 1; Hulten; Hunter 6; Hunter, ed.; Jakovski; Janis and Blesh 1; Janis, S.; Kozloff 3; Kuh 1, 2, 3; Langui; Licht, F.; Lowry; Lynton; McCurdy, ed.; Mellquist; Mendelowitz; *Metro; Monumenta;* **Mulas and Arnason;** Myers 2; Neumeyer; Paalen; Pearson 2; Ragon 1, 2; Ramsden 1, 2; Read, 1, 3, 5, 6; Rickey; Ritchie 1, 3; Rodman 1, 3; Rose, B. 1, 4; Rubin 1; Sachs; Selz, J.; Seuphor 2, 3; Soby 1, 5; Sutton; **Sweeny 1;** Tomkins; Tomkins and Time-Life Books; Trier 1, 2; Tuchman 1; Valentine 2; Waldberg 4; "What Abstract Art Means to Me"; Weller; Wilenski. Archives.

CALLAHAN, KENNETH. b. October 30, 1907, Spokane, Wash. Self-taught in art. Traveled USA, Europe, Central America, Mexico, Southeast Asia, South Pacific. **Taught:** Privately and as Visiting Artist in various parts of the USA; Boston U., 1954-66; Skowhegan School, 1958, 63, 66; Port Townsend Summer School, 1974. Curator, Seattle/AM, 1933-53. Subject of "Callahan the Artist," a 30-minute color film, 1973; overall design for *Macbeth,* Seattle Repertory Theater, 1973. **Commissions** (murals): Marine Hospital, Seattle; US Post Offices, Centralia and Anacostes, Wash., and Rugby, N.D.; Washington State Library, Olympia, Wash.; Syracuse U., 1964; Seattle Civic Center, 1966. **Awards:** J. S. Guggenheim Fellowship, 1954; AAAL, Arts and Letters Grant, 1968; State of Washington Governor's Award, 1968. **Address:** P.O. Box 493, Long Beach, Wash. 98631. **Dealer:** Kraushaar Galleries. **One-man Exhibitions:** (first) American-British Art Center, NYC, 1944; Maynard Walker Gallery, NYC, 11 exhibitions 1946-64; SFMA; Santa Barbara/MA; La Jolla; Colorado Springs/FA; Phoenix; Roswell; Williams College; Columbia, S.C./MA; U. of Arkansas; U. of Rochester; Detroit/Institute; Renaissance Society, Chicago; Seattle/AM; Portland, Ore./AM; Spokane Art Center of Washington State U.; Tacoma; Galerie George Giraux, Brussels, 1947; Boston U., 1966; Kraushaar Galleries, 1967, 69, 71, 74. **Retrospectives:** Emily Winthrop Miles Collection, circ., 1961-64; Syracuse/Everson; Henry Art Gallery, Seattle, circ., 1973. **Group:** Japan; Formosa; Korea; Phillippines; Australia; New Zealand; Brazil; USA; Great Britain; France; Italy; Sweden; Denmark; Yugoslavia; Germany. **Collections:** Andover/Phillips; Beloit College; Brooklyn Museum; Chase Manhattan Bank; Chicago/AI; The U. of Chicago; Colby College; Columbus; Corcoran; Des Moines; Detroit/Institute; Fort Worth; Garnett Public Library; La Jolla; MMA; MOMA; Memphis/Brooks; U. of Michigan; Minneapolis/Institute; NCFA; U. of Nebraska; Norfolk; PAFA; PMA; Phillips; Phoenix; Portland, Ore./AM; U. of Rochester; SFMA; SRGM; St. Louis/City; Santa Barbara/MA; Seattle/AM; Spelman College; Springfield, Mo./AM; Syracuse U.; Tacoma; Utica; WMAA; Walker; Washington State U.; U. of Washington; Wichita/AM. **Bibliography:** Baur 7; Bruce and Watson; Cheney; Eliot; Nordness, ed.; Pousette-

Dart, ed.; Richardson, E. P.; Ritchie 1. Archives.

CALLERY, MARY. b. June 19, 1903, NYC. **Studied:** ASL, with Edward McCarten; privately in Paris with Jacques Loutchansky. Resides in Paris part of each year. **Taught:** Black Mountain College. **Commissions:** Aluminum Co. of America, 1953; P.S. 34, NYC, 1954; Gen. George W. Wingate High School, Brooklyn, N.Y., 1955; Lincoln Center; Exxon Building, NYC; Brooklyn Court House, N.Y. **Address:** 168 East 68 Street, NYC 10021; 29 Place du Marche St. Honore, 75001 Paris, France. **One-man Exhibitions:** (first) Buchholz Gallery, NYC, 1944; Arts Club of Chicago, 1946; Curt Valentine Gallery, NYC, 1947, 49, 50-52, 55; Salon du Mai, Paris, 1949; Margaret Brown Gallery, Boston, 1951; Galerie des Cahiers d'Art, 1954; M. Knoedler & Co., NYC, 1957, 61, 65, Paris, 1962; B. C. Holland Gallery, 1968. **Group:** Salon des Tuileries, Paris; MOMA; WMAA; Chicago/AI; Houston/MFA, 1939; St. Louis/City, 1946; PMA, 1949; Utica, 1956; Dallas/MFA, 1958; Brussels World's Fair, 1958. **Collections:** Alcoa; Andover/Phillips; CIT Corporation; Cincinnati/AM; Detroit/Institute; Eastland Shopping Center, Detroit; 525 William Penn Plaza; Hartford/Wadsworth; MOMA; NYU; Publishers Printing Co.; SFMA; Toledo/MA; WMAA. **Bibliography:** Baur 7; Gertz; Giedion-Welcker 1; Licht, F.; Ramsden 2; Read 3; Ritchie 3; Seuphor 3; Trier 1; Valentine 2; Zervos and Adams.

CAMPOLI, COSMO. b. 1922, South Bend, Ind. **Studied:** Chicago Art Institute School, 1950-52; Academie de la Grande Chaumiere. Traveled France, Spain, Italy, England. **Taught:** Hull House, Chicago, 1947, 48, 49; Contemporary Art Workshop, Chicago, 1952-69; Institute of Design, Chicago, 1953-69; The U. of Chicago, summers, 1963-66. **Member:** President, Active

Arts Collaborative, Chicago, 1974. **Awards:** Chicago/AI, James Nelson Raymond Traveling Fellowship, 1950; Ford Foundation Grant, 1960; Chicago/AI, Sixteen Sculptors, First Prize. **Address:** 5326 South Cornell Street, Chicago, Ill. 60615. **One-man Exhibitons:** Allan Frumkin Gallery, NYC and Chicago; Contemporary Art Workshop, Chicago; Institute of Design, Chicago; Illinois State Council on the Arts, circ., 1971-73. **Retrospective:** Chicago/Contemporary, 1971; **Group:** Beloit College, 1958; MOMA, New Images of Man, 1959; Michigan State U.; Lake Forest College, 1960; Galerie du Dragon, Paris, Eight Chicago Artists, 1962; U. of Colorado, 1962; Silvermine Guild, 1962; Chicago/AI, Exhibition Momentum; Madrid/Nacional, II Biennial, 1969; Festival of Two World, Spoleto, 1972; The U. of Chicago, Chicago-Style Sculpture, 1974. **Collections:** Exchange National Bank; MOMA; RAC; U. of Southern Illinois; VMFA; Willowbrook High School. **Bibliography:** Schulze.

CANDELL, VICTOR. b. May 11, 1903, Budapest, Hungary. To USA 1921; citizen 1927. Self-taught. Traveled Europe, resided Paris 1928-31. Federal A.P.: Easel pictures. **Taught:** Brooklyn Museum School, 1946-54; Columbia U., 1952-56; Cooper Union, 1954-68; Provincetown Workshop, summers, 1958- ; NYU, 1968- ; and privately since 1940. **Member:** International Institute of Arts and Letters; American Association of University Professors; Audubon Artists; Artists Equity. **Awards:** Audubon Artists, 1952, Emily Lowe Prize, 1956, The Lamont Award, 1961; AAAL, Childe Hassam Award; MacDowell Colony Fellowship; Silvermine Guild Prize for Painting ($500); Audubon Artists, Silver Medal, 1973. **Address:** 22 East 10 Street, NYC 10003. **Dealer:** Grand Central Galleries. **One-man Exhibitions:** Grand Central Moderns, NYC, 1954-59, 1964; Philadelphia Art Alliance, 1958; Hofstra College, 1959; Silvermine Guild, 1962; Scranton/Ever-

hart; Mortimer Brandt, NYC. **Retrospective:** Molloy College, Rockville Centre, N.Y., 1974. **Group:** WMAA Annuals, 1951-61; Carnegie, 1952, 55; Brooklyn Museum, Watercolor Biennials; U. of Illinois, 1952, 55, 57; Corcoran, UNESCO Exhibition; Audubon Artists; U. of Nebraska; MOMA, American Painting, circ. Europe, 1956-57; PAFA, 1964. **Collections:** Brandeis U.; Carnegie; Corcoran; U. of Illinois; MMA; Montclair/AM; Mount Holyoke College; NIAL; NYU; U. of Nebraska; Newark Museum; U. of Notre Dame; Slater; Syracuse U.; U. of Texas; US Treasury Department; Utica; WMAA. **Bibliography:** American Artists Congress, Inc. Archives.

CAPARN, RHYS. b. July 28, 1909, Onteora Park, N.Y. **Studied:** Bryn Mawr College; privately in Paris with Edouard Navellier; privately in New York with Alexander Archipenko. Traveled Europe; resided France. **Taught:** Dalton School, NYC, 1946-55, 1960-72. Master Institute of United Arts, Inc., NYC, 1963- . **Member:** Federation of Modern Painters and Sculptors; Sculptors Guild; American Abstract Artists; International Institute of Arts and Letters. **Commissions:** Brooklyn Botanic Garden; Wollman Library, Barnard College; National Furniture Mart, NYC; private portrait commissions. **Awards:** MMA, American Sculpture, Second Prize, 1951; New York State Fair, First Prize for Sculpture, 1958; National Association of Women Artists, Medal of Honor for Sculpture, 1960, 61. **Address:** Taunton Hill Road, Newtown, Conn. 06470. **Dealer:** The New Bertha Schaefer Gallery. **One-man Exhibitons:** (first) Delphic Studios, NYC, 1933, also 1935; Architectural League of New York, 1941; New York Zoological Park (Bronx), 1942; Wildenstein & Co., NYC, 1944, 47; Dartmouth College, 1949, 55; John Heller Gallery, NYC, 1953; Doris Meltzer Gallery, NYC, 1956, 59, 60; La Boetie, NYC, 1970; The New Bertha Schaefer Gallery, 1973. **Retrospective:** Riverside Museum, NYC, 1961. **Group:** MOMA, Fifteen Sculptors, circ., 1941; WMAA Annuals, 1941, 53, 54, 56, 60; Musee du Petit Palais, Paris, 1950; PAFA, 1951-53, 60, 64; ICA, London/ Tate, International Unknown Politcal Prisoner Competition, 1953; Silvermine Guild, 1956; USIA, American Drawings, Prints, and Watercolors, circ. Europe, 1957; VMFA, American Sculpture Today, 1958; Claude Bernard, Paris, 1960; NIAL, 1968; PMA/Museum of the Philadelphia Civic Center, Focus, 1974. **Collections:** Barnard College; Brandeis U.; Bryn Mawr College; Colorado Springs/FA; Corcoran; Dartmouth College; Harvard U.; La Jolla; Museum of the City of New York; Norfolk/Chrysler; Raleigh/NCMA; St. Louis/City; WMAA; Youngstown/Butler. **Bibliography:** *Art: A Woman's Sensibility;* Seuphor 3. Archives.

CAREWE, SYLVIA. b. February 22, 1914, NYC. **Studied:** Columbia U.; Atelier 17, NYC; New School for Social Research, with Yasuo Kuniyoshi; Hofmann School. Traveled Europe extensively; Mexico; St. Thomas. **Commissions:** First American artist to be commissioned by the College de la Manufacture d'Aubusson, 1957; several portrait commissions. Lectures. **Address:** 500 East 83 Street, NYC 10028. **One-man Exhibitions:** Three Arts Gallery, Poughkeepsie, 1947, 52, 54; ACA Gallery, 1948, 51, 53, 54, 56, 58, 61; Barnett Aden Gallery, Washington, D.C., 1950; Indiana U., circ., 1955; Galerie Granoff, Paris, 1957; Condon Riley Gallery, NYC, 1959; Youngstown/Butler, 1960; French & Co. Inc., NYC, 1962; Fordham U., 1970. **Group:** MOMA; WMAA; Brooklyn Museum; Boston/MFA; Bruge, Belgium; Smith College; Silvermine Guild; The Print Club, Philadelphia. **Collections:** Brandeis U.; Djakarta Museum; Howard U.; Paris/Moderne; Tel Aviv; WMAA; Youngstown/Butler. Archives.

CARLES, ARTHUR B. b. 1882, Philadelphia, Pa.; **d.** June 18, 1952, Chestnut Hill, Pa. **Studied:** PAFA. Traveled Spain,

France, Italy. **Taught:** PAFA, 1917-25. **Awards:** PAFA: Cresson Fellowship; Walter Lippincott Prize, 1917; Stotesbury Prize, 1919; J. Henry Schiedt Memorial Prize, 1939; Joseph E. Temple Gold Medal, 1930; Chicago/AI, The Mr. & Mrs. Frank G. Logan Prize. **One-man Exhibitions:** Montross Gallery, NYC, 1922; Gimbel Gallery, Philadelphia, 1935; Marie Harriman Gallery, NYC, 1936; PAFA, 1941, 53; Philadelphia Art Alliance, 1944; Karl Nierendorf Gallery, NYC, 1944; PMA (two-man), 1946; Dubin Gallery, Philadelphia, 1953; Oberlin College (two-man), 1955; The Graham Gallery, 1959; Peal Gallery, Philadelphia, 1967. **Retrospective:** PAFA, 1953. **Group:** The Armory Show, 1913; WMAA, 1963; PAFA. **Collections:** Chicago/AI; MOMA; U. of Nebraska; PAFA; PMA; SFMA; Syracuse U. **Bibliography:** *Avant-Garde Painting and Sculpture;* Baur 7; Richardson, E. P.; Rose, B. 1, 4. Archives.

CASARELLA, EDMOND. b. September 3, 1920, Newark, N.J. **Studied:** Cooper Union, 1938-42; Brooklyn Museum School, 1949-51, with Gabor Peterdi. US Army, 1944-46. Traveled Italy and Greece, 1951-52, 1960-61, France. **Taught:** Brooklyn Museum School, 1956-60; Yale-Norfolk Summer Art School, 1958; NYU, 1962; Cooper Union; ASL; Hunter College, 1963- ; Columbia U., summers, 1963, 64; Pratt Graphic Art Center, 1964; Yale U., 1964- Rutgers U., 1964- ; Pratt Institute, 1964- ; Finch College, NYC, 1969-74; Manhattanville College of the Sacred Heart, 1973, 74. **Member:** SAGA; Sculptors Guild. National Youth Administration: Designed posters. **Awards:** Fulbright Fellowship (Italy), 1951; U. of Illinois, Graphic Art exhibitions, **P.P.**, 1954, 56; L. C. Tiffany Grant, 1955; Bay Printmakers Society, Oakland, 1955, 57; Library of Congress, 1955, 56, 58; The Print Club, Philadelphia, 1956; Northwest Printmakers Annual, 1956; Boston Printmakers, 1957; New York State Fair, 1958; PCA, 1959; Brooklyn Museum, Print and Watercolor Biennials; Guggenheim Foundation Fellowship, 1960; SAGA, 100 Prints of the Year, 1962, 63. **Address:** 83 East Linden Avenue, Englewood, N.J. 07631. **Dealer:** Cramer Gallery. **One-man Exhibitions:** Brooklyn Museum, 1952 (two-man); The Zabriskie Gallery, 1953, 56; Obelisk Gallery, Washington, D.C., 1956, 61; Louisiana State U., 1957; U. of Mississippi, 1957; U. of Kentucky, 1964; Rutgers U., 1964; Hudson River Museum, Yonkers, N.Y., 1965; Montclair State College, 1966; Trenton State College, 1967; Merida Gallery, Inc., 1967, 68; Louisville/Speed, 1968-69; Naroden Muzej na Bitolkiot Kraj, Bitola, Yugoslavia; Free Public Library, Fair Lawn, N.J., 1970; Cramer Gallery, 1972, 73. **Retrospectives:** Naroden Muzej na Grad Skopje, Skopje, Yugoslavia, 1967; YMHA, Hackensack, N.J., 1969. **Group:** Brooklyn Museum, Print and Watercolor Biennials; International Print Exhibition, Salzburg, 1952, 58; PAFA, 1953, 59, 63; Bay Printmakers Society, Oakland, 1955-57; Library of Congress, 1955, 56, 58; Corcoran, 1955, 56, 58, 59, 63; The Print Club, Philadelphia, 1956; U. of Illinois, 50 Contemporary American printmakers, 1956; Boston/MFA, 1957; Grenchen, Graphics International, 1958; I Inter-American Paintings and Prints Biennial, Mexico City, 1958; The Pennsylvania State U., 10 American Printmakers, 1959; Trenton/State, Contemporary Printmakers, 1959; Victoria and Albert Museum, 1959; Gallery of Modern Art, Ljubljana, Yugoslavia, III & IV International Exhibitions of Prints, 1959, 61; WMAA, American Prints Today, 1959, 62; Yale U., 1960; Cincinnati/AM, 1960; Philadelphia Art Alliance, 1960; American Academy, Rome, 1960, 61; Memphis/Brooks, 1960-62; WMAA, American Painting, 1961; A.A.A. Gallery, NYC, 100 Prints of the Year, 1962; New York Foundation/USIA, American Prints Around the World, circ., 1963; Los Angeles/County MA, 1963; Riverside Museum, 1963; WMAA, New York Hilton Hotel Collection, 1963; USIA,

Graphic Arts—USA, circ. USSR, 1963; Jewish Museum, 100 Contemporary Prints, 1964; St. Louis/City, 1964; New York World's Fair, 1964-65; I Triennale Internazionale della Xilografia Contemporanea, Capri, 1969; Monstra Internazionale della Xilografia Contemporanea, Bologna, 1971; Madrid/Nacional, Exposicion Internacional de la Xilografia Contemporanea, 1972; Landmark Gallery Inc., NYC, 1973, 74; Bergen Community College, Outdoor Sculpture, 1974. **Collections:** Bibliotheque Nationale; Brooklyn Museum; U. of Illinois; Library of Congress; Louisville/Speed; Trenton/State; Victoria and Albert Museum. **Bibliography:** Chaet; Peterdi.

CASTELLON, FEDERICO. b. September 14, 1914, Almeria, Spain; **d.** September 27, 1971, NYC. Self-taught in art. Traveled Europe and Latin America extensively; resided Spain, 1914-21, 1961-62; France, 1934-36, 1962-63. US citizen 1943. **Taught:** Columbia U., 1948-61; Pratt Institute, 1951-61, 1964-1971; Queens College, 1964; NAD, 1964- ; **Member:** SAGA; NAD; NIAL. **Commissions:** Illustrations for numerous books and magazines; two prints for International Graphic Arts Society. **Awards:** Four-year Fellowship from the Spanish Republic, 1933; Chicago/AI, The Mr. & Mrs. Frank G. Logan Prize, *ca.* 1940; PAFA, Alice McFadden Eyre Medal, 1940; A.A.A. Gallery, NYC, National Print Competition, First Prize, 1948; Library of Congress, First Pennell **P.P.**, 1949; Guggenheim Foundation Fellowship, 1940, 50; NIAL Grant, 1950; SAGA, 1963. **One-man Exhibitions:** (first) Raymond and Raymond, Inc., NYC; Weyhe Gallery, 1934-41; A.A.A. Gallery, NYC, 1947-52; Bucknell U.; Philadelphia Art Alliance; Albany/Institute; Bennington College; Swarthmore College; Princeton U.; Columbia U.; California Palace; Madrid/Nacional; Caracas; La Paz, Bolivia; Argentina/Nacional; Asuncion, Paraguay; Montevideo/Municipal; a gallery in Paris; Bombay; Los Angeles/County MA; Slater, 1969. **Group:** College d'Espagne, Paris, 1934;

Corcoran; Chicago/AI; Brooklyn Museum; PAFA; WMAA; SAGA. **Collections:** Brooklyn Museum; Chicago/AI; Dartmouth College; U. of Georgia; Kalamazoo/Institute; Library of Congress; MMA; U. of Minnesota; Montclair/AM; NYPL; PAFA; PMA; Princeton U.; Syracuse U.; Utica; WMAA; Yale U. **Bibliography:** American Artists Group Inc. 3; Baur 7; Frost; Goodrich and Baur 1; Mendelowitz; Pearson 1; Reese; Zigrosser 1. Archives.

CAVALLON, GIORGIO. b. March 2, 1904, Sorio, Vicenza, Italy. To USA 1920. **Studied:** NAD, 1925-30; with C. W. Hawthorne, *ca.* 1929; Hofmann School, 1935-36. Resided Italy, 1930-33. **Taught:** Pratt Institute, 1952, 54 (woodworking); U. of North Carolina, 1964; Yale U., 1964; Columbia U., summer, 1969. **Member:** American Abstract Artists, 1936-57. Federal A.P.: Mural project assistant to Arshile Gorky, and easel painting. **Awards:** L. C. Tiffany Grant, 1929; Guggenheim Foundation Fellowship, 1966-67. **Address:** 178 East 95 Street, NYC 10028. **Dealer:** A. M. Sachs Gallery. **One-man Exhibitions:** (first) Bottege d'Arte, Vicenza, Italy, 1932; ACA Gallery, 1934; Eighth Street Playhouse, NYC, 1940; Charles Egan Gallery, 1946, 48, 51, 54; The Stable Gallery, 1957, 59; The Kootz Gallery, NYC, 1961, 63; U. of North Carolina, 1964; A. M. Sachs Gallery, 1969, 71, 72, 74, 76. **Group:** WMAA, 1947, 48, 59, 61; Salon des Realites Nouvelles, Paris, 1950; MOMA, Abstract Painting and Sculpture in America, 1951; MMA, American Watercolors, Drawings and Prints, 1952; U. of Nebraska, 1955; Documenta II, Kassel, 1959; Chicago/AI, 1959; Carnegie, 1959, 61; Walker, 1960; SRGM, Abstract Expressionists and Imagists, 1961; U. of Illinois, 1963; MOMA, 60 Modern Drawings, 1963; PAFA Annual, 1966; WMAA, The 1930's, 1968; A.F.A., 1968-69; MOMA, The New American Painting and Sculpture, 1969; A.F.A., Geometric Abstraction of the 1930s, 1972. **Collections:** American Republic Insurance Co.; Avco

Giorgio Cavallon *Untitled* 1974-75

Corp.; Avon Products; Buffalo/Albright; U. of California; Chase Manhattan Bank; Ciba-Geigy Corp.; Continental Grain Company; MOMA; Marine Midland Bank and Trust Co.; NYU; U. of North Carolina; Prudential Insurance Co. of America; SRGM; The Singer Company Inc.; U. of Texas; Tishman Realty & Construction Co. Inc.; Union Carbide Corp.; WMAA. **Bibliography:** Blesh 1; Hess, T. B. 1; McCurdy, ed.; O'Hara 1; Pousette-Dart, ed.; Ritchie 1; Rose, B. 1. Archives.

CHAET, BERNARD. b. March 7, 1924, Boston, Mass. **Studied:** Tufts U., BS.Ed.; Boston Museum School, with Karl Zerbe. Traveled Europe; resided Paris, 1949. **Taught:** Yale U., 1951- ; American Academy, Rome. Contributing editor, *Arts* Magazine, 1956-59. **Awards:** Silvermine Guild Award, 1955; Yale U., Senior Faculty Fellowship, 1962; St. Paul Art Center, Drawing USA, Merit Award, 1963; National Council on the Arts, Grant, 1966-67. **Address:** 141 Cold Spring Street, New Haven, Conn. **Dealer:** Alpha Gallery. **One-man Exhibitions:** (first) Boris Mirski Gallery, Boston, 1946, also 1951, 54, 57, 59, 61, 65; The Bertha Schaefer Gallery, 1954; The Stable Gallery, 1959, 61, 67; Cornell U., 1961; Alpha Gallery, 1967, 68, 69, 71; Swarthmore College, 1971; Haslem Fine Arts, Inc., 1973; The Forum Gallery, 1975. **Retrospective:** Brockton/Fuller, 1970. **Group:** U. of Illinois, 1951, 53, 61; PAFA; Los Angeles/County MA; Phillips; Chicago/AI; U. of Nebraska; ICA, Boston, 6 New England Painters, 1954; Corcoran; Contemporary American Drawings,

circ. France, 1957-58; Hartford/Wadsworth, 8 From Connecticut, 1961; Detroit/Institute; MOMA; Brooklyn Museum. **Collections:** Andover/Phillips; Boston/MFA; Brandeis U.; Brooklyn Museum; Brown U.; U. of Connecticut; Cortland/SUNY; Dartmouth College; Harvard U.; Indiana U.; Lincoln, Mass./De Cordova; U. of Massachusetts; RISD; UCLA; Worcester/AM; Yale U. **Bibliography: Chaet.**

CHAMBERLAIN, ELWIN. b. May 19, 1928, Minneapolis, Minn. **Studied:** Minneapolis Institute School; U. of Idaho, BA; U. of Wisconsin, MA. US Navy, 1944-46. **Address:** 222 Bowery, NYC. **One-man Exhibitions:** Hewitt Gallery, NYC, 1953, 56; "G" Gallery, NYC, 1959; Lee Nordness Gallery, NYC, 1961. **Group:** Boston/MFA; Bresler Galleries Inc., Milwaukee; Lincoln, Mass./De Cordova; PAFA, 1953; Denver/AM, 1955; Layton School of Art; Philadelphia Art Alliance; Princeton U.; RISD; Walker; WMAA; Yale U., 1955, 57; Festival of Two Worlds, Spoleto, 1958. **Collections:** Sara Roby Foundation; WMAA. **Bibliography:** Nordness, ed.

CHAMBERLAIN, JOHN. b. 1927, Rochester, Ind. **Studied:** Chicago/AI School, 1950-52; Black Mountain College, 1955-56. US Navy, 1943-46. **Address:** 222 Bowery, NYC 10012 **Dealer:** Leo Castelli Inc. **One-man Exhibitons:** (first) Wells Street Gallery, Chicago, 1957; Davida Gallery, Chicago, 1958; Martha Jackson Gallery, 1960; Dilexi Gallery, Los Angeles, 1962; Dilexi Gallery, San Francisco, 1962; Leo Castelli Inc., 1962 (two-man), 1964, 65, 68, 69, 71, 73; Leo Castelli Warehouse, 1969; The Pace Gallery, Boston, 1963; Robert Fraser Gallery, 1963 (two-man); Dwan Gallery, Los Angeles, 1965; Cleveland/MA, 1967; Contemporary Arts Center, Cincinnati, 1968; Mizuno Gallery, 1969; LoGiudice Gallery, Chicago, 1970; Taft Museum (two-man), 1972; Dag Hammarskjold Plaza, NYC, 1973; Walter Kelly Gallery, Chicago, 1974. **Retrospective:** SRGM, 1971. **Group:** MOMA, Recent Sculpture USA, 1959; Buenos Aires Museum of Modern Art, International Sculpture Exhibition, 1960; Martha Jackson Gallery, New Media—New Forms, I & II, 1960, 61; WMAA Annuals, 1960, 62, 65; Sculpture Annuals, 1966, 68; Galerie Rive Droite, Paris, Le Nouveau Realisme, 1961; VI Sao Paulo Biennial, 1961; MOMA, The Art of Assemblage, circ., 1961; Chicago/AI, 1961, 67; Carnegie, 1961, 67; Seattle World's Fair, 1962; SRGM, The Joseph H. Hirshhorn Collection, 1962; Battersea Park, London, International Sculpture Exhibition, 1963; Musee Cantonal des Beaux-Arts, Lausanne, I Salon International de Galeries Pilotes, 1963; Pasadena/AM, New American Sculpture, 1964; New York World's Fair, 1964-65; Tate, Painting and Sculpture of a Decade, 1954-64, 1964; XXXII Venice Biennial, 1964; Jewish Museum, 1964; ICA, U. of Pennsylvania, The Atmosphere of '64, 1964, also 1965; Flint/Institute, 1965; ICA, Boston, Painting without a brush, 1965; Indianapolis/Herron, 1965, 69; WMAA, Contemporary American Sculpture, Selection I, 1966; MOMA, The 1960's, 1967; HemisFair '68, San Antonio, Tex., 1968; Swarthmore College, 1969; Trenton/State, Soft Art, 1969; York U., Toronto, 1969; ICA, U. of Pennsylvania, Highway, 1970; Indianapolis, 1970, 72; Cincinnati/Contemporary, Monumental Art, 1970; WMAA Sculpture Annual, 1970; MOMA, Younger Abstract Expressionists of the Fifties, 1971; Hofstra U., Art around the Automobile, 1971; Dusseldorf/Kunsthalle, Prospect '71, 1971. **Collections:** Buffalo/Albright; Los Angeles/County MA; MOMA; U. of North Carolina; Rome/Nazionale; WMAA. **Bibliography:** Battcock, ed.; Craven, W.; Hunter, ed.; Janis and Blesh 1; Kozloff 3; Kuh 3; Licht, F.; Lippard 5; *Metro; Monumenta;* Read 3; *Report;* Rose, B. 1; Seitz 3; Seuphor 3; Tuchman 1.

CHERNEY, MARVIN. b. November 1, 1925, Baltimore, Md.; **d.** March 17,

1967, NYC. **Studied:** Maryland Institute; School for Art Studies, NYC, with Maurice Glickman, Sol Wilson, Isaac Soyer. Traveled Europe, USA. **Taught:** Brooklyn Museum School; South Shore Arts Workshop, 1953-58. **Awards:** Baltimore/MA, Freeland Award, 1951; Brooklyn Museum, First Prize, 1954; Baltimore/MA, First Prize (Artists Award), 1955; Silvermine Guild, Lucille Lortel Award, 1958; L. C. Tiffany Grant, 1959, 60: NIAL Grant, 1960; NAD, Isaac N. Maynard Prize, 1961. **One-man Exhibitions:** (first) AFI Gallery, NYC, 1953; The Babcock Gallery, 1958; Capitol Art Gallery, Washington, D.C., 1959; Washington Irving Gallery, NYC, 1960; Garelick's Gallery, Detroit, 1961, 63; Bernard Crystal Gallery, NYC, 1961; Arnold Finkel Gallery, Philadelphia, 1961, 64; Mary Washington College, 1961; Bucknell U., 1962; Swarthmore College, 1962: Athena Gallery, New Haven, 1963; ACA Gallery, NYC, 1964, 66, Rome, 1964; International Gallery, Baltimore, 1965; Kennedy Gallery, 1970. **Retrospective:** Morgan State College, 1968. **Group:** NAD, 1950; Brooklyn Museum, 1954, 56, 58; Smithsonian; MOMA, Recent Drawings USA, 1956; U. of Nebraska, 1957; PAFA, 1957; WMAA, 1960; Chicago/AI, 1961. **Collections:** Kalamazoo Institute; PAFA; Reading/Public; Syracuse U.; WMAA; Youngstown/ Butler.

CHESNEY, LEE R., JR. b. June 1, 1920, Washington, D.C. **Studied:** U. of Colorado, with James Boyle, BFA; State U. of Iowa, with Mauricio Lasansky, James Lechay, MFA; Universidad Michoacana, Morelia, Mexico, with Alfredo Zalce. **Taught:** U. of Illinois, 1950-67; U. of Southern California, 1967-72; U. of Hawaii, 1972- . **Awards:** PMA, 1953; Bradley U., **P.P.**, 1953; U. of Southern California, **P.P.**, 1953, 54; Dallas/MFA, **P.P.**, 1953, 54; Brooklyn Museum, **P.P.**, 1953, 56; Library of Congress, 1954, 58; Denver/AM, **P.P.**, 1954, 59, 60, 61; Chicago/AI, John Taylor Arms Medal, 1955; Washington U., **P.P.**, 1955; Texas

Wesleyan College, **P.P.**, 1955; Michigan State U., **P.P.**, 1956; Fulbright Fellowship, 1956-57; Oakland/AM, **P.P.**, 1957; Silvermine Guild, 1959; Youngstown/ Butler, 1959; Seattle/AM, 1959, 61; Pasadena/AM, 1960; Oklahoma, 1960; SAGA, 1961. **Address:** c/o Dealer. **Dealer:** Cynthia Comsky Gallery. **Group Exhibitions:** Des Moines, 1947-50; The Print Club, Philadelphia, 1947, 49, 50, 53, 55, 58; Seattle/AM, 1947-51, 1953-56; Brooklyn Museum, 1948, 50, 52, 54, 56, 58; SFMA, 1949, 50, 53, 54; Denver/AM, 1949, 49, 52, 55, 56; Bradley U., 1950, 52-55; Library of Congress, 1950, 54, 56, 58; International Biennial Exhibition of Paintings, Tokyo; U. of Illinois; IV Bordighera Biennial, 1957. **Collections:** Albion College; Bibliotheque Nationale; Bradley U.; Brooklyn Museum; Dallas/MFA; Denver/AM; Illinois Wesleyan U.; Library of Congress; MOMA; Michigan State U.; Milwaukee-Downer College; National Gallery; Oakland/AM; The Ohio State U.; PMA; Seattle/AM; Stockholm/National; Tate; Texas Wesleyan College; Tokyo/Modern; Tokyo U. of Arts; Victoria and Albert Museum.

CHINNI, PETER. b. March 21, 1928, Mt. Kisco, N.Y. **Studied:** ASL, 1947, with Edwin Dickinson, Kenneth Hayes Miller, Julian Levi; Academy of Fine Arts, Rome, 1949-50, with Emilio Sorrini. Traveled Puerto Rico, Mexico, Europe; resided Italy 13 years. **Member:** Sculptors Guild. **Commissions:** Denver/AM (bronze mural). **Awards:** ASL, Daniel Schnackenberg Scholarship, 1948; Silvermine Guild, First Prize, 1958, 60, 61; Denver/AM, Second Prize, 1960. **Address:** c/o Dealer. **Dealer:** Harriet Griffin Gallery. **One-man Exhibitions:** (first) Fairleigh Dickinson U., 1951; Galleria San Marco, Rome, 1955; Il Torcoliere, Rome, 1956; Kipnis Gallery, Westport, Conn., 1956; R. R. Gallery, Denver, 1957; Galleria Schneider, Rome, 1957; Janet Nessler Gallery, NYC, 1959, 61; Royal Marks Gallery, 1964; Albert Loeb Gallery, NYC, 1966; Loeb & Krugier Gallery,

1969. **Group:** Audubon Artists Annuals, 1958, 59, 61, 62; Festival of Two Worlds, Spoleto, 1960; Boston Arts Festival, 1960, 62; Connecticut Academy of Fine Arts, 1960, 62; WMAA Annuals, 1960, 62, 64, 65; Corcoran, 1962; Galleria Pagani del Grattacielo, Milan, 1962; Waitsfield/Bundy, 1963; Sculptors Guild, 1963, 64, 66, 68; Carnegie, 1964; Heseler Gallery, Munich, 1968; Rome/Nazionale, 1968. **Collections:** Denver/AM; Fontana-Hollywood Corp.; St. Louis/City; WMAA.

CHRISTENSEN, DAN. b. 1942, Lexington, Neb. **Studied:** Kansas City/AI, BFA. **Address:** 17 Leonard Street, NYC 10013. **Dealer:** Andre Emmerich Gallery, NYC. **One-man Exhibitions:** Noah Goldowsky, 1967, 68; Galerie Rudolf Zwirner, 1967; Galerie Rolf Ricke, Cologne, 1968, 71; Andre Emmerich Gallery, NYC, 1969, 71, 72, 74, 75; Nicholas Wilder Gallery, 1970, 72; Edmonton Art Gallery, Alberta, 1973; Ronald Greenberg Gallery, St. Louis, 1974. **Group:** WMAA, 1967, 69, 72, 73;

Washington U., Here and Now, 1969; Corcoran, 1969; Buffalo/Albright, Color and Field: 1890-1970, 1970; WMAA, The Structure of Color, 1971; WMAA, Lyrical Abstraction, 1971; Buffalo/Albright, Six Painters, 1971; Boston/MFA, Abstract Painting in the '70s, 1972. **Bibliography:** *Kunst um 1970*; Wood.

CHRISTO (Javacheff). b. June 13, 1935, Gabrovo, Bulgaria. **Studied:** Academy of Fine Arts, Sofia, 1951-56; theater design at Burian Theater, Prague, 1956; Academy of Fine Arts, Vienna, 1957. To Geneva, 1957, Paris, 1958, NYC, 1964. **Address:** 48 Howard Street, NYC 10013. **One-man Exhibitions:** Galerie Haro Lauhus, Cologne, 1961; Galerie J, Paris, 1962; Galerie Schemla, 1963, 64; Galleria Apollinaire, Milan, 1963; Galleria del Leone, Venice, 1963, 68; Galleria la Salita, Rome, 1963; Galerie Ad Libitum, Antwerp, 1964; Gian Enzo Sperone, Turin, 1964; Eindhoven, 1966; Leo Castelli Inc., NYC, 1966; Walker, 1966; Wide White Space Gallery, Antwerp, 1967, 69; Galerie der Spiegel, Cologne, 1967, 69; John Gibson Gallery,

Christo *Running Fence* 1973-76

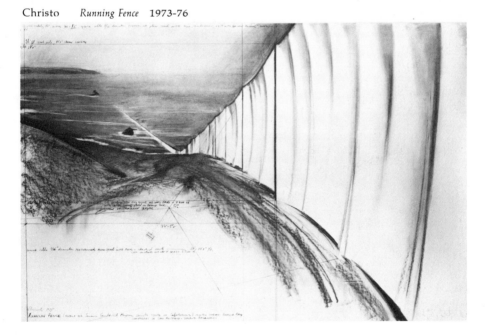

1968, 69; MOMA, 1968; ICA, U. of Pennsylvania, 1968; Chicago/Contemporary, 1969; Little Bay, Australia, Wrapped Coast, 1969; Central Street Gallery, Sydney, 1969; Melbourne/National, 1969; New Gallery, Cleveland, 1970; Françoise Lambert, Milan, 1970; Annely Juda Fine Art, London, 1971; Zurich, 1973; Allan Frumkin Gallery, Chicago, 1973; La Jolla, 1975; White Gallery, Lutry, 1975; Edificio Galipan, Caracas, 1975. **Group:** Gulbenkian Foundation, Lisbon, 1960; Kunstlerhaus, Munich, Festival du Nouveau Realisme, 1963; Paris/Moderne, Salon Comparaisons, 1963, 64; San Marino, IV Biennial, 1963; III Paris Biennial, 1963; Salon du Mai, Paris, 1964, 66; The Hague, Nieuwe Realisten, 1964; Museum des 20. Jahrhunderts, Pop Art, 1964; ICA, U. of Pennsylvania, Aspects, 1966; Documenta V, Kassel, 1968; Festival of Two Worlds, Spoleto, 1968; Chicago/AI, 1966; Walker, Eight Sculptors, 1966; Museum of Contemporary Crafts, Monument and Tombstone, 1967; MOMA, Dada, Surrealism and Their Heritage, 1968; Institut fur Moderne Kunst, Von der Collage zur Assemblage, 1968; Hayward Gallery, London, Pop Art, 1969; Museo de Arte Contemporaneo, Cali, Colombia, S.A., Festival de Arte, 1969; CNAC, Monuments, 1969; ICA, U. of Pennsylvania, Highway, 1970; Turin/Civico, Conceptual Art, Arte Povera, Land Art, 1970. **Bibliography:** *Art Now 74;* **Bourdon;** Calas, N. and E.; *Contemporanea;* Davis, D.; Friedman and van der Marck; *Happening & Fluxus; Kunst um 1970; Monumenta; Report.* Archives.

CHRISTOPHER, WILLIAM. b. March 4, 1924, Columbus, Ga.; **d.** December 5, 1973, Malaga, Spain. **Studied:** Sorbonne, 1946-47; Academie Julian, Paris, 1946-48; with Ossip Zadkine, Paris, 1947; Ecole des Beaux-Arts, Fontainebleau, 1947; with Amédée Ozenfant, NYC, 1948-50; with Hans Hofmann, NYC, 1950. Traveled Europe, Latin America. Changed from sculpture to painting in Paris, 1948. **Taught:** Poly-technic Preparatory School, Brooklyn (woodworking), 1956-60; Dartmouth College, 1966. **Awards:** Brooklyn Museum, Shiva Award, 1956; Silvermine Guild, Painting Award, 1962; Boston Arts Festival, Gold Medal of Merit, 1964; U. of Tennessee, First **P.P.**; AAAL, Childe Hassam Award, 1968; NAD, Frank C. Kirk Memorial Prize, 1968; NIAL Grant, 1969. **One-man Exhibitions:** (first) Roko Gallery, NYC, 1952; Nexus Gallery, Boston, 1957, 59, 60; Harvard U., 1959; The Amel Gallery, NYC, 1961; Joan Peterson Gallery, 1961, 62, 65, 66, 70, 72; Boston Architectural Center, 1963; Dartmouth College, 1964-66; Andover/Phillips, 1966; Richard Larcada Gallery, 1968; Drew U., 1968. **Group:** Andover/Phillips; Harvard U.; Sorbonne; WMAA; Smithsonian; Brooklyn Museum; Boston/MFA; A.F.A., circ.; Boston Arts Festival; ICA, Boston, 1959-67, incl. View, 1960, 1960; Corcoran, 1961, 64, 65; Lincoln, Mass./De Cordova, 1966; Norfolk, 1967; AAAL, 1968; PAFA, 1969; NIAL, 1969. **Collections:** Andover/Phillips; Boston/MFA; Boston U.; Dartmouth College; Lincoln, Mass./De Cordova; U. of Massachusetts; Seattle/AM; U. of Tennessee; WMAA; Wichita/AM. Archives.

CHRYSSA. b. 1933, Athens, Greece. **Studied:** Academie de la Grande Chaumiere, 1953-54; California School of Fine Arts, 1954-55. US citizen 1955. Traveled Europe, USA. **Address:** c/o Dealer. **Dealer:** Galerie Denise Rene, Paris. **One-man Exhibitions:** (first) Betty Parsons Gallery, 1961; SRGM, 1961; Cordier & Ekstrom, Inc., 1962; Robert Fraser Gallery, 1962; The Pace Gallery, 1966, 67, 68; The Graphic Gallery, San Francisco, 1968; Galerie der Spiegel, Cologne, 1968; Harvard U., 1968; Obelisk Gallery, 1969; Galerie Rive Droite, Paris, 1969; WMAA, 1972; Galerie Denise Rene, NYC, 1973; Galerie Denise Rene, Paris, 1974. **Group:** MOMA, Americans 1963, circ., 1963-64; Sao Paulo Biennials, 1963, 69; WMAA Annuals; Carnegie; Martha

Jackson Gallery, New Media—New Forms, I, 1960; Boston Arts Festival, 1960; Seattle World's Fair, 1962; Jewish Museum; Documenta IV, Kassel, 1968; Venice Biennial, 1972. **Collections:** Buffalo/Albright; Chase Manhattan Bank; MOMA; SRGM; WMAA. **Bibliography:** Battcock, ed.; Calas, N. and E.; Hunter, ed.; Lippard 5; Tuchman 1; **Waldman 2**.

CICERO, CARMEN LOUIS. b. August 14, 1926, Newark, N.J. US Army, World War II, Philippines. **Studied:** Newark State Teachers College, BA, 1947-51; Hunter College (with Robert Motherwell), 1953-55; Hofmann School, NYC. Traveled Europe. **Taught:** Sarah Lawrence College, 1959-68; School of Visual Arts, NYC, 1965-67; New School for Social Research, 1967-70; Newark State College, 1969-70; Montclair (N.J.) State College, 1969- . **Awards:** Guggenheim Foundation Fellowship, 1957, 63, 64; Ford Foundation, **P.P.**, 1961, 65. **Address:** 268 Bowery, NYC 10012. **Dealer:** Rankow Gallery. **One-man Exhibitions:** The Peridot Gallery, NYC, 1956, 57, 59, 61, 62, 64, 66, 68, 69; Arts Club of Chicago, 1958; Galerie Simone Stern, New Orleans; Kendall Gallery, Wellfleet, Mass., and Palm Beach; Rankow Gallery, 1971. **Group:** Corcoran, 1953; MOMA, 1953, 55; WMAA, 1955, 57, Annuals, 1960-63, 1965; U. of Nebraska, 1957; Chicago/AI, 1957; Worcester/AM, 1958; PAFA; Brooklyn Museum; Museum des 20. Jahrhunderts, 1963. **Collections:** Albion College; Amsterdam/Stedelijk; Brooklyn Museum; Cornell U.; Hirshhorn; MOMA; U. of Michigan; NYU; U. of Nebraska; Newark Museum; Ridgefield/Aldrich; Rotterdam; SRGM; Schiedam/Stedelijk; Southern Illinois U.; Toronto; Trenton/State; WMAA; Worcester/AM. **Bibliography:** Gerdts.

CIKOVSKY, NICOLAI. b. December 10, 1894, Pinsk, Russia. **Studied:** Royal Art School, Vilna; Technical Institute of Arts, Moscow. To USA 1923. **Taught:** Ekaterinenburg Higher Technical Art Institute, Russia; Columbus, Ga., Museum of Arts and Crafts; St. Paul School of Art; Art Academy of Cincinnati; The Corcoran School of Art; Chicago Art Institute School; ASL. **Member:** NAD. **Commissions** (murals): Interior Department, Washington, D.C.; US Post Offices, Towson and Silver Springs, Md. **Awards:** Chicago/AI, Norman Wait Harris Bronze Medal, 1932; Chicago/AI, The Mr. & Mrs. Frank G. Logan Medal, 1933; Worcester/AM, First Prize, 1933; PAFA, Lambert **P.P.**, 1937; NIAL Grant, 1962; NAD, Isaac N. Maynard Prize, 1964; Southampton/Parrish, First Prize, 1968. **Address:** 500 West 58 Street, NYC. **Dealer:** ACA Gallery. **One-man Exhibitions:** The Downtown Gallery, 1933, 38; Whyte Gallery, Washington, D.C., 1939; A.A.A. Gallery, NYC, 1944, 46, 49, 52, 56; ACA Gallery, 1959, 63, 67. **Group:** Brooklyn Museum, 1927; Chicago/AI, 1932, 33, 60, 61; A Century of Progress, Chicago, 1933-34; New York World's Fair, 1939; NAD, 1959; Toledo/MA; MOMA; Newark Museum; U. of Glasgow; Walker; Carnegie; Corcoran; Boston/MFA; Worcester/AM; Cleveland/MA; Los Angeles/County MA. **Collections:** Brooklyn Museum; Chicago/AI; Cleveland/MA; Kansas City/Nelson; Los Angeles/County MA; MOMA; PAFA; Phillips; WMAA; Worcester/AM. **Bibliography:** American Artists Group Inc. 2, 3; Bethers; Cheney; Gerdts; Hall; Mellquist; Pagano. Archives.

CLARKE, JOHN CLEM. b. 1937, Bend, Ore. **Studied:** Oregon State U.; Mexico City College; U. of Oregon, BFA, 1960. Traveled Mexico, Europe, USA. **Address:** 465 W. Broadway, NYC 10012. **Dealer:** OK Harris Works of Art. **One-man Exhibitions:** The Kornblee Gallery, 1968, 69, 71; Franklin Siden Gallery, Detroit, 1969; OK Harris Works of Art, 1970, 72, 75; Michael Walls Gallery, 1970; Gallerie M. E. Thelen, Essen, 1970; Phyllis Kind Gallery, Chicago, 1971; Pyramid Art Galleries Ltd., 1971; Galerie de Gestlo, 1971; Jack Glenn

John Clem Clarke
Plywood with Roller Marks #4 1974

Gallery, Corona del Mar, 1972; Carl Solway Gallery, Cincinnati, 1972; D. M. Gallery, London, 1974. **Group:** WMAA, 1967, 69, 72, 75; U. of Illinois, 1969; Milwaukee, Aspects of a New Realism, 1969; WMAA, 22 Realists, 1970; Chicago/AI, 1970; Potsdam/SUNY, New Realism, 1971; Chicago/Contemporary, Radical Realism, 1971; Santa Barbara/MA, Spray, 1971; U. of Miami, Phases of New Realism, 1972; New York Cultural Center, Realism Now, 1972; Indianapolis, 1974; Hartford/Wadsworth, New/Photo Realism, 1974; Tokyo Biennial, 1974; Cleveland/MA, Aspects of the Figure, 1974; Skidmore College, New Realism, 1974. **Collections:** Akron/AI; Baltimore/MA; U. of California, Berkeley; Chase Manhattan Bank; Cleveland/MA; Dallas/MFA; Flint/Institute; Kansas City/Nelson; Milwaukee; Security Pacific National Bank; Syracuse U.; VMFA; WMAA. **Bibliography:** *Amerikanischer Fotorealismus; Kunst um 1970;* Sager. Archives.

CLERK, PIERRE. b. March 26, 1928, Atlanta, Ga. **Studied:** McGill U., Mon-

treal; Loyola College; Montreal/MFA; Academie Julian, Paris; Academy of Fine Arts, Florence, Italy. Resided seven years in Europe. **Commissions:** (tapestries) Skidmore, Owings & Merrill; Commerce Trust Co., Kansas City. **Awards:** Canada Council Award, 1971, 72; Tamarind Fellowship, 1972. **Address:** 70 Grand Street, NYC 10013. **Dealers:** Brooke Alexander; Gimpel Fils; Gimpel & Hanover. **One-man Exhibitions:** Numero Gallery, Florence, Italy; Galleria Totti, Milan; Cittadella Gallery, Ascona, Switzerland; Beno Gallery, Zurich; Montreal/MFA; New Gallery, NYC; Galleria del Cavallino, Venice; Siegelaub Gallery, NYC, 1965, 67; Gimpel Fils, 1971; Gimpel & Hanover, 1971; Gimpel & Weitzenhoffer Ltd., 1971; Tirca Karlis Gallery, 1971; Gallery Moos, Montreal, 1972. **Group:** XXVIII & XXIX Venice Biennials, 1956, 1958; Carnegie, 1959; Expo '67, Montreal, 1967; Dublin/Municipal, International Quadriennial (ROSC), 1971; Indianapolis, 1972; Bradford, England, III British Print Biennial, 1972. **Collections:** American National Fire Insurance Co.; Atlantic Richfield Co.; Avon Corp.; The Bank of New York; Brandeis U.; Buffalo/Albright; Burlington Mills; Chase Manhattan Bank; First National City Bank; U. of Glasgow; Gulf Oil Corp.; Gulf and Western Industries Inc.; IBM; MOMA; McCrory Corporation; Mobil Oil Corp; Montreal/Contemporain; Montreal/MFA; Ottawa/National; Philip Morris; Purchase/SUNY; Quebec; Queens College; Radio Corporation of America; SRGM; The Singer Company Inc.; U.S. Steel Corp.; WMAA.

CLOAR, CARROLL. b. January 18, 1913, Earle, Ark. **Studied:** Memphis Academy of Arts; ASL, with William C. McNulty, Harry Sternberg; Southwestern College, BA. US Air Force, World War II, three years. Traveled Central and South America, Europe. **Taught:** Memphis Academy of Arts, 1956. **Member:** Artists Equity. **Awards:** MacDowell Traveling Fellowship, 1940; Guggenheim Foundation Fellowship,

1946; Youngstown/Butler, **P.P.**, Brooklyn Museum, **P.P.**; Library of Congress, **P.P.**; Mead Painting of The Year; Hon. PBK. **Address:** 235 S. Greer, Memphis, Tenn. 38111. **One-man Exhibitions:** (first) Memphis/Brooks, 1955, also 1957; The Alan Gallery, NYC, 1956, 58, 60, 62, 64, 65, 68; U. of Arkansas, 1956, 61; Fort Worth, 1963; Charleston Art Gallery, Charleston, W. Va.; U. of Georgia; Montgomery (Ala.) Museum of Fine Arts; Utah State Institute of Fine Arts, Salt Lake City; Columbia, S.C./MA; Dulin Gallery. **Retrospective:** Memphis/Brooks, 1960; Albany/SUNY, 1968. **Group:** PAFA; MMA; Carnegie; MOMA; WMAA; Brooklyn Museum; Dallas/MFA; U. of Nebraska. **Collections:** Abbott Laboratories; Albany/SUNY; Atlanta/AA; Brandeis U.; Bridgeport; Brooklyn Museum; Chase Manhattan Bank; Corcoran; First National Bank of Memphis; Friends of Art; Hartford/Wadsworth; Library of Congress; MMA; MOMA; Mead Corporation; Memphis/Brooks; Newark Museum; St. Petersburg, Fla.; Southwestern (College) at Memphis; WMAA; Youngstown/Butler. Archives.

CLOSE, CHUCK (Charles). b. July 5, 1940, Monroe, Wash. **Studied:** U. of Washington, 1958-62, BA; Yale U. Summer School, Norfolk, Conn., 1961; Yale U., 1962-64, BFA, 1963, MFA, 1964; Akademie der Bildenen Kunste, Vienna, 1964-65. Traveled Europe. **Taught:** U. of Massachusetts, 1965-67; School of Visual Arts, NYC, 1967-71; NYU, 1970- ; U. of Washington, 1970; Yale U. Summer School, Norfolk, Conn., 1971, 72. **Awards:** National Endowment for the Arts Grant ($7500), 1973. **Address:** 101 Prince Street, NYC 10012; **Studio:** 89 West 3 Street, NYC 10012. **Dealer:** Bykert Gallery. **One-man Exhibitions:** U. of Massachusetts, 1967; Bykert Gallery, 1970, 71, 73, 75; Los Angeles/County MA, 1971; Chicago/Contemporary, 1972; MOMA, 1973; Akron/AI, 1973. **Group:** WMAA Annuals, 1969, 72; WMAA, 22 Realists, 1970; Oberlin College, Three Young Americans (with Ron Cooper and Neil Jenny), 1970; Dusseldorf/Kunsthalle, Prospect '72, 1971; Documenta V, Kassel, 1972; Galerie des 4 Mouvements, Paris, Hyperrealistes Americains, 1972; Stuttgart/WK, Amerikanischer Fotorealismus, circ., 1972; WMAA, American Drawings: 1963-1973, 1973; Ars 74, Helsinki, 1974; Worcester/AM, Three Realists, 1974; XI Tokyo Biennial, 1974. **Collections:** Aachen/NG; MOMA; Minneapolis/Institute; Oberlin College; Ottawa/National; Toronto; WMAA; Walker. **Bibliography:** *Amerikanischer Fotorealismus; Kunst um 1970;* Sager; *Three Realists.*

CLUTZ, WILLIAM. b. March 19, 1933, Gettysburg, Pa. **Studied:** Mercersburg Academy, 1948-51; State U. of Iowa, with James Lechay, Stuart Edie, 1951-55, BA; ASL, 1956, with Robert Brackman. **Taught:** Artist-in-Residence, Bucknell U., 1957; Philadelphia College of Art, 1967; U. of Minnesota, 1967-68; Parsons School of Design, NYC, 1969- . **Address:** 370 Riverside Drive, NYC 10025. **Dealer:** Brooke Alexander. **One-man Exhibitions:** (first) Penn Hall Junior College and Preparatory School, Chambersburg, Pa., 1954; Bucknell U., 1957; Mercersburg Academy, 1958, 59; Condon Riley Gallery, NYC, 1959; David Herbert Gallery, NYC, 1962; The Bertha Schaefer Gallery, 1963, 64, 66, 69; Triangle Art Gallery, 1967; The Graham Gallery, 1972; Brooke Alexander, 1973. **Retrospectives:** Brooklyn College, 1969; Andover/Phillips, 1973. **Group:** MOMA, Recent Drawings USA, 1956; A.F.A., The Figure, circ., 1960; Houston/MFA, The Emerging Figure, 1961; MOMA, Recent Painting USA: The Figure, circ., 1962-63; PAFA Annuals, 1964-66; MOMA, Art in Embassies, circ.; U. of Nebraska, 1965; Norfolk, 1966; Perdue U., 1968; Ringling, 1969; Columbus, 1970. **Collections:** Andover/Phillips; Ball State U.; Brooklyn College; Chase Manhattan Bank; Exeter; Hagerstown/County MFA; Harvard U.; MOMA; Mills College; Milwaukee; Minnesota/MA; U. of

of Minnesota; NYU; U. of Nebraska; Newark Museum; New York School of Interior Design; SRGM; J. Henry Schroder Banking Corp.

COATES, ROSS. b. November 1, 1932, Hamilton (Ont.), Canada. **Studied:** U. of Michigan, 1951-53; Chicago Art Institute School, 1956, BFA; NYU, 1960, MA. Traveled Canada, USA, Europe, Africa. **Taught:** New York Community College, 1963; Kansas City Art Institute and School of Design, 1963-64; Montclair State College, 1965-68; Canon Lawrence T.T.C., Lira, Uganda, 1968-70; Russell Sage College; 1971- . **Address:** Stanley Shepherd Rd., Stephentown, N.Y. 12168. **One-man Exhibitions:** (first) Isaacs Gallery, 1957, also 1961; Camino Gallery, NYC, 1961; Louis Alexander Gallery, NYC, 1963; Galerie Niepel, Dusseldorf, 1966;

Springfield College, 1966; Jerrold Morris Gallery, Toronto, 1967; Galerie Seyfried, Munich, 1967; Kansas City Jewish Community Center, 1968; Russell Sage College, 1972; Schenectady Museum, 1974; U. of Rochester, 1974. **Collections:** U. of Alberta; Brandeis U.; Chase Manhattan Bank; U. of California; NYU; Springfield College; Stony Brook/SUNY.

CONGDON, WILLIAM. b. April 15, 1912, Providence, R.I. **Studied:** Yale U., BA; Cape School of Art, with Henry Hensche; PAFA; Folly Cove School of Art, with George Demetrios. American Field Service, World War II. Active in post-war Italy with American Friends Service Committee. Traveled Mexico, North Africa, India, Cambodia, Central America, Europe. **Awards:** RISD, 1949, 50; PAFA, Joseph E. Temple Gold

Ross Coates *Pine Mesa* 1975

Medal, 1951; U. of Illinois, **P.P.**, 1951; Corcoran, William A. Clark Prize, 1952; International Novara, Trieste, Gold Medal, 1961; U. of Portland, Hon. DFA, 1969. **Address:** Vicolo Bovi 1, Assisi, Italy 06081. **Dealers:** Betty Parsons Gallery; Galleria Cadario. **One-man Exhibitions:** (first) Betty Parsons Gallery, 1949, also 1950, 52, 53, 54, 56, 59, 62, 67; ICA, Boston, 1951; Margaret Brown Gallery, Boston, 1951, 56; Phillips, 1952; L'Obelisco, Rome, 1953, 58; Providence (R.I.) Art Club, 1953; Santa Barbara/MA, 1954; UCLA, 1954; Arts Club of Chicago, 1954; Art of This Century (Peggy Guggenheim), 1957; Denver/AM, 1957; MIT, 1958; Arthur Jeffress Gallery, London, 1958; Michigan State U., 1959; Pro-Civitate-Christiana, 1961; Palazzo Reale, Milan, 1962; U. of Notre Dame, circ., 1964-65; New York World's Fair, Vatican Pavilion, 1964-65; Cambridge U., 1968; Galleria Cadario, 1969. **Retrospectives:** RISD, 1965; Galleria Cadario, 1969. **Group:** PAFA, 1936-38, 1951-53, 1956, 58, 60; NAD, 1939; Carnegie, 1940, 52, 58; Andover/Phillips, 1941; MMA, American Painters Under 35, 1950; WMAA, 1950, 51, 53, 56, 58; Buffalo/Albright, 1952; California Palace, 1952; U. of Illinois, 1952, 53, 55, 57, 59; Chicago/AI, 1952, 54, 57; XXVI & XXIX Venice Biennials, 1952, 58; WMAA, The New Decade, 1954-55; Walker, Expressionism, 1900-1955, 1956; International Novara, Trieste, 1961, 66; Musee Cantonal des Beaux-Arts, Lausanne, II Salon de Galeries Pilotes, 1966; Hartford/Wadsworth; Cincinnati/AM; Lincoln, Mass./De Cordova. **Collections:** Andover/Phillips; Boston/MFA; Carnegie; Cleveland/MA; Detroit/Institute; Hartford/Wadsworth; Houston/MFA; U. of Illinois; MMA; MOMA; Phillips; Pro-Civitate-Christiana; RISD; U. of Rochester; St. Louis/City; Santa Barbara/MA; Smithsonian; Toledo/MA; Venice/Contemporaneo; WMAA. **Bibliography:** McCurdy, ed.; Nordness, ed.; Pousette-Dart, ed.; Rodman 2.

CONNER, BRUCE. b. November 18, 1933, McPherson, Kans. **Studied:** U. of Nebraska, BFA; U. of Wichita; Brooklyn Museum School, with Reuben Tam; Kansas City Art Institute and School of Design; U. of Colorado. **Taught:** California College of Arts and Crafts, 1965-66; SFAI, 1966, 67, 72; UCLA, summer 1973; San Jose State U., 1974. Produced the light show for the Avalon Ballroom; filmmaker. **Awards:** IV International Art Biennial, San Marino (Europe), Gold Medal, 1963; The U. of Chicago, Midwest Film Festival, First Prize; SFMA, Nealie Sullivan Award, 1963; Ford Foundation Grant, 1964; Tamarind Fellowship, 1965; Copley Foundation Award, 1965; National Endowment for the Arts Grant, 1973. **Address:** 45 Sussex Street, San Francisco, Calif. 94131. **Dealer:** Quay Gallery. **One-man Exhibitons:** Rienzi Gallery, NYC, 1956; East West Gallery, San Francisco, 1958; Designers Gallery, San Francisco, 1958; Spatsa Gallery, San Francisco, 1959; The Alan Gallery, NYC, 1960, 61, 63, 64, 65, 66; Batman Gallery, San Francisco, 1960, 62; Glantz Gallery, Mexico City, 1962; Antonio Suza Gallery, Mexico City; Ferus Gallery, Los Angeles, 1963; Wichita/AM, 1963; The Swetzoff Gallery, Boston, 1963; George Lester Gallery, Rome, 1964; Robert Fraser Gallery, London, 1964, 66; Brandeis U., 1965; Western Association of Art Museums, circ., 1965-66; U. of British Columbia, 1965; Galerie J, Paris, 1965; Quay Gallery, 1966, 72, 74; ICA, U. of Pennsylvania, 1967; SFAI, 1967, 71; Molly Barnes Gallery, Los Angeles, 1971; Reese Palley Gallery, San Francisco, 1971, 72; Martha Jackson Gallery, 1972; The Texas Gallery, 1972, 73; Nicholas Wilder Gallery, 1972; Jacqueline Anhalt Gallery, 1973; Tyler (Tex.) Museum of Art, 1974; Smith-Andersen Gallery, Palo Alto, 1974; de Young, 1974. **Retrospective:** ICA, U. of Pennsylvania, 1967. **Group:** SFAI Annuals, 1958, 63; San Francisco Episcopal Diocese, Church Art Today, 1960; U. of Illinois, 1961; MOMA, The Art of Assemblage, circ., 1961; WMAA, Fifty California Artists,

1962-63; IV International Art Biennial, San Marino, 1963; Chicago/AI, 66th Annual, 1963; Brandeis U., Recent American Drawings, 1964; ICA, Boston, Selection 1964, 1964; U. of California, Berkeley, Funk, 1967; Omaha/Joslyn, Nebraska Art Today, 1967; Los Angeles/County MA, American Sculpture of the Sixties, circ., 1967; WMAA, Human Concern/Personal Torment, 1969; Dallas/MFA, Poets of the Cities, 1974. Films: "A Movie," 1958; "Cosmic Ray," 1962; "Report"; "Vivian"; "The White Rose"; "Marilyn Times Five"; "Permian Strate." **Collections:** Andover/Phillips; U. of Arizona; U. of California, Berkeley; Chicago/AI; Indiana U.; Kansas City/Nelson; Los Angeles/County MA; MOMA; U. of Missouri; U. of Nebraska; Netherlands Film Museum; Oakland/AM; Pasadena/AM; SFMA; WMAA; Wichita/AM; Worcester/AM. **Bibliography:** *Art as a Muscular Principle; Bruce Conner Drawings;* Janis and Blesh 1; Lippard 5; Rose, B. 1; Selz, P. 2; **Siegfried;** Tuchman 1. Archives.

CONOVER, ROBERT. b. July 3, 1920, Trenton, N.J. **Studied:** Philadelphia Museum School, 1938-42; ASL, with Morris Kantor, Cameron Booth, Will Barnet; Brooklyn Museum School, with Max Beckmann, John Ferren, Reuben Tam, William Kienbusch, William Baziotes. Corps of Army Engineers, World War II. Traveled Europe, Canada. **Taught:** New School for Social Research, 1957- ; Brooklyn Museum School, 1961- ; Newark (N.J.) School of Fine and Industrial Art, 1967- . **Member:** American Abstract Artists; SAGA. Federal A.P.: National Youth Act, Philadelphia, 1939-41. **Commissions:** International Graphic Arts Society, 1957, 62 (woodcuts); New York Hilton Hotel, 1963; *Business Week* Magazine, 1963. **Awards:** MacDowell Colony Fellowship; Brooklyn Museum, **P.P.,** 1951, 56; The Print Club, Philadelphia, **P.P.,** PAFA, Samuel S. Fleisher Memorial **P.P.;** SAGA, **P.P.,** 1967 ($1,000), 1969; Trenton/State, **P.P.,** 1969. **Address:** 162 East 33 Street, NYC 10016. **Dealer:**

A.A.A. Gallery. **One-man Exhibitions:** (first) Laurel Gallery, NYC, 1949; The New Gallery, NYC, 1951, 53, 55; The Zabriskie Gallery, 1957, 59, 61; New School for Social Research, 1968, 74. **Group:** WMAA Annuals, 1950, 51, 53, 54, 55, 61; PAFA, 1951, 53; Chicago/AI; Cincinnati/AM; MOMA, Abstract Painting and Sculpture in America, 1951; Brooklyn Museum, 1952, 54, 56, 58, 60, 62, 64, 66, 68; Newark Museum; Los Angeles/County MA; Memphis/Brooks; Walker, The Classic Tradition, 1953; MOMA, Young American Printmakers, 1953; WMAA, American Prints Today, 1958; ART:USA:59, NYC, 1959; New York World's Fair, 1964-65; SAGA, 1965-69; American Abstract Artists, 1966-69; International Graphic Arts Exhibition, Zagreb; WMAA, Landscape in American Art; Pratt Institute, circ. Japan, 1967; Newark Museum, 1968; Trenton/State, 1968, 69; Library of Congress, 1969. **Collections:** Baltimore/MA; Brooklyn Museum; Ciba-Geigy Corp.; Cincinnati/AM; U. of Illinois; Library of Congress; MOMA; NCFA; NYPL; National Gallery; PAFA; PMA; Syracuse/Everson; Tokyo/Modern; Trenton/State; VMFA; WMAA. **Bibliography:** Baur 5; Ritchie 1.

CONSTANT, GEORGE. b. April 2, 1892, Greece. **Studied:** Washington U., 1912; Chicago Art Institute School, 1914-18; and with George Bellows, C. W. Hawthorne. Traveled Europe, USA. **Taught:** Dayton Art Institute School, 1920-22. **Member:** Federation of Modern Painters and Sculptors; Audubon Artists. Federal A.P.: Easel painting and graphic art. **Awards:** MMA, Alexander Shilling Prize, 1939, 45, 56; Chicago/AI, The Mr. & Mrs. Frank G. Logan Prize, 1943; Audubon Artists, 1946, Emily Lowe Prize, 1968; Library of Congress, Pennell **P.P.,** 1947; Southampton/Parrish, 1950, 51, First Prize, 1966; Greek Government, Cross of the Phoenix Brigade, 1963; Guild Hall, The Carolyn Tyson Award for Best Abstract Painting, 1966; Mark Rothko Foundation Grant, 1970. **Address:** 187 East Broad-

way, NYC 10002. **One-man Exhibitions:** (first) Arts Club of Chicago, 1929; Albert Roullier Gallery, Chicago; J. B. Neumann Gallery, NYC; Contemporary Arts Gallery, NYC; College Art Association Exhibit, circ., 1932-35; Boyer Gallery, Philadelphia, 1937, NYC, 1939; Marquie, NYC; Dikram Kelekian Gallery, NYC; Weyhe Gallery; Ferargil Galleries, NYC, 1944-48, 1950, 51; Grace Borgenicht Gallery Inc., 1952, 55; Philadelphia Art Alliance; Valentine-Dudensing Gallery, NYC; A. Oliva Gallery, Southampton, N.Y., 1965; Southampton/Parrish, 1965; The Harbor Gallery, Cold Spring Harbor, N.Y., 1966; Tirca Karlis Gallery, 1968; and some 30 others. **Retrospectives:** Southampton/Parrish, 1971; June 1 Gallery, Washington, D.C., 1972. **Group:** Victoria and Albert Museum; Brooklyn Museum; WMAA; Chicago/AI; MMA; PAFA; Carnegie; Amsterdam/Stedelijk; Minneapolis/Institute; Paris/Moderne; Corcoran; Library of Congress; State U. of Iowa; Golden Gate International Exposition, San Francisco, 1939; New York World's Fairs, 1939, 1964-65; Walker, 1944, 48; Brooklyn Museum, 10 Years of American Prints—1947-56, 1956; USIA, 1956-57, 1960-61; USIA, 20th Century Highlights, circ., 1957-58; ART:USA:59, NYC, 1959; New School for Social Research, Humanists of the 60's, 1963, also 1965. **Collections:** Amsterdam/Stedelijk; Andover/Phillips; Auburn U.; Ball State U.; Baltimore/MA; Brandeis U.; Brooklyn Museum; Dayton/AI; Detroit/Institute; Guild Hall; Hirshhorn; Library of Congress; MMA; Michigan State U.; NPG; NYU; U. of Nebraska; New Orleans/Delgado; Norfolk; PAFA; PMA; Pinacotheque National Museum; Purchase/SUNY; SFMA; St. Lawrence U.; Smithsonian; Tel Aviv; US State Department; WMAA; Walker; Wichita State U.; Youngstown/Butler. Archives.

COOK, HOWARD. b. July 16, 1901, Springfield, Mass. **Studied:** ASL, 1919-21, with George Bridgeman, Wallace Morgan, Joseph Pennell, Andrew Dasburg, Maurice Sterne. Artist War Correspondent, South Pacific, World War II. Traveled extensively, USA, North Africa, the Orient, Europe. **Taught:** U. of Texas, 1942-43; Minneapolis Institute School, 1945-50; U. of New Mexico, 1947; U. of California, Berkeley, 1948; Colorado Springs Fine Arts Center, 1949; Scripps College, 1951; Washington U., 1954; New Mexico Highlands U., 1957. **Member:** NAD; SAGA. Federal A.P.: Mural painting. **Commissions** (murals): Hotel Tasqueno, Taxco, Mexico; Law Library, Springfield, Mass.; Federal Court House, Pittsburgh, Pa.; US Post Offices, Alamo Plaza (San Antonio) and Corpus Christi; Mayo Clinic, Rochester, Minn. **Awards:** Two Guggenheim Foundation Fellowships; Architectural League of New York, Gold Medal; NAD, Samuel F. B. Morse Gold Medal; MMA, **P.P.**, 1942; PMA, **P.P.**; Denver/AM, **P.P.**; Tupperware National Competition, **P.P.**, 1956; Orlando, **P.P.**; Oklahoma, First Painting Award; Tucson Fine Arts Association, Art Prize. **Address:** Route 1, Box 264R, Roswell, N.M. 88201. **One-man Exhibitions:** (first) Denver/AM, 1928; Weyhe Gallery, 1929, 31, 34, 37, 41; Springfield, Mass./MFA, 1936; The Print Club, Philadelphia, 1937; Kennedy Gallery, 1942, 44; National Gallery, 1944; Rehn Galleries, 1945, 50; Dallas/MFA, 1945, 53; Minneapolis/Institute, 1950; Grand Central Moderns, NYC, 1951, 53, 56, 60, 64; San Diego, 1952; Santa Barbara MA, 1952; de Young, 1952; Kansas City/Nelson, 1953; Omaha/Joslyn, 1953; G.W.V. Smith Art Museum, Springfield, Mass., 1954; Houston/MFA, 1954; Dartmouth College, 1954; Montclair/AM, 1954; Carnegie, 1958; Raymond Burr Gallery, Los Angeles, 1962, 63. **Retrospective:** Roswell, 1975. **Group:** WMAA, 20th-Century Drawings from the Permanent Collection, 1975. **Collections:** Baltimore/MA; Chicago/AI; Dallas/MFA; Dartmouth College; Denver/AM; de Young; Harvard U.; MMA; MOMA; Minneapolis/Institute; Oklahoma; Omaha/Joslyn; Orlan-

do; PMA; U. of Rochester; Santa Barbara/MA; Santa Fe, N.M.; WMAA. **Bibliography:** American Artists Congress, Inc.; American Artists Group Inc. 1, 3; Bethers; Bruce and Watson; Cheney; Coke 2; Hall; Kent, N.; Mellquist; Pearson 1; Pousette-Dart, ed.; Reese; Wheeler; Zigrosser 1.

CORBETT, EDWARD. b. August 22, 1919, Chicago, Ill; **d.** June 6, 1971, Provincetown, Mass. **Studied:** California School of Fine Arts, two years. Traveled Mexico, USA, Philippines. US Army, US Navy, Merchant Marine, 1941-44. **Taught:** San Francisco State Teachers College, 1947; California School of Fine Arts, 1947-50; U. of California, Berkeley, 1950; Mount Holyoke College, 1953-62; U. of New Mexico, 1955; U. of Minnesota, 1960-61; American U., 1966-67; U. of California, Santa Barbara, 1967-68. **Awards:** Abraham Rosenberg Foundation Fellowship, 1951. **One-man Exhibitions:** Grace Borgenicht Gallery Inc., 1956, 59, 61, 64, 70, 73; Quay Gallery, 1967; SFMA, 1969. **Retrospective:** MIT, 1959; Walker, 1961. **Group:** California Palace, 1947, 50; Riverside Museum, 1948; Chicago/AI, American Abstract Artists, 1948; de Young, 1951; MOMA, Fifteen Americans, circ., 1952; WMAA Annuals, 1953, 55, 58, 61, 63, 65-68; U. of Illinois, 1954; U. of Nebraska, 1955; Carnegie, 1955; Corcoran, 1956, 1966-68; Walker, 1961; Sao Paulo, 1962; NCFA, 1966; WMAA, Art of the U.S. 1670-1966, 1966. **Collections:** Andover/Phillips; Bankers Trust Company; Buffalo/Albright; U. of California; Chase Manhattan Bank; Chicago/AI; Harcourt, Brace & World, Inc.; MOMA; Mount Holyoke College; Newark Museum; SFMA; Tate; WMAA; Walker. **Bibliography:** McChesney.

CORBINO, JON. b. April 3, 1905, Vittoria, Sicily; **d.** July 10, 1964, Sarasota, Fla. To USA 1913. **Studied:** PAFA, with Daniel Barber; ASL, with George Luks, Frank V. DuMond, William Von Schlegell. **Taught:** ASL, 1938-56; NAD, 1945. **Member:** NAD; ASL; Lotus Club; PAFA; Philadelphia Watercolor Club; Audubon Artists. Federal A.P.: US Post Office, Long Beach, N.Y. (mural). **Awards:** Chicago/AI, The M. V. Kohnstamm Prize, 1937; PAFA, Walter Lippincott Prize and Purchase, 1938; NAD, The Adolph and Clara Obrig Prize, 1938; Lotus Club, Drawing Award, 1938; New Rochelle Art Association, Silver Medal, 1940; NIAL, Painting Award, 1941; Leonardo da Vinci Art School, NYC, Da Vinci Silver Medal, 1942; Chicago/AI, Watson F. Blair Prize, 1944; NAD, Saltus Gold Medal for Merit, 1944; Audubon Artists, Gold Medal of Honor, 1945; Salmagundi Club, NYC, **P.P.,** 1945; Pepsi-Cola, 1945; La Tausca Competition, 1946; Rockport (Mass.) Art Association, Hayward Neidringhause Memorial Prize, 1950; National Arts Club, Gold Medal, 1950; NAD, Ellen P. Speyer Prize, 1961. **One-man Exhibitions:** (first) Oberlin College, 1927, also 1939; Contemporary Arts Gallery, NYC, 1934; Goodman Walker, Inc., Boston, 1935; Macbeth Gallery, NYC, 1937, 38, 40; A.A.A. Gallery, NYC, 1937; Corcoran, 1938; Warner Gallery, Los Angeles, 1939; Carnegie, 1939; Grace Horne Galleries, Boston, 1939; J. Seligmann and Co., 1942; Kleemann Gallery, NYC, 1944, 45; Marshall Field & Co., Chicago, 1948; Rehn Galleries, 1948, 51, 55, 59; Boris Mirski Gallery, Boston, 1950; The Manor Club, Pelham, N.Y., 1952; Frank Oehlschlaeger Gallery, Chicago, 1953, 56, 60; Cowie Galleries, Los Angeles, 1959; O'Briens Art Emporium, Scottsdale, Ariz., 1960; Art Center, Bradenton, Fla., 1961; Ringling, 1963; Harmon Gallery, Naples, Fla., 1964. **Group:** Chicago/AI, 1926, 36, 43, 44; Brooklyn Museum, 1931, 39, 43; Andover/Phillips, 1936; Carnegie, 1936, 37, 38, 40, 42, 50; U. of Minnesota, 1936; WMAA, 1937, 38, 40, 49, 52; PAFA, 1937, 50; Detroit/Institute, 1937; Worcester/AM, 1938, 42; St. Louis/City, 1938; NAD, 1938, 39, 44, 47; VMFA, 1938, 44; Toledo/MA, 1938, 40, 41; Golden Gate International Exposition, San Francisco,

1939; New York World's Fair, 1939; Cranbrook, 1940; MMA, 1941, 42, 50; Audubon Artists, 1945; Los Angeles/ County MA, 1945; U. of Illinois, 1948; Sao Paulo, 1960; U. of South Florida, 1962. **Collections:** ASL; Amherst College; Andover/Phillips; Ball State U.; Brigham Young U.; Britannica; Brooklyn Museum; Canajoharie; Carnegie; Chicago/AI; Clearwater/Gulf Coast; Davenport/Municipal; Downtown Community School; Hebron Academy; Hickory, N.C.; Howard U.; IBM; Indianapolis/Herron; Kalamazoo/Institute; Kansas City/Nelson; Lotus Club; MMA; Memphis/Brooks; Montclair/ AM; Mount Holyoke College; Municipal U. of Omaha; NAD; New Britain; Northwest Missouri State College; PAFA; Pasadena/AM; Portland, Me./MA; Quaker Ridge School; Ripon College; San Diego; Society of the Four Arts; Southampton/Parrish; Sweet Briar College; Toledo/MA; WMAA; Walker; Worcester/AM; Youngstown/Butler. **Bibliography:** Baur 7; Boswell 1; Cheney; Flexner; Genauer; Hall; Kent, N.; Pagano. Archives.

CORNELL, JOSEPH. b. December 24, 1903, Nyack, N.Y.; **d.** December 29, 1972, NYC. **Awards:** William and Noma Copley Foundation Grant, 1954; Chicago/AI, Ada S. Garrett Prize, 1959; AAAL, Award of Merit, 1968. **One-man Exhibitions:** (first) Julien Levy Galleries, NYC, 1932, also 1933, 39, 40; Hugo Gallery, NYC, 1946; Copley Gallery, Hollywood, 1948; Charles Egan Gallery, 1949, 50; Allan Frumkin Gallery, Chicago, 1953; Walker, 1953; The Stable Gallery, 1957; Bennington College, 1959; Richard Feigen Gallery, Chicago, 1960 (three-man); Ferus Gallery, Los Angeles, 1962; Robert Schoelkopf Gallery, NYC, 1966; J. L. Hudson Art Gallery, Detroit, 1966; Brandeis U., 1968; Allan Stone Gallery, 1972; Buffalo/Albright, 1972; Chicago/Contemporary, 1973. **Retrospectives:** Pasadena/AM, 1966; SRGM, 1967. **Group:** MOMA, Fantastic Art, DADA, Surrealism, 1936; Galerie des Beaux Arts, Paris,

Exposition Internationale du Surrealisme, 1938; Art of This Century, NYC, 1942; Carnegie, 1958; MOMA, The Art of Assemblage, 1961; Seattle World's Fair, 1962; WMAA Annuals, 1962, 66; NYU, Boxes and Collages, 1963; Chicago/AI, 1964; Musee Rodin, Paris, Sculpture of the 20th Century, 1965; U. of Illinois, 1967. **Collections:** Boston/MFA; MOMA; Pasadena/AM; WMAA. **Bibliography:** Ashton, ed.; Baur 7; Blesh 1; Breton 2; Calas, N. and E.; Finch; Flanagan; Guggenheim, ed.; Hunter 6; Hunter, ed.; Janis and Blesh 1; Janis, S.; Kozloff 3; Licht, F.; *Metro*; Read 3; Rickey; Rose, B. 1; Rubin 1; Steitz 3; Seuphor 3; *7 Decades*; Tuchman 1; **Waldman 3.** Archives.

COTTINGHAM, ROBERT. b. September 26, 1935, Brooklyn, N.Y. **Studied:** Pratt Institute, 1959-64, Associate Degree in Advertising Art. US Army, 1955-58. **Taught:** Art Center College of Design, Los Angeles, 1969-70. **Awards:** National Endowment for the Arts, 1974. **Address:** 21 Felden Street, London, S.W. 6, England. **Dealer:** OK Harris Gallery. **One-man Exhibitions:** Molly Barnes Gallery, Los Angeles, 1968, 69, 70; OK Harris Gallery, 1971, 74; D. M. Gallery, London, 1975. **Group:** Fresno State College, The Persistent Image, 1970; ICA, U. of Pennsylvania, Highway, 1970; Chicago/Contemporary, Radical Realism, 1971; Potsdam/SUNY, New Realism, 1971; Documenta V, Kassel, 1972; Stuttgart/WK, Amerikanischer Fotorealismus, circ., 1972; New York Cultural Center, Realism Now, 1972; Lincoln, Mass./De Cordova, The Super-Realist Vision, 1973; Los Angeles Municipal Art Gallery, Separate Realities, 1973; Cincinnati/Contemporary, Options, 73/30, 1973; CNAC, Hyperrealistes Americains/Realistes Europeens, 1974; Hartford/Wadsworth, New/Photo Realism, 1974; Tokyo Biennial, 1974. **Collections:** Honolulu Academy; Indianapolis; Sunflower Corp.; Syracuse U.; Toledo/MA. **Bibliography:** *Amerikanischer Fotorealismus*; Sager; *The State of California Painting*.

COVERT, JOHN. b. 1882, Pittsburgh, Pa.; **d.** December 24, 1960, NYC. **Studied:** Pittsburgh School of Design, 1902-08; in Munich, 1908-12, on a German Government scholarship. Traveled France, Germany, England. A founder and director of the Society of Independent Artists, 1916. The collection of the Societe Anonyme was started with a gift of six of his paintings in 1923. Stopped painting between 1923 and 1949. **Group Exhibitions:** Paris Salon, 1914; Independent Artists, NYC, 1917; PAFA, 1921; Societe Anonyme, 1921; Vassar College, 1923; Detroit/Institute, 1923; Brooklyn Museum, 1926; Delphic Studios, NYC, 1936; Dallas Museum for Contemporary Arts, 1961; WMAA, 1963. **Collections:** MOMA; PMA; Seattle/AM; Yale U. **Bibliography:** *Avant-Garde Painting and Sculpture*; Baur 7; Hunter 6; Rose, B. 1; Tashjian.

COWLES, RUSSELL. b. October 7, 1887, Algona, Iowa. **Studied:** Dartmouth College; ASL; American Academy, Rome; NAD (assistant to Douglas Volk and Barry Faulkner in mural painting). Traveled Europe and Asia extensively. US Army Intelligence, 1917. **Awards:** Prix de Rome, 1915; Chicago/AI, Norman Wait Harris Silver Medal, 1926; Denver/AM, Yetter Prize, 1936; Hon. DFA, Grinnell College, 1945; Hon. DFA, Dartmouth College, 1951; Hon. DFA, Cornell U., 1958. **Address:** 179 East 70 Street, NYC 10021. **Dealer:** Kraushaar Galleries. **One-man Exhibitions:** Ferargil Galleries, NYC, 1935; Los Angeles/County MA, 1937; Dalzell Hatfield Gallery, 1939, 43; Kraushaar Galleries, 1939, 41, 44, 46, 48, 50, 54, 59, 73; Dayton/AI, 1942 (three-man); Dartmouth College, 1948, 63; Des Moines, 1955. **Group:** Carnegie; PAFA; WMAA; Los Angeles/County MA; Des Moines; Architectural League of New York; Chicago/AI; California Palace; Wichita/AM; Corcoran. **Collections:** Andover/Phillips; Britannica; Dartmouth College; Denver/AM; Des Moines; Fort Dodge/Blanden; Los Angeles/County MA; Minneapolis-/Institute; New Britain; PAFA; Santa Barbara/MA; Terre Haute/Swope; Wichita/AM. **Bibliography: Baer;** Bethers; Cheney; Hall; Kent, N.; Pearson 2; Watson, E. W. 2; Wheeler. Archives.

CRAMER, KONRAD. b. November 9, 1888, Wurzburg, Germany; **d.** January, 1965, Woodstock, N.Y. **Studied:** Academy of Fine Arts, Karlsruhe, Germany. **Taught:** Bard College, 1940. Founder, Woodstock (N.Y.) School of Photography, 1936. **One-man Exhibitions:** Woodstock (N.Y.) Art Gallery, 1952; New Paltz/SUNY, 1952; Long Island U., 1958; Rochester Institute of Technology, 1966; The Zabriskie Gallery, 1973. **Group:** MacDowell Club, NYC, 1912; Whitney Studio Club, NYC, 1924; WMAA, Abstract Painting in America, 1935; PAFA, 1936; Carnegie, 1937, 38; Corcoran, 1938, 39; WMAA, Pioneers of Modern Art in America, 1946; Woodstock (N.Y.) Art Gallery. **Collections:** MMA; MOMA; WMAA. **Bibliography:** *Avant-Garde Painting and Sculpture*; Baur 7; Brown; Janis, S.; Rose, B. 1. Archives.

CRAMPTON, ROLLIN McNEIL. b. March 9, 1886. New Haven, Conn.; **d.** January 17, 1970, Woodstock, N.Y. **Studied:** Yale U., with Lanzetell, Thompson; ASL, with Thomas Fogarty, Renterdahl. Federal A.P.: Mural Supervisor. **Awards:** AAAL Grant; Longview Foundation Grant; Louisiana State U., **P.P. One-man Exhibitions:** (first) Woodstock (N.Y.) Art Gallery; The Peridot Gallery, 1958; The Krasner Gallery, 1960, 71; The Stable Gallery, NYC, 1961, 64, 68, 69. **Collections:** Buffalo/Albright; Hartford/Wadsworth; Kalamazoo/Institute; Louisiana State U.; MIT; MMA; New Paltz-/SUNY; U. of Texas; WMAA; Walker. **Bibliography:** Read 4; Zaidenberg, ed.

CRAWFORD, RALSTON. b. September 5, 1906, St. Catharines (Ont.), Canada. **Studied:** Otis Art Institute, Los Angeles, 1926-27; PAFA, 1927-30, with Henry Breckenridge, Henry McCarter;

Barnes Foundation, 1927-30; Academie Colarossi and Academie Scandinave, Paris, 1932-33; Columbia U., 1933. Traveled Europe, Canada, South Pacific, North Africa, USA, Mediterranean. **Taught:** Art Academy of Cincinnati, 1940-41, 1949; Buffalo Fine Arts Academy, 1942; Honolulu Academy School, summer, 1947; Brooklyn Museum School, 1948-49; U. of Minnesota; Louisiana State U., 1949-50; New School for Social Research, 1952-57; U. of Colorado summer, 1953; U. of Michigan, summer, 1953; lecture tour of USA for American Association of Colleges, 1956; Hofstra College, 1960-62; U. of Southern California, summer, 1961; U. of Nebraska, 1965; U. of Illinois, 1966. **Awards:** L. C. Tiffany Grant, 1931; Wilmington, 1933; Mary Curtis Bok Foundation Fellowship, 1937; MMA, **P.P.**, 1942; Tamarind Fellowship, 1966. **Address:** 60 Gramercy Park, NYC 10010. **Dealer:** The Zabriskie Gallery. **One-man Exhibitions:** (first) Maryland Institute, 1934; Boyer Gallery, Philadelphia 1937; NYC, 1939; Philadelphia Art Alliance, 1938; Cincinnati/AM, 1941; Flint/Institute, 1942; Artists' Gallery, Philadelphia, 1943; The Downtown Gallery, 1943, 44, 46, 50; Arts Club of Chicago, 1945 (three-man); Portland, Ore./AM, 1946; Santa Barbara/MA, 1946; Howard U., 1947; MacMurray College, 1949; Hofstra College, 1952; U. of Alabama, 1953; Grace Borgenicht Gallery Inc., 1954, 56, 58; Louisiana State U., 1956; Milwaukee, 1958; Lee Nordness Gallery, NYC, 1961, 63; U. of Nebraska, 1965; U. of Illinois, 1966; The Zabriskie Gallery, 1973; Ronald Greenberg Gallery, St. Louis, 1974; Corcoran & Greenberg Gallery, Inc., Coral Gables. **Retrospectives:** U. of Alabama, 1953; Milwaukee, 1958; U. of Kentucky, 1961; U. of Minnesota, 1961; Creighton U., 1968; U. of Nebraska (photographs); Utica; Montgomery Museum. **Group:** PAFA; WMAA; MOMA; MMA; Corcoran; Phillips; Chicago/AI. **Collections:** American Export Isbrandtsen Lines Inc.; Auburn U.; Baton Rouge; Buffalo/Albright; Cincinnati/AM; Flint/

Institute; U. of Georgia; Hamline U.; Hofstra U.; Honolulu Academy; Houston/MFA; Howard College; Illinois Wesleyan U.; Library of Congress; MMA; MOMA; MacMurray College; Michigan State U.; The Miller Co.; U. of Minnesota; Newark Museum; U. of Oklahoma; Phillips; SFMA; Toledo/MA; Vassar College; WMAA; Walker; Wesleyan U.; Youngstown/Butler. **Bibliography:** Baur 7; Boswell 1; Frost; Halpert; Janis, S.; Kootz 2; McCurdy, ed.; Nordness, ed.; Pagano; Reese; Ritchie 1; Rodman 2; Rose, B. 1. Archives.

CREMEAN, ROBERT. b. September 28, 1932, Toledo, Ohio. **Studied:** Alfred U., 1950-52; Cranbrook Academy of Art, 1954, BA, 1956, MFA. **Taught:** The Detroit Institute of Arts; UCLA, 1956-57; Art Center in La Jolla, 1957-58. **Awards:** Fulbright Fellowship (Italy), 1954; Tamarind Fellowship, 1966. **Address:** c/o Dealer. **Dealer:** Esther Robles Gallery. **One-man Exhibitions:** Esther Robles Gallery, 1960-66, 73; The Landau-Alan Gallery, NYC, 1968; Wisconsin State U., 1969; Melbourne/National, 1970; Archer Gallery, London, 1972. **Group:** Detroit/Institute, 1956; Houston/MFA, 1957; Santa Barbara/MA, 1957; U. of Nebraska, 1958; Chicago/AI, 1960, 61; Los Angeles/County MA, The Image Retained, 1961; SFMA, Bay Area Artists, 1961; California Palace, 1961; WMAA Annuals, 1961, 62; U. of Illinois, 1961, 63; Western Association of Art Museum Directors, Light, Space, Mass, circ., 1962; WMAA, Fifty California Artists, 1962-63; XXXIV Venice Biennial, 1968. **Collections:** Cleveland/MA; Detroit/Institute; Los Angeles/County MA; U. of Miami; U. of Michigan; U. of Nebraska; St. Louis/City; Santa Barbara/MA; Toledo/MA; UCLA.

CRISS, FRANCIS H. b. April 26, 1901, London, England; **d.** November 27, 1973, NYC. **Studied:** PAFA; ASL, with Jan Matulka. **Taught:** Brooklyn Museum School; Albright Art School; ASL;

Graphic Sketch Club, Philadelphia. **Awards:** PAFA, Cresson Fellowship; Guggenheim Foundation Fellowship, 1934. **One-man Exhibitions:** (first) Contemporary Arts Gallery, NYC; Mellon Galleries, Philadelphia, 1933, 34; Philadelphia Art Alliance, 1953; School of Visual Arts, NYC. **Retrospective:** School of Visual Arts, NYC, 1967. **Group:** WMAA, 1936, 37, 38, 40, 42, 51; Corcoran, 1939; PAFA, 1939, 41, 43, 45; MMA, 1941; Chicago/AI, 1942, 43; Carnegie, 1944, 45. **Collections:** Kansas City/Nelson; La France Art Institute; National Gallery; PMA; WMAA. **Bibliography:** Baur 7; Pagano. Archives.

CRONBACH, ROBERT M. b. February 10, 1908, St. Louis, Mo. **Studied:** Washington School of Fine Arts, 1926, with Victor Holm; PAFA, 1927-30, with Charles Grafly, Albert Laesslie; assistant in Paul Manship Studio, NYC and Paris, 1930. Traveled Europe extensively. **Taught:** Adelphi College, 1947-62; North Shore Community Art Center, 1949-54; Skowhegan School, summers, 1959, 60, 64. **Member:** Sculptors Guild; Architectural League of New York; Artists Equity. Federal A.P.: Willerts Park Housing Project, Buffalo, N.Y., 1939 (sculpture). **Commissions** (architectural): St. Louis (Mo.) Municipal Auditorium, 1933; Social Security Building, Washington, D.C., 1940; Cafe Society Uptown, NYC, 1940; Hotel Hollenden, Cleveland, 1946; Hopping Phillips Motor Agency, Newark, N.J., 1948; 240 Central Park South, NYC, 1954; Dorr-Oliver Building, Stamford, Conn., 1957; Adelphi College, 1958; Ward School, New Rochelle, N.Y., 1959; National Council for U.S. Art, 1960 (a gift to the United Nations); Temple Chizuk Amuno, Baltimore, 1962, 68; Federal Building, St. Louis 1964; Temple Israel, St. Louis, 1964; Charleston (W. Va.) Public Library, 1965. **Awards:** PAFA, Stewardson Prize, 1938; PAFA, Cresson Fellowship, 1929, 30; National Sculpture Competition for Social Security Building, Washington, D.C., First

Award, 1939. **Address:** 170 Henry Street, Westbury, N.Y. 11590. **Dealer:** The New Bertha Schaefer Gallery. **One-man Exhibitions:** (first) Hudson D. Walker Gallery, NYC, 1939; The Bertha Schaefer Gallery, 1951 (two-man), 1952, 1960 (two-man), 1967, 71; The New Bertha Schaefer Gallery, 1974. **Group:** New York World's Fairs, 1939, 1964-65; Sculptors Guild, 1939-42, 1945-62, 1967; City of Philadelphia Sculpture International, 1940, 49; MMA, 1943; Denver/AM, The Modern Artist and His World, 1947; WMAA Annuals, 1948, 1956-59; Riverside Museum, 1957; Silvermine Guild, 1957, 58, 60; Brussels World's Fair, 1958; ART:USA:59, NYC, 1959; HemisFair '68, San Antonio, Tex., 1968; PAFA; Architectural League of New York; Brooklyn Museum; St. Louis/City; Houston/MFA; MOMA. **Collections:** U. of Minnesota; Rosenthal China Co.; St. Louis/City; Springfield, Mo./AM; Walker. **Bibliography:** Baur 7. Archives.

CURRY, JOHN STEUART. b. November 14, 1897, Dunavant, Kans.; **d.** 1946, Madison, Wisc. **Studied:** Kansas City Art Institute and School of Design, 1916; Chicago Art Institute School, 1916-18, with E. J. Timmons, John W. Norton; Geneva College, 1918-19; Studio of B. Schoukhaieff, Paris, 1926-27. Traveled France. **Taught:** Cooper Union, 1932-34; ASL, 1932-36; U. of Wisconsin, 1936. **Commissions** (murals): Justice Department, Washington, D.C., 1936-37; Kansas State Capitol, 1938-40; U. of Wisconsin, 1940-42. **Awards:** Carnegie, 1933; PAFA, Gold Medal, 1941; MMA, Artists for Victory, Second Prize, 1942. **One-man Exhibitions:** (first) Whitney Studio Club, NYC, 1930; Ferargil Galleries, NYC, 1933, 35; U. of Wisconsin, 1937; Hudson D. Walker Gallery, NYC, 1938; Milwaukee, 1946; A.A.A.Gallery, NYC, 1947; Syracuse U., 1956; U. of Kansas, 1957; NCFA, 1971. **Group:** WMAA; Chicago/AI; Wichita/AM; Milwaukee. **Collections:** Andover/Phillips; Britannica; Chicago/AI; First National Bank, Mad-

ison; Kansas State College; MMA; Muskegon/Hackley; U. of Nebraska; St. Louis/City; WMAA; Wichita/AM. **Bibliography:** American Artists Group Inc. 1; Baigell 1; Baur 7; Bazin; Benton 1; Biddle 4; Blesh 1; Boswell 1; Brown; Bruce and Watson; Cahill and Barr, eds.; Canaday; Cheney; Christensen; Craven, T. 1; **Curry 1, 2, 3;** Flanagan; Flexner; Goodrich and Baur 1; Hall; Hunter 6; *Index of 20th Century Artists;* Jewell 2; McCurdy, ed.; Mellquist; Mendelowitz; Newmeyer; Pagano; Pearson 1; Reese; Richardson, E. P.; Rose, B. 1; **Schmeckebier 2;** Wight 2. Archives.

CUSUMANO, STEFANO. b. February 5, 1912, Tampa, Fla. **Studied:** Metropolitan Art School, with Arthur Schiewder; Cooper Union. Traveled Europe. **Taught:** Leonardo da Vinci Art School, NYC, 1932-40; Art Career School, 1945-54; NYU, 1954- ; Cooper Union, 1956- ; U. of Minnesota, 1971, 72; Cornell U., 1973. **Awards:** Ford Foundation, **P.P.**, 1963; AAAL, Childe Hassam Award, 1968, 71. **Address:** 170 West Street, NYC 10023. **One-man Exhibitions:** (first) Montross Gallery, NYC, 1942; G. Binet Gallery, NYC, 1946, 47, 48, 50; Philadelphia Art Alliance, 1948; Tampa/AI, 1949; Woodmere Art Gallery, Philadelphia, 1950; Oregon State College, 1951; Washington State U., 1951; Passedoit Gallery, NYC, 1953, 56, 57, 59; Mari Gallery, Woodstock, N.Y., 1962; Gallery 63, Inc., NYC, 1963, 64, Rome, 1964; Terry Dintenfass, Inc., 1967; U. of Minnesota, 1971, 72. **Group:** WMAA, 1947; Carnegie, 1949; U. of Illinois, 1950; Corcoran, 1951; PAFA, 1951, 52, 67; NIAL, 1952, 61; Youngstown/Butler, 1968; St. Paul Gallery, 1968; Indianapolis/Herron, 1968; AAAL, 1968, 71; Randolph-Macon Woman's College, 1968. **Collections:** Brooklyn Museum; Florida State U.; U. of Illinois; Johns Hopkins U.; MMA; U. of Minnesota; National Gallery; Newark Museum; U. of North Carolina; Omaha/Joslyn; PMA; Pensacola; WMAA; Wesleyan U. Archives.

DAPHNIS, NASSO. b. July 23, 1914, Krockeai, Greece. To USA 1930. Self-taught. Traveled USA, Greece, Italy, France. **Taught:** Horace Mann School, Riverdale, N.Y., 1953-58. **Member:** American Abstract Artists. **Awards:** Ford Foundation, 1962; National Council on the Arts, 1966; National Endowment for the Arts, 1971; New England 350th Celebration Exhibition, 1972; A. P. Saunders Medal, Tree Peony Award, 1973. **Address:** 362 West Broadway, NYC 10012. **One-man Exhibitions:** (first) Contemporary Arts Gallery, NYC, 1938, also 1947, 49; Charlotte/ Mint, 1949; Galerie Colette Allendy, Paris, 1950; Leo Castelli Inc., 1959-61, 1963, 65, 68, 71, 73, 75; Galleria Toninelli, Milan, 1961; Iris Clert Gallery, 1962; Franklin Siden Gallery, Detroit, 1967; Syracuse/Everson, 1969; Brockton/Fuller, 1970; Andre Zarre Gallery, NYC, 1974; Printers Gallery, Ithaca, 1975. **Retrospective:** Buffalo/Albright, 1969; Syracuse/Everson, 1969. **Group:** Carnegie, 1955, 58, 61, 70; Corcoran Biennial, 1959, 63, 69; WMAA Annual, 1960-65, 1967; Walker, Purist Painting, 1961; American Abstract Artists Annual, 1961; SRGM, Abstract Expressionists and Imagists, 1961; Seattle World's Fair, 1962; WMAA, Geometric Abstraction in America, circ., 1962; Musee Cantonal des Beaux-Arts, Lau-

sanne, I Salon International de Galeries Pilotes, 1963; Lincoln, Mass./De Cordova, 1965; U. of Illinois, 1969. **Collections:** Akron/AI; Baltimore/MA; Buffalo/Albright; Carnegie; MOMA; U. of Michigan; Norfolk; Norfolk/Chrysler; RISD; Reading/Public; SRGM; South Mall, Albany; Tel Aviv; Union Carbide Corp.; Utica; WMAA. **Bibliography: Murdock 2.** Archives.

D'ARCANGELO, ALLAN. b. June 16, 1930, Buffalo, N.Y. **Studied:** U. of Buffalo, 1948-52, BA (History and Government); City College of New York; New School for Social Research, 1953-54; Mexico City College, 1957-59, with Dr. John Golding, Fernando Belain; studio work with Boris Lurie, NYC, 1956-66. Traveled Mexico, USA, Japan, Far East, North Africa. **Taught:** NYC public schools, 1956-62; School of Visual Arts, NYC, 1963-68; Cornell U., 1968; Syracuse U., 1971; U. of Wisconsin, 1972; St. Cloud State College, 1972; Memphis Academy of Arts, 1975; Brooklyn College, 1973- . **Member:** SAGA. **Commissions:** Transportation and Travel Pavilion, New York World's Fair, 1964-65 (mural). **Awards:** Municipal U. of Omaha, First **P.P.**, 1966; NIAL, 1970. **Address:** Kenoza Lake, N.Y. 12750. **Dealer:** Marlborough Gallery, Inc., NYC. **One-man Exhibitions:** Galeria Genova, Mexico City, 1958 (two-man); Long Island U., 1961; Thibaut Gallery, NYC, 1963; Fishbach Gallery, 1964, 65, 67, 69; Ileana Sonnabend Gallery, Paris, 1965; Galerie Rudolf Zwirner, 1965; Galerie Hans R. Neuendorf, Hamburg, 1965; Galerie Muller, 1965; Dwan Gallery, Los Angeles, 1966; Wurttembergischer Kunstverein, Stuttgart, 1967; Galerie Rolf Ricke, Kassel, 1967; Minami Gallery, 1967; Obelish Gallery, 1967 (two-man), 1970; Franklin Siden Gallery, Detroit, 1968, 72; Lambert Gallery, Paris, 1968; Wisconsin State U., Eau Claire, 1970; Marlborough Gallery Inc., NYC, 1971, 75; U. of Wisconsin, Madison, 1972; Hokin Gallery, Chicago, 1974; Patricia Moore Inc., Aspen, 1974; Russell Sage

College, 1974; Gallery Kingpitcher, Pittsburgh, 1975. **Retrospective:** ICA, U. of Pennsylvania, 1971. **Group:** Sarah Lawrence College, Popular Imagery, 1963; ICA, London, 1963; Oakland/AM, Pop Art USA 1963; Buffalo/Albright, Mixed Media and Pop Art, 1963; Salon du Mai, Paris, 1964; The Hague, New Realism, 1964; Salon des Comparaisons, Paris, 1964; Dwan Gallery, Los Angeles, Boxes, 1964, also 1965; Milwaukee, 1965; Galerie Hans R. Neuendorf, Hamburg, 1965, 66; Galerie Friedrich & Dahlem, Munich, 1966; V. International Biennial Exhibition of Prints, Tokyo, 1966; V. International Biennial Exhibition of Prints, Tokyo, 1966; Amsterdam/Stedelijk, New Shapes of Color, 1966; Expo '67, Montreal, 1967; Detroit/Institute, Color, Image and Form, 1967; Torcuato di Tella, Buenos Aires, 1967; WMAA Annual, 1967; Brandeis U., 1968; Foundation Maeght, 1968; MOMA, Social Comment in America, circ., 1968; ICA, U. of Pennsylvania, Highway, 1970; Utica, American Prints Today, 1973; WMAA, American Pop Art, 1974. **Collections:** Atlantic Richfield Co.; Brandeis U.; Brooklyn Museum; Buffalo/Albright; Chase Manhattan Bank; Cleveland/MA; Detroit/Institute; Gelsenkirchen; The Hague; Hannover/Kunstverein; The Hertz Corp.; Hirshhorn; MIT; MOMA; Munster/WK; NYU; Nagaoka, Japan; New Orleans/Delgado; Ridgefield/Aldrich; Skopje/Modern; WMAA; Walker; U. of Wisconsin. **Bibliography:** Battcock, ed.; Calas, N. and E.; Hunter, ed.; *Kunst um 1970;* Lippard 5.

D'ARISTA, ROBERT. b. July 2, 1929, Pelham, N.Y. **Studied:** NYU, with Philip Guston; Columbia U., with John Heliker; American Art School, NYC; Academie de la Grande Chaumiere. Traveled France, Italy. **Taught:** American U., 1961- ; Artist-in-Residence, Boston U., spring, 1973. **Awards:** Fulbright Fellowship, 1956; NIAL. **Address:** 3125 Quebec Place, N.W., Washington, D.C. 20008. **Dealer:** Nordness Galleries. **One-Man Exhibitions:** (first) The Alan Gallery, NYC, 1955, also 1956, 60; Grippi Gallery, NYC, 1962; Jefferson Place Gallery, 1962; Lee Nordness Gallery, 1964, 67, 69; Boston U., 1973. **Group:** PAFA, 1954, 60; Brooklyn Museum; U. of Illinois, 1955; U. of Nebraska, 1955, 56, 57; Columbia, S.C./MA Annual; Bogota, Colombia; SRGM; Detroit/Institute, 1955, 58; Chicago/AI; Carnegie, 1956, 59; WMAA Annuals, 1956, 57, 59. **Collections:** American U., NCFA; Smith College; Toledo/MA; Yale U. **Bibliography:** Nordness, ed.

DARROW, PAUL GARDNER. b. October 31, 1921, Pasadena, Calif. **Studied:** Art Center School, Los Angeles; Colorado Springs Fine Arts Center, with Boardman Robinson; Claremont Graduate School, with Millard Sheets, Sueo Serisawa, Henry McFee, Howard Cook. **Taught:** Coronado School of Fine Arts, summers, 1953, 55; Brigham Young U., 1954; Otis Art Institute, 1955-67; Scripps College, 1955-69; Claremont Graduate School, 1955-69, 1970- ; Laguna Beach (Calif.) School of Art and Design, 1960-69. **Commissions** (murals): Richmond (Calif.) Youth Center, 1952; Convair Aircraft Corp., San Diego, 1953; National American Insurance Co., Los Angeles, 1954; Kaiser Aluminum Corp.; Disneyland, Calif., 1955; Broadway Dept. Stores, Anaheim and Van Nuys, Calif., 1955; Gourmet Shop, Hollywood, 1955; Air France, International Airport, Los Angeles, 1960-61; Home Insurance Co., Los Angeles. Traveled Japan, Taiwan, Philippines, Okinawa. US Navy artist correspondent, Vietnam. **Awards:** California State Fair, 1950; Los Angeles/County MA, First Prize Watercolor, 1954; Pasadena/AM, **P.P.,** 1954, 58. **Address:** 690 Cuprien Way, Laguna Beach, Calif. 92651. **Dealer:** Comara Gallery. **One-man Exhibitions:** Philadelphia Art Alliance, 1948; Mezzanine Gallery, Oakland, Calif., 1953; Gump's Gallery, 1954; RAC, 1954; Pasadena/AM, 1955; Scripps College, 1958; Drake Gallery, Carmel, Calif., 1960;

Comara Gallery, 1961, 64, 68; San Joaquin Pioneer Museum and Haggin Art Galleries, Stockton, Calif., 1963; Sacramento State College, 1966; Hartnell College, 1968; California Institute of Technology, Pasadena, 1970. **Group:** U. of Vienna, 1951; Los Angeles/County MA, 1951-54; Santa Barbara/MA, 1952-55; SFMA, 1952, 53; Seattle/AM, 1953; Youngstown/Butler, 1953, 54; PAFA, 1954; Denver/AM, 1954; Corcoran, 1954; Sao Paulo, 1955; Smithsonian, circ., 1955-56; Long Beach/MA, 1958-61; Oakland/AM; Newport Harbor Art Museum, Balboa, Calif., 1964. **Collections:** Long Beach/MA; U. of Michigan; Palos Verdes; Pasadena/AM; Scripps College.

DASBURG, ANDREW. b. May 4, 1887, Paris, France. To USA 1892. **Studied:** ASL, with Kenyon Cox, Frank V. DuMond; privately with Birge Harrison; also with Robert Henri. **Awards:** Pan-American Exhibition, Los Angeles, 1925; Carnegie, 1927, 31; Guggenheim Foundation Fellowship, 1932; Ford Foundation Grant. **Address:** Ranchos de Taos, N.M. 87571. **Dealer:** Mission Gallery. **One-man Exhibitions:** Dallas/MFA, 1957; Rehn Galleries, 1958; U. of New Mexico, 1966. **Retrospective:** A.F.A./Ford Foundation, circ., 1959. **Group:** WMAA; SFMA; MMA; Denver/AM; Santa Fe, N.M. **Collections:** Barnes Foundation; California Palace; Cincinnati/AM; Colorado Springs/FA; Dallas/MFA; Denver/AM; Los Angeles/County MA; MMA; SFMA; Santa Barbara/MA; Santa Fe. N.M.; WMAA. **Bibliography:** *Avant-Garde Painting and Sculpture;* Baur 7; Brown; **Bywaters 1, 2;** Cahill and Barr, eds.; Cheney; Coke 2; Goodrich and Baur 1; Hunter 6; *Index of 20th Century Artists;* Janis, S.; McCurdy, ed.; Neuhaus; Richardson, E. P.; Rose, B. 1, 4; Wright 1. Archives.

DASH, ROBERT. b. June 8, 1934, NYC. **Studied:** U. of New Mexico, BA (Anthropology and English). Traveled Italy, Mexico, USA, Ireland, West Germany. **Taught:** Southampton College, Long Island U., 1972. **Member:** Fellow, Royal

Andrew Dasburg *Landscape—New Mexico* 1932

Robert Dash *Dull Spring No. 1* 1972

Horticultural Society. **Awards:** New York State Board of Regents Scholarship. **Address:** Sagaponack, N.Y. 11962. **Dealer:** Fischbach Gallery. **One-Man Exhibitions:** (first) The Kornblee Gallery, 1961, also 1962, 63; The Osborne Gallery, NYC, 1964, 65, 66; The Graham Gallery, 1964, 68, 69, 70; Crane-Kalman Gallery, London, 1966; Munich/Modern, 1969; FAR Gallery, 1972, 73; Vick Gallery, Philadelphia. **Retrospective:** Southampton/Parrish, 1969; Allentown/AM, 1971. **Group:** Yale U., The New York Season, 1961; MOMA, Eight American Painters of the Landscape, circ., 1964; Corcoran; U. of Colorado; Norfolk, Contemporary Art USA, 1966; AAAL, Childe Hassam Fund Exhibition, 1973; Omaha/Joslyn, A Sense of Place, 1973. **Collections:** The Bank of New York; Bristol-Meyers Co.; Brooklyn Museum; U. of California; Chase Manhattan Bank; Federal Deposit Insurance Corporation; First National Bank of Memphis; The Grace Line; National Life Insurance Co.; PMA; Suffolk County National Bank. Archives.

DAVEY, RANDALL. b. May 24, 1887, East Orange, N.J.; **d.** November 7, 1964, Santa Fe, N.M. **Studied:** Cornell U., 1905-07; in Europe with Robert Henri, 1908-09. Traveled USA, Europe. **Taught:** Chicago Art Institute School, 1920; Kansas City Art Institute and School of Design, 1921-24; Broadmoor Art Academy, Colorado Springs, 1924-31; U. of New Mexico, 1945-46. **Commissions** (murals): US Post Offices, Vinita and Claremore, Okla., 1939. **Awards:** NAD, Hallgarten Prize, 1915; SFMA, Hon. Men., 1915; NAD, The Thomas B. Clarke Prize, 1938; NAD, 1939. **One-Man Exhibitions:** California Palace; San Diego; U. of New Mexico; Vassar College; Vose Gallery, Boston; Whitney Studio Club, NYC; Macbeth Gallery, NYC, 1916; Montross Gallery, NYC, 1922; Rehn Galleries, 1930; Ferargil Galleries, NYC, 1933, 34; Kraushaar Galleries, 1938; Grand Central, NYC, 1941; Santa Fe, N.M., 1946; Buffalo/Albright; Chicago/AI; Symphony Hall, Boston; Broadmoor Art Academy, Colorado Springs; Carnegie; Carroll Gallery, NYC; Kleemann Gallery, NYC; Findlay Gallery, NYC, 1967. **Retrospective:** Santa Fe, N.M., 1957. **Group:** Corcoran; Chicago/AI; WMAA; Kansas City/Nelson; Santa Fe, N.M.; Taos, N.M. **Collections:** Britannica; Chicago/AI; Cleveland/MA; Corcoran; Detroit/Institute; Kansas City/Nelson; Montclair/AM; U. of New Mexico; Will Rogers Shrine; Santa Fe, N.M.; US Navy; WMAA. **Bibliography:** Bryant, L.; Cheney; Coke 2; **Davey;** Hall; Jewell 2; Neuhaus. Archives.

DAVIS, GENE. b. August 22, 1920, Washington, D.C. **Studied:** U. of Maryland; Wilson Teachers College. **Taught:** The Corcoran School of Art, 1967-68; 1970; American University, 1968-70; Skidmore College, 1969; U. of Virginia, 1972. **Commissions:** South Mall, Albany, 1969 (mural); Neiman-Marcus Co., Bal Harbour, Fla., 1970 (mural). **Awards:** Corcoran, Bronze Medal for Painting and $1000 Award, 1965; National Council on the Arts, $5000 Grant, 1967; Guggenheim Foundation Fellowship, 1974. **Address:** 2480 16 Street, N.W., Washington, D.C. **Dealer:**

Fischbach Gallery. **One-man Exhibitions:** (first) The Catholic U. of America, 1953; American U., 1955; Bader Gallery, Washington, D.C., 1956; Jefferson Place Gallery, 1959, 61, 63, 67; Poindexter Gallery, 1963, 65-67; Corcoran, 1964, 68, 70; Hofstra U., 1966; MIT, 1967; Des Moines, 1967; Galerie Rolf Ricke, 1967; Fischbach Gallery, 1967-69, 1970, 71, 72, 73; SFMA, 1968; WGMA, 1968; Jewish Museum, 1968; Henri Gallery, 1968-70; Chapman Kelly Gallery, 1969; Axiom Gallery, London, 1969; Nova Scotia College of Art and Design, 1970; Galerie Annemarie Verna, Zurich, 1971; Dunkelman Gallery, Toronto, 1971-73; J. L. Hudson Art Gallery, Detroit, 1972; U. of Utah, 1972; Omaha/Joslyn, 1972; Max Protetch Gallery, Washington, D.C., 1972; Michael Berger Gallery, Pittsburgh, 1973; Quay Gallery, 1973; New Gallery, Cleveland, 1974; Tibor de Nagy, Houston, 1974. **Group:** WGMA, The Formalists, 1963; Brandeis U., New Directions in American Painting, 1963; Los Angeles/County MA, Post Painterly Abstraction, 1964; MOMA, The Responsive Eye, 1965; WGMA, circ., 1965; MOMA, Two Decades of American Painting, circ. Japan, India, Australia, 1967; Corcoran Biennial, 1967; Detroit/Institute, Color, Image and Form, 1967; WMAA Annuals, 1968, 71, 73; Milwaukee, Directions I: Options, circ., 1968; Art Fair, Cologne, 1968; Edmonton Art Gallery, Alberta, Ten Washington Artists: 1950-1970, 1970; Baltimore/MA, Washington Art: 1950-1970, 1970; ICA, U. of Pennsylvania, Two Generations of Color Painting, 1970; WMAA, The Structure of Color, 1971; U. of Texas, Color Forum, 1972; West Palm Beach/Norton, The Vincent Melzac Collection—Part One: The Washington Color Painters, 1974; SRGM, Within the Decade, 1974. **Collections:** Brandeis U.; Buffalo/Albright; Cleveland/MA; Corcoran; Denver/AM; Des Moines; Florsheim Foundation; High Museum; Indianapolis/Herron; Jacksonville/AM; MIT; MMA; MOMA; Milwaukee; NCFA; National Gallery; Oklahoma; Omaha/Joslyn; PMA; Phillips; Ringling; SFMA; SRGM; Tate; WMAA; Wellesley College; Woodward Foundation; Yale U. **Bibliography:** *Art Now 74;* Atkinson; Davis, D.; **Gene Davis.**

DAVIS, JERROLD. b. November 2, 1926, Chico, Calif. **Studied:** U. of California, Berkeley, BA, 1953, MA. Traveled Latin America, Europe. **Taught:** U. of California, summer, 1967. **Awards:** Sigmund Martin Heller Traveling Fellowship, 1953; Guggenheim Foundation Fellowship, 1958; Ford Foundation Artist-in-Residence, 1964. **Address:** 66 Twain Avenue, Berkeley, Calif. 94708. **Dealer:** Jacqueline Anhalt Gallery. **One-Man Exhibitions:** Instituto Brasil-Estados-Unidos, Rio de Janeiro, 1951; California Palace, 1957; Everett Ellin Gallery, Los Angeles, 1958; The Rose Rabow Gallery, San Francisco, 1963, 74; Esther Robles Gallery, 1964; Flint/Institute, 1964; Gallery of Modern Art, 1965; Quay Gallery, 1967, 68; Fleischer Anhalt Gallery, 1968; Jacqueline Anhalt Gallery, 1970; Newport Harbor, 1973. **Group:** Sao Paulo Biennial, 1951; Oberlin College, 3 Young Painters, 1958; Carnegie, 1958; U. of Illinois, 1959, 61, 63; California Palace, 1960-64; Flint/Institute, 1964; Phoenix, 1964; Los Angeles/County MA, 1965; U. of Arizona, 1967; Omaha/Joslyn, A Sense of Place, 1973. **Collections:** Bank of America; Carnegie; Flint/Institute; Los Angeles/County MA; Oakland/AM; SFMA; Santa Barbara/MA.

DAVIS, RONALD. b. June 29, 1937, Santa Monica, Calif. **Studied:** U. of Wyoming; San Francisco Art Institute (with Jack Jefferson, Frank Lobdell), 1960-64; Yale-Norfolk Summer Art School (with Philip Guston), 1962. **Taught:** U. of California, 1967. **Awards:** National Council on the Arts Grant, 1968. **Address:** 6950 Grasswood Avenue, Malibu, Calif. 90265. **Dealers:** Nicholas Wilder Gallery; Leo Castelli Inc.; Kasmin Ltd. **One-Man Exhibitions:** (first) Nicholas Wilder Gallery, 1965, also 1967, 69; Tibor de Nagy Gallery,

1966; Leo Castelli Inc., 1968; Kasmin Ltd., 1968, 71; David Mirvish Gallery, 1970; Pasadena/AM, 1971. **Group:** San Francisco Art Festival, 1961-63; SFMA, Arts of San Francisco, 1964; RAC, 1964; U. of Illinois, 1965; WGMA, A New Aesthetic, 1967; WMAA Annual, 1967; Documenta IV, Kassel, 1968; Corcoran Biennial, 1967; Venice Biennial, 1972; Montreal/Contemporain, 11 Artistes Americains, 1973. **Collections:** Baltimore/MA; MOMA; Tate. **Bibliography:** Davis, D.; *Report; The State of California Painting; USA West Coast;* Wood.

DAVIS, STUART. b. December 7, 1894, Philadelphia, Pa.; **d.** June 24, 1964, NYC. **Studied** with Robert Henri, 1910-13. US Army Intelligence, World War I. Traveled Europe, Cuba, USA. **Taught:** ASL, 1931-32; New School for Social Research, 1940-50; lectured at museums and universities. Federal A.P.: 1933-39. Editor: *Art Front* Magazine. **Commissions** (murals): Radio City Music Hall, NYC, 1932; Indiana U., 1938; New York World's Fair, 1939; Municipal Broadcasting Co., NYC, 1939; Drake U., 1955; Heinz Research Center, Pittsburgh, 1957. **Awards:** Pepsi-Cola, 1944; Carnegie, Hon. Men., 1944; PAFA, J. Henry Schiedt Memorial Prize, 1945; Chicago/AI, Norman Wait Harris Silver Medal, 1948; La Tausca Competition, **P.P.**, 1948; VMFA, John Barton Payne Medal, 1950; Chicago/AI, Ada S. Garrett Prize, 1951; Guggenheim Foundation Fellowship, 1952; Hallmark International Competition, 1956; PAFA, Hon. Men., 1956; Brandeis U., Creative Arts Award, 1957; Guggenheim International, 1958, 60; Chicago/AI, Flora Mayer Witkowsky Prize, 1961; PAFA, Joseph E. Temple Gold Medal, 1964; Chicago/AI, The Mr. & Mrs. Frank G. Logan Medal and Prize. **One-Man Exhibitions:** Sheridan Square Gallery, NYC, 1917; Ardsley Gallery, 1918; Newark Museum, 1925; Whitney Studio Club, NYC, 1926-29; The Downtown Gallery, 1927, 30, 31, 32, 34, 43, 46, 52, 54, 56, 60, 62; Curt Valentine Gallery, NYC, 1928; Crillon Galleries, Philadelphia, 1931; Katherine Kuh Gallery, Chicago, 1939; Modern Art Society, Cincinnati, 1941 (two-man); Arts Club of Chicago, 1945; MOMA, 1945; Baltimore/MA, 1946; Santa Barbara/MA, 1949 (three-man); XXVI Venice Biennial, 1952; Contemporary Arts Gallery, NYC, 1955, 59; Brandeis U., 1957; Peale House, Philadelphia, 1964; Lawrence Rubin Gallery, NYC, 1971; **Retrospectives:** Walker, 1947; NCFA, 1965. **Group:** The Armory Show, 1913; Independents, NYC, 1916; Golden Gate International Exposition, San Francisco, 1939; Tate, American Painting, 1946; I Sao Paulo Biennial, 1951; MOMA, 12 Modern American Painters and Sculptors, circ. Europe, 1953-55; MOMA, Modern Art in the United States, circ. Europe, 1955-56; I Inter-American Paintings and Prints Biennial, Mexico City, 1958; American Painting and Sculpture, Moscow, 1959; WMAA, The 1930's, 1968. **Collections:** AAAL; Andover/Phillips; Arizona State College; U. of Arizona; Baltimore/MA; Bezalel Museum; Brandeis U.; Britannica; Brooklyn Museum; Buffalo/Albright; Carnegie; Chicago/AI; Cincinnati/AM; Cranbrook; Dartmouth College; U. of Georgia; Hartford/Wadsworth; Harvard U.; Honolulu Academy; IBM; U. of Illinois; State U. of Iowa; U. of Kentucky; Library of Congress; Los Angeles/County MA; MMA; MOMA; Milwaukee; Minneapolis/Institute; U. of Nebraska; Newark Museum; New Trier High School; Ogunquit; U. of Oklahoma; PAFA; PMA; The Pennsylvania State U.; Phillips; Randolph-Macon Woman's College; Sara Roby Foundation; U. of Rochester; Roswell; SFMA; SRGM; St. Louis/City; San Diego; Seattle/AM; Utica; VMFA; Vassar College; WMAA; Walker; Washington U.; Wellesley College; Wichita/AM; Yale U. **Bibliography: Arnason 3, 4;** *Avant-Garde Painting and Sculpture;* Baigell 1; Barker 1; Barr 3; Battcock, ed.; Baur 5, 7; Bazin; Beekman; Biddle 4; Biederman 1; **Blesh 1, 2;** Brown; Cahill and Barr, eds.; Cheney; Chipp; Christensen; Coke 2; **Davis, S.;** Eliot; **Elliott;** Flanagan; Flexner; Frost; Genauer;

Gerdts; Goodrich and Baur 1; **Goossen 4;** Greengood; Haftman; Halpert; Hess, T. B. 1; Hunter 1, 6; Hunter, ed.; Huyghe; Janis, S.; **Kelder;** Kepes 2; Kootz 2; Kozloff 3; Kuh 2, 3; Lee and Burchwood; Lippard 5; McCurdy, ed.; Mendelowitz; Munsterberg; Newmeyer; Nordness, ed.; Pagano; Pearson 1; Phillips 1; Pousette-Dart, ed.; Read 2; Richardson, E. P.; Rickey; Ringel, ed.; Ritchie 1; Rodman 2; Rose, B. 1, 4; Rosenblum 1; Sachs; Sandler; Seuphor 1; Sutton; **Sweeney 4;** Tashjian; Weller; "What Abstract Art Means to Me"; Wheeler; Wight 2. Archives.

DAY, WORDEN. b. June 11, 1916, Columbus, Ohio. **Studied:** Randolph-Macon Woman's College, BA; NYU, MA; with Maurice Sterne, Jean Charlot, Vaclav Vytlacil, Hans Hofmann, S. W. Hayter in NYC. Traveled USA, North Africa, Europe, Greece. **Taught:** U. of Wyoming; Pratt Institute; State U. of Iowa; New School for Social Research; ASL. **Member:** Federation of Modern Painters and Sculptors; Sculptors Guild. Included in USIA film "Printmaking, USA." **Commissions:** International Graphic Arts Society, 1964. **Awards:** VMFA Fellowship, 1940; Lessing J. Rosenwald Fund Fellowship, 1942-44; Guggenheim Foundation Fellowship, 1951, 52, 61, 62; Brooklyn Museum, **P.P.**; Library of Congress, Pennell **P.P. Address:** R. D. 2, Newtown-Richboro Road, Newtown, Pa. 18940. **Dealers:** A.A.A. Gallery, NYC; Sculpture Center; Discovery Art Galleries. **One-Man Exhibitions:** Perls Galleries, 1940; VMFA, 1940; The Bertha Schaefer Gallery, 1948, 51; Cincinnati/AM, 1948-58; Norfolk; Baltimore/MA, 1948-58; The Krasner Gallery, 1959; Grand Central Moderns, NYC, 1961; Mills College; U. of Minnesota. **Group:** U. of Illinois, 1950; WMAA; MOMA; Chicago/AI; Brooklyn Museum; MMA; USIA, 10 American Artists of Woodcut, circ.; Montclair/AM (two-man), 1970; Sculpture Center, 1972. **Collections:** Bradley U.; Brooklyn Museum; Carnegie; Detroit/Institute; Hartford/Wadsworth;

U. of Illinois; Kalamazoo/Institute; Library of Congress; U. of Louisville; MMA; MOMA; Mills College; U. of Minnesota; Montclair/AM; NYPL; National Gallery; U. of Nebraska; Newark Museum; Norfolk; PMA; Rutgers U.; St. Louis/City; Seagram Collection; The Singer Company Inc.; Trenton/State; Utica; VMFA; WMAA; Walker; U. of Wyoming; Yale U. **Bibliography:** Ritchie 1. Archives.

DE ANDREA, JOHN. b. December 24, 1941, Denver, Colo. **Studied:** U. of Colorado, 1964, BFA. Traveled Europe, Mexico, USA. **Taught:** U. of New Mexico, 1965. **Awards:** National Endowment for the Arts, 1974. **Address:** 1235 Pierce Street, Lakewood, Colo. 80214. **Dealer:** OK Harris Works of Art. **One-man Exhibitions:** OK Harris Works of Art, 1970, 71, 73. **Group:** Chicago/Contemporary, Radical Realism, 1971; VII Paris Biennial, 1971; Documenta V, Kassel, 1972; Galerie des 4 Mouvements, Paris, Hyperrealistes Americains, 1972; Harvard U., Recent Figure Sculpture, 1972; New York Cultural Center, Realism Now, 1972; Lunds Konsthall, Sweden, Amerikansk Realism, 1973; Lincoln, Mass./De Cordova, The Super-Realist Vision, 1973; Hofstra U., The Male Nude, 1973; CNAC, Hyperrealistes Americains/Realistes Europeens, 1974; Hartford/Wadsworth, New/Photo Realism, 1974. **Collections:** Aachen/NG; Syracuse/Everson. **Bibliography:** *Kunst um 1970; Recent Figure Sculpture;* Sager.

DECKER, LINDSEY. b. 1923, Lincoln, Neb. **Studied:** American Academy of Art, Chicago, 1942-43; State U. of Iowa, 1946-50, BFA, MFA. **Taught:** Michigan State U., 1950-62; Queens College, 1962-64; Cooper Union, 1962-65; U. of Wisconsin, 1965. Subject of a film, "The World of Lindsey Decker," on drawings and sculpture (11 min., color). **Commissions:** Eastland Center, Detroit, 1957; Atomic Energy Commission, Oak Ridge, Tenn. **Awards:** Detroit/Institute, **P.P.**, also Dr. & Mrs. Meyer O. Cantor

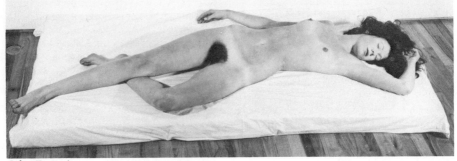

John DeAndrea *Woman on Foam Mattress* 1974

Prize, 1956; Italian Government Fellowship for work in creative sculpture, 1957; Fullbright Fellowship (Italy), 1957. **Address:** 78 Greene Street, NYC. **One-man Exhibitions:** Chiku-Rin Gallery, Detroit; Michigan State U.; Kalamazoo/Institute; Los Artesantos Gallery, Las Vegas, N.M.; The Zabriskie Gallery, 1959, 60; 131 Prince Street, NYC, 1969. **Group:** Chicago/AI, Exhibition Momentum, 1950, 51, 52, 53, 54; Philadelphia Art Alliance, 1954; WMAA Annuals, 1956, 60; Houston/MFA, Irons in the Fire, 1957; A.F.A., New Talent, circ., 1957; MOMA, Recent Sculpture USA, 1959; A.F.A., Contemporary Sculpture, 1960; PAFA, 1960; Cincinnati/AM, Midwest Sculpture, 1960. **Collections:** Albion College; Cranbrook; Detroit/Institute.

DE CREEFT, JOSE. b. November 27, 1884, Guadalajara, Spain. **Studied:** Atelier of Don Augustin Querol, Barcelona, 1906; apprenticed to Idalgo de Caviedas; Academie Julian, Paris, 1906; Maison Greber, Paris, 1910-14. To USA 1929; citizen 1940. **Taught:** New School for Social Research, 1932-48, 1957-62; ASL, 1934-62. **Member:** Artists Equity (founding member); Audubon Artists; National Sculpture Society; Federation of Modern Painters and Sculptors (President, 1943); NIAL, 1955; NAD, 1964; AAAL; Sculptors Guild. **Commissions:** Saugues (Puy de Dome), France, 1918 (World War I Memorial); Fortress of Ramonje, Mallorca, 1932 (200 pieces of sculpture); Fairmount Park, Philadelphia, 1950; Central Park, NYC, 1959 (Alice in Wonderland group); Bronx (N.Y.) Municipal Hospital, 1962 (mosaic for nurses' residence); New Public Health Laboratory, NYC, 1966. **Awards:** Officier de l'Instruction Publique, France; MMA, Artists for Victory, First Prize, 1942; PAFA, George D. Widener Memorial Gold Medal, 1945; Audubon Artists, Gold Medal of Honor, 1954, 57; Ford Foundation Traveling Retrospective, 1960; National Sculpture Society, Therese and Edwin Richard Prize for Portrait Sculpture, 1969; Comendador de la Orden de Isabel la Catolica, 1973; National Arts Club, Gold Medal, 1975. m. Lorrie Goulet. **Address:** 241 West 20 Street, NYC 10011. **One-man Exhibitions:** (first) El Circulo de Bellas Artes, Madrid, 1903; Seattle/AM, 1929; Ferargil Galleries, NYC, 1929; Arts Club of Chicago, 1930; Philadelphia Art Alliance, 1933; Passedoit Gallery, NYC, 1936, 1938-49; Santa Barbara/MA, 1937; St. Paul Gallery, 1943; College of William and Mary, 1944; West Palm Beach/Norton, 1949, 50; The Contemporaries, NYC, 1956, 58, 60, 64, 65; Kennedy Gallery, 1970, 71, 72, 75. **Retrospectives:** A.F.A./Ford Foundation, circ., 1960; New School for Social Research, 1974. **Group:** Salon d'Automne, Paris, 1910-29; Chicago/AI Annuals, 1939-51; MMA, National Sculpture Exhibition, 1942, 51; WMAA Annuals, 1942-57; PAFA Annuals, 1944-62; Carnegie; MOMA, Sculpture

of the XXth Century, 1953; Worcester/ AM; Brooklyn Museum; Sculptors Guild Annuals; Audubon Artists Annuals; Federation of Modern Painters and Sculptors; Artistes Français; Societe Nationale des Beaux Arts, Paris; Salon des Artistes Independants, Paris. **Collections:** Bezalel Museum; Brooklyn Museum; Columbia U.; Hirshhorn; IBM; MMA; MOMA; Museum of the City of New York; U. of Nebraska; New Paltz/SUNY; PAFA; U. of Puerto Rico; SFMA; Seattle/AM; Trenton/State; U. of Tucson; Utica; WMAA; West Palm Beach/Norton; Wichita/AM. **Bibliography:** Baur 7; Brumme; **Campos;** Cheney; Craven, W.; **de Creeft; Devree;** Goodrich and Baur 1; McCurdy, ed.; Pearson 2; Ritchie 3; Selz, J.; Seuphor 3. Archives.

DEEM, GEORGE. b. August 18, 1932, Vincennes, Ind. **Studied:** Vincennes U.; The U. of Chicago; Chicago Art Institute School, with Paul Wieghardt, Boris Margo, 1958, BFA. US Army, two years. Resided London, 1966-67. **Taught:** School of Visual Arts, NYC, 1965-66; U. of Pennsylvania, 1968-69. **Address:** c/o Dealer. **Dealer:** Allan Stone Gallery. **One-man Exhibitions:** (first) Allan Stone Gallery, 1962, also 1963-66, 68, 69; Merida Gallery, Inc., 1964, 68; The Goodman Gallery, Buffalo, 1965; Ferrier Gallery, Houston, 1969; Sneed Gallery, Rockford, Ill., 1969. **Group:** Corcoran; Baltimore/MA, 1962; Buffalo/Albright, 1962; Chicago/AI, 1963, 65; MOMA; Barnard College; Silvermine Guild; The Hague, New Realism, 1964; Brandeis U., 1964; Cornell U., 1965; ICA, U. of Pennsylvania, 1965. **Collections:** Houston/MFA; Oberlin College; U. of Rochester; SFMA; The Singer Company Inc. **Bibliography:** *Kunst um 1970;* Sager; Weller.

DE ERDELY, FRANCIS. b. 1904, Budapest, Hungary; **d.** 1959, Los Angeles, Calif. **Studied:** Academy of Fine Arts, Budapest; Real Academia de Bellas Artes de San Fernando, Madrid; Sorbonne; Ecole du Louvre. **Taught:** Royal Netherlands Art Academy, The Hague; Pasadena Museum School, 1944-46; U. of Southern California, 1945-59. **One-man Exhibitions:** Hungarian Relief Library, NYC, 1939; Bonestell Gallery, NYC, 1940; de Young; Santa Barbara/ MA; Pasadena/AM, 1950, 60; Laguna Beach (Calif.) Art Gallery; Sacramento/ Crocker; San Joaquin Pioneer Museum and Haggin Art Galleries, Stockton, Calif.; La Jolla; Oakland/AM, 1950; Seattle/AM; Kansas City/Nelson; Lane Gallery, 1960; Los Angeles/County MA, Memorial Exhibition, 1960; Mills College, 1962. **Collections:** Antwerp; Brussels/Moderne; Carnegie; Chicago/ AI; Colorado Springs/FA; Corcoran; Denver/AM; Detroit/Institute; Ghent; The Hague; Los Angeles/County MA; MMA; Melbourne/National; Mons; Oakland/AM; PAFA; Pasadena/AM; San Diego; Youngstown/Butler. **Bibliography:** Watson, E. W. 2.

DE FOREST, ROY DEAN. b. February 11, 1930, North Platte, Neb. **Studied:** Yakima Valley Junior College; California School of Fine Arts, with Edward Corbett, Hassel Smith, David Park; San Francisco State College, with Seymour Locks, Alexander Nepote (AA, BA, MA). Traveled Paris, London, 1971. **Taught:** California College of Arts and Crafts; Bayview High School (San Quentin Prison); San Francisco State College; Contra Costa College; Yakima Valley Junior College; U. of California, Davis, 1955- . **Awards:** Bay Printmakers Society, Oakland, **P.P.,** 1956; San Francisco Art Association, 1956; SFMA, Nealie Sullivan Award, 1962; National Endowment for the Arts, 1972. **Address:** P. O. Box 47, Port Costa, Calif. 94569. **Dealers:** Hansen-Fuller Gallery; Allan Frumkin Gallery, NYC; Darthea Speyer Gallery; Gallery Allen. **One-man Exhibitions:** (first) The East-West Gallery, San Francisco, 1955, also 1958; Stonecourt Gallery, Yakima, Wash., 1960; Dilexi Gallery, San Francisco, 1960, 63; Dilexi Gallery, Los Angeles, 1962; San Francisco Art Association, 1962, 65; Allan Frumkin Gallery, NYC,

George Deem *Eight Women* 1967

1966, 73; Peninsula Gallery, Menlo Park, Calif., 1966; Sacramento City College Art Gallery, 1967; Allan Frumkin Gallery, Chicago, 1968; Candy Store Art Gallery, Folsom, Calif., 1969; Mabikudes Gallery, Seattle, 1971; California Palace, 1971; Hansen-Fuller Gallery, 1971, 73, 73; Glenbow Alberta Institute, Calgary, 1974; Darthea Speyer Gallery, 1974; Gallery Allen, 1974. **Retrospective:** SFMA, circ., 1974. **Group:** Cincinnati/AM, 1952; SFMA, 1952, 63, 64; Sao Paulo, 1955; Reed College, 1957; California Palace, 1960, 63; WMAA, 1962; Pasadena/AM, 1962; Buffalo/Albright, 1963; Walker, 1963; U. of Illinois, 1964, 69; U. of California, Berkeley, Funk, 1967; Portland, Ore./AM, The West

Coast Now, 1968; WMAA, Extraordinary Realities, 1973; Sacramento/Crocker, Sacramento Sampler 2, 1973. **Collections:** U. of California, Berkeley; Chicago/AI; U. of Kansas; Oakland/AM; Omaha/Joslyn; SFMA; Sacramento/Crocker; U. of Utah; WMAA. **Bibliography: Humphrey;** Janis and Blesh 1; Selz, P. 2; *The State of California Painting.*

DEHN, ADOLF ARTHUR. b. November 22, 1895, Waterville, Minn.; **d.** May 19, 1968, NYC. **Studied:** Minneapolis Institute School; ASL. **Taught:** Famous Artists Schools, Inc. **Member:** NAD. **Awards:** Philadelphia Art Alliance, 1936; The Print Club, Philadelphia, 1939; Guggenheim Foundation Fellowship, 1939, 51; Chicago/AI, 1943; Library of Congress, Pennell **P.P.,** 1946. **One-man Exhibitions:** Macbeth Gallery, NYC, 1933; A.A.A. Gallery, NYC, 1941, 51; Brooklyn Public Library, 1944; Dayton/AI, 1946; The Milch Gallery, 1957, 60, 68; FAR Gallery, 1964, 65; Studio North, Towson, Md., 1969; Kennedy Gallery, 1971. **Retrospective:** Amon Carter Museum. **Group:** MMA; MOMA; NYPL; Brooklyn Museum; Chicago/AI; Boston/MFA; WMAA. **Collections:** Boston/MFA; Brooklyn Museum; Chicago/AI; Cincinnati/AM; Cleveland/MA; Indianapolis/Herron; Lehigh U.; MMA; MOMA; Minneapolis/Institute; NYPL; Newark Museum; Standard Oil Co.; US Navy; Utica; WMAA. **Bibliography:** American Artists Group Inc. 1, 2, 3; Brown; **Dehn;** Goodrich 1; Goodrich and Baur 1; *Index of 20th Century Artists;* Mellquist; Mendelowitz; Pagano; Pearson 1, 2; Pousette-Dart, ed.; Reese; Zigrosser 1. Archives.

DEHNER, DOROTHY. b. December 23, 1908, Cleveland, Ohio. **Studied:** UCLA; Skidmore College, BS (Art); Pasadena Playhouse, with Gilmor Brown; ASL, with Kimon Nicolaides, Boardman Robinson, Jan Matulka, Kenneth Hayes Miller. Traveled Europe, USSR, Mexico, USA. Began as a painter, became a sculptor in 1955.

Taught: New York State Extension Program, 1952-54; Barnard School, NYC, 1954-56; Parsons School of Design, NYC, 1950- ; Boas Dance Studio, Bolton Landing, N.Y.; and privately. **Commissions:** Great Southwest Industrial Park (outdoor relief), 1969; Union Camp Corp., Wayne, N.J., 1971; Rockefeller Center, 1972. **Awards:** Audubon Artists, First Prize, 1949; ART: USA: 59, NYC, Second Prize for Sculpture, 1959; Tamarind Fellowship, 1965; Kane Memorial Exhibition, Providence, R.I., First Prize for Sculpture, 1962; Yaddo Fellowship, 1971. **Address:** 33 Fifth Avenue, NYC 10003. **Dealers:** The Willard Gallery; A.A.A. Gallery. **One-man Exhibitions:** Albany/Institute, *ca.* 1944 (two-man, with David Smith), also 1954; Skidmore College, 1948, 53, 59; Rose Fried Gallery, 1952; Howard U., 1954; U. of Virginia, 1954; Chicago/AI, 1955; The Willard Gallery, 1955, 57, 59, 61, 63, 66, 70, 73; Wittenborn Gallery, NYC, 1956; Gres Gallery, Washington, D.C., 1959; Columbia U., 1961; Philadelphia Art Alliance, 1962; U. of Michigan, 1963; Cornell U., 1964. **Retrospectives:** Jewish Museum, 1965; Hyde Collection, 1967; Jacksonville/Cummer; Fort Wayne/AM; Design Corner, Cleveland. **Group:** Brooklyn Museum; Sculptors Guild Annuals; Baltimore/MA; Los Angeles/County MA; Utica; PAFA; Walker; Hartford/Wadsworth; New Sculpture Group, NYC; Rome/Nazionale; SFMA, 1944; WMAA Annuals, 1950, 51, 54, 60, 63; MMA, 1953; Carnegie, 1961; MOMA, 1962, 64. **Collections:** AT&T; Bankers Trust Company; Calcutta; Chase Manhattan Bank; Cleveland/MA; Columbia U.; Columbus; First National Bank of Chicago; Free Library of Philadelphia; Great Southwest Industrial Park; Hemisphere Club; Hyde Collection; Jacksonville/Cummer; MMA; MOMA; Minnesota/MA; NYPL; U. of New Mexico; The New York Bank for Savings; U. of North Carolina; St. Lawrence U.; Seattle/AM; Skidmore College; US State Department; Utica;

Wellesley College; Wichita State U.; U. of Wisconsin. **Bibliography:** Bihalji-Merin; Read 1. Archives.

DE KNIGHT, AVEL. b. 1933, NYC. **Studied:** Ecole des Beaux-Arts, Paris, 1955-56; Academie de la Grande Chaumiere, Paris, 1956-57; Academie Julien, Paris, 1957-58. Art critic for *France-Amerique,* 1958-68. **Taught:** New School for Social Research, 1967; Brooklyn Museum School, 1969-70. **Member:** NAD; American Watercolor Society. **Awards:** NAD, Palmer Memorial Prize, 1958, Ranger Fund, **P.P.,** 1958, 64, 66; AAAL, Childe Hassam Fund Purchase, 1960, 70; US State Department Exchange Grant to travel USSR, 1961; NAD, Grumbacher Award, 1962, 64, Samuel F. B. Morse Medal, 1966, William A. Paton Prize, 1967, 71; American Watercolor Society, Grand Prize and Gold Medal, 1967; Audubon Artists Medal of Honor, 1969. **Address:** 81 Perry Street, NYC 10014. **Dealer:** The Babcock Gallery. **One-man Exhibitions:** Richard Larcada Gallery, 1968, 71; The Babcock Gallery, 1973. **Group:** Youngstown/Butler, 1958-73; PAFA, 1965; Boston/MFA, Black Artists: New York and Boston, 1970; WMAA, Contemporary Black Artists in America, 1971; Finch College, NYC, Projected Art, 1971; Jacksonville/Cummer, Remnants of Things Past, 1971. **Collections:** Chase Manhattan Bank; Denison U.; Lehigh U.; MMA; Massillon Museum; Miles College; NAD; Norfolk; Southern Vermont Art Center; Springfield, Mo./AM; Walker.

DE KOONING, ELAINE. b. March 20, 1920, NYC. **Studied:** Leonardo da Vinci Art School, NYC, 1937; American Artists School, NYC, 1938, with Conrad Marca-Relli; privately with Willem de

Avel DeKnight　　*Guardian of the Night (Mirage Series)*　1973

Kooning, 1938-43. Traveled France, Belgium, Spain. **Taught:** U. of New Mexico, 1959; The Pennsylvania State U., 1960; U. of California, Davis, 1963-64; Yale U., 1967; Pratt Institute, 1968; Carnegie-Mellon U., 1968-70; U. of Pennsylvania, 1971-72; Wagner College, 1971; New York Studio School, Paris, 1974; Parsons School of Design, NYC, 1974-75. **Member:** Artists Equity. Commissioned by President Harry S. Truman to paint portrait of John F. Kennedy, 1963. **Awards:** Hon. DFA, Webster College, 1964; Moore College of Art, Philadelphia, 1972. **Address:** 51 Raynor Street, Freeport, N.Y. 11520. **Dealer:** The Graham Gallery. **One-man Exhibitions:** The Stable Gallery, NYC, 1954, 56; Tibor de Nagy Gallery, NYC, 1957; U. of New Mexico, 1958; Santa Fe, N.M., 1959; Gump's Gallery, 1959; Dord Fitz Gallery, Amarillo, 1959; Holland-Goldowsky Gallery, Chicago, 1960; The Howard Wise Gallery, Cleveland, 1960; Ellison Gallery, Fort Worth, 1960; Tanager Gallery, NYC, 1960; The Graham Gallery, 1960, 61, 64; De Aenlle Gallery, NYC, 1961; Drew U., 1966; Montclair/AM, 1973; Benson Gallery, 1973; Illinois Wesleyan U., 1975; St. Catherine's College, St. Paul, 1975. **Retrospective:** New London, 1959. **Group:** The Kootz Gallery, NYC, New Talent, 1950; International Biennial Exhibition of Paintings, Tokyo; Walker, Expressionism, 1900-1955, 1956; Carnegie, 1956; A.F.A., Sports in Art, 1957; Jewish Museum, The New York School, Second Generation, 1957; MOMA, Younger American Painters, circ., 1957-59; Houston/MFA, Action Painting, 1958; Walker, 60 American Painters, 1960; Hallmark Art Award, 1960; WMAA Annuals 1963, 74; Carnegie, 1964; PMA/Museum of the Philadelphia Civic Center, Focus, 1974; NPG, American Self-Portraits: 1670-1973, 1974. **Collections:** U. of Arkansas; Ciba-Geigy Corp.; Elmira College; Kennedy Library; MOMA; Montclair/AM; NYU; Purchase/SUNY; Harry S. Truman Library. **Bibliography:** Blesh 1; Chipp; Hunter 6; Janis and Blesh 1; O'Hara 1.

DE KOONING, WILLEM. b. April 24, 1904, Rotterdam, Holland. **Studied:** Academie voor Beeldende Kunsten ed Technische Wetenschappen, Amsterdam, 1916-24. To USA 1926. Federal A.P.: Mural painting, 1935-39. **Taught:** Black Mountain College, 1948; Yale U., 1950-51. **Member:** NIAL. **Commissions** (murals): New York World's Fair, 1939; French Line Pier, NYC (with Fernand Leger); Williamsburgh Housing Project, NYC. **Awards:** State Academy Medal, Rotterdam; Academy of Plastic Arts, Rotterdam, Silver Medal; Chicago/AI, The Mr. & Mrs. Frank G. Logan Medal, 1951; The President's Medal, 1963. **Address:** Woodbine Drive, East Hampton, N.Y. 11973. **Dealer:** Fourcade, Droll Inc. **One-man Exhibitions:** (first) Charles Egan Gallery, 1948, also 1951; Arts Club of Chicago, 1951; Sidney Janis Gallery, 1953, 56, 59, 62, 72; Boston Museum School, 1953; Workshop Art Center, Washington, D.C., 1953; Martha Jackson Gallery, 1955; Paul Kantor Gallery, Beverly Hills, Calif., 1961, 65; Allan Stone Gallery, 1962 (two-man), 1964, 65, 71, 72; The Goodman Gallery, Buffalo, 1964; Smith College, 1965; M. Knoedler & Co., NYC, 1967, 69, 71, Paris, 1968, 71; Betty Gold, Los Angeles, 1971; Fourcade, Droll Inc., 1972; Richard Gray Gallery, 1974; Walker, 1974; Galerie Biedermann, Munich, 1974. **Retrospective:** Amsterdam/Stedelijk, 1968; MOMA, 1968. **Group:** MOMA, New Horizons in American Art, 1936; WMAA Annuals, 1948, 50, 51; VMFA, American Painting, 1950; California Palace, 1950; XXV, XXVI, & XXVIII Venice Biennials, 1950, 52, 56; MOMA, Abstract Painting and Sculpture in America, 1951; Sao Paulo, 1951, 53; Chicago/AI, 1951, 54; Buffalo/Albright, Expressionism in American Painting, 1952; Carnegie, 1952; 55; Baltimore/MA, 1953; WMAA, The New Decade, 1954-55; WMAA, Nature in Abstraction, 1958; Brussels World's Fair, 1958; MOMA, The New American Painting, circ. Europe, 1958-59; Hartford/Wadsworth, Continuity and Change, 1962; Seattle World's Fair, 1962; Art: USA: Now, circ., 1962-67; SRGM, Guggen-

heim International, 1964; Tate, Painting and Sculpture of a Decade, 1954-64, 1964; SRGM, American Drawings, 1964; Los Angeles/County MA, New York School, 1965; U. of Illinois, 1967; Melbourne/National, Two Decades of American Painting, 1967; Frankfurter Kunstverein, Kompass New York, 1968; ICA, London, The Obsessive Image, 1968; MOMA, The New American Painting and Sculpture, 1969. **Collections:** Baltimore/MA; Brooklyn Museum; Buffalo/Albright; Carnegie; Chicago/AI; Container Corp. of America; Inland Steel Co.; Kansas City/Nelson; MMA; MOMA; U. of Nebraska; U. of North Carolina; Phillips; SRGM; Vassar College; WMAA; Walker; Washington U. **Bibliography:** Ashton 5; Barr 3; Battcock, ed.; Baur 5, 7; Becker and Vostell; Biddle 4; Bihalji-Merin; Blesh 1; Brion 1; Calas, N. and E.; Canaday; Chipp; **de Kooning;** Eliot; Elsen 1; Finch; Flanagan; Goodrich and Baur 1; Greenberg 1; Haftman; Henning; **Hess, T. B. 1, 4, 5;** Hunter 1, 6; Hunter, ed.; **Janis and Blesh 1, 2;** Janis, S.; Kozloff 3; Kuh 3; Langui; **Larson and Schjeldahl;** Lippard 5; Lynton; McCoubrey 1; McCurdy, ed.; Mendelowitz; *Metro; Monumenta;* Motherwell and Reinhardt, eds.; Neumeyer; Nordness, ed.; Plous; Ponente; Pousette-Dart; Ragon 1; Read 2; Richardson, E. P.; Rickey; Ritchie 1; Rodman 1, 2, 3; Rose, B. 1, 4; **Rosenberg;** Rothschild; Sandler; Seitz 1, 3; Seuphor 1; Soby 6; Tomkins; Tomkins and Time-Life Books; Tuchman, ed.; Weller; "What Abstract Art Means to Me."

DE LAP, TONY. b. November 4, 1927, Oakland, Calif. **Studied:** California College of Arts and Crafts; Menlo Junior College; Academy of Art, San Francisco; Claremont Graduate School, AA. Traveled Europe for 3 months, 1954. **Taught:** Academy of Art, San Francisco, 1957-59; California College of Arts and Crafts, 1961-63; U. of Wisconsin, summer 1963; Scripps College; U. of California, Davis, 1964-65; Claremont Colleges, 1964; San Francisco Art Institute, 1964-67; U. of Califor-

nia, Irvine, 1965- . Art Commissioner, San Francisco Municipal Art Commission. **Commissions:** Brooks Hall, San Francisco; Carborundum Co., 1969; C.C.H. Building, San Rafael, Calif., 1972; City of Inglewood, Calif., 1973. **Awards:** San Francisco Art Festival, First Prize, Mural Competition, 1957; SFMA, Nealie Sullivan Award, 1964; Ford Foundation/A.F.A. Artist-in-Residence, 1966; Long Beach/MA, **P.P.,** 1969; and others. **Address:** 225 Jasmine Street, Corona del Mar, Calif. 92625. **Dealers:** Robert Elkon Gallery; Felix Landau Gallery. **One-man Exhibitions:** (first) Gump's Gallery; SFMA; RAC, 1954; Oakland/AM, 1960; Dilexi Gallery, San Francisco, 1963, 67; Robert Elkon Gallery, 1965, 66, 68, 70, 73, 75; Felix Landau Gallery, 1966, 69; Mt. San Antonio College, 1969 (two-man); Nicholas Wilder Gallery, 1972, 74; California State U., Long Beach, 1974; John Berggruen Gallery, 1974; California Institute of Technology, Pasadena, 1975. **Retrospective:** U. of California, Irvine, Tony DeLap: The Last Five Years: 1963-68, 1969. **Group:** Stanford U., 1961; Kaiser Center, Oakland, Sculpture Today, 1964; Carnegie, 1964; WMAA, 1964; Chicago/AI; MOMA, 1964, The Responsive Eye, 1965, The 1960's, 1967; La Jolla, 1965, 66; Jewish Museum, Primary Structures, 1966; WMAA, Contemporary American Sculpture, Selection I, 1966; Musee Cantonal des Beaux-Arts, Lausanne, II Salon de Galeries Pilotes, 1966; Seattle/AM, 1966; Los Angeles/County MA, American Sculpture of the Sixties, 1967; Scripps College, 1967; San Marino (Europe), Nuove Tecniche dell'immagine, 1967; Portland, Ore./AM, 1968; U. of California, Irvine, A Los Angeles Esthetic, 1969; Pasadena/AM, West Coast: 1945-1969, 1969; La Jolla, The Wall Object, 1973; Newport Harbor, Modern and Contemporary Sculpture, 1974. **Collections:** Arizona State U.; Atlantic Richfield Co.; Hartford/Wadsworth; Hirshhorn; Los Angeles/County MA; MOMA; Oakland/AM; Ridgefield/Aldrich; SFMA; San Francisco

Municipal Art Commission; Santa Barbara/MA; State of California; Tate; WMAA; Walker. **Bibliography:** Tuchman 1.

DELLA-VOLPE, RALPH. b. May 10, 1923, New Jersey. **Studied:** NAD; ASL (with Edwin Dickinson, Will Barnet, Harry Sternberg). Traveled USA, Mexico. **Taught:** Bennett College, Millbrook, N.Y., 1949- . **Member:** College Art Association; Association of American University Professors. **Awards:** MacDowell Colony Fellowship, 1963; Library of Congress,Pennell **P.P.**; NIAL, Drawing Prize, 1963, 64. **Address:** Bennett College, Millbrook, N.Y. 12545. **Dealers:** Peter M. David Gallery; Kendall Gallery, Wellfleet, Mass.; Island Art Gallery; Wolfe Street Gallery. **One-man Exhibitions:** Bennett College, 1949-63; Three Arts Gallery, Poughkeepsie, N.Y., 1951; Artists' Gallery, NYC, 1959; The Babcock Gallery, 1960, 62, 63; Lehigh U., 1963; Mansfield State College, 1964; Pittsfield/Berkshire, 1964; Cobleskill/SUNY, 1968; Dutchess Community College, Poughkeepsie, N.Y.; Centenary College, Hackettstown, N.J.; The Hotchkiss School, Lakeville, Conn. **Retrospectives:** The Gallery, West Cornwall, Conn., 1974; Columbia, S.C./MA, 1975. **Group:** PAFA; Library of Congress; NIAL; American Color Print Society; Youngstown/Butler; Bradley U.; Brooklyn Museum; Hartford/Wadsworth; San Antonio/McNay; Vassar College; Newport (R.I.) Art Association; Audubon Artists, NYC. **Collections:** ASL; Chase Manhattan Bank; Library of Congress; Mansfield State College; Slater; Wichita/AM.

DE MARIA, WALTER. b. 1935, Albany, Calif. **Studied:** U. of California, BA, MA (with David Park). Traveled Europe, 1968. **Awards:** Guggenheim Foundation Fellowship, 1969. **Address:** 27 Howard Street, NYC 10013. **One-man Exhibitions;** (first) Nine Great Jones Street, NYC (two-man, with Robert Whitman), 1963; Paula Cooper Gallery, 1965;

Cordier & Ekstrom, Inc., 1966; Nicholas Wilder Gallery, 1968; Galerie Heiner Friedrich, Munich, 1968; Dwan Gallery, 1969, 70; Cinema Odeon, Turin, 1969; Iris Clert Gallery, 1969; Gian Enzo Sperone, Turin, 1969, 70. **Group:** Jack London Outdoor Art Annual, Oakland, Calif., 1959; Douglass College, 1964; Jewish Museum, Primary Structures, 1966; WMAA Sculpture Annual, 1967, 68; Museum of Contemporary Crafts, 1967; Los Angeles/County MA, American Sculpture of the Sixties, 1967; A.F.A., circ., 1967; Milwaukee, Directions I: Options, circ., 1968; Documenta IV, Kassel, 1968; Prospect '68, Dusseldorf, 1968; Berne, When Attitudes Become Form, 1969; Amsterdam/Stedelijk, 1969; MOMA; circ., 1969. **Collections:** MOMA; WMAA. **Bibliography:** Atkinson; Battcock, ed.; Calas, N. and E.; Celant; *Contemporanea; Davis, D.; Happening & Fluxus; Kunst um 1970;* Lippard, ed.; Muller; *Report;* Tuchman 1; *When Attitudes Become Form.* Archives.

DE MARTINI, JOSEPH. b. July 20, 1896, Mobile, Ala. **Studied:** NAD, with Leon Kroll, Ivan Olinsky. **Taught:** U. of Georgia, 1952-53. Federal A.P.: Easel painting. **Awards:** Pepsi-Cola, 1944; U. of Illinois, **P.P.,** 1948; NAD, 1950; Guggenheim Foundation Fellowship, 1951; PAFA, Gold Medal, 1952. **Address:** 103 West 27 Street, NYC 10001. **One-man Exhibitions:** (first) Dorothy Paris Gallery, NYC, 1932; Eighth Street Gallery, NYC, 1935; Macbeth Gallery, NYC, 1941, 43, 47; Hudson D. Walker Gallery, NYC, 1942. **Group:** WMAA, 1934, 42-45; St. Louis/City, 1938, 41, 42, 46; New York World's Fair, 1939; PAFA, 1940, 42-45; Chicago/AI, 1941, 42; de Young, 1941, 43; MOMA, 1941-43; Carnegie, 1941, 43, 44, 46; Corcoran 1941, 43, 45; Colorado Springs/FA, 1942; VMFA, 1942, 44, 46; Brooklyn Museum, 1943; Indianapolis/Herron, 1945; Worcester/AM, 1945; U. of Nebraska, 1945, 46. **Collections:** Andover/Phillips; U. of Arizona; Boston/MFA; Britannica; Canajoharie; U. of

Georgia; IBM; Iowa State U.; MMA; MOMA; Memphis/Brooks; U. of Nebraska; New Britain; Pepsi-Cola Co.; Phillips; U. of Rochester; Rockland/Farnsworth; St. Louis/City; San Diego; U. of Texas; US State Department; WMAA; Walker; Washington State U.; Wichita/AM. **Bibliography:** Baur 7; Cheney; Frost; Genauer.

DE MOULPIED, DEBORAH. b. November 22, 1933, Manchester, N.H. **Studied:** Boston Museum School (with E. Morenon, P. Abate, Russell T. Smith), four-year diploma, 1956; Yale U. (with Josef Albers, S. Sillman, Robert Engman, E. Hauer, Bernard Chaet), BFA, 1960, MFA, 1962. Traveled USA, Canada, Western Europe. **Taught:** Creative Arts Workshop, 1962-65; U. of Bridgeport, 1965-68; Paterson State College, 1969- . **Awards:** Tuition scholarships to Boston Museum School and Yale U.; Boston Museum School, Clarissa Bartlett Traveling Fellowship, 1961-62; MacDowell Colony Fellowship, 1968-69. **Address:** 248 Pine Orchard Road, Branford, Conn. 06405. **Dealer:** Galerie Chalette. **Group:** Galerie Chalette, 1961; USIA, Plastics—USA, circ. USSR, 1961; MOMA, Recent American Painting and Sculpture, circ. USA and Canada, 1961-62; WMAA, Geometric Abstraction in America, circ., 1962; NIAL, 1968; WMAA Annual, 1968-69. **Collections:** Chase Manhattan Bank; MOMA.

DEMUTH, CHARLES. b. November 8, 1883, Lancaster, Pa.; **d.** October 23, 1935. **Studied:** Franklin and Marshall College; Drexel Institute of Technology, 1901; Pennsylvania School of Industrial Art, Philadelphia; PAFA, 1905-08, with Thomas Anshutz, Henry McCarter; Academie Colarossi, Academie Moderne, and Academie Julian, Paris, 1912-14. Traveled Europe, eastern USA. **One-man Exhibitions:** (first) The Daniel Gallery, NYC, 1915, also 1916, 17, 18, 20, 22, 23, 24, 25; Stieglitz's Intimate Gallery, NYC, 1926, 29; An American Place (Gallery), NYC, 1931;

The Downtown Gallery, 1931, 50, 54, 58; Smith College, 1934; WMAA, 1935; WMAA, Memorial Exhibition, 1937; U. of Minnesota, 1937; Franklin and Marshall College, 1941, 48; Cincinnati/AM, 1941; Phillips, 1942; PMA, 1944; The U. of Chicago, 1946; Graphische Sammlung Albertina, 1949; Ogunquit, 1959; U. of California, Santa Barbara, 1971; Kennedy Gallery, 1971. **Retrospective:** MOMA, 1949; Harrisburg/Pa. State Museum, 1966. **Group:** MOMA; WMAA; MMA; PAFA; Phillips; Pomona College, Stieglitz Circle, 1958; **Collections:** Amherst College; Andover/Phillips; Arizona State College; Baltimore/MA; Barnes Foundation; Boston/MFA; Brooklyn Museum; Buffalo/Albright; Chicago/AI; Cleveland/MA; Columbus; Detroit/Institute; Fisk U.; Hartford/Wadsworth; Harvard U.; Honolulu Academy; MMA; MOMA; Milwaukee; National Gallery; U. of Nebraska; Newark Museum; New Britain; Ogunquit; PMA; Phillips; Princeton U.; RISD; San Antonio/McNay; Santa Barbara/MA; Toledo/MA; Utica; WMAA; Walker; Wellesley College; West Palm Beach/Norton; Wichita/AM; Worcester/AM; Yale U. **Bibliography:** *Avant-Garde Painting and Sculpture;* Barnes; Baur 7; Bazin; Biddle 4; Blesh 1; Born; Brown; Cahill and Barr, eds.; **Charles Demuth;** Cheney; Christensen; *8 American Masters of Watercolor;* Eliot; **Farnham;** *Forerunners;* Frost; Gallatin 1; Goodrich and Baur 1; Haftman; Hall; Hunter 6; Huyghe; *Index of 20th Century Artists;* Janis, S.; Jewell 2; Kootz 1, 2; Lane; Mather 1; McCoubrey 1; McCurdy, ed.; **Murrell 1;** Neuhaus; Phillips 2; Poore; Richardson, E. P.; Ringel, ed.; **Ritchie 2;** Rose, B. 1; Rosemblum 1; Sachs; Sager; Soby 5; Sutton; Tashjian; Tomkins and Time-Life Books; Wight 2.

DE NIRO, ROBERT. b. May 3, 1922, Syracuse, N.Y. **Studied:** Syracuse Museum School, 1935-39; Hofmann School, Provincetown, summers, 1939, 40; Black Mountain College, with Josef Albers. Traveled France; resided Paris. **Taught:** New School for Social Re-

search, 1966- ; School of Visual Arts, NYC, 1966-70; Buffalo/SUNY, summers, 1969, 70, 71; Wagner College, 1970, 71; Cooper Union, 1971- ; The Pennsylvania State U., 1973; Fine Arts Work Center, Provincetown, Mass., 1973; Michigan State U., 1974; New York Studio School, Paris, 1974. **Awards:** V Hallmark International Competition; Longview Foundation Grant; Guggenheim Foundation Fellowship, 1968; Tamarind Institute Grant, 1974. **Address:** 465 West Broadway, NYC 10012. **Dealer:** The Poindexter Gallery. **One-man Exhibitions:** (first) Art of This Century, NYC, 1946; Charles Egan Gallery, 1950, 52, 54; Poindexter Gallery, 1955, 56; The Zabriskie Gallery, 1958, 60 (2), 62, 65 (2), 67, 68; Ellison Gallery, Fort Worth (two-man), 1959; Buffalo/SUNY, 1967; Galleries Reese Palley, Atlantic City and San Francisco, 1968, 69; Bard College, 1969; Brenner Gallery, Provincetown, 1971; The Pennsylvania State U., 1973; Kansas City/AI, 1974. **Group:** WMAA Annuals; Jewish Museum, The New York School, Second Generation, 1957; ICA, Boston, 100 Works on Paper, circ. Europe, 1959; U. of Nebraska, 1960; A.F.A., The Figure, circ., 1960; Felix Landau Gallery, Los Angeles-New York, 1960; Colorado Springs/FA Annual, 1961; MOMA, Recent Painting USA: The Figure, circ., 1962-63; Illinois Wesleyan U. Annual, 1962; New School for Social Research, Portraits from the American Art World, 1965. **Collections:** Brandeis U.; Houston/MFA; Longview Foundation; U. of North Carolina.

DE RIVERA, JOSE. b. September 18, 1904, West Baton Rouge, La. **Studied:** Studio School, Chicago, with John W. Norton, 1928-30. Traveled USA, Europe, Mediterranean, North Africa. Federal A.P.: Mural painting, 1937-38. US Army Air Corps, 1942-43. **Taught:** Brooklyn College, 1953; Yale U., 1954-55; North Carolina School of Design, Raleigh, 1957-60. **Member:** NIAL. **Commissions:** Cavalry Monument, El Paso, 1938-40; Newark Air-

port, 1938; Soviet Pavilion, New York World's Fair, 1939; Wm. Kaufman Inc., NYC, 1955; Hotel Statler-Hilton, Dallas, 1956; Moore-McCormack Lines Inc., *SS Argentina*, 1958; Reynolds Metals Co., 1958, City of Lansing, Mich. **Awards:** Chicago/AI, Watson F. Blair Prize, 1957; NIAL Grant, 1959; Washington U., Hon. Ph.D. **Address:** 435 East 57 Street, NYC 10022. **Dealer:** Grace Borgenicht Gallery Inc. **One-man Exhibitions:** Harvard U. (two-man, with Burgoyne Diller), 1945; Mortimer Levit Gallery, NYC, 1946; Grace Borgenicht Gallery Inc., 1952, 56, 57, 58, 59, 60, 72; Walker, 1957. **Retrospective:** A.F.A./Ford Foundation, circ., 1961. **Group:** Chicago/AI, 1934; Brooklyn Museum, 1938; WMAA Annuals, 1938- ; MOMA, Twelve Americans, circ., 1956; Brussels World's Fair, 1958; American Painting and Sculpture, Moscow, 1959; MOMA, Recent Sculpture USA, 1959; Public Education Association, NYC, 1966; U. of New Mexico, 1966, Los Angeles/County MA, Sculpture of the Sixties, circ., 1967. **Collections:** The M. L. Annenberg Foundation; Brooklyn Museum; Chicago/AI; Des Moines; Fort Dodge/Blanden; Hirshhorn; La Jolla; Lembke Construction Co.; MMA; MOMA; Newark Museum; U. of New Mexico; U. of Pennsylvania; Purchase/SUNY; Ridgefield/Aldrich; U. of Rochester; SFMA; St. Louis/City; Smithsonian; Tate; Toronto; Utica; VMFA; WMAA. **Bibliography:** Baur 7; Brumme; Craven, W.; Flanagan; Gerdts; Gertz; Goodrich and Baur 1; **Jose De Rivera;** Licht, F.; McCurdy, ed.; Mendelowitz; Read 3; Rickey; Ritchie 1, 3; Rodman 3; Seuphor 3; Trier 1. Archives.

DESHAIES, ARTHUR. b. July 6, 1920, Providence, R.I. **Studied:** Cooper Union, 1939-42; RISD, 1947-48; BFA; Indiana U., 1948-50, MFA; self-taught as a printmaker. Traveled Mexico, USA, Europe. **Taught:** RISD, 1947-48; Indiana U., 1949-56; Pratt Institute, 1956-57; Pratt Graphic Art Center, 1962; Florida State U., 1963-75; lectures and

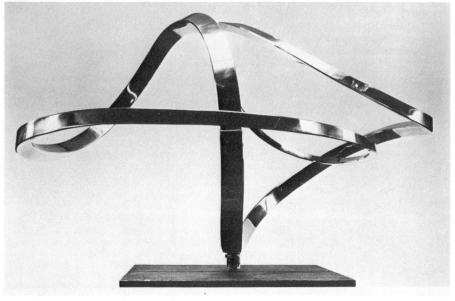

Jose de Rivera *Construction #158* 1974-75

writes extensively on art and printmaking. **Awards:** Indiana U., Faculty Research Grant for Painting, 1950; Fulbright Fellowship, 1952; MacDowell Colony Fellowship, winters, 1959, 60, 61, 62; Yaddo Fellowship, 1960; L. C. Tiffany Grant, 1960; Guggenheim Foundation Fellowship 1961; Brooklyn Museum; Bradley U.; Oklahoma Print Society; Indianapolis/Herron; U. of Kentucky, **P.P.**; Otis Art Institute, Los Angeles; Memphis/Brooks, **P.P. Address:** 1314 Dillard Street, Tallahassee, Fla. 32303. **One-man Exhibitions:** (first) Weyhe Gallery, 1940; Philadelphia Art Alliance; Galerie Paul Fachetti, 1954; Coker College, Hartsville, S.C., 1957; The Little Gallery, Tallahassee, 1964. **Group:** PCA, American Prints Today, circ., 1959-62; Brooklyn Museum; III International Biennial Exhibition of Prints, Tokyo, 1962; Otis Art Institute; WMAA. **Collections:** Bibliotheque Nationale; Bradley U.; British Museum; Brooklyn Museum; MMA; MOMA; RISD. **Bibliography:** Hayter 1; Peterdi.

DICKINSON, EDWIN. b. October 11, 1891, Seneca Falls, N.Y. **Studied:** Pratt Institute, 1910-11; ASL, 1911-12, with William M. Chase; Provincetown, summers, 1912, 13, 14, with C. W. Hawthorne. US Navy, 1917-19. Traveled Europe, Near East, North Africa, Greece. **Taught:** Buffalo Fine Arts Academy, 1916, 39; ASL, 1922-23, 1944-66; Provincetown Art Association, 1929-30; Stuart School, Boston, 1940-41; Association of Art and Music, Cape Cod, 1941; Cooper Union, 1945-49; Midtown School, NYC, 1946-47; Brooklyn Museum School, 1946-47; Pratt Institute, 1950-58; Dennis Foundation, Dennis, Mass., 1951; Skowhegan School, 1956, 58; Cornell U., 1957; Boston U., 1961. **Member:** NAD, 1948; NIAL; AAAL; Audubon Artists; The Patteran Society. Federal A.P.: Easel painting, 1934. **Awards:** NAD, Benjamin Altman Prize, 1929, 58; Benjamin West Medal; NAD, First Prize, 1949; Century Association, Medal; NIAL Grant, 1954; Brandeis U., Creative Arts Medal, 1959; Ford Foundation Grant, 1959. **Address:** P. O. Box 793, Wellfleet, Mass. 02667. **One-man Exhibitions:** (first) Buffalo/Albright, 1927; Worcester/AM; Boston/MFA; Houston/MFA;

U. of Rochester; Cornell U.; Province-
town/Chrysler; Passedoit Gallery,
NYC, 1939; Wood Memorial Gallery,
Provincetown, 1939; Wellesley College,
1940; Nantucket Museum, 1943; Cush-
man Gallery, Houston, 1958; MOMA
(circ. only), 1961; The Graham Gallery,
1961, 65, 68; Kansas City/Nelson, 1964
(two-man, with Lennart Anderson);
Peale House, Philadelphia, 1966; Kato-
nah (N.Y.) Art Gallery, 1966; Gilman
Galleries, Chicago, 1966; Provincetown
Art Association, 1967; XXXIV Venice
Biennial, 1968. **Retrospective:** Boston
U., 1958; WMAA, 1965. **Group:**
MOMA, Fifteen Americans, circ., 1952;
WMAA; Brooklyn Museum; Boston/
MFA; PMA; PAFA; Carnegie; U. of
Rochester. **Collections:** Atlanta/AA;
Bowdoin College; Brooklyn Museum;
Buffalo/Albright; Chicago/AI; Cornell
U.; Hirshhorn; MMA; MOMA;
Montpelier/Wood; NAD; U. of Nebras-
ka; Sara Roby Foundation; Springfield,
Mass./MFA; Syracuse U.; Yale U.
Bibliography: Goodrich 2, 5; Goodrich
and Baur 1; Haftman; Kuh 2; McCurdy,
ed.; Mellquist; Nordness, ed.; Pousette-
Dart, ed.; Rose, B. 1; Soyer, R. 1.
Archives.

DIEBENKORN, RICHARD. b. April 22,
1922, Portland, Ore. **Studied:** Stanford
U., 1940-43; U. of California, Berkeley,
1943-44; CSFA, 1946; Stanford U.,
1949, BA; U. of New Mexico, 1952, MA.
US Marines, 1943-45. Traveled USSR.
Taught: U. of Illinois, 1952-53; Califor-
nia College of Arts and Crafts, 1955-57;
SFAI, 1959-63; Stanford U., 1963-64;
UCLA, 1966- ; U. of Colorado. **Mem-
ber:** National Council on the Arts, 1966-
69. **Awards:** CSFA, Albert M. Bender
Fellowship, 1946; Rosenberg Traveling
Fellowship, 1959; Olivet College, **P.P.**;
NIAL, 1962; PAFA, Gold Medal, 1968.
Address: 334 Amalfi Drive, Santa
Monica, Calif. 90402. **Dealer:** Marlbor-
ough Gallery Inc., NYC. **One-man
Exhibitions:** (first) California Palace,
1948, also 60; U. of New Mexico, 1951;
Paul Kantor Gallery, 1952, 54; SFMA,
1954, 73; Allan Frumkin Gallery, Chica-
go, 1954; Poindexter Gallery, 1955, 58,

61, 63, 66, 68; Phillips, 1958, 61; de
Young, 1963; Stanford U., 1964; Pavili-
on Art Gallery, Newport Beach, Calif.,
1965; Waddington Galleries, London,
1965, 67; U. of Washington, 1967;
Kansas City/Nelson, 1968; RAC, 1968;
Los Angeles/County MA, 1969; Irving
Blum Gallery, Los Angeles, 1971; Marl-
borough Gallery Inc., NYC, 1971, 74;
James Corcoran Galleries, Los Angeles,
1975; John Berggruen Gallery, San
Francisco, 1975. **Retrospectives:** Pasa-
dena/AM, 1960; WGMA, 1964; Jewish
Museum, 1964. **Group:** SRGM, Young-
er American Painters, 1954; WMAA
Annuals, 1955, 58, 61; Carnegie, 1955,
58, 61, 70; IV Sao Paulo Biennial, 1957;
Brussels World's Fair, 1958; MOMA,
New Images of Man, 1959; Tate,
Painting and Sculpture of a Decade,
1964; Edinburgh/National, Two Ameri-
can Painters: Sam Francis, Richard
Diebenkorn, 1965; WMAA, Art of the
United States: 1670-1966, 1966; XXIV
Venice Biennial, 1968; SFMA, Untitled
1968, 1968; Eindhoven, Kompas IV,
1969-70; Omaha/Joslyn, Looking West,
1970; Boston U., Drawings: Elmer
Bischoff and Richard Diebenkorn, 1974;
Oakland/AM, California Landscape,
1975; Corcoran Biennial, 1975. **Collec-
tions:** Baltimore/MA; Buffalo/Albright;
California Palace; U. of California,
Berkeley; Carnegie; Cincinnati/AM;
Cleveland/MA; Grand Rapids; Hirsh-
horn; Kansas City/Nelson; Los Ange-
les/County MA; U. of Michigan; U. of
New Mexico; Norfolk/Chrysler; Okla-
homa; Oakland/AM; Oberlin College;
Olivet College; PAFA; Pasadena/AM;
Phillips; Phoenix; Raleigh/NCMA; *Read-
ers Digest;* SFMA; Santa Barbara/MA;
Skidmore College; Stanford U.; Toron-
to; WMAA; Washington U. **Bibliogra-
phy:** Blesh 1; Mendelowitz; Neumeyer;
Nordness, ed.; Read 2; Rose, B. 1.

DILLER, BURGOYNE. b. 1906, NYC; **d.**
January 30, 1965, NYC. **Studied:** Michi-
gan State College; ASL. US Navy, World
War II. **Taught:** Brooklyn College, 1945-
64; Pratt Institute, 1945-64. **Member:**
American Abstract Artists. Federal
A.P.: Head, Mural Division, 1935-40;

Assistant Technical Director, New York Art Project, 1940-41; Director, New York Art Project, 1940-41; Director, New York City Art Section, 1939-42. **Awards:** Ford Foundation, **P.P.**, 1963. **One-man Exhibitions:** Harvard U., 1945 (two-man, with Jose de Rivera); The Pinacotheca, NYC, 1946; Galerie Chalette, 1961, 64; Goldowsky Gallery, 1968, 72; Los Angeles/County MA, 1968. **Retrospective:** Trenton/State, 1966; Walker, circ., 1971. **Group:** American Abstract Artists Annuals to 1940; WMAA; Geometric Abstraction in America, circ., 1962; VII Sao Paulo Biennial, 1963; Corcoran, 1963; WMAA, 1964; SFMA, Colorists 1950-1965, 1965; SRGM, Guggenheim International, 1967; WMAA, The 1930s, 1968; MMA, New York Painting and Sculpture: 1940-1970, 1969-70. **Collections:** Buffalo/Albright; Corcoran; MMA; MOMA; NYU; Trenton/State; WMAA; Yale U. **Bibliography:** Blesh 1; Gerdts; Hess, T.B. 1; Janis and Blesh, 1; Janis, S.; **Larson;** MacAgy 2; McCurdy, ed.; Rickey; Ritchie 1; Rose, B. 1,4; Seuphor 1,3. Archives.

DINE, JIM. b. June 16, 1935, Cincinnati, Ohio. **Studied:** U. of Cincinnati; Boston Museum School; Ohio U., 1957, BFA, and 1958. An early creator of Happenings and Environments. Subject of a 16mm. sound film, "Jim Dine," directed by Lane Slate, produced by National Educational Television. **Address:** Putney, Vt. 05346. **Dealer:** Ileana Sonnabend Gallery, NYC and Paris. **One-man Exhibitions:** Judson Gallery, NYC, 1959 (two-man, with Claes Oldenburg); Reuben Gallery NYC, 1960; Martha Jackson Gallery, 1952; Galleria dell'Ariete, 1962; Ileana Sonnabend Gallery, Paris, 1963, 69, 72, 75, NYC, 71, 73, 74; Brussels/Beaux Arts, 1963, 70; Sidney Janis Gallery, 1963, 64; Galleria Sperone, Turin, 1965; Oberlin College, 1965; Robert Fraser Gallery, London, 1965, 66, 69; Galerie Rolf Ricke, Kassel, 1967; Galerie Rudolf Zwirner, 1967; The Gallery Upstairs, Buffalo, 1967; Harcus-Krakow Gallery, 1967; Toronto, circ., 1967 (three-man, with Oldenburg,

George Segal); MOMA, Jim Dine Designs for "A Midsummer Night's Dream," 1967; Sidney Janis Gallery, 1967; Amsterdam/Stedlijk, 1967; Cornell U., 1967; MOMA, 1969; Dunkelman Gallery, Toronto, 1970; Turin/Civico, 1970; Dusseldorf/Kunsthalle, 1970; Hannover/K-G, 1970; Rotterdam, 1970; Berlin Festival, 1970; Gimpel & Hanover Gallery, 1972; Aronson Gallery, Atlanta, Ga., 1972; Modern Art Agency, Naples, 1972; Gimpel Fils, 1973; D.M. Gallery, London, 1973; Felicity Samuel Gallery, London, 1973; Galerie Sonnabend, Geneva, 1974; La Jolla, 1974; Dartmouth College, 1974; Petersburg Press, NYC, 1974; Centre d'Arts Plastiques Contemporains, Bordeaux, 1975; Gian Enzo Sperone, Rome, 1975. **Retrospective:** WMAA, 1970. **Happenings:** Judson Gallery, NYC, The Smiling Workman, 1959; Reuben Gallery, NYC, Car Crash, 1960, Jim Dine's Vaudeville, 1960, The Shining Bed, 1960; First New York Theatre Rally, NYC, Natural History (The Dreams), 1965; **Group:** Cornell U., Young Americans, 1960; Martha Jackson Gallery, New Media—New Forms, I, 1960; USIA Gallery, London, Modern American Painting, 1961; Dallas/MFA, "1961," 1961; Sidney Janis Gallery, The New Realists, 1962; Philadelphia YM-YWHA Arts Council, Art, A New Vocabulary, 1962; Pasadena/AM, New Paintings of Common Objects, 1962; International Biennial Exhibition of Paintings, Tokyo; SRGM, Six Painters and The Object, circ., 1963; Houston/MFA, Pop Goes the Easel, 1963; WGMA, The Popular Image, 1963; ICA, London, The Popular Image, 1963; Buffalo/Albright, 1963; Cincinnati/AM, An American Viewpoint, 1963; Jewish Museum, Black and White, 1963; Hartford/Wadsworth, Black, White, and Gray, 1964; Tate, Gulbenkian International, 1964; Chicago/AI, 1964, 69; Milwaukee, Popular Art and the American Tradition, 1965; Worcester/AM, New American Realism, 1965; WMAA, A Decade of American Drawings, 1965; WMAA, Art of the U.S. 1670-1966, 1966; Dublin/Municipal, I International Quadrennial

(ROSC), 1967; Expo '67, Montreal, U.S. Pavilion, 1967; Honolulu Academy, Signals of the 60's, 1967; Corcoran Annual, 1967; Documenta IV, Kassel, 1968; Hayward Gallery, London, 1969; Cincinnati/AM, 1973; WMAA, American Drawings: 1963-1973, 1973; Musee Galliera, Paris, Festival d'Automne, 1973; Parcheggio di Villa Borghese, Contemporanea, 1974; Dallas/MFA, Poets of the Cities, 1974; Moore College of Art, Philadelphia, 1975. **Collections:** Amsterdam/Stedelijk; Ball State U.; Brandeis U.; Buffalo/Albright; Dallas/MFA; Eindhoven; Jewish Museum; MOMA; NYU; Oberlin College; Ohio U.; SRGM; Tate; Toronto; WGMA; WMAA; Woodward Foundation. **Bibliography:** Allen, V.; Alloway 1; Battcock, ed.; Becker and Vostell; Bihalji-Merin; Calas, N. and E.; *Celebrate Ohio; Contemporanea*; Dienst 1; Finch; Hansen; *Happening & Fluxus*; Hunter, ed.; Janis and Blesh 1; Kaprow; Kirby; Kozloff 3; Lippard 5; *Metro*; Rose, B. 1; Rubin 1; Russell and Gablik; Sager; Sontag; Tomkins and Time-Life Books.

DI SUVERO, MARK. b. September 18, 1933, Shanghai, China. To USA 1941; **Studied:** U. of California, BA. Traveled USA, Mexico. **Awards:** Longview Foundation Grant; Walter K. Gutman Foundation Grant; Chicago/AI, 1963; National Endowment for the Arts Grant; Brandeis U. Creative Arts Award; Skowhegan School Award for Sculpture. **Address:** 195 Front Street, NYC 10038. **Dealer:** Richard Bellamy. **One-man Exhibitions:** (first) Green Gallery, NYC, 1960; Dwan Gallery, Los Angeles, 1965; Park Place Gallery, NYC, 1966; Goldowsky Gallery, 1968; LoGiudice Gallery, Chicago, 1968; Eindhoven, 1972; Duisburg, 1972; City of Chalon-sur-Saone, 1973; Le Jardin des Tuileries, Paris, 1975. **Retrospective:** WMAA, 1975. **Group:** Green Gallery, NYC, 1961, 62, 63; Hartford/Wadsworth, Continuity and Change, 1962; March Gallery, NYC (three-man); Chicago/AI, 1963; 79 Park Place Gallery, NYC, 1963, 64; Peace Tower, Los Angeles, 1966; Los Angeles/County MA, American Sculp-

ture of the Sixties, 1967; WMAA, 1966, 67, 68, 70; SFMA, 1969; MMA, New York Painting and Sculpture: 1940-1970, 1969-70; Cincinnati/Contemporary, Monumental Art, 1970; Walker, Works for New Spaces, 1971; WMAA, American Drawings: 1963-1973, 1973; Seattle/ AM, American Art — Third Quarter Century, 1973; Vassar College, Contemporary Collage, 1974; Venice Biennial, 1975. **Collections:** Chicago/AI; City of Chalon-sur-Saone; City of Toronto; Dallas/MFA; Hartford/Wadsworth; Hirshhorn; U. of Iowa; MIT; NYU; Otterlo; RISD; St. Louis/City; Storm King Art Center; WMAA; Walker; Western Washington State College. **Bibliography:** Battcock, ed.; Hunter, ed.; MacAgy 2; *Report*; Rose, B. 1; Tuchman 1.

DOBKIN, ALEXANDER. b. May 1, 1908, Genoa, Italy; **d.** March 21, 1975, Saint-Martin, West Indies. **Studied:** City College of New York, BS; Columbia U., MA; ASL, with George Bridgeman, Dimitri Romanovsky, Jose Clemente Orozco. Traveled Europe, Scandinavia, Israel; resided Paris. **Taught:** Lecturer, A Century of Progress, Chicago, 1933-34; New Art School, NYC, 1937-41; City College of New York; Educational Alliance, NYC, Art Director, 1934-55, Director, 1955-75. **Member:** Artists Equity. Federal A.P.: Easel painting for public buildings. **Awards:** Augustus Saint-Gaudens Medal from Cooper Union, 1930; Roosevelt Memorial Award, 1936; AAAL, Childe Hassam Award, 1947; Library of Congress, Pennell **P.P.**, 1949, 55; AAAL, **P.P.**, 1956. **One-man Exhibitions:** (first) ACA Gallery, 1935, also 1938, 47, 51, 58; Philadelphia Art Alliance, 1957; Garelick's Gallery, Detroit, 1957; Michel Galerie, Paris, 1959; A.A.A. Gallery, NYC, 1960, 69; The Forum Gallery, 1962, 68. **Retrospective:** A.A.A. Gallery, NYC, 1969. **Group:** A Century of Progress, Chicago, 1933-34; ART:USA:58, NYC, 1958; Brooklyn Museum; Chicago/AI; MOMA; PMA; PAFA; Carnegie; Corcoran; Festival of Two Worlds, Spoleto;

Library of Congress; New York World's Fair, 1964-65. **Collections:** Harvard U.; Library of Congress; MOMA; Newark Museum; PMA; Phoenix; Tel Aviv; WMAA; Youngstown/Butler. Archives.

DODD, LAMAR. b. September 22, 1909, Fairburn, Ga. **Studied:** Georgia Institute of Technology, 1926-27; ASL, 1929-33, with George Luks, Boardman Robinson, John Steuart Curry, Jean Charlot, George Bridgeman; LHD, DFA. Traveled USA, Europe. **Taught:** Five Points, Ala., 1927-28; U. of Georgia, 1937- . **Member:** NAD; Audubon Artists. Federal A.P.: Easel painting. **Awards:** Chicago/AI, 1936; Pepsi-Cola, 1947, 48; VMFA, Virginia Artists Biennial, **P.P.**, 1948; NIAL Grant, 1950; NAD, Edwin Palmer Memorial Prize, 1953; PAFA, **P.P.**, 1958; WMAA, **P.P.**, 1958. **Address:** 590 Springdale, Athens, Ga. **One-man Exhibitions:** (first) Ferargil Galleries, NYC, 1933; Grand Central Moderns, NYC, 1965, 67; U. of Georgia, 1969; Rehn Galleries, 1973. **Group:** U. of Nebraska; PAFA; NIAL; Audubon Artists; Chicago/AI; Corcoran; Boston/MFA; NAD; U. of Illinois; Santa Barbara/MA; Carnegie, 1936; WMAA Annuals, 1937-57; Golden Gate International Exposition, San Francisco, 1939; New York World's Fair, 1939. **Collections:** Atlanta/AA; Chicago/AI; Cranbrook; U. of Georgia; IBM; MMA; Montclair/AM; PAFA; Pepsi-Cola Co.; U. of Rochester; Savannah/Telfair; VMFA; WMAA; Wilmington. **Bibliography:** Baur 7; Bethers; Cheney; Wheeler.

DODD, LOIS. b. April 22, 1927, Montclair, N.J. **Studied:** Cooper Union, with Byron Thomas, Peter Busa. Traveled Italy, France, Switzerland. **Taught:** Philadelphia College of Art, 1963, 65; Wagner College, 1963-64; Brooklyn College, 1965-69, 1971- . A co-founder of the Tanager Gallery, NYC. **Commissions:** New York Hilton Hotel (lithographs). **Awards:** Italian Government Scholarship, 1959-60; Longview Foundation Grant, 1962; Ingram Merrill Foundation Grant, 1971. **Address:** 30 East Second Street, NYC 10003. **Dealer:** Green Mountain Gallery. **One-man Exhibitions:** (first) Tanager Gallery, NYC, 1954, also 1957, 58, 61, 62; Purdue U., 1965; Ithaca College, 1966; Wilmington, 1967; Green Mountain Gallery, 1969, 70, 71, 74; Thomas College, Waterville, Me., 1973. **Group:** The Stable Gallery Annuals, 1956, 58; USIA, Americans in Rome, Rome, 1960; U. of Kentucky, Drawings, 1961; Yale U., Drawings and Watercolors, 1964; A.F.A., Painterly Realism, 1970; U. of Vermont, New England Landscapes, 1971; New York Cultural Center, Women Choose Women, 1973; Omaha/Joslyn, A Sense of Place, 1973; Queens Museum, New Images, 1974. **Collections:** Brooklyn Museum; Ciba-Geigy Corp.; Colby College; Cooper Union; Hartford/Wadsworth; Kalamazoo/Institute; New York Hilton Hotel; WMAA, Archives.

DOLE, WILLIAM. b. September 2, 1917, Angola, Ind. **Studied:** Olivet College (with George Rickey, Harris King Prior), 1937, AB; Mills College, 1940, 49; U. of California, Berkeley, 1947, MA. Traveled Mexico, Europe; resided Florence, Rome. **Taught:** U. of California, Berkeley, 1947-49, Santa Barbara, 1949- . **Member:** Trustee, Santa Barbara/MA. **Address:** 340 East Los Olivos, Santa Barbara, Calif. 93105. **Dealers:** Esther Baer Gallery; Jodi Scully Gallery; Staempfli Gallery. **One-man Exhibitions:** (first) Santa Barbara/MA, 1951, also 1954, 58, 62, 68; de Young, 1951; Mills College, 1951; Geddis-Martin Studios, Santa Barbara, 1952; Rotunda Gallery, San Francisco, 1954; La Jolla, 1954, 64; Bertha Lewinson Gallery, Los Angeles, 1955; Eric Locke Gallery, San Francisco, 1956; Galerie Springer, Berlin, 1956, 64; Galleria Sagittarius, Rome, 1957; U. of California, Santa Barbara, 1958; Duveen-Graham Gallery, NYC, 1958; 60; Esther Baer Gallery, 1960, 61, 63, 65, 67, 70, 71, 73; Galeria Antonio Souza, Mexico City, 1961; The Thacher School, Ojai, Calif., 1961; Rex Evans Gallery, 1961, 63, 64, 65, 67, 68, 69; California Palace, 1962;

McRoberts & Tunnard Gallery, London, 1966; San Antonio/McNay, 1969; U. of California, Santa Cruz, 1969; Mary Moore Gallery, 1971; Jodi Scully Gallery, 1971, 74; Graphics Gallery, 1972; Mount Holyoke College, 1974; Staempfli Gallery, 1974. **Retrospective:** U. of California, Santa Barbara, 1965. **Group:** California Palace, 1947, 52; Denver/AM, 1948; SFMA, 1948-51; California State Fair, 1950, 51; PAFA, 1950, 60, 65, 68; Los Angeles County Fair, 1951; Hallmark Art Award, 1958; Long Beach/MA, 1953, 60, 63, 69; Santa Barbara/MA, 1955, 57; Los Angeles/County MA, 1958. **Collections:** Amherst College; U. of California; Fort Worth; Harvard U.; Hirshhorn; Honolulu Academy; Long Beach/MA; Mills College; Minnesota/MA; Mount Holyoke College; PAFA; Palm Springs Desert Museum; Phoenix; Rockefeller Institute; Santa Barbara/MA; Storm King Art Center; Walker.

DONATI, ENRICO. b. February 19, 1909, Milan, Italy. To USA 1934; citizen 1945. **Studied:** U. of Pavia, Italy; New School for Social Research; ASL. Traveled Europe, India, USA. **Taught:** Yale U., 1960-62. **Member:** Advisory Board of Brandeis U., 1956- ; Jury of Fulbright Program, 1954-56, 1963-64; Yale U. Council for Arts and Architecture, 1962-72; belonged to the Surrealist group of Andre Breton, to 1950. **Address:** 222 Central Park South, NYC 10019. **Dealer:** Staempfli Gallery. **One-man Exhibitions:** New School for Social Research, 1942; Passedoit Gallery, NYC, 1942, 44; Arts Club of Chicago, 1944, 59; Durand-Ruel Gallery, NYC, 1945, 46, 47, 49; Galerie Drouant, Paris, 1947; P. Rosenberg and Co., 1950; L'Obelisco, Rome, 1950; Galleria Il Milione, Milan, 1950; Alexander Iolas Gallery, 1952; Galleria del Cavallino, Venice, 1952; Galleria d'Arte del Naviglio, Milan, 1953; Betty Parsons Gallery, 1954, 55, 57, 59, 60; Syracuse U., 1958; Neue Galerie, Munich, 1962; Staempfli Gallery, 1962, 64, 66, 68, 70, 72, 74; MIT, 1964; J. L. Hudson Art Gallery, Detroit, 1964, 66, 69; Obelisk Gallery,

1965. **Retrospective:** Palais des Beaux-Arts, Brussels, 1961. **Group:** Carnegie, 1950, 52, 54, 56, 58, 61; Venice Biennial; Sao Paulo, 1953; International Biennial Exhibition of Paintings, Tokyo; A.F.A., The Embellished Surface, circ., 1953-54; Chicago/AI, 1954, 57; WMAA Annuals, 1954, 56, 58, 59, 61, 62, 64, 70; Santa Barbara/MA, 1954; SRGM, Younger American Painters, 1954; Utica, 1955; SFMA, 1955; Indiana U., 1957, 59; PAFA, 1957; VMFA, American Painting, 1958; I Inter-American Paintings and Prints Biennial, Mexico City, 1958; U. of Illinois, 1959; Lincoln, Mass./De Cordova, Decade in Review, 1959; A.F.A., V International Exhibition, 1959; Corcoran, 1960; St. Paul Gallery, 1960; Walker, 60 American Painters, 1960; SRGM, Abstract Expressionists and Imagists, 1961; New York World's Fair, 1964-65. **Collections:** American Republic Insurance Co.; Arthur Anderson & Co.; Anderson Clayton Company; Atlantic Richfield Co.; Avon Products; Baltimore/MA; Bezalel Museum; Brussels/Moderne; Buffalo/Albright; U. of California; Chase Manhattan Bank; Detroit/Institute; Doane College; Ford Motor Company; High Museum; Houston/MFA; J. L. Hudson Co.; IBM; Indian Head Mills, Inc.; International Institute for Aesthetic Research; Johns Hopkins U.; MIT; MOMA; Michigan Consolidated Gas Co.; U. of Michigan; Milan; Minnesota/MA; Needham Harper & Steers Inc.; Newark Museum; Northwestern National Life Insurance Co.; Oslo/National; Owen-Corning Fiberglass Corp.; Palm Beach Company; Prudential Life Insurance Co.; St. Louis/City; The Singer Company, Inc.; Temple Beth El; U. of Texas; Tougaloo College; Turin/Civico; U.S. Steel Corp.; WGMA; WMAA; Washington U.; Yale U. **Bibliography:** Breton 2, 3; Goodrich and Baur 1; Read 2; Rubin 1.

DOVE, ARTHUR G. b. August 2, 1880, Canandaigua, N.Y.; **d.** November 1946, Centerport, N.Y. **Studied:** Cornell U., 1903. Commercial illustrator, 1903-07. Traveled Europe, 1907-09, with Alfred Maurer and Arthur B. Carles, Jr. Met

Alfred Stieglitz 1910. **One-man Exhibitions:** (first) Photo-Secession, NYC, 1912; Scott Thurber Gallery, Chicago, 1912; Stieglitz's Intimate Gallery, NYC, 1926, 27, 29; An American Place (Gallery), NYC, annually, 1930-46; Springfield, Mass./MFA, 1933; Phillips, 1937; Vanbark Studios, Studio City, Calif., 1947; Utica, 1947; The Downtown Gallery, 1949, 52, 54, 55, 56, 67; Houston/MFA, 1951; Walker, 1954; Deerfield (Mass.) Academy, 1956; Paul Kantor Gallery, Beverly Hills, Calif., 1956; U. of Maryland, 1967; Terry Dintenfass, Inc., 1970, 71. **Retrospective:** The Downtown Gallery, 1947; Cornell U., 1954; UCLA, circ., 1958-59; SFMA, circ., 1974. **Group:** Salon d'Automne, Paris, 1908, 09; National Arts Club Annual, NYC, 1914; Anderson Galleries, NYC, Forum Exhibition, 1916; Society of Independent Artists, NYC, 1917; PAFA, 1921; Wildenstein & Co., NYC, Tri-National Art, 1926; Brooklyn Museum, International Exhibition of Modern Art (assembled by Societe Anonyme), 1926; Salons of America, NYC, 1929; MOMA, Paintings by 19 Living Americans, 1929; Cleveland/MA Annuals, 1931, 32, 35; WMAA Annuals, 1932, 34; A.F.A., Abstraction, 1932; A Century of Progress, Chicago, 1933-34; WMAA, Abstract Painting in America, 1935; Buffalo/Albright, 1935; U. of Minnesota, 1937; Cleveland/MA, American Painting from 1860 Until Today, 1937; Worcester/AM, 1938; Musee du Jeu de Paume, Trois Siecles d'Art aux Etats-Unis, 1938; MOMA, Art in Our Time: 10th Anniversary Exhibition, 1939; Boston/MFA, 10 American Watercolor Painters, 1939; Golden Gate International Exposition, San Francisco, 1939; Cornell U., 1940; MOMA, Cubist and Abstract Art, 1942; PMA, History of An American, Alfred Stieglitz: "291" and After, 1944. **Collections:** American U.; Andover/Phillips; Arizona State College; Baltimore/MA; Boston U.; Britannica; Brooklyn Museum; Buffalo/Albright; Carnegie; Chicago/AI; Colorado Springs/FA; Columbus; Cornell U.; Des

Arthur G. Dove *A Cross in a Tree* 1935

Moines; Detroit/Institute; Fisk U.; Fort Worth; Hartford/Wadsworth; Honolulu Academy; IBM; Inland Steel Co.; MMA; MOMA; Milwaukee; U. of Minnesota; National Gallery; U. of Nebraska; Omaha/Joslyn; PMA; Phillips; Phoenix; Randolph-Macon Woman's College; U. of Rochester; SFMA; Smith College; Springfield, Mass./MFA; Utica; WMAA; Washington U ; Wellesley College; West Palm Beach/Norton; Wichita/AM; Wilmington; Yale U. **Bibliography: Arthur Dove: The Years of Collage;** Ashton 5; *Avant-Garde Painting and Sculpture;* Barr 3; Baur 5, 7; Blanchard; Blesh 1; Brown; Cahill and Barr, eds.; Cheney; *8 American Masters of Watercolor;* Eliot; *Forerunners;* Frank, ed.; Frost; Gerdts; Goodrich and Baur 1; Haftman; **Haskell 1;** Hess, T. B. 1; Hunter 6; Janis and Blesh 1; Janis, S.; Kootz 1; Kozloff 3; Mather 1; McCurdy, ed.; Mellquist; Mendelowitz; Neuhaus; Newmeyer; Phillips 1, 2; Poore; Read 2; Richardson, E. P.; Ringel, ed.; Ritchie 1; Rodman 2; Rose, B. 1, 4; Rosenblum 2; Rubin 1; Seitz 3; Sutton; Tashjian; Wight 2; Wright 1. Archives.

DOWNING, THOMAS. b. June 13, 1928, Suffolk, Va. **Studied:** Randolph-Macon College, 1948, BA; Pratt Institute, 1948-50; The Catholic U. of America. Traveled Europe, USA. **Taught:** Virginia public schools; The Corcoran School of Art. **Awards:** VMFA travel-study grant, 1950. **Address:** c/o Dealer. **Dealer:** Pyramid Art Galleries Ltd. **One-man Exhibitions:** (first) Jefferson Place Gallery, 1961; Allan Stone Gallery, 1962, 66, 68; The Stable Gallery, 1963, 65; Corcoran, 1966, 69; Henri Gallery, 1967; A. M. Sachs Gallery, 1968; Pyramid Art Galleries Ltd., 1970; Galerie Arnaud, 1973. **Retrospective:** La Jolla, 1968. **Group:** Lincoln, Mass./De Cordova, New Experiments in Art, 1963; Corcoran Biennial, 1963, 67; Los Angeles/County MA, Post Painterly Abstraction, 1964; SFMA, The Colorists, 1965; MOMA, The Responsive Eye, 1965; WGMA, 1965; Corcoran, 1966; SRGM, Systemic Painting, 1966; PAFA Annual, 1966; WMAA Annual, 1967. **Collections:** Corcoran; Hartford/Wadsworth; La Jolla; Norfolk; PMA; RAC; WGMA; WMAA. **Bibliography:** Alloway 3; Battcock, ed.

DOYLE, TOM. b. May 23, 1928, Jerry City, Ohio. **Studied:** Miami U.; The Ohio State U. (with Roy Lichtenstein, Stanley Twardowicz), BFA, MA. Traveled Europe. **Taught:** Brooklyn Museum School, 1961-68; New School for Social Research, 1961-68; School of Visual Arts, NYC, 1969. **Awards:** Ohio State Fair, 2 First and 2 Second Prizes. **Address:** 189 Bowery, NYC 10002. **One-man Exhibitions:** (first) The Ohio State U., 1956; Allan Stone Gallery, 1961, 62; Dwan Gallery, 1966, 67, 72; Brata Gallery, NYC, 1972; 55 Mercer Street, NYC, 1974. **Group:** Cornell U., 1960; Martha Jackson Gallery, New Media—New Forms, I & II, 1960, 61; Oberlin College, 1961; Carnegie, 1961; Seattle World's Fair, 1962; Berne, 1964; WMAA Annual, 1966; Los Angeles/County MA; PMA, American Sculpture of the Sixties, 1967. **Collections:**

Carnegie. **Bibliography:** Atkinson; Tuchman 1.

DREWES, WERNER. b. July 27, 1899, Canig, Germany. **Studied:** Gymnasium, Brandenburg/Havel, 1909-17; Charlottenburg Technische Hochschule, Berlin, 1919; Stuttgart School of Architecture, 1920; Stuttgart School of Arts and Crafts, 1921; Bauhaus, Weimar, 1921-22, with Josef Itten, Paul Klee; Bauhaus, Dessau, 1927-28, with Vassily Kandinsky, Lyonel Feininger. To USA 1930; citizen 1936. Traveled Europe, South and Central America, Asia, USA. **Taught:** Columbia U., 1937-40; Master Institute of United Arts, Inc., NYC, 1940; Brooklyn College, 1944; Institute of Design, Chicago, 1945; Washington U., 1946-65. Federal A.P.: Instructor, Brooklyn Museum, 1934-36; Technical Supervisor, Graphic Art Project, 1940-41. **Member:** American Artists Congress; co-founder, American Abstract Artists, 1936. **Commissions:** International Graphic Arts Society, 1954, 57. **Awards:** 50 Best Prints of the Year, 1932, 44; PAFA, **P.P.,** 1933; MOMA, Plexiglas Sculpture Competition, Third Prize, 1939; MOMA, Textile Design Competition, First and Second Prizes, 1941; The Print Club, Philadelphia, Hon. Men., 1946; A.A.A. Gallery, NYC, **P.P.,** 1959; St. Louis Artists' Guild, Bader Art Prize, 1960. **Address:** 11526 Links Drive, Reston, Va. 22090. **Dealers:** Weyhe Gallery; A.A.A. Gallery, NYC; Princeton Gallery of Fine Art. **One-man Exhibitions:** Madrid/Nacional, 1923; Montevideo/Municipal, 1924; St. Louis Public Library, 1924; Gump's Gallery, 1926; Flechtheim and Kahnweiler, Frankfurt, 1928; Galerie del Vecchio, Leipzig, 1929; Morton Gallery, NYC, 1932, 33; New School for Social Research, 1935; Artists' Gallery, NYC, 1939, 41; Lilienfeld Gallery, NYC, 1945; Indiana U., 1945; Kleemann Gallery, NYC, 1945, 46, 47, 49; Princeton U., 1946 (four-man); Smithsonian, 1948; Pen and Palette Gallery, St. Louis, 1949; Lutz and Meyer Gallery, Stuttgart, 1951; Argent Gallery, NYC, 1951;

Neue Galeries Gurlitt, Linz, 1952; St. Louis Artists' Guild, 1953; Beloit College, 1954; Schermahorn Gallery, Beloit, 1955, 56; Los Angeles/County MA, 1956; Memphis/Brooks, 1957; Springfield, Mo./AM, 1958; Oregon State College, circ., 1959; Cleveland/MA, 1961; Washington U., 1962; Hom Gallery, Washington, D.C., 1971; Princeton Gallery of Fine Art, 1972. **Retrospective:** California Palace, 1962; Washington U., 1965; Smithsonian, 1969; US Embassy Program, Turkey, 1974. **Group:** Carnegie; Brooklyn Museum; Chicago/AI; MMA; USIA; WMAA; U. of Illinois; PAFA; SRGM; Bennington College. **Collections:** U. of Alabama; Andover/Phillips; Bibliotheque Nationale; Boston/MFA; Boston Public Library; Brooklyn Museum; Chicago/AI; Cleveland/MA; Cologne; Frankfurt am Main; Hartford/Wadsworth; Harvard U.; Honolulu Academy; U. of Illinois; Kansas City/Nelson; Karlsruhe; Library of Congress; Los Angeles/County MA; MOMA; Memphis/Brooks; Mills College; NCFA; NYPL; National Gallery; Newark Public Library; PAFA; RISD; SFMA; SRGM St. Louis/City; Seattle/AM; Springfield, Ill./State; Springfield Mo./AM; Trenton/State; Victoria and Albert Museum; Washington U.; Wells College; Wichita/AM; Worcester/AM; Yale U. **Bibliography:** American Artists Congress, Inc.; Baur 7; Bazin; Cheney. Archives.

DRUMMOND, SALLY HAZELET. b. June 4, 1924, Evanston, Ill. **Studied:** Rollins College, 1942-44; Columbia U., with John Heliker, Peppino Mangravite, 1946-48, BA; Institute of Design, Chicago, 1949-50, with Hugo Weber, Emerson Woelffer; U. of Louisville, with Ulfert Wilke, 1950-52, MA. Traveled Italy, France, England. A co-organizer of the Tanager Gallery, NYC. **Awards:** Fullbright Fellowship (Italy), 1952; Guggenheim Foundation Fellowship, 1967-68. **Address:** One Wilton Road, East Ridgefield, Conn. 06877. **Dealer:** Fischbach Gallery. **One-man Exhibitions:** (first) Hadley Gallery, Louisville, 1952, also 1961; Art Center Associa-

tion, Louisville, 1955; Tanager Gallery, NYC, 1955, 57, 60; Green Gallery, NYC, 1962; Louisville/Speed, 1967 (two-man); Fischbach Gallery, 1968, 72. **Retrospective:** Corcoran, 1972. **Group:** American Embassy, Rome, 1953; Bordighera, 1953; A.F.A., Fulbright Artists, circ., 1958; Houston/MFA, 1959; WMAA Annual, 1960; A.F.A., Lyricism in Abstract Art, circ., 1962-63; MOMA, Americans, 1963, circ., 1963-64; Trenton/State, Focus on Light, 1967. **Collections:** Avco Corp.; Ciba-Geigy Corp.; Hirshhorn; Interchemical Corporation; Louisville/Speed; MOMA; MMA; Union Carbide Corp.; WMAA.

DU BOIS, GUY PENE. b. January 4, 1884, Brooklyn, N.Y.; **d.** July 18, 1958, Boston, Mass. **Studied:** W. M. Chase School, NYC, 1899-1905, with J. C. Beckwith, Frank V. DuMond, Robert Henri, Kenneth Hayes Miller; Academie de la Grande Chaumiere, with Theophile A. Steinlen. Traveled USA, Europe. Reporter and critic for New York *American,* New York *Tribune,* New York *Evening Post;* Editor of *Arts and Decoration* Magazine for seven years. **Awards:** Pan-American Exhibition, Los Angeles, 1925, Third Prize; Chicago/AI, Norman Wait Harris Silver Medal, 1930; NAD, Benjamin Altman Prize, 1936; Corcoran, Second William A. Clark Prize, 1937. **One-man Exhibitions:** Kraushaar Galleries, 1922, 24, 30, 32, 35, 36, 38, 42, 43, 46; Staten Island, 1954; The Graham Gallery, 1961, 63. **Retrospective:** Hagerstown/County MFA, 1940. **Group:** Salon des Beaux-Arts, Paris, 1906; Corcoran; Chicago/AI; PAFA; WMAA. **Collections:** Amherst College; Andover/Phillips; Baltimore/MA; Barnes Foundation; Brooklyn Museum; Chicago/AI; Cleveland/MA; Detroit/Institute; Los Angeles/County MA; MMA; MOMA; Milwaukee; Newark Museum; New Britain; PAFA; PMA; Phillips; San Diego; Toledo/MA; WMAA. **Bibliography:** Baur 7; Bazin; Brown; Bruce and Watson; Cahill and Barr, eds.; Cheney; **Cortissoz 2; Du Bois 1, 2, 3, 4, 5, 6;** Ely; Gerdts; Glackens; Goodrich and Baur 1;

Hall; Hunter 6; *Index of 20th Century Artists;* Jewell 2; Kent, N.; Mather 1; McCoubrey 1; **Medford;** Mellquist; Neuhaus; Pagano; Pearson 1; Phillips 2; Poore; Richardson, E. P.; Ringel, ed.; Rose, B. 1, 4; Smith, S. C. K. Archives.

DUCHAMP, MARCEL. b. July 28, 1887, Blainville, near Rouen, France; **d.** October 1, 1968, Neuilly, France. **Studied:** Academie Julian, Paris, 1904. To USA 1915; citizen 1955. Traveled Europe, Argentina, USA. Founding Member Society of Independent Artists, 1916. Co-founder (with Man Ray and Francis Picabia) of DADA group, NYC, 1917. Co-organizer (with Katherine S. Dreier and Man Ray) of Societe Anonyme (Museum of Modern Art), 1920. Published one issue of *New York DADA* with Man Ray, 1921. Produced a film, "Anemic Cinema," 1925. **One-man Exhibitions:** Montross Gallery, NYC, 1916 (four-man); Arts Club of Chicago, 1937; Rose Fried Gallery, 1952 (three-man); SRGM, 1957 (three-man); Galerie de l'Institute, Paris, 1957; Sidney Janis Gallery, 1958, 59; La Hune, Paris, 1959; Pasadena/AM, 1963; Eva de Buren Gallery, Stockholm, 1963; Walker, 1965; Milwaukee, 1965; Cordier & Ekstrom, Inc., 1965, 67, 68; Tate, 1966; Fourcade, Droll Inc.; Galerie Rene Block, Berlin, 1971; Galleria Civica d'Arte Moderna, Ferrara, 1971; Galleria Schwarz, 1972; Jerusalem/National, 1972; L'Uomo e l'Arte, Milan, 1973; Dayton's Gallery 12, Minneapolis, 1973, 74. **Retrospectives:** Gimpel Fils Ltd., 1964; Galleria Solaria, Milan, 1967; Paris/Moderne, 1967; Cologne, 1968; PMA, 1969, 73. **Group:** Salon des Artistes Independents, Paris, 1909-12; Salon d'Automne, Paris, 1909-12; Salon de la Section d'Or, 1912; The Armory Show, 1913; Societe Anonyme, NYC, 1920; Salon DADA, Paris, 1920; A Century of Progress, Chicago, 1933-34; MOMA, Cubism and Abstract Art, 1936; MOMA, Fantastic Art, DADA, Surrealism, 1936; WMAA, European Artists in America, 1945; MOMA, Eleven Europeans, 1946; XXIV Venice Biennial, 1948; California Palace, 1948;

Chicago/AI, 1949; MOMA, The Machine, 1968; Haus der Kunst, Munich, Der Surrealismus 1922-1942, 1972. **Collections:** MOMA; Ottawa/National; PMA; SRGM; Yale U. **Bibliography:** Barr 1, 3; Battcock, ed.; Baur 7; Becker and Vostell; Biddle 4; Biederman 1; Bihalji-Merin; Blesh 1; Breton 2; Brion 2; Brown; Bulliet 1, 2; **Cabanne;** Calas, N. and E.; Canaday; Cassou; Chipp; Christensen; Coplans 3; Davidson 1; Davis, D.; De Vries; **D'Harnoncourt and McShine, eds.;** Dorival; Dorner; Dreier 2; **Duchamp 1,2;** Elsen 1; Finch; Flanagan; Frost; Gascoyne; Gaunt; Gerdts; Giedion-Welcker 1, 2; Guggenheim, ed.; Haftman; **Hamilton, R.;** Honnef; Hulten; Hunter 6; Hunter, ed.; Huyghe; Janis and Blesh 1; Janis, S.; Kepes 2; Kozloff 3; Kuh 1, 2, 3; Kyrou; Langui; **Lebel;** Lee and Burchwood; Licht, F.; Lippard 5; Lippard, ed.; Lowry; Lynton; McCurdy, ed.; Mellquist; **Metro;** Motherwell 1; Neumeyer; Newmeyer; Pach 2, 3; Ramsden 1; **Raymond Duchamp-Villon/Marcel Duchamp;** Raynal 3, 4; Read 2, 3; Richardson, E. P.; Richter; Rickey; Rose, B. 1, 4; Rosenblum 1; Rubin 1; Sager; **Schwarz 1, 2;** Seitz 3; Selz, J.; Seuphor 1, 3; Soby 1, 5, 6; **Sweeney 2;** Tashjian; Tomkins; Tomkins and Time-Life Books; Trier 1, 2; Valentine 2; Verkauf; Waldberg 2, 3, 4; Weller.

DUGMORE, EDWARD. b. February 20, 1915, Hartford, Conn. **Studied:** Hartford Art School, 1934-38; California School of Fine Arts (with Clyfford Still), 1948-50; U. of Guadalajara, 1951-52, MA. US Marine Corps, 1943-44. Traveled Mexico, USA extensively, Europe, 1966-67. **Taught:** St. Joseph College, 1946-49; Southern Illinois U.; Pratt Institute, 1964-72; U. of Minnesota, 1970; Des Moines, 1972; Maryland Institute, 1973, 74. A co-founder of Metart Gallery, San Francisco. **Awards:** Chicago/AI, The M. V. Kohnstamm Prize, 1962; Guggenheim Foundation Fellowship, 1966-67. **Address:** 100 West 14 Street, NYC 10011. **One-man Exhibitions:** (first) Metart Gallery, San Francisco, 1949; The Stable Gallery,

1953, 54, 56; Holland-Goldowsky Gallery, Chicago, 1959; The Howard Wise Gallery, Cleveland, 1960; The Howard Wise Gallery, NYC, 1960, 61, 63; Green Mountain Gallery, 1971, 73; Des Moines, 1972. **Group:** Carnegie, 1955; Walker, Vanguard, 1955; WMAA Annual, 1959; SRGM, Abstract Expressionists and Imagists, 1961; Chicago/AI Annual, 1962 SFMA, Directions—Painting U.S.A., 1963; U. of Texas, Recent American Painting, 1964, also 1968; Green Mountain Gallery, 1971; Buffalo/Albright, Abstract Expressionism: First and Second Generations, 1972; Oakland/AM, A Period of Exploration, 1973. **Collections:** Buffalo/Albright; Ciba-Geigy Corp.; Des Moines; Housatonic Community College; Michigan State U.; Minneapolis/Institute; U. of North Carolina; Southern Illinois U.; Walker. **Bibliography:** McChesney.

DURAN, ROBERT. b. 1938, Salinas, Calif. **Studied:** Richard Stockton State College, 1958-60; San Francisco School of Fine Arts, 1960-61. Traveled Mexico, USA, Morocco, Europe, India. **Address:** 431 Broome Street, NYC 10013. **Dealer:** Bykert Gallery. **One-man Exhibitions:** Bykert Gallery, 1968 (two-man), 1970 (two-man), 1971, 72, 73; The Texas Gallery, 1973. **Group:** Park Place Gallery, NYC, 1966; Ithaca College, Drawings 1967, 1967; A.F.A., Rejective Art, 1967; ICA, U. of Pennsylvania, Between Object and Environment, 1969; WMAA, 1969, 73; Columbus, Beaux-Arts Twenty-Fifth Anniversary Exhibition, 1971; Corcoran Biennial, 1971; Indianapolis, 1972; Storm King Art Center, 1972. **Collections:** Amstar Corp.; Betcar Corp.; Business Card, Inc.; Columbus; General Reinsurance Corp.; National Gallery; Port Authority of New York & New Jersey; J. Henry Schroder Banking Corp.; Two Trees; United Mutual Savings Bank; WMAA.

DZUBAS, FRIEDEL. b. April 20, 1915, Berlin, Germany. To USA 1939. Traveled Europe extensively. **Taught:** U. of South Florida, 1962; Artist-in-Residence, Dartmouth College, 1962; Aspen Institute, 1965, 66; Cornell U.,

1967, 1969-74; U. of Pennsylvania, 1968. **Commissions:** National Shawmut Bank of Boston (mural). **Awards:** Guggenheim Foundation Fellowship, 1966; J. S. Guggenheim Fellowship, 1968; National Council on the Arts, 1968. **Address:** 119 The Knoll, Ithaca, N.Y. 14850. **Dealers:** Knoedler Contemporary Art; David Mirvish Gallery; Watson/De Nagy. **One-man Exhibitions:** Tibor de Nagy Gallery, 1952; Leo Castelli Inc., 1958; French & Co. Inc., NYC, 1959; Dwan Gallery, 1960; Robert Elkon Gallery, 1961-65; Kasmin Ltd., 1964, 65; Nicholas Wilder Gallery, 1966; Andre Emmerich Gallery, 1966, 67, 68; Jack Glenn Gallery, Corona del Mar, 1971; Lawrence Rubin Gallery, NYC, 1971, 72, 73; Gallerie Hans Strelow, Cologne, 1971, 72; David Mirvish Gallery, 1973, 74, 75; Knoedler Contemporary Art, 1974, 75. **Retrospective:** Houston/MFA, 1974; Boston/MFA, 1975. **Group:** Chicago/AI Annuals, 1942, 43, 44; MMA, American Painters Under 35, 1950; Ninth Street Exhibition, NYC, 1951; WMAA Annuals, 1958, 59, 64; Corcoran, 1959, 63, Biennial, 1967; The Kootz Gallery, NYC, New Talent, 1960; Carnegie, 1961; SRGM, Abstract Expressionists and Imagists, 1961; Dayton/AI, 1963; Jewish Museum, Black and White, 1963; Los Angeles/County MA, Post Painterly Abstraction, 1964; Detroit/Institute, Color, Image and Form, 1967; U. of Illinois, 1967; Expo '67, Montreal, 1967; Buffalo/Albright, Color and Field: 1890-1970; Boston/MFA, Abstract Painting in the '70s, 1972; Houston/MFA, The Great Decade of American Abstraction: Modernist Art 1960 to 1970, 1974; Corcoran Biennial, 1975. **Collections:** Baltimore/MA; Boston/MFA; Brandeis U.; Buffalo/Albright; Chase Manhattan Bank; Cornell U.; Dayton/AI; Dartmouth College; Hirshhorn; Houston/MFA; MMA; Manufacturers Hanover Trust; NYU; Oberlin College; Phillips; Ridgefield/Aldrich; Rutgers U.; SFMA; SRGM; St. Louis/City; Syracuse/Everson; Tufts Dental College; Utica; WMAA; Wellesley College; Yale U. **Bibliography:** *The Great Decade*; Rose, B. 1.

EDDY, DON. b. November 4, 1944, Long Beach, Calif. **Studied:** Fullerton Junior College; U. of Hawaii, 1967, BFA, 1969, MFA; U. of California, Santa Barbara, 1969-70. US Navy, 1967-68. **Taught:** U. of Hawaii, 1967-69; NYU, 1972- . **Address:** c/o Nancy Hoffman Gallery. **Dealer:** Nancy Hoffman Gallery. **One-man Exhibitions:** Ewing Krainin Gallery, Honolulu, 1968; Molly Barnes Gallery, Los Angeles, 1970, 71; Esther Baer Gallery, 1970; Galerie M. E. Thelen, Essen and Cologne, 1970; Galerie de Gestlo, 1971; French & Co. Inc., NYC, 1971; Aktionsgalerie, Bern (two-man), 1971; Nancy Hoffman Gallery, 1973; Galerie Petit, Paris, 1973; **Group:** Stockton, Beyond The Actual, 1970; Sacramento/Crocker, West Coast '70, 1970; Munster/WK, Verkenhrskultur, 1971; Santa Barbara/MA, Spray, 1971; VII Paris Biennial, 1971; Potsdam/SUNY, New Realism, 1971; Documenta V, Kassel, 1972; Cleveland/MA, 32 Realists, 1972; Stuttgart/WK, Amerikanischer Fotorealismus, circ., 1972; Kunsthalle, Recklinghausen, Mit Kamera, Pinsel und Spritzpistole, 1973; Los Angeles Municipal Art Gallery, Separate Realities, 1973; U. of Illinois, 1974; HartfordWadsworth, New/Photo Realism, 1974. **Collections:** Aachen/NG; American Republic Insurance Co.;

Claremont College; Cleveland/MA; Des Moines; Harvard U.; U. of Massachusetts; Oklahoma; St.-Etienne; Santa Barbara/MA; Storm King Art Center; Toledo/MA; Williams College. **Bibliography:** *Amerikanischer Fotorealismus; Kunst um 1970;* Sager.

EDIE, STUART. b. November 10, 1908, Wichita Falls, Tex.; **d.** March 17, 1974, Guanajuato, Mexico. **Studied:** Kansas City Art Institute and School of Design; ASL, with Thomas Hart Benton, Boardman Robinson, John Sloan. Traveled Europe, Mexico, North Africa, Canada, West Indies. **Taught:** State U. of Iowa, 1944- Federal A.P.: Easel painting; mural for US Post Office, Honeoye Falls, N.Y. **Awards:** L. C. Tiffany Grant; Walker; Missouri Valley Annual; Omaha/Joslyn, The Midwest; Des Moines. **Address:** 111 South Summit Street, Iowa City, Iowa. **One-man Exhibitions:** (first) An American Group (Gallery), NYC, 1932; galleries in Des Moines, Kansas City, Iowa City. **Group:** PAFA; Corcoran; NAD; WMAA; Chicago/AI; Brooklyn Museum; MMA; MOMA. **Collections:** ASL; U. of Arizona; Des Moines; U. of Georgia; Grinnell College; State College of Iowa; State U. of Iowa; Kansas City/Nelson; MMA; Newark Museum; Omaha/Joslyn; Syracuse U.; Toledo/MA; WMAA; Washburn U. of Topeka. **Bibliography:** Zaidenberg, ed.

EDMONDSON, LEONARD. b. June 21, 1916, Sacramento, Calif. **Studied:** Los Angeles City College, 1934-37; U. of California, Berkeley, 1937-42, BA (1940), MA (1942). US Army Intelligence, 1942-46. **Taught:** Los Angeles County Art Institute, 1954-56; Pasadena City College, 1947-54; 1956-64; U. of California, Berkeley, summers, 1960, 64; Pratt Institute, summer, 1961; Los Angeles State College, 1964-74; Otis Art Institute, 1974- . **Member:** Board of Directors, Pasadena/AM, 1957-63; Los Angeles Printmaking Society, president, 1966; Pasadena Society of Artists, president, 1967. **Commissions** (prints): International Graphic Arts Society, 1960; New York Hilton Hotel, 1962. **Awards:** SFMA, First **P.P.**, 1946, Second

Prize, 1951, 52, James D. Phelan Award, 1951, 53, **P.P.**, 1957; California State Fair, First Prize for Etching, 1951, Second **P.P.**, 1952, 56; Brooklyn Museum, 1951, 56; Oakland/AM, First Prize, Etching, 1952; Seattle/AM, **P.P.**, 1952, 53, 54, 59; Pasadena/AM, **P.P.**, 1952, 54, 57, 58, 59, 62; L. C. Tiffany Grant, 1952, 55; U. of Illinois, **P.P.**, 1954, 55; MMA, $500; American Color Print Society, Prize for Etching, 1954, 55; Los Angeles/County MA, Patronnaires Prize, 1957; Library of Congress, Pennell **P.P.**, 1957, 63; J. S. Guggenheim Fellowship, 1960; Los Angeles State College, Foundation Grants, 1965, 67; U. of North Carolina, **P.P.**, 1966; Los Angeles Printmaking Society, **P.P.**, 1968; and many others. **Address:** 714 Prospect Boulevard, Pasadena, Calif. 91103. **Dealer:** Adele Bednarz Gallery. **One-man Exhibitions:** (first) Felix Landau Gallery, 1950, also 1953, 55, 58, 60; de Young, 1952; Pasadena/AM, 1953; Santa Barbara/MA, 1953, 66; SFMA, 1956, 67; The Gallery, Denver, 1963; Comara Gallery, 1963; Laguna Beach (Calif.) Art Gallery, 1964; Oklahoma City U., 1964; Adele Bednarz Gallery, 1965, 68; Lincoln, Mass./De Cordova, 1967; Ventura College, 1969; Heath Gallery, Atlanta, 1969; Louisiana State U., 1969; California State College, Dominguez Hills, 1969; California Institute of the Arts, Valencia, 1970; U. of Colorado, 1972. **Group:** MMA, 1952; WMAA, 1952, 53, 55, 56, 58; U. of Illinois, 1953, 55, 58, 69, 50 Contemporary American Printmakers, 1956; SRGM, Younger American Painters, 1954; Carnegie, 1955; Sao Paulo, 1955; SFMA, Art in the Twentieth Century, 1955; Corcoran, 1957, 59; Chicago/AI, 1957; VMFA, 1958; PCA, American Prints Today, circ., 1959-62; USIA, 30 Contemporary American Prints, circ., 1964; Taiheiyo Art Association, Tokyo, I International, LX Annual, 1964; California Society of Printmakers, 50th Anniversary Exhibition, 1964; New York World's Fair, 1964-65; Temple U., Rome, 1967; Brooklyn Museum, Print Biennial, 1968. **Collections:** Bibliotheque Nationale; Brooklyn Museum;

California State U., Los Angeles; U. of California; U. of Colorado; Dallas/MFA; U. of Delaware; Grunwald Foundation; U. of Illinois; Ithaca College; Karachi; Library of Congress; Lincoln, Mass./De Cordova; Lindenwood College; Los Angeles/County MA; MMA; Montana State U.; NYPL; National Gallery; U. of North Carolina; U. of North Dakota; Oakland/AM; Olivet College; Orange Coast College; Otis Art Institute; PMA; Pasadena/AM; Potsdam/SUNY; SFMA; St. Lawrence U.; Seattle/AM; Southern Illinois U.; State of California; USIA; Utica; VMFA; Victoria and Albert Museum; Western Michigan U.; Western New Mexico U.; U. of Wisconsin; College of Wooster.

ELLIOTT, RONNIE. b. December 16, 1916, NYC. **Studied:** Hunter College; NYU; ASL. Traveled Europe, Mexico, Puerto Rico, Canada; resided continental USA, Honolulu, Paris. **Taught:** Fine Arts Work Center, Provincetown, Mass., 1973. Federal A.P.: Easel and mural painting; also mosaic and stained glass windows. **Awards:** New Orleans Arts and Crafts Society, First Prize for Sculpture, 1935. **Address:** 68 East Seventh Street, NYC 10003. **One-man Exhibitions:** (first) Delphic Gallery, NYC, 1937; Marquie, NYC, 1942, 43, 44; Norlyst Gallery, NYC, 1947; Carlebach Gallery, NYC, 1948; Galerie Creuze, Paris, 1948; Galerie Colette Allendy, Paris, 1952; Rose Fried Gallery, 1957, 58, 67; Granville Gallery, NYC, 1964; Brooklyn College, 1968. **Retrospective:** Grand Central Moderns, NYC, 1963. **Group:** PAFA, 1933, 34, 39; Golden Gate International Exposition, San Francisco, 1939; Corcoran, 1939, 41; NAD, 1941; Carnegie, 1941; MMA, Contemporary American Art, 1942; Museum of Non-Objective Art, NYC, 1946; MOMA, Collage, 1948; Salon des Realites Nouvelles, Paris, 1948, 49, 51; A.F.A., Cross-Currents, circ., 1958; Houston/MFA, 1958; A.F.A., Collage in America, circ., 1957-58; WMAA Annual, 1964; U. of Nebraska; Musee des Arts Decoratifs, 1964; St.-Etienne, 1964; A.F.A., 1968; Annely Juda Fine Art,

London, The Non-Objective World: 1914-1955, 1972; PMA/Museum of the Philadelphia Civic Center, Focus, 1974. **Collections:** Baltimore/MA; Calcutta; Carnegie; Chase Manhattan Bank; Ciba-Geigy Corp.; Cornell U.; MOMA; NYU; New York Hospital; Rockland/Farnsworth; St.-Etienne; WMAA; Wellesley College. **Bibliography:** Janis and Blesh 1.

ENGEL, JULES. b. 1915, Budapest, Hungary. **Studied:** Chouinard Art Institute, Los Angeles. **Taught:** California Institute of the Arts, Valencia, 1971. **Awards:** SFMA, **P.P.**, 1950, 51; Los Angeles/County MA, **P.P.**, 1951; Ford Foundation Grant, 1960; Atlanta Film Festival, Gold Medal, 1971. **Address:** c/o Dealer. **Dealer:** Cynthia Comsky Gallery. **One-man Exhibitions:** Paul Kantor Gallery, Beverly Hills, Calif., 1952, 54, 56, 58, 60, 63; Forsyth Gallery, Los Angeles, 1950; The New Gallery, NYC, 1951; Esther Robles Gallery, 1961, 62, 69; Ruth White Gallery, 1966, 67; Cynthia Comsky Gallery, 1972. **Group:** de Young, 1945-53; Chicago/AI, 1949; WMAA, 1951, 52; MMA, 1952; Denver/AM; Santa Barbara/MA; Pasadena/AM; Sao Paulo, 1955. **Collections:** Los Angeles/County MA; SFMA.

ENGMAN, ROBERT. b. 1927, Belmont, Mass. **Studied:** RISD, 1948-52, BFA; Yale U. (with Josef Albers, Jose de Rivera), 1952-54, MFA. US Navy, 1944-46. **Taught:** Yale U., 1954; U. of Pennsylvania, 1963. **Awards:** NAD, Samuel F. B. Morse Fellowship, 1963-64. **Address:** Durham, Conn. 06422. **One-man Exhibitions:** (first) The Stable Gallery, 1960, also 1962; MIT, 1966; Kanegis Gallery, 1967; John Bernard Myers Gallery, NYC, 1972. **Group:** ICA, Boston, 1959; MOMA, Recent Sculpture USA, 1959; Sao Paulo, 1961; SRGM, 1962; WMAA, 1965; Los Angeles/County MA, American Sculpture of the Sixties, 1967. **Collections:** Franchard Corp.; MOMA; Revere; Wellesley College; Yale U.

ERNST, JIMMY. b. June 24, 1920,

Jimmy Ernst *Across a Wall* 1964

Cologne, Germany. **Studied:** Cologne-Lindenthal Real-Gymnasium; Altona Arts and Crafts School. To USA 1938. **Taught:** U. of Colorado, summers, 1954, 56; Museum of Fine Arts of Houston, 1956; Brooklyn College, 1951- ; Pratt Institute; lectures extensively. Sent by US State Department to USSR, 1961. **Commissions:** General Motors Technical Center, Detroit (10-ft. mural); NBC-TV, "Producers' Showcase," 1954 (plastic sculpture signature); Abbott Laboratories, 1955; *Fortune* Magazine, 1955, 61 (paintings); NBC-TV, "Playwrights '56" (welded steel sculpture signature, with Albert Terris); American President Lines, *USS President Adams*, 1956 (mural); Continental National Bank, Lincoln, Neb., 1956 (96-ft. mural); Envoy Towers, 300 East 46 Street, NYC, 1960 (relief mural). **Awards:** Pasadena/AM, Hattie Brooks Stevens Memorial **P.P.**, 1946; WMAA, Juliana Force Memorial **P.P.**, 1951; Chicago/AI, Norman Wait Harris Bronze Medal, 1954; Brandeis. U., Creative Arts Award, 1957; Guggenheim Foundation

Fellowship, 1961. **Address:** Cottage Avenue, East Hampton, N.Y. 11937. **Dealer:** Grace Borgenicht Gallery Inc. **One-man Exhibitions:** (first) Norlyst Gallery, NYC, 1941; Philadelphia Art Alliance, 1948; Grace Borgenicht Gallery Inc., 1951-55, 1957, 61, 62, 68, 71, 72; Walker, 1954; Silvermine Guild, 1955; Houston/MFA, 1956; Brandeis U., 1957; Detroit/Institute, 1963; PAFA, 1965; West Palm Beach/Norton, 1965; Des Moines, 1966; Arts Club of Chicago, 1968. **Group:** Pasadena/AM, 1946; Brooklyn Museum, Watercolor Biennial; California Palace, 1952; U. of Colorado, 1953, 54, 56; Detroit/Institute, 1953, 59; *Life* Magazine, Painters Under 35, NYC, 1954; MMA, 100 Years of American Painting, 1954; SRGM, Younger American Painters, 1954; American Embassy, Paris, American Drawing, 1954; Toledo/MA, 1954, 55; Carnegie, 1955; WMAA, Young America, 1955; XXVIII Venice Biennial, 1956; U. of Nebraska, 1956; U. of Illinois, 1957; Brooklyn Museum, Golden Years of American Drawing, 1957; Brussels World's Fair, 1958; NIAL, 1958, 60, 65; PAFA, 1959, 65; Chicago/AI, Directions in American Painting, 1960; WMAA Annual, 1966; Washburn U. of Topeka, 1966; WMAA, Art of the U.S. 1670-1966, 1966; Honolulu Academy, 1967. **Collections:** Allentown/AM; Bielefeld; Brandeis U.; Brooklyn Museum; Buffalo/Albright; Chicago/AI; Clearwater/Gulf Coast; Cologne; U. of Colorado; U. of Connecticut; Corcoran; Cranbrook; Detroit/Institute; Hartford/Wadsworth; Houston/MFA; Lehigh U.; MMA; MOMA; Michigan State U.; U. of Michigan; NCFA; NYU; U. of Nebraska; PAFA; Pasadena/AM; SFMA; SRGM; Southern Illinois U.; Toledo/MA; Toronto; Tulsa/Philbrook; Utica; VMFA; WMAA; Walker; West Palm Beach/Norton. **Bibliography:** Baur 7; Beekman; Blesh 1; Goodrich and Baur 1; Guggenheim, ed.; McCurdy, ed.; Janis and Blesh 1; Janis, S.; Mendelowitz; Motherwell and Reinhardt, eds.; Nordness, ed.; Pousette-Dart, ed.; Read 2; Ritchie 1. Archives.

ESTES, RICHARD. b. 1936, Evanston, Ill. **Studied:** Chicago/AI School, 1952-56. **Address:** c/o Dealer. **Dealer:** Allan Stone Gallery. **One-man Exhibitions:** Allan Stone Gallery, 1968, 69, 70, 72; Hudson River Museum, 1968. **Group:** Milwaukee, Aspects of a New Realism, 1969; U. of Illinois, 1969; Newport Harbor, Directly Seen: New Realism in California, 1970; WMAA, 22 Realists, 1970; Syracuse/Everson, Cool Realism, 1970; Chicago/Contemporary, Radical Realism, 1971; Documenta V, Kassel, 1972; Stuttgart/WK, Amerikanischer Fotorealismus, circ., 1972. **Collections:** American Broadcasting Co.; Ivest-Wellington Corp. **Bibliography:** *Amerikanischer Fotorealismus;* Sager; *Three Realists.*

ETTING, EMLEN. b. 1905, Philadelphia, Pa. **Studied:** Harvard U., 1928; Academie de la Grande Chaumiere; with Andre Lhote in Paris. **Taught:** Philadelphia Museum School; Stella Elkins Tyler School of Fine Arts, Temple U.; Philadelphia College of Art. Hon. President, Artists Equity. **Member:** Century Association. **Commissions** (murals): Market Street National Bank, Philadelphia; Italian Consulate, Philadelphia. **Awards:** Italian Star of Solidarity; Chevalier de la Legion d'Honneur. **Address:** 1921 Manning Street, Philadelphia, Pa. 19103. **Dealer:** The Midtown Galleries. **One-man Exhibitions:** The Midtown Galleries, 1940, 43, 44, 46, 48, 50, 51, 57, 66, 71; ICA, Boston; Cleveland/MA; Warwick Gallery, Philadelphia; Philadelphia Art Alliance, 1946; Phoenix, 1965. **Group:** WMAA; Corcoran; PAFA; Florida Southern College; VMFA; NAD; Audubon Artists; St. Louis/City; Philadelphia Art Alliance; Youngstown/Butler; Dayton/AI; Indiana U.; Illinois Wesleyan U.; West Palm Beach/Norton. **Collections:** Andover/Phillips; Atwater Kent Museum; La France Institute; PAFA; WMAA. **Bibliography:** Etting; Frost; Hall. Archives.

EVERGOOD, PHILIP HOWARD FRANCIS DIXON. b. October 26, 1901, NYC; **d.** March 11, 1973, Bridgewater,

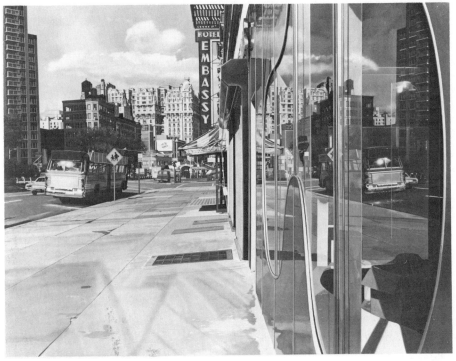

Richard Estes *Bus Reflection* 1972

Conn. **Studied:** Eton College, England, 1914-18; Trinity Hall, Cambridge, 1918-20; U. of London, Slade School, 1920-23, with Henry Tonks; ASL, 1923-25, with George Luks, William Von Schlegell; Academie Julian, Paris, 1925, with Jean Paul Laurens, Andre Lhote. Traveled North Africa, USA and Europe extensively. **Taught:** The Kalamazoo Institute of Arts; American Artists School, NYC; Contemporary School of Art, NYC; Iowa State College, 1952-58; U. of Minnesota, Duluth, 1955; Muhlenberg College; Settlement Music School, Philadelphia; extensive lecturing. Wrote for *Art Front* and *Direction* Magazines. **Member:** NIAL; Artists Equity. Federal A.P.: Mural painting; Managing Supervisor, Easel Painting Division; mural for Richmond Hill (N.Y.) Public Library. **Commissions** (murals): Kalamazoo College; US Post Office, Jackson, Ga. **Awards:** Chicago/ AI, The M. V. Kohnstamm Prize, 1935;

MMA, **P.P.**, 1942; Carnegie, Hon. Men., 1945; Chicago/AI, W. H. Tuthill **P.P.**, 1946; Carnegie, Second Prize, 1949; PAFA, Carol H. Beck Gold Medal, 1949, Joseph E. Temple Gold Medal, 1958; Corcoran, Second Prize, 1951; AAAL Grant, 1956; Ford Foundation, **P.P.**, 1962. **One-man Exhibitions:** (first) Dudensing Gallery, NYC, 1927; Montross Gallery, NYC, 1929, 33, 35; Balzac Gallery, NYC, 1931; Denver/AM, 1936; Atheneum Gallery, Melbourne, 1937; ACA Gallery, 1938, 40, 42, 44, 46, 48, 51, 53, 1955-62; Kalamazoo/Institute, 1941; Norlyst Gallery, NYC, 1948; State U. of Iowa; Utica; Hartford/Wadsworth; Halkins College, 1953; Garelick's Gallery, Detroit, 1953, 55; Tulane U., 1957; Gallery 63, Inc., Rome, 1963, NYC, 1964; Hammer Gallery, 1967; Kennedy Gallery, 1972; Terry Dintenfass, Inc., 1974. **Retrospective:** U. of Minnesota, Duluth, 1955; WMAA, 1960. **Group:** An American Group (Gallery), NYC; Am-

erican Society of Painters, Sculptors and Gravuers; Salon d'Automne, Paris, 1924; NAD; Independent Artists, NYC; WMAA Annuals since 1934; PAFA; Chicago/AI; Brooklyn Museum; Corcoran; Carnegie; Venice Biennial. **Collections:** Arizona State College; Atlanta/AA; Baltimore/MA; Boston/MFA; Britannica; Brooklyn Museum; Carnegie; Chicago/AI; Corcoran; Cornell U.; Dallas/MFA; Denver/AM; Free Library of Philadelphia; Grolier Club; Hartford/Wadsworth; Harvard U.; IBM; U. of Illinois; Kalamazoo/Institute; Lehigh U.; Library of Congress; Los Angeles/County MA; U. of Louisville; MMA; MOMA; Melbourne/National; Muhlenberg College; PAFA; Pepsi-Cola Co.; Santa Fe, N.M.; Smith College; Syracuse U.; WMAA; Youngstown/Butler. **Bibliography:** American Artists Congress, Inc.; **Baur 6,** 7; Biddle 4; Cheney; Eliot; Finkelstein; Genauer; Goodrich and Baur 1; Haftman; Kootz 2; **Lippard 3,** 5; McCurdy, ed.; Mendelowitz; Nordness, ed.; Pagano; Pousette-Dart, ed.; Reese; Richardson, E. P.; Rose, B. 1; Shapiro, ed. Archives.

FAHLSTROM, OYVIND. b. 1928, Sao Paulo, Brazil. To Sweden 1939; to USA 1961. Wrote plays, poetry, journalism, criticism, 1950-55; manifesto for concrete poetry (Stockholm), 1953; produced happenings, 1966-68. **Awards:** Sao Paulo Biennial, Hon. Men., 1959; Guggenheim Foundation Fellowship, 1964. **Address:** 121 Second Avenue, NYC 10003. **Dealer:** Sidney Janis Gallery. **One-man Exhibitions:** (first) Numero Gallery, Florence, Italy, 1952; Daniel Cordier, Paris, 1959, 62; Galerie Blanche, Stockholm, 1959; Cordier & Ekstrom, Inc., 1964; Sidney Janis Gallery, 1967, 69, 71, 73; MOMA, circ., 1969; Galerie Rudolf Zwirner, 1969; U. of Minnesota, 1969. **Group:** Exposition Phases, Paris, 1956; V Sao Paulo Biennial, 1959; Carnegie, 1960, 67; Venice Biennials, 1964, 1966; EAT, NYC, 1966; Chicago/Contemporary, Pictures to be Read/Poetry to be Seen, 1967; Musee des Arts Decoratifs, 1967; Documenta IV, Kassel, 1968; ICA, U. of Pennsylvania, The Spirit of the Comics, 1969; Hayward Gallery, London, Pop Art, 1969; Los Angeles/County MA, Art & Technology, 1971; Tokyo/Modern, Swedish Art 1972, 1972. **Collections:** Cologne; Los Angeles/County MA; Stockholm/National; Stuttgart.

FARR, FRED W. b. August 9, 1914, St. Petersburg, Fla.; **d.** June 16, 1973, NYC. **Studied:** U. of Oregon; ASL; American Artists School, NYC. Traveled Mexico. **Taught:** Brooklyn Museum School, 1950-73; MOMA School, 1947; Hunter College, 1954; Dalton Schools, NYC, 1950; U. of Colorado; Dayton Art Institute School; U. of Oregon, 1948. **Member:** Artists Equity. Federal A.P.: Social Security Building, Washington, D.C. (mural). **Commissions:** Moore-McCormack Lines Inc., *SS Argentina* (mural). **Awards:** Port-au-Prince Bicentennial Exposition, 1950, Haiti Silver Medal. **One-man Exhibitions:** (first) The Bertha Schaefer Gallery; P. Rosenberg and Co., 1957, 58, 61, 64, 69. **Group:** MOMA, 1946; Springfield, Mass./MFA, 1947; Walker, 1948; Utica; U. of Michigan; Ohio U.; The Ohio State U.; U. of Delaware, 1948; RISD, 1949; WMAA; U. of New Hampshire; Northwestern U.; U. of Tennessee; U. of Wisconsin; Port-au-Prince (Haiti) Bicentennial Exposition, 1950; Walters Art Gallery, Baltimore, 1953; ART USA:59, NYC, 1959; U. of Illinois, 1961. **Collections:** Ball State U.; Detroit/Institute; U. of Illinois; Phillips; Portland, Me./MA.

FEELEY, PAUL. b. July 27, 1913, Des Moines, Iowa; **d.** June 10, 1966, NYC. **Studied:** Menlo Junior College; privately with Hobart Jacobs in California and Cecilia Beaux in NYC; ASL, with Thomas Hart Benton, George Bridgeman; Beaux-Arts Institute of Design, NYC. Traveled Spain, Morocco, Greece, USA. **Taught:** Cooper Union, 1936-39; Bennington College, 1940-66. US Marine Corps, 1943-46. **Member:** National Society of Mural Painters. **One-man Exhibitions:** (first) Palo Alto (Calif.) Public Library, 1929; New School for Social Research, 1948; Santa Barbara/MA, 1950; The Rose Rabow Gallery, San Francisco, 1951; Stanford U., 1951; Mills College, 1951; SFMA, 1951; Tibor de Nagy Gallery, 1955, 57, 58; Betty Parsons Gallery, 1960, 1962-66, 1970, 71; Kasmin Ltd., 1964, 65, 67; Nicholas Wilder Gallery, 1966; Smithsonian, 1970. **Retrospective:** SRGM, 1968.

Group: Walker, 1950; ICA, Boston, 1952; PAFA; The Kootz Gallery, NYC, New Talent, 1954; Chicago/AI; Lincoln, Mass./De Cordova, New Experiments in Art, 1963; Los Angeles/County MA, Post Painterly Abstraction, 1964; SRGM, American Drawings, 1964, also 1965, Systemic Painting, 1966; SFMA, The Colorists, 1965; MOMA, The Responsive Eye, 1965; Amsterdam/ Stedelijk, New Shapes of Color, 1966; Mexico City/Nacional, 19th Olympiad, 1968. **Bibliography:** Alloway 3; **Baro;** Battcock, ed.; Goossen 1. Archives.

FEININGER, LYONEL. b. July 17, 1871, NYC; **d.** January 13, 1956. Studied the violin with his father and played in concerts from the age of 12; went to Germany in 1880 to study music, but changed to painting. **Studied:** Kunstgewerbeschule, Hamburg; Academy of Fine Arts, Berlin, with Ernst Hancke, Woldemar Friedrich; Jesuit College, Liege, Belgium, 1887-91; Academie Colarossi, Paris, 1892-93. Traveled Europe, USA. **Taught:** Bauhaus, Weimar, 1919-24; Bauhaus, Dessau, 1925-33; Mills College, summers, 1936, 37. Cartoonist and Illustrator for *Ulk* and *Lustige Blatter,* Berlin, 1893-1906, *Le Temoin,* Paris, 1906-07, and Chicago *Sunday Tribune.* A member of the Blue Four, 1924 (with Vassily Kandinsky, Paul Klee, and Alexej von Jawlensky). **Commissions:** New York World's Fair, 1939 (murals for Marine Transport Building and Masterpieces of Art Building). **One-man Exhibitions:** Emil Richter Gallery, Dresden, 1919; Anger-Museum, Erfurt, Germany, 1920, 27, 29, 30; Kunst und Bucherstube, Erfurt, 1921; Goldschmidt-Wallerstein, Berlin, 1922, 25; Anderson Galleries, NYC, 1923; Wiesbaden, 1925; Neue Kunstfides, Dresden, 1925, 26, 31; Brunswick, 1926; Kassel, 1927; Staaliche Galerie Moritzburg, Halle, Germany, 1928; Anhalt Gallery, Dessau, 1929; Kunstverein, Prague, 1930; Mills College, 1936, 37; SFMA, 1937; Los Angeles/ County MA, 1937; Seattle/AM, circ., 1937; Andover/Phillips, 1938; Curt Valentine Gallery, NYC, 1941, 44,46, 48, 50, 52, 54; Buchholz Gallery, NYC, 1941, 43, 44; Karl Nierendorf Gallery, NYC, 1943; The Willard Gallery, 1943, 44; Dalzell Hatfield Gallery, 1944; Fort Worth, 1956; Harvard U., 1958; Detroit/Institute, 1964; R. N. Ketterer, Campione, Switzerland, 1965; Pasadena/ AM, 1966; LaBoetie Gallery, NYC, 1966; MOMA, 1967; Marlborough-Gerson Gallery Inc., 1969; A.A.A. Gallery, 1972; Serge Sabarsky Gallery, NYC, 1972, 74; Haus der Kunst, Munich, 1973; Marlborough Gallery Inc., NYC, 1974. **Retrospective:** Berlin, 1931; MOMA, 1944 (two-man); ICA, Boston, 1949; Jeanne Bucher, Paris, circ. Europe, 1950-51; Print Club of Cleveland, 1951; Hannover, circ. Europe, 1954-55; SFMA, circ., 1959-61. **Group:** Salon des Artistes Independants, Paris, 1911; Der Sturm, Berlin, 1917; Documenta I, Kassel, 1955; WMAA; Tate; Mannheim; Allentown/AM, The Blue Four and German Expressionism, 1974. **Collections:** Baltimore/MA; Buffalo/Albright; Chicago/AI; Cranbrook; U. of Houston; Kansas City/Nelson; Lehigh U.; MMA; MOMA; U. of Michigan; Milwaukee; Minneapolis/Institute; PMA; Phillips; RISD; Raleigh/NCMA; SRGM; San Antonio/McNay; Seattle/AM; Toledo/MA; Utica; WMAA; Walker; Washington U. **Bibliography:** Barr 1; Baur 5, 7; Bazin; Beekman; Biddle 4; Blanchard; Blesh 1; Born; Brion 2; Brown; Bulliet 1; Cassou; Cheney; Eliot; Feininger, T. L.; Flanagan; Frost; Goodrich and Baur 1; Haftman; Hess, H.; Hess, T. B. 1; Hulten; Hunter 6; Huyghe; Janis, S.; Kouvenhoven; Kuh 1; Langui; Lee and Burchwood; MacAgy 2; McCurdy, ed.; Mendelowitiz; Munsterberg; **Ness, ed.;** Neumeyer; Newmeyer; Pousette-Dart, ed.; Raynal 3, 4; Read 2; Richardson, E. P.; Rickey; Ritchie 1; Rose, B. 1; Rosenblum 1, 2; Roters; Sachs; Scheyer; Selz, P. 3; Sutton; Valentine 2; Verkauf; Wight 2; Wingler, ed. Archives.

FEITELSON, LORSER. b. 1898, Savannah, Ga. **Taught:** Art Center School,

Los Angeles. **Address:** 8307 West Third Street, Los Angeles, Calif. 90048. **One-man Exhibitions:** The Daniel Gallery, NYC, 1924; San Diego, 1928; California Palace, 1928, 32; Los Angeles/County MA, 1929, 44; SFMA, 1944; Lucien Labaudt Gallery, San Francisco, 1949; San Antonio/McNay, 1955; Paul Rivas Gallery, Los Angeles, 1959 (two-man); Ankrum Gallery, 1964; Art Center School, Los Angeles (two-man); Scripps College, 1958, 61; Long Beach/MA, 1962; Chapman College, Los Angeles, 1963; Occidental College, Los Angeles, 1965; Los Angeles Art Association Galleries, 1968. **Retrospectives:** Pasadena/AM, 1952; Los Angeles Municipal Art Gallery, 1972. **Group:** Brooklyn Museum, 1936; SFMA, 1936; MOMA, Fantastic Art, DADA, Surrealism, 1936; Chicago/AI, Abstract and Surrealist Art, 1948; U. of Illinois, 1950, 51, 53, 65; Sao Paulo, 1955; WMAA, 1955, Annuals, 1965, 67; MOMA, The Responsive Eye, 1965; Sacramento/Crocker, 1967, 68; Pasadena/AM, West Coast: 1945-1969, 1969; Museum of Fine Arts, St. Petersburg, Color in Control, 1969; Sacramento/Crocker, Century of California Painting, 1970; VMFA, American Painting, 1970. **Collections:** Atlantic Richfield Co.; Bank of Omaha; Brooklyn Museum; Craig Elwood Associates; Great Western Savings and Loan Association; Hirshhorn; Industrial Electronics Engineers, Inc.; Lansing Sound Corp.; Long Beach/MA; Los Angeles/County MA; MOMA; SFMA; Xerox Corp. **Bibliography:** *Avant-Garde Painting and Sculpture;* Baur 7; Flanagan; Rickey. Archives.

FENTON, ALAN. b. July 29, 1927, Cleveland, Ohio. **Studied:** Pratt Institute, with Jack Tworkov, Adolph Gottlieb, BFA; ASL, with Richard Bove. US Merchant Marine, World War II. Traveled Europe, Mexico, Canada, USA. **Taught:** Housatonic State College, Stratford, Conn.; Pratt Institute. **Awards:** City Center Gallery, NYC, Hon. Men., 1958; Cleveland/MA, First Prize, 1960, 61. **Address:** 333 Park Avenue South, NYC 10010. **One-man Exhibitions:** (first) The Pace Gallery, 1963; Alhar, Stratford, Conn., 1968; Bridgeport, 1973; New York Cultural Center, 1974. **Group:** ART:USA:58, NYC, 1958; Cleveland/MA, 1959, 60, 61; Artists of the Western Reserve, circ., 1961; SFMA, 1963; New York World's Fair, 1964-65; Corcoran, 1970. **Collections:** Baltimore/MA; Bobbie Brooks Inc.; CIA; Cleveland/MA; Corcoran; H. E. Laufer Co.; New College (Sarasota, Fla.); Pratt Institute; Rich-Lan Corp.; Stony Brook/SUNY; Westport Savings Bank.

FERBER, HERBERT. b. April 30, 1906, NYC. **Studied:** City College of New York, 1923-26; Columbia U. School of Dental and Oral Surgery, 1927, BS, 1930, DDS; Beaux-Arts Institute of Design, NYC, 1927-30; NAD, 1930. Traveled Italy, France, Mexico, Great Britain, Egypt. **Taught:** U. of Pennsylvania, 1963-64; Columbia U. School of Dental and Oral Surgery; Rutgers U., 1965-67. **Commissions:** B'nai Israel Synagogue, Millburn, N.J., 1950; Brandeis U., Jewish Chapel, 1955; Temple Anshe Chesed, Cleveland, 1955; Temple of Aaron, St. Paul, 1955; WMAA, Sculpture as Environment, 1961; Rutgers U., 1968; John F. Kennedy Federal Office Building, Boston, 1969; American Dental Association Building, Chicago, 1974. **Awards:** Beaux-Arts Institute of Design, NYC, Paris Prize, 1929; L. C. Tiffany Grant, 1930; MMA, Artists for Victory, $1,000 Prize, 1942; ICA, London/Tate, International Unknown Political Prisoner Competition, 1953; Guggenheim Foundation Fellowship, 1969. **Address:** 44 MacDougal Street, NYC 10012. **Dealer:** Andre Emmerich Gallery. **One-man Exhibitions:** (first) The Midtown Galleries, 1937, also 1943; Betty Parsons Gallery, 1947, 50, 53; The Kootz Gallery, NYC, 1955, 57; Columbia U., 1960; Andre Emmerich Gallery, 1960, 62, 67, 69, 70, 71, 72, 73, 75; U. of Vermont, 1964; Rutgers U., 1968. **Retrospectives:** Bennington College, 1958; WMAA, 1961; SFMA, 1962;

Walker, circ., 1962-63. **Group:** NAD, 1930; Brooklyn Museum; PAFA, 1931, 42, 43, 45, 46, 54, 58; Corcoran, 1932; Philadelphia Art Alliance, 1933; American Artists Congress, 1936, 40; Musee du Jeu de Paume, 1938; Sculptors Guild, 1938-42, 1944, 48, 64; Golden Gate International Exposition, San Francisco/ AI, 1940, 41, 45; WMAA Annuals, 1940, 42, 1945- ; Federation of Modern Painters and Sculptors, 1941-49; A.F.A., Sculpture in Wood, 1941; MMA, 1942; Sao Paulo, 1951; MOMA, Abstract Painting and Sculpture in America, 1951; MOMA, Fifteen Americans, circ., 1952; Tate, 1953; WMAA, The New Decade, 1954-55; Brussels World's Fair, 1958; Carnegie, 1958; A.F.A., God and Man in Art, circ., 1958-59; Documenta II, Kassel, 1959; St. Paul Gallery, Drawings, USA, 1961; Baltimore/MA; Cranbrook; Battersea Park, London, International Sculpture Exhibition, 1963; Musee Rodin, Paris, 1965; MOMA, The New American Painting and Sculpture, 1969. **Collections:** Bennington College; Brandeis U.; Buffalo/Albright; Cranbrook; Detroit/Institute; Grand Rapids; Indiana U.; MMA; MOMA; NYU; Newark Museum; WMAA; Walker; Williams College; Yale U. **Bibliography:** Baur 5, 7; Blesh 1; Brumme; Chipp; Craven, W.; Flanagan; Giedion-Welcker 1; Goodrich and Baur 1; **Goosen 5;** Henning; Hunter 6; Hunter, ed.; McCurdy, ed.; *Monumenta;* Motherwell and Reinhardt, eds.; Read 3; Ritchie 1, 3; Rose, B. 1; Rubin 1; Seuphor 3; Trier 1. Archives.

FERREN, JOHN. b. October 17, 1905, Pendleton, Ore.; **d.** July 24, 1970, Southampton, N.Y. **Studied:** Academie de la Grande Chaumiere; Sorbonne; U. of Florence; U. of Salamanca; Academie Ranson, Paris; Academie Colarossi, Paris. Traveled Europe, USA, Middle East; resided, worked in Paris, 1931-38. Civilian employee of War Department and OWI, 1941-45; Psychological Warfare Division, SHAEF (Propaganda Chief, Italian Radio Section); Algiers headquarters (Chief of Publications for

France); received Bronze Star. **Taught:** Brooklyn Museum School, 1946-50; Cooper Union, 1947-54; Art Center School, Los Angeles, summer, 1948; Queens College, 1952-70; UCLA, summer, 1953; privately in New York; U. of Saskatchewan, summer, 1960; Yale U., summer, 1962; lectured extensively and published essays. Advisory work on "The Trouble with Harry" (1955) and "Vertigo" (1958), films directed by Alfred Hitchcock. **Member:** Advisory Council to the School of Art and Architecture, Yale U., 1959-62. **One-man ˙Exhibitions:** Art Center, San Francisco, 1930; Galerie Zak, Paris, 1932; Gallerie Pierre, Paris, 1936; Pierre Matisse Gallery, 1936, 37, 38; Minneapolis/Institute, 1936; Howard Putzell Gallery, Hollywood, 1936; SFMA, 1936, 52; Arts Club of Chicago, 1937; Galerie Beaune, Paris, 1938; The Willard Gallery, 1942; Art Project Gallery, Hollywood, 1942; Kleemann Gallery, NYC, 1947, 49; Santa Barbara/MA, 1952; Tacoma, 1952; Portland (Ore.) Arts Club, 1952; Alexander Iolas Gallery, 1953; UCLA, 1953; U. of Washington, 1953; The Stable Gallery, 1954, 55, 56,

John Ferren *Eucalyptus* 1955

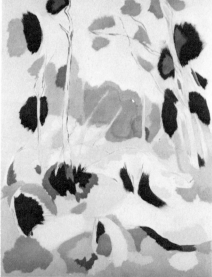

57, 58; Phillips, 1958; U. of Wisconsin, 1959; Glassboro State College, 1959; Trenton State College, 1959; Rose Fried Gallery, 1962, 1965-68; Queens College, 1963; Centre d'Art Gallery, Beirut, Lebanon, 1964; American Embassy, London, 1965; Pageant Gallery, Florida, 1968; Southampton College, 1968 (two-man); A. M. Sachs Gallery, 1969, 72, 74, 75; Southampton/Parrish, 1969. **Group:** Los Angeles/County MA Annuals, 1925-29; SFMA Annuals, 1925-29; California Palace, 1931; American Abstract Artists, 1934, 35, 37; Musee du l'Orangerie, Paris, 1937; Salon des Surindependants, Paris, 1937; Royal Institute of the Arts, Copenhagen, 1937; Corcoran, 1940; Chicago/AI, 1947; Brooklyn Museum, 1949; U. of Minnesota, Pioneers in American Abstract Art, 1951; Ninth Street Exhibition, NYC, 1951; MOMA, Abstract Painting and Sculpture in America, 1951; WMAA Annuals, 1952, 55, 56, 58, The 1930's, 1968; Carnegie 1955; MOMA, 7 American Watercolorists, circ. Europe, 1956; Chicago/AI, 1956; U. of Illinois, 1957; WMAA, Nature in Abstraction, 1958; U. of Kentucky, Graphics, 1958, 59; Pasadena/AM, A Decade in the Contemporary Gallery, 1959; ART:USA:59, NYC, 1959; Walker, 60 American Painters, 1960; SRGM, Abstract Expressionists and Imagists, 1961; A.F.A., Affinities, circ., 1962; PAFA, 1964, 66; Gallery of Modern Art, NYC, 1965. **Collections:** Allentown/ AM; Art of This Century (Peggy Guggenheim); Arts Club of Chicago; Birmingham, Ala./MA; Brandeis U.; Buffalo/Albright; California Palace; U. of California; Cedar Rapids/AA; Cleveland/MA; Detroit/Institute; Hartford/ Wadsworth; High Museum; Hirshhorn; Los Angeles/County MA; MOMA; NYU; U. of Nebraska; Norfolk/Chrysler; Oklahoma; PMA; Phillips; SFMA; SRGM; Sacramento/ Crocker; Santa Barbara/MA; Scripps College; Tel Aviv; U. of Texas; Tougaloo College; WGMA; WMAA; Washington U.; Yale U. **Bibliography:** Baur 5, 7; Chipp; Eliot; Frost; Goodrich and Baur 1; Guggenheim, ed.; Hayter 2; Janis, S.; Passloff; Ritchie 1; Rose, B. 1, 4. Archives.

FIENE, ERNEST. b. November 2, 1894, Eberfeld, Germany; **d.** August 10, 1965, Paris, France. To USA 1912; citizen 1928. **Studied:** NAD, 1914-18; Beaux-Arts Institute of Design, NYC, 1916-18; ASL, 1923; Academie de la Grande Chaumiere, 1929; Florence, Italy (fresco painting), 1932. Traveled Europe, Mexico, USA. **Taught:** Westchester County Center, 1930-31; Colorado Springs Fine Arts Center, 1935; Cooper Union, 1938-39; ASL, 1938-65; Ogunquit School of Painting, 1950-51; Famous Artists Schools, Inc., 1956-65; NAD, 1960-65. **Member:** Artists Equity (Hon. President); NAD; Century Association; ASL. **Commissions** (portraits): Columbia U.; New York Hospital; Ohio U.; Abbott Laboratories; (series of paintings): Scruggs,Vandervoort and Barney; Gimbels, Philadelphia; Central Needle Trades High School of New York; (murals): International Ladies' Garment Workers Union, NYC; Abraham Lincoln High School, Brooklyn (2); US Post Office, Canton, Mass.; New Interior Building, Washington, D.C. **Awards:** Guggenheim Foundation Fellowship, 1932; Chicago/AI, Norman Wait Harris Prize, 1937; Corcoran, William A. Clark Prize, 1938; Carnegie, Hon. Men., 1938; Chicago/AI, Ada S. Garrett Prize, 1940; Library of Congress, Pennell **P.P.**, 1940; Library of Congress, First Pennell **P.P.**, 1944; NAD, Edwin Palmer Memorial Prize, 1961. **One-man Exhibitions:** (first) Whitney Studio Club, NYC, 1923; The New Gallery, NYC, 1924; Kraushaar Galleries, 1927; The Downtown Gallery, 1928, 33, 36; Rehn Galleries, 1930-32; Western Association of Art Museum Directors, circ., 1938; A.A.A. Gallery, NYC, 1938-41, 1945; M. Knoedler & Co., 1949-51; The Midtown Galleries, 1959; Stonington Gallery, Conn., 1963; Bay Head Art Center, 1964; Washington Irving Gallery, NYC, 1969. **Group:** WMAA, 1930-45; Carnegie, 1930-45; PAFA, 1930-45; NAD;

MOMA; Youngstown/Butler; Chicago-/AI, 1930-33, 1936-45; Corcoran, 1931-45; MMA; Boston/MFA. **Collections:** ASL; Abbott Laboratories; Boston/MFA; Bowdoin College; Britannica; Brooklyn Museum; California Palace; Chicago/AI; Cleveland/MA; Columbia U.; Dartmouth College; Denver/AM; Detroit/Institute; Drake U.; Library of Congress; Los Angeles/County MA; MIT; MMA; MOMA; NAD; NYPL; U. of Nebraska; Newark Museum; Ogunquit; Ohio U.; PAFA; Phillips; SFMA; Syracuse U.; Tel Aviv; Terre Haute/Swope;Tulsa/Philbrook;WMAA;Yale U. **Bibliography:** American Artists Congress, Inc.; American Artists Group Inc. 1, 2, 3; Cahill and Barr, eds.; Goodrich and Baur 1; Hall; Pearson 1; Phillips 1; Reese; Richardson, E. P. Archives.

FISH, JANET. b. 1938, Boston Mass. **Studied:** Smith College, BA; Yale U., MFA. **Awards:** Chicago/AI, Norman Wait Harris Award, 1974. **Taught:** Skowhegan School. **Address:** 625 Broadway, NYC 10012. **Dealer:** The Kornblee Gallery. **One-man Exhibitions:** The Kornblee Gallery, 1971, 72, 73, 74; Pace College, NYC, 1972; Russell Sage College, 1972; Galerie Alexandra Monett, Brussels, 1974; Galerie Kostiner-Silvers, Montreal, 1974. **Group:** A.F.A., Still Life Today, 1970-71; NIAL, 1972; Chicago/AI, 1972, 74; Indianapolis, 1972; Lakeview Center, American Women: 20th Century, 1972; Randolph-Macon College, Paintings by Some Contemporary American Women, 1972; Cleveland/MA, 32 Realists, 1972; A.F.A., The Realist Revival, 1972; WMAA, American Drawings: 1963-1973, 1973; Yale U., 7 Realists, 1973; PMA/Museum of the Philadelphia Civic Center, Focus, 1974; Tokyo Biennial, 1974; Queens Museum, New Images, 1974. **Collections:** A.F.A.; AT&T; American Airlines, Amstar Corp.; Chase Manhattan Bank; Colby College; Dallas/MFA; Heublein Inc.; Minneapolis/Institute; Newark Museum; New York State Health and Hospitals Corp.; Oberlin College; Port Authority of New York & New Jersey; RISD; U. of Sydney; WMAA; Wellington Management Corp.; Yale U.

FLANNAGAN, JOHN. b. April 7, 1895, Fargo, N.D.; **d.** January 6, 1942, NYC. **Studied:** Minneapolis Institute School, 1914-17, with R. Koehler. US Merchant Marine, 1914-17. Traveled Ireland, USA, France. **Awards:** Guggenheim Foundation Fellowship, 1932; MMA, Alexander Shilling Prize, 1940. **One-man Exhibitions:** Whitney Studio Club, NYC, 1925; Weyhe Gallery, 1927, 28, 30, 31, 34, 36, 38, 73; Arts Club of Chicago, 1934; Vassar College, 1936; Bard College, 1937; Buchholz Gallery, NYC, 1942 (2); VMFA, 1946; A.F.A., circ., 1959; International Exhibitions Foundation, Washington, D.C., 1965-76. **Group:** WMAA; MOMA; MMA; Brooklyn Museum; Carnegie, Forerunners of American Abstraction, 1971. **Collections:** Andover/Phillips; Cincinnati/AM; Cleveland/MA; Detroit/Institute; Dublin/Municipal; Harvard U.; Honolulu Academy; MMA; U. of Nebraska; Oberlin College; Vassar College; WMAA; Wichita/AM. **Bibliography:** *Avant-Garde Painting and Sculpture*; Baur 7; Brumme; Cheney; Craven, W.; Fierens; *Forerunners*; Goodrich and Baur 1; Hunter 6; Jackman; Licht, F.; McCurdy, ed.; Mellquist; Mendelowitz; **Miller, ed. 3**; Ritchie 3; Rose, B. 1, 4; Selz, J.; Seuphor 3; Seymour; **Valentine 1, 2**; Wheeler.

FLAVIN, DAN. b. 1933, NYC. **Studied:** Cathedral College of the Immaculate Conception, 1947-52; US Air Force Meteorological Technician Training School, 1953; U. of Maryland (Extension, Korea), 1954-55; New School for Social Research, 1956; Columbia U., 1957-59. **Address:** Garrison, N.Y. 10524. **Dealers:** Leo Castelli Inc., NYC; John Weber Gallery. **One-man Exhibitions:** Judson Gallery, NYC, 1961; Kaymar Gallery, NYC, 1964; Green Gallery, NYC, 1964; Ohio State U., 1965; Galerie Rudolf Zwirner, 1966; Nicholas Wilder Gallery, 1966; The

Janet Fish *Painted Water Glasses* 1974

Kornblee Gallery, 1967; Chicago/Contemporary, 1968; Galleria Sperone, Turin, 1968; Galerie Heiner Friedrich, Munich, 1968; Konrad Fischer Gallery, Dusseldorf, 1969; Irving Blum Gallery, Los Angeles, 1969; Galerie Bischofberger, Zurich, 1969; Ottawa/National, 1969; Vancouver, 1970; Jewish Museum, 1970; Dwan Gallery, NYC, 1970; Leo Castelli Inc., NYC, 1970, 71, 72, 73, 74; Los Angeles/County MA, 1970; Galerie Heiner Friedrich, Munich, 1970; ACE Gallery, Los Angeles, 1971; John Weber Gallery, 1971, 73; Galerie Heiner Friedrich, Cologne, 1971, 73; Janie C. Lee Gallery, Dallas, 1971; Rice U., 1972; St. Louis/City, 1973; U. of Bridgeport, 1973; Locksley-Shea Gallery, 1973; Lisson Gallery, London, 1973; Ronald Greenberg Gallery, St. Louis, 1974; Jared Sable Gallery, Toronto, 1974; Pasquale Trisorio, Naples, 1974; Weinberg Gallery, San Francisco, 1974. **Group:** Hartford/Wadsworth, Black, White, and Gray, 1964; ICA, Boston, 1966; U. of California, Irvine, 5 Los Angeles Sculptors, 1966; Jewish Museum, Primary Structures, 1966; Finch College, 1966; Eindhoven, Kunst-Licht-Kunst, 1966; Los Angeles/County MA, PMA, American Sculpture of the Sixties, 1967; Trenton/State, Focus on Light, 1967; Goethe U., Frankfurt, Germany, 1967; WGMA, A New Aesthetic, 1967; VI International Art Biennial, San Marino (Europe), 1967; Buffa-

lo/Albright, Plus by Minus, 1968; The Hague, Minimal Art, 1968; Documenta IV, Kassel, 1968; WMAA, Light: Object and Image, 1968; UCLA, Electric Art, 1969; MMA, New York Painting and Sculpture: 1940-1970, 1969-70; Fort Worth Art Museum, Drawings, 1969; U. of California, Irvine, Five Sculptors, 1969; MOMA, Spaces, 1969; WMAA Annual, 1970; SRGM, Guggenheim International, 1971; Buffalo/Albright, Kid Stuff, 1971; Walker, Works for New Spaces, 1971; Los Angeles/County MA, Art & Technology, 1971; High Museum, The Modern Image, 1972; Detroit/Institute, Art in Space, 1973; MOMA, Some Recent American Art, circ., 1973; Musee Galliera, Paris, Festival d'Automne, 1973; Parcheggio di Villa Borghese, Rome, Contemporanea, 1974; Indianapolis, 1974; U. of North Carolina, Light/Sculpture, 1975. **Collections:** Amsterdam/Stedelijk; Basel; Cologne; Eindhóven; Harvard U.; Krefeld/Kaiser Wilhelm; Los Angeles/County MA; MOMA; Ottawa/National; Pasadena/AM; RISD; SRGM; Tate; WMAA; Walker. **Bibliography:** *Art Now 74;* Battcock, ed.; Calas, N. and E.; *Contemporanea;* **Dan Flavin;** Davis, D.; De Vries; Lippard, 4, 5; MacAgy 2; Muller; Tuchman 1; *Report.*

FLEISCHMANN, ADOLF R. b. March 18, 1892, Esslingen, Germany; **d.** January 28, 1968, Stuttgart, Germany. **Studied:** Academy of Fine Arts, Stuttgart; Academy of Fine Arts, Munich, with Carl Caspar. Traveled Europe extensively. **Taught:** Palma de Mallorca, 1933-36; and privately. To USA 1952. **Member:** American Abstract Artists; Groupe Espace, Paris; Salon des Realites Nouvelles, Paris. **One-man Exhibitions:** (first) Kunsthaus Schaller, Stuttgart; Galerie Creuze, Paris, 1948; Galerie Colette Allendy, Paris, 1950, 51; Lutz and Meyer Gallery, Stuttgart, 1952, 60, 62; Johannesburg/Municipal, 1953; Rose Fried Gallery, 1955, 57; Galerie Weiss, Kassel, 1959; Parma Gallery, NYC, 1961; Apiaw (Gallery), Liege,

1962; Kunstverein Freiburg im Breisgau, 1962; The Stable Gallery, 1963; Hessisches Landesmuseum, Kassel, circ., 1964. **Group:** Neue Sezession, Munich; Salon des Realites Nouvelles, Paris, 1946; Groupe Espace, Paris, 1946; American Abstract Artists Annuals; WMAA, Geometric Abstraction in America, circ., 1962; SFMA; Yale U.; Chicago/AI. **Collections:** Boulogne; Busch-Reisinger Museum; Ceret; Esslingen; Grenoble; Havard U.; Kassel; New London; Stuttgart; Union Carbide Corp.; WMAA; Wellesley College. **Bibliography:** Read 2; Seuphor 1.

FLOCH, JOSEPH. b. November 5, 1895, Vienna, Austria. **Studied:** Academy of Fine Arts, Vienna, MA. Traveled Europe; resided Paris, twenty years. To USA 1941. **Taught:** New School for Social Research. **Member:** Federation of Modern Painters and Sculptors; NAD; Salon d'Automne, Paris; Salon des Tuileries, Paris. **Commissions:** French Government, 1939 (murals); costumes and stage sets (with Louis Jouvet) for the Jean Giraudoux play *Judith.* **Awards:** Chevalier of the Order of Arts and Letters (France); Paris World's Fair, 1937, Gold Medal; William Palmer Memorial Prize; PAFA, Walter Lippincott Prize; Eastern States exhibit, Springfield, Mass., 1966; NAD, Saltus Gold Medal for Merit, 1967. **Address:** 61 West 74 Street, NYC 10023. **Dealer:** The Forum Gallery. **One-man Exhibitions:** (first) a gallery in Vienna, 1917; Galerie Berthe Weill, Paris; A.A.A. Gallery, NYC; Toledo/MA; de Young; Syracuse U., 1965; The Forum Gallery (three-man), 1975. **Retrospective:** Belvedere, 1972. **Group:** MMA; WMAA; New York World's Fair, 1939; Paris World's Fair, 1937. **Collections:** Belvedere; Bezalel Museum; de Young; Graphische Sammlung Albertina; Grenoble; Kansas City/Nelson; Lille; MMA; MOMA; Montclair/AM; Musee du Jeu de Paume; Paris/Moderne; Smithsonian; Southampton/Parrish; Springfield, Mass./MFA; Tel Aviv;

Toledo/MA; Vienna/Stadt; WMAA. **Bibliography: Held;** Huyghe; Pagano; Soyer, R. 1. Archives.

FOLLETT, JEAN F. b. June 5, 1917, St. Paul, Minn. **Studied:** U. of Minnesota; St. Paul School of Art, with Cameron Booth; Hofmann School; Atelier Fernand Leger, Paris. US Army, 1943-46. **Taught:** St. Paul School of Art, 1942-43. **Awards:** Longview Foundation Grant, 1961; Marie Hofmann Grant, 1963; National Council on the Arts, $5000, 1967. **Address:** 1510 English Street, St. Paul, Minn. 55106. **One-man Exhibitions:** (first) Hansa Gallery, NYC, 1952, also 1953, 56, 57; Leo Castelli Inc., NYC, 1960. **Group:** The Stable Gallery Annual, NYC, 1957; Houston/MFA, 1957; Cornell U., 1958; Carnegie, 1958; MOMA, Recent Sculpture USA, 1959; Claude Bernard, Paris, 1960; Martha Jackson Gallery, New Media—New Forms, I, 1960; WMAA Annual, 1961. **Collections:** Houston/MFA; MIT; MOMA; WMAA. **Bibliography:** Kaprow; Rose, B. 1; Seitz 3.

FORAKIS, PETER. b. October 2, 1927, Hanna, Wyo. **Studied:** San Francisco Art Institute, with Bud Dixon, Thomas Hardy, Nathan Oliveira, 1954-57, BA. **Taught:** San Francisco Art Institute, 1958; Brooklyn Museum School, 1961-63; The Pennsylvania State U., 1965; Carnegie, 1965; U. of Rhode Island, 1966; Windham College, 1968- . **Commissions:** Mural for a motion picture theater, San Francisco, 1956; North Jersey Culture Council, Paramus; Great Southwest Industrial Park. **Awards:** National Endowment for the Arts, 1972. Editor, publisher, *Grope* Magazine, 1964, 66. **Address:** Putney, Vt. 05346. **Dealer:** Paula Cooper Gallery. **One-man Exhibitions:** (first) Gallery Six, San Francisco, 1955, also 1956, 58; Spasta Gallery, San Francisco, 1959; David Anderson Gallery, NYC, 1961 (two-man); Tibor de Nagy Gallery, 1962, 64; Park Place Gallery, NYC, 1966; Windham College, 1967; Paula Cooper Gal-

lery, 1968, 70. **Group:** Uiano Museum, Tokyo, 1952, 53; SFMA, 1955-58; Oakland/AM, 1957; Martha Jackson Gallery, New Media—New Forms, I, 1960; SRGM, Drawings and Prints, 1964; Jewish Museum, Primary Structure Sculptures, 1966; Los Angeles/County MA, American Sculpture of the Sixties, circ., 1967; Milwaukee, Directions I: Options, circ., 1968; Indianapolis, 1970; Storm King Art Center, Sculpture 1973, 1973; U. of Vermont, Vermont '73, 1973; Hirshhorn, Inaugural Exhibition, 1974. **Collections:** Bergen Community College; Buffalo/SUNY; Hirshhorn; U. of Houston; Northwood Institute; Ridgefield/Aldrich.

FORST, MILES. b. August 18, 1923, Brooklyn, N.Y. **Studied:** New School for Social Research; Veterans Art Center, MOMA, with Mervin Jules; ASL, with Morris Kantor; Hofmann School, NYC. Traveled Europe, Mexico, Nova Scotia. **Taught:** Assistant to Hans Hofmann at his school, 1952-53; Great Neck (N.Y.) Adult Education Program, 1958-60; School of Visual Arts, NYC, 1964-71; U. of California, Davis, 1965-66; Brooklyn Museum School, 1966-69; U. of California, San Francisco, 1971-72; Otis Art Institute, 1971-75. **Awards:** Laurian Fund Award, 1954; Walter K. Gutman Foundation Grant, 1960, 62, 65; Longview Foundation Grant, 1961, 62; Ford Foundation Fellowship, 1965; MacDowell Colony Fellowship, 1965, 67. **Address:** 1318 Pacific Avenue, Venice, Calif. 90291. **Dealer:** Richard Bellamy. **One-Man Exhibitions:** (first) Hansa Gallery, NYC, 1953, also 1954, 55, 58; Wittenborn Gallery, NYC, 1955; The Drawing Shop, NYC, 1964; Goldowsky Gallery, 1964. **Group:** Chicago/AI, 1953; SRGM, 1954; A.F.A., Collage in America, circ., 1957-58; Cornell U., 1958; Carnegie, 1959; A.F.A., The Figure, circ., 1960; Green Gallery, NYC, 1961, 62; MOMA, Hans Hofmann and His Students, circ., 1963-64; Hartford/Wadsworth, 1964; U. of Illinois; Gal-

lery of Modern Art, NYC, 1965; 112 Greene Street, NYC, 1974; Otis Art Institute, 1975. **Collections:** Allentown/AM; Bowdoin College; Charlotte/Mint; Dillard U.; Hartford/Wadsworth; MIT; Newark Museum; Newport/Chrysler; Tulane U.

FORTESS, KARL E. b. October 13, 1907, Antwerp, Belgium. **Studied:** Chicago Art Institute School; ASL; Woodstock School of Painting, with Yasuo Kuniyoshi. US citizen 1923. **Taught:** ASL; Brooklyn Museum School; Louisiana State U.; American Art School, NYC; Boston U. Federal A.P.: Painter. **Member:** Artists Equity; SAGA. **Awards:** Woodstock Artists Association, E. Keith Memorial Award, 1935; Carnegie, First Hon. Men., 1941; Guggenheim Foundation Fellowship, 1946; AAAL, Childe Hassam Award, 1952; NAD, Salmagundi Club Prize, 1973. **Address:** 311 Plochmann Lane, Woodstock, N.Y. 12498. **Dealer:** A.A.A. Gallery, NYC. **One-man Exhibitions:** Boris Mirski Gallery, Boston; A.A.A. Gallery, NYC, 1948, 51; Ganso Gallery, NYC; Vose Gallery, Boston; Sawkill Gallery, Woodstock, N.Y.; Bucknell U.; Louisiana State U.; U. of Georgia; The Krasner Gallery. **Retrospective:** A.A.A. Gallery, NYC, 1973. **Group:** NIAL; Chicago/AI; Carnegie; U. of Illinois; Boston Arts Festival; Corcoran; MOMA; NAD; PAFA; WMAA. **Collections:** U. of Arizona; Brandeis U.; Brooklyn Museum; Colby College; Cornell U.; Lincoln, Mass./De Cordova; MOMA; U. of Massachusetts; U. of Miami; Montpelier/Wood; New Britain/American; Newark Museum; U. of North Carolina; The Ohio State U.; Roanoke; U. of Rochester; St. Joseph/Albrecht; Smith College; Syracuse U.; Utica; U. of Washington; Youngstown/Butler. **Bibliography:** Cheney; Pearson 2; Zaidenberg, ed.

FOULKES, LLYN. b. November 17, 1934, Yakima, Wash. **Studied:** Central Washington College, 1953; U. of Wash-

ington, 1952-54; Chouinard Art Institute, 1957-59, with Richards Ruben, Emerson Woelffer, Don Graham. US Army, Germany, 1955-56. Traveled Europe, North Africa, USA. **Taught:** UCLA, 1965-71; Art Center School, Los Angeles, 1971-74. **Awards:** Chouinard Art Institute, First Prize, 1959; SFMA, First Prize, 1963; V Paris Biennial, First Prize, 1967. **Address:** 6010 Eucalyptus Lane, Los Angeles, Calif. 90042. **Dealers:** David Stuart Gallery, The Willard Gallery; Darthea Speyer Gallery. **One-man Exhibitions:** (first) Ferus Gallery, Los Angeles, 1961; Pasadena/AM, 1962, 67 (four-man); Rolf Nelson Gallery, Los Angeles, 1963-65; Oakland/AM, 1964; Robert Fraser Gallery, 1966 (four-man); David Stuart Gallery, 1969, 74; Darthea Speyer Gallery, 1970, 75; The Willard Gallery, 1975. **Retrospective:** Newport Harbor, 1974. **Group:** Los Angeles/County MA Annuals, 1960, 61, 63; Pomona College, Object Makers, 1961; SFMA, West Coast Artists, circ., 1961; SFMA, Directions—Painting U.S.A., 1963; Pasadena/AM, Directors Choice, 1964; Sao Paulo, 1964; New York World's Fair, 1964-65; SRGM, 1966; V Paris Biennial, 1967; WMAA Annuals, 1967, 69, 71, 74; IX Sao Paulo Biennial, 1967; Brandeis U., 1968; Foundation Maeght, 1968; Los Angeles/County MA, 5 Los Angeles Artists, 1968; VMFA, American Painting, 1970; ICA, U. of Pennsylvania, The Topography of Nature: The Microcosm and Macrocosm, 1972; Los Angeles Municipal Art Gallery, Separate Realities, 1973; Chicago/AI, 71st American Exhibition, 1974; Corcoran Biennial, 1975. **Collections:** Chicago/AI; La Jolla; Los Angeles/County MA; MOMA; Museum des 20 Jahrhunderts; Oakland/AM; Pasadena/MA; Rotterdam; Stanford U.; UCLA; WMAA. **Bibliography:** Weller.

FRANCIS, SAM. b. June 25, 1923, San Mateo, Calif. **Studied:** U. of California, Berkeley, 1941-43; 1949, BA; 1950, MA; Atelier Fernand Leger, Paris. US Air Force, 1943-45. Began painting under

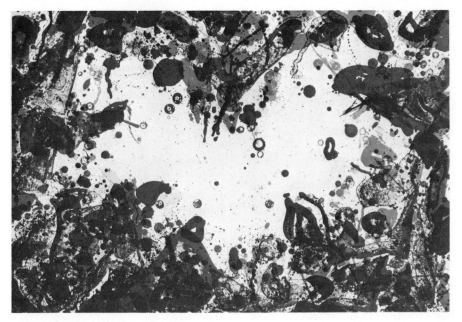

Sam Francis *Untitled* 1971

the encouragement of David Park while hospitalized in 1945. Traveled Europe, Japan, USA; resided and worked in Paris, 1950-57. **Commissions** (murals): Kunsthalle Berne, 1957; Sofu School of Flower Arrangement, Tokyo, 1957; Chase Manhattan Bank, NYC, 1959. **Awards:** III International Biennial Exhibition of Prints, Tokyo, First Prize, 1962; Tate, $5,000 Dunn International Prize, 1963; U. of California, Hon. DFA, 1969. **Address:** 345 West Channel Road, Santa Monica, Calif. **Dealers:** Pierre Matisse Gallery; Minami Gallery; Andre Emmerich Gallery, NYC. **One-man Exhibitions:** (first) Galerie Nina Dausset, Paris, 1952; Galerie du Dragon, 1952; Galerie Rive Droite, Paris, 1955, 56; Martha Jackson Gallery, 1956, 58, 63, 64, 68, 70; Gimpel Fils Ltd., 1957; Klipstein & Kornfeld, Berne, 1957, 61, 66, 68; Zoe Dusanne Gallery, Seattle, 1957; Tokyo Department Store Gallery, 1957; Kintetsu Department Store Gallery, Osaka, 1957; Phillips, 1958; Seattle/AM, 1959; SFMA, 1959, 67; Esther

Baer Gallery, 1962, 63; Galerie Engelberts, Geneva, 1962; Galerie Pauli, Lausanne, 1962; A. Tooth & Sons, London, 1965; Pierre Matisse Gallery, 1967; Houston/MFA, 1967; U. of California, 1967; Kunstverein, Basel, 1968; Galerie Gunther Franke, Munich, 1968; CNAC, 1968; Shasta College, 1969; Minami Gallery, 1969, 74; Andre Emmerich Gallery, 1969, 70, 71, 72, 73, 74; Felix Landau Gallery, 1970; Los Angeles/County MA, 1970; Nicholas Wilder Gallery, 1971; Pace Editions, NYC, 1973; Galerie Fournier, Paris, 1973; Margo Leavin Gallery, 1974; Jack Glenn Gallery, San Diego, 1975. **Retrospectives:** Berne, 1960; Hannover/K-G., 1963; Amsterdam/Stedelijk, 1968; CNAC, 1969; Buffalo/Albright, circ., 1972. **Group:** Salon du Mai, Paris, 1950; Studio Paul Facchetti, Signifiants de l'Informal, 1952; Studio Paul Facchetti, Un Art Autre, 1953; ICA, London, Opposing Forces, 1953; Berne, Tendences Actuelles, 1955; Carnegie, 1955; MOMA, Twelve Americans, circ., 1956;

International Biennial Exhibition of Paintings, Tokyo; Arts Council Gallery, London, New Trends in Painting, 1957; Brussels World's Fair, 1958; MOMA, The New American Painting, circ. Europe, 1958-59; American Cultural Center, Paris, 3 Americans, 1958; Brooklyn Museum, 1959; Sao Paulo, 1959; III International Biennial Exhibition of Prints, Tokyo, 1962; Chicago/AI, 1962; Musee Cantonal des Beaux-Arts, Lausanne, I Salon International de Galeries Pilotes, 1963; Tate, Dunn International, 1964, Gulbenkian International, 1964; Flint/Institute, The Coming of Color, 1964; WMAA Annual, 1964, 65; Toronto, 1964; SRGM, American Drawings, 1964; Los Angeles/County MA, Post Painterly Abstraction, 1964; U. of Arkansas, 1965; Dayton/AI, 1966; Tokyo/Modern, 1966; II Internationale der Zeichnung, Darmstadt, 1967; Kunsthalle, Cologne, 1968; Carnegie, 1970; Buffalo/Albright, Color and Field: 1890-1970, 1970; Foundation Maeght, L'Art Vivant, 1970; VMFA, American Painting, 1970; Indianapolis, 1970; Chicago/AI Annual, 1970; Wilmington, 1970; Corcoran Biennial, 1971; Chicago/Contemporary, White on White, 1971-72; Toledo/MA, The Fresh Air School, 1973. **Collections:** Amsterdam/Stedelijk; Berne; Buffalo/Albright; U. of California; Dayton/AI; Dusseldorf/KN-W; Hamburg; Hannover/K-G; Idemitsu Museum; MOMA; National Gallery; National Museum of Western Art, Tokyo; OBD/Basel; Ohara Art Museum; Paris/Moderne; Pasadena/AM; SRGM; Seattle/AM; Sofu School of Flower Arrangement; Stockholm/National; Stuttgart; Tate; Toronto; WMAA; Washington U.; Zurich. **Bibliography:** Blesh 1; Haftman; Hunter 1; Hunter, ed.; Langui; Lippard 5; Lynton; McCurdy, ed; *Metro*; Nordness, ed.; Ponente; Read 2; *Report*; Restany 2; Rickey; Rose, B. 1; **Sam Francis**; Schneider; Seuphor 1; *The State of California Painting*; **Sweeney 3**; Tapie 1; Weller. Archives.

FRANK, MARY. b. February 4, 1933, London, England. **Studied:** NYC, with Max Beckmann, 1950; Hans Hofmann, 1951. Traveled Spain, France, England. **Taught:** New School for Social Research, 1970-75; Queens College, 1970- . **Awards:** Ingram Merrill Foundation Grant, 1962; Longview Foundation Grant, 1964-66; National Council on the Arts, 1969; Guggenheim Foundation Fellowship, 1973; CAPS, 1973. **Address:** 463 West Street, NYC 10014. **Dealers:** The Zabriskie Gallery; Donald Morris Gallery; Richard Gray Gallery. **One-man Exhibitions:** (first) Stephen Radich Gallery, 1961, also 1963, 66; Boris Mirski Gallery, Boston, 1964, 66; The Drawing Shop, NYC; Bennett College, 1966; The Zabriskie Gallery, 1968, 70, 71, 73, 75; Donald Morris Gallery, 1968; Richard Gray Gallery, 1969; U. of Connecticut, 1975. **Group:** MIT; Yale U.; Brandeis U.; MOMA, Hans Hofmann and His Students, circ., 1963-64; SRGM, 10 Independents, 1972; GEDOK, Hamburg, American Woman Artist Show, 1972; WMAA Annuals, 1972, 73; PMA/Museum of the Philadelphia Civic Center, Focus, 1974. **Collections:** Akron/AI; Brandeis U.; Brown U.; Chicago/AI; Bank of Chicago; Hirshorn; Kalamazoo/Institute; MOMA; U. of Massachusetts; U. of New Mexico; U. of North Carolina; Southern Illinois U.; WMAA; Wichita/AM; Worcester/AM; Yale U.

FRANKENTHALER, HELEN. b. December 12, 1928, NYC. **Studied:** Dalton School, NYC, with Rufino Tamayo; Bennington College, with Paul Feeley, 1945-49, BA; ASL, with Vaclav Vytlacil, 1946; with Wallace Harrison, NYC, 1948; with Hans Hofmann, 1950. Traveled Europe extensively. **Taught:** NYU, 1958; U. of Pennsylvania, 1958; Yale U., 1967, 70; School of Visual Arts, NYC, 1967; Hunter College, 1970; U. of Rochester, 1971; Bennington College, 1972; Brooklyn Museum School, 1973; Swarthmore College, 1974; Drew U., 1975. **Member:** NIAL, 1974. Trustee,

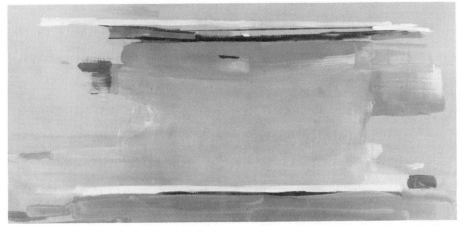

Helen Frankenthaler *Inplace* 1975

Bennington College, 1967- ; Fellow, Calhoun College, Yale U., 1968. Member of the Corporation of Yaddo, 1974. Designed and executed set for *Of Love* for Erick Hawkins Dance Company, 1971. **Commissions:** Temple of Aaron, St. Paul (ark curtain tapestry); First Wisconsin National Bank, Milwaukee, 1973; North Central Bronx Hospital (mural), 1973-74; The Fourth National Bank, Wichita (tapestry), 1974. **Awards:** I Paris Biennial, First Prize, 1959; PAFA, Joseph E. Temple Gold Medal, 1968; Honorary Doctor of Humane Letters, Skidmore College, 1969; Albert Einstein College, Spirit of Achievement Award, 1970; Chicago/AI, Ada S. Garrett Prize, 1972; III Biennale della Grafica d'Arte, Florence, Italy, Gold Medal, 1972; Hon. DFA, Smith College, 1973; Hon. DFA, Moore College of Art, Philadelphia, 1974; Creative Arts Award, American Jewish Congress, National Women's Division, 1974. **Address:** 173 East 94 Street, NYC 10028. **Dealer:** Andre Emmerich Gallery, NYC. **One-man Exhibitions:** (first) Tibor de Nagy Gallery, 1951, also 1952-58; Andre Emmerich Gallery, NYC, 1959-63, 1965, 66, 68, 69, 71, 72, 73; Jewish Museum, 1960; Everett Ellin Gallery, Los Angeles, 1961; Bennington College, 1962; Galerie Lawrence, Paris, 1961, 63;

Galleria dell'Ariete, 1962; Kasmin Ltd., 1964; David Mirvish Gallery, 1965, 71, 73, 75; St. John, N.B., 1966 (three-man, with Kenneth Noland, Jules Olitski); Gertrude Kasle Gallery, 1967; Nicholas Wilder Gallery, 1967; Heath Gallery, Atlanta, 1971; Fendrick Gallery, 1972, 74; Portland, Ore./AM, 1972; Waddington Galleries, London, 1973, 74; Janie C. Lee Gallery, Dallas, 1973; MMA, 1973; Swarthmore College, 1974; Corcoran, 1975; SRGM, 1975. **Retrospectives:** WMAA, 1969; John Berggruen Gallery (prints) 1972. **Group:** The Kootz Gallery, NYC, New Talent, 1951; Ninth Street Exhibition, NYC, 1951; WMAA Annuals, 1955, 58, 61, 63, 67, 69, 70, 71, 72, 73, Young America, 1957, Nature in Abstraction, 1958, The Structure of Color, 1971; Carnegie, 1955, 58, 61; Sao Paulo, 1958; International Beinnial Exhibition of Paintings, Tokyo; Documenta II, Kassel, 1959; U. of Illinois, 1959, 63, 65, 67; SRGM, Abstract Expressionists and Imagists, 1961; Chicago/AI, 1961, 63; Seattle World's Fair, 1962; PAFA Annuals, 1963, 66, 68; Los Angeles/County MA, Post Painterly Abstraction, 1964; New York World's Fair, 1964-65; U. of Michigan, 1965; Detroit/Institute, 1965, Color, Image and Form, 1967; ICA, Boston, Painting without a Brush, 1965; XXXIII Venice

Biennial, 1966; Public Education, Association, NYC, 1966; Expo '67, Montreal, 1967; Corcoran Biennial, 1967; MOMA, Two Decades of American Painting, circ. Japan, India, Australia, 1967; U. of Oklahoma, East Coast—West Coast Paintings, 1968; SFMA, Untitled 1968, 1968; Washington U., The Development of Modernist Painting, 1969; MMA, New York Painting and Sculpture: 1940-1970, 1969-70, Prints by Four New York Painters, 1969; Baltimore/MA, Washington Art: 1950-1970, 1970; Boston U., American Artists of the Nineteen Sixties, 1970; Foundation Maeght, L'Art Vivant, 1970; Buffalo/Albright, Color and Field: 1890-1970, 1970; ICA, U. of Pennsylvania, Two Generations of Color Painting, 1970; Boston/MFA, Abstract Painting in the '70s, 1972; Lakeview Center, American Women: 20th Century, 1972; Museum of Fine Arts, St. Petersburg, Flowing Form, 1973; Houston/MFA, The Great Decade of American Abstraction: Modernist Art 1960-1970, 1974; A.A.A. Gallery, One Hundred Prints, 1975. **Collections:** Baltimore/MA; Bennington College; Brooklyn Museum; Buffalo/Albright; U. of California, Carnegie; Chicago/AI; Cincinnati/AM; Cleveland/MA; Cologne; Columbia U.; Detroit/Institute; Hartford/Wadsworth; Honolulu Academy; Houston/Contemporary; Houston/MFA; Louisville/Speed; MMA; MOMA; Melbourne/National; Milwaukee; NCFA; NYU; U. of Nebraska; Newark Museum; Pasadena/AM; RISD; SFMA; St. Louis/City; Smithsonian; U. of Sydney; Syracuse/Everson; Ulster Museum; Victoria and Albert Museum; WGMA; WMAA; Walker; U. of Wisconsin; Yale U. **Bibliography:** Battcock, ed.; Baur 5; Friedman, ed.; Goodrich and Baur 1; Goossen 3; *The Great Decade;* Hunter, 1, 6; Hunter, ed.; Janis and Blesh 1; Kozloff 3; *Metro;* O'Hara 1; **Rose, B.** 1, 3. Archives.

FRASCONI, ANTONIO. b. April 28, 1919, Montevideo, Uruguay. **Studied:** Circulo de Bellas Artes, Montevideo;

ASL, 1946, with Yasuo Kuniyoshi; New School for Social Research, 1947, with Camilio Egas. To USA 1945. **Taught:** New School for Social Research, 1951-52; Brooklyn Museum School; Pratt Institute; Vassar College; Atlanta Art Institute; Purchase/SUNY. **Member:** SAGA. **Awards:** Guggenheim Foundation Fellowship, 1952; NIAL Grant, 1954; Venice International Film Festival, 1960, Grand Prix for "The Neighboring Shore" (15 min., more than 300 woodcuts); US Post Office Department, Design Competition, 1963; Connecticut State Commission on the Arts, 1974; IX International Biennial Exhibition of Prints, Tokyo. **Address:** 26 Dock Road, South Norwalk, Conn. 06854. **Dealers:** Terry Dintenfass, Inc.; Weyhe Gallery. **One-man Exhibitions:** Ateneo Gallery, Montevideo, 1939; Montevideo YMCA, 1940; Agrupacion Intelectual, Montevideo, 1944; Brooklyn Museum, 1946; San Jose State College, 1946; Pasadena/AM, 1946; Santa Barbara/MA, 1946, 50, 51, 55; New School for Social Research, 1947; Philadelphia Art Alliance, 1948; Weyhe Gallery, 1948-54, 1956, 60; Pan-American Union, Washington, D.C., 1949; Utica, 1949; San Diego, 1950; SFMA, 1950; Honolulu Academy, 1950; Princeton Print Club, 1950, 52; Art Association, Madison, Wisc., 1951; Prang Institute, NYC, 1951; U. of Delaware, 1951; Bennington College, 1952; Louisville/Speed, 1953; Detroit/Institute, 1953; Los Angeles/County MA, 1953; Currier, 1955; Chattanooga/AA, 1955; Fort Worth, 1955; Wesleyan U., 1956; U. of Maine, 1956; Scripps College, 1958; Berea College, 1958; Collectors Art Center, Tallahassee, 1958; Atlanta/AA, 1959; Carnegie, 1959; San Antonio/McNay, 1959; Terry Dintenfass, Inc., 1962, 63, 64, 66, 69, 71; The Print Club, Philadelphia, 1963; The Pennsylvania State U., 1963; Ankrum Gallery, 1963; Esther Baer Gallery, 1967; Bridgeport, 1967; Lincoln, Mass./De Cordova, 1967. **Retrospective:** Cleveland/MA, 1952; Smithsonian, circ., 1953-55; Monte-

video/Municipal, 1961; Baltimore/MA, 1963; Brooklyn Museum, 1964. **Group:** Brooklyn Museum; Corcoran; Boston/MFA; Detroit/Institute; Hartford/Wadsworth; PAFA; Newark Museum; MOMA; Carnegie; St. Louis/City; San Diego; Baltimore/MA; New School for Social Research, Protest and Hope, 1967; XXXIV Venice Biennial, 1968. **Collections:** Akron/AI; Albion College; Allegheny College; Alverthorpe Gallery; U. of Arizona; Arts Council of Great Britain; Atlanta/AA; Baltimore/MA; Boston/MFA; Boston Public Library; Brandeis U.; Brooklyn Museum; U. of California, Berkeley; Carnegie; La Casa del Libro; Chicago/AI; Cincinnati/AM; Cleveland/MA; Dartmouth College; U. of Delaware; Des Moines; Detroit/Institute; Fort Worth; Geneseo/SUNY; Georgia State U.; Grand Rapids; Hamilton College; Hartford/Wadsworth; Harvard U.; Honolulu Academy; Hunter College; State College of Iowa; Kalamazoo/Institute; U. of Kentucky; Lawrence College; Library of Congress; Louisville/Speed; MMA; MOMA; U. of Maine; Memphis/Brooks; U. of Michigan; U. of Minnesota; Minnesota/MA; Montclair/AM; Montevideo/Municipal; NYPL; Newark Museum; New Britain; New Paltz/SUNY; U. of Notre Dame; Omaha/Joslyn; PAFA; PMA; The Pennsylvania State U.; Princeton U.; RISD; U. of Rochester; Rutgers U.; St. Louis/City; San Diego; Santa Barbara/MA; Seattle/AM; Smith College; Smithsonian; Springfield, Mo./AM; Uruguay/Nacional; Utica; Wake Forest U.; Washington U.; Wesleyan U.; College of William and Mary; Williams College; U. of Wisconsin. **Bibliography:** Frasconi; Sachs. Archives.

FREILICHER, JANE. b. November 19, 1924, NYC. **Studied:** Brooklyn College, BA; Columbia U., MA; Hofmann School. Traveled Europe, Morocco. **Taught:** Great Neck (N.Y.) Adult Education Program; New Jersey public schools; U. of Pennsylvania, 1968; Skowhegan School, 1968; Boston U., 1968; Swarthmore College, 1969; Carnegie-Mellon Institute, 1971; Cooper Union, 1972; Louisiana State U., 1973; Galveston Arts Center, 1973; Maryland Institute, 1973. **Awards:** Hallmark International Competition, 1960; *Art News* Magazine, 10 Best Shows of 1962. **Address:** 51 Fifth Avenue, NYC 10003. **Dealer:** Fischbach Gallery. **One-man Exhibitions:** (first) Tibor de Nagy Gallery, 1952, also 1953-64, 70; John Bernard Myers Gallery, NYC, 1971; Benson Gallery, 1972, 74; Fischbach Gallery, 1975. **Group:** RISD, Four Young Americans, 1955; MOMA, Recent Drawings USA, 1956; WMAA Annual, 1958; PAFA, 1961; U. of Nebraska, 1963; MOMA, Hans Hofmann and His Students, circ., 1963-64; Chicago/AI; Brooklyn Museum; Yale U.; Corcoran; A.F.A., 1965; MOMA, 1966; A.F.A., Painterly Realism, 1970; Omaha/Joslyn, A Sense of Place, 1973; PMA/Museum of the Philadelphia Civic Center, Focus, 1974; AAAL, 1975. **Collections:** Brandeis U.; Brooklyn Museum; Chase Manhattan Bank; Greenville; Hampton Institute; MOMA; NYU; U. of North Carolina; RISD; Southampton/Parrish; Stratford College; Union Carbide Corp.; U. of Utah. WMAA. **Bibliography:** *Art: A Woman's Sensibility.*

FRENCH, JARED. b. February 4, 1905, Ossining, N.Y. **Studied:** ASL, with Thomas Hart Benton, Boardman Robinson, Kimon Nicolaides; Amherst College, BA. Traveled Europe, northeastern USA. Federal A.P.: US Post Offices, Richmond, VA., and Plymouth, Pa., 1935-39 (murals). Designed costumes and sets for the ballet, *Billy the Kid.* **Awards:** NIAL Grant, 1967. **Address:** Hartland, VT. 05048. **One-man Exhibitions:** (first) Julien Levy Galleries, NYC, 1939; Hewitt Gallery, NYC, 1950; Robert Isaacson Gallery, NYC; The Banfer Gallery, 1967. **Retrospective:** The Banfer Gallery, 1969. **Group:** Arts Club of Chicago; PAFA; WMAA; Chi-

cago/AI; Carnegie; NAD; Walker; U. of Rochester, 1964-65; Youngstown/Butler, 1967. **Collections:** Baltimore/MA; Baseball Museum; Dartmouth College; WMAA. **Bibliography:** Baur 7; Goodrich and Baur 1.

FRIEDENSOHN, ELIAS. b. December 12, 1924, NYC. **Studied:** Stella Elkins Tyler School of Fine Arts, Temple U., 1942-43, with Rafael Sabatini; Queens College, with Cameron Booth, 1946-48, AB; NYU, Institute of Fine Arts, 1949-50; privately with Gabriel Zendel in Paris. Traveled Europe. **Taught:** Queens College, 1959- ; Kirkland College, 1970-71. **Member:** College Art Association. **Awards:** Joe and Emily Lowe Foundation Award, 1951; Fulbright Fellowship (Italy), 1957; U. of Illinois, **P.P.**, 1957; National Arts Club Annual, NYC, Stephens Award, 1958; Guggenheim Foundation Fellowship, 1960; MacDowell Colony Fellowship, 1969, 70; AAAL, **P.P.**, 1972. **Address:** 209 Hillcrest Avenue, Leonia, N.J. 07605. **Dealer:** Terry Dintenfass, Inc. **One-man Exhibitions:** (first) Roko Gallery, NYC, 1951; Hewitt Gallery, NYC, 1955, 57, 59; Vassar College, 1958; Robert Isaacson Gallery, NYC, 1960; Feingarten Gallery, NYC, San Francisco, Los Angeles and Chicago, 1961, 62; Feingarten Gallery, Los Angeles, 1964; The Contemporaries, NYC, 1964; Terry Dintenfass, Inc., 1967, 70, 74. **Group:** Audubon Artists Annual, 1957; WMAA, Young America, 1957; Fulbright Artists, 1958, Annuals, 1958, 59, 60, 62; Chicago/AI Annuals, 1957, 59; U. of Illinois, 1957, 59, 61, 63; National Arts Club Annual, NYC, 1958; Galleria Schneider, Rome, Fulbright Artists, 1958; Festival of Two Worlds, Spoleto, 1958; Corcoran Annuals, 1960, 62; Denver/AM, 1962; Smithsonian; Buffalo/Albright; Philadelphia Art Alliance; Syracuse U.; U. of Wisconsin; PAFA Annual, 1967; New School for Social Research, 1969; Minnesota/MA, Drawings USA, 1971, 73; NAD, 1971; VMFA, Works on Paper, 1974. **Collec-**

tions: Chicago/AI; Hampton Institute; U. of Illinois; Kalamazoo/Institute; Kirkland College; Little Rock/MFA; The Joe And Emily Lowe Foundation; U. of Massachusetts; U. of Okahoma; Queens College; Sara Roby Foundation; WMAA; Walker. **Bibliography:** Weller.

FULLER, SUE. b. August 11, 1914, Pittsburgh, Pa. **Studied** with Hans Hofmann, 1934; with S. W. Hayter, 1943-44; privately with Josef Albers, T. Tokuno; Carnegie Institute of Technology, 1936, BA; Teachers College, Columbia U., 1939, MA. Traveled Europe, Africa, Japan. **Taught:** U. of Minnesota, 1950; Stourbridge (England) School of Arts and Crafts, 1951; U. of Georgia, 1951, 52; Teachers College, Columbia U., 1958; Pratt Institute, 1964-65. **Awards:** Charles M. Rosenbloom Prize, 1942; The Print Club, Philadelphia, 1944, 45, Charles.M. Lea Prize, 1949; Northwest Printmakers Annual, **P.P.**, 1945; Society of American Etchers and Engravers, NYC, 1947; L. C. Tiffany Grant, 1948; Guggenheim Foundation Fellowship, 1949; NIAL Grant, 1950; Eliot D. Pratt Foundation Fellowship, 1966, 67, 68; Carnegie-Mellon U., Alumni Merit Award, 1974. **Address:** 44 East 63 Street, NYC 10021. **Dealer:** Galerie Chalette. **One-man Exhibitions:** Village Art Center, NYC, 1947; Corcoran, 1951; U. of Georgia, 1951; The Bertha Schaefer Gallery, 1952, 55, 56, 61, 65, 67; 69; Nishi Machi School, Tokyo, 1954; Fort Worth, 1956; Currier, 1956; San Antonio/McNay, 1956, 66; Grand Rapids, 1957; Charlott/Mint, 1957; Grinnell College, 1960; Chatham College, 1960; Eleanor Rigelhaupt Gallery, Boston, 1965; Storm King Art Center, 1966; Norfolk, 1967; McNay Art Institute, 1967; Southern Vermont Art Center, 1968; Chattanooga/AA, 1969. **Group:** MOMA, Master Prints from the Museum Collection, 1949, Abstract Painting and Sculpture in America, 1951, The Responsive Eye, 1965; SAGA, 1951; I Sao Paulo Biennial, 1951; WMAA Annuals, 1951, 53, 54, 56,

The New Decade, 1954-55, Geometric Abstraction in America, circ., 1962; Salon du Mai, Paris, 1952; PMA, A Decade of American Print Making, 1952, also 1964; III Biennial of Spanish-American Art, Barcelona, 1955; Brooklyn Museum, 14 Painter Printmakers, 1955; Chicago/AI Annual, 1957; A.F.A., 14 Painter-Printmakers, circ., 1957, Collage in America, circ., 1957-58, The New Landscape in Art and Science, circ., 1958-59, Explorers of Space, circ., 1961-62, Hayter and Atelier 17, circ., 1961-62; USIA, American Prints, circ. Middle East, 1957-59, Plastics—USA, circ. USSR, 1961; Corcoran Biennials, 1963, 65; Buffalo/Albright, Box Show, 1966; Cornell U., Small Sculpture, 1967; Flint/Institute, Made of Plastic, 1968; Denver/AM, Report on the Sixties, 1969; Colgate U., Viewpoints 3, 1969; Skidmore College, Contemporary Women Artists, 1970; U. of Nebraska, American Sculpture, 1970; Finch College, NYC, Projected Art, 1971; Potsdam/SUNY, Women in Art, 1971; PMA/Museum of the Philadelphia Civic Center, Focus, 1974. **Collections:** Albion College; American Republic Insurance Co.; Amherst College; Andover/Phillips; Baltimore/MA; Boston/MFA; Brooklyn Museum; CIT Corporation; Carnegie; Chase Manhattan Bank; Chicago/AI; Des Moines; Ford Foundation; Hartford/Wadsworth; Harvard U.; Honolulu Academy; NYPL; National Gallery; Norfolk; PMA; Peabody Institute; Ridgefield/Aldrich; St. Louis/City; San Antonio/McNay; Seaton Hall Inc.; Storm King Art Center; Tate; Union Carbide Corp.; WMAA. **Bibliography:** Hayter 2; Janis and Blesh 1; Newmeyer; Reese; Ritchie 1. Archives.

GABO, NAUM NEEMIA PEVSNER. b.
August 5, 1890, Briansk, Russia. **Studied:** U. of Munich, medical faculty, 1910, natural science, 1911; Polytechnic Engineering School, Munich, 1912. Traveled.Italy, Scandinavia, Great Britain, USA, Russia. To USA 1946; citizen 1952. **Taught:** Harvard U., 1953-54. Designed set for "La Chatte" (Ballet Russe, 1926). Edited *Circle* (with Leslie Martin and Ben Nicholson), 1937. **Member:** AAAL, 1965. **Commissions:** Bijenkorf Building, Rotterdam, 1955; U.S. Rubber Co. Building, NYC, 1956. **Awards:** ICA, London/Tate, International Unknown Political Prisoner Competition, Second Prize, 1953; Guggenheim Foundation Fellowship, 1954; Chicago/AI, The Mr. & Mrs. Frank G. Logan Medal, 1954; Royal College of Art, London, Hon. DFA, 1967; NIAL. **Address:** Breakneck Hill, Middlebury, Conn. 06762. **One-man Exhibitions:** Gallery Percier, Paris, 1924; Little Review Gallery, NYC, 1926; Hannover/K-G., 1930; Arts Club of Chicago, 1934, 1952 (two-man); Lefevre Gallery, London, 1936; Musee du Jeu de Paume, 1937; The London Gallery, London, 1937; Julien Levy Galleries, NYC, 1938; Hartford/Wadsworth. 1938, 53; Museum of the City of London, 1942; MOMA, 1948; Baltimore/MA, 1950; MIT, 1952; Pierre Matisse Gallery, 1953; France/National, Paris, 1971; Berlin/National, 1971. **Retrospectives:** Amsterdam/Stedelijk, circ., 1965-66; Buffalo/Albright, 1968. **Group:** Golden Gate International Exposition, San Francisco, 1939; MOMA; WMAA; Chicago/AI; Paris/Moderne. **Collections:** Buffalo/Albright; Hartford/Wadsworth; MOMA; Princeton U.; Tate; U.S. Rubber Co.; WMAA; Yale U. **Bibliography:** Baldinger; Barr 1; Battcock, ed.; Baur 7; Biederman 1; Bihalji-Merin; Blanchard; Blesh 1; Calas, N. and E.; Canaday; Cassou; Chipp; Craven, W.; Davis, D.; Flanagan; **Gabo;** Gaunt; Gertz; Giedion-Welcker 1, 2; Goodrich and Baur 1; Guggenheim, ed.; Henning; Hess, T. B. 1; Hulten; Hunter, ed.; Janis and Blesh 1; Janis, S.; Kepes 2; Kepes, ed.; Kuh 1, 2, 3; Langui; Licht, F; Lowry; Lynton; Mac-Agy 2; McCurdy, ed.; **Martin, Nicholson and Gabo, eds.;** Mendelowitz; *Metro*; Myers 2; Neumeyer; Newmeyer; Newton 2; **Olson and Chanin;** Ramsden 1, 2; Read 1, 3, 6; **Read and Martin;** Rickey; Ritchie 3; Rose, B. 1; Selz, J.; Pelz, P. 3; Seuphor 3; Seymour; Trier 1, 2; Valentine 2; Zervos. Archives.

GALLATIN, ALBERT E. b. 1882, Villanova, Pa.; **d.** June 17, 1952. **Studied:** Cutler School, Vermont; New York Law School. Traveled Europe, USA. Founder of Museum of Living Art, now housed at The Philadelphia Museum of Art. **One-man Exhibitions:** (first) Galerie Pierre, Paris, 1938; Passedoit Gallery, NYC, 1938, 42; Pittsfield/Berkshire, 1939; J. Seligmann and Co., 1939 (three-man); The Willard Gallery, 1941; Mortimer Brandt, NYC, 1945; Durand-Ruel Gallery, NYC, 1947, 48; The Pinacotheca, NYC, 1950; The Zabriskie Gallery, 1972. **Retrospective:** Rose Fried Gallery. **Group:** Salon des Surindependants, Paris, 1938; American Abstract Artists Annuals, 1938-48; New York World's Fair, 1939; Arts Club of Chicago, 1940; SFMA, 1940; MOMA, 1942; Federation of Modern Painters and Sculptors, 1943; PMA, 1945; Corcoran, 1947. **Collections:** Black Mountain College; MMA;

MOMA; PMA; Phillips; Pittsfield/Berkshire; SFMA; SRGM. **Bibliography:** American Abstract Artists, ed.; Baur 7; Bazin; Blesh 1; Frost; **Gallatin 1, 2, 3, 4, 5, 6, 7, 8;** McCurdy, Ed.; Morris; Ritchie 1; Rose, B. 1. Archives.

GALLO, FRANK. b. 1933, Toledo, Ohio. **Studied:** Toledo/MA, 1954, BFA; Cranbrook, 1955; U. of Iowa, 1959, MFA. **Taught:** U. of Illinois, 1960- . **Awards:** Des Moines, First Prize, 1958, 59; Guggenheim Foundation Fellowship, 1966. **Address:** c/o Art Department, U. of Illinois, Urbana, Ill. 61801. **One-man Exhibitions:** Toledo/MA, 1955; Gilman Galleries, Chicago, 1963-66; Sherry-Netherland Hotel, NYC, 1964; The Graham Gallery, 1965, 67; Felix Landau Gallery, 1966; Time, Inc., 1969; Danenberg Gallery, 1972; Puck Gallery, NYC, 1974. **Group:** Des Moines, 1958, 59; U. of Illinois, 1963-65; Chicago/AI, 1964; WMAA Annual, 1964-67; Youngstown/Butler, 1965; WMAA, Young America, 1965; Toronto International Sculpture Symposium, 1967; XXXIV Venice Biennial, 1968; Owens-Corning Fiberglas Corp., Corning, N.Y., 1970. **Collections:** Baltimore/MA; Caracas; Chicago/AI; Cleveland/MA; Colorado State U.; U. of Illinois; Los Angeles/County MA; MOMA; Melbourne/National; U. of Nebraska; Princeton U.; WMAA; U. of Wisconsin. **Bibliography:** *Recent Figure Sculpture.*

GANSO, EMIL. b. April 14, 1895, Halberstadt, Germany; **d.** April 18, 1941, Iowa City, Iowa. To USA 1912. **Studied:** NAD. **Taught:** Lawrence College, 1940; State U. of Iowa, 1941. **Awards:** Guggenheim Foundation Fellowship, 1933. **One-man Exhibitions:** Weyhe Gallery, 1926-28, 1930-36, 1944, 46; Washington Irving Gallery, NYC, 1960; Kenan Center, Lockport, N.Y., 1969. **Retrospectives:** WMAA, 1941; Brooklyn Museum, 1944. **Group:** WMAA; Salons of America, NYC; Brooklyn Museum; Chicago/AI; Cleveland/MA; PAFA; Corcoran; NAD. **Collections:** Boston/MFA; Dartmouth College; Denver/AM; MMA; U. of Rochester; WMAA. **Bibliography:** American Artists Group Inc. 1, 3; Cahill and Barr, eds.; Cheney; Hall; *Index of 20th Century Artists;* Jewell 3; Mellquist; Pearson 1; Reese; Ringel, ed.; Zigrosser 1. Archives.

GATCH, LEE. b. September 10, 1902, Baltimore, Md.; **d.** November 10, 1968, Trenton, N.J. **Studied:** Maryland Institute, 1924; Academie Moderne, Paris, 1924, with Andre Lhote, Moise Kisling. Traveled France, Italy. **Member:** NIAL, 1966. **Commissions** (murals): US Post Offices, Mullins, S.C., and Elizabethtown, Pa. **Awards:** Chicago/AI, Watson F. Blair Prize, 1957; Corcoran, 1960. **One-man Exhibitions:** (first) J. B. Neumann's New Art Circle, NYC, 1927, also 1932, 37, 46, 49; The Willard Gallery, 1943; Grace Borgenicht Gallery Inc., 1954; Phillips, 1954, 56, 60; World House Galleries, NYC, 1958; Staempfli Gallery, 1963, 67, 72, 74; NCFA, 1971. **Retrospective:** WMAA, 1960. **Group:** XXV & XXVIII Venice Biennials, 1950, 56; Santa Barbara/MA, 1952; Detroit/Institute, 1959; U. of Illinois, 1961. **Collections:** Andover/Phillips; Atlanta U.; Baltimore/MA; Boston/MFA; Detroit/Institute; Hartford/Wadsworth; U. of Illinois; Los Angeles/County MA; MMA; MOMA; U. of Nebraska; PAFA; PMA; Phillips; St. Louis/City; Utica; WMAA; Washington U. **Bibliography:** Baur 5; Blesh 1; Eliot; Frost; Gerdts; Goodrich and Baur 1; Hess, T. B. 1; Janis and Blesh 1; Janis, S.; McCurdy, ed.; Nordness, ed.; Pousette-Dart, ed.; Richardson, E. P. Archives.

GECHTOFF, SONIA. b. September 25, 1926, Philadelphia, Pa. **Studied:** Philadelphia Museum School, BFA. Traveled Europe. **Taught:** California School of Fine Arts, 1957-58; NYU, 1961-70; Queens College, 1970-74; U. of New Mexico, 1974- . **Member:** National Advisory Board, Tamarind Institute. **Awards:** SFMA, P.P., Santa Barbara/MA, P.P.; Tamarind Fellowship, 1963. m. James Kelly. **Address:** 463 West

Street, NYC 10014. **One-man Exhibitions:** (first) Dubin Gallery, Philadelphia, 1949; Lucien Labaudt Gallery, San Francisco, 1952, 53; Gallery Six, San Francisco, 1955; de Young, 1957; Ferus Gallery, San Francisco, 1957, 59; Poindexter Gallery, 1959, 60; East Hampton Gallery, 1963, 67, 68; Montclair State College, 1974. **Group:** SFMA Annuals, 1952-58; SRGM, Younger American Painters, 1954; Brussels World's Fair, 1958; Carnegie, 1958; I Paris Biennial, 1959; WMAA Annual, 1959; WMAA, Young America, 1960; Walker, 60 American Painters, 1960; VI Sao Paulo Biennial, 1961; MOMA, Abstract American Drawings and Watercolors, circ. Latin America, 1961-63; U. of Texas, 1966; Florida State U., 1967; Los Angeles/County MA, 1968; New York Cultural Center, Women Choose Women, 1973. **Collections:** AT&T; U. of California; Amon Carter Museum; La Jolla; Los Angeles/County MA; MOMA; U. of Massachusetts; Oakland/AM; Pasadena/AM; SFAI; SFMA; The Singer Company Inc.; Woodward Foundation. **Bibliography:** *Art: A Woman's Sensibility.*

GELB, JAN. b. July 18, 1906, NYC. **Studied:** Yale U., 1928; Atelier Sigrid Skou, NYC and Brittany, 1928-29; ASL occasionally, 1930-34; NAD, 1924-27, 1928. Traveled Europe, Near East, Japan. **Taught:** Elementary Schools, 1928-early 1960s; Truro (Mass.) Center for the Fine Arts, 1973-75. **Member:** SAGA (vice-president); MacDowell Colony; Artists Equity. **Awards:** The Print Club, Philadelphia, **P.P.**, 1958; Boston Arts Festival, Second Prize; Potsdam/SUNY, **P.P.**, 1966, 67; Dulin Gallery, Knoxville, Tenn., **P.P.**, 1968; Vera List **P.P.**, 1968; SAGA, 1968. m. Boris Margo. **Address:** 749 West End Avenue, NYC 10025. **Dealer:** A.A.A. Gallery. **One-man Exhibitions:** (first) West Haven (Conn.) Public Library, 1929 or 1930; Delphic Studios, NYC, 1940; Weyhe Gallery, 1948, 50; Research Studio, Maitland, Fla., 1948, 50; Ganso Gallery, NYC, 1954; Artists' Gallery, Provincetown, 1955, 56; New

Brunswick (N.J.) Art Center, 1957; Ruth White Gallery, 1957, 59, 61, 62, 64; Esther Robles Gallery, 1958; Galerie A. G., Paris, 1960; Piccadilly Gallery, London, 1960; Shore Galleries, Provincetown, 1961; Marberg Inc., El Paso, 1965; Wichita State U., 1971; U. of Louisville, 1971; Charles W. Bowers Memorial Museum, Santa Ana, 1971; Michigan State U., 1972; The Ohio State U., 1972. **Retrospective:** Smithsonian, 1963. **Group:** WMAA Annuals; PAFA; Brooklyn Museum, Print Biennials; MMA, American Watercolors, Drawings and Prints, 1952; Boston Arts Festival; NAD; Oakland/AM; SAGA; Brooklyn Museum, 14 Painter Printmakers, 1955; A.F.A. and USIA circ. exhibitions; WMAA, Nature in Abstraction, 1958. **Collections:** Abbot Academy; Baltimore/MA; Brooklyn Museum; U. of Connecticut; U. of Delaware; Howard U.; Library of Congress; Los Angeles/County MA; MMA; MOMA; U. of Minnesota; NYPL; National Gallery; Norfolk; PMA; Phoenix; Potsdam/SUNY; St. Lawrence U.; Syracuse/Everson; Syracuse U.; WMAA. **Bibliography:** Baur 5. Archives.

GEORGE, THOMAS. b. July 1, 1918, NYC. **Studied:** Dartmouth College, 1940, BA; ASL; Academie de la Grande Chaumiere; Academy of Fine Arts, Florence, Italy. US Navy, 1942-46. Traveled Europe, Far East, North Africa, China. **Member:** MacDowell Colony. **Awards:** Brooklyn Museum, **P.P.**, 1955; Rockefeller Foundation Grant, 1957; Ford Foundation, **P.P.**, 1962, 63. **Address:** 20 Greenhouse Drive, Princeton, N.J. 08540. **Dealer:** Betty Parsons Gallery. **One-man Exhibitions:** Ferargil Galleries, NYC, 1951, 53; Korman Gallery, NYC, 1954; Dartmouth College, 1956; The Contemporaries, NYC, 1956; Bridgestone Museum, 1957; Diamaru, Osaka, 1957; Betty Parsons Section Eleven (Gallery), NYC, 1959, 70, 72, 74; The Reid Gallery, London; Bennington College, 1967; U. of California, Santa Cruz, 1967; Axiom Gallery, London, 1968; Esther Baer Gallery,

1969; Delaware Art Museum, 1971; Henies-Onstadts Stiftelser, 1971; Tranegarden Gallery, Hellerup, Copenhagen, 1971; Princeton Gallery of Fine Art, 1972, 74; Oslo Kunstforening, 1973; Jefferson Place Gallery, Washington, D.C., 1974. **Retrospective:** Dartmouth College, 1965. **Group:** MOMA, Recent Drawings USA, 1956; Carnegie, 1958, 61; WMAA Annuals, 1960-62, 1965; PAFA, 1962; Corcoran, 1963; International Biennial Exhibition of Paintings, Tokyo; Lincoln, Mass./De Cordova, 1963; San Antonio/McNay, 1964; SFMA, 1965; Musee Cantonal des Beaux-Arts, Lausanne, II Salon International de Galeries Pilotes, 1966; NCFA, 1968; US Mission to the United Nations. **Collections:** Brandeis U.; Bridgestone Museum; Brooklyn Museum; Buffalo/Albright; U. of California, Santa Cruz; Chase Manhattan Bank; Colby College; Dartmouth College; Delaware Art Museum; Flint/Institute; Ford Motor Company; Henies-Onstadts Stiftelser; Library of Congress; MOMA; Musee Cantonal des Beaux-Arts; NCFA; Oklahoma; U. of Rochester; SFMA; SRGM; Tate; Trenton/State; WGMA; WMAA; Yale U.

GEORGES, PAUL. b. 1923, Portland, Ore. **Studied:** U. of Oregon; Hofmann School; Atelier Fernand Leger In Paris, 1949-52. Traveled France, USA. **Taught:** U. of Colorado, 1960; Dartmouth College, 1961; Yale U. **Awards:** Longview Foundation Grant; Hallmark International Competition, P.P., 1961; PAFA, Carol H. Beck Gold Medal, 1964. **Address:** 85 Walker Street, NYC 10013. **Dealers:** Fischbach Gallery; Green Mountain Gallery. **One-man Exhibitions:** Reed College, 1948, 56, 61; Tibor de Nagy Gallery, 1955, 57; The Zabriskie Gallery, 1959; Great Jones Gallery, NYC, 1960, 61; Allan Frumkin Gallery, NYC and Chicago, 1962, 64, 66, 67, 68; Dorsky Gallery, 1968; Fischbach Gallery, 1974; Green Mountain Gallery, 1975. **Group:** Salon du Mai, Paris, 1949; The Kootz Gallery, NYC, New Talent, 1952; PAFA, 1952, 64; Corcoran, 1962;

Chicago/AI, 1962; WMAA, 1962, 63; MOMA; U. of Colorado; U. of Kentucky, Drawings, 1963; MOMA, Hans Hofmann and His Students, circ., 1963-64; Boston U., 1964; Silvermine Guild, 1964; Youngstown/Butler, 1964. **Collections:** 57th Madison Corp.; Hallmark Collection; Hirshhorn; MIT; MOMA; U. of Massachusetts; NYU; Newark Museum; U. of North Carolina; Reed College; WMAA.

GIAMBRUNI, TIO. b. August 30, 1925, San Francisco, Calif.; **d.** May 17, 1971, Davis, Calif. **Studied:** U. of California, Berkeley, with Glenn Wessels, John Haley, Jacques Schnier, Richard O'Hanlon, BA, MA. US Army. **Taught:** Modesto (Calif.) High School, 1951-52; Liberty High School, 1953-56; Miramonte (Calif.) High School, 1956-59; California College of Arts and Crafts, 1959-60; U. of California, 1960-71. **Commissions:** Golden Gateway Redevelopment Project, San Francisco. **Awards:** SFMA, Patrons of Music and Art Award, 1959. **One-man Exhibitions:** (first) Nevada Art Gallery, Reno, 1958; RAC, 1960; Barrios Art Gallery, Sacramento, 1963; Mills College, 1963; Berkeley Gallery, 1963, 64, 66; **Group:** SFMA Annuals, 1951-70; Santa Barbara/MA, 1959; SFMA, Tradition and Invention, 1962; SFMA, Molten Image—Seven Sculptors, 1962; Stanford U., Some Points of View for '62, 1962; Museum of Contemporary Crafts, Creative Casting, 1963; New Orleans/Delgado, Bay Area Artists, 1963; New School for Social Research, The Artist's Reality, 1964.

GIBRAN, KAHLIL. b. November 29, 1922, Boston, Mass. **Studied:** Boston Museum School, 1940-43, with Karl Zerbe. Changed from painting to sculpture, 1953-54. **Taught:** Wellesley College, 1958; Boston U. **Member:** National Sculpture Society; New England Sculptors Association. **Awards:** PAFA, George D. Widener Memorial Gold Medal, 1958; Guggenheim Foundation Fellowship, 1959, 60; NIAL Award, 1961; Boston Arts Festival, Grand Prize,

1964. **Address:** 160 West Canton Street, Boston, Mass. 02118. **One-man Exhibitions:** (first) Stuart Gallery, Boston, 1944; Mortimer Levitt Gallery, NYC; Margaret Brown Gallery, Boston; U. of Kansas; Lee Nordness Gallery, NYC, 1962 (sculpture); Cambridge (Mass.) Art Association, 1969. **Group:** WMAA Annual, 1960; Boston Arts Festival; Carnegie; Dallas/MFA; NAD; Chicago/AI; ICA, Boston. **Collections:** Brockton/Fuller; Kansas City/Nelson; Nashville; Norfolk; Norfolk/Chrysler; PAFA; Terre Haute/Swope. **Bibliography:** Pousette-Dart, ed.

GIKOW, RUTH. b. January 6, 1915, Russia. **Studied:** Cooper Union, 1932-35, with John Steuart Curry, Austin Purvis; American Art School, NYC, with Raphael Soyer. Traveled Europe, Mexico, Asia, USSR. **Taught:** New School for Social Research, *ca.* 1961-71. Illustrated: *Crime and Punishment* (World Publishing Co.) and *History of the Jews in America* (Jewish Theological Seminary). Subject of a film demonstrating the cutting and printing of linoleum blocks, produced by Walter O. Gutjohn, 1943. **Member:** Artists Equity. Federal A.P.: Mural painter and graphic artist; mural for Bronx County Hospital, 1940. **Commissions** (murals): New York World's Fair, 1939; Rockefeller Center, NYC, 1943. **Awards:** NIAL Grant, 1961. **m.** Jack Levine. **Address:** 68 Morton Street, NYC 10014. **Dealer:** Kennedy Gallery. **One-man Exhibitions:** (first) National Serigraph Society, 1943, also 1947; Weyhe Gallery, 1946; Grand Central Moderns, NYC, 1948, 50; Philadelphia Art Alliance, 1949; Ganso Gallery, NYC, 1952, 53, 54; Rehn Galleries, 1956, 57, 59; Lee Nordness Gallery, NYC, 1961, 63; The Forum Gallery, 1970; Kennedy Gallery, 1972; The Margo Feiden Galleries, NYC, 1974. **Group:** Carnegie; Corcoran; Utica; Youngstown/Butler; MMA; MOMA; U. of Nebraska; PAFA; Springfield, Mass./MFA; WMAA; State U. of Iowa; SFMA; Toledo/MA; San Diego. **Collections:** Brandeis U.; Colby College; MMA; MOMA; NCFA; NIAL; NYU; PMA; Portland, Me./MA; Smithsonian; Springfield, Mass./MFA; Syracuse/Everson; Terre Haute/Swope; WMAA. **Bibliography:** Bethers; Nordness, ed. Archives.

GILL, JAMES b. December 10, 1934, Tahoka, Tex. **Studied:** U. of Texas. Traveled USA, Mexico, Europe. **Taught:** U. of Idaho, 1968. **Awards:** U. of Texas, painting fellowship, 1960; Chicago/AI, **P.P.**, 1964. **Address:** Whale Gulch, Whitethorn, Calif. 95489. **Dealer:** Mitzi Landau Gallery. **One-man Exhibitions:** (first) The Alan Gallery, NYC 1962, also 1964; Felix Landau Gallery, 1963, 65, 68; Galleria George Lester, Rome, 1964; Sacramento/Crocker, 1966; The Landau-Alan Gallery, NYC, 1966, 69. **Group:** Chicago/AI Annual, 1964; Brandeis U., circ., 1964-65; San Francisco Art Institute Annual, 1965; WMAA Annual, 1966-68; IX Sao Paulo Biennial, 1967; NCFA, circ., 1968-69. **Collections:** U. of California; Chicago/AI; Container Corp. of America; MOMA; Mead Corporation; Time Inc.; WMAA.

GINNEVER, CHARLES. b. August 28, 1931, San Mateo, Calif. **Studied** with Ossip Zadkine, William Stanley Hayter, Paris, 1953-55; SFAI, 1955-57, BFA; Cornell U., 1957-59, MFA. Traveled Europe, USA. **Awards:** Vermont State Council on the Arts, 1972; Guggenheim Foundation Fellowship, 1974; National Endowment for the Arts, 1975. **Address:** P. O. Box 411, Putney, Vt. 05346. **Dealer:** Max Hutchinson Gallery. **One-man Exhibitions:** (first) Allan Stone Gallery, 1961; Bennington College, 1965; Washington Shuare Park, 1968; Battery Park, NYC, 1969-74; Paula Cooper Gllery, 1970-72; Dag Hammarskjold Plaza, NYC, 1973. **Collections:** Hartford/Wadsworth; Norfolk/Chrysler; Storm King Art Center.

GIOBBI, EDWARD. b. July 18, 1926, Waterbury, Conn. US Army, 1944-46. **Studied:** Whitney School of Art, 1946, 47; Vesper George School of Art, 1947-

50; ASL, 1950-51; Academy of Fine Arts, Florence, Italy, 1951-54, 1955-56. Traveled Europe. **Taught:** Memphis Academy of Arts, 1960, 61 (Artist-in-Residence). **Awards:** Joe and Emily Lowe Foundation Award, 1951, and Special Grant, 1952; Yaddo Fellowship, 1957; Ford Foundation, 1966; Guggenheim Foundation Fellowship, 1971. **Address:** 161 Croton Lake Road, Katonah, N.Y. 10536. **Dealers:** Galleria d'Arte l'Obelisco; Crane Kalman Gallery. **One-man Exhibitions:** (first) Ward Eggleston Gallery, NYC, 1950, also 1952; Galerie An Der Reuss, Lucerne, 1953 (two-man); Nexus Gallery, Boston, 1956 (two-man); Artists' Gallery, NYC, 1956; John Heller Gallery, NYC, 1957, 58; The Contemporaries, NYC, 1960, 61, 63; Memphis/Brooks, 1961; Memphis Academy, 1962; Katonah (N.Y.) Art Gallery, 1963; The New Art Centre, 1964, 67; The Bear Lane Gallery, Oxford, 1964; The Queen Square Gallery, Leeds, 1964; Tirca Karlis Gallery, 1964-66; Mickelson's Gallery, Washington, D.C., 1966; The Alan Gallery, NYC, 1966; Waddell Gallery, 1967; Obelisk Gallery, 1968; Gertrude Kasle Gallery, 1968. **Group:** WMAA Annuals, 1957, 61, 66, Young America, 1961, Forty Artists Under Forty, circ., 1962; MOMA, Recent Drawings USA, 1956, Recent Painting USA: The Figure, circ., 1962-63; PAFA, 1961; U. of Arkansas, 1966; Finch College, 1967. **Collections:** Allentown/AM; Baltimore/MA; Boston/MFA; Brandeis U.; Brooklyn Museum; Cambridge; Chicago/AI; Detroit/Institute; Florence, Italy; Memphis/Brooks; U. of Michigan; Oxford; Poole Technical College; San Antonio/McNay; Spelman College; Syracuse U.; Tate; WMAA; Wesleyan College; U. of Wisconsin.

GIRONA, JULIO. b. December 29, 1914, Manzanillo, Cuba. **Studied:** Escuela San Alejandro, Havana, 1930-34; Academie Ranson, Paris, 1935-36; ASL, 1950-56, with Morris Kantor. Traveled Europe extensively, Mexico, Cuba. To USA 1941. **Taught:** Werkkunstschule, Krefeld, Germany, 1963-64. **Commissions:** Colegio Medicos, Havana (5 murals). **Awards:** Newark Museum, First Prize; Havana/Nacional. **Address:** 53 Genesee Avenue, Teaneck, N.J. 07666. **Dealer:** The New Bertha Schaefer Gallery. **One-man Exhibitions:** (first) Colegio de Arquitectos, Havana, 1934; Havana/Nacional, 1947, 54; Artists' Gallery, NYC, 1953; The Bertha Schaefer Gallery, 1956, 59, 61, 63; Galerie Gunar, Dusseldorf, 1958; Recklinghausen, 1959; Galerie Seide, Hannover, 1960; Werkkunstschule, Krefeld, Germany, 1963. **Retrospective:** Galeria de la Habana, 1975. **Group:** Venice Biennial; Baltimore/MA, 1956, 59, 60; Chicago/AI, 1957; Minneapolis/Institute, American Painting, 1945-57, 1957; Ball State Teachers College, 1958, 60; MOMA, 1958, 60; Brooklyn Museum, 1959; U. of Nebraska, 1958, 59; Buffalo/Albright, 1959, 60; Argentina/Nacional; MMA; Houston/MFA; SFMA; Newark Museum; Denver/AM. **Collections:** Argentina/Nacional; Havana/Nacional; Newark Museum; Recklinghausen; Trenton/State; Union Carbide Corp. **Bibliography:** Janis and Blesh 1.

GLACKENS, WILLIAM. b. March 13, 1870, Philadelphia, Pa.; **d.** May 22, 1938, Westport, Conn. **Studied:** Central High School, Philadelphia, BA; PAFA. Traveled France, Spain, Canada. Newspaper illustrator for many years. **Member:** Society of Independent Artists, NYC (First President, 1916-17); The Eight; NAD, 1937 (Associate, 1896); NIAL. **Awards:** Buffalo/Albright, Gold Medal, 1901; St. Louis Exposition, 1904, Silver and Bronze Medals; Carnegie, Hon. Men., 1905; Panama-Pacific Exposition, San Francisco, 1915, Bronze Medal; PAFA, Joseph E. Temple Gold Medal, 1924; Carnegie, Second Prize, 1929; PAFA, Carol H. Beck Gold Medal, 1933; PAFA, Jennie Sesnan Gold Medal, 1936; Paris World's Fair, 1937, Grand Prix; PAFA, J. Henry Schiedt Memorial Prize, 1938. **One-man Exhibitions:** (first) New Arts Club, NYC; Academy of Fine Arts, Berlin, 1910; Kraushaar Galleries, 1925,

28, 35, 42, 57; Andover/Phillips, 1936; Louisville/Speed, 1939; 10 West Ninth Street, NYC, Memorial Exhibition, annually, 1939-49; NCFA, 1972. **Retrospective:** WMAA, 1938, 67; Carnegie, 1939; Kraushaar Galleries, 1949; Dartmouth College, 1960; St. Louis/City, 1966; NCFA, 1967. **Group:** Paris Salon, 1895, 1900; Macbeth Gallery, NYC, The Eight, 1908; Independents, NYC, 1910; The Armory Show, 1913; WMAA, New York Realists, 1937; Brooklyn Museum, The Eight, 1943; PMA, Artists of the Philadelphia Press, 1945; Renaissance Society, Chicago, 1955; Syracuse/Everson, The Eight, 1958. **Collections:** Andover/Phillips; Barnes Foundation; Boston/MFA; Buffalo/Albright; Chicago/AI; Columbus; Detroit/Institute; MMA; U. of Nebraska; Newark Museum; PMA; Sweet Briar College; WMAA. **Bibliography:** Barnes; Bazin; Biddle 4; Born; Bulliet 1; Canaday; Cheney; **Du Bois 5, 6;** Gallatin 2; **Glackens;** Hall; Hartmann; Huyghe; *Index of 20th Century Artists;* Jackman; **Katz;** Kent, N.; McCoubrey 1; McCurdy, ed.; Neuhaus; Pach 1; Perlman; Phillips 2; Poore; Ringel, ed.; Rose, B. 1, 4; Sachs; **Watson, F.** Archives.

GLARNER, FRITZ. b. July 20, 1899, Zurich, Switzerland; **d.** September 18, 1972, Locarno, Switzerland. **Studied:** Academy of Fine Arts, Naples. To USA 1936. **Commissions:** Time & Life Building, lobby, NYC, 1960 (mural); Dag Hammarskjold Library, United Nations, NYC. **Awards:** Corcoran, 1957. **One-man Exhibitions:** Galerie Povolotzki, Paris, 1930; Civic Club, NYC, 1931; The Kootz Gallery, NYC, 1945; Rose Fried Gallery, 1949, 51; Galerie Louis Carre, Paris, 1952, 55; ICA, U. of Pennsylvania, 1971; SFMA, 1971; Gimpel & Hanover Gallery, 1972; Gimpel Fils, 1972. **Retrospective:** Berne, 1972. **Group:** Buffalo/Albright, 1931; American Abstract Artists, 1938-44; Chicago/AI, 1947, 58, 64; Toronto, 1949; California Palace, 1950; WMAA, 1950, 51, 53, 54, 55; VMFA, 1950, 58; Sao Paulo, 1951; Brooklyn Museum,

1951; U. of Minnesota, 1951; MOMA, 1951, 52, 54, 55; U. of Illinois, 1952, 65; Carnegie, 1952, 58, 61; Tokyo/Modern, 1953; SRGM, 1954; U. of Nebraska, 1955; Documenta I, Kassel, 1955; Corcoran, 1955, 57, 60; Zurich, 1956; Musee Neuchatel, 1957; Kunstverein, Winterthur, 1958; Congresshalle, Berlin, 1958; XXIX & XXXII Venice Biennials, 1958, 64; Heimethuus, Zurich, 1960; Seattle World's Fair, 1962; WMAA, Geometric Abstraction in America, circ., 1962; WGMA, The Formalists, 1963; St. Paul Gallery, Drawing USA, 1963; Tate, Dunn International, 1964; Musee Cantonal des Beaux-Arts, Lausanne, 1964; MOMA, Contemporary Painters and Sculptors as Printmakers, 1964; Indiana U., 1965; PAFA, 1965. **Collections:** Baltimore/MA; Boston/MFA; Brandeis U.; Brooklyn Museum; Buffalo/Albright; Chase Manhattan Bank; Florida State U.; Karachi; MOMA; Minnesota/MA; NYU; National Gallery; U. of Nebraska; PMA; Phillips; Rockefeller Institute; Smithsonian; WMAA; Walker; Yale U.; Zurich. **Bibliography:** Baur 7; Biddle 4; Blesh 1; **Fritz Glarner;** Haftman; Hess, T. B. 1; Janis, S; MacAgy 2; McCurdy, ed.; Neumeyer; Pousette-Dart, ed.; Read 2; Rickey; Ritchie 1; Rose, B. 1; Seuphor 1; "What Abstract Art Means to Me."

GLASCO, JOSEPH. b. January 19, 1925, Paul's Valley, Okla. **Studied:** U. of Texas, 1941-43; Jepson Art Institute, Los Angeles; Art Center School, Los Angeles, 1946-48; privately with Rico Lebrun, 1946-48; Escuela de Bellas Artes, San Miguel de Allende, Mexico, 1948; ASL, 1949. US Army Air Force, 1943-45, Infantry, 1945-46. Traveled Mexico, Europe, Africa. **Commissions:** Amarillo (Tex.) Air Field (mural). **Address:** 1005 Camino San Acacio, Santa Fe, N.M. **Dealer:** Catherine Viviano Gallery. **One-man Exhibitions:** (first) Perls Galleries, 1950; Caterine Viviano Gallery, 1951, 52, 53, 54, 56, 58, 61, 63, 70; Arts Club of Chicago, 1954, 57; U. of Oklahoma, 1965 (three-man); Rizzoli

Gallery, NYC, 1967; Kiko Gallery, Houston, 1968, 69. **Group:** MOMA, New Talent; MMA; WMAA; Corcoran; SRGM; Brooklyn Museum; Chicago/AI; Dallas/MFA; Detroit/Institute; Los Angeles/County MA; U. of Illinois; U. of Nebraska; Carnegie, 1958; PAFA. **Collections:** Brooklyn Museum; Buffalo/Albright; Corcoran; High Museum; MMA; MOMA; Newark Museum; Princeton U.; WMAA; Yale U. **Bibliography:** Goodrich and Baur 1; Mendelowitz; Rodman 1; Tapie 1.

GOINGS, RALPH. b. May 9, 1928, Corning, Calif. **Studied:** California College of Arts and Crafts, 1953, BFA; Sacramento State U., 1966, MA. US Army, 1946-48. Traveled England, Europe. **Taught:** La Sierra High School, 1969; U. of California, Davis, 1971. **Address:** Charlotteville, N.Y. 12036. **Dealer:** OK Harris Works of Art. **One-man Exhibitions:** Artists Cooperative Gallery, Sacramento, 1960, 62, 68; OK Harris Works of Art, 1970, 73. **Group:** SFMA Annual, 1961; Milwaukee, Aspects of a New Realism, 1969; Newport Harbor, Directly Seen: New Realism in California, 1970; Potsdam/ SUNY, New Realism, 1971; Hamburg/ Kunstverein, USA: West Coast, circ., 1972; Documenta V, Kassel, 1972; Stuttgart/WK, Amerikanischer Fotorealismus, circ., 1972; Cincinnati/Contemporary, Options, 73/30, 1973; Randers Kunstmuseum, Denmark, Amerikanske Realister, 1973; Tokyo Biennial, 1974; CNAC, Hyperrealistes Americains/Realistes Europeens, 1974; Akron/AI, Selections in Contemporary Realism, 1974; Hamilton College, California Climate, 1974. **Collections:** Borgon Associates; Chicago/Contemporary; Essen/NG; F.T.D. Association; Hamburg/Kunstverein; ICA, U. of Pennsylvania; U. of Miami; U. of Nebraska. **Bibliography:** *Amerikanischer Fotorealismus; Kunst um 1970;* Sager; *The State of California Painting; USA West Coast.*

GOLDBERG, MICHAEL. b. 1924, NYC. **Studied:** ASL, 1938-42, 1946, with Jose de Creeft; City College of New

Ralph Goings *Market* 1973

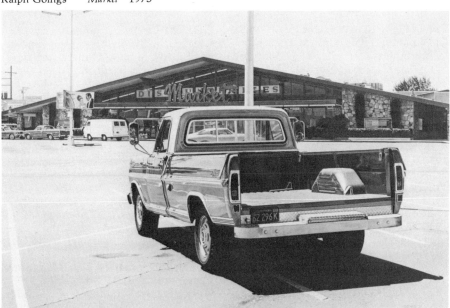

York, 1940-42, 1946-47; Hofmann School, 1941-42, 1948-50. US Army, 1942-46. **Taught:** U. of California, 1961-62. **Address:** 222 Bowery, NYC 10012. **One-man Exhibitions:** (first) Tibor de Nagy Gallery, 1953; Poindexter Gallery, 1956, 58; Martha Jackson Gallery, 1960, 64, 66; Paul Kantor Gallery, Beverly Hills, Calif., 1960; Holland-Goldowsky Gallery, Chicago, 1960 (two-man); B. C. Holland Gallery, 1961; Galerie Anderson-Mayer, Paris, 1963; Bob Keene, Southampton, N.Y., 1963; Paley & Lowe Inc., NYC, 1971 (two-man), 1972, 73; Vancouver, 1971 (two-man). **Group:** Ninth Street Exhibition, NYC, 1951; The Stable Gallery Annuals, 1952-57; Sidney Janis Gallery, Four Younger Americans, 1956; Carnegie, 1958; WMAA Annuals, 1958, 67; Gutai 9, Osaka, 1958; Turin Art Festival, 1959; V Sao Paulo Biennial, 1959; Documenta II, Kassel, 1959; Walker, 60 American Painters, 1960; Columbus, Contemporary American Painting, 1960; MOMA, Hans Hofmann and His Students, circ., 1963-64; Musee Cantonal des Beaux-Arts, Lausanne, I Salon International de Galeries Pilotes, 1963; Lehigh U., 1966; Smithsonian, 66; Star Turtle Gallery, NYC, The Tenants of Sam Wapnowitz, 1969; Corcoran, 1969. **Collections:** Baltimore/MA; Buffalo/Albright; Cornell U.; Lincoln, Mass./De Cordova; Norfolk/Chrysler; Walker. **Bibliography:** Janis and Blesh 1; O'Hara 1. Archives.

GOLDIN, LEON. b. January 16, 1923, Chicago, Ill. **Studied:** State U. of Iowa, with Mauricio Lasansky, 1948, BFA, 1950, MFA; Chicago Art Institute School, with Robert Von Neuman. Traveled Europe extensively; resided Paris, 1952-53, Rome 1955-58. **Taught:** California College of Arts and Crafts, 1950-52, 1954-55; Philadelphia Museum School, 1960-62; Queens College, 1960-62; Cooper Union, 1961-64; Columbia U., 1962- . **Awards:** L. C. Tiffany Grant, 1951; Fulbright Fellowship (France), 1952; SFMA, H. S. Crocker Co. Award, 1952; Prix de Rome, 1955, renewed 1956-57; Guggenheim Foundation Fellowship, 1959; Ford Foundation, **P.P.,** 1960; PAFA, Jennie Sesnan Gold Medal, 1965; National Endowment for the Arts Grant, 1966; NIAL Grant, 1968; and many print awards. **Address:** 438 West 116 Street, NYC 10027. **Dealer:** Kraushaar Galleries. **One-man Exhibitions:** (first) Oakland/AM, 1955; Felix Landau Gallery, 1956, 57, 59; Galleria L'Attico, Rome, 1958; Kraushaar Galleries, 1960, 64, 68, 72. **Group:** Chicago/AI Annuals, 1946, 48; SFMA Annuals, 1948, 1951-54; Los Angeles/County MA, 1949, 50; MMA, American Paintings Today, 1950; PAFA, 1951, 1960-64; MOMA, Contemporary American Painting, 1953; Santa Barbara/MA, 1955; MOMA, Recent Drawings USA, 1956; Corcoran, 1963; Carnegie, 1964. **Collections:** Andover/Phillips; Arts Council of Great Britain; Brooklyn Museum; Cincinnati/AM; Los Angeles/County MA; Morgan State College; NCFA; U. of Nebraska; Oakland/AM; PAFA; RAC; St. Louis/City; Santa Barbara/MA; U. of Southern California; Utica; Worcester/AM. **Bibliography:** Nordness, ed.

GOLUB, LEON. b. January 23, 1922, Chicago, Ill. **Studied:** The U. of Chicago, 1942, BA; Chicago Art Institute School, with Paul Wieghardt, Kathleen Blackshear, Robert Lifuendahl, 1949, BFA, 1950, MFA. US Army, 1942-46. Traveled Europe; resided Italy 1956-57, Paris 1959-64. **Taught:** Illinois Institute of Technology, 1955-56; Indiana U., 1957-59; Wright Junior College; Northwestern U.; Stella Elkins Tyler School of Fine Arts, Temple U., 1965-66; School of Visual Arts, NYC, 1966-69; Fairleigh Dickinson U., 1969; Rutgers U., 1970- **Awards:** Chicago/AI, Florsheim Memorial Prize, 1954; Ford Foundation Grant, 1960; Chicago/AI, Watson F. Blair Prize; II Inter-American Paintings and Prints Biennial, Mexico City, Hon. Men., 1960; Cassandra Foundation Grant, 1967; Guggenheim Foundation Fellowship, 1968; AAAL; NIAL, 1973. **Address:** 171

West 71 Street, NYC 10023. **Dealers:** Darthea Speyer Gallery; Walter Kelly Gallery. **One-man Exhibitions:** (first) Contemporary Gallery, Chicago, 1950; Purdue U., 1951; Wittenborn Gallery, NYC, 1952, 57; Kerrigan-Hendricks Gallery, Chicago, 1954; Artists' Gallery, NYC, 1954; Allan Frumkin Gallery, Chicago, 1955, 60, 64, NYC, 1959, 61, 63; Feigl Gallery, NYC, 1955, 56; Chicago Public Library, 1956; Pomona College, 1956; Pasadena/AM, 1956; ICA, London, 1957; Indiana U., 1958; American Cultural Center, Paris, 1960; Iris Clert Gallery, 1962; Hanover Gallery, 1962; Gallery A, Melbourne, 1963, The U. of Chicago, 1966; Pro Graphica Arte, 1968; MIT, 1970; Melbourne/National, 1970; Darthea Speyer Gallery, 1971; Herbert H. Lehman College, Bronx, N.Y., 1972; Bienville Gallery, 1972; Stony Brook/SUNY, 1975; Trenton/State, 1975. **Retrospectives:** Temple U., 1964; Chicago/Contemporary, 1974; New York Cultural Center, 1975. **Group:** Chicago/AI, Exhibition Momentum, 1948-58; SRGM, Younger American Painters, 1954; Chicago/AI, 1954, 62; Carnegie, 1955, 64, 67; Premio Marzotto; U. of Illinois, 1957, 61, 63; MOMA, New Images of Man, 1959; Documenta II & III, Kassel, 1959, 64; Sao Paulo, 1962; Corcoran, 1962; Salon des Realites Nouvelles, Paris, 1962; MOMA, Recent Painting USA: The Figure, circ., 1962-63; Art:USA:Now, circ., 1962-67; SFMA, Directions— Painting U.S.A., 1963; Smithsonian, Graphics, circ. USA, 1963; Ghent, Figuration d'Aujourd'hui, 1964; Paris/Moderne, Mythologiques Quotidiennes, 1964; PAFA Annuals, 1964, 65; New York World's Fair, 1964-65; VMFA, American Painting, 1966, 70; II Internationale der Zeichnung, Darmstadt, 1967; Paris/Moderne, Le Monde en Question, 1967; ICA, London, The Obsessive Image, 1968; Madrid/Nacional, II Biennial, 1969; Chicago/Contemporary, Chicago Imagist Art, 1972. **Collections:** Allentown/AM; Amon Carter Museum; U. of California; Chicago/AI; Grunwald Foundation;

Hampton Institute; Hirshhorn; Indiana U.; Kansas City/Nelson; Kent State U.; La Jolla; Los Angeles; MOMA; Melbourne/National; NCFA; Nashville; Nashville/State; U. of North Carolina; Pasadena/AM; Southern Illinois U.; Tel Aviv; U. of Texas. **Bibliography:** Nordness, ed.; Schulze. Archives.

GONZALEZ, XAVIER. b. February 15, 1898, Almeria, Spain. US citizen 1930. Traveled Greece, Crete, USA. **Taught:** H. Sophie Newcomb Memorial College; Brooklyn Museum School; Western Reserve U., 1953-54; Summer School of Art, Wellfleet, Mass. President, National Society of Mural Painters. **Awards:** AAAL Grant; PAFA, Dawson Memorial Medal, 1946; Guggenheim Foundation Fellowship, 1947; Audubon Artists, Gold Medal of Honor. **Address:** 222 Central Park South, NYC 10019. **Dealer:** Richard Larcada Gallery. **One-man Exhibitions:** Joseph Luyber Galleries, NYC, 1946, 47; Arts and Crafts Club, New Orleans, 1948; Philadelphia Art Alliance, 1949; Norlyst Gallery, NYC; Shore Studio, Boston; Grand Central Moderns, NYC, 1951, 52, 53; The Howard Wise Gallery, Cleveland, 1958; Widdifield Gallery, NYC, 1958; The Milch Gallery, 1960, 63; Richard Larcada Gallery, 1974. **Group:** PAFA; Corcoran; U. of Nebraska; Carnegie; Brooklyn Museum; WMAA; Indianapolis/Herron. **Collections:** Wellesley College. **Bibliography:** Biddle 4; Cheney; Pearson 2; Pousette-Dart, ed. Archives.

GOODE, JOE. b. March 23, 1937, Oklahoma City, Okla. **Studied:** Chouinard Art Institute. Traveled Mexico, England, Europe, South America, India, Iceland. **Awards:** Cassandra Foundation Grant. **Address:** 5405 Sierra Vista, Los Angeles, Calif. 90031. **Dealer:** Nicholas Wilder Gallery. **One-man Exhibitions:** Nicholas Wilder Gallery, 1966, 69, 70, 72, 74; Rowan Gallery, London, 1967; Gallery Hans R. Neuendorf, Hamburg, 1970, 72, 73, 75; Galleria Milano, Milan, 1971; La Jolla, 1971; Mueller Gallery, 1971; Felicity Samuel Gallery, London,

1972, 73; Fort Worth, 1973; Houston/ Contemporary, 1973. **Group:** WMAA Annuals 1966, 67, 69; Carnegie, 1967; Portland Ore./AM, The West Coast Now, 1968; WMAA, American Pop Art, 1974; Chicago/AI, 1974. **Collections:** Fort Worth; Los Angeles/County MA; MOMA; Oklahoma; Pasadena/AM. **Bibliography:** Alloway 1; *The State of California Painting; USA West Coast.*

GOODMAN, SIDNEY. b. January 19, 1936, Philadelphia, Pa. **Studied:** Philadelphia Museum School, 1958, with Jacob Landau, Larry Day, Morris Berd. US Army, 1958-59. Traveled Europe. **Taught:** Philadelphia College of Art. **Awards:** PAFA, First Watercolor Prize, 1961; Guggenheim Foundation Fellowship, 1963; Ford Foundation Fellowship, 1963; Ford Foundation, **P.P.,** Yale-Norfolk Summer School Fellowship; National Endowment for the Arts, 1974; PAFA, Fellowship Prize, 1974. **Address:** 323 Harrison Avenue, Elkins Park, Pa. **Dealer:** Terry Dintenfass, Inc.

One-man Exhibitions: (first) The Print Club, Philadelphia, 1958, also 1963; Terry Dintenfass, Inc., 1961, 1963-1966, 68, 75; Bard College, 1968; George Washington U., 1969; PAFA, Peale House, 1969 (two-man), 1975 (two-man); U. of Rhode Island, 1974; Moravian College, 1974. **Group:** PAFA, 1960-64, 67, 68; MOMA, 1962; NAD, 1962; WMAA, Forty Artists Under Forty, circ., 1962; MOMA, Recent Painting USA: The Figure, circ., 1962-63; WMAA Annuals, 1962-64, 1967-68; 73; Corcoran, 1963; Brooklyn Museum, 1963, 1968-69; Newark Museum, 1967; New School for Social Research, Protest and Hope, 1967; Vassar College, 1968; U. of Miami, 1968; U. of Kentucky, 1968; Indianapolis/Herron, 1969; U. of Illinois, 1969; Southern Methodist U., 1969; Tulsa/Philbrook, 1969; Iowa State U., American Drawing, 1971; Boston U., The American Landscape, 1972; Cleveland/MA, 32 Realists, 1972; Sweden/Goteburgs, Warmwind: American Realists, 1972; Omaha/Joslyn, A Sense

Sidney Goodman *Portrait of Five Figures* 1974

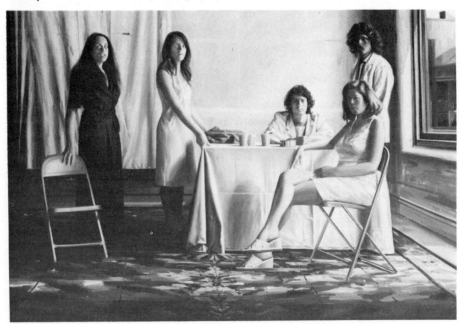

of Place, 1973; VMFA, Works on Paper, 1974; AAAL, 1974; Harrisburg/Pa. State Museum, The Figure in American Art, 1975. **Collections:** Brandeis U.; Chicago/AI; Delaware Art Museum; Kalamazoo/Institute; Library of Congress; MOMA; U. of Maine; Miami-Dade; Minnesota/MA; Moravian College; PMA; The Pennsylvania State U.; WMAA; Wake Forest U.

GOODNOUGH, ROBERT. B. October 23, 1917, Cortland, N.Y. **Studied:** Syracuse U., BFA; NYU, MA; New School for Social Research; Hofmann School; Ozenfant School of Art, NYC. **Taught:** Cornell U.; NYU; Fieldston School, NYC. Critic for *Art News* Magazine, 1950-57. Secretary, *Documents of Modern Art* (edited by Robert Motherwell), 1951. **Commissions:** Manufacturers Hanover Trust Co. **Awards:** Syracuse U., Hiram Gee Fellowship; Chicago/AI, Ada S. Garrett Prize, 1962; Ford Foundation, **P.P.**, 1962. **Address:** 15 Barrow Street, NYC 10014. **Dealer:** Andre Emmerich Gallery, NYC. **One-man Exhibitions:** (first) Tibor de Nagy Gallery, 1952, also 1953-70; RISD, 1956; Dwan Gallery, 1959-62; Jefferson Place Gallery, 1960; Ellison Gallery, Fort Worth, 1960; Nova Gallery, Boston, 1961; U. of Minnesota; U. of Notre Dame, 1964; Arts Club of Chicago, 1964; New Vision Center, London, 1964; USIS Gallery, London, 1964; Gertrude Kasle Gallery, 1966, 69, 72, 74; Reed College, 1967; Buffalo/Albright, 1969; Axiom Gallery, London, 1969; Cayuga Museum of History and Art, Auburn, N.Y., 1969; Galerie Simone Stern, New Orleans, 1969, 70; Kasmin Ltd., 1970; Harcus-Krakow Gallery, 1972; Nicholas Wilder Gallery, 1972; Syracuse U., 1972; Andre Emmerich Gallery, NYC, 1972, 73; David Mirvish Gallery, 1973, 75. **Group:** The Kootz Gallery, NYC, New Talent, 1950; Sidney Janis Gallery, Four Younger Americans, 1956; WMAA; Yale U.; Carnegie; Chicago/AI; NIAL, 1964; MOMA, The New American Painting and Sculpture, 1969; U. of Illinois, 1969;

Indianapolis, 1969; XXV Venice Biennial, 1970; AAAL, 1971. **Collections:** Baltimore/MA; Birmingham, Ala./MA; Boston/MFA; Buffalo/Albright; Chase Manhattan Bank; Chicago/AI; Hartford/Wadsworth; MMA; MOMA; Manufacturers Hanover Trust Co.; Michigan State U.; NYU; Newark Museum; U. of Notre Dame; RISD; Raleigh/NCMA; SRGM: Syracuse U.; WMAA. **Bibliography:** Baur 5; Blesh 1; **Bush and Moffett;** Friedman, ed.; Goodrich and Baur 1; Guest and Friedman; Janis and Blesh 1; Nordness, ed.; Rose, B. 1; Seitz 3.

GOODYEAR, JOHN. b. October 22, 1930, Los Angeles, Calif. **Studied:** U. of Michigan (with Richard Wilt, Chet LaMore, Gerome Kamrowski), B. Design, 1952, M.Design, 1954. Traveled Mexico, Western Europe; resided USA, Japan. **Taught:** U. of Michigan; U. of Massachusetts; Douglass College 1964- . **Awards:** Graham Foundation Fellowship, 1962, 70; Trenton/State, Gov. Hughes **P.P.**, 1967; MIT, Center For Advanced Visual Studies Grant, 1970-71. **Address:** R.D. #2, Lambertville, N.J. 08530. **One-man Exhibitions:** The Amel Gallery, NYC, 1964-66; ICA, Boston, 1971; Musee de Quebec, 1971; Electric Gallery, Toronto, 1971; Cornell U., 1972; Syracuse U., 1972; Allegheny College, 1972; Inhibodress Gallery, Sydney, 1972; New Jersey State Cultural Center, 1975. **Group:** MOMA, The Responsive Eye, 1965; Buffalo/Albright, 1965; ICA, Boston, 1965; Harvard U., 1965; WMAA, Art of the U.S. 1670-1966, 1966; Walker and Milwaukee, Light Motion Space, 1967; Buffalo/Albright, Plus by Minus, 1968; Milwaukee, Directions I: Options, circ., 1968; WMAA Sculpture Annual, 1968; Newark Museum, 1969; Jewish Museum, Software, 1970; Boston/MFA, Elements of Art, 1971; Centro de Arte y Communicacion, Buenos Aires, Arte de Sistemas, II, 1972; MIT, Interaction, 1973; New Jersey Cultural Center, Constructivist Art, 1975. **Collections:** Cornell U.; MOMA; U. of Massachu-

setts; Mills College; Milwaukee; Muske-gon/Hackley; NYU; Newark Museum; New Jersey Cultural Center; Nor-folk/Chrysler; U. of North Carolina; Purchase/SUNY; Quebec; Smith College; Spelman College; U. of Texas; Trenton/State; WMAA. **Bibliography:** Atkinson; MacAgy 2; Rickey.

GORCHOV, RON. b. April 5, 1930, Chicago, Ill. **Studied:** U. of Mississippi, 1947-48; Roosevelt College; Chicago/AI School, 1948-50; U. of Illinois, 1950-51. Traveled USA, Europe. **Taught:** Hunter College, 1962- . Designed stage sets for Theater Club of New York production of Lorca's *Shoemaker's Prodigious Wife*, 1957. **Awards:** Ingram Merrill Foundation Grant, 1959; National Arts Club Annual, NYC, Hon. Men., 1959. **Address:** 74 Grand Street, NYC 10013. **One-man Exhibitions:** Tibor de Nagy Gallery, NYC, 1960, 63, 66; Syracuse/Everson, 1972; The Texas Gallery, 1974; Fischbach Gallery, 1975; Henri 2, Washington, D.C. (two-man), 1975. **Group:** The Stable Gallery, NYC, Invitational, 1958; National Arts Club Annual, NYC, 1959; WMAA, Young America, 1960; VMFA, 1964; Syracuse/Everson, 1971. **Collections:** Glen Alden Corp.; Hartford/Wadsworth; SRGM; Syracuse/Everson; WMAA.

GORDIN, SIDNEY. b. October 24, 1918, Cheliabinsk, Russia. **Studied:** Cooper Union, 1937-41, with Morris Kantor, Carol Harrison, Leo Katz. **Taught:** Pratt Institute, 1953-58; Brooklyn College, 1955-58; New School for Social Research, 1956-58; Sarah Lawrence College, 1957-58; U. of California, Berkeley, 1958- . **Commissions** (sculpture): Temple Israel, Tulsa, Okla., 1959; Envoy Towers, 300 East 46 Street, NYC, 1960. **Address:** 903 Camilia Street, Berkeley, Calif. **One-man Exhibitions:** Bennington College, 1951; Peter Cooper Gallery, NYC, 1951; Grace Borgenicht Gallery Inc., 1953, 55, 58, 60, 61; New School for Social Research, 1957; Dilexi Gallery, San Francisco, 1959, 63, 65; de Young, 1962;

Los Angeles/County MA, 1963. **Group:** MMA, 1951; WMAA Annuals, 1952-57; MOMA; Chicago/AI; PAFA, 1954, 55; Brooklyn Museum; Newark Museum; SFMA; Oakland/AM; Tulsa/Philbrook, 1960. **Collections:** Chicago/AI; Newark Museum; Norfolk/Chrysler; Southern Illinois U.; WMAA. **Bibliography:** Goodrich and Baur 1; Mendelowitz; Seuphor 3.

GORKY, ARSHILE (Vosdanig Manoog Adoian). b. 1905, Khorkom Vari Haiyotz Dzor, Armenia; **d.** July 21, 1948, Sherman, Conn. To USA 1920. **Studied:** Polytechnic Institute, Tiflis, 1916-18; RISD; Providence (R.I.) Technical High School; New School of Design, Boston, 1923; NAD, 1925. **Taught:** New School of Design, Boston, 1924; Grand Central School, NYC, 1925-31. Federal A.P.: Newark (N.J.) Airport, 1935-38 (mural). **Commissions:** Aviation Building, New York World's Fair, 1939 (mural). Fire destroyed 27 paintings in his studio, January, 1946. **One-man Exhibitions:** (first) Guild Art Gallery, NYC, 1932, also 1935, 36; Mellon Galleries, Philadelphia, 1934; Boyer Gallery, Philadelphia, 1935; Boyer Gallery, NYC, 1938; The Kootz Gallery, NYC, 1942, 50, 51; Julien Levy Galleries, NYC, 1945, 46, 47, 1948 (two-man, with Howard Warshaw); WMAA, Memorial Exhibition, 1951; Princeton U., 1952; Paul Kantor Gallery, Beverly Hills, Calif., 1952; Sidney Price Gallery, NYC, 1952, 55, 57; U. of Maryland, 1969; M. Knoedler & Co., 1969, 70, 73, 75; Dunkelman Gallery, Toronto, 1972; Galatea Galleria d'Arte, Turin, 1972; Allan Stone Gallery, 1973; Richard Feigen Gallery, NYC, 1973. **Retrospectives:** SFMA, 1941; MOMA, 1963. **Group:** WMAA Annuals; MOMA, 46 Painters and Sculptors Under 35 Years of Age, 1930; WMAA, Abstract Painting in America, 1935; MOMA, Fourteen Americans, circ., 1946; Galerie Maeght, 6 Surrealists in 1947, 1947; XXIV & XXV Venice Biennials, 1948, 50; Galerie de France, Paris, 1952; MOMA, The New American Painting, circ. Europe,

1958-59; MOMA, The New American Painting and Sculpture, 1969. **Collections:** U. of Arizona; Buffalo/Albright; MMA; MOMA; Oberlin College; SFMA; Utica; WMAA; Washington U. **Bibliography:** Ashton 5; Barr 3; Baur 5, 7; Blesh 1; Breton 2, 3; Calas Cheney; Chipp; Eliot; Flanagan; Gerdts; Goodrich and Baur 1; Greenberg 1; Haftman; Hess, T. B. 1; Hunter 1, 6; Hunter, ed.; Janis, S.; **Joyner;** Kozloff 3; Langui; **Levy 1;** Lynton; McCoubrey 1; McCurdy, ed.; Miller, ed. 2; Myers 2; Neumeyer; Newmeyer; Passloff; Ponente; Pousette-Dart, ed.; Ragon 1; Read 2; Richardson, E. P.; Ritchie 1; Rodman 2; Rose, B. 1, 4; **Rosenberg 1;** Rubin 1; Sandler, **Schwabacher; Seitz** 1, 2; Seuphor 1; Soby 6; Tomkins and Time-Life Books; Tuchman, ed.; Waldberg 3, 4; Weller.

GOTO, JOSEPH. b. January 7, 1920, Hilo, Hawaii. **Studied:** Chicago/AI School; Roosevelt U. **Taught:** College of William and Mary, 1958-59; U. of Michigan, 1959-63; RISD, 1963-65; U. of Illinois, 1965; Carnegie, 1968; Brandeis U., 1970. **Awards:** Chicago/AI, **P.P.,** 1957; Graham Foundation Fellowship, 1957; John Hay Whitney Fellowship; Chicago/AI, Watson F. Blair Prize; Chicago/AI, The Mr. & Mrs. Frank G. Logan Prize; Chicago/AI, Pauline Palmer Prize; J. S. Guggenheim Fellowship, 1969; Rhode Island, Governor's Arts Award, 1972. **Address:** 17 Sixth Street, Providence, R.I. **Dealer:** The Zabriskie Gallery. **One-man Exhibitions:** Allan Frumkin Gallery, NYC and Chicago, 1962; Stephen Radich Gallery, NYC, 1964, 65, 67; Honolulu Academy, 1973; Contemporary Arts Center of Hawaii,

Joseph Goto #12 1963

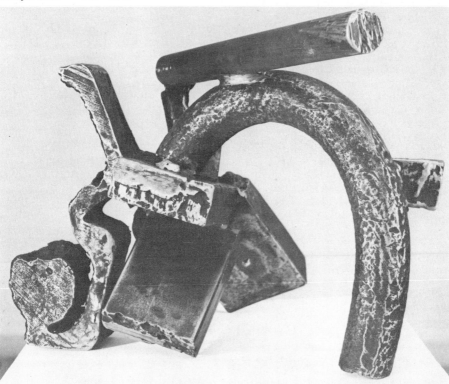

Honolulu, 1973; The Zabriskie Gallery, 1973. **Retrospective:** RISD, 1972. **Group:** Chicago/AI; Carnegie; U. of Illinois; Louisville/Speed; WMAA; Chicago/AI, Exhibition Momentum; Denver/AM; Houston/MFA, 1957; VMFA, 1958; Carnegie, 1970. **Collections:** Chicago/AI; Indiana U.; MOMA; U. of Michigan; Union Carbide Corp. **Bibliography:** Joseph Goto; Rubin 1.

GOTTLIEB, ADOLPH. b. March 14, 1903, NYC; **d.** March 4, 1974, NYC. **Studied:** ASL, 1919, with John Sloan, Robert Henri; Academie de la Grande Chaumiere, 1921; Parsons School of Design, 1923. Exhibited with The Ten, NYC, 1935-40. President, Federation of Modern Painters, 1944-45. **Taught:** Pratt Institute, 1958; UCLA, 1958. **Awards:** Winner of Dudensing National Competition, 1929; US Treasury Department, Mural Competition, 1939; Brooklyn Museum, First Prize, 1944; U. of Illinois, **P.P.**, 1951; Carnegie, Third Prize, 1961; VII Sao Paulo Biennial, First Prize, 1963; American Academy of Achievement, 1965; Flint/Institute, **P.P.**, 1966. **One-man Exhibitions:** (first) Dudensing Gallery, NYC, 1930; Uptown Gallery, NYC, 1934; Theodore A. Kohn Gallery, NYC, 1934; Artists' Gallery, NYC, 1942, 43; Wakefield Gallery, NYC, 1944; "67" Gallery, NYC, 1945; Karl Nierendorf Gallery, NYC, 1945; The Kootz Gallery, NYC, 1947, 1950-54; J. Seligmann and Co., 1949; Area Arts Gallery, San Francisco, 1953; Williams College, 1954; The Kootz Gallery, Provincetown, Mass., 1954; Martha Jackson Gallery, 1957; HCE Gallery, Provincetown, Mass., 1957; Andre Emmerich Gallery, 1958, 59; Galerie Rive Droite, Paris, 1959; Paul Kantor Gallery, Beverly Hills, Calif., 1959; ICA, London, 1959; French & Co. Inc., NYC, 1960; Sidney Janis Gallery, 1960, 62; Galleria dell'Ariete, 1961; Galerie Handschin, Basel, 1961; Walker, 1963; Marlborough-Gerson Gallery Inc., 1964, 66, 71, 72, 73, 74; MIT, 1966; Arts Club of Chicago, 1967; U. of Maryland, 1970; Galleria Lorenzelli,

Bergamo, 1970; Gertrude Kasle Gallery, 1970, 74; Marlborough Fine Art Ltd., London, 1972; MOMA, 1974. **Retrospectives:** Bennington College, 1954; Jewish Museum, 1957; WMAA and SRGM, 1968. **Group:** WMAA Annuals, 1944, 45, 46, 48, 51, 53, 55, 61; PAFA; Walker; Chicago/AI, Abstract and Surrealist Art, 1948; Carnegie, 1952, 55, 58, 61; SRGM, Younger American Painters, 1954; WMAA, The New Decade, 1954-55; MOMA, The New American Painting, circ. Europe, 1958-59; Documenta II, Kassel, 1959; Seattle World's Fair, 1962; VII Sao Paulo Biennial, 1963; Tate, Gulbenkian International, 1964, Dunn International, 1964; Chicago/AI Annual, 1966; Flint/Institute, I Flint Invitational, 1966; Corcoran, 1966, Biennial, 1967; Winnipeg Art Gallery, 1967; MOMA, The New American Painting and Sculpture, 1969. **Collections:** Andover/Phillips; Atlanta/AA; Ball State U.; Bezalel Museum; Brandeis U.; Brooklyn Museum; Buffalo/Albright; Carnegie; Chicago/AI; Columbia U.; Corcoran; Cornell U.; Dallas/MFA; Des Moines; Detroit/Institute; Flint/Institute; Hartford/Wadsworth; U. of Illinois; Jewish Museum; Los Angeles/County MA; MMA; MOMA; U. of Miami; NYU; U. of Nebraska; U. of Nevada; Newark Museum; New Orleans/Delgado; Pasadena/AM; Phillips; SRGM; San Jose Library; Santa Barbara/MA; Seagram Collection; Smith College; Society of the Four Arts; Tel Aviv; Utica; VMFA; WMAA; Walker; Yale U.; Youngstown/Butler. **Bibliography:** Ashton 5; Barr 3; Baur 5, 7; Blesh 1; Chipp; Eliot; **Friedman, M. 1;** Goodrich and Baur 1; *The Great Decade;* Greenberg 1; Haftman; Hess, T. B. 1; Hunter 1, 6; Hunter, ed.; Janis, S.; Kootz 2; Mendelowitz; *Metro;* Motherwell and Reinhardt, eds.; Myers 2; Neumeyer; Nordness, ed.; Pousette-Dart, ed.; Read 2; Richardson, E. P.; Rodman 1, 2, 3; Rose, B. 1, 4; Rosenblum 2; Rubin 1; Sandler; Seuphor 1; Soby 5; Tuchman, ed.; Weller; Wight 2. Archives.

GOULET, LORRIE. b. August 17, 1925,

Riverdale, N.Y. **Studied:** Black Mountain College, 1943-45, with Josef Albers, Jose de Creeft. Traveled USA, Europe. **Taught:** Scarsdale Art Workshop and privately, 1957-61; MOMA School, 1957-64; New School for Social Research, 1961- . **Member:** Sculptors Guild; Artists Equity; Audubon Artists. **Commissions:** Grand Concourse (Bronx) Public Library, 1958 (ceramic relief); Nurses Residence and School, Bronx Municipal Hospital Center, 1961 (relief); 48th Precinct Police and Fire Station, Bronx, 1971. CBS-TV, lecture-demonstrations on sculpture for children's series *Around the Corner*, 1964, 66, 67, 68. **Awards:** West Palm Beach/Norton, First Prize, 1949, 50; Westchester (N.Y.) Art Society, First Prize, 1964; Aububon Artists, Solten Engel Memorial Award, 1966. **m.** Jose de Creeft. **Address:** 241 West 20 Street, NYC 10011. **Dealer:** Kennedy Gallery. **One-man Exhibitions:** (first) Clay Club, NYC, 1948; Sculpture Center, 1955; The Contemporaries, NYC, 1959, 62, 66, 68; New School for Social Research, 1968; Temple Emeth, N.J. 1969; Kennedy Gallery, 1971, 72. **Group:** PAFA, annually since 1948; Audubon Artists, annually since 1948; WMAA Annuals, 1948, 49, 50, 53, 55; Philadelphia Art Alliance, 1950; MMA, 1951; Sculptors Guild, annually since 1960; AAAL, 1961; A.F.A., Mother and Child in Modern Art, circ., 1963; Carroll Reece Memorial Museum, Johnson City, Tenn.; Black Mountain College, 1964; New York World's Fair, 1964-65; NAD, 1966; New School for Social Research, Erotic Art, 1973. **Collections:** Trenton/State; WMAA; Wichita/AM. Archives.

GRAHAM, JOHN D. b. 1881, Kiev, Russia; **d.** 1961, London, England. **Studied:** U. of Kiev, degree in Law, 1911; ASL, 1921, with John Sloan. To USA 1920; became a citizen. Traveled Europe, Asia, Africa, USA. **One-man Exhibitions:** (first) Baltimore/MA, 1926; Galerie Zborowski, Paris, 1929; Societe Anonyme, NYC, 1931; Eighth Street Gallery, NYC, 1933; Artists'

Gallery, NYC, 1941; The Pinacotheca, NYC, 1946; Dudensing Gallery, NYC; The Stable Gallery, 1954; Gallery Mayer, NYC, 1960; Arts Club of Chicago, 1963; U. of Minnesota, 1964; Andre Emmerich Gallery, 1966; MOMA, 1968; Phyllis Kind Gallery, Chicago, 1970; Donald Morris Gallery, 1972; Allan Stone Gallery, 1973; The Zabriskie Gallery, 1973; Andre Emmerich Gallery, NYC. **Group:** MOMA; WMAA; U. of Minnesota; Societe Anonyme, NYC. **Collections:** Carnegie; MOMA; Nashville; Phillips; WMAA. **Bibliography:** Baur 7; **George 2; Graham;** Hunter 6; Janis, S.; Kootz 2; Passloff; Phillips 1; Rose, B. 1, 4; Sandler. Archives.

GRAHAM, ROBERT. b. August 19, 1938, Mexico, D.F. **Studied:** San Jose State College; SFAI, MFA. Traveled Germany, Switzerland, England. **Address:** 69 Windward Avenue, Venice, Calif. 90291. **Dealers:** Nicholas Wilder Gallery; The Kornblee Gallery. **One-man Exhibitions:** The Lanyon Gallery, 1964; Nicholas Wilder Gallery, 1966, 67, 69, 74; M.E. Thelen Gallery, Essen, 1967; The Kornblee Gallery, 1968, 69; Galerie Hans R. Neuendorf, Hamburg, 1968, 70, 74, Cologne, 1968, 70; Galerie Rudolf Zwirner, 1970; Galerie Rene Block, Berlin, 1970; Whitechapel Art Gallery, London, 1970; Ileana Sonnabend Gallery, NYC, 1971; Hamburg/Kunstverein, 1971; Galerie Herbert Meyer-Ellingen, Frankfort, 1972; Dallas/MFA, 1972; Felicity Samuel Gallery, London, 1974; Gimpel & Hanover, 1975. **Group:** WMAA Sculpture Annuals, 1966, 69, 71; Washington U. (St. Louis), Here and Now, 1969; Victoria and Albert Museum, Three Americans, 1971; Hamburg/Kunstverein, USA: West Coast, circ., 1972. **Collections:** Cologne; Pasadena/AM; WMAA. **Bibliography:** *Kunst um 1970;* Sager; *USA West Coast.*

GRANLUND, PAUL. b. October 6, 1925, Minneapolis, Minn. **Studied:** Gustavus Adolphus College, 1952, BA;

U. of Minnesota; Cranbrook Academy of Art, 1954, MFA. **Taught:** Cranbrook Academy of Art, 1954; Minneapolis Institute School, 1955-68; U. of California, summer, 1959; Gustavus Adolphus College, 1968- . **Awards:** Cranbrook, George A. Booth Scholarship, 1953; Fulbright Fellowship, 1954; Guggenheim Foundation Fellowship, 1957, 58. **Address:** c/o Art Department, Gustavus Adolphus College, St. Peter, Minn. 56082. **One-man Exhibitions:** Minnesota State Fair, 1957; Minneapolis/Institute, 1959; Walker, 1956; Gustavus Adolphus College, 1956, 60; Allan Frumkin Gallery, Chicago, 1959, 66, 68, NYC, 1960, 63; Esther Robles Gallery, 1962; California Palace, 1962; Gethsemane Lutheran Church, Seattle, 1962; U. of Nebraska, 1964; Washington U., 1965. **Group:** American Academy, Rome, 1959; U. of Illinois, 1961; Cincinnati/AM, 1961; Corcoran, 1961; U. of Colorado, 1962; Buffalo/Albright, 1962; VMFA, 1962; Louisiana State U., 1964; Minneapolis School of Art, Art of Two Cities, 1965. **Collections:** A.F.A.; American Swedish Institute; Cranbrook; Minneapolis/Institute; VMFA; Walker.

GRANT, JAMES. b. 1924, Los Angeles, Calif. **Studied:** U. of Southern California, B.Ed., 1945, MFA, 1950; Jepson Art Institute, Los Angeles, 1947-49. **Taught:** Pomona College, 1950-59. **Address:** c/o Dealer. **Dealer:** Hansen-Fuller Gallery. **One-man Exhibitions:** Pasadena/AM, 1952; U. of California, 1958; Humboldt State College, 1959; Pomona College, 1959; Grand Central Moderns, NYC, 1961, 63; Pogliani Gallery, Rome, 1962; de Young, 1963; Hansen Gallery, San Francisco, 1964-66. **Retrospective:** Mills College, 1970. **Group:** U. of Nebraska, 1962; U. of Virginia, 1963; M. Knoedler & Co., Art Across America, 1965-67; Sacramento/Crocker, 1966; San Francisco Art Association, 1966; U. of Illinois, 1967, 69; La Jolla; Cornell U.; Los Angeles/County MA; MOMA. **Collections:** Bank of America; Bank of California; Mary Washington College; Mead Corporation; U. of the Pacific; Pasadena/AM; Pomona College; SFMA.

GRAVES, MORRIS COLE. b. August 28, 1910, Fox Valley, Ore. **Studied** with Mark Tobey. Traveled Europe, the Orient, USA. Federal A.P.: Easel painting, 1936-39. US Army, 1943. **Awards:** Seattle/AM, Northwest Annual, $100 Award, 1933; Guggenheim Foundation Fellowship, 1946; Chicago/AI, Norman Wait Harris Medal, 1947; Chicago/AI, Watson F. Blair Prize, 1949; U. of Illinois, **P.P.**, 1955; NIAL Grant, 1956; Windsor Award, 1957. **Address:** c/o Dealer. **Dealer:** The Willard Gallery. **One-man Exhibitions:** (first) Seattle/AM, 1936, also 1956; The Willard Gallery, 1942, 44, 45, 48, 53, 54, 55, 59, 71, 73; Arts Club of Chicago, 1943; U. of Minnesota, 1943; Detroit/Institute, 1943; Phillips, 1943, 54; Philadelphia Art Alliance, 1946; Santa Barbara/MA, 1948; Los Angeles/County MA, 1948; Chicago/AI, 1948; Margaret Brown Gallery, Boston, 1950; Beaumont (Tex.) Art Museum, 1952; Kunstnernes hus, Oslo, 1955; La Jolla, 1957; Bridgestone Museum, 1957; Phoenix, 1960; Roswell, 1961; Kalamazoo/Institute, 1961; Richard White Gallery, Seattle, 1969. **Retrospective:** California Palace, 1948; WMAA, circ., 1956; Pavilion Gallery, Balboa, Calif., 1963; U. of Oregon, 1966; Tacoma, 1971. **Group:** Seattle/AM; WMAA; U. of Illinois; Chicago/AI; Phillips; MOMA, Americans 1942, circ., 1942; Houston/MFA, 1956; ICA, London, 1957; Brussels World's Fair, 1958; Seattle World's Fair, 1962; ICA, Boston, American Art since 1950, 1962; Amon Carter Museum, The Artist's Environment: West Coast, 1962; PAFA, 1963; Columbia, S.C./MA, Ascendancy of American Painting, 1963; Tate, American Painting, 1963; St. Louis/City, 200 Years of American Painting, 1964; U. of Michigan, One Hundred Contemporary American Drawings, 1965; MOMA, The Object Transformed, 1966; U. of Illinois, 1969; Minnesota/MA, Drawings USA, 1971; St. Joseph/Albrecht, Drawing—America: 1973, 1973; NAD,

1974. **Collections:** Baltimore/MA; Boston/MFA; Buffalo/Albright; U. of California; Chicago/AI; Cincinnati/AM; Cleveland/MA; Denver/AM; Detroit/ Institute; Fort Wayne/AM; Hartford/ Wadsworth; Harvard U.; Hirshhorn; U. of Illinois; MMA; MOMA; Milwaukee; NIAL; U. of Nebraska; Ogunquit; Pasadena/AM; Phillips; Portland, Ore./AM; Purchase/SUNY; SFMA; SRGM; Santa Barbara/MA; Seattle/AM; Tacoma; U. of Texas; Toronto; Upjohn Co.; Utica; WMAA; U. of Washington; Wilmington; Worcester/ AM. **Bibliography:** Baldinger; Barker 1; Barr 3; Baur 7; Bazin; Beekman; Blesh 1; **Cage;** Canaday; Flanagan; Flexner; Frost; Goodrich and Baur 1; Haftman; Hunter 6; Janis, S.; Kootz 2; Kuh 1, 2; Langui; McCurdy, ed.; Mendelowitz; Miller, ed. 1; Munsterberg; Neumeyer; Nordness, ed.; Pousette-Dart, ed.; Ragon 1; Read 2, 3; Richardson, E. P.; Rodman 1, 2; Rose, B. 1; Sachs; Soby 5; Sutton; Valentine 2; Weller; Wight 2; **Wight, Baur and Phillips.**

GRAVES, NANCY STEVENSON. b. December 23, 1940, Pittsfield, Mass. **Studied:** Vassar College, 1961, BA; Yale U., 1962, BFA, 1964, MFA. Filmmaker, 1970- . **Awards:** Fulbright Fellowship, 1965; Vassar College Grant, 1971; Paris Biennial Grant, 1971; National Endowment for the Arts, 1972; CAPS, 1973. **Address:** 69 Wooster Street, NYC 10012. **Dealers:** Janie C. Lee Gallery, Houston; Andre Emmerich Gallery, NYC. **One-man Exhibitions:** The Graham Gallery, 1968; WMAA, 1969; Ottowa/National, 1970, 71, 73; Reese Palley Gallery, NYC, 1971, Reese Palley Gallery, San Francisco, 1971; Aachen/NG, 1971; Vassar College, 1971; MOMA, 1971; New Gallery, Cleveland, 1972; Janie C. Lee Gallery, Dallas, 1972, 73, 75; ICA, U. of Pennsylvania, 1972; Pittsfield/Berkshire, 1973; Art Museum of South Texas, Corpus Christi, 1973; Andre Emmerich Gallery, NYC, 1974; Buffalo/Albright, 1974. **Group:** WMAA Annuals, 1970, 71, 73; MOMA, Information, 1971; Corcoran, Depth and Presence, 1971; Dusseldorf/Kunsthalle, Prospect '71, 1971; Chicago/Contemporary, Six Sculptors, 1971; VII Paris Biennial, 1971; Kunsthaus, Hamburg, American Women Artists, 1972; Documenta V, Kassel, 1972; New York Cultural Center, 3D into 2D, 1973; WMAA, American Drawings: 1963-1973, 1973. **Collections:** Aachen/NG; Buffalo/Albright; CNAC; U. of California, Berkeley; Chicago/AI; Cologne; Des Moines; Houston/MFA; La Jolla; MOMA; WMAA. **Bibliography:** *Art: A Woman's Sensibility; Art Now 74; Kunst um 1970;* **Nancy Graves,** 1973; **Nancy Graves,** 1971; Sager. Archives.

GRAY, CLEVE. b. September 22, 1918, NYC. **Studied:** Princeton U., 1940, BA summa cum laude, PBK; Academie Andre Lhote; privately with Jacques Villon in Paris. US Army, 1943-46. Traveled Europe, USA. **Taught:** Honolulu Academy, 1970-71. Trustee, New York Studio School, 1970- . **Member:** Century Association. **Awards:** U. of Illinois, **P.P.;** Ford Foundation, **P.P. Address:** Cornwall Bridge, Cornwall, Conn. 06754. **Dealers:** Betty Parsons Gallery; Sneed-Hillman Gallery. **One-man Exhibitions:** (first) J. Seligmann and Co., 1947, also 1948, 49, 50, 52, 54, 57, 59; Staempfli Gallery, 1960, 62, 64; Galleria Pagani del Grattacielo, Milan, 1963; Jerrold Morris Gallery, Toronto, 1963; Oklahoma, 1963; Saidenberg Gallery, 1965, 67; Hargate Art Center, Concord, Mass., 1969; Betty Parsons Gallery, 1970, 72, 74; Sneed-Hillman Gallery, 1970, 73, 74; Honolulu Academy, 1970, 71; Princeton U., 1970. **Group:** WMAA Annuals, 1946- ; Chicago/AI; SRGM, Abstract Expressionists and Imagists, 1961; Hartford/Wadsworth; PAFA; El Retiro Parquet, Arte de America y España, 1963; Andover/ Phillips, Decades, 1969. **Collections:** Andover/Phillips; Brandeis U.; U. of California; Corcoran; Columbia U.; Columbus; Hartford/Wadsworth; Honolulu Academy; U. of Illinois; MMA; Minnesota/MA; NCFA; NYU; Nashville; U. of Nebraska; New School for

Social Research; U. of Notre Dame; Oklahoma; Purchase/SUNY; RISD; SRGM; Vanderbilt U.; WMAA; Williams College. **Bibliography:** Goodrich and Baur 1; *7 Decades.* Archives.

GREENE, BALCOMB. b. May 22, 1904, Shelby, N.Y. **Studied:** Syracuse U., 1922-26, AB; Columbia U., 1927; U. of Vienna, 1926-27; NYU, 1943, MA; self-taught in art. Traveled Europe extensively. **Taught:** Dartmouth College (English), 1928-31; Carnegie, 1942-59. Editor, *Art Front* Magazine, 1935-36. Fire in New York studio, 1941, destroyed many early paintings. **Member:** American Abstract Artists (First Chairman, 1936-37, 1938-39, 1940-41); International Institute of Arts and Letters; Cosmopolitan Club, NYC. Federal A.P. (Mural Division): New York World's Fair, 1939, Federal Hall of Medicine (mural); Bronx (N.Y.) High School of Science (stained glass window); Williamsburg Housing Project, Brooklyn, 1939 (mural). **Awards:** *Art News* (Magazine) Critics Choice, 1950, 53, 55, 56; PAFA, Carol H. Beck Gold Medal, 1961. **Address:** 2 Sutton Place South, NYC 10022; Montauk Point, N.Y. **Dealer:** The Forum Gallery. **One-man Exhibitions:** (first) a gallery in Paris, 1932; J. B. Neumann's New Art Circle, NYC, 1947; The Bertha Schaefer Gallery, 1952, 54, 55, 56, 58, 59, 61; Arts and Crafts Center, Pittsburgh, 1953, 66; American U., 1957; Brookhaven National Laboratory, 1959; American Cultural Center, Paris, 1960; Saidenberg Gallery, 1962, 63, 65, 67, 68; Feingarten Gallery; Los Angeles, 1963, 64; La Jolla, 1964; U. of Florida, 1965; Tampa/AI, 1965; James David Gallery, Miami, 1965, 66; Main Street Gallery, Chicago, 1966; Santa Barbara/MA, 1966; Phoenix, 1966; Adele Bednarz Gallery, 1966-69; Occidental College, 1967; The Berenson Gallery, 1967, 68, 69; Makler Gallery, Philadelphia, 1968; The Forum Gallery, 1970, 73. **Retrospective:** WMAA/A.F.A., circ., 1961. **Group:** American Abstract Artists Annuals; WMAA Annuals; U. of Illinois;

Chicago/AI; Walker; SRGM; Brooklyn Museum; Carnegie. **Collections:** Ball State U.; Baltimore/MA; Brooklyn Museum; Carnegie; Chicago/AI; Corcoran; Guild Hall; Hartford/Wadsworth; Indianapolis/Herron; MIT; MMA; MOMA; U. of Miami; NCFA; U. of Nebraska; Omaha/Joslyn; PAFA; Pasadena/AM; Portland, Ore./AM; SRGM; U. of Texas; WMAA; Walker; Youngstown/Butler. **Bibliography:** Bauer 5, 7; Flanagan; Frost; Goodrich and Baur 1; Hess, T. B. 1; Janis, S.; Kootz 2; Newmeyer; Nordness, ed.; Pousette-Dart, ed.; Read 2; Richardson, E. P.; Ritchie 1; Rodman 3; Rose, B. 4. Archives.

GREENE, STEPHEN. b. September 19, 1918, NYC. **Studied:** ASL, with Morris Kantor, 1937; State U. of Iowa, with Philip Guston, 1939-42, 1944-45, BFA, MA. Traveled Europe, North Africa. **Taught:** Indiana U., 1945-56; Washington U., 1946-47; Pratt Institute, 1959-64; Parsons School of Design; NYU; Princeton U., Artist-in-Residence, 1956-59; ASL, 1959-65; Columbia U., 1961-68; Stella Elkins Tyler School of Fine Arts, Temple U., 1968- . **Awards:** Prix de Rome, 1949; Corcoran, William A. Clark Prize and Corcoran Medal, 1966; National Council on the Arts, $5,000, 1966; NIAL, $2500, 1967; NAD, Andrew Carnegie Prize, 1970. **Address:** 408A Storms Road, Valley Collage, N.Y. 10989. **Dealer:** William Zierler Inc. **One-man Exhibitions:** (first) Durlacher Brothers, 1947, also 1949, 52; Grace Borgenicht Gallery Inc., 1955, 57, 58; Staempfli Gallery, 1961 (circ. 1964), 64, 66, 69; William Zierler Inc., 1971, 72, 73; U. of Wisconsin, 1972; U. of Alberta, circ., 1972; Galleria d'Arte l'Obelisco, 1975. **Retrospectives:** Corcoran, 1963; Lincoln, Mass./De Cordova, 1953. **Group:** MMA, American Paintings Today, 1950; Chicago/AI, Contemporary Drawings from 12 Countries, 1952; Walker, Reality and Fantasy, 1954; Paris/Moderne, American Drawings, 1954; WMAA, The New Decade, 1954-55; MOMA, Recent Drawings USA,

1956; I International Religious Art Biennial, Salzburg, 1958; VI Sao Paulo Biennial, 1961; WMAA Annuals; SRGM, Abstract Expressionists and Imagists, 1961; Corcoran; Carnegie; Chicago/AI; El Retiro Parquet, Madrid, Arte de America y España, 1963; Internationale der Zeichnung, Darmstadt, 1964; MMA, American Paintings, Drawings and Watercolors from the Museum's Collections, 1969; WMAA, Human Concern/Personal Torment, 1969; Foundation Maeght, L'Art Vivant, 1970; Museo Comunale, Prato, Italy, American Painters in Europe, 1973; SRGM, American Painters through Two Decades, 1973. **Collections:** American Republic Insurance Co.; Andover/Phillips; Atlantic Richfield Co.; Brandeis U.; Chase Manhattan Bank; Chicago/AI; Corcoran; Dayton/AI; Detroit/Institute; Hamline U.; Hartford/Wadsworth; Harvard U.; Hirshhorn; U. of Illinois; Indiana U.; Indianapolis/Herron; Kalamazoo/Institute; Kansas City/Nelson; U. of Kentucky; MMA; MOMA; Minnesota/MA; NYU; Nashville; New Orleans/Delgado; Owens-Corning Fiberglas Corp.; Pasadena/AM; Princeton U.; SFMA; SRGM; St. Louis/City; Santa Barbara/MA; Tate; Trenton/State; Utica; VMFA; WMAA. **Bibliography:** Baur 7; Bazin; Genauer; Mendelowitz; Sachs; Soby 5. Archives.

GREENLY, COLIN. b. January 21, 1928, London, England. **Studied:** Harvard U., AB, 1948; American U. (with Robert Gates); Columbia U. (with Oronzio Maldarelli, Peppino Mangravite): Traveled Western USA, France, Italy, England. **Taught:** Established art programs for employee groups at Standard Oil, Metropolitan Life Insurance Co., Union Carbide Corp., New York Life Insurance, all NYC, 1951-53; US Dept. of Agriculture, Graduate School, 1954-56; Madeira School, Greenway, Va., 1955-68; Colgate U., 1972-73; Central Michigan U., 1972; Finch College, NYC, 1974. **Commissions:** New York State Office Building,

Utica (twelve color panels), 1973. **Awards:** Corcoran, **P.P.**, 1956; The Corcoran School of Art, National Playground Sculpture Competition, First Prize, 1967; National Council on the Arts, Grant, 1967; CAPS, 1972; Committee for the Visual Arts Grant, NYC, 1974. **Address:** 179 Duane Street, NYC 10013. **One-man Exhibitions:** (first) Jefferson Place Gallery, 1958, also 1960, 63, 65; The Bertha Schaefer Gallery, 1964, 66, 68; Corcoran, 1968; Royal Marks Gallery, 1968, 70; Syracuse/Everson, 1971; Cornell U., 1972; Fredonia/SUNY, 1973; Colgate U., 1973; The Schenectady (N.Y.) Museum, 1973; Alfred/SUNY, 1974, 75; Nassau Community College, Garden City, N.Y., 1974; Finch College, NYC, 1974; Creative Arts Workshop, New Haven, 1975; 112 Greene Street, NYC, 1976. **Group:** MOMA, Young American Printmakers, 1953; Corcoran, 1955-57; Lincoln, Mass./De Cordova, 1965; Flint/Institute, Made of Plastic, 1968; Grand Rapids, Sculpture of the 60s, 1969; Baltimore/MA, Washington: Twenty Years, 1970; New York State Fair, Enviro-Vision, circ., 1972; U. of Illinois, 1974. **Collections:** Corcoran; Cornell U.; Des Moines; High Museum; MOMA; Manufacturers and Traders Trust Co., Buffalo, N.Y.; NCFA; National Gallery; PMA; Virginia National Bank.

GRILLO, JOHN. b. July 4, 1917, Lawrence, Mass. **Studied:** Hartford Art School, 1935-38; California School of Fine Arts, 1946; Hofmann School, NYC, 1949-50. US Armed Forces, 1944-46. **Taught:** Southern Illinois U., 1960; School of Visual Arts, NYC, 1961; U. of California, Berkeley, 1962-63; New School for Social Research, 1964-66; Pratt Institute, 1965-66; State U. of Iowa, 1967- ; U. of Massachusetts, Artist-in-Residence, 1968-69. **Awards:** CSFA, Albert M. Bender Fellowship, 1947; Ford Foundation Fellowship (Tamarind Lithography Workshop and Youngstown/Butler), 1964. **Address:** 111 Chestnut Street, Amherst, Mass.

01002. **One-man Exhibitions:** Daliel Gallery, Berkeley, 1947; Artists' Gallery, NYC, 1948; Tanager Gallery, NYC, 1952, 60; Tibor de Nagy Gallery, NYC, 1953, 70; The Bertha Schaefer Gallery, 1955, 57, 59; HCE Gallery, Provincetown, Mass., 1959, 62; The Howard Wise Gallery, NYC, 1961; 62, 63; Ankrum Gallery, 1962; U. of California, Berkeley, 1962; East End Gallery, Provincetown, 1963; Youngstown/Butler, 1964; Waitsfield/Bundy, 1966; New School for Social Research, 1967; State U. of Iowa, 1967; Simmons College, 1968; Eleanor Rigelhaupt Gallery, Boston, 1968; Benedict Art Center, St. Joseph, Minn., 1969; Horizon Gallery, NYC, 1969; Robert Dain Gallery, NYC, 1970; Landmark Gallery Inc., NYC. **Retrospective:** The Olsen Foundation Inc., circ. USA, 1956-60. **Group:** The Kootz Gallery, NYC, Fifteen Unknowns, 1950; Walker, Vanguard, 1955; WMAA Annual, 1959; Walker, 60 American Painters, 1960; SRGM, Abstract Expressionists and Imagists, 1961; Yale U., Contemporary Painting, 1961; Dallas/MFA, 1961, 62; Seattle World's Fair, 1962; MOMA, Hans Hofmann and His Students, circ., 1963-64; SFMA, Directions—Painting U.S.A., 1963; Buffalo/Albright, 1964; Brooklyn Museum Print Biennial, 1970. **Collections:** Baton Rouge; Bennington College; Brooklyn Museum; Ciba-Geigy Corp.; Hartford/Wadsworth; Los Angeles/County MA; Newark Museum; Norfolk/Chrysler; The Olsen Foundation Inc.; Portland, ME./MA; SRGM; Smith College; Southern Illinois U.; U. of Texas; Union Carbide Corp.; WMAA; Waitsfield/Bundy; Walker; Youngstown/Butler. **Bibliography:** Blesh 1; McChesney.

GRIPPE, PETER. b. August 8, 1912, Buffalo, N.Y. **Studied:** Albright Art School; Buffalo Fine Arts Academy, with E. Wilcox, Edwin Dickinson, William Ehrich; Atelier 17, NYC. Traveled Europe. **Taught:** Black Mountain College, 1948; Pratt Institute, 1949-50; Smith College, 1951-52; Atelier 17,

NYC, 1951-52; Brandeis U., 1953- . Federal A.P.: Taught sculpture and drawing, 1939-42. **Commissions:** Creative Arts Award Medallion design for Brandeis U., 1954; Puerto Rican Information Center, NYC, 1958 (2 sculpture murals); Theo. Shapiro Forum, Brandeis U., 1963 (sculpture). **Awards:** Brooklyn Museum, **P.P.**, 1947; MMA, $500 First Prize, 1952; The Print Club, Philadelphia, Charles M. Lea Prize, 1953; National Council for United States Art, $1,000 Sculpture Award, 1955; Boston Arts Festival, First Prize for Sculpture, 1955; Rhode Island Arts Festival, Sculpture Award, 1961; Guggenheim Foundation Fellowship, 1964; 70. **Address:** c/o Brandeis U., Department of Fine Arts, Waltham, Mass. 02154. **One-man Exhibitions:** (first) Orrefors Galleries, NYC, 1942; The Willard Gallery, 1944, 45, 46, 48; Brandeis U., 1957; The Peridot Gallery, 1957, 59; Lee Nordness Gallery, NYC, 1960, 63. **Group:** MMA, Contemporary American Art, 1942; WMAA Annuals, 1944, 45, 47, 48, 50, 51, 52, 54, 56, 57, 60, 62; Federation of Modern Painters and Sculptors, 1944, 45, 52; American Abstract Artists Annuals, 1946, 47, 49; Carnegie, 1946, 48; Brooklyn Museum, 1947, 48, 49, 53, 56, 58; Detroit/Institute, Origins of Modern Sculpture, 1948; Chicago/AI, Abstract and Surrealist Art, 1948; A.F.A., Tradition and Experiment in Modern Sculpture, circ., 1950-51; MMA, National Sculpture Exhibition, 1951; MOMA, Abstract Painting and Sculpture in America, 1951; Ninth Street Exhibition, NYC, 1951; MOMA, From Sketch to Sculpture, 1952; PAFA, 1952, 59; U. of Illinois, 50 Contemporary American Printmakers, 1956; ART: USA:59, NYC, 1959; PCA, American Prints Today, circ., 1959-62; ICA, Boston, View, 1960; U. of Illinois, 1961; Chicago/AI, 1961; Smithsonian, Drawings by Sculptors, circ. USA, 1961-63; A.F.A., Hayter and Atelier 17, circ., 1961-62; Hartford/Wadsworth, Eleven New England Sculptors, 1963; MOMA, The New American Painting and Sculpture, 1969; Brandeis U., 1973. **Collec-**

tions: Andover/Phillips; Brandeis U.; Brooklyn Museum; Buffalo/Albright; Fort Dodge/Blanden; U. of Georgia; Library of Congress; MMA; MOMA; U. of Michigan; Milwaukee-Downer College; NYPL; National Gallery; Newark Museum; Norfolk/Chrysler; PCA; PMA; The Print Club, Philadelphia; Raleigh/NCMA; Simmons College; Tel Aviv; Toledo/MA; USIA; WMAA; Walker; Washington U. **Bibliography:** Baur 7; Blesh 1; Brumme; Flanagan; Hayter 1; Mendelowitz; Motherwell and Reinhardt, eds.; Ritchie 1; Seuphor 3; Trier 1.

GROOMS, RED. b. June 1, 1937, Nashville, Tenn. **Studied:** Peabody College; privately with J. Van Sickle; New School for Social Research; Chicago Art Institute School; Hofmann School, Provincetown. Traveled Europe, Near East. Sets and costumes for *Guinevere,* a play by Kenneth Koch, 1964. **Commissions:** Center for Modern Culture, Florence, Italy (mural, with Mimi Gross). **Awards:** Ingram Merrill Foundation Grant, 1968; AAAL Grant, 1969; CAPS, 1970. **Address:** 186 Grand Street, NYC 10013. **Dealer:** Marlborough Gallery Inc., NYC. **One-man Exhibitions:** (first) Sun Gallery, Provincetown, 1958; City Gallery, NYC, 1958-59; Reuben Gallery, NYC, 1960; Tibor de Nagy Gallery, NYC, 1963, 65, 66, 67, 69, 70; Artists Guild, Nashville, 1962; Walker, 1970; John Bernard Myers Gallery, 1971, 74; Allan Frumkin Gallery, Chicago, 1972; Fendrick Gallery, 1972; Graphics 1 & Graphics 2, Boston, 1972; Nashville, 1972; Rutgers U., 1973. **Happenings:** Fire, Sun Gallery, Provincetown, 1958; Walking Man, Sun Gallery, Provincetown, 1959; Burning Building, Delancey Street Museum, NYC, 1959; Magic Train Ride, Reuben Gallery, NYC, 1960. **Movies:** "Unwelcome Guests," 1961; "Shoot the Moon," 1962; "Miracle on the BMT," 1963; "Lurk," 1964; "Spaghetti Trouble," 1964; "Man or Mouse," 1964; "Umbrellas, Bah!," 1965; "Big Sneeze," 1965; "Secret of Wendel Sampson,"

1965-66; "Before 'n' After," 1966; "Washington's Wig Whammed!," 1966; "Fat Feet," 1966; "Meow, Meow!," 1967; "Tappy Toes," 1969-70; "Hippodrome Hardware," 1972-73; "The Conquest of Libya by Italia, 1913-1912," 1972-73. **Group:** Delancey Street Museum, NYC, 1959, 60; Chicago/AI, 1964; Provincetown/Chrysler; SRGM, 1965; Southampton/Parrish, 1965; Worcester/AM, 1965; A.F.A., 1965-66; Chicago/AI, Twenty Americans, 1966; MOMA, 1966; XXXIV Venice Biennial, 1968; Cologne/Kunstverein, Happening & Fluxus, circ., 1970; ICA, U. of Pennsylvania, The Spirit of the Comics, 1969; SRGM, 10 Independents, 1972; Harvard U., Recent Figure Sculpture, 1972; WMAA, Extraordinary Realities, 1973; Hirshhorn, Inaugural Exhibition, 1974; Dallas/MFA, Poets of the Cities, 1974. **Collections:** Caracas/Contemporaneo; Charlotte/Mint; Chicago/AI; Delaware Art Museum; Hirshhorn; MOMA; Nashville; New School for Social Research; Norfolk/Chrysler; Raleigh/NCMA; Stockholm/National. **Bibliography:** Becker and Vostell; *Figures/ Environments; Happening & Fluxus;* Janis and Blesh 1; Kaprow; Kirby; Lippard 5; *Recent Figure Sculpture;* Sontag. Archives.

GROPPER, WILLIAM. b. December 3, 1897, NYC. **Studied:** Ferrer School, San Francisco, with Robert Henri, George Bellows, 1912-13; NAD, 1913-14; New York School of Fine and Applied Art, with Howard Giles, Jay Hambidge, 1915-18. Traveled Europe, USA, USSR. Staff Artist, New York *Tribune,* 1919-21; New York *World,* 1925-27. **Taught:** American Art School, NYC, 1946-48. **Member:** Artists Equity; NIAL, 1968; NAD. **Commissions:** New Interior Building, Washington, D.C.; Northwestern Postal Station, Detroit; US Post Office, Freeport, N.Y.; Schenley Industries, Inc., NYC. **Awards:** Young Israel Prize; Los Angeles/County MA, **P.P.**; Indianapolis/Herron, Prize for Lithography; *Collier's* (Magazine) Prize for Illustration, 1920; Harmon Foundation Award, 1930; J. S. Guggenheim Fellow-

ship, 1937; Carnegie, Third Prize; MMA, Artists for Victory, Lithography Prize, 1942; Tamarind Fellowship, 1967; NAD, Thomas B. Clarke Prize, 1973, Andrew Carnegie Prize, 1975. **Address:** 33 Hickory Drive, Great Neck, N.Y. 11021. **Dealer:** Heritage Galleries. **Retrospectives:** Phoenix; Evansville; Palm Springs Desert Museum; Syracuse U.; U. of Miami, 50 Years Drawing and Cartoons, circ., 1968. **Group:** MMA; WMAA; Chicago/AI; MOMA; Los Angeles/County MA. **Collections:** Abbott Laboratories; U. of Arizona; Brandeis U.; Britannica; Canton Art Institute; Chicago/AI; Cornell U.; Evansville; Hartford/Wadsworth; Harvard U.; Hirshhorn; Library of Congress; Los Angeles/County MA; MMA; MOMA; Montclair/AM; Moscow/Western; NYPL; Newark Museum; PAFA; Phillips; St. Louis/City; Sofia; Storm King Art Center; Syracuse U.; Tate; U. of Tucson; WMAA; Walker; Youngstown/Butler. **Bibliography:** American Artists Congress, Inc.; Barr 3; Baur 7; Bazin; Boswell 1; Brown; Canaday; Cheney; Christensen; **Freundlich;** Goodrich and Baur 1; Hall; Kootz 2; McCurdy, ed.; Mellquist; Mendelowitz; Pagano; Pearson 1; Reese; Richardson, E.P.; Rose, B. 1; Shapiro, ed.; Wight 2.

GROSS, CHAIM. b. March 17, 1904, Kolomea, East Austria. To USA 1921. **Studied:** Kunstgewerbe Schulle; Educational Alliance, NYC; Beaux-Arts Institute of Design, with Elie Nadelman; ASL, with Robert Laurent. Traveled Europe, Israel, Turkey. **Taught:** Educational Alliance, NYC; New School for Social Research. **Member:** Sculptors Guild (President); Artists Equity; Federation of Modern Painters and Sculptors; NIAL. Federal A.P.: Teacher, supervisor, sculptor. **Commissions:** Main Post Office, Washington, D.C., 1936; Federal Trade Commission Building, Washington, D.C., 1938; France Overseas Building, New York World's Fair, 1939; US Post Office, Irwin, Pa., 1940; Reiss-Davis Child Guidance Clinic, Beverly

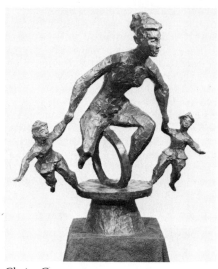

Chaim Gross
Mother and Children on a Unicycle n.d.

Hills, 1961; Hadassah Hospital, Jerusalem, 1964; Temple Shaaray Tefila, NYC, 1964; U. of Rhode Island, 1972; International Synagogue, Kennedy International Airport, 1972. **Awards:** L. C. Tiffany Grant, 1933; Paris World's Fair, 1937, Silver Medal; MMA, Artists for Victory, $3,000 Second Prize, 1942; Boston Arts Festival, Third Prize for Sculpture, 1954; PAFA, Hon. Men., 1954; Audubon Artists, Prize for Sculpture, 1955; NIAL Grant, 1956; Boston Arts Festival, First Prize, 1963; NIAL, Award of Merit Medal, 1963. **Address:** 526 West Broadway, NYC. **Dealer:** The Forum Gallery. **One-man Exhibitions:** (first) Gallery 144, NYC, 1932; Boyer Gallery, Philadelphia, 1935; Boyer Gallery, NYC, 1937; A.A.A. Gallery, NYC, 1942, 69; Massillon Museum, 1946; Akron/AI, 1946; Youngstown/Butler, 1946; New Paltz/SUNY, 1952; Jewish Museum, 1953; Shore Studio, Boston, 1954; Muriel Latow Gallery, Springfield, Mass., 1956; Duveen-Graham Gallery, NYC, 1957; WMAA, circ., 1959; The Marble Arch Gallery, Miami Beach, 1961; Anna Werbe Gallery, Detroit, 1962; The Forum Gallery,

1962, 64, 67, 72, 73; Irving Galleries, Inc., Milwaukee, 1963; New School for Social Research, 1971; NCFA, 1974; Leonard Hutton Gallery, NYC, 1974. **Group:** WMAA Sculpture Annuals; Sculptors Guild Annuals; PAFA; A.F.A., Sculpture in Wood, circ., 1941-42; American Painting and Sculpture, Moscow, 1959; MOMA, The Making of Sculpture, circ., 1961-62; Smithsonian, Drawings by Sculptors, circ. USA, 1961-63; New York World's Fair, 1964-65. **Collections:** Ain Harod; Andover/Phillips; Atlanta/AA; Baltimore/MA; Bezalel Museum; Boston/MFA; Brandeis U.; Brooklyn Museum; Bryn Mawr College; Chicago/AI; Colby College; Dayton/AI; Des Moines; Fairleigh Dickinson U.; U. of Georgia; Haifa; Jewish Museum; Kalamazoo/Institute; Kansas City/Nelson; U. of Kansas; La Jolla; MMA; MOMA; Massillon Museum; Milwaukee; U. of Minnesota; Newark Museum; Ogunquit; PAFA; PMA; Phoenix; Queens College; Reading/Public; Reed College; Rutgers U.; Scranton/Everhart; Scripps College; Smith College; Tel Aviv; WMAA; Walker; West Palm Beach/Norton; Worcester/AM; Youngstown/Butler. **Bibliography:** Baur 7; Brumme; Cheney; Craven, W.; Flanagan; **Getlein 1; Goodrich and Baur 1, 2;** Gross; **Lombardo;** McCurdy, ed.; Mendelowitz; Sutton; Wheeler. Archives.

GROSSER, MAURICE. b. October 23, 1903, Huntsville, Ala. **Studied:** Harvard U., 1920-24, with M. Mower. Traveled Europe, USA, Latin America, Africa. **Taught:** U. of Ife, Nigeria, 1970. **Member:** The Travelers, London. Librettist of the Gertrude Stein-Virgil Thomson operas, *Four Saints in Three Acts* and *The Mother of Us All.* **Address:** 219 West 14 Street, NYC 10011; Inmeuble Itese, Calle Campoamor, Tangier. **Dealers:** Richard Larcada Gallery; Capricorn Gallery. **One-man Exhibitions:** Grace Horne Galleries, Boston, 1925; Grand Central Palace, NYC, 1928; Galerie Vignon, Paris, 1931; Galerie des Quatre Chemins, Paris, 1933, 39; Hendrix, Inc.

(Gallery), NYC, 1935; Arts Club of Chicago, 1939; Julien Levy Galleries, NYC, 1940, 41, 42, 44, 46; High Museum, 1941; Houston/MFA, 1942; M. Knoedler & Co., 1948, 50; Hugo Gallery, NYC, 1954; Alexander Iolas Gallery, 1955; Carstairs Gallery, NYC, 1957, 60, 62; Carlen Gallery, Philadelphia, 1958; The Banfer Gallery, 1963, 65; U. of Ife, 1970; Hirshl & Adler Galleries, 1971; Capricorn Gallery, 1972. **Group:** U. of Minnesota; MOMA; WMAA; Cleveland/MA; VMFA. **Collections:** The Bank of New York; Cleveland/MA; Columbus; MOMA; U. of Minnesota; Rockland/Farnsworth; Springfield Art Center; VMFA; U. of Vermont. **Bibliography:** Grosser, 1, 2. Archives.

GROSSMAN, NANCY. b. April 28, 1940, NYC. **Studied:** Pratt Institute, BFA. **Awards:** Ida C. Haskell Scholarship for Foreign Travel, 1962; Guggenheim Foundation Fellowship, 1965; Pratt Institute, Inaugural Contemporary Achievement Award, 1966; AAAL, 1974. **Address:** 105 Eldridge Street, NYC 10002. **Dealer:** Cordier & Ekstrom, Inc. **One-man Exhibitions:** The

Nancy Grossman *Head* 1968

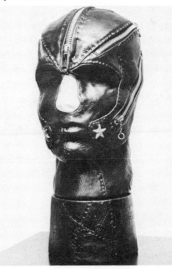

Krasner Gallery, 1964, 65 (2), 67; Cordier & Ekstrom, Inc., 1969 (two-man), 1971, 73, 75. **Group:** PAFA, 1963; Corcoran, 1963; WMAA Annuals, 1968, 73, Contemporary American Sculpture, 1968-69, Human Concern/Personal Torment, 1969; Museum of Contemporary Crafts, Face Coverings, 1970-71; Harvard U., Recent Figure Sculpture, 1972; PMA/Museum of the Philadelphia Civic Center, Focus, 1974. **Collections:** Alcoa; Baltimore/MA; U. of California, Berkeley; Columbia Broadcasting System; Cornell U.; Dallas/MFA; Hamline U.; Kutztown State College; Minneapolis/MA; Pratt Institute; Princeton U.; Ridgefield/Aldrich; Rotterdam; U. of Utah; WMAA. **Bibliography:** Nemser; *Recent Figure Sculpture.*

GROSVENOR, ROBERT. b. 1937, NYC. **Studied:** Ecole des Beaux-Arts, Dijon, 1956; Ecole Nationale des Arts Decoratifs, 1957-59; Universita di Perugia, 1958. Traveled France, England, Italy, Germany, USA, Mexico. **Taught:** School of Visual Arts, NYC. **Awards:** National Council on the Arts, 1969. **Address:** 302 Elizabeth Street, NYC 10012. **Dealer:** Paula Cooper Gallery. **One-man Exhibitions:** Park Place Gallery, NYC, 1962-66; Dwan Gallery, Los Angeles, 1966; NYU, 1967; Galerie Rolf Ricke, 1970; Fischbach Gallery, 1970; Paula Cooper Gallery, 1970, 71, 74; La Jolla, 1971; City U. of New York Graduate Center, NYC, 1973; Françoise Lambert, Milan, 1974. **Group:** New York World's Fair, 1964-65; Jewish Museum, Primary Structures, 1966; ICA, U. of Pennsylvania, 1967; Buffalo/Albright, Plus by Minus, 1968; The Hague, Minimal Art, 1968; WMAA Sculpture Annual, 1968-69; U. of Minnesota, 1969; Walker, 1969; Chicago/Contemporary, 1969; ICA, Boston, Art on Paper, 1970; Cincinnati/Contemporary, Monumetal Art, 1970; **Arnhem, Sonsbeek '71, 1971; Middelheim Park, Antwerp, XI Sculpture** Biennial, 1971; Houston/Contemporary, Eight, 1972; WMAA, 1973; Newport, R.I., Monumenta, 1974. **Collec-**

tions: Lannan Foundation; Lipschultz Foundation; MIT; MOMA; NYU; Ridgefield/Aldrich; WMAA; Walker. **Bibliography:** Battcock, ed.; Friedman, M. 2; *Monumenta;* Lippard 4; MacAgy 2; Tuchman 1. Archives.

GROSZ, GEORGE. b. July 26, 1893, Berlin, Germany; **d.** July 6, 1959, Berlin, Germany. **Studied:** Royal Saxon Academy of Fine Art, Dresden, 1909-11, with R. Muller, O. Schindler, R. Sterl, R. Wehle; School of Fine and Applied Arts, Berlin, 1911, with E. Orlik; Academie Colarossi, Paris, 1913. German Army, 1914-16, 1917-18. Traveled Russia, Europe, USA. To USA 1932; citizen 1938. **Taught:** Maurice Sterne School, NYC, 1933; ASL, 1933-36, 1940-42, 1943-44, 1950-53; Columbia U., 1941-42. Designed sets for Max Reinhardt Theatre, 1920-30. **Commissions:** A. Harris & Co., Dallas (portfolio of drawings entitled *Impressions of the City).* **Awards:** Chicago/AI, Watson F. Blair Prize, 1931, 40; Guggenheim Foundation Fellowship, 1937; PAFA, Carol H. Beck Gold Medal, 1940; Carnegie, Second Prize, 1945. **One-man Exhibitions:** (first) Goltz Gallery, Berlin, 1918; Gallery A. Flechtheim, Berlin, 1926; M. Wasservogel, Berlin, 1926; A.A.A. Gallery, NYC, 1926, 41, 43, 46, 48, 54; Club of Chicago, 1933; Crillon Galleries, Philadelphia, 1933; Milwaukee, 1933; Mayor Gallery, London, 1934; An American Place (Gallery), NYC, 1935; Contemporary Arts Gallery, NYC, 1935; Harvard U., 1935, 49, 73; Municipal U. of Omaha, 1936; Smith College, 1936 (three-man); Chicago/AI, 1938; Currier, 1939; Hudson D. Walker Gallery, NYC, 1938 (2), 1941; MOMA, 1941, 69; Denver/AM, 1943; Baltimore/MA, 1944; Leicester Gallery, London, 1946; Print Club of Cleveland, 1949; The Swetzoff Gallery, Boston, 1950; Dallas/MFA, 1952; Vera Lazuk, Cold Spring Harbor, N.Y., 1959; The Forum Gallery, 1963; E. V. Thaw, NYC, 1963; Arts Council of Great Britain, circ., 1963; Paul Kantor Gallery, Beverly Hills, Calif., 1964; Graphische Samm-

lung Albertina, 1965; Claude Bernard, Paris, 1966; Ira Spanierman Gallery, NYC, 1967, 69; Donald Morris Gallery, 1968; Peter H. Deitsch Gallery, 1968, 69; LoGiudice Gallery, Chicago, 1969; Stuttgart/WK, 1969; La Medusa Gallery, 1970; Richard Feigen Gallery, NYC, 1971; Lunn Inc., Washington, D.C., 1974; Serge Sabarsky Gallery, NYC, 1975. **Retrospective:** WMAA, 1954. **Group:** WMAA Annuals; MOMA; Chicago/AI; Los Angeles/County MA; SFMA; Newark Museum; St. Louis/City; Dallas/MFA. **Collections:** Berlin/National; Boston/MFA; Chicago/AI; Cleveland/MA; Detroit/Institute; Essen; Galerie des 20. Jahrhunderts; Harvard U.; Huntington, N.Y./Heckscher; MOMA; Newark Museum; Stuttgart; WMAA. **Bibliography: Ballo, ed.; Baur 2, 7; Bazalgette;** Bazin; Biddle 4; Bihalji-Merin; **Bittner;** Blesh 1; Bulliet 1, 2; Canaday; Cassou; Cheney; Christensen; Craven, T. 1, 2; Davidson 2; Flanagan; Frost; Genauer; *George Grosz: Dessins et Aquarelles;* Goodrich and Baur 1; **Grosz 1, 2, 3, 4, 5;** Haftman; Hess, T. B. 1; Hulten; Hunter, ed.; Huyghe; Janis, S.; Kent, N.; Kouvenhoven; Kuh 1, 3; Langui; Lynton; McCurdy, ed.; **Mehring;** Mendelowitz; Newmeyer; Pagano; Pearson 1, 2; Pousette-Dart, ed.; Read 2; Richardson, E. P.; Richter; Rodman 3; Rose, B. 1; Rubin 1; Sachs; Salvini; Seitz 3; Selz, P. 3; **Tavolato;** Verkauf; Wingler, ed. Archives.

GUERRERO, JOSE. b. October 27, 1914, Granada, Spain. **Studied:** Escuela de Artes y Oficios Artisticos, Granada, 1930-34; Real Academia de Bellas Artes de San Fernando, Madrid, 1940-44; Academie des Beaux-Arts, Paris, 1945-46. Traveled Europe, 1947-49; resided Spain, 1965-68. To USA 1949; citizen 1952. **Taught:** New School for Social Research, 1962- ; Cleveland Institute of Art, 1974; Atlanta College of Art, 1975. **Awards:** *Art in America* Magazine, New Talent, 1958; Graham Foundation Grant, 1958-59; Chevalier of the Order of Arts and Letters (France), 1959;

Society for Contemporary American Art annual prize donation to The Art Institute of Chicago, 1959. **Address:** 406 West 20 Street, NYC 10011, and Cuenca, Spain. **Dealers:** Galeria Juana Mordo; A. M. Sachs Gallery. **One-man Exhibitions:** Galerie Altarriba, Paris, 1946 (two-man); Galleria Secolo, Rome, 1948; Lou Cosyn Gallery, Brussels, 1948; St. George's Gallery, London, 1949 (two-man); Buchholz Gallery, Madrid, 1950; Arts Club of Chicago, 1954 (two-man); Betty Parsons Gallery, 1954, 57, 58, 60, 63; Rose Fried Gallery, 1964; Galeria Juana Mordo, 1964, 67, 71, 75; Buchholz Gallery, Lisbon, 1967; French & Co. Inc., 1967; Galleri Ostermalm, Stockholm, 1970; The Graham Gallery, 1970; Vali 30 Gallery, Valencia, 1972; Mikelki Gallery, Bilbao, 1972; A. M. Sachs Gallery, 1974; Galerie Wolfgang Ketterer, Munich, 1975. **Group:** SRGM, Younger American Painters, 1954; Galerie de France, 10 Jeune Peintres de l'Ecole de Paris, 1956; Salon des Realites Nouvelles, Paris, 1957; Worcester/AM, 1958; Dallas/MFA, 1958; Rome-New York Foundation, Rome, 1958; Buffalo/Albright, 1958; I Inter-American Paintings and Prints Biennial, Mexico City, 1958; WMAA Annuals, 1958, 59, 62; American Abstract Artists, 1958, 61, 62; Carnegie, 1958, 61, 63; Corcoran, 1959; Spanish Art Today, circ. Germany, Holland, Denmark, 1967-68; Spanish Culture Institute, Munich, 1968; Sweden/Goteborgs, Spanish Painters, 1970; Dublin/Municipal, International Quadriennial (ROSC), 1971; Madrid, March Foundation Collection, circ., 1973-74; Mexico City/Nacional, Masters of Spanish Contemporary Art, 1974. **Collections:** Belgian Ministry of National Education; Beloit College; Brooklyn Museum; Buffalo/Albright; California Palace; Carnegie; Chase Manhattan Bank; Chicago/AI; Cleveland/MA; Cornell U.; Cuenca; Dartmouth College; French Ministry of National Education; Friends of Art; Harvard U.; Houston/MFA; Humlebaek/Louisiana; Madrid/Nacional; NYU; New School for Social Re-

search; PAFA; Purchase/SUNY; RISD; SRGM; Sweden/Goteborgs; Toronto; WMAA; Westinghouse Electric Corp.; Yale U. Archives.

GUGLIELMI, O. LOUIS. b. April 9, 1906, Cairo, Egypt; **d.** September 3, 1956, Amagansett, N.Y. To USA 1914. **Studied:** NAD, 1920-25. Corps of Army Engineers, 1943-45. **Taught:** Louisiana State U., 1952-53; New School for Social Research, 1953. Federal A.P.: Easel painting. **Awards:** L. C. Tiffany Grant, Yaddo Fellowship, and MacDowell Colony Fellowship, 1925-32; Chicago/ AI, Ada S. Garrett Prize, 1943; Pepsi-Cola, Hon. Men., 1944; Carnegie, Hon. Men., 1944; AAAL Grant, 1946; PAFA, Joseph E. Temple Gold Medal, 1952. **One-man Exhibitions:** (first) The Downtown Gallery, 1938, also 1942, 46, 47, 51, 67; New Art Center, NYC; J. Seligmann and Co.; Julien Levy Galleries, NYC; Lee Nordness Gallery, NYC, 1958, 61, 62. **Group:** Musee du Jeu de Paume; New York World's Fair, 1939; MOMA, Americans 1943: Realists and Magic-Realists, circ., 1943; Chicago/AI, 1943; WMAA, The Precisionists, 1961; PAFA; Pepsi-Cola Co.; Newark Mu-

seum; U. of Minnesota; Denver/AM; PMA. **Collections:** Auburn U.; Britannica; Chicago/AI; Cornell U.; Cranbrook; U. of Georgia; MMA; MOMA; Newark Museum; SFMA; Tel Aviv; WMAA; Walker. **Bibliography:** Baur 7; Bethers; Blesh 1; Genauer; Goodrich and Baur 1; Haftman; Hall; Halpert; Janis, S.; McCurdy, ed.; Pagano. Archives.

GUSSOW, ALAN. b. May 8, 1931, NYC. **Studied:** Middlebury College, 1952, AB; Cooper Union, 1952-53, with Morris Kantor; Atelier 17, NYC. Traveled Europe, USA; resided Rome, two years. **Taught:** Parsons School of Design, 1956-68, Chairman, Department of Fashion Illustration, 1959-68; Sarah Lawrence College, 1958-59; U. of Massachusetts, 1968-69; Rockland Community College, Suffern, N.Y., 1974. **Commissions:** Skidmore, Owings and Merrill, Architects (mural). **Awards:** Prix de Rome, 1953-54, renewed 1954-55; Artist-in-Residence, Cape Cod National Seashore, 1968; CAPS, 1971; AFE Grant, Artist-in-Residence, Delaware Water Gap, 1974-75. US Department of the Interior,

Roy Gussow *Two Forms* 1973

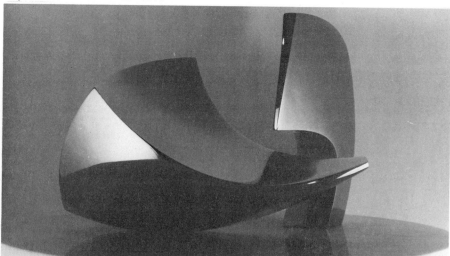

National Parks Service, Environmental Consultant, 1968- . **Address:** 121 New York Avenue, Congers, N.Y. 10920. **Dealers:** Washburn Gallery Inc.; Frost Gully Gallery. **One-man Exhibitions:** (first) Hagerstown/County MFA, 1961; Middlebury College, 1961; The Peridot Gallery, 1962, 63, 66, 67, 69, 70; Kendall Gallery, Wellfleet, Mass., 1971; The Joe and Emily Lowe Art Gallery, Syracuse, 1972; Washburn Gallery Inc., 1972, 73; Jacobs Ladder Gallery, Washington, D.C., 1974. **Retrospectives:** Portland, Me./MA, 1971; Arnot, 1975. **Group:** III Mostra di Pittura Americana, Bordighera, 1955; Main State Art Festival, 1961- ; Youngstown/Butler, 1963; U. of Nebraska; PAFA Annual, 1966; A.F.A., Maine—50 Artists of the 20th Century, circ., 1966; AAAL, 1966; Colgate U., Viewpoints 7, 1972; Omaha/Joslyn, A Sense of Place, 1973; Queens Museum, New Images, 1974. **Collections:** Arnot; Guild Hall; Montgomery Museum; U. of Nebraska; Portland, Me./MA; Wichita/AM.

GUSSOW, ROY. b. November 12, 1918, Brooklyn, N.Y. **Studied:** New York State Institute of Applied Agriculture (Farmingdale), 1938; Institute of Design, Chicago, 1945, with Lazlo Moholy-Nagy, and 1946, with Alexander Archipenko, 1948, BS. Traveled Europe and USA extensively. **Taught:** Bradley U., 1948; Colorado Springs Fine Arts Center, 1949-51; North Carolina State College, 1951-62; Pratt Institute, 1962-68. **Commissions:** US Commerce Department Trade Fair, circ. Bangkok and Tokyo, 1956 (American Pavilion); Lenoir-Rhyne College, 1957; Cooperative Savings & Loan Association, Wilmington, N.C., 1959; North Carolina State College, 1961; North Carolina State College Faculty Club, 1962; San Francisco Museum of Science and Industry, 1962; Phoenix-Mutual Building, Hartford, Conn., 1963 (8-ft. stainless steel sculpture commissioned by Max Abramovitz); Reynolds Metals Co., 1967; Tulsa Civic Center, 1968; Xerox

Corp., 1968; Creedmore State Hospital, Queens, N.Y., 1970; Heublein Inc., Farmington Conn., 1974; Family Court Building, NYC, 1975; Combustion Engineering Corp., Stamford, Conn., 1976. **Awards:** Raleigh/NCMA, **P.P.**, 1957, 61; PAFA, Hon. Men., 1958; Ford Foundation, **P.P.**, 1960, 62; National Gold Medal Exhibition for the Building Arts, NYC, 1962. **Address:** 4040 24th Street, Long Island City, N.Y. 11101. **Dealer:** Grace Borgenicht Gallery Inc. **One-man Exhibitions:** (first) Design Associates Gallery, Greensboro, N.C., 1952; The Pennsylvania State U., 1959; Grace Borgenicht Gallery Inc., 1964, 71, 73; Chicago/AI, 1947, 48, 49; U. of Arkansas, 1948; Omaha/Joslyn, 1949, 50; Denver/AM, 1949-51; SFMA, 1951; MMA, 1951; PAFA, annually 1951-59; Raleigh/NCMA, annually 1952-61; WMAA, 1956; Oakland/AM, 1959; WMAA, Sculpture Annual, 1964, 66, 68; WMAA, Contemporary American Sculpture, Selection II, 1969. **Collections:** American Tobacco Co.; Atlanta/AA; Brooklyn Museum; California Academy of Science; Equitable Life Assurance Society; MOMA; Newark Museum; U. of North Carolina; Radcliffe College; Raleigh/NCMA; Tulsa/Philbrook; WMAA. **Bibliography:** Craven, W. Archives.

GUSTON, PHILIP. b. June 27, 1913, Montreal, Canada. To USA 1916. **Studied:** Otis Art Institute, Los Angeles, for 3 months, 1930. Traveled Spain, Italy, France, USA. **Taught:** State U. of Iowa, 1941-45; Washington U., 1945-47; U. of Minnesota, 1950; NYU, 1951-59; Pratt Institute, 1953-57; Yale U., 1963; Brandeis U., 1966; Columbia U., 1969, 70, 74; New York Studio School; Skidmore College, 1968; Boston U., 1973- . Federal A.P.: 1935-40, murals: WPA Building, New York World's Fair, 1939 (façade); Queensbridge Housing Project, 1940; Forestry Building, Laconia, N.H., 1941. Section of Fine Arts (murals): Social Security Building, Washington, D.C., 1942; US Post Office, Commerce, Ga., 1938.

Trustee, American Academy, Rome. **Member:** NIAL. **Awards:** Carnegie, First Prize, 1945; Guggenheim Foundation Fellowship, 1947, renewed 1968; Prix de Rome, 1948; AAAL Grant, 1948; Ford Foundation Grant, 1948, $10,000, 1959; Boston U., Hon. DFA, 1970; College Art Association, Distinguished Teaching of Art Award, 1975. **Address:** Box 660, Woodstock, N.Y. 12498. **Dealer:** David McKee Gallery. **One-man Exhibitions:** (first) The Midtown Galleries, 1945; Boston Museum School, 1947; Utica, 1947; U. of Minnesota, 1950; The Peridot Gallery, 1952; Charles Egan Gallery, 1953; Sidney Janis Gallery, 1956, 58, 60, 61; Dwan Gallery, Los Angeles (two-man, with Franz Kline), 1962; Jewish Museum, 1966; Santa Barbara/MA, 1966, 67; Gertrude Kasle Gallery, 1969, 73, 74; Marlborough Gallery Inc., NYC, 1970; Boston U., 1970, 74; La Jolla, 1971; MOMA, 1973; David McKee Gallery, 1974. **Retrospectives:** V Sao Paulo Biennial, 1959; XXX Venice Biennial, 1960; SRGM, 1962; Amsterdam/Stedelijk, 1962; Los Angeles/County MA, 1963; Brandeis U., 1966. **Group:** U. of Illinois, 1944, 67; Walker, Contemporary American Painting, 1950; U. of Minnesota, 40 American Painters, 1940-50, 1951; MOMA, Abstract Painting and Sculpture in America, 1951; Baltimore/MA, Abstract Expressionists, 1953; MOMA, Twelve Americans, circ., 1956; Sao Paulo, 1957; WMAA, Nature in Abstraction, 1958; I Inter-American Paintings and Prints Biennial, Mexico City, 1958; MOMA, The New American Painting, circ. Europe, 1958-59; St. Louis/City, Modern American Painting, 1959; WMAA, 18 Living American Artists, 1959, also Annuals; Documenta II, Kassel, 1959; Ringling, 1961; SRGM/USIA, American Vanguard, circ. Europe, 1961-62; PAFA; SFMA; Chicago/AI; Corcoran; SRGM, circ., 1963; Tate, Painting and Sculpture of a Decade, 1954-64, 1964; Carnegie, 1964; Los Angeles/County MA, New York School: The First Generation, 1965; U. of St. Thomas (Tex.), 1967;

ASL, 1967-68; MOMA, The New American Painting and Sculpture: The First Generation, 1969; MMA, New York Painting and Sculpture: 1940-1970, 1969-70; Ente Manifestazioni Genovesi, Immagine per la Citta, Genoa, 1972; National Gallery, American Art at Mid-Century, 1973; MIT, Drawings by Five Abstract Expressionist Painters, 1975. **Collections:** Allentown/AM; Baltimore/MA; Buffalo/Albright; Chicago/AI; Cleveland/MA; Detroit/Institute; Harvard U.; High Museum; Hirshhorn; U. of Illinois; State U. of Iowa; Los Angeles/County MA; MMA; MOMA; Minneapolis/Institute; NCFA; Phillips; Purchase/SUNY; SFMA; SRGM; St. Louis/City; Seagram Collection; Tate; Utica; WMAA; Washington U.; Worcester/AM; Yale U. **Bibliography:** Arnason 2; Ashton 2, 3, 5; Baur 5; Bazin; Biddle 4; Blesh 1; Canaday; Genauer; Goodrich and Baur 1; Haftman; Henning; **Hunter** 1, 6, **7**; Hunter, ed.; Kozloff 3; McCoubrey 1; McCurdy, ed.; Nordness, ed.; O'Hara 1; Ponente; Read 2; Ritchie 1; Rose, B. 1; Sandler; Seuphor 1; Tuchman, ed.; Weller.

GUY, JAMES. b. 1910, Middletown, Conn. **Studied:** Hartford Art School, with Albertus Jones, Kimon Nicolaides. Traveled Mexico, Europe, USA. Articles on fishing for leading outdoor publications. Federal A.P.: Easel painting; mural for Hartford (Conn.) High School. **Address:** 82 Neptune Avenue, Moodus, Conn. 06469. **One-man Exhibitions:** (first) Boyer Gallery, NYC, 1939, also 1940; Ferargil Galleries, NYC, 1941, 42, 44; a gallery in Hollywood, Calif., 1945; Lehigh U., 1945; Bennington College, 1947; Carlebach Gallery, NYC, 1949, 50; MacMurray College, 1949; St. Louis/City, 1952; Hartford College for Women, 1960; Wesleyan U., 1961; Rose Fried Gallery; Charles Egan Gallery, 1969. **Group:** Paris World's Fair, 1937; New York World's Fair, 1939; Golden Gate International Exposition, San Francisco, 1939; WMAA Annuals; MOMA; MMA; Chicago/AI. **Collections:** Hartford/

Wadsworth, The Miller Co.; The Olsen Foundation Inc.; SRGM; Society of the Four Arts. **Bibliography:** Hall.

GWATHMEY, ROBERT. b. January 24, 1903, Richmond, Va. **Studied:** North Carolina State College, 1924-25; Maryland Institute, 1925-26; PAFA, 1926-30, with George Harding, Daniel Garber. Traveled Europe, Caribbean, Mexico, Egypt. **Taught:** Beaver College, 1930-37; Carnegie Institute of Technology, 1938-42; Cooper Union, 1942-68; Boston U., 1968-69; Syracuse U., 1970. **Member:** Artists Equity; NIAL; NAD. **Commissions:** US Post Office, Eutaw, Ala. **Awards:** PAFA, Cresson Fellowship, 1929, 30; US Government 48 State Mural Competition winner, 1939; San Diego, First Prize, Watercolors, 1940; Carnegie, Second Prize, 1943; Lessing J. Rosenwald Fund Fellowship, 1944; AAAL Grant, 1946; Corcoran, Fourth Prize, 1957; NAD, Joseph Isidor Gold Medal, 1971. **Address:** Box 108, Amagansett, N.Y. 11930. **Dealer:** Terry Dintenfass, Inc. **One-man Exhibitions:** (first) ACA Gallery, 1940, also 1946, 49; VMFA; Terry Dintenfass, Inc., 1961, 64, 68, 71, 74. **Retrospective:** Randolph-Macon Woman's College, 1967; Boston U., 1969. **Group:** WMAA Annuals; Corcoran; PAFA; MMA; Boston/MFA; Carnegie, 1964, 65; U. of Illinois, 1965; NAD, 1973; St. Joseph/Albrecht, Drawing—America: 1973, 1973; Ball State U. Annual, 1974. **Collections:** Alabama Institute; Auburn U.; Birmingham, Ala./MA; Boston/MFA; Brandeis U.; Brooklyn Museum; California Palace; Carnegie; U. of Georgia; Guild Hall; Hirshhorn; IBM; U. of Illinois; Los Angeles/County MA; U. of Nebraska; U. of Oklahoma; PAFA; PMA; Randolph-Macon Woman's College; U. of Rochester; St. Joseph/Albrecht; San Diego; Sao Paulo; Savannah/Telfair; Springfield, Mass./MFA; U. of Texas; VMFA; WMAA; Youngstown/Butler. **Bibliography:** Baldinger; Baur 7; Bazin; Goodrich and Baur 1; McCurdy, ed.; Mendelowitz; Nordness, ed.; Pousette-Dart, ed; Reese. Archives.

HAAS, RICHARD. b. August 29, 1936, Spring Green, Wisc. **Studied:** U. of Wisconsin, Milwaukee, 1954-58, BS; U. of Minnesota, 1961-64, MFA, with Jack Tworkov, Peter Busa, Malcolm Myers. Traveled Mexico, Europe, Morocco. US Army, 1959. **Taught:** U. of Minnesota, 1963-64; Michigan State U., 1964-68; Bennington College, 1968- . **Awards:** Taliesen Fellowship, 1955, 56; Ford Foundation **P.P.**, 1964; CAPS, 1972. **Address:** 81 Greene Street, NYC 10012. **Dealers:** Hundred Acres Gallery, Ltd.; Brooke Alexander. **One-man Exhibitions:** Bennington College, 1968, 71, 74; Hundred Acres Gallery Ltd., 1971, 73, 74; Brooke Alexander, 1972, 75; Contract Graphics Associates, Houston, 1973; Boston U., 1973; WMAA, 1974. **Group:** Walker, Five Young Minnesota Artists, 1963; Indianapolis, 1972; Yale U., American Drawing: 1970-1973, 1973; Brooklyn Museum Print Biennial, 1974. **Collections:** Chicago/AI; Fort Worth; Harvard U.; Houston/MFA; MMA; Minneapolis/Institute; WMAA; Yale U.

HADZI, DIMITRI. b. March 21, 1921, NYC. **Studied:** Polytechnic Institute of Brooklyn; Cooper Union; Polytechneion, Athens; Museo Artistico Industriale, Rome; Brooklyn Museum School. US Air Force, 1943. Traveled Europe,

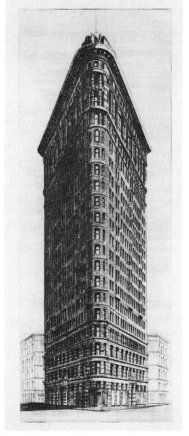

Richard Haas *Flatiron Building* 1973

USA. **Taught:** Dartmouth College, 1969; U. of Oregon, summer, 1974; Fullerton Junior College, 1974. **Commissions:** MIT; Philharmonic Hall, Lincoln Center for the Performing Arts, NYC; sculpture for the Reynolds Metal Co. Memorial Award; Sun Life Insurance Co., Baltimore; John F. Kennedy Federal Office Building, Boston; Federal Reserve Bank, Minneapolis, 1971; St. Paul's Church, Rome; Lane County's Public Service Building. **Awards:** Fulbright Fellowship (Greece), 1950; L. C. Tiffany Grant, 1955; Guggenheim Foundation Fellowship, 1957; NIAL, 1962; American Academy, Rome, 1973-74. **Address:** 435 West 23 Street, NYC 10011; Via Elenora Pimentel 2, Rome 00195, Italy. **Dealers:** Alpha Gallery; Richard Gray Gallery; Jodi Scully Gal-

lery; Galleria d'Arte l'Obelisco. **One-man Exhibitions:** Galleria Schneider, Rome, 1958, 60; Seiferheld Gallery, NYC, 1959; Galerie Van der Loo, Munich, 1961; Stephen Radich Gallery, 1961; Gallery Hella Nebulung, Dusseldorf, 1962; MIT, 1963; Temple U., Rome, Temple Abroad, 1968; Felix Landau Gallery, 1969; Dartmouth College, 1969; Alpha Gallery, 1971; Richard Gray Gallery, 1972; Jodi Scully Gallery, 1973; Galleria d'Arte l'Obelisco, 1974. **Retrospective:** MIT, 1963; Tyler School, Temple U., Rome, 1968. **Group:** MOMA, New Talent, 1956; Middelheim Park, Antwerp, Outdoor Sculpture, 1957, 59, 71; Carnegie, 1958, 61; MOMA, Recent Sculpture USA, 1959; Smith College, New Sculpture Now, 1960; WMAA, Business Buys American Art, 1960; RISD, Bronze Figure Sculpture Today, 1960; U. of Nebraska, 1960; Claude Bernard, Paris, Aspects of American Sculpture, 1960; WMAA Annuals, 1960, 63; Boston Arts Festival, 1961; XXXI Venice Biennial, 1962; Seattle World's Fair, 1962; Battersea Park, London, International Sculpture Exhibition, 1963; New York World's Fair, 1964-65; Hannover/Kunstverein,

1965; The White House, Washington, D.C., 1965; Musee Rodin, Paris, 1966; Rome/Nazionale, 1970; Athens Panhellenic Exhibitions, 1973. **Collections:** Andover/Phillips; Buffalo/Albright; Chase Manhattan Bank; City of Tilburg; Fullerton Junior College; Harvard U.; Hirshhorn; MIT; MOMA; Montreal/MFA; New School for Social Research; Princeton U.; UCLA; RISD; SRGM; Smith College; Union Carbide Corp.; U. of Vermont; WMAA; Yale U. **Bibliography:** Craven, W.

HAINES, RICHARD. b. December 29, 1906, Marion, Iowa. **Studied:** Minneapolis Institute School, 1932-34; Ecole des Beaux-Arts, Fontainebleau. Traveled around the world, 1966. US Navy, combat artist, South Vietnam, 1967. **Taught:** Minneapolis Institute School, 1941; Chouinard Art Institute, 1945-54; Otis Art Institute, 1954-74. **Member:** President, California Watercolor Society, 1948, 50; American Association of University Professors. Federal A.P.: 1937-41, murals: Fort Snelling, Minn.; Sebeka (Minn.) High School; City Armory, Willmar, Minn.; US Post

Dimitri Hadzi *Thermopylae* n.d.

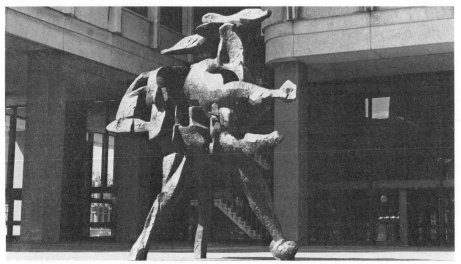

Offices in Wichita, Neb., Cresco, Iowa, Hastings, Minn., Clinton, Mo., Berwyn, Ill., Shelton, Wash. **Commissions:** Mayo Clinic, Rochester, Minn., 1952; UCLA, 1954, 63; Welton Beckett Building, Century City, Calif., 1958; U. of Kentucky, 1962; Federal Building, Los Angeles, 1965; library, Montebello, Calif., 1966-72; Temple Beth Hillel, North Hollywood, Calif., 1966. **Awards:** Vanderlip Traveling Scholarship, 1933; Los Angeles/County MA, First Award, 1944, Third Award, 1945; Oakland/AM, 1947; Denver/AM, Hon. Men., 1947; California State Fair, First **P.P.**, 1948; California Watercolor Society, First **P.P.**, 1948; SFMA, Artists Council Prize, 1948; Society of Etchers, Engravers and Lithographers, NYC, First Prize, Lithography, 1948; California State Fair, Second Award, 1949; Los Angeles Centennial, Second **P.P.**, 1949; SFMA, Art Association Prize, 1949; Corcoran, Third Award, 1951; Los Angeles County Fair, First **P.P.**, 1951; Tupperware National Competition, 600 **P.P.**, 1957. **Address:** 247 Amalfi Drive, Santa Monica, Calif. **Dealer:** Adele Bednarz Gallery. **One-man Exhibitions:** (first) Dalzell Hatfield Gallery, 1948, also 1958, 62, 64; Rutherford Gallery, San Francisco, 1957; Santa Barbara/MA, 1959; Pasadena/AM, 1960. **Group:** SFMA; Oakland/AM; Los Angeles-/County MA; MMA; Dallas/MFA; Corcoran; San Diego; Kansas City/Nelson; California State Fair; U. of Illinois; Sao Paulo Biennial. **Collections:** Arizona State College; Britannica; California State Fair; California Watercolor Society; Corcoran; Dallas/MFA; Kansas City/Nelson; Library of Congress; Los Angeles/County MA; Los Angeles County Fair; MMA; San Diego; Santa Barbara/MA; U. of Utah. **Bibliography:** Pousette-Dart, ed.

HALE, NATHAN CABOT. b. July 5, 1925, Los Angeles, Calif. **Studied:** Chouinard Art Institute, Los Angeles, 1945; ASL, 1945-50; Santa Monica City College, 1952. Traveled Mexico, Europe, South Pacific, USA, Greece, Israel.

Taught: Los Angeles City Art Education and Recreation Program, 1956-57; Pratt Institute, 1963-64; ASL, 1966-72. Designed sets for off-Broadway production of *The Affairs of Anatole*, 1958. **Member:** Architectural League of New York; Municipal Art Society of New York. **Commissions:** Architectural and portrait; sculpture for St. Anthony of Padua, East Northport, N.Y. **Awards:** Los Angeles/County MA, **P.P.** for Sculpture, 1953; Audubon Artists, 1974. **Address:** Sheffield Road, Amenia, N.Y. 12501. **Dealer:** The Midtown Galleries. **One-man Exhibitions:** (first) Felix Landau Gallery, 1957; Washington Irving Gallery, NYC, 1960; Feingarten Gallery, NYC and Chicago, 1961; The Midtown Galleries, NYC, 1964, 68, 74; Hazleton Art League, 1966; Fort Wayne/AM, 1966; Queens College, 1966; Franklin and Marshall College, 1967; NYU, 1967; Quinata Gallery, Nantucket, 1968. **Group:** J. Seligmann and Co., 1947-49; Roko Gallery, NYC, 1948-50; Los Angeles/County MA, 1953-55; Colorado Springs/FA, 1961; Hirschl & Adler Galleries, Inc., NYC, Continuing Traditions of Realism in American Art, 1962; Lehigh U., 1963; Corcoran, 1963, 64; Buffalo/Albright, 1963, 68; Wayne State U., 1964; United States Government, Art in the Embassies, 1965-66; National Art Museum of Sport, NYC, 1969. **Collections:** Indianapolis/Herron; Los Angeles/County MA; Sara Roby Foundation; Wake Forest U.

HALE, ROBERT BEVERLY. b. January 29, 1901, Boston, Mass. **Studied:** Columbia U. School of Architecture, 1923, AB; Sorbonne; with Jean Despujol, Fontainebleau and Paris; ASL, with George Bridgeman, William C. McNulty. Traveled Europe. **Taught:** ASL, 1942- ; Columbia U., 1946-67; PAFA, 1968; Cooper Union, 1972- . Fellow of the Royal Society of Arts, London; Curator Emeritus, MMA. Associate Editor, *Art News* Magazine, 1941-49. **Awards:** Hon. Memb., ASL, 1975. **Address:** 2 West 67 Street, NYC 10023. **Dealer:** Staempfli Gallery. **One-**

man **Exhibitions:** (first) Stamford (Conn.) Museum and Nature Center, 1959; Staempfli Gallery, 1960. **Collections:** U. of Arizona; Chase Manhattan Bank; MMA; Norfolk; WMAA. **Bibliography:** Biddle 4; **Hale.** Archives.

HALEY, JOHN CHARLES. b. September 21, 1905, Minneapolis, Minn. **Studied:** Minneapolis Institute School, with Cameron Booth; Hofmann School, Munich and Capri; Scuola Mosaico, Ravenna, Italy. US Navy, World War II. Traveled Europe, USA. **Taught:** U. of California, Berkeley. Federal A.P.: Fresco painter, briefly. **Commissions:** Stained glass in churches in St. Paul, Duluth, Rochester, and Benson, Minn.; a fresco at Government Island. **Awards:** San Francisco Art Association, 1936, 39, 44, 51, 53, 56; California State Fair, 1950, 51; RAC, 1956, 58. **Address:** Point Station, P.O. Box 31, Richmond, Calif. 94807. **One-man Exhibitions:** (first) SFMA, mid-1930; Mortimer Levitt Gallery, NYC, 1949, 52; U. of California, Worth Ryder Gallery, 1962; de Young, 1962; Chico State College, 1963; Four Winds Gallery, Kalamazoo, 1974. **Group:** SFMA Annuals, 1932- ; California Palace Annuals; U. of Illinois Annuals, 1948-51; III & VI Sao Paulo Biennials, 1955, 61; Chicago/AI; MMA; PAFA; Dallas/MFA; Denver/AM; RAC; Pasadena/AM; Colorado Springs/FA; Santa Barbara/MA; St. Louis/City; MOMA, circ. **Collections:** U. of California, Berkeley; Chico State College; First National Bank of Nevada; IBM; Mills College; Oakland/MA; Phillips; SFMA.

HAMMERSLEY, FREDERICK. b. January 5, 1919, Salt Lake City, Utah. **Studied:** U. of Idaho, 1936-38; San Francisco Junior College, 1938-39; Academy of Advertising Art, San Francisco, 1939-40; Chouinard Art Institute, Los Angeles, 1940-42, 1946-47, with Henry McFee; Jepson Art Institute, Los Angeles, 1947-49, with Rico Lebrun; Academie des Beaux-Arts, Paris, 1945. US Army, 1942-46. **Taught:** Jepson Art Institute, Los Angeles, 1949-51; Pomo-

na College, 1953-62; Pasadena Museum School, 1956-61 (children's painting class), 1963- (adult classes); occasional private lessons; Chouinard Art Institute, 1964-68; U. of New Mexico, 1968-71. **Awards:** Laguna Beach Art Gallery, First Prize, 1949; City of Claremont, First Prize, 1960; Youngstown/Butler, **P.P.**, 1961; Guggenheim Foundation Fellowship, 1973. **Address:** 608 Carlisle S.E., Albuquerque, N.M. 87106. **Dealer:** Brandywine Ltd. **One-man Exhibitions:** (first) Fullerton (Calif.) Art Museum, 1959; Pasadena/AM, 1961; Heritage Gallery, Los Angeles, 1961, 63; Occidental College, 1962; California Palace, 1962; La Jolla, 1963; Santa Barbara/MA; Hollis Gallery, San Francisco; Whittier College; U. of New Mexico. **Group:** SFMA, Abstract Classicists, circ. Los Angeles/County MA; ICA, London; USIA, Drawings from California, circ. Europe, 1958-59; Queens U., Belfast, 1959-60; Western Association of Art Museum Directors, circ., 1960-61; A.F.A., Purist Painting, circ., 1960-61; WMAA, Geometric Abstraction in America, circ., 1962; WMAA, Fifty California Artists, 1962-63; MOMA, The Responsive Eye, 1965; M. Knoedler & Co., Art Across America, circ., 1965-67; U. of Nebraska, Geometric Abstraction, 1974. **Collections:** U. of California; City of Claremont; U. of New Mexico; Santa Barbara/MA; US Navy; Youngstown/Butler. **Bibliography:** Rickey; Seuphor 1.

HANSEN, JAMES LEE. b. June 13, 1925, Tacoma, Wash. **Studied:** Portland (Ore.) Museum School. **Taught:** Oregon State U., 1957-58; U. of California, Berkeley, 1958; Portland (Ore.) State College, 1964-69. Founder of The Fine Arts Collaborative, 1959. **Commissions:** Vancouver (Wash.) Federal Savings and Loan Building; Land Title Building, Vancouver, Wash.; Sacred Heart Nurses Dormitory, Eugene, Ore.; Corvallis (Ore.) First Federal Savings and Loan; Alder Way Building, Portland, Ore.; St. Louise Church, Bellevue, Wash.; Providence Heights College,

Pine Lake, Wash.; St. Mary's Mission, Pioneer, Wash.; Fresno (Calif.) Civic Mall; St. Ann's Church, Butte, Mont., 1966; Holy Trinity Parish, Bremerton, Wash., 1967; Graphic Arts Center, Portland, Ore., 1968; Harrison Square, Portland (Ore.) Civic Center; State Capitol Campus, Olympia, Wash.; U. of Oregon. **Awards:** SFMA, First **P.P.**, 1952, 60; Seattle/AM, First **P.P.**, 1952; SFMA, American Trust Co. Award, 1956; Seattle/AM, Norman Davis **P.P.**, 1958; Fellow of the International Institute of Arts and Letters. **Address:** 4115 "Q" Street, Vancouver, Wash. 98663. **Dealers:** Fountain Gallery; Polly Friedlander Gallery. **One-man Exhibitions:** Kraushaar Galleries, 1952; Dilexi Gallery, San Francisco; The Morris Gallery, NYC, 1951; Fountain Gallery, 1966, 69; U. of Oregon, 1969; Cheney Cowles Memorial Museum, Spokane, 1972; Polly Friedlander Gallery, 1973. **Retrospective:** Portland, Ore./AM, 1971. **Group:** Portland, Ore./AM, 1951-60; Santa Barbara/MA; U. of Oregon; Fort Worth; U. of Washington; SFMA, 1952, 56, 60; Seattle/AM, 1952-57, 1959, 60, Northwest Annual, 1967; Denver/AM, 1952, 61; WMAA, 1953; San Diego; The Morris Gallery, NYC, 1961; State of Washington Governor's Invitational, circ., 1964-75. **Collections:** The Bank of California, N.A., Portland, Ore.; First Federal Savings and Loan Association of Corvallis; First National Bank of Oregon; First National Bank of Seattle; U. of Oregon; Portland, Ore./AM; SFMA; Seattle/AM. **Bibliography:** *Recent Figure Sculpture.*

HANSEN, ROBERT. b. January 1, 1924, Osceola, Neb. **Studied:** U. of Nebraska, with Kady Faulkner, Dwight Kirsch, 1948, AB, BFA; Escuela de Bellas Artes, San Miguel de Allende, Mexico; Universidad Michoacana, Morelia, Mexico,with Alfredo Zalce. US Army, 1943-46. Resided Mexico, Hawaii, India, Spain. **Taught:** Bradley U., 1949-55; U. of Hawaii, 1955-56; Occidental College, 1956- . **Commissions** (murals): Public School and State Library, Morelia,

Mexico. **Awards:** Fulbright Fellowship (India), 1961; Guggenheim Foundation Fellowship, 1961; Tamarind Fellowship, 1965. **Address:** 1974 Addison Way, Los Angeles, Calif. 90041. **Dealer:** Comara Gallery. **One-man Exhibitions:** (first) Peoria (Ill.) Art Center, 1951; Occidental College, 1957; Ferus Gallery, Los Angeles, 1958; Bertha Lewinson Gallery, Los Angeles, 1959; Huysman Gallery, Los Angeles, 1961; Comara Gallery, 1963, 64, 66, 68, 70, 72, 75. **Retrospectives:** Long Beach/MA, 1967; Los Angeles Municipal Art Gallery, 1973. **Group:** SFMA Annuals, 1957-59; Ball State Teachers College Annuals, 1957, 58, 60; U. of Nebraska, 1958; Oakland/AM Annuals, 1958, 60; UCLA, California Painters Under 35, 1959; Pasadena/AM, Pacific Profile, 1960; Carnegie, 1961, 64; WMAA, Fifty California Artists, 1962-63; MOMA, Recent Painting USA: The Figure, circ., 1962-63; Beloit College, 1963; Pasadena/AM, Ten Californians, 1964; WMAA Annual, 1965; US State Department, circ., 1968-70; MOMA, 1969. **Collections:** Long Beach/MA; Los Angeles/ County MA; MOMA; U. of Nebraska; Princeton U.; San Diego; WMAA.

HANSON, DUANE. b. January 17, 1925, Alexandria, Minn. **Studied:** Luther College, 1943-44; U. of Washington, 1944-45; Macalester College, 1945-46, BA; Cranbrook, 1950-51, MFA. **Traveled:** Western Europe, Egypt, USSR, Mexico, Canada, West Indies; resided seven years in Germany. **Taught:** US Dependent Schools in Germany, 1953-60; Miami-Dade, 1965-69. **Commissions:** Chase Manhattan Bank, 1975; Kansas City/Nelson, 1975. **Awards:** Harvard U., Ella Ayman Cabot Trust, 1963; Chicago/AI, Blair Award, 1974; DAAD Grant (Berlin), 1974. **Address:** 6109 Southwest 55 Court, Davie, Fla. 33314. **Dealer:** OK Harris Works of Art; Galerie de Gestlo. **One-man Exhibitions:** Cranbrook, 1951; Wilton (Conn.) Gallery, 1952; Galerie Netzel, Bremen, 1958; U. of South Florida, 1968; West Palm Beach/Nor-

Duane Hanson *Man against Wall* 1974

ton, 1968; Ringling, 1968; OK Harris Works of Art, 1970, 72, 74; Onnasch Galerie, Berlin, 1972; Chicago/Contemporary, 1974; Galerie de Gestlo, 1974. **Retrospective:** Stuttgart/WK, circ., 1974. **Group:** WMAA, Human Concern/Personal Torment, 1969; WMAA Annuals, 1970, 73; Walker, Figures/Environments, circ., 1970-71; Aachen/NG, Klischee und Antiklischee, 1970; Corcoran, Depth and Presence, 1971; Chicago/Contemporary, Radical Realism, 1971; Documenta V, Kassel, 1972; Galerie des 4 Mouvements, Paris, Hyperrealistes Americains, 1972; Harvard U., Recent Figure Sculpture, 1972; Lunds Konsthall, Sweden, Amerikansk Realism, 1973; Lincoln, Mass./De Cor-

dova, The Super-Realist Vision, 1973; Randers Kunstmuseum, Denmark, Amerikanske Realister, 1973; Hartford/Wadsworth, New/Photo Realism, 1974; Chicago/AI, 1974; CNAC, Hyperrealistes Americains/Realistes Europeens, 1974. **Collections:** Aachen/NG; Adelaide; Caracas; Cologne; Duisburg; Milwaukee; RAC; Rotterdam. **Bibliography:** *Figures/Environments; Kunst um 1970;* Sager.

HARE, DAVID. b. March 10, 1917, NYC. **Studied** in New York, Arizona, Colorado (majored in experimental color photography). Researched and published a portfolio of color photographs on the American Indian, in collaboration with Dr. Clark Whissler of the American Museum of Natural History, 1940. Editor, *VVV* (surrealist magazine), 1942-44. Lectured extensively. **Commissions** (sculpture): NYC; Massachusetts; Rhode Island; Illinois. **Address:** 34 Leroy Street, NYC. **One-man Exhibitions:** (first) Hudson D. Walker Gallery, NYC, 1939; Julien Levy Galleries, NYC, 1946; Art of This Century, 1946, 47; The Kootz Gallery, NYC, 1946, 48, 51, 52, 55, 56, 58, 59; SFMA, 1947; Galerie Maeght, 1948; Saidenberg Gallery, 1960-63; Staempfli Gallery, 1969. **Retrospective:** PMA, 1969. **Group:** MOMA, Fourteen Americans, circ., 1946; I & IV Sao Paulo Biennials, 1951, 57; WMAA, The New Decade, 1954-55; MOMA, Modern Art in the United States, circ. Europe, 1955-56; Musee Rodin, Paris, International Sculpture, 1956; Seattle/AM, circ. Far East and Europe, 1958; Brussels World's Fair, 1958; Chicago/AI, 1961; Seattle World's Fair, 1962; Pittsburgh Bicentennial, 1962; WMAA, 1962; MOMA, Dada, Surrealism and Their Heritage, 1968; MOMA, The New American Painting and Sculpture, 1969. **Collections:** Brandeis U.; Buffalo/Albright; Carnegie; Hartford/Wadsworth; MMA; MOMA; SFMA; SRGM; WMAA; Washington U.; Yale U. **Bibliography:** Baur 5; Biddle 4; Blesh 1; Breton 3; Brumme; Calas; Craven, W.; Giedion-

Welcker 1; Goodrich and Baur 1;
Goossen 5; Hess, T. B. 1; Hunter 6; Janis
and Blesh 1; Janis, S.; McCurdy, ed.;
Mendelowitz; Miller, ed. 2; Motherwell
and Reinhardt, eds.; Paalan; Read 3;
Ritchie 3; Rodman 1; Rose, B. 1; Rubin 1;
Seuphor 3; Trier 1; Waldberg 4.
Archives.

HARRIS, PAUL. b. 1925, Orlando, Fla.
Studied with Jay Karen Winslow, Or-
lando, Fla.; Chouinard Art Institute;
New School for Social Research (with
Johannes Molzahn); U. of New Mexico;
Hans Hofmann School. **Taught:** U. of
New Mexico; Knox College, Jamaica, W.
I.; New Paltz State College; Montclair
State College; California Institute of the
Arts, Valencia; Universidad Catolica,
Santiago; California College of Arts and
Crafts. Editorial Associate, *Art News*
Magazine, 1955-56. **Commissions:** U.
of New Mexico. **Awards:** Fulbright
Fellowship (Chile), 1962-63; Tamarind
Fellowship, 1969-70. **Address:** Box 214,
Bolinas, Calif. 94924. **Dealers:** Poindex-
ter Gallery; William Sawyer Gallery.
One-man Exhibitions: Poindexter Gal-
lery, 1961, 63, 67, 70, 72; The Lanyon
Gallery, 1965; Berkeley Gallery, San
Francisco, 1965; Candy Store Art Gal-
lery, Folsom, Calif., 1967; William Saw-
yer Gallery, 1969, 71; M.E. Thelen
Gallery, Essen, 1970; SFMA, 1972; U. of
California, Santa Barbara, 1972; U. of
New Mexico, 1973; Arkansas Art Cen-
ter, Little Rock, 1974. **Group:** New
School for Social Research; U. of New
Mexico; MOMA, Recent Sculpture
USA, 1959, Hans Hofmann and His
Students, circ., 1963; Chicago/AI, 1965;
New York World's Fair, 1964-65; IX Sao
Paulo Biennial, 1967; Los Angeles/
County MA, American Sculpture of
the Sixties, circ., 1967; Dusseldorf/
Kunsthalle, Prospect '68, 1968; NCFA,
New American Figurative, 1968; Tren-
ton/State, Soft Art, 1969; International
Exhibitions Foundation, Washington,
D.C., Tamarind: A Renaissance of
Lithography, circ., 1971-72. **Collec-
tions:** Aachen/NG; Los Angeles/Coun-
ty MA; MOMA; U. of New Mexico; Yale
U. **Bibliography:** Tuchman 1.

HARTELL, JOHN. b. January 30, 1902,
Brooklyn, N.Y. **Studied:** Cornell U.
(Architecture), 1925; Royal Academy of
Fine Arts, Stockholm. Traveled Europe,
Puerto Rico, England. **Taught:** Clemson
College (Architecture), 1927-28; U. of
Illinois, 1928-30; Cornell U., now Prof.
Emeritus after teaching since 1930.
Awards: Utica, 1948, 52; Illinois Wesley-
an U., 1950; New York State Fair, 1951;
U. of Rochester, 1953; Fellow of the
American Scandinavian Foundation.
Address: 319 The Parkway, Ithaca, N.Y.
14850. **Dealer:** Kraushaar Galleries.
One-man Exhibitions: Kleemann Gal-
lery, NYC, 1937; Kraushaar Galleries,
1943, 45, 49, 53, 57, 63, 66, 69, 72;
Cornell U., 1943, 46, 53, 57, 62, 66;
Wells College, 1945, 49, 55; Utica, 1952;
U. of Rochester, 1954; Upstairs Gallery,
Ithaca, N.Y., 1968, 73; Lehigh U., 1971.
Group: Architectural League of New
York, 1932; U. of Rochester, 1943, 53,
54; ICA, Boston; Cincinnati/AM, 1945;
St. Louis/City, 1945; Carnegie, 1945-
47; WMAA, 1946, 50, 53; Utica, 1948,
51, 52, 54; Illinois Wesleyan U., 1950, 57;
U. of Illinois, 1951; PAFA, 1953; US
State Department, Traveling Show to
Australia, 1967-68; Indianapolis/Her-
ron, 1970. **Collections:** Atlanta U.;
Cornell U.; Illinois Wesleyan U.; U. of
Nebraska; Utica; Wake Forest U.

HARTIGAN, GRACE. b. March 28,
1922, Newark, N.J. **Studied** with Isaac
Lane Muse, NYC, mid-1940's. Traveled
Europe; resided Mexico, 1949. Designed
set for *Red Riding Hood,* by Kenneth Koch,
for the Artists Theater, NYC, 1953.
Taught: Maryland Institute, Artist-in-
Residence, 1967- . **Awards:** Moore
Institute of Art, Science and Industry,
Hon. DFA, 1969; AAAL, Childe Hassam
Fund Purchase, 1975. **Address:** 1710 ½
Eastern Avenue, Baltimore, Md. 21231.
Dealer: William Zierler Inc. **One-man
Exhibitions:** (first) Tibor de Nagy
Gallery, 1951, also 1952-55, 1957, 59;
Vassar College, 1954; Gres Gallery,
Washington, D.C., 1960; Chatham
College, 1960; Carnegie, 1961; Martha
Jackson Gallery, 1962, 64, 67, 70; U. of
Minnesota, 1963; Franklin Siden Gal-

lery, Detroit, 1964; Kent State U., 1966; The U. of Chicago, 1967; Maryland Institute, 1967; Gertrude Kasle Gallery, 1968, 70, 72, 74; Grand Rapids, 1968 (two-man); William Zierler Inc., 1975. **Group:** Ninth Street Exhibition, NYC, 1951; U. of Minnesota, Rising Talent, 1955; MOMA, Modern Art in the United States, circ. Europe, 1955-56; MOMA, Twelve Americans, circ., 1956; Jewish Museum, The New York School, Second Generation, 1957; International Biennial Exhibition of Paintings, Tokyo; IV Sao Paulo Biennial, 1957; MOMA, The New American Painting, circ. Europe, 1958-59; Brussels World's Fair, 1958; ART:USA:59, NYC, 1959; Documenta II, Kassel, 1959; Walker, 60 American Painters, 1960; SRGM, Abstract Expressionists and Imagists, 1961; SRGM/USIA, American Vanguard, circ. Europe, 1961-62; WMAA Annual, 1963; PAFA, 1963, 68; Ghent, The Human Figure since Picasso, 1964; White House Festival of the Arts, Washington, D.C., 1965; Drexel Institute of Technology, 1966; Flint/Institute, 1966; U. of Illinois, 1967, 69; Ball State U., Collages by American Artists, 1971; Delaware Art Museum, American Painting since World War II, 1971; WMAA, Frank O'Hara: A Poet Among Painters, 1974. **Collections:** American Republic Insurance Co.; American U.; Baltimore/MA; Bezelel Museum; Brandeis U.; Brooklyn Museum; Buffalo/Albright; Carnegie; Chicago/AI; The U. of Chicago; Flint/Institute; Grand Rapids; Hartford/Wadsworth; Kansas City/Nelson; MMA; MOMA; Minneapolis/Institute; NCFA; New Paltz/SUNY; New School for Social Research; Oklahoma; PAFA; PMA; Princeton U.; RISD; Raleigh/NCMA; Ringling; Vassar College; WGMA; WMAA; Walker; Washington U.; Woodward Foundation. **Bibliography:** *Art: A Woman's Sensibility;* Friedman, ed.; Goodrich and Baur 1; Haftman; Hunter 1, 6; Hunter, ed.; McCurdy, ed.; *Metro;* Nemser; Nordness, ed.; Read 2.

HARTL, LEON. b. January 31, 1889, Paris, France; **d.** December 1973, Sche-nectady, N.Y. To USA 1912; citizen 1922. Self-taught. Expert on aniline dyes. **Taught:** Brooklyn Museum School. **Member:** Artists Equity. Federal A.P.: Easel painting. **Awards:** NIAL, Marjorie Peabody Waite Award, 1959; Youngstown/Butler, Hon. Men., 1960; MacDowell Colony Fellowship, 1959-61; Yaddo Fellowship, 1960, 61, 63; Ingram Merrill Foundation Grant, 1968. **One-man Exhibitions:** (first) Whitney Studio Club, NYC, 1925, also 1926; Curt Valentine Gallery, NYC, 1927, 30, 36; Joseph Brummer Gallery, NYC, 1934, 38; The Peridot Gallery, 1954, 55, 58, 60, 62, 64, 66; The Zabriskie Gallery, 1967; Ingber Art Gallery, 1971. **Group:** Youngstown/Butler; Carnegie; Chicago/AI; Corcoran; Independent Artists, NYC, 1917, 18, 19; NIAL; Palazzo del Parco, Bordighera; PAFA; U. of Nebraska. **Collections:** Corcoran; Hallmark Collection; Hartford/Wadsworth; U. of Nebraska; Phillips; Society of New York Hospitals; Syracuse U.; WMAA. Archives.

HARTLEY, MARSDEN. b. January 4, 1877, Lewiston, Me.; **d.** September 2, 1943, Ellsworth, Me. **Studied:** Cleveland Institute of Art, 1892, with C. Yates, N. Waldeck, C. Sowers; privately with John Semon; W. M. Chase School, NYC, 1898-99, with Frank V. DuMond, William M. Chase, F. L. Mora; NAD, 1900, with F. C. Jones, E. M. Ward, G. W. Maynard, E. H. Blashfield, F. J. Dillman, F. S. Hartley. Traveled USA extensively; Germany, France, Mexico. Federal A.P.: Easel painting. **Awards:** Guggenheim Foundation Fellowship, 1931. **One-man Exhibitions:** (first) Photo-Secession, NYC, 1909, also 1912, 14; The Daniel Gallery, NYC, 1915; Montross Gallery, NYC, 1920; Anderson Galleries, NYC, 1921; Stieglitz's Intimate Gallery, NYC, 1926-29; Arts Club of Chicago, 1928, 45; An American Place (Gallery), NYC, 1930, 36, 37; The Downtown Gallery, 1932; Galeria de la Escuela Nacional de Artes Plasticas, Mexico City, 1933; Hudson D. Walker Gallery, NYC, 1938, 39, 40; Carlen

Gallery, Philadelphia, 1938; Symphony Hall, Boston, 1939; Portland, Ore./AM, 1940; California Palace, 1940; Walker, 1940; M. Knoedler & Co., 1942, 44, 68; Phillips, 1943; P. Rosenberg and Co., 1944, 47, 48, 50, 55; Macbeth Gallery, NYC, 1945; Indianapolis/Herron, 1946; The Bertha Schaefer Gallery, 1948, 56; U. of Minnesota, 1952; Santa Fe, N.M., 1958; The Babcock Gallery, 1959-61; Shore Studio, Boston, 1962; Alfredo Valente Gallery, NYC, 1966; La Jolla, 1966; Colby College, 1967; U. of Southern California, 1968; Tucson Art Center, 1969; U. of Texas, 1969; Danenberg Gallery, 1969; U. of Kansas, 1972. **Retrospectives:** Cincinnati/AM, 1941; MOMA, 1944; A.F.A., circ., 1960; Danenberg Gallery, 1969. **Group:** The Armory Show, 1913; The Forum Gallery, 1916; Brooklyn Museum, 1926; WMAA, 1935, 38; U. of Minnesota, 1937; Baltimore/MA, 1942. **Collections:** Andover/Phillips; Barnes Foundation; Boston/MFA; Bowdoin College; Brooklyn Museum; Buffalo/Albright; Carnegie; Amon Carter Museum; Cleveland/MA; Colorado Springs/FA; Columbus; Cornell U.; Denver/AM; Des Moines; Detroit/Institute; U. of Georgia; Hartford/Wadsworth; Indiana U.; Kalamazoo/Institute; Lewiston (Me.) Public Library; Los Angeles/County MA; Louisville/Speed; MMA; MOMA; U. of Michigan; Milwaukee; U. of Minnesota; U. of Nebraska; Newark Museum; Omaha/Joslyn; PMA; Pasadena/AM; Phillips, Phoenix; Portland, Ore./AM; SFMA; St. Louis/City; San Antonio/McNay; Santa Barbara/MA; Santa Fe, N.M.; Smith College; U. of Texas; Utica; VMFA; Vassar College; WMAA; Walker; Wichita/AM; Williams College; Worcester/AM; Yale U.; Youngstown/Butler. **Bibliography:** *Avant-Garde Painting;* Barker 1; Baur 7; Bazin; Biddle 4; Blesh 1; Born; Brown; Cahill and Barr, eds.; Canaday; Chipp; Coke 2; Eliot; Flexner; Frank, ed.; Frost; Goldwater and Treves, eds.; Goodrich and Baur 1; Haftman; **Hartley;** Hunter 6; *Index of 20th Century Artists;* Janis, S.; Kootz 1, 2; **McCausland;** McCoubrey 1; McCurdy, ed.; Mellquist; Mendelowitz; Phillips 2; Read 2; Richardson, E. P.; Ritchie 1; Rodman 2; Rose, B. 1, 4; Soby 6; Sutton; Tashjian; **Well, ed.;** Wight 2; Wright 1. Archives.

HARTMAN, ROBERT. b. December 17, 1926, Sharon, Pa. **Studied:** U. of Arizona, BFA, MA; Colorado Springs/FA, with Peppino Mangravite, 1947, with Vaclav Vytlacil, Ludwig Sander, Emerson Woelffer, 1951; Brooklyn Museum School, with William King, Hui Ka Kwong, 1953-54. **Taught:** U. of Arizona, 1952-53; Texas Technological College, 1955-58; U. of Nevada, 1958-61; U. of California, 1961- . **Awards:** Youngstown/Butler, **P.P.,** 1955; La Jolla, 1962; SFMA, Emanuel Walter Bequest and Purchase Award, 1966; IV International Young Artists Exhibit, America-Japan, Tokyo, Hon. Men., 1967. **Address:** 1265 Mountain Boulevard, Oakland, Calif. 94611. **Dealers:** The New Bertha Schaefer Gallery; Hank Baum Gallery, San Francisco. **One-man Exhibitions:** (first) Kipnis Gallery, Westport, Conn., 1954; Roswell, 1957; U. of Nevada, 1958; U. of California, 1961; RAC, 1963; Comara Gallery, 1963, 65; Berkeley Gallery, 1965, 67, 68; The Bertha Schaefer Gallery, 1966, 69, 74; Santa Barbara/MA, 1973; Hank Baum Gallery, San Francisco, 1973. **Group:** New York World's Fair, 1964-65; U. of Illinois, 1965; M. Knoedler & Co., Art Across America, 1965-67; San Francisco Art Association, 1966; VMFA, American Painting, 1966; U. of Washington, 1967; Colorado Springs/FA, 1967; IV International Young Artists Exhibit, America-Japan, Tokyo, 1967. **Collections:** Achenbach Foundation; Colorado Springs/FA; Dublin/Municipal; Long Beach/MA; Mead Corporation; NCFA; Oakland/AM; Roswell; SFAI; U. of Washington; Youngstown/Butler.

HARVEY, JAMES. b. March 9, 1929, Toronto (Ont.), Canada; **d.** July 15, 1965, NYC. **Studied:** Chicago Art Institute School, with Paul Wieghardt,

BFA. Traveled Middle East, Europe, Russia. **Awards:** Fulbright Fellowship (Egypt), 1953; Yaddo Fellowship, 1960. **One-man Exhibitions:** (first) Roko Gallery, NYC, 1953; Cairo, Egypt, 1954; Parma Gallery, NYC, 1956, 58; The Graham Gallery, 1959, 60, 61, 63; Gertrude Kasle Gallery, 1968. **Group:** MMA, American Paintings Today, 1950; WMAA Annual, 1952; WMAA, Fulbright Artists, 1958; Baltimore/MA, 1958; WMAA, Young America, 1960; Corcoran, 1960; Yale U., 1961. **Collections:** Toronto. Archives.

HARVEY, ROBERT. b. September 16, 1924, Lexington, N.C. **Studied:** Ringling School of Art, with Elmer Harmes, Georgia Warren; San Francisco Art Institute, with Nathan Oliveira, Sonia Gechtoff. Traveled Great Britain, France, North Africa, Italy; resided Spain, 1966-68. **Awards:** Corcoran, Hon. Men. and Ford Foundation Purchase, 1963; San Francisco Art Festival, Award of Merit, 1963; Western Washington State College, **P.P.**, 1965; Mead Painting of the Year, 1967. **Address:** La Huerta del Angel, Macharaviaya, Malaga, Spain. **Dealers:** The Krasner Gallery; Charles Campbell Gallery; Brena Gallery; Gallery Malacke. **One-man Exhibitions:** (first) Saidenberg Gallery, 1954; Gump's Gallery, 1959, 61, 63, 64; La Escondida, Taos, N.M., 1962; Bedell Gallery, Santa Fe, N.M., 1962; Terry Dintenfass, Inc., 1963; Phoenix, 1964; Jefferson Gallery, 1964; David Stuart Gallery, 1964, 65, 67, 69; 75; Wichita/AM, 1965; Sacramento/Crocker, 1965; The Krasner Gallery, 1967-74; San Diego, 1968; Richard White Gallery, Seattle, 1969; Owen Gallery, Denver, 1970-74; Charles Campbell Gallery, 1972, 74; Parlade, Marbella, 1972; Galeria Diaz Lario, Malaga, 1975; Gallery Malacke, 1975. **Retrospective:** Ringling, 1970; Sacred Heart College, Atherton, Calif., 1974. **Group:** Corcoran, 1963, Biennial, 1967; de Young, New Images of San Francisco; Oakland/AM; California Palace; Kansas City/Nelson; Denver/AM; Santa Barbara/MA; Phoe-

nix; Santa Fe, N.M.; Raleigh/NCMA, 1965; VMFA, American Painting, 1966; Youngstown/Butler, 1966; U. of Illinois, 1967, 69. **Collections:** City of San Francisco; Corcoran; Crown Zellerbach Foundation; Hirshhorn; Mead Corporation; Stanford U.; Storm King Art Center; Western Washington State College; Wichita/AM.

HATCHETT, DUAYNE. b. May 12, 1925, Shawnee, Okla. **Studied:** U. of Oklahoma (with John O'Neil), 1950, BFA, 1952, MFA. **Taught:** U. of Oklahoma, 1949-50; Oklahoma City U., 1951-54; U. of Tulsa, 1954-64; The Ohio State U., 1964-65; Buffalo/SUNY, 1968- . **Commissions:** First National Bank of Tulsa; Boston Avenue Methodist Church, Tulsa; Trader's National Bank, Kansas City, Mo.; Northeastern State College; Tulsa Fire Department. **Address:** 347 Starin Avenue, Buffalo, N.Y. 14216. **One-man Exhibitions:** Haydon Calhoun Gallery, Dallas; U. of Oklahoma; Oklahoma State U.; Oklahoma; Bryson Gallery, Columbus, Ohio; Royal Marks Gallery, 1966, 68, 69, 70; Tulsa/Philbrook (three-man), 1973; Rochester Institute of Technology, 1973; Buffalo/Albright, 1974. **Group:** New York World's Fair, 1964-65; WMAA Sculpture Annual, 1966, 68; U. of Illinois, 1967; Los Angeles/County MA, American Sculpture of the Sixties, 1967; Carnegie, 1967; HemisFair '68, San Antonio, 1968; U. of Minnesota, 1969; U. of Nebraska, American Sculpture, 1970; Carnegie, 1970. **Collections:** Alcoa; Andover/Phillips; Atlanta Corp.; Carnegie; Columbus; Dallas/MFA; Fort Worth; State U. of Iowa; U. of Minnesota; The Ohio State U.; Oklahoma; U. of Oklahoma; Ridgefield/Aldrich; San Antonio/McNay; WMAA. **Bibliography:** Tuchman 1.

HAYES, DAVID V. b. March 15, 1931, Hartford, Conn. **Studied:** U. of Notre Dame, with Antony Lauck, 1949-53, AB; Indiana U., with Robert Laurent, David Smith, 1955, MFA; Ogunquit School of Painting. US Navy, 1955-57.

Traveled USA, Europe. **Taught:** Harvard U., 1972-73. **Awards:** Hamilton Easter Field Foundation Scholarship, 1953; Silvermine Guild, Sculpture Award, 1958; Fulbright Fellowship, 1961; Guggenheim Foundation Fellowship, 1961; Chicago/AI, The Mr. & Mrs. Frank G. Logan Medal, 1951; NIAL, 1965. **Address:** P. O. Box 109, Coventry, Conn. 06238. **Dealers:** Martha Jackson Gallery; Munson Gallery; Sunne Savage Gallery. **One-man Exhibitions:** (first) Indiana U., 1955; Wesleyan U., 1958; New London, 1959; The Willard Gallery, 1961, 63, 64, 66, 69, 71; David Anderson Gallery, Paris, 1966; Galerie de Haas, Rotterdam, 1968; Bard College, 1969; U. of Arizona, 1969; U. of Connecticut, 1970; Manchester Community College, 1970; St. Joseph College, West Hartford, Conn., 1970; Connecticut College, 1971; Agra Gallery, Washington, D.C., 1971, 72; Gallery 5 East, East Hartford, Conn., 1971, 73; Harvard U., 1972; New Britain, 1972; Munson Gallery, 1973; Sunne Savage Gallery, 1973, 74; Albany/Institute, 1973; Copley Square, Boston, 1974; Martha Jackson Gallery, 1974; Columbus, 1974. **Retrospectives:** U. of Notre Dame, 1962; Utica, 1963; New London, 1966. **Group:** MOMA, New Talent; SRGM, 1958; MOMA, Recent Sculpture USA, 1959; Boston Arts Festival, 1960; Claude Bernard, Paris, 1960; Chicago/AI, 1961; Forma Viva sculpture symposium, Portoroz, Yugoslavia, 1963; Salon du Mai, Paris, 1966; Musee Rodin, International Sculpture, 1966; Houston Festival of Arts, 1966; Carnegie, 1967; Paris/Moderne, 1968; Galerie D'Eendt NV, Amsterdam, Three Americans, 1970; Lincoln, Mass./De Cordova, Sculpture in the Park, 1972; Corcoran, 1973. **Collections:** Andover/Phillips; Arizona State U.; Carnegie; U. of Connecticut; Columbus; Currier; Dallas/MFA; Detroit/Institute; Elmira College; First National Bank of Chicago; Great Southwest Industrial Park; Hartford/Wadsworth; Harvard U.; Hirshhorn; Houston/MFA; Indiana U.; MOMA; U. of Michigan; Moriarty Brothers; Musee des Arts Decoratifs; NCFA; U. of Notre Dame; Ringling; SRGM; Michael Schiavone & Sons Inc.; U. of Vermont.

HEBALD, MILTON. b. May 24, 1917, NYC. **Studied:** ASL, with Ann Goldwaithe, 1927-28; NAD, with Gordon Samstag, 1931-32; Roerich Master Institute of Arts, Inc., NYC, 1931-34; Beaux-Arts Institute of Design, NYC, 1932-35. US Army, 1944-46. Traveled Europe, Near East, North Africa, USSR; resided Italy, 1955- . **Taught:** Brooklyn Museum School, 1946-51; Cooper Union, 1946-53; U. of Minnesota, 1949; Skowhegan School, summers, 1950-52; Long Beach State College, summer, 1968. Federal A.P.: Taught sculpture and worked on sculpture project, three years. **Commissions:** Ecuador Pavilion, New York World's Fair, 1939 (façade); US Post Office, Toms River, N.J., 1940 (relief); Republic Aviation Trophy, 1942; Isla Verde Aeroport, San Juan, P.R., 1954; East Bronx (N.Y.) TB Hospital, 1954; AAAL, 1957 (portrait bust of Archibald MacLeish); Pan American Airways Terminal, NYC, 1957-58 (110-ft. bronze relief, "Zodiac"); 333 East 79 Street Building, NYC, 1962 (bronze fountain); U. of North Carolina, 1962; James Joyce Monument, Zurich, 1966; Central Park, NYC, 1973; C. V. Starr Memorial, Tokyo, 1974; Augenhaug Press, Oslo, 1975. **Awards:** ACA Gallery Competition, Exhibition Prize, 1937; Brooklyn Museum, First Prize, 1950; Prix de Rome, 1955-59. **Address:** Via Santo Celso 22, 00062 Bracciano, Italy. **Dealer:** Mickelson Gallery. **One-man Exhibitions:** ACA Gallery (prize show), 1937, also 1940; Grand Central Moderns, NYC, 1949, 52; Galleria Schneider, Rome, 1957, 63; Lee Nordness Gallery, NYC, 1959-61, 1963, 66; Mickelson's Gallery, Washington, D.C., 1963; Cheekwood, 1966; Penthouse Gallery, San Francisco, 1966; Gallery of Modern Art, 1966, 68; VMFA, 1967; Kovler Gallery, 1967-68; London Arts: Cincinnati/AM; West Palm Beach/Norton, 1969; Yares Gallery, Scottsdale,

Ariz. **Group:** Sculptors Guild, 1937-46; WMAA Annuals, 1937-63; PAFA, 1938-64; Arte Figurativo, Rome, 1964, 67; Carnegie, 1965. **Collections:** AAAL; U. of Arizona; Bezalel Museum; Calcutta; Cheekwood; James Joyce Museum; Little Rock/MFA; MOMA; Museum of the City of New York; U. of North Carolina; U. of Notre Dame; PAFA; PMA; Tel Aviv; VMFA; WMAA; Yale U. **Bibliography:** Brumme; Cheney.

HEIZER, MICHAEL. b. 1944, Berkeley, Calif. **Studied:** SFAI, 1963-64. **Address:** c/o Dealer. **Dealer:** Fourcade, Droll Inc. **One-man Exhibitions:** Galerie Heiner Friedrich, Munich, 1969; Dwan Gallery, NYC, 1970; Detroit/Institute, 1971; ACE Gallery, Los Angeles, 1974; Fourcade, Droll Inc., 1974. **Group:** WMAA, 1968, 70; Amsterdam/Stedelijk, Op Losse Schroeven, 1969; Detroit/Institute, Other Ideas, 1969; Berne, When Attitudes Become Form, 1969; Dusseldorf/Kunsthalle, Prospect '70, 1970; XXXV Venice Biennial, 1970; Cornell U., Earth Art, 1970; SRGM, Guggenheim International, 1971; Durer Centennial, Nurnberg, 1971; Rijksmuseum Kroller-Muller, Diagrams and Drawings, 1972; WMAA, American Drawings: 1963-1973, 1973; New York Cultural Center, 3**D** into 2**D**, 1973; MIT, Interventions in Landscape, 1974; Chicago/AI, 71st American Exhibition, 1974. **Bibliography:** *Art Now 74;* Calas, N. and E.; Celant; *Contemporanea; Kunst um 1970;* Lippard, ed.; Muller; *When Attitudes Become Form.*

HELD, AL. b. October 12, 1928, Brooklyn, N.Y. **Studied:** ASL, with Kimon Nicolaides, Robert B. Hale, Harry Sternberg; Academie de la Grande Chaumiere; Siquieros in Mexico, 1949. US Navy, 1945-47. Traveled France, USA. **Taught:** Yale U., 1962- . **Awards:** Chicago/AI, The Mr. and Mrs. Frank G. Logan Medal, 1964; Guggenheim Foundation Fellowship, 1966. **Address:** 435 West Broadway, NYC 10012. **Dealer:** Andre Emmerich Gallery, NYC. **One-man Exhibitions:** (first) Galerie Huit,

Paris, 1952; Poindexter Gallery, 1958 (two-man), 1959, 61, 62; Galeria Bonino, Buenos Aires, 1961; Ziegler Gallery, 1964, 70; Galerie Gunar, Dusseldorf, 1964; Andre Emmerich Gallery, NYC, 1965, 67, 68, 70, 72, 73; Amsterdam/Stedelijk, 1966; Galerie Muller, 1966; SFMA, 1968; Corcoran, 1968; ICA, U. of Pennsylvania, 1968; Houston/Contemporary, 1969; Current Editions, Seattle; Donald Morris Gallery, 1971, 74; Andre Emmerich Gallery, Zurich, 1974. **Retrospective:** WMAA, 1974. **Group:** SRGM, Abstract Expressionists and Imagists, 1961; Marlborough Fine Art Ltd., 1961; ICA, Boston, 1961; Carnegie, 1961; Dallas/MFA, 1961, 62; MOMA, Abstract American Drawings and Watercolors, circ. Latin America, 1961-63; WMAA, Geometric Abstraction in America, circ., 1962; Yale U., 1962; Corcoran, 1962; Jewish Museum, Toward a New Abstraction, 1963; Chicago/AI, 1963, 64; Los Angeles/County MA, Post Painterly Abstraction, 1964; WMAA Annuals, 1964, 65, 67, 69, 72, 73; Kunsthalle, Basel, Signale, 1965; U. of Michigan, 1965; NYU, 1965; Amsterdam/Stedelijk, New Shapes of Color, 1966; WMAA, Art of the U.S. 1670-1966, 1966; SRGM, Systemic Painting, 1966; Flint/Institute, I Flint Invitational, 1966; Jewish Museum, 1967; Documenta IV, Kassel, 1968; Chicago/AI, 1969;

Al Held *Flemish X* 1975

Fort Worth Art Museum, Drawings, 1969; VMFA, 1970; Dublin/Municipal, International Quadriennial (ROSC), 1971; Indianapolis/Herron, 1974. **Collections:** Akron/AI; Brandeis U.; Buffalo/Albright; Ciba-Geigy Corp.; Cleveland Trust Co.; Dayton/AI; First National Bank of Seattle; Greenville; Kunsthalle, Basel; MOMA; SFMA; Syracuse/Everson; Treadwell Corp.; WMAA. **Bibliography:** Al Held; Alloway 3; Battcock, ed.; Calas, N. and E.; Hunter, ed.; Rose, B. 1; **Tucker.** Archives.

HELIKER, JOHN EDWARD. b. January 16, 1909, Yonkers, N.Y. **Studied:** ASL, 1927-29, with Kimon Nicolaides, Thomas Hart Benton, Kenneth Hayes Miller, Boardman Robinson. Traveled Europe; resided Italy, two years. **Taught:** Colorado Springs Fine Arts Center; Columbia U. Federal A.P.: Easel painting. **Membership:** NIAL, 1969, vice-president, 1971-74. **Awards:** Corcoran, First Prize, 1941; Pepsi-Cola, 1946; Prix de Rome, 1948; NAD, The Adolph and Clara Obrig Prize, 1948; Guggenheim Foundation Fellowship 1952; NIAL Award, 1957; Ford Foundation, **P.P.**, 1960, 61; AAAL, Award of Merit Medal and $1000, 1967. **Address:** 865 West End Avenue, NYC. **Dealer:** Kraushaar Galleries. **One-man Exhibitions:** (first) Maynard Walker Gallery, NYC, 1936, also 1938, 41; Kraushaar Galleries, 1945, 51, 54, 68; Lehigh U., 1970; Drew U., Madison, N.J., 1971; Saint-Gaudens National Historical Site, Cornish, N.H., 1972; Edmonton Art Gallery, Alberta, 1974. **Retrospective:** WMAA, 1968. **Group:** MOMA; MMA; Corcoran; VMFA; WMAA, 1941-46, 1955-57; Chicago/AI, 1942, 43, 45; Toledo/MA, 1942, 43, 45; Carnegie, 1943-45; PAFA, 1944, 46; WMAA, The New Decade, 1954-55; Brussels World's Fair, 1958; U. of Illinois, 1961; New York World's Fair, 1964-65; Expo '70, Osaka, 1970; Huntington, N.Y./Heckscher, Windows and Doors, 1972; ASL Centennial, 1975. **Collections:** Arizona State College; Atlanta U.; Atlantic

Richfield Co.; Ball State U.; Britannica; Brooklyn Museum; Chicago/AI; Clearwater/Gulf Coast; Cleveland/MA; Colby College; Colorado Springs/FA; Columbia U.; Commerce Trust Co., Kansas City, Mo.; Corcoran; Currier; Denver/AM; Des Moines; Hartford/Wadsworth; Harvard U.; Hirshhorn; Illinois Wesleyan U.; U. of Illinois; Kansas City/Nelson; Lehigh U.; Louisville/Speed; MMA; U. of Miami; NCFA; U. of Nebraska; New Britain/American; U. of Notre Dame; Ogunquit; PAFA; PMA; The Pennsylvania State U.; RISD; U. of Rochester; SFMA; Savannah/Telfair; Storm King Art Center; U. of Texas; Utica; WMAA; Walker; Washington U.; Whitney Communications Corp.; Wichita/AM. **Bibliography:** Baur 5, 7; Goodrich and Baur 1; **Goodrich and Mandel;** Kent, N.; Nordness, ed.; Pagano; Pousette-Dart, ed.; Ritchie 1. Archives.

HENDLER, RAYMOND. b. February 22, 1923, Philadelphia, Pa. **Studied:** Academie de la Grande Chaumiere; Contemporary School of Art, NYC; Temple U.; PAFA; Philadelphia Museum School; Graphic Sketch Club, Philadelphia, intermittently 1938-51. US Army in Europe, 1942-45. Traveled Europe extensively; resided Paris. **Taught:** Assistant to Moses Soyer in NYC; adult classes, Philadelphia public school system; Contemporary School of Art, Brooklyn, N.Y., 1948-49; Fleicher Art Memorial, Philadelphia, 1953-55; Moore College of Art, Philadelphia, 1955-56; Minneapolis College of Art, 1958-62; Parsons School of Design, NYC, 1962-65; Pratt Institute, 1964-66; School of Visual Arts, NYC, 1966-68; Long Island U., 1968; U. of Minnesota, 1968- . A co-organizer of Galerie Huit, Paris, 1949. Director of the Hendler Gallery, Philadelphia, 1952-54. **Awards:** Longview Foundation Grant, 1963. **Address:** 221 Seabury Avenue South, Minneapolis, Minn. 55406. **One-man Exhibitions:** (first) Galerie Huit, Paris, 1951; Dubin Gallery, Philadelphia, 1952; Hendler Gallery, Philadelphia,

1953; Minneapolis/Institute, 1959; Rose Fried Gallery, 1962, 64, 67. **Group:** Newark Museum; Paris/Moderne; Salon d'Art Libre, Paris; U. of Pennsylvania; U. of South Carolina; Montreal/MFA; Stanford U.; U. of Manitoba; Massillon Museum; Houston/MFA; Minneapolis/Institute; Walker; NYU. **Collections:** Calcutta; Ciba-Geigy Corp.; Minneapolis College of Art; NYU; U. of Notre Dame; PAFA; PMA; J. Walter Thompson Co.; Walker.

HENRY, CHARLES T. b. February 7, 1902, Niagara Falls, N.Y. **Studied:** Kirksville State College, BS.Ed.; ASL, with Thomas Hart Benton, George Grosz. Traveled Canada, Mexico, New Zealand, USA. **Taught** privately intermittently. Life **Member** ASL, Federal A.P.: Easel painting, 1934-37; taught for US Bureau of Prisons, Atlanta, Ga., 1938-39; murals for US Labor Department, Washington, D.C., and US Post Office, Cornelia, Ga. **Awards:** L. C. Tiffany Grant, $929. **One-man Exhibitions:** (first) Eighth Street Playhouse, NYC, 1934; Theodore A. Kohn Gallery, NYC, 1934; Kirksville State College, 1936; Atlanta/AA, 1939; Laurel Gallery, NYC, 1949; Havenstrite Gallery, Los Angeles, 1949; Chabot Gallery, Los Angeles, 1951. **Group:** City of Los Angeles Annuals, 1957, 59; Los Angeles County MA; San Diego; Oakland/AM; WMAA; PAFA; NAD; Carnegie. **Collections:** Northeast Missouri State Teachers College; Tiffany Foundation.

HESSE, EVA. b. January 11, 1936, Hamburg, Germany; **d.** May 29, 1970, NYC. **Studied:** Cooper Union, 1954-57; Yale U. Summer School, Norfolk, Conn., 1957; Yale U., 1969, BFA. **Taught:** School of Visual Arts, NYC, 1968; Oberlin College, 1968. **One-man Exhibitions:** Allan Stone Gallery, 1963; Dusseldorf/Kunsthalle, 1965; Fischbach Gallery, 1968, 70; School of Visual Arts, NYC, 1971. **Retrospective:** SRGM, circ., 1972. **Group:** Brooklyn Museum, Watercolor Biennial, 1961; Riverside Museum, NYC, American

Abstract Artists, 1966; Ithaca College, Drawings 1967, 1967; U. of North Carolina, 1967; New York State Fair, Art Today: 1967, 1967; Finch College, NYC, Art in Process, 1967, 69; Moore College of Art, Philadelphia, American Drawing, 1968; Milwaukee, Directions I: Options, circ., 1968; A.F.A., Soft Sculpture, 1968; WMAA, 1968; Fort Worth Art Museum, Drawings, 1969; Trenton/State, Soft Art, 1969; ICA, U. of Pennsylvania, Plastics and New Art, 1969; Seattle/AM, 557,087, 1969; Milwaukee, A Plastic Presence, circ., 1969; Berne, When Attitudes Become Form, 1969; WMAA, Anti-Illusion: Procedures/Materials, 1969; Princeton U., American Art since 1960, 1970; Foundation Maeght, 1970; ICA, U. of Pennsylvania, Projected Art, 1970; New York Cultural Center, 3D into 2D, 1973; WMAA (downtown), Sculpture of the Sixties, 1975. **Collections:** Cologne; Dusseldorf/Kunsthalle; MOMA; Milwaukee; U. of North Carolina; Oberlin College; Ridgefield/Aldrich; WMAA. **Bibliography:** Celant; **Eva Hesse: A Memorial Exhibition;** Nemser; *When Attitudes Become Form.*

HIGGINS, EDWARD. b. 1930, Gaffney, S.C. **Studied:** U. of North Carolina, 1954, BA. **Taught:** Parsons School of Design, 1962-63; Philadelphia Museum School, 1963; Cornell U.; U. of Wisconsin; U. of Kentucky; School of Visual Arts, NYC. **Commissions** (sculpture): Cameron Building, NYC, 1962; New York State Theater, Lincoln Center, NYC, 1964. **Awards:** L. C. Tiffany Grant, 1962; Flint/Institute, I Flint Invitational, **P.P.,** 1966. **Address:** RFD #4, Box 345, Easton, Pa. 18042. **One-man Exhibitions:** (first) Leo Castelli Inc., 1960, also 1963, 66; Richard Feigen Gallery, NYC, 1964; Minneapolis/Institute, 1964. **Group:** MOMA, Recent Sculpture USA, 1959; Cornell U., 1959; Claude Bernard, Paris, 1960; WMAA, 1960, 62, Annual, 1965, Sculpture Annual, 1966; Houston/MFA, 1961; Chicago/AI, 1961; Carnegie, 1961; Seattle World's Fair, 1962; SRGM, The

Joseph H. Hirshhorn Collection, 1962; MOMA, Americans 1963, circ., 1963-64; Pasadena/AM, New American Sculpture, 1964; A.F.A., Decade of New Talent, circ., 1964; Tate, Gulbenkian International, 1964; New York World's Fair, 1964-65; WMAA, Contemporary American Sculpture, Selection I, 1966; Flint/Institute, I Flint Invitational, 1966; Documenta IV, Kassel, 1968; Duke U., 1969. **Collections:** Buffalo/Albright; Chase Manhattan Bank; Chicago/AI; Dallas/MFA; MOMA; SRGM; WMAA. **Bibliography:** Baur 7; Brown; Hunter, ed.; Janis and Blesh 1; *Metro;* Trier 1.

HILLSMITH, FANNIE. b. March 13, 1911, Boston, Mass. **Studied:** Boston Museum School, with Burns, Guthrie; U. of London, Slade School, 1930-34; ASL, 1934-35, with Alexander Brook, Yasuo Kuniyoshi, William Zorach, John Sloan; Atelier 17, NYC, 1946-50, with S. W. Hayter. **Taught:** Black Mountain College, 1945; Cornell U., 1963. **Awards:** Boston Arts Festival, First Prize, 1957, 63; Boston Museum School, Traveling Scholarship, 1958; Portland, Me./MA, First Prize, 1958. **Address:** 915 Second Avenue, NYC 10017. **One-man Exhibitions:** Norlyst Gallery, NYC, 1943; Charles Egan Gallery, 1949, 54; The Swetzoff Gallery, Boston, 1949, 50, 54, 57, 63; Colby College, 1950; Santa Barbara/MA, 1950; Milton Academy, 1952; Currier, 1954; Dayton/AI, 1954; ICA, Boston, 1954; Lincoln, Mass./De Cordova, 1954, 58; The Peridot Gallery, 1957, 58, 62, 65; Cornell U., 1963; Green Mountain College, 1965; Weeden Gallery, Boston, 1967; Fitchburg/AM, 1969; Jaffrey Civic Center, 1970; Brockton/Fuller, 1971; Thorne Gallery, Keene, N.H., 1972; Brattleboro (Vt.) Museum and Art Center, 1974. **Group:** Art of This Century, NYC; Corcoran; Phillips; A.F.A.; MOMA; Boston/MFA; Brooklyn Museum; The Print Club, Philadelphia; American Abstract Artists, 1946-58; Chicago/AI, 1947, 48, 54; WMAA, 1949, 51, 55; Walker, 1953, 54; SRGM, 1954; Carnegie, 1955; U. of Illinois,

1955, 57, 59; Federation of Modern Painters and Sculptors, 1956-58; AAAL, 1964; Hartford/Wadsworth, 1966. **Collections:** Andover/Phillips; Boston/ MFA; Currier; Harvard U.; MOMA; NYPL; PMA. **Bibliography:** Janis, S.

HINMAN, CHARLES. b. December 29, 1932, Syracuse, N.Y. **Studied:** Syracuse U., BFA, 1955; ASL (with Morris Kantor), 1955-56. Played professional baseball, Milwaukee Braves, 1954-55. US Army, 1956-58. Traveled Japan, India, Europe and around the world. **Taught:** Staten Island Academy, 1960-62; Woodmere Academy, 1962-64; Aspen Institute, Artist-in-Residence; Cornell U., 1968-69; Syracuse U., 1971. **Commissions:** Neiman-Marcus Co., Atlanta (sculpture). **Awards:** Syracuse U., Augusta Hazard Fellowship, 1955-56; Nagaoka, Japan, First Prize, 1965; Flint/Institute, First Prize, 1966; Torcuato di Tella, Buenos Aires, Special Mention, 1967. **Address:** 213 Bowery, NYC 10002. **Dealers:** Galerie Denise Rene, NYC, Paris, Dusseldorf; Hokin Gallery, Chicago and Palm Beach; Donald Morris Gallery. **One-man Exhibitions:** (first) Richard Feigen Gallery, NYC, 1964, also 1966, 67; Feigen-Palmer Gallery, Los Angeles, 1964; Oberlin College (three-man), 1965; Richard Feigen Gallery, Chicago, 1965, 66; Tokyo Gallery, 1966; Galerie Denise Rene/Hans Mayer, Krefeld, W. Germany, 1970; Galerie Denise Rene, Paris, 1971, NYC, 1972, 73, 75. **Retrospective:** Lincoln Center, 1969. **Group:** Riverside Museum, 1965; WMAA, Young America, 1965; Chicago/AI, 1965, 66, 69; SFMA, The Colorists, 1965; Nagaoka, Japan, 1965; U. of Notre Dame, 1965; Finch College, 1966; WMAA, Art of the U. S. 1670-1966; U. of Illinois, 1967; VI International Art Biennial, San Marino (Europe), 1967; Carnegie, 1967; WMAA Annual, 1967; Carnegie, 1967; WMAA Annual, 1967; Honolulu Academy, 1968; Jewish Museum, Superlimited, 1969; A.F.A., 1969; Indianapolis/Herron, 1969. **Collections:** American Republic Insurance Co.; Aspen Institute;

Boise-Cascade Corp.; Buffalo/Albright; Chase Manhattan Bank; Detroit/Institute; Flint/Institute; U. of Illinois; Lehigh U.; Los Angeles/County MA; MOMA; McCrory Corporation; Nagaoka, Japan; Oberlin College; The 180 Beacon Collection; The Pennsylvania State U.; Ridgefield/Aldrich; WMAA. **Bibliography:** Battcock, ed.; Hunter, ed.

HIRSCH, JOSEPH. b. April 25, 1920, Philadelphia, Pa. **Studied:** Philadelphia Museum School, 1927-31; privately with Henry Hensche in Provincetown; with George Luks in NYC. Traveled Europe, the Orient, USA; resided France, five years. **Taught:** Chicago Art Institute School; American Art School, NYC; U. of Utah; ASL, 1959- ; Dartmouth College, 1966; Utah State U., 1967; Brigham Young U., 1971; NAD. Artist war correspondent, 1943-44. **Member:** Artists Equity (founder and first treasurer); NAD; Philadelphia Watercolor Club; NIAL, 1967. Federal A.P.: Easel painting; first WPA murals in Philadelphia, for Amalgamated Clothing Workers Building and Municipal Court. **Awards:** Scholarship from the City of Philadelphia; PAFA, Walter Lippincott Prize; American Academy, Rome; International Institute of Education Fellowship, 1935-36; New York World's Fair, 1939, First Prize; Guggenheim Foundation Fellowship, 1942-43; Library of Congress, Pennell P.P., 1944, 45; NIAL Grant, 1947; Carnegie, Second Prize, 1947; Chicago/AI, Watson F. Blair Prize; Fulbright Fellowship, 1949; MMA, 1950; NAD, Benjamin Altman Prize, 1959, 66; NAD Annual Andrew Carnegie Prize, 1968; Davidson College, **P.P.**, 1972, 73; Oklahoma, **P.P.**, 1974. **Address:** 90 Riverside Drive, NYC 10024. **Dealer:** Kennedy Gallery. **One-man Exhibitions:** ACA Gallery, Philadelphia; A.A.A. Gallery, NYC, 1946, 48, 54; The Forum Gallery, 1965, 69, 74; Oklahoma, 1974. **Group:** WMAA; Newark Museum; Walker; MMA; Kansas City/Nelson; PAFA. **Collections:** AAAL; Andover/Phillips; U. of Arizona; Boston/MFA; Dartmouth College; U. of

Hans Hofmann *Pre-Dawn* 1960

Georgia; IBM; Kansas City/Nelson; Library of Congress; MMA; MOMA; Museum of Military History; NAD; U. of Oklahoma; PMA; Southampton/Parrish; Springfield, Mass./MFA; Harry S. Truman Library; WMAA; Walker; College of Wooster. **Bibliography:** Baur 7; Cheney; Genauer; **Joseph Hirsch;** Miller, ed. 1; Nordness, ed.; Pagano; Phillips 2; Reese; Richardson, E.P.Wight 2. Archives.

HOFMANN, HANS. b. March 21, 1880, Weissenberg, Bavaria, Germany; **d.** February 17, 1966, NYC. **Studied:** Gymnasium, Munich; Academie de la Grande Chaumiere, 1904. Resided Paris, 1904-14, with the patronage of Phillip Freudenberg, department store owner and art collector. **Taught:** Opened first art school, 1915, in Munich; held summer sessions at Ragusa, 1924, Capri, 1925-27, Saint-Tropez, 1928, 29; Chouinard Art Institute, Los Angeles, 1930; U. of California, Berkeley, summer, 1930; ASL, 1932-33; Thurn School, Provincetown, summers, 1923, 33; opened own school in NYC, 1933, own summer school in Provincetown, 1934. Stopped teaching 1958, to devote

full time to painting. US citizen 1941. **Awards:** U. of Illinois, **P.P.**, 1950; Society for Contemporary American Art, Chicago, **P.P.**, 1952; PAFA, J. Henry Schiedt Memorial Prize, 1952; Chicago/ AI, The Mr. & Mrs. Frank G. Logan Medal, 1953; Chicago/AI, Flora Mayer Witkowsky Prize, 1959; II Inter-American Paintings and Prints Biennial, Mexico City, 1960, Hon. Men.; Chicago/ AI, Ada S. Garrett Prize, 1961; Dartmouth College, hon. degree, 1962; U. of California, hon. degree, 1964; elected to the NIAL, 1964. **One-man Exhibitions:** (first) Paul Cassirer Gallery, Berlin, 1910; California Palace, 1931; New Orleans/Delgado, 1940; Art of This Century, NYC, 1944; "67" Gallery, NYC, 1944, 45; Betty Parsons Gallery, 1946, 47; The Kootz Gallery, NYC, 1947, 49, 1950-55, 1957, 58, 1960-64, 1966; Galerie Maeght, 1949; Boris Mirski Gallery, Boston, 1954; Baltimore/ MA, 1954; Rutgers U., 1956; Dartmouth College, 1962; Stanford U., 1966; Andre Emmerich Gallery, NYC, 1967-69, 1972, 73, 74, 75; Richard Gray Gallery, 1968, 72; Obelisk Gallery, 1969; David Mirvish Gallery, 1969, 73, 74; MMA, 72; John Berggruen Gallery, 1973; Buffalo/Albright, 1973; Art Museum of South Texas, Corpus Christi, 1974. **Retrospectives:** Arts Club of Chicago, 1944; Andover/Phillips, 1948; Bennington College, 1955; Philadelphia Art Alliance, 1956; WMAA, circ., 1957; The Kootz Gallery, NYC, 1959; Germanisches National Museum, Nurnberg, circ. Germany, 1962; MOMA, circ. USA, Latin America, and Europe, 1963. **Group:** Chicago/AI; U. of Illinois; Carnegie; Documenta II, Kassel, 1959; XXX & XXXIV Venice Biennials, 1960, 68; WMAA Annual, 1965; Corcoran Biennial, 1965; Marlborough-Gerson Gallery Inc., 1967; MOMA, The New American Painting and Sculpture, 1969. **Collections:** Abbott Laboratories; Andover/Phillips; Art of This Century (Peggy Guggenheim); Baltimore/MA; Buffalo/Albright; U. of California (Museum Hofmann); Chicago/AI; Cleveland/MA; Columbia Broadcasting System; Dallas/MFA; Dayton/AI; Fort Dodge/Blanden; Grenoble; U. of Illinois; Indianapolis/Herron; International Minerals & Chemicals Corp.; MMA; MOMA; Montreal/MFA; U. of Nebraska; Newark Museum; PMA; U. of Rochester; SRGM; Santa Barbara/MA; Toronto; WMAA; Walker; Washington U.; Yale U. **Bibliography:** Ashton 5; Barker 1; Baur 5, 7; Biddle 4; Blesh 1; Brion 1; Cheney; Chipp; Eliot; Goodrich and Baur 1; *The Great Decade;* **Greenberg** 1, **2**; Haftman; Henning; Hess, T. B. 1; **Hofmann; Hunter** 1, 2, 6; Hunter, ed., Janis and Blesh 1; Janis, S.; Kozloff 3; Kuh 2; **Loran 2**; McCurdy, ed.; Mendelowitz; *Metro;* Motherwell and Reinhardt, eds.; Newmeyer; Nordness, ed.; Ponente; Pousette-Dart, ed.; Read 2; Richardson, E. P.; Ritchie 1; Rose, B. 1, 4; Rothschild; Sandler; **Seitz** 1, **4**; Tapie 1; Tuchman, ed.; Weller; **Wight** 1. Archives.

HOLLAND, THOMAS. b. 1936, Seattle, Wash. **Studied:** Willamette U., 1954-56; U. of California, Santa Barbara and Berkeley, 1957-59. **Awards:** Fulbright Fellowship, 1960. **Taught:** SFAI, 1962-67; U. of California, Berkeley. **Address:** c/o Dealer. **Dealers:** Knoedler Contemporary Art; Hansen-Fuller Gallery. **One-man Exhibitions:** Universidad Catolica, Santiago, 1961; RAC, 1962; New Mission Gallery, San Francisco, 1962; Hansen-Fuller Gallery, 1962-66, 1968, 70, 72; The Lanyon Gallery, 1963-65; Nicholas Wilder Gallery, 1965, 68; Robert Elkon Gallery, 1970; Galerie Hans R. Neuendorf, Cologne, 1971; Lawrence Rubin Gallery, NYC, 1972; Ronald Greenberg Gallery, St. Louis, 1972. **Group:** SFMA, Bay Area Artists, 1964; Stanford U., Current Painting and Sculpture of the Bay Area, 1964; La Jolla, 1965; PAFA, 1968; Ringling, California Painters, 1968; U. of Illinois, 1969; Corcoran, 1969; WMAA Annual, 1969; Pasadena/AM, West Coast: 1945-1969, 1969; SFAI, Centennial Exhibition, 1971; Hamburg/Kunstverein, USA: West Coast, circ., 1972. **Collections:** Oakland/AM; RISD; SRGM;

Stanford U., Walker. **Bibliography:** *The State of California Painting; USA West Coast.*

HOLTY, CARL ROBERT. b. June 21, 1900, Freiburg, Germany; **d.** March 23, 1973, NYC. To USA 1900; citizen 1906. US Army, 1917-18. **Studied:** Marquette U., 1918-19; NAD, 1920-22; Academy of Fine Arts, Munich, 1925-26; Hofmann School, Munich. Traveled Europe. **Taught:** ASL, 1939-40, 1950-51; U. of Georgia, 1948-50; U. of California, Berkeley, summer, 1951; U. of Florida, 1952-53; Brooklyn College, 1955-60, 1964- ; U. of Wisconsin, 1961; U. of Louisville, 1962-63; lectures extensively. **Member:** Abstraction-Creation, Paris, 1931-32; American Abstract Artists, 1936-43. **Awards:** U. of Illinois, **P.P.**, 1948; Ford Foundation, 1963. **One-man Exhibitions:** J. B. Neumann Gallery, NYC, 1936-44; Karl Nierendorf Gallery, NYC, 1938; The Kootz Gallery, NYC, 1946, 48; J. B. Neumann's New Art Circle, 1951, 52; Duveen-Graham Gallery, NYC, 1956; The Graham Gallery, 1959-62, 64, 67; Poindexter Gallery, 1972; City U. of New York Graduate Center, 1972; Andrew Crispo Gallery, 1974. **Group:** WMAA; PAFA; Corcoran; Chicago/AI; MMA; St. Louis/City; Los Angeles/County MA; Cincinnati/AM; Columbus. **Collections:** U. of Arkansas; U. of California; Chattanooga/AA; Exeter; U. of Georgia; U. of Illinois; Louisville/Speed; Milwaukee; NYU; U. of Nebraska; SRGM; St. Louis/City; Seattle/AM; U. of Tennessee; U. of Texas; WMAA; U. of Wisconsin; Youngstown/Butler. **Bibliography:** Baur 7; Blesh 1; **Carl Holty Memorial Exhibition;** Hess, T. B. 1; Janis, S.; Kootz 2; McCurdy, ed.; Passloff; Ritchie 1; Seuphor 1. Archives.

HOPKINS, BUDD. b. June 15, 1931, Wheeling, W. Va. **Studied:** Oberlin College, 1949-53, BA. Traveled Europe. **Taught:** Wagner College, 1955; MOMA, summers, 1955, 56; WMAA,

Budd Hopkins *Mahler's Castle* 1972

1957-60; Pratt Institute, 1959, Provincetown, summer, 1974; RISD, 1967, 68, 69; U. of Minnesota, 1975. **Commissions:** Provincetown/Chrysler, 1958 (large painting). **Awards:** West Virginia, Arts and Humanities Council, 1972. **Address:** 246 West 16 Street, NYC 10011. **Dealers:** Tirca Karlis Gallery; William Zierler Inc. **One-man Exhibitions:** (first) Poindexter Gallery, 1956, also 1962, 63, 66, 67, 69, 71; Tirca Karlis Gallery, 1958, 60, 1962-69, 73; The Zabriskie Gallery, 1959; Kasha Heman, Chicago, 1962, 63; Art Galleries Ltd., Washington, D.C., 1963; Athena Gallery, New Haven, 1964; Bradford Junior College, 1965; Obelisk Gallery, 1966; Reed College, 1967; Exeter, 1968; William Zierler Inc., 1972, 73, 74, 75; Galerie Liatowitsch, Basel, 1974. **Retrospectives:** Huntington, W. Va., 1973; U. of North Carolina, 1974; Michigan State U., 1974. **Group:** Wagner College, 1957; Oberlin College, 3 Young Painters, 1957; Festival of Two Worlds, Spoleto, 1958; WMAA, 1958, 63, Annuals, 1965, 67, 72; WMAA, Young America, 1960; Charlotte/Mint, 1960; PAFA, 1964; Cincinnati/AM, 1968; WMAA, Free Form Abstraction, 1972; SRGM, American Painters through Two Decades, 1973; New School for Social Research, Erotic Art, 1973. **Collections:** Ashland Oil Co.; Block Drug Co.; Bradford Junior College; Ciba-Geigy Corp.; Delaware Art Museum; Hirshhorn; Historical Society of Montana; Hotel Corp. of America; Huntington, W. Va.; Litton Industries; U. of Massachusetts; Michigan State U.; Norfolk; Norfolk/Chrysler; U. of North Carolina; Oberlin College; Pioneer Aerodynamic Systems; Reading/Public; Reed College; SRGM; Simmons College; United Aircraft Corp.; WMAA; Westinghouse; Williams College.

HOPPER, EDWARD. b. July 22, 1882, Nyack, N.Y.; **d.** May 15, 1967, NYC. **Studied:** New York School of Art, 1900-06, with Kenneth Hayes Miller, Robert Henri, George Luks, A. B. Davies; a commercial art school, NYC, 1899-1900; Paris, 1906-07, 1909-10. Traveled USA, France. **Awards:** US Shipping Board, Poster Prize, 1918; Los Angeles/County MA, W. A. Bryan Prize, 1923; Chicago Society of Etchers, The Mr. & Mrs. Frank G. Logan Medal, 1923; NIAL, Gold Medal; Baltimore/MA, Hon. Men., 1931; Brooklyn Museum, 1931; PAFA, Joseph E. Temple Gold Medal, 1935; Worcester/AM, First P.P., 1935; Corcoran, William A. Clark Prize, 1937; Chicago/AI, The Mr. & Mrs. Frank G. Logan Medal, 1945; Chicago/AI, Hon. Men., 1946; Chicago/AI, Hon. DFA, 1950; Rutgers U., Hon. Litt.D., 1953; Hallmark International Competition, 1957; Edward MacDowell Medal, 1966. **One-man Exhibitions:** (first) Whitney Studio Club, NYC, 1919, also 1922; Rehn Galleries, 1924, 27, 29, 46, 48, 65; PAFA, 1925, 71; Arts Club of Chicago, 1934; Carnegie, 1937; Currier, 1959; U. of Arizona, 1963; WMAA, 1971. **Retrospectives:** MOMA, 1933; WMAA, 1960, 64. **Group:** WMAA; Chicago/AI; Boston/MFA; PAFA; Corcoran; The Armory Show, 1913; Smith College, Five Americans, 1934; Cincinnati/AM, 1948; IX Sao Paulo Biennial, 1967. **Collections:** Andover/Phillips; U. of Arizona; Boston/MFA; Brooklyn Museum; California State Library; Carnegie; Chicago/AI; Cleveland/MA; Corcoran; Hartford/Wadsworth; Harvard U.; IBM; Indianapolis/Herron; Kansas City/Nelson; Library of Congress; MMA; MOMA; Montclair/AM; Muskegon/Hackley; NYPL; U. of Nebraska; Newark Museum; New Orleans/Delgado; PAFA; Phillips; Randolph-Macon College; Terre Haute/Swope; Toledo/MA; Victoria and Albert Museum; WMAA; Walker; West Palm Beach/Norton; Wichita/AM; Worcester/AM; Yale U.; Youngstown/Butler. **Bibliography:** Barker 1; **Barr 2, 3;** Baur 7; Bazin; Blesh 1; Boswell 1; Brown; Canaday; Cheney; Christensen; Coke 1; **Du Bois 2;** Eliot; Flexner; Goldwater and Treves, eds.; **Goodrich** 1, **3, 4;** Goodrich and Baur 1; Haftman; Hall; **Hopper;** Hunter 6; *Index of 20th Century Artists;* Jewell 2; Kozloff 3; Kuh 1,

2; Langui; McCoubrey 1; McCurdy, ed.; Mellquist; Mendelowitz; Neuhaus; Newmeyer; Nordness, ed.; Pagano; Pearson 1; Phillips 1, 2; Poore; Pousette-Dart, ed.; Print Council of America; Reese; Richardson, E. P.; Ringel, ed.; Rodman 1; Rose, B. 1, 4; Sachs; Sager; Soby 5, 6; Soyer, R. 1; Sutton; Tomkins and Time-Life Books; Weller; Wight 2. Archives.

HORIUCHI, PAUL. b. April 12, 1906, Japan. Self-taught. Traveled Europe, Japan. **Commissions:** Seattle World's Fair, 1962 (free-standing mural). **Awards:** Ford Foundation, **P.P.**; Tupperware National Competition; Rockford/ Burpee, 1966; U. of Puget Sound, Hon. H.H.D.; and some 30 others. **Address:** 9773 Arrowsmith Avenue So., Seattle, Wash. 98118. **Dealer:** Gordon Woodside Gallery. **One-man Exhibitions:** (first) Seattle/AM, 1954, also 1958; Little Rock/MFA, 1958; Zoe Dusanne Gallery, Seattle, 1959, 63; Everett Junior College, 1960; U. of Arizona, 1962; Lee Nordness Gallery, NYC, 1963, 65; Felix Landau Gallery, 1963, 66; Reed College, 1964; Spelman College, 1965; Utica, 1965; Gordon Woodside Gallery, Seattle, 1965, 67, 72, 74; San Francisco, 1966, 68; Tacoma, 1967. **Retrospective:** U. of Oregon, 1969; Seattle/AM, 1969. **Group:** Rome-New York Foundation, Rome, 1959; ART:USA:59, NYC, 1959; SFMA Annuals; Denver/AM; Seattle/AM; Carnegie, 1961; Seattle World's Fair, 1962; Rikkikai (Group), Tokyo, 1963; M. Knoedler & Co., Art Across America, circ., 1965-67; VMFA, American Painting, 1966; Expo '74, Spokane, 1974; NCFA, Art of the Pacific Northwest, 1974. **Collections:** U. of Arizona; Chase Manhattan Bank; Colorado Springs/FA; Denver/AM; Everett Junior College; First National Bank of Seattle; Fort Worth; Hartford/Wadsworth; Harvard U.; Imperial Household, Tokyo; Little Rock/MFA; Lytton Savings and Loan Association; Marylhurst College; Mead Corporation; National Economics Research Association; U. of Oregon; Reed College; SFMA;

Safeco Building; Santa Barbara/MA; Seattle/AM; Seattle Civic Center; Seattle Public Library; Seattle U.; Spelman College; Spokane Coliseum; Tacoma; Tokyo/Modern; Tupperware Museum; U.S. Steel Corp.; Utica; Vancouver; Victoria (B.C.); U. of Washington.

HORWITT, WILL. b. 1934, NYC. **Studied:** Chicago/AI, 1952-54. **Awards:** Guggenheim Foundation Fellowship, 1965; L. C. Tiffany Foundation Grant, 1968. **Address:** 131 East 15 Street, NYC 10003. **Dealer:** Lee Ault & Co. **One-man Exhibitions:** Stephen Radich Gallery, NYC, 1963, 65, 67; Lee Ault & Co., 1972, 74; Tanglewood, Lenox, Mass., 1974. **Group:** MIT, Seven Sculptors, 1964; WMAA, 1964, 66, 68, 73; Flint/Institute, American Sculpture: 1900-1965, 1965; Chicago/AI, 1965; WMAA, Young America, 1965; Stephens College, 1966; Lincoln, Mass./De Cordova, Outdoor Sculpture, 1966; Hofstra U., Seven Sculptors, 1968; Middelheim Park, Antwerp, XI Sculpture Biennial, 1971. **Collections:** Boston/MFA; Chase Manhattan Bank; Hartford/Wadsworth; SRGM; Smith College; South Mall, Albany; Stephens College; Yale U.

HOVANNES, JOHN. b. December 31, 1900, Smyrna, Turkey; **d.** April 2, 1973, NYC. **Studied:** RISD. **Taught:** Cooper Union, 1945-65; ASL, 1945-46. **Awards:** Guggenheim Foundation Fellowship, 1940; Eugene Meyer Award, 1941; MMA, Artists for Victory, 1942. **One-man Exhibitions:** Robinson Galleries, NYC, 1941; AGBU, NYC, 1967. **Group:** New York World's Fair, 1939; Chicago-/AI, 1942, 43; PAFA, 1942, 43, 45, 46; WMAA, 1942-46; MMA, 1942, 51; NAD, 1943; Riverside Museum, 1943; U. of Nebraska, 1945. **Collections:** Newark Museum; Society of the Four Arts; Tel Aviv. **Bibliography:** Baur 7; Brumme. Archives.

HOWARD, CHARLES. b. January 2, 1899, Montclair, N.J. **Studied:** U. of California, Berkeley, 1921; Harvard U.; Columbia U. Traveled USA, Europe.

Taught: Camberwell School, London, 1959- . Federal A.P.: Design Supervisor, mural at US Naval Air Station, Alameda, Calif. **Awards:** SFMA, **P.P.,** 1940; SFMA, 1942; MMA, Artists for Victory, 1942; Pasadena/AM, Third Prize, 1946; California Palace, First Prize; La Tausca Competition, **P.P.,** 1947. **Address:** Granaiola, Bagni di Lucca, Ponte, Italy. **One-man Exhibitions:** (first) Whitney Studio Club, NYC, 1926; Julien Levy Galleries, NYC, 1933; Bloomsbury Gallery, London, 1935; Guggenheim Jeune (Gallery), London, 1939; Courvoisier Gallery, San Francisco, 1941; U. of California, Berkeley, 1941; SFMA, 1942; Karl Nierendorf Gallery, NYC, 1946; Hanover Gallery, 1949; Heller Gallery, Cambridge, England, 1951; Santa Barbara/MA, 1953; St. George's Gallery, London, 1958; The Howard Wise Gallery, 1965. **Retrospective:** California Palace, 1946; Whitechapel Art Gallery, London, 1956. **Group:** Salons of America, NYC, 1933; New Burlington Galleries, London, International Surrealist Exhibition, 1936; Sao Paulo, 1938; SFMA, 1940-46; Carnegie, 1941, 46; MOMA, Americans 1942, circ., 1942; Chicago/AI, 1942, 46, 48; MMA, 1942, 52; WMAA, 1943-46; Corcoran, 1943-47; California Palace, 1945-59; Tate, American Painting, 1946; Salon des Realites Nouvelles, Paris, 1949. **Collections:** Chicago/AI; Container Corp. of America; Dallas/MFA; Jesus College; MMA; Pasadena/AM; SFMA; SRGM. **Bibliography:** Baur 7; Blesh 1; Frost; Genauer; Guggenheim, ed.; **Howard;** Janis, S.; McCurdy, ed.; Miller, ed. 1; Ragon 2; Read 2; Richardson, E. P.; Ritchie 1; **Robertson 1.**

HOWARD, ROBERT A. b. April 5, 1922, Sapulpa, Okla. **Studied:** Phillips U.; U. of Tulsa, BA, MA, 1949; privately with Ossip Zadkine, Paris. Traveled Mexico and Western Europe. **Taught:** U. of North Carolina, 1951-72, 73- ; U. of Southern California, 1972-73. **Address:** 1201 Hillview Rd., Chapel Hill, N.C. 17514. **Dealer:** Royal Marks, Gallery.

One-man Exhibitions: (first) Person Hall Art Gallery, Chapel Hill, N.C., 1951; Charlotte/Mint, 1954; Greenville (N.C.) Library, 1959; Royal Marks Gallery, 1967, 68. **Group:** Syracuse, National Ceramic Exhibition, 1949; PAFA Annual, 1958; Detroit/Institute, 1958; WMAA Sculpture Annual, 1964-58; New York World's Fair, 1964-65; Los Angeles/County MA, American Sculpture of the Sixties, 1967; U. of Illinois, 1969. **Collections:** Duke U.; U. of North Carolina; Raleight/NCMA. **Bibliography:** Tuchman 1.

HUDSON, ROBERT H. b. September 8, 1938, Salt Lake City, Utah. **Studied:** San Francisco Art Institute, BFA, MFA. **Taught:** U. of California, Davis. **Awards:** RAC, 1959; San Francisco Art Festival, **P.P.,** 1961; SFMA, 1963; San Jose State College, **P.P.,** 1964; SFMA, Nealie Sullivan Award, 1965. **Address:** P.O. Box 153, Stinson Beach, Calif. **Dealers:** Nicholas Wilder Gallery; Allan Frumkin Gallery, NYC. **One-man Exhibitions:** RAC, 1961; Batman Gallery, San Francisco, 1961; Bolles Gallery, San Francisco, 1962; The Lanyon Gallery, 1964; San Francisco Art Institute, 1965; Allan Frumkin Gallery, Chicago, 1964, 68, NYC, 1965, 71; Nicholas Wilder Gallery, 1967; Michael Walls Gallery, 1970; U. of California, Berkeley, 1971. **Group:** RAC, 1959-61; La Jolla, 1961; Oakland/AM, 1961, 63; Stanford U., Some Points of View for '62, 1962; SFMA, 1962, 64; WMAA Sculpture Annual, 1964, 67, 68; WMAA, Young America, 1965; Westmoreland County-/MA, 1966; U. of California, Berkeley, Funk, 1967; Los Angeles/County MA, American Sculpture of the Sixties, 1967; Chicago/AI, 1967; Walker, 1969. **Collections:** American Republic Insurance Co.; Los Angeles/County MA; Oakland/AM; SFMA. **Bibliography:** Friedman, M. 2; Selz, P. 2; Tuchman 1.

HUETER, JAMES W. b. May 15, 1925, San Francisco, Calif. **Studied:** Pomona College, BA, MFA; Claremont Graduate School, 1963, with Henry McFee, Sueo

Serisawa, Millard Sheets, Albert Stewart; Pitzer College, 1972. **Taught:** Mount San Antonio College, 1952- ; Pomona College, 1959-60. **Awards:** Los Angeles County Fair, 1951; Pasadena/AM, 1953; Los Angeles/County MA, 1955; California State Fair, **P.P.**, 1957; Long Beach State College, 1960, 61. **Address:** 190 E. Radcliffe Drive, Claremont, Calif. 91711. **One-man Exhibitions:** Mount San Antonio College, 1952; First National Bank, Ontario, Calif., 1954; Pasadena/AM, 1955; Long Beach State College, 1957; Whittier (Calif.) Art Association, 1959; Monrovia (Calif.) Public Library, 1961; Heritage Gallery, Los Angeles, 1964, 67. **Group:** Los Angeles County Fair, 1949, 51, 52; Pasadena/AM, 1950-54; Newport Harbor, 1950, 54, 55; California State Fair, 1950-55, 1958; Chaffey College, 1951, 55, 59, 60; Los Angeles/County MA, 1952, 54, 55, 57, 58, 61; Palos Verdes, 1953, 55; Denver/AM, 1954; Youngstown/Butler, 1955, 58, 59; Long Beach/MA, 1960; RAC, 1960; California Palace, 1960; Long Beach State College, 1960, 61; Pomona College, 1961; Mount San Antonio College, 1961. **Collections:** California State Fair; Long Beach State College; Los Angeles County Fair Association; National Orange Show; Pasadena/AM; Scripps College.

HULTBERG, JOHN. b. February 8, 1922, Berkeley, Calif. **Studied:** Fresno State College, 1939-43, BA; ASL, 1941-51, with Morris Kantor; California School of Fine Arts, with Clay Spohn, Richard Diebenkorn, David Park, Clyfford Still, Mark Rothko. US Navy, 1943-46. **Taught:** Boston Museum School, 1958; ASL, summer, 1960; Portland, Ore./AM, Artist-in-Residence, 1964. **Commissions:** *Fortune* Magazine (portfolio of drawings of Newport News Shipbuilding Co.). **Awards:** CSFA, Albert M. Bender Fellowship, 1949; Corcoran, First Prize, 1955; Congress for Cultural Freedom, First Prize, 1955; Carnegie, Hon. Men., 1955; Guggenheim Foundation Fellowship, 1956; Hallmark International Competition, 1957; Chicago/AI, Norman Wait Harris Medal, 1962; Ford Foundation/A.F.A. Artist-in-Residence, 1964; NAD, Benjamin Altman Prize, 1972. **Address:** 495 Broome Street, NYC 10013. **Dealer:** Martha Jackson Gallery. **One-man Exhibitions:** (first) Contemporary Gallery, Sausalito, Calif., 1949; Korman Gallery, NYC, 1953; Martha Jackson Gallery, 1955, 58, 59, 61, 63, 66, 67, 69; ICA, London, 1956; Galerie Rive Droite, Paris, 1957; The Swetzoff Gallery, Boston, 1957; Phoenix, 1957; Galerie du Dragon, Paris, 1957, 59; Numero Galleria d'Arte, Florence, Italy, 1958; Main Street Gallery, Chicago, 1959; David Anderson Gallery, NYC, 1961; Piccadilly Gallery, 1961, 65; Museum of Malmo, Sweden, 1962; Esther Baer Gallery, 1962, 64; Roswell, 1963; Galerie Pauli, Lausanne, 1965; Galerie Anderson-Mayer, Paris, 1966; Museum of Contemporary Crafts Council, 1966; Honolulu Academy, 1967; Gallery of Modern Art, 1967; Apiaw (Gallery), Paris, 1968; Long Island U., 1968; American Cultural Center, Paris, 1968. **Group:** California Palace, 1947; MOMA, New Talent; Corcoran, 1955; WMAA Annuals, 1955, 64, 68; XXVIII Venice Biennial, 1956; Gutai 9, Osaka, 1958; Carnegie, 1958; ART:USA:**59**, NYC, 1959; Chicago/AI, 1962; Brooklyn Museum, 1964; Salon du Mai, Paris, 1964; Ghent, 1964; VIII Sao Paulo Biennial, 1965; Museo Civico, Bologna, 1965; U. of Kentucky, 1968; PAFA, 1968; AAAL, 1969. **Collections:** U. of Arizona; Atlanta/AA; Baltimore/MA; Boston U.; U. of California; Carnegie; Chase Manhattan Bank; Dallas/MFA; Davenport/Municipal; Dayton/AI; Eindhoven; Honolulu Academy; U. of Illinois; Indianapolis/Herron; MIT; MMA; MOMA; U. of Michigan; Musee Cantonal des Beaux-Arts; NYU; U. of Nebraska; New School for Social Research; Philadelphia Art Alliance; Phoenix; Quaker Ridge School; RISD; Roswell; St. Louis/City; Santa Barbara/MA; The Singer Company Inc.; Stamford Museum; Stockholm/National; WMAA; Walker. **Bibliography:** Blesh 1; Janis and Blesh 1;

Hunter, ed.; McChesney; Nordness, ed. Archives.

HUMPHREY, RALPH. b. 1932, Youngstown, Ohio. **Studied:** Youngstown U., 1951-52, 1954-56. **Taught:** ASL; Harley House, NYC, 1959-60; Bennington College, 1961-63; New School for Social Research; Hunter College. **Address:** c/o Dealer. **Dealer:** Bykert Gallery. **One-man Exhibitions:** Tibor de Nagy Gallery, 1959, 60; Gallery Mayer, NYC, 1961; Green Gallery, NYC, 1965; Bykert Gallery, 1967, 68, 69, 70, 72, 73, 74, 75; Dunkleman Gallery, Toronto, 1970; Andre Emmerich Gallery, NYC, 1971; The Texas Gallery, 1973. **Group:** SRGM, Abstract Expressionists and Imagists, 1961; SRGM, Systemic Painting, 1966; Ithaca College, 1967; Trenton/State. Focus on Light, 1967; ICA, U. of Pennsylvania, A Romantic Minimalism, 1967; MOMA, The Art of the Real, 1968; WMAA, 1969; Buffalo/Albright, Color and Field: 1890-1970, 1970; WMAA, The Structure of Color, 1971; Indianapolis, 1972; Chicago/AI, 1974. **Collections:** Bennington College; Brandeis U.; Hartford/Wadsworth; MOMA; U. of North Carolina. **Bibliography:** Alloway 3; Battcock, ed.; Goossen 1.

HUNT, RICHARD. b. September 12, 1935, Chicago, Ill. **Studied:** U. of Illinois; The U. of Chicago; Chicago Art Institute School, 1959, BA.Ed. US Army, 1958-60. Traveled Europe. **Taught:** U. of Illinois, 1960-62; Chicago Art Institute School, 1960-61; Yale U., 1964; Chouinard Art Institute, Los Angeles, 1964-65. **Commissions:** Louisiana State U., 1960. **Awards:** Chicago/AI, James Nelson Raymond Traveling Fellowship, 1957; Guggenheim Foundation Fellowship, 1962; Chicago/AI, The Mr. & Mrs. Frank G. Logan Prize. **Address:** 1503 No. Cleveland Avenue, Chicago, Ill. 60610. ˙**Dealer:** Dorsky Gallery. **One-man Exhibitions:** (first) The Alan Gallery, NYC, 1958, also 1960, 63; Stewart Rickard Gallery, San Antonio, 1960, 64; B. C. Holland Gallery, 1961, 63, 70; U. of Tulsa, 1964; Wesleyan College, 1964; Felix Landau Gallery; Cleveland/MA; Milwaukee; U. of Illinois; U. of Notre Dame; The Ohio State U.; Dorsky Gallery, 1968, 69, 71; Wisconsin State U., Oshkosh, 1969; Southern Illinois U., 1970; MOMA, 1971. **Group:** New Sculpture Group, NYC, 1960, 61; U. of Illinois; MOMA; WMAA; Michigan State U.; Smith College; Yale U.; Newark Museum; Carnegie; Seattle World's Fair, 1962; HemisFair '68, San Antonio, Tex., 1968. **Collections:** Bezalel Museum; Buffalo/Albright; Chicago/AI; Cleveland/MA; MOMA; Milwaukee; WMAA. **Bibliography:** Dover.

HUOT, ROBERT. b. September 16, 1935, Staten Island, N.Y. **Studied:** Wagner College, BS; Hunter College. Traveled Europe, Africa, Greenland, Iceland, California. **Taught:** Hunter College, 1963- . **Awards:** National Council on the Arts. **Address:** 104 Franklin Street, NYC. **Dealer:** Paula Cooper Gallery. **One-man Exhibitions:** (first) Stephen Radich Gallery, 1964, also 1965-67; Galerie Muller, 1967; Ziegler Gallery, 1968, 70; Galerie Schmela, 1968; Paula Cooper Gallery, 1969, 73. **Group:** Hudson River Museum, Yonkers, N.Y., 1964; Vassar College, 1964; SRGM, Systemic Painting, 1966; IV International Young Artists Exhibit, America-Japan, Tokyo, 1967; A.F.A., 1967; MOMA, The Art of the Real, 1968. **Collections:** Torrington Mfg. Corp. **Bibliography:** Alloway 3; Battcock, ed.; Goossen 1; Lippard, ed.; Murdock 1.

INDIANA, ROBERT. b. September 13, 1928, New Castle, Ind. **Studied:** John Herron Art Institute, 1945-46; Munson-Williams-Proctor Institute, Utica, N.Y., 1947-48; Chicago Art Institute School, BFA, 1949-53; Skowhegan School, summer, 1953; U. of Edinburgh; Edinburgh College of Art, 1953-54; Aspen Institute, Artist-in-Residence, summer, 1968. Traveled USA, Mexico, Europe. **Commissions:** New York State Pavilion, New York World's Fair, 1964-65 (mural); New York State Theater, Lincoln Center for the Performing Arts, NYC (poster); costumes, sets, and poster for the Walker Art Center Opera Company's production of the Virgil Thomson/Gertrude Stein opera *The Mother of Us All*, Tyrone Guthrie Theater, Minneapolis, 1967; 8¢ US Postage Stamp (400,000,000 printed), 1973. **Awards:** Chicago/AI, Traveling Fellowship, 1953; Franklin and Marshall College, Hon. DFA, 1970; Indiana State Commission on the Arts Award, 1973. **Address:** 2 Spring Street, NYC 10012. **Dealer:** Galerie Denise Rene, NYC. **One-man Exhibitions:** (first) The Stable Gallery, 1962, also 1964, 66; ICA, Boston, 1963; Walker, 1963 (two-man, with Richard Stankiewicz); Rolf Nelson Gallery, Los Angeles, 1965; Dayton's Gallery 12, Minneapolis, 1966; Galerie

Schmela, 1966; Eindhoven, 1966; Krefeld/Haus Lange, 1966; Wurttembergischer Kunstverein, Stuttgart, 1966; ICA, U. of Pennsylvania, 1968; San Antonio/McNay, 1968; Indianapolis/Herron, 1968; Toledo/MA, 1968; Hunter Gallery, Aspen, Colo., 1968; Creighton U., 1969; St. Mary's College (Ind.), 1969; Colby College, 1969; Dartmouth College, 1970; Bowdoin College, 1970; Brandeis U., 1970; Badischer Kunstverein, Karlsruhe, 1971; Humlebaek/Louisiana, 1972; Galerie Denise Rene, NYC, 1972; Didrichsenin Konsmuseum, Helsinki, 1972. **Group:** MOMA, The Art of Assemblage, circ., 1961; Chicago/AI Annual, 1963; WMAA, New Directions in American Painting, 1963; ICA, London, The Popular Image, 1963; Bertrand Russell Peace Foundation, Woburn Abbey, England, 1963; MOMA, Americans 1963, circ., 1963-64; Tate, Dunn International, 1964; Tate, Painting and Sculpture of a Decade, 1954-64, 1964; Museum des 20. Jahrhunderts, 1964; New York World's Fair, 1964-65; WMAA Annuals, 1964, 65, 67, Sculpture Annual, 1966; Corcoran Biennial, 1965; Palais des Beaux-Arts, Brussels, 1965; WMAA, A Decade of American Drawings, 1965; SRGM, 1965; Milwaukee, 1965; U. of Illinois, 1965, 67; PAFA, 1966; ICA, Boston, 1966; Eindhoven, Kunst-Licht-Kunst, 1966; Expo '67, Montreal 1967; VI International Art Biennial, San Marino (Europe), 1967; IX Sao Paulo Biennial, 1967; Carnegie, 1967; Dublin/Municipal, I International Quadrennial (ROSC), 1967; Documenta IV, Kassel, 1968; Chicago/Contemporary, 1968; WMAA, Contemporary American Sculpture, Selection II, 1969; Cologne, 1969; Fine Arts Academy of Finland, Helsinki, 1969; Jewish Museum, Superlimited, 1969; WMAA, Seventy Years of American Art, 1969; Hayward Gallery, London, Pop Art, 1969; ICA, U. of Pennsylvania, Highway, 1970; Cincinnati/Contemporary, Monumental Art, 1970; Foundation Maeght, L'Art Vivant, 1970; Museo de Arte Contemporaneo, Cali, Colombia, S.A., I Bienal Graficas, 1971; Dussel-

dorf, Zero Raum, 1973; WMAA (down-town), Nine Artists/Coenties Slip, 1974; WMAA, American Pop Art, 1974; Newport, R.I., Monumenta, 1974; Hirshhorn, Inaugural Exhibition, 1974; Corcoran, 1975. **Collections:** Aachen/NG; Allentown/AM; Amsterdam/Stedelijk; Baltimore/MA; Brandeis U.; Buffalo/Albright; Carnegie; Cologne; Detroit/Institute; Delaware Art Museum; U. of Dublin; Eindhoven; Honolulu Academy; Humlebaek/Louisiana; ICA, U. of Pennsylvania; U. of Illinois; Indianapolis/Herron; Krefeld/Kaiser Wilhelm; Los Angeles/County MA; MMA; MOMA; U. of Michigan; U. of Nebraska; Oklahoma; Ridgefield/Aldrich; SFMA; Spelman College; Stanford U.; U. of Texas; Toronto; VMFA; WGMA; WMAA; Walker; Wuppertal/von der Heydt. **Bibliography:** Alloway 1; Calas, N. and E.; Dienst 1; Hunter, ed.; *Kunst um 1970;* Lippard 5; **McCoubrey 2;** *Monumenta;* Russell and Gablik; Seitz 3; Weller. Archives.

INSLEY, WILL. b. October 15, 1929, Indianapolis, Ind. **Studied:** Amherst College, BA, 1951; Harvard U., B.Arch., 1955. **Taught:** Oberlin College Artist-in-Residence, 1966; U. of North Carolina, 1967-68; Cornell U., 1969; School of Visual Arts, NYC, 1969-71; Cooper Union, 1972. **Commissions:** Great Southwest Industrial Park. **Awards:** National Council on the Arts, 1966; Guggenheim Foundation Fellowship, 1969-70. **Address:** 231 Bowery, NYC, 10002. **Dealers:** Fischbach Gallery; Paul Maenz Gallery, Cologne. **One-man Exhibitions:** (first) Amherst College, 1951; The Stable Gallery, NYC, 1965-68; Oberlin College, 1967; U. of North Carolina, 1967; Walker, 1968; Buffalo/Albright, 1968; Cornell U. (three-man), 1969; ICA, U. of Pennsylvania, 1969; John Gibson Gallery, 1969; MOMA, 1971; School of Visual Arts, NYC, 1972; Paul Maenz Gallery, Cologne, 1972; Krefeld/Haus Lange, 1973; Fischbach Gallery, 1973, 74; Galerie Annemarie Verna, Zurich, 1974; Stuttgart/WK, 1974; Wisconsin State U.,

Oshkosh, 1975. **Group:** WMAA Annual, 1965, 67; Riverside Museum, 1966; SRGM, Systemic Painting, 1966; U. of Illinois, 1967; VI International Art Biennial, San Marino (Europe), 1967; U. of North Carolina, 1967; Ridgefield/Aldrich, 1968; J. L. Hudson Art Gallery, Detroit, 1968; New Delhi, First World Triennial, 1968; ICA, U. of Pennsylvania, 1969; Fort Worth Art Museum, Drawings, 1969; Foundation Maeght, L'Art Vivant, 1970; Finch College, NYC, Projected Art, 1971; Arnhem, Sonsbeek '71, 1971; U. of Washington, Drawing from New York, 1972; ICA, U. of Pennsylvania, Grids, 1972; Documenta V, Kassel, 1972; WMAA, American Drawings: 1963-1973, 1973; Tyler School of Art, Philadelphia, American Drawings, 1973; Kennedy Center, Art Now '74, 1974. **Collections:** Brandeis U.; Colby College; U. of North Carolina. **Bibliography:** Alloway 3; *Art Now 74;* Battcock, ed.

IPPOLITO, ANGELO. b. November 9, 1922, St. Arsenio, Italy. **Studied:** Ozenfant School of Art, NYC, 1946-47; Brooklyn Museum School, 1948; Instituto Meschini, Rome, 1949-50. Traveled Europe. **Taught:** Cooper Union, 1956-59, 1962-64; Sarah Lawrence College, 1957; Yale U., Visiting Critic, 1961; U. of

Will Insley *Wall Fragment* 1975

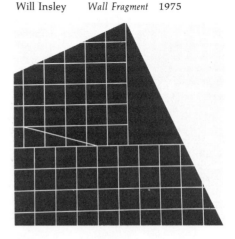

California, Berkeley, 1961-62; Queens College, 1963-64; Michigan State U., Artist-in-Residence, 1966-67. A co-founder of the Tanager Gallery, NYC; Binghamton/SUNY, 1971- . **Commissions:** New York Hilton Hotel, 1963. **Awards:** Fulbright Fellowship (Italy), 1959. **Address:** Friendsville Stage, Binghamton, N.Y. 13903. **Dealer:** Grace Borgenicht Gallery Inc. **One-man Exhibitions:** (first) Galleria della Rotondo, Bergamo, 1950; Tanager Gallery, NYC, 1954, 62; The Bertha Schaefer Gallery, 1956, 58; HCE Gallery, Provincetown, Mass., 1957, 61; Massillon Museum; Canton (Ohio) Museum; Cleveland Institute of Art, 1960; U. of California, 1961; Michigan State U., 1962; Bolles Gallery, 1962 (two-man, with Harold P. Paris); Grace Borgenicht Gallery Inc., 1962, 64, 67, 72, 75; Jesse Besser Museum, Alpena, Mich., 1968; Albion College, 1969; Western Michigan U., 1969; Grand Valley State College, Allandale, Mich., 1970. **Retrospective:** Binghamton/SUNY, 1975. **Group:** Arts Club of Chicago, 1953; Walker, Vanguard, 1955; Utica, 1955, 57; WMAA Annuals, 1955, 57, 59, 62; USIA, 20th Century Graphics, circ., 1956-58; WMAA, Young America, 1957; A.F.A., Collage in America, circ., 1957-58; WMAA, Nature in Abstraction, 1958; VI Sao Paulo Biennial, 1961; Silvermine Guild, 1963; IIE, 1975. **Collections:** Chase Manhattan Bank; CIT Corporation; General Electric Corp., Hirshhorn; IIE; MMA; Massillon Museum; Michigan State U.; U. of Michigan; Milwaukee: Montreal Trust Co.; Norfolk/Chrysler; Phillips; Purchase/SUNY; Sarah Lawrence College; Utica; WMAA. **Bibliography:** Baur 5; Goodrich and Baur 1; Janis and Blesh 1.

IRWIN, ROBERT. b. 1928, Long Beach, Calif. **Studied:** Otis Art Institute, 1948-50; Jepson Art Institute, Los Angeles, 1951. **Taught:** Chouinard Art Institute, 1957-58; UCLA, 1962; U. of California, Irvine, 1968-69. **Address:** 13327 Beach Avenue, Venice, Calif. 90291. **Dealer:** The Pace Gallery. **One-man Exhibitions:** Felix Landau Gallery, 1957; Ferus Gallery, Los Angeles, 1959, 60, 62, 64; Pasadena/AM, 1960, 68; The Pace Gallery, 1966, 68, 69, 71, 73, 74; Los Angeles/County MA (two-man), 1966; Jewish Museum, 1968; Fort Worth (two-man), 1969; MOMA, 1970; Walker, 1971; ACE Gallery, Los Angeles, 1972; Harvard U., 1972; Ileana Sonnabend Gallery, Paris, 1972; Wright State U., 1974; U. of California, Santa Barbara, 1974. **Group:** Los Angeles/County MA Annual, 1952-53, 1956-60; WMAA Annual, 1957; UCLA, 1960; SFMA, Fifty California Artists, circ., 1962; MOMA, The Responsive Eye, 1965; VIII Sao Paulo Biennial, 1965; Vancouver, 1968; Documenta IV, Kassel, 1968; Walker, 1968; Eindhoven, Kompas, 1970; U. of Washington, 1971; Corcoran, 1971; Hayward Gallery, London, 11 Los Angeles Artists, 1971; SFMA, Works in Spaces, 1973; Kennedy Center, Art Now '74, 1974. **Collections:** Buffalo/Albright; U. of California, Berkeley; Chicago/AI; Cleveland/MA; Des Moines; Fort Worth; Harvard U.; La Jolla; Los Angeles/County MA; MOMA; Melbourne/National; Omaha/Joslyn; Pasadena/AM; RISD; SFMA; Sydney/AG; Tate; Vancouver; WMAA; Walker. **Bibliography:** *Art Now 74*; Davis, D.; *Report; The State of California Painting; Transparency; USA West Coast.*

JACOBS, DAVID. b. March 1, 1932, Niagara Falls, N.Y. **Studied:** Orange Coast College, 1951-53; Los Angeles State College of Applied Arts and Sciences, 1953-57. **Taught:** The Ohio State U., 1957-62; Hofstra U., 1962- . Huntington Township Art League, Huntington, N.Y., 1963-64. **Commissions:** Valley Mall, Hagerstown, Md. **Awards:** CAPS, 1974. **Address:** 51 Eighth Avenue, Sea Cliff, N.Y. 11579. **One-man Exhibitions:** Barone Gallery, NYC, 1961; The Kornblee Gallery, 1963-65; Emily Lowe Gallery, Hempstead, N.Y., 1964; D'Arcangelo Studio, NYC, 1967; Hofstra U., 1967, 73; Colgate U., 1970; San Jose State College, 1970; Albion College, 1970; Cor-

nell U., 1971; Wesleyan U., 1971; Kenyon College, 1971; 152 Wooster Street Gallery, NYC, 1971; Colby College, 1973; Edinboro (Pa.) State College, 1973. **Group:** MOMA, 1961; SRGM; SFMA; Dayton/AI; Vassar College, Indianapolis/Herron; Akron/AI, 1964; Chicago/AI, 1966; Kansas City/Nelson, Sound, Light, Silence, 1966; Milwaukee, Directions I: Options, circ., 1968; Finch College, NYC, Documentation, 1968; Jewish Museum, Inflatable Sculpture, 1969; Vancouver, Sound Sculpture, 1973. **Collections:** Frank Construction Company; Hofstra U.; The Ohio State U.; Otterbein College; Raycom Industries; SRGM; E. Sherry Truck Company; VMFA. **Bibliography:** Atkinson.

JARVAISE, JAMES. b. February 16, 1932, Indianapolis, Ind. **Studied:** U. of Southern California, 1950, BFA, 1953, MFA, 1955. Traveled Europe, resided Spain, France. **Taught:** U. of Southern California, 1955-62, 1966, summer, 1967; The Pennsylvania State U., 1963; Occidental College, 1965-67; California Institute of the Arts, Valencia, 1964-68. **Address:** 726 Benson Way, Thousand Oaks, Calif. 91360. **Dealers:** Felix Landau Gallery, Ruth S. Schaffner Gallery, Los Angeles; Martha Jackson

Gallery. **One-man Exhibitions:** (first) Felix Landau Gallery, 1952, also 1955, 58, 60, 61, 62, 64; Thibaut Gallery, NYC, 1961; Gump's Gallery, 1961 (two-man); The Alan Gallery, NYC, 1967. **Group:** Seattle/AM, 1951; Santa Barbara/MA, 1951; Oakland/AM, 1951, 57; MMA, 1953; Denver/AM, 1953, 54, 58; U. of Illinois, 1953, 57, 66; Long Beach/MA, Fifteen Americans, circ., 1956; Corcoran, 1958; U. of Nebraska, 1958; Carnegie, 1959; MOMA, Sixteen Americans, circ., 1959; El Retiro Parquet, Madrid, Arte de America y España, 1963; VMFA, American Painting and Sculpture, 1966. **Collections:** Andover/Phillips; Buffalo/Albright; Carnegie; The Coca-Cola Co.; Los Angeles/County MA; MOMA; Ridgefield/Aldrich; Youngstown/Butler.

JENKINS, PAUL. b. 1923, Kansas City, Mo. **Studied:** Kansas City Art Institute and School of Design, 1938-41; ASL, 1948-51. Resides Paris, New York. **Awards:** Corcoran Biennial, Silver Medal, 1966; Golden Eagle Award for a film, "The Ivory Knife," of which he is the subject, 1966; Honorary Doctor of Humanities, Linwood College, 1973. **Address:** 31 East 72 Street, NYC 10021; studio: 831 Broadway, NYC 10003. **Dealers:** Gimpel & Weitzenhoffer Ltd.;

Paul Jenkins *Phenomena Winds of Trance* 1974

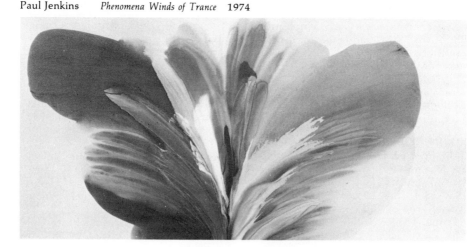

Galerie Karl Flinker; Gimpel Fils. **One-man Exhibitions:** (first) Studio Paul Facchetti, Paris, 1954; Zimmergaleries Franck, Frankfurt am Main, 1954; Zoe Dusanne Gallery, Seattle, 1955; Martha Jackson Gallery, 1956, 58, 60, 61, 64, 66, 68, 69, 70, 71; Galerie Stadler, Paris, 1957, 59; A. Tooth & Sons, London, 1960, 63; Galerie Karl Flinker, 1960, 61, 63, 65, 73; Galleria Toninelli, Milan, 1962; Galerie Charles Leinhard, Zurich, 1962; Galleria Odyssia, Rome, 1962; Cologne/Kunstverein, 1962; Esther Robles Gallery, 1963; Eva de Buren Gallery, Stockholm, 1963; Hannover/K-G., 1964; Tokyo Gallery, 1964; Court Gallery, Copenhagen, 1964; Gutai Museum, Osaka, 1964; Gertrude Kasle Gallery, 1965, 71; Gallery of Modern Art, 1965, 66; Makler Gallery, Philadelphia, 1966; SRGM, 1966; Moss Gallery Ltd., Toronto, 1968; Daniel Gervis Gallery, Paris, 1968; Bernard Raeder Gallery, Lausanne, 1968; Richard Gray Gallery, 1971; Suzanne Saxe Gallery, San Francisco, 1971; SFMA, 1972; Images Gallery, Toledo, 1972; Gimpel Fils, 1972; Corcoran, 1972; Baukunst Galerie, Cologne, 1974; Gimpel & Weitzenhoffer Ltd., 1974; Galerie Ulysses, Vienna, 1974; Galerie Tanit, Munich, 1975. **Group:** Musee du Petit Palais, Paris, 1955; MOMA, Recent Drawings USA, 1956; Arts Council Gallery, London, New Trends in Painting, 1957; WMAA, Young America, 1957; WMAA, Nature in Abstraction, 1958; Carnegie, 1958, 61; Corcoran, 1958, 66; SRGM, Abstract Expressionists and Imagists, 1961; Salon du Mai, Paris, 1962; Seattle World's Fair, 1962; WMAA Annuals, 1962, 65; Art:USA:Now, circ., 1962-67; Salon des Realites Nouvelles, Paris, 1963; Tate, Painting and Sculpture of a Decade, 1954-64, 1964; PAFA, 1965; ICA, Boston, Painting without a brush, 1965; M. Knoedler & Co., Art Across America, circ., 1965-67; Smithsonian, 1966; U. of Illinois, 1967, 68; U. of Oklahoma, 1968; Indianapolis, 1969; U. of California, Santa Barbara, 1970. **Collections:** Amsterdam/Stedelijk; Be-

zalel Museum; Brooklyn Museum; Buffalo/Albright; Busch-Reisinger Museum; U. of California, Berkeley; Cologne/Kunstverein; Corcoran; Dallas/MFA; Des Moines; France/National; Hannover/K-G.; Hirshhorn; U. of Illinois; Jewish Museum; Liverpool/Walker; MOMA; Musee Guimet; NCFA; National Museum of Western Art, Tokyo; Niigata Museum; Norfolk/Chrysler; SRGM; Stanford U.; Stuttgart; Tate; U. of Texas: Toronto; Victoria and Albert Museum; WMMA; Walker; Worcester/AM. **Bibliography:** Elsen 1; Nordland 4. Archives.

JENSEN, ALFRED. b. December 11, 1903, Guatemala City, Guatemala. **Studied:** San Diego Fine Arts School, 1925; Hofmann School, Munich, 1927-28; Academie Scandinave, Paris, with Charles Despiau, Charles Dufresne, Othon Friesz, Marcel Gromaire, Andre Masson. Traveled USA, Europe. **Taught:** Maryland Institute, 1958. **Commissions:** Time Inc. (mural). **Awards:** Tamarind Fellowship, 1965. **Address:** 152 Hawthorne Avenue, Glen Ridge, N.J. 07028. **One-man Exhibitions:** (first) John Heller Gallery, NYC, 1952; Tanager Gallery, NYC, 1955; The Bertha Schaefer Gallery, 1957; Martha Jackson Gallery, 1957, 59, 61, 67; SRGM, 1961; Farleigh Dickinson U., 1963; The Graham Gallery, 1963-65; Klipstein & Kornfeld, Berne, 1964; Rolf Nelson Gallery, Los Angeles, 1964; Kunsthalle, Basel, 1964 (two-man, with Franz Kline); Amsterdam/Stedelijk, 1964; Ziegler Gallery, 1966; Royal Marks Gallery, 1966; Cordier & Ekstrom, Inc., 1967, 68, 70; The Pace Gallery, 1972; Hannover/K-G, 1973; Humlebaek/Louisiana, 1973; Kunsthalle, Baden-Baden, 1973; Dusseldorf/Kunsthalle, 1973; Berne, 1973. **Group:** San Diego; Baltimore/MA; MOMA; The Stable Gallery, 1954-57; II Inter-American Paintings and Prints Biennial, Mexico City, 1960; ICA, Boston, 1960; Chicago/AI, 1961; Corcoran Biennial, 1962; WMAA, Geometric Abstraction in America, circ., 1962; WMAA Annual,

1963; Los Angeles/County MA, Post Painterly Abstraction, 1964; XXXII Venice Biennial, 1964; International Biennial Exhibition of Paintings, Tokyo; Buffalo/Albright, Plus by Minus, 1968; Documenta IV, Kassel, 1968; Lafayette College, Black—White, 1969; Indianapolis, 1970; VMFA, 1970; WMAA, The Structure of Color, 1971; ICA, U. of Pennsylvania, Grids, 1972; Documenta V, Kassel, 1972; WMAA, 1973. **Collections:** American Republic Insurance Co.; Baltimore/MA; Brandeis U.; Chase Manhattan Bank; Dayton/AI; Health and Hospital Corp.; MOMA; SRGM; San Diego; Time Inc.; WMAA. **Bibliography:** Alfred Jensen; Calas, N. and E.; *Kunst um 1970;* MacAgy 2.

JOHNS, JASPER, b. May, 1930, Augusta, Ga. **Studied:** U. of South Carolina. Artistic advisor to Merce Cunningham Dance Company. **Member:** NIAL, 1973. **Awards:** Gallery of Modern Art, Ljubljana, Yugoslavia, VII International Exhibition of Prints, First Prize, 1967; IX Sao Paulo Biennial, 1967. **Address:** c/o Dealer. **Dealer:** Leo Castelli Inc. **One-man Exhibitions:** Leo Castelli Inc., 1958, 60, 61, 63, 66, 68, 70, 71, 76; Galleria d'Arte del Naviglio, Milan, 1959; Galerie Rive Droite, Paris, 1959, 61; Columbia, S.C./MA, 1960; U. of Minnesota, 1960; Ferus Gallery, Los Angeles, 1960 (two-man); Ileana Sonnabend Gallery, Paris, 1962; Everett Ellin Gallery, Los Angeles, 1962; Whitechapel Art Gallery, London, 1964; Pasadena/ AM, 1965; Ashmolean Museum, Oxford, England, 1965; American Embassy, London, 1965; Minami Gallery, 1965; NCFA, 1966; MOMA, circ., 1968; Eva de Buren Gallery, Stockholm; Castelli-Whitney, NYC, 1969; PMA, 1970; U. of Iowa, 1970; MOMA, 1970; Minneapolis/Institute, 1971; Dayton's Gallery 12, Minneapolis, 1971; Chicago/ Contemporary, 1971; MOMA, Thirty Lithographs: 1960-68, circ., 1972; Fendrick Gallery, Washington, D.C., 1972; Houston/MFA, 1972; Hofstra U., 1972; Lo Spazio, Rome, 1974; Modern Art Agency, Naples, 1974; Galerie Folker Skulima, Berlin, 1974; Galerie Mikro,

Berlin, 1974; Museum of Modern Art, Oxford, England, 1974; Arts Council of Great Britain, Drawings, 1975. **Retrospective:** Jewish Museum, 1964; Whitechapel Art Gallery, London, 1964; Pasadena/AM, 1965. **Group:** Jewish Museum, The New York School, Second Generation, 1957; A.F.A., Collage in America, circ., 1957-58; Houston/ MFA, Collage International, 1958; XXIX & XXXII Venice Biennials, 1958, 64; Carnegie, 1958, 61, 64, 67; Houston/ MFA, Out of the Ordinary, 1959; Daniel Cordier, Paris, Exposition InteRnatiOnale de Surrealisme, 1959; Columbus, Contemporary American Painting, 1960; A.F.A., School of New York— Some Younger American Painters, 1960; Martha Jackson Gallery, New Media—New Forms, I & II, 1960, 61; WMAA Annuals, 1960, 61, 62, 64, 65; SRGM, Abstract Expressionists and Imagists, 1961; Dallas/MFA, 1961-62; SRGM/USIA, American Vanguard, circ. Europe, 1961-62; MOMA, Abstract Watercolors and Drawings:USA, circ. Latin America and Europe, 1961; MOMA, American Drawings, circ. Europe, 1961-62; MOMA, Lettering by Hand, 1962; Seattle World's Fair, 1962; Berne, 4 Americans, 1962; Chicago/AI, 1962; Stockholm/National; Amsterdam/Stedelijk; Salon du Mai, Paris, 1962, 64; SRGM, Six Painters and The Object, circ., 1963; WGMA, The Popular Image, 1963; Musee Cantonal des Beaux-Arts, Lausanne, I Salon International de Galeries Pilotes, 1963; ICA, London, The Popular Image, 1963; Buffalo/Albright, Mixed Media and Pop Art, 1963; El Retiro Parquet, Madrid, Arte de America y España, 1963; Jewish Museum, Black and White, 1963; Hartford/Wadsworth, Black, White, and Gray, 1964; Tate, Dunn International, 1964; Tate, Painting and Sculpture of a Decade, 1954-64, 1964; SRGM, 1964; Documenta III & IV, Kassel, 1964, 68; Palais des Beaux-Arts, Brussels, 1965; MOMA, Art in the Mirror, 1966; Jewish Museum, 1966; Expo '67, Montreal, 1967; IX Sao Paulo Biennial, 1967; Gallery of Modern Art, Ljubljana, Yugoslavia, VII International Exhibition

of Prints, 1967; MOMA, Dada, Surrealism and Their Heritage, 1968; Vancouver, 1969; Cincinnati/Contemporary, Monumental Art, 1970; Dublin/Municipal, International Quadriennial (ROSC), 1971; Chicago/Contemporary, White on White, 1971-72; ICA, U. of Pennsylvania, Grids, 1972; WMAA, Biennial, 1973; New York Cultural Center, 3D into 2D, 1973; Seattle/AM, American Art—Third Quarter Century, 1973; Parcheggio di Villa Borghese, Rome, Contemporanea, 1973; Art Museum of South Texas, Corpus Christi, Eight Artists, 1974; Chicago/AI, Idea and Image in Recent Art, 1974; WMAA, American Pop Art, 1974; Walker, Eight Artists, 1974. **Collections:** Buffalo/Albright; Hartford/Wadsworth; MOMA; Stockholm/National; Tate. **Bibliography:** Alloway 1; Battcock, ed.; Becker and Vostell; Bihalji-Merin; Calas, N. and E.; *Contemporanea;* Davis, D.; De Vries, ed.; Dienst 1; Finch; Friedman, ed.; Goossen 1; Honnef; Hunter, ed.; Janis and Blesh 1; **Kozloff 2,** 3; Licht, F.; Lippard 5; Lynton; *Metro;* Rickey; Rodman 3; Rose, B. 1, 4; Rubin 1; Russell and Gablik; Seitz 3; **Steinberg, L.;** Tomkins; Tomkins and Time-Life Books; Weller.

JOHNSON, BEN. b. September 11, 1902, NYC; **d.** February 1967, Sarasota, Fla. **Studied:** Pratt Institute. **Awards:** Two L. C. Tiffany Grants, 1930-33; Saratoga Springs Centennial, First Prize, 1963. **One-man Exhibitions:** (first) Jumble Shop Restaurant, NYC, 1930; Parnassus Square Gallery, Woodstock, N.Y.; Advanced Gallery, NYC; The Zabriskie Gallery, 1957, 59; Cober Gallery, 1960; The Kornblee Gallery, 1963; David Stuart Gallery, 1963; Gallery 63, Inc., NYC, 1964, 65; Selected Artists Gallery, NYC, 1966; Gallery Dache, NYC, 1967. **Group:** WMAA, 1963; Brooklyn Museum, Watercolor Biennials; WGMA; A.F.A., Mother and Child in Modern Art, circ., 1963; Chicago/AI, 1964.

JOHNSON, BUFFIE. b. February 20, 1912, NYC. **Studied:** ASL; Atelier 17, Paris, with S. W. Hayter (engraving);

UCLA, MA. Traveled extensively, Europe, Mexico, USA. **Taught:** Parsons School of Design, 1946-50; US State Department lecturer; UCLA; Aegina Art Center, Greece, 1973. **Commissions:** Astor Theater, NYC, 1959 (murals). **Awards:** Le Salon International de la Femme, Nice, Second Prize, 1970; Yaddo Fellowship, 1974. **Address:** 333 East 43 Street, NYC 10017; studio: 87 Bowery, NYC 10003. **Dealers:** Max Hutchinson Gallery; Hirschl & Adler Galleries. **One-man Exhibitions:** (first) Jake Zeitlin Gallery, Los Angeles, 1937; Galerie Rotge, Paris, 1939; Wakefield Gallery, NYC, 1939; Vose Gallery, Boston, 1942; Caresse Crosby, Washington, D.C., 1944; "67" Gallery, NYC, 1945; Ringling, 1948; Galleria del Cavallino, Venice, 1948; Hanover Gallery, 1949; Galerie Colette Allendy, Paris, 1949; Betty Parsons Gallery, 1950; Choate School, Wallingford, Conn., 1951; Galeries Bing, Paris, 1956, 60; Bodley Gallery, NYC, 1960; Thibaut Gallery, NYC, 1961; Granville Gallery, NYC, 1964; Galeria Antonio Souza, Mexico City, 1964; Max Hutchinson Gallery, 1973; Palm Beach Gallery, Palm Beach, Fla., 1975; New School for Social Research. **Group:** Carnegie, 1941; Art of This Century, NYC, 1943; Salon des Realites Nouvelles, Paris, 1949, 50; Baltimore/MA; Walker; Brooklyn Museum, 1950, 54; WMAA; U. of Illinois, 1955; GEDOK, Hamburg, American Woman Artist Show, 1972; New York Cultural Center, Women Choose Women, 1973; WMAA Biennial. **Collections:** Baltimore/MA; Bezalel Museum; Boston/MFA; Calcutta; Ciba-Geigy Corp.; Cincinnati/AM; City Investing Corp.; Cornell U.; U. of Illinois; International Nickel Co.; Layton School of Art; U. of Michigan; NCFA; NYU; Newark Museum; U. of New Mexico; The Ohio State U.; Purchase/SUNY; RISD; Santa Barbara/MA; U. of Texas; Utica; Valley Bank of Springfield; WMAA; Walker; Yale U. Archives.

JOHNSON, LESTER. b. January 27, 1919, Minneapolis, Minn. **Studied:** Minneapolis Institute School (with

Alexander Masley, Glen Mitchel), St. Paul School of Art (with Cameron Booth), Chicago Art Institute School, 1942-47. Traveled Europe. **Taught:** St. Bernard School, NYC, 1955-61; The Ohio State U., 1963; U. of Wisconsin, 1964; School of Visual Arts, NYC, 1964; Yale U., 1964- ; American Center, Paris, summer, 1966. **Awards:** Alfred Pillsbury Scholarship; St. Paul Gallery Scholarship; Midwestern Artists Competition, First Prize, 1942; Guggenheim Foundation Fellowship, 1973. **Address:** c/o Dealer. **Dealers:** Martha Jackson Gallery; Galerie Paul Facchetti; Donald Morris Gallery. **One-man Exhibitions:** (first) Artists' Gallery, NYC, 1951; Korman Gallery, NYC, 1954; The Zabriskie Gallery, 1955, 57, 58, 59, 61; Sun Gallery, Provincetown, 1956-59; City Gallery, NYC, 1959; HCE Gallery, Provincetown, 1960, 62; Minneapolis/Institute, 1961; B. C. Holland Gallery, 1962; Dayton/AI, 1962; Fort Worth;

The Ohio State U.; Martha Jackson Gallery, 1962, 63, 66, 69, 71, 73, 74; Donald Morris Gallery, 1965, 74; Smithsonian, 1968; Alpha Gallery, 1972; Gallery Moos, Toronto, 1973; Richard Gray Gallery, 1973; Ruth S. Schaffner Gallery, Santa Barbara, 1973, 74; Smith-Andersen Gallery, Palo Alto, 1974; Peter M. David Gallery, 1974. **Group:** PAFA; Minneapolis/Institute; Jewish Museum, The New York School, Second Generation, 1957; Minneapolis/Institute, American Painting, 1945-1957, 1957; Baltimore/MA, Critics Choice, 1958; WMAA, 1958, 68, Annual, 1967; ICA, Boston, 100 Works on Paper, circ. Europe, 1959; A.F.A., The Figure, circ., 1960; ICA, Boston, Future Classics, 1960; A.F.A., Graphics '60, 1960; Carnegie, 1961, 68; MOMA, Recent American Painting and Sculpture, circ. USA and Canada, 1961-62; Chicago/AI, Recent Trends in Painting, USA, 1962; MOMA, Recent Painting

Lester Johnson *Tip of Broadway II* 1973

USA: The Figure, circ., 1962-63; Lehigh U., 1967; MOMA, The 1960's, 1967; Dublin/Municipal, I International Quadrennial (ROSC), 1967; U. of Kentucky, 1968; Madrid/Nacional, II Biennial, 1969; Star Turtle Gallery, NYC, The Tenants of Sam Wapnowitz, 1969; Philadelphia Art Alliance, 1969; Smithsonian, Neue Figuration USA, circ., 1969; Brooklyn Museum Print Biennial, 1970; Carnegie, 1970; U. of North Carolina, Works on Paper, 1971; SRGM, 10 Independents, 1972; Chicago/ AI, 70th American Exhibition, 1972; Minnesota/MA, 1973; WMAA, 1973; NAD, 1974. **Collections:** U. of Arizona; Baltimore/MA; Buffalo/Albright; California College of Arts and Crafts; Chase Manhattan Bank; Ciba-Geigy Corp.; Dayton/AI; Goldring International; Hartford/Wadsworth; MOMA; U. of Nebraska; New School for Social Research; Norfolk/Chrysler; Northwestern U.; Philip Morris Collection; Phoenix; Smithsonian; Stony Brook/ SUNY; Tulsa/Philbrook; U.S. Steel Corp.; Walker; U. of Wisconsin; Yale U.

JOHNSON, RAY. b. October 16, 1927, Detroit, Mich. **Studied:** ASL; Black Mountain College (with Josef Albers, Robert Motherwell, Mary Callery, Ossip Zadkine), 1945-48. **Member:** American Abstract Artists, 1949-52. Operates the New York Correspondence School. **Awards:** NIAL Grant, $2000, 1966. **Address:** 44 West Seventh Street, Locust Valley, N.Y. 11560. **One-man Exhibitions:** (first) The Willard Gallery, 1965, also 1966, 67; Richard Feigen Gallery, Chicago, 1966, NYC, 1968, 70, 71; Wooster Community Art Center, Danbury, Conn., 1968; Kunstmarkt, Cologne, 1968; U. of Virginia, 1968; U. of British Columbia (two-man), 1969; Boylston Print Center Gallery, Cambridge, Mass.; U. of Sacramento, 1969; WMAA, New York Correspondence School, 1970; Betty Parsons Gallery, 1972; Angela Flowers Gallery, London, 1972; Jacob Ladder Gallery, Washington, D.C., 1972; Chicago/AI, Correspondence Show, 1972; Marion

Locks Gallery, Philadelphia, 1973; Gertrude Kasle Gallery, 1975; Massimo Valsecchi Gallery, Milan, 1975. **Group:** American Abstract Artists, 1949-52; MOMA, Art in the Mirror, 1966; Chicago/Contemporary, Pictures to be Read/Poetry to be Seen, 1967; Finch College, NYC; A.F.A., circ., 1967; Hayward Gallery, London, Pop Art, 1969; U. of British Columbia, Concrete Poetry, 1969; Fort Worth Art Museum, Drawings, 1969; Dallas/MFA, Poets of the Cities, 1974. **Collections:** Chicago/ AI; Dulin Gallery; Houston/MFA; Lincoln, Mass./De Cordova; MOMA. **Bibliography:** Becker and Vostell; Hansen; *Happening & Fluxus;* Russell and Gablik.

JOHNSTON, YNEZ. b. May 12, 1920, Berkeley, Calif. **Studied:** U. of California, Berkeley, BA, 1946, MA. Traveled Europe, USA, India, England. **Taught:** Colorado Springs Fine Arts Center, summers, 1945, 55; U. of California, Berkeley, 1950-51. **Commissions:** International Graphic Arts Society, 1958, 60. **Awards:** Guggenheim Foundation Fellowship, 1952; MMA, 1952; L. C. Tiffany Grant, 1955; SFMA, James D. Phelan Award, 1958; Tamarind Fellowship, 1966. **Address:** 569 Crane Boulevard, Los Angeles, Calif. 90065. **Dealers:** Jodi Scully Gallery; Van Straaten Gallery; Graphics Gallery. **One-man Exhibitions:** SFMA, 1943; U. of Redlands, 1947; American Contemporary Gallery, Hollywood, 1948; Fraymont Gallery, Los Angeles, 1952; Chicago/AI, 1952 (two-man); Santa Barbara/MA, 1952, 57; Paul Kantor Gallery, Beverly Hills, Calif., 1952, 53, 57, 58, 59, 64; Pasadena/AM, 1954; Colorado Springs/ FA, 1955; California Palace, 1956; Ohana Gallery, London, 1958; California State U., Long Beach, 1967; Moore Galleries, Inc., San Francisco, 1968; Benjamin Galleries, Chicago, 1969; Jodi Scully Gallery, 1971, 72, 74. **Retrospective:** Mount San Antonio College, 1974. **Group:** WMAA, 1951-55; U. of Illinois, 1951-54; Carnegie, 1955; SFMA; Los Angeles/County MA; MOMA, New

Talent; Ohio U., Ultimate Concerns, 1968; Palazzo Strozzi, Florence, Italy, I Biennale Internazionale della Grafica, 1968; California State U., Los Angeles, Small Images, 1969; California Institute of Technology, Pasadena, Four Printmakers, 1969; U. of Kentucky, Graphics '71, 1971; International Exhibitions Foundation, Washington, D.C., Tamarind; A Renaissance of Lithography, circ., 1971-72; Scripps College, California Women Artists, 1972. **Collections:** Albion College; California State U., Los Angeles; Hartford/Wadsworth; U. of Illinois; La Jolla; Los Angeles/County MA; MMA; MOMA; Michigan State U.; U. of Michigan; PMA; Pasadena/AM; RISD; St. Louis/City; San Diego; Santa Barbara/MA; Schaeffer School of Design; Tulsa/Philbrook; Tusculum College; WMAA. **Bibliography:** Pousette-Dart, ed.

JONES, HOWARD W. b. June 20, 1922, Ilion, N.Y. **Studied:** Syracuse U., BFA Cum Laude, 1948; Columbia U.; Cranbrook. USAAF, World War II. Traveled Europe, Near and Middle East, North Africa. **Taught:** Tulane U., 1951-54; Florida State U., 1954-56; Washington U. (St. Louis), 1956- ; Yale U., 1967. Subject of TV film, "Artist in America: Howard Jones." **Commissions:** WMAA, 1968; Kansas City/Nelson, 1968. **Awards:** *Art In America* (Magazine), New Talent, 1966; Graham Foundation Fellowship, 1966-67; Syracuse U., Roswell S. Hill Prize; Syracuse U., four-year scholarship. **Address:** 12 North Newstead, St. Louis, Mo. **One-man Exhibitions:** Utica; Mitchell Gallery, Woodstock, N.Y.; Forida State U.; Fairmont Gallery, St. Louis, 1961; H. Balaban Carp Gallery, St. Louis, 1963; Kansas City/Nelson, 1965; Royal Marks Gallery, 1966; The Howard Wise Gallery, 1968, 70; Electric Gallery, Toronto, 1971; St. Louis/City, 1973; Kansas City/Nelson, 1973; Hartford/Wadsworth, 1974. **Group:** Kansas City/Nelson, Sound, Light, Silence, 1966; ICA, Boston, 1966; Worcester/AM, 1967; Flint/Institute, 1967; U. of Illinois, 1967; Walker and Milwaukee, Light Motion

Space, 1967; ICA, London, circ., 1968; Milwaukee, Directions I: Options, circ., 1968; WMAA, Light: Object and Image, 1968; Kansas City/Nelson, The Magic Theatre, 1968; La Jolla, 1969; Jewish Museum, Superlimited, 1969; Hayward Gallery, London, Kinetics, 1970; Princeton U., American Art since 1960, 1970; Rockefeller U., Kinetic Art, 1970; PMA, Multiples, 1971; Trenton/State, Responsive Environment, 1972. **Collections:** Buffalo/Albright; Jewish Museum; Kansas City/Nelson; Milwaukee; Ridgefield/ Aldrich; St. Louis/ City; Walker; Washington U. (St. Louis). **Bibliography:** Atkinson.

JONES, JOHN PAUL. b. November 18, 1924, Indianola, Iowa. **Studied:** State U. of Iowa, 1949, BFA, 1951, MFA. Traveled Europe; resided Great Britain, 1960-61. **Taught:** U. of Oklahoma, 1951-52; State of Iowa, 1952-53; UCLA, 1953-63; U. of California, Irvine 1969- . **Awards:** L. C. Tiffany Grant, 1951; Guggenheim Foundation Fellowship, 1960; and more than 40 others. **Address:** 22370 Third Avenue, South Laguna, Calif. 92677. **Dealer:** Jodi Scully Gallery. **One-man Exhibitions:** Iowa Wesleyan College, 1951; Des Moines, 1951; Fort Dodge/Blanden, 1951; San Antonio/McNay, 1951; U. of Oklahoma, 1952; Los Angeles/County MA, 1954 (two-man); Kalamazoo/Institute, 1955; Oakland/AM, 1956; Felix Landau Gallery, 1956, 58, 62, 64, 67, 70; Laguna Blanca School, Santa Barbara, 1958; Santa Barbara/MA, 1958; Pasadena/AM, 1959; Taft College, 1959; Galleria Cadario, 1961; Arizona State U., 1962; U. of Minnesota, 1963; U. of Nebraska, 1963; Terry Dintenfass, Inc., 1963, 65; Louisville/Speed, 1964; San Jose State College, 1965; Container Corp. of America, 1965; Brook Street Gallery, London, 1965; The Landau-Alan Gallery, NYC, 1967, 69; La Jolla, 1970; Graphics Gallery, 1973; Jodi Scully Gallery, 1973, 75; Charles Campbell Gallery, 1974; U. of California, Riverside, 1975. **Retrospectives:** Brooklyn Museum, 1963; Los Angeles/County MA, 1965. **Group:** Youngstown/Butler;

U. of Illinois; State U. of Iowa; MOMA; WMAA; Oakland/AM; Santa Barbara/ MA; SFMA; Pasadena/AM; Library of Congress; Brooklyn Museum; U. of Minnesota. **Collections:** Achenbach Foundation; Ball State U.; Bibliotheque Nationale; Bradley U.; Brooklyn Museum; U. of Calgary; California State Fair; UCLA; Coos Bay; Dallas/MFA; Des Moines; Fort Dodge/Blanden; U. of Illinois; Iowa State Fair; Iowa Wesleyan College; State U. of Iowa; Kalamazoo/ Institute; Kansas City/Nelson; Kansas State College; Karachi; Kentucky Southern College; La Jolla; Library of Congress; Los Angeles/County MA; Lytton Savings and Loan Association; MOMA; Michigan State U.; Minnesota/ MA; NYPL; National Gallery; U. of Nebraska; Oakland/AM; Omaha/Joslyn; Otis Art Institute; Palomar College; Pasadena/AM; SFMA; San Diego; Santa Barbara/MA; Seattle/AM; Texas Western College; Tulane U.; Utica; Victoria and Albert Museum; Walker; Youngstown/Butler.

JUDD, DON. b. June 3, 1928, Excelsior Springs, Mo. **Studied:** College of William and Mary, 1948-49; Columbia U., BS, 1949-53, MFA; ASL, with Johnson, Stewart Klonis, Robert Beverly Hale, Louis Bouche', Will Barnet. Traveled Western Europe, Southwestern USA. **Taught:** Allen Stevenson School, 1957-61; Hunter College, 1966; Yale U., 1967. **Awards:** Swedish Institute Grant, 1965; U.S. Government Grant, 1967; Guggenheim Foundation Fellowship, 1968. **Address:** 101 Spring Street, NYC 10012. **Dealers:** Leo Castelli Inc.; Ileana Sonnabend Gallery, Paris; Galerie Rudolf Zwirner. **One-man Exhibitions:** (first) Green Gallery, NYC, 1964; Leo Castelli Inc., 1966, 67; WMAA, 1968; Ileana Sonnabend Gallery, Paris, 1969; Galerie Rudolf Zwirner, 1969; Eindhoven, 1970; Joseph Helman Gallery, St. Louis, 1970; Essen, 1970; Hannover/ Kunstverein, 1970; Whitechapel Art Gallery, London, 1970; Locksley-Shea Gallery, 1970, 73; Janie C. Lee Gallery,

Dallas, 1970; Galerie Heiner Friedrich, Munich, 1971; Ronald Greenberg Gallery, St. Louis, 1972; Galerie Rolf Ricke, 1972; Leo Castelli Inc., NYC, 1973; Galerie Daniel Templon, Paris, 1973; Gian Enzo Sperone and Galerie Konrad Fischer, Rome, 1973; Gian Enzo Sperone, Turin, 1973; Galerie Annemarie Verna, Zurich, 1973; Lisson Gallery, London, 1974; Portland (Ore.) Center for the Visual Arts, 1974. **Retrospective:** WMAA; Ottowa/National, 1975. **Group:** VIII Sao Paulo Biennial, 1965; ICA, U. of Pennsylvania, 1965; Stockholm/National, 1965; Jewish Museum, Primary Structures, 1966; WMAA, Contemporary American Sculpture, Selection I, 1966; Walker, 1966; WMAA Sculpture Annual, 1966, 68; Los Angeles/County MA, American Sculpture of the Sixties, 1967; Detroit/Institute, Color, Image and Form, 1967; WGMA, A New Aesthetic, 1967; SRGM, Sculpture International, 1967; Walker, 1969; Vancouver, 1969; Expo '70, Osaka, 1970; Indianapolis, 1970; Princeton U., American Art since 1960, 1970; Brooklyn Museum, Attitudes, 1970; Cincinnati/Contemporary, Monumental Art, 1970; WMAA, 1970, 73; SRGM, Guggenheim International, 1971; Dublin/ Municipal, International Quadriennial (ROSC), 1971; High Museum, The Modern Image, 1972; Rijksmuseum Kroller-Muller, Diagrams and Drawings, 1972; New York Cultural Center, 3D into 2D, 1973; Musee Galliera, Paris, Festival d'Automne, 1973; Parcheggio di Villa Borghese, Rome, Contemporanea, 1974; Art Museum of South Texas, Corpus Christi, Eight Artists, 1974; Cologne/Kunstverein, Kunst uber Kunst, 1974. **Collections:** Chicago/AI; Detroit/Institute; Los Angeles/County MA; MOMA; Pasadena/AM; St. Louis/ City; WMAA; Walker. **Bibliography:** *Art Now 74;* Battcock, ed.; Calas, N. and E.; *Contemporanea;* Davis, D.; De Vries, ed.; Friedman, M. 2; Friedman and van der Marck; Goossen 1; Honnef; Hunter, ed.; Kozloff 3; Lippard 4, 5; MacAgy 2; *Report;* Rickey; Rose, B. 4; **Smith, B.,** 1975; Trier 1; Tuchman 1. Archives.

KABAK, ROBERT. b. February 15, 1930, NYC. **Studied:** Brooklyn College, with Burgoyne Diller, Mark Rothko, Ad Reinhardt, Alfred Russell, Robert Wolff, 1952, BA; Yale U., with Josef Albers, Abraham Rattner, Ad Reinhardt, 1954, MFA. Traveled France, Great Britain, Netherlands, USA. **Taught:** Greenport (N.Y.) Public Schools, 1953-54; P. S. 108, Queens (N.Y.), 1954-56; High School of Music and Art, NYC, 1956-60; Brooklyn College, 1960-62; U. of California, Berkeley, 1962-66; Northern Illinois U., 1968-73; U. of Missouri, 1973- . **Awards:** MacDowell Colony Fellowship, 1956, 57, 59, 60, 61, 62, 67-68; Huntington Hartford Foundation, 1960, 61, 63; Yaddo Fellowship, 1961; U. of California Institute for Creative Work in the Arts, 1965-66. **Address:** c/o Department of Home Economics, U. of Missouri, Columbia, Mo. 65201. **One-man Exhibitions:** The Salpeter Gallery, 1958; Nonagon Gallery, NYC, 1960; Angeleski Gallery, NYC, 1960, 61; Osgood Gallery, NYC, 1962; Gump's Gallery, 1963; SFMA (two-man), 1964; U. of California, 1966; Oakland/AM-Kaiser Center, 1966; Betty Parsons Gallery, 1967; Allan Stone Gallery, 1968; Rogue Gallery, Medford, Ore., 1968; Lower Columbia Junior College, 1968; Western Washington State Col-

lege, 1968; Cheney Cowles Memorial Museum, Spokane, 1969; Oregon State U., 1969. **Group:** MOMA, New Talent; WMAA Annuals, 1956, 58; U. of Illinois, 1959; California Palace, 1964; State U. of Iowa; U. of Nebraska; Southern Illinois U.; Carnegie, 1967. **Collections:** MOMA.

KACERE, JOHN. b. June 23, 1920, Walker, Iowa. **Studied:** Mizen Academy of Art, Chicago, 1938-42; State U. of Iowa, BFA, 1946-49, MFA, 1950-51. **Taught:** State U. of Iowa, 1949-50 (graduate assistant to Mauricio Lasansky); U. of Manitoba, 1950-53; U. of Florida, 1953- ; Cooper Union; Parsons School of Design, NYC; U. of Florida, 1953-65; U. of New Mexico. **Address:** 100 West 14 Street, NYC 10011. **Dealer:** OK Harris Works of Art. **One-man Exhibitions:** The Little Art Gallery, Cedar Rapids, Iowa, 1942; U. of Florida, 1953, 57; Korman Gallery, NYC, 1954; Mirell Gallery, Miami, Fla., 1955; Cedar Rapids/AA, 1955; The Zabriskie Gallery, 1956; Louisiana State U., 1957; Allan Stone Gallery, 1963; OK Harris Works of Art, 1971, 73; Galerie de Gestlo, Hamburg, 1972, 73. **Group:** Walker, circ. USA, Canada, South America, 1949-51; MOMA; Chicago/AI; PMA; Omaha/Joslyn; Dallas/MFA; Ringling; Jacksonville/AM; U. of Georgia; Corcoran, 1963; U. of Illinois, 1965; John Michael Kohler Arts Center, Sheboygan, The Human Image, 1970; Chicago Contemporary, Radical Realism, 1971; Cleveland/MA, 32 Realists, 1972; MOMA, The Realist Revival, 1972; Stuttgart/WK, Amerikanischer Fotorealismus, circ., 1972; Lincoln, Mass./De Cordova, The Super-Realist Vision, 1973; Tokyo Biennial, 1974; Chicago/AI, 1974. **Bibliography:** *Amerikanischer Fotorealismus;* Sager.

KAHN, WOLF. b. October 4, 1927, Stuttgart, Germany. To Great Britain 1939; to USA 1940. **Studied:** Hofmann School, 1947-49; The U. of Chicago, 1950-51, BA. Traveled Europe, Mexico, USA. **Taught:** U. of California, Berke-

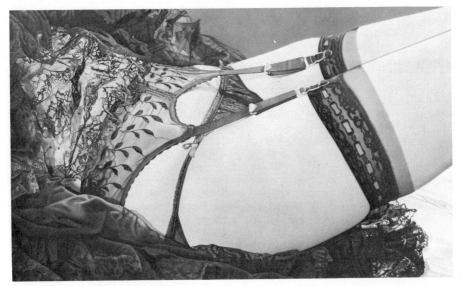

John Kacere *Naija III* 1975

ley, 1960; Cooper Union, 1961- ; Haystack School, Deer Isle, Me., 1961, 62. **Commissions:** Jewish Theological Seminary, NYC (portraits). **Awards:** Ford Foundation, **P.P.**, 1962; Fulbright Fellowship, 1962, 64; J. S. Guggenheim Fellowship, 1966-67. **Address:** 813 Broadway, NYC 10003. **Dealers:** Grace Borgenicht Gallery Inc.; Meredith Long Gallery. **One-man Exhibitions:** (first) Hansa Gallery, NYC, 1953, also 1954; Grace Borgenicht Gallery Inc., 1956, 58, 60, 61, 62, 65, 67, 69, 71, 73, 74, 75; U. of California, 1960; Union College (N.Y.), 1960; U. of Michigan, 1961; Ellison Gallery, Fort Worth, 1961; RISD, 1961; Kansas City/Nelson, 1962; Michigan State U., 1963; Stewart Richard Gallery, San Antonio, 1964; Obelisk Gallery, 1964; Nashville, 1964; Sabersky Gallery, Los Angeles, 1966; Marlboro College, 1967; Princeton Gallery of Fine Art, 1970, 72, 74, 75; Meredith Long Gallery, 1971, 73, 74; Harcus Krakow Rosen Sonnabend, 1972; U. of Nebraska, 1973; Norfolk/Chrysler, 1973; Rudolph Galleries, Coral Gables, 1974. **Group:** The Stable Gallery Annuals, 1954, 55; WMAA Annuals, 1958, 60, 61;

Utica, 1959; ART:USA:59, NYC, 1959; WMAA, Young America, 1960; International Biennial Exhibition of Paintings, Tokyo; SFMA, 1961; PAFA, 1961, 65; American Art Gallery, Copenhagen, 1963; MOMA, Hans Hofmann and His Students, circ., 1963-64; Omaha/Joslyn, A Sense of Place, 1973; IIE, 20 American Fulbright Artists, 1975. **Collections:** Brandeis U.; Brooklyn Museum; U. of California; Chase Manhattan Bank; Dallas/MFA; Fort Worth; Houston/ MFA; ICA, Boston; U. of Illinois; Jewish Museum; Lincoln Life Insurance Co.; MOMA; U. of Massachusetts; Michigan State U.; U. of Nebraska; U. of Nevada; St. Louis/City; Union Carbide Corp.; VMFA; WMAA. **Bibliography:** Blesh 1. Archives.

KAISH, LUISE. b. September 8, 1925, Atlanta, Ga. **Studied:** Syracuse U., with Ivan Mestrovic, BFA, MFA; Escuela de Pintura y Escultura, Mexico City, with Alfredo Zalce, J. G. Galvan. Traveled Europe, Scandinavia, Italy, Israel, Middle East. **Taught:** Columbia U., 1974-75. **Member:** Sculptors Guild. **Commissions:** Temple B'rith Kodesh, Roches-

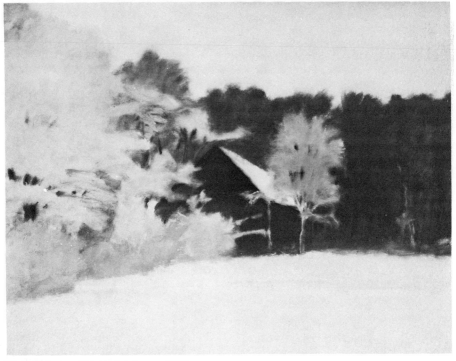

Wolf Kahn *Height of Autumn* 1973

ter, N.Y.; Container Corp. of America; Syracuse U.; Amoco Building, NYC; Jewish Museum; Temple Beth Shalom, Wilmington, Del.; Temple Israel, Westport, Conn.; Holy Trinity Mission Seminary, Silver Spring, Md.; Beth El Synagogue Center, New Rochelle, N.Y.; Temple B'nai Abraham, Essex County, N.J.; U.A.H.C., Jerusalem, Israel. **Awards:** Guggenheim Foundation Fellowship; L. C. Tiffany Grant; Audubon Artists, Medal; Ball State Teachers College, **P.P.**; Joe and Emily Lowe Foundation Award; National Association of Women Artists; U. of Rochester; Syracuse/Everson; American Academy, Rome, Fellowship, 1970-71. **Address:** 610 West End Avenue, NYC 10024. **Dealer:** Staempfli Gallery. **One-man Exhibitions:** U. of Rochester, 1954; Sculpture Center, NYC, 1955, 58; Staempfli Gallery, 1968; St. Paul Gallery, 1969; Dartmouth College (two-

man), 1974. **Retrospective:** Jewish Museum, 1973. **Group:** MMA, National Sculpture Exhibition, 1951; WMAA, 1955, 62, 64, 66; MOMA, Recent Sculpture USA, 1959; U. of Nebraska; Ball State Teachers College; U. of Notre Dame; Ohio U.; NAD; Sculptors Guild; Buffalo/Albright; AAAL; Newark Museum, Women Artists of America, 1966; U. of Illinois, 1968; New School for Social Research, Drawings by Painters and Sculptors, 1967; U. of Nebraska, American Sculpture, 1970; Minnesota/MA, Drawings, USA, 1970; Finch College, NYC, Artists at Work, 1970; USIS, Rome, 1973. **Collections:** High Museum; Jewish Museum; U. of Miami; U. of Rochester; Syracuse U.; WMAA.

KAMIHIRA, BEN. b. March 16, 1925, Yakima, Wash. **Studied:** Art Institute of Pittsburgh; PAFA, 1948-52. US Army, 1944-47. **Taught:** The Pennsylvania

State U.; Philadelphia Museum School; PAFA, 1953- . **Awards:** PAFA, Cresson Fellowship, 1951; PAFA, J. Henry Schiedt Scholarship, 1952; NAD, Hallgarten Prize, 1952; L. C. Tiffany Grant, 1952, 58; Guggenheim Foundation Fellowship, 1955, 56; PAFA, Walter Lippincott Prize, 1958; NAD, Benjamin Altman Prize, 1958, 62; Corcoran, First William A. Clark Prize, 1961; NAD, Gold Medal, 1975. **Address:** Cheyney Road, Cheyney, Pa. 19319. **Dealer:** The Forum Gallery. **One-man Exhibitions:** Dubin Gallery, Philadelphia, 1952; Philadelphia Art Alliance, 1954; PAFA, 1956; Janet Nessler Gallery, NYC, 1961; Durlacher Brothers, NYC, 1964; The Forum Gallery, 1966, 73; Maxwell Gallery, San Francisco, 1969. **Group:** NAD, 1952, 54, 56, 58, 61; Youngstown/Butler, 1953, 1958-61; PAFA, 1954, 58, 60; WMAA, 1958; Corcoran, 1961. **Collections:** Colorado Springs/FA; Dallas/MFA; NAD; PAFA; Ringling; WMAA. **Bibliography:** Goodrich and Baur 1.

KAMROWSKI, GEROME. b. January 29, 1914, Warren, Minn. **Studied:** St. Paul School of Art, with L. Turner, Cameron Booth; ASL; Hofmann School.

Ben Kamihira *Fantasia* 1972-73

Taught: U. of Michigan, 1946- . Federal A.P.: Mural painting in Minnesota and New York. **Awards:** Guggenheim Foundation Fellowship; Detroit/Institute, 1949, 54, 55, 61, Merit Prize, 1967; Cranbrook, Horace H. Rackham Research Grant, 1957. **Address:** 1501 Beechwood Drive, Ann Arbor, Mich. 48103. **One-man Exhibitions:** Mortimer Brandt, NYC, 1946; Betty Parsons Gallery, 1948; Alexander Iolas Gallery; Galerie Creuze, Paris, 1950, 58; Hugo Gallery, NYC, 1951; U. of Michigan, 1952, 59, 61; The Saginaw Museum, 1954; Jackson Art Association; Cranbrook, 1947; Gallery Mayer, NYC, 1961; S. W. Wind Gallery, Ann Arbor; Eastern Michigan U. (two-man). **Group:** Chicago/AI, 1945, 46; Buffalo/Albright, 1946; Galerie Maeght, 6 American Painters, 1947; WMAA Annuals, 1947, 48, 51, 53; Detroit/Institute, 1948, 50, 52, 54, 58; U. of Illinois, 1950; Sidney Janis Gallery, Surrealist and Abstract Art; MOMA; SRGM; U. of Michigan (four-man); 12 Canadian and American Painters, NYC. **Collections:** Detroit/Institute; Flint/Institute; Simon Frazer U.; Knoll Associates Inc.; Minnesota/MA; U. of North Carolina; Phillips. **Bibliography:** Baur 7; Breton 3; Calas; Janis, S.; Ritchie 1.

KAMYS, WALTER. b. June 8, 1917, Chicago, Ill. **Studied:** Chicago Art Institute School, 1943, with Hubert Ropp, Boris Anisfeld; privately in Mexico with Gordon Onslow-Ford, 1944. Traveled Mexico, Europe. **Taught:** The Putney School, Vermont, 1945; G. W. V. Smith Art Museum, Springfield, Mass., 1947-60; U. of Massachusetts, 1960- . Director Art Acquisition Program, U. of Massachusetts Collection, 1962-74. **Awards:** Prix de Rome, 1942; Chicago/AI, Anna Louise Raymond Fellowship, 1942-43; Chicago/AI, Paul Trebilcock **P.P.**, 1943; Chicago/AI, James Nelson Raymond Traveling Fellowship, 1943-44; Boston Arts Festival, Second Prize, 1955; State College at Westfield, **P.P.**, 1968. **Address:** North Main Street, Sunderland, Mass. 01375. **One-man**

Exhibitions: (first) Cliff Dwellers Club, Chicago, 1944; Dartmouth College, 1946; Margaret Brown Gallery, Boston, 1949; The Little Gallery, Springfield, Mass., 1951; Mortimer Levitt Gallery, NYC, 1954; Muriel Latow Gallery, Springfield, Mass., 1954; The Bertha Schaefer Gallery, 1955, 57, 61; Deerfield (Mass.) Academy, 1956, A Painter with a Camera (abstract photos), 1960; Concordia College, 1957; Springfield, Mass./MFA, 1948, 59; New Vision Center, London, 1960; Univision Gallery, London, 1960; U. of Massachusetts, 1961; Stanhope Gallery, Boston, 1963; Ward-Nasse Gallery, Boston, 1968; East Hampton Gallery, N.Y., 1970. **Group:** Chicago/AI; Salon des Realites Nouvelles, Paris; PAFA; Carnegie; USIA, 20th Century American Graphics, circ.; Corcoran; ICA, Boston, Younger New England Graphic Artists, 1954; MOMA, Recent Drawings USA, 1956; ICA, Boston, View, 1960; Northeastern U., 1965; Silvermine Guild, 1967; Smithsonian, The Art of Organic Forms, 1968; U. of Connecticut, New England Artists, 1971; G. W. V. Smith Museum, Springfield, Mass., 1973. **Collections:** Albion College; Harvard U.; U. of Massachusetts; Mount Holyoke College; NYU; Smith College; U. of Vermont; WDAY; Westfield; Wright State U.; Yale U. **Bibliography:** Janis and Blesh 1.

KANEMITSU, MATSUMI. b. May 28, 1922, Ogden, Utah. **Studied:** Atelier Fernand Leger, Paris (painting); ASL, with Yasuo Kuniyoshi, Harry Sternberg, C. P. Austin, Byron Browne; privately with Karl Metzler in Baltimore (sculpture). US Army, 1941-46. Traveled Europe, USA, the Orient. **Taught:** Chouinard Art Institute, 1965-67, 1969-72; U. of California, Berkeley, 1966, 1970-71; Honolulu Academy School, 1967-68; Otis Art Institute, 1971; U. of California, Santa Barbara, 1972-73. **Awards:** Ford Foundation Grant for Tamarind, 1961; Longview Foundation Grant, 1962, 64; Ford Foundation/A.F.A. Artist-in-Residence,

1964. **Address:** 854 South Berendo Street, Los Angeles, Calif. 90005. **Dealer:** Jodi Scully Gallery. **One-man Exhibitions:** (first) Fort Riley, Kans., 1942; Gallery 77, New Haven 1953; Western Maryland College, 1954; Baltimore/MA, 1954; Zoe' Dusanne Gallery, 1955; The New Gallery, NYC, 1957; Widdifield Gallery, NYC, 1959; Dwan Gallery, 1960, 61, 63; Stephen Radich Gallery, 1961, 62; Southern Illinois U., 1961; i Gallery, La Jolla, 1963; Akron/AI, 1964; Occidental College, 1966; U. of California, 1966; Honolulu Academy, 1967; Paul Gallery, 1967; Chouinard Art Institute, 1968; Serisawa Gallery, 1970; Michael Smith Gallery, Los Angeles, 1972; Pacific Culture Asia Museum, Pasadena, 1973; Jodi Scully Gallery, 1974. **Group:** Baltimore/MA, 1948-52; Corcoran, 1950; Chicago/AI, 1952; Academy of Fine Arts, Berlin, 1954; MOMA, 1956; WMAA, 1956; Dallas/MFA, 1960; WMAA Annual, 1962; MOMA, Art in Embassies, circ. internationally, 1963-64; MOMA, Americans 1963, circ., 1963-64. **Collections:** Akron/AI; U. of Arizona; Baltimore/MA; Baltimore/Walters; Chicago/AI; Cincinnati/AM; Corcoran; Dillard U., Fort Worth; Hall of Justice; Hiroshima State Museum; Honolulu Academy; Housatonic Community College; Kansas City/Nelson; La Jolla; Los Angeles/County MA; MOMA; NCFA; Nagoya City Hall; National Museum of Wales; U. of New Mexico; Norfolk/Chrysler; Osaka/Municipal; SFMA; Santa Barbara/MA; Tokyo/Modern; Tougaloo College; Turin/Civico; UCLA; Worcester/AM.

KANOVITZ, HOWARD. b. February 9, 1929, Fall River, Mass. **Studied:** Providence College, 1949, BS; RISD, 1949-51; ASL, Woodstock, 1951, with Yasuo Kuniyoshi; New School for Social Research, 1949-52; U. of Southern California, 1958; NYU, 1960-61. Traveled Europe, North Africa, 1956-58. **Taught:** Brooklyn College, 1961-64; Pratt Institute, 1964-66. **Address:** c/o Dealer. **Dealer:** M. E. Thelen Gallery,

Cologne. **One-man Exhibitions:** The Stable Gallery, NYC, 1962; Fall River (Mass.) Association, 1964; Jewish Museum, 1966; Waddell Gallery, 1969, 71; Everyman Gallery, NYC, 1970; M. E. Thelen Gallery, Cologne, 1970, 73; Benson Gallery, 1970, 71; Galleri Ostergren, Malmo, 1971; Hedendaagse Kunst, Utrecht, 1973; Duisburg, 1974; Stefanotty Gallery, NYC, 1975. **Group:** Chicago/AI, 1961; U. of Illinois, 1963; WMAA, 1965, 67, 72; Riverside Museum, NYC, Paintings from the Photo, 1969; Sweden/Goteborgs, Warmwind, 1970; WMAA, 22 Realists, 1970; VMFA, American Painting, 1970; Chicago/ Contemporary, Radical Realism, 1971; NIAL, 1972; Stuttgart/WK, Amerikanischer Fotorealismus, circ., 1972; Kunsthalle, Recklinghausen, Mit Kamera, Pinsel und Spritzpistole, 1973; **Collections:** Aachen/NG; Cologne; Duisburg; F.T.D. Association; Indianapolis; Rotterdam; Sweden/Goteborgs; Utrecht; WMAA. **Bibliography:** *Amerikanischer Fotorealismus;* **Howard Kanovitz;** *Kunst um 1970;* Sager.

KANTOR, MORRIS, b. April 15, 1896, Minsk, Russia; **d.** January 30, 1974. **Studied:** Independent School of Art, with Homer Boss. **Taught:** ASL, 1934- ; U. of Michigan, 1958; Michigan State U., 1960; U. of Colorado, 1962; U. of Illinois, 1963; U. of Minnesota, Duluth, 1963; U. of New Mexico, 1964. **Member:** Federation of Modern Painters and Sculptors. Federal A.P.: Supervisor in Rockland County, N.Y. (about 6 months). **Awards:** Chicago/AI, The Mr. & Mrs. Frank G. Logan Medal, 1931; Corcoran, Third Prize, 1939; PAFA, Joseph E. Temple Gold Medal, 1940; U. of Illinois, **P.P.**, 1951; Riverside Museum, **P.P.**, 1960; National Council on the Arts, 1968. **One-man Exhibitions:** (first) Rehn Galleries, 1930, also 1932, 35, 38, 40, 43, 45, 47, 49, 53, 59; Chicago/AI, 1932; U. of Michigan, 1958; The Bertha Schaefer Gallery, 1959, 62, 65, 67; Comara Gallery, 1962; U. of Illinois, 1963; U. of Minnesota, Duluth, 1963; The Bertha Schaefer Gallery,

1971; The Zabriskie Gallery, 1971. **Retrospective:** Davenport/Municipal, 1965. **Group:** Society of Independent Artists, annually since 1920; MMA; WMAA; MOMA; Brooklyn Museum; PAFA; Newark Museum; Chicago/AI; Corcoran; XXIV Venice Biennial, 1948; III International Biennial Exhibition of Prints, Tokyo, 1962; Smithsonian, 1966; U. of New Mexico, 1967. **Collections:** U. of Arizona; Brandeis U.; Chicago/AI; Davenport/Municipal; Des Moines; Detroit/Institute; Fort Wayne/AM; U. of Illinois; Knox College; MMA; MOMA; U. of Michigan; U. of Minnesota; NCFA; U. of Nebraska; Newark Museum; PAFA; Phillips; Santa Barbara/MA; Utica; WMAA; Wesleyan U. (Conn.); Wilmington; Worcester/AM. **Bibliography:** *Avant-Garde Painting and Sculpture;* Baur 7; Brown, Cahill and Barr, eds.; Cheney; Flanagan; Goodrich and Baur 1; Huyghe; *Index of 20th Century Artists;* Janis, S.; Jewell 2; Kootz 1; Mellquist; Pagano; Pearson 1; Phillips 1; Poore; Pousette-Dart, ed.; Wheeler; Wight 2. Archives.

KAPROW, ALLAN. b. August 23, 1927, Atlantic City, N.J. **Studied:** NYU, 1945-49, BA; Hofmann School, NYC, 1947-48; Columbia U., with Meyer Schapiro, 1950-52, MA (Art History); privately with John Cage in NYC, 1956-58. Traveled Europe, USA. **Taught:** Rutgers U., 1953-61; Pratt Institute, 1960-61; Stony Brook/SUNY, 1961-69; California Institute of the Arts, Los Angeles, 1969- . A co-founder of Hansa Gallery, NYC, 1952, and Reuben Gallery, NYC, 1959. Designed sets and costumes for Eileen Passloff Dance Co., 1958. Initiated the first Environments and Happenings, 1958. **Awards:** Katherine White Foundation Grant, 1951; Rutgers U. Research Fund Grant, 1957; William and Noma Copley Foundation Grant, 1962; J. S. Guggenheim Fellowship, 1967. **Address:** 270 Wigmore Drive, Pasadena, Calif. 91125. **Dealer:** M. L. D'Arc Gallery. **One-man Exhibitions:** (first) Hansa Gallery, NYC, 1953, also 1955, 57; Rutgers U., 1953, 55;

Urban Gallery, NYC, 1955, 56; Sun Gallery, Provincetown, 1957; John Gibson Gallery, NYC, 1969; Galerie Rene Block, Berlin, 1970; Galleria Bertesca, Milan, 1973; Stefanotty Gallery, NYC, 1974. **Environments:** Hansa Gallery, NYC, 1958; Judson Gallery, NYC, 1960; Martha Jackson Gallery, 1961; U. of Michigan, 1961; Rijksmuseum Amsterdam and Stockholm/National, 1961; Smolin Gallery, NYC, and Stony Brook/SUNY, 1962; Smolin Gallery, NYC, 1964. **Happenings:** Douglass College, 1958; Reuben Gallery, NYC, 1959, 61; Judson Memorial Church, NYC, 1960; U. of Michigan, 1961; Maidman Playhouse, NYC, 1962; Walker, 1962; Theatre des Nations, Paris, 1963; Edinburgh, Scotland, 1963; Southern Illinois U., 1964; Miami, Fla., 1964; U. of California, Berkeley, 1964; Cornell U., 1964; Florida State U., 1965; Judson Hall, NYC, 1965; ICA, Boston, 1966; Central Park, NYC, 1966; Westchester Art Society, White Plains, N.Y., 1966; Stony Brook/SUNY, 1967; Aspen Design Conference, 1970; Merriewold West Gallery, Far Hills, N.J., 1975; and many others. **Retrospective:** Pasadena/AM, 1967. **Group Exhibitions:** Boston Arts Festival, 1957; A.F.A., Collage in America, circ., 1957-58; Cornell U., 1958; Carnegie, 1958; A.F.A., New Talent, circ., 1958; Rijksmuseum Amsterdam and Stockholm/National, 1960; MOMA, Hans Hofmann and His Students, circ., 1963-64; Jewish Museum, Work, 1969, Software, 1970; Cologne/Kunstverein, Happening & Fluxus, circ., 1970. **Bibliography:** Battcock, ed.; Becker and Vostell; *Contemporanea;* Davis, D.; Hansen; *Happening & Fluxus;* Hunter, ed.; Janis and Blesh 1; **Kaprow;** Kirby; Kozloff 3; Lippard 5; Lippard, ed.; *Metro;* Rubin 1; Sontag.

KARFIOL, BERNARD. b. May 6, 1886, Budapest, Hungary; **d.** 1952. **Studied:** Academie Julian, Paris, 1901, with Jean Paul Laurens; Academie des Beaux-Arts, Paris; Pratt Institute, 1899; NAD, 1900. Traveled Mexico, Europe, West Indies. **Awards:** Pan-American Exhibi-

tion, Los Angeles, 1925; Carnegie, 1927, 29; Corcoran, First William A. Clark Prize and Corcoran Gold Medal, 1928; Fort Dodge/Blanden, **P.P.**, 1940; VMFA, **P.P.**, 1942. **One-man Exhibitions:** (first) Joseph Brummer Gallery, NYC, 1924, also 1925, 27; The Downtown Gallery, 1931, 33, 35, 41, 43, 46, 50, 56; Baltimore/MA, 1939; Carnegie, 1939; Vanbark Studios, Studio City, Calif., 1946; Grover Cronin Gallery, Waltham, Mass., 1957; The Forum Gallery, 1967. **Group:** Grand Salon, Paris, 1903; Salon d'Automne, Paris, 1904; The Armory Show, 1913; MOMA, Paintings by 19 Living Americans, 1929; Carnegie; Corcoran; Baltimore/MA, Six Americans, 1939. **Collections:** AAAL; Andover/Phillips; Baltimore/MA; Brandeis U.; Britannica; Brooklyn Museum; California Palace; Carnegie; Corcoran; Dartmouth College; Detroit/Institute; Fisk U.; Fort Dodge/Blanden; Los Angeles/County MA; MMA; MOMA; Newark Museum; New Britain; New London; Ogunquit; Phillips; Southampton/Parrish; Upjohn Co.; VMFA; WMAA; Wellesley College; Wichita/AM. **Bibliography:** Bethers; Blesh 1; Brown; Cahill and Barr, eds.; Cheney; Goodrich and Baur 1; Hall; Halpert; Huyghe; *Index of 20th Century Artists; Jewell 2;* **Karfiol;** Kootz 1, 2; McCurdy, ed.; Mellquist; Neuhaus; Pagano; Phillips 2; Pousette-Dart, ed.; Richardson, E. P.; Ringel, ed.; **Slusser;** Wight 2. Archives.

KASTEN, KARL. b. March 5, 1916, San Francisco, Calif. **Studied:** U. of California, with Worth Ryder, John Haley, Erle Loran; State U. of Iowa, with Mauricio Lasansky; Hofmann School; San Francisco Art Institute (AB, MA). Traveled Europe, Turkey, Morocco. **Taught:** San Francisco Art Institute, 1941; U. of Michigan, 1946-47; San Francisco State College, 1947-50; U. of California, 1950- . **Member:** California Society of Printmakers. **Commissions:** North American Title Co., Berkeley, Calif. (mural). **Awards:** U. of California Institute for Creative Work in the Arts, 1964-65; Tamarind Fellowship, 1968.

Address: 1884 San Lorenzo Avenue,
Berkeley, Calif. 94707. **Dealers:** Arlene
Lind Gallery; Van Straaten Gallery.
One-man Exhibitions: (first) U. of
Michigan, 1946; SFMA; Galerie Bre-
teau, Paris; Rennes; California Palace;
The Lanyon Gallery; Hollis Gallery, San
Francisco; St. Mary's College (Ind.);
Oakland/AM; Lanai Gallery; Chico
State College; Bolles Gallery, 1965, 68,
71, 73; RAC, 1968; The Catholic U. of
America, 1968; Dohan Gallery, Sher-
man Oaks, Calif., 1969; Sacramento/
Crocker, 1969; Achenbach Foundation,
1975. **Retrospective:** Walnut Creek
Civic Arts Gallery, 1973. **Group:** de
Young; SFMA; WMAA; MMA; Chi-
cago/AI; Detroit/Institute; Seattle/AM;
Pasadena/AM; Oakland/AM; I & III Sao
Paulo Biennials, 1951, 55; U. of Illinois,
50 Contemporary American Printmak-
ers, 1956, Contemporary American
Painting and Sculpture, 1969; Pomona
College, California Drawing, 1957; Art
Center, Berkeley, 1967; Los Angeles
Printmakers Society, 1968; Moore Col-
lege of Art, Philadelphia, American
Drawings, 1968; U. of the Pacific, 1969;
U. of Illinois, 1969. **Collections:** Achen-
bach Foundation; Auckland; U. of
California; de Young; College of Idaho;
Ithaca College; Los Angeles/County
MA; MOMA; Mills College; NYPL;
Oakland/AM; U. of Oklahoma; U. of the
Pacific; Pasadena/AM; Rennes; SFMA;
San Francisco State College; US State
Department; Victoria and Albert Mu-
seum.

KATZ, ALEX. b. July 24, 1927, NYC.
Studied: Cooper Union; Skowhegan
School. **Taught:** Brooklyn Museum
School, 1959; Skowhegan School, 1959;
Yale U., 1960-61; Pratt Institute, 1963-
66; School of Visual Arts, NYC, 1965,
66; New York Studio School, 1968-69.
Stage sets and costumes for: Paul
Taylor Dance Company, Festival of
Two Worlds, Spoleto, 1960, 64; Ken-
neth Koch's *George Washington Crossing the
Delaware*, 1962; Artists Festival Theater,
Southampton, *Little Eyolf*, by Henrik
Ibsen, 1968. **Awards:** Guggenheim

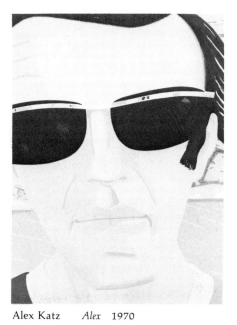

Alex Katz *Alex* 1970

Foundation Fellowship, 1972. **Address:**
435 West Broadway, NYC 10013.
Dealer: Marlborough Gallery Inc.,
NYC. **One-man Exhibitions:** Roko
Gallery, 1954, 57; The Pennsylvania
State U., 1957; Sun Gallery, Province-
town, 1958; Tanager Gallery, NYC,
1959, 62; The Stable Gallery, NYC,
1960; Martha Jackson Gallery, 1962;
Fischbach Gallery, 1962-68, 70, 71;
Thibaudt Gallery, NYC, 1963; Tanager
Gallery, NYC (two- and three-man
shows), 1953, 57, 60; David Stuart
Gallery, 1966; Bertha Eccles Art Center,
Ogden, Utah, 1968; State Teachers
College at Towson, 1968; Phyllis Kind
Gallery, Chicago, 1969, 71; Galerie
Dieter Brusberg, Hanover, 1971; M. D.
Thelen Gallery, 1971; Reed College,
1972; Sloan O'Sickey Gallery, Cleve-
land, 1972; Carlton Gallery, NYC, 1973;
Assa Galleria, Helsinki, 1973; Marlbor-
ough Gallery Inc., NYC, 1973; Colgate
U., 1974; Wesleyan U. (Conn.), 1974;
Marlborough Godard Ltd., Toronto and
Montreal, 1974; Marlborough Fine Art
Ltd., London, 1975; Galerie Arensen,
Copenhagen, 1975. **Retrospectives:**

U. of Utah, circ., 1971; WMAA, circ., 1974. **Group:** New York Art Alliance, Younger Artists, 1959; PAFA, 1960; WMAA, Young America, 1960, Annual, 1967-68; Houston/MFA, 1961; Chicago/AI, 1961, 62, 64; Colby College, Maine and Its Artists, 1963; Swarthmore College, Two Generations of American Art, 1964; MOMA, 1964-65, American Collages, 1965, The Inflated Image, circ., 1968; RISD, Recent Still Life, 1966; Milwaukee, 1966; Bennington College, 1967; U. of California, San Diego, The Impure Image, 1969; Tulsa/Philbrook, The American Sense of Reality, 1969; Milwaukee, Aspects of a New Realism, 1969; Walker, Figures/Environments, circ., 1970-71; Sweden/Goteborgs, Warmwind, 1970; Corcoran Biennial, 1971; PAFA, Contemporary Realism, 1971; SFMA, Color/Constructivism/Realism in Contemporary Graphics, 1971-72; WMAA Annual 1972, 73; Boston U., The American Landscape, 1972; WMAA, American Draw-ings: 1963-1973, 1973; Cleveland/MA, 1974. **Collections:** Aachen/NG; Allentown/AM; Boston/MFA; Bowdoin College; Brandeis U.; Chase Manhattan Bank; Chicago/AI; Ciba-Geigy Corp.; Cincinnati/AM; Colby College; Commerce Bank of St. Louis; Detroit/Institute; Hartford/Wadsworth; Harvard U.; Helsinki; Hirshhorn; MOMA; Miami-Dade; Milwaukee; NYU; U. of North Carolina; Oberline College; Scranton/Everhart; J. Henry Schroder Banking Corp.; Trenton/State; US State Department; WMAA; Wake Forest U. **Bibliography:** *Figures/Environments*; Hunter, ed.; *Kunst um 1970*; Lippard 5; O'Hara 1; Sager. Archives.

KATZMAN, HERBERT. b. January 8, 1923, Chicago, Ill. **Studied:** Chicago Art Institute School, 1940-46. Traveled Great Britain; resided Paris, Florence. **Taught:** Rockland Foundation, 1952-53; Pratt Institute; School of Visual Arts, NYC, 1959- . **Awards:** Chicago/AI,

Herbert Katzman *New York Harbor—Rainy Day* 1974

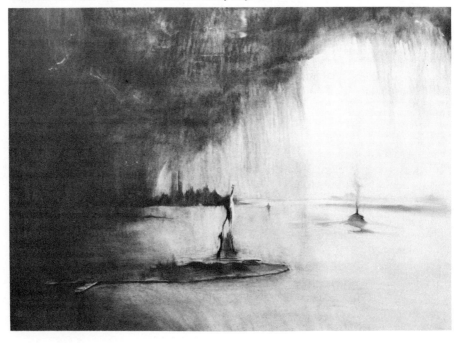

Traveling Fellowship, 1946; Chicago/ AI, Campana Prize, 1951; PAFA, J. Henry Schiedt Memorial Prize, 1954; Fulbright Fellowship, 1956; AAAL Grant, 1958; National Council on the Arts, 1967; Guggenheim Foundation Fellowship, 1968. **Address:** 463 West Street, NYC 10014. **Dealer:** Terry Dintenfass, Inc. **One-man Exhibitions:** (first) The Alan Gallery, NYC, 1954, also 1957, 59; Terry Dintenfass, Inc., 1962, 64, 66, 68, 71, 72; U. of Illinois; Brooklyn Museum. **Group:** Chicago/AI, 1951; MOMA, Fifteen Americans, circ., 1952; U. of Illinois; PAFA, 1952, Annuals, 1967, 69; Carnegie, 1953, 55; WMAA, The New Decade, 1954-55; XXVIII Venice Biennial, 1956; WMAA, Forty Artists Under Forty, circ., 1962; Gallery of Modern Art, NYC, 1967-68; New School for Social Research, 1968. **Collections:** Chicago/AI; Hirshhorn; MOMA; U. of Massachusetts; Minnesota/MA; NCFA; Sacramento/Crocker; St. Lawrence U.; WMAA; Wright State U. **Bibliography:** Nordness, ed.; Pousette-Dart, ed.

KAUFFMAN, CRAIG. b. March 31, 1932, Eagle Rock, Calif. **Studied:** U. of Southern California, 1950-52; UCLA, BA, MA, 1952-56. Traveled Europe, 1956-57; resided Paris 1960-62. **Taught:** U. of California, 1967- . **Address:** 160 La Brea, Laguna Beach, Calif. 92651. **Dealers:** The Pace Gallery; Mizuno Gallery. **One-man Exhibitions:** (first) Felix Landau Gallery, 1953; Dilexi Gallery, San Francisco, 1958, 60; Ferus Gallery, Los Angeles, 1958, 63, 65, 67; The Pace Gallery, 1967, 69, 70, 73; Ferus/Pace Gallery, Los Angeles, 1967; Irving Blum Gallery, Los Angeles, 1969, 72; Pasadena/AM, 1970; U. of California, Irvine, 1970; Darthea Speyer Gallery, 1973; Mizuno Gallery, 1975. **Group:** SFMA Annual, 1952, 54, 59-61; UCLA, California Painters Under 35, 1959; U. of Illinois, 1961, 67; Seattle/AM, 1966; Detroit/Institute, Color, Image and Form, 1967; MOMA, The 1960's, 1967; WGMA, A New Aesthetic, 1967; V. Paris Biennial, 1967; CSCS, Los Angeles, 1968; Des Moines, Painting Out from the Wall, 1968; Vancouver, 1968; Pasadena/AM, West Coast: 1945-1969, 1969; Jewish Museum, Using Walls, 1970; Govett-Brewster, The State of California Art, 1971; Corcoran Biennial, 1973; Chicago/AI, 71st American Exhibition, 1974; WMAA (downtown), Illuminations and Reflections, 1974; U. of Illinois, 1974; ICA, Los Angeles, Current Concerns, 1975. **Collections:** U. of Arizona; Buffalo/Albright; Los Angeles/County MA; MOMA; Pasadena/AM; Ridgefield/Aldrich; Tate; WMAA; Walker. **Bibliography:** Davis, D.; Friedman, M. 2; *The State of California Painting; Transparency.*

KEARL, STANLEY BRANDON b. December 23, 1913, Waterbury, Conn. **Studied:** Yale U., 1941, BFA, 1942, MFA; State U. of Iowa, 1948, Ph.D. Traveled the world extensively; resided Rome, nine years. **Taught:** U. of Minnesota, Duluth, 1947-48; Pratt Institute, 1967; YMHA, Scarsdale, 1974-75. Federal A.P.: Easel painting. **Awards:** Fulbright Exchange Professor to Rome U., Italy, 1949-50; Institute of Contemporary Arts, Florence, Italy, 1952; Connecticut Academy Sculpture Prize, 1958. **Address:** 344 Sprain Road, Scarsdale, N.Y. 10583. **One-man Exhibitions:** (first) L'Obelisco, Rome, 1950; Galerie d'Art Moderne, Basel, 1951; Samlaren Gallery, Stockholm, 1951; Marbach Galerie, Berne, 1952; Galerie 16, Zurich, 1952; Beaux Arts Gallery, London, 1956; Galleria Selecta, Rome, 1957; Obelisk Gallery, Washington, D.C., 1958; Wakefield Gallery, NYC, 1961; D'Arcy Gallery, NYC, 1962; Hudson River Museum, Yonkers, N.Y., 1964; Grand Central Moderns, NYC, 1965, 68. **Group:** XXVI Venice Biennial, 1952; PAFA, 1959; MOMA, 1961; WMAA Annual, 1962; Hudson River Museum, Yonkers, N.Y., 1963; Institute of International Education; The Graham Gallery, 1969; Stamford Museum, 1974. **Collections:** State U. of Iowa; Marbach Galerie; U. of Minnesota; Northland College; Rome/Nazionale; Stockholm/

National; Sweden/Goteborgs. **Bibliography:** Seuphor 3.

KEARNS, JAMES. b. August 7, 1924, Scranton, Pa. **Studied:** Chicago Art Institute School, De Paul U., The U. of Chicago, 1946-50 (BFA). **Taught:** School of Visual Arts, NYC, 1959- ; Skowhegan School, summers, 1961-64; Fairleigh Dickinson U., 1962-63. Illustrated *Can These Bones Live,* by Edward Dahlberg (New Directions, 1960), and *The Heart of Beethoven,* by Selman Rodman (Shorewood Press, 1962). **Awards:** NIAL Grant in Art, 1959; Montclair/AM, First Prize for Painting, 1961. **Address:** 452 Rockaway Road, Dover, N.J. 07801. **Dealers:** Grippi Gallery; David Gallery. **One-man Exhibitions:** (first) Grippi Gallery, 1956, also 1957, 60, 62, 68; Fairleigh Dickinson U., 1962; Scranton/Everhart, 1963; Lee Nordness Gallery, NYC, 1964; Bloomfield College, 1967; David Gallery, 1969, 71; Bloomfield College, 1972; Free Public Library, Fair Lawn, N.J., 1972; Sculpture Center, NYC, 1973. **Group:** A.F.A., Drawings, 1959; WMAA Annuals, 1959-61; A.F.A., New Talent, circ., 1960; A.F.A., Private Worlds, 1960; Newark Museum, Survey of American Sculpture, 1962; PAFA Annual; New York World's Fair, 1964-65; Monmouth Museum, Three Centuries of Art in New Jersey, 1969; San Diego, National Invitational Print Show, 1969; SAGA Annual, 1971. **Collections:** Colby College; MMA; MOMA; Montclair/AM; NCFA; Newark Museum; Scranton/Everhart; Topeka Public Library; Trenton/State; WMAA. **Bibliography:** Gerdts; Nordness, ed.; Rodman 1, 3.

KELLY, ELLSWORTH. b. May 31, 1923, Newburgh, N.Y. **Studied:** Boston Museum School; Academie des Beaux-Arts, Paris. US Army, 1943-46. Traveled France, 1948-54. **Commissions:** Transportation Building, Philadelphia, 1957 (sculpture); Eastmore House, NYC (mural); New York State Pavilion, New York World's Fair, 1964-65 (sculpture); UNESCO, Paris, 1969 (mural). **Awards:** Brandeis U., 1962; Carnegie, 1962, 64;

International Biennial Exhibition of Paintings, Tokyo; Chicago/AI, Flora Mayer Witkowsky Prize, 1964; Chicago/AI, Painting Prize, 1974. **Address:** Box 170B R.D., Chatham, N.Y. 12037. **Dealer:** Leo Castelli Inc., NYC. **One-man Exhibitions:** (first) Galerie Arnaud, 1951; Betty Parsons Gallery, 1956, 57, 59, 61, 63; Galerie Maeght, 1958, 64; A. Tooth & Sons, London, 1962; WGMA, 1964; ICA, Boston, 1964; Ferus Gallery, Los Angeles, 1965; Sidney Janis Gallery, 1965, 67, 71; Irving Blum Gallery, Los Angeles, 1967, 68, 73; Galerie Denise Rene/Hans Mayer, Dusseldorf, 1972; Buffalo/Albright, 1972; Leo Castelli Inc., NYC, 1973, 75 (2); Ronald Greenberg Gallery, St. Louis, 1973. **Retrospectives:** MOMA, 1973; Walker, 1974; Detroit/Institute, 1974. **Group:** Salon des Realites Nouvelles, Paris, 1950, 51; Galerie Maeght, Tendence, 1951, 62; Brussels World's Fair, 1958; Carnegie, 1958, 62, 64, 66, 67; MOMA, Sixteen Americans, circ., 1959; SRGM, Abstract Expressionists and Imagists, 1961; VI Sao Paulo Biennial, 1961; Chicago/AI, 1961, 62, 64, 66; Seattle World's Fair, 1962; Jewish Museum, Toward a New Abstraction, 1963; Los Angeles/County MA, Post Painterly Abstraction, 1964; Tate, Gulbenkian International, 1964; SRGM, American Drawings, 1964; Tate, Dunn International, 1964; MOMA, The Responsive Eye, 1965; Amsterdam/Stedelijk, New Shapes of Color, 1966; SRGM, Systemic Painting, 1966; Jewish Museum, Primary Structures, 1966; XXXIII Venice Biennial, 1966; Brandeis U., 1966; WMAA, Sculpture Annuals, 1966, 68; Annual, 1967; Tokyo/Modern, 1966-67; Detroit/Institute, Color, Image and Form, 1967; Expo '67, Montreal, 1967; Los Angeles/County MA, American Sculpture of the Sixties, 1967; SRGM, 1967; MOMA, The Art of the Real, 1968; Buffalo/Albright, Plus by Minus, 1968; Documenta IV, Kassel, 1968; Pasadena/AM, Serial Imagery, 1968; WMAA, Contemporary American Sculpture, 1968-69; WMAA Annuals, 1969, 73; MMA, New York Painting and Sculpture: 1940-1970, 1969-70;

Chicago/Contemporary (four-man), 1970; WMAA, The Structure of Color, 1971; MOMA, Technics and Creativity: Gemini G.E.L., 1971; ICA, U. of Pennsylvania, Grids, 1972; Kunstmuseum, Lucerne, 1973; Musee Galliera, Paris, Festival d'Automne, 1973; Parcheggio di Villa Borghese, Rome, Contemporanea, 1974. **Collections:** Amsterdam/Stedelijk; Brandeis U.; Buffalo/Albright; Carnegie; Chicago/AI; Cincinnati/AM; Cleveland/MA; Cologne; Dartmouth College; Eindhoven; Fort Worth; Foundation Maeght; Harvard U.; Los Angeles/County MA; MMA; MOMA; Milwaukee; Munster/WK; Omaha/Joslyn; Pasadena/AM; RISD; Rijksmuseum Kroller-Muller; SFMA; SRGM; St. Louis/City; Tate; Toronto; WGMA; WMAA; Walker; Worcester/AM; Yale U. **Bibliography:** Alloway 3; Battcock, ed.; Calas, N. and E.; *Contemporanea;* **Coplans 1,** 3; Davis, D.; Friedman, M. 2; Gaunt; **Goossen** 1, **2;** Hunter, ed.; Kozloff 3; *Kunst um 1970;* Lippard 5; MacAgy 2; Nordness, ed.; *Report;* Rickey; Rose, B. 1; Seuphor; Tuchman 1; Weller.

KELLY, JAMES. b. 1913, Philadelphia, Pa. **Studied:** Philadelphia Museum School, 1937; PAFA, 1938; Barnes Foundation, 1941; California School of Fine Arts, 1951-54. US Air Force, 1941-45. **Taught:** U. of California, Berkeley, 1957. **Awards:** Ford Foundation Grant for Tamarind, 1963. **m.** Sonia Gechtoff. **Address:** 463 West Street, NYC 10014. **One-man Exhibitions:** (first) California Palace, 1954; SFMA, 1956; The Stryke Gallery, NYC, 1963; East Hampton Gallery, N.Y., 1965, 69; Albright College, Reading, Pa., 1966; Long Island U., 1968; Westbeth Gallery, NYC, 1971, 72. **Group:** PAFA, 1951; SFMA Annuals, 1955-58; U. of Minnesota, California Painters, 1956; Minneapolis/Institute, American Painting, 1945-57, 1957; Santa Barbara/MA, II Pacific Coast Biennial, 1957; A.F.A., West Coast Artists, circ., 1959-60; Los Angeles County/MA, Late Fifties at the Ferus, 1968; Oakland/AM, A Period of Exploration, 1973. **Collections:** Amon Carter Museum; Chicago/AI; Fort Worth; La

Jolla; Los Angeles/County MA; MOMA; U. of Massachusetts; Oakland/AM; Pasadena/AM; SFMA; UCLA; Westinghouse. **Bibliography:** McChesney.

KELLY, LEON (León Kelly y Corrons). **b.** October 1, 1901. Perpignan (Pyrenees-Orientales), France. **Studied:** Philadelphia Museum School; PAFA; privately with Arthur B. Carles, Jr., and Earl Horter. Traveled Europe, North Africa, USA; resided Paris, 1924-30. Federal A.P.: Supervisor of Artists in Philadelphia; mural and easel painting. **Commissions:** Portraits. **Awards:** PAFA, Cresson Fellowship, 1924; William and Noma Copley Foundation Grant, 1959. **Address:** 268 Pompano Drive, Loveladies, N.J. 08008. **Dealer:** Alexandre Iolas Gallery, NYC. **One-man Exhibitions:** (first) Gallery of Contemporary Art, Philadelphia, 1925, also 1932; Galerie du Printemps, Paris, 1926; Contemporary Arts Gallery, NYC, 1933; Julien Levy Galleries, NYC, 1942, 44, 45; Philadelphia Art Alliance, 1943; Hugo Gallery, NYC, 1950; Galleria Amici di Francia, Milan, 1954; Hewitt Gallery, NYC, 1956; Alexandre Iolas Gallery, NYC, 1959, 61; The Zabriskie Gallery, 1963. **Retrospectives:** Philadelphia Art Alliance, 1928; International Gallery, Baltimore, 1965. **Group:** European International 1927: A Century of Progress, Chicago, 1933-34; WMAA Annuals; Carnegie; U. of Nebraska; PMA; Chicago/AI; Corcoran; Newark Museum, 1968. **Collections:** Allentown/AM; Andover/Phillips; Chicago/AI; Clearwater/Gulf Coast; Hartford/Wadsworth; La France Art Institute; MMA; MOMA; Museo Nacional de Historia; National Arts Foundation; U. of Nebraska; Newark Museum; PAFA; PMA; The Pennsylvania State U.; Steuben Glass; Tel Aviv; Utica; WMAA. **Bibliography:** *Avant-Garde Painting and Sculpture;* Gerdts; Janis, S. Archives.

KENT, ROCKWELL. b. June 21, 1882, Tarrytown Heights, N.Y., **d.** March 13, 1971, Plattsburg, N.Y. **Studied:** Columbia U., 1906-10, with William M. Chase,

Robert Henri, Kenneth Hayes Miller, Abbott Thayer. Traveled Canada, USA, Europe, Latin America, Greenland. **Member:** NIAL; Hon. member, Academy of Fine Arts of the USSR. **Commissions** (murals): US Post Office, Washington, D.C.; Federal Building, Washington, D.C. **One-man Exhibitions:** Clausen Galleries, NYC, 1908, 19; Wildenstein & Co., NYC, 1925, 42; Macbeth Gallery, NYC, 1934; Richard Larcada Gallery, 1966, 69, 72; Bowdoin College, 1969. **Retrospective:** Wildenstein & Co., NYC, 1924; Syracuse/Everson, 1937; Bowdoin College, 1969. **Group:** NAD, 1905; Academy of Fine Arts, Berlin, 1910; Century Association, 1940; Cleveland/MA; WMAA. **Collections:** American Car and Foundry Co.; Andover/Phillips; Baltimore/MA; Boston/MFA; British Museum; Brooklyn Museum; Chicago/AI; Cleveland/MA; Columbus; Corcoran; Detroit/Institute; Harvard U.; Honolulu Academy; Houston/MFA; Indianapolis/Herron; Library of Congress; MMA; NYPL; Newark Museum; Phillips; Victoria and Albert Museum; WMAA; Yale U. **Bibliography:** American Artists Congress, Inc.; American Artists Group Inc. 1, 3; **Armitage;** Baur 7; Biddle 4; Birchman; Blesh 1; Brown; Cahill and Barr, eds.; Cheney; Finkelstein; Goodrich and Baur 1; Hall; Hartmann; *Index of 20th Century Artists;* Jackman; **Jones, D. B.;** Kent, N.; **Kent, R. 1, 2, 3; Kent, R., ed.;** Lee and Burchwood; Mather 1; Mellquist; Narodny; Neuhaus; Pagano; Pearson 1; Phillips 1, 2; Reese; Richardson, E. P.; Ringel, ed.; Ritchie 1; Rose, B. 1; Smith, S. C. K.; Zigrosser 1. Archives.

KEPES, GYORGY. b. October 4, 1906, Selyp, Hungary. **Studied:** Academy of Fine Arts, Budapest, 1924-28. **Taught:** New Bauhaus, Chicago, 1937-43; a founding collaborator, with Lazlo Moholy-Nagy and Robert Wolff, of the Institute of Design, Chicago, 1938-42; MIT, 1946- . Co-director, Rockefeller Foundation Research Project: Perceptual Form of Cities. **Commissions** (murals): Harvard U. Graduate Center;

KLM Royal Dutch Airlines, NYC; Travelers Insurance Companies, Los Angeles; Sheraton Hotels, Dallas and Chicago; Children's Library, Fitchburg, Mass.; American Housing Exhibit, Paris, 1946. **Awards:** American Institute of Graphic Art, 1944, 49; U. of Illinois, **P.P.,** 1954; Guggenheim Foundation Fellowship, 1960-61; Art Directors Club, Chicago, 1963. **Address:** 90 Larchwood Drive, Cambridge, Mass. 02138. **Dealer:** Saidenberg Gallery. **One-man Exhibitions:** Katherine Kuh Gallery, Chicago, 1939; Chicago/AI, 1944, 54; Outline Gallery, Pittsburgh, 1945; Royal Academy, Copenhagen, 1950; Margaret Brown Gallery, Boston, 1951, 55; San Diego, 1952; Amsterdam/Stedelijk, 1952; Long Beach/MA, 1952; U. of California, Berkeley, 1952; SFMA, 1952, 54; Currier, 1953; Cranbrook, 1954; ICA, Boston, 1954; Syracuse/Everson, 1957; Houston/MFA, 1958; Dallas/MFA, 1958; L'Obelisco, Rome, 1958; Ivrea Gallery, Florence, Italy, 1958; The Howard Wise Gallery, Cleveland, 1959; Baltimore/MA, 1959; Saidenberg Gallery, 1960, 66, 68; Lincoln, Mass./De Cordova, 1969; NCFA, 1970; Saidenberg Gallery, 1970, 72; Alpha Gallery, 1970, 72, 74; Museum of Science and Hayden Planetarium, Boston, 1973. **Group:** MOMA, 1947, 52; Chicago/AI, 1951, 53, 57; U. of Illinois, 1952, 53; SFMA; Cranbrook; Dallas/MFA; Andover/Phillips; San Diego; WMAA; Denver/AM, 1953; Carnegie, 1955. **Collections:** Andover/Phillips; Boston/MFA; Buffalo/Albright; Chase Manhattan Bank; Cranbrook; Dallas/MFA; Des Moines; Houston/MFA; U. of Illinois; Indianapolis/Herron; Lincoln, Mass./De Cordova; MIT; MOMA; SFMA; San Diego; VMFA; WMAA. **Bibliography:** Alfieri; Davis, D.; Janis and Blesh 1; Janis, S.; **Kepes 1, 2; Kepes, ed.;** Kuh 1; Nordness, ed.; Pearson 1; Rickey. Archives.

KEYSER, ROBERT. b. July 27, 1924, Philadelphia, Pa. **Studied:** U. of Pennsylvania; Atelier Fernand Leger, Paris, 1949-51. US Navy, World War II (three

years). Traveled Europe, North Africa (two years). **Taught:** Philadelphia Museum School, 1963- . **Address:** Box 391, R.D. #4, Quakertown, Pa. 18951. **Dealer:** P. Rosenberg and Co. **One-man Exhibitions:** (first) Galerie Huit, Paris, 1951; Hendler Gallery, Philadelphia, 1952; Parma Gallery, NYC, 1954, 56, 58; P. Rosenberg and Co., 1959, 60, 62, 66, 71, 75; Gimpel Fils, 1962; Gallery Marc, Washington, D.C., 1972; Marian Locks Gallery, Philadelphia, 1974. **Group:** PAFA Annual; WMAA Annual; A.F.A., Collage in America, circ., 1957-58; Joachim Gallery, Chicago, 1960; U. of Illinois, 1961; Salon du Mai, Paris; Salon d'Automne, Paris; Salon des Realites Nouvelles, Paris; Corcoran, 1975. **Collections:** Brandeis U.; New London; PMA; Phillips; Utica; Vassar College.

KIENBUSCH, WILLIAM. b. April 13, 1914, NYC. **Studied:** Princeton U., 1936, BA, PBK (Fine Arts major); ASL, 1936-37; Colorado Springs Fine Arts Center, with Henry Poor; Academie Colarossi, Paris; privately with Abraham Rattner in Paris; with Anton Refregier and Stuart Davis in New York. US Army, World War II. **Taught:** Brooklyn Museum School, 1948- . **Awards:** Brooklyn Society of Artists Annual, First Prize, 1952; MMA, Drawing Prize, 1952; Columbia, S.C./MA, First **P.P.,** Watercolors, 1957; Guggenheim Foundation Fellowship, 1958; Ford Foundation, **P.P.,** 1961; Boston Arts Festival, First Prize for Watercolor, 1961. **Address:** 120 East 80 Street, NYC 10028. **Dealer:** Kraushaar Galleries. **One-man Exhibitions:** Kraushaar Galleries, 1949, 52, 56, 59, 63, 65, 69, 72; U. of Maine, 1956; Cornell U., 1958; Princeton U., 1962; Fort Worth, 1964 (two-man). **Retrospective:** Carnegie, 1954 (two-man, with Dioda). **Group:** Buffalo/Albright; Chicago/AI; MMA, 1952; Brooklyn Museum, 1953, 59; WMAA, The New Decade, 1954-55; Carnegie, 1955; WMAA, 1955; Walker; MOMA, Twelve Americans, circ., 1956; Brussels World's Fair, 1958; PAFA Annuals, 1962, 65, 67; New York

World's Fair, 1964-65; WMAA, Art of the U.S. 1670-1966, 1966. **Collections:** Atlanta U.; Boston/MFA; Bowdoin College; Brooklyn Museum; Buffalo/Albright; Carnegie; Colorado Springs/FA; Columbia, S.C./MA; Commerce Trust Co.; Currier; Dartmouth College; U. of Delaware; Des Moines; Detroit/Institute; Fort Worth; Hartford/Wadsworth; Houston/MFA; Kansas City/Nelson; Lehigh U.; MMA; MOMA; U. of Maine; U. of Michigan; U. of Minnesota; Montclair/AM; NCFA; U. of Nebraska; Newark Museum; New Britain; Norfolk/Chrysler; PAFA; PMA; Portland, Me./MA; U. of Rochester; Toledo/MA; Toronto; Utica; VMFA; WMAA; Wichita/AM; Williams College. **Bibliography:** Baur 5; Eliot; Goodrich and Baur 1; McCurdy, ed.; Nordness, ed.; Pousette-Dart, ed.; Ritchie 1; Seitz 3. Archives.

KIENHOLZ, EDWARD. b. 1927, Fairfield, Wash. **Studied:** Eastern Washington College of Education. Founded the Now Gallery, Los Angeles, 1956, and later the Ferus Gallery, Los Angeles. **Address:** Hope, Idaho 83836. **One-man Exhibitions:** (first) Cafe Galleria, Los Angeles, 1955; Syndell Studios, Los Angeles, 1956; Exodus Gallery, San Pedro, Calif., 1958; Ferus Gallery, Los Angeles (three-man), 1958, (two-man), 1959, 1960, 62; Pasadena/AM, 1961; Alexander Iolas Gallery, 1963; Dwan Gallery, Los Angeles, 1963-65; Dwan Gallery, NYC, 1967 (2); WGMA, 1967; Gallery 699, Los Angeles, 1968; Eugenia Butler, 1969; Stockholm/National, 1970; Dusseldorf/Kunsthalle, 1970; CNAC, 1970; Zurich, 1971; ICA, London, 1971; Wide White Space Gallery, Antwerp, 1972; Galerie Onnasch, Cologne, 1973; Galleria Bocchi, Milan, 1974. **Group:** MOMA, The Art of Assemblage, circ., 1961; Vancouver, 1968. **Collections:** Los Angeles/County MA; MOMA; WMAA. **Bibliography:** Battcock, ed.; Calas, N. and E.; Davis, D.; Hulten; **Edward Kienholz; Edward Kienholz: 11 + 11 Tableaux;** Kozloff 3; Lippard 5; Lippard, ed.; Rose B. 1; Rubin

1; Russell and Gablik; Tuchman 1, 2; *When Attitudes Become Form.*

KIESLER, FREDERICK J. b. 1896, Vienna, Austria; **d.** December 27, 1965, NYC. To USA 1926; became a citizen. Scenic Director, Julliard School of Music, NYC, 1933-57. Registered Architect; designed and built the Art of This Century Gallery, NYC (1940), the Galerie Maeght, Paris (1947), the World House Galleries, NYC (1957) and the Kamer Gallery, NYC (1959). **One-man Exhibitions:** MOMA, 1951 (sculpture); MOMA, Endless House, 1960, also 1966; U. of Houston, Architectural Plans, 1960; Leo Castelli Inc., 1961, 62; SRGM, Environmental Sculptures, 1964. The Howard Wise Gallery, NYC, 1969. **Retrospective:** Galerie Nachst St. Stephan, Vienna, 1975. **Group:** WMAA; A.F.A., Universal Theater, circ., 1961-64. **Collections:** MOMA. **Bibliography:** Arp; Barr 1; Blesh 1; Breton 3; Calas; *Frederick Kiesler;* Janis and Blesh 1; Janis, S.; *Metro;* Rose, B. 1; Rubin 1; Seuphor 3; Tuchman 1. Archives.

KING, WILLIAM DICKEY. b. February 25, 1925, Jacksonville, Fla. **Studied:** U. of Florida, 1942-44; Cooper Union, 1945-48, with Milton Hebald, John Hovannes; Brooklyn Museum School, 1948-49, with Hebald; Central School of Arts and Crafts, London, 1952. Traveled Italy, Greece. **Taught:** Brooklyn Museum School, 1953-60; U. of California, Berkeley, 1965-66; ASL, 1968-69; U. of Pennsylvania, 1972-73; SUNY, 1974-75. **Commissions** (murals): *SS United States,* 1952; Bankers Trust Company, NYC, 1960; Miami-Dade, 1972. **Awards:** Cooper Union, Sculpture Prize, 1948, Augustus Saint-Gaudens Medal, 1964; Fulbright Fellowship (Italy), 1949; Margaret Tiffany Blake Competition, First Prize, 1951; Moorehead Patterson Award (sculpture/to AMF Company), 1960; CAPS, 1974. **Address:** 17 East 96 Street, NYC 10028. **Dealer:** Terry Dintenfass, Inc. **One-man Exhibitions:** The Alan Gallery, NYC, 1954, 55, 61; Terry Dintenfass,

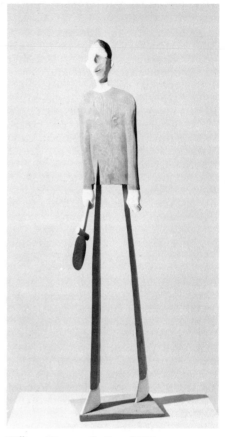

William King *Boating* 1975

Inc., 1962, 64-71, 1973, 74; The Gallery, Norwalk, Ohio, 1963; Donald F. Morris Gallery, Detroit, 1964; Washington Federal Savings & Loan Association of Miami Beach, Fla., 1965; Felix Landau Gallery, 1966; Berkeley Gallery, San Francisco, 1966; Feigen-Palmer Gallery, Los Angeles, 1966; U. of Miami, 1967; Guild Hall, 1969; Galerie Ann, Houston, 1970; The Berenson Gallery, 1970; SFMA, 1970, 74, circ.; Alpha Gallery, 1971; U. of Nebraska, 1972; U. of Connecticut, 1973; Aronson Gallery, Atlanta, 1973; Moravian College, 1974. **Retrospective:** SFMA, circ., 1970, 74. **Group:** City of Philadelphia, Sculpture International, 1949; MOMA, New

Talent; Brooklyn Museum, 1949, 50, 54, 55, 57, 58; WMAA Annuals, 1950-56, 1958-60, 1962-64, 1966, 68; U. of Illinois, 1954, 56, 62, 63, 65; New Sculpture Group, NYC, 1957-60; Carnegie, 1958; MOMA, Recent Sculpture USA, 1959; Newark Museum, Survey of American Sculpture, 1962; SRGM, The Joseph H. Hirshhorn Collection, 1962; Museum of Contemporary Crafts, 1966; Drexel Institute, 1966; Indianapolis/Herron, 1968; AAAL, 1970, 74; New School for Social Research, Humor, Satire, and Irony, 1972; Harvard U., Recent Figure Sculpture, 1972; Art Gallery of Budapest, II International Biennial of Small Sculpture, 1973; San Diego, Sculpture in the Street, 1973; Cranbrook, WAVES: An Artist Selects, 1974; Newport, R.I., Monumenta, 1974. **Collections:** American Export Isbrandtsen Lines Inc.; Andover/Phillips; U. of Arkansas; Bankers Trust Company; Brandeis U.; U. of California; Cheekwood; Cornell U.; Dartmouth College; Guild Hall; U. of Massachusetts; Miami-Dade; U. of North Carolina; Syracuse U. **Bibliography:** Lippard 5; *Monumenta; Recent Figure Sculpture;* Seuphor 3. Archives.

KIPNISS, ROBERT. b. February 1, 1931, NYC. **Studied:** Wittenberg College, 1948-50; State U. of Iowa, 1950-54, BA (English Literature), MFA (Painting and Art History); ASL, with Alice Murphy. US Army, 1956-58. **Address:** 829 Sixth Avenue, NYC 10001. **Dealers:** FAR Gallery; Merrill Chase Galleries. **One-man Exhibitions:** (first) Creative Gallery, NYC, 1951; The Salpeter Gallery, NYC, 1953; The Contemporaries, NYC, 1959, 60, 66, 67; Alan Auslander Gallery, NYC, 1963; Gallery Vendome, Pittsburgh, 1964; U. of Louisville, 1965; FAR Gallery, 1968, 70, 72, 75; Merrill Chase Galleries, 1972, 74. **Retrospective:** Museo de Arte Contemporaneo, Cali, Columbia, S.A., 1975. **Group:** Youngstown/Butler, 1951; Columbus, 1958; A.F.A., New Talent, circ., 1961; U. of Minnesota, Duluth; A.F.A., circ., 1963-65; Indiana-

polis/Herron, 1964; Utah State Institute of Fine Arts, Salt Lake City, 1964; Cornell U., 1964; Cranbrook, 1964; Corcoran, 1966, 67; Buffalo/Albright, 1966, 67; MOMA, 1966, 67; Massillon Museum, 1967; NAD, 1974; NYPL, 1974. **Collections:** Ball State U.; Chicago/AI; Cleveland/MA; Detroit/Institute; Los Angeles/County MA; Library of Congress; NYPL; U. of Notre Dame; Ohio U.; RISD; WMAA; Yale U.

KIPP, LYMAN. b. December 24, 1929, Dobbs Ferry, N.Y. **Studied:** Pratt Institute, 1950-54; Cranbrook, 1952-53. **Taught:** Bennington College, 1960-63; Hunter College, 1964-67; Herbert H. Lehman College, Bronx, N.Y., 1968- ; Dartmouth College, 1969. **Member:** American Association of University Professors. **Commissions:** Lambert Corp., Dallas; General Services Administration, Federal Office Building and Post Office, Van Nuys, Calif. **Awards:** Guggenheim Foundation Fellowship, 1965; Fulbright Fellowship, 1965. **Address:** North Salem, N.Y. 10560. **Dealer:** Galerie Denise Rene, NYC. **One-man Exhibitions:** Cranbrook, 1954; Betty Parsons Gallery, 1954, 56, 58, 60, 62, 64, 65, 68; Arizona State College, 1957; Myrtle Todes Gallery, Glencoe, Ill., 1957, 60; Bennington College, 1961; Dartmouth College, 1965; Buffalo/Albright, 1967; Katonah (N.Y.) Art Gallery, 1968; Obelisk Gallery, 1969; A. M. Sachs Gallery, 1970; Chapman Kelly Gallery, Dallas, 1971; Adam Gallery, NYC, 1972; City U. of New York Graduate Center, 1972; Richard Gray Gallery, 1973. **Group:** RISD, Four Young Americans, 1955; WMAA Annuals, 1956, 60, 62, 66, 68; Pensacola, Freedom of Inspiration, 1958; Claude Bernard, Paris, 1960; U. of Illinois, 1961; Carnegie, 1961, 62; Chicago/AI, 1961, 62; Sao Paulo, 1963; Drawing Society, National Exhibition, 1965; Jewish Museum, Primary Structures, 1966; Musee Cantonal des Beaux-Arts, Lausanne, II Salon International de Galeries Pilotes, 1966; Los Angeles/County MA, American Sculpture of the Sixties, 1967;

Ridgefield/Aldrich, 1968; MOMA, The Art of the Real, 1968; U. of Nebraska, American Sculpture, 1970; San Diego, Art is for People, 1973; Grand Rapids, Sculpture off the Pedestal, 1973. **Collections:** Buffalo/Albright; U. of California; Cranbrook; Dartmouth College; Fort Worth; High Museum; MIT; U. of Michigan; South Mall, Albany; State College at Salem; Storm King Art Center; WMAA. **Bibliography:** Battcock, ed.; Goossen 1; MacAgy 2; *Monumenta;* Seuphor 3; Tuchman 1.

KIRSCHENBAUM, JULES b. March 25, 1930, NYC. **Studied:** Brooklyn Museum School, 1948-50. **Awards:** Joe and Emily Lowe Foundation Award, 1950; PAFA, Dana Watercolor Medal, 1952; NAD, Hallgarten Prize, 1953; NAD, Isaac N. Maynard Prize, 1954; NAD, S. J. Wallace Truman Prize, 1955; Fulbright Fellowship (Italy), 1956; PAFA, Hon. Men., 1957; AAAL, Childe Hassam Award, 1957; Youngstown/Butler, First Prize, 1957; NAD, First Prize, Figure Painting, 1960. **Address:** 3908 Grand Avenue, Des Moines, Iowa 50312. **Dealer:** The Forum Gallery. **One-man Exhibitions:** The Salpeter Gallery, NYC, 1955, 56; Des Moines, 1964; The Forum Gallery, 1969. **Group:** MMA, 1952; MOMA; PAFA, 1952, 53, 54, 57; WMAA, 1953-57; Brooklyn Museum; NYU; Chicago/AI, 1957; U. of Illinois, 1957; Youngstown/Butler, 1957; Corcoran; Festival of Two Worlds, Spoleto, 1958; Santa Barbara/MA; Pasadena/AM; Houston/MFA; Dallas/MFA. **Collections:** U. of Nebraska; WMAA; Youngstown/Butler.

KLINE, FRANZ. b. May 23, 1910, Wilkes-Barre, Pa.; **d.** May 13, 1962, NYC. **Studied:** Girard College; Boston U., 1931-35; Heatherley School of Fine Art, London, 1937-38. **Taught:** Black Mountain College, 1952; Pratt Institute, 1953; Philadelphia Museum School, 1954; **Awards:** NAD, S. J. Wallace Truman Prize, 1944; Chicago/AI, 1957; XXX Venice Biennial, 1960. **One-man Exhibitions:** (first) Charles Egan Gallery, 1950, also 1951, 54; Margaret Brown Gallery, Boston, 1952; Institute of Design, Chicago, 1954; Allan Frumkin Gallery, Chicago, 1954; Sidney Janis Gallery, 1956, 58, 60, 61, 63; La Tartaruga, Rome, 1958; Galleria d'Arte del Naviglio, Milan, 1958; XXX Venice Biennial, 1960; Arts Club of Chicago, 1961; Collectors Gallery, NYC, 1961; New Arts Gallery, Atlanta, 1961; Galerie Lawrence, Paris, 1962; Dwan Gallery, 1962 (two-man, with Philip Guston); Kunsthalle, Basel, 1964 (two-man, with Alfred Jensen); Marlborough-Gerson Gallery Inc., 1967; Marlborough Fine Art Ltd., London, 1972; David McKee Gallery, 1975. **Retrospectives:** WGMA, 1962; Whitechapel Art Gallery, London, 1964; WMAA, 1968. **Group:** NAD, 1942-45; Galerie de France, Paris, 1952; 10th Inter-American Conference, Caracas, 1954; WMAA, The New Decade, 1954-55; MOMA, Twelve Americans, circ., 1956; Tate, 1956; XXVIII & XXX Venice Biennials, 1956, 60; Sao Paulo, 1957; MOMA, The New American Painting, circ. Europe, 1958-59; Baltimore/MA, 1960; SRGM, 1961; Hartford/Wadsworth, 1962; WMAA, 1966, 69; U. of St. Thomas (Tex.), 1967; MOMA, The New American Painting and Sculpture, 1969. **Collections:** Baltimore/MA; Buffalo/Albright; Carnegie; Cleveland; Houston/MFA; International Minerals & Chemicals Corp.; Kansas City/Nelson; Kunsthalle, Basel; MMA; MOMA; Norfolk/Chrysler; PMA; Raleigh/NCMA; Rockefeller Institute; SRGM; Tate; Toronto; Utica; WMAA. **Bibliography:** Ashton 5; Baur 5; Bihalji-Merin; Blesh 1; **Breeskin 1;** Calas, N. and E.; **Dawson;** Eliot; Elsen 2; Flanagan; Gaunt; Goodrich and Baur 1; **Gordon 1;** Greenberg 1; Haftman; Henning; Hess, T. B. 1; Hunter 1, 6; Hunter, ed.; Janis and Blesh 1; Kuh 2, 3; Langui; Lynton; McCoubrey 1; McCurdy, ed.; Mendelowitz; Neumeyer; Nordness, ed.; O'Hara 1, 3; Ponente; Pousette-Dart, ed.; Read 2; Rodman 1, 3; Rose, B. 1, 4; Sandler; Seuphor 1; Tomkins and Time-Life Books; Tuchman, ed.; Weller. Archives.

KNATHS, KARL. b. October 21, 1891, Eau Claire, Wisc.; d. March 9, 1971, Provincetown, Mass. Studied: Chicago Art Institute School. Taught: The Phillips Gallery School; Bennington College. Member: Audubon Artists. Federal A.P. (murals): Falmouth (Mass.) High School; US Post Office, Rehoboth Beach, Del.; Provincetown (Mass.) Town Hall. Awards: Chicago/AI, Norman Wait Harris Prize, 1928; Boston Tercentenary Art Exhibit, Gold Medal; Carnegie, First Prize, 1946; Carnegie International, Third Hon. Men., 1950; Chicago Art Institute School, Hon. DFA, 1951; elected to NIAL, 1955; Brandeis U., Creative Arts Award, 1961; NAD Annual, Andrew Carnegie Prize, 1962. One-man Exhibitions: (first) The Phillips Gallery and The Daniel Gallery, NYC (concurrently); P. Rosenberg and Co., 1946-69, 1974. Retrospective: Provincetown Art Association, 1974. Group: WMAA: Corcoran; Chicago/AI; Carnegie; U. of Illinois; PAFA; MMA. Collections: Boston/MFA; Brooklyn Museum; Buffalo/Albright; California Palace; Chicago/AI; Corcoran; Currier; Dayton/AI; Des Moines; Ford Foundation; Hartford/Wadsworth; U. of Illinois; Indianapolis/Herron; Los Angeles/County MA; MMA; MOMA; Mary Washington College; U. of Nebraska; PAFA; PMA; Phillips; U. of Rochester; Rockefeller Institute; St. Louis/City; Santa Barbara/MA; Stanford U.; Toledo/MA; Utica; WMAA; Walker; West Palm Beach/Norton; Wilmington; Woodward Foundation; Worcester/AM. Bibliography: American Abstract Artists, ed.; Baur 5, 7; Bazin; Bethers; Blanchard; Blesh 1; Cheney; Eliot; Frost; Goodrich and Baur 1, 2; Hess, T. B. 1; Janis, S.; Jewell 2; Kootz 2; Leepa; McCurdy, ed.; Mellquist; Mocsanyi; Morris; Nordness, ed.; Pearson 1; Phillips 1, 2; Pousette-Dart, ed.; Read 2; Richardson, E. P.; Ringel, ed.; Ritchie 1; Wight 2. Archives.

KNIPSCHILD, ROBERT. b. August 17, 1927, Freeport, Ill. Studied: U. of Wisconsin, with Alfred Sessler, 1947-50, BA, 1950, MFA, 1951; Cranbrook, with Zoltan Sepeshy. Traveled USA, Canada, Mexico. US Army, 1945-47. Taught: Baltimore/MA, 1951-52; American U., 1952; U. of Connecticut, 1954-56; U. of Wisconsin, 1956-60; U. of Iowa, 1960-66; U. of Cincinnati, 1966- . Address: 3346 Jefferson Avenue, Cincinnati, Ohio 45220. Dealer: Sneed-Hillman Gallery. One-man Exhibitions: Cranbrook, 1951; Baltimore/MA, 1952-53, 55; American U., 1952; The Alan Gallery, NYC, 1953-55, 57, 58, 61; U. of Iowa, 1960; U. of Wisconsin, 1960-65; Lubetkin Gallery, Des Moines, 1962; Sneed-Hillman Gallery, 1962, 64, 67, 68; Skidmore College, 1969; Louisiana State U., 1970; U. of Massachusetts, Madison College, 1972. Retrospectives: U. of Cincinnati, 1974; Western Michigan U., 1975. Group: MMA, American Painting Today, 1950; PAFA Biennial, 1951, 53; WMAA Annual, 1952; Youngstown/Butler Biennial, 1954; Corcoran; Carnegie. Collections: Baltimore/MA; Brandeis U.; Cedar Rapids/AA; U. of Cincinnati; Cranbrook; Davenport/Municipal; Grinnell College; Hirshhorn; Hope College; Illinois Wesleyan U.; Library of Congress; Madison College; U. of Michigan; U. of Minnesota; Murray State U.; PAFA; Phillips; Skidmore College; Springfield, Ill./State; Stephens College; Upjohn Co.; U. of Wisconsin; Wisconsin State U.

KOCH, GERD. b. January 30, 1929, Detroit, Mich. Studied: Wayne State U., with David Mitchell, David Smith, L. J. Nobili, 1951, BFA; UCLA Graduate School, with Sam Amato, 1957; U. of California, Santa Barbara, MFA, 1967. Traveled Europe, USA extensively. Taught: Palos Verdes Community Arts Association, 1953- ; Ventura College, 1959-60, 1967- ; U. of California, Extension Division, 1966- . Awards: California Watercolor Society, M. Grumbacher P.P., 1956, 60; Los Angeles/County MA, First P.P., 1959; Palos Verdes Invitational, 1960; Bay Printmakers Society, Oakland, Adell Hyde Morrison Memorial Medal, 1960; Cali-

fornia Watercolor Society, Lytton **P.P.**, 1962; California State Fair, **P.P.**, 1963; and others. **Address:** 444 Aliso, Ventura, Calif. 93001. **Dealer:** Comara Gallery. **One-man Exhibition:** (first) Ojai Music Festival, 1956; Pasadena/AM, 1958; Santa Monica (Calif.) Art Gallery, 1958; Esther Robles Gallery, 1959, 61, 63, 65; Santa Barbara/MA, 1960; Long Beach/MA, 1961; La Jolla, 1962; Esther Baer Gallery, 1964, 65, 67; Ojai Art Center, 1965, 69; Comara Gallery, 1968. **Group:** Los Angeles Art Association, 7 Artists, 1955; California Watercolor Society, 1955-60, 62, 63, 1965-68; Los Angeles/County MA, 1957, 1959-61; SFMA, 1957, 62, 63, New Paintings, 1964; Pasadena/AM, A Decade in the Contemporary Gallery, 1959; Tucson Art Center, 1960; Oakland/AM, 1960; La Jolla, 1961, 62; San Diego, 1961, 62; California State Fair, 1961-64, 67; Occidental College, Art and Anti-Art, 1964; U. of North Carolina, 1966; Youngstown/Butler, 1966; California Palace, 1967; California Art Festival, 1968. **Collections:** CSCS, Long Beach; California State Fair; La Jolla; Long Beach/MA; Los Angeles/County MA; Lytton Savings and Loan Association; Palos Verdes; Pasadena/AM; Santa Barbara/MA; VMFA.

KOCH, JOHN. b. August 18, 1909, Toledo, Ohio. Self-taught in art. Traveled France, Great Britain; resided Paris, 1929-33. **Taught:** ASL, 1944-45; Chairman of the School Committee, NAD. **Member:** NAD; Century Association; Lotus Club; Audubon Artists; NIAL. **Awards:** Salon de Printemps, Paris, Hon. Men., 1929; Carnegie, First Hon. Men., 1943; NAD, 1952; NAD, Benjamin Altman Prize, 1959; NAD, 137th Annual, Saltus Gold Medal for Merit; Youngstown/Butler, Dr. John J. McDonough Award, 1962; Lotus Club, 1964. **Address:** 300 Central Park West, NYC 10024. **Dealer:** Kraushaar Galleries. **One-man Exhibitions:** (first) Bonestell Gallery, Detroit, 1927; Curt Valentine Gallery, NYC, 1935; Kraushaar Galler-

ies, 1939, 41, 43, 46, 49, 51, 54, 58, 61, 65, 69, 72; Kansas City/Nelson, 1940; J. L. Hudson Art Gallery, 1941; Whyte Gallery, Washington, D.C., 1944; Philadelphia Art Alliance, 1945; Portraits, Inc., NYC; Syracuse/Everson, 1951; Cowie Galleries, Los Angeles, 1951; 460 Park Avenue Gallery, NYC, 1951. **Retrospective:** Suffolk Museum, Stony Brook, N.Y., 1951; Museum of the City of New York, 1963; Pittsfield/Berkshire, 1963; VMFA, 1962; Louisville/Speed, 1971; Akron/AI, 1971. **Group:** Salon de Printemps, Paris, 1929; Salon des Tuileries, Paris, 1929; NAD, 1939- . **Collections:** ASL; Bennington College; Boston/MFA; Brooklyn Museum; California Palace; Canajoharie; Chicago/AI; Des Moines; Detroit/Institute; U. of Georgia; Kansas City/Nelson; Lehigh U.; MMA; MOMA; NAD; Newark Museum; New Britain; Norfolk; Omaha/Joslyn; U. of Rochester; Southampton/Parrish; Springfield, Mass./MFA; Storm King Art Center; Toledo/MA; VMFA; Youngstown/Butler. **Bibliography:** *Celebrate Ohio;* Eliot; **Koch, J.;** Soyer, R. 1. Archives.

KOENIG, JOHN FRANKLIN. b. October 24, 1924, Seattle, Wash. **Studied:** U. of California, Berkeley; Washington State College; U. of Washington, 1948, BA (Romance Languages); U. of Biarritz; Sorbonne, MA. US Army, 1943-45. Traveled Europe and the Orient extensively. General Secretary, *Cimaise* (art magazine), Paris, 1953-58. **Commissions:** Hopital St. Antoine, Paris, 1964. **Awards:** Paris/Moderne, (Third) Prix des Peintres Etrangers, 1959; I Paris Biennial, 1959; Prix des Critiques d'Art de la Presse Parisienne. **Address:** 10 rue Richer, 75009 Paris, France. **Dealers:** Galerie Arnaud; Foster-White Gallery. **One-man Exhibitions:** Librairie Selection, Paris, 1948; Galerie Arnaud, 1952 (collages), 1953, 55, 57, 59-61, 1963, 66, 68, 72, 74, 75; La Citadella d'Arte Internazionale e d'Avanguardia, Ascona, Switzerland, 1955, 57; Galleria del Cavallino, Venice, 1957; Brussels/Beaux-Arts, 1957; Grange

(Gallery), Lyon, 1958; Zoe Dusanne Gallery, Seattle, 1958, 60; Tokyo Gallery, 1960, 62; Seattle/AM, 1960, 61, 70, 71; Gordon Woodside Gallery, Seattle and San Francisco, 1962, 65, 67; The Willard Gallery, 1963, 65; Musee de Verviers, 1963; San Antonio/McNay, 1963; Le Lutrin, Lyon, 1965, 66; Montreal/Contemporain, 1966, 73; Holst Halvorsen Konsthandel, Oslo, 1966, 69; Quebec, 1966; Portland, Ore./AM, 1966; Tacoma, 1967; Musee Vivenel, Compiegne, 1969; Galleria Lorenzelli, Bergamo, 1970; Galerie Gilles Corbeil, Montreal, 1970, 71; Jongeward Gallery, Seattle, 1971; Galleria San Fedele, Milan, 1972; Foster-White Gallery, 1973, 74; American Cultural Center, Istanbul, 1975; i. e. Graphics, Copenhagen, 1975. **Retrospectives:** Musee Vivenel, Compiegne, 1969; Seattle/AM, 1970. **Group:** International Congress of Museums, Marseilles, 1953; ICA, London, Collages and Objects, 1954; Palais des Beaux-Arts, Brussels, 1954; Amsterdam/Stedelijk, 1956; Palais des Beaux-Arts, Charleroi, Belgium, L'Art de XXIeme Siecle, 1958; ICA, Boston, 100 Works on Paper, circ. Europe, 1959; Salon des Realites Nouvelles, Paris, Artistes Americains en France, circ. France, 1960; Tate, Ecole de Paris, 1962; Havana/Nacional; Carnegie, 1964; USA: Nouvelle Peinture, circ. French museums, 1965; Musee de Lyon, USA: Groupe 68, 1968; Musee Municipal, Brest, 21 Peintres Americains, 1968; Salon des Realities Nouvelles, 1973; Menton Biennale de Tapisserie, 1975. **Collections:** Bibliotheque Nationale; CNAC; Grenoble; Houston/MFA; MMA; Montreal/Contemporain; Montreal/MFA; Musee de Verviers; NYPL; National Museum of Western Art, Tokyo; Ottawa/National; Paris/Moderne; Reykjavik; St.-Etienne; Salzburg; San Antonio/McNay; Seattle/AM; Seattle Public Library; Tacoma; Tokyo/Modern; Venice/Contemporaneo. **Bibliography:** Ragon 1; Read 4; **Restany** 1, 2.

KOHN, GABRIEL. b. 1910, Philadelphia, Pa.; **d.** May 21, 1975, Los Angeles, Calif. **Studied:** Cooper Union, 1929; Beaux-Arts Institute of Design, NYC, 1930-34; Zadkine School of Sculpture, Paris, 1946. **Awards:** Augustus Saint-Gaudens Medal from Cooper Union, 1925; Beaux-Arts Institute of Design, NYC, 14 awards in sculpture, 1929-32, and a Silver Medal, 1932; Nicholas Roerich Society, First Prize, 1932; Cranbrook, George A. Booth Scholarship, 1952; ICA, London/Tate, International Unknown Political Prisoner Competition, 1953; Ford Foundation Grant, 1960; Guggenheim Foundation Fellowship, 1967; Mark Rothko Foundation Grant, 1971. **One-man Exhibitions:** Atelier Mannucci, Rome, 1948; Galleria Zodiaco, Rome, 1950; Cranbrook, 1953; Tanager Gallery, NYC, 1958; Leo Castelli Inc., 1959; Otto Gerson Gallery, NYC, 1963; Ringling, 1964; La Jolla, 1963; David Stuart Gallery, 1963-66, 1972; The Zabriskie Gallery, 1972. **Retrospective:** Newport Harbor, circ., 1971. **Group:** Pershing Hall, Paris, American Veterans in Paris, 1948; Salon de la Jeune Sculpture, Paris, 1950; Los Angeles/County MA, 1950; Salon d'Art Libre, Paris, 1951; MMA, National Sculpture Exhibition, 1951; PAFA, 1953; WMAA Annuals, 1953, 60, 62; II Sculpture Biennial, Antwerp, 1953; MOMA, New Talent; MOMA, Recent Sculpture USA, 1959; Sao Paulo, 1959; Claude Bernard, Paris, Aspects of American Sculpture, 1960; New School for Social Research, Mechanism and Organism, 1961; Seattle World's Fair, 1962; MOMA, Americans 1963, circ. 1963-64; Ringling, 1964. **Collections:** Buffalo/Albright; Cranbrook; Hirshhorn; MOMA; Pasadena/AM; Ringling; WMAA. **Bibliography:** Goodrich and Baur 1; Hunter, ed.; Read 3; Rose, B. 1; Seuphor 3; Tuchman 1.

KOHN, MISCH. b. March 26, 1916, Kokomo, Ind. **Studied:** John Herron Art Institute, 1939; in Mexico, 1943-44, with Jose Clemente Orozco, Mendez, Diego Rivera. **Taught:** Institute of Design, Chicago; Illinois Institute of

Technology, 1949-75; Indiana U. **Awards:** PAFA, Alice McFadden Eyre Medal, 1949; Seattle/AM, **P.P.**, 1950; Brooklyn Museum, **P.P.**, 1950, 51; The Print Club, Philadelphia, 1950, 51, 55, 56, 58; Chicago/AI, 1951, 52, 58; PAFA, Pennell Memorial Medal, 1952; Guggenheim Foundation Fellowship, 1952, 54; Indianapolis/Herron, 1952, 56; NAD, 1955; Salon du Mai, Paris, 1960; Gallery of Modern Art, Ljubljana, Yugoslavia, IV International Exhibition of Prints, 1961; Tamarind Fellowship, 1961; Ford Foundation Grant. **Address:** 1860 Grove Way, Castro Valley, Calif. 94546. **One-man Exhibitions:** Philadelphia Art Alliance; Chicago/AI; St. Amands Gallery, Sarasota, Fla., 1969; Weyhe Gallery, 1970; Los Angeles/ County MA; Kansas City/Nelson. **Retrospective:** A.F.A./Ford Foundation, *1961.* **Group:** PAFA, 1949, 52, 56; Brooklyn Museum, 1949-57; Boston/MFA; Seattle/AM; Chicago/AI, 1949-58; The Print Club, Philadelphia, 1949-58; Salon du Mai, Paris, 1952, 53. **Collections:** Brooklyn Museum; Chicago/AI; Library of Congress; MOMA; NYPL; National Gallery; PMA; Rio de Janeiro; Stockholm/National. **Bibliography:** Hayter 1; Peterdi.

KONZAL, JOSEPH. b. November 5, 1905, Milwaukee, Wisc. **Studied:** ASL, with Max Weber, Walt Kuhn, Robert Laurent, 1926-30; Layton School of Art, 1927; Beaux-Arts Institute of Design, NYC, 1928-30. **Taught:** Brooklyn Museum School, 1949-71; Adelphi U., 1954-71; Newark (N.J.) Public School for Fine and Industrial Art, 1960-67; Queens College, 1966-69; Kent State U., 1971- . Federal A.P.: Supervised Federal Art Project Gallery; architectural sculpture project. **Awards:** Brooklyn Museum Biennial, 2 First Prizes; Guggenheim Foundation Fellowship, 1966. **Address:** 428 Park Avenue, Kent, Ohio 44240. **Dealer:** The New Bertha Schaefer Gallery. **One-man Exhibitions:** (first) Eighth Street Playhouse, NYC, 1938; Contemporary Arts Gallery, NYC, 1950, 52, 55; The Bertha Schaefer Gallery, 1960, 63, 65, 67, 71; Canton Art

Institute, 1974. **Retrospectives:** Adelphi U., 1965; Kent State U., 1971. **Group:** ˙Chicago/AI, 1938; MOMA, Subway Art, 1938; New York World's Fair, 1939; Sculptors Guild Annuals, 1941-71; WMAA Annuals, 1948, 60, 62, 64, 66, 68; Riverside Museum, NYC, 14 Sculptors, 1958; MOMA, Recent Sculpture USA, 1959; Newark Museum, 1961, 64; Carnegie International, 1962; WMAA, Geometric Abstraction in America, circ., 1962; New York World's Fair, 1964-65; Federation of Modern Painters and Sculptors Annuals, 1964-71; Cleveland/MA, 1972; Canton Art Institute, 1973; Dayton/AI, 1974. **Collections:** American Can Corp.; Garcia Corp.; R. H. Macy & Co.; New School for Social Research; San Antonio/McNay; Storm King Art Center; Tate; Trenton/State; Union Carbide Corp.; WMAA. Archives.

KOPMAN, BENJAMIN. b. December 25, 1897, Vitebsk, Russia; **d.** December 4, 1965, Teaneck, N.J. To USA 1903; citizen 1913. **Studied:** NAD. Illustrated *Crime and Punishment* (Random House, 1956). **Member:** Artists Equity. Federal A.P.: Paintings, lithographs. **Awards:** PAFA, Gold Medal for Landscape, 1947, 53; MMA, Fourth Prize for Etching. **One-man Exhibitions:** (first) Scott Thurber Gallery, Chicago; Macbeth Gallery, NYC, 1912; ACA Gallery; J.B. Neumann Gallery, NYC; The Milch Gallery; John Heller Gallery, NYC; Newhouse Gallery, NYC; The Forum Gallery; Phillips; Klutznick Hall, Washington, D.C., 1964. **Group:** NAD; PAFA; Carnegie; Corcoran; Phillips; Youngstown/Butler; Ringling; MMA; MOMA; La Napoule Art Foundation, Paris. **Collections:** Atlanta U.; Brooklyn Museum; Carnegie; Colgate U.; Kansas City/Nelson; MMA; U. of Michigan; New Paltz/SUNY; PAFA; PMA; Syracuse U.; Tel Aviv; WMAA; Worcester/AM. **Bibliography:** Baur 7; Brown; Cheney; **Ignatoff;** Kootz 1; Mellquist; Poore; Reese; Ringel, ed.

KOPPELMAN, CHAIM. b. 1920, Brooklyn, N.Y. **Studied:** Brooklyn Col-

lege, 1938; Educational Alliance, NYC, 1938; American Artists School, NYC, 1939, with Eugene Morley, Carl Holty; New School for Social Research, with Amédée Ozenfant; Art College of Western England, Bristol, 1944; Ecole Regionale de Beaux-Arts, Reims, 1945; ASL, 1946, with Will Barnet, Jose de Creeft; privately with Amé dée Ozenfant, 1946-49 (and served concurrently as his assistant). US Air Force, 1942-45. **Taught:** NYU; Brooklyn College; New Paltz/SUNY; School of Visual Arts, 1959- ; Aesthetic Realism Foundation, NYC, 1971- . **Member:** Society for Aesthetic Realism. **Commissions:** International Graphic Arts Society, 1958; A.A.A. Gallery, NYC, 1959, 61, 64. **Awards:** L. C. Tiffany Grant, 1956, 59; PAFA, Hon. Men., 1959; Audubon Artists, Medal for Graphics, 1960; Library of Congress, Pennell **P.P.**; SAGA, List Prize ($1000), 1967; IBM Gallery of Arts and Sciences, NYC, III International Miniature Print Exhibition, 1968; Brooklyn Museum, Print Biennial, 1968. **Address:** 498 Broome Street, NYC 10012. **Dealers:** The Terrain Gallery; A.A.A. Gallery, NYC. **One-Man Exhibitions:** (first) Outline Gallery, Pittsburgh, 1943; "67" Gallery, NYC, 1945; The Terrain Gallery, 1956, 69 (two-man, with wife, Dorothy), 1974; Philadelphia Art Alliance, 1959; Kornbluth Gallery, Paterson, N.J., 1964; Hinckley and Brohel Galleries, Washington, D.C., 1967; A.A.A. Gallery, NYC, 1973; AFS Gallery, Binghamton, N.Y., 1973; U. of Maine, 1974; Warwick (Eng.) Gallery (two-man), 1975. **Group:** Boston/MFA; Los Angeles/County MA; Chicago/AI; Walker; Baltimore/MA; Detroit/Institute; Brooklyn Museum Print Biennial; WMAA Annuals, 1948, 50, 61, 63; Yale U., 1949, 60; Documenta II, Kassel, 1959; USIA, Contemporary American Prints, circ. Latin America, 1959-60; II Inter-American Paintings and Prints Biennial, Mexico City, 1960; MOMA, Recent Painting USA: The Figure, circ., 1962-63; Graphics:USA, Moscow, 1964; St. Paul Gallery, 1966; Mexico City/Nacional, 1967; IBM Gallery of Arts and

Sciences, NYC, 1968; Cranbrook, 6th Biennial, National Religious Art Exhibition, 1968; Western New Mexico U., 1969; Library of Congress Print Annual, 1969; A.F.A., The Indignant Eye, 1971; Purdue U., Print Invitational, 1972; Utah State U., Print Invitational, 1972; Anchorage, Print Invitational, 1972, 74. **Collections:** Anchorage; Boston/MFA; Brooklyn Museum; CSCS, Long Beach; Caracas; Long Beach State College; MMA; MOMA; National Gallery; Otis Art Institute; Peabody Museum; Syracuse U.; US State Department; Victoria and Albert Museum; Walker; Western New Mexico U.; Yale U. Archives.

KORTLANDER, WILLIAM CLARK. b. February 9, 1925, Grand Rapids, Mich. **Studied:** Michigan State U., BA; State U. of Iowa, MA, Ph.D. US Army, 1943-46. Traveled USA, Western Europe; resided Western Europe, 1967-68. **Taught:** State U. of Iowa, 1950-54; Lawrence U., 1954-56; U. of Texas, 1956-61; Michigan State U., 1960; Ohio U., 1961- . **Awards:** Mead Painting of the Year, 1965; Ohio U., Baker Award, 1967-68. **Address:** Angel Ridge, Route 4, Athens, Ohio 45701. **Dealer:** A. M. Sachs Gallery. **One-man Exhibitions:** (first-NYC) A.M. Sachs Gallery, 1967, also 1968; The Jewish Center, Columbus, Ohio, 1964; Bryson Gallery, Columbus, 1965; Denison U., 1965; Otterbein College, 1965; Battelle Memorial Institute, Columbus, 1966; George Bennett Gallery, Toledo, Ohio, 1966; Western Electric Co., Columbus, 1966; West Virginia State College, 1966; Zanesville/AI, 1966; Merida Gallery, Inc., 1967; Montana State College, 1969; Gallery 200, Columbus, Ohio, 1974. **Retrospective:** Springfield Art Center, 1974. **Group:** Dallas Museum for Contemporary Arts, 1959; Witte, 1961; Ball State U., Drawings and Sculpture Annual, 1964-65; PAFA Annual, 1965; Dayton/AI, 1965; Villanova U., 1968; U. of Wisconsin, 1968; U. of North Carolina, 1970; New School for Social Research, American Drawings of the Sixties, 1970. **Collections:** Columbus; Huntington, W. Va.; Mead Corporation; Ohio U.; Otterbein College; West

Virginia State College; Zanesville/AI.

KOSUTH, JOSEPH. b. January 13, 1945, Toledo, Ohio. **Studied:** Toledo Museum School of Design, with Line Bloom Draper, 1955-62; Cleveland Institute of Art, 1963-64; private study; with Roger Barr, Paris, 1964-65; School of Visual Arts, NYC, 1965-67; New School for Social Research, 1971-72. Traveled Europe, South America, Asia, the Orient, Pacific Islands. **Taught:** School of Visual Arts, NYC, 1968. Founded and directed the Museum of Normal Art, NYC, 1967. **Award:** Cassandra Foundation Grant, 1968. **Address:** 35 Bond Street, NYC 10012. **Dealer:** Leo Castelli Inc., NYC. **One-man Exhibitions:** Museum of Normal Art, NYC, 1967; Gallery 669, Los Angeles, 1968; Bradford Junior College (two-man), 1968; Douglas Gallery, Vancouver, 1969; Instituto Torcuato di Tella, Buenos Aires, 1969; Nova Scotia College of Art and Design, Halifax, 1969; St. Martin's School of Art, London, 1969; Art & Project, Amsterdam, 1969; Coventry (Eng.) College of Art and Design, 1969; Gian Enzo Sperone, Turin, 1969, 70; A 37 90 89, Antwerp, 1969; Pinacotheca, St. Kilda, Victoria, Australia, 1969; Leo Castelli Inc., NYC, 1969, 71, 72 (2), 1975; Toronto, 1969; Pasadena/AM, 1970; Jysk Kunstgalerie, Copenhagen, 1970; Galerie Daniel Templon, Paris, 1970; Paul Maenz Gallery, Cologne, 1971; Protetch-Rivkin, Washington, D.C., 1971; Centro de Arte y Comunicacion, Buenos Aires, 1971; Lia Rumma Studio d'Arte, Naples, 1971; Carmen Lamanna Gallery, Toronto, 1971, 72; Galleria Toselli, Milan, 1971; Gian Enzo Sperone and Konrad Fischer Gallery, Rome, 1972, 74; Galerie Gunter Sachs, Hamburg, 1973; Paul Maenz Gallery, Brussels, 1973; Kunstmuseum, Lucerne, 1973; Claire S. Copley Gallery, Los Angeles, 1974; Galeria La Bertesca, Dusseldorf, 1974. **Group:** Lannis Gallery, NYC, Non-Anthropomorphic Art, 1967; U. of Rochester, New York Art, 1968; A.F.A., The Square in Painting, 1968; UCLA, Electric Art, 1969; Berne, When Attitudes Become Form, 1969; Amsterdam/Stedelijk, Op Losse Schroeven, 1969; Seattle/AM, 557,087, 1969; Dusseldorf/Kunsthalle, Prospect '69, 1969; Chicago/Contemporary, Art by Telephone, 1969; WMAA Annual, 1969; Turin/Civico, Conceptual Art, Arte Povera, Land Art, 1970; Jewish Museum, Software, 1970; Galerie im Taxispalais, Innsbruck, Concept Art, 1970; MOMA, Information, 1971; SRGM, Guggenheim International, 1971; VII Paris Biennial, 1971; Buenos Aires/Moderno, Art Systems, 1971; Kunsthalle, Nurnberg, Biennial, 1971; Munster/WK, Das Konzept ist die Form, 1972; Kunstmuseum, Lucerne, Joseph Kosuth: Investigationen uber Kunst und 'Problemkreise' seit 1965, 1973; Chicago/AI, Idea and Image in Recent Art, 1974; Kennedy Center, Art Now '74, 1974. **Collections:** MOMA; Oberlin College; Ottawa/National; SRGM; Tate. **Bibliography:** *Art Now 74;* Celant; *Contemporanea;* Davis, D.; Honnef; Lippard, ed.; Meyer; Sager; *When Attitudes Become Form.*

KRASNER, LEE. b. 1911, Brooklyn, N.Y. **Studied:** Cooper Union; NAD; Hofmann School, 1938. Federal A.P.: Mural Painting. **Commissions:** 2 Broadway Building, NYC (86-ft. mural). **Awards:** Cooper Union, Saint-Gaudens Medal, 1974. **m.** Jackson Pollock (1944). **Address:** 180 East 79 Street, NYC 10021; Springs, East Hampton, N.Y. 11937. **Dealer:** Marlborough Gallery Inc., NYC. **One-man Exhibitions:** (first) Betty Parsons Gallery, 1950; The Stable Gallery, 1955; Martha Jackson Gallery, 1958; The Howard Wise Gallery, NYC, 1961, 62; Whitechapel Art Gallery, London, 1965; Arts Council Gallery, London, circ., 1966; U. of Alabama, 1967; Marlborough Gallery Inc., NYC, 1968, 69, 73; Reese Palley Gallery, San Francisco, 1969; WMAA, 1973; Miami-Dade, 1974; Gibbes Art Gallery, Charleston, S.C., 1974; Corcoran, 1975. **Group:** MacMillin Gallery, NYC, French and American Painting, 1942;

Howard Putzell Gallery, Hollywood, 1945; Marlborough Fine Arts Ltd., London, The New, New York Scene, 1961; PAFA, 1962; PMA; MOMA, Hans Hofmann and His Students, circ., 1963-64; SRGM, American Drawings, 1964; Gallery of Modern Art, NYC, 1965; U. of Illinois, 1969; MOMA, The New American Painting and Sculpture: The First Generation, 1969; Finch College, NYC, Projected Art, 1971; WMAA, 1973; PMA/Museum of the Philadelphia Civic Center, Focus, 1974. **Collections:** WMAA. **Bibliography:** *Art: A Woman's Sensibility;* Hunter 6; Janis and Blesh 1; Janis, S.; Nemser.

KRIESBERG, IRVING. b. March 13, 1919, Chicago, Ill. **Studied:** Chicago Art Institute School, 1941, BFA; Escuela Nacional de Artes Plasticas, Mexico City, 1941-44; NYU, 1972, MA (cinema). **Taught:** Brooklyn College; Yale U.; New School for Social Research; Queens College, 1967-70. Made experimental animated films: "Pastoral," 1954; "Out of Into," 1972. Federal A.P.: Mural in Chicago, 1940-41. **Awards:** Ford Foundation, **P.P.**, 1946; Fulbright Fellowship (India), 1965-66; CAPS (films), 1974; CAPS (painting), 1974. **Address:** 463 West Street, NYC 10014. **One-man Exhibitions:** Curt Valentine Gallery, NYC; Chicago/AI, 1946; MOMA, 1953; St. Louis/City, 1954; Detroit/Institute, 1954; Jewish Museum, 1961. **Group:** Chicago/AI, 1946; MOMA, New Talent; MOMA, Fifteen Americans, circ., 1952; Detroit/Institute, 1953; St. Louis/City, 1954; Milwaukee, Directions I: Options, circ., 1968; SRGM, 1972. **Collections:** Baltimore/MA; Brandeis U.; MOMA; Santa Barbara/MA; WMAA. **Bibliography:** Atkinson.

KROLL, LEON. b. December 6, 1894, NYC; **d.** October 25, 1974, NYC. **Studied:** ASL, with John Henry Twachtman; NAD; Academie Julian, Paris, with Jean Paul Laurens. Traveled France, USA. **Taught:** NAD and ASL, 1911-73; Marland Institute, 1919-21; Chicago Art Institute School, 1924-25; PAFA,

1929-30. **Member:** NAD; AAAL; NIAL. Federal A.P.: Mural Division. **Commissions** (murals): US Justice Department, Washington, D.C., 1936-37; Worcester (Mass.) War Memorial Building, 1938-41; Johns Hopkins U.; US Military Cemetery, Omaha Beach, France. **Awards:** Chicago/AI, The Mr. & Mrs. Frank G. Logan Prize, 1919, 32, 35; NAD, Benjamin Altman Prize, 1923, 32, 35; Chicago/AI, Potter Palmer Gold Medal, 1924; PAFA, Joseph E. Temple Gold Medal, 1927; Carnegie, First Prize, 1936; Chevalier of the Legion of Honor; and more than 20 others. **One-man Exhibitions:** (first) NAD, 1910; Buffalo/Albright, 1929; Toronto, 1930 (three-man); Worcester/AM, 1937; Cleveland/MA, 1945; French & Co. Inc., NYC, 1947; The Milch Gallery, 1947, 59; Danenberg Gallery, 1970. **Group:** The Armory Show, 1913; Chicago/AI; Cleveland/MA; St. Louis/City; U. of Nebraska; WMAA; Detroit/Institute; Baltimore/MA; MMA. **Collections:** Baltimore/MA; Britannica; Carnegie; Chicago/AI; Cleveland/MA; Corcoran; Dayton/AI; Denver/AM; Detroit/Institute; U. of Illinois; Indianapolis/Herron; Los Angeles/County MA; MMA; MOMA; Minneapolis/Institute; Municipal U. of Omaha; U. of Nebraska; PAFA; SFMA; St. Louis/City; San Diego; WMAA; West Palm Beach/Norton; Wilmington. **Bibliography:** Baur 7; Biddle 4; Boswell 1; Brown; Bruce and Watson; Bryant, L.; Cheney; Coke 2; Eliot; Gerdts; Hall; *Index of 20th Century Artists;* Jackman; Jewell 2; Kent, N.; **Kroll 1, 2;** Mather 1; McCurdy, ed.; Mellquist; Narodny; Neuhaus; Pagano; Poore; Watson 1. Archives.

KRUSHENICK, NICHOLAS. b. May 31, 1929, NYC. **Studied:** ASL, 1948-50; Hofmann School, NYC, 1950-51. US Army, 1947-48. **Taught:** U. of Wisconsin, 1969; Dartmouth College, 1969; Yale U., 1969, 70; Cornell U., 1970; Ball State U., 1971; Herbert H. Lehman College, Bronx, N.Y., 1972; California State U., Long Beach, 1973; U. of Alabama, 1973; St. Cloud State College,

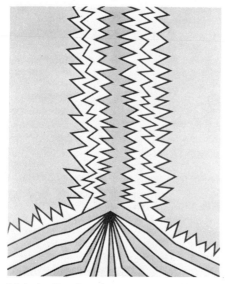

Nicholas Krushenick *A New 25 Inch* 1971

1973; U. of California, Berkeley, 1973-74; The Ohio State U., 1974; U. of Washington, 1974. **Commissions:** Designed production of Haydn's "Man in the Moon," Guthrie Theater, Minneapolis, 1968. **Awards:** Longview Foundation Grant, 1962; Tamarind Fellowship, 1965; Guggenheim Foundation Fellowship, 1967. **Address:** 595 Broadway, NYC 10012. **One-man Exhibitions:** (first) Camino Gallery, NYC, 1956; Brata Gallery, NYC, 1958, 60; The Graham Gallery, 1962, 64; Cinema I and Cinema II, NYC, 1964; Fischbach Gallery, 1965; WGMA, 1965; Galerie Muller, 1966, 67; Ileana Sonnabend Gallery, Paris, 1967; The Pace Gallery, 1967, 69, 72; Galerie Nachst St. Stephan, Vienna, 1967; Walker, 1968; Galerie der Spiegel, Cologne, 1968; Galerie Rene Ziegler, Zurich, 1969, 70; Dartmouth College, 1969; Harkus-Krakow Gallery, 1969; U. of Southern Florida, 1970; Galerie Beyeler, 1971; Herbert H. Lehman College, Bronx N.Y., 1972; Hannover/K-G, 1972; Galerie Denise Rene/Hans Mayer, Dusseldorf, 1973; U. of Alabama, 1973; Jack Glenn Gallery, Corona del Mar, 1973; California State

U., Long Beach, 1974; ADI Gallery, San Francisco, 1974; Portland (Ore.) Center for the Visual Arts, 1974; Reed College, 1974; Foster-White Gallery, 1975. **Retrospective:** Walker, 1968. **Group:** Wagner College, 1958; Galerie Creuze, Paris, 1958; Tokyo/Modern, 1959, 66; The Howard Wise Gallery, Cleveland, 1960; Barnard College, 1962; Lincoln, Mass./De Cordova, 1962; WMAA Annuals, 1963, 65, 67; Los Angeles/County MA, Post Painterly Abstraction, 1964; MOMA, Contemporary Painters and Sculptors as Printmakers, 1964; Corcoran Biennial, 1965; MOMA, American Collages, 1965; SRGM, Systemic Painting, 1966; Amsterdam/Stedelijk, New Shapes of Color, 1966; Expo '67, Montreal, 1967; Documenta IV, Kassel, 1968; Ars 69, Helsinki, 1969; ICA, U. of Pennsylvania, The Spirit of the Comics, 1969; Humlebaek/Louisiana, Amerikanst Kunst: 1950-1960, 1969; Berlin/National, 1973; WMAA Biennial, 1973; Long Beach/MA, Mixing Masters, 1974. **Collections:** Albany/SUNY; Albright/Buffalo; Amsterdam/Stedelijk; Ball State U.; Chase Manhattan Bank; The Coca-Cola Co.; Cornell U.; Dallas/MFA; Essen; Fort Lauderdale; Kalamazoo/Institute; Los Angeles/County MA; MMA; MOMA; NCFA; Norfolk; Norfolk/Chrysler; Owens-Corning Fiberglas Corp.; Ridgefield/Aldrich; Skidmore, Owings, & Merrill; Stuttgart; WGMA; WMAA; Walker. **Bibliography:** Alloway 3; Lippard 5; Rose, B. 1. Archives.

KUHN, WALT. b. October 27, 1877, Brooklyn, N.Y.; **d.** July 13, 1949, NYC. **Studied:** Academie Colarossi, Paris, 1901; Academy of Fine Arts, Munich, 1901, with H. von Zugel; Artists Sketch Class, NYC, 1905. **Taught:** New York School of Art, 1908-09. Executive Secretary, Association of American Painters and Sculptors, sponsor of The Armory Show, NYC, 1913. Founder of the Penguin Club, 1917-19. Designed sets and directed many revue skits for Broadway in the 1920's. **One-man Exhibitions:** (first) Madison Gallery,

NYC, 1910, also 1911; Montross Gallery, NYC, 1914, 15, 22, 24, 25; DeZayas Gallery, NYC, 1920; Grand Central, NYC, 1927; M. Knoedler & Co., 1928; The Downtown Gallery, 1928; Marie Harriman Gallery, NYC, 1930-42; Durand-Ruel Gallery, NYC, 1944, 45, 46, 48; Colorado Springs/FA, 1947, 64; Maynard Walker Gallery, NYC, 1954, 57, 62, 66; Amon Carter Museum, 1964; Kennedy Gallery, 1967, 68, 72. **Retrospectives:** Phillips, 1944 (two-man); A.F.A., circ., 1951; Albany/Institute, 1958; Cincinnati/AM, 1960; Fort Worth, 1964; U. of Arizona, 1966. **Group:** WMAA; Chicago/AI; Detroit/Institute; Cincinnati/AM; MOMA. **Collections:** Buffalo/Albright; Cincinnati/AM; Colorado Springs/FA; Columbus; Currier; Denver/AM; Des Moines; Detroit/Institute; New York Cultural Center; Indianapolis/Herron; Kansas City/Nelson; MMA; MOMA; U. of Nebraska; Ogunquit; Phillips; WMAA; Wellesley College; Wichita/AM. **Bibliography:** Adams 1, 2; Baur 7; Bazin; Biddle 4; **Bird;** Blesh 1; Brown; Bulliet 1; Cahill and Barr, eds.; Cheney; Eliot; Flanagan; Genauer; Gerdts; Goodrich and Baur 1; Hunter 6; *Index of 20th Century Artists;* Janis, S.; Jewell 2; Kootz 1; **Kuhn 1, 2;** McCurdy, ed.; Mellquist; Mendelowitz; Newmeyer; Pagano; Phillips 2; Poore; Richardson, E. P.; Ringel, ed.; Rose, B. 1; Smith, S.C.K.; Wight 2. Archives.

KULICKE, ROBERT. b. March 9, 1924, Philadelphia, Pa. **Studied:** Temple U., Philadelphia Museum School, Atelier Fernand Leger, 1946-50. **Taught:** U. of California, 1964, 1970; Kulicke Cloisonne Workshop, NYC, 1964- . **Awards:** American Institute of Interior Designers, International Design Award, 1968. **Address:** 309 Second Street, Belvedere, N.J. 07823. **Dealer:** Davis & Long Company. **One-man Exhibitions:** Parma Gallery, NYC, 1960; Allan Stone Gallery, 1962, 63; Multiples, 1966; The Kornblee Gallery, 1968, 69, 72; Benson Gallery, 1968, 69. **Group:** WGMA, 1964; Silvermine Guild, 1964; Chicago/

AI; Dayton/AI; A.F.A., 100 Years of American Realism, 1965; WMAA, 1969. **Collections:** PMA. Archives.

KUNIYOSHI, YASUO. b. September 1, 1893, Okayama, Japan; **d.** May 14, 1953, NYC. To USA 1906. **Studied:** Los Angeles School of Art, three years; NAD; Robert Henri School, 1910; Independent School of Art, 1914-16, with Homer Boss; ASL, 1916-20, with Kenneth Hayes Miller. Traveled Europe, Japan, USA. **Taught:** ASL, 1933-53; New School for Social Research, 1936-53; Brooklyn Museum School. **Member:** Salons of America, 1922-38 (Director); Hamilton Easter Field Foundation; American Artists Congress; An American Place (President, 1939-44); Artists Equity (President, 1947-50, Hon. President until his death). Federal A.P.: Graphics Division, two years, *ca.* 1936. **Commissions:** Radio City Music Hall, NYC (mural). **Awards:** Carnegie, Hon. Men., 1931, Second Prize, 1939, and First Prize, 1944; Los Angeles/County MA, Second Prize, 1934; PAFA, Joseph E. Temple Gold Medal, 1934; Guggenheim Foundation Fellowship, 1935; Golden Gate International Exposition, San Francisco, 1939, First Prize; PAFA, J. Henry Schiedt Memorial Prize, 1944; VMFA, **P.P.,** 1944; Chicago/AI, Norman Wait Harris Bronze Medal and Prize, 1945; La Tausca Competition, Fifth Award, 1947, 48; *Look* Magazine poll of "Ten Best Painters," February, 1948; MMA, Second Prize, 1950. **One-man Exhibitions:** The Daniel Gallery, NYC, 1922, also 1928, 30; Tokyo/Modern and Osaka/Municipal, 1931-32; The Downtown Gallery, 1933, 36, 39, 40, 41, 45, 48, 50, 52, 55, 61, 65; ASL, 1936; Baltimore/MA, 1939; Boston Museum School, 1950; Woodstock (N.Y.) Art Gallery, 1956; FAR Gallery, 1970; Paul Gallery, 1971. **Retrospectives:** The Downtown Gallery, benefit for United China Relief, 1942; WMAA, 1948; Tokyo/Modern, 1954; Boston U., 1961; U. of Florida, 1969; U. of Texas, 1975. **Group:** Society of Independent Artists, NYC; Penguin Club, NYC, 1917;

MOMA, Paintings by 19 Living Americans, 1929; MOMA, Twentieth Century Portraits, 1942; The U. of Chicago, 1948; Portland, Me./MA, 1949; XXVI Venice Biennial, 1952; U. of Illinois; U. of Nebraska. **Collections:** AAAL; Agricultural and Mechanical College of Texas; Andover/Phillips; Arizona State College; U. of Arizona; Atlanta/AA; Auburn U.; Baltimore/MA; Britannica; Brooklyn Museum; Buffalo/Albright; Carnegie; Chicago/AI; Cincinnati/AM; Clearwater/Gulf Coast; Cleveland/MA; Columbus; Cranbrook; Dallas/MFA; Des Moines; Detroit/Institute; Hamilton Easter Field Foundation; Fort Worth; U. of Georgia; Hartford/Wadsworth; Honolulu Academy; Houston/MFA; U. of Illinois; Indiana U.; Indianapolis/Herron; Kalamazoo/Institute; Kansas City/Nelson; Library of Congress; MMA; MOMA; U. of Michigan; Milwaukee; U. of Nebraska; Newark Museum; New London; Ogunquit; PMA; Phillips; Portland, Ore./AM; Santa Barbara/MA; Sao Paulo; Tel Aviv; Tokyo/Modern; Utica; VMFA; WMAA; Walker; Washington U.; West Palm Beach/Norton; Wichita/AM; Wilmington; Youngstown/Butler. **Bibliography:** American Artists Congress, Inc.; American Artists Group Inc. 3; Barker 1; Baur 7; Bazin; Bethers; Biddle 4; Blesh 1; Boswell 1; Brown; Cahill and Barr, eds.; Cheney; Coke 2; Eliot; Genauer; **Goodrich 8;** Goodrich and Baur 1; **Goodrich and Imgizumi;** Haftman; Hall; Halpert; Hunter, ed.; *Index of 20th Century Artists;* Jewell 2; Kootz 1, 2; **Kuniyoshi;** McCurdy, ed.; Mellquist; Newmeyer; Pagano; Pearson 1, 2; Poore; Pousette-Dart, ed.; Reese; Richardson, E. P.; Ringel, ed.; Rose, B. 1; Wheeler; Wight 2; Zaidenberg, ed.; Zigrosser 1. Archives.

KUNTZ, ROGER. b. January 4, 1926, San Antonio, Tex. **Studied:** Pomona College, 1943-44, 1946-48, BA; Claremont Graduate School, 1948-50, MFA; in France and Italy, 1950. **Awards:** Arizona State Fair, Second Prize, 1949, and First Prize, 1950; NAD Annual, Andrew Carnegie Prize, 1952; Denver/AM, **P.P.,** 1952, 53; Los Angeles/County MA, **P.P.,** 1953, 55, and First Prize, 1954; U. of Illinois, **P.P.,** 1955; Jose Drudis Foundation **P.P.,** ($400), 1956; Guggenheim Foundation Fellowship, 1956; Los Angeles Art Festival, 1959; Chaffey College, First Award, 1960. **Address:** 483 Jasmine Street, Laguna Beach, Calif. 97651. **Dealer:** Felix Landau Gallery. **One-man Exhibitions:** Scripps College, 1950, 54; San Diego, 1951; Felix Landau Gallery, 1952, 54, 56, 58, 62, 64; Pasadena/AM, 1953, 63; Urban Gallery, NYC, 1955; Barone Gallery, NYC, 1957; Gump's Gallery, 1957; Sierra Madre (Calif.) Public Library, 1958; San Bernardino Valley College, 1959; Whittier (Calif.) Art Association, 1960; Mount San Antonio College, 1961. **Group:** Los Angeles/County MA, California Centennial Art Exhibition, 1949; Los Angeles/County MA Annuals, 1951, 53, 57; NAD, 1952, 53; Denver/AM, 1952, 53, 54, 55; PAFA, 1952, 55; Corcoran, 1953; Carnegie, 1955, 64; Sao Paulo, 1955; U. of Illinois, 1955, 57; Santa Barbara/MA, I West Coast Biennial, 1958; Long Beach/MA, Arts of Southern California II, 1958; Oakland/AM, Pop Art USA, 1963. **Collections:** Denver/AM; U. of Illinois; Los Angeles/County MA; NAD; Pasadena/AM; Scripps College.

KUPFERMAN, LAWRENCE. b. March 25, 1909, Boston, Mass. **Studied:** Boston Museum School, 1929-31; Massachusetts School of Art, Boston, 1931-35, BS.Ed. **Taught:** Massachusetts College of Art, 1941-69 (Head, Department of Painting). **Member:** SAGA; NAD; Fellow of the Royal Society of Arts, London. Federal A.P.: Easel painting. **Commissions** (murals): *SS Constitution* and *SS Independence,* American Export Isbrandtsen Lines Inc. **Awards:** U. of Illinois, $1,000 **P.P.,** 1953; Rhode Island Arts Festival, First Prize for Painting, 1961. **Address:** 38 Devon Road, Newton Centre, Mass. 02159. **Dealer:** Harold Ernst Gallery. **One-man Exhibitions:** (first) Boris Mirski Gallery, Boston, 1944, also 1945, 46, 47; Mortimer Brandt, NYC, 1946; Philadelphia Art

Alliance, 1947; Mortimer Levitt Gallery, NYC, 1948, 49, 51, 53; Martha Jackson Gallery, 1955; The Swetzoff Gallery, Boston, 1956; Verna Wear Gallery, NYC, 1956; Ruth White Gallery, 1958; Gropper Gallery, Cambridge, Mass., 1958; The Pace Gallery, Boston, 1960, 61, 63; Lincoln, Mass./De Cordova, 1961; Irla Kert Gallery, Montreal, 1962; Art Unlimited, Providence, 1963; Horizon Gallery, Rockport, Me., 1969; The Point Gallery, Kittery Point, Me., 1969. **Retrospective:** Massachusetts College of Art, 1969; Brockton/Fuller, 1974. **Group:** Chateau de Rohan, Strasbourg, France; Omaha/Joslyn; U. of Connecticut; Chicago/AI Annuals; PAFA; WMAA Annuals; Venice Biennial; U. of Illinois; Brooklyn Museum Biennials; MMA; Hartford/Wadsworth; NAD; Carnegie; Musee du Petit Palais, Paris. **Collections:** Andover/Phillips; Baltimore/MA; Boston/MFA; Boston Public Library; Bowdoin College; Brooklyn Museum; Carnegie; Hartford/Wadsworth; Harvard U.; U. of Illinois; La Jolla; Library of Congress; MMA; MOMA; U. of Massachusetts; U. of Michigan; Mills College; NYU; SFMA; Syracuse U.; WMAA; Walker. **Bibliography:** Baur 7; Pousette-Dart, ed.; Reese. Archives.

LABAUDT, LUCIEN. b. May 14, 1880, Paris, France; **d.** December 13, 1943, Assam, India. Primarily self-taught. To London 1903; to USA 1906; became a citizen. French Army, World War I; US War Department, World War II. Artist War Correspondent for *Life* Magazine, 1943. **Commissions** (murals): Coit Memorial Tower, San Francisco; George Washington High School, San Francisco; Beach Chalet, San Francisco; US Post Office, Los Angeles; US Court House, Los Angeles; California State Building and Auditorium, Golden Gate International Exposition, San Francisco, 1939. **Awards:** SFMA, Anne Bremer Memorial Prize, 1927; Gump's Gallery, First Prize, 1932; Radical Group, Los Angeles, First Prize, 1937; SFMA, First Municipal **P.P.**, 1937. **One-man Exhibitions:** Beaux Arts Gallery, San Francisco; California Palace; Stanley Rose Gallery, Hollywood; Stendahl Gallery, Los Angeles; Oakland/AM; San Joaquin Pioneer Museum and Haggin Art Galleries, Stockton, Calif.; SFMA, 1940; SFMA, Memorial Exhibition, 1944; Lucien Labaudt Gallery, San Francisco, Memorial Exhibition, annually. **Group:** SFMA Annuals, 1920-43; Salon des Artistes Independants, Paris, 1921-26; Society of Independent Artists, NYC, 1922-31; Salon d'Automne, Paris, 1924-26; Paris Salon, 1928; Carnegie, 1931, 1933-37; MOMA, 1933, 34, 36; Brooklyn Museum, 1936. **Collections:** SFMA; San Francisco Municipal Art Commission. **Bibliography:** Cheney.

LACHAISE, GASTON. b. March 19, 1882, Paris, France; **d.** October, 1935, NYC. **Studied:** Ecole Bernard Palissy, Paris, 1895; Academie des Beaux-Arts, Paris, 1898-1904, with G. J. Thomas. Worked for Rene Lalique. To USA 1906. Worked for H. H. Kitson in Boston, 1906-12. **Commissions:** Electricity Building, A Century of Progress, Chicago, 1933-34; Rockefeller Center, NYC; Fairmount Park, Philadelphia. **One-man Exhibitions:** (first) Bourgeois Gallery, NYC, 1918, also 1920; Stieglitz's Intimate Gallery, NYC, 1927; Joseph Brummer Gallery, NYC, 1928; Philadelphia Art Alliance, 1932; WMAA, 1937; Brooklyn Museum, 1938; M. Knoedler & Co., 1947; Weyhe Gallery, 1956; Margaret Brown Gallery, Boston, 1957; MOMA, circ. only, 1962; Robert Schoelkopf Gallery, 1964, 66, 69, 73; Felix Landau Gallery, 1965; Cornell U., 1974; UCLA, 1975; The Zabriskie Gallery, 1975. **Retrospective:** MOMA, 1935; Los los Angeles/County MA, 1963; SFMA, 1967. **Group:** MOMA; WMAA; Phillips; Hartford/Wadsworth. **Collections:** Andover/Phillips; Arizona State College; Cincinnati/AM; Cleveland/MA; Hartford/Wadsworth; Harvard U.; Los Angeles/County MA; MMA; MOMA; Museum of the City of New York; New London; PMA; Phillips; U. of Rochester; Santa Barbara/MA; Smith College; U. of Texas; WMAA. **Bibliography:** *Avant-Garde Painting and Sculpture;* Baur 7; Biddle 4; Blesh 1; Brumme; Cahill and Barr, eds.; Cheney; Elsen 2; Fierens; **Gallatin 4;** Goodrich and Baur 1; Hunter 6; **Kramer 3;** Lee and Burchwood; McCurdy, ed.; **Nordland 1, 2;** Parkes; Ringel, ed.; Ritchie 3; Rose, B. 1, 4; Selz, J.; Seuphor 3; Seymour; Sutton. Archives.

LADERMAN, GABRIEL. b. October 26, 1929, Brooklyn, N.Y. **Studied:** Hans Hofmann School, 1949; privately with Willem de Kooning, 1949-50; Brooklyn

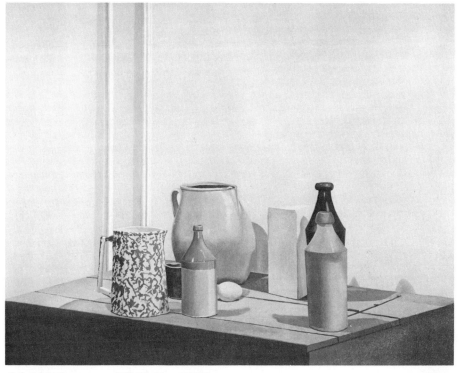

Gabriel Laderman *Still Life #4* c. 1968

College, 1948-52, BA; Atelier 17, Paris, 1949-50, 1952-53; Cornell U., 1955-57, MFA; Academy of Fine Arts, Florence, Italy, 1962-63. **Taught:** Cornell U., 1955-57; New Paltz/SUNY, 1957-59; Art Center of Northern New Jersey, 1960-64; Brooklyn College, 1961-62, 1967-68; Queens College, 1965-66, 1968-75; Pratt Institute, 1959-68, 1968-75; Yale U., 1968-69; Louisiana State U., 1966-67. **Awards:** L. C. Tiffany Award, 1969; Yaddo Fellowship, 1960, 61, 65; Fulbright Fellowship, 1962-63. **Address:** c/o Dealer. **Dealer:** Robert Schoelkopf Gallery. **One-man Exhibitions:** Cornell U., 1957; New Paltz/SUNY, 1958; Woodstock (N.Y.) Artists' Association, 1958, 59; Three Arts Gallery, 1959; Montclair State College (three-man), 1961; Pratt Institute, 1961; Robert Schoelkopf Gallery, 1964, 67, 69, 72, 74, 75, 76; Felix Landau Gallery

(four-man), 1965; Louisiana State U., 1966; Gallery 331, New Orleans, 1967; Hobart and William Smith College, 1970; U. of Rhode Island, 1970; Tyler School of Art, Philadelphia, 1971; Harwood Gallery, Springfield, Mo., 1972; Tanglewood, Mass., 1973. **Group:** Laurel Gallery, NYC, 1949; Brooklyn College 1951, 57, 58, 60; Library of Congress, 1955, 56, 57; Philadelphia Print Club, 1955, 56, 58; Tanager Gallery, NYC, 1957, 62; Utica, 1957; SAGA, 1960; Cornell U., Arts Festival, 1961; Boston U., Nine Realists, 1964; Columbia U., The Natural Vision, 1965; U. of North Carolina, 1966, 67; Tulsa/ Philbrook, The American Sense of Reality, 1969; Milwaukee, Aspects of a New Realism, 1969; Indiana U., Six Figurative Artists, 1969; New Paltz/ SUNY, 20 Representational Artists, 1969; WMAA, 22 Realists, 1970; Tren-

ton/State, Four Views, 1970; Lincoln, Mass./De Cordova, Landscape, 1971; A.F.A., Realist Revival, 1972; Boston U., The American Landscape, 1972; AAAL, 1972; Omaha/Joslyn, A Sense of Place, 1973; Arts Club of Chicago, American Landscape, 1973; The Pennsylvania State U., Contemporary Artists and the Figure, 1974; Boston/MFA, Trends in Contemporary Realist Painting, 1974. **Collections:** Chase Manhattan Bank; Cornell U.; Fidelity Bank, Philadelphia; Montclair State College; New Paltz/ SUNY; Uris-Hilton Hotels. **Bibliography:** Sager.

LAMIS, LEROY. b. September 27, 1925, Eddyville, Iowa. **Studied:** New Mexico Highlands U., BA, 1953; Columbia U., MA, 1956. Traveled Europe, Canada, Mexico. **Taught:** Cornell College, 1956-60; Indiana State U. (Terre Haute), 1961- ; Dartmouth College, Artist-in-Residence, 1970. **Commissions:** New York State Council on the Arts, 1970. **Address:** 3101 Oak Street, Terre Haute, Ind. 47803. **Dealer:** Staempfli Gallery. **One-man Exhibitions:** (first) Staempfli Gallery, 1966, also 1969; Gilman Galleries, Chicago, 1967; Fort Wayne/AM, 1968; Louisville/Speed, 1969; Indianapolis/Herron, 1969; Des Moines, 1969; La Jolla, 1969; Dartmouth College. **Group:** Buffalo/Albright; Mixed Media and Pop Art, 1963, Art Today, 1965; WMAA Sculpture Annual, 1964, 66, 68; MOMA, The Responsive Eye, 1965; Ridgefield/Aldrich, 1965-66; Riverside Museum, 1965-67; U. of Illinois, 1965-69; Flint/Institute, I Flint Invitational, 1966. **Collections:** Brooklyn Museum; Buffalo/Albright; Des Moines; Hirshhorn; Louisville/Speed; Lytton Savings and Loan Association; Ridgefield/Aldrich; Terre Haute/Swope; WMAA; Walker.

LANDAU, JACOB. b. December 17, 1917, Philadelphia, Pa. **Studied:** Philadelphia Museum School, with Franklin Watkins, H. C. Pitz; New School for Social Research, 1947-48, 1952-53; Academie de la Grande Chaumiere,

Paris, 1949-52. US Army, 943-46. **Taught:** School of Visual Arts, NYC, 1954; Philadelphia College of Art, 1954-56; Pratt Institute, 1958-74. **Member:** Philadelphia Watercolor Club. **Commissions:** International Graphic Arts Society; A.A.A. Gallery; National Broadcasting Co.; The Limbach Co.; McGraw-Hill Inc. **Awards:** The Print Club, Philadelphia, Lessing J. Rosenwald **P.P.**, 1955, 59; L. C. Tiffany Grant, 1962; PAFA, Watercolor Prize, 1963; Tamarind Fellowship, 1965; National Council on the Arts, Sabbatical Leave Grant ($7,500), 1966; J. S. Guggenheim Fellowship, 1968; AAAL, Childe Hassam, **P.P.**, 1973. **Address:** 2Pine Drive, Roosevelt, N.J. 08555. **Dealers:** A.A.A. Gallery, NYC; Lerner-Heller Gallery. **One-man Exhibitions:** (first) Galerie Le Bar, Paris, 1952; Philadelphia Art Alliance, 1954; Samuel S. Fleisher Art Memorial, Philadelphia, 1959; A.A.A. Gallery, NYC, 1960, 70; U. of Maine, 1961, 71; Cober Gallery, 1961, 63; Zora Gallery, Los Angeles, 1964; Glassboro State College, 1966; Manhattanville College of the Sacred Heart, 1966; Earlham College, 1967; Instituto General Electric, Montevideo, 1967; U. of Notre Dame, 1969; U. of New Hampshire, 1970; U. of Connecticut, 1971; Galeria Pecanins, Mexico City, 1972; The Ohio State U., 1973; Imprint, San Francisco, 1973. **Group:** NAD Annual, 1953; Boston/MFA, 1955; Seattle/AM, 1957; Cober Gallery, The Insiders, 1960; Brooklyn Museum Biennials, 1960, 62; SAGA; PAFA Annuals, 1961, 63; St. Paul Gallery, Drawings, USA, 1961, 68; A.A.A. Gallery, NYC, 100 Prints of the Year, 1962; MOMA, Recent Painting USA: The Figure, circ., 1962-63; USIA, Graphic Arts—USA, circ. USSR, 1963; Library of Congress, 1963; PCA/USIA, 30 Contemporary Prints, circ. Europe, 1964; Corcoran, 1964; Otis Art Institute, 1964; New York World's Fair, 1964-65; PMA, 1965; New Jersey Tercentenary Exhibition, New Brunswick, 1965; WMAA Annual, 1966; U. of Southern California, 1967; Mexico City/Nacional, 1967; U. of Kentucky,

1968; MOMA, Tamarind: Homage to Lithography, 1969; SAGA, Fifty Years of American Printmaking, 1969; WMAA, Human Concern/Personal Torment, 1969; A.F.A., The Indignant Eye, 1971; Museo de Arte Contemporaneo, Cali, Colombia, S.A., 1971, 73; Sao Paulo, American and Brazilian Printmakers, 1972; NAD, 1974. **Collections:** Baltimore/MA; Bibliotheque Nationale; Brooklyn Museum; U. of California; High Museum; U. of Kentucky; Library of Congress; Los Angeles/ County MA; MMA; MOMA; U. of Maine; Malmo; U. of Minnesota; Montclair/AM; NYPL; Newark Museum; New Orleans/Delgado; Norfolk; Nurnberg; PAFA; PMA; Princeton U.; Rutgers U.; San Antonio/McNay; Slater; Syracuse U.; Trenton/State; Utica; VMFA; Yale U.; Youngstown/Butler.

LANDON, EDWARD. b. March 13, 1911, Hartford, Conn. **Studied:** Hartford Art School; ASL, with Jean Charlot; privately in Mexico with Carlos Merida. Traveled Europe, Scandinavia, Mexico. **Taught** privately (serigraphy). Subject of a film, "How to Make a Serigraph," produced by the Harmon Foundation. Charter **member** and past President, National Serigraph Society; member: Boston Printmakers; American Color Print Society; The Print Club, Philadelphia. Federal A.P.: Easel painting and murals. **Awards:** Northwest Printmakers Annual, 1944, 46, 52; Brooklyn Museum, 1947; American Color Print Society, 1947; National Serigraph Society, 1947, 54, 57, 58; Boston Printmakers; San Francisco Art Association, 1949; Fulbright Fellowship (Norway), 1950, 51. **Address:** Lawrence Hill Road, Weston, Vt. 05161. **One-man Exhibitions:** (first) Boston/MFA, 1934; Smith College, 1941; Norlyst Gallery, NYC, 1945; Unge Kunstneres Samfund, Oslo, 1950; The Print Club, Philadelphia, 1953; Fine Arts Gallery, Hartford, 1954; Doris Meltzer Gallery, NYC, 1957, 58; Bennington, Vt., 1967; Sunapee, N.H., 1968; Woodstock, Vt., 1969. **Group:** Brooklyn Museum; Northwest Print-

makers Annuals; American Color Print Society; National Serigraph Society; MOMA; Library of Congress; MMA; Cooper Union, 1968; and many others. **Collections:** Bezalel Museum; Bibliotheque Nationale; Brooklyn Museum; Buffalo/Albright; Library of Congress; Kansas City/Nelson; MMA; MOMA; PMA; SFMA; Tel Aviv; Turku Museum, Finland; Victoria and Albert Museum; Worcester/AM. **Bibliography:** American Artists Congress, Inc.; **Landon;** Reese. Archives.

LANDSMAN, STANLEY. b. January 23, 1930, NYC. **Studied:** U. of New Mexico (with Randall Davey, Adja Yunkers, Agnes Martin), BFA, 1947-50, 1954-55. US Navy, 1950-54. Traveled extensively, around the world. **Taught:** Adelphi College; School of Visual Arts, NYC; Pratt Institute; Artist-in-Residence, Aspen Institute and U. of Wisconsin. **Address:** 45 Downing Street, NYC 10014. **Dealer:** Leo Castelli Inc., NYC. **One-man Exhibitions:** (first) March Gallery, NYC; Allan Stone Gallery; Richard Feigen Gallery, NYC; Richard Feigen Gallery, Los Angeles, 1965; Leo Castelli Inc., 1966; Iris Clert Gallery (two-man); Houston/Contemporary, 1970. **Group:** Kansas City/Nelson, Sound, Light, Silence, 1966; MOMA, The 1960's, 1967; Kansas City/Nelson, 1967; Ridgefield/Aldrich; New Delhi, First World Triennial, 1968; Cleveland/MA, 1968; Milwaukee, Directions I: Options, circ., 1968; WMAA, Light: Object and Image, 1968; WMAA Sculpture Annual, 1968; UCLA, Electric Art, 1969; U. of Illinois, 1969; Automation House, NYC, 1970. **Collections:** Des Moines; Kansas City/Nelson; MOMA; Milwaukee; Paris/Moderne; Ridgefield/Aldrich; WMAA; Walker. **Bibliography:** Atkinson; Davis, D. Archives.

LANGLAIS, BERNARD. b. July 23, 1921, Old Town, Me. **Studied:** The Corcoran School of Art; Skowhegan School; Brooklyn Museum School; Academie de la Grande Chaumiere;

Academy of Art, Oslo. US Navy, 1942-48. **Taught:** The Pennsylvania State U., 1972; U. of Pennsylvania, 1974. **Member:** Maine State Commission on the Arts and Humanities. **Commissions:** Samoset Hotel, Rockland, Me., 1974; General Services Administration, Federal Building, Sandpoint, Idaho. **Awards:** Fulbright Fellowship (Norway), 1954; Ford Foundation, **P.P.**, 1963; Guggenheim Foundation Fellowship, 1972; Maine State Commission on the Arts and Humanities Award, 1972; Hon. DFA, U. of Maine. **Address:** Star Route, Cushing, P.O. Thomaston, Me. 04861. **Dealers:** Lee Ault & Co.; Makler Gallery; Alpha Gallery. **One-man Exhibitions:** Roko Gallery, NYC, 1956; Area Gallery, NYC, 1959; U. of Maine, 1960, 67, 74; Leo Castelli Inc., 1961; Allan Stone Gallery, 1962; Grippi and Waddell Gallery, NYC, 1964; Seton Hall U., 1965; Makler Gallery, 1966, 72; Portland, Me./MA, 1968; Maine Art Gallery, 1969; Marlboro (Vt.) College, 1969; Bowdoin College, 1969; Lee Ault & Co., 1971; Alpha Gallery, 1972; Exeter, 1972; Governor Dummer Academy, Byfield, Mass., 1973; Frost Gully Gallery, 1974; Bates College, 1974; Colby College, 1974. **Group:** Art:USA:58 and ART:USA:59, NYC, 1958, 59; Yale U., Best of Contemporary Painting from New York Galleries, 1960; Boston Arts Festival, 1960, 61; Martha Jackson Gallery, New Media—New Forms, I & II, 1960, 61; Chicago/AI Annuals, 1960, 61, 64; WMAA Annuals, 1960, 63; Houston/MFA, New Media, 1961; MOMA, The Art of Assemblage, circ., 1961; Carnegie, 1961; A.F.A., circ., 1961-62; Colby College, Maine and Its Artists, 1963, Drawing Exhibition, 1970. **Collections:** Chase Manhattan Bank; Chicago/AI; Chrysler Corp.; Colby College; U. of Indiana; U. of Maine; Norfolk/Chrysler; Ogunquit; Olsen Foundation Inc.; PMA; Philadelphia Zoological Gardens; The Singer Company Inc.; J. Walter Thompson Co.; WMAA. Archives.

LANING, EDWARD. b. April 26, 1906, Petersburg, Ill. **Studied:** The U. of Chicago; ASL, with Boardman Robinson, Max Weber, John Sloan, Kenneth Hayes Miller; Academy of Fine Arts, Rome. Traveled USA, Europe, North Africa. **Taught:** Cooper Union, 1938-41; Kansas City Art Institute and School of Design, 1945-50; Pratt Institute, 1952-56; ASL, 1952-75. **Member:** NAD; ASL; National Society of Mural Painters. Federal A.P. (murals): Ellis Island; New York Public Library; US Post Offices, Rockingham, N.C., and Bowling Green, Ky. **Commissions:** *Life* Magazine (paintings); murals for Sheraton Corporation hotels in Los Angeles, Dallas, Louisville, Niagara Falls, NYC; US Department of Interior, Bureau of Reclamation, 1969. **Awards:** Guggenheim Foundation Fellowship, 1945; AAAL Grant; VMFA, 1945; Chicago/AI, 1945; Fulbright Fellowship, 1950. **Address:** 30 East 14 Street, NYC 10003. **One-man Exhibitions:** (first) Dudensing Gallery, NYC, 1932; The Midtown Galleries; Kansas/Nelson, 1945; Hewitt Gallery, NYC, 1950; The Griffin Gallery, NYC, 1963; Danenberg Gallery, 1969. **Group:** WMAA; MMA; Chicago/AI; Cleveland/MA; VMFA; NAD; Audubon Artists. **Collections:** Kansas City/Nelson; MMA; WMAA. **Bibliography:** Boswell 1; Cheney; Hall. Archives.

LANSNER, FAY. b. June 21, 1921, Philadelphia, Pa. **Studied:** Wanamaker Institute, 1939-41; Stella Elkins Tyler School of Fine Arts, Temple U., 1945-47; Columbia U., 1947-48; ASL, 1947-48, with Vaclav Vytlacil; Hofmann School, 1948; Atelier Fernand Leger, Paris, 1950; Academie Andre Lhote, Paris, 1950. Traveled Europe extensively; resided Paris, 1950-52. **Taught:** New School for Social Research, 1974-75. **Address:** 317 West 80 Street, NYC 10024. **Dealers:** Arras Gallery; Marlborough Gallery Inc., NYC. **One-man Exhibitions:** (first) Galerie Huit, Paris, 1951; Le Gerrec, Paris, 1952; Peretz Johannes Gallery, NYC, 1952; Hansa Gallery, NYC, 1955, 56, 58; Hood College, 1961; David Herbert Gallery,

NYC, 1961; The Zabriskie Gallery, 1963; The Kornblee Gallery, 1963, 65; James David Gallery, Miami, 1965; Douglass College, 1975. **Group:** Finch College, NYC, Paul Magriel Collection; Southampton/Parrish; Houston/MFA, The Emerging Figure, 1961; Louis Alexander Gallery, NYC, Recent American Drawings, 1962; Stanhope Gallery, Boston, Works on Paper; New School for Social Research, International Year of the Women, 1975. **Collections:** Ciba-Geigy Corp.; Lehigh U.; NYU; *Newsweek;* U. of North Carolina. **Bibliography:** *Art: A Woman's Sensibility.* Archives.

LANYON, ELLEN. b. December 21, 1926, Chicago, Ill. **Studied:** Chicago Art Institute School, The U. of Chicago, Roosevelt College (with Max Kahn, Kathleen Blackshear, Joseph Hirsch, 1944-48, BFA); State U. of Iowa, with Mauricio Lasansky, Eugene Ludins, 1948-50, MFA; Courtauld Institute, 1950-51. Traveled Europe, USA. **Taught:** Chicago/AI, 1952-54 (Junior School), 1964-65, 73; Rockford College, 1954; Saugatuck Summer School of Painting, 1961, 62, 67, 68, 69; U. of Illinois, 1966; Oxbow Summer School, 1970, 71, 72, 73; U. of Wisconsin, 1972; Stanford U., 1973; U. of California, Davis, 1973; Sacramento State U., 1973; The Pennsylvania State U., 1974; Boston U., 1975; U. of Iowa, 1975. A founder and active **Member** of the Chicago/AI Exhibition Momentum, 1948-52. **Awards:** Chicago/AI, Mr. & Mrs. Frank H. Armstrong Prize, 1946, 55; Denver/AM, **P.P.**, 1950; Library of Congress, Pennell **P.P.**, 1950; Fulbright Fellowship (England), 1950; Chicago/AI, Watson F. Blair Prize, 1958; Chicago/AI, Martin B. Cahn Award, 1961; Chicago/AI, Pauline Palmer Prize, 1962, 64; Dallas/MFA, 1965; Chicago/AI, Vielehr Award, 1967; Cassandra Foundation Grant, 1971; Yaddo Fellowship, 1974, 75; National Endowment for the Arts Grant, 1974. **Address:** 412 North Clark Street, Chicago, Ill. 60610. **Dealers:** Richard Gray Gallery; Brooke Alexander; Galerie du Dragon. **One-**

man Exhibitions: (first) Carlebach Gallery, NYC, 1949; Bordelon's, Chicago, 1952; Superior Street Gallery, Chicago, 1958; Stewart Rickard Gallery, San Antonio, 1962, 65 (two-man); Fairweather-Hardin Gallery, 1962; The Zabriskie Gallery, 1962, 64, 69, 72; Haydon Calhoun Gallery, Dallas, 1963; B. C. Holland Gallery, 1965, 68; Fort Wayne/AM, 1967; Kendall College, 1967; Richard Gray Gallery, 1970, 73; Wabash Transit Gallery, Chicago, 1972; Madison Art Center, 1972; NCFA, 1972; Stephens College, 1973; U. of California, Davis, 1974; The Pennsylvania State U., 1974; Odyssia Gallery, Rome, 1975; Documenta Gallery, Rome, 1975. **Retrospectives:** Rockford College, 1970; One Illinois Center, Chicago, 1973; John Michael Kohler Arts Center, Sheboygan, 1974. **Group:** PMA, 1946, 47, 50, 54; Chicago/AI Annuals, 1946, 47, 51, 53, 55, 57, 58, 60, 61, 62, 66-69; Chicago/AI, Exhibition Momentum, 1948, 50, 52, 54, 56; Omaha/Joslyn, 1949, 58; Library of Congress, 1950, 52; Denver/AM, 1951, 52; MMA, 1952; U. of Illinois, 1953; MOMA, Young American Printmakers, 1953; The Downtown Gallery, Chicago Artists, 1954; Chicago/AI, Prints from the Graphic Workshop, 1955; Corcoran, 1961; MOMA, Recent Painting USA: The Figure, circ., 1962-63; Northern Illinois U., 1966; Illinois Arts Council, circ., 1967-69; Chicago/Contemporary, 1968, Chicago Imagist Art, 1972; Moore College of Art, Philadelphia, Artists' Books, 1973; Galleria Comunale d'Arte Contemporanea, Una Tendenza Americana, 1973; Sacramento State U., National Print Annual, 1974. **Collections:** AT&T; Borg-Warner International Corporation; Boston Public Library; Brandeis U.; Brooklyn Museum; Chicago/AI; Container Corp. of America; Denver/AM; Des Moines; F.T.D. Association; First National Bank of Chicago; Galleria Comunale d'Arte Contemporanea; IIE; Illinois Bell Telephone Company; U. of Illinois; Illinois Wesleyan U.; Library of Congress; Madison Art Center; U. of Massachusetts; NCFA;

The Singer Company Inc.; Springfield, Ill./State; Trenton/State. **Bibliography:** *Art: A Woman's Sensibility.*

LASANSKY, MAURICIO. b. October 12, 1914, Buenos Aires, Argentina. **Studied:** Superior School of Fine Arts, Buenos Aires. Traveled Europe, Latin America. To USA 1943; citizen 1952. **Taught:** Director, Free Fine Arts School, Villa Maria, Argentina, 1936; Taller Manualidad, 1939; Atelier 17, NYC; State U. of Iowa, 1954- . **Awards:** Guggenheim Foundation Fellowship (USA), 1943, renewed 1944; Seattle/AM, Seattle International, First Prize, 1944; The Print Club, Philadelphia, **P.P.**, 1945, 48; Library of Congress, Pennell **P.P.**, 1945, 48, 50, 56, 59, 62, 63; Denver/AM, **P.P.**, 1946, 47; Des Moines, **P.P.**, 1946, 49, 51, 57, 58; Iowa State Fair, First Prize, 1947; Society of American Etchers and Engravers, NYC, 1947; PAFA, Alice McFadden Eyre Medal, 1948, 57; Brooklyn Museum, **P.P.**, 1948, 58; Northwest Printmakers Annual, **P.P.**, 1948, 51, 55, 59, 61; Walker, First and Second Prizes, 1949; The Print Club, Philadelphia, Charles M. Lea Prize, 1951, 57, 62; Printmakers of Southern California, **P.P.**, 1952; Bradley U., **P.P.**, 1952; Des Moines, IV Annual, Edmundson Award, 1952; Des Moines, V Annual, Special Commendation, 1953; Des Moines, Prize in Painting, 1955; Des Moines, Younkers Professional Award, 1956; I Inter-American Paintings and Prints Biennial, Mexico City, Posada Award, 1958; Silvermine Guild, **P.P.**, 1958; Walker Biennial, **P.P.**, 1958; De Pauw U., **P.P.**, 1959; Illinois Wesleyan College, Hon. DFA, 1959; Kansas City/Nelson, **P.P.**, 1960; II Inter-American Paintings and Prints Biennial, Mexico City, Special Hon. Men. with Gold Medal, 1960; PAFA, Hon. Men. and one-man exhibition, 1961; Pasadena/AM, **P.P.**, 1962; Ford Foundation, **P.P.**, 1962; Guggenheim Foundation Fellowship (Spain and France), 1963, 64; Pacific Lutheran U., Hon. DFA, 1969; Philadelphia Print Club Annual, Bertha von Moschzisker Prize, 1971; Dickinson College Arts Award, 1974. **Address:** Quail Creek Condominium, Rural Route 1, North Liberty, Iowa 52317. **One-man Exhibitions:** (first) Fort General Roca, Rio Negro, Argentina, 1935; Whyte Gallery, Washington, D.C., 1945; SFMA, 1945, 50; Chicago/AI, 1947; U. of Louisville, 1948; Walker, 1949; Houston/MFA, 1949; Milwaukee, 1949; Purdue U., 1949; Santa Barbara/MA, 1950; Northwestern U., 1950; Cornell U., 1951; Tulane U., 1952; Memphis/Brooks, 1953; Madrid/Nacional, 1954; Oakland/AM, 1958; USIA, Intaglios (one-man and his students), circ. Latin America and USA, 1959-61; PAFA Annual, 1961; Des Moines, 1967; Carleton College, 1965; PMA, circ., 1966; Dickinson College, 1972; Fort Dodge/Blanden, 1973. **Retrospectives:** State U. of Iowa, 1957; A.F.A./Ford Foundation, circ., 1960-62; Iowa State U., 1967. **Group:** Carnegie, American Prints, 1949; Sao Paulo, 1951; U. of Illinois, Graphic Art, USA, 1954; France/National, 50 Ans d'Art aux Etats-Unis, circ. Europe, 1955; Gallery of Modern Art, Ljubljana, Yugoslavia, I, II, and V International Exhibitions of Prints, 55, 57, 63, 67, 71; Michigan State U., 20 American Printmakers, 1956; Achenbach Foundation, Prints Since the 14th Century, 1957; SAGA, 1957; U. of California, Berkeley, Modern Master Prints, 1958; I & II Inter-American Paintings and Prints Biennials, Mexico City, 1958, 60; ICA, Boston, 100 Works on Paper, circ. Europe, 1959; PAFA, 1959, 60; PCA, American Prints Today, circ., 1959-62; Yale U., American Prints, 1950-60, 1960; USIA, Graphic Arts—USA, circ. USSR, 1963; I & II International Print Biennials, Kracow, 1966, 68; MOMA, The Artist as His Subject, 1967; National Academy of Fine Arts, Amsterdam, American Prints, 1968; Bradford, England, British Print Biennial, 1969; XXXV Venice Biennial, 1970; San Juan, Puerto Rico, Biennial del Grabado, 1970, 72, 74; Graphische Sammlung Albertina, Graphic der Welt, 1971; WMAA, Oversized Prints, 1971. **Collections:** Albion Col-

lege; American Life and Casualty Insurance Co.; Argentina/Nacional; Barcelona; Bradley U.; Brooklyn Museum; Buenos Aires/Municipal; Cedar Rapids /AA; Chicago/AI; Colorado Springs /FA; Cordoba/Municipal; Cordoba/Provincial; U. of Delaware; De Pauw U.; Des Moines; Detroit/Institute; First National Bank, Iowa City; Flint/Institute; U. of Georgia; Gettysburg College; IBM; Illinois State Normal U.; U. of Illinois; Indiana U.; Iowa Wesleyan College; State College of Iowa; State U. of Iowa; Kansas City/Nelson; La Plata; Library of Congress; Louisiana State U.; Luther College; MOMA; Madrid/Nacional; U. of Maine; Melbourne/National; Mendoza; U. of Michigan; Millikin U.; U. of Minnesota; Museo Rosario; NYPL; National Gallery; U. of Nebraska; New Britain; Oakland/AM; Omaha/Joslyn; PAFA; PMA; Pasadena/AM; Portland, Ore./AM; Rio Cuarto; SFMA; St. Louis/City; Salt Lake City Public Library; Seattle/AM; Silvermine Guild; Southwest Missouri State College; Springfield, Mo./AM; Syracuse U.; Time Inc.; USIA; U. of Utah; Walker; Washburn U. of Topeka; Washington U.; U. of Washington; Wesleyan U.; Yale U. **Bibliography:** Hayter 1, 2; **Honig; Reese; Soyer, R. 1; Zigrosser 2.**

LASSAW, IBRAM. b. May 4, 1913, Alexandria, Egypt. To USA 1921; citizen 1928. **Studied:** City College of New York; Clay Club, 1926-30; Beaux-Arts Institute of Design, NYC, 1930-31; Ozenfant School of Art, NYC. Traveled Europe. US Army, 1942-44. **Taught:** American U., 1950; Duke U., 1962-63; Long Island U.; U. of California, Berkeley, 1965-66; and privately. A founder and **Member** of American Abstract Artists (President, 1946-49); charter member, Artist's "Club," 1949. Federal A.P.: 1933-42. **Commissions:** Beth El Temple, Springfield, Mass.; Beth El Temple, Providence, R.I.; Temple of Aaron, St. Paul; Temple Anshe Chesed, Cleveland; Kneses Tifereth Israel Synagogue, Port Chester, N.Y.; House of Theology of the Franciscan Fathers,

Centreville, Ohio; Washington U., 1959; New York Hilton Hotel; Yale & Towne Inc.; Rockefeller Center, NYC, Celanese Building; Long Island Hall of Fame; Springfield, Mass./MFA. **Address:** 678 Fireplace Road, Springs, East Hampton, N.Y. 11937. **Dealer:** Kennedy Gallery. **One-man Exhibitions:** (first) The Kootz Gallery, NYC, 1951, also 1952, 54, 58, 60, 63, 64; Duke U., 1963; Benson Gallery, 1966; Gertrude Kasle Gallery, 1968; Carnegie-Mellon U., 1969. **Retrospective:** MIT, 1957; Huntington, N.Y./Heckscher, 1973. **Group:** WMAA Annuals, 1936-46; American Abstract Artists Annuals, 1937- ; Salon des Realites Nouvelles, Paris, 1950; MOMA, Abstract Painting and Sculpture in America, 1951; MOMA, Sculpture of the XXth Century, 1953; XXVII Venice Biennial, 1954; Chicago/AI, 1954; WMAA, The New Decade 1954-55; U. of Illinois, 1955, 57, 59, 61; MOMA, Twelve Americans, circ., 1956; IV Sao Paulo Biennial, 1957; Brussels World's Fair; 1958; Documenta II, Kassel, 1959; Cleveland/MA, Paths of Abstract Art, 1960; Carnegie, 1961; Seattle World's Fair, 1962; WGMA, Sculptors of Our Time, 1963; WMAA, Between the Fairs, 1964; Musee Rodin, Paris, 1965; Indianapolis/Herron, 1965; Public Education Association, NYC, 1966; WMAA, Art of the U.S. 1670-1966, 1966; WMAA, The 1930's, 1968; MOMA, The New American Painting and Sculpture, 1969; Washburn Gallery Inc., Art of the 1940s, 1972; Duke U., 1972; Katonah (N.Y.) Art Gallery, Drawing in Space, 1972; Society of the Four Arts, Contemporary American Sculpture, 1974; NIAL, 1974. **Collections:** Baltimore/MA; Bezalel Museum; Brooklyn Museum; Buffalo/Albright; Calcutta; U. of California; Carnegie; Chase Manhattan Bank; Cornell U.; Hartford/Wadsworth; Harvard U.; MOMA; Metalcraft Corp.; Newark Museum; Rio de Janeiro; WMAA; Washington U.; Wichita/AM; Worcester/AM. **Bibliography:** Baur 5, 7; Blesh 1; Brumme; Craven, W.; Giedion-Welcker 1; Goodrich and Baur 1;

Goossen 5; Henning; Hunter 6; Hunter, ed.; McCurdy, ed.; Mendelowitz; Myers 2; Read 3; Ritchie 1, 2; Rose, B. 1; Seuphor 3; Trier 1; Weller. Archives.

LAUFMAN, SIDNEY. b. October 29, 1891, Cleveland, Ohio. **Studied:** Chicago Art Institute School, with Reynolds, Buehr; ASL, with Robert Henri. Traveled Europe; resided France, 1920-33. **Taught:** ASL, 1938-50; Brandeis U., 1959-60. **Member:** NAD; Woodstock Artists Association. Federal A.P.: Easel painting. **Awards:** Chicago/AI, The Mr. & Mrs. Frank G. Logan Prize, 1932; Carnegie, Third Prize, 1934; NAD, Benjamin Altman Prize, 1937, 63, Landscape Prize, 1971; NAD, Special Landscape Prize, 1949; ASL, Diamond Jubilee **P.P.**, 1950; PAFA, Jennie Sesnan Gold Medal, 1951; Corcoran, Hon. Men., 1951; NAD, Samuel F. B. Morse Gold Medal, 1953, 70; Youngstown/Butler, First **P.P.**, 1954; NAD Annual, Andrew Carnegie Prize, 1959; Woodstock Artists Association, Sally Jacobs Memorial Award, 1968. **Address:** 1038 S. Osprey Avenue, Sarasota, Fla. 35377. **Dealer:** The Forum Gallery. **One-man Exhibitions:** (first) Galerie Devambez, Paris, 1922; Marie Sterner Gallery, NYC, 1923; Gage Gallery, Cleveland, 1927; Arts Club of Chicago, 1927; The New Gallery, NYC, 1927; Galerie Granoff, Paris, 1930; de Hauke Gallery, NYC, 1931; The Milch Gallery, 1934, 44, 48, 53, 56, 58; East End Gallery, Provincetown, 1960, 61, 62, 63; The Forum Gallery, 1962; Rudolph Gallery, Coral Gables, Fla., 1964; Peabody Museum, 1963; U. of Miami, 1964; Brandeis U., 1960. **Group:** Carnegie; NAD; PAFA; Corcoran; WMAA; Chicago/AI; Youngstown/Butler; and many others since 1922. **Collections:** AAAL; Bezalel Museum; Brandeis U.; Chicago/AI; Cleveland/MA; Colorado Springs/FA; Corcoran; Fort Lauderdale; U. of Georgia; Hagerstown/County MFA; Hirshhorn; Indianapolis/Herron; Kansas City/Nelson; Lakeview Center; MMA; MOMA; U. of Miami; Minneapolis/Institute; NCFA; Norfolk/Chrysler; U. of Oregon; Peabody College; Rochester Institute; St. Louis/City; Southampton/Parrish; Tel Aviv; Toledo/MA; WMAA; Youngstown/Butler; Zanesville/AI.

LAURENT, JOHN. b. November 27, 1921, Brooklyn, N.Y. **Studied:** Syracuse U.; Indiana U. (MFA); Academie de la Grande Chaumiere (with Walt Kuhn, Othon Friesz, Stephen Greene). Traveled France, Italy. **Taught:** Virginia Polytechnic Institute, 1949-53; U. of New Hampshire, 1954- ; Ogunquit School of Painting, 1952- . **Commissions:** U. of New Hampshire (mural for Student Union building). **Awards:** L. C. Tiffany Grant; Syracuse U., Traveling Fellowship; Silvermine Guild, Larry Aldrich Prize; National Council on the Arts, Sabbatical Leave Grant ($7,500), 1966. **Address:** Mill Lane Road, York, Me. 03909. **Dealer:** Shore Gallery. **One-man Exhibitions:** (first) Kraushaar Galleries, 1955; Smithsonian; U. of New Hampshire, 1956, 67; Lincoln, Mass./De Cordova, 1959; Bowdoin College, 1959; Indiana U.; Currier, Ogunquit, 1967. **Retrospective:** Andover/Phillips, 1973. **Group:** WMAA Annual; PAFA, 1951, 54; ART:USA:58, NYC, 1958; Boston Arts Festival; U. of Nebraska; MMA; Carnegie; Corcoran; Chicago/AI; Audubon Artists; Newark Museum. **Collections:** Andover/Phillips; Hollins College; Illinois Wesleyan U.; U. of Illinois; Indiana U.; Lehigh U.; U. of Nebraska; Syracuse U. Archives.

LAURENT, ROBERT. b. June 29, 1890, Concarneau, France; **d.** April 20, 1970, Cape Neddick, Me. **Studied:** British School, Rome, 1908-09, with Frank Burty; also with Hamilton Easter Field, Maurice Sterne, Giuseppe Doratore. US Naval Aviation, World War I. Traveled Europe, Cuba, Canada, Mexico, USA; resided France, Italy. **Taught:** ASL, fifteen years intermittently (sculpture); Vassar College, 1939-40; Goucher College, 1940-41; The Corcoran School of Art, 1940-42; Indiana U., 1942-60 (Prof. Emeritus, 1960-69). **Member:** Sculptors

Guild; National Sculpture Society; Audubon Artists; Indiana Artists; New England Sculptors Association, Cambridge, Mass. Federal A.P.: Federal Trade Building, Washington, D.C. (relief); New York World's Fair, 1939; US Post Office, Garfield, N.J. **Commissions:** Fairmount Park, Philadelphia (sculpture); Radio City Music Hall, NYC; Indiana U. (a relief, a fountain, and several sculptures); many portrait busts. **Awards:** Chicago/AI, First Prize, and The Mr. & Mrs. Frank G. Logan Medal, 1924, 38; Fairmount Park (Philadelphia), International Sculpture Competition, 1935 (monument); Brooklyn Museum, First Prize, 1942; Audubon Artists, 1945; Indianapolis/Herron, five First Prizes; Louisville/Speed, First Prize, 1954; Artist-in-Residence, American Academy, Rome, 1954-55. **One-man Exhibitions:** (first) The Daniel Gallery, NYC, 1915; Bourgeois Gallery, NYC; Curt Valentine Gallery, NYC; Worcester/AM; Arts and Crafts Club, New Orleans; Vassar College; Corcoran; Indiana U.; Indianapolis/Herron; Kraushaar Galleries Galleria Schneider, Rome; Art Association of Richmond, Ind.; New England Sculptors Association, Cambridge, Mass. **Retrospective:** Indiana U., Laurent; Fifty Years of Sculpture, 1961; U. of New Hampshire, 1972. **Group:** Salons of America, NYC; Society of Independent Artists, NYC; Audubon Artists; Sculptors Guild; American Society of Painters, Sculptors and Gravuers; National Sculpture Society; WMAA; MMA; Brooklyn Museum; Newark Museum; Portland, Me./MA; Boston/MFA; Colby College; Riverside Museum; Louisville/Speed; Indianapolis/Herron; Chicago/AI; PMA; American Painting and Sculpture, Moscow, 1959. **Collections:** Barnes Foundation; Brookgreen Gardens; Brooklyn Museum; Chicago/AI; Colby College; Hartford/Wadsworth; IBM; Indiana U.; MMA; MOMA; U. of Nebraska; Newark Museum; Ogunquit; PAFA; Society of the Four Arts; Vassar College; WMAA. **Bibliography:** *Avant-Garde Painting and Sculpture;* Baur 7; Blesh

1; Brumme; Cahill and Barr, eds.; Cheney; Craven, W.; Goodrich and Baur 1; *Index of 20th Century Artists:* **Moak;** Parkes; Richardson, E.P.; Ringel, ed.; Rose, B. 1; *Sculpture of the Western Hemisphere.* Archives.

LAWRENCE, JACOB. b. September 7, 1917, Atlantic City, N.J. **Studied:** College Art Association, Harlem Workshop, 1932, with Charles Alston, Federal Art Project class, NYC, 1934-37, with Henry Bannarn; American Artists School, NYC, 1937-39, with Anton Refregier, Sol Wilson, Eugene Morley. Traveled USA, British West Indies, Africa. **Taught:** Black Mountain College, summer, 1947; Five Towns Music and Art Foundation, Cedarhurst, N.Y., 1956-60; Pratt Institute, 1956-71; Brandeis U., 1965; New School for Social Research, 1966; ASL, 1967; U. of Washington, 1971- . **Member:** NIAL. Federal A.P.: Easel painting, 1938-39. **Commissions:** *Fortune* Magazine, 1947 (10 paintings). **Awards:** Scholarship to American Artists School, NYC, 1937; Lessing J. Rosenwald Fund Fellowship, 1940, 41, 42; MMA, Sixth **P.P.,** 1942; Guggenheim Foundation Fellowship, 1946; PAFA, Hon. Men., 1948; Brooklyn Museum, Hon. Men., 1948; Chicago/AI, Norman Wait Harris Silver Medal, 1948; Nial Grant, 1953; Chapelbrook Foundation Grant, 1954; NAACP, Springarn Medal, 1970; NAD, 1971; Pratt Institute, Hon. DFA, 1972. **Address:** 4316 37 Avenue, N.E., Seattle, Wash. 98105. **Dealer:** Terry Dintenfass, Inc. **One-man Exhibitions:** (first) Harlem YMCA, NYC, 1938; Baltimore/MA, 1938; Columbia U., 1940; The Downtown Gallery, 1941, 43, 45, 47, 50, 53; Portland, Me./MA, 1943; MOMA, 1944; Institute of Modern Art, Boston, 1945; Trenton/State, 1947; The Alan Gallery, NYC, 1957, 60; Terry Dintenfass, Inc., 1963, 65, 68, 73; Seattle/AM, 1974; St. Louis/City, 1974; Birmingham, Ala./MA, 1974; Kansas City/Nelson, 1975; New Orleans Museum, 1975. **Retrospectives:** A.F.A., circ., 1960; WMAA, 1974. **Group:** WMAA;

Brooklyn Museum; Phillips; PAFA Annuals, 1966, 67; City College, 1967; Johnson C. Smith U., 1968; Dartmouth College, 1968; Carnegie, 1968; MOMA, The Artist as Adversary, 1971. **Collections:** Alabama Polytechnic; Andover/ Phillips; U. of Arizona; Atlanta U.; Auburn U.; Baltimore/MA; Boston/ MFA; Brooklyn Museum; Buffalo/Albright; U. of California; Container Corp. of America; Cornell U.; Detroit/ Institute; George Washington Carver Junior College; Harmon Foundation Inc.; Hirshhorn; Howard U.; IBM; Johnson Publishing Co.; Karamu House; MMA; MOMA; Milwaukee; Newark Public Library; Omaha/Joslyn; Phillips; Portland, Me./MA; RISD; Sao Paulo; Southern Illinois U.; Spelman College; Trenton/State; VMFA; WMAA; Wichita/AM; Worcester/AM. **Bibliography:** Dover; Eliot; Finkelstein; Goodrich and Baur 1; Halpert; McCurdy, ed.; Newmeyer; Nordness, ed.; Pearson 2; Richardson, E. P.; Shapiro, ed. Archives.

LAWSON, ERNEST. b. 1873, San Francisco, Calif.; **d.** 1939, Miami Beach, Fla. **Studied:** ASL; Cos Cob, Conn., with John Henry Twachtman, J. Alden Weir; Academie Julian, Paris, with Jean Pierre Laurens, B. Constant. Traveled Europe, USA. **Taught:** Broadmoor Art Academy, Colorado Springs; Kansas City Art Institute and School of Design. **Member:** NAD; NIAL; National Arts Club; Century Association. **Awards:** St. Louis Exposition, 1904, Silver Medal; PAFA, Jennie Sesnan Gold Medal, 1907; American Academy of Arts and Sciences, Gold Medal, 1907; NAD, Hallgarten Prize, 1908; Panama-Pacific Exposition, San Francisco, 1915, Gold Medal; NAD, Benjamin Altman Prize, 1916, 21, 28; Corcoran, Second William A. Clark Prize, 1916; NAD, Innes Gold Medal, 1917; PAFA, Joseph E. Temple Gold Medal, 1920; Carnegie, First Prize, 1921; NAD, Saltus Gold Medal for Merit, 1930. **One-man Exhibitions:** The Milch Gallery; Ferargil Galleries, NYC; The Babcock Gallery; Hirschl & Adler

Galleries, Inc., NYC, 1964; ACA Gallery, 1967; Berry-Hill Gallery, NYC, 1970; Danenberg Gallery, 1970. **Retrospective:** Ottawa/National, 1967. **Group:** WMAA; MMA; NAD; Corcoran; Brooklyn Museum; Carnegie; PAFA. **Collections:** Barnes Foundation; Brooklyn Museum; Carnegie; Chicago/ AI; Columbus; Corcoran; Detroit/Institute; Kansas City/Nelson; MMA; Montclair/AM; National Gallery; Newark Museum; St. Louis/City; San Diego; Savannah/Telfair; Toronto; WMAA; Worcester/AM; Youngstown/ Butler. **Bibliography:** Baur 7; Bazin; Blesh 1; Born; Brown; Cahill and Barr, eds.; Canaday; Cheney; **Du Bois 3;** Eliot; Ely; Gallatin 2; Glackens; Goodrich and Baur 1; Hartmann; Hunter 6; McCoubrey 1; McCurdy, ed.; **O'Neal;** Perlman; Phillips 2; Richardson, E. P.; Ringel, ed.; Rose, B. 1; Sutton. Archives.

LEBRUN, RICO. b. December 10, 1900, Naples, Italy; **d.** May 10, 1964, Malibu, Calif. **Studied:** Academy of Fine Arts, Naples, 1919-21. Italian Army, 1917-18. To USA 1924. Traveled USA, Europe. **Taught:** ASL, 1936-37; Chouinard Art Institute, Los Angeles, 1938-39; H. Sophie Newcomb Memorial College, 1942-43; Colorado Springs Fine Arts Center, 1945; Jepson Art Institute, Los Angeles, 1947-50; Escuela de Bellas Artes, San Miguel de Allende, Mexico, 1953; Yale-Norfolk Summer Art School, 1956; UCLA, summers, 1956, 57; Yale U., 1958-59; American Academy, Rome, 1959-60; Santa 'Barbara Museum School, 1962. **Commissions** (murals): Pomona College; Pennsylvania Station, NYC, 1936-38. **One-man Exhibitions:** San Diego, 1940; Faulkner Gallery, Santa Barbara, 1940, 47; de Young, 1942; Santa Barbara/MA, 1942, 47, 51, 56 (three-man, with Channing Peake and Howard Warshaw); Julien Levy Galleries, NYC, 1944; Colorado Springs/FA, 1945; Philadelphia Art Alliance, 1945, 50; Jepson Art Institute, Los Angeles, 1947, 49; A.F.A., Drawings, 1949; J. Seligmann and Co., 1950, 51; Los Angeles/County MA, 1950, 61;

Frank Perls Gallery, 1955; Chicago/AI, 1955; Whyte Gallery, Washington, D.C., 1956; Pomona Gallery, 1956; Toronto, 1958; Yale U., 1958; Boston U.; Boris Mirski Gallery, Boston, 1959, 62; U. of California, Santa Barbara, 1960; Esther Baer Gallery, 1960; Princeton U., 1961; Obelisk Gallery, Washington, D.C., 1962; Cornell U., 1962; Syracuse U., 1962; Nordness Gallery, NYC, 1962, 64, 69; AAAL, 1965; Antioch College, 1966. **Retrospective:** Los Angeles/ County MA, 1967. **Group:** U. of Illinois; MOMA; Chicago/AI; SFMA; Oakland/AM; Carnegie, 1945, 52, 55, 59; WMAA, 1948, 50, 52, 57, 58, 60; XXV Venice Biennial, 1950; PAFA, 1951, 52, 53, 56. **Collections:** Andover/ Phillips; Boston/MFA; Britannica; Colby College; de Young; Denver/AM; Harvard U.; U. of Hawaii; U. of Illinois; Kansas City/Nelson; Los Angeles/ County MA; MMA; MOMA; Mills College; U. of Nebraska; Pomona College; RISD; Santa Barbara/MA; Syracuse U.; Toronto; Utica; WMAA. **Bibliography:** Barker 1; Baur 7; Biddle 4; Frost; Getlein, F. and D.; Goodrich and Baur 1; Mendelowitz; Miller, ed. 1; Nordness, ed.; Pearson 2; Pousette-Dart, ed.; Rodman 1, 2, 3; Sachs; **Seldis;** Weller; Wight 2. Archives.

LECHAY, JAMES. b. July 5, 1907, NYC. **Studied:** U. of Illinois, 1928, BA; privately with Myron Lechay. Traveled Canada, Europe, USA. **Taught:** State U. of Iowa, 1945- ; Stanford U., 1949; NYU, 1952; Skowhegan School, summer, 1961. Federal A.P.: Easel painting. **Awards:** Chicago/AI, Norman Wait Harris Medal, 1941; PAFA, Lambert **P.P.,** 1942; Society for Contemporary American Art, Presentation Prize, 1942; Chicago/AI, Hon. Men., 1942, 43; Portrait of America Prize, 1945; Iowa State Fair, First Prize, 1946, Second Prize, 1951; Denver/AM, Hon. Men., 1946; Walker, First Prize, 1947; Des Moines, Edmundson Trustee Prize, 1950; Davenport/Municipal, 1950; Des Moines, First Prize, 1952, 53; Hon. DFA, Coe College, 1961; two University

Fellowships, 1962, 67; Tamarind Fellowship, 1973; AAAL, Childe Hassam Fund Purchase, 1974. **Address:** 1191 Hotz Avenue, Iowa City, Iowa 52240; summer: Box 195, Wellfleet, Mass. 02667. **Dealers:** Kraushaar Galleries; Cherry Stone Gallery; La Lanterna. **One-man Exhibitions:** (first) Another Place, NYC, 1936; Artists' Gallery, NYC, 1938, 40; Ferargil Galleries, NYC, 1942, 43; Toledo/MA, 1943; Wally Findlay Galleries, Chicago, 1944; American-British Gallery, NYC, 1945; Macbeth Gallery, NYC, 1946, 47, 50; Cedar Rapids/AA, 1946; Springfield (Ill.) Art Association, 1946; Louisville (Ky.) Art Center, 1949; Des Moines, 1951, 60; U. of Iowa, 1951, 55, 59, 64, 67, 72; Fort Dodge/Blanden, 1952; Wesleyan U. (Conn.), 1953; Kraushaar Galleries, 1955, 64, 68, 70, 73; Cedar Falls Art Association, 1955; Davenport/Municipal, 1956; Sioux City (Iowa) Art Center, 1958; Omaha/Joslyn, 1958; Coe College, 1959; Dubuque/AA, 1961; Rochester (Minn.) Art Center, 1962; U. of Northern Iowa, 1962; Lubetkin Gallery, Des Moines, 1963; Hollins College, 1964; Waterloo, 1970; MacNider Museum, 1971; Luther College, 1971; Cherry Stone Gallery, 1973; La Lanterna, 1974. **Retrospective:** U. of Iowa, 1972. **Group:** Toledo/MA; MMA; Corcoran; RAC; WMAA; Carnegie; Arts Club of Chicago; St. Louis/City; Worcester/AM; California Palace; U. of Illinois; Indiana U.; Phillips. **Collections:** American Life and Casualty Insurance Co.; Andover/Phillips; U. of Arizona; Brooklyn Museum; Chicago/AI; Coe College; Davenport/Municipal; Des Moines; First National Bank of Chicago; First National Bank, Iowa City; Grinnell College; Hirshhorn; Illinois Wesleyan U.; State College of Iowa; State U. of Iowa; Luther College; Memphis/ Brooks; U. of Nebraska; New Britain; U. of Northern Iowa; Omaha/Joslyn; PAFA; Potsdam/SUNY; Rensselaer Polytechnic Institute; U. of Rochester; Syracuse U.; Tulsa/Philbrook; Washburn U. of Topeka; Waterloo; Wichita/ AM.

LEIBER, GERSON. b. 1921, Brooklyn, N.Y. **Studied:** Academy of Fine Arts, Budapest; ASL, with Will Barnet, Louis Bosa, Vaclav Vytlacil, Morris Kantor; Brooklyn Museum School, with Gabor Peterdi. US Armed Forces, 1943-47. Traveled Europe. **Taught:** Creative Graphic Workshop, NYC (five years); Newark (N.J.) School of Fine and Industrial Art, 1959-66. **Member:** Boston Printmakers; SAGA; California Society of Printmakers; American Color Print Society; ASL. **Awards:** L. C. Tiffany Grant (2); Audubon Artists, Joseph Mayer Award, Gold Medal of Honor, Presidents Award; Brooklyn Museum, **P.P.**; Arden Prize; Francesca Wood Award; A.A.A. Gallery, NYC, National Print Competition, Second Prize; Henry B. Shope Prize; Hunterdon County (N.J.) Art Center, **P.P.**; SAGA, $1,000 **P.P.**, 1968; American Color Print Society, Sonia Wather Award, 1968; NAD, John Taylor Arms Memorial Prize, 1971; Los Angeles Printmaking Society, **P.P. Address:** 120 East 34 Street, NYC 10016. **Dealers:** A.A.A. Gallery, NYC; Roko Gallery. **One-man Exhibitions:** Oakland/AM, 1960; Matrix Gallery, NYC, 1960; A.A.A. Gallery, NYC, 1961-64; Roko Gallery, NYC, 1961-64, 72; East Side Gallery, NYC, 1963; Riverdale-on-the-Hudson Museum, Riverdale, N.Y., 1963; Queens College; Raleigh/NCMA, 1964. **Group:** Library of Congress; Cincinnati/AM, Cincinnati International Biennial of Contemporary Color Lithography; PCA, American Prints Today, circ., 1959-62; Brooklyn Museum; PAFA; WMAA; Oakland/AM; Lincoln, Mass./De Cordova; MMA; Cincinnati/AM; SAGA. **Collections:** Abbot Academy; Anchorage; Boston/MFA; Brooklyn Museum; Cincinnati/AM; Clairol Inc.; Cooper Union; U. of Delaware; Free Library of Philadelphia; Guild Hall; Hamilton College; Karachi; Library of Congress; Lincoln, Mass./De Cordova; Lindenwood College; MMA; U. of Maine; Malmo; Memphis/Brooks; Minneapolis/Institute; Montclair/AM; NCFA; NYPL; NYU; National Gallery;

U. of Nebraska; New York Hilton Hotel; Norfolk; The Ohio State U.; PMA; Potsdam/SUNY; Rutgers U.; Seattle/AM; Topeka Public Library; USIA; US State Department; Victoria and Albert Museum; WMAA; Wilmington; Walker; Wesleyan U.; Yale U.

LEKAKIS, MICHAEL. b. March 1, 1907, NYC. Self-taught. US Army Air Corps, 1942-45. Traveled Mexico, Europe, Egypt, Greece. **Address:** 57 West 28 Street, NYC 10001. **One-man Exhibitions:** Artists' Gallery, NYC, 1941; San Antonio/McNay, 1946; The Bertha Schaefer Gallery, 1946, 48; American U., 1949; Signa Gallery, East Hampton, N.Y., 1959; The Howard Wise Gallery, NYC, 1961; Dayton/AI, 1968, 69; Flair Gallery, Cincinnati, 1968, 69. **Group:** WMAA Annuals, 1948-52, 1958, 60, 62; SRGM, Sculpture and Drawings, 1958; Cleveland/MA, 1961; Boston.Arts Festival, 1961; Hartford/Wadsworth, Continuity and Change, 1962; Seattle World's Fair, 1962; MOMA, Americans 1963, circ., 1963-64. **Collections:** Dayton/AI; Greece/National; Hartford/Wadsworth; MOMA; U. of Nebraska; U. of North Carolina; Portland, Ore./AM; SRGM; Seattle/AM; Tel Aviv; WMAA. **Bibliography:** *Sculpture and Drawings*. Archives.

LEONG, JAMES C. b. November 27, 1929, San Francisco, Calif. **Studied:** California College of Arts and Crafts, 1951-53, BFA, MFA; San Francisco State College, 1954, MA. US Army, 1952-53. Traveled Europe, USA. **Taught:** U. of Georgia, 1971. Prologue sequence for "Freud," directed by John Huston, 1962. **Commissions** (murals): Chung Mei Home for Boys, El Cerrito, Calif., 1950; Ping Yuen Federal Housing Project, San Francisco, 1951; San Francisco State College, 1951. **Awards:** Fulbright Fellowship; Guggenheim Foundation Fellowship; San Francisco Art Festival, Third Prize, 1951; SFMA, 1962. **Address:** Piazza del Biscione 95, Interno 4, Rome 00186, Italy. **Dealers:** Richard Larcada Gallery; Gloria Luria

Gallery; Kama Studio. **One-man Exhi-bitions:** (first) Hungry i, San Francisco, 1951; Barone Gallery, NYC, 1955, 56, 57, 60; American Gallery, Los Angeles, 1955; Holst Halvorsen Gallery, Oslo, 1956; Galerie Paletten, Oslo, 1957; Erling Haghfelt, Copenhagen, 1957; L'Obelisco, Rome, 1960, 61; Feingarten Gallery, NYC, 1962; Galleria dell'Ariete, 1962; Royal Athena II, NYC, 1963, 67; Temple U., Rome, 1967; Cerberus Gallery, 1969; Gloria Luria Gallery, 1970; U. of Georgia, 1971; Middle Tennessee State U., 1971; The Pennsylvania State U., 1971; Kama Studio, 1975; Richard Larcada Gallery, 1975. **Group:** SFMA; de Young; WMAA, 1955; American Academy, Rome; MOMA, 1960; Internazionale di Arte Astratta, Prato, Italy, 1960; Brooklyn Museum, 1961; Carnegie, 1961; U. of Rochester, 1962; Rome National Art Quadrennial, 1967; NIAL, 1967. **Collections:** Brooklyn Museum; Dallas/MFA; U. of Georgia; Harvard U.; MIT; Middle Tennessee State U.; NYU; Princeton U.; U. of Rochester; U. of Texas. Archives.

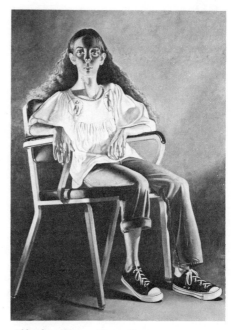

Alfred Leslie *Diana Cheyette* 1974-75

LESLIE, ALFRED. b. October 29, 1927, NYC. **Studied** with Tony Smith, William Baziotes, Hale Woodruff, John McPherson; NYU, 1956-57; Pratt Institute; ASL. US Coast Guard, 1945-46. **Taught:** Great Neck (N.Y.) Adult Education Program, 1956-57; San Francisco Art Institute, summer, 1964. Co-director-producer (with Robert Frank and Jack Kerouac) of the film "Pull My Daisy." **Awards:** J. S. Guggenheim Fellowship, 1969. **Address:** c/o Dealer. **Dealer:** Allan Frumkin Gallery, NYC. **One-man Exhibitions:** (first) Tibor de Nagy Gallery, 1951, also 1952, 53, 54, 57; Martha Jackson Gallery, 1959, 60; Holland-Goldowsky Gallery, Chicago, 1960; Noah Goldowsky, 1968, 69, 71; Allan Frumkin Gallery, NYC, 1975. **Group:** Festival of Two Worlds, Spoleto, 1958; Paris/Moderne, Young Americans, 1958; V Sao Paulo Biennial, 1959; Walker, Sixty American Painters, 1960;

Carnegie, 1961; Stockholm/National, Four Americans, 1961; WMAA Annuals, 1961, 65, 67, 68, 71, 72, 73; Kunsthalle, Basel, 4 Americans, 1963; Bennington College, Recent Figurative Art, 1967; MOMA, In Memory of My Feelings: Frank O'Hara, 1967; WMAA, 22 Realists, 1970; MIT, Contemporary Views of Man, 1971; WMAA, American Drawings: 1963-1973, 1973. **Collections:** U. of Alabama; Amsterdam/Stedelijk; Buffalo/Albright; Cornell U.; Hirshhorn; Kunsthalle, Basel; MOMA; Milwaukee; Minneapolis/Institute; Sao Paulo; Stockholm/National; WMAA; Walker. **Bibliography:** Friedman, ed.; Hunter 1; Hunter, ed.; Janis and Blesh 1; *Kunst um 1970;* Sager. Archives.

LEVEE, JOHN. b. April 10, 1924, Los Angeles, Calif. **Studied:** UCLA, BA (Philosophy); New School for Social Research, with Stuart Davis, Yasuo Kuniyoshi, Adja Yunkers, Abraham Rattner; Academie Julian, Paris. Trav-

eled Europe, North Africa, Middle East; resides Paris, 1949- . **Taught:** U. of Illinois, 1965; Washington U. (St. Louis), 1967, 68; NYU, 1967-68; U. of Southern California, Los Angeles, 1971. **Awards:** Deauville Salon, 1951; California Watercolor Society, 1955, 56; I Paris Biennial, First Prize, 1959; VMFA, Virginia Artists Biennial, **P.P.**, 1966; Tamarind Fellowship, 1969; Woolmark Foundation Prize, 1974. **Address:** 119 rue Notre Dame des Champs, Paris 6, France. **Dealers:** Margo Leavin Gallery; Van Straaten Gallery. **One-man Exhibitions:** (first) Galerie Huit, Paris, 1951; Twenster, Rotterdam, 1953; Felix Landau Gallery, 1954; Andre Emmerich Gallery, NYC, 1956, 58, 59, 62, 65, 66; Gimpel Fils Ltd., 1958, 60, 66; Galerie de France, Paris, 1958, 61, 62, 64, 69; Esther Robles Gallery, 1962, 63, 65; Haifa, 1964; Phoenix, 1964; U. of Illinois, 1965; Walker, 1965; Margo Leavin Gallery, 1970; Galerie Henri Mayer, Lausanne, 1971; Galerie Liatowitsch, Basel, 1972; American Embassy, London, 1974; Palm Springs Desert Museum, 1976. **Retrospectives:** Tel Aviv, 1969; Galerie la Tortue, Paris, 1975. **Group:** Carnegie, 1955, 58; Corcoran, 1956, 58, 66; WMAA, Young America, 1957; Brooklyn Museum, Watercolor Biennials; MOMA, Younger American Painters, circ., 1957-59; Arts Club of Chicago, 1958; Smithsonian, American Painters in France, circ. USA; WMAA Annuals, 1958, 59, 65, 66; Foundation Maeght, l'Art Vivant, circ. French museums, 1966, 67; UNESCO, 1975. **Collections:** Allentown/AM; Amsterdam/Stedelijk; U. of Arizona; Baltimore/MA; Basel; CNAC; U. of California, Berkeley; Carnegie; Cincinnati/AM; Columbus; Corcoran; Dallas/MFA; Des Moines; Djakarta Museum; Grenoble; Haifa; Harvard U.; Honolulu Academy; Los Angeles/County MA; MOMA; Musee du Havre; NYPL; Oberlin College; Oklahoma; Palm Springs Desert Museum; Phoenix; SRGM; Santa Barbara/MA; Smith College; U. of Sydney; Tel Aviv; Towner Art Gallery; VMFA; WGMA;

WMAA; Walker; Washington U.; Yale U. **Bibliography:** Juin; Read 2.

LEVI, JOSEF. b. February 17, 1938, NYC. **Studied:** U. of Connecticut (with Walter Meigs), BA; Columbia U. Traveled Spain, France, Belgium, Holland, England, Mexico, Middle East. **Taught:** Appalachian State U., Artist-in-Residence, 1969; Fairleigh Dickinson U., 1971. Director, Encounter, Inc. (drug rehabilitation program), NYC, 1974. **Awards:** U. of Illinois, **P.P.**, 1967. **Address:** 171 West 71 Street, NYC 10023. **One-man Exhibitions:** (first) The Stable Gallery, NYC, 1966, also 1967, 69, 70; Arts Club of Chicago, 1968; Louisville/Speed, 1968; Appalachian State U., 1969; Lambert Studios Inc., Los Angeles, 1971; Jacobs Ladder Gallery, Washington, D.C., 1972; Images Gallery, Toledo, 1972. **Group:** Houston/Contemporary, 1966; Kansas City/Nelson, Sound, Light, Silence, 1966; U. of Illinois, 1967; Walker, Light Motion Space, 1967; MOMA, The 1960's, 1967; Flint/Institute, 1967; Indianapolis/Herron, 1968; WMAA Annual, 1968; Brooklyn Museum, 1969; RISD, 1972. **Collections:** Albion College; The Bank of New York; Buffalo/Albright; Chrysler Corp.; Corcoran; Des Moines; U. of Illinois; Louisville/Speed; MOMA; U. of Maryland; U. of Notre Dame; Ridgefield/Aldrich; Spelman College.

LEVI, JULIAN. b. June 20, 1900, NYC. **Studied:** PAFA, with Henry McCarter, Henry Breckenridge, Arthur B. Carles, Jr.; and five years in France and Italy. **Taught:** ASL; PAFA; New School for Social Research. **Awards:** PAFA, Cresson Fellowship, 1920; Chicago/AI, The M. V. Kohnstamm Prize, 1942; Chicago/AI, Norman Wait Harris Medal, 1943; Carnegie, Hon. Men., 1945; NAD, The Adolph and Clara Obrig Prize, 1945; U. of Illinois, 1948; PAFA, Fellowship, 1954; NIAL Grant, 1955; elected to the NIAL, 1960. **Address:** 79 West 12 Street, NYC 10014; summer: 791 Fireplace Road, East Hampton, N.Y.

11937. **Dealer:** Rehn Galleries. **One-man Exhibitions:** Crillon Galleries, Philadelphia, 1933; The Downtown Gallery, 1940, 42, 45, 50; Philadelphia Art Alliance, 1953, 63; The Alan Gallery, NYC, 1955; Lee Nordness Gallery, NYC, 1961; Anna Werbe Gallery, Detroit, 1961. **Retrospective:** Boston U., 1962; New Britain; Rehn Galleries, 1974. **Group:** Detroit/Institute; PAFA; NAD; U. of Illinois; WMAA; Newark Museum; Youngstown/Butler. **Collections:** U. of Arizona; Britannica; Buffalo/Albright; Chicago/AI; Cranbrook; Des Moines; Detroit/Institute; U. of Georgia; U. of Illinois; MMA; MOMA; Michigan State U.; NAD; NCFA; U. of Nebraska; Newark Museum; New Britain; PAFA; Reed College; Santa Barbara/ MA; Scripps College; Springfield, Mass./MFA; Toledo/MA; WMAA; Walker; Wilmington; Youngstown/Butler. **Bibliography:** Baur 7; Blesh 1; Halpert; Hess, T. B. 1; Kootz 2; Nordness, ed.; Pagano; Passloff; Rose, B. 1; Watson, E. W. 2; Wheeler. Archives.

LEVINE, JACK. b. January 3, 1915, Boston, Mass. **Studied** with Denman W. Ross, Harold Zimmerman. Traveled Europe, Mexico; resided Rome, one year. **Member:** NIAL; American Academy of Arts and Sciences; Artists Equity. Federal A.P.: Easel painting. **Taught:** American Art School, NYC; PAFA; Skowhegan School; Cleveland/MA; Chicago/AI; U. of Illinois. **Awards:** Carnegie, 1946; Corcoran, 1959; PAFA, 1948; NIAL, 1946; Guggenheim Foundation Fellowship, 1946; Hon. DFA, Colby College; NAD, Benjamin Altman Prize, 1975. **m.** Ruth Gikow. **Address:** 68 Morton Street, NYC 10014. **Dealer:** Kennedy Gallery. **One-man Exhibitions:** (first) The Downtown Gallery, 1938; The Alan Gallery, NYC; Ogunquit, 1963; Kennedy Gallery, 1972, 75. **Retrospectives:** ICA, Boston, 1953; WMAA, 1955; Mexico City/Nacional, 1960. **Group:** PAFA; Corcoran; Chicago/AI; WMAA; Boston/MFA; MOMA. **Collections:** Andover/Phillips; Boston/MFA; Brooklyn Museum; Califor-

nia Palace; Chicago/AI; Harvard U.; State U. of Iowa; U. of Kansas; MMA; MOMA; U. of Nebraska; U. of Oklahoma; PAFA; Phillips; Portland, Ore./AM; Utica; WMAA; Wichita/AM; Walker. **Bibliography:** Barker 1; Baur 7; Blesh 1; Cheney; Christensen; Eliot; Finkelstein; Frost; Genauer; **Getlein 2;** Getlein, F. and D.; Goodrich and Baur 1; Halpert; Hunter 6; Kootz 2; McCurdy, ed.; Mendelowitz; Miller, ed. 1; Munsterberg; Newmeyer; Nordness, ed.; Pousette-Dart, ed.; Read 2; Richardson, E. P.; Rodman 1, 2, 3; Rose, B. 1; Sachs; Shapiro, ed.; Soby 5, 6; Soyer, R. 1; Wight 2. Archives.

LEVINE, LES. b. October 6, 1935, Dublin, Ireland. **Studied:** Central School of Arts and Crafts, London. To Canada 1958; to USA 1966. **Taught:** NYU, 1972- ; William Paterson College; Nova Scotia College of Art and Design, 1973- . Artist-in-Residence, Aspen Institute, 1967, 69. Produced Levine's Restaurant, NYC, 1969. **Awards:** National Endowment for the Arts, 1974. **Address:** 181 Mott Street, NYC 10012. **Dealer:** M. L. D'Arc Gallery. **One-man Exhibitions:** U. of Toronto, 1964; Blue Barn Gallery, Ottawa, 1964, 66; David Mirvish Gallery, 1965; Isaacs Gallery, 1965, 67, 70, 73; Fischbach Gallery, 1966, 67, 68, 69, 70, 72, 73; Toronto, 1966; Lofthouse Gallery, Ottawa, 1966; U. of Western Ontario, 1966; Walker, 1967; MOMA, 1967; York U., 1968; John Gibson Gallery, 1968; Molly Barnes Gallery, Los Angeles, 1969; ICA, Chicago, 1969; U. of Michigan, 1969; Rowan Gallery, London, 1969; Phyllis Kind Gallery, Chicago, 1969; NYU, 1969; Galerie de Gestlo, 1971, 73, 74; Finch College, NYC, 1972; Rivkin Gallery, Washington, D.C., 1972; Nova Scotia College of Art and Design, 1973; Vancouver, 1974; U. of California, San Diego, 1974; Stefanotty Gallery, NYC, 1974; The Video Distribution Inc., 1974. **Group:** Ottawa/National, Canadian Sculpture Exhibitions, 1964, 65, 67; MOMA, The Object Transformed, 1966; ICA, Boston, Nine Canadians, 1967; Expo '67,

Montreal, 1967; MOMA, Dada, Surrealism, and Today, 1967; MOMA, Canadian Prints Today, 1967; Union Carbide Corp., NYC, Canada '67, 1967; ICA, Boston, The Projected Image, 1967; Finch College, NYC, Schemata 7, 1967; U. of North Carolina, Works on Paper, 1968; Newark College of Engineering, Light as Art, 1968; Edinburgh Festival, 1968; Finch College, NYC, Destructionists, 1968; HemisFair '68, San Antonio, Tex., 1968; Brandeis U., Vision and Television, 1969; Milwaukee, A Plastic Presence, circ., 1969; Edmonton Art Gallery, Alberta, Place and Process, 1969; X Sao Paulo Biennial, 1969; ICA, U. of Pennsylvania, Between Object and Environment, 1969; Buffalo/Albright, Manufactured Art, 1969; UCLA, Electric Art, 1969; Cincinnati/Contemporary, Monumental Art, 1970; Moore College of Art, Philadelphia, Recorded Image, 1970; ICA, London, Multiple Art, 1970; Jewish Museum, Software, 1970; MOMA, Information, 1971; Montreal/Contemporain, Conceptual Decorative, 1971; Dalhousie U., Halifax, Morbus Exhibition, 1973; Walker, New Learning Spaces, 1974; Cologne, Project '74, 1974; ICA, U. of Pennsylvania, Video and Television, 1975. **Collections:** MOMA; WMAA; PMA; Ottawa/National. **Bibliography:** Calas, N. and E.; Davis, D.; Lippard, ed.; *Report.* Archives.

LEVINSON, MON. b. January 6, 1926, NYC. **Studied:** U. of Pennsylvania, 1948, BS.Econ.; self-taught in art. US Army, 1945-46. Traveled Mexico, Europe. **Taught:** Boston Museum School, 1969; C. W. Post College, 1970-72. **Commissions:** Betsy Ross Flag & Banner Co., 1963 (banner); MOMA, 1964 (greeting card); Astor Foundation Grant, 1967 (sculpture for P.S. 166, NYC); Housing and Redevelopment Board, NYC, 1967-69 (murals for demountable vest pocket parks); Great Southwest Industrial Park, 1968 (mural); Machpelah Cemetery, Flint, Mich., 1969 (sculpture). **Awards:** Cassandra Foundation Grant, 1972; CAPS, New York State Council on the Arts, 1974. **Address:** 309 West Broadway, NYC 10013. **Dealer:** Rosa Esman Gallery. **One-man Exhibitions:** (first) The Kornblee Gallery, 1961, also 1963-66, 1968, 69, 71, 72; Cinema I and Cinema II, NYC, 1965; Franklin Siden Gallery, Detroit, 1965-67, 69; Obelisk Gallery, 1968; C. W. Post College, 1970; A Clean Well-Lighted Place, Austin, Tex., 1970; Southern Methodist U., 1971; John Weber Gallery, 1973; Gertrude Kasle Gallery, 1975. **Group:** Martha Jackson Gallery, New Media—New Forms, I, 1960; MOMA, 1962, 63; Sidney Janis Gallery, 1964; Chicago/AI, 1964; A.F.A., circ.; Buffalo/Albright, 1964; RISD, 1965; Staatliche Kunsthalle, Baden-Baden, 1965; MOMA, 1967; Buffalo/Albright, Plus by Minus, 1968; Finch College, 1968; Museum of Contemporary Crafts, 1968; Flint/Institute, Made of Plastic, 1968; Grand Rapids, 1969; Jewish Museum, Superlimited, 1969; Foundation Maeght, L'Art Vivant, 1970; WMAA, 1970, 73; Lincoln, Mass./De Cordova, Refracted Images, 1973; Indianapolis, 1973; U. of Miami, Less is More: The Influence of the Bauhaus on American Art, 1974. **Collections:** Brandeis U.; Caracas; Hirshhorn; NYU; Spelman College; WMAA. **Bibliography:** MacAgy 2, Rickey.

LEVITAN, ISRAEL. b. June 13, 1912, Lawrence, Mass. **Studied:** Chicago Art Institute School; Ozenfant School of Art, NYC; Hofmann School, NYC; Zadkine School of Sculpture, Paris. Traveled Europe, USA extensively; India. **Taught:** Cooper Union, 1955; Brooklyn Museum School, 1956-60; NYU, 1956-65, 1967; U. of California, Berkeley, 1962; Philadelphia Museum School, 1962-66; Florida Humanistic Institute, St. Petersburg, Fla.; and privately. **Member:** American Abstract Artists, 1954-57. **Commissions:** Interchurch Center, NYC. **Awards:** MacDowell Colony Fellowship, 1956; Guild Hall, First Prize, Sculpture, 1960. **Address:** 1348 High Bluff Drive, Largo, Fla. 33540; summer: 45 Alewive Brook

Road, East Hampton, N.Y. 11937. **One-man Exhibitions:** (first) Artists' Gallery, NYC, 1952; Weyhe Gallery, 1953; Barone Gallery, NYC, 1957, 59, 60; U. of California, Berkeley, 1962; PMA, 1963; Grand Central Moderns, NYC, 1964; The Gallery, Memphis, 1964; Benson Gallery, 1970; Artist Market Gallery, Clearwater, Fla., 1972. **Group:** WMAA Annuals, 1952, 53; American Abstract Artists, 1953-57; PAFA; Paris/Moderne; SFMA; Brooklyn Museum; PMA; Claude Bernard, Paris, Aspects of American Sculpture, 1960; Clearwater/Gulf Coast, 1972. **Collections:** Guild Hall; Interchurch Center, NYC. **Bibliography:** Seuphor 3.

LEWANDOWSKI, EDMUND D. b. July 3, 1914, Milwaukee, Wisc. **Studied:** Layton School of Art, 1932-35. **Taught:** Florida State U., 1949-54; Layton School of Art, 1945-49, 1954-72. **Commissions:** Commemorative Stamp, Polish Millennium. **Awards:** Hallmark International Competition, 1950, 53, 57; Milwaukee, Medal, 1940. **Address:** 537 Meadowbrook Lane, Rockhill, S.C. 29730. **Dealer:** Fairweather-Hardin Gallery. **One-man Exhibitions:** Layton School of Art; Minnesota State Fair; Florida State U., 1950; Fairweather-Hardin Gallery, 1973. **Group:** Chicago/AI; Carnegie; Corcoran; PAFA; Brooklyn Museum; New York World's Fair, 1939; Phillips. **Collections:** AAAL; Allen-Bradley Co. Inc.; Andover/Phillips; Beloit College; Boston/MFA; Brooklyn Museum; Chicago/AI; Dartmouth College; Flint/Institute; Florida State U.; Gimbel Bros.; Grand Rapids; Hallmark Collection; Krakow/National; Layton School of Art; MOMA; Marquette U.; U. of Oklahoma; St. Patrick's, Menasha, Wisc.; Shell Oil Co.; US Maritime Commission; Warsaw; Warsaw/National; U. of Wisconsin. **Bibliography:** Baur 7; Cheney; Halpert; Pousette-Dart, ed.; Ritchie 1.

LEWIS, NORMAN. b. July 23, 1909, NYC. **Studied:** Columbia U., with Augusta Savage. **Taught:** Junior high school, NYC, 1935; Harlem Art Center, NYC, 1937; Thomas Jefferson School, NYC, 1944-49; Indian Hill Music School, Stockbridge, Mass., 1954; HARYOU-ACT, 1965-70; ASL, 1972- . Traveled Europe, North Africa, Greece. Organized an art center at Bennett College under Government sponsorship, 1938. Supervised a mural for Thomas Jefferson High School, St. Albans, N.Y., 1939. **Awards:** Carnegie, Popularity Prize, 1955; AAAL, 1970; NIAL, 1971; Mark Rothko Foundation, 1972; National Endowment for the Arts, 1972. **Address:** 64 Grand Street, NYC 10013. **One-man Exhibitions:** Harlem Artists Guild, 1936; Fisk U., 1939; Baltimore/MA, 1939; The Willard Gallery, 1949, 51, 52, 54, 56. **Group:** Carnegie, 1955; XXVIII Venice Biennial, 1956; U. of Illinois; NIAL; PAFA; PMA; Library of Congress. **Collections:** Andover/Phillips; Chicago/AI; IBM; MOMA; Manufacturers Hanover Trust Co.; Utica. **Bibliography:** Baur 5; Dover; Motherwell and Reinhardt, eds.; Ritchie 1. Archives.

LEWITT, SOL. b. 1928, Hartford, Conn. **Studied:** Syracuse U., 1945-49, BFA. **Taught:** MOMA School, 1964-67; Cooper Union, 1967. **Address:** 117 Hester Street, NYC 10002. **Dealer:** John Weber Gallery. **One-man Exhibitions:** The Daniel Gallery, NYC, 1965; Dwan Gallery, NYC, 1966, 68, 70, 71; Dwan Gallery, Los Angeles, 1967; Galerie Bischofberger, Zurich, 1968; Galerie Heiner Friedrich, Munich, 1968; Konrad Fischer Gallery, Dusseldorf, 1968, 69, 71; ACE Gallery, Los Angeles, 1968; Galleria l'Attico, Rome, 1969, 73; Galerie Ernst Joachim, Hanover, 1969; Krefeld/Haus Lange, 1969; Wisconsin State U., 1970; Art & Project, Amsterdam, 1970, 71; Yvon Lambert, Paris, 1970, 73, 74; The Hague, 1970; Pasadena/AM, 1970; Protetch-Rivkin, Washington, D.C., 1971; Galleria Toselli, Milan, 1971; Lisson Gallery, London, 1971, 73, 74; John Weber Gallery, 1971, 73, 74; Dunkelman Gallery, Toronto, 1971; MIT, 1972; Harkus-Krakow Gallery,

1972; Dayton/AI, 1972; Berne, 1972, 74; Rosa Esman Gallery, 1973; Vehicule Art Inc., Montreal, 1973; Museum of Modern Art, Oxford, England, 1973; Galerie MTL, Brussels, 1973; Portland (Ore.) Center for the Visual Arts, 1973; Cusack Gallery, Houston, 1973; Max Protetch Gallery, Washington, D.C., 1974; Galerie December, Munster, 1974; Brussels/Beaux-Arts, 1974; Rijksmuseum Kroller-Muller, 1974; Amsterdam/Stedelijk, 1974; Douglas Christmas, Los Angeles, 1974; Weinberg Gallery, San Francisco, 1974; Gian Enzo Sperone, Turin, 1974; Vancouver, 1974; Galerie Vega, Liege, 1974; Sperone Westwater Fisher Inc., NYC, 1974; Galleria Scipione, Macerata, Italy, 1975. **Group:** World House Galleries, NYC, 1965; Finch College, 1966, 67; WMAA Sculpture Annual, 1967; Los Angeles/County MA, PMA, American Sculpture of the Sixties, 1967; Ridgefield/Aldrich, 1968; The Hague, Minimal Art, 1968; Documenta IV, Kassel, 1968; Prospect '68, Dusseldorf, 1968; Munich/Modern, New Art: USA, 1968; Stadtische Kunsthalle, Dusseldorf, 1969; U. of British Columbia, 1969; U. of Illinois, 1969; Berne, When Attitudes Become Form, 1969; ICA, U. of Pennsylvania, Between Object and Environment, 1969; Seattle/AM, 557,087, 1969; Chicago/Contemporary, Art by Telephone, 1969; Chicago/AI, 1970; Tokyo Biennial, 1970; Turin/Civico, Conceptual Art, Arte Povera, Land Art, 1970; MOMA, Information, 1971; SRGM, Guggenheim International, 1971; Arnhem, Sonsbeek '71, 1971; Chicago/Contemporary, White on White, 1971-72; ICA, U. of Pennsylvania, Grids, 1972; Walker, Painting: New Options, 1972; New York Cultural Center, 3D into 2D, 1973; Basel, Diagrams and Drawings, 1973; WMAA, American Drawings: 1963-1973, 1973; Hartford Art School, Drawings: Seventies, 1973; Princeton U., Line as Language, 1974; Cologne/Kunstverein, Kunst uber Kunst, 1974; Neuer Berliner Kunstverein, Berlin, Multiples, 1974; Indianapolis, 1974. **Collections:** Amsterdam/Stedelijk; Buffalo/Albright; CNAC; Dayton/AI; Edinburgh/

Modern; U. of Illinois; Grenoble; Krefeld/Kaiser Wilhelm; Humlebaek/Louisiana; MOMA; Oberlin College; RISD; St. Louis/City; Stockholm/National; Storm King Art Center; Tate; Toronto; Walker. **Bibliography:** Art Now 74; Battcock, ed.; Calas, N. and E.; Contemporanea; De Vries, ed.; Goossen 1; Honnef; Lippard 2, 4; Lippard, ed.; Meyer; Muller; When Attitudes Become Form; Tuchman 1. Archives.

LIBERMAN, ALEXANDER. b. 1912, Kiev, Russia. **Studied:** Academie Andre Lhote, Paris, 1929-31 (painting); Academie des Beaux-Arts, Paris, with August Perret (architecture). With the Louvre Museum, made "La Femme Francais," 1936, one of the first color films on painting. US citizen 1946. Art Editor of VU, 1933-37. Joined Vogue Magazine, 1941; became its Art Director, 1943; became Art Director of Conde Nast Publications Inc., USA and Europe, 1944, and the organization's Editorial Director, 1962. **Address:** 173 East 70 Street, NYC 10021. **Dealer:** Andre Emmerich Gallery, NYC. **One-man Exhibitions:** MOMA, The Artist in His Studio, 1959; Betty Parsons Gallery, 1960, 62, 63, 64, 67, 69; Robert Fraser Gallery, 1964; Bennington College, 1964; Galleria dell'Ariete, 1965; Galleria d'Arte, Naples, 1965; Jewish Museum, 1966; Andre Emmerich Gallery, 1967-69. **Retrospectives:** Houston/MFA, 1970; Corcoran, 1970; Honolulu Academy, 1972. **Group:** SRGM, Younger American Painters, 1954; A. Tooth & Sons, London, Six American Painters, 1961; MOMA, Modern American Drawings, circ. Europe, 1961-62; Chicago/AI, 1961, 62; WMAA, Geometric Abstraction in America, circ., 1962; III International Biennial Exhibition of Prints, Tokyo, 1962; WMAA Annuals, 1962, 63, 65; Corcoran, 1963; Roswell, 1963; Hartford/Wadsworth, 1964; Los Angeles/County MA, Post Painterly Abstraction, 1964; MOMA, Contemporary Painters and Sculptors as Printmakers, 1964; SRGM, American Drawings, 1964; Galerie Denise Rene, Paris, Hard-Edge, 1964; New York World's

Fair, 1964-65; PAFA, 1965; MOMA, The Responsive Eye, 1965; Amsterdam/ Stedelijk, New Shapes of Color, 1966; WMAA Sculpture Annuals, 1966, 69; Los Angeles/County MA, American Sculpture of the Sixties, 1967; U. of Illinois, 1967; HemisFair '68, San Antonio, Tex., 1968; MOMA, The Art of the Real, 1968; PMA, 1969; MOMA, The New American Painting and Sculpture, 1969. **Collections:** Andover/Phillips; Brandeis U.; Buffalo/Albright; U. of California; Chase Manhattan Bank; Chicago/AI; Civic Center Synagogue, NYC; Hartford/Wadsworth; Lincoln, Mass./De Cordova; MOMA; U. of Minnesota; NCFA; RISD; Smith College; Tate; VMFA; WGMA; WMAA; Woodward Foundation; Yale U. **Bibliography: Alexander Liberman;** Battcock, ed.; Calas, N. and E.; Goossen 1; *Monumenta;* Rickey; Tuchman 1.

LICHTENSTEIN, ROY. b. October 27, 1923, NYC. **Studied:** The Ohio State U., 1940-43, BFA, 1946-49, MA; ASL, 1940, with Reginald Marsh. US Army, 1943-46. **Taught:** The Ohio State U., 1946-51; New York State College of Education, Oswego, 1957-60; Douglass College, 1960-63. **Commissions:** New York State Pavillion, New York World's Fair, 1964-65 (mural). **Address:** P. O. Box 1369, Southampton, N.Y. 11968. **One-man Exhibitions:** (first) Carlebach Gallery, NYC, 1951; John Heller Gallery, NYC, 1952, 53, 54, 57; Leo Castelli Inc., NYC, 1962-65, 67, 69, 71, 72, 73, 74; Ferus Gallery, Los Angeles, 1963; Ileana Sonnabend Gallery, Paris, 1963, 65, 70; Il Punto, Turin, 1964; Galleria Apollinaire, Milan, 1965; Cleveland/ MA, 1966; Contemporary Arts Center, Cincinnati, 1967; Amsterdam/Stedelijk, 1967; Berne, 1968; Irving Blum Gallery, Los Angeles, 1968, 69, 71; Hannover/K-G., 1969; U. of Puerto Rico, 1970; Kansas City/Nelson, 1970; Chicago/ Contemporary, 1970; Seattle/AM, 1970; Columbus, 1970; U. of California, Irvine, 1970; Houston/Contemporary, 1972; Ronald Greenberg Gallery, St. Louis, 1973; Galerie Beyeler, 1973; Galerie Mikro, Berlin, 1974; Margo Leavin Gallery, 1974; Current Editions, Seattle, 1974; F. H. Mayor Gallery, London, 1974; CNAC, 1975. **Retrospectives:** Pasadena/AM, 1967; Tate, 1968; SRGM, 1969. **Group:** Dayton/AI, 1962; Pasadena/AM, New Paintings of

Roy Lichtenstein *Entablature* 1975

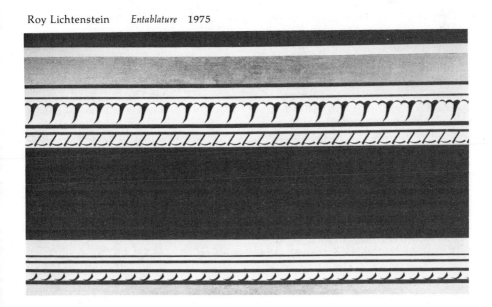

Common Objects, 1962; Sidney Janis Gallery, The New Realists, 1962; Galerie Saqqarah, Gstaad, Switzerland, The Figure and the Object from 1917 to the New Vulgarians, 1962; Chicago/AI, 1963; SRGM, Six Painters and The Object, circ., 1963; WGMA, The Popular Image, 1963; ICA, London, The Popular Image, 1963; Houston/Contemporary, Pop Goes the Easel, 1963; Brandeis U., New Directions in American Painting, 1963; Festival of Two Worlds, Spoleto, 1965; SRGM, Word and Image, 1965; WMAA Annuals, 1965, 68; ICA, U. of Pennsylvania, The Other Tradition, 1966; RISD, Recent Still Life, 1966; XXXIII Venice Biennial, 1966; Expo '67, Montreal, 1967; U. of St. Thomas (Tex.), 1967; Carnegie, 1967; IX Sao Paulo Biennial, 1967; Documenta IV, Kassel, 1968; Brooklyn Museum, Print Biennial, 1968; Turin/Civico, 1969; Ars 69, Helsinki, 1969; WMAA Annuals, 1970, 72, 73; Expo '70, Osaka, 1970; Foundation Maeght, L'Art Vivant, 1970; Cincinnati/Contemporary, Monumental Art, 1970; Corcoran Biennial, 1971; Buffalo/Albright, Kid Stuff, 1971; Chicago/AI, 70th American Exhibition, 1972; Indianapolis, 1972; Detroit/Institute, Art in Space, 1973; Art Museum of South Texas, Corpus Christi, Eight Artists, 1974; Chicago/AI, Idea and Image in Recent Art, 1974; WMAA, American Pop Art, 1974; MOMA, Works from Change, 1974. **Collections:** Amsterdam/Stedelijk; Brandeis U.; Buffalo/Albright; Chicago/AI; Cologne; Darmstadt/Hessisches; Dayton/AI; Des Moines; Detroit/Institute; Dusseldorf/KN-W; Indiana U.; Kansas City/Nelson; MOMA; Milwaukee; U. of Minnesota; PMA; Pasadena/AM; RISD; SRGM; Tate; WMAA; Walker. **Bibliography:** Alloway 1; Battcock, ed.; Becker and Vostell; **Beeren;** Bihalji-Merin; Calas, N. and E.; *Contemporanea;* **Coplans 2; Coplans, ed.;** Davis, D.; Dienst 1; Finch; Hunter, ed.; Kozloff 3; *Kunst um 1970;* Lippard 5; *Metro; Report;* Rose, B. 1, 4; Rubin 1; Rublowsky; Russell and Gablik; Tomkins and Time-Life Books; Weller. Archives.

LINDNER, RICHARD. b. November 11, 1901, Hamburg, Germany. **Studied:** School of Fine and Applied Arts, Nurnberg; Academy of Fine Arts, Munich, 1924; in Berlin, 1927-28. Concert pianist, 1919-23. To Paris 1933-39; English Army 1939-41; to USA 1941; citizen 1948. Traveled Europe, Mexico. **Taught:** Pratt Institute, 1951-63; Yale U., 1963. **Awards:** William and Noma Copley Foundation Grant, 1957. **Address:** 3 East 71 Street, NYC 10021. **One-man Exhibitions:** Betty Parsons Gallery, 1954, 56, 59; Cordier and Warren, NYC, 1961; Robert Fraser Gallery, 1962; Cordier & Ekstrom, Inc., 1963-67; Claude Bernard, Paris, 1965; Galleria d'Arte Contemporanea, Turin, 1966; Il Fante di Spade, Rome, 1966; Leverkusen, 1968; Hannover/K-G., 1968; Kunstverein Museum, Berlin, 1969; Staatliche Kunsthalle, Baden-Baden, 1969; U. of California, Berkeley, 1969; Galerie Rudolf Zwirner, 1969; Spencer A. Samuels & Co., NYC, 1971; Kunstsalon Wolfsberg, Zurich, 1971; Fischer Gallery, London, 1972; Rotterdam, 1974; Dusseldorf/Kunsthalle, 1974. **Retrospective:** Paris/Moderne, 1974. **Group:** Walker, 1954; Chicago/AI, 1954, 57, 66; Brooklyn Museum, 1955; Yale U., 1955; WMAA, 1959, 60, 61, 67; MOMA, Americans 1963, circ., 1963-64; Tate, Dunn International, 1964, Gulbenkian International, 1964; Documenta III, Kassel, 1964; Brandeis U., Recent American Drawings, 1964; Corcoran, 1965; Milwaukee, 1965; Worcester/AM, 1965; International Biennial Exhibition, Tokyo; SFMA, 1966; Flint/Institute, I Flint Invitational, 1966; Detroit/Institute, Color, Image and Form, 1967; U. of Colorado, 1967; IX Sao Paulo Biennial, 1967; ICA, London, The Obsessive Image, 1968. **Collections:** Chicago/AI; Cleveland/MA; MOMA; Tate; WMAA. **Bibliography:** Ashton 4; Battcock, ed.; **Dienst 2;** Hunter, ed.; Lippard 5; **Tillim.** Archives.

LIPCHITZ, JACQUES. b. August 22, 1891, Druskieniki, Lithuania; **d.** March 26, 1973, NYC. **Studied:** Academie des

Beaux-Arts, Paris, 1909-11, with Jean Antonine Ingalbert, Dr. Richet; Academie Julian, Paris, with Raoul Verlet; Academie Colarossi, Paris. Became French citizen 1924; to USA 1941. Traveled Europe, Middle East, USA. Fire destroyed Manhattan studio, 1952. **Commissions:** Dr. Albert Barnes, 1922 (5 bas-reliefs); Vicomte Charles de Noailles, Hyeres, France, 1927 ("Joy of Life"); Paris World's Fair, 1937 ("Prometheus"); Brazilian Ministry of Health and Education, 1943 ("Prometheus Strangling the Vulture"); Notre Dame de Toute-Grace, Assy, Haute-Savoie, France, 1956 (baptismal font); Mrs. John D. Rockefeller III, 1950 (bas-relief); Fairmount Park Association, Philadelphia, 1958 (sculpture); Presidential Scholars Medallion (USA) 1965; U. of Minnesota, Duluth, 1964 (9-ft. statue of Sieur Duluth). **Awards:** Academie Julian, Paris, First Prize for Sculpture, 1909; Paris World's Fair, 1937, Gold Medal; Legion of Honor (France), 1946; PAFA, George D. Widener Memorial Gold Medal, 1952; Hon. DFA, Brandeis U., 1958; AAAL, Gold Medal, 1966. **One-man Exhibitions:** (first) Leonce Rosenberg Gallery, Paris, 1920; Galerie de la Renaissance, Paris, 1930; Joseph Brummer Gallery, NYC, 1935; Musee du Petit Palais, Paris World's Fair, 1937; Buchholz Gallery, NYC, 1942, 43, 46, 48, 51; Galerie Maeght, 1946; Petite Galerie Seminaire, Brussels, 1950; Portland, Ore./AM, 1950; SFMA, 1951, 63; Cincinnati/AM, 1951; Frank Perls Gallery, 1952, 57; Santa Barbara/ MA, 1952; XXVI Venice Biennial, 1952; MOMA, 1954; Walker, 1954, 63; Cleveland/MA, 1954; Otto Gerson Gallery, NYC, 1957, 59, 61; Amsterdam/Stedelijk, 1958; Rijksmuseum Kroller-Muller, 1958; Brussels/Royaux, 1958; Basel, 1958; Paris/Moderne, 1959; Tate, 1959; Cornell U., 1961; Denver/AM, 1962; UCLA, 1963; Fort Worth, 1963; Buffalo/Albright, 1963; Des Moines, 1964; PMA, 1964; Omaha/Joslyn, 1964; Marlborough-Gerson Gallery Inc., 1964, 66; Newark Museum, 1965; Boston U., 1965; AAAL, 1966; Dunkelman Gallery, Toronto, 1967; Marlborough Gallery Inc., NYC, 1968, 75; Tel Aviv, 1971; Marlborough Godard Ltd., Toronto, 1972; Marlborough Fine Art Ltd., London, 1973; Makler Gallery, 1973. **Retrospectives:** Berlin/National, 1971; MMA, 1972. **Group:** Salon d'Automne, Paris, 1913; WMAA; MOMA; Tate; Paris/Moderne; Chicago/AI. **Collections:** Baltimore/MA; Barnes Foundation; Buffalo/Albright; Carleton College; Chicago/AI; Cleveland/MA; Cornell U.; Currier; Dartmouth College; Des Moines; Detroit/Institute; Harvard U.; Hunt Foods & Industries; Jewish Museum; Los Angeles/County MA; MOMA; Mansion House Project; U. of Minnesota; Montreal/MFA; U. of Nebraska; New Orleans/Delgado; PMA; Paris/Moderne; Phillips; Princeton U.; Regina/MacKenzie; Rijksmuseum Kroller-Muller; Rouen; SRGM; St. Louis/City; Syracuse U.; Tate; Tel Aviv; Toronto; Utica; Zurich. **Bibliography:** Barr 1; Baur 7; Biddle 4; Biederman 1; Bihalji-Merin; Blesh 1; Canaday; Cassou; Craven, W.; Elsen 2; Fierens; George 1; Gertz; Giedion-Welcker 1, 2; Goodrich and Baur 1; Greenberg; Hayter 1, 2; Henning; Hess, T. B. 1; **Hope;** Huyghe; **Jacques Lipshitz;** Kuh 2, 3; Langui; Licht, F.; Lowry; McCurdy, ed.; Mendelowitz; *Metro;* Myers 2; Neumeyer; **Raynal 2;** Read 1, 3; Rickey; Rodman 1; Rose, B. 1; Rosenblum 1; Rothschild; Rubin 1; Sachs; Salvini; Selz, J.; Seuphor 3; Seymour; Tomkins and Time-Life Books; Trier 1, 2; Valentine 2; **Van Bork;** Waldberg 4; Wingler, ed.; Zervos.

LIPPOLD, RICHARD. b. May 3, 1915, Milwaukee, Wisc. **Studied:** The U. of Chicago and Chicago Art Institute School, 1933-37, BFA (industrial design). Traveled Mexico, Europe, Greece, Turkey, North Africa. **Taught:** Layton School of Art, 1940-41; U. of Michigan, 1941-44; Goddard College, 1945-47; Trenton Junior College (Head of Art Department, 1947-52; Queens College, 1947-48; Black Mountain College, 1948; Hunter College, 1952-68. Designer,

Chicago Corporation, 1937-41. Began wire constructions 1942. **Commissions:** Harvard U. Graduate Law School, 1950; MMA, 1952-56; Inland Steel Building, Chicago, 1957; Longview Bank, Longview, Tex., 1958; Four Seasons Restaurant, NYC, 1959; Festival of Two Worlds, Spoleto, 1959 (stage set); Benedictine Chapel, Portsmouth, R.I., 1960; Musee du Vin, Chateau Mouton Rothschild, Pouillac, France, 1960; J. Walter Thompson, NYC, 1960; Pan-Am Building, NYC, 1961; Philharmonic Hall, Lincoln Center for the Performing Arts, NYC, 1961; Jesse Jones Hall, Houston Tex.; Cathedral of St. Mary, San Francisco, 1969; North Carolina National Bank, Charlotte, 1969; Fairlane, Dearborn, 1974; Christian Science Center, Boston, 1974; Hyatt Regency Hotel, Atlanta, 1975; National Air and Space Museum, Washington, D.C., 1975. **Awards:** ICA, London/Tate, International Unknown Political Prisoner Competition, Third Prize, 1953; Brandeis U., Creative Arts Award, 1958; American Institute of Architects, Chicago Chapter, Honors Award, 1958; American Institute of Architects, New York Chapter, Silver Medal, 1960; Hon. PBK, NYC, 1961; Municipal Art Society of New York, Citation, 1963; elected to the NIAL, 1963; Ripon College, Hon. DFA, 1968. **Address:** 27 Frost Creek Drive, Locust Valley, N.Y. **Dealer:** The Willard Gallery. **One-man Exhibitions:** (first) The Willard Gallery, 1947, also 1948, 50, 52, 68; Arts Club of Chicago, 1953; Layton School of Art, 1953; Brandeis U., 1958. **Group:** MOMA, Fifteen Americans, circ., 1952; PMA, Sculpture of the Twentieth Century, 1953; ICA, London/Tate, International Unknown Political Prisoner Competition, 1953; WMAA, The New Decade, 1954-55; France/National, 50 Ans d'Art aux Etats-Unis, circ. Europe, 1955; Brooklyn Museum, Sculpture in Silver, 1955; Newark Museum, Abstract Art, 1910 to Today, 1956. **Collections:** Andover/Phillips; Des Moines; Detroit/Institute; Harvard U.; Hartford/Wadsworth; MMA; MOMA; Musee du Vin; Newark Museum; Utica; VMFA; WMAA; Yale

U. **Bibliography:** Baur 7; Blesh 1; Brumme; Craven, W.; Flanagan; Giedion-Welcker 1; Hunter 6; Licht, F.; McCurdy, ed.; Mendelowitz; *Metro;* Motherwell and Reinhardt, eds.; Neumeyer; Read 1, 3; Rickey; Ritchie 1, 3; Rose, B. 1; Seuphor 3; Trier 1; Weller. Archives.

LIPTON, SEYMOUR. b. November 6, 1903, NYC. **Studied:** City College of New York, 1922-23; Columbia U., 1923-27. **Taught:** Cooper Union, 1943-44; Newark State Teachers College, 1944-45; Yale U., 1957-59; New School for Social Research, 1940-64. **Member:** NIAL, 1975. **Commissions:** Temple Israel, Tulsa, Okla.; Temple Beth-El, Gary, Ind.; Manufacturers Hanover Trust Co., NYC; Inland Steel Building, Chicago; Reynolds Metals Co. (NYC); International Business Machines Corp. (Yorktown Heights, N.Y.); Dulles International Airport, Washington, D.C.; Golden Gateway Redevelopment Project, San Francisco; Philharmonic Hall, Lincoln Center for the Performing Arts, NYC; Milwaukee Center for the Performing Arts, 1967. **Awards:** Chicago/AI, 1957; IV Sao Paulo Biennial, Top Acquisition Prize, 1957; NIAL, 1958; Guggenheim Foundation, 1960; New School for Social Research, 1960; Ford Foundation Grant, 1961; PAFA, George D. Widener Memorial Gold Medal, 1968. **Address:** 302 West 98 Street, NYC 10025. **Dealer:** Marlborough Gallery Inc., NYC. **One-man Exhibitions:** ACA Gallery, 1938; Gallery St. Etienne, NYC, 1943; Betty Parsons Gallery, 1948, 50, 52, 54, 58, 62; Watkins Gallery, Washington, D.C., 1951; New Paltz/SUNY, 1955; Troy, N.Y., 1961; Phillips, 1964; Marlborough-Gerson Gallery Inc., 1965; Milwaukee, 1969; U. of Wisconsin, 1969; Marlborough Gallery Inc., NYC, 1971; MIT, 1971; VMFA, 1972; Cornell U., 1973; Syracuse/Everson, 1973; Marlborough Galerie AG, Zurich, 1974. **Group:** WMAA Annuals since 1941; IV Sao Paulo Biennial, 1957; XXIX Venice Biennial, 1958; Carnegie, 1958, 61; Brussels World's Fair, 1958; Seattle

World's Fair, 1962; New York World's Fair, 1964-65; Chicago/AI Annual, 1966; Flint/Institute, I Flint Invitational, 1966; MOMA, Dada, Surrealism and Their Heritage, 1968; PAFA Annual, 1968; Smithsonian, 1968; MOMA, The New American Painting and Sculpture, 1969. **Collections:** Baltimore/MA; Brooklyn Museum; Buffalo/Albright; Cornell U.; Des Moines; Detroit/Institute; Didrichsen Foundation; Franklin Institute; H. J. Heinz Co.; Hirshhorn; IBM; Inland Steel Co.; U. of Kansas; MMA; MOMA; Manufacturers Hanover Trust Co.; U. of Massachusetts; U. of Michigan; NCFA; New School for Social Research; PMA; Phillips; RISD; Reynolds Metals Co.; Santa Barbara/MA; South Mall, Albany; Tel Aviv; Toronto; Utica; WGMA; WMAA; Yale U. **Bibliography:** Baur 5, 7; Biddle 4; Blesh 1; Brumme; Chaet; Craven, W.; Christensen; **Elsen** 1, **3;** Flanagan; Goodrich and Baur 1; Henning; Hunter 6; Hunter, ed.; Langui; McCurdy, ed.; Mendelowitz; *Metro;* Myers 2; Neumeyer; Read 3; Ritchie 1, 3; Rose, B. 1; Seuphor 3; Trier 1; Weller. Archives.

LOBDELL, FRANK. b. 1921, Kansas City, Mo. **Studied:** St. Paul School of Art, 1938-39, with Cameron Booth; California School of Fine Arts, 1947-50. US Army, 1942-46. Resided Paris, 1950-51. **Taught:** California School of Fine Arts, 1957- ; Stanford U., 1965- . **Awards:** SFMA, Artists Council Prize, 1948; SFMA, **P.P.,** 1950; SFMA, Nealie Sullivan Award, 1960; Tamarind Fellowship, 1966; A Knight of Mark Twain, 1971. **Address:** 340 Palo Alto Avenue, Palo Alto, Calif. 94301. **One-man Exhibitions:** (first) Lucien Labaudt Gallery, San Francisco, 1949; Martha Jackson Gallery, 1958, 60, 63, 72, 74; de Young, 1959; Pasadena/AM, 1961; Ferus Gallery, Los Angeles, 1962; Galerie D. Benador, Geneva, 1964; Galerie Anderson-Mayer, Paris, 1965; Pasadena/AM and Stanford U., 1966; Marylhurst College, 1967; SFMA, 1969; St. Mary's College, Moraga, Calif., 1970, 71. **Retrospective:** Pasadena/AM, 1963. **Group:** San Francisco Art Asso-

ciation Annual, 1950; III Sao Paulo Biennial, 1955; WMAA, Fifty California Artists, 1962-63; SRGM, American Drawings, 1964; U. of Washington, Drawings by Americans, 1967; Albany/SUNY, Giant Prints, 1967; Eindhoven, Kompas IV, 1969-70; Pasadena/AM, West Coast: 1945-1969, 1969; Corcoran, 1971; WMAA Annual, 1972; U. of Illinois. **Collections:** Los Angeles/County MA; Oakland/AM; Pasadena/AM; SFMA; Stanford U. **Bibliography:** Hopps.

LOBERG, ROBERT W. b. December 1, 1927, Chicago, Ill. US Marine Corps, 1946-47. **Studied:** Glendale College, 1948, City College of San Francisco, 1948-50, AA, U. of California, Berkeley, 1950-52, BA, 1953-54, MA (painting, with Karl Kasten, Ward Lockwood, John Haley, Erle Loran, James McCray, Glenn Wessels, Worth Ryder, Felix Ruvulo, William H. Calfee, Carl Holty, Kyle Morris); Hofmann School, Provincetown, 1956, with Hans Hofmann. Traveled northern China, Japan, Europe. **Taught:** U. of California, Berkeley, 1955, 56, 58, 59, 65; California College of Arts and Crafts, 1961-62; San Francisco Art Institute, 1962-66; U. of Washington, 1967-68. **Awards:** California State Fair, Hon. Men., 1955; RAC, Prize in Graphics, 1955; Yaddo Fellowship, 1957; RAC, Prize in Watercolors, 1959; MacDowell Colony Fellowship, 1959, 60; SFMA, Anne Bremer Memorial Prize, 1961; San Francisco Art Festival, **P.P.** in Painting, 1962; La Jolla, Prize in Painting, 1962. **Address:** 2708 Sunset Avenue, Berkeley, Calif. **One-man Exhibitions:** (first) Artist's Gallery, NYC, 1959; SFMA (three-man), 1961; Staempfli Gallery, 1962; David Stuart Gallery, 1962, 64; Richard White Gallery, Seattle, 1968; California College of Arts and Crafts, 1969; Berkeley Gallery, 1969; California College of Arts and Crafts, 1969. **Retrospective:** U. of Washington, 1968. **Group:** Chicago/AI, 1948, 62; RAC; Oakland/AM; SFMA Annuals since 1955; de Young; California Palace; Carnegie, 1959; SFMA, Abstract Expressionism in the West,

circ., 1961; SFMA, Collage in San Francisco, 1962; WMAA, Fifty California Artists, 1962-63; SFMA, New Paintings, 1964. **Collections:** California College of Arts and Crafts; Chicago/AI; Oakland/AM; Portland, Ore./AM; San Francisco Municipal Art Commission; WGMA; U. of Washington.

LOEW, MICHAEL. b. May 8, 1907, NYC. **Studied:** City College of New York; ASL, 1926-29, with Richard Lahey, Boardman Robinson; Academie Scandinave, Paris, 1930, with Othon Friesz; Hofmann School, NYC, 1947-49; Atelier Fernand Leger, Paris, 1950, with F. Leger. US Navy "Seabees," Battalion Artist, Pacific theater, 1943-46. Traveled France, Germany, Italy, Africa, Mexico, Central America, Spain, England. **Taught:** Portland (Ore.) Museum School, 1956-57; U. of California, Berkeley, 1960-61, 1967; School of Visual Arts, NYC, 1958- . **Member:** American Abstract Artists; Federation of Modern Painters and Sculptors. Federal A.P.: Gustave Straubenmuller Junior High School, NYC (series of 5 murals); U. of California, Berkeley, 1960-61, 1966. **Commissions** (murals): Hall of Man and Pharmacy Building, New York World's Fair, 1939; US Post Offices, Amherst, Ohio, and Belle Vernon, Pa. **Awards:** Sadie May Fellowship, 1929; Section of Fine Arts, National Mural Competition for Social Security Building and War Department Building, Washington, D.C., Hon. Men., 1941, 42; Ford Foundation, **P.P.,** 1964; Chicago/AI Annual, 1964. **Address:** 280 Ninth Avenue, NYC 10001. **One-man Exhibitions:** (first) Artists' Gallery, NYC, 1949; Rose Fried Gallery, 1953, 55, 57, 59; Portland, Ore./AM, 1956; Rutgers U. (two-man), 1959; T. K. Gallery, Provincetown, Mass., 1959; Holland-Goldowsky Gallery, Chicago, 1960; U. of California, Berkeley, 1960, 67; The Stable Gallery, NYC, 1961, 62, 64, 65; Landmark Gallery Inc., NYC, 1973. **Retrospectives:** Holland-Goldowsky Gallery, Chicago, 1960; The Stable Gallery, 1962. **Group:** American Abstract Artists Annuals, 1949- ; Salon des Realites Nouvelles, Paris, 1950; WMAA, 1950, 61; MMA, 1952; Walker, The Classic Tradition, 1953; International Association of Plastic Arts, Contemporary American Painting, circ. Europe, 1956-57; A.F.A., Collage in America, circ., 1957-58; Douglass College, 1959; ART:USA:59, NYC, 1959; Federation of Modern Painters and Sculptors Annuals, 1959- ; WMAA, Geometric Abstraction in America, circ., 1962; MOMA, Hans Hofmann and His Students, circ., 1963-64; Chicago/AI, 1964; Colby College, 100 Artists of the 20th Century, 1964; PAFA, 1966; Allentown/AM, Monhegan Island Painters, 1974. **Collections:** Atlanta U.; Baltimore/MA; Calcutta; U. of California; Ciba-Geigy Corp.; Conover-Mast Publications Inc.; Hampton Institute; Hirshhorn; U. of Nebraska; PMA; US Navy; Union Carbide Corp.; WMAA; Wichita State U. Archives.

LONGO, VINCENT. b. February 15, 1923, NYC. **Studied:** Cooper Union, with Leo Katz, Sidney Delevant, 1942-46; Brooklyn Museum School, 1950, with Max Beckmann, 1953, with Louis Schanker. Traveled Europe. **Taught:** Brooklyn Museum School, 1955-56; Yale U. Summer School, Norfolk, Conn., 1967-68; Bennington College, 1957-67; Hunter College, 1967- . **Member:** SAGA. **Awards:** Fulbright Fellowship (Italy), 1951; Philadelphia Print Club, First Prize, 1954; Yaddo Fellowship, 1954; Guggenheim Foundation Fellowship, 1971; Cooper Union, Achievement Citation, 1973; National Endowment for the Arts, 1974. **Address:** 50 Greene Street, NYC 10013. **Dealer:** Susan Caldwell Inc. **One-man Exhibitions:** Regional Arts Gallery, NYC, 1949; Korman Gallery, NYC, 1954; The Zabriskie Gallery, 1956; Yamada Art Gallery, Kyoto, 1959; Area Gallery, NYC, 1960; Wheaton College, 1969; Thibaut Gallery, NYC, 1963; U. of Vermont, 1965; Reese Palley Gallery, NYC, 1970; Susan Caldwell Inc., 1974. **Retrospectives:** Bennington College,

1970; Corcoran, 1970; Detroit/Institute, 1970. **Group:** WMAA Annuals, 1951, 71; PAFA Annual, 1953; MOMA, Young Printmakers, 1954; Brooklyn Museum, 1954, 55; Philadelphia Print Club (three-man), 1955; MOMA, Drawings USA, 1956; American Abstract Artists, 1957, 58, 59; New York Coliseum, ART:USA:59, 1959; U. of Kentucky, Graphics '60, 1960; USIA, Contemporary American Woodcut and Its Variations, 1962; PCA, American Prints Today, 1962; Brooklyn Museum, Two Decades of American Prints, 1969; WMAA, American Drawings: 1963-1973, 1973. **Collections:** Bibliotheque Nationale; Brooklyn Museum; Ciba-Geigy Corp.; Corcoran; Detroit/Institute; Library of Congress; MOMA; NCFA; PMA; Syracuse/Everson. Archives.

LORAN, ERLE. b. October 3, 1905, Minneapolis, Minn. **Studied:** U. of Minnesota; Minneapolis Institute School, with Cameron Booth; Hofmann School, 1954. Traveled Europe extensively. **Taught:** U. of California, Berkeley. Federal A.P.: Easel painting, teaching. **Awards:** Chaloner Prize Foundation Award ($6,000), 1926; SFMA, Artists' Fund Prize, 1944; Pepsi-Cola Bronze Medal, 1949; San Francisco Art Association, **P.P.**, 1956; California Palace, H. S. Crocker Co. Award, 1963; U. of Illinois, **P.P.**, 1965; Minneapolis Institute School, Hon. MFA, 1968; and some 20 others. **Address:** 10 Kenilworth Court, Berkeley, Calif. 94707. **Dealer:** The New Bertha Schaefer Gallery. **One-man Exhibitions:** (first) Kraushaar Galleries, 1931; SFMA, 1936, 39, 44; Artists' Gallery, NYC, 1938; Pasadena/AM, 1947; Santa Barbara/MA, 1947, 50; Dalzell Hatfield Gallery, 1949; de Young, 1949, 54, 63; Catherine Viviano Gallery, 1952, 54; Comara Gallery, 1964; The Bertha Schaefer Gallery, 1965; Arleigh Gallery, 1969. **Group:** MOMA, 1935; Oakland/AM, 1936, 46; SFMA, 1936-64; WMAA, 1937, 41, 44, 48, 51, 52; Chicago/AI, 1938, 39, 43, 44, 46, 48;

Carnegie, 1941; Toledo/MA, 1943; PAFA, 1945; U. of Illinois, 1949, 52, 53, 63, 65, 69; MMA, 1951, 53; Cranbrook, 1953; Sao Paulo, 1955, 56, 61; California Palace, 1961, 62, 63; MOMA, Hans Hofmann and His Students, circ., 1963-64. **Collections:** Brigham Young U.; U. of California; Denver/AM; IBM; U. of Illinois; U. of Minnesota; SFMA; San Diego; Santa Barbara/MA; Smithsonian; US State Department; Utah State U. **Bibliography:** Bethers; Blanchard; Cheney; Flanagan; **Loran 1, 2;** Pousette-Dart, ed. Archives.

LOUIS, MORRIS. b. November 28, 1912, Baltimore, Md.; **d.** September 7, 1962, Washington, D.C. **Studied:** Maryland Institute, 1920-33. **One-man Exhibitions:** (first) Martha Jackson Gallery, 1957; French & Co. Inc., NYC, 1959, 60; ICA, London, 1960; Bennington College, 1960; Galleria dell'Ariete, 1960; Galerie Neufville, Paris, 1961; Galerie Schmela, 1962; Galerie Lawrence, Paris, 1962; Galerie Muller, 1962; Andre Emmerich Gallery, NYC, 1961, 62, 65, 68, 69, 72, Zurich, 1973; Ziegler Gallery, 1964; Staatliche Kunsthalle, Baden-Baden, 1965; WGMA, 1966; Seattle/AM, 1967; MOMA (three-man), 1968; Lawrence Rubin Gallery, NYC, 1970, 73, 74; David Mirvish Gallery, 1971. **Retrospective:** SRGM, 1963; XXXII Venice Biennial, 1964; WGMA, 1967; Boston/MFA, circ., 1967. **Group:** The Kootz Gallery, NYC, New Talent, 1954; Rome-New York Foundation, Rome, 1960; SRGM, Abstract Expressionists and Imagists, 1961; Seattle World's Fair, 1962; WMAA, 1962; Jewish Museum, Toward a New Abstraction, 1963; Tate, Painting and Sculpture of a Decade, 1954-64, 1964; Corcoran; Los Angeles/County MA, Post Painterly Abstraction, 1964; Documenta III & IV, Kassel, 1964, 68; MOMA, The Responsive Eye, 1965; SFMA, The Colorists, 1965; WGMA, 1965-66; WMAA, Art of the U.S. 1670-1966, 1966; Chicago/AI Annual, 1966; Wurttembergischer Kunstverein, Stuttgart, 1967; Detroit/Institute, Co-

lor, Image and Form, 1967; Trenton/ State, Focus on Light, 1967; MOMA, The Art of the Real, 1968; Pasadena/ AM, Serial Imagery, 1968; MOMA, The New American Painting and Sculpture, 1969; WMAA, 1970; Edmonton Art Gallery, Alberta, Ten Washington Artists: 1950-1970, 1970; Auckland, 1971; Hayward Gallery, London, 1974. **Collections:** Allentown/AM; Boston/MFA; Brandeis U.; Buffalo/Albright; Harvard U.; MOMA; Phillips; SRGM; WGMA. **Bibliography:** Battcock, ed.; Calas, N. and E.; Coplans 3; Davis, D.; Fried 1, 2; Goossen 1; *The Great Decade;* Hunter, ed.; Kozloff 3; Rickey; Weller. Archives.

LOZOWICK, LOUIS. b. December 10, 1892, Russia; **d.** September 9, 1973, South Orange, N.J. To USA 1906. **Studied:** The Ohio State U., 1915-1918, BA; NAD, with Carlson, Ivan Olinsky, 1912-15. US Army, 1918-19. Traveled Europe, Russia, the Orient. **Taught:** Educational Alliance, NYC; and privately. **Member:** SAGA; Boston Printmakers. Federal A.P.: Main Post Office, NYC (mural); printmaker. **Awards:** Brewster Prize for Lithography; PMA, International Print Competition, First Prize; Society of American Etchers and Engravers, NYC, Knobloch Prize; Brooklyn Museum, **P.P.**; U. of Rochester, 150 Years of Lithography, Second Prize; SAGA; Audubon Artists. **One-man Exhibitions:** (first) Heller Gallery, Berlin, 1923; Weyhe Gallery; Courvoisier Gallery, San Francisco; Stendahl Gallery, Los Angeles; Casson Gallery, Boston; J. B. Neumann's New Art Circle, NYC; The Zabriskie Gallery, 1961, 71, 72; Galerie Zak, Paris; Smithsonian; Argus Gallery, Madison, N.J., 1965; Heritage Art Gallery, South Orange, N.J., 1967; WMAA, 1972; Robert Dain Gallery, NYC, 1973. **Retrospectives:** Newark Public Library, 1969; Seton Hall U., South Orange, N.J., 1975. **Group:** Brooklyn Museum, 1926; Chicago/AI, 1929; Carnegie, 1930, 39; Corcoran, 1932; A Century of Progress, Chicago, 1933-34; WMAA Annuals,

1933, 41; New York World's Fair, 1939; MMA, 1942; MOMA, 1943; Youngstown/Butler, 1960; Gallery of Modern Art, NYC, 1965; Boston/MFA. **Collections:** Boston/MFA; Cincinnati/AM; Cleveland/MA; Honolulu Academy; Houston/MFA; Library of Congress; Los Angeles/County MA; MMA; MOMA; Montclair/AM; Moscow/ Western; NYPL; Newark Museum; PMA; U. of Rochester; Syracuse/Everson; Trenton/State; Victoria and Albert Museum; WMAA. **Bibliography:** American Artists Congress, Inc.; American Artists Group Inc. 3; Baur 7; Brown; Gerdts; *Index of 20th Century Artists;* Mellquist; Reese. Archives.

LUCCHESI, BRUNO. b. July 31, 1926, Fibbiano, Italy. To USA 1957. **Studied:** Institute of Art, Lucca, 1953, MFA. **Taught:** Academy of Fine Arts, Florence, 1952-57; New School for Social Research, 1962- . **Commissions:** Trade Bank and Trust Co., NYC; Cornell U. **Awards:** NAD, Elizabeth N. Watrous Gold Medal, 1961; Guggenheim Foundation Fellowship, 1962; National Arts Club, NYC, Gold Medal, 1963; NAD, Samuel F. B. Morse Medal, 1965. **Address:** 14 Stuyvesant Street, NYC 10003. **Dealer:** The Forum Gallery. **One-man Exhibitions:** The Forum Gallery, 1961, 63, 66, 68. **Group:** Corcoran; NAD; PAFA; WMAA. **Collections:** Columbia, S.C./MA; Dallas/MFA; Hirshhorn; PAFA; Ringling; WMAA.

LUKIN, SVEN. b. February 14, 1934, Riga, Latvia. **Studied:** U. of Pennsylvania. **Awards:** J. S. Guggenheim Fellowship, 1966. **Address:** 807 Avenue of the Americas, NYC 10001. **Dealer:** The Pace Gallery. **One-man Exhibitions:** (first) Nexus Gallery, Boston, 1959; Betty Parsons Gallery, 1961; Martha Jackson Gallery, 1962; Dwan Gallery, Los Angeles, 1963; The Pace Gallery, Boston, 1963; The Pace Gallery, NYC, 1964, 66, 68. **Group:** Carnegie, 1961; WMAA Annual, 1962, 66, 68; Chicago/ AI, 1964; SRGM, American Drawings,

1964, The Shaped Canvas, 1964; U. of Illinois, 1965; Torcuato di Tella, Buenos Aires, 1965; Amsterdam/Stedelijk, New Shapes of Color, 1966; U. of Colorado, 1967; Des Moines, Painting: Out from the Wall, 1968. **Collections:** American Republic Insurance Co.; Buffalo/Albright; Los Angeles/County MA; U. of Miami; Ridgefield/Aldrich; South Mall, Albany; U. of Texas; WMAA. **Bibliography:** Battcock, ed.; Hunter, ed.; Weller.

LUND, DAVID. b. October 16, 1925, NYC. **Studied:** Queens College, with Vaclav Vytlacil, Cameron Booth, 1944-48, BA (major in Painting); NYU, 1948-50, with Hale Woodruff; New School for Social Research, with Yasuo Kuniyoshi. Traveled Europe, southwestern USA, Mexico. **Taught:** Cooper Union, 1955-57, 1959- ; Parsons School of Design, 1963-66, 1967- ; Queens College, 1964-66; Washington U. (St. Louis), 1966-67; Columbia U. **Awards:** Fulbright Fellowship (Rome), 1957-58, renewed 1958-59; WMAA Annual, Ford Foundation Purchase, 1961. **Address:** 470 West End Avenue, NYC 10024. **Dealer:** Grace Borgenicht Gallery Inc. **One-man Exhibitions:** (first) Grand Central Moderns, NYC, 1954; Galleria Trastevere di Topazia Alliata, Rome, 1955; Grace Borgenicht Gallery Inc., 1960, 63, 67, 69; Martin Schweig Gallery, 1966. **Group:** Tanager Gallery, NYC, Invitational; The Stable Gallery Annual, 1956; Galleria Schneider, Rome, Fulbright Artists, 1958, 59; WMAA, Fulbright Artists, 1958; Hirschl & Adler Galleries, Inc., NYC, Experiences in Art, I, 1959; WMAA, Young America, 1960; WMAA Annual, 1961; WMAA, Forty Artists Under Forty, circ., 1962; PAFA, 1965, 69; School of Visual Arts, NYC, 1966; Omaha/Joslyn, A Sense of Place, 1973; City Hall, Rockport, Me., Maine Coast Artists, 1974; Oklahoma, Contemporary American Landscape Painting, 1975; IIE, 20 American Fulbright Artists, 1975. **Collections:** Baltimore/MA; Brandeis U.; Chase Manhattan Bank; Colby College; Commerce Trust Co., Kansas City, Mo.; Fort Worth; Harcourt Brace Jovanovich Inc.; Manufacturers Hanover Trust Co.; U. of Massachusetts; McDonnell & Co. Inc.; *The New York Times;* The Pure Oil Co.; South County Bank; Toronto; WMAA.

LUNDEBERG, HELEN. b. June 1908, Chicago, Ill. **Studied:** Privately with Lorser Feitelson. Federal A.P.: Painting, lithography, mural designer. **Address:** 8307 West 3 Street, Los Angeles, Calif. 90048. **One-man Exhibitions:** (first) Stanley Rose Gallery, Hollywood, 1933; Mid-20th Century Art Gallery, Los Angeles, 1947; Art Center School, Los Angeles (two-man); Lucien Labaudt Gallery, San Francisco (two-man), 1949; Pasadena/AM; Santa Barbara, 1958; Paul Rivas Gallery, Los Angeles, 1959; Long Beach/MA, 1963; Occidental College, 1965; David Stuart Gallery, 1970, 71. Retrospective: La Jolla, 1971. **Group:** Brooklyn Museum, 1936; SFMA, 1936; MOMA, Fantastic Art, DADA, Surrealism, 1936; MOMA, Americans 1942, circ., 1942; Chicago/AI, Abstract and Surrealist Art, 1948; U. of Illinois, 1950-52, 55, 57, 65; Carnegie, 1952; III Sao Paulo Biennial, 1955; WMAA, Geometric Abstraction in America, circ., 1962; WMAA, Fifty California Artists, 1962-63; WMAA Annual, 1965, 67; Sacramento/Crocker, 1968; Los Angeles Institute of Contemporary Art, 1974. **Collections:** Atlantic Richfield Co.; Chaffey College; Craig Ellwood Associates; Great Western Savings and Loan Association; Hirshhorn; Honolulu Academy; La Jolla; Lansing Sound Corp.; Los Angeles/County MA; Palm Springs Desert Museum; Pasadena/AM; SFMA; Santa Barbara/MA; Xerox Corp. **Bibliography:** Rickey. Archives.

LYE, LEN. b. July 5, 1901, Christchurch, New Zealand. **Studied:** Wellington Technical College; Canterbury College of Fine Arts. To London, 1926; to USA 1946; became a citizen. Traveled Samoa, Europe, USA, around the world, 1968. **Taught:** City College of New York (film technique); NYU. International **awards**

for experimental films. Began kinetic constructions in the 1920s. Created "direct animation" technique, working directly on film strip without camera, 1935. **Address:** P. O. Box 206, Warwick, N.Y. 10990. **One-man Exhibitions:** London Film Society ("Tusalava"), 1928; MOMA, Tangible Motion Sculpture, 1961; St. Luke's School, NYC, Wind Wands, 1962; The Howard Wise Gallery, 1965; Buffalo/Albright, 1965. **Group:** Seven & Five Society, London, 1928-33; a Surrealists group, London, 1937; Amsterdam/Stedelijk, Art in Motion, circ. Europe, 1961-62; WMAA Annual, 1962; The Howard Wise Gallery, NYC, On The Move, 1963. **Collections:** Buffalo/Albright; U. of California, Berkeley; Chicago/AI; Tel Aviv; WMAA. **Film Collections:** U. of California, Berkeley; London Film Society; MOMA. **Bibliography:** Battcock, ed.; Bihalji-Merin; Calas, N. and E.; Davis, D.; Kuh 3; Read 5; *Report;* Rickey; Selz, P. 1; Tuchman 1.

LYTLE, RICHARD. b. February 14, 1935, Albany, N.Y. **Studied:** Cooper Union, with Nicholas Marsicano, Victor Candell; Yale U., with Josef Albers (whom he assisted as teaching fellow in color and drawing), James Brooks, Bernard Chaet, 1957, BFA, 1960, MFA. Traveled Europe, northeastern USA. **Taught:** Yale U., 1960-63, 1966- ; Dean, Silvermine Guild, 1963-66. **Commissions:** Fairfield U. (concrete relief mural). **Awards:** Scholarship to the Cummington School of Fine Arts, 1956; Fulbright Fellowship (Italy), 1958; New Haven Arts Festival, First Prize, 1958. **Address:** Sperry Road, Woodbridge, Conn. 06525. **Dealer:** Grace Borgenicht Gallery Inc. **One-man Exhibitions:** (first) Grace Borgenicht Gallery Inc., 1961, also 1963, 64, 66, 68, 72; Silvermine Guild, 1964; Cortland/SUNY, 1969; U. of Hartford, 1970; U. of Connecticut, 1973; Lincoln, Mass./De Cordova, 1974. **Group:** Brooklyn Museum, 1956; A.F.A., American Art, circ. Europe, 1956-59; Boston Arts Festival, 1958; MOMA, Sixteen Americans, circ., 1959; Chicago/AI Annuals, 1960, 61; Houston/MFA, The Emerging Figure, 1961; Seattle World's Fair, 1962; PAFA, 1962, 63, 64; Art:USA:Now, circ., 1962-67; WMAA, 1964; Silvermine Guild, 1964; U. of Illinois, 1967; Yale U., 1967; Ringling, Young New England Painters, 1969; Yale U., American Drawing, 1970-1973, 1973; Harvard U., Works by Students of Josef Albers, 1974; IIE, 20 American Fulbright Artists, 1975. **Collections:** Chase Manhattan Bank; Cincinnati/AM; Columbia U.; Lincoln, Mass./De Cordova; MOMA; U. of Massachusetts; NCFA; Yale U. **Bibliography:** Nordness, ed.

MACDONALD-WRIGHT, STANTON. b. July 8, 1890, Charlottesville, Va.; d. August 24, 1973, Pacific Palisades, Calif. **Studied:** Sorbonne; Academie des Beaux-Arts, Paris; Academie Colarossi, Paris; Academie Julian, Paris; ASL, with W. T. Hedges, J. Greenbaum. Met Morgan Russell in Paris, 1912, and with him founded the Synchromist movement in 1913. Studied the color theories of Michel Eugene Chevruel, Herman von Helmholz, and O. N. Rood. Returned to USA 1916. Traveled Japan, 1937, 1952-53. **Taught:** U. of California, 1942-50; U. of Southern California; Scripps College, 1946; U. of Hawaii, 1949; Fulbright Exchange Professor to Japan, 1952-53; lectured on art history and Oriental aesthetics. Federal A.P.: California State Director, 1935-42, and technical advisor to seven Western states. **Commissions** (murals): Santa Monica (Calif.) Public Library; Santa Monica City Hall; Santa Monica High School (mosaic). **One-man Exhibitions:** (first) Photo-Secession, NYC, 1917; Stendahl Gallery, Los Angeles, 1942 (two-man); Rose Fried Gallery, 1955; Duveen-Graham Gallery, NYC, 1956; Esther Robles Gallery, 1965; UCLA, 1970; Suzuki Graphics, NYC, 1972. **Retrospectives:** Los Angeles/County MA, 1956; NCFA, 1967. **Group:** Salon d'Automne, Paris, 1910; The Synchromists, Munich and Paris, 1913; Salon des Artistes Independants, Paris, 1913-14; MMA; Brooklyn Museum; Honolulu Academy. **Collections:** Boston/MFA; Brooklyn Museum; Carnegie; Chicago/AI; Columbus; Corcoran; Denver/AM; Detroit/Institute; Grand Rapids; Los Angeles/County MA; MMA; MOMA; U. of Minnesota; Newark Museum; Omaha/Joslyn; PMA; Pasadena/AM; San Diego; Santa Barbara/MA; Toledo/MA; WMAA; Walker. **Bibliography:** *Avant-Garde Painting and Sculpture;* Baur 7; Blanchard; Blesh 1; Brown; Cheney; Chipp; Christensen; Craven. T. 1; Goodrich and Baur 1; Haftman; Hess, T. B. 1; Hunter 6; Huyghe; Jackman; Janis, S.; McCurdy, ed.; Mellquist; Neuhaus; Read 2; Richardson, E. P.; Rickey; Ringel, ed.; Ritchie 1; Rose, B. 1, 4; **Scott;** Seuphor 1, 2; Wright 1, 2. Archives.

MACHLIN, SHELDON. b. September 6, 1918, NYC; d. June 8, 1975, Brooklyn, N.Y. **Studied:** NYU; ASL; New York School of Fine and Applied Art; School of Modern Photography. Traveled Europe, Asia, Africa. **Member:** American Field Service; Press Club of America; Artists Equity; Federation of Modern Painters and Sculptors. **One-man Exhibitions:** (first) Bolles Gallery, NYC, 1962; Bolles Gallery, San Francisco, 1963; Galerie Galaxie, Detroit, 1963; The Bertha Schaefer Gallery (two-man), 1963; Waddell Gallery, 1965, 67. **Group:** MOMA, 1963; VMFA, American Sculpture Today, 1963; WMAA Sculpture Annual, 1964, 66, 68; MOMA, The Responsive Eye, 1965; ICA, Boston, 1966; Trenton/State, Focus on Light, 1967; U. of Kentucky, 1968; Milwaukee, Directions I: Options, circ., 1968; La Jolla, 1969. **Collections:** Brandeis U.; Colgate U., Ford Foundation; Harvard U.; MMA; MOMA; Milwaukee; New York Cultural Center; Ridgefield/Aldrich; Svenska Handelsbanken; United Nations; VMFA; WMAA; Westinghouse; Wheaton College. **Bibliography:** Atkinson.

MAC IVER, LOREN. b. February 2, 1909, NYC. **Studied:** ASL, 1919-20. Traveled Europe. Lighting and decor for four Coffee Concerts, MOMA, 1941. **Member:** NIAL, 1959. Federal A.P.: 1936-39, New York. **Commissions** (murals): Moore-McCormack Lines Inc., *SS Argentina,* 1947; American Export Lines, *SS Excalibur, SS Exeter, SS Exochorda, SS Excambion,* 1948. **Awards:** Corcoran, First Prize, 1957; Ford Foundation Grant, 1960. **Address:** 61 Perry Street, NYC. **Dealer:** Pierre Matisse Gallery. **One-man Exhibitions:** (first) East River Gallery, NYC, 1938; Pierre Matisse Gallery, 1940, 44, 49, 56, 61, 70; Arts Club of Chicago, 1941; MOMA, circ., 1941; Baltimore/MA, 1945; Vassar College, circ., 1950; Santa Barbara/MA, 1951; Margaret Brown Gallery, Boston, circ., 1951; Phillips, 1951; Corcoran, 1956; Fairweather-Hardin Gallery, 1959; Southern Vermont Art Center, Manchester, Vt., 1968; Paris/Moderne, 1968; Musees Classes de Nice, 1968. **Retrospectives:** WMAA, circ., 1953; Paris/Moderne, 1968. **Group:** WMAA Annuals; MOMA, Fourteen Americans, circ., 1946; Corcoran. **Collections:** Andover/Phillips; Baltimore/MA; Bibliotheque Nationale; Brooklyn Museum; Chicago/AI; Corcoran: Detroit/Institute; Hartford/Wadsworth; Los Angeles/County MA; MMA; MOMA; National Gallery; Newark Museum; U. of Oklahoma; PMA; Phillips; Utica; Vassar College; WMAA; Walker; Williams College; Yale U. **Bibliography:** Barr 3; **Baur 4,** 5, 7; Bazin; Blesh 1; Eliot; Flanagan; Genauer; Goodrich and Baur 1; Hunter 6; Janis, S.; McCurdy, ed.; Mendelowitz; Miller, ed. 2; Newmeyer; Nordness, ed.; Pousette-Dart, ed.; Read 2; Richardson, E. P.; Soby 5, 6; Wight 2. Archives.

MALDARELLI, ORONZIO. b. September 9, 1892, Naples, Italy; **d.** January 4, 1963, NYC. To USA 1900. **Studied:** Cooper Union, 1906-08; NAD, 1908, with Leon Kroll, Ivan Olinsky, Hermon McNeil; Beaux-Arts Institute of Design, NYC, 1912, with Solon Borglum, Jo Davidson, John Gregory, Elie Nadelman. **Taught:** Sarah Lawrence College, 1933-61. **Member:** NIAL; NAD; Architectural League of New York; National Sculpture Society. **Commissions:** St. Patrick's Cathedral, NYC, 1947; James Weldon Johnson Houses, NYC, 1953-55; State Insurance Fund Building, NYC, 1957-58; Hartford (Conn.) Public Library, 1957-58; **Awards:** Fairmount Park Association, Philadelphia, First Prize, Sculpture, 1930; J. S. Guggenheim Fellowship, 1931-33; Chicago/AI, The Mr. & Mrs. Frank G. Logan Medal, 1941; NIAL Grant, 1948; PAFA, George D. Widener Memorial Gold Medal, 1951; Architectural League of New York, Silver Medal of Honor, 1954, 56. **Exhibitions:** NAD, 1922, 23, 58, 62, 63; California Palace, 1930; Chicago/AI, 1935, 36, 40, 42, 57; WMAA, 1936, 56, 62; U. of Minnesota, 1937; Society of Independent Artists, NYC, 1941; PAFA, 1943; Sao Paulo, 1951; MOMA, 1953; U. of Illinois, 1953, 55; Hartford/Wadsworth, 1957; P. Rosenberg and Co., 1959, Memorial Exhibition, 1963. **Collections:** Chicago/AI; Dallas/MFA; Fairmount Park Association; MMA; Newark Museum; Ogunquit; PAFA; Sara Roby Foundation; Utica; VMFA; WMAA. **Bibliography:** Baur 7; Brumme; Cheney; Pearson 2; Ritchie 3.

MALLARY, ROBERT. b. December 2, 1917, Toledo, Ohio. **Studied:** La Escuela de las Artes del Libro, Mexico City, 1938; privately with Koloman Sokol (graphics), Mexico City and New York, 1941-42. **Taught:** Pratt Institute, 1959-67; The Pennsylvania State U., 1962; U. of California, Davis, 1963, 67; U. of Minnesota, 1965; U. of Massachusetts, 1967- . Director, ARSTECNICA, U. of Massachusetts/Amherst College. **Commissions:** Beverly Hilton Hotel, Beverly Hills, Calif., 1954-55 (mural, with Dale Owen); New York State Pavilion, New York World's Fair, 1964-65. **Awards:** Tamarind Fellowship, 1962; Guggenheim Foundation Fellowship, 1964. **Address:** P. O. Box 48, Conway, Mass. 01341. **Dealer:** Allan Stone Gallery.

One-man Exhibitions: SFMA, 1944; Sacramento/Crocker, 1944, 52; Santa Barbara/MA, 1952; Gump's Gallery, 1953; San Diego, 1953; Urban Gallery, NYC, 1954; U. of New Mexico, 1956-59; Jonson Gallery, Albuquerque, N.M., 1957-59; Santa Fe, N.M., 1958; Allan Stone Gallery, 1961, 62, 66; Purdue U., 1974. **Retrospective:** Potsdam/SUNY, 1969. **Group:** Salon de Grabado, Mexico City, 1942; SFMA, 1945; Los Angeles/County MA Annuals, 1951, 53, 56; Denver/AM Annual, 1955; III & VII Sao Paulo Biennials, 1955, 63; Smithsonian, California Painters, circ. USA, 1956-58; MOMA, Recent Sculpture USA, 1959; MOMA, Sixteen Americans, circ., 1959; SRGM, Guggenheim International, 1960; WMAA Annuals, 1960, 62; MOMA, The Art of Assemblage, circ., 1961; Martha Jackson Gallery, New Media—New Forms, II, 1961; Seattle World's Fair, 1962; Carnegie, 1962; Chicago/AI Annual, 1962; A.F.A., Relief Sculpture, circ., 1964. **Collections:** Brandeis U.; Buffalo/Albright; U. of California; Houston/MFA; Kalamazoo/Institute; Los Angeles/County MA; MOMA; U. of New Mexico; U. of North Carolina; Roswell; Smith College; U. of Texas; WMAA. **Bibliography:** *Celebrate Ohio;* Davis, D.; Hunter, ed.; Janis and Blesh 1; *Report;* Seitz 3; Weller.

MALLORY, RONALD. b. June 17, 1935, Philadelphia, Pa. **Studied:** U. of Colorado, 1951; U. of Florida, B.Arch., 1952; School of Fine Arts, Rio de Janeiro (with Roberto Burle Marx), 1956; Academie Julian, Paris, 1958. Traveled Brazil, Europe, USA. **Address:** 2140 Bush Street, San Francisco, Calif. 94115. **Dealer:** Galeria Bonino Ltd. **One-man Exhibitions:** (first) Galerie Claude Volney, 1960; Mirell Gallery, Miami, Fla., 1961; The Stable Gallery, 1966, 67; Esther Robles Gallery, 1968; Galeria Bonino Ltd., 1969, 73. **Group:** Palais des Beaux-Arts, Brussels, 1965; Houston/Contemporary, 1966; U. of Illinois, 1967, 68; Carnegie, 1967; ICA, Boston, 1967; Flint/Institute, 1967; Worcester/AM, 1967; Salon des Jeunes

Peintres, Paris, 1967; HemisFair '68, San Antonio, Tex., 1968; UCLA, Electric Art, 1969; Torcuato di Tella, Buenos Aires, 1969; MOMA; WMAA. **Collections:** U. of Arizona; U. of California; Chase Manhattan Bank; ICA, Boston; MOMA; Munich/Modern; Ridgefield/Aldrich; WMAA.

MANGOLD, ROBERT. b. 1937, North Tonawanda, N.Y. **Studied:** Cleveland Institute of Art, 1956-59; Yale U., 1959, 1960-62, BFA, 1963, MFA. **Taught:** School of Visual Arts, NYC, 1963- ; Hunter College, 1964-65; Skowhegan School, 1968; Yale U. Summer School, Norfolk, Conn., 1969; Cornell U., 1970. **Address:** c/o Dealer. **Dealer:** John Weber Gallery. **One-man Exhibitions:** Thibaut Gallery, NYC, 1964; Fischbach Gallery, 1965, 67, 69, 70, 71, 73; Galerie Muller, 1968; SRGM, 1971; Yvon Lambert, 1973; Galleria Toselli, Milan, 1973; Lisson Gallery, 1973; Galerie Annemarie Verna, Zurich, 1973; Galleria Marilena Bonomo, Bari, Italy, 1973; Max Protetch, Washington, D.C., 1973; Weinberg Gallery, San Francisco, 1973; John Weber Gallery, 1974; Konrad Fischer Gallery, Dusseldorf, 1974. **Group:** SRGM,. Systemic Painting, 1966; Yale U., Twelve Yale Artists, 1966; ICA, U. of Pennsylvania, A

Robert Mangold
Two Quarter Circles within a Square 1975

Romantic Minimalism, 1967; Ithaca College, Selected New York Artists, 1967; Trenton/State, Focus on Light, 1967; WMAA, Artists under Forty, 1968; Buffalo/Albright, Modular Paintings, 1970; Documenta V, Kassel, 1972; WMAA, American Drawings: 1963-1973, 1973; Parcheggio di Villa Borghese, Rome, Contemporanea, 1973; Chicago/Contemporary, Five Artists: A Logic of Vision, 1974; MOMA, Color as Language, circ., 1975. **Collections:** Amsterdam/Stedelijk; Los Angeles/County MA; MOMA; McCrory Corporation; Oberlin College; RISD; Ridgefield/Aldrich; SRGM; WMAA. **Bibliography:** *Art Now 74; Contemporanea;* Lippard 2; Murdoch 1; *Options and Alternatives;* **Waldman 4.**

MAN RAY (Emmanuel Radinski). b. August 27, 1890, Philadelphia, Pa. **Studied:** NAD, 1908; ASL; Ferrer Center, NYC, with Robert Henri and George Bellows. Co-founder (with Marcel Duchamp and Francis Picabia) of DADA group, NYC, 1917. Co-organizer (with Katherine S. Dreier and Marcel Duchamp) of Societe Anonyme (Museum of Modern Art), 1920. Published one issue of *New York DADA* with Marcel Duchamp, 1921. To Paris, 1921, and became a member of the DADA and Surrealist groups, 1924-39. Developed the rayograph technique in photography, 1921. Created abstract and surrealist films: "Le Retour de la Raison," 1923; "Emak Bakia," 1926; "L'Etoile de Mer," 1928; "Les Mysteres du Chateau de Des," 1929. Resided Hollywood, 1940-50; returned to Paris. **Address:** 2 Bis rue Ferou, Paris, France. **Dealer:** Cordier & Ekstrom, Inc. **One-man Exhibitions:** (first) Daniel Gallery, NYC, 1915, also 1916, 19; Librarie Six, Paris, 1922; Galerie Surrealiste, Paris, 1926; Myrbor Galerie, Paris, 1929; Galerie Vanleer, Paris, 1929; Galerie Vignon, Paris, 1932; Curt Valentine Gallery, NYC, 1936; Galerie Beaune, Paris, 1939; The London Gallery, London, 1939; Frank Perls Gallery, 1941; Julien Levy Galleries, NYC, 1945;

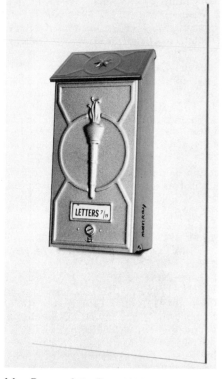

Man Ray *Letter Box* 1966

Copley Gallery, Hollywood, Calif., 1948; Paul Kantor Gallery, Beverly Hills, 1953; Galerie Furstenberg, Paris, 1954; Galerie Rive Droite, Paris, 1959; Bibliotheque Nationale, 1962; Cordier & Ekstrom, Inc., 1963, 70; Princeton U., 1963; Galleria Schwarz, 1964, 71; Los Angeles/County MA, 1966; Martha Jackson Gallery, 1968; Galerie der Spiegel, Cologne, 1968, 75; Hanover Gallery, 1969; Trenton/State, 1969; Noah Goldowsky, 1971; La Boetie, NYC, 1972; MMA, 1973; Alexandre Iolas Gallery, NYC, 1974; Galleria Il Fauno, Turin, 1974; Studio Marconi, Milan, 1975; Chicago/Contemporary, 1975. **Retrospectives:** Paris/Moderne, 1971; New York Cultural Center, 1974. **Group:** Societe Anonyme, NYC, 1920; Brooklyn Museum, 1926; Springfield, Mass./MFA, 1929; MOMA, 1936;

WMAA, 1946; Yale U., 1948. **Collections:** MOMA. **Bibliography:** *Avant-Garde Painting and Sculpture;* Barr 1; Baur 7; Biddle 4; Blesh 1; **Bourgeade;** Breton 1, 2, 3; Brown; Bryant, L.; Cassou; Christensen; Crespelle; Davis, D.; Flanagan; Gascoyne; Gerdts; Guggenheim, ed.; Haftman; Hulten; Hunter 6; Hunter, ed.; Huyghe; Janis and Blesh; Janis, S.; Kozloff 3; Kyrou; **Langsner; Man Ray 1, 2, 3, 4; Man Ray;** McCurdy, ed.; Mellquist; Motherwell 1; **Penrose;** Raynal 3; Read 2, 3, 5; **Ribemont-Dessaignes;** Richter; Ritchie 1; Rose, B. 1; Rubin 1; Seitz 3; Soby 1; Tashjian; Tomkins; Tomkins and Time-Life Books; Verkauf; Waldberg 2, 3, 4; Wright 1; Zervos.

MANSHIP, PAUL. b. December 25, 1885, St. Paul, Minn.; **d.** February 1, 1966, NYC. **Studied:** St. Paul School of Art, 1892-1903; ASL, 1905; PAFA, 1906-08; American Academy, Rome, 1909-12. Traveled Europe, USA; resided Paris, 1922-26. **Taught:** PAFA, 1943-46. **Member:** (Federal) Commission of Fine Arts (President, 1937-41); National Sculpture Society (President, 1939-42); AAAL (President, 1948-53); Century Association (President, 1950-54); Academy of St. Luca, Rome, 1952. **Commissions:** Designed coinage for Irish Free State, 1927. **Awards:** NAD, Helen Foster Barnett Prize, 1913, 17; PAFA, George D. Widener Memorial Gold Medal, 1914; Panama-Pacific Exposition, San Francisco, 1915, Gold Medal; NAD, 1920; elected to the NIAL, 1920; American Independent Artists Medal, 1921; American Institute of Architects, Gold Medal, 1921; NAD, Saltus Gold Medal for Merit, 1924; Philadelphia Art Week, Gold Medal, 1925; Philadelphia Sesquicentennial, 1926, Gold Medal; Legion of Honor, 1929; elected to the AAAL, 1932; Paris World's Fair, 1937, Diplome d'Honneur; National Sculpture Society, Medal of Honor, 1939; NIAL, Gold Medal, 1945. **One-man Exhibitions:** Architectural League of New York, 1912; A.F.A.,

1914; Corcoran, 1920, 37; Leicester Gallery, London, 1921; PMA, 1926; U. of Rochester, 1927; Toronto, 1928; Averell House, NYC, 1933; Tate, 1935; Century Association, 1935; VMFA, 1936; Arden Gallery, NYC, 1941; AAAL, 1945; Walker, 1948; St. Paul Gallery, 1967; Robert Schoelkopf Gallery, 1971, 72; Hamline U., 1972. **Retrospectives:** Smithsonian, 1958; NCFA, 1966. **Group:** Corcoran, 1920; PAFA; NAD; WMAA; MMA; and many others in America and abroad. **Collections:** American Academy, Rome; Andover/Phillips; Chicago/AI; Cochran Memorial Park; Detroit/Institute; Harvard U.; League of Nations; MMA; Minneapolis/Institute; New York Coliseum; Pratt Institute; Rockefeller Center; St. Louis/City; Smith College; West Palm Beach/Norton. **Bibliography:** Baur 7; **Beggs;** Birnbaum; Brumme; Cahill and Barr, eds.; Cortissoz 1; **Gallatin 7;** *Index of 20th Century Artists;* Jackman; Lee and Burchwood; **Leach;** Licht, F.; Mather 1; Mellquist; Mendelowitz; **Murtha;** Pach 1; Poore; Rose, B. 1; **Vitry.** Archives.

MANSO, LEO. b. April 15, 1914, NYC. **Studied:** Educational Alliance, NYC, 1929; NAD, 1930-34; New School for Social Research. Traveled Mexico, Africa, India, Nepal. **Taught:** Cooper Union, 1947-70; Columbia U., 1950-55; NYU, 1950- ; Provincetown Workshop, 1959 (co-founder); ASL, 1974; New School for Social Research, 1975. **Member:** American Abstract Artists. **Commissions:** Public Library, Lincoln, Neb. (mural), 1965. **Awards:** U. of Illinois, **P.P.**, 1951; Audubon Artists, 1952, 57; Ford Foundation, **P.P.**, 1963; AAAL, Childe Hassam Award, 1968. **Address:** 460 Riverside Drive, NYC 10027. **One-man Exhibitions:** (first) Norlyst Gallery, NYC, 1947; Guadalajara Institute, Mexico, 1948; Mortimer Levitt Gallery, NYC, 1950; The Babcock Gallery, 1953, 56; Columbia U., 1954; NYU, 1957; Grand Central Moderns, NYC, 1957, 60, 61, 63, 64; Philadelphia Art Alliance, 1961, 69; Tirca Karlis Gallery, 1963, 65, 67, 69, 70, 72, 73; Arts Council of

Winston-Salem (N.C.), 1966; Rose Fried Gallery, 1966, 68, 70; George Washington U., 1968; Rehn Galleries, 1974. **Group:** PAFA, 1947-50, 1952, 54, 61, 62, 64, 68; WMAA Annuals, 1948-66; U. of Illinois, 1950, 51, 52, 54, 57; A.F.A., circ.; U. of Nebraska Annual; American Abstract Artists Annual; Brooklyn Museum, Watercolor Biennials; ART: USA:58, NYC, 1958; MOMA, The Art of Assemblage, circ., 1961; NIAL, 1961, 68; MOMA, 1965. **Collections:** Alcoa; Boston/MFA; Brandeis U.; Brooklyn Museum; Cape Town; Charleston, W. Va.; Corcoran; U. of Illinois; MOMA; Michigan State U.; Mount Holyoke College; NYU; U. of Nebraska; Norfolk; PAFA; Portland, Ore./AM; RISD; Safad; Syracuse U.; WMAA; Wesleyan U.; West Palm Beach/Norton; Worcester/AM. **Bibliography:** Seitz 3. Archives.

MARCA-RELLI, CONRAD. b. June 5, 1913, Boston, Mass. **Studied:** Cooper Union, one year; mostly self-taught. US Army, 1941-45. Traveled Europe, USA, Mexico. **Taught:** Yale U., 1954-55, 1959-60; U. of California, Berkeley, 1958; New College, Sarasota, Fla., 1966. Federal A.P.: Easel and mural painting; also art teacher. **Awards:** Chicago/AI, The Mr. & Mrs. Frank G. Logan Medal, 1954; Ford Foundation, 1959; Detroit/Institute, **P.P.**, 1960; II Inter-American Paintings and Prints Biennial, Mexico City, 1960, Hon. Men.; Chicago/AI, The M. V. Kohnstamm Prize, 1963. **Address:** Box 1367, Apaquogue Road, East Hampton, N.Y. 11937; Urbanization Can Pepsimo, Ibiza (Baleares), Spain. **Dealer:** Marlborough Gallery Inc., NYC. **One-man Exhibitions:** (first) Niveau Gallery, NYC, 1948, also 1950; The New Gallery, NYC, 1951; The Stable Gallery, 1953-58 (4); Frank Perls Gallery, 1956; La Tartaruga, Rome, 1957, 62; The Kootz Gallery, NYC, 1959-64; Bolles Gallery, 1961; Galerie Schmela, 1961 (two-man, with Robert

Motherwell), 71; Lima, Peru, 1961; Joan Peterson Gallery, 1961; Galerie de France, Paris, 1962; Galerie Charles Leinhard, Zurich, 1963; Tokyo Gallery, 1963; James David Gallery, Miami, 1966, 67; Makler Gallery, 1967, 74; WMAA, 1967; Brandeis U., 1967-68; U. of Alabama, 1968; Buffalo/Albright, 1968; Alpha Gallery, 1968; Reed College, 1969; Seattle/AM, 1969; Marlborough Gallery Inc., NYC, 1970, 75; U. of Maryland, 1970; West Palm Beach/Norton, 1970; Fort Lauderdale, 1971; U. of Miami, 1971; Galeria Carl van der Voort, Ibiza, 1972; Darthea Speyer Gallery, 1972; Galerie Numaga, Auvernier, Switzerland, 1973; Galeria Inguanzo, Madrid, 1973; Marlborough Galerie AG, Zurich, 1974; Marlborough Godard Ltd., Toronto, 1975. **Retrospective:** WMAA, 1967. **Group:** Ninth Street Exhibition, NYC, 1951; WMAA Annuals; Chicago/AI; U. of Illinois; U. of Nebraska; Carnegie; Venice Biennial; Yale U.; Corcoran; Arts Club of Chicago; Rome-New York Foundation, Rome; Boston Arts Festival; Minneapolis/Institute; PAFA; Montreal/MFA; Brussels World's Fair, 1958; Documenta II, Kassel, 1959; American Painting and Sculpture, Moscow, 1959; Sao Paulo Biennial; Seattle World's Fair, 1962; A.F.A., 1967-68; MOMA, The New American Painting and Sculpture, 1969. **Collections:** U. of Alabama; Allentown/AM; Brandeis U.; Buffalo/Albright; Carnegie; Chase Manhattan Bank; Chicago/AI; Cleveland/MA; Colby College; Columbia Broadcasting System; Detroit/Institute; Hartford/Wadsworth; Harvard U.; High Museum; Houston/MFA; Indianapolis/Herron; International Minerals & Chemicals Corp.; Los Angeles/County MA; MMA; MOMA; U. of Michigan; Minneapolis/Institute; Minnesota/MA; NCFA; U. of Nebraska; PAFA; U. of Rochester; SFMA; SRGM; Seattle/AM; The Singer Company Inc.; Union Carbide Corp.; Utica; WMAA; Waitsfield/Bundy; Walker; Washington U.; Yale U. **Bibliography:** Agee; Arnason 1; Chaet;

Goodrich and Baur 1; Henning; Hunter, ed.; Janis and Blesh 1; *Metro;* Nordness, ed.; Rodman 3; Rose, B. 1; Seitz 3; **Tyler, P. 2.**

MARCUS, MARCIA. b. January 11, 1928, NYC. **Studied:** NYU, 1943-47, BFA; Cooper Union, 1950-52; ASL, 1954, with Edwin Dickinson. Traveled Europe. **Taught:** Purdue U.; Moore Institute of Art, Science and Industry; RISD; Cooper Union, 1970-71; Louisiana State U., 1972; NYU, 1972; Vassar College, 1973-74; Cornell U., 1975. **Awards:** Ingram Merrill Grant, 1964; NIAL, Richard and Hinda Rosenthal Foundation Award, 1964; Ford Foundation Grant, 1966. **Address:** 80 North Moore Street, NYC 10013. **Dealer:** ACA Gallery. **One-man Exhibitions:** (first) March Gallery, NYC, 1957; Delancey Street Museum, NYC, 1960; Cober Gallery, 1961; The Alan Gallery, NYC, 1962; RISD, 1966; The Graham Gallery, 1966; Tirca Karlis Gallery, 1966, 67; The Zabriskie Gallery, 1970; Makler Gallery, 1972; Louisiana State U., 1972; Vassar College, 1974; ACA Gallery, 1974. **Group:** WMAA, Young America, 1960; WMAA Annual, 1963; NIAL, 1964; MOMA, Contemporary Portraits, circ.; New York Cultural Center, Women Choose Women, 1973; PMA/Museum of the Philadelphia Civic Center, Focus, 1974. **Collections:** Hirshhorn; NIAL; Newark Museum; Purchase/SUNY; RISD; WMAA. **Bibliography:** *Art: A Woman's Sensibility.* Archives.

MARDEN, BRICE. b. October 15, 1938, Bronxville, N.Y. **Studied:** Boston U., 1958-61, BFA; Yale U. Summer School, Norfolk, Conn., 1961; Yale U., 1961-63, MFA. Traveled: USA, France, Greece. **Taught:** School of Visual Arts, NYC, 1969-74. **Address:** 105 Bowery, NYC 10002. **Dealers:** Locksley-Shea Gallery; Konrad Fischer Gallery, Dusseldorf; Gian Enzo Sperone, NYC, Rome, Turin;

Brice Marden *Painting Study #1* 1974

The Texas Gallery. **One-man Exhibitions:** (first) Swarthmore College, 1964; Bykert Gallery, 1966, 68, 69, 70, 72, 73, 74; Yvon Lambert, 1969, 73; Françoise Lambert, Milan, 1970; Gian Enzo Sperone, Turin, 1971; U. of Utah, 1971; Locksley-Shea Gallery, 1972; Jack Glenn Gallery, Corona del Mar, 1973; Konrad Fischer Gallery, Dusseldorf, 1972, 73; John Berggruen Gallery (two-man), 1972; Cirrus Editions Ltd., 1974; Jared Sable Gallery, Toronto, 1974; SRGM, 1975. **Group:** New London, Drawings by New England Artists, 1960; U. of Illinois, 1967; Ithaca College, Drawings 1967, 1967; ICA, U. of Pennsylvania, A Romantic Minimalism, 1967; WMAA Annuals, 1968, 73; Buffalo/Albright, Modular Painting, 1970; Foundation Maeght, L'Art Vivant, 1970; WMAA, The Structure of Color, 1971; U. of Utah, 1971; U. of Rochester, Aspects of Current Painting, 1971; Chicago/Contemporary, White on White, 1971-72; Indianapolis, 1972; U. of California, Berkeley, Eight New York Painters, 1972; Chicago/AI, 1972; Walker, Painting: New Options, 1972; Documenta V, Kassel, 1972; Yale U., Options and Alternatives, 1973; WMAA, American Drawings: 1963-1973, 1973; Seattle/AM, American Art: Third Quarter

Century, 1973; MOMA, Some Recent American Art, circ., 1973; Chicago/ Contemporary, Five Artists: A Logic of Vision, 1974; MOMA, Eight Contemporary Artists, 1974. **Bibliography:** *Contemporanea;* Licht, J.; Murdoch 1; *Options and Alternatives;* **Shearer.** Archives.

MARGO, BORIS. b. November 7, 1902, Wolotschisk, Russia. **Studied:** Polytechnik School, Odessa, 1919; Futemas, Moscow, 1924; Filonoy School, Leningrad, 1927. To USA 1930; citizen 1937. Traveled Western Europe, Israel 1968, Hawaii. **Taught:** Master Institute of United Arts, Inc., 1932; American U., 1946; U. of Michigan, 1957; Chicago Art Institute School, 1957; Michigan State U., 1959; U. of Illinois, 1960; U. of Minnesota, Duluth, 1962; U. of North Carolina, 1963; Ford Foundation/A.F.A. Artist-in-Residence, 1965; Syracuse U., 1966-67; The Ohio State U., 1968; Honolulu Academy, 1973; Potsdam/ SUNY, 1974; Fine Arts Work Center, Provincetown, Mass., 1974. **Member:** SAGA. Federal A.P.: Newark (N.J.) Airport (assisted Arshile Gorky on a mural). **Commissions:** Honolulu Academy (sculpture), 1973. **Awards:** Chicago/AI, Watson F. Blair Prize, 1947; Brooklyn Museum Print Exhibitions, 1947, 53, 55, 60, 64, 68; Portland, Me./MA, **P.P.,** 1960; National Endowment for the Arts Grant, 1974. **m.** Jan Gelb. **Address:** 749 West End Avenue, NYC 10025. **Dealers:** Betty Parsons Gallery; A.A.A. Gallery. **One-man Exhibitions:** (first) Artists' Gallery, NYC, 1939, also 1941, 42; Norlyst Gallery, NYC, 1943; Mortimer Brandt, NYC, 1946, 47; American U., 1946, 47; J. Seligmann and Co., 1947; Brooklyn Museum, 1947; Smithsonian, 1948; Betty Parsons Gallery, 1950, 53, 55, 57, 60; World House Galleries, NYC, 1964; Honolulu Academy, 1973. **Retrospectives:** Syracuse U., 1966; A.A.A. Gallery, NYC, 1967. **Group:** MMA, Artists for Victory, 1942; Mortimer Brandt, NYC, Abstract and Surrealist Art in the U.S., circ. Western museums, 1944;

NAD, 1946; Library of Congress, 1946; Carnegie, 1946, 52; WMAA Annuals, 1947-50, 1953-55; Chicago/AI, Abstract and Surrealist Art, 1948; U. of Illinois, 1950, 52; Chicago/AI, 1950, 54; I Sao Paulo Biennial, 1951; MOMA, XXVth Anniversary Exhibition, 1954; Federation of Modern Painters and Sculptors Annual, 1955; XXXV Venice Biennial, 1970; U. of Illinois, 1971. **Collections:** Albion College; Andover/Phillips; Baltimore/MA; Brooklyn Museum; Brown U.; Buffalo/Albright; Chase Manhattan Bank; Chicago/AI; Cincinnati/AM; Corcoran; Cornell U.; Currier; Dartmouth College; Evansville; U. of Georgia; U. of Illinois; Kalamazoo/Institute; Los Angeles/County MA; Louisville/ Speed; MIT; MMA; MOMA; U. of Maine; U. of Michigan; U. of Minnesota; NYPL; National Gallery; New Orleans/ Delgado; U. of North Carolina; The Ohio State U.; Omaha/Joslyn; PMA; Phoenix; RISD; SFMA; San Jose State College; Sao Paulo; Slater; Syracuse U.; Utica; WMAA; Yale U. **Bibliography:** Baur 5, 7; Blesh 1; Hayter 1; Janis, S.; Peterdi; Pousette-Dart, ed.; Reese; **Schmeckebier 1.** Archives.

MARIN, JOHN. b. December 3, 1870, Rutherford, N.J.; **d.** October 1, 1953, Cape Split, Me. **Studied:** Hoboken Academy; Stevens Preparatory School; Stevens Institute of Technology; PAFA, 1899-1901, with Thomas Anshutz, Henry Breckenridge; ASL, 1901-03, with Frank V. DuMond. Worked as a freelance architect. Traveled Europe, 1905-11. **Member:** AAAL, 1945. **Awards:** Philadelphia Watercolor Club, 1940; American Institute of Architects, 1948; U. of Maine, Hon. DFA, 1940; MMA, 1952; PAFA, Joseph E. Temple Gold Medal, 1954; Yale U., Hon. DFA. **One-man Exhibitions:** (first) Photo-Secession, NYC, 1909, also 1910, 13, 15; Brooklyn Museum, 1922; Montross Gallery, NYC, 1922, 24; Stieglitz's Intimate Gallery, NYC, 1925, 28; An American Place (Gallery), NYC, 1929-35, 1937-42, 1944-50; Cleveland/MA, 1939; The Downtown Gallery, 1939, 48;

1950-54, 1963; ICA, Boston, 1947; de Young, 1949; XXV Venice Biennial, 1950; A.F.A., 1952-54; Detroit/Institute, 1954; Philadelphia Art Alliance, 1954; The Willard Gallery, 1965; La Jolla, 1966; M. Knoedler & Co., 1967; U. of Utah, 1969; PMA, 1969; Los Angeles/County MA, 1970; Marlborough Gallery Inc., NYC, 1972. **Retrospectives:** The Daniel Gallery, NYC, 1920; MOMA, 1936; Trenton/State, 1950; U. of Michigan, 1951; Houston/MFA, 1953; AAAL, 1954; UCLA, 1955. **Group:** Salon d'Automne, Paris, 1908; Salon des Artistes Independants, Paris, 1904; The Armory Show, 1913; WMAA; MOMA; Chicago/AI; Detroit/Institute; Cleveland/MA; Walker; Cincinnati/AM; SFMA; Toronto; Dallas/MFA; Utica; Corcoran; MMA. **Collections:** Andover/Phillips; Arizona State U.; Auburn U.; Baltimore/MA; Brooklyn Museum; Buffalo/Albright; Chicago/AI; Cleveland/MA; Colorado Springs/FA; Columbus; Cranbrook; Denver/AM; Des Moines; Detroit/Institute; Fisk U.; U. of Georgia; Hagerstown/County MFA; Hartford/Wadsworth; Harvard U.; Houston/MFA; IBM; Indiana U.; Indianapolis/Herron; Lane Foundation; MMA; MOMA; U. of Maine; The Miller Co.; National Gallery; U. of Nebraska; Newark Museum; New Britain; Ogunquit; Omaha/Joslyn; PAFA; Phillips; U. of Rochester; Roswell; SFMA; St. Louis/City; San Antonio/McNay; San Diego; Santa Barbara/MA; Springfield, Mo./AM; Utica; WMAA; Walker; Wellesley College; West Palm Beach/Norton; Wichita/AM; Wilmington; Yale U.; Youngstown/Butler. **Bibliography:** American Artists Group Inc. 3; *Avant-Garde Painting and Sculpture*; Baldinger; Barker 1; Barr 3; Baur 5, 7; Bazin; Beekman; **Benson**; Bethers; Biddle 4; Blesh 1; Born; Brown; Bryant, L.; Cahill and Barr, eds.; Canaday; Cassou; Cheney; Chipp; Christensen; Coke 2; Craven, T. 1; *8 American Masters of Watercolor*; Eliot; Elsen 2; Flanagan; Flexner; Flockhart; *Forerunners*; Frank, ed.; Frost; Gallatin 1; Gaunt; Gerdts; Goldwater and Treves, eds.; Goodrich 1; Goodrich and Baur 1; Haas;

Haftman; Hartmann; **Helm; Helm and Wight**; Hess, T. B. 1; Hunter 6; Huyghe; *Index of 20th Century Artists*; Janis, S.; Jewell 2; Kootz 1, 2; Kuh 1, 3; Lane; Langui, Lee and Burchwood; Leepa; Mather 1; **McBride**; McCoubrey 1; McCurdy, ed.; Mellquist; Mendelowitz; Munsterberg; Neuhaus; Newmeyer; **Norman; Norman, ed.**; Pach 1; Pearson 2; Phillips 1, 2; Pousette-Dart, ed.; Raynal 3, 4; Read 2; Richardson, E. P.; Ritchie 1; Rodman 2; Rose, B. 1, 4; Rosenblum 1; Rubin 1; Sachs; **Seligmann, ed.**; Soby 5, 6; Sutton; Tashjian; Tomkins and Time-Life Books; Valentine 2, Wight 2, Wright 1; Zigrosser 1. Archives.

MARISOL (Escobar). b. May 22, 1930, Paris, France. **Studied:** ASL, 1950, with Yasuo Kuniyoshi; Hofmann School, 1951-54; Academie des Beaux-Arts, Paris, 1949; New School for Social Research, 1951-54. Traveled Venezuela, USA, Europe. **Awards:** Academy of Achievement, San Diego. **Address:** c/o Dealer. **Dealer:** Sidney Janis Gallery. **One-man Exhibitions:** (first) Leo Castelli Inc. NYC, 1957; The Stable Gallery, NYC, 1962, 64; Arts Club of Chicago, 1965; Sidney Janis Gallery, 1966, 67, 73, 75; Hanover Gallery, 1967; XXIV Venice Biennial, 1968; Moore College of Art, Philadelphia, 1970; Worcester/AM, 1971; New York Cultural Center, 1973; Ohio U., 1974; Estudio Actual, Caracas, 1974. **Group:** Festival of Two Worlds, Spoleto, 1958; Dallas/MFA, Humor in Art, 1958; Chicago/AI, Pan American Art, 1959; Carnegie, 1959, 64, 67; U. of Illinois, 1961; MOMA, The Art of Assemblage, circ., 1961; A.F.A., Wit and Whimsey in 20th Century Art, circ., 1962-63; WMAA Annuals, 1962, 64, 66; MOMA, Americans 1963, circ., 1963-64; Chicago/AI, 1963, 66, 68; Tate, Painting and Sculpture of a Decade, 1954-64, 1964; The Hague, New Realism, 1964; WMAA, Art of the U.S. 1670-1966, 1966; II Internationale der Zeichnung, Darmstadt, 1967; Los Angeles/County MA, American Sculpture of the Sixties, 1967; Houston Festival of Arts, 1967; ICA,

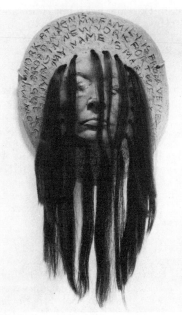

Marisol *Veil* 1975

London, 1968; MOMA, circ., 1968-70; Finch College, NYC, The Dominant Woman, 1968; Chicago/AI, 1969; Hayward Gallery, London, Pop Art, 1969; Carnegie, 1970; Foundation Maeght, 1970; Skidmore College, Contemporary Women Artists, 1970; Potsdam/SUNY, Contemporary Women Artists, 1972; Baltimore/MA, Drawing Exhibition, 1973. **Collections:** Arts Club of Chicago; Brandeis U.; Buffalo/Albright; MOMA; WMAA. **Bibliography:** Bihalji-Merin; Calas, N. and E.; Craven, W.; Hunter, ed.; Lippard 5; **Medina**; Nemser; Seitz 3; Seuphor 3; Trier 1; Tuchman 1; Weller. Archives.

MARKMAN, RONALD. b. 1931, Bronx, N.Y. **Studied:** Yale U., BFA, 1957, MFA, 1959. **Taught:** U. of Florida, 1959; Chicago/AI, 1960-64; Indiana U., 1964- . **Awards:** Fulbright Fellowship, 1962. **Address:** 719 South Jordan, Bloomington, Ind. 47401. **Dealer:** Terry Dintenfass,

Inc. **One-man Exhibitions:** Terry Dintenfass, Inc., 1965, 66, 68, 71, 72; Reed College, 1966; U. of Manitoba, 1972. **Group:** Boston Arts Festival, 1959, 60; WMAA, Young America, 1960; Chicago/AI, 1964; Ball State U., 1966; PAFA Annual, 1967; Anderson (Ind.) Fine Arts Center, 1967; Brooklyn Museum, Print Biennial; Indianapolis/Herron, 1968, 69; New School for Social Research, Humor, Satire, and Irony, 1972; Indianapolis, 1972, 74; Harvard U., Work by Students of Josef Albers, 1974. **Collections:** U. of Arkansas; Brooklyn Museum; Chicago/AI; Hirshhorn; MMA; MOMA; Worcester/AM.

MARSH, REGINALD. b. March 14, 1898, Paris France; **d.** July 3, 1954, Dorset, Vt. **Studied:** The Lawrenceville School, 1915-16; Yale U., 1916-20, AB; ASL, 1919, 1920-24, 1927-28, with John Sloan, Kenneth Hayes Miller, George Bridgeman, George Luks. Traveled Europe extensively. Artist War Correspondent for *Life* Magazine, 1943. **Taught:** ASL; Moore Institute of Art, Science and Industry, Philadelphia, 1953-54. **Commissions:** US Post Office, Washington, D.C., 1937; US Customs House, NYC, 1937. **Awards:** Chicago/AI, The M. V. Kohnstamm Prize, 1931; Wanamaker Prize, 1934; NAD, The Thomas B. Clarke Prize, 1937; Limited Editions Club, 1938; Chicago/AI, Watson F. Blair Prize, 1940; PAFA, Dana Watercolor Medal, 1941; NAD, 1943; Corcoran, First William A. Clark Prize, 1945; Salmagundi Club, NYC, T. J. Watson Prize, 1945; NIAL, 1946; NIAL, Gold Medal for Graphics, 1954. **One-man Exhibitions:** (first) Whitney Studio Club, NYC, 1924, also 1928; Curt Valentine Gallery, NYC, 1927; Weyhe Gallery, 1928; Marie Sterner Gallery, NYC, 1929; Rehn Galleries, 1930-34, 36, 38, 40, 41, 43, 44, 46, 48, 50, 53, 62, 64, 65, 70, 73; Yale U., 1937; Andover/Phillips, 1937; McDonald Gallery, NYC, 1939; Carnegie, 1946; Print Club of Cleveland, 1948 (two-man); Philadelphia Art Alliance, 1950; Martha Jackson Gallery, 1953; Steeplechase Park, Co-

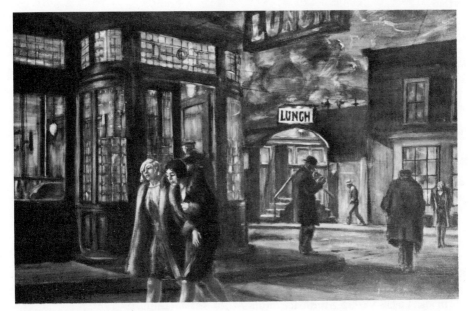

Reginald Marsh *Lunch* 1927

ney Island, NYC, 1953; Moravian College, 1954; Kennedy Gallery, 1964; Danenberg Gallery, 1969, 71; U. of Arizona, 1969; City Center Gallery, NYC, 1969. **Retrospectives:** Gallery of Modern Art, NYC, 1964; Newport Harbor, 1972. **Group:** WMAA; MMA; MOMA; Corcoran; Carnegie. **Collections:** Andover/Phillips; Boston/ MFA; Chicago/AI; Hartford/Wadsworth; MMA; U. of Nebraska; PAFA; Springfield, Mass./MFA; WMAA. **Bibliography:** American Artists Group Inc. 1,3; Baigell 1; Barker 1; Baur 7; Bazin; Boswell 1; Brown; Bruce and Watson; Cahill and Barr, eds.; Canaday; Cheney; Christensen; Craven, T. 2; Eliot; Flanagan; Flexner; Gerdts; **Goodrich** 1, **11**; Goodrich and Baur 1; Hall; Hunter 6; Kent, N.; Kuh 1; **Marsh;** McCoubrey 1; McCurdy, ed.; Mellquist; Mendelowitz; Newmeyer; Nordmark; Pagano; Pearson 1; Reese; Richardson, E. P.; Ringel, ed.; Rose, B. 1, 4; **Sasowsky;** Soyer, R. 1; Sutton. Wight 2. Archives.

MARSICANO, NICHOLAS. b. October 1, 1914, Shenandoah, Pa. **Studied:**

PAFA and Barnes Foundation, 1931-34; abroad, 2933-36. Traveled Europe, North Africa, Mexico, USA. **Taught:** Cooper Union, 1948- ; U. of Michigan, summer, 1950; Yale U., summers, 1951-54; Brooklyn Museum School, 1951-58; Pratt Institute, 1957-60; Cornell U., summer, 1959; Silvermine College of Fine Arts, 1965-69; Davenport/Municipal, summer, 1972. **Awards:** PAFA, Cresson Fellowship, and Barnes Foundation Scholarship, 1933-36; V Hallmark International Competition, Second Prize, 1960; Guggenheim Foundation Fellowship, 1974. **Address:** 42 West 15 Street, NYC 10011. **Dealer:** A. M. Sachs Gallery. **One-man Exhibitions:** The Salpeter Gallery, NYC, 1948; The Bertha Schaefer Gallery, 1957, 59, 60, 61; San Joaquin Pioneer Museum and Haggin Art Galleries, Stockton, Calif., 1959; Stewart Richard Gallery, San Antonio, 1959; The Howard Wise Gallery, NYC, 1963; Des Moines, 1963, 64; Huntington, W. Va., 1967; A. M. Sachs Gallery, 1971, 72, 73; Davenport/Municipal, 1972. **Group:** U. of Nebraska, 1954, 58, 60; Walker, Vanguard,

1955; II Inter-American Paintings and Prints Biennial, Mexico City, 1960; A.F.A., The Figure, circ., 1960; WMAA Annuals, 1960-62; Chicago/AI, 1961, 64; Dallas/MFA, 1961, 62; MOMA, Abstract American Drawings and Watercolors, circ. Latin America, 1961-63; PAFA, 1962, 64; MOMA, Recent Painting USA: The Figure, circ., 1962-63; U. of Kentucky, 1963; U. of Texas, 1968; MOMA, The New American Painting and Sculpture, 1969. **Collections:** Baltimore/MA; Chicago/AI; Ciba-Geigy Corp.; Dallas/MFA; Davenport/Municipal; Des Moines; Hallmark Collection; Housatonic Community College; Huntington, W. Va.; ICA, Boston; MIT; MOMA; U. of Massachusetts; NYU; U. of North Carolina; Ridgefield/Aldrich; SFMA; U. of Texas. Archives.

MARTIN, AGNES. b. 1912, Maklin, Canada. To USA 1932. **Studied:** Columbia U. Teachers College, 1941-42, 1951-52, with Arthur Young; Columbia U., MFA. **Taught:** Eastern Oregon College; U. of New Mexico. **Awards:** National Endowment for the Arts Grant, $5000, 1966. Did not paint 1967-74. **Address:** Cuba, N.M. 87013. **Dealer:** The Pace Gallery. **One-man Exhibitions:** Betty Parsons Gallery, 1958, 59, 61; Robert Elkon Gallery, 1961, 63, 66, 70, 72; Nicholas Wilder Gallery, 1966, 67, 73; Visual Arts Gallery, NYC, 1971; Kunstraum, Munich, 1973; Pasadena/AM, 1973; ICA, U. of Pennsylvania, 1973; MOMA, 1973; The Pace Gallery, 1975. **Group:** Carnegie, 1960; WMAA, Geometric Abstraction, 1962; Hartford/Wadsworth, Black, White, and Grey, 1964; SRGM, American Drawings, 1964, Systemic Painting, 1966; MOMA, The Responsive Eye, 1965; ICA, U. of Pennsylvania, A Romantic Minimalism, 1967; WMAA Annual, 1967; Detroit/Institute, Color, Image and Form, 1967; Corcoran, 1967; PMA, The Pure and Clear, 1968; Chicago/Contemporary, White on White, 1971-72; ICA, U. of Pennsylvania, Grids, 1972; Documenta V, Kassel, 1972; WMAA (downtown), Nine Artists/Coenties Slip,

1974. **Collections:** Amsterdam/Stedelijk; Hartford/Wadsworth; Jerusalem/National; Los Angeles/County MA; MOMA; Ridgefield/Aldrich; SRGM; WMAA. **Bibliography:** *Options and Alternatives.*

MARTIN, FLETCHER. b. April 29, 1904, Palisade, Colo. Self-taught in art. **Taught:** State U. of Iowa, 1940; Kansas City Art Institute and School of Design, 1941-42; ASL, 1948-67; U. of Florida, 1949-52; Mills College, 1951; U. of Minnesota, 1954; San Antonio Art Institute, 1957; Los Angeles/County MA, 1958-59; Washington State U., 1960-61. Artist War Correspondent for *Life* Magazine, 1943. Federal A.P.: Mural painting, 1936-37. Traveled USA, Mexico, Europe, North Africa, Australia. **Member:** Woodstock Artists Association; NAD. **Commissions:** US Bureau of Reclamation, 1971-73; National Aeronautics & Space Administration, 1975. **Awards:** PAFA, Walter Lippincott Prize, 1947; NAD, Benjamin Altman Prize, 1949; Ford Foundation/A.F.A. Artist-in-Residence Grant, 1964. **Address:** Apartado 73, Guanajuato, Gto. Mexico. **Dealers:** Loring Gallery; Rudolph Gallery. **One-man Exhibitions:** San Diego, 1934; Jake Zeitlin Gallery, Los Angeles, 1939; The Midtown Galleries, 1940, 43; A.A.A. Gallery, NYC, 1948; John Heller Gallery, NYC, 1955, 57. **Retrospective:** U. of Minnesota, 1954; Roberson Center for the Arts & Sciences, Binghamton, N.Y., 1968. **Group:** MOMA, Americans 1942, circ., 1942; U. of Minnesota; Venice Biennial. **Collections:** Abbott Laboratories; Albany/Institute; Andover/Phillips; Brandeis U.; Britannica; Carleton College; Clearwater/Gulf Coast; Cranbrook; Davenport/Municipal; Denver/AM; Houston/MFA; Huntington, W. Va.; IBM; State U. of Iowa; Kansas City/Nelson; Library of Congress; Los Angeles County Fair Association; Los Angeles/County MA; MMA; MOMA; U. of Maine; U. of Miami; U. of Minnesota; PAFA; Roswell; SFMA; WMAA; Witte; Youngstown/Butler. **Bibliography:** American

Artists Group Inc. 2; Baur 7; **Ebersole; Kent, N.**; Miller, ed. 1; Zaidenberg, ed.

MARTIN, FRED. b. June 13, 1927, San Francisco, Calif. **Studied:** U. of California (with James McCray, Glenn Wessels), BA, 1949, MA, 1954; California School of Fine Arts (with David Park, Clyfford Still, Mark Rothko), 1949-50. **Taught:** Oakland/AM, 1954-56; San Francisco Art Institute, 1958- ; Director, 1965- . **Awards:** National Council on the Arts Fellowship, 1971. **Address:** 232 Monte Vista, Oakland, Calif. 94611. **Dealer:** Hansen-Fuller Gallery. **One-man Exhibitions:** (first) Contemporary Gallery, Sausalito, Calif., 1949; Lucien Labaudt Gallery, San Francisco, 1950; Zoé Dusanne Gallery, Seattle, 1952; de Young, 1954, 64; 6, 7-6 Gallery, San Francisco, 1955; Oakland/AM, 1958; SFMA, 1958; Spasta Gallery, San Francisco, 1959; Dilexi Gallery, San Francisco, 1961, 66, 68; Cain Gallery, Aspen, Colo., 1962; Minami Gallery, 1963; The Lanyon Gallery, 1964; Royal Marks Gallery, 1965, 66, 68, 70; RAC, 1969; Berkeley Gallery, San Francisco, 1970, 71; SFAI, 1972; SFMA, 1973. **Group:** de Young; California Palace; SFMA, Bay Area 1945-1962, 1968; WMAA Annual, 1969, Extraordinary Realities, 1973. **Collections:** Achenbach Foundation; Oakland/AM; Pasadena/AM; RAC; SFMA; WMAA. **Bibliography:** *Art as a Muscular Principle*.

MARTIN, KNOX. b. 1923, Barranquilla, Colombia. **Studied:** ASL. US Navy, three years. **Taught:** Yale U., 1965-71; ASL, 1972- ; U. of Minnesota, 1972. **Address:** 128 Fort Washington Avenue, NYC. **One-man Exhibitions:** Charles Egan Gallery, 1954, 61; Avant Garde Gallery, NYC, 1956; Holland-Goldowsky Gallery, Chicago, 1958; Rose Fried Gallery, 1963; Fischbach Gallery, 1964, 66; Galeria Bonino Ltd., 1972, 74; Ingber Art Gallery, 1974; IKI, Dusseldorf, 1974; National Arts Club, NYC, 1975; Gallery G., Wichita, 1975. **Group:** WGMA, 1963; Chicago/AI,

1963; Baltimore/MA, 1963; Buffalo/Albright, 1963; WMAA, 1972; Bradford, England, British Print Biennial, 1974. **Collections:** Austin; U. of California, Berkeley; Corcoran; U. of Illinois; MOMA; NYU; WMAA.

MARTINELLI, EZIO. b. November 27, 1913, West Hoboken, N.J. **Studied:** Academy of Fine Arts, Bologne, Italy, 1931; NAD, 1932-36, with Leon Kroll, Gifford Beal, Robert Aitken (sculpture), Ivan Olinsky. Traveled France, Italy. **Taught:** Pennsylvania School of Industrial Art, Philadelphia, 1946-49; Philadelphia Museum School, 1946-49; Sarah Lawrence College, 1947- ; Parsons School of Design, 1953- ; American Academy, Rome, Artist-in-Residence, 1964-65 (appointed Trustee, 1966). Painted only until 1952; began sculpture in 1938. Federal A.P.: Teacher, NYC; easel painter and unit supervisor, 1937-41. **Commissions:** United Nations General Assembly Building, NYC (30-ft. sculpture); Joint Industries Board, 1964 (bronze); Revere Aluminum Co., 1966 (aluminum). **Awards:** L. C. Tiffany Grant, 1936, 64; Guggenheim Foundation Fellowship, 1958, 62; NAD, President's Award; Ford Foundation, **P.P.**, 1963; appointed to the Jury of Selection, John Simon Guggenheim Memorial Foundation, 1963; Ford Foundation/A.F.A. Artist-in-Residence, Sarasota, 1964; NIAL, 1966. **Address:** 11 Jane Street, Saugerties, N.Y. 12477. **One-man Exhibitions:** Philip Ragan Gallery, Philadelphia, 1943; The Willard Gallery, 1946, 47, 52, 55, 64, 66; Seattle/AM; U. of Minnesota; Chicago/AI; Benson Gallery, 1968. **Group:** Art of This Century, 1942-44; PAFA, 1944, 58, 64, 67; Brooklyn Museum, 1947; Chicago/AI, Abstract and Surrealist Art, 1948; WMAA Annuals, 1948, 61, 62, 66; Chicago/AI, Drawings, 1952; Contemporary American Drawings, circ. France, 1954; Walker, Expressionism, 1900-1955, 1956; A.F.A., Major Work in Minor Scale, circ., 1957; USIA, Eight American Artists, circ. Europe and Asia, 1957-58; VMFA, American Sculpture

Today, 1958; Carnegie, 1959; NIAL, 1959, 66; WMAA, Business Buys American Art, 1960; Claude Bernard, Paris, Aspects of American Sculpture, 1960; Newark Museum, Survey of American Sculpture, 1962; Gallery of Modern Art, NYC, 1965; Lincoln, Mass./De Cordova, 1965; U. of St. Thomas (Tex.) 1966. **Collections:** Brooklyn Museum; Chicago/AI; U. of Illinois; Memphis/Brooks; Newark Museum; PMA; SRGM; Seattle/AM; United Nations; WMAA; U. of Wisconsin. **Bibliography:** Seuphor 3.

MARYAN. b. January 1, 1927, Poland. **Studied:** Bezalel Art School; l'Ecole National Superieure des Beaux-Arts, Paris, 1951-53. Traveled Israel, Europe, USA; resided Paris, 1950-62. **Awards:** Prix des Critiques d'Art a Paris, 1959. **Address:** 301 East 63 Street, NYC 10021. **Dealer:** Allan Frumkin Gallery, NYC. **One-man Exhibitions:** (first) Jerusalem, Israel, 1949; Galerie Breteau, Paris, 1952; Galerie Le Miroir, Brussels, 1954; Tourcoing, 1956; Galerie Rive Gauche, Paris (two-man), 1957; Galerie de France, Paris, 1958, 60, 65; Galerie Kunstnernes Kunsthandel, Copenhagen, 1959; Andre Emmerich Gallery, 1960; Allan Frumkin Gallery, NYC, 1963-66, 68, 69, Chicago, 1963-66, 70; Galleria Juana Mordo, 1964; David Stuart Gallery, 1964; Galerie D. Benador, Geneva, 1966; Galerie Van de Loo, Munich, 1966; Galerie Nova Spectra, The Hague, 1966, 71; Claude Bernard, Paris, 1966, 70; Galeria Sen, Madrid, 1970; Galerie Nord, Lille, 1970; Eindhoven, 1970; Galerie Nicholas, Amsterdam, 1971, 73; Galeria d'Arte la Bussola, Turin, 1971; Galerie Espace, Amsterdam, 1973, 74. **Retrospective:** Galerie de France, Paris, 1974. **Group:** Salon des Surindependants, Paris, 1952, 53; Salon du Mai, Paris, 1953-65; Festival de l'Art d'Avant-Garde, Marseille, 1956; Paris Biennial, Musee de Nantes, 1958; Festival de Bayreuth, 1958; Walker, 1959; XXX Venice Biennial, 1960; Carnegie, 1961, 64, 67; SFMA, Directions—Painting U.S.A., 1963; Torcuato di Tella, Buenos Aires, 1963; Ghent, The Human Figure since Picasso, 1964; The Hague, New Realism, 1964; Chicago/AI, 1964; Paris/Moderne, 1965; PAFA Annual, 1965; Foundation Maeght, 1967; U. of Colorado, 1967; MOMA, 1969; SRGM, 10 Independents, 1972. **Collections:** Carnegie; Chicago/AI; Le Havre/Municipal; MOMA; Museum des 20. Jahrhunderts; Paris/Moderne; Tourcoing.

MASON, ALICE TRUMBULL. b. November 16, 1904, Litchfield, Conn.; **d.** June 28, 1971, NYC. **Studied :** British School, Rome, 1922; NAD, 1923; privately with C. W. Hawthorne, 1924, and Arshile Gorky, 1926. Traveled Italy and around the world, 1920. **Member:** American Abstract Artists; Federation of Modern Painters and Sculptors; SAGA; American Color Print Society. **Awards:** The Print Club, Philadelphia, Charles M. Lea Prize, 1945; Longview Foundation Grant, 1963. **One-man Exhibitions:** (first) Museum of Living Art, NYC, 1948; Hansa Gallery, NYC, 1958; The XXth Century Gallery, NYC, 1967; Washburn Gallery, Inc., 1974. **Retrospectives:** Nassau Community College, Garden City, N.Y., 1967; WMAA, circ., 1974. **Group:** Federation

Alice T. Mason *The Beehive* 1950

of Modern Painters and Sculptors Annuals; A.A.A. Gallery, NYC, Annuals; PMA, "8 x 8," 1945; Brooklyn Museum, 1949. **Collections:** Brooklyn Museum; Free Library of Philadelphia; ICA, Washington, D.C.; Library of Congress; MMA; NYPL; PMA; The Pennsylvania State U.; WMAA. **Bibliography:** Reese. Archives.

MATULKA, JAN. b. November 7, 1890, Prague, Czechoslovakia; **d.** June 22, 1972, Queens, N.Y. **Studied:** NAD, with G. W. Maynard. Traveled Europe, USA. **Taught:** ASL, 1929, 31. Federal A.P.: Mural for a hospital in Brooklyn, N.Y. **Awards:** Pulitzer Scholarship for Painting. **One-man Exhibitions:** (first) Modern Gallery, NYC, 1927, also 1930; Rehn Galleries, 1928, 29, 31, 32, 33, 35, 56; Whitney Studio Club, NYC, 1929; The Zabriskie Gallery, 1965; SRGM; Columbia U.; Robert Schoelkopf Gallery, 1970, 72. **Group:** WMAA, 1944; MMA; Chicago/AI; Carnegie, 1944; U. of New Mexico, 1967. **Collections:** Brooklyn Museum; Chicago/AI; Cincinnati/AM; Detroit/Institute; Hirshhorn; MMA; PAFA; SFMA; SRGM; WMAA. **Bibliography:** *Avant-Garde Painting and Sculpture;* Blesh 1; Hunter 6; Janis, S.; Rose, B. 1. Archives.

MAYHEW, RICHARD. b. April 3, 1924, Amityville, N.Y. **Studied:** Brooklyn Museum School, with Edwin Dickinson, Reuben Tam. **Taught:** ASL, to 1969; Smith College, 1969-70; Pratt Institute; Hunter College. **Member:** NAD. **Awards:** John Hay Whitney Fellowship, 1958; Ingram Merrill Foundation Grant, 1960; L. C. Tiffany Grant, 1963; NAD, **P.P.,** 1964; NIAL Grant, 1966; NAD, Benjamin Altman Prize, 1970. **Address:** c/o Dealer. **Dealer:** The Midtown Galleries. **One-man Exhibitions:** The Morris Gallery, NYC, 1957; Washington Irving Gallery, NYC, 1958; Robert Isaacson Gallery, NYC, 1959, 61, 62; Durlacher Brothers, NYC, 1963, 66; The Contemporaries, NYC, 1967; The Midtown Galleries, 1969, 71, 73, 74. **Group:** NAD, 1955, 59; Brooklyn Society of Artists Annual, 1956; ART:

USA:58, NYC, 1958; Chicago/AI, 1961; Youngstown/Butler, 1961; Carnegie, 1961; Brooklyn Museum, 1961; WMAA Annuals; U. of Illinois, 1963. **Collections:** Brooklyn Museum; MMA; NAD; WMAA.

MAZUR, MICHAEL B. b. November 2, 1935, NYC. **Studied:** Amherst College, 1954-58, BA; Academy of Fine Arts, Florence, Italy, 1956-57; Yale U., with Gabor Peterdi, Rico Lebrun, Josef Albers, Jon Schueler, Bernard Chaet, Nicholas Carone, 1959-61, BFA, MFA; privately with Leonard Baskin (printmaking), 1956-58. **Taught:** Yale U., 1960-61, 1972; RISD, 1961-64; Yale U. Summer School, Norfolk, Conn., 1963; Brandeis U., 1965, 1972- ; Queens College, 1973; Brown U., 1974; U. of California, Santa Barbara, 1974, 75. **Commissions:** US Department of the Interior. **Awards:** Memphis/Brooks, **P.P.,** 1961, 62; Boston Printmakers, **P.P.,** 1962; L. C. Tiffany Grant, 1962; Guggenheim Foundation Fellowship, 1964; NIAL, 1964; Library of Congress, Pennell **P.P.;** SAGA, Second Prize; Tamarind Fellowship, 1968; NAD, 1974; Philadelphia Print Club, **P.P. Address:** 5 Walnut Avenue, Cambridge, Mass. 02140. **Dealers:** Terry Dintenfass, Inc.; Haslem Fine Arts, Inc.; Alpha Gallery. **One-man Exhibitions:** (first) The Kornblee Gallery, 1961, also 1962, 63, 65; The Gallery, Northampton, Mass., 1963; Boris Mirski Gallery, Boston, 1964; Silvermine Guild, 1964; Alpha Gallery, 1966, 68, 74; Juniata College, 1966; A.A.A. Gallery, NYC, 1968; Finch College, NYC, 1971; U. of Connecticut, 1972; Exeter, 1972; Kutztown State College, 1973; Goddard College, 1973; Cortland/SUNY (two-man), 1973; The Ohio State U., 1975. **Retrospectives:** Brandeis U., 1969; Colgate U., 1973. **Group:** USIA, 10 American Printmakers, circ. Europe; MOMA, 60 Modern Drawings, 1963, also 1965; Library of Congress; Seattle/AM; Kansas City/Nelson; Smith College; The Print Club, Philadelphia; Boston Arts Festival; WMAA Annual, 1967; PAFA, 1967, 69; ICA, Boston,

Boston Now; Boston/MFA, Prints of the Sixties; Salon du Mai, Paris, 1969; Museo de Arte Contemporaneo, Cali, Colombia, S.A., I & II Bienals Graficas; XXXV Venice Biennial, 1970; Pratt Graphics Center, NYC, Monotypes, 1972; Library of Congress, 1972, 73, 74; Cleveland/MA, 32 Realists, 1972; Omaha/Joslyn, A Sense of Place, 1973; MOMA, American Prints: 1913-1963, 1974-75. **Collections:** Andover/Phillips; Boston/MFA; Boston Public Library; Brandeis U.; Brooklyn Museum; Chicago/AI; Cincinnati/AM; Colgate U.; Cortland/SUNY; Delaware Art Museum; Fredonia/SUNY; Harvard U.; Kalamazoo/Institute; Library of Congress; MOMA; U. of Maine; U. of Massachusetts; Memphis/Brooks; Minneapolis/Institute; Montreal/MFA; The Ohio State U.; PMA; The Pennsylvania State U.; Portland, Ore./AM; Smith College; Toldeo/MA; USIA; WMAA; Wellesley College; Westminster Foundation; Yale U.

MC CHESNEY, ROBERT P. b. January 16, 1913, Marshall, Mo. **Studied:** Washington U., with Fred Conway; Otis Art Institute, Los Angeles. Resided Mexico, one year. **Taught:** California School of Fine Arts, 1949-51; Santa Rosa Junior College, 1957-58. Federal A.P.: Federal Building, Golden Gate International Exposition, San Francisco, 1939 (mural). **Commissions:** *SS Monterey* (wall decoration). **Awards:** San Francisco Municipal Art Commission, **P.P.**, 1950, 69; WMAA Annual, **P.P.**, 1955; SFMA, First Prize, 1960. **Address:** 2955 Sonoma Mountain Road, Petaluma, Calif. 94952. **One-man Exhibitions:** (first) Raymond and Raymond, Inc., San Francisco, 1944; Pat Wall Gallery, Monterey, 1946; Lucien Labaudt Gallery, San Francisco, 1947, 51; Murquis Gallery, Los Angeles, 1949; SFMA, 1949, 53, 57, 64; Daliel Gallery, Berkeley, 1950; Gump's Gallery, 1952, 53, 55; Myrtle Todes Gallery, Glencoe, Ill., 1958; Bolles Gallery, NYC, 1960, San Francisco, 1960, 61; Parsons Gallery, Los Angeles, 1960, 61; Marshall Art Gallery, Marshall, Calif., 1964; Twen-

tieth Century West Gallery, NYC, 1965; Triangle Art Gallery, 1966; San Francisco Theological Seminary, San Anselmo, Calif., 1966, 69; California State College, Sonoma, 1970; Both-Up Gallery, Berkeley, Calif., 1973, 74; Santa Rosa City Hall, Calif., 1974. **Retrospective:** Capricorn Asunder Gallery, San Francisco, 1974. **Group:** SFMA, 1945, 50, 53, 60; Phillips, 1947; de Young, 1947, 51, 53, 59, 60, 61; Chicago/AI Annuals, 1947, 54, 60, 61; Los Angeles/County MA, 1949; Sao Paulo, 1955; WMAA Annual, 1955; Corcoran, 1957; California Palace, 1962, 64; Oakland/AM, 1972; Reed College, 1973; UCLA, Extension Gallery, 1975. **Collections:** Chicago/AI; Oakland/AM; SFMA; San Francisco Municipal Art Commission; WMAA. **Bibliography:** McChesney. Archives.

MC CLELLAN, DOUGLAS EUGENE. b. October 10, 1921, Pasadena, Calif. **Studied:** Art Center School, Los Angeles; Colorado Springs Fine Arts Center, with Boardman Robinson, Jean Charlot; Claremont Graduate School, MFA. **Taught:** Chaffey College, 1950-59; Otis Art Institute, Los Angeles, 1959-61; Scripps College; U. of California, Santa Cruz. **Awards:** Los Angeles/County MA, **P.P.**, 1950, 53; National Orange Show, 1954. **Address:** c/o Art Department, U. of California, Santa Cruz, Calif. 95064. **One-man Exhibitions:** Felix Landau Gallery, 1953, 55, 57, 59; Pasadena/AM, 1954; U. of California, Riverside, 1955. **Group:** Library of Congress, 1948; SFMA, 1949, 52; Los Angeles/County MA, 1949, 50, 52, 54, 55; Los Angeles County Fair, 1949, 53; MMA, 1950; PAFA, 1953; Corcoran, 1953; Santa Barbara/MA, I Pacific Coast Biennial, 1955; Carnegie, 1955, 57; WMAA, 1957. **Collections:** Los Angeles/County MA; Los Angeles County Fair Association; Pasadena/AM.

MC CRACKEN, JOHN. b. December 9, 1934, Berkeley, Calif. **Studied:** California College of Arts and Crafts, 1962,

BFA, and 1962-65. **Taught:** U. of California, Irvine and Los Angeles, 1965-68; School of Visual Arts, NYC, 1968-69; Hunter College, 1971; U. of Nevada. **Address:** c/o Dealer. **Dealers:** Robert Elkon Gallery; Nicholas Wilder Gallery. **One-man Exhibitions:** Nicholas Wilder Gallery, 1965, 67, 68; Robert Elkon Gallery, 1966, 67, 68, 72, 73; Ileana Sonnabend Gallery, Paris, 1969, Toronto, 1969, NYC, 1970; ACE Gallery, Vancouver, 1970; Pomona College, 1971; U. of Nevada, 1974. **Group:** Barnsdall Park Municipal Art Gallery, Los Angeles, Los Angeles Sculpture, 1965; Jewish Museum, Primary Structure Sculptures, 1966; WMAA, 1966, 68, 70; Seattle/AM, Ten from Los Angeles, 1966; Los Angeles/County MA, Sculpture of the Sixties, circ., 1967; WGMA, A New Aesthetic, 1967; Paris/Moderne, 1967; Milwaukee, Directions 1: Options, circ., 1968; MOMA, The Art of the Real, 1968; ICA, U. of Pennsylvania, Between Object and Environment, 1969; Eindhoven, Kompas IV, 1969-70; Chicago/AI, 1970; Chicago/Contemporary, Permutations: Light & Color, 1970; MOMA, Ways of Looking, 1971; Documenta V, Kassel, 1972. **Collections:** Chicago/AI; Los Angeles/County MA; MOMA; Milwaukee; Pasadena/AM; SRGM; Toronto; WMAA. **Bibliography:** *Report; USA West Coast.*

MC FEE, HENRY LEE. b. April 14, 1886, St. Louis, Mo.; **d.** 1953, Claremont, Calif. **Studied:** Washington U. School of Fine Arts; ASL, Woodstock, N.Y., 1908, with Birge Harrison; Stevenson Art Center, Philadelphia. **Awards:** Carnegie, Hon. Men., 1923; Corcoran, Fourth William A. Clark Prize, 1928; Carnegie, First Hon. Men., 1930; VMFA, **P.P.,** 1935; PAFA, Joseph E. Temple Gold Medal, 1937; Los Angeles County Fair, **P.P.,** 1940, 49; Guggenheim Foundation Fellowship, 1941; NIAL, 1945; elected an Associate of the NAD, 1949. **One-man Exhibitions:** Rehn Galleries, 1927, 29, 33, 36, 50; Pasadena/AM, 1950. **Retrospective:** Scripps College, 1950. **Group:** Panama-Pacific Exposition, San Francisco, 1915; Detroit/Institute; Cleveland/MA; Anderson Galleries, NYC, Forum Exhibition, 1916; Carnegie, 1923-49; Corcoran, 1924, 26, 1928-44; PAFA; Chicago/AI; St. Louis/City; U. of New Mexico, Cubism: its impact in the USA, 1967. **Collections:** Brooklyn Museum; Buffalo/Albright; Carnegie; Cleveland/MA; Columbus; Corcoran; Detroit/Institute; Los Angeles County Fair Association; MMA; PMA; Phillips; St. Louis/City; Scripps College; Taft Museum; VMFA; WMAA. **Bibliography:** **Barker 2;** Baur 7; Brown; Cahill and Barr, eds.; Cheney; Hall; Hunter 6; Huyghe; *Index of 20th Century Artists;* Janis, S.; Kent, N.; Mellquist; Mendelowitz; **Millier 1;** Pearson 2; Poore; Pousette-Dart, ed.; Richardson, E. P.; Smith, S. C. K.; Watson, E. W. 2; Wright 1.

MC GARRELL, JAMES. b. February 22, 1930, Indianapolis, Ind. **Studied:** Indiana U., with Alton Pickens, Leo Steppat, AB; UCLA, with John Paul Jones, Gordon Nunes, MA; Skowhegan School; Academy of Fine Arts, Stuttgart. Traveled USA, Europe; resided Paris, 1964-65. **Taught:** Reed College, 1956-59; Indiana U., 1959- ; Skowhegan School, summers, 1964, 68. Foreign correspondent **member** of the Academie des Beaux-Arts de l'Institute de France, 1970. **Awards:** Fulbright Fellowship, 1955; Tamarind Fellow, 1962; NIAL Grant, 1963; Ford Foundation, **P.P.,** 1963, 64; J. S. Guggenheim Fellowship, 1964; National Council on the Arts, Sabbatical Grant to Artists Who Teach. **Address:** Polgeto, 06019 Umbertide, Italy; Department of Fine Art, Indiana U., Bloomington, Ind. 47401. **Dealer:** Allan Frumkin Gallery, NYC. **One-man Exhibitions:** (first) Frank Perls Gallery, 1955, also 1957, 58, 62, 64; Portland, Ore./AM, 1959, 62; Indiana U., 1960, 63; Allan Frumkin Gallery, Chicago, 1960, 62, 65, 67, 71, NYC, 1961, 64, 66, 69, 71, 73; Salt Lake Art Center, Salt Lake City, 1962; Gallery 288, St. Louis, 1963; U. of Florida, 1964; Galleria Galatea, Turin, 1965, 66, 68; Pittsfield/

Berkshire, 1966; Tragos Gallery, Boston, 1967; Il Fante di Spada, Rome, 1967, 71; Claude Bernard, Paris, 1967, 68, 74; Galleria dei Lanzi, Milan, 1970, 72; Utah, 1972. **Group:** WMAA Annuals, 1957, 59, 60, 67; MOMA, New Images of Man, 1959; U. of Illinois, 1959, 61, 63; Carnegie, 1959, 64; III International Biennial Exhibition of Prints, Tokyo, 1962; WMAA, Fifty California Artists, 1962-63; Chicago/AI Annual, 1963; Tate, Dunn International, 1964; Documenta III, Kassel, 1964; PAFA, 1964; U. of Kentucky, 1966, Graphics 1968, 1968; XXXIV Venice Biennial, 1968; SFMA, 1968; Smithsonian, 1969; Indiana U., American Scene: 1900-1970, 1970; Le Centre Culturel Americain, Paris (four-man), 1971; Kansas City/AI, Narrative Painting, 1972; Dayton/AI, Eight American Painters, 1972; Galleria Comunale d'Arte Contemporanea, Una Tendenza Americana, 1973; MOMA, American Prints: 1913-1963, 1974-75. **Collections:** Baltimore/MA; Brooklyn Museum; Chicago/AI; Hamburg; Hirshhorn; Indiana U.; Kansas City/ Nelson; MOMA; U. of Massachusetts; National Gallery; U. of Nebraska; U. of Oregon; PAFA; Paris/Moderne; Portland, Ore./AM; Reed College; SFMA; Santa Barbara/MA; U. of Texas; Utah; WMAA.

MC LAUGHLIN, JOHN. b. May 21, 1898, Sharon, Mass. **Studied:** Roxbury Latin School; Andover/Phillips; self-taught in art. US Army Intelligence, 1941-45. Traveled the Orient, resided Japan for many years beginning 1935. Began to paint 1938. **Awards:** Tamarind Fellowship, 1963; Corcoran Biennial, Bronze Medal, 1967; National Council on the Arts, Visual Arts Award, 1967. **Address:** Box 840, Dana Point, Calif. 92629. **Dealers:** Andre Emmerich Gallery, NYC; Nicholas Wilder Gallery. **One-man Exhibitions:** Felix Landau Gallery, 1953, 58, 62, 63, 66; U. of California, Riverside, 1958; Long Beach/MA, 1960; K. Kazimir Gallery, Chicago, 1964; Occidental College, 1968; The Landau-Alan Gallery, NYC,

1968; U. of California, Irvine, 1971; Nicholas Wilder Gallery, 1972; Andre Emmerich Gallery, NYC, 1972; Corcoran and Corcoran, Coral Gables, 1973; La Jolla, 1973. **Retrospectives:** Pasadena/ AM, 1956, 63; Corcoran, 1968; WMAA, 1974. **Group:** Los Angeles/ County MA Annuals, 1949, 50, 54-60; California State Fair, 1950; Los Angeles/County MA, Contemporary Painting in the United States, 1951; Sao Paulo, 1955; SFMA, Art in the Twentieth Century, 1955; Corcoran, 1955; Long Beach/MA, Fifteen Americans, circ., 1956; Walker, 1956; Houston/ MFA, The Sphere of Mondrian, 1957; VMFA, American Painting, 1958; U. of Nebraska, 1958; Denver/AM, 1958; Los Angeles/County MA, Four Abstract Classicists, circ., 1959-61; ICA, London, 1960; A.F.A., Purist Painting, circ., 1960-61; SFMA, Fifty California Artists, circ., 1962; WMAA, Geometric Abstraction in America, circ., 1962; Chicago/AI, 1964; MOMA, The Responsive Eye, 1965; Corcoran, 1967; Pasadena/AM, West Coast: 1945-1969, 1969; Hayward Gallery, London, 11 Los Angeles Artists, 1971. **Collections:** Amherst College; Andover/Phillips; Bowdoin College; U. of California; Corcoran; Hartford/Wadsworth; Long Beach/MA; Los Angeles/County MA; MIT; MMA; MOMA; NCFA; U. of New Mexico; Oakland/AM; Pasadena/AM; Santa Barbara/MA; Stanford U. **Bibliography:** John McLaughlin; 7 Decades; The State of California Painting; Weller. Archives.

MC LEAN, RICHARD. b. April 12, 1934, Hoquiam, Wash. **Studied:** California College of Arts and Crafts, 1958, BFA; Mills College, 1962, MFA; Oakland/AM, 1962. **Taught:** San Francisco State College, 1963- . **Address:** c/o Dealer. **Dealer:** OK Harris Works of Art. **One-man Exhibitions:** Lucien Labaudt Gallery, San Francisco, 1957; RAC, 1963; Berkeley Gallery, San Francisco, 1964, 66, 68; Valparaiso U. (Ind.), 1965; U. of Omaha, 1967; OK Harris Works of Art (two-man), 1971,

73. **Group:** SFAI Annuals, 1961, 62, East Bay Realists, circ., 1966; Hayward Gallery, London, Four Painters, 1967; U. of Arizona, 80 Contemporaries in the West, 1967; U. of California, Davis, People Painters, 1970; WMAA, 22 Realists, 1970; Expo '70, Osaka, 1970; Chicago/Contemporary, Radical Realism, 1971; Documenta V, Kassel, 1972; Buffalo/Albright, Working in California, 1972; Stuttgart/WK, Amerikanischer Fotorealismus, circ., 1972; Cleveland/MA, 32 Realists, 1972; New York Cultural Center, Realism Now, 1972; Lunds Konsthall, Sweden, Amerikansk Realism, 1973; Los Angeles Municipal Art Gallery, Separate Realities, 1973; CNAC, Hyperrealistes Americains/Realistes Europeens, 1974; Hartford/Wadsworth, New/Photo Realism, 1974; Tokyo Biennial, 1974. **Collections:** Aachen/NG; A. V. Gumuchian, Inc.; Reed College; VMFA; WMAA. **Bibliography:** *Amerikanischer Fotorealismus; Kunst um 1970*; Sager; *The State of California Painting*.

MC NEIL, GEORGE. b. February 22, 1908, NYC. **Studied:** Pratt Institute, 1927-29; ASL, 1930-33; Hofmann School, 1933-36; Columbia U., BS, MA, Ed.D. US Navy, 1943-46. Traveled Cuba, Europe, North Africa, the Orient. **Taught:** Pratt Institute, 1946- ; U. of Wyoming, 1946-48; U. of California, Berkeley, 1955-56; Syracuse U., 1974; Columbia U., 1975. Federal A.P.: Designed abstract murals, 1935-40. **Awards:** Ford Foundation, **P.P.,** 1963; National Council on the Arts, 1966; Guggenheim Foundation Fellowship, 1969. **Address:** 195 Waverly Avenue, Brooklyn, N.Y. 11205. **One-man Exhibitions:** (first) Lyceum Gallery, Havana, 1941; Black Mountain College, 1947; U. of Wyoming, 1948; U. of New Mexico, 1948; U. of Colorado, 1948; Charles Egan Gallery, 1950, 52, 53, 54; Margaret Brown Gallery, Boston, 1953; Hendler Gallery, Philadelphia, 1954; de Young, 1955; Poindexter Gallery, 1957, 59; The Howard Wise Gallery, NYC, 1960, 62, 64, 67; Nova Gallery, Boston, 1961;

Colby Junior College, 1965; U. of Texas, 1966; Great Jones Gallery, NYC, 1966. **Group:** American Abstract Artists, 1936; MOMA, New Horizons in American Art, 1936; New York World's Fair, 1939; Chicago/AI, Abstract and Surrealist Art, 1948; MOMA, Abstract Painting and Sculpture in America, 1951; WMAA Annuals, 1953, 57, 61; Carnegie, 1953, 55, 58; Walker, 60 American Painters, 1960; Cleveland/MA, Some Contemporary American Artists, 1961; SRGM, Abstract Expressionists and Imagists, 1961; USIA, American Painting, circ. Latin America, 1961; PAFA, 1962; Hartford/Wadsworth, 1962; Chicago/AI, 1963; MOMA, Hans Hofmann and His Students, circ., 1963-64; WMAA, The 1930's, 1968; MOMA, The New American Painting and Sculpture, 1969. **Collections:** Alcoa; Havana/Nacional; MOMA; NYU; Newark Museum; Oklahoma; U. of Texas; WGMA; WMAA; Waitsfield/Bundy; Walker. **Bibliography:** Passloff; Pousette-Dart, ed.; Ritchie 1; Sandler. Archives.

MEEKER, DEAN JACKSON. b. May 18, 1920, Orchard, Colo. **Studied:** Chicago Art Institute School, BFA, MFA; Northwestern U.; U. of Wisconsin. **Taught:** U. of Wisconsin, 1946- . **Awards:** Milwaukee, Medal of Honor, 1952, 56; Guggenheim Foundation Fellowship, 1959. **Address:** 309 Parkway, Glen Oak Hills, Madison, Wisc. **Dealer:** Jacques Baruch Gallery. **One-man Exhibitions:** Milwaukee, 1950; Lawrence College, 1953; U. of North Dakota, 1954; U. of Wisconsin, 1955; Chicago/AI, 1956; U. of New Mexico, 1956; Los Angeles/County MA, 1957; La Gravure, Paris, 1959; Maxwell Galleries, Ltd., San Francisco, 1968; Haslem Fine Arts, Inc., 1969; Jacques Baruch Gallery, 1974. **Group:** PAFA, 1946-53; Brooklyn Museum, 1951-55; Chicago/AI, 1952; SFMA, 1952-54; Walker, 1952-54; Chicago/AI, Exhibition Momentum, 1952-54; Milwaukee; Connecticut College; U. of Missouri; Lawrence College; Library of Congress,

1952, 54, 55; MMA, 1953; Seattle/AM, 1953-1955; The Hague, 1954; Boston/ MFA, 1954-56; MOMA, 1955; Los Angeles/County MA, 1959. **Collections:** Beloit College; Bibliotheque Nationale; Boston/MFA; Brooklyn College; Carleton College; Cornell U.; Dallas/MFA; Denison U.; Denver/AM; Kansas City/ Nelson; Library of Congress; Lincoln, Mass./De Cordova; MOMA; Milwaukee; U. of Oklahoma; PAFA; The Print Club, Philadelphia; SFMA; Seattle/AM; USIA; Victoria and Albert Museum; U. of Wisconsin. **Bibliography:** Hayter 1.

MEHRING, HOWARD. b. February 19, 1931, Washington, D.C. **Studied:** Wilson College, BS.Ed., 1953; The Catholic U. of America, MFA, 1955. Traveled Spain, Portugal, Italy, France, England, 1962-66, 1968. **Awards:** Corcoran, First Prize, 1965. **Address:** c/o Dealer. **Dealer:** A. M. Sachs Gallery. **One-man Exhibitions:** (first) Sculptors Studio, Washington, D.C., 1957; Origo Gallery, Washington, D.C., 1959; Jefferson Place Gallery, 1961, 62; Adams Morgan Gallery, Washington, D.C., 1963; A. M. Sachs Gallery, 1965, 66, 68, 70; Galerie Haselem, Munich, 1970. **Group:** Carnegie, 1961; Los Angeles/County MA, Post Painterly Abstraction, 1964; WGMA, circ., 1965-66; Corcoran, 1966; NCFA, 1966; SRGM, Systemic Painting, 1966; SRGM, Seven Decades, 1967; MOMA, The 1960's, 1967; WMAA Annual 1967; Ringling, Washington Painters, 1969; Edmonton Art Gallery, Alberta, Ten Washington Artists: 1950-1970, 1970. **Collections:** Brandeis U.; Chase Manhattan Bank; Corcoran; Hartford/Wadsworth; Los Angeles/County MA; MOMA; NCFA; The New York Bank for Savings; Phillips; SRGM; Seagram Collection; U. of Texas; WGMA; WMAA; Woodward Foundation. **Bibliography:** Alloway 3.

MEIGS, WALTER. b. September 21, 1918, NYC. **Studied:** Ecole des Beaux-Arts, Fontainebleau, Diplome, 1939; Syracuse U., BFA, 1941; State U. of Iowa, MFA, 1949; and with R. Lotterman. US Army, more than three years,

World War II. Traveled France, Greece; resided Greece, 1961-64, Spain, 1965- . **Taught:** U. of Nebraska, 1949-53; U. of Connecticut, 1953-61. **Awards:** Walker, 1951; Silvermine Guild, 1954; Slater, First Prize, 1955, 56; Boston Arts Festival, Grand Prize, 1956; and some 20 others. **Address:** c/o Dealer. **Dealer:** Nordness Galleries. **One-man Exhibitions:** (first) The Downtown Gallery; U. of Nebraska, 1952; The Alan Gallery, NYC, 1954; Wesleyan U., 1956; New London, 1956; Boris Mirski Gallery, Boston, 1957; Lee Nordness Gallery, NYC, 1958, 64, 67; Lincoln, Mass./De Cordova, 1959; Frank Oehlschlaeger Gallery, Sarasota, Fla., 1965; Harmon Gallery, Naples, Fla., 1966. **Group:** Walker Biennial, 1951; Omaha/Joslyn, 1952; Boston Arts Festival; Berkshire Art Festival; Youngstown/Butler, 1957; Carnegie; WMAA Annuals; U. of Illinois. **Collections:** Amherst College; Birmingham, Ala./MA; Denver/AM; Fort Worth; Hartford/Wadsworth; Lincoln, Mass./De Cordova; The Pennsylvania State U.; Springfield, Mo./AM; USIA; Utica; Youngstown/Butler. **Bibliography:** Nordness, ed. Archives.

MENKES, SIGMUND. b. May 7, 1896, Lwow, Poland. **Studied:** in Europe. **Member:** NAD; Federation of Modern Painters and Sculptors. **Awards:** Corcoran, 1941, First Prize, Gold Medal, 1947; PAFA, Medal, 1945; NIAL, 1955; ART:USA:58, NYC, 1958; Audubon Artists, Gold Medal of Honor, 1965, Silver Anniversary Medal, 1967; Polish Institute of Arts and Sciences, Award for Collective Work, 1968. **Address:** 5075 Fieldstone Road, Riverdale, N.Y. **One-man Exhibitions:** Mrs. Cornelius J. Sullivan Gallery, NYC; Le Portique, Paris, 1928; A.A.A. Gallery, NYC, 1936-54; Durand-Ruel Gallery, NYC, 1941. **Group:** Carnegie; Chicago/AI; Corcoran; PAFA; U. of Nebraska; Cleveland/ MA; American U.; State U. of Iowa; Cranbrook; MMA; WMAA; Toronto. **Collections:** Abbott Laboratories; Belgrade/National; Britannica; Brooklyn Museum; Cranbrook; Davenport/Municipal; Denver/AM; Greece/National;

Hirshhorn; Jerusalem/National; MMA; U. of Miami; Montclair/AM; Musee du Jeu de Paume; NIAL; PAFA; Tel Aviv; WMAA; Walker; Warsaw/National; Wichita/AM. **Bibliography:** Genauer; Pousette-Dart, ed.; Zaidenberg, ed.

MESIBOV, HUGH. b. December 29, 1916, Philadelphia, Pa. **Studied:** Graphic Sketch Club, Philadelphia; PAFA; Barnes Foundation. Traveled Europe, Mediterranean, Israel, USA. **Taught:** Lenox Hill Neighborhood Association, NYC, 1949-57; Wiltwyck School for Boys, Esopus, N.Y., 1957-66; Rockland Community College, Suffern, N.Y., 1966. **Member:** PAFA Fellowship Association; Philadelphia Watercolor Club. Federal A.P.: Graphics, drawings, watercolors, oils, mural design. **Commissions:** US Post Office, Hubbard, Ohio (mural). **Awards:** The Print Club, Philadelphia, 1941, 46; Hallmark International Competition, 1952; PAFA, 1952, 58. **Address:** 377 Saddle River Road, Monsey, N.Y. 10952. **One-man Exhibitions:** (first) Carlen Gallery, Philadelphia, 1940; Philadelphia Art Alliance, 1945; Chinese Gallery, NYC, 1947; Bookshop Gallery, Aspen, Colo., 1951, 53; The Morris Gallery, NYC, 1954; Pied Piper Gallery, Aspen, Colo., 1954; Artists' Gallery, NYC, 1956, 58; Sunken Meadow Gallery, Kings Park, N.Y., 1958; Gallery Mayer, NYC, 1959; Elizabeth Nelson Gallery, Chicago, 1962; Rockland Community College, 1964-68, 69, 72; Mansfield State College, 1968; High Point Galleries, Lenox, Mass., 1968; Tappan Zee Theater Nyack, N.Y., 1967, 68, 69; St. Thomas Aquinas College, Sparkhill, N.Y., 1971. **Group:** New York World's Fair, 1939; Carnegie, 1939; Philadelphia Art Alliance, 1940, 41, 45; Harrisburg, Pa.; PAFA, 1943, 1952-55, 57; Library of Congress, 1951; Brooklyn Museum, 1951, 1953-55; WMAA, 1956-59; Corcoran, 1959; MOMA, 1961; Philadelphia Art Alliance, 1967; AAAL, 1967. **Collections:** Albion College; Barnes Foundation; Canadian Society of Graphic Art; Carnegie; Free Library of Philadelphia; MMA; NYU; New York Hilton Hotel; U. of Oregon; PAFA; PMA; U. of Wyoming.

MESTROVIC, IVAN. b. August 15, 1883, Vrpolje, Croatia; **d.** January 17, 1962, Notre Dame, Ind. **Studied:** Privately with Otto Koenig in Vienna, 1899; Academy of Fine Arts, Vienna, 1900-04, with E. Hellmer, H. Bitterlich, Otto Wagner. Member of Yugoslav Provisional National Assembly, 1919. Traveled Italy, France, Austria, USA. To USA 1947; citizen 1954. **Taught:** Syracuse U., 1947-55; U. of Notre Dame, 1956-62. **Member:** AAAL, 1953. **Commissions:** Grant Park, Chicago, 1925; Unknown Soldier Memorial, Belgrade, 1934; equestrian figure of King Carol, 1938-39; Vatican commissions, 1942. **Awards:** Hon. Member, Academy of Fine Arts, Vienna, 1952; AAAL, Award of Merit Medal, 1953; American Institute of Architects, Fine Arts Medal, 1955; Hon. DFA from Colgate U., Ohio Wesleyan U., Syracuse U., Marquette U., U. of Notre Dame, and Columbia U. **One-man Exhibitions:** Vienna Sezession, 1909; Mestrovic Museum, 1910; Musee du Jeu de Paume, 1933; MMA, 1947; Musee Rodin, Paris, 1969. **Group:** Vienna Sezession, 1903, 04; Salon d'Automne, Paris, 1905; International Exhibition, Rome, 1911; Victoria and Albert Museum, 1915; Musee du Petit Palais, Paris, 1919. **Collections:** Belgrade/National; Brooklyn Museum; Buffalo/Albright; Chicago/AI; Detroit/Institute; Mestrovic Gallery; Mestrovic Museum; U. of Minnesota; Montreal/MFA; Prague/National; St. Antony's College; San Diego; Syracuse U.; Tate; Toronto; Victoria and Albert Museum. **Bibliography:** Bulliet 1; Cheney; Christensen; **Keckemet;** Lee and Burchwood; Licht, F.; Mendelowitz; Pach 1; Ramsden 2; Salvini; Selz, J.; Taft.

METCALF, JAMES. b. March 11, 1925, NYC. **Studied:** Dayton Art Institute School; PAFA, 1944-46; Central School of Arts and Crafts, London, 1950-53. US Army, 1943-44. Traveled Europe, USA; resided Paris. **Commissions:** War Memorial for Middletown, Ohio, 1949.

Awards: William and Noma Copley Foundation Grant, 1957; Clark Foundation Grant. **Address:** Springfield Pike, Yellow Springs, Ohio 45387. **One-man Exhibitions:** Galerias Augusta, Barcelona, 1955; Galerie Furstenberg, Paris, 1959; Alexander Iolas Gallery, 1961; Galerie J. Paris, 1962; Galerie Europe, Paris, 1963; Albert Loeb Gallery, NYC, 1964. **Group:** Dayton/AI, 1946; Cincinnati/AM, 1947; a gallery in Springfield, Ohio, 1947, 48; Goldsmith's Hall, London, 1952; III Biennial of Spanish-American Art, Barcelona, 1955; V Sao Paulo Biennial, 1959; Exposition Internationale de la Sculpture, Paris, 1961; Un Demi-Siecle de la Sculpture, Paris, 1962; Actualite de la Sculpture, Paris, 1963; Documenta III, Kassel, 1964. **Collections:** U. of Arizona; Museum des 20. Jahrhunderts; New York Hilton Hotel; Yale U. **Bibliography:** Hunter 4; Read 3; Seuphor 3.

MILLER, KENNETH HAYES. b. March 11, 1878, Oneida, N.Y.; **d.** January 1, 1952, NYC. **Studied:** ASL, with H. S. Mowbray, Kenyon Cox, F. L. Mora, Frank V. DuMond. Traveled Europe. **Taught:** New York School of Art, 1899-1911; ASL, 1911-35, 1937-43, 1945-52. **Member:** NAD; Artists Equity; NIAL. **Awards:** Chicago/AI, Ada S. Garrett Prize, 1945; NAD, Gold Medal, 1943; NIAL, 1947. **One-man Exhibitions:** Montross Gallery, NYC, 1922, 23, 25, 28; Rehn Galleries, 1929; 35; Utica, 1953; ASL, 1953; The Zabriskie Gallery, 1970, 71. **Group:** Chicago/AI; The Armory Show, 1913; Buffalo/Albright; RISD; PAFA; Musee de Luxembourg, Paris; Brooklyn Museum; Carnegie; Corcoran; NAD; WMAA. **Collections:** Andover/Phillips; Bibliotheque Nationale; Chicago/AI; Cleveland/MA; Columbus; Hartford/Wadsworth; Library of Congress; Los Angeles/County MA; MMA; MOMA; NYPL; PAFA; Phillips; San Diego; Utica; VMFA; WMAA. **Bibliography:** American Artists Group Inc. 1, 3; Baur 7; Blesh 1; Brown; Burroughs; Cahill and Barr, eds.; Cheney; Gerdts; Goodrich and Baur 1; Hall;

Index of 20th Century Artists; Hunter 6; Jewell 2; McCurdy, ed.; Mellquist; **Miller;** Pach 3; Pagano; Phillips 2; Reese; Richardson, E. P.; **Rothschild, L.;** Rose, B. 1; Wight 2. Archives.

MILLER, RICHARD. b. March 15, 1930, Fairmount, W. Va. **Studied:** PAFA, with Franklin Watkins, 1948; American U., with William H. Calfee, BA, 1949-53; Columbia U., with John Heliker, MA, 1956. Traveled Europe and USA extensively. **Taught:** Kansas City/AI, 1968-69; Scarsdale Studio School, 1970-75; privately. Professional actor-singer. **Commissions:** General Motors Building, NYC. **Awards:** Gertrude V. Whitney Scholarship, 1948, 56; Fulbright Fellowship (Paris), 1953. **Address:** 222 West 83 Street, NYC 10024. **Dealers:** The Graham Gallery; Peter Rose Gallery. **One-man Exhibitions:** (first) Washington D.C., Public Library, 1945; Trans-Lux Gallery, Washington, D.C., 1948; Watkins Gallery, Washington, D.C., 1951; Bader Gallery, Washington, D.C., 1954, 61; Baltimore/MA, 1955; The Graham Gallery, 1960, 62, 63, 65; Jefferson Place Gallery, 1966; Drew U., 1967; Jewish Community Center, Kansas City, Mo., 1969; Albrecht Gallery, St. Joseph, Mo., 1969; Long Island U., 1973. **Group:** WMAA Annual; PAFA Annual; WMAA, Fulbright Artists, 1958; Salon National, Paris; Pan-American Union, Washington, D.C.; U. of Nebraska; San Antonio/McNay, 1960; Carnegie, 1961; Corcoran, 1961; Finch College; V International Biennial Exhibition of Prints, Tokyo, 1966. **Collections:** U. of Arizona; Columbia U.; Phillips; U. of Rochester.

MILLER, RICHARD MC DERMOTT. b. April 30, 1922, New Philadelphia, Ohio. **Studied:** Cleveland Institute of Art, 1940-42, 1949-52. US Army, 1942-46. Traveled Mexico. **Taught:** Queens College, City University of New York, 1967. **Member:** Sculptors Guild. **Awards:** May Page Scholarship, Cleveland Institute of Art, 1951; Youngs-

town/Butler, **P.P.**, 1970; NAD, Elizabeth N. Watrous Gold Medal, 1974. **Address:** 53 Mercer Street, NYC 10013. **Dealer:** Washburn Gallery Inc. **One-man Exhibitions:** Peridot Gallery, 1964, 66, 67, 69; Holland Gallery, 1965; Feingarten, 1966; Duke U. 1967; Raleigh/NCMA, 1967; Cleveland/MA 1968; Alwin Gallery, London, 1968; Columbia, S.C./MA 1969; Duke U. (two-man) 1971; Washburn Gallery Inc., 1971, 74. **Group:** WMAA, Sculpture Annual, 1964; NIAL, 1965; New Paltz/SUNY, 20 Representational Artists, 1969; Baltimore/MA, The Part is the Whole, 1969; Youngstown/Butler, Sculpture Annual, 1970, 71; U. of Nebraska, American Sculpture, 1970, 73; St. Cloud State College, New Realism '70, 1970. **Collections:** Canton Art Institute; Columbia, S.C./MA; Hirshhorn; U. of Houston; Massillon Museum; U. of Nebraska; U. of North Carolina; Youngstown/Butler.

MILLMAN, EDWARD. b. January 1, 1907, Chicago, Ill.; **d.** February 11, 1964, Woodstock, N.Y. **Studied:** Chicago Art Institute School, 1923-28, with Leon Kroll; privately with Diego Rivera in Mexico City, 1934-35 (fresco painting). **Taught:** Florida Gulf Coast Art Center, Inc., 1951; Indiana U., 1951-52; Washington U., 1952; U. of Arkansas, 1953; Cornell U., 1954; ASL, 1954-56, summer, 1950; Layton School of Art, 1955; U. of Buffalo, 1955, summer, 1956; Munson-William-Proctor Institute, Utica, N.Y., 1955-56; Rensselaer Polytechnic Institute, 1956-64. **Commissions** (murals): US Post Offices in Moline, Ill., 1935, Decatur, Ill., 1936, and St. Louis, Mo. (with Mitchell Siporin), 1939-41; Chicago City Hall. **Awards:** Guggenheim Foundation Fellowship, 1945; Ohio U., First Prize, 1952. **One-man Exhibitions:** The Downtown Gallery, 1942; A.A.A. Gallery, NYC, 1948; U. of Kansas City, 1949; Louisiana State U., 1949; Florida State U., 1949; Clearwater/Gulf Coast, 1950; Indiana U., 1951; U. of Arkansas, 1953; Tulsa/Philbrook, 1953; The Alan

Gallery, NYC, 1954; Cornell U., 1954; Layton School of Art, 1955; Buffalo/Albright, 1955; Utica, 1956; Chicago/AI, 1956, 62; Lee Nordness Gallery, NYC, 1959, 61; Galleria d'Arte Annunciata, Milan, 1960; Rensselaer Polytechnic Institute, 1961; Ulster Community College, Stone Ridge, N.Y. (two-man), 1972. **Group:** WMAA Annuals; Chicago/AI; Brooklyn Museum; and many others. **Collections:** Abbott Laboratries; Brandeis U.; Brooklyn Museum; Chicago/AI; Clearwater/Gulf Coast; Jewish Museum; MOMA; PAFA; U. of Pennsylvania; St. Louis/City; US Navy; Utica; WMAA; Washington U.; Youngstown/Butler. **Bibliography:** Bruce and Watson; Nordness, ed.; Pousette-Dart, ed.; Zaidenberg, ed.

MITCHELL, FRED. b. November 24, 1923, Meridian, Miss. **Studied:** Carnegie Institute of Technology, 1942-43; Cranbrook Academy of Art, 1946-48, BFA, MFA; Academy of Fine Arts, Rome. **Taught:** Cranbrook Academy of Art, 1955-59; Positano (Italy) Art Workshop, 1956; NYU, 1961- ; Cornell U., 1969. A co-founder of the Tanager Gallery, NYC. **Commissions:** Mississippi State College for Women (cast concrete screen). **Awards:** Scholarship to Carnegie Institute of Technology; Traveling Fellowship (Italy), 1948-51; Ford Foundation Artist-in-Residence, Columbia, S.C./MA. **Address:** 92 Hester Street, NYC 10002. **One-man Exhibitions:** (first) Municipal Gallery, Jackson, Miss., 1942; Tanager Gallery, NYC, 1953; Positano (Italy) Art Workshop, 1956; The Howard Wise Gallery, Cleveland, 1957, 59; The Howard Wise Gallery, NYC, 1960, 63; i Gallery, La Jolla, 1964; Kasha Heman, Chicago, 1964; Columbia, S.C./MA, 1965; Wooster Community Center, Danbury, Conn., 1966; Cornell U. (three-man), 1969; Roko Gallery, 1973. **Group:** SRGM, Younger American Painters, 1954; Dallas/MFA, 1954; Walker, Vanguard, 1955; Cranbrook, 1958; Carnegie, 1961. **Collections:** Columbus; Cranbrook.

MITCHELL, JOAN. b. 1926, Chicago, Ill. **Studied:** Smith College, 1942-44; Columbia U.; Chicago Art Institute School, 1944-47, BFA; NYU, 1950, MFA. Resides in France. **Address:** c/o Dealer. **Dealer:** Fourcade, Droll Inc. **One-man Exhibitions:** U. of Illinois, 1946 (two-man, with Richard Bowman); St. Paul Gallery, 1950; The New Gallery, NYC, 1952; The Stable Gallery, 1953, 54, 55, 57, 58, 61, 65; Galerie Neufville, Paris, 1960; B. C. Holland Gallery, 1961; Dwan Gallery; Southern Illinois U.; Jacques Dubourg, Paris, 1962; Galerie Lawrence, Paris, 1962; Klipstein & Kornfeld, Berne, 1962; MIT, 1962; Galerie Fournier, Paris, 1967, 69, 71; Martha Jackson Gallery, 1968, 71, 72; Syracuse/Everson, 1972; Ruth S. Schaffner Gallery, Santa Barbara, 1974; Arts Club of Chicago, 1974. **Retrospective:** WMAA, 1974. **Group:** U. of Illinois, 1950, 67; WMAA, 1950, 65-66, Annuals, 1967, 73; Chicago/AI; Walker, Vanguard, 1955; Corcoran; Arts Club of Chicago; U. of North Carolina; Minneapolis/Institute; PAFA, 1966; MOMA, Two Decades of American Painting, circ. Japan, India, Australia, 1967; U. of Illinois, 1967; Jewish Museum, 1967; Montclair/AM, The Recent Years, 1969; Carnegie, 1970; VMFA, 1970; MOMA, Younger Abstract Expressionists of the Fifties, 1971; Carnegie, Fresh Air School, circ., 1972; New York Cultural Center, Women Choose Women, 1973; WMAA, American Drawings: 1963-1973, 1973; Indianapolis, 1974; Corcoran, 1975. **Collections:** Basel; Buffalo/Albright; Chase Manhattan Bank; Chicago/AI; MOMA; Phillips; Rockefeller Institute; The Singer Company Inc.; Union Carbide Corp.; WMAA; Walker. **Bibliography:** Baur 5; Blesh 1; Friedman, ed.; Hunter 1; Hunter, ed.; **Joan Mitchell;** McCoubrey 1; *Metro;* Nordness, ed.; O'Hara 1; Plous; Read 2; Seuphor 1.

MITCHELL, WALLACE. b. October 9, 1911, Detroit, Mich. **Studied:** Northwestern U., BA; Cranbrook Academy of Art, with Zoltan Sepeshy; Columbia U.,

MA. **Taught:** Cranbrook Academy of Art, 1936- . **Awards:** Springfield, Ill./State, Old Northwest Territory Exhibition; Detroit/Institute, 1945. **Address:** Cranbrook Academy of Art, Bloomfield Hills, Mich. **One-man Exhibitions:** Detroit Artists Market, 1938; Cranbrook, 1947, 53; The Bertha Schaefer Gallery, 1950, 57, 58; U. of Minnesota, 1954. **Retrospective:** Cranbrook, 1970. **Group:** Chicago/AI, 1938-41; Detroit/Institute; Buffalo/Albright, 1939; U. of Nebraska; Springfield, Ill./State, Old Northwest Territory Exhibition. **Collections:** Cranbrook; Detroit/Institute.

MOHOLY-NAGY, LAZLO. b. July 20, 1895, Bacsbarsod, Hungary; **d.** November 24, 1946, Chicago, Ill. **Studied:** U. of Budapest, 1913-14, LL.B. **Taught:** Staatliche Bauhaus, Berlin, 1922; a founding collaborator, with Gyorgy Kepes and Robert Wolff, of the Institute of Design, Chicago, 1938-42; Director of the New Bauhaus, Chicago. Designed for State Opera and the Piscator Theatre, Berlin, 1928. Traveled Europe extensively. To England, 1935, where he produced three volumes of photo document and a film, "Life of the Lobster." To USA 1937. **One-man Exhibitions:** Amsterdam/Stedelijk; Brno, Czechoslovakia; Hamburg; Mannheim; Cologne; Budapest/National; Stockholm/National; A.F.A.; The London Gallery, London, 1937; Houston/Contemporary, 1948; Harvard U., 1950; Rose Fried Gallery, 1950; Colorado Springs/FA, 1950; Zurich, 1953; Kunst Kabinett Klihm, 1956, 59, 62, 66, 71; Kleeman Gallery, NYC, 1957; New London Gallery, London, 1961; Dusseldorf, 1961; Eindhoven, 1967, 72; Brandeis U., 1968; The Howard Wise Gallery, NYC, 1970; Galerie Rudolf Zwirner, 1971; Bauhaus-Archiv, Berlin, 1972; Ileana Sonnabend Gallery, NYC, 1973. **Retrospectives:** SRGM, 1947; Chicago/AI, 1969; Chicago/Contemporary, circ., 1969; Stuttgart/WK, 1974. **Group:** WMAA; SRGM; Yale U.; Harvard U.; MOMA, The Machine as Seen

at the End of the Mechanical Age, 1968, and others. **Collections:** Chicago/AI; Dayton/AI; Detroit/Institute; Jacksonville/AM; Los Angeles/County MA; MOMA; SFMA; SRGM. **Bibliography:** Barr 1; Battcock, ed.; Bijalji-Merin; Blanchard; Calas, N. and E.; Cassou; Craven, W.; Davis, D.; Frost; Giedion-Welcker 2; Goodrich and Baur 1; Hulten; Huyghe; Janis and Blesh 1; Janis, S.; **Kostelanetz;** Langui; Licht, F.; MacAgy 2; **Moholy-Nagy, L. 1, 2;** **Moholy-Nagy, S. 1, 2;** Morris: Motherwell 1; Ramsden 1; Read 3; Roters; Selz, J.; Seuphor 3; Tomkins; Trier 1; Valentine 2; **Weitemeir;** Weller; Wingler, ed. Archives.

MOLLER, HANS. b. March 20, 1905, Wuppertal-Barmen, Germany. **Studied:** Art School, Barmen, 1919-27; Academy of Fine Arts, Berlin, 1927-28. To USA 1928. **Taught:** Cooper Union, 1944-56. **Member:** Federation of Modern Painters and Sculptors. **Commissions:** William Douglas McAdams Inc., NYC (mural); Percival Goodman, Architect; tapestry design for synagogue ark curtains; A.F.A./Stained Glass Industry (stained glass window); Christ Church, Washington, D.C. (stained glass windows), 1968. **Awards:** Art Directors Club, NYC, Distinctive Merit Award, 1944, 55, 56; Corcoran, Hon. Men., 1949; American Institute of Graphic Art, Certificate of Excellence, 1949 (2), 51; National Religious Art Exhibition, Detroit, First Prize, 1964; Audubon Artists Annual, Salmagundi Club Award, 1967; NAD, Edwin Palmer Memorial Prize, 1968; NAD, Samuel F.B. Morse Gold Medal, 1969; Audubon Artists, Murray Kupferman Prize, 1973; NAD, Andrew Carnegie Prize, 1974. **Address:** 2207 Allen Street, Allentown, Pa. 18104; summer: Monhegan, Me. 04852. **Dealer:** The Midtown Galleries. **One-man Exhibitions:** (first) Bonestell Gallery, NYC, 1942, also 1943; Arts Club of Chicago, 1945; U. of Michigan, 1945; Kleemann Gallery, NYC, 1945, 47, 48, 49, 50; Pen and Palette Gallery, St. Louis, 1949; Macon,

Ga., 1949; Atlanta/AA, 1950; Grace Borgenicht Gallery Inc., 1951, 53, 54, 56; Fine Arts Associates, NYC, 1957, 60; Albert Landry, NYC, 1962; The Midtown Galleries, 1964, 67, 70, 73; Philadelphia Art Alliance, 1968; Allentown/AM, 1969; Norfolk, 1970. **Retrospective:** The Olsen Foundation Inc., Leetes Island, Conn., Hans Moller: 1926-56, circ., 1956-64. **Group:** MMA; Brooklyn Museum; PAFA; Chicago/AI; The Print Club, Philadelphia; Des Moines; Detroit/Institute; Corcoran; U. of Illinois; Walker; Buffalo/Albright; SFMA; Colby College, 100 Artists of the 20th Century, 1964; WMAA Annual, 1965, and others; NAD Annuals, 1965, 67, 68, 69; Federation of Modern Painters and Sculptors, 1966, 67; NIAL, 1969. **Collections:** Allentown/AM; Bennington College; Brooklyn Museum; Detroit/Institute; U. of Georgia; IBM; MOMA; Melbourne/National; Meta-Mold Aluminum Co.; NYPL; Norfolk; PAFA; Phillips; Sacred Heart Seminary; Society of the Four Arts; Spelman College; U. of Texas; USIA; U.S. Rubber Co.; WMAA; Walker; Washington U.; Wuppertal; Yellowstone Art Center. **Bibliography:** Baur 5; Genauer.

MORIN, THOMAS. b. September 22, 1934, Malone, N.Y. **Studied:** Massachusetts School of Art, with Lawrence Kupferman, 1952-56, BS.Ed.; Cranbrook Academy of Art, 1956-57, MFA; Academy of Fine Arts, Florence, Italy, 1960-61; Brown U., 1962-63. Traveled Europe. **Taught:** Cranbrook Academy of Art, 1957-58; Silvermine Guild, 1958-60; RISD, 1961- . **Member:** American Foundrymens Society. **Commissions:** Brown U. (40 x 8-ft. cast aluminum relief). **Awards:** Fulbright Fellowship, 1960; Silvermine Guild, First Prize, 1960; Rhode Island Arts Festival, First Prize. **Address:** 62 Waterman Street, Providence, R.I. 02906. **One-man Exhibitions:** (first) Margaret Brown Gallery, Boston, 1954; Gallery Four, Detroit, 1957; Kanegis Gallery, Boston, 1958, 60; Silvermine Guild,

1960; The Kornblee Gallery, 1961, 64; Lincoln, Mass./De Cordova, 1963; Providence (R.I.) Art Club, 1963; Trinity Square Playhouse, Providence, R.I., 1966; South County Art Association, Kingston, R.I., 1966; U. of New Hampshire, 1968; State U. of New York at Oneonta, 1968. **Group:** Boston Arts Festival, 1953, 54, 55, 58, 59, 60, 62; PAFA, 1958, 64; Detroit/Institute Annuals, 1958, 64; ICA, Boston, View, 1960; WMAA Annual, 1961; Houston/MFA, Ways and Means, 1961; Audubon Artists Annual, 1962; Hartford/Wadsworth, Eleven New England Sculptors, 1963; Silvermine Guild, 1963; Lincoln, Mass./De Cordova, 1964. **Collections:** Brown U.; VMFA.

MORLEY, MALCOLM. b. 1931, London, England. **Studied:** Camberwell School of Arts and Crafts, London, 1953; Royal College of Art, London, 1957; Yale U., MFA. **Address:** 16 Crosby Street, NYC 10013. **One-man Exhibitions:** The Kornblee Gallery, 1967, 69; Stefanotty Gallery, NYC, 1973. **Group:** SRGM, The Photographic Image, 1966; IX Sao Paulo Biennial, 1967; Vassar College, Realism Now, 1968; Akron/AI, Directions 2: Aspects of a New Realism, 1969; Riverside Museum, NYC, Paintings from the Photo, 1969; WMAA, 22 Realists, 1970; Princeton U., American Art since 1960, 1970; Documenta V, Kassel, 1972. **Collections:** Cologne/NG; Hartford/Wadsworth; MOMA; The Ohio State U.; Paris/Moderne; Victoria and Albert Museum. **Bibliography:** *Amerikanischer Fotorealismus; Kunst um 1970;* Sager.

MORRIS, CARL. b. May 12, 1911, Yorba Linda, Calif. **Studied:** Fullerton Junior College, 1930-31; Chicago Art Institute School; Kunstgewerbeschule, Vienna, 1933-34; Academy of Fine Arts, Vienna, 1933-34. Traveled Italy. **Taught:** ASL, 1937-38; privately 1940-41; U. of Colorado, summer, 1957. **Federal A.P.:** Director at Spokane, Wash., 1938-39. **Commissions** (murals): US Post Office, Eugene, Ore.,

1941-42; Hall of Religion, Oregon Centennial Exposition, Portland, 1959. **Awards:** Austro-American Scholarship, 1935; Institute of International Education Fellowship (Paris), 1935-36; Werkbund Scholarship, 1939; Seattle/AM, Hon. Men., 1939, 46, 47; Seattle/AM, Second Prize, 1943; Denver/AM, **P.P.,** 1946; Seattle/AM, Margaret E. Fuller Award, 1946; SFMA, Anne Bremer Memorial Prize, 1946; Pepsi-Cola Bronze Medal, 1948; SFMA, James D. Phelan Award, 1950; U. of Illinois, **P.P.,** 1958. **Address:** 919 N.W. Skyline Boulevard, Portland, Ore. 97229. **Dealers:** Kraushaar Galleries; Triangle Art Gallery; Gordon Woodside Gallery; Fountain Gallery. **One-man Exhibitions:** (first) Foundation des Etats-Unis, Paris, 1935; Paul Elder Gallery, San Francisco, 1937; Seattle/AM, 1940; Portland, Ore./AM, 1946, 52, 55; California Palace, 1947; U. of Oregon, 1947; Opportunity Gallery, NYC, 1948; Santa Barbara/MA, 1956; Zivile Gallery, Los Angeles, 1956; Mills College, 1956; Rotunda Gallery, San Francisco, 1956; Kraushaar Galleries, 1956, 57, 58, 61, 64, 67, 73; Reed College, 1959, 69 (two-man, with Hilda Morris), 1972; U. of Colorado, 1957; Fountain Gallery, 1963, 64, 65, 69, 71, 75; Feingarten Gallery, San Francisco, 1965; Triangle Art Gallery, 1966, 68, 70, 73; Gordon Woodside Gallery, 1966, 69, 73. **Retrospective:** A.F.A./Ford Foundation, circ., 1960. **Group:** Chicago/AI; Carnegie; Corcoran; MMA; WMAA; SRGM, Younger American Painters, 1954; III Sao Paulo Biennial, 1955; Colorado Springs/FA, 1965; Denver/AM, 1965; Art in the USA, 1965; Tamarind Lithography Workship, 1967; PAFA, 1969; SFMA, Tamarind, 1969; MOMA, Tamarind: Homage to Lithography, 1969; Minnesota/MA, Drawings USA, 1971; NCFA, Art of the Pacific Northwest, 1974; NAD, 1974. **Collections:** Allentown/AM; Buffalo/Albright; California Palace; Chicago/AI; Colorado Springs/FA; U. of Colorado; Columbus; Corcoran; Dayton/AI; Denver/AM; Eastern Oregon College; Hartford/Wadsworth;

Houston/MFA; Hirshhorn; U. of Illinois; Kansas City/Nelson; MMA; Mead Corporation; Michigan State U.; Mills College; Minnesota/MA; NCFA; Norfolk/Chrysler; U. of Oregon; Portland, Ore./AM; Portland State College; Reed College; U. of Rochester; SFMA; SRGM; Santa Barbara/MA; Sao Paulo; Seattle/AM; Southern Oregon College; Stanford U.; U. of Texas; Toronto; Utica; WMAA; Walker; Wichita. **Bibliography:** Monte and Tucker; Nordness, ed.; Pousette-Dart, ed.; Read 2.

MORRIS, GEORGE L.K. b. November 14, 1905, NYC; **d.** June 26, 1975, Stockbridge, Mass. **Studied:** Groton School, 1924; Yale U., 1928, BA; ASL, with John Sloan, Kenneth Hayes Miller; Academie Moderne, Paris, with F. Leger, Amedee Ozenfant. Traveled around the world, and spent much time in Paris. **Taught:** ASL, 1943-44; St. John's College, Annapolis, Md., 1950-61. Editor: *Yale Literary Magazine*, 1928; *The Miscellany*, 1929-31; *Plastique*, Paris, 1937-39; *Partisan Review*, 1937-43. **Member:** American Abstract Artists (a founder, 1936, and President, 1948-50); Federation of Modern Painters and Sculptors; NAD, Saltus Gold Medal, 1973. **Commissions:** Lenox (Mass.) Elementary School (mosaic). **Awards:** Pepsi-Cola, 1948; Pittsfield/Berkshire, Berkshire Hills Award, 1963; PAFA, Joseph E. Temple Gold Medal, 1965. **One-man Exhibitions:** (first) Valentine Dudensing Gallery, 1933; Pittsfield/Berkshire, 1933; Museum of Living Art, NYC, 1935; Passedoit Gallery, NYC, 1938; The Downtown Gallery, 1943, 44, 50, 64, 67; Galerie Colette Allendy, Paris, 1946; The Alan Gallery, NYC, 1955; Montclair/AM, 1971; Jacksonville/Cummer, 1973; Chattanooga/AA, 1973; Charleston/Carolina, 1973; Hirschl & Adler Galleries, 1974. **Retrospectives:** ICA, Washington, D.C., 1958; Sharon (Conn.) Creative Arts Foundation; Century Association; Corcoran; Pittsfield/Berkshire; Hirschl & Adler Galleries, 1971. **Group:** WMAA; American Abstract Artists, annually;

Salon des Realites Nouvelles, Paris; MOMA; SRGM; Chicago/AI; SFMA; Rome/Nazionale. **Collections:** Brandeis U.; Brooklyn Museum; Chattanooga/AA; Corcoran; Dallas/MFA; Darmstadt/Kunsthalle; U. of Georgia; High Museum; Honolulu Academy; U. of Illinois; MMA; Madison Square Garden; U. of Michigan; Montclair/AM; U. of Oklahoma; PAFA; PMA; Phillips; Pittsfield/Berkshire; Portland, Ore./AM; Raleigh/NCMA; Syracuse U.; Utica; WMAA; Wichita/AM; Yale U. **Bibliography:** American Abstract Artists, ed.; Arp; Baur 7; Biederman 1; Blanchard; Blesh 1; Cheney; Flanagan; Frost; Kootz 2; McCurdy, ed.; **Morris**; Newmeyer; Pagano; Pearson 2; Pousette-Dart, ed.; Read 2; Ritchie 1; Rose, B. 1, 4; Seuphor 1, 3; "What Abstract Art Means to me." Archives.

MORRIS, KYLE R. b. January 17, 1918, Des Moines, Iowa. **Studied:** Northwestern U., 1935-39, BA, 1940, MA; Chicago Art Institute School, 1935-39; Cranbrook Academy of Art, 1947, MFA. US Army Air Force, 1942-45. Traveled Europe. **Taught:** Stephens College, 1940-41; U. of Texas, 1941-42, 1945-46; U. of Minnesota, 1947-51; U. of California, Berkeley, 1952-54; Cooper Union, 1958. Art Consultant to Sandak, Inc. Editor and Publisher, *Contemporary Slides* (Magazine), 1954-59. Organized the Vanguard, 1955, exhibition for The Walker Art Center. **Commission:** Kellog Citizens National Bank (mural), 1975. **Awards:** Walker, **P.P.**, 1948; SFMA, Oil Painting Award, 1953; II Inter-American Paintings and Prints Biennial, Mexico City, 1960, Hon. Men.; Ford Foundation, **P.P.**, 1963. **Address:** 173 Main Street, East Hampton, N.Y. 11937. **One-man Exhibitions:** (first) Pepsi-Cola Opportunity Art Gallery, NYC, 1945; Walker, 1952; Des Moines, 1955; The Stable Gallery, 1955; The Kootz Gallery, NYC, 1959, 60, 62, 63, 64; Galleria d'Arte del Naviglio, Milan, 1960; James David Gallery, Miami and Sarasota, 1966, 67; Landmark Gallery Inc., NYC, 1974. **Group:** WMAA Annu-

als from 1952; SRGM, Younger American Painters, 1954; Chicago/AI, 1954; U. of Nebraska, 1954; U. of Illinois, 1954, 56, 61, 63; Corcoran, 1956, 58, 61, 63; Minneapolis/Institute, 1957; WMAA, Nature in Abstraction, 1958; Brussels World's Fair, 1958; VMFA, 1958; Rome-New York Foundation, Rome, 1958; PAFA, 1959, Annual, 1964; Detroit/Institute, 1959; Carnegie, 1961; SRGM, Abstract Expressionists and Imagists, 1961; Brandeis U., New Directions in American Painting, 1963; Boston/MFA, 1966; Arts Club of Chicago, Liberman, Morris, Tworkov, 1975. **Collections:** Buffalo/Albright; Chase Manhattan Bank; Ciba-Geigy Corp.; Continental Grain Company; Des Moines; Detroit-/Institute; Ellerby Associates; U. of Illinois; Newark Museum; Reynolds Metals Co.; SRGM; The Singer Company Inc.; Toledo/MA; Union Carbide Corp.; WMAA; Walker; Washington U. **Bibliography:** Baur 5.

MORRIS, ROBERT. b. February 9, 1931, Kansas City, Mo. **Studied:** Kansas City Junior College; Kansas City Art Institute, 1948-50; U. of Kansas City; San Francisco Art Institute; Reed College, 1953-55; Hunter College, MA, 1966. US Army Engineers. Traveled USA, Orient, Europe. **Taught:** Hunter College, 1967- . **Commissions:** National Planning Commission, Ottawa, Earth Project. **Awards:** National Council on the Arts, **P.P.**; Chicago/AI, 1966; SRGM, 1967; Torcuato di Tella, Buenos Aires, 1967; Guggenheim Foundation Fellowship, 1969. **Address:** c/o Dealer. **Dealer:** Leo Castelli Inc. **One-man Exhibitions:** (first) Dilexi Gallery, San Francisco, 1957, also 1958; Green Gallery, NYC, 1963, 64, 65; Galerie Schmela, 1964; Dwan Gallery, Los Angeles, 1966; Leo Castelli Inc., 1967, 68, 69, 70, 72, 74; Eindhoven, 1968; Ileana Sonnabend Gallery, Paris, 1968, 71, 73, NYC, 1974; Corcoran, 1969; Gian Enzo Sperone, Turin, 1969; Irving Blum Gallery, Los Angeles, 1969, 70; Tate, 1971; Konrad Fischer Gallery, Dusseldorf, 1973; Max Protetch Gallery, Washington, D.C., 1973; Galleria Forma, Genoa, 1973; Modern Art Agency, Naples, 1973; ICA, U. of

Robert Morris *Untitled* 1974

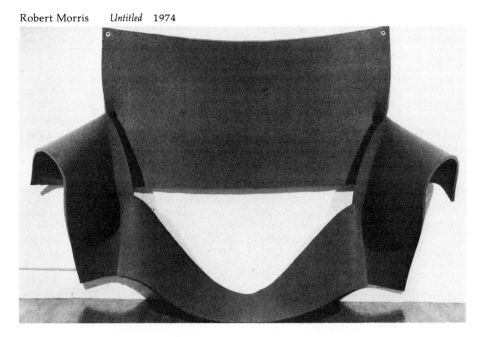

Pennsylvania, 1974; Galerie Art in Progress, Munich, 1974; Belknap Park, Grand Rapids, 1974. **Retrospective:** WMAA, 1970; Detroit/Institute, 1970. **Group:** Hartford/Wadsworth, Black, White, and Gray, 1964. WMAA, Young America, 1965; ICA, U. of Pennsylvania, The Other Tradition, 1966; Jewish Museum, Primary Structures, 1966; WMAA, Contemporary American Sculpture, Selection I, 1966; Chicago/AI, 1966; Walker, 1966; WMAA Sculpture Annuals, 1966, 68, 70; Detroit/Institute, Color, Image and Form, 1967; Los Angeles/County MA and PMA, American Sculpture of the Sixties, 1967; MOMA, The 1960's, 1967; Torcuato di Tella, Buenos Aires, 1967; Eindhoven, 1967; SRGM, Guggenheim International, 1967, 71; Buffalo/Albright, 1968; The Hague, Minimal Art, 1968; Foundation Maeght, 1968; MOMA, The Art of the Real, 1968; PMA, 1968; ICA, U. of Pennsylvania, 1969; Berne, When Attitudes Become Form, 1969; Walker, 14 Sculptors: The Industrial Edge, 1969; Indianapolis, 1969; WMAA, Anti-Illusion: Procedures/Materials, 1969; Hayward Gallery, London, Pop Art, 1969; MOMA, Spaces, 1969; MMA, New York Painting and Sculpture: 1940-1970, 1969-70; New School for Social Research, American Drawings of the Sixties, 1970; Boston U., American Artists of the Nineteen Sixties, 1970; Cornell U., Earth Art, 1970; Cincinnati/Contemporary, Monumental Art, 1970; ICA, U. of Pennsylvania, Against Order: Chance and Art, 1970; MOMA, Information, 1971; Kunsthalle, Nurnberg, Artist-Theory-Work, 1971; Buffalo/Albright, Kid Stuff, 1971; Dusseldorf/Kunsthalle, Prospect '71, 1971; Dublin/Municipal, International Quadriennial (ROSC), 1971; Chicago/Contemporary, Six Sculptors, 1971; Los Angeles/County MA, Art & Technology, 1971; Rijksmuseum Kroller-Muller, Diagrams and Drawings, 1972; New York Cultural Center, 3D into 2D, 1973; Parcheggio di Villa Borghese, Rome, Contemporanea, 1974; Princeton U., Line as Language, 1974; MIT,

Interventions in Landscapes, 1974; Cologne/Kunstverein, Kunst uber Kunst, 1974; CNAC, Art/Voir, 1974; Dusseldorf/Kunsthalle, Surrealitat-Bildrealitat: 1924-1974, 1974; Ackland, Light/Sculpture, 1975; Leverkusen, Drawings 3: American Drawings, 1975. **Collections:** Dallas/MFA; Detroit/Institute: Hartford/Wadsworth; Melbourne/National; Milwaukee; Oberlin College; Ottawa/National; Pasadena/AM; Stockholm/National; Tate; WMAA; Walker. **Bibliography:** *Art Now 74;* Battcock, ed.; Calas, N. and E.; Celant; *Contemporanea;* Davis, D.; De Vries, ed.; Friedman, M. 2; Friedman and van der Marck; Goossen 1; *Happening & Fluxus;* Honnef; Kozloff 3; *Kunst um 1970;* Lippard 4, 5; Lippard, ed.; Meyer; Muller; *Report;* Russel and Gablik; Trier 1; Tuchman 1; *When Attitudes Become Form.* Archives.

MOTHERWELL, ROBERT. b. January 24, 1915, Aberdeen, Wash. **Studied:** Stanford U., 1932-37, AB (Philosophy); California School of Fine Arts, *ca.* 1935; Harvard U., 1937-38; U. of Grenoble, summer, 1938; Columbia U., 1940-41; primarily self-taught in art. Traveled extensively, USA, Europe, Mexico. **Taught:** Hunter College, 1951-57; Columbia U., 1964-65; lectures extensively in American universities and museums. Series of paintings, "Elegy to Spanish Republic," begun 1947. Co-founder of a school, "Subject of the Artist," with William Baziotes, Barnett Newman, and Mark Rothko, NYC, 1948. Art Director, *Partisan Review,* 1962-65. Director, *Documents of Modern Art,* NYC, and *Documents of 20th Century Art.* **Commissions:** John F. Kennedy Federal Office Building, Boston, 1966; Stanford U., 1975; U. of Iowa. **Awards:** IV Guggenheim International, 1964 ($2500). **Address:** 909 North Street, Greenwich, Conn. 06830. **Dealer:** Knoedler Contemporary Art. **One-man Exhibitions:** (first) Art of This Century, NYC, 1944; Arts Club of Chicago, 1946; The Kootz Gallery, NYC, 1946, 47, 49, 52; SFMA, 1946, 67; New London, 1953; Sidney Janis Gal-

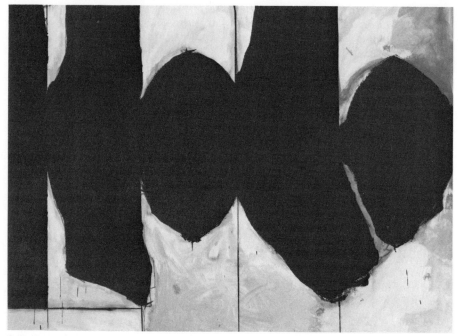

Robert Motherwell *Elegy to the Spanish Republic No. 128* 1974

lery, 1957, 59, 61, 62; Bennington College, 1959; John Berggruen Gallery, Paris, 1961, San Francisco, 1973; Sao Paulo, 1961; Pasadena/AM, 1962; Galleria Odyssia, Rome, 1962; Galerie der Spiegel, Cologne, 1962; Smith College, 1963; MIT, 1963; Galerie Schmela (two-man, with Conrad Marca-Relli); Duke U., 1965; Walker, 1965, 72, 74; College of St. Benedict, 1965; U. of Utah, 1966; Witte, 1966; U. of South Florida, 1966; Houston/Contemporary, 1966; Baltimore/MA, 1966; Indiana U., 1966; Amsterdam/Stedelijk, 1966; Whitechapel Art Gallery, London, 1966; Essen, 1966; Turin/Civico, 1966; WMAA, 1968; VMFA, 1969; Toledo/MA, 1969; Marlborough-Gerson Gallery Inc., 1969; Marlborough Galleria d'Arte, Rome, 1969; MOMA, 1969; David Mirvish Gallery, 1970, 73; Galerie Im Erker, St. Gallen, Switzerland, 1971; Kunstverein, Freiburg, 1971; Dayton's Gallery 12, Minneapolis, 1972; Lawrence Rubin Gallery, NYC, 1972,

73; MMA, 1972; U. of Iowa, 1972; Fendrick Gallery, 1972; Houston/MFA, 1972; Gertrude Kasle Gallery, 1972; Cleveland/MA, 1973; Princeton U., 1973; Current Editions, Seattle, 1973; Hartford/Wadsworth, 1973; Knoedler Contemporary Art, 1974, 75; Brooke Alexander, 1974; Otis Art Institute, 1974; Museum of Modern Art, Mexico City, 1975. **Retrospectives:** Phillips, 1965; MOMA, 1965-66. **Group:** Venice Biennial; Sao Paulo Biennial; WMAA Annuals; Brussels World's Fair, 1958; American Painting and Sculpture, Moscow, 1959; Documenta II & III, Kassel, 1959, 64; Tate, Dunn International, 1964; Tate, Gulbenkian International, 1964; U. of Illinois, 1967; Winnipeg Art Gallery, 1967; Chicago/AI Annuals; Boston Arts Festival; ICA, Boston, 1968; Carnegie, 1968, and others; MOMA, The New American Painting and Sculpture, 1969; Edmonton Art Gallery, Alberta, Masters of the Sixties, 1972; VMFA, Twelve American Paint-

ers, 1974. **Collections:** Amsterdam/ Stedelijk; Andover/Phillips; Baltimore/ MA; Bennington College; Brooklyn Museum; Brown U.; Buffalo/Albright; Chicago/AI; Cleveland/MA; Dallas/ MFA; Dayton/AI; Fort Dodge/Blanden; Harvard U.; Houston/MFA; U. of Illinois; Kultusministerium Baden-Wurttemberg; Los Angeles/County MA; MMA; MOMA; U. of Minnesota; NYU; U. of Nebraska; Pasadena/AM; Phillips; Provincetown/Chrysler; Raleigh/NCMA; Rio d Janeiro; SFMA; Smith College; Smithsonian; Society of the Four Arts; South Mall, Albany; Tel Aviv; Toronto; WMAA; Walker; Washington U.; U. of Washington; Yale U. **Bibliography:** Ashton 3, 5; Baur 7; Biederman 1; Bihalji-Merin; Blanchard; Blesh 1; Chipp; Eliot; Finkelstein; Flanagan; Goodrich and Baur 1; *The Great Decade;* Greenberg 1; Haftman; Henning; Hess, T. B. 1; Hunter 1, 6; Hunter, ed.; Janis and Blesh 1; Janis, S.; Kozloff 3; McCoubrey 1; McCurdy, ed.; Mendelowitz; *Metro;* Miller, ed. 2; **Motherwell 1, 2; Motherwell, ed.; Motherwell and Reinhardt, eds.**; Nordness, ed.; O'Hara 1; Paalen; Plous; Ponente; Pousette-Dart, ed.; Read 2; Ritchie 1; Rose, B. 1, 4; Rubin 1; Sandler; Seitz 1, 3; Seuphor 1; Soby 5; Tuchman, ed.; Weller; "What Abstract Art Means to Me." Archives.

MOY, SEONG. b. October 20, 1921, Canton, China. To USA 1931. **Studied:** Federal Art Project School, with Ben Swanson; St. Paul School of Art, 1936-40, with Cameron Booth; ASL, with Vaclav Vytlacil; Hofmann School, 1941-42, with Hans Hofmann; Atelier 17, NYC, 1948-50. US Air Force, 1943-46. **Taught:** U. of Minnesota, 1951; Indiana U., 1953; Smith College, 1954; Vassar College, 1955; Cooper Union, 1957- ; Columbia U., 1959- ; ASL, 1963- ; Moy Summer School, Provincetown; City College. Federal A.P.: Assistant in graphic shop. **Member:** Artists Equity; SAGA; Audubon Society. **Commissions:** International Graphic Arts Society (3 editions); New York Hilton Hotel; Fourth National Bank and Trust, Wichi-

ta (2 murals). **Awards:** Minneapolis/Institute, First Prize, 1939; The Print Club, Philadelphia, First Prize, 1948; John Hay Whitney Fellowship, 1950; Brooklyn Museum, **P.P.** 1953; Guggenheim Foundation Fellowship, 1955. **Address:** 100 La Salle Street, NYC 10027; Studio: 2231 Broadway, NYC 10024. **One-man Exhibitions:** (first) Carmel (Calif.) Art Association, 1943; Ashby Gallery, NYC, 1947; Carlebach Gallery, NYC, 1949; Springfield, Ill./ State, 1949; Hacker Gallery, NYC, 1950; Dubin Gallery, Philadelphia, 1950; U. of Minnesota, 1951; The New Gallery, NYC, 1951, 52, 54; Boris Mirski Gallery, Boston, 1955; The Contemporaries, NYC, 1955; The Howard Wise Gallery, Cleveland, 1958; Grand Central Moderns, NYC, 1959; Yamada Gallery, Kyoto, 1959; The Miller Gallery, Cincinnati, 1974. **Group:** MMA, 1950; U. of Illinois, 1951, 53, 54; Carnegie, 1955; U. of Minnesota; Brooklyn Museum; Chicago/AI; MOMA; PAFA; Library of Congress; New York World's Fair, 1964-65. **Collections:** Abbott Laboratories; Andover/Phillips; Bibliotheque Nationale; Boston/MFA; Brooklyn Museum; Indiana U.; Library of Congress; MMA; MOMA; Memphis/Brooks; U. of Minnesota; NYPL; PAFA; PMA; Smith College; Smithsonian; Tel Aviv; Victoria and Albert Museum; WMAA; Walker; Worcester/AM. Archives.

MOYER, ROY. b. August 20, 1921, Allentown, Pa. **Studied:** Columbia U., BA, MA; U. of Oslo; self-taught in art. Traveled extensively; resided in Europe (mainly Greece), four years. **Taught:** U. of Salonica, Greece, 1948-51; U. of Toronto, 1953-55. Director, American Federation of Arts, 1963-72. **Awards:** Audubon Artists, Jane Peterson Award, 1969, 72; Youngstown/Butler, First Prize for Painting, 1973. **Address:** 440 Riverside Drive, NYC 10027. **Dealer:** Rolly-Michaux, NYC and Boston. **One-man Exhibitions:** (first) Salonica, Greece, 1949; The Contemporaries, NYC, 1958, 59, 61, 62, 65; The Midtown

Galleries, 1967; Rockford/Burpee, 1969; Sneed-Hillman Gallery, 1969; Rolly-Michaux, NYC, 1974, Boston, 1975; Kendall Gallery, Wellfleet, Mass., 1975. **Group:** U. of Illinois, 1959; WMAA Annual, 1960; Washington U., 1967; Colorado Springs/FA, 1967; Louisville/Speed, 1967; Akron/AI, 1968; U. of Georgia, 1968; and others. **Collections:** Brandeis U.; Sara Roby Foundation; U. of Rochester; Rockford/Burpee; Wichita/AM.

MULLER, JAN. b. December 27, 1922, Hamburg, Germany; **d.** January 29, 1958, NYC. Traveled Czechoslovakia, Switzerland, Holland, southern France, 1933-41. To USA 1941. **Studied:** Hofmann School, 1945-50. Co-founder of Hansa Gallery, NYC, 1952. **One-man Exhibitions:** (first) Hansa Gallery, NYC, 1953, also 1954, 55, 56, 57, 58; Sun Gallery, Provincetown, 1955, 56; U. of Minnesota, 1960; The Zabriskie Gallery, 1961; Noah Goldowsky, 1970, 71, 72. **Retrospective:** Hansa Gallery, NYC, 1959; SRGM, 1962. **Group:** 813 Broadway (Gallery), NYC, 1952; Chicago/AI, 1953; U. of Minnesota, 1955; The Stable Gallery Annual, 1956; Jewish Museum, The New York School, Second Generation, 1957; WMAA, Young America, 1957; Carnegie, 1958; Festival of Two Worlds, Spoleto, 1958; ICA, Boston, 1958, 59; MOMA, New Images of Man, 1959; A.F.A., The Figure, circ., 1960. **Collections:** Charlotte/Mint; MOMA; Newark Museum. **Bibliography:** Messer.

MULLICAN, LEE. b. December 2, 1919, Chickasha, Okla. **Studied:** Abilene Christian College, 1937; U. of Oklahoma, 1939; Kansas City Art Institute and School of Design, 1941, with Fletcher Martin. Corps of Army Engineers, 1942-46. Traveled Europe, South America. **Taught:** UCLA, 1962-75; U. of Chile, Artist-in-Residence Exchange Program, 1968. **Awards:** Guggenheim Foundation Fellowship, 1959; U. of California, Creative Arts Grant, 1964; Tamarind Fellowship, 1964-65. **Address:** 370 Mesa Road, Santa Monica, Calif. **Dealer:** Gallery of Contemporary Art, Taos. **One-man Exhibitions:** SFMA, 1949; The Swetzoff Gallery, Boston, 1950; The Willard Gallery, 1950, 52, 53, 59, 61, 67; Dynation Exhibition, San Francisco, 1951; Oklahoma, 1951, 67; Paul Kantor Gallery, Beverly Hills, Calif., 1952, 53, 56; The Rose Rabow Gallery, San Francisco, 1955, 74; Santa Barbara/MA, 1958; Silvan Simone Gallery, 1965-67; Santiago, Chile, 1968; UCLA, 1969; Jodi Scully Gallery, 1973; Contemporary Art Gallery, Santa Fe, 1973. **Group:** Corcoran, 1948; Denver/AM Annuals, 1950, 55, 56, 57; Chicago/AI, 1951, 54; Carnegie, 1951, 64, 66; WMAA Annuals, 1952, 56; U. of Nebraska, 1953; U. of Illinois, 1953, 55, 57; MMA, 1954; Sao Paulo, 1955; Santa Barbara/MA, 1957; MOMA, 1957; PAFA, 1958, 67; Rome-New York Foundation, Rome, 1960; Pasadena/AM, 1961; Newport Harbor, The Artist Collects, 1975. **Collections:** U. of California; Colorado Springs/FA; Denver/AM; Detroit/Institute; Los Angeles/County MA; MOMA; New Orleans/Delgado; Oklahoma; Pasadena/AM; Phillips; SFMA; San Francisco Municipal Art Commission; Santa Barbara/MA; Santiago, Chile; Syracuse U.; Tulsa/Philbrook; Wichita State U. **Bibliography:** Pousette-Dart, ed.; Richardson, E. P.

MURCH, WALTER TANDY. b. August 17, 1907, Toronto, Canada; **d.** December 11, 1967, NYC. **Studied:** Ontario College of Art, 1924-27, with Arthur Lismer, L. Harris; ASL, 1929-30, with Kenneth Hayes Miller, William Von Schlegell; Grand Central School, NYC, 1930, with Arshile Gorky; and privately, with Gorky, 1931-32. US citizen, 1948. Traveled Mexico, Canada, France. **Taught:** Pratt Institute, 1952-61; NYU, 1961; Boston U., 1961-67; Columbia U., 1964. **Commissions:** *Scientific American; Fortune* Magazine. **Awards:** U. of Illinois, **P.P.,** 1949; NIAL Grant, 1961; Ford Foundation, **P.P.** (2). **One-man Exhibitions:** (first) Wakefield Gallery, NYC,

1941; Mortimer Brandt, NYC, 1946; Betty Parsons Gallery, 1947, 49, 51, 54, 57 59, 62, 66, 70, 71; St. Louis Art Center, 1949; Allan Frumkin Gallery, Chicago, 1953; Worth Avenue Gallery, Palm Beach, Fla., 1955; Choate School, Wallingford, Conn., 1959; Hampton Gallery, Huntington, W. Va., 1964; Lehigh U., 1966. **Retrospective:** RISD, 1966. **Group:** Andover/Phillips, 1945; Corcoran, 1945, 46, 52-55, 58, 61, 64; Chicago/AI, 1945, 46, 54, 56, 58, 59, 60, 62, 63; PAFA, 1945, 46, 53, 54, 55, 57, 59, 60, 63, 64; WMAA Annuals, 1945-64; Worcester/AM, 1947; U. of Illinois, 1951, 52, 54, 61, 63; Contemporary American Painting, Tokyo, 1952; Detroit/Institute, 1952, 57; MMA, Edward Root Collection, 1953; PMA, 1954; Dallas/MFA, 1954; Indianapolis/Herron, 1954; WMAA, The New Decade, 1954-55; Walker, 1955; A.F.A., World at Work, 1955; ICA, London, American Painting; XXVIII Venice Biennial, 1956; Minneapolis/Institute, American Painting, 1945-57, 1957; ART:USA:59, NYC, 1959; A.F.A., Private Worlds, 1960; Milwaukee, American Painting, 1760-1960, 1960; NIAL, 1961; New School for Social Research, The Creative Process, 1961; Carnegie, 1964; U. of Rochester, In Focus, 1964; New York World's Fair, 1964-65; Detroit/Institute, 40 Key Artists of the Mid-20th Century, 1965; WMAA, A Decade of American Drawings, 1965; RISD, Recent Still Life, 1966. **Collections:** Andover/Phillips; Barnes Foundation; Brooklyn Museum; Buffalo/Albright; Carnegie; Chase Manhattan Bank; Corcoran; First National City Bank; Hallmark Collection; Hartford/Wadsworth; IBM; U. of Illinois; Jay Mfg. Co.; Kalamazoo/Institute; Lane Foundation; MMA; MOMA; NCFA: Newark Museum; Omaha/Joslyn; PAFA; Scientific American Inc.; Toledo/MA; Union Carbide Corp.; Upjohn Co.; Utica; WGMA; WMAA; Westmoreland County/MA. **Bibliography:** Baur 7; Flanagan; Goodrich and Baur 1; Nordness, ed.; Pousette-Dart, ed.; **Robbins;** Soby 5. Archives.

MURRAY, ROBERT. b. March 2, 1936, Vancouver (B.C.), Canada. **Studied:** School of Art, U. of Saskatchewan (with Arthur McKay, Roy Kiyooka, Kenneth Lochhead, R. Simmons), 1956-58; Emma Lake Artist's Workshops, U. of Saskatchewan, with Will Barnet, 1957, Barnett Newman, 1959, John Ferren, 1960, Clement Greenberg, 1962, Jack Shadbolt. Traveled Western Hemisphere. Royal Canadian Air Force (auxiliary). **Taught:** U. of Saskatchewan; Hunter College; Yale U.; U. of Oklahoma; School of Visual Arts, NYC. **Commissions:** Saskatoon City Hall, 1959-60; Long Beach State College, 1965; Expo '67, Montreal, 1967; Vancouver International Airport, 1967. **Awards:** Canada Arts Council Scholarship, 1960, Grant, 1969; National Council on the Arts, 1968; National Endowment for the Arts Grant, 1969; Sao Paulo Biennial, Second Prize, 1969. **Address:** 22 Cooper Square, NYC 10003; Coatesville, Pa. 19320. **Dealers:** David Mirvish Gallery; Paula Cooper Gallery; Lippincott Inc. **One-man Exhibitions:** (first US) Betty Parsons Gallery, 1965, also 1966, 68; Jewish Museum, 1967; David Mirvish Gallery, 1967, 68, 70, 72, 74, 75; Vancouver (two-man), 1969 and 1970; Battery Park, NYC; Dag Hammarskjold Plaza, NYC, 1971; Paula Cooper Gallery, 1974. **Group:** Ottawa/National, Outdoor Sculpture Exhibition, 1962; Hart House, U. of Toronto, 1964; Finch College, NYC, Artists Select, 1964; U. of Toronto Sculpture Annuals, 1964, 67; WMAA Sculpture Annuals, 1964, 66, 68, 70, 73; WMAA, Young America, 1965; Toronto, 1965; Musee Cantonal des Beaux-Arts, Lausanne, II Salon International de Galeries Pilotes, 1966; Los Angeles/County MA, American Sculpture of the Sixties, circ., 1967; Expo '67, Montreal, 1967; ICA, Boston, Nine Canadians, 1967; SRGM, Guggenheim International, 1967; WMAA, 1967; Paris/Moderne, Canada: Art d'Aujourd'hui, 1968; Walker, 14 Sculptors: The Industrial Edge, 1969; X Sao Paulo Biennial, 1969; Grand Rapids, 1969; Cincinnati/Contemporary, Mon-

umental Art, 1970; Chicago/Contemporary, 49th Parallel: New Canadian Art, 1971; Middelheim Park, Antwerp, XI Sculpture Biennial, 1971; Grand Rapids, Sculpture off the Pedestal, 1973; Newport, R. I., Monumenta, 1974. **Collections:** U. of Alberta; City of Saskatoon; Fredonia/SUNY; Hirshhorn; Long Beach State College; Melbourne/National; Montreal/MFA; New Brunswick Museum; Ottawa/National; St. John, N.B.; Seagram Collection; Swarthmore College; U. of Sydney; Syracuse/Everson; Toronto; Vancouver; WMAA; Walker; Wayne State U. **Bibliography:** Friedman, M. 2; *Monumenta;* Tuchman 1.

NADELMAN, ELIE. b. February 20, 1882, Warsaw, Poland; **d.** December 28, 1946, NYC. **Studied:** Art Academy, Warsaw, 1901; Academie Colarossi, Paris, 1904; privately with Konstantin Lazczka, 1902. Imperial Russian Army, 1900. Traveled Russia, Europe, USA. To USA 1914. **Awards:** Sztuka Prize, 1902. **One-man Exhibitions:** (first) Galerie Drouant, Paris, 1909, also 1913; Photo-Secession, NYC, 1915; Scott and Fowles Gallery, NYC, 1917, 25; M. Knoedler & Co., NYC, 1919, 27; Galerie Bernheim-Jeune, Paris, 1920, 27; Arts Club of Chicago, 1925; MOMA, 1948; The Zabriskie Gallery, 1967; Stanford U., 1968. **Retrospective:** WMAA, 1975. **Group:** Salon des Artistes Independants, Paris, 1905-08; Salon d'Automne, Paris, 1905-08; Non-Jury Salon, Berlin, 1913; The Armory Show, 1913; Photo-Secession, NYC, 1915; Carnegie, 1938; WMAA; MOMA; MMA. **Collections:** MOMA; Newark Museum; Utica; WMAA. **Bibliography:** *Avant-Garde Painting and Sculpture;* Baur 7; Biddle 4; Birnbaum; Blesh 1; Brumme; Cheney; Craven, W.; Goodrich and Baur 1; Hunter 6; Huyghe; *Index of 20th Century Artists;* **Kirstein 1, 2, 4;** Licht, F.; McCurdy, ed.; Mendelowitz; Motherwell 1; **Murrell 2;** Richardson, E.P; Ringel, ed.; Rose, B. 1; Selz, J.

NAKIAN, REUBEN. b. August 10, 1897, College Point, N.Y. **Studied:** Robert Henri School, with Homer Boss, A.S. Baylinson; ASL, 1912; apprenticed to Paul Manship, 1917-20, and Gaston Lachaise. Traveled Italy, France. **Taught:** Newark Fine Arts and Industrial Arts College; Pratt Institute, 1949. **Commissions:** NYU, 1960 (sculpture). **Awards:** Guggenheim Foundation Fellowship, 1930; Ford Foundation Grant, 1959 ($10,000); Sao Paulo, 1960. **Address:** 30 Windmill Circle, Stamford, Conn. **Dealer:** The Graham Gallery. **One-man Exhibitions:** (first) The Downtown Gallery, 1933, also 1935; Charles Egan Gallery, NYC, 1949, 50, 52, 63, 64, 65, 68, 70; Stewart-Marean Gallery, NYC, 1958; Sao Paulo, 1961; Los Angeles/County MA, 1962; WGMA, 1963; Felix Landau Gallery, 1967; U. of Bridgeport, 1972; New York Studio School, Paris, 1974; The Graham Gallery, 1975. **Retrospective:** MOMA, 1966. **Group:** Salons of America, NYC, 1922; Whitney Studio Club, NYC; WMAA; Chicago/AI; PAFA; XXXIV Venice Biennial, 1968; MOMA, The New American Painting and Sculpture, 1969. **Collections:** MOMA; NYU. **Bibliography:** Cahill and Barr, eds.; Cheney; Craven, W.; Hunter, ed.; **O'Hara 1, 5;** Rose, B. 1; Tuchman 1.

NATKIN, ROBERT. b. November 7, 1930, Chicago, Ill. **Studied:** Chicago/AI School, 1952. Designed Backdrop for Paul Sanasardo Dance Co., NYC, 1974. **Address:** 924 West End Avenue, NYC 10025. **Dealer:** Andre Emmerich Gallery, NYC. **One-man Exhibitions:** Wells Street Gallery, Chicago, 1957, 58; Poindexter Gallery, 1959, 61, 63, 65, 67, 68; Ferus Gallery, Los Angeles, 1960; Fairweather-Hardin Gallery, 1963, 64, 66, 68, 73; Gertrude Kasle Gallery, 1966, 68, 74; Meredith Long Gallery, 1968; Andre Emmerich Gallery, NYC, 1970, 73, 74, Zurich, 1974; The Pennsylvania State U. (two-man), 1973; Jack Glenn Gallery, Corona del Mar, 1973; Makler Gallery, 1974; Holburne of Menstrie Museum and Festival, Bath,

England, 1974; William Sawyer Gallery, 1974; Galerie Merian Edition, Krefeld, 1974; Il Cerchio, Milan, 1974; Galleria Venezia, Venice, 1974. **Retrospective:** SFMA, 1969. **Group:** Chicago/AI, Exhibition Momentum, 1950, 56, 57, also 1955, 57, 59, 62; WMAA, Young America, 1960; Carnegie, 1961; ICA, Boston, 1961; WGMA, Lyricism in Abstract Art, 1962; International Mitsubishi, Tokyo and other Japanese cities, 1963; WMAA Annual, 1966, 68; Galerie Paul Facchetti, 1968; SFMA, 1969; WMAA Annual, 1969; SRGM, 1970, 74; Festival of Two Worlds, Spoleto, 1972. **Collections:** Carnegie; Brandeis U.; Duke U.; Hartford/Wadsworth; ICA, Boston; U. of Illinois; Los Angeles/ County MA; MOMA; NYU; The Pennsylvania State U.; RISD; SFMA; SRGM; WMAA; Worcester/AM.

NAUMAN, BRUCE. b. December 6, 1941, Fort Wayne, Ind. **Studied:** U. of Wisconsin, BS, 1960-64, with Italo Scanga; U. of California, Davis, 1965, MA. **Taught:** U. of California, Irvine, 1970. **Awards:** National Endowment for the Arts Grant, 1968; Aspen Institute, 1970. **Address:** c/o Dealer. **Dealer:** Leo Castelli Inc., NYC. **One-man Exhibitions:** Nicholas Wilder Gallery, 1966, 69, 70; Leo Castelli Inc., NYC, 1968, 69, 71, 73; Konrad Fischer Gallery, Dusseldorf, 1968, 70, 71, 74; Sacramento State College, 1968; Ileana Sonnabend Gallery, Paris, 1969, 71; Gian Enzo Sperone, Turin, 1970; ACE Gallery, Vancouver, 1971; Joseph Helman Gallery, St. Louis, 1971; Françoise Lambert, Milan, 1971; U. of California, Irvine, 1973; Eindhoven, 1973; Galerie Art in Progress, Munich, 1974; Wide White Space Gallery, Antwerp, 1974; Cirrus Editions Ltd., 1974. **Retrospectives:** Dusseldorf/ Kunsthalle, 1973; Los Angeles/County MA, 1973. **Group:** SFMA, New Directions, 1966; Los Angeles/County MA, American Sculpture of the Sixties, circ., 1967; Documenta IV, Kassel, 1968; Oberlin College, Three Young Americans, 1968; A.F.A., Soft Sculpture, 1968; Corcoran, 1969; Berne, When Attitudes

Become Form, 1969; WMAA, Anti-Illusion: Procedures/Materials, 1969; SRGM, 1969; Chicago/Contemporary, Holograms and Lasers, 1970; ICA, U. of Pennsylvania, Against Order: Chance and Art, 1970; WMAA, 1970; Dusseldorf/Kunsthalle, Prospect '71, 1971; MOMA, Information, 1971; Hayward Gallery, London, 11 Los Angeles Artists, 1971; Rijksmuseum Kroller-Muller, Diagrams and Drawings, 1972; Hamburg/Kunstverein, USA: West Coast, circ., 1972; New York Cultural Center, 3D into 2D, 1973; Seattle/AM, American Art—Third Quarter Century, 1973; Parcheggio di Villa Borghese, Rome, Contemporanea, 1974; Chicago/ AI, Idea and Image in Recent Art, 1974; Indianapolis, 1974; CNAC, Art/Voir, 1974. **Collections:** Aachen/Kunstverein; Cologne; Southwestern College, Chula Vista; WMAA. **Bibliography:** *Art Now 74;* Celant; *Contemporanea;* Davis, D.; *Kunst um 1970;* Lippard, ed.; **Livingston and Tucker;** Meyer; Muller; *Report; USA West Coast; When Attitudes Become Form.*

NEAL, REGINALD. b. May 20, 1909, Leicester, England. **Studied:** Yale U., 1929-30; Bradley U., BA, 1932; State U. of Iowa, summer, 1936; The U. of Chicago, MA (Art History), 1939; Colorado Springs Fine Arts Center, summer, 1941. **Taught:** Millikin U., 1940-46; Escuela de Bellas Artes, San Miguel de Allende, Mexico, summer, 1944; U. of Mississippi, 1951-57; The Contemporaries Graphic Center, NYC, summer, 1956; New Paltz/SUNY, 1957-58; Southern Illinois U., 1958-59, 1966, 67; Douglass College, 1959- ; Yale U., 1966. **Commissions:** A.A.A. Gallery, NYC (two editions of lithographs). **Awards:** Film Council of America, Golden Reel Award, 1956 (American Film Festival, Chicago), for a 30-min. color film, "Color Lithography—An Art Medium." **Address:** Circle Drive, RD 1, Lebanon, N.J. 08833. **Dealer:** A.M. Sachs Gallery. **One-man Exhibitions:** Decatur, 1944; Davenport/Municiapl, 1945, 51; South Bend (Ind.) Art Center, 1950; A.A.A. Gallery, Chicago, 1950; U.

of Mississippi, 1951, 55; The Salpeter Gallery, NYC, 1953; New Paltz/SUNY, 1953; Pratt-Contemporaries, NYC, 1960; Allan Stone Gallery, 1962; Primus-Stuart Gallery, Los Angeles, 1962; Rutgers U., 1965; A.M. Sachs Gallery, 1968. **Group:** MMA; Cincinnati/AM, 1954, 56, 58; Brooklyn Museum; Library of Congress; Houston/MFA, 1956; Oakland/AM; Riverside Museum; Gallery of Modern Art, Ljubljana, Yugoslavia, III & IV International Exhibitions of Prints, 1959, 61; Albany/Institute, 1965; U. of North Carolina, 1965. **Collections:** Allentown/AM; American Republic Insurance Co.; Atlanta/AA; Cincinnati/AM; Davenport/Municipal; Decatur; Des Moines; Grenchen; Hartford/Wadsworth; Library of Congress; MOMA; U. of Massachusetts; Memphis/Brooks; Philip Morris Collection; Princeton U.; Queens U.; Rutgers U.; Southern Illinois U.; WGMA. **Bibliography:** Bijalji-Merin; Reese.

NEPOTE, ALEXANDER. b. November 6, 1913, Valley Home, Calif. **Studied:** California College of Arts and Crafts, BA; Mills College; U. of California, MA. Traveled Europe. **Taught:** California College of Arts and Crafts, 1945-50; San Francisco State College, 1950- . **Awards:** SFMA, James D. Phelan Award, 1941, 42; Oakland/AM, 1947, 48, **P.P.**, 1955, Silver Medal, 1957; San Francisco Art Festival, 1951, 53, 59, 60; San Mateo County Fair, 1954, 57; Pasadena/AM, **P.P.**, 1957; California State Fair, 1957, 58; California Palace, 1958; California Watercolor Society, First Award, 1965; Northern California Artists, First Award, 1965; Rio Hondo College Invitational, First Award, 1968; San Mateo Art Fiesta, First Award, 1969. **Address:** 410 Taylor Boulevard, Millbrae, Calif. 94030. **One-man Exhibitions:** Quay Gallery, 1966; Kramer Gallery, San Francisco, 1968; Richard White Gallery, Seattle, 1968; Emerson Gallery, Encino, Calif., 1969; Barrios Art Gallery, Sacramento, 1969; St. Mary's College, Moraga, Calif.,

1969; College of Idaho, 1970. **Retrospective:** Redwood City Municipal Gallery, 1974. **Group:** United Nations Conference Exhibition, San Francisco, 1945; California Palace, 1947, 48, 52, 59, 60, 61; Grand Central, NYC, 1948; WMAA, 1951; U. of Illinois, 1951, 52; A.F.A.; MMA, 1952; Sao Paulo, 1955; SFMA, 1955; a gallery in Provincetown, Mass., 1958; ART:USA:58, NYC, 1958; VMFA, American Painting, 1962; Expo '70, Osaka, 1970; Auckland, Art of the Pacific Basin, 1971; National Watercolor Society Annuals, 1973, 74. **Collections:** California Palace; Chico State College; Denver/AM; Los Angeles/County MA; MMA; U. of Michigan; Mills College; Oakland/AM; Pasadena/AM; Rio Hondo College; SFMA; Sacramento/Crocker; San Francisco Municipal Art Commission; Southern Idaho College; Utah State U.; Walnut Creek Municipal Collection.

NESBITT, LOWELL. b. October 4, 1933, Baltimore, Md. **Studied:** Temple U., BFA, 1950-55; Royal College of Art, London, 1955-56. US Army, 1957-58. Traveled Europe. **Taught:** Baltimore/MA; Towson State Teachers College; Morgan State College; School of Visual Arts, NYC. **Commissions:** National Aeronautics & Space Administration. **Address:** 389 West 12 Street, NYC 10014. **Dealers:** Gertrude Kasle Gallery; Andrew Crispo Gallery; Pyramid Art Galleries; Brooke Alexander. **One-man Exhibitions:** (first) Baltimore/MA, 1958, also 1959-69; Bader Gallery, Washington, D.C., 1963; Corcoran, 1964; Rolf Nelson Gallery, Los Angeles, 1966; Henri Gallery, 1965-67, 1969; The Howard Wise Gallery, NYC, 1965, 66; Gertrude Kasle Gallery, 1966-69, 1970, 71, 74; Jefferson Gallery, 1967; Temple U., 1967; Galleria Sperone, Turin, 1967 (two-man, with Joseph Raffael); The Stable Gallery, NYC, 1968, 69; U. of Richmond; M. E. Thelen Gallery, Cologne, 1969, 70, 72; Gimpel Fils, 1970, 74; Gimpel & Weitzenhoffer Ltd., 1971, 73; Pyramid Art Galleries, 1971, 75; Hansen-Fuller Gallery, 1972; Gimpel &

Hanover, 1972; Galleri Fabian Carlsson, Goteborg, 1972; Corcoran and Corcoran, Coral Gables, 1972; Galleri Ostergren, Malmo, 1972; Kunstverein, Freiburg, 1972; Galerie Arnesen, Copenhagen, 1972, 74; Galerie Aronowitsch, Stockholm, 1972; Marion Locks Gallery, Philadelphia, 1973; Galerie Craven, Paris, 1973; Corcoran, 1973; Stefanotty Gallery, NYC, 1973, 74; Fendrick Gallery, 1974; Brooke Alexander, 1974; Walton Gallery, San Francisco, 1974; H.M., Brussels, 1974; Museo de Bellas Artes, San Jaun, 1974; U. of Rochester, 1975; City Center, NYC, 1975. **Group:** Pan-American Union, Washington, D.C., circ. Latin America, 1964-66; New York World's Fair, 1964-65; Ridgefield/Aldrich, 1965; Flint/Institute, Realism Revisited, 1966; U. of Illinois, 1967; Milan, 1967; Los Angeles/County MA, 1967; International Biennial of Paintings, Tokyo, 1967; IX Sao Paulo Biennial, 1967; ICA, London, 1968; WMAA Annual, 1967; Milwaukee, Aspects of a New Realism, 1969; Sweden/Goteborgs, Warmwind, 1970; Cologne, Target Moon, 1971; Brooklyn Museum, Print Exhibition, 1972; Galerie des 4 Mouvements, Paris, Hyperrealistes Americains, 1972; Bibliotheque Nationale, L'Estampe Contemporaine, 1973; Tokyo Biennial, 1974; Paris/Moderne, 1974; West Palm Beach/Norton, Imagist Realism, 1975; U. of Redlands, Handcolored Prints, circ., 1975. **Collections:** Aachen/NG; Baltimore/MA; The Bank of New York; Bibliotheque Nationale; CNAC; Chase Manhattan Bank; Chicago/AI; Cleveland/MA; Corcoran; Detroit/Institute; F.T.D. Association; Ford Motor Company; Fort Worth; Goucher College; International Monetary Fund; La Jolla; Library of Congress; MOMA; U. of Maryland; NCFA; National Gallery; Northern Trust Co.; J.C. Penny Corp.; Phillips; Ponce; U. of Rochester; Saginaw; Temple U.; U. of Virginia; WGMA; Worcester/AM; Yale U. **Bibliography:** Davis, D.; *Kunst um 1970*; Sager.

NEUMAN, ROBERT S. b. September 9, 1926, Kellogg, Ida. **Studied:** California School of Fine Arts; Mills College, with Max Beckmann; U. of Idaho; Academy of Fine Arts, Stuttgart, with Willi Baumeister. Traveled Europe, USA. **Taught:** Harvard U., Carpenter Center for Visual Arts, 1963-64; Brown U.; Keene (N.H.) State College, 1972- . **Awards:** Fulbright Fellowship, 1953; Guggenheim Foundation Fellowship, 1956-57; Boston Arts Festival, Grand Prize, 1961; Brown U., Howard Foundation Grant for Painting, 1967. **Address:** 178 Main Street, Keene, N.H. 03431. **Dealer:** Allan Stone Gallery. **One-man Exhibitions:** Gump's Gallery, 1952; Felix Landau Gallery, 1954; La Escondida, Taos, N.M., 1956; Sala Vayreda, Barcelona, 1956; Galleria del Cavallino, Venice, 1957, 60; The Swetzoff Gallery, Boston, 1957, 58; Allan Stone Gallery, Harrison, N.Y., 1959; Gres Gallery, Washington, D.C., 1959; The Pace Gallery, Boston, 1960, 62; Lincoln, Mass./De Cordova, 1963; Allan Stone Gallery, NYC, 1966; Ward-Nasse Gallery, Boston, 1966, 67; Exeter, 1967; Waitsfield/Bundy, 1968; Michael Walls Gallery, 1968; Bristol (R.I.) Museum of Art, 1968 (two-man, with Hugh Townley); U. of Idaho, 1969. **Group:** California Palace, 1951; SFMA, 1951-53; Denver/AM, 1952; MMA, 1952; WMAA, 1952, 58; U. of Illinois, 1952, 61; PAFA, 1953; Colorado Springs/FA, 1953; Kyoto, Japan, 1956; ICA, Boston, 1958-60; Carnegie, 1961; Seattle World's Fair, 1962; M. Knoedler & Co., Art Across America, circ., 1965-67; New School for Social Research, 1966; State U. of Iowa, 1968. **Collections:** American Broadcasting Co.; Andover/Phillips; Boston/MFA; Boston U.; Carnegie; ICA, Boston; Lincoln, Mass./De Cordova; MOMA; SFMA; Worcester/AM; Yale U.

NEVELSON, LOUISE. b. 1900, Kiev, Russia. To USA 1905. **Studied:** ASL, 1929-30, with Kenneth Hayes Miller; Hofmann School, Munich, 1931; assistant to Diego Rivera in Mexico City, 1932-33. Traveled Europe, Central and South America. **Taught:** Educational Alliance, NYC; Great Neck (N.Y.) Adult Education Program; New York School

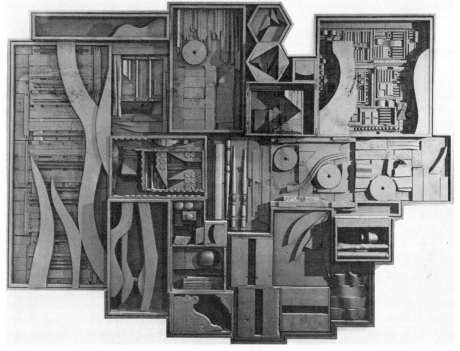

Louise Nevelson *Night Zug Wall* 1973

for the Deaf. **Member:** Artists Equity (President); Sculptors Guild (Vice President); Federation of Modern Painters and Sculptors (Vice President). **Federal A.P.:** Easel painting. **Awards:** ART: USA:59, NYC, Grand Prize, 1959; Chicago/AI, The Mr. & Mrs. Frank G. Logan Prize, 1960; Tamarind Fellowship, 1963; MacDowell Colony Medal, 1969; Hamline U., Honorary Doctor of Humanities; Brandeis U., Creative Arts Award, 1971; Hobart and William Smith College, Honorary Doctor of Humane Letters, 1971; Smith College, Hon. DFA, 1973. **Commissions:** Princeton U., 1969; Temple Beth-El, Great Neck, N.Y., 1970; Temple Israel, Boston, 1973; City of Scottsdale, 1973; City of Binghamton, N.Y., 1973; Federal Courthouse, Philadelphia, 1975; MIT. **Address:** 29 Spring Street, NYC 10012. **Dealer:** The Pace Gallery. **One-man Exhibitions:** (first) Karl Nierendorf Gallery, NYC, 1941, also 1943, 44, 46; Norlyst Gallery, NYC, 1941, 43; Lotte Jacobi Gallery, NYC, 1950; Grand Central Moderns, NYC, 1951, 54, 56, 57, 58; Esther Stuttman Gallery, NYC, 1958; Martha Jackson Gallery, 1959, 61, 70; Daniel Cordier, Paris, 1960; David Herbert Gallery, NYC, 1960; Devorah Sherman Gallery, 1960; The Pace Gallery, Boston, 1960, 64, NYC, 1965, 66, 69, 72, 74; Sidney Janis Gallery, 1963; Hanover Gallery, 1963; Gimpel & Hanover Galerie, Zurich, 1964; Berne, 1964; Galleria d'Arte Contemporanea, Turin, 1964; David Mirvish Gallery, 1965; Galerie Schmela, 1965; Ferus/Pace Gallery, Los Angeles, 1966; Arts Club of Chicago, 1968; Turin/Civico, 1969; Harcus-Krakow Gallery, 1969; Galerie Jeanne Bucher, Paris, 1969; Pace Gallery, Columbus, 1969, 74; Houston/MFA, 1969; Rijksmuseum Kroller-Muller, 1969; U. of Texas, 1970; WMAA, 1970; Makler Gallery, 1971, 74; Dunkelman Gallery, Toronto, 1972; Parker Street 470 Gallery, Boston, 1972; Studio Marconi, Milan, 1973; Stockholm/Na-

tional, 1973; Brussels/Beaux-Arts, 1974; Paris/Moderne, 1974; Berlin/National, 1974; Minami Gallery, 1975; Galleria d'Arte Spagnoli, Florence, Italy, 1975; Harcus Krakow Rosen Sonnabend, Boston, 1975. **Retrospectives:** WMAA, 1966; Walker, circ., 1973. **Group:** Sezession Gallery (Europe), 1933-38; Contemporary Arts Gallery, NYC; Jacobsen Gallery, NYC; Society of Independent Artists, NYC; Brooklyn Museum; ACA Gallery; Federal Art Project Gallery, NYC, 1933-38; PAFA, 1944; VMFA, 1957; Riverside Museum, Directions in Sculpture, 1957; A.F.A., Art and the Found Object, circ., 1959; Jeanne Bucher, Paris (three-man), 1958; MOMA, Sixteen Americans, circ., 1959; ART:USA:59, NYC, 1959; Rome-New York Foundation, Rome, Ciphers, 1960; Utica, Art Across America, 1960; A.F.A., Unique Impressions, 1960; XXXI Venice Biennial, 1962; WMAA Annuals, 1947, 57, 61, 64, 66, 69; Federation of Modern Painters and Sculptors Annuals, 1955, 56, 57, 59; A.F.A., Contemporary Trends, circ., 1955-56; American Abstract Artists Annuals, 1956, 57, 59, 60; Documenta III, Kassel, 1964; MOMA, Contemporary Painters and Sculptors as Printmakers, 1964; Dallas/MFA, 1965; WMAA, Art of the U.S. 1670-1966, 1966; Chicago/AI, 1966, 67; Los Angeles/County MA, American Sculpture of the Sixties, 1967; SRGM, 1967; Jewish Museum, 1968; WMAA, 1969, 73; MOMA, Tamarind: Homage to Lithography, 1969; Princeton U., American Art since 1960, 1970; Expo '70, Osaka, 1970; Carnegie, 1970; Society of the Four Arts, Calder/Nevelson/David Smith, 1971; Seattle/AM, American Art—Third Quarter Century, 1973; National Gallery, American Art at Mid-Century, 1973; Newport, R.I., Monumenta, 1974; WMAA, The 20th Century: 35 Artists, 1974. **Collections:** Arts Club of Chicago; Birmingham, Ala./MA; Brandeis U.; Buffalo/Albright; Brooklyn Museum; Carnegie; Chicago/AI; Fairmount Park Association; Grenoble; Hirshhorn; Hospital Corp. of America; Houston/MFA;

Indiana U.; Jerusalem/National; Jewish Museum; Juilliard; MMA; MOMA; NYU; U. of Nebraska; Newark Museum; Paris/Moderne; Pasadena/AM; Princeton U.; Queens College; Rijksmuseum Kroller-Muller; Sara Roby Foundation; Rockland/Farnsworth; Rotterdam; SRGM; St. Lousi/City; South Mall, Albany; Tate; WMAA. **Bibliography:** Baur 5; Calas, N. and E.; Craven, W.; **Friedman, M. 3; Glimcher;** Goodrich and Baur 1; **Gordon 4;** Janis and Blesh 1; Licht, F.; *Metro; Monumenta;* Nemser; Neumeyer; Rickey; Rose, B. 1; Seitz 3; Selz, J.; Seuphor 3; Trier 1; Tuchman 1. Archives.

NEVELSON, MIKE. b. February 23, 1922, NYC. **Studied:** NYU; self-taught in art. Traveled Europe, Mediterranean, Africa, Central and South America. **Taught:** Wooster Community Art Center, Danbury, Conn., 1965-68; Brookfield (Conn.) Craft Center, 1968; U. of New Mexico, 1969-70. **Member:** Artists Equity. **Awards:** Silvermine Guild, 1966. **Address:** 3 Milltown Road, New Fairfield, Conn. 06810. **One-man Exhibitions:** Roko Gallery, 1945; Rockland/Farnsworth, 1953; U. of Maine, 1953; Haystack Mountain School of Crafts, 1956; Carl Seimbab Gallery, 1959; Staempfli Gallery, 1961; The Amel Gallery, NYC, 1964; Wooster Community Art Center, Danbury, 1966; Dartmouth College, 1966; Grand Central Moderns, NYC, 1967; Expo '67, Montreal, 1967; Sachs New York, Inc., NYC, 1969; A.A.A. Gallery, NYC (two-man), 1970; Christ-Janer Gallery, New Canaan, Conn. (two-man), 1975. **Group:** Portland, Me./MA, 1956; Boston Arts Festival, 1959; Norfolk Art Festival, Va., 1959; Carnegie, 1961; Houston/Contemporary, 1961; U. of Illinois, 1961; WMAA, 1962, 64; Hartford/Wadsworth, 1963; Silvermine Guild, 1964, 68, 69; Lincoln, Mass./De Cordova, 1964; Four Seasons Restaurant, Pop Exhibition, 1965; U. of Connecticut, 1965; Brooklyn Museum, 1972; Potsdam/SUNY, 1973; Norske Internasjo-

nale Grafikk Biennale, Fredrikstad, Norway, 1974. **Collections:** Colby College; Hartford/Wadsworth; Housatonic Community College; Slater; Stratford College; WMAA; Youngstown/ Butler. Archives.

NEWBILL, AL. b. January 13, 1921, Springfield, Mo. **Studied:** Society of Arts and Crafts, Detroit, with John Caroll; Brooklyn Museum School, with John Ferren; Hofmann School, with Hans Hofmann. Traveled Europe, USA. **Taught:** Queens College, 1947; Southern Illinois U.; U. of California, Berkeley; Rodman Job Corps (Director, Art Program), 1966-67; U. of Kansas, 1967-68; The Ohio State U., 1968- ; and privately. **Address:** c/o Dealer. **Dealer:** Benson Gallery. **One-man Exhibitions:** (first) Creative Gallery, NYC, 1949; Hendler Gallery, Philadelphia; Holland-Goldowsky Gallery, Chicago; Leo Castelli Inc., 1959; Parma Gallery, NYC, 1960; U. of Kansas, 1968. **Group:** Detroit/Institute; Cleveland/MA; Santa Fe, N.M.; Rose Fried Gallery, International Collage Exhibition, 1956. **Collections:** Detroit/Institute; U. of Kansas; MOMA; Marist College, Poughkeepsie, N.Y.; Southern Illinois U.

NEWMAN, BARNETT. b. January 29, 1905, NYC; **d.** July 4, 1970, NYC. **Studied:** Cornell U., 1922-26; City College of New York, BA, 1927; ASL, with Duncan Smith, John Sloan, William Von Schlegell. Traveled USA, Canada, Europe. **Taught:** U. of Saskatchewan, 1959; U. of Pennsylvania, 1962-64. Co-founder of a school, "Subject of the Artist," with William Baziotes, Robert Motherwell, and Mark Rothko, NYC, 1948. **One-man Exhibitions:** (first) Betty Parsons Gallery, 1950, also 1951; Bennington College, 1958; French & Co. Inc., NYC, 1959; Allan Stone Gallery, 1962 (two-man); SRGM, 1966; M. Knoedler & Co., 1969; Irving Blum Gallery, Los Angeles, 1970; Kammerkunsthalle, Berlin, 1970; U. of Washington, 1971. **Retrospectives:** Pasadena/ AM, 1970; MOMA, 1971; Tate, 1972.

Group: Chicago/AI, Abstract and Surrealist Art, 1948; Minneapolis/Institute, American Painting, 1945-57, 1957; MOMA, The New American Painting, circ. Europe, 1958-59; Documenta II, Kassel, 1959; Kimura Gallery, Tokyo, 1959; SRGM, Abstract Expressionists and Imagists, 1961; SRGM/USIA, American Vanguard, circ. Europe, 1961-62; Seattle World's Fair, 1962; WMAA Annual, 1963; Brandeis U., New Directions in American Painting, 1963; Jewish Museum, Black and White, 1963; Tate, Dunn International, 1964; Chicago/AI Annual, 1964; SRGM, Guggenheim International, 1964; Kunsthalle, Basel, International Painting Since 1950, 1964; MOMA, The New American Painting and Sculpture, 1969. **Collections:** Amsterdam/Stedelijk; Basel; Kunsthalle, Basel; MOMA; Stockholm/National. **Bibliography:** Battcock, ed.; Calas, N. and E.; Chipp; De Vries, ed.; *The Great Decade;* Goossen 1; Greenberg 1; Haftman; **Hess, T.B. 2, 3;** Hunter 1; Hunter, ed.; Kozloff 3; Lippard 5; *Metro; Monumenta;* Motherwell and Reinhardt, eds.; Rickey; Rose, B. 1, 4; Rosenblum 2; Rubin 1; Sandler; Schneider; Seuphor 1; Tuckman, ed.

NIVOLA, CONSTANTINO. b. July 5, 1911, Orani, Sardinia. **Studied:** Instituto Superiore d'Arte, Monza, Italy, with Marino Marini, Marcello Nizzoli, 1930-36, MA. Art Director for Olivetti Company, 1936-39. Traveled Europe, USA. To USA 1939. Art Director, *Interiors* Magazine, 1941-45. **Taught:** Director, Design Workshop of Harvard U. Graduate School, 1953-57; Columbia U., 1961-63; Harvard U., 1970-73; International U. of Art, Florence, Italy, 1971. **Member:** Architectural League of New York; NIAL. **Commissions:** Milan Triennial, 1933 (mural, with S.R. Francello); Italian Pavilion, Paris World's Fair, 1937; Olivetti Showroom, NYC, 1953-54 (mural); Four Chaplains Memorial Fountain, Falls Church, Va., 1955; 1025 Fifth Avenue, NYC, 1955 (gardens); William E. Grady Vocational High School, Brooklyn, N.Y., 1957;

Mutual Insurance Co. of Hartford, Hartford, Conn., 1957 (façade); P.S. 46, Brooklyn, N.Y., 1959 (murals and sculptures for playground); McCormick Place, Exposition Hall, Chicago, 1960 (façade); Motorola Building, Chicago, 1960 (murals); Saarinen Dormitories, Yale U., 1962 (35 sculptures); designed a memorial plaza in Nuoro, Italy, 1966; P.S. 320, Brooklyn, N.Y., 1967 (sculpture); Mexico City/Nacional, 19th Olympiad, 1968 (sculpture). **Awards:** Philadelphia Decorators Club Award, 1959; Carborundum Major Abrasive Marketing Award, 1962; Municipal Art Society of New York, Certificate of Merit, 1962; Architectural League of New York, Silver Medal of Honor in Sculpture, 1962; Regional Exhibition of Figurative Art, Cagliari, Italy, Gold Medal; Federation of Graphic Arts, Diploma; Park Association of New York, NYC, Certificate of Commendation, 1965; American Institute of Architects, Fine Arts Medal, 1968. **Address:** 410 Stone Road, Springs, East Hampton, N.Y. 11937. **One-man Exhibitions:** (first) Sassari Gallery, Sardinia, 1927 (paintings); Betty Parsons Gallery, 1940 (two-man, with Saul Steinberg); (first one-man in USA) Tibor de Nagy Gallery,1950; The Peridot Gallery, 1954, 57; Harvard U., 1956; The Bertha Schaefer Gallery, 1958; Architectural League of New York, 1958; Galleria Il Milione, Milan, 1959; Arts Club of Chicago, 1959; A.F.A., circ., 1960; Galleria dell' Ariete, 1962; The Byron Gallery, 1964-67; Andrew-Morris Gallery, NYC; Marlborough Galleria d'Arte, Rome, 1973; The Willard Gallery, 1973; Cagliari U., Italy, 1973; ICA, Boston, 1974. **Group:** Brooklyn Museum, 1947; American Abstract Artists, 1947; Rome National Art Quadriennial, 1950, 73; Riverside Museum, NYC, 1955; WMAA, 1957, Carnegie, 1958; Museum of Contemporary Crafts, 1962; National Gold Medal Exhibition of the Building Arts, NYC, 1962; A.F.A., American Drawing, circ., 1964. MOMA. **Collections:** Hirshhorn; MOMA; PMA; WMAA. **Bibliography:** Giedion-

Welcker 1; Licht, F.; *Metro*; Seuphor 3; Trier 1.

NOGUCHI, ISAMU. b. November 17, 1904, Los Angeles, Calif. Resided Japan, ages 2-14. **Studied:** Columbia U., 1923-25 (pre-medical); apprenticed briefly to Gutzon Borglum; Leonardo da Vinci Art School, NYC; East Side Art School, NYC; apprenticed to Constantin Brancusi, Paris, 1927-29. Traveled Mexico, USSR, the Orient, Europe, Israel, USA. Designed numerous stage sets for Martha Graham Dance Co. **Member:** National Sculpture Society. **Commissions:** Connecticut General Life Insurance Co. (gardens and sculpture); First National Bank of Fort Worth, Tex. (piazza and sculpture); John Hancock Building (fountain and sculpture); Chase Manhattan Bank, NYC (garden); Associated Press, NYC (relief), 1938; Yale U. Library of Precious Books; Keyo

Isamu Noguchi *Humpty Dumpty* 1959-73

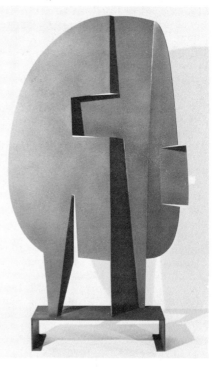

U., Japan (2 gardens); UNESCO, Paris (garden); International Business Machines, Armonk, N.Y.; Billy Rose Garden, Jerusalem; Detroit Civic Center Plaza, 1974; Horace E. Dodge & Son Memorial Fountain, 1974; Pepsico, Purchase, N.Y., 1974. **Awards:** Guggenheim Foundation Fellowship, 1927; Bollingen Foundation Fellowship, 1950; Chicago/AI, The Mr. & Mrs. Frank G. Logan Medal; New School for Social Research, Hon. DFA, 1974. **Address:** 33-38 Tenth Street, Long Island City, N.Y. 11106. **Dealer:** The Pace Gallery, NYC. **One-man Exhibitions:** (first) Eugene Schoen Gallery, NYC, 1929; Marie Sterner Gallery, NYC, 1930; Harvard Society for Contemporary Art, 1930; Arts Club of Chicago, 1930; Buffalo/Albright, 1930; Reinhardt Galleries, NYC, 1932; Demotte Gallery, NYC, 1932; Mellon Galleries, Philadelphia, 1933; Marie Harriman Gallery, NYC, 1934; Sidney Burney Gallery, London, 1934; Western Association of Art Museum Directors, circ., 1934; Honolulu Academy, 1934, 39; John Becker (Gallery), NYC, 1939, 42; SFMA, 1942; Charles Egan Gallery, 1948; Daniel Cordier, Paris; Cordier & Ekstrom, Inc., 1963, 65, 67-69, 70; Gimpel & Hanover, 1968, 72; Gimpel Fils, 1968, 72; Minami Gallery, 1973; The Pace Gallery, NYC, 1975. **Retrospective:** WMAA, 1968. **Group:** MOMA, Fantastic Art, Dada, Surrealism, 1936; Musee du Jeu de Paume, Trois Siecles d'Art aux Etats-Unis, 1938; MOMA, Art in Our Time, 1939; MOMA, 14 Americans, 1946; MOMA, Abstract Painting and Sculpture in America, 1951; WMAA, Nature and Abstraction, 1958; Documenta II & III, Kassel, 1959, 64; WMAA, American Art of Our Century, 1961; Seattle World's Fair, 1962; Los Angeles/ County MA, American Sculpture of the Sixties, circ., 1967; WMAA, 1970; Carnegie, 1970; Venice Biennial, 1972; SRGM, Masters of Modern Sculpture, 1974. **Collections:** Brooklyn Museum; Buffalo/Albright; Chicago/AI; Cleveland/MA; Des Moines; Hartford/Wadsworth; Hirshhorn; Honolulu Academy;

Jerusalem/National; Kamakura; Los Angeles/County MA; MMA; MOMA; U. of Nebraska; New School For Social Research; Rijksmuseum Kroller-Muller; SFMA; SRGM; Society of Four Arts; Tate; Toledo/MA; Toronto; WMAA; Walker; West Palm Beach/Norton. **Bibliography:** Baur 5, 7; Biddle 4; Blesh 1; Breton 3; Brumme; Cahill and Barr, eds.; Calas; Cheney; Craven, W.; Flanagan; Giedion-Welcker 1; Goodrich and Baur 1; **Gordon 2;** Hunter 6; *Index of 20th Century Artists;* **Isamu Noguchi;** Kuh 2; Licht, F.; McCurdy, ed.; Mendelowitz; *Metro;* Miller, ed. 2; Neumeyer; **Noguchi;** Read 3; Ritchie 1, 3; Rose, B. 1; Rubin 1; Seuphor 3; Seymour; **Takiguchi;** Trier 1; Tuchman 1. Archives.

NOLAND, KENNETH. b. April 10, 1924, Asheville, N.C. **Studied:** Black Mountain College, 1946, with Ilya Bolotowsky; Zadkine School of Sculpture, Paris, 1948-49. US Air Force, 1942-46. **Taught:** The Catholic U. of America; ICA, Washington, D.C.; Emma Lake Artist's Workshops, U. of Saskatchewan; Bennington College. **Awards:** Corcoran, 1967. **Address:** South Shaftsbury, Vt. 05262. **Dealer:** Andre Emmerich Gallery, NYC and Zurich. **One-man Exhibitions:** (first) Galerie Creuze, Paris, 1949; French & Co. Inc., NYC, 1959; Galleria dell'Ariete, 1960; Galerie Lawrence, Paris, 1961; Bennington College, 1961; Andre Emmerich Gallery, NYC, 1961-64, 1966, 67, 71, 73; Galerie Charles Leinhard, Zurich, 1962; Galerie Schmela, 1962, 64; Kasmin Ltd., 1963, 65, 68; David Mirvish Gallery, 1965; Harvard U., Three American Painters (with Jules Olitski, Frank Stella), circ. Pasadena, 1965; St. John, N.B., 1966 (three-man, with Helen Frankenthaler, Jules Olitski); MMA, 1968 (three-man, with Morris Louis, Anthony Caro); Lawrence Rubin Gallery, 1969; Dayton's Gallery 12, Minneapolis, 1969 (three-man, with Anthony Caro, Frank Stella); Galerie Mikro, Berlin, 1972; Waddington Galleries, London, 1973; Jack Glenn Gallery, Corona del Mar, 1974; Janie C.

Lee Gallery, Houston, 1974; Rutland Gallery, London, 1974; School of Visual Arts, NYC, 1975. **Retrospective:** Jewish Museum, 1964. **Group:** The Kootz Gallery, NYC, New Talent, 1954; Corcoran, 1958, 63, 67; SRGM, Abstract Expressionists and Imagists, 1961; Seattle World's Fair, 1962; WMAA, Geometric Abstraction in America, circ., 1962; Jewish Museum, Toward a New Abstraction, 1963; XXXII Venice Biennial, 1964; Los Angeles/County MA, New Abstraction, 1964; Tate, Gulbenkian International, 1964; Carnegie, 1964-65, 67; Detroit/ Institute, Color, Image and Form, 1967; Expo '67, Montreal, 1967; Dublin/Municipal, I International Quadrennial (ROSC), 1967; International Biennial Exhibition of Paintings, Tokyo; Documenta IV, Kassel, 1968; MOMA, The Art of the Real, 1968; Pasadena/AM, Serial Imagery, 1968; Washington U., The Development of Modernist Painting, 1969; U. of California, Irvine, New York: The Second Breakthrough, 1959-1964, 1969; MMA, New York Painting and Sculpture: 1940-1970, 1969-70; Buffalo/Albright, Color and Field: 1890-1970, 1970; WMAA, The Structure of Color, 1971; Carnegie, 1971; Boston/ MFA, Abstract Painting in the '70s, 1972; Houston/MFA, The Great Decade of American Abstraction: Modernist Art 1960-1970, 1974. **Collections:** Buffalo/Albright; Detroit/Institute; WMAA. **Bibliography:** Alloway 3; Battcock, ed.; Bihalji-Merin; Calas, N. and E.; *Contemporanea;* Coplans 3; De Vries, ed.; *The Great Decade;* Goossen 1; Hunter, ed.; Kozloff 3; Lippard 5; Lynton; *Metro;* Rickey; Rose, B. 1; Weller. Archives.

NORDFELDT, B.J.O. b. 1897; **d.** 1955. **Studied:** Chicago Art Institute School; Academie Julian, Paris. Traveled France, Italy, Sweden, 1908-09. **Taught:** Minneapolis Institute School, 1933. **Awards:** Milan Triennial, Silver Medal, 1906; Panama-Pacific Exposition, San Francisco, 1915, Silver Medal; Philadelphia Sesquicentennial, 1926, Bronze Medal; Chicago/AI, The Mr. & Mrs. Frank G.

Logan Medal, 1926; Brooklyn Society of Etchers, First Prize, 1927; Chicago Society of Etchers, First Prize, 1928; Denver/AM, First Yetter Prize, 1937; Worcester/AM, **P.P.,** 1947; Corcoran, Bronze Medal, 1949. **One-man Exhibitions:** Scott Thurber Gallery, Chicago, 1912, 13; The Daniel Gallery, NYC, 1914, 17; Montross Gallery, NYC, 1923; Lilienfeld Gallery, NYC, 1937-43; Hudson D. Walker Gallery, NYC, 1940; Passedoit Gallery, NYC, 1944-55; Minneapolis/Institute; U. of Minnesota; Arts Club of Chicago; Wichita/AM; SFMA; The Zabriskie Gallery, 1962, 63, 65, 74. **Retrospective:** U. of Minnesota, 1972. **Group:** MMA, 1956; Carnegie; Corcoran; WMAA; Brussels World's Fair, 1958; A.F.A., Expressionists in American Painting. **Collections:** Atlanta U.; Corcoran; Des Moines; U. of Illinois; MMA; Minneapolis/Institute; U. of Minnesota; U. of Oregon; U. of Rochester; Santa Fe, N.M.; U. of Texas; Toledo/MA; Walker; Wichita/AM; Worcester/AM. **Bibliography:** Cheney; Coke 1, 2; Hartmann. Archives.

NOVROS, DAVID. b. 1941, Los Angeles, Calif. **Address:** 59 Wooster Street, NYC 10012. **Dealer:** Bykert Gallery. **One-man Exhibitions:** Dwan Gallery, Los Angeles, 1966, NYC, 1967; Galerie Muller, Stuttgart, 1967; Bykert Gallery, 1968, 69, 73, 74; Mizuno Gallery, 1969, 70; The Texas Gallery, 1973; Weinberg Gallery, San Francisco, 1973; Rose Esman Gallery, 1973. **Group:** SRGM, Systemic Painting, 1966; Kansas City/Nelson, Sound, Light, Silence, 1966; ICA, U. of Pennsylvania, A Romantic Minimalism, 1967; A.F.A., Rejective Art, 1967; WMAA, 1967, 69, 73; Washington U., The Development of Modernist Painting, 1969; Buffalo/Albright, Modular Painting, 1970; WMAA, The Structure of Color, 1971; Corcoran Biennial, 1971; Chicago/Contemporary, White on White, 1971-72; Chicago/AI, 1972; Chicago/Contemporary, Five Artists: A Logic of Vision, 1974. **Bibliography:** Murdock 1.

NOWACK, WAYNE K. b. May 7, 1923, Des Moines, Iowa. **Studied:** Drake U., 1943-45; State U. of Iowa, with Mauricio Lasansky, James Lechay, Stuart Edie, 1945-47, BA, PBK, 1948, MA (Art History), 1950, MFA (Painting). Traveled Mexico. **Awards:** Des Moines, First Prize, 1950; Danforth Foundation Grant, 1962; National Endowment for the Arts Grant, 1973. **Address:** R.D. 1, Spencer, N.Y. 14883. **Dealer:** Allan Stone Gallery. **One-man Exhibitions:** (first) Des Moines, 1950, also 1957; Union College (N.Y.), 1957; Albany/Institute, 1961; Schenectady Museum Association, 1961; Allan Stone Gallery, 1967, 70, 74. **Group:** Omaha/Joslyn Annuals, 1947, 50; Denver/AM, 1948; Library of Congress Print Annual, 1948; Des Moines, 1948, 50-53; Silvermine Guild, 1954; Utica, 1961; Skidmore College, 1961; Brandeis U., Recent American Drawings, 1964; New School for Social Research, Albert List Collection, 1965; WMAA, Human Concern/Personal Torment, 1969. **Collections:** Des Moines; Drake U.; Fort Worth; Hirshhorn; State U. of Iowa; Skidmore College; Union College (N.Y.); Williams College.

O'HANLON, RICHARD. b. October 7, 1906, Long Beach, Calif. **Studied:** California College of Arts and Crafts, 1926-27; California School of Fine Arts, 1930-33. Traveled the Orient and around the world. **Taught:** U. of California, 1947-74. **Commissions:** Oakland/AM, 1974; U. of California, Berkeley, 1975. **Awards:** SFAI, Anne Bremer Traveling Scholarship; SFMA, Edgar Walter Memorial Prize, 1940; CSFA, Albert M. Bender Fellowship, 1940; Marin Society Annual, First Prize; SFMA, First Prize, 1950. **Address:** 616 Throckmorton Avenue, Mill Valley, Calif. 94941. **Dealer:** The Willard Gallery. **One-man Exhibitions:** The Willard Gallery, 1953; U. of Rochester; U. of Kentucky; Carnegie, 1967; Santa Barbara/MA, 1969. **Retrospective:** SFMA, 1961. **Group:** SFMA; Baltimore/MA. **Collec-**

Wayne Nowack *Theoretical Instrument for the Extradition of Anemie* 1969

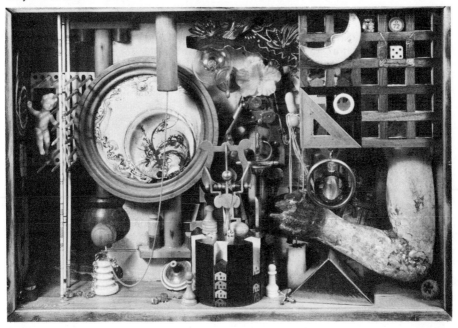

tions: Andover/Phillips; Baltimore/MA; U. of California, Berkeley and Davis; City of Mill Valley; Denver/AM; SFMA; Smith College; Steuben Glass; WMAA; Walker; Worcester/AM.

OHASHI, YUTAKA. b. August 19, 1923, Hiroshima, Japan. **Studied:** Academy of Arts, Tokyo, 1941-46, BFA; Boston Museum School, 1950-55, with David Aronson, Karl Zerbe. Japanese Army, 1943-45. Traveled Europe, the Orient, USA. **Taught:** Boston Museum School, 1958; Cornell U., 1961, 67, 69. **Awards:** Boston/MFA, James William Paige Fellowship (Europe), 1955-57, Traveling Scholarship (Japan), 1967-68; J. S. Guggenheim Fellowship (Japan), 1959. **Address:** 5 Great Jones Street, NYC 10012; 5,17-44, 3 Chome, Nishi-Azabu, Minato-Ku, Tokyo, Japan. **Dealer:** Nordness Galleries. **One-man Exhibitions:** (first) Margaret Brown Gallery, Boston, 1955; The Alan Gallery, NYC, 1957, 60, 63, 65; The Swetzoff Gallery, Boston, 1958, 60, 63, 64, 66, 67; Dennenchof Studio, Tokyo, 1960; Cornell U., 1961; Nordness Galleries, 1969, 73; Galeria Santiago, San Juan, 1971; Boston Athenaeum, 1975. **Group:** Rome-New York Foundation, Rome; SRGM; Chicago/AI; U. of Illinois; Carnegie; ICA, Boston, Contemporary Painters of Japanese Origin in America, 1958, also 1962; VMFA; Utica; Tokyo/Modern; Southern Illinois U.; Montclair/AM, 1970. **Collections:** Andover/Phillips; Boston/MFA; Buffalo/Albright; Cornell U.; Lincoln, Mass./De Cordova; Lincoln Center; SRGM; U. of Texas; Tokyo/Modern; U. of Wyoming; Yale U.

OHLSON, DOUG. b. November 18, 1936, Cherokee, Iowa. **Studied:** U. of Minnesota, 1959-61, BA. US Marine Corps, 1955-58. **Taught:** Hunter College, 1964- . **Awards:** Guggenheim Foundation Fellowship, 1969; CAPS Grant, 1974. **Address:** 35 Bond Street, NYC 10012. **Dealer:** Susan Caldwell Inc. **One-man Exhibitions:** Fischbach Gallery, 1964, 66, 67, 68, 69, 70, 72; Susan Caldwell Inc., 1974. **Group:**

Detroit/Institute, Color, Image and Form, 1967; MOMA, The Art of the Real, 1968; WMAA, The Structure of Color, 1971; Corcoran, 1975; UCLA, Fourteen Abstract Painters, 1975. **Collections:** Corcoran; U. of Iowa; Minneapolis/Institute; U. of North Carolina. **Bibliography:** Murdock 1.

OKADA, KENZO. b. September 28, 1902, Yokohama, Japan. **Studied:** Meiji-gakuin Middle School; Tokyo U. of Arts, three semesters; in Paris, 1924-27. **Taught:** Nippon Art College, 1940-42; Musashino Art Institute, 1947-50; Tama College of Fine Arts, Tokyo, 1949-50. To USA 1950; citizen 1960. **Member:** Nikakai (Group), Japan, 1938- . **Awards:** Nikakai (Group), Japan 1936; Showa Shorei, 1938; Yomiuri Press, 1947; Chicago/AI, 1954, 57; Carnegie, 1955; Columbia, S.C./MA, First Prize, 1957; XXIX Venice Biennial, 1958; Tate, Dunn International Prize, 1964; Mainichi Art Award, 1966. **Address:** 101 West 12 Street, NYC 10011. **Dealer:** Betty Parsons Gallery. **One-man Exhibitions:** Nichido Gallery, Tokyo, 1929-35; Hokuso Gallery, 1948, 50; US Army Education Center, Tokyo, 1949, 50; US Army Education Center, Yokohama, 1950; Betty Parsons Gallery, 1953, 55, 56, 59, 62-64, 67, 69, 71, 73; Corcoran, 1955; Sao Paulo, 1955; Fairweather-Hardin Gallery, 1956; Myrtle Todes Gallery, Glencoe, Ill., 1957; Venice/Contemporaneo, 1958; Ferus Gallery, Los Angeles, 1959; MIT, 1963; Buffalo/Albright, 1965. **Retrospective:** Traveling Exhibition, 1966-67, circ. Tokyo, Kyoto, Honolulu, San Francisco, and Austin, Tex. **Group:** Salon d'Automne, Paris, 1924-27; Nikakai (Group), Japan, 1938- ; WMAA; Chicago/AI; U. of Illinois; III Sao Paulo Biennial, 1955; Corcoran; MOMA; XXIX Venice Biennial, 1958; Tate, Dunn International, 1964. **Collections:** Baltimore/MA; Boston/MFA; Brooklyn Museum; Buffalo/Albright; Carnegie; Chase Manhattan Bank; Chicago/AI; U. of Colorado; Columbia, S.C./MA; Equitable Life Assurance Society; Honolulu

Academy; Lincoln Center; MMA; MOMA; Memphis/Brooks; Phillips; Portland, Ore./AM; Reynolds Metals Co.; Rockefeller Institute; SFMA; SRGM; St. Lawrence U.; St. Louis/City; Santa Barbara/MA; Tougaloo College; Utica; WMAA; Yale U. **Bibliography:** Baur 5; Hunter, ed.; Goodrich and Baur 1; Nordness, ed.; Ponente; Read 2; Rodman 1.

OKAMURA, ARTHUR. b. February 24, 1932, Long Beach, Calif. **Studied:** Chicago Art Institute School, with Paul Wieghardt, 1950-54; The U. of Chicago, 1951, 53, 57; Yale U., 1954. US Army, 1954. Traveled France, Spain, North Africa, Japan; resided Mallorca for a year. **Taught:** Central YMCA College, Chicago, 1956-57; Evanston (Ill.) Art Center, 1956-57; Northshore Art League, Winnetka, Ill., 1957; Academy of Art, San Francisco, 1957; Chicago Art Institute School, 1957; California School of Fine Arts, 1958; California College of Arts and Crafts, 1958-59, 1966-69; Saugatuck Summer School of Painting, 1959, 62; U. of Utah, 1964. **Awards:** The U. of Chicago, Religious Arts, 1953; four-year scholarship to the Chicago Art Institute School; Edward L. Ryerson Traveling Fellowship, 1954; Chicago/AI, Martin B. Cahn Award, 1957; U. of Illinois, **P.P.,** 1960; WMAA, Neysa McMein **P.P.,** 1960; NIAL, **P.P.;** SFMA, Schwabacher-Frey Award, 1960. **Address:** P.O. Box 21, Ocean Parkway, Bolinas, Calif. 94924. **Dealers:** Feingarten Gallery; Hansen-Fuller Gallery. **One-man Exhibitions:** (first) Frank Ryan Gallery, Chicago, 1953; La Boutique, Chicago, 1953, 54; Feingarten Gallery, Chicago, NYC, San Francisco, and Los Angeles, 1956-64, 69, 71, 73, 75; Santa Barbara/MA, 1958; Oakland/AM, 1959; California Palace, 1961; Dallas/MFA, 1962; La Jolla, 1963; U. of Utah, 1964; Hansen Gallery, San Francisco, 1964, 65, 66, 68, 71, 74; M. Knoedler & Co., 1965; College of the Holy Names, Oakland, Calif., 1966; SFMA, 1968; California College of Arts and Crafts, 1972; Southern Idaho College, 1972; Kent State U., 1973; Honolulu Academy, 1973. **Group:** Chicago/AI Annuals, 1951-54; U. of Illinois, 1955, 59; Ravinia Festival, Highland Park, Ill., 1956, 64; Los Angeles/County MA, Contemporary Americans, 1957; SFMA, Art in Asia and the West, 1957; PAFA, 1954; de Young, Fresh Paint, 1958; U. of Nebraska, 1958; Denver/AM, 1958; USIA, Drawings from California, circ. Europe, 1958-59; A.F.A., New Talent, circ., 1959; Dallas/MFA, 1959; California Palace, 1959, Painters behind Painters, 1967; WMAA, 1960, Forty Artists Under Forty, circ., 1962, Annuals, 1962, 63, 64; Friends of the Whitney, 1964; SFMA, Sculpture and Drawings, 1961, 1966; Sacramento/Crocker, 1966; Carnegie, 1967; California Palace, Painters behind Painters, 1967; Carnegie, 1967; Expo '70, Osaka, 1970. **Collections:** Achenbach Foundation; Borg-Warner International Corporation; California College of Arts and Crafts; California Palace; Chicago/AI; The U. of Chicago; Cincinnati/AM; Container Corp. of America; Corcoran; Hirshhorn; Illinois Bell Telephone Company; Illinois State Normal U.; U. of Illinois; Kalamazoo/Institute; Miles Laboratories Inc.; NCFA; NIAL; Oakland/AM; Phoenix; SFMA; Santa Barbara/MA; Southern Idaho College; Stanford U.; Steel Service Institute; WMAA. **Bibliography:** Nordness, ed.

O'KEEFFE, GEORGIA. b. November 15, 1887, Sun Prairie, Wisc. **Studied:** Chatham Episcopal Institute (Va.), 1901; Chicago Art Institute School, 1904-05, with John Vanderpoel; ASL, 1907-08, with William M. Chase; Columbia U., 1916, with Arthur Dow, Alan Bement. Traveled Europe, Mexico, USA, Peru, Japan. **Taught:** U. of Virginia; Supervisor of Art in public schools, Amarillo, Tex., 1912-16; Columbia College (S.C.); West Texas Normal College. **Awards:** Hon. DFA, College of William and Mary, 1939; Hon. Litt.D., U. of Wisconsin, 1942; elected to the NIAL, 1947, AAAL, 1962; Brandeis U., Creative Arts Award, 1963; Randolph-

Macon Woman's College, Hon. DFA, 1966. **m.** Alfred Stieglitz (1924). **Address:** Abiquiu, N.M. **One-man Exhibitions:** (first) "291," NYC, 1917, also 1926; Anderson Galleries, NYC, 1924; Stieglitz's Intimate Gallery, NYC, 1927, 29; An American Place (Gallery), NYC, 1931, 32, 35-42, 44-46, 50; U. of Minnesota, 1937; The Downtown Gallery, 1937, 52, 55, 58, 61; College of William and Mary, 1938; La Escondida, Taos, N.M., 1951; Dallas/MFA, 1953; Mayo Hill, Delray Beach, Fla., 1953; Gibbes Art Gallery, Charleston, S.C., 1955; Pomona College, 1958; Milton College, 1965; U. of New Mexico, 1966; SFMA, 1971; Bryn Mawr College, 1971. **Retrospective:** Anderson Galleries, NYC, 1923; Chicago/AI, 1943; MOMA, 1946; Dallas/MFA, 1953; Worcester/AM, 1960; Amon Carter Museum, 1966; WMAA, 1970. **Group:** "291," NYC, 1916; MOMA, Paintings by 19 Living Americans, 1929; U. of Minnesota, 5 Painters, 1937; U. of Illinois, 1955, 57, 59, 69; Pomona College, Stieglitz Circle, 1958; MMA, 14 American Masters, 1958. **Collections:** Amon Carter Museum; Andover/Phillips; Arizona State College; U. of Arizona; Auburn U.; Baltimore/MA; Brooklyn Museum; Bryn Mawr College; Buffalo/Albright; Chicago/AI; Cleveland/MA; Colorado Springs/FA; Currier; Dallas/MFA; Detroit/Institute; Fisk U.; Fort Worth; U. of Georgia; IBM; Indianapolis/Herron; MMA; MOMA; The Miller Co.; Milwaukee; U. of Minnesota; NCFA; National Gallery; U. of Nebraska; Newark Museum; U. of Oklahoma; Omaha/Joslyn; PMA; Phillips; Randolph-Macon Woman's College; Reed College; U. of Rochester; Roswell; SFMA; St. Louis/City; Santa Barbara/MA; Shelburne; Smith College; Springfield, Mass./MFA; Tate; Texas Technological College; Toledo/MA; Utica; Valparaiso U. (Ind.); WMAA; Walker; Wellesley College; Westminster Academy; West Palm Beach/Norton; Wichita/AM; Wilmington. **Bibliography:** *Avant-Garde Painting and Sculpture;* Barker 1; Baur 5, 7; Bazin; Bethers; Biddle 4; Blanchard; Blesh 1;

Boswell 1; Brown; Bulliet 1; Cahill and Barr, eds.; Cheney; Christensen; Coke 2; Craven, T. 1; Eliot; Flanagan; Frank, ed.; Frost; *Forerunners;* Goodrich and Baur 1; Goossen 1; Haftman; Hall; Hunter 6; Huyghe; *Index of 20th Century Artists;* Janis, S.; Jewell 2; Kootz 1; Kozloff 3; Kuh 1, 2, 3; Lane; Lee and Burchwood; Mather 1; McCoubrey 1; McCurdy, ed.; Mellquist; Mendelowitz; Neuhaus; Newmeyer; Nordness, ed.; Pearson 1; Phillips 1, 2; Poore; Pousette-Dart, ed.; **Rich 1, 2;** Richardson, E. P.; Ringel, ed.; Ritchie 1; Rose, B. 1, 4; Rosenblum 2; Smith, S. C. K.; Soby 6; Sutton; Weller. Archives.

OLDENBURG, CLAES THURE. b. January 28, 1929, Stockholm, Sweden. **Studied:** Yale U., 1950, BA; Chicago Art Institute School, 1952-55, with Paul Wieghardt. Traveled USA, Europe, Japan. Apprentice reporter, City News Bureau, Chicago, 1950-52. Films: "Collosal Keepsake No. 1," 1969; "Sort of a Commercial for an Icebag," 1969; "The Great Ice Cream Robbery," 1970; "Birth of the Flag, Part One and Two," 1965-74; "Ray Gun Theater," 1962-75. **Member:** NIAL. **Commissions:** Oberlin College, 1970; Southern Methodist U., 1970; St. Louis/City, 1971; Rijksmuseum Kroller-Muller, 1971; Morse College, Yale U., 1974; Walker, 1974; South Mall, Albany, 1975; Hirshhorn, 1975. **Awards:** Brandeis U., Creative Arts Award; Skowhegan School Medal; Fellow of Morse College, Yale U.; Honorary Degrees: Oberlin College, 1973; Minneapolis College of Art and Design, 1974; Moore College of Art, Philadelphia, 1974. **Address:** 556 Broome Street, NYC, 10013. **Dealer:** Leo Castelli Inc., NYC. **One-man Exhibitions:** (first) Judson Gallery, NYC, 1959 (sculpture, drawings, poems); Judson Gallery, NYC (two-man, with Jim Dine), 1959; Reuben Gallery, NYC, 1960; Green Gallery, NYC, 1962; Dwan Gallery, 1963; Sidney Janis Gallery, 1964-67, 69, 70; The Pace Gallery, Boston, 1964; **Ileana Sonnabend Gallery, Paris, 1964; Stockholm/National,**

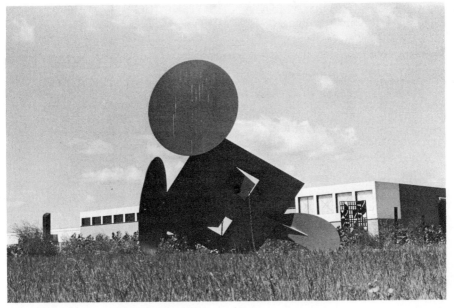

Claes Oldenburg *Geometric Mouse, Scale X* 1971

1966; Robert Fraser Gallery, 1966; U. of Illinois, 1967; Toronto, 1967 (three-man, with Jim Dine, George Segal); Chicago/Contemporary, 1967; Irving Blum Gallery, 1968; Richard Feigen Gallery, Chicago, 1969; UCLA, 1970; Tate, 1970; Dusseldorf/Kunsthalle, 1970; Amsterdam/Stedelijk, 1970; Margo Leavin Gallery, 1971, 75; Kansas City/Nelson, 1972; Fort Worth, 1972; Des Moines, 1972; PMA, 1972; Chicago/AI, 1973; Minami Gallery, 1973; Leo Castelli Inc., NYC, 1974; Yale U., 1974. **Environments:** Judson Gallery, NYC, Ray Gun Street, 1960; Ray Gun Mfg. Co., The Store, 1961; Sidney Janis Gallery, Bedroom Ensemble, 1964. **Happenings:** Judson Gallery, NYC, Snapshots from the City, 1960; Reuben Gallery, NYC, Blackouts, 1960; Reuben Gallery, NYC, Ironworks and Foto-death, 1961; Dallas/MFA, Injun, 1962; Ray Gun Mfg. Co., Ray Gun Theater, 1962; The U. of Chicago, Gayety, 1963; WGMA, Stars, 1963; Los Angeles/County MA, Autobodys, 1963; Al Roon's Health Club, NYC, Washes,

1965; Film Maker's Cinematheque, NYC, Moviehouse, 1965; Stockholm/National, Massage 1966; *Esquire* Magazine, The Typewriter, 1969. **Retrospective:** MOMA, 1969; Pasadena/AM, 1971; Walker, circ., 1975; Kunsthalle, Tubingen, circ., 1975. **Group:** Buffalo/Albright, Mixed Media and Pop Art, 1963; Oberlin College, 3 Young Painters, 1963; Chicago/AI, 1962, 63; Brandeis U., New Directions in American Painting, 1963; Cincinnati/AM, An American Viewpoint, 1963; Dallas/MFA; Tate, Dunn International, 1964; ICA, London, The Popular Image, 1963; Martha Jackson Gallery, New Media—New Forms, I & II, 1960, 61; Stockholm/National, American Pop Art, 1964; MOMA, Americans 1963, circ., 1963-64; Oakland/AM, Pop Art USA, 1963; Hartford/Wadsworth, Continuity and Change, 1962; WGMA, The Popular Image, 1963; Philadelphia YM-YWHA Arts Council, Art, A New Vocabulary, 1962; Sidney Janis Gallery, The New Realists, 1962; XXXII Venice Biennial, 1964; Akademie der Kunst, Berlin, Neue

Realism und Pop Art, 1965; WMAA, A Decade of American Drawings, 1965; Musee Rodin, Paris, Sculpture of the 20th Century, 1965; WMAA Annuals, 1965, 68, 69; RISD, Recent Still Life, 1966; Walker, Eight Sculptors, 1966; Los Angeles/County MA, American Sculpture of the Sixties, 1967; IX Sao Paulo Biennial, 1967; SRGM, 1967; Carnegie, 1967; Expo '67, Montreal, U.S. Pavilion, 1967; Moore College of Art, American Drawing, 1968; ICA, London, The Obsessive Image, 1968; Documenta IV, Kassel, 1968; Hayward Gallery, London, Pop Art, 1969; Berne, When Attitudes Become Form, 1969; MMA, 1969; MOMA, Technics and Creativity: Gemini G.E.L., 1971; Los Angeles/County MA, Art & Technology, 1971; Arnhem, Sonsbeek '71, 1971; Expo '70, Osaka, 1970; Foundation Maeght, 1970; Documenta V, Kassel, 1972; Seattle/AM, American Art—Third Quarter Century, 1973; WMAA, American Pop Art, 1974; Newport, R.I., Monumenta, 1974. **Collections:** Amsterdam/Stedelijk; Basel; Brandeis U.; Brussels/Beaux-Arts; Buffalo/Albright; **Chicago/AI; Fort Worth; Houston/ MFA; U. of Illinois; Kansas City/Nelson;** Los Angeles/County MA; MOMA; Norfolk/Chrysler; Oberlin College; Pasadena/AM; Rijksmuseum Kroller-Muller; SFAI; St. Louis/City; Southern **Methodist U.; Stockholm/National;** Tate; Toronto; Vancouver; WMAA; Walker. **Bibliography: Adriani, Koepplin, and Rose;** Alloway 1; Battcock, ed.; Becker and Vostell; Bihalji-Merin; Calas, N. and E.; Chipp; *Contemporanea;* Craven, W.; Davis, D.; De Vries, ed.; Dienst 1; Finch; Friedman and van der Marck; Hansen; *Happening & Fluxus;* **Haskell 2;** Hulten; Hunter, ed.; Janis and Blesh 1; Kaprow; Kirby; Kozloff 3; Lippard 5; Lippard, ed.; *Metro; Monumenta;* **Oldenburg 1, 2, 3;** *Oldenburg: Six Themes; Report;* **Rose, B. 1, 2, 4;** Rubin 1; Rublowsky; Russell and Gablik; Sontag; Tomkins and Time-Life Books; Trier 1; Tuchman 1; Weller; *When Attitudes Become Form.* Archives.

OLITSKI, JULES. b. March 27, 1922, Snovsk, USSR. **Studied:** NAD, with Sidney Dickinson, 1939-42; Beaux-Arts Institute of Design, NYC, 1940-47; Zadkine School of Sculpture, Paris, 1949; Academie de la Grande Chaumiere, 1949-50; NYU, BA, 1952, MA (Art Education), 1954; and privately with Chaim Gross. Traveled USA, Europe, Mexico. **Taught:** New Paltz/SUNY, 1954-55; C. W. Post College of Long Island U., Chairman of Fine Arts, 1956-63; Bennington College, 1963-67. Curator, NYU Art Education Gallery, 1955-56. **Awards:** Carnegie Second Prize, 1961; Ford Foundation, **P.P., 1964;** Corcoran, 1967. **Address:** 827 Broadway, NYC 10003; summer: RD #1, Lovejoy Sands Road, Meredith, N.H. 03253. **Dealer:** Knoedler Contemporary Art. **One-man Exhibitions:** (first) Galerie Huit, Paris, 1950; Alexandre Iolas Gallery, 1958; French & Co. Inc., NYC, 1959-61; Poindexter Gallery, 1961-65, 1968; Bennington College, 1962; Galleria Santa Croce, Florence, Italy, 1963; Galleria Trastevere, Rome, 1963; Galleria Toninelli, Milan, 1963; Richard Gray Gallery, 1964; David Mirvish Gallery, 1964-75; Kasmin Ltd., 1964-66, 1968-70, 1972; Galerie Lawrence, Paris, 1964; Harvard U. (three-man, with Kenneth Noland, Frank Stella), 1965; St. John, N.B., 1966; Nicholas Wilder Gallery, 1966, 73; Andre Emmerich Gallery, NYC, 1966-68, Zurich, 1973; ICA, U. of Pennsylvania, 1968; MIT, 1968; MMA, 1969; Lawrence Rubin Gallery, NYC, 1969-73; Knoedler Contemporary Art, 1973, 75; Corcoran, 1974. **Retrospectives:** Corcoran, circ., 1967; Boston/ MFA, circ., 1973. **Group:** Carnegie, 1961, 64; WMAA Annuals, 1962, 68, 69, 70, 72; WGMA, The Formalists, 1963; Festival of Two Worlds, Spoleto, 1963; SFMA, Directions: American Painting, 1963; MOMA, Recent Acquisitions, 1963; Worcester/AM, 1963; IV International Art Biennial, San Marino, 1963; Chicago/AI Annuals, 1964, 69; ICA, U. of Pennsylvania, The Atmosphere of 1964, 1964; Los Angeles/County MA,

Post Painterly Abstraction, 1964; SRGM, American Drawings, 1964; Chicago/AI, 67th American Exhibition, 1967; Kunsthalle, Basel, Ausstellung Signale, 1965; XXXIII Venice Biennial, 1966; Corcoran, 1967; Detroit/Institute, Color, Image and Form, 1967; Tokyo Biennial, 1967; Trenton/State, Focus on Light, 1967; Jewish Museum, Large Scale American Paintings, 1967; Honolulu Academy, 1967; Documenta IV, Kassel, 1968; MMA, New York Painting and Sculpture: 1940-1970, 1969-70; Pasadena/AM, Painting in New York: 1944 to 1969, 1969; Chicago/AI, 69th American Exhibition, 1969; Buffalo/Albright, Color and Field: 1890-1970, 1970; ICA, U. of Pennsylvania, Two Generations of Color Painting, 1970; Boston U., American Artists of the Nineteen Sixties, 1970; Youngstown/Butler Annual, 1970; WMAA, The Structure of Color, 1971; Boston/MFA, Abstract Painting in the '70s, 1972; Dusseldorf/Kunsthalle, Prospect '73, 1973; Montreal/Contemporain, 11 Artistes Americaines, 1973; Houston/MFA, The Great Decade of American Abstraction: Modernist Art 1960-1970, 1974; Indianapolis, 1974. **Collections:** Buffalo/Albright; Cleveland/MA; Chicago/AI; Corcoran; Dayton/AI; Hirshhorn; MOMA; Norfolk/Chrysler; Pasadena/AM; Regina/MacKenzie; U. of Saskatchewan; WMAA. **Bibliography:** Battcock, ed.; Calas, N. and E.; De Vries, ed.; *The Great Decade;* Hunter, ed.; Kozloff 3; **Krauss; Moffett;** *Monumenta; Report;* Rose, B. 4.

OLIVEIRA, NATHAN. b. December 19, 1928, Oakalnd, Calif. **Studied:** Mills College, California College of Arts and Crafts (MFA, 1952). US Army, 1953-55. Traveled Europe. **Taught:** San Francisco Art Institute; California College of Arts and Crafts, 1955-56; U. of Illinois, 1961-62; UCLA, 1963-64; Cornell U., 1964; Stanford U., 1964- ; U. of Colorado, 1965; U. of Hawaii, 1971; Cranbrook, 1972; Baltimore Art Institute, 1972; Indianapolis/Herron, 1972; Kent State U., 1973. **Awards:** L.C. Tiffany Grant, 1957; Guggenheim Foundation Fellowship, 1958; Chicago/AI, Norman Wait Harris Bronze Medal, 1960; El Retiro Parquet, Madrid, Arte de America y España, Special Prize, 1963; Tamarind Fellowship, 1964; National Endowment for the Arts, 1974. **Address:** 785 Santa Marin Avenue, Stanford, Calif. 94305. **Dealers:** Dorsky Gallery; Charles Campbell Gallery; Smith Andersen Gallery, Palo Alto. **One-man Exhibitions:** (first) The Alan Gallery, NYC, 1958, also 1959, 60, 63, 65; Paul Kantor Gallery, Beverly Hills, Calif., 1959, 60, 62, 63; U. of Illinois, 1961; Walker, 1961; Felix Landau Gallery, 1965, 68; The Landau-Alan Gallery, NYC, 1967; Gump's Gallery, 1968; Galerie Bleue, Stockholm, 1968; Stanford U., 1968; SFMA, 1969; Martha Jackson Gallery, 1969; Wisconsin State U., Oshkosh, 1970; Terry Dintenfass, Inc., 1971; Michael Smith Gallery, Los Angeles, 1971; Smith Andersen Gallery, Palo Alto, 1971, 74; Charles Campbell Gallery, 1972, 75; Jack Glenn Gallery, Corona del Mar, 1973; Fullerton Junior College, 1973. **Retrospectives:** UCLA, circ., 1963; Oakland/AM, circ., 1973. **Group:** Chicago/AI; Carnegie; Denver/AM; SFMA; Corcoran Annual; I Inter-American Paints and Prints Biennial, Mexico City, 1958; WMAA Annuals, 1958-61; I Paris Biennial, 1959; MOMA, New Images of Man, 1959; SRGM, 1961; U. of Illinois, 1961, 63, 67, 69; Seattle World's Fair, 1962; MOMA, Recent Painting USA: The Figure, circ., 1962-63; WMAA, 1967, 68. **Collections:** Brooklyn Museum; U. of California; Chicago/AI; Cleveland/MA; Dallas/MFA; Hirshhorn; Illinois Wesleyan U.; Lytton Savings and Loan Association; MOMA; U. of Michigan; NCFA; Oakalnd/AM; PMA; Ridgefield/Aldrich; SFMA; SRGM; Stanford U.; UCLA; Walker; Youngstown/Butler. **Bibliography:** Nordness, ed.; Weller; **Wight 4.** Archives.

ONSLOW-FORD, GORDON. b. De-

cember 26, 1912, Wendover, England. **Studied:** Dragon School, Oxford, England; Royal Naval College, Dartmouth and Greenwich; self-taught in art; frequent visits to the studio of Fernand Leger. Traveled Europe, the Orient, and most of the world; resided in Paris, 1936-39, and Mexico, 1941-47. **Taught:** Series of lectures, New School for Social Research, 1940-41; California College of Arts and Crafts, 1956-58. **One-man Exhibitions:** N.S.F.S.R., NYC, 1940; Karl Nierendorf Gallery, NYC, 1946; SFMA (three-man, with Wolfgang Paalen, Lee Mullican), 1950; SFMA (two-man, with Richard Bowman), 1959; The Rose Rabow Gallery, San Francisco, 1956, 64, 72. **Retrospectives:** SFMA; de Young; Victoria (B.C.), 1971. **Group:** SFMA, 1948, 60; de Young, 1962. **Collections:** Boston/MFA; U. of California; de Young; Honolulu Academy; MOMA; SFMA; SRGM; Tate WMAA. **Bibliography:** Breton 2; Onslow-Ford; Paalen; Ragon 1; Rubin 1; Weller. Archives.

OPPENHEIM, DENNIS. b. September 6, 1938, Mason City, Wash. **Studied:** Stanford U., BA, MA; California College of Arts and Crafts, with Norman Kantor. Traveled Europe, 1969-75. **Taught:** Yale U.; Chicago/AI; Stony Brook/SUNY. **Awards:** Guggenheim Foundation Fellowship, 1972; National Endowment for the Arts, 1974. **Address:** 85 Franklin Street, NYC 10013. **Dealers:** Yvon Lambert; M.L. D'Arc Gallery; Galleria A. Castelli, Milan. **One-man Exhibitions:** John Gibson Gallery, 1968, 69, 70, 74; Yvon Lambert, 1969, 71, 75; MOMA, 1969; Reese Palley Gallery, San Francisco, 1970; Gallery 20, Amsterdam, 1971; Harcus-Krakow Gallery, 1971; Françoise Lambert, Milan, 1971, 75; Gallery D, Brussels, 1972, 73, 74; Galleria l'Attico, Rome, 1972; Tate, 1972; Mathias Fels & Cie., Paris, 1972; Nova Scotia College of Art and Design, Halifax, 1972; Ileana Sonnabend Gallery, NYC, 1972, 73, Paris, 1973; M.O.C.A., San Francisco, 1973;

F.H. Mayor Gallery, London, 1973; Galleria Forma, Genoa, 1973, 74; Rivkin Gallery, Washington, D.C., 1973; Paolo Barrozzi, Milan, 1974; Amsterdam/Stedelijk, 1974; Galleria A. Castelli, Milan, 1975. **Retrospectives:** Brussels/Beaux-Arts, 1975; Rotterdam, 1975. **Group:** WMAA Annuals, 1968, 70; Seattle/AM, 557, 087, 1969; Berne, When Attitudes Become Form 1969; Amsterdam/Stedelijk, Op Losse Schroeven, 1969; MOMA, New Media: New Methods, circ., 1969; ICA, U. of Pennsylvania, Against Order: Chance and Art, 1970; Turin/Civico, Conceptual Art, Arte Povera, Land Art, 1970; New York Cultural Center, Conceptual Art and Conceptual Aspects, 1970; Finch College, NYC, Artist/Videotape/Performance, 1971; VII Paris Biennial, 1971; Dusseldorf/Kunsthalle, Prospect '71, 1971; Documenta V, Kassel, 1972; WMAA, American Drawings: 1963-73, 1973; Cologne, Project '74, 1974; MIT, Interventions in Landscape, 1974. **Collections:** Amsterdam/Stedelijk; MOMA; Tate; Turin/Civico. **Bibliography:** *Art Now 74*; Celant; Contemporanea; Honnef; Lippard, ed.; Meyer.

OPPER, JOHN. b. October 29, 1908, Chicago, Ill. **Studied:** Cleveland Institute of Art, 1926-28; Chicago Art Institute School, 1928-29; Western Reserve U., BS, 1931; Hofmann School, 1936; Columbia U., MA, 1942, Ed.D., 1952. Traveled Europe. **Taught:** U. of Wyoming; U. of North Carolina; Columbia U.; NYU. **Member:** American Abstract Artists, since 1936. **Federal A.P.:** Easel painting. **Awards:** Guggenheim Foundation Fellowship, 1969-70; National Endowment for the Arts, 1974. **Address:** Box 347, Amagansett, N.Y. 11930. **Dealer:** Grace Borgenicht Gallery Inc. **One-man Exhibitions:** (first) Artists' Gallery, NYC, 1938, also 1940; SFMA, 1939; San Diego, 1939; Charles Egan Gallery, 1955; The Stable Gallery, 1959, 60, 61, 62; Drew U., 1966; Grace Borgenicht Gallery Inc., 1966, 68, 69, 71, 73; Benson Gallery, 1967. **Group:** Carnegie; MOMA; MMA;

Brooklyn Museum; Chicago/AI; Baltimore/MA; Santa Barbara/MA, 1964. **Collections:** Chase Manhattan Bank; Harcourt Brace Jovanovich Inc., High Museum; MOMA; Montclair/AM; NYU; U. of North Carolina; U. of Texas; Union Carbide Corp. Archives.

ORTMAN, GEORGE. b. October 17, 1926, Oakalnd, Calif. **Studied:** California College of Arts and Crafts, 1947-48; Atelier 17, NYC, 1949, with S.W. Hayter; Academie Andre Lhote, Paris, 1950; Hofmann School, 1950-51. Traveled Europe, North America. **Taught:** School of Visual Arts, NYC, 1960-65; NYU, 1963-65; Fairleigh Dickinson College, summer, 1964; Princeton U., 1966-69; Honolulu Academy, 1969-70; Cranbrook, 1970- . **Awards:** Birmingham, Ala./MA, 1966; Trenton/State, 1967; Guggenheim Foundation Fellowship; Ford Foundation Grant. **m.** Constance Whidden. **Address:** 45 Academy Way, Bloomfield Hills, Mich. 48013; summer: Bos 192, Castine, Me. 04421. **Dealer:** Gimpel & Weitzenhoffer Ltd. **One-man Exhibitions:** (first) Tanager Gallery, NYC, 1953; Wittenborn Gallery, NYC, 1956; The Stable Gallery, 1957, 60; The Swetzoff Gallery, Boston, 1961, 62; The Howard Wise Gallery, NYC, 1962, 63, 64, 67, 69; Fairleigh Dickinson U., 1962; David Mirvish Gallery, 1964; Container Corp. of America, 1965; Walker, 1965; Milwaukee, 1966; Dallas/MFA, 1966; Akron/AI, 1966; Portland, Me./MA, 1966; Harcus-Krakow Gallery, 1966; David Stuart Gallery, 1966; The U. of Chicago, 1967; Galeria Van der Voort, 1967-69; Princeton U., 1967; Temple U., 1968; Middlebury College, 1969; Reed College, 1970; Cranbrook, 1970; J.L. Hudson Art Gallery, Detroit, 1971; Indianapolis, 1971; Western Michigan U., 1972;

George Ortman *Badge* 1969

Gimpel & Weitzenhoffer Ltd., 1972. **Retrospective:** Fairleigh Dickinson U., 1963; Walker, 1965; Princeton U., 1967. **Group:** Salon du Mai, Paris, 1950; SFMA Annual, 1952; Martha Jackson Gallery, New Media—New Forms, I, 1960; Claude Bernard, Paris, 1960; WMAA, Young America, 1960; Carnegie, 1960, 64, 67, 70; Chicago/AI Annuals, 1961, 62; WMAA, Geometric Abstraction in America, circ., 1962; Seattle World's Fair, 1962; MOMA, Hans Hofmann and His Students, circ., 1963-64; Amsterdam/Stedelijk, 1963; Jewish Museum, Toward a New Abstraction, 1963; SFMA, Directions—Painting U.S.A., 1963; WMAA Annuals, 1962-67; A.F.A., Comtemporary Wall Sculpture, circ., 1963-64; A.F.A., Decade of New Talent, circ., 1964; International Biennial Exhibition of Paintings, Tokyo; WMAA, A Decade of American Drawings, 1965; U. of Illinois, 1965; WMAA, Art of the U.S. 1670-1966, 1966; Finch College, NYC, Holograms, 1971. **Collections:** Allentown/AM; American Republic Insurance Co.; Buffalo/Albright; U. of California; Christian Theological Seminary; Des Moines; Lincoln, Mass./De Cordova; MOMA; Manufacturers Hanover Trust Co.; U. of Massachusetts; Milwaukee; NYPL; NYU; Omaha/Joslyn; P.S. 144, NYC; Portland, Me./MA; St. George's Episcopal Church, NYC; Trenton/State; Unitarian Church, Princeton, N.J.; WMAA; Walker; Worcester/AM. **Bibliography:** Calas, N. and E.; Hunter, ed.; Janis and Blesh 1; Weller. Archives.

OSSORIO, ALFONSO. b. August 2, 1916, Manila, Philippine Islands. **Studied** in England, 1924; Harvard U., BA, 1938; RISD, 1938-39. To USA 1929. US Army, 1943-46. **Address:** The Creeks, East Hampton, N.Y. 11937. **Dealer:** Cordier & Ekstrom, Inc. **One-man Exhibitions:** (first) Wakefield Gallery, NYC, 1941, also 1943; Mortimer Brandt, NYC, 1945; Galerie Paul Facchetti, 1951; Betty Parsons Gallery, 1951, 53, 56, 58, 59, 61; Galerie Stadler, Paris, 1960, 61; Cordier & Ekstrom, Inc.,

1961, 64, 65, 67, 68, 69, 72. **Group:** WMAA Annuals, 1953- ; The Downtown Gallery, 1954; The Stable Gallery Annuals, 1955, 56; Rome-New York Foundation, Rome, 1957-59; Galerie Beyeler, Basel; Turin Art Festival, 1959; Martha Jackson Gallery, New Media—New Forms; Osaka (Japan) Art Festival; Gutai Sky Festival, Osaka; Carnegie; MOMA, The Art of Assemblage, circ., 1961; SRGM/USIA, American Vanguard, circ. Europe, 1961-62; Musee Cantonal des Beaux-Arts, Lausanne, I Salon International de Galeries Pilotes, 1963; St.-Etienne, 1964; Documenta III, Kassel, 1964; Intuitiones y Realizaciones Formales, Buenos Aires, 1964; U. of Illinois, 1965; Chicago/AI, 1966; WMAA, Art of the U.S. 1670-1966, 1966; MOMA, The 1960's, 1967; Munich/Modern, New Art: USA, 1968; MOMA, Dada, Surrealism and Their Heritage, 1968; MOMA, The New American Painting and Sculpture, 1969. **Collections:** Brandeis U.; Cuenca; Hartford/Wadsworth; International Institute for Aesthetic Research; MMA; Manila; NYU; PMA; WMAA; Yale U. **Bibliography:** Calas, N. and E.; **Friedman, B.H. 1**; Seitz 3; **Tapie 1, 2.** Archives.

OSVER, ARTHUR. b. July 26, 1912, Chicago, Ill. **Studied:** Northwestern U., 1930-31; Chicago Art Institute School, with Boris Anisfeld. Traveled Europe; resided in France and Italy for several years. **Taught:** Brooklyn Museum School, 1947; Columbia U., 1950-51; U. of Florida; Cooper Union, 1955, 58; Yale U., 1956-57; American Academy, Rome, 1957-58; Washington U., 1960- . **Member:** Artists Equity; Audubon Artists. **Federal A.P.:** Teaching, painting. **Commissions:** *Fortune* Magazine, 1960 (cover). **Awards:** Chicago/AI, James Nelson Raymond Traveling Fellowship ($2,000), 1936; VMFA, John Barton Payne Medal; Pepsi-Cola $500 Award, 1947; PAFA, Joseph E. Temple Gold Medal, 1947; Guggenheim Foundation Fellowship, 1948, renewed 1949; U. of Illinois, **P.P.**, 1949; Prix de Rome,

1952, renewed 1953; Audubon Artists, Emily Lowe Prize, 1961; Art Directors Club, Chicago, Medal, 1961; PAFA, J. Henry Schiedt Memorial Prize, 1966; National Council on the Arts, Sabbatical Leave Grant ($7500), 1966; AAAL, **P.P.**, 1974. **Address:** 465 Foote Avenue, St. Louis, Mo. 63119. **Dealer:** Fairweather-Hardin Gallery. **One-man Exhibitions:** (first) Mortimer Brandt, NYC, 1943; Arts and Crafts, 1947-48; Atelier 17, NYC, 1949, with S.W. Hayter; Academie Andre Lhote, Paris, 1950; Hofmann School, 1950-51. Traveled Europe, North America. **Taught:** School of Visual Arts, NYC, 1960-65; NYU, 1963-65; Fairleigh Dickinson College, summer, 1964; Princeton U., 1966-69. **Awards:** Birmingham, Ala./MA, 1966; Trenton/State, 1967. **Address:** Box 192, Castine, Me. **Dealers:** The Howard Wise Gallery, NYC; Harcus-Krakow Gallery. **One-man Exhibitions:** (first) Tanager Gallery, NYC, 1953; Wittenborn Gallery, NYC, 1956; The Stable Gallery, 1957, 60; The Swetzoff Gallery, Boston, 1961, 62; The Howard Wise Gallery, NYC, 1962, 63, 64, 67, 69; Fairleigh Dickinson U., 1962; David Mirvish Gallery, 1964; Container Corp of America, 1965; Walker, 1965; Milwaukee, 1966; Dallas/MFA, 1966; Akron/AI, 1966; Portland, Me./MA, 1966; Harcus-Krakow Gallery, 1966; David Stuart Gallery, 1966; The U. of Chicago, 1967; Galeria Van der Voort, 1967; Princeton U., 1967; Temple U., 1968; Middlebury College, 1969; St. Louis/City; Terry Moore Gallery, St. Louis, 1975. **Retro-spectives:** Fairleigh Dickinson U., 1963; Walker, 1965; Princeton U., 1967; Kansas City/Nelson, 1973. **Group:** Salon du Mai, Paris, 1950; SFMA Annual, 1952; Martha Jackson Gallery, New Media—New Forms, I, 1960; Claude Bernard, Paris, 1960; WMAA, Young America, 1960; Carnegie, 1960, 64, 67; Chicago/AI Annuals, 1961, 62; WMAA, Geometric Abstraction in America, circ., 1962; Seattle World's Fair, 1962; MOMA, Hans Hofmann and His Students, circ., 1963-64; Amsterdam/Stedelijk, 1963; Jewish Museum, Toward a New Abstraction, 1963; SFMA, Directions—Painting U.S.A., 1963; WMAA Annuals, 1962-67; A.F.A., Contemporary Wall Sculpture, circ., 1963-64; A.F.A., Decade of New Talent, circ., 1964; International Biennial Exhibition of Paintings, Tokyo; WMAA, A Decade of American Drawings, 1965; U. of Illinois, 1965; WMAA, Art of the U.S. 1670-1966, 1966; Venice Biennial. **Collections:** U. of Cincinnati; Colorado Springs/FA; Davenport/Municipal; Des Moines; U. of Georgia; Houston/MFA; Hunter College; IBM; U. of Illinois; Inland Steel Co.; International Minerals & Chemical Corp.; MMA; MOMA; Montclair/AM; NCFA; U. of Nebraska; New Orleans/Delgado; PAFA; PMA; Peabody Museum; Phillips; U. of Rochester; St. Louis/City; Syracuse U.; Toledo/MA; WMAA; Walker; Washburn U. of Topeka; Washington U.; Wilmington. **Bibliography:** Hunter, ed.; Janis and Blesh 1; Weller.

PACE, STEPHEN. b. 1918, Charleston, Mo. **Studied:** Evansville Museum School, 1937-41, with Robert Lahr; Escuela de Bellas Artes, San Miguel de Allende, Mexico, 1945-46; ASL, 1948-49, with Cameron Booth, Morris Kantor; Academie de la Grande Chaumiere, 1950; Academy of Fine Arts, Florence, Italy, 1951; Hofmann School, 1951. US Army, 1943-46. Traveled Mexico; Europe, Canada, USA. **Taught:** Washington U., 1959; Pratt Institute, 1962-69; U. of California, Berkeley, 1968; Bard College, 1969-71; Des Moines, 1970; Kansas City/AI, 1973; Syracuse U., 1975. **Awards:** Dolia Laurian Fund Award, 1954; Hallmark International Competition, 1961; CAPS Grant, 1974. **Address:** 345 West 29 Street, NYC 10001. **Dealer:** A. M. Sachs Gallery. **One-man Exhibitions:** (first) Evansville, 1946; Hendler Gallery, Philadelphia, 1953; Artists' Gallery, NYC, 1954; Poindexter Gallery, 1956, 57; HCE Gallery, Provincetown, Mass., 1956-59, 62-66; Washington U., 1959; Dilexi Gallery, San Francisco, 1960; Holland-Goldowsky Gallery, Chicago, 1960; The Howard Wise Gallery, Cleveland, 1960, NYC, 1960, 61, 63, 64; Dwan Gallery, 1961; MIT, 1961; Ridley Gallery, Evansville, Ind., 1966; U. of California, 1968; The Graham Gallery, 1969; Walker, 1962; Columbus, 1962; Kalamazoo/In-

stitute, 1962; Des Moines, 1970; U. of Texas, 1970; Kansas City/AI, 1973; A. M. Sachs, 1974; Drew U., 1975. **Retrospective:** Bard College, 1975. **Group:** Brooklyn Museum, 1953, Gallery, 1969. **Group:** Brooklyn Museum, 1953, 55; WMAA Annuals, 1953, 54, 56, 57, 58, 61; PAFA, 1954; Carnegie, 1955; Walker, Vanguard, 1955; International Biennial Exhibition of Paintings, Tokyo; Walker, 60 American Painters, 1960; Cleveland/MA, Paths of Abstract Art, 1960; Hallmark Art Award, 1960; Brandeis U. (two-man), circ., 1961; USIA, American Paintings, circ. Latin America, 1961; Corcoran, 1963; MOMA, Hans Hofmann and His Students, circ., 1963-64; U. of Texas, Recent American Painting, 1964; MOMA, circ. Europe, Asia, Australia, 1964-66; Chicago/AI, 1966. **Collections:** U. of California; Chase Manhattan Bank; Ciba-Geigy Corp.; Des Moines; Evansville; Norfolk; Norfolk/Chrysler; Southern Illinois U.; U. of Texas; Utica; WMAA; Waitsfield/Bundy; Walker.

PACHNER, WILLIAM. b. April 7, 1915, Brtnice u Jihlavy, Moravia, Czechoslovakia. **Studied:** Kunstgewerbeschule, Vienna, 1930-33. Staff artist, Melantrich Publishing Co., Prague, 1933-35. To USA 1939. Art Director, *Esquire* Magazine, 1940-43. **Taught:** Florida Gulf Coast Art Center, Inc., 1953-57; Tampa Art Institute, Inc., 1957; Director of own school, 1957-69. **Awards:** NIAL Grant, 1949; Mead Painting of the Year, $1,000 Prize, 1958; New Orleans/Delgado, First Prize, 1958; Youngstown/Butler, First Prize, 1959; Guggenheim Foundation Fellowship, 1960. **Address:** 962 Ohayo Mountain Road, Woodstock, N.Y. 12498. **One-man Exhibitions:** Barry Stephens Gallery, NYC, 1945; Weyhe Gallery, 1948; A.A.A. Gallery, NYC, 1949; Ganso Gallery, NYC, 1951, 55; Ringling, 1954; The Krasner Gallery, 1959, 60, 61, 68, 69; J. Camp Gallery, NYC, 1974. **Retrospective:** A.F.A./Ford Foundation, circ., 1959. **Group:** Carnegie, 1948; WMAA,

1948-51, 58, 60; Corcoran, 1949, 51; PAFA, 1950, 59; ART:USA:58, NYC, 1958; U. of Nebraska; U. of Michigan; Detroit/Institute, 1959; New York World's Fair, 1965; New York Cultural Center, 1968. **Collections:** Ain Harod; Brandeis U.; Fort Worth; State College of Iowa; Milwaukee; Norfolk/Chrysler; Ringling; WMAA; Witte; Youngstown/ Butler. **Bibliography:** Zaidenberg, ed.

PACKARD, DAVID. b. May 29, 1928, Albany, N.Y.; **d.** February 2, 1968, Chicago, Ill. **Studied:** PAFA, with Walker Hancock, 1946-48; Syracuse U., with Ivan Mestrovic, 1951-56, BFA. **Taught:** Layton School of Art, 1964-65; U. of Illinois, 1965-67; and privately. **Awards:** William and Noma Copley Foundation Grant, 1962; New Horizons in Sculpture, First Prize ($2,000), Chicago, 1962; Wisconsin Painters and Sculptors Annual, cash award, 1965; U. of Illinois summer fellowship, 1966. **One-man Exhibitions:** (first) Main Street Gallery, Chicago, 1960, also 1962, 64, 68; Milwaukee, 1963. **Retrospective:** Milwaukee, 1963. **Group:** PAFA, 1953; Audubon Artists, 1953, 62; Ravinia Festival, Highland Park, Ill., 1961; Springfield, Ill./State, 1962; New Horizons in Sculpture, Chicago, 1962,65,66, 67; Ball State Teachers College, Drawings and Sculpture Annual, 1963. **Collections:** Milwaukee; Syracuse U.

PADOVANO, ANTHONY. b. July 19, 1933, NYC. **Studied:** Brooklyn Museum School; Pratt Institute, with Alexander Kostellow; Columbia U., with Oronzio Maldarelli, 1957, BFA; Carnegie Institute of Technology. Traveled Italy, Switzerland; resided Rome, two years. **Taught:** U. of Connecticut, 1962-64; Columbia U., 1964-70; Queens College, 1971-73; Sarah Lawrence College, 1974-75; Westchester County Center, 1973-75. **Member:** Silvermine Guild; American Association of University Professors; Sculptors Guild (vice president). **Commissions:** World Trade Center, NYC, 1971; U. of Northern Iowa, 1972. **Awards:** Prix de Rome,

1960-62; III International Exhibition of Figurative Art, Rome, First Prize, 1962; Silvermine Guild, Olivetti Prize for Sculpture, 1963, 64; Guggenheim Foundation Fellowship, 1964; Ford Foundation, **P.P.,** 1964. **Address:** Box 64, Ancram, N.Y. 12502. **Dealer:** The Graham Gallery. **One-man Exhibitions:** Lincoln, Mass./De Cordova, 1954 (drawings); Geejon Gallery, NYC, 1957; Sculptors Studio, Washington, D.C., 1958; Galleria George Lester, Rome, 1962; Ruth White Gallery, 1962; U. of Connecticut, 1962, 63; Richard Feigen Gallery, NYC, 1964; The Bertha Schaefer Gallery, 1968, 70; The Graham Gallery, 1972, 75; IFA Gallery, Washington, D.C., 1975. **Group:** Carnegie, 1952; Portland, Me./MA, 1959; American Academy, Rome, 1960, 61, 62; Palazzo dell'Esposizione, Rome, 1961, 62; WMAA Annual, 1962; Baltimore/MA, 1963; Waitsfield/Bundy, Bundy Sculpture Competition, 1963; Lincoln, Mass./De Cordova, New England Sculpture, 1964; Finch College, 1964; HemisFair '68, San Antonio, Tex., 1968. **Collections:** American Academy, Rome; U. of Delaware; U. of Illinois; Indianapolis/Herron; U. of Northern Iowa; Port Authority of New York & New Jersey; Ridgefield/Aldrich; Silvermine Guild; Trenton/State; WMAA; Worcester/AM.

PALMER, WILLIAM C. b. January 20, 1906, Des Moines, Iowa. **Studied:** ASL, 1924-26, with Boardman Robinson, Henry Schnakenberg, A. Tucker, Thomas Hart Benton, Kenneth Hayes Miller, and privately with Miller, 1928-29; Ecole des Beaux-Arts, Fontainebleau, with M. Baudoin. US Army, 1943-45. **Taught:** ASL, 1936-40; Hamilton College, 1941-47; Munson-Williams-Proctor Institute, Utica, N.Y., 1941-73. Federal A.P.: Mural painter and supervisor, 1933-39; murals for: Queens General Hospital, Jamaica, N.Y., 1934-36; US Post Office Department Building, Washington, D.C., 1936; US Post Offices at Monticello, Iowa, 1935, and Arlington, Mass., 1938.

Commissions (murals): First National City Bank, Socony Building, NYC; Homestead Savings and Loan Association, Utica, N.Y., 1957. **Awards:** Paris Salon Medal, 1937; NAD, 1946, elected National Academician, 1965; Audubon Artists, 1947; AAAL Grant, 1953. **Address:** Butternut Hill, Chestnut Street, Clinton, N.Y. 13323. **Dealer:** The Midtown Galleries. **One-man Exhibitions:** (first) The Midtown Galleries, 1932, also 1937, 40, 44, 50, 52, 54, 57, 59, 62, 67, 68, 69, 74; Des Moines, 1948, 49; Cazenovia Junior College, 1949; Utica, 1956; Syracuse U.; Skidmore College; Kansas City/Nelson; Colgate U.; St. Lawrence U.; Jacksonville/Cummer, 1972. **Retrospective:** Utica, 1971. **Group:** Corcoran; VMFA; Carnegie, 1936; Brooklyn Museum; Chicago/AI; Toledo/MA; WMAA; New York World's Fair, 1939; MOMA; Kansas City/Nelson; Audubon Artists. **Collections:** AAAL; Allentown/AM; Andover/Phillips; Atlanta U.; Baltimore/MA; Britannica; Columbia S.C./MA; Columbus; Columbus, Ga.; Continental Grain Company; Cranbrook; Dallas/MFA; Des Moines; MMA; Phoenix; U. of Rochester; St. Lawrence U.; Syracuse U.; Transamerica Corp.; Upjohn Co.; Utica; WMAA; The White House, Washington, D.C. **Bibliography:** Boswell 1; Bruce and Watson; **Palmer;** Watson, E. W. 2.

PAONE, PETER. b. October 2, 1936, Philadelphia, Pa. **Studied:** Barnes Foundation, 1953-54; Philadelphia Museum School, 1953, BA. Traveled Europe; resided London, two years. **Taught:** Pratt Institute, 1956-66; Philadelphia Museum School, 1958-59; Samuel S. Fleisher Art Memorial, Philadelphia, 1958-65; Positano (Italy) Art Workshop, 1961; U. of New Mexico, 1974. **Member:** SAGA. **Awards:** PMA, **P.P.,** 1959; Library of Congress, Pennell **P.P.,** 1962; L. C. Tiffany Grants, 1962, 64; The Print Club, Philadelphia, **P.P.,** 1963; Syracuse U., **P.P.,** 1964. **Address:** 1027 Westview Street, Philadelphia, Pa. 19119. **Dealer:** Robinson Galleries.

One-man Exhibitions: (first) Dubin Gallery, Philadelphia, 1957; The Print Club, Philadelphia, 1958, 61, 62; Gallery Ten, New Hope, Pa., 1959; Grippi Gallery, NYC, 1959-62; Fort Worth, 1964; The Forum Gallery, 1965; Jessop Gallery, London, 1967; Benson Gallery, 1967; David Gallery, 1968. **Group:** PMA, 1959, 62; Brooklyn Museum, 1962, and Print Biennials; Escuela Nacional de Artes Plasticas, Mexico City, 1963; III Paris Biennial, 1963; Dallas/MFA, Four Young Artists, 1964; Syracuse/Everson, American Printmakers, 1964; New York World's Fair, 1964-65; Otis Art Institute. **Collections:** British Museum; Fort Worth; Free Library of Philadelphia; General Mills Inc.; Library of Congress; MOMA; U. of Massachusetts; National Gallery; PMA; Princeton U.; The Print Club, Philadelphia; Carl Sandburg Memorial Library; Syracuse U.; Trenton/State; U. of Utah; Victoria and Albert Museum. **Bibliography:** Rodman 3.

PARIS, HAROLD P. b. August 16, 1925, Edgemere, N.Y. **Studied:** Atelier 17, NYC, 1949; Creative Graphic Workshop, NYC, 1951-52; Academy of Fine Arts, Munich, 1953-56. Traveled Europe. **Taught:** U. of California, Berkeley. **Awards:** L. C. Tiffany Grant, 1949; Guggenheim Foundation Fellowship, 1953; Fulbright Fellowship (Germany), 1953; U. of California, Creative Arts Award and Institute Fellowship, 1967-68. **Address:** 326 Athol Avenue, Oakland, Calif. 94606. **Dealer:** Hansen-Fuller Gallery. **One-man Exhibitions:** (first) Argent Gallery, NYC, 1951; Philadelphia Art Alliance, 1951; Village Art Center, NYC, 1952; Wittenborn Gallery, NYC, 1952; Galerie Moderne, NYC, 1953; Esther Stuttman Gallery, NYC, 1960; Tulane U., 1960; Pratt Graphic Art Center, 1960; Silvan Simone Gallery, 1960; U. of California, Berkeley, 1961; Paul Kantor Gallery, Beverly Hills, Calif., 1961; Bolles Gallery, 1962 (two-man, with Angelo Ippolito); Humboldt State College, 1963; Hansen Gallery, San Francisco, 1965,

67; Mills College, 1967; Reed College, 1967; Sally Judd Gallery, Portland, Ore., 1968; Michael Smith Gallery, Los Angeles, 1972; Smith-Andersen Gallery, San Francisco, 1975. **Retrospective:** UCLA, 1971. **Group:** MMA; Boston/ MFA; Vienna Sezession; The Hague; Amerika Haus, Munich; California Palace; Baltimore/MA; Smithsonian; New Orleans/Delgado; Pasadena/AM; Brooklyn Museum, 1948, 49, 50, 52, 54; PAFA, 1949, 50, 52, 54; Galerie Kunst der Gegenwart, Salzburg, 1952; MOMA, 1953; PMA, 1953-56, 1959, 64; SFMA, 1953, 1960-65, Annual, 1963; III Biennial of Spanish-American Art, Barcelona, 1955; Ottawa/National, 1956; WMAA, 1956, Sculpture Annual, 1964; Salon de la Jeune Sculpture, Paris, 1958; Stanford U., Some Points of View for '62, 1962; Museum of Contemporary Crafts, 1963, 66; U. of California, circ., 1963-64; France/National, 1964; San Francisco Art Institute, 1964; New School for Social Research, 1964; La Jolla, 1965; The Pennsylvania State U., 1965; Newport Harbor Art Museum, Balboa, Calif., 1965; M. Knoedler & Co., Art Across America, circ., 1965-67; Los Angeles/County MA, 1966. **Collections:** California Palace; U. of California; Chicago/AI; U. of Delaware; Goddard College; La Jolla; Library of Congress; MOMA; Memphis/Brooks; NYPL; U. of North Dakota; Oakland/ AM; Ottawa/National; PMA; SFMA; WMAA; U. of Wisconsin. **Bibliography:** Selz, P. 2; Tuchman 1.

PARK, DAVID. b. March 17, 1911, Boston, Mass.; **d.** September 20, 1960, Berkeley, Calif. **Studied:** Otis Art Institute, Los Angeles, 1928, assistant to Ralph Stackpole, 1929. **Taught:** Various private schools, San Francisco, 1931-36; Winsor School, Boston, 1936-41; California School of Fine Arts, 1943-52; U. of California, Berkeley, 1955-60. Designed sets and costumes for the U. of California, Berkeley, production of the opera *The Sorrows of Orpheus*, by Darius Milhaud, 1958. Federal A.P.: Mural painting, San Francisco. **Awards:**

SFMA, 1935, 51, 53, 55, 57; Oakland/ AM, Gold Medal, 1957; PAFA, Walter Lippincott Prize, 1960. **One-man Exhibitions:** SFMA, 1935, 40; Delphic Studios, NYC, 1936; New Gallery, Boston, 1939; Albany/Institute (two-man, with Dorothy Dehner), *ca.* 1944; California Palace, 1946; Paul Kantor Gallery, Beverly Hills, Calif., 1954; RAC, 1955; U. of California, College of Architecture, 1956; Oakland/AM, 1957; de Young, 1959; Staempfli Gallery, 1959, 61, 63, 65; U. of California, Berkeley, circ., 1964; Santa Barbara/MA, 1968; Maxwell Galleries, Ltd., San Francisco, 1970. **Group:** PAFA, 1950; U. of Illinois, 1952, 57, 59, 61; III Sao Paulo Biennial, 1955; ART:USA:58 and ART:USA:59, NYC, 1958, 59; WMAA Annual, 1959; Indiana U., New Imagery in American Painting, 1959; A.F.A., The Figure, circ., 1960; Chicago/AI; Corcoran; SRGM/ USIA, American Vanguard, circ. Europe, 1961-62; J. L. Hudson Art Gallery, Detroit, Four California Painters, 1966. **Collections:** U. of California, Berkeley; ICA, Boston; U. of Illinois; Indian Head Mills, Inc.; Oakland/AM; SFMA; WMAA. **Bibliography:** Goodrich and Baur 1. Archives.

PARKER, RAYMOND. b. August 22, 1922, Beresford, S.D. **Studied:** U. of Iowa, 1946, BA, 1948, MFA. **Taught:** Hunter College, 1955- ; U. of Southern California, summer, 1959; State U. of Iowa; U. of Minnesota; Columbia U., 1970-71. **Awards:** Ford Foundation, **P.P.,** 1963; Ford Foundation/A.F.A. Artist-in-Residence Grant, 1965; National Council on the Arts, 1967; Guggenheim Foundation Fellowship, 1967. **Address:** 52 Carmine Street, NYC. **Dealer:** Fischbach Gallery. **One-man Exhibitions:** Walker, 1950; Memphis/Brooks, 1953; Paul Kantor Gallery, Beverly Hills, Calif., 1953, 56; Louisville/Speed, 1954; Union College (N.Y.), 1955; Widdifield Gallery, NYC, 1957, 59; U. of Southern California, 1959; Dwan Gallery, 1960, 62; Galerie Lawrence, Paris, 1960; The Kootz Gallery, NYC, 1960-64; Galleria dell'Ariete,

1961; SRGM, 1961; Bennington College, 1961; Des Moines, 1962 (three-man); Gertrude Kasle Gallery, 1966, 70; U. of New Mexico, 1967; Galerie Muller, 1967; Simone Sterne Gallery, New Orleans (two-man), 1968; Molly Barnes Gallery, Los Angeles, 1968, 70; Quay Gallery, 1970, 72; Fischbach Gallery, 1971, 73, 74; Arts Club of Chicago, 1971; Miami-Dade, 1971; Michael Berger Gallery, Pittsburgh, 1974; Portland (Ore.) Center For the Visual Arts, 1974; Benson Gallery, 1974. **Retrospectives:** Dayton/AI, 1965; WGMA, 1966; SFMA, 1967; School of Visual Arts, NYC, 1971. **Group:** Minnesota State Historical Society, St. Paul, Centennial Minnesota; Walker Biennial, 1949, 51; MOMA, New Talent; MMA, American Paintings Today, 1950; WMAA Annuals, 1950, 52, 58, 67, 69, 72, 73; Oberlin College, 1951; Walker, Vanguard, 1955; Tokyo/Modern, 1957; Walker, 60 American Painters, 1960; II Inter-American Paintings and Prints Biennial, Mexico City, 1960; SRGM, Abstract Expressionists and Imagists, 1961; U. of Illinois, 1961, 62; Seattle World's Fair, 1962; Corcoran, 1963; Jewish Museum, Toward a New Abstraction, 1963; Hartford/Wadsworth, Black, White, and Gray, 1964; Chicago/AI, 1964; Los Angeles/County MA, Post Painterly Abstraction, 1964; Tate, Painting and Sculpture of a Decade, 1954-64, 1964; XXXII Venice Biennial, 1964; Carnegie, 1964, 65; MOMA, The Art of the Real, 1968; MOMA, Younger Abstract Expressionists of the Fifties, 1971; U. of Texas, Color Forum, 1972. **Collections:** AAAL; Akron/AI; Allentown/AM; Brandeis U.; Buffalo/Albright; Chicago/AI; Ciba-Geigy Corp.; Cleveland/MA; Commerce Bank of Kansas City; Dayton/AI; Des Moines; Fort Worth; Hartford/Wadsworth; International Minerals & Chemicals Corp.; State U. of Iowa; Los Angeles/County MA; MIT; MMA; MOMA; Miami-Dade; Minneapolis/Institute; Minnesota State Historical Society; U. of New Mexico; New Orleans/Delgado; PMA; Portland, Ore./AM; Ridgefield/Aldrich; SFMA;

SRGM; Tate; U. of Texas; WMAA; Walker. **Bibliography:** Friedman, ed.; Goossen 1; McChesney; *Metro;* Rickey; Weller.

PARKER, ROBERT ANDREW. b. May 14, 1927, Norfolk, Va. **Studied:** Chicago Art Institute School, with Paul Wieghardt, Rudolph Pen, Max Kahn, 1948-52, BA.Ed.; Atelier 17, NYC, 1952-53, with Peter Grippe. US Army Air Force, 1945-46. Traveled Europe, Africa, Central and South America. **Taught:** New York School for the Deaf, 1952-55; School of Visual Arts, NYC, 1959-63. **Member:** American Federation of Musicians. Worked on film, "The Days of Wilfred Owen," with Richard Burton. **Commissions:** Illustrated *8 Poems,* by Marianne Moore (MOMA, 1962); sets for the MOMA production of *The Mighty Casey,* opera by William Schuman; New York World's Fair, 1964-65. **Awards:** Chicago/AI, 1952; Skowhegan School, 1952; Chicago/AI, Maurice L. Rothchild Schlorship, 1962; NIAL, Richard and Hinda Rosenthal Foundation Award, 1962; Tamarind Fellowship, 1967; J.S. Guggenheim Fellowship, 1969. **Address:** Kent Cliffs Road, Carmel, N.Y. 10512. **Dealer:** Terry Dintenfass, Inc. **One-man Exhibitions:** (first) The Little Gallery, Chicago, 1949; Roko Gallery, NYC, 1953, 54, 57, 58, 59; Palmer House Galleries, Chicago, 1957; Nexus Gallery, Boston, 1957; Katonah (N.Y.) Library, 1957, 63; Felix Landau Gallery, 1961; St. Paul Gallery, 1961; Nashville, 1961; World House Galleries, NYC, 1961, 62, 64; Raymond Burr Gallery, Los Angeles, 1962; Obelisk Gallery, Washington, D.C., 1963; J.L. Hudson Art Gallery, Detroit, 1963, 69; Terry Dintenfass, Inc., 1966, 67, 69, 70, 71, 72; The Schuman Gallery, Rochester, N.Y., 1967; Lehigh U., 1969; U. of Connecticut, 1971; Achim Moeller Ltd., London, 1973. **Group:** MMA, American Watercolors, Drawings and Prints, 1952; MOMA, Young American Printmakers, 1953; WMAA Annuals, 1955, 56, 59; A.F.A., New Talent, circ., 1956; La Napoule, France, 5 Masters of Line,

1957; WMAA, Young America, 1957; USIA, Contemporary Graphic Art in the USA, circ. Europe and Asia, 1957-59; WMAA, Forty Americans Under Forty, circ., 1962; Brooklyn Museum, 1963, 1968-69; MOMA, 1966; PAFA Annuals, 1966, 67; Indianapolis/Herron, 1967, 68; Brooklyn Museum Print Biennials, 1968, 69; U. of North Carolina, 1969, 71; New School for Social Research, Humor, Satire, and Irony, 1972. **Collections:** U. of Arkansas; Brooklyn Museum; Dublin/Municipal; Hirshhorn; Kalamazoo/Institute; Los Angeles/County MA; MOMA; U. of Massachusetts; U. of Michigan; Minnesota/MA; Montclair/AM; The Morgan Library; Nashville; Newark Museum; Pasadena/AM; Phoenix; Raleigh/NCMA; Smith College; Tacoma; WMAA.

PASILIS, FELIX. b. 1922, Batavia, Ill. **Studied:** Hofmann School, 1949-52; American U., 1946-48, with William H. Calfee. A co-founder of Hansa Gallery, NYC. **Awards:** Longview Foundation Grant; Walter K. Gutman Foundation Grant. **Address:** 95 East 10 Street, NYC. **One-man Exhibitions:** Hansa Gallery, NYC, 1952, 53; Urban Gallery, NYC, 1954, 55; Tibor de Nagy Gallery, 1956; The Zabriskie Gallery, 1957; Green Gallery, NYC, 1961; RJ Gallery, NYC, 1962; The Greer Gallery, NYC, 1963; Great Jones Gallery, NYC, 1966. **Group:** 813 Broadway Gallery, NYC, 1951; The Stable Gallery, 21 Young Americans, 1955; Carnegie, 1955, 58, 61; Jewish Museum, The New York School, Second Generation, 1957; Staten Island, Richard Brown Baker Collection, 1959; Yale U., 1961. **Collections:** Agricultural and Mechanical College of Texas; Charlotte/Mint; MIT.

PATTISON, ABBOTT. b. May 15, 1916, Chicago, Ill. **Studied:** Yale U., 1937, BA, 1939, BFA. US Navy, four years. Resided China, Japan, France, Italy. **Taught:** Chicago Art Institute School, 1946-50; Northshore Art League, Winnetka, Ill., 1947-62; U. of

Georgia, 1954-55; Skowhegan School, summers, 1955, 56. **Member:** Arts Club of Chicago; Sculptors Guild. **Commissions:** National Bar Association; Mayo Clinic, Rochester, Minn.; Stanford U. Medical Center; Inland Steel Co.; Union Tank Co.; U. of Chicago; Central National Bank, Cleveland; Illinois State Capitol, Springfield. **Awards:** Yale U. Traveling Fellowship; MMA, $1500 Prize; Chicago/AI (5); Waitsfield/Bundy, Bundy Sculpture Competition, Second Prize; and some dozen others. **Address:** 334 Woodland Avenue, Winnetka, Ill. 60093; Lincolnville, Me. 04849. **Dealer:** Fairweather-Hardin Gallery. **One-man Exhibitions:** (first) Chicago/AI, 1946; Sculpture Center, NYC; Santa Barbara/MA; La Jolla; U. of Georgia; U. of Florida; U. of Pittsburgh; U. of Wisconsin; Lee Nordness Gallery, NYC; Feingarten Gallery, Chicago. **Group:** MMA; WMAA; PMA; Cleveland/MA; Detroit/Institute; Los Angeles/County MA; Oakland/AM; Santa Barbara/MA; Chicago/AI. **Collections:** Andover/Phillips; Brandeis U.; Buckingham Palace; California Palace; Chicago/AI; Corcoran; Davenport/Municipal; Evansville; Fort Wayne; U. of Georgia; Jerusalem/National; La Jolla; Minnesota/MA; U. of Minnesota; Mount Holyoke College; Norfolk/Chrysler; Northwestern U.; U. of Notre Dame; Palm Springs Desert Museum; Phoenix; Portland, Me./MA; SFMA; St. Louis/City; Syracuse U.; WMAA; Wells College; Wichita/AM.

PEAKE, CHANNING. b. October 24, 1910, Marshall, Colo. **Studied:** California College of Arts and Crafts, 1928; Santa Barbara School of Art, 1929-31; ASL, 1935-36, with Rico Lebrun. Traveled Europe, Mexico, Guatemala. A founder of the Santa Barbara (Calif.) Museum of Art. Operates a large ranch in Lompoc, California; first president, American Quarter Horse Association. **Commissions** (murals): Germanic Museum, Harvard U., 1936 (assistant to Louis Rubenstein); Pennsylvania Station, NYC, 1936-38 (assistant to Rico Lebrun); Santa Barbara (Calif.) Public

Library, 1958 (with Howard Warshaw). **Address:** Box 662, Santa Ynez, Calif. 93460. **One-man Exhibitions:** Frank Perls Gallery, 1952; Santa Barbara/MA, 1953, 56 (three-man, with Rico Lebrun and Howard Warshaw); de Young (three-man), 1953; J. Seligmann and Co. (two-man, with Howard Warshaw), 1957; Galerie Zak, Paris, 1961; The Willard Gallery, 1963; Portland, Ore./AM, 1964; Galleria Toninelli, Rome, 1969; Esther Baer Gallery, 1970; Mary Moore Gallery, 1971. **Group:** PAFA; U. of Illinois, 1953, 55; Colorado Springs/FA; Los Angeles/County MA. **Collections:** Santa Barbara/MA.

PEARLSTEIN, PHILIP. b. May 24, 1924, Pittsburgh, Pa. **Studied:** Carnegie Institute of Technology, with Sam Rosenberg, Robert Lepper, Balcomb Greene; NYU, BA, MFA. **Taught:** Pratt Institute, 1959-63; Brooklyn College, 1963- . **Member:** Tanager Gallery, NYC. **Awards:** Fulbright Fellowship (Italy), 1958; National Council on the Arts Grant, 1969; AAAL, **P.P.**, 1973. **Address:** 163 West 88 Street, NYC 10024. **Dealer:** Allan Frumkin Gallery, NYC and Chicago. **One-man Exhibitions:** (first) Tanager Gallery, NYC, 1955, also 1959; The Peridot Gallery, 1956, 57, 59; Allan Frumkin Gallery, Chicago, 1960, 65, 69, 73, NYC, 1961-67, 1969, 72, 74, 76; Kansas City/Nelson, 1962; Reed College, 1965; Ceeje Galleries, Los Angeles, 1965, 66; Bradford Junior College, 1967; Carnegie, 1968; U. of South Flordia, 1969; Chatham College, Pittsburgh, 1970; Graphics I & Graphics II, Boston, 1971; M.E. Thelen Gallery, Cologne, 1972; Galleri Ostergren, Malmo, 1972; Galerie Kornfeld, Zurich, 1972; Staatliche Museen-Kupferstichkabinett, Berlin, 1972; Donald Morris Gallery, 1972; Parker Street 470 Gallery, Boston, 1973; Galerie la Tortue, Paris, 1973; Finch College, NYC, circ., 1974; Gimpel Fils, 1975. **Retrospective:** U. of Georgia, 1970. **Group:** The Kootz Gallery, NYC, New Talent, 1954; The Stable Gallery Annuals, 1955-57; Carnegie, 1955, 66; 73; U. of Nebraska, 1956, 57; Walker,

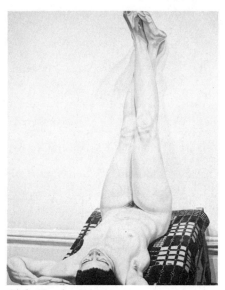

Philip Pearlstein
Female Model, Legs Up against Wall 1975

Expressionism, 1900-1955, 1956, also 1958; Chicago/AI, 1959, 62; Kansas City/Nelson, 1962; U. of Colorado, 1962, 67; SFMA, Directions—Painting U.S.A., 1963, also 1968; Boston U., 1964; U. of Illinois, 1965, 67, 69; U. of Texas, 1966; Corcoran, 1967; Harvard U., 1967; Trenton/State, Focus on Light, 1967; Torcuato di Tella, Buenos Aires; Vassar College, 1968; Smithsonian, circ. Latin America, 1968-70; Milwaukee, Aspects of a New Realism, 1969; WMAA, 22 Realists, 1970; MIT, Leslie, Pearlstein, Thiebaud, 1971; Indianapolis, 1972; A.F.A., Realist Revival, 1972; WMAA, American Drawings: 1963-1973, 1973; Yale U., American Drawing: 1970-1973, 1973; Hofstra U., The Male Nude, 1973; Ars 74, Helsinki, 1974. **Collections:** Chicago/AI; Colgate U.; Colorado Springs/FA; Corcoran; Des Moines; Hirshhorn; U. of Indiana; Louisville/Speed; MOMA; Milwaukee; NYU; U. of Nebraska; Newark Museum; U. of North Carolina; Reed College; Renssalaer Polytechnic Institute; Syracuse U.; Vassar College; WMAA. **Bibliography:** *Kunst um 1970;* **Nochlin;** Rubin 1; Sager; Weller. Archives.

PEARSON, HENRY CHARLES. b. October 8, 1914, Kinston, N.C. **Studied:** U. of North Carolina; Yale U., BA, MFA; ASL, 1953-55, with Reginald Marsh, Will Barnet, Robert Hale. US Army and Air Force, 1942-53. Traveled USA, the Orient. **Taught:** Boston Museum School; New School for Social Research; U. of Minnesota, Duluth; Ball State U.; PAFA; and privately. **Member:** American Abstract Artists. **Awards:** Raleigh/NCMA, 1957; Tamarind Fellowship, 1964; Corcoran, **P.P.**, 1965; PAFA, J. Henry Schiedt Memorial Prize, 1968; North Carolina Governor's Arts Medal, 1969. **Address:** 58 West 58 Street, NYC 10019; 1601 Cambridge Drive, Kinston, N.C. 28501. **Dealer:** Betty Parsons Gallery. **One-man Exhibitions:** (first) Workshop Gallery, NYC, 1958; Stephen Radich Gallery, NYC, 1961, 62, 66, 69; Ball State U., 1965; U. of Minnesota, 1965; Betty Parsons Gallery, 1971, 74; Parsons-Truman Gallery, NYC, 1975. **Retrospective:** Raleigh/NCMA, 1969. **Group:** Scranton/Everhart, Contemporary Americans, 1956; PAFA, 1956, 64; American Abstract Artists Annuals, 1958-64; A.F.A., Purist Painting, circ., 1960-61; A.F.A., Drawings from the WMAA Annual 1960, circ., 1961-62; WMAA, Geometric Abstraction in America, circ., 1962; MOMA, Contemporary Painters and Sculptors as Printmakers, 1964, The Responsive Eye, 1965, also 1969; Corcoran Biennial, 1965; Chicago/AI, 1965; Gallery of Modern Art, NYC, 1965; WMAA Annuals, 1965, 66, 68; Brooklyn Museum, Print Biennial; Grolier Club, 1966; Gallery of Modern Art, Ljubljana, Yugoslavia, VII International Exhibition of Prints, 1967; Utica, 1968. **Collections:** Ackland; Buffalo/Albright; Burlington Mills Collection; Chase Manhattan Bank; Chicago/AI; Ciba-Geigy Corp.; Cincinnati/AM; Columbia Broadcasting System; Corcoran; Housatonic Community College; Kansas City/Nelson; MMA; MOMA; Malmo; U. of Massachusetts; Minneapolis/Institute; U. of Minnesota; NYPL; U. of Nebraska; U. of North Carolina; Oslo/National, Raleigh/NCMA; St. Louis/City; The Singer Company Inc.; Southern Illinois U.; Trinity College, Dublin; U.S. Steel Corp.; Union Carbide Corp.; WMAA; Wells College; Archives.

PEIRCE, WALDO. b. December 17, 1884, Bangor, Me.; **d.** March 8, 1970, Newburyport, Mass. **Studied:** Phillips Academy; Harvard U., 1908, AB; Academie Julian, Paris, 1911. Traveled Europe, North Africa, Spain. **Commissions** (murals): US Post Offices, Westbrooke, Me., Troy, N.Y., and Peabody, Mass.; Field Service Building, NYC, 1961. **Awards:** Pomona College, 1939; Pepsi-Cola, 1944; Carnegie, First Hon. Men., 1944. **One-man Exhibitions:** (first) Wildenstein & Co., NYC, 1926, 41 (two-man); The Midtown Galleries, 1939, 41, 44, 45, 49, 60, 68, 72. **Retrospective:** Rockland/Farnsworth, 1950. **Group:** Salon du Mai, Paris, 1912, 13, 14; Salon d'Automne, Paris, 1922. **Collections:** Andover/Phillips; Arizona State U.; U. of Arizona; Augusta, Me./State; Bangor Public Library; Britannica; Brooklyn Museum; Carnegie; Colby College; Columbus; Harvard U.; MMA; U. of Maine; U. of Nebraska; PAFA; Pepsi-Cola Co.; Rockland/Farnsworth; Upjohn Co.; WMAA; Youngstown/Butler. **Bibliography:** American Artists Group Inc. 3; Baur 7; Bazin; Bethers; Boswell 1; Eliot; **Hale**; Hall; Mellquist; **Peirce**; *7 Decades*; **Varga**. Archives.

PENNEY, JAMES. b. September 6, 1910, St. Joseph, Mo. **Studied:** U. of Kansas, with Albert Bloch, Karl Mattern, R.J. Eastwood, 1931, BFA; ASL, 1931-34, with George Grosz, Charles Locke, William Von Schlegell, Thomas Hart Benton, John Sloan. Traveled USA, Mexico, Europe, Canada. **Taught:** U. of Kansas, 1938-39; Hunter College, 1941-42; Bennett College (N.Y.), 1945-46; Bennington College, 1946-47; School for Art Studies, NYC, 1947; Munson-Williams-Proctor Institute, Utica, N.Y., 1948-55; Hamilton College, 1948- ; Kansas State U., summer, 1955; Vassar College, 1955-56; California College of Arts and Crafts, summer,

1960. **Member:** ASL; National Society of Mural Painters; Audubon Artists; NAD. **Federal A.P.** (murals): Greenpoint Hospital, Brooklyn, N.Y. (with Moses Soyer); Flushing (N.Y.) High School, P.S. 231, NYC; Far Rockawar (N.Y.) High School; New York World's Fair, 1939. **Commissions** (murals): Section of Fine Arts, Washington, D.C., 1939; Bristol Center, Hamilton College, 1959; Nebraska State Capitol, 1962-63 (3); US Post Offices, Union, Mo., and Palmyra, Mo.; Omaha National Bank Centennial, 1966. **Awards:** Kansas City/Nelson, Medal, 1931; Section of Fine Arts, 1939, 40, 41; Pepsi-Cola, Award and Medal, 1948; Western New York Printmakers Annual, First Prize, 1950; Kansas State U., **P.P.**, 1951, 53, 57; AAAL, Childe Hassam Award, 1953; Utica, **P.P.**, 1955, 57; Yaddo Fellowship, 1956, 61; Our Town Competition, 1958; Audubon Artists Award, 1967. **Address:** 101 Campus Road, Clinton, N.Y. 13323. **Dealer:** Kraushaar Galleries. **One-man Exhibitions:** U. of Kansas, 1934, 37; Eighth Street Playhouse, NYC, 1936; Mulvane Art Museum, 1937; Hudson D. Walker Gallery, NYC, 1939; Bennington College, 1946; Kraushaar Galleries, 1950, 54, 57, 61, 65, 69, 74; Utica, 1951, 74; Colgate U., 1952, 54; Wells College, 1953; Union College (N.Y.), 1955; Kansas State College, 1955; Wichita/AM, 1955; Vassar College, 1956; Syracuse U., 1957; Cazenovia Junior College, 1962; Kirkland Art Center, Clinton, N.Y., 1964; Omaha/Joslyn, 1966; Root Art Center, Hamilton College, 1967, 71; Upstairs Gallery, Ithaca, N.Y., 1967-68; Cooperstown (N.Y.) Art Association, 1969. **Retrospectives:** Utica, 1955; Hamilton College, 1962; Utica College, 1972. **Group:** Carnegie; Brooklyn Museum; PAFA; American Watercolor Society; New York World's Fair, 1939; Pepsi-Cola; Audubon Artists; U. of Illinois; Chicago/AI; WMAA Annuals; California Palace; Kansas City/Nelson; Cleveland/MA; National Gallery; Newark Museum; Walker; Fort Worth; Colby College; Toledo/MA; Atlanta/AA; NIAL; New

York State Fair, Syracuse, 1966; NAD, 1973, 74, 75; Syracuse U., Art in Crisis, 1974; AAAL, 1973. **Collections:** Clearwater/Gulf Coast; Columbus; Continental Grain Company; Des Moines; Exeter; Fort Worth; Hirshhorn; Howard U.; Kansas City/Nelson; Kansas State College; Lehigh U.; Lincoln Life Insurance Co.; U. of Minnesota; Montreal/MFA; Mount Holyoke College; NAD; NCFA; U. of Nebraska; New Britain; Omaha/Joslyn; St. Joseph/Albrecht; Springfield, Mass./MFA; Syracuse U.; Upjohn Co.; Utica; Wichita/AM. **Bibliography:** Bauer 5.

PEREIRA, I. RICE. b. August 5, 1901, Boston, Mass.; **d.** January 11, 1971, Marbella, Spain. **Studied:** ASL, with Richard Lahey, Jan Matulka. Traveled Europe, North Africa; resided London, Paris. **Taught:** Pratt Institute. **Federal A.P.:** Easel painting, teaching. **Awards:** Pepsi-Cola, 1943. **One-man Exhibitions:** ACA Gallery, 1933, also 1934, 35, 46, 49; Howard U., 1938; East River Gallery, NYC, 1939; Julien Levy Galleries, NYC, 1939; Art of This Century, NYC, 1944; Arts Club of Chicago, 1945; SFMA, 1947; Barnett Aden Gallery, Washington, D.C., 1948; Andover/Phillips, 1949; Santa Barbara/MA, 1950; Portland, Ore./AM, 1950; de Young, 1950; Syracuse U., 1951; Baltimore/MA, 1951; Ball State Teachers College, 1951; Durlacher Brothers, NYC, 1951; Phillips, 1952; Dayton/AI, 1952; Adele Lawson Gallery, Chicago, 1954; Hofstra College, 1954; U. of Michigan, 1954; Philadelphia Art Alliance, 1955; Corcoran, 1956; Adele Lawson Gallery, NYC, 1956; Lee Nordness Gallery, NYC, 1958, 59, 61; Rome-New York Foundation, Rome, 1960; A.A.A. Gallery, Washington, D.C., 1961; The Amel Gallery, NYC, 1961; Galerie Internationale, NYC, 1964; Agra Gallery, 1965; Distelheim Gallery, 1965; Wilmington College (N.C.), 1968; U. of North Carolina, 1968; Charlotte/Mint, 1968; Andre Zarre Gallery, NYC, 1974. **Retrospective:** WMAA, circ., 1953. **Group:** Venice Biennial; Tate; ICA,

London; MOMA, Fourteen Americans, circ., 1946; Darmstadt/Kunsthalle; Lille; Internationale Kunstausstellung, Berlin, 1951; Chicago/AI Annuals; PAFA; Carnegie; I Sao Paulo Biennial, 1951; USIA, 20th Century Highlights, circ., 1957-58; WMAA, 1966-68; Corcoran, 1969. **Collections:** Allentown/AM; Andover/Phillips; Arizona State College; U. of Arizona; Atlanta U.; Ball State U.; Baltimore/MA; Boston/MFA; Boston U.; Brandeis U.; The Catholic U. of America; Chicago/AI; Connecticut College; Dallas/MFA; Detroit/Institute; Goucher College; Hartford/Wadsworth; Harvard U.; Howard U.; State U. of Iowa; Kansas City/Nelson; MMA; MOMA; The Miller Co.; U. of Minnesota; NCFA; Newark Museum; New London; New Orleans/Delgado; New Paltz/SUNY; Norfolk; Phillips; Phoenix; SFMA; SRGM; Smith College; Syracuse U.; Toledo/MA; Utica; Vassar College; WMAA; Walker; Worcester/AM; Youngstown/Butler. **Bibliography:** Baur 4, 5, 7; Bazin; Flanagan; Genauer; Goodrich and Baur 1; Janis, S.; Kootz 2; Mendelowitz; Miller, ed. 2; Nordness, ed.; Pearson 2; Pousette-Dart, ed.; Read 2; Richardson, E.P.; Ritchie 1; Soby 5, 6; Wight 2. Archives.

PERLIN, BERNARD. b. November 21, 1918, Richmond, Va. **Studied:** New York School of Design, 1934-36; NAD, 1936-37, with Leon Kroll; ASL, 1936-37, with Isabel Bishop, William Palmer, Harry Sternberg. Traveled Europe, Mediterranean, the Orient; resided Italy, 1948-54. **Taught:** Brooklyn Museum School, 1947-48; Wooster Community Art Center, Danbury, Conn., 1967-69. **Commissions:** US Treasury Department; US Post Office Department, 1940. **Awards:** Kosciuszko Foundation, 1938; Chaloner Prize Foundation Award, 1948; Fulbright Fellowship, 1950; Guggenheim Foundation Fellowship, 1954, 59; NIAL, 1964. **Address:** Shadow Lake Road, Ridgefield, Conn. 06877. **One-man Exhibitions:** M. Knoedler & Co., 1948; Catherine Viviano

Gallery, 1955, 58, 63, 66, 70; Wooster School, Danbury, Conn., 1968. **Retrospective:** U. of Bridgeport, 1969. **Group:** Chicago/AI Annuals, 1948, 54, 59; Carnegie, 1949, 52; MMA, 1950; Palazzo di Venezia, Rome, 1950; ICA, London, 1950; WMAA Annuals, 1951, 55; Corcoran, 1953, 59; WMAA, The New Decade, 1954-55; U. of Illinois, 1955, 59; XXVIII Venice Biennial, 1956; Brussels World's Fair, 1958; Cincinnati/AM, 1958; Detroit/Institute, 1960; PAFA, 1960. **Collections:** California Palace; Chicago/AI; Denver/AM; Detroit/Institute; Kansas City/Nelson; MOMA; NCFA; Princeton U.; Springfield, Mass./MFA; Tate; WMAA. **Bibliography:** Baur 7; Eliot; Goodrich and Baur 1; McCurdy, ed.; Mendelowitz; Pousette-Dart, ed.; Rodman 1, 2. Archives.

PETERDI, GABOR. b. September 17, 1915, Budapest, Hungary. **Studied:** Academy of Fine Arts, Budapest, 1929; Academie Julian, Paris, 1931; Academie Scandinave, Paris, 1932; Academy of Fine Arts, Rome, 1930; Atelier 17, Paris, 1935. **Taught:** Brooklyn Museum School, 1948-53; Yale U., 1954- ; Hunter College, 1960- . **Member:** Silvermine Guild. **Awards:** Prix de Rome, 1930; Paris World's Fair, 1937, Gold Medal (jointly with Lurçat); Brooklyn Museum, 1950, 52, 60; American Color Print Society, 1951; Oakland/AM, 1957, 60; PAFA, Gold Medal, 1957; Boston Printmakers, 1959; Seattle/AM, **P.P.,** 1960; Pasadena/AM, **P.P.,** 1960; Bay Printmakers Society, Oakland, Adell Hyde Morrison Memorial Medal, 1960; Ford Foundation Grant, 1960; PAFA, Pennell Memorial Medal, 1961; IV International Biennial Exhibition of Prints, Tokyo, Museum of Western Art Prize, 1964; Guggenheim Foundation Fellowship, 1964-65. **Address:** 108 Highland Avenue, Rowayton, Conn. 06853. **Dealers:** Grace Borgenicht Gallery Inc.; Haslem Fine Arts, Inc.; Jacques Baruch Gallery; Nielsen Gallery. **One-man Exhibitions:** (first) Ernst Museum, Budapest, 1930, also 1934; Bratislava,

Czechoslovakia, 1930; Prague/National, 1930; Rome/Nazionale, 1930; Jeanne Bucher, Paris, 1936; Julien Levy Galleries, NYC, 1939; Norlyst Gallery, NYC, 1943, 44; Laurel Gallery, NYC, 1948, 49; Philadelphia Art Alliance, 1950, 55; Smithsonian, 1951; Silvermine Guild, 1952; Grace Borgenicht Gallery Inc., 1952, 55, 59, 61, 66; NYPL, 1956; Kanegis Gallery, 1956, 57, 59, 61; St. George's Gallery, London, 1958; The Howard Wise Gallery, Cleveland, 1959; Boston/MFA, 1959; Achenbach Foundation, 1960; Lincoln, Mass./De Cordova, 1964; Corcoran, 1964; Michigan State U., 1964; Yale U., 1964; Atlanta/AA, 1965; Ridgefield/Aldrich, 1965. **Group:** Salon des Surindependants, Paris, 1936, 38; Library of Congress, 1943, 47; The Print Club, Philadelphia, 1948; Brooklyn Museum, 1948, 49, 64; WMAA, 1949; MOMA, 1949; Yale U., 1949; Corcoran, 1949; PAFA, 1949, 61; Silvermine Guild; NYPL; Chicago/AI; Achenbach Foundation; U. of Nebraska; Minneapolis/Institute; Oakland/AM; U. of Illinois. **Collections:** Abilene Christian College; Achenbach Foundation; Albion College; Andover/Phillips; Baltimore/MA; Beloit College; Berea College; Boston/MFA; Brandeis U.; Brooklyn Museum; Brown U.; Budapest/National; Buffalo/Albright; Chicago/AI; Clearwater/Gulf Coast; Cleveland/MA; Columbia, S.C./Ma; Corcoran; Cranbrook; Currier; Dartmouth College; U. of Georgia; Hartford/Wadsworth; Honolulu Academy; Illinois Wesleyan U.; U. of Illinois; Indiana U.; MMA; MOMA; Memphis/Brooks; Michigan State U.; U. of Michigan; Minneapolis/Institute; NYPL; U. of Nebraska; Northwestern U.; Oakland/AM; U. of Oklahoma; Oregon State U.; PAFA; PMA; Pasadena/AM; Prague/National; Princeton U.; RISD; Rome/Nazionale; Rutgers U.; Sao Paulo; Seattle/AM; Smith College; Smithsonian; Texas Wesleyan College; Vassar College; WMAA; Walker. **Bibliography:** Baur 5, Chaet; Goodrich and Baur 1; Hayter 1; **Johnson 1; Peterdi.** Archives.

PETERSEN, ROLAND CONRAD. b. March 31, 1926. Endelave, Horsens, Denmark. **Studied:** With Glenn Wessels, Chiura Obata, Erle Loran, John Haley, Worth Ryder, James McCray, U. of the Pacific and U. of California, AB, 1949, MA, 1950; Hofmann School, 1950-51; Atelier 17, Paris, 1950, and with S. W. Hayter, Paris, 1963, 70; California School of Fine Arts, 1951, with Minor White, 1952; California College of Arts and Crafts, 1954. Traveled Europe, 1950-51, 1963-64, 1970-71. **Taught:** Washington State U., 1952-56; U. of California, 1956- . **Awards:** Sigmund Martin Heller Traveling Fellowship, 1950; SFMA, Anne Bremer Memorial Prize, 1950; Oakland/AM, First Prize, Gold Medal, 1953; California State Fair, **P.P.**, 1957, 60; J.S. Guggenheim Fellowship, 1963; U. of the Pacific, **P.P.**, 1969. **Address:** 858 Linden Lane, Davis, Calif. 95616. **Dealers:** Staempfli Gallery; Adele Bednarz Gallery. **One-man Exhibitions:** (first) Oakland/AM, 1954; Spokane Art Center of Washington State U., 1954, 55; Boise (Idaho) Art Association, 1954; Esther Robles Gallery, 1961; City Library, Sacramento, Calif., 1961; California Palace, 1961; Gump's Gallery, 1962; Staempfli Gallery, 1963, 65, 67; Sacramento/Crocker, 1966; Adele Bednarz Gallery, 1966, 69, 72, 73, 75; Chico State College, 1966; de Young, 1968; Western Association of Art Museum Directors, circ., 1968-69; Phoenix, 1972; Santa Barbara/MA, 1973. **Retrospectives:** Chico State College (15-year, 1950-65), 1966; de Young (5-year, 1963-68), 1968. **Group:** Pasadena/AM, Pacific Profile, 1961; Poindexter Gallery, 1961; U. of Illinois, 1961, 63, 69; Santa Barbara/MA, 1962; Carnegie, 1964; Chicago/AI Annual, 1965; VMFA, American Painting, 1966; New School for Social Research, Humanist Tradition, 1968. **Collections:** Achenbach Foundation; CSCS; U. of California, Davis; Chase Manhattan Bank; De Beers Collection; de Young; Illinois Wesleyan U.; La Jolla; Long Beach/MA; MOMA; U. of Miami;

Musee Municipal, Brest; NCFA; U. of North Carolina; Oakland/AM; Oakland Public Library; Ohio U.; PMA; U. of the Pacific; Phoenix; Sacramento/Crocker; San Diego; Santa Barbara/MA; Shasta College; Spokane Coliseum; VMFA; WMAA; Washington State U.

PETLIN, IRVING. b. December 17, 1934, Chicago, Ill. **Studied:** Chicago/AI, 1952-56, BFA; Yale U., 1959, MFA, with Josef Albers. US Army, 1957-59. Traveled USA; resided France, 1959-63. **Taught:** UCLA, 1963-66. **Awards:** Ryerson Fellowship, 1956; Copley Foundation Grant, 1961; Guggenheim Foundation Fellowship, 1971. **Address:** 267 West 11 Street, NYC 10014. **Dealers:** Odyssia Gallery, NYC; Galerie du Dragon; Rebecca Cooper Gallery. **One-man Exhibitions:** Dilexi Gallery, San Francisco, 1956; Galerie du Dragon, 1960, 62, 63, 64, 68, 75; Odyssia Gallery, NYC, 1967, 69, 71, Rome, 1973; Rolf Nelson Gallery, Los Angeles, 1966; Documenta Gallery, Turin, 1974. **Retrospective:** Brussels/Beaux-Arts, 1965. **Group:** Chicago/AI, 1953, 56, 72; Paris/Moderne, 1961-66; WMAA, 1973; Chicago/Contemporary, Chicago Imagist Art, 1972. **Collections:** MOMA; Paris/Moderne. **Bibliography:** Schulze.

PETTET, WILLIAM. b. October 10, 1942, Whittier, Calif. **Studied:** California Institute of the Arts, Valencia; Chouinard Art Institute, 1965, BFA. **Taught:** Skowhegan School, 1972. **Awards:** Tamarind Fellowship, 1970. **Address:** 31 Desbrosses Street, NYC 10013. **Dealer:** The Willard Gallery. **One-man Exhibitions:** Nicholas Wilder Gallery, 1966, 68, 70; Robert Elkon Gallery, 1968, 69; David Whitney Gallery, NYC, 1970, 71; Dunkelman Gallery, Toronto, 1971, 73; The Willard Gallery, 1973, 74. **Group:** Trenton/State, Focus on Light, 1967; WMAA Annuals, 1967, 69, 73; Corcoran, 1969; Washington U., Here and Now, 1969; Ridgefield/Aldrich, Lyrical Abstraction, 1970; ICA, U. of Pennsylvania, Two

Generations of Color Painting, 1970; Santa Barbara/MA, Spray, 1971; WMAA, Lyrical Abstraction, 1971; Hamburg/Kunstverein, USA: West Coast, circ., 1972. **Collections:** MOMA; WMAA. **Bibliography:** *USA West Coast.*

PFRIEM, BERNARD. b. September 7, 1916, Cleveland, Ohio. **Studied:** John Huntington Polytechnical Institute, 1934-36; Cleveland Institute of Art, 1936-40. US Air Force, 1942-46. Traveled Europe, Mediterranean; resided Mexico, 1940-42, Paris, 1952-63. **Taught:** Cleveland Institute of Art School, 1938-40; Peoples Art Center (MOMA), 1946-51; Cooper Union, 1963-71; Sarah Lawrence College, 1969- . US Army Air Force, 1942-46. Assistant to Jose Clemente Orozco on frescoes, Jiquilpan (Michoacan), Mexico, and to Julio Castellanos on murals, Mexico City. Chief Designer, US Government exhibitions and pavilions in Europe, 1953-56. **Awards:** Agnes Gund and Mary S. Ranney Traveling Fellowship, 1940; William and Noma Copley Foundation Grant, 1959. **Address:** 115 Spring Street, NYC 10012. **One-man Exhibitions:** (first) Hugo Gallery, NYC, 1951; US Cultural Center, Paris, 1954; Galerie du Dragon, 1960; Alexandre Iolas Gallery, NYC, 1961, 63; Obelisk Gallery, Washington, D.C., 1963; International Gallery, Baltimore, 1965; Wooster Community Art Center, Danbury, 1965; Richard Feigen Gallery, Chicago, 1966; Sarah Lawrence College, 1969; U. of Arkansas, 1970; Midtown Gallery, Atlanta, 1971. **Retrospective:** Cleveland Institute of Art, 1963. **Group:** Cleveland/MA, 1939-41; Youngstown/Butler, 1941; Columbus, 1942; Carnegie, 1942; Hugo Gallery, NYC, 1948, 49, 50; WMAA Annual, 1951; Smithsonian, circ., American Drawings, circ., 1965; WMAA, A Decade of American Drawings, 1955-1965, 1965; American Drawing Society, 1970; Cleveland Institute of Art, 1973; The Pennsylvania State U., 1974. **Collections:** U. of Arkansas; Brooklyn Museum; Chase Manhattan

Bank; Chicago/AI; Columbia Banking, Savings and Loan Association; Corcoran; MMA; MOMA; Minnesota/MA; Utah; Worcester/AM. **Bibliography:** Waldberg 1, 2.

PINEDA, MARIANNA. b. May 10, 1925, Evanston, Ill. **Studied:** Cranbrook, with Carl Milles, 1942; Bennington College, 1942-43; U. of California, Berkeley, with Raymond Puccinelli 1943-45; Columbia U., with Oronzio Maldarelli, 1945-46; with George Stanley, Los Angeles (sculpture); with Ossip Zadkine, Paris, 1949-50; Scholar, Radcliffe Institute for Independent Study, 1962-64. Resided Paris, 1949-51, Florence, 1954-57, Rome, 1966. **Taught:** Newton College, Mass., 1972- ; Boston U., 1974- . **Member:** Artists Equity; Sculptors Guild. **Commissions:** Boston Conservatory of Music, Jan Veen Memorial Medal. **Awards:** Buffalo/Albright, 1948; Walker, **P.P.**, 1951; Boston Arts Festival, 1957, 60; San Francisco Art Association, First Prize for Sculpture, 1955; Chicago/AI, 1957. m. Harold Tovish. **Address:** 164 Rawson Road, Brookline, Mass. 02146. **Dealer:** Alpha Gallery. **One-man Exhibitions:** (first) Slaughter Gallery, San Francisco, 1951; Walker, 1952; The Swetzoff Gallery, Boston, 1953, 64; Lincoln, Mass./De Cordova, 1954; Premier Gallery, Minneapolis, 1963; Honolulu Academy, 1970; Alpha Gallery, 1972; Newton College, Mass., 1972; Bumpus Gallery, Duxbury, 1974. **Group:** Buffalo/Albright, 1948; WMAA, 1953, 54, 57, 59; MMA, 1957; U. of Illinois, 1957; Chicago/AI, 1957, 60; Boston Arts Festival, 1957, 58, 60; Carnegie, 1958; MOMA, 1959; Waitsfield/Bundy, 1963; New York World's Fair, 1964-65; Lincoln, Mass./De Cordova, Sculpture in the Park, 1972; The Pennsylvania State U., Contemporary Artists and the Figure, 1974; Lincoln, Mass./De Cordova, New England Women, 1975. **Collections:** Andover/Phillips; Boston/MFA; Boston Public Library; Bowdoin College; Dartmouth College; Hartford/Wadsworth; Harvard U.; U. of Massachusetts;

Mount Holyoke College; Radcliffe College; State of Hawaii; Utica; Walker; Williams College.

PITTMAN, HOBSON L. b. January 14, 1900, Tarboro, N.C.; **d.** May 5, 1972, Bryn Mawr, Pa. **Studied:** Rouse Art School, Tarboro, 1912-16, Penn State College, 1921-22, Carnegie Institute of Technology, 1924, Columbia U., 1925-26 (with Molly Rouse, Albert Heckman, Doris Rosenthal, Harold Dickson). Traveled Europe, North Africa, USA, Mexico, Canada, South America, Far East; summered in Woodstock, N.Y., 1920-30. **Taught:** Friends Central School, Philadelphia, 1931-58; PAFA; The Pennsylvania State U.; Philadelphia Museum School. **Member:** Philadelphia Watercolor Club; International Institute of Arts and Letters; NAD; Fellowship of the PAFA; past member, Artists Equity. **Commissions:** *Holiday* Magazine (cover); De Beers Diamonds (painting); Radio Corporation of America (2 paintings for music advertisements). **Awards:** Golden Gate International Exposition, San Francisco, 1939, Hon. Men.; PAFA, J. Henry Schiedt Memorial Prize, 1943; PAFA, Dawson Memorial Medal, 1944; California Palace, American Exhibition, Second Prize, 1947; Corcoran, William A. Clark Prize, 1947; Carnegie, Third Prize, 1949; Youngstown/Butler, First Prize, 1950; Corcoran, Second William A. Clark Prize, 1953; Guggenheim Foundation Fellowship, 1956; PAFA, Distinguished Artist of Pennsylvania, 1960; State of North Carolina Medal in Fine Arts, 1968. **One-man Exhibitions:** (first) Edward Side Gallery, Philadelphia, 1928; Hudson D. Walker Gallery, NYC, 1938; Biltmore Galleries, Los Angeles, 1940, 46; Philadelphia Art Alliance, 1941; The Pennsylvania State U., 1945, 60; San Antonio/McNay; PAFA, 1946, 60, 64; The Milch Gallery, 1947, 54; Raleigh/NCMA, 1950; Sheppard Memorial Gallery, Greenville, N.C., 1957; Winston-Salem (N.C.) Gallery of Fine Arts, 1968; The Babcock Gallery, 1970. **Retrospectives:** Youngstown/Butler, 1942; Ral-

eigh/NCMA, 1963. **Group:** Carnegie; PAFA; Corcoran; Venice Biennial; Chicago/AI; WMAA; MMA; PMA; Golden Gate International Exposition, San Francisco, 1939; New York World's Fair, 1939; Tate, American Painting, 1946; Raleigh/NCMA; Youngstown/Butler. **Collections:** Abbott Laboratories; Andover/Phillips; Britannica; Brooklyn Museum; Carnegie; Cleveland/MA; Corcoran; Cranbrook; Eaton Paper Co.; Florence, S.C., Museum; IBM; Indianapolis/Herron; MMA; MOMA; Memphis/Brooks; Montclair/AM; NIAL; U. of Nebraska; North Carolina/State; Oklahoma; PAFA; PMA; The Pennsylvania State U.; Phillips; Phoenix; Raleigh/NCMA; St. Albans School, Washington, D.C.; San Antonio/McNay; Santa Barbara/MA; Toledo/MA; Twentieth Century Fox Film Corp.; VMFA; WMAA; Wilmington; Youngstown/Butler. **Bibliography:** American Artists Congress, Inc.; Baur 7; Genauer; Hall; **Pittman**; Watson, E. W. 2.

POLLACK, REGINALD. b. July 29, 1924, Middle Village, N.Y. **Studied:** ASL, with Wallace Harrison, Moses Soyer, Boardman Robinson. US Navy, 1941-45. Resided France, 1948-59, 1960-61. Traveled France, Italy, Caribbean Islands. **Taught:** Yale U., 1962-63; Cooper Union, 1963-64. **Commissions:** Seagram Corporation; Container Corp. of America; New York State Telephone System; original film using his painting on the theme of riots, segregation, and war, commissioned by Zuban Mehta for the Los Angeles Philharmonic Orchestra; Washington Cathedral, 1974. **Awards:** Prix Neumann, Paris, 1952; Prix Othon Friesz, Paris, Mention, 1954, 57; Paris/Moderne, Prix de Peintres Etrangers, Second Prize, 1958; Ingram Merrill Foundation Grant, 1964, 70, 71. **Address:** 205 River Bend Road, Great Falls, Va. 22066. **One-man Exhibitions:** (first) Charles Fourth Gallery, NYC, 1948; The Peridot Gallery, 1949, 52, 55, 56, 57, 59, 60, 63, 65, 67, 69; Galerie Saint-Placide, Paris, 1952; Dwan Gallery,

1960; Goldwach Gallery, Chicago, 1964-66; Felix Landau Gallery, 1964, 66; Original Graphics Ltd., Los Angeles, 1968; Olson-Resnick Gallery, Los Angeles, 1968; Jefferson Gallery, Los Angeles, 1969; Gallery Z, Beverly Hills, 1973, 75. **Group:** WMAA, 1953, 55, 56, 58, 63; U. of Nebraska, 1957; Chicago/AI; Carnegie; NIAL; PAFA, 1962, 66; Salon du Mai, Paris; U. of Illinois, 1964; Salon des Artistes Independants, Paris, 1952, 53, 54; Corcoran, 1963; Newark Museum, 1964; New School for Social Research, 1964; Lytton Art Center, Los Angeles, 1967; Long Beach/MA, circ.; Smithsonian, circ., 1968-69. **Collections:** Bezalel Museum; Brooklyn Museum; Collection de l'Etat; U. of Glasgow; Haifa; MOMA; U. of Nebraska; Newark Museum; New York Hilton Hotel; Rockefeller Institute; Southern Illinois U.; Tel Aviv; WMAA; Worcester/AM; Yale U. **Bibliography:** Tomkins. Archives.

POLLOCK, JACKSON. b. January 28, 1912, Cody, Wyo.; **d.** August 11, 1956, Southampton, N.Y. **Studied:** ASL, 1929-31, with Thomas Hart Benton. Federal A.P.: Easel painting, 1938-42. **m.** Lee Krasner (1944). Subject, and narrator, of a 1951 film, "Jackson Pollock," produced by Hans Namuth and Paul Falkenberg. **One-man Exhibitions:** (first) Art of This Century, NYC, 1943, also 1946, 47; Arts Club of Chicago, 1945, 51; Museo Civico Correr, Venice; Galleria d'Arte del Naviglio, Milan, 1950; Galerie Paul Facchetti, 1952; Sidney Janis Gallery, 1952, 54, 55, 57; Zurich, 1953; IV Sao Paulo Biennial, 1957; Marlborough Galleria d'Arte, Rome, 1962; Marlborough-Gerson Gallery Inc., NYC, 1964, 69; Marlborough Fine Art Ltd., London, 1965; WMAA, 1970. **Retrospective:** MOMA, 1956, 67. **Group:** XXIV, XXV, and XXVIII Venice Biennials, 1948, 50, 56; I Sao Paulo Biennial, 1951; MOMA, Fifteen Americans, circ., 1952; Galerie de France, Paris, American Vanguard, 1952; MOMA, 12 Modern American Painters and Sculptors, circ. Europe,

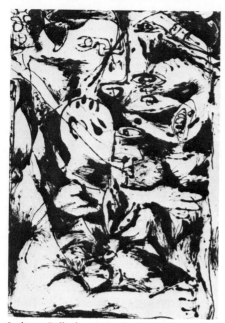

Jackson Pollock *Number 9* 1951

1953-55; WMAA, The New Decade, 1954-55; SRGM, 75 Paintings from The Solomon R. Guggenheim Museum, circ. Europe, 1957; PAFA; Chicago/AI; Brooklyn Museum; Buffalo/Albright; MOMA, The New American Painting and Sculpture, 1969. **Collections:** Andover/Phillips; Baltimore/MA; Brooklyn Museum; Buffalo/Albright; Canberra/National; Carnegie; Chicago/AI; Dallas/MFA; Dusseldorf/KN-W.; Hartford/Wadsworth; State U. of Iowa; Los Angeles/County MA; MMA; MOMA; Ohara Art Museum; Omaha/Joslyn; Ottawa/National; Rio de Janeiro; SFMA; SRGM; Stuttgart; Utica; WMAA; Washington U.; West Palm Beach/Norton; Yale U. **Bibliography:** Ashton 5; Barr 3; Battcock, ed.; Baur 5, 7; Bazin; Beekman; Biddle 4; Bihalji-Merin; Blesh 1; Brion 1; Calas, N. and E.; Canaday; Chipp; Christensen; Davis, D.; De Vries, ed.; Eliot; Elsen 2; Finch; Flanagan; **Friedman, B. H. 2;** Gaunt; Goodrich and Baur 1; Goossen 1; Greenberg 1; Greengood; Haftman;

Henning; Hess, T. B. 1; Hunter 1, 6; Hunter, ed.; Janis and Blesh 1; Janis, S.; **Kligman;** Kozloff 3; Kuh 3; Langui; Leepa; Lippard 5; Lowry; Lynton; McCoubrey 1; McCurdy, ed.; Mendelowitz; Motherwell, ed.; Neumeyer; **O'Hara** 1, **4;** Paalen; Ponente; Pousette-Dart, ed.; Ragon 1, 2; Read 2, 3, 6; Restany 2; Richardson, E. P.; Rickey; Ritchie 1; **Robertson 2;** Rodman 1, 2, 3; Rose, B. 1, 4; **Rose, Bernice;** Rosenblum 2; Rubin 1; Sandler; Seuphor 1; Soby 5; Tapie 1; Tomkins; Tomkins and Time-Life Books; Tuchman, ed.; Weller. Archives.

PONCE DE LEON, MICHAEL. b. July 4, 1922, Miami, Fla. **Studied:** NAD; ASL, with Cameron Booth, Vaclav Vytlacil, Will Barnet, Harry Sternberg; PAFA; Brooklyn Museum School, with Ben Shahn, Gabor Peterdi, John Ferren; U. of Mexico City, BA. US Air Force, three years. Traveled Mexico, Norway and Europe extensively. **Taught:** Vassar College; Cooper Union; Pratt Graphic Art Center; Hunter College; in India and Pakistan, 1967-68. **Member:** SAGA. **Commissions:** US Post Office Department (design for fine arts commemorative stamp). **Awards:** L. C. Tiffany Grant, 1953, 55; Bradley U., **P.P.**, 1954; Dallas/MFA, **P.P.**, 1954; SAGA, Gold Medal, 1954; U. of Nebraska; Oakland/AM, Gold Medal; Fulbright Fellowship, 1956, 57; The Print Club, Philadelphia, 1958; Audubon Artists, Gold Medal of Honor; Guggenheim Foundation Fellowship, 1967. **Address:** 463 West Street, NYC 10014. **One-man Exhibitions:** (first) Galeria Proteo, Mexico City, 1954; Oslo/National; Oakland/AM; Corcoran, 1967; Cynthia Comsky Gallery, 1970. **Retrospective:** Pioneer-Moss Gallery, NYC, 1975. **Group:** MMA; MOMA; Brooklyn Museum; Walker; Victoria and Albert Museum; PAFA; SAGA; Portland, Me./MA; Audubon Artists; Denver/AM; Bradley U.; Chicago/AI; I Inter-American Paintings and Prints Biennial, Mexico City, 1958; NAD; Boston/MFA; U. of Illinois. **Collections:** Achenbach

Foundation, Brooklyn Museum; Cincinnati/AM; Columbia, S.C./MA; Dallas/MFA; U. of Florida; U. of Illinois; Indiana U.; Jacksonville/AM; Library of Congress; MOMA; Melbourne/National; Mexico City/Nacional; NYPL; NYU; National Gallery; U. of Nebraska; Oslo/National; PAFA; PMA; SFMA; US State Department; United Nations; Victoria and Albert Museum; Walker. Archives.

POND, CLAYTON. b. June 10, 1941, Bayside, N.Y. **Studied:** Hiram College, 1959-61; Carnegie Tech, BFA, 1964; Pratt Institute, MFA, 1964-66. Traveled Europe, Africa, Japan. **Taught:** Junior High School, Palm Beach, Fla., 1964; C. W. Post College, 1966-68; School of Visual Arts, NYC, 1968-70. **Member:** Boston Printmakers; The Print Club, Philadelphia. **Commissions:** New York State Council on the Arts, 1967. **Awards:** Bradley U., Print Annual, **P.P.**, 1966; Kalamazoo/Institute, **P.P.**, 1966; Arden Prize, 1966; US State Department Grant, 1967; Albion College, **P.P.**, 1968; Boston Printmakers, **P.P.**, 1968; Dulin Gallery Fifth National Print and Drawing Exhibition, **P.P.**, 1969. **Address:** 130 Greene Street, NYC 10012. **Dealer:** Martha Jackson Gallery. **One-man Exhibitions:** (first) Pratt Institute, 1966; Dartmouth College, 1966; C. W. Post College (two-man), 1966; Gordon Craig Gallery, Miami, Fla., 1968; WGMA, 1968; Princeton U. (two-man), 1968; Martha Jackson Gallery, 1968, 72, 73, 75; Port Washington (N.Y.) Public Library, 1968, 72; Kalamazoo/Institute, 1969; The Print Club, Philadelphia, 1969; Nassau Community College, Garden City, N.Y., 1969; Upstairs Gallery, Ithaca, 1970; Gallery 2, Woodstock, Vt., 1970; Van Straaten Gallery, 1971, 73; Images Gallery, Toledo, 1971; Lincoln, Mass./De Cordova, 1972; Madison Art Center, 1972; Arts & Crafts Center of Pittsburgh, 1972; Langman Gallery, Jenkintown, Pa., 1973; Graphics I & Graphics II, Boston, 1973, 75; Montgomery Museum, 1973; U. of Florida, Gainsville, 1973; U. of Nebras-

ka, 1974; Phoenix, 1974; Yumi Gallery, Tokyo, 1975. **Group:** San Francisco Art Institute Annual, 1965; Brooklyn Museum, Print Biennial; NAD, 1966; Pratt Institute, 1966; Pacific Print Invitational, 1966-67; WMAA Sculpture Annual, 1966; Boston/MFA, 1967-69; Gallery of Modern Art, Ljubljana, Yugoslavia, VII International Exhibition of Prints, 1967; Seattle Civic Center, 1968; Library of Congress Print Annual, 1969; Boston/MFA, Boston Printmakers, 1969; Expo '70, Osaka, 1970; Paris/Moderne, International Exhibition of Colored Prints, 1970; USIA, Vienna, New American Prints, circ., 1971; City Museum and Art Gallery, Hong Kong, Graphics Now! USA, 1972; NCFA, XXIII Library of Congress Exhibition, 1973. **Collections:** AT&T; Albany/SUNY; Albion College; American Republic Insurance Co.; The Bank of New York; Bezalel Museum; Boston/MFA; Bradley U.; Buffalo/Albright; U. of California; Amon Carter Museum; Chase Manhattan Bank; Chicago/AI; Colgate U.; College of St. Benedict; Columbus, Ga.; Dartmouth College; Dulin Gallery; First National Bank of Chicago; Fort Worth; Grunwald Foundation; Indiana U.; Indianapolis/Herron; Kalamazoo/Institute; Library of Congress; Los Angeles/County MA; MOMA; Manufacturers Hanover Trust Co.; Minneapolis/Institute; NCFA; PMA; Pasadena/AM; Potsdam/SUNY; Princeton U.; Quaker Oats Co.; U. of Tennessee; Toledo/MA; US State Department; Washington Post; Western Michigan U.; U. of Wisconsin.

POONS, LARRY. b. October 1, 1937, Tokyo, Japan. **Studied:** New England Conservatory of Music, 1955-57; Boston Museum School, 1958. **Address:** 831 Broadway, NYC 10003. **Dealer:** Knoedler Contemporary Art. **One-man Exhibitions:** (first) Green Gallery, NYC, 1963, also 1964, 65; Leo Castelli Inc., 1967, 68, 69; Kasmin Ltd., 1968, 71; Lawrence Rubin Gallery, NYC, 1969, 70, 72; David Mirvish Gallery, 1970; ACE Gallery, Los Angeles, 1975. **Group:** WGMA, 1963; Sidney Janis

Larry Poons *Goodbye Vinnie* 1975

Gallery, The Classic Spirit, 1964; SRGM, American Drawings, 1964, Systemic Painting, 1966; MOMA, The Responsive Eye, 1965; Smithsonian, 1965; VIII Sao Paulo Biennial, 1965; WMAA Annuals, 1965, 67, also Young America, 1965; Chicago/AI, 1966; Corcoran, 1967; Carnegie, 1967; Documenta IV, Kassel, 1968. **Collections:** Buffalo/Albright; MOMA. **Bibliography:** Alloway 3; Battcock, ed.; Calas, N. and E.; Goossen 1; *The Great Decade;* Hansen; Hunter, ed.; Kozloff 3; Lippard 2, 5; MacAgy 2; Rickey; Rose, B. 1; Wood.

POOR, HENRY VARNUM. b. September 30, 1888, Chapman, Kans.; **d.** December 8, 1970, New City, N.Y. **Studied:** Stanford U., AB, PBK, 1910; U. of London, Slade School, 1910, with Walter Sickert; Academie Julian, Paris, 1911, with Jean Paul Laurens. US Army, 1918. **Taught:** Stanford U.; Mark Hopkins Art School, 1917; Colorado Springs Fine Arts Center, 1937; Skowhegan School. Active 1920-30 only as a potter; there are no paintings from this period.

Commissions (murals): Justice Department, Washington, D.C., 1935; Interior Department, Washington, D.C., 1937; Penn State College, 1940; Deerfield (Mass.) Academy; Mt. Sinai Hospital, NYC. **Awards:** Chicago/AI, Norman Wait Harris Silver Medal, 1932; Carnegie, Third Prize, 1933; Syracuse/Everson, First Prize, 1937; Architectural League of New York, Gold Medal of Honor, 1938. **One-man Exhibitions:** (first) H. Kevorkian, NYC, 1920; Montross Gallery, NYC, 1921-31; Rehn Galleries, 1933- . **Group:** WMAA; Carnegie; Chicago/AI; U. of Illinois. **Collections:** Andover/Phillips; Brooklyn Museum; Cleveland/MA; Columbus; U. of Kansas; MMA; U. of Nebraska; Newark Museum; SFMA; San Diego; WMAA; Wichita/AM. **Bibliography:** Baur 7; Biddle 4; **Boswell 1, 2;** Bruce and Watson; Cahill and Barr, eds.; Cheney; Genauer; Goodrich and Baur 1; Hall; Kent, N.; Mellquist; Nordmark; **Poor 1, 2;** Richardson, E. P.; Soyer, R. 1. Archives.

PORTER, DAVID. b. May 18, 1912, Chicago, Ill. **Studied:** Chicago Art Institute School, briefly. Traveled USA, Mexico, Italy, France, Switzerland. **Taught:** Privately, 1952-57; Ogunquit, 1964; Dartmouth College, 1964; Cooper Union, 1968. Co-author of the Broadway play *Mrs. Patterson.* Operated the David Porter Gallery, Washington, D.C., 1942-46. Publisher, *Cosmopolitan* Magazine, 1954-55. **Awards:** Guild Hall, Hon. Men., 1951; Provincetown Arts Festival, First Prize, 1958; Sassoferrato (Italy) International, Second Gold Medal, 1960, and First Prize, Gold Medal of President Gronchi, 1961; Guild Hall, First Prize, 1964. **Address:** Box 711, Wainscott, N.Y. 11975. **One-man Exhibitions:** (first) Hugo Gallery, NYC, 1952; Deerfield (Mass.) Academy, 1953; Galerie Herve, NYC, 1955; The New Gallery, NYC, 1957; Obelisk Gallery, Washington, D.C., 1958; Tirca Karlis Gallery, 1959; Galleria L'Incontro, Rome, 1960; Modern Art Gallery, Palermo, Sicily, 1960; Ann Ross Gallery,

White Plains, N.Y., 1961, 62; Southampton/Parrish, 1962; Alan Auslander Gallery, NYC, 1962; Ferrill Galleries, Santa Fe, N.M., 1963; Royal Athena II, NYC, 1964; Mickelson's Gallery, Washington, D.C., 1964, 68; Dartmouth College, 1964; NYPL, 1966; American Institute of Architects, N.Y. Chapter, 1969. **Group:** Ninth Street Exhibition, NYC, 1951; WMAA Annual, 1951; Guild Hall, 1951, 54, 55, 56, 58, 64; Chicago/AI, 1952; U. of Illinois, 1952, 53; Carnegie, 1958; Corcoran, 1959; Dayton/AI, Modern Americans, 1959; Lincoln. Mass./De Cordova, 1965. **Collections:** American Airlines; Brown U.; Dartmouth College; Dayton/AI; Guild Hall; Hempstead Bank; Miami/Modern; NYU; Norfolk; Norfolk/Chrysler; Southampton/Parrish; Union Carbide Corp.; WMAA. **Bibliography:** Janis and Blesh 1. Archives.

PORTER, FAIRFIELD. b. June 10, 1907, Winnetka, Ill.; **d.** September, 1975 Southampton, N.Y. **Studied:** Harvard U.; ASL, with Boardman Robinson, Thomas Hart Benton. Traveled Europe, USSR, Scandinavia, USA, Canada. **Taught:** Long Island U., Southampton College, 1965-66; Queens College, 1968; Amherst College, 1969-70; School of Visual Arts, NYC, 1974-75. Editorial Associate, *Art News* Magazine, 1951-58; Art Critic, *The Nation* Magazine, 1959-60. **Awards:** Longview Foundation (for art criticism), 1959; Purdue U., **P.P.**, 1966; NAD, **P.P. One-man Exhibitions:** (first) Community House, Winnetka, Ill., 1939; Tibor de Nagy Gallery, 1951-70; RISD, 1959; U. of Alabama, 1963; Reed College, 1965; Trinity College (Conn.), 1966; Kent State U., 1967; Swarthmore College, 1967; Hirschl & Adler Galleries, 1972, 74. **Retrospectives:** Cleveland/MA, 1966; Huntington, N.Y./Heckscher, circ., 1974. **Group:** Dayton/AI, 1961; MOMA, 1961; Yale U., 1961-62; WMAA Annuals, 1961-66; PAFA, 1962; NIAL, 1962; U. of Nebraska, 1963; Colby College, Maine and Its Artists, 1963; Chicago/AI; Venice Biennial; New York World's Fair, 1964-65; Gallery of Modern Art, NYC, 1965; Purdue U., 1966; Akron/AI, 1967; Flint/Institute, 1967. **Collections:** Brooklyn Museum; Chase Manhattan Bank; Cleveland/MA; Corcoran; Hartford/Wadsworth; Hirshhorn; MOMA; U. of Nebraska; U. of North Carolina; Purdue U.; Santa Fe, N. M.; WMAA; Woodward Foundation. **Bibliography:** McCoubrey 1; **Porter.** Archives.

POSEN, STEPHEN. b. September 27, 1939, St. Louis, Mo. **Studied:** Washington U., 1962, BFA; Yale U., 1964, MFA. US Army, 1957. Traveled Europe. **Taught:** Cooper Union. **Awards:** Fulbright Fellowship, 1964-66; Milliken Traveling Scholarship, 1964; CAPS, 1973. **Address:** 115 Spring Street, NYC 10012. **Dealer:** OK Harris Works of Art. **One-man Exhibitions:** OK Harris Works of Art, 1971, 74. **Group:** Chicago/Contemporary, Radical Realism, 1971; Eindhoven, Relativerend Realisme, 1972; WMAA Annual, 1972; Documenta V, Kassel, 1972; Cleveland/MA, 32 Realists, 1972; Yale U., 7 Realists, 1973; Chicago/AI, New Realism, 1973; Lunds Konsthall, Sweden, Amerikansk Realism, 1974; Tokyo Biennial, 1974; Chicago/AI, 71st American Exhibition, 1974. **Collections:** Chase Manhattan Bank; RAC. **Bibliography:** Sager.

POUSETTE-DART, NATHANIEL. b. September 7, 1886, St. Paul, Minn.; **d.** October 17, 1965, Valhalla, N.Y. **Studied:** ASL; W. M. Chase School, NYC, 1918; with Robert Henri; PAFA, 1920-24, with Thomas Anshutz. Traveled Europe, southern USA. **Taught:** Minnesota College; College of Saint Catherine; various art schools in NYC. **Member:** Federation of Modern Painters and Sculptors (President); Art Directors Club, NYC (an organizer and Past President); American Society for Aesthetics; Architectural League of New York; Fellowship of The Pennsylvania Academy of the Fine Arts. **Awards:** PAFA, Cresson Fellowship (2); Westchester (N.Y.) Art Society, First Prize,

1963; Nantucket, First Prize, 1963. **One-man Exhibitions:** (first) Stevens Art Gallery, St. Paul, 1910; American-British Art Center, NYC, 1934; Kenneth Taylor Gallery, Nantucket, 1959; Sunken Meadow Gallery, Kings Park, N.Y., 1961. **Retrospective:** Anderson Galleries, NYC, 1926. **Bibliography:** Blesh 1; **Pousette-Dart; Pousette-Dart, ed.**

POUSETTE-DART, RICHARD. b. June 8, 1916, St. Paul, Minn. **Studied:** Bard College, 1936. Traveled France. **Taught:** New School for Social Research, 1959-61; School of Visual Arts, NYC, 1965; Columbia U., 1968-69; Sarah Lawrence College, 1970- **Awards:** S. R. Guggenheim Fellowship, 1951; Ford Foundation Grant, 1959; Corcoran Biennial, Silver Medal, 1965; Honorary Doctor of Humane Letters, Bard College, 1965; National Endowment for the Arts Grant, 1967. **Address:** 286 Haverstraw Road, Suffern, N.Y. 10901. **Dealer:** Andrew Crispo Gallery. **One-man Exhibitions:** (first) Artists' Gallery, NYC, 1941; The Willard Gallery, 1943, 45, 46; Art of This Century, NYC, 1947; Betty Parsons Gallery, 1948-51, 1953, 55, 58, 59, 61, 64, 67; Katonah (N.Y.) Art Gallery, 1967; Washington U., 1969; Obelisk Gallery, 1969; Andrew Crispo Gallery, 1974; MOMA, circ., 1969-70. **Retrospectives:** WMAA, 1963, 74. **Group:** Chicago/AI, Abstract and Surrealist Art, 1948; WMAA Annuals, 1949, 51, 53, 1955-59, 1961, 72, 73; MOMA, Abstract Painting and Sculpture in America, 1951; U. of Illinois, 1951-53; Buffalo/Albright, Expressionism in American Painting, 1952; WMAA, The New Decade, 1954-55; WMAA, Nature in Abstraction, 1958; I Inter-American Paintings and Prints Biennial, Mexico City, 1958; Carnegie, 1958, 61; Documenta II, Kassel, 1959; SRGM, Abstract Expressionists and Imagists, 1961; MOMA, The Art of Assemblage, circ., 1961; Hartford/Wadsworth, Continuity and Change, 1962; MOMA, The New American Painting and Sculpture, 1969; National Gallery, American Art as Mid-

Century, 1973. **Collections:** Andover/Phillips; Buffalo/Albright; Chase Manhattan Bank; Equitable Life Assurance Society; MOMA; NCFA; North Central Bronx Hospital; The Singer Company Inc.; Union Carbide Corp.; Upjohn Co.; WMAA. **Bibliography:** Baur 5; Blesh 1; Goodrich and Baur 1; Janis and Blesh 1; Motherwell and Reinhardt, eds.; Nordness, ed.; Pousette-Dart, ed.; Ragon 2; Ritchie 1; Seitz 3; Tuchman, ed. Archives.

POZZATTI, RUDY. b. January 14, 1926, Telluride, Colo. **Studied:** U. of Colorado, with Wendell Black, Ben Shahn, Max Beckmann, 1948, BFA, 1950, MFA. US Army, 1943-46. Traveled Europe, USSR, Mexico, South America; resided Italy. **Taught:** U. of Colorado, 1948-50, summers, 1951, 54; U. of Nebraska, 1950-56; Cooper Union, summer, 1955; Indiana U., 1956-60; Yale-Norfolk Summer Art School, 1957; The Ohio State U., summer, 1959; Florence, Italy, Print Workshop, summer, 1967; Honolulu Academy, 1971; Instituto d'Arte, Massa, Italy, 1974. **Member:** SAGA; Board of Directors, College Art Association, 1974-78. Subject of "Artists in America," half-hour TV color film, N.E.T., 1971. **Commissions:** International Graphic Arts Society (3 editions); Print Club of Cleveland; New York Hilton Hotel. **Awards:** U. of Illinois, Graphic Art Exhibition, First Prize, 1949; Walker, **P.P.**, 1951; Youngstown/Butler, **P.P.**, 1951, 52; St. Louis/City, Vladimir Golschmann Prize, 1952; Fulbright Fellowship (Italy), 1952-53; St. Louis/City, Henry V. Putzell Prize, 1955; The Print Club, Philadelphia, Mildred Boericke Award, 1955, also 1969; PAFA, Alice McFadden Eyre Medal, 1957; Library of Congress, Pennell **P.P.**, 1958; Boston Printmakers, Paul J. Sachs Award, 1958, 61; PAFA, **P.P.**, 1959 (2); AAAL, **P.P.**, 1960; SAGA, 100 Prints of the Year, First Prize, 1963; Guggenheim Foundation Fellowship, 1963-64; Ford Foundation Grant; US State Department Cultural Exchange Grant, 1965; Flint/Institute, 1965; American Color Print Society, **P.P.**, 1968;

Dulin Gallery, Knoxville, Tenn., **P.P.**, 1968; III Annual 500 Mile Race Art Exhibit, Indianapolis, First Prize ($1,000), 1968; U. of Colorado, George Norlin Silver Medal for Distinguished Achievements in Chosen Profession, 1972; Honorary Doctor of Humane Letters, U. of Colorado, 1973; and many others. **Address:** 117 South Meadowbrook, Bloomington, Ind. 47401. **Dealer:** Haslem Fine Arts, Inc. **One-man Exhibitions:** (first) Chicago/AI, 1953; Philadelphia Art Alliance, 1953; Martha Jackson Gallery, 1954; Cleveland/MA, 1955; Kansas City/Nelson, 1955; U. of Maine, 1956; U. of Nebraska, 1956; Gump's Gallery, 1956, 60; Weyhe Gallery, 1957; Clarke College, 1957; Carleton College, 1957; U. of Minnesota, 1958; Louisville/Speed, 1958; Ohio U., 1960; Walker, 1960; J. Seligmann and Co., 1961; U. of Louisville, 1963; Jane Haslem Gallery, Durham, N.C., 1963; Kalamazoo/Institute, 1967; Merida Gallery, Inc., 1967; Daberkow Gallery, Frankfort, 1969; Karlsruhe, 1969; Honolulu Academy, 1971; Louisville/Speed, 1973; Institute of Fine Arts, Salvadore, Brazil, 1974; Institute of Fine Arts, Sao Paolo, 1974; I.B.E.U., Rio de Janiero, 1974; US Embassy, Ankara (two-man), 1975. **Retrospective:** U. of Nebraska, 1971. **Group:** The Print Club, Philadelphia, 1954; U. of Oklahoma, 1956; WMAA, Fulbright Artists, 1958; U. of Michigan, 1959; The Pennsylvania State U., 10 American Printmakers, 1959; WMAA, Young America, 1960; Syracuse U., 1962; PCA, American Prints Today, circ., 1962; U. of Kentucky, Graphics IV, 1962; IBM Gallery of Arts and Sciences, NYC, 30 American Printmakers, circ., 1974. **Collections:** Achenbach Foundation; Albion College; Allegheny College; Alverthorpe Gallery; Anchorage; Ashland Oil Inc.; Ball State U.; Baltimore/MA; Bibliotheque Nationale; Boston/MFA; Bradley U.; Brooklyn Museum, U. of California, Berkeley; Cleveland/MA; U. of Colorado; Concordia Teachers College (Neb.); Davidson, N.C.; Dayton/AI; U. of Delaware; De Pauw U.; Duke U.; Eastern Michigan U.; Hamline U.;

Harvard U.; Indiana U.; Indianapolis/Herron; State College of Iowa; Jacksonville/AM; Kansas City/Nelson; Kansas State College; Kemper Insurance Co.; La Jolla; Library of Congress; Los Angeles/County MA; Louisville/Speed; U. of Louisville; MMA; MOMA; U. of Maine; Malmo; Marshall U.; U. of Michigan; NYPL; National Gallery; Nebraska State Teachers College; U. of Nebraska; Newark Museum; Oakland/AM; Oberlin College; The Ohio State U.; Oklahoma City U.; U. of Oklahoma; Omaha/Joslyn; PAFA; PMA; U. of Puerto Rico; SFMA; St. Cloud State College; St. Lawrence U.; St. Louis/City; St. Mary's College (Ind.); San Jose State College; Seattle/AM; Sioux City Art Center; Springfield, Mo./AM; Syracuse U.; Texas Western College, Toronto; Texas Tech U.; US State Department; Utica; Victoria and Albert Museum; Walker; Washburn U. of Topeka; Wichita/AM; College of William and Mary; U. of Wisconsin; Yale U.; Youngstown/Butler; Youngstown U. **Bibliography:** Chaet, **Print Club of Cleveland.**

PRESTOPINO, GREGORIO. b. June 21, 1907, NYC. **Studied:** NAD, with C. W. Hawthorne. Traveled Europe, southwestern USA, Mexico. **Taught:** Veterans Art Center, MOMA, 1946-48; Brooklyn Museum School, 1946-49; New School for Social Research, 1949-56, 57, 65; American Academy, Rome, 1968-69. Federal A.P.: Easel painting. **Awards:** PAFA, Joseph E. Temple Gold Medal, 1946; Pepsi-Cola, Third Prize, 1946; Youngstown/Butler, First Prize, 1958; Cannes Film Festival, First Prize (for the art film "Harlem Wednesday"), 1958; NIAL Grant, 1961; NAD, Benjamin Altman Prize, 1972. **Address:** 20 Farm Lane, Roosevelt, N.J. 08555. **Dealer:** Terry Dintenfass, Inc. **One-man Exhibitions:** (first) ACA Gallery, 1943, also 1946, 48, 50, 51, 53, 54, 57; Lee Nordness Gallery, NYC, 1959, 60, 61, 62, 64; Rex Evans Gallery, 1961; Witte; Terry Dintenfass, Inc., 1966, 68, 71, 74; Virginia Union U., 1967. **Retrospective:** Michigan State U. **Group:**

WMAA Annuals; MOMA; Corcoran; New York World's Fair, 1939; Golden Gate International Exposition, San Francisco, 1939; Chicago/AI; Venice Biennial; USIA; PAFA Annual, 1967; and others. **Collections:** U. of Alabama; Andover/Phillips; Brandeis U.; Chicago/ AI; Currier; U. of Hawaii; IBM; U. of Illinois; MOMA; Martha Washington U.; Mary Washington College; Montclair/AM; NCFA; U. of Nebraska; U. of Notre Dame; U. of Oklahoma; Phillips; U. of Rochester; Southern Methodist U.; U. of Texas; Trenton/State; WMAA; Walker; Youngstown/Butler. **Bibliography:** Genauer; Nordness, ed.; Pousette-Dart, ed. Archives.

PRICE, CLAYTON S. b. May 24, 1874, Bedford, Iowa; **d.** May 1, 1950, Portland, Ore. **Studied:** Washington U. School of Fine Arts, 1905-06. Traveled Canada, western USA. PWA, 1933-34. Federal A.P.: Easel painting, intermittently 1935-40. **Awards:** Seattle/AM, Katherine Baker Memorial Award, 1929; Portland, Ore./AM, **P.P.,** 1950; Hon. MA, Reed College, 1948. **One-man Exhibitions:** (first) Beaux Arts Gallery, San Francisco, 1925; Berkeley (Calif.) League of Fine Art, 1927; Oregon Society of Artists, Portland, 1929; Valentine Dudensing Gallery, NYC, 1945; Reed College, 1948; Portland, Ore./AM, 1949; The Willard Gallery, 1949. **Retrospective:** Portland, Ore./AM, Price Paintings 1900-42, 1942; Portland, Ore./AM, Memorial Exhibition, circ., 1951. **Group:** Detroit/ Institute, 1944; MOMA, Fourteen Americans, circ., 1946. **Collections:** Andover/Phillips; Beach Public School; Detroit/Institute; Los Angeles/County MA; MMA; U. of Oregon; Pendleton High School; Portland, Ore./AM; Reed College; Seattle/AM; US Treasury Department; Utica. **Bibliography:** Baur 7; Blesh 1; Janis, S.; Miller, ed. 2; Richardson, E. P.

PRICE, KENNETH. b. 1935, Los Angeles, Calif. **Studied:** U. of California; Otis Art Institute; Chouinard Art Institute; U. of Southern California,

BFA, 1956; Alfred/SUNY, MFA, 1958. **Awards:** Tamarind Fellowship, 1968. **Address:** Taos, N.M. 87571. **Dealers:** The Willard Gallery; Kasmin Ltd. **One-man Exhibitions:** U. of California, 1956; Ferus Gallery, Los Angeles, 1960, 61, 64; Los Angeles/County MA (two-man), 1966; Kasmin Ltd., 1968, 70; WMAA, 1969; Mizuno Gallery, 1969, 71; David Whitney Gallery, NYC, 1971; Galerie Hans R. Neuendorf, Cologne, 1971, Hamburg, 1971; D. M. Gallery, London, 1972; Nicholas Wilder Gallery, 1973; Felicity Samuel Gallery, London, 1974; The Willard Gallery, 1974. **Group:** SFMA, Fifty California Artists, circ., 1962; Pasadena/AM, New American Sculpture, 1964; Seattle/AM, Ten from Los Angeles, 1966; U. of California, Irvine, Abstract Expressionist Ceramics, 1966; Los Angeles/County MA, American Sculpture of the Sixties, 1967; MOMA, Tamarind: Homage to Lithography, 1969; Fort Worth Art Museum, Drawings, 1969; Pasadena/AM, West Coast: 1945-69, 1969; Eindhoven, Kompas IV, 1969-70. **Collections:** Los Angeles/County MA. **Bibliography:** Selz, P. 2; *The State of California Painting; USA West Coast.*

QUAYTMAN, HARVEY. b. April 20, 1937, Far Rockaway, N.Y. **Studied:** Syracuse U., 1955-57; Skowhegan School, 1957; Boston Museum School, with Jan Cox, 1957-60; Tufts U., 1957-60, BFA; Royal College of Art, London, 1961-62. **Taught:** Tufts U., 1959; Boston Museum School, 1960, 1962-63; Middlebury College, 1961; Newton Creative Arts Centers, 1961, 63, 64; Roxbury (Mass.) Latin School, 1962-63; Harvard U., 1961, 64, 65. **Awards:** New York Board of Regents Scholarship, 1955-57; Boston/MFA, James William Paige Traveling Fellowship, 1960; CAPS, 1973. **Address:** 231 Bowery, NYC 10002. **Dealers:** David McKee Gallery; Cunningham Ward Inc. **One-man Exhibitions:** A.I.A. Gallery, London, 1962; Ward-Nasse Gallery, Boston, 1964; Royal Marks Gallery, 1966; Ohio State U.,1967; Houston/Contemporary, 1967, 73; Paula Cooper Gallery, 1967,

71; U. of Rochester, 1971; Galerie Onnasch, Cologne, 1971; Galerie Mikro, Berlin, 1971; Galleri Ostergren, Malmo, 1973; Henri 2, Washington, D.C., 1973; Cunningham-Ward Gallery, 1974; David McKee Gallery, 1975. **Group:** ICA, Boston, Painting without a Brush, 1965; U. of Illinois, 1967; WMAA Annuals, 1969, 71, 73; Indianapolis, 1970; Jewish Museum, Beautiful Painting & Sculpture, 1970; Foundation Meaght, 1970; WMAA, The Structure of Color, 1971; UCLA, Fourteen Abstract Painters, 1975; ICA, Boston, Contemporary Painters, 1975. **Collections:** Chase Manhattan Bank; Corcoran; Cornell U.; Dartmouth College; Emory U.; Harvard U.; Houston/MFA; Kent State U.; U. of Massachusetts; Middlebury College; U. of Minnesota; NYU; Oberlin College; Pasadena/AM; Port Authority of New York & New Jersey; U. of Sydney; VMFA; WMAA; Worchester/AM; Wright State U.

QUIRT, WALTER. b. November 24, 1902, Iron River, Mich.; **d.** 1968, Minneapolis, Minn. **Studied:** Layton School of Art, 1921-23. Traveled Mexico, Canada. **Taught:** Layton School of Art, 1924-29; U. of Minnesota, 1945-47, 1952-67. Federal A.P.: Easel painting, 1936-37. **Commissions:** Bellevue Hospital, NYC, 1939 (mural). **Awards:** Detroit/Institute, Cranbrook Prize, 1946. **One-man Exhibitions:** (first) Julien Levy Galleries, NYC, 1936, also 1939; The Pinacotheca, NYC, 1942; A.A.A. Gallery, NYC, 1943; Durlacher Brothers, NYC, 1944, 45; U. of Minnesota, 1949, 59, 68; The New Gallery, NYC, 1951; Duveen-Graham Gallery, NYC, 1957; The Greer Gallery, NYC, 1963. **Retrospective:** A.F.A./Ford Foundation,

circ., 1960. **Group:** MOMA; WMAA; California Palace; St. Louis/City; Hartford/Wadsworth; Walker; Minneapolis/ Institute; Newark Museum; U. of Illinois. **Collections:** Andover/Phillips; Hartford/Wadsworth; U. of Illinois; State U. of Iowa; La Jolla; MOMA; U. of Minnesota; Newark Museum; WMAA; Walker; Washington U. **Bibliography:** Baur 7; Biddle 4; **Coates;** Janis, S.; Kootz 2. Archives.

QUISGARD, LIZ WHITNEY. b. October 23, 1929, Philadelphia, Pa. **Studied:** Johns Hopkins U.; U. of Baltimore; Maryland Institute, 1947-49, MFA, 1966; privately with Morris Louis, 1957-60. **Taught:** Baltimore Hebrew Congregation, 1962- ; Maryland Institute, 1965- ; Goucher College, 1966-68; U. of Maryland, 1970-71. Art critic, *Baltimore Sun*, 1968-70. Set designer for theater productions at Goucher College, Center Stage and Theater Hopkins, 1966- . **Awards:** Baltimore/MA, Second Prize, 1958; Maryland Institute, Fellow of the Rinehart School of Sculpture, 1964-65; National Scholastic Art Awards Scholarship; E.M. Reed Scholarship. **Address:** 321 Rossiter Avenue, Baltimore, Md. 21212. **One-man Exhibitions:** (first) Ef Gallery, Baltimore, 1954; Main Gallery, Maryland Institute, 1955; Martick's Gallery, Baltimore, 1956, 58; Johns Hopkins U., 1958; Jefferson Place Gallery, 1961; Key Gallery, NYC, 1961; Andre Emmerich Gallery, NYC, 1962. **Group:** Peale Museum, Baltimore, 1947, 50; Baltimore/MA, 1951, 52, 53, 58; Youngstown/Butler, 1956; Corcoran, 1957, 64; PAFA Annual, 1964. **Collections:** U. of Arizona; U. of Baltimore; Hampton School.

RABKIN, LEO. b. July 21, 1919, Cincinnati, Ohio. **Studied:** U. of Cincinnati, BA, B.Ed.; Art Academy of Cincinnati; NYU, with Robert Iglehart, Hale Woodruff, Tony Smith, William Baziotes, MA. Traveled Mexico, Europe, Guatemala. **Taught:** NYC public school system. **Member:** American Abstract Artists (President). **Awards:** MOMA, Larry Aldrich **P.P.**, 1959; Ford Foundation, **P.P.**, 1961; Silvermine Guild, Watercolor Award, 1961, 64. **Address:** 218 West 20 Street, NYC 10011. **One-man Exhibitions:** (first) Stairway Gallery, NYC, 1954; Muriel Latow Gallery, NYC, 1961; Gotham Gallery, New Hope, Pa., 1961; Louis Alexander Gallery, NYC, 1962, 63; Gertrude Kasle Gallery, 1965; Richard Feigen Gallery, 1965, 67; Drew U., 1966; Benson Gallery, 1970; Fairleigh Dickinson U., 1971. **Retrospective:** Storm King Art Center, 1970. **Group:** Brooklyn Museum, Watercolor Biennial; Hirschl & Adler Galleries, Inc., NYC, Experiences in Art, I & II, 1959, 60; MOMA, New Talent; WMAA Annual, 1959; Martha Jackson Gallery, New Media—New Forms, I & II, 1960, 61; MOMA, Abstract American Drawings and Watercolors, circ., Latin America, 1961-63; A.F.A., Affinities, circ., 1962; SRGM, 1962, 65; American Abstract Artists Annuals, 1963, 64, 66, 68, 70; WMAA,

1959, 60, 61, 64, 66, 68, 69; Eindhoven, 1966; Walker, Light Motion Space, 1967; Smithsonian, 1967; Trenton/ State, Focus on Light, 1967; Brooklyn Museum Print Exhibitions; Finch College, NYC, Destructionists, 1968; Milwaukee, A Plastic Presence, circ., 1969; Honolulu Academy, 1971; Sculptors Guild, 1972, 74. **Collections:** U. of California, Berkeley; Chase Manhattan Bank; Ciba-Geigy Corp.; MOMA; NYU; Purchase/SUNY; Raleigh/NCMA; Randolph-Macon College; SRGM; Savings Bank Association of New York State; The Singer Company Inc.; Smithsonian; Storm King Art Center; WMAA; Woodward Foundation. Archives.

RACZ, ANDRE. b. November 21, 1916, Cluj, Rumania. **Studied:** U. of Bucharest, 1935, BA; Atelier 17, NYC, 1943-45; New School for Social Research, 1943-45. To USA 1939; citizen 1948. Traveled Europe, Latin America, Mexico. **Taught:** U. of Chile, 1957; Columbia U., 1951- ; U. of Kentucky, 1960. **Member:** American Association of University Professors; SAGA. **Awards:** SAGA, Mrs. A.W. Erickson Prize, 1953; Noyes Memorial Prize, 1955; Guggenheim Foundation Fellowship, 1956; Fulbright Research Scholar (Chile), 1957; U. of Kentucky, **P.P.**, 1959; Ford Foundation, **P.P.**, 1962. **Address:** P.O. Box 43, Demarest, N.J. 07627. **One-man Exhibitions:** (first) New School for Social Research, 1942; A.F.A., circ., 1948-51; and exhibits in NYC nearly every year. **Retrospective:** NYPL, 1954; Museo de Bellas Artes, Santiago, Chile, 1957; U. of Kentucky, 1960. **Group:** MOMA; WMAA Annuals; Brooklyn Museum; Corcoran; Library of Congress; MOMA, 50 Years of American Art, circ. Europe, 1955; I Inter-American Paintings and Prints Biennial, Mexico City, 1958; I International Religious Art Biennial, Salzburg, 1958; MOMA, American Prints, 1913-1963, 1974-75. **Collections:** Bibliotheque Nationale; Brooklyn Museum; Columbia U.; Cordoba/Provincial; George Washington U.; U. of Kentucky;

Library of Congress; MMA; MOMA; Melbourne/National; U. of Minnesota; NYPL; National Gallery; Oslo/National; PMA; SFMA; Salzburg; Smith College; Smithsonian; WMAA; Youngstown/ Butler. **Bibliography:** Baur 7; Hayter 2; Janis, S.

RAFFAEL, JOSEPH. b. February 22, 1933, Brooklyn, N.Y. **Studied:** Cooper Union, 1951-54, with Sidney Delevante, Leo Manso; Yale U., with Josef Albers, James Brooks, BFA. Traveled Europe, Hawaiian Islands; resided Rome and Florence, 1958-60. **Taught:** U. of California, Davis, 1966, Berkeley, summer, 1969; School of Visual Arts, NYC, 1967-69; California State U., Sacramento, 1969-1973. **Awards:** Yale-Norfolk Summer Art School Fellowship, 1954, 55; Fulbright Fellowship, 1958; L.C. Tiffany Grant, 1961; Tokyo Biennial, First Prize, Figurative Painting, 1974. **Address:** 3 Tamarack Drive, San Geronimo, Calif. 94963. **Dealer:** Nancy Hoffman Gallery. **One-man Exhibitions:** (first) Kanegis Gallery, 1958; Numero Galleria d'Arte, Florence, Italy, 1959; D'Arcy Gallery, NYC, 1962, 63; The Stable Gallery, 1965, 66, 68; Galleria Sperone, Turin, 1967 (two-man, with Lowell Nesbitt); Berkeley Gallery, San Francisco, 1968; Sacramento State U., 1969; U. of California, Berkeley, 1969, 73; Wichita/AM, 1970; Reese Palley Gallery, San Francisco, 1970, 72; U. of California, San Diego, 1971; Nancy Hoffman Gallery, 1972, 73, 74; Chicago/Contemporary, 1973; Worcester/AM (three-man), 1974; de Young, 1975. **Group:** Brooklyn Museum; Chicago/AI, 1965; Corcoran, 1966; MOMA, Art in the Mirror, 1966, and others; ICA, U. of Pennsylvania, The Other Tradition, 1966; IX Sao Paulo Biennial, 1967; Los Angeles/County MA, 1967; U. of Illinois, 1967; U. of Miami, 1968; ICA, London, The Obsessive Image, 1968; Indianapolis/Herron, 1969; WMAA, Human Concern/Personal Torment, 1969; VMFA, American Painting, 1970; Darmstadt Biennial, 1970; U. of Miami, Phases of New Realism, 1972; Chicago/ AI, 1972, 74; WMAA Annual, 1973;

Joseph Raffael *City of Refuge* 1975

Cincinnati/Contemporary, Options 70/30, 1973; Los Angeles Municipal Art Gallery, Separate Realities, 1973; Hartford/Wadsworth, New/Photo Realism, 1974; Indianapolis, 1974; U. of Illinois, 1974. **Collections:** Brooklyn Museum; U. of California, Berkeley; U. of Connecticut; U. of Florida; U. of Illinois; Long Beach/MA; Los Angeles/County MA; MMA; U. of Massachusetts; U. of New Mexico; Omaha/Joslyn; SFMA; Syracuse/Everson; Toledo/MA; WMAA; Walker. **Bibliography:** *Three Realists.*

RAMOS, MEL. b. July 24, 1935, Sacramento, Calif. **Studied:** San Jose State College, 1954-55; Sacramento State College, AB, MA, 1955-58. Traveled England, Spain, France, Italy, 1964, Hawaii, 1967, Africa. **Taught:** Mira Loma High School, Sacramento, Calif., 1960-66; California State College at Hayward, 1966- ; Arizona State U., 1967. **Awards:** SFMA, **P.P.**, 1948; Oakland/AM, **P.P.**, 1959. **Address:** 5941 Ocean View Drive, Oakland, Calif. 94618; Moragrega 38, Horta de San Juan (Tarragone), Spain. **Dealers:** Louis K. Meisel Gallery; David Stuart Gallery; Galerie Rolf Ricke. **One-man Exhibitions:** (first) The Bianchini Gallery, NYC, 1964, also 1965; David Stuart Gallery, 1965, 67, 68; Galerie Rolf Ricke, Kassel, 1966; Galerie Tobies-Silex, Cologne, 1967; Berkeley Gallery (two-man), 1967; SFMA, 1967; Galleries Reese Palley, 1969; Galerie Bischofberger, Zurich, 1971; Utah, 1972; Louis K. Meisel Gallery, 1974. **Retrospective:** Krefeld/Kaiser Wilhelm, 1975. **Group:** California Palace, 1959, 60, 61, Painters behind Painters, 1967; Houston/Contemporary, Pop Goes the Easel, 1963; Oakland/AM, Pop Art USA, 1963; Los Angeles/County MA, 1963; Buffalo/Albright, Mixed Media and Pop Art, 1963; ICA, London, The Popular Image, 1963; II American Art Biennial, Cordoba, Argentina, 1964; Akademie der Kunst, Berlin, 1965; Palais des Beaux-Arts, Brussels, 1965; Hamburg, 1965; Milwaukee, 1965; La Jolla, 1966; Portland,

Ore./AM, 1968; WMAA, Human Concern/Personal Torment, 1969; Omaha/Joslyn, Looking West, 1970; WMAA, American Pop Art, 1974; U. of Illinois, 1974. **Collections:** Aachen; Krefeld/Kaiser Wilhelm; Norfolk/Chrysler; Oakland/AM; SFMA. **Bibliography:** Alloway 1; *Kunst um 1970*; Lippard 5; Sager.

RANDELL, RICHARD K. b. 1929, Minneapolis, Minn. **Taught:** Assistant to John Rood, Minneapolis, 1954-57; Hamline U., 1954-61; Macalaster College, 1961; U. of Minnesota, 1961-65; Sacramento State College, 1966. **Awards:** Walker Biennial, **P.P.**, 1956, 62, 66; Minneapolis/Institute, First Prize and **P.P.**, 1957, Hon. Mention, 1959; St. Paul Gallery, **P.P.**, 1961. **Address:** c/o Dealer. **Dealer:** Royal Marks Gallery. **One-man Exhibitions:** Walker, 1959, 64; Minneapolis/Institute, 1964; Royal Marks Gallery, 1965, 66, 68, 69, 71. **Group:** Minneapolis/Institute, 1956, 57, 59, 61, 63; Walker Biennial, 1956, 58, 62, 66; PAFA Annual, 1959; Detroit/Institute, 1959; Chicago/AI Annual, 1961; St. Paul Gallery, 1961; Museum of Contemporary Crafts, 1963; M. Knoedler & Co., Art Across America, circ., 1965-67; New York World's Fair, 1964-65; The Ohio State U., 1966; U. of Illnois, 1967; Los Angeles/County MA, American Sculpture of the Sixties, 1967; Southern Illinois U., 1967; Indianapolis/Herron, 1967. **Collections:** Minneapolis/Institute; Minnesota/MA; U. of Minnesota; Walker. **Bibliography:** Friedman, M. 2; Tuchman 1.

RATTNER, ABRAHAM. b. July 8, 1895, Poughkeepsie, N.Y. **Studied:** George Washington U.; The Corcoran School of Art; PAFA, 1916-17; Academie des Beaux-Arts, Paris; Academie Julian, Paris; Academie Ranson, Paris; Academie de la Grande Chaumiere, 1920. US Army, 1917-19. Traveled Europe, USA; resides New York and Paris. **Taught:** New School for Social Research, 1947-55; Yale U., 1949; Brooklyn Museum School, 1950-51; American Academy,

Rome, 1951; U. of Illinois, 1952-54; ASL, 1954; PAFA, 1954; Sag Harbour Summer Art Center, 1956; Michigan State U., 1956-58. **Commissions:** St. Francis Monastery, Chicago, 1956; Fairmount Temple, Cleveland, 1957; Loop Synagogue, Chicago, 1958; Duluth (Minn.) Synagogue; De Waters Art Center, Flint, Mich., 1958; US Navy Department, Washington, D.C. **Awards:** PAFA, Cresson Fellowship, 1919; PAFA, Joseph E. Temple Gold Medal, 1945; Pepsi-Cola, Second Prize, 1946; La Tausca Competition, First Prize, 1947; Carnegie, Hon. Men., 1949; U. of Illinois, **P.P.**, 1950; Corcoran, First Prize, 1953; NIAL, 1958. **Address:** 830 Greenwich Street, NYC 10014. **Dealer:** Kennedy Gallery. **One-man Exhibitions:** (first) Galerie Bonjean Paris, 1935; Julien Levy Galleries, NYC, 1936-41; Courvoisier Gallery, San Francisco, 1940; Arts Club of Chicago, 1940; P. Rosenberg and Co., 1943, 44, 46, 48, 50, 52, 56; Stendahl Gallery, Los Angeles, 1943; Santa Barbara/MA, 1943; Philadelphia Art Alliance, 1945; Arts and Crafts Club, New Orleans, 1952; Chicago/AI, 1955; Renaissance Society, 1957; The Downtown Gallery, 1957, 58, 60, 66; Corcoran, 1958; North Shore Congregation Israel, Chicago, 1958; WMAA, 1959 (four-man); Galerie Internationale, NYC, 1961; The Contemporaries, NYC, 1967; Kennedy Gallery, 1969, 70, 72, 74, 75; New School for Social Research, 1970. **Retrospectives:** Baltimore/MA, 1946; Vassar College, 1948; U. of Illinois, 1952; A.F.A., circ., 1960. **Group:** PAFA; Corcoran; Chicago/AI; U. of Illinois; Carnegie; MMA; WMAA; Buffalo/Albright; Baltimore/MA; Detroit/Institute; Des Moines; New School for Social Research. **Collections:** Arizona State College; Ball State U.; Baltimore/MA; Bezalel Museum; Brandeis U.; Britannica; Buffalo/Albright; CIT Corporation; Chicago/AI; Cornell U.; Dartmouth College; Des Moines; Detroit/Institute; Fort Worth; Hartford/Wadsworth; U. of Illinois; Jewish Museum; Johnson College; MMA; Manufacturers Hanover Trust Co.; Marquette U.; Michigan State U.; Musee du Jeu de Paume; U. of Nebraska; Newark Museum; New School for Social Research; U. of Oklahoma; PAFA; PMA; Phillips; St. Louis/City; Santa Barbara/MA; Vassar College; WMAA; Walker; Washington U.; Williams College; Yale U.; Youngstown/Butler. **Bibliography:** Baur 5, 7; Biddle 4; Eliot; Frost; Genauer; Getlein 2; **Goodrich and Baur** 1, **2**; Hayter 1, 2; Janis, S.; Kootz 2; Leepa; Mendelowitz; Newtown 1; Nordness, ed.; Pagano; Pearson 2; Pousette-Dart, ed.; Read 2; Richardson, E.P.; Weller, Wight 2. Archives.

RAUSCHENBERG, ROBERT. b. October 22, 1925, Port Arthur, Tex. **Studied:** Kansas City Art Institute and School of Design, 1946-47; Academie Julian, Paris, 1947; Black Mountain College, 1948-49, with Josef Albers; ASL, 1949-50, with Vaclav Vytlacil, Morris Kantor. US Navy. Traveled Italy, North Africa, 1952-53. **Taught:** Black Mountain College, 1952. Designs stage sets and costumes for the Merce Cunningham Dance Co. (since 1955); Technical Director since early 1960's. **Awards:** Gallery of Modern Art, Ljubljana, Yugoslavia, V International Exhibition of Prints, First Prize, 1963; XXXII Venice Biennial, First Prize, 1964; Corcoran, First Prize, 1965. **Address:** c/o Dealer. **Dealer:** Leo Castelli Inc. **One-man Exhibitions:** Betty Parsons Gallery, 1951; The Stable Gallery, 1953; Galleria d'Arte Contemporanea, Florence, Italy, 1953; Charles Egan Gallery, 1955; Leo Castelli Inc., 1958-61, 1963, 65, 67-69, 70, 71, 73, 74; La Tartaruga, Rome, 1959; Galerie 22, Dusseldorf, 1959; Daniel Cordier, Paris, 1961; Galleria dell'Ariete, 1961; Dwan Gallery, 1962; L'Obelisco, Rome, 1963; Ileana Sonnabend Gallery, Paris, 1963, 64, 71, 72, 73, NYC, 1974; Galleria Civica d'Arte Moderna, Turin, 1964; Amerika Haus, Berlin, 1965; Contemporary Arts Society, Houston, 1965; Walker, 1965; Stockholm/National, 1965; MOMA, 1966; 68; Douglas Gallery, Vancouver, 1967, 69; Amsterdam/

Stedelijk, 1968; Peale House, Philadelphia, 1968; Cologne/Kunstverein, 1968; Paris/Moderne, 1968; Fort Worth, 1969; Newport Harbor, 1969; Phoenix, 1970; Seattle/AM, 1970; ICA, U. of Pennsylvania, 1970; Dayton's Gallery 12, Minneapolis, 1970, 71, 75; Automation House, NYC, 1970; New York Cultural Center, 1970; Minneapolis/Institute, 1970; Hannover/Kunstverein, 1970; Chicago/Contemporary, 1970; Fort Worth, 1970; Galerie Rene Ziegler, Zurich, 1970; Visual Arts Gallery, NYC, 1970; Chicago/AI, 1971; Centro C., Caracas, 1971; Galerie Buren, Stockholm, 1972; F.H. Mayor Gallery, London, 1973; ACE Gallery, Venice, Calif., 1973, 74, Vancouver, 1973; Jack Glenn Gallery, San Diego, 1973; Galerie Mikro, Berlin, 1974; Jerusalem National, 1974; Modern Art Agency, Naples, 1974; Galerie Sonnabend, Geneva, 1974; Jared Sable Gallery, Toronto, 1974; Margo Leavin Gallery, 1975. **Retrospective:** Jewish Museum, 1963; Whitechapel Art Gallery, London, 1964. **Group:** The Stable Gallery Annuals, 1951-56; Jewish Museum, The New York School, Second Generation, 1957; A.F.A., Collage in America, circ., 1957-58; Houston/MFA, Collage International, 1958; Carnègie, 1958, 61, 64, 67; A.F.A., Art and the Found Object, circ., 1959; I Paris Biennial, 1959; Daniel Cordier, Paris, Exposition InteRnatiOnale de Surrealisme, 1959; MOMA, Sixteen Americans, circ., 1959; V & IX Sao Paulo Biennials, 1959, 67; Documenta II & IV, Kassel, 1959, 68; A.F.A., School of New York—Some Younger American Painters, 1960; Martha Jackson Gallery, New Media—New Forms, I & II, 1960, 61; Des Moines, Six Decades of American Painting, 1961; MOMA, The Art of Assemblage, circ., 1961; SRGM, Abstract Expressionists and Imagists, 1961; Galerie Rive Droite, Paris, Le Nouveau Realisme, 1961; MOMA, Abstract Watercolors and Drawings: USA, circ. Latin America and Europe, 1961-62; SRGM/USIA, American Vanguard, circ. Europe, 1961-62; Stockholm/National, 4 Americans, circ.,

1962; Salon Du Mai, Paris, 1962; Seattle World's Fair, 1962; III International Biennial Exhibition of Prints, Tokyo, 1962; Art: USA: Now, circ., 1962-67; SRGM, Six Painters and The Object, circ., 1963; WGMA, The Popular Image, 1963; Musee Cantonal des Beaux-Arts, Lausanne, I Salon International de Galeries Pilotes, 1963; ICA, London, The Popular Image, 1963; El Retiro Parquet, Madred, Arte de America y España, 1963; Gallery of Modern Art, Ljubljana, Yugoslavia, V International Exhibition of Prints, 1963; Brandeis U., New Directions in American Painting, 1963; Jewish Museum, Black and White, 1963; Corcoran, 1963, 65; Chicago/AI, 1963, 66; Tate, Dunn Interrational, 1964; Hartford/Wadsworth, Black, White, and Gray, 1964; New York State Pavilion, New York World's Fair, 1964-65; SRGM, 1964, 65; Kunstverein in Hamburg, 1965; U. of Texas, 1965; Cincinnati/Contemporary, 1965; Kansas City/Nelson, Sound, Light, Silence, 1966; Flint/Institute, I Flint Invitational, 1966; Expo '67, Montreal, 1967; MOMA, The 1960's, 1967; Eindhoven, 1967; Foundation Maeght, l'Art Vivant, circ. French museums, 1968; MOMA, Dada, Surrealism and Their Heritage, 1968; Milwaukee, Directions I: Options, circ., 1968; Jewish Museum, 1968; Vancouver, 1968; U. of California, Irvine, 1968; Arts Council of Great Britain, 1968; MMA, New York Painting and Sculpture: 1940-1970, 1969-70; Expo '70, Osaka, 1970; Los Angeles/County MA, Art & Technology, 1971; WMAA, 1973; Parcheggio di Villa Borghese, Rome, Contemporanea, 1974; Chicago/AI, Idea and Image in Recent Art, 1974; WMAA, American Pop Art, 1974. **Collections:** Buffalo/Albright; Cornell U.; Goucher College; NCFA; The Singer Company Inc.; Tate; WMAA. **Bibliography:** *Art Now 74*; Ashton 5; Atkinson; Battcock ed.; Becker and Vostell; Bihalji-Merin; Calas, N. and E.; *Contemporanea*; Davis, D.; De Vries, ed.; Dienst 1; Elsen 2; Finch; Friedman, ed.; *Happening & Fluxus*; Hulten; Hunter, ed.; Janis and Blesh 1;

Kaprow; Kozloff 3; *Kunst um 1970;* Licht, F.; Lippard 5; Lynton; *Metro;* Newmeyer; Nordness, ed.; Read 3; *Report;* Rickey; Rodman 3; Rose, B. 1, 4; Rubin 1; Russell and Gablik; Sager; Seitz 3; Sontag; Tomkins and Time-Life Books; Tuchman 1; Weller.

REDER, BERNARD. b. June 29, 1897, Czernowitz, Bukovina, Austria; **d.** September 7, 1963, NYC. Austrian Army, 1914-18. **Studied:** Academy of Fine Arts, Prague, 1919, with Peter Bromse, Jan Stursa. Traveled Cuba, USA, Europe extensively. To USA 1943; citizen 1948. **Awards:** International architectural competition to house the monument to Christopher Columbus in Santo Domingo, 1927; Ford Foundation Grant, Program in Humanities and the Arts ($10,000), 1960. **One-man Exhibitions:** (first) The Rudolphinium, Prague, 1928 (watercolors); Manes Gallery, Prague, 1935; Galerie de Berri, Paris, 1940; Lyceum Gallery, Havana, 1942; U. of Ravenna, 1942; Weyhe Gallery, 1943; Philadelphia Art Alliance, 1950; Bezalel Museum, 1950; The Print Club, Philadelphia, 1950; Tel Aviv, 1950, 63; Grace Borgenicht Gallery Inc., 1951, 52, 53; Dominion Gallery, Montreal, 1953; Chicago/AI, 1953; Galleria d'Arte Moderna L'Indiano, Florence, Italy, 1956, 57; The Contemporaries, NYC, 1956; Palazzo Torrigiani, Florence, Italy, 1957; World House Galleries, NYC, 1951, 61. **Retrospective:** WMAA, 1961. **Group:** WMAA, European Artists in America, 1945; Chicago/AI; PMA, 1949; MOMA, 1949, 51; U. of Illinois, 1953. **Collections:** Baltimore/MA; Brooklyn Museum; Chicago/AI; Harvard U.; Jewish Museum; MMA; MOMA; NYPL; National Gallery; PMA; Sao Paulo. **Bibliography: Bernard Reder;** Goodrich and Baur 1; Licht, F. Archives.

REICHEK, JESSE. b. August 16, 1916, Brooklyn, N.Y. **Studied:** Institute of Design, Chicago, 1941-42; Academie Julian, Paris (diploma), 1947-51. US

Army Engineers, 1942-46. Traveled Europe, India, the Orient; resided Paris, India. **Taught:** U. of Michigan, 1946-47; Illinois Institute of Technology, 1951-53; U. of California, Berkeley, 1953- ; American Academy, Rome, 1971. **Awards:** Graham Foundation Grant, 1962; Tamarind Fellowship, 1966. **Address:** 5925 Red Hill Road, Petaluma, Calif. 94952. **Dealers:** Betty Parsons Gallery; Galeria Van der Voort; Galerie des Cahiers d'Art. **One-man Exhibitions:** (first) Galerie des Cahiers d'Art, 1951, also 1959; U. of California, 1954; Betty Parsons Gallery, 1958-60, 63, 65, 67, 68, 70; Wittenborn Gallery, NYC, 1962; Molton Gallery, London, 1962; Bennington College, 1963; American Cultural Center, Florence, Italy, 1964; U. of New Mexico, 1966; Axiom Gallery, London, 1968; Yoseido Gallery, Tokyo, 1968; Galeria Van der Voort, 1969; Los Angeles/County MA, 1971. **Retrospective:** U. of Southern California, 1967. **Group:** Brooklyn Museum, 1959; MOMA, 1962; Buffalo/Albright, 1965; Cincinnati/AM, 1966; Arts Club of Chicago, 1966; Cranbrook, 1967; Finch College, 1967; Caracas, 1969; Foundation Maeght, 1971. **Collections:** Bibliotheque Nationale; U. of California; Amon Carter Museum; Chicago/AI; Grunwald Foundation; La Jolla; Los Angeles/County MA; MOMA; U. of New Mexico; Pasadena/AM; San Diego; Victoria and Albert. **Bibliography:** *Report.*

REINHARDT, AD. b. December 24, 1913, Buffalo, N.Y.; **d.** August 30, 1967, NYC. **Studied:** Columbia U., with Meyer Schapiro, 1931-35, BA, 1936-37; NAD, 1936-37, with Francis Criss, Carl Holty; NYU, Institute of Fine Arts, 1945-51, with Alfred Salmony. US Navy photographer, 1944-45. Traveled Europe and Asia extensively. **Taught:** Brooklyn College, 1947-67; California School of Fine Arts, 1950; U. of Wyoming, 1951; Yale U., 1952-53; Syracuse U., 1957; Hunter College, 1959-67. Worked for *PM* (newspaper), NYC, 1944-47. Articles in *Art International, Art News,*

College Art Journal, It Is (magazines). **Member:** American Abstract Artists, 1937-47; Asia Society; Chinese Art Society. Federal A.P.: Easel painting, 1936-39. **One-man Exhibitions:** (first) Columbia U., 1943; Artists' Gallery, NYC, 1944; Mortimer Brandt, NYC, 1945; Brooklyn Museum School, 1946; Betty Parsons Gallery, 1946-53, 55, 56, 59, 60; Syracuse U., 1957; Leverkusen, 1961; Dwan Gallery, 1961, 63; Iris Clert Gallery, 1963; ICA, London, 1964; Marlborough Gallery Inc., NYC, 1970, 74; Irving Blum Gallery, Los Angeles, 1970; Richard Feigen Gallery, 1970; Dusseldorf/Kunsthalle, 1972; Eindhoven, 1973; Marlborough Galerie AG, Zurich, 1974. **Retrospective:** Jewish Museum, 1967. **Group:** New York World's Fair, 1939; American Abstract Artists Annuals; MOMA, Abstract Painting and Sculpture in America, 1951; WMAA, The New Decade, 1954-55, and others; Brussels World's Fair, 1958; SRGM, Abstract Expressionists and Imagists, 1961; Seattle World's Fair, 1962; MOMA, Americans 1963, circ., 1963-64; Tate, 1964; WMAA, The 1930's, 1968; MOMA, The New American Painting and Sculpture, 1969. **Collections:** Baltimore/MA; Buffalo/Albright; Dayton/AI; Leverkusen; Los Angeles/County MA; MOMA; U. of Nebraska; Oslo/National; PMA; SFMA; Toledo/MA; WMAA; Yale U. **Bibliography:** Battcock, ed.; Blesh 1; Calas, N. and E.; *Contemporanea*; Coplans 3; De Vries, ed.; Goossen 1; Hess, T. B. 1; Janis and Blesh 1; Janis, S.; **Lippard 1;** MacAgy 2; McChesney; **Motherwell and Reinhardt, eds.;** Nordness, ed.; Pousette-Dart, ed.; Rickey; Ritchie 1; Rodman 1; Rose, B. 1, 4; Sandler; Tuchman, ed.; Weller. Archives.

REINHARDT, SEIGFRIED GERHARD. b. July 31, 1925, Eydkuhnen, Germany. To USA 1928; citizen 1936. **Studied:** Washington U., AB. **Taught:** Washington U., 1955-70. **Awards:** Scholarship, John Herron Art Institute, 1943; 20th Century Book Club Award, 1945; St. Louis Artists' Guild, 1951, 53, 54, 55, 57, 58; St. Louis/City, 1951, 53, 55, 56; Cincinnati/AM, 1958; International Novara, Trieste, 1961. **Address:** 635 Craig Woods Drive, Kirkwood 22, Mo. 63122. **Dealer:** The Midtown Galleries. **One-man Exhibitions:** Eleanor Smith Gallery, St. Louis, 1942,43,47; Southern Illinois U., 1951, 52; St. Louis Artists' Guild, 1951, 58; Stevens-Gross Gallery, Chicago, 1952; Art Mart, Clayton, Mo., 1953; Texas Western College, 1954; Illinois State Normal U., Normal, Ill., 1954; Martin Schweig Gallery, 1956; Hewitt Gallery, NYC, 1957; The Midtown Galleries, 1961, 66. **Group:** St. Louis/City, 1943, 45, 47, 49, 51, 53, 58, 61; Chicago/AI, 1947, 54; Washington U., 1950; MMA, 1950; Los Angeles/County MA, 1951, 55; WMAA, 1951-55, 1960; Walker, 1954; Dallas/MFA, 1954; Beloit College, 1954; A.F.A. (stained glass), circ.; Cincinnati/AM, 1955, 58, 61; ICA, Boston, 1958; PAFA, 1958, ART:USA:58, NYC, 1958; Kansas State College, 1958; USIA, circ. Europe, 1959; Boston/MFA, 1960, 61; Columbus, 1961; Trieste, 1961. **Collections:** AAAL; Abbott Laboratories; Beloit College; Cincinnati/AM; Concordia Teachers College (Neb.); Jacksonville/Crummer; Kansas City/Nelson; Newark Museum; RISD; St. Louis/City; Southern Illinois U.; WMAA. **Bibliography:** Nordness, ed.; Pousette-Dart, ed.

REMINGTON, DEBORAH. b. June 25, 1930, Haddonfield, N.J. **Studied:** California School of Fine Arts, 1949-52; San Francisco Art Institute, BFA, 1955. Traveled Asia, 1955-58, Europe, 1967-68. **Taught:** San Francisco Art Institute, 1958-65, 66, 68; U. of California, Davis, 1962; San Francisco State College, 1965; Cooper Union, 1970- . **Awards:** Tamarind Fellowship, 1973. **Address:** 309 West Broadway, NYC 10013. **Dealers:** The Pace Gallery, NYC; Darthea Speyer Gallery. **One-man Exhibitions:** SFMA, 1964; Dilexi Gallery, San Francisco, 1962, 63, 65; Bykert Gallery, 1967, 69, 72, 74; Darthea Speyer Gallery, 1968, 71, 73; Obelisk Gallery, 1971; Pyramid Art Galleries, 1973; Michael Berger

Gallery, Pittsburgh, 1974; Brooke Alexander, 1974. **Group:** WMAA Annual, 1965, 67, Recent Acquisitions, 1966; Musee Cantonal des Beaux-Arts, Lausanne, II Salon International de Galeries Pilotes, 1966; U. of Illinois Biennial, 1967; Smithsonian, The Art of Organic Forms, 1968; Foundation Maeght, l'Art Vivant, circ French museums, 1968; Smithsonian, The Art of Organic Form, 1968; U. of North Carolina, Works on Paper, 1968; Foundation Maeght, 1970; VMFA, American Painting, 1970; Oakland/AM, A Period of Exploration, 1973; PMA/Museum of the Philadelphia Center, Focus, 1974; Chicago/AI, 71st American Exhibition, 1974; Toledo/MA, Image, Color and Form, 1975. **Collections:** Achenbach Foundation; Andover/Phillips; Auckland; CNAC; CSCS; California Palace; U. of California, Berkeley; Crown Zellerbach Foundation; Indianapolis; Rotterdam; SFMA; Toledo/MA; WMAA. **Bibliography:** *Art: A Woman's Sensibility*; McChesney. Archives.

RESIKA, PAUL. b. August 15, 1928, NYC. **Studied:** Privately in NYC with Sol Wilson, 1940-44, and Hans Hofmann, 1945-47. Traveled France, Italy. **Taught:** U. of Oregon, 1965; ASL, 1968-69; Cooper Union, 1966- ; Dartmouth College, 1972; Skowhegan School 1973; U. of Pennsylvania, 1974. **Awards:** Bordighera, Americans in Europe, **P.P.**, 1952; L.C. Tiffany Grant, 1959; NAD, Ranger Fund **P.P.**, 1961; Ingram Merrill Grant, 1969; AAAL, Childe Hassam Fund Purchase, 1970. **Address:** 114 East 84 Street, NYC 10028. **Dealer:** Washburn Gallery Inc. **One-man Exhibitions:** (first) George Dix Gallery, NYC, 1948; The Peridot Gallery, 1964, 65, 67-69, 1970; Washburn Gallery Inc., 1971, 73; Dartmouth College, 1972; Swain School of Design, New Bedford, Mass., 1974; Carlton Gallery, NYC, 1975. **Group:** American Painters in Venice, 1952; Hartford/Wadsworth, 1964; Swarthmore College, 1968; Rijksakademie Amsterdam, 1968; State Universities of New York, 1969; AAAL, 1969,

70, 71, 75; A.F.A., Realism and Surrealism in American Art, 1971; NAD, 1972; Omaha/Joslyn, A Sense of Place, 1973. **Collections:** Bordighera; Chase Manhattan Bank; Dartmouth College; Goddard Art Center; Hirshhorn; Indianapolis/Herron; Lenox School; U. of Nebraska.

RESNICK, MILTON. b. January 8, 1917, Bratslov, Russia. Resided Paris, 1946-48. **Taught:** Pratt Institute, 1954-55; U. of California, Berkeley, 1955-56. **Federal A.P.:** Teacher. **Address:** 80 Forsyth Street, NYC 10002. **One-man Exhibitions:** (first) Poindexter Gallery, 1955, also 1957, 59; de Young, 1955; Ellison Gallery, Fort Worth, 1959; Holland-Goldowsky Gallery, Chicago, 1959; The Howard Wise Gallery, Cleveland, 1960; The Howard Wise Gallery, NYC, 1960, 61, 64; Feiner Gallery, NYC, 1964; Anderson Gallery, Edgartown, Mass., 1969; Forth Worth, 1971; Max Hutchinson Gallery, 1972. **Group:** WMAA Annuals, 1957, 59, 61, 63; Carnegie, 1958; Walker, 60 American Painters, 1960; SRGM, Abstract Expressionists and Imagists, 1961; USIA, Contemporary American Prints, circ. Latin America, 1961-62; Chicago/AI Annual, 1962; PAFA Annual, 1962; Seattle World's Fair, 1962; SFMA, Directions—Painting U.S.A., 1963; MOMA, The New American Painting and Sculpture, 1969; U. of California, Santa Barbara, 5 American Painters, 1974. **Collections:** Akron/AI; U. of California, Berkeley; Cleveland/MA; Hartford/Wadsworth; MOMA; WMAA; Waitsfield/Bundy. **Bibliography:** Goodrich and Baur 1; Hunter 1; Nordness, ed.; Passloff; Plous. Archives.

REYNAL, JEANNE. b. April 1, 1903, White Plains, N.Y. Privately educated; apprenticed to Atelier Boris Anrep, Paris, 1930-38. Traveled the world extensively. **Commissions:** Ford Foundation, 1959; Our Lady of Florida Monastery, 1962. **Awards:** SFMA, Emanuel Walter Bequest and Purchase Award, 1945. **Address:** 240 West 11

Street, NYC 10014. **Dealer:** Betty Parsons Gallery. **One-man Exhibitions:** (first) SFMA, 1942, also 1943-46; Arts Club of Chicago, 1943; Baltimore/MA, 1943; Betty Parsons Gallery, 1971. **Group:** SFMA, 1944, 45; WMAA Annuals, 1950-56; Seattle World's Fair, 1962; MOMA; Hartford/Wadsworth, 1962. **Collections:** Andover/Phillips; Ciba-Geigy Corp.; Denver/AM; Ford Foundation; MOMA; Mills College of Education; NYU; SFMA; WMAA. **Bibliography:** *Art: A Woman's Sensibility*; Ashton 1; Breton 3; Calas; Janis and Blesh 1; Ritchie 1. Archives.

RICE, DAN. b. June, 1926, Long Beach, Calif. **Studied:** UCLA, 1943; U. of California, Berkeley, 1946; Black Mountain College, with Franz Kline, Robert Motherwell, Ben Shahn, Jack Tworkov. US Navy, 1943-46. **Taught:** ASL, 1968- . **Address:** Rocklanding Road, Haddam Neck, East Hampton, Conn. 06424. **Dealer:** Catherine Viviano Gallery. **One-man exhibitions:** Catherine Viviano Gallery, 1960, 62, 63, 66, 70. **Group:** U. of Virginia; Buffalo/Albright; Mary Washington College. **Collections:** Dillard U.; Princeton U.

RICHARDSON, SAM. b. July 19, 1934, Oakland, Calif. **Studied:** California College of Arts and Crafts, 1956, BA, 1960, MFA. **Taught:** Oakland City College, 1959-60; San Jose State College, 1963- . Art director, Museum of Contemporary Crafts, 1960-63. **Address:** c/o Dealer. **Dealers:** Martha Jackson Gallery; Hansen-Fuller Gallery. **One-man Exhibitions:** Hansen Gallery, San Francisco, 1961, 66, 68, 69; Humboldt (Calif.) State College, 1967; Esther Robles Gallery, 1968; California State U., Fullerton, 1968; U. of Nebraska, 1968; Martha Jackson Gallery, 1969, 70, 73, 74, 75; Hansen-Fuller Gallery, 1971, 74, 75; Akron/AI, 1972; Contemporary Arts Center, Cincinnati, 1972; Mills College, 1973; Cranbrook, 1973; St. Mary's College, Moraga, Calif., 1975. **Group:** California Palace, Winter Invitational, 1961; SFMA, 1965, 66; California

Palace, Painters behind Painters, 1967; U. of Illinois, 1967, 69; Sacramento/Crocker, West Coast '68, 1968; Museum of Contemporary Crafts, Plastic as Plastic, 1968; WMAA, 1968; ICA, U. of Pennsylvania, Plastics and New Art, 1969; MOMA, New Media: New Methods, circ., 1969; Occidental College, Los Angeles, Four Directions, 1969; WMAA, Contemporary American Sculpture, 1968-69; Milwaukee, A Plastic Presence, circ., 1969; SFAI, Centennial Exhibition, 1971; Chicago/Contemporary, White on White, 1971-72; Stanford U., Sculpture '72, 1972; Vassar College, New American Landscapes, 1972; Museum of Contemporary Crafts, Creative Casting, 1973; Rutgers U., Response to the Environment, 1975. **Collections:** Fort Worth; Milwaukee; U. of Nebraska; U. of Sydney; WMAA; U. of Wisconsin.

RICHENBURG, ROBERT B. b. July 14, 1917, Boston, Mass. **Studied:** Boston Museum School; George Washington U.; Boston U.; The Corcoran School of Art; Ozenfant School of Art, NYC; Hofmann School; ASL, with Reginald Marsh, George Grosz. US Army, 1942-45. **Taught:** Schrivenham American U.; Brooklyn-Queens Central YMCA, 1947-51; City College of New York, 1947-52; Pratt Institute, 1951-64; Cooper Union, 1954-55; NYU, 1960-61; Cornell U., 1964-67; Hunter College, 1967-70; Ithaca College, 1970- . **Awards:** Boston Museum School, Scholarship; *Art in America* (Magazine), New Talent. **Address:** 121 East Remington Road, Ithaca, N.Y. 14850. **Dealer:** Tibor de Nagy Gallery. **One-man Exhibitions:** (first) Hendler Gallery, Philadelphia, 1954; Artists' Gallery, NYC, 1957; Artists' Gallery, Provincetown, 1958; Hansa Gallery, NYC, 1958; Tibor de Nagy Gallery, 1959-64; Dwan Gallery, 1960; RISD, 1960 (four-man); Santa Barbara/MA, 1961; Dayton/AI, 1962; Cornell U., 1964. **Retrospectives:** Colgate U., 1970; Ithaca College, 1971. **Group:** SRGM, 1949; Eighth Street Exhibition, NYC; Ninth Street Exhibi-

tion, NYC; MOMA, The Art of Assemblage, circ., 1961; SRGM, Abstract Expressionists and Imagists, 1961; Baltimore/MA, 1961; WMAA Annuals, 1961, 64, 68, Sculpture Annuals, 1968-69; Dayton/AI, 1962; Kansas City/Nelson, 1962; U. of Illinois, 1963; Corcoran, 1963; MOMA, Hans Hofmann and His Students, circ., 1963-64; U. of Nebraska; A.F.A., New Talent, circ., 1964, also 1968-69; Seattle/AM, 1965; Hamilton College, 1965; A.F.A., The Square in Painting, 1968; WMAA Annual, 1968. **Collections:** Allentown/AM; U. of California; Hirshhorn; Ithaca College; MOMA; Norfolk; Norfolk/Chrysler; PMA; Pasadena/AM; Ridgefield/Aldrich; U. of Texas; WMAA; College of William and Mary. **Bibliography:** Seitz 3.

RICKEY, GEORGE. b. June 6, 1907, South Bend, Ind. To Scotland, 1913. **Studied:** Trinity College, Glenalmond, Scotland, 1921-26; Balliol College, Oxford, 1926-29, BA, 1941, MA with honors; Ruskin School of Drawing and of Fine Art, Oxford, 1928-29; Academie Andre Lhote and Academie Moderne, Paris, 1929-30; NYU, 1945-46; State U. of Iowa, 1947, with Mauricio Lasansky; Institute of Design, Chicago, 1948-49. Traveled Europe and Mexico extensively; resided Paris, 1933-34. US Army Air Corps, 1941-45. **Taught:** Groton School, 1930-33 (History Department); Knox College, 1940-41; Muhlenberg College, 1941, 1946-48; U. of Washington, 1948; Indiana U., 1949-55; Tulane U., 1955-62; U. of California, Santa Barbara, 1960; Rensselaer Polytechnic Institute, 1961-65. Editorial Department, *Newsweek* Magazine, 1936. Director, The Kalamazoo Institute of Arts, 1939-40. Shifted emphasis from painting to sculpture, 1950. **Member:** NIAL. **Commissions** (murals): Olivet College, 1938-39; US Post Office, Selinsgrove, Pa., 1938; Knox College, 1940-41; (sculpture): Belle Boas Memorial Library, Baltimore Museum, 1955; Union Carbide Corp., Toronto, 1960; The Joseph H. Hirshhorn Collection, NYC,

1962; Hamburger Kunsthalle, 1963; Westland Center, Detroit, 1964; Keene Teachers College, 1964; Lytton Savings and Loan Association, Oakland, Calif., 1964; The Singer Company Inc., 1964; Hood College, 1964; Berlin/National; Rijksmuseum Kroller-Muller; Oakland/AM; Siemens Research Center, Erlangen, Germany; Henkel GMBH, Germany; NCFA; Nordpark, Dusseldorf, 1965; State Employment Building, Albany, 1966; Omaha National Bank, 1967; Berlin/National, 1969; High Museum, 1969; The Free University, Berlin, 1969; Neue Heimat Bayern, Munich, 1969; U. of Glasgow, 1971; U. of Heidelberg, 1972; Fort Worth City Hall, 1974. **Awards:** Guggenheim Foundation Fellowship, 1960, 61; Knox College, Hon. DFA, 1970; American Institute of Architects, Fine Arts Honor Award, 1972; Williams College, Hon. DFA, 1972; Skowhegan School, Medal for Sculpture, 1973; Union College, 1973; Indiana U., Hon. DFA, 1974. **Address:** RD #2, East Chatham, N.Y. **Dealers:** Staempfli Gallery; Hanover Gallery. **One-man Exhibitions:** (first) Caz-Delbo Gallery, NYC, 1933; Denver/AM, 1935, 43, 45, 48; Indianapolis/Herron, 1953 (first sculpture shown); The Little Gallery, Louisville, 1954; Kraushaar Galleries, 1955, 59, 61; New Orleans/Delgado, 1956; Amerika Haus, Hamburg, 1957; Orleans Gallery, New Orleans, 1960; Santa Barbara/MA, 1960; U. of Oklahoma, 1961; Phoenix, 1961; Primus-Stuart Gallery, Los Angeles, 1962; Galerie Springer, Berlin, 1962; Grand Rapids, 1962; Hyde Park Art Center, Chicago, 1963; Williams College, 1963; U. of Rochester, 1963; Dartmouth College, 1963; ICA, Boston, 1964; David Stuart Gallery, 1964; Kalamazoo/Institute, 1964 (two-man, with Ulfert Wilke); Staempfli Gallery, 1964, 67, 71, 75; Skidmore College, 1965; Walker, 1967; Haus am Waldsee, Berlin, circ., 1969; Kunsthalle, Nurnberg, 1969; Trenton/State, 1969; Whatcom, 1970; U. of Washington, 1970; Indiana U. (three-man), 1970; U. of Iowa, 1972; Hannover/K-G., 1973;

Berlin/National, 1973; Galerie Buchholz, Munich, 1974; Galerie Espace, Amsterdam, 1974; Gimpel & Hanover, 1975; Gimpel Fils, 1975. **Retrospectives:** Corcoran, 1966; UCLA, circ., 1971. **Group:** Salon des Artistes Indepandants, Paris, 1930; MMA, National Sculpture Exhibition, 1951; WMAA, 1952, 53, 66, 68-69, Annual, 1964; PAFA, 1953, 54; Chicago/AI, Exhibition Momentum, 1954, 55; U. of Nebraska, 1955; U. of Minnesota, 1955; MOMA, Recent Sculpture USA, 1959; Santa Barbara/MA, 1960; Amsterdam/Stedelijk, Art in Motion, circ. Europe, 1961-62; Battersea Park, London, International Sculpture Exhibition, 1963; Documenta III & IV, Kassel, 1964, 68; Berne, 1965; Palais des Beaux-Arts, Brussels, 1965; Staatliche Kunsthalle, Baden-Baden, 1965; St. Louis Bicentennial Sculpture Exhibition, 1965; Park Sonsbeek, Holland, 1966; Los Angeles/County MA, 1967; Carnegie, 1967; XXXIV Venice Biennial, 1968; Denver/AM, Report on the Sixties, 1969; Hayward Gallery, London, Kinetics, 1970; U. of Nebraska, American Sculpture, 1970; Katonah (N.Y.) Art Gallery, Drawing in Space, 1972; Newport, R.I., Monumenta, 1974. **Collections:** Allentown/AM; Andover/Phillips; Atlanta/AA; Ball State U.; Baltimore/MA; Bethlehem Steel Corp.; Boston/MFA; Buffalo/Albright; Dallas/MFA; Dartmouth College; Hamburg; Kansas City/Nelson; MOMA; Montclair/AM; Raleigh/NCMA; Tate, Union Carbide Corp.; WMAA; Walker. **Bibliography:** Battcock, ed.; Calas, N. and E.; Chipp; Craven, W.; Davis, D.; **George Rickey**; MacAgy 2; *Monumenta*; Read 3; **Rickey**; Rodman 1; Selz, P. 1; Trier 1; Tuchman 1. Archives.

RIVERS, LARRY. b. 1923, NYC. US Army Air Corps, 1942-43. **Studied:** Juilliard School of Music, NYC, 1944-45; Hofmann School; NYU, 1947-48. Traveled Europe, USA, USSR, Africa. Active as a professional jazz musician. Began sculpture 1953. Appeared on

Larry Rivers *Kinko the Nymph Bringing Happy Tidings* 1974

"$64,000 Question" (CBS-TV) as an art expert, and ran his winnings to $32,000 on "$64,000 Challenge," 1957-58. **Commissions:** Outdoor Billboard for First New York Film Festival, 1963. **Awards:** Corcoran, Third Prize, 1954. **Address:** 404 East 14 Street, NYC 10013. **Dealer:** Marlborough Gallery Inc. **One-man Exhibitions:** (first) Jane Street Gallery, NYC, 1949; Tibor de Nagy Gallery, 1951-54, 1957-60, 1962; The Stable Gallery, 1954 (sculpture); Martha Jackson Gallery, 1960 (sculpture); Dwan Gallery, 1960; Galerie Rive Droite, 1962; Gimpel Fils Ltd., 1962, 64; Marlborough Gallery Inc., 1970, 71, 73, 75; Brandeis U.; Chicago/AI, circ., 1970; Quay Gallery, 1972; Tower Gallery, Southampton, 1973; Olympia Galleries, Glenside, Pa., 1975. **Group:** WMAA Annuals, 1954, 58, 60, 61, 63, 66; MOMA, Twelve Americans, circ., 1956; Sao Paulo, 1957; Carnegie, 1958, 61; WMAA, Business Buys American Art, 1960; II Inter-American Paintings and Prints Biennial, Mexico City, 1960; Seattle World's Fair, 1962; PAFA, 1963; WMAA, Between the Fairs, 1964; WMAA, Art of the U.S. 1670-1966, 1966; Flint/Institute, I Flint Invitational, 1966; Indianapolis/Herron, 1966; SFMA, 1966; MOMA, Two Decades of American Painting, circ. Japan, India, Australia, 1967; U. of Illinois, 1967; Documenta IV, Kassel, 1968. **Collections:** Baltimore/MA; Brandeis U.; Brooklyn Museum; Buffalo/Albright; Chicago/AI; Container Corp. of America; Corcoran; Fort Wayne/AM; Hirshhorn; Kansas City/AI; Kansas City/Nelson; MMA; MOMA; Minneapolis/Institute; National Gallery; New England Merchants National Bank, Boston; New Paltz/SUNY; Norfolk/Chrysler; U. of North Carolina; RISD; Raleigh/NCMA; Seagram Collection; Southampton/Parrish; Stockholm/SFK; Tate; Utica; Victoria and Albert Museum; WMAA. **Bibliography:** Alloway 1; Calas, N. and E.; Dienst 1; Friedman, ed.; Gaunt; **Hunter** 5; Hunter, ed.; Lippard 5; McCurdy, ed.; *Metro*; Nordness, ed.; O'Hara 1; Rodman 1; Russell and Gablik; Soby 6; Weller.

Archives.

ROBINSON, BOARDMAN. b. September 6, 1876, Somerset (Nova Scotia), Canada; **d.** September 6, 1952, Colorado Springs, Colo. To USA 1894. **Studied:** Academie Colarossi, Academie des Beaux-Arts, and Academie Julian, Paris, 1898-1900; Boston Normal Art School, 1894-97, with E.W. Hamilton. Traveled the world extensively. **Taught:** ASL, 1919-22, 1924-26; Fountain Valley School, Colorado Springs, 1930-44; Colorado Springs Fine Arts Center, 1937-39; Michigan State College, 1945. Illustrated many editions of classics, as well as popular books. Drew cartoons for the *Morning Telegraph*, 1907-10, and the New York *Tribune* (four years). **Commissions** (murals): Kaufmann Department Store, Pittsburgh, 1928-29; Colorado Springs/FA, 1936; Justice Department Building, Washington, D.C., 1937 (18); US Post Office, Englewood, Colo., 1940. **One-man Exhibitions:** Thumb Box Gallery, NYC, 1916; M. Knoedler & Co., 1919; Weyhe Gallery, 1924; ASL, 1929; Delphic Studios, NYC, 1930; Hudson D. Walker Gallery, NYC, 1940; Chicago/AI, 1942. **Retrospective:** Colorado Springs/FA, 1943; Dallas/MFA, 1946; Kraushaar Galleries, 1946. **Group:** WMAA; Chicago/AI; Colorado Springs/FA; Cleveland/MA; Los Angeles/County MA; MMA; NAD. **Collections:** AAAL; U. of Arizona; Chicago/AI; Cleveland/MA; Colorado Springs/FA; Cranbrook; Dallas/MFA; Denver/AM; U. of Georgia; Harvard U.; IBM; Los Angeles/County MA; MMA; Minneapolis/Institute; NYPL; NYU; U. of Nebraska; Newark Museum; New Britain; PMA; U. of Vermont; WMAA; Wichita/AM. **Bibliography:** Baur 7, **Biddle 2, 4;** Brown; Bruce and Watson; Cahill and Barr, eds.; Cheney; **Christ-Janer;** Gallatin 2; Genauer; *Index of 20th Century Artists;* Mather 1; Mellquist; Poore; Richardson, E.P.; Rose, B. 1.

ROBUS, HUGO. b. May 10, 1885, Cleveland, Ohio; **d.** January 14, 1964,

NYC. **Studied:** Cleveland Institute of Art, 1904-08; NAD, 1910-11; Academie de la Grande Chaumiere, 1912-14, with Antoine Bourdelle. **Taught:** Myra Carr Art School, *ca.* 1915-17; Columbia U., summers, 1942, 43, 46, 48, 50, 52, 53, 55, 56; Munson-Williams-Proctor Institute, Utica, N.Y., 1948; Hunter College, 1950-58; Brooklyn Museum School, 1955-56. Changed from painting to Sculpture, 1920. **Federal A.P.:** 1937-39. **Awards:** MMA, Artists for Victory, Second Prize, 1942; PAFA, George D. Widener Memorial Gold Medal, 1950; PAFA, Alfred G. B. Steel Memorial Prize, 1953; NIAL, Citation and Grant, 1957. **One-man Exhibitions:** (first) Grand Central, NYC, 1946, also 1948; Utica, 1948; Corcoran, 1958; The Forum Gallery, 1963, 66, 74. **Retrospective:** A.F.A./Ford Foundation, 1961. **Group:** WMAA; PAFA; MMA; Corcoran. **Collections:** Cleveland/MA; Corcoran; Fairleigh Dickinson U.; IBM; MMA; MOMA; Utica; WMAA. **Bibliography:** *Avant-Garde Painting and Sculpture;* Baur 7; Brumme; Craven, W.; Goodrich and Baur 1; Mendelowitz; Pearson 2. Archives.

ROCKLIN, RAYMOND. b. August 18, 1922, Moodus, Conn. **Studied:** MOMA School, 1940; Cooper Union, 1951, with Milton Hebald, John Hovannes, Warren Wheelock; Educational Alliance, NYC, with Abbo Ostrowsky; Temple U., 1942. Traveled Europe, USA. **Taught:** American U., 1956; U. of California, Berkeley, 1959-60; Scarsdale Studio Workshop, 1960- ; Ball State Teachers College, 1964; YMHA, Essex County, N.J., 1971-74. **Member:** American Abstract Artists; Federation of Modern Painters and Sculptors; Sculptors Guild. **Awards:** Fulbright Fellowship (Italy), 1952; Yaddo Fellowship, 1956. **Address:** 232B Watch Hill Road, Peekskill, N.Y. 10566. **Dealer:** Sculptors Guild. **One-man Exhibitions:** (first) Tanager Gallery, NYC, 1956; American U., 1956; Oakland/AM, 1956; U. of California, Berkeley, 1959; Pomona College, 1960; Santa Barbara/MA, 1960; Dilexi Gallery, San Francisco, 1960; The Bertha Schaefer Gallery, 1960 (two-man); Ball State Teachers College, 1964; Briarcliff College, 1973. **Group:** WMAA, Young America; WMAA, New Talent, 1957; U. of Illinois, 1959; WMAA Annual, 1960; Claude Bernard, Paris, 1960; American Abstract Artists Annuals; U. of Nebraska, 1960. **Collections:** Norfolk/Chrysler; Skowhegan School; Temple Israel, St. Louis; WMAA. **Bibliography:** Seuphor 3.

ROESCH, KURT. b. September 12, 1905, near Berlin, Germany. **Studied:** Jaeckel School, Berlin, 1924; Academy of Fine Arts, Berlin, 1925-26, with Karl Hofer, and 1928-29, with Hofer and Meid. To USA 1933. Traveled Europe, USA; resided Paris, Berlin, NYC. **Taught:** New School for Social Research, 1934-36; Sarah Lawrence College, 1934-72; Skowhegan School. **Awards:** Prize of the League of German Artists, 1931; Medal of the Academy of Fine Arts, Berlin, 1932; MMA, Artists for Victory, Sixth Prize, 1942; First New Hampshire Art Association Annual, J.W. Hill Co. Award, 1947; Century Association Medal, 1969. **Address:** Richards Lane, New Canaan, Conn. 06840. **One-man Exhibitions:** Berlin Sezession, 1928; Gallery A. Flechtheim, Berlin, 1930; New School for Social Research, 1934; U. of Minnesota, 1936; Buchholz Gallery, NYC, 1939, 41, 43, 45, 46; Curt Valentine Gallery, NYC, 1949, 53. **Group:** U. of Illinois; Carnegie; Documenta, Kassel; PMA; New Hampshire Art Association Annuals, 1947, 48, 49; MMA; WMAA, 1964. **Collections:** Brandeis U.; Buffalo/Albright; Colby College; Currier; Fort Worth; MMA; MOMA; U. of Minnesota; NYPL; U. of Nebraska; RAC; Sarah Lawrence College; VMFA. **Bibliography:** Janis, S.; Pousette-Dart, ed.

ROGALSKI, WALTER. b. April 10, 1923, Glen Cove, N.Y. **Studied:** Brooklyn Museum School, 1947-51, with Xavier Gonzalez, Arthur Osver, C. Seide, Gabor Peterdi. US Marine Corps,

1941-42. **Taught:** Pratt Graphic Art Center; Brooklyn Museum School; Pratt Institute. **Member:** SAGA. **Awards:** Brooklyn Museum, **P.P.**, 1951, 52; New Britain, **P.P.**; Northwest Printmakers Annual, **P.P.**; Dallas/MFA, **P.P.**, 1953. **Address:** 15 Cross Street, Locust Valley, N.Y. 11560. **One-man Exhibitions:** Korman Gallery, NYC, 1954, 55; Cleveland/MA, 1954. **Group:** U. of Minnesota, 1950; Brooklyn Museum, 1951, 52, 54, 60; Library of Congress, 1951; MOMA, New Talent; Seattle/AM, 1952; Dallas/MFA, 1953; The Print Club, Philadelphia, 1958, 60; Riverside Museum, 1959; The Terrain Gallery, 1961; SAGA, 1961; A.A.A. Gallery, NYC, 1961; Merrick (Long Island) Art Gallery, 1961. **Collections:** Brooklyn Museum; Cleveland/MA; Dallas/MFA; Harvard U.; MOMA; NYPL; New Britain; Seattle/AM; Yale U. **Bibliography:** Rogalski.

ROHM, ROBERT. b. February 6, 1934, Cincinnati, Ohio. **Studied:** Pratt Institute, B. Industrial Design, 1956; Cranbrook Academy of Art (with Berthold Schewitz), MFA, 1960. Traveled USA, England; resided Mexico, 1964. **Taught:** Columbus College of Art and Design, 1956-59; Pratt Institute, 1960-65; U. of Rhode Island, 1965- ; Stourbridge (Eng.) College of Art, 1974. **Member:** Sculptors Guild. **Awards:** PAFA, Hon. Men., 1959; Columbus, Sculpture Prize, 1957, 59; Guggenheim Foundation Fellowship, 1964; U. of Rhode Island Research Grant-in-Aid, 1965, 66, 69; Cassandra Foundation, 1966; Rhode Island State Council on the Arts Grant, 1973; National Endowment for the Arts, 1974. **Address:** 5 Marion Road, Kingston, R.I. 02881. **Dealers:** OK Harris Works of Art; Harcus Krakow Rosen Sonnabend. **One-man Exhibitions:** Columbus (two-man), 1958; Aspen, (Colo.) Art Gallery, 1963; Royal Marks Gallery, 1964; U. of Rhode Island, 1966, 72; U. of Maine (two-man), 1969; Nova Scotia College of Art and Design, Halifax, 1969; Massachusetts College of Art, Boston, 1970; Parker

Street 470 Gallery, Boston, 1970, 72; OK Harris Works of Art, 1970, 72, 73; U. of Rochester, 1971; Hobart and William Smith College, 1973; Boston/MFA (two-man), 1974. **Group:** PAFA, 1961; Silvermine Guild, 1962; Aspen (Colo.) Art Gallery, 1963; Waitsfield/Bundy, Bundy Sculpture Competition, 1963; WMAA Annual, 1963, 64; Tufts U., 1968; The Pennsylvania State U., 1968; WMAA, 1969; Lincoln, Mass./De Cordova, 1969; Trenton/State, Soft Art, 1969; WMAA, Anti-Illusion: Procedures/Materials, 1969; Seattle/AM, 557,087, 1969; Indianapolis, 1970; MIT, Six Artists, 1970; ICA, Boston, Art on Paper, 1970; WMAA Annuals, 1970, 73; New Delhi, Second World Triennial, 1971; Harvard U., Recent Abstract Art, 1971. **Collections:** Brandeis U.; Columbus; Fontana-Hollywood Corp.; MOMA; Oberlin College; The Pennsylvania State U.; Sarah Lawrence College; VMFA; Waitsfield/Bundy; Worcester/AM; Zurich. **Bibliography:** Monte and Tucker.

RONALD, WILLIAM. b. August 13, 1926, Stratford (Ont.), Canada. **Studied:** Ontario College of Art, 1951, with Jock Macdonald. US citizen 1963. **Commissions:** National Arts Center, Ottawa, 1969 (mural). Host of Canadian television programs: "The Umbrella," 1966-67; "Theme and Variations," 1968; "As It Happens," 1969; "Free for All," 1972-74. Founding **Member:** Painters Eleven. **Awards:** Hallmark International Competition, 1952; Canada Foundation Scholarship, 1954; SRGM, Award for Canadian Painting, 1956. **Address:** 392 Brunswick Avenue, Toronto 4 (Ont.), Canada M5R224. **One-man Exhibitions:** (first) Hart House, U. of Toronto, 1954; Greenwich Gallery, Toronto, 1957; The Kootz Gallery, NYC, 1957-61, 1963; Laing Galleries, Toronto, 1960; Douglass College, 1960; Isaacs Gallery, 1961, 63; Princeton U., 1963; David Mirvish Gallery, 1964, 65; Dunkelman Gallery, Toronto, 1970; Tom Thomson Memorial Gallery, Owen Sound, Ont., 1971; Brandon U., Manito-

ba, 1972. **Retrospective:** Robert McLaughlin Gallery, Oshawa, circ., 1975. **Group:** Smithsonian, 1956; Toronto Gallery, Toronto, Four Young Canadians, 1956; Carnegie, 1958, 61; Brussels World's Fair, 1958; V Sao Paulo Biennial, 1959; WMAA Annuals, 1959; U. of Illinois, 1961, 63; Corcoran, 1962. **Collections:** Baltimore/MA; Brandeis U.; U. of British Columbia; Brooklyn Museum; Buffalo/Albright; The Canada Council; Canadian Industries Ltd.; Carnegie; Chicago/AI; Hartford/Wadsworth; Hudson River Museum; International Minerals & Chemicals Corp.; MOMA; Montreal/MFA; NYU; Newark Museum; U. of North Carolina; Ottawa/National; Pasadena/AM; Phoenix; Princeton U.; Queens U.; RISD; Ridgefield/Aldrich; SRGM; U. of Texas; Toronto; Trenton/State; WGMA; WMAA; Walker; Williams College; Windsor; York U. Archives.

ROOD, JOHN. b. February 22, 1906, Athens, Ohio; **d.** March, 1974, Minneapolis, Minn. Self-taught in art. Traveled the world extensively. **Taught:** Ohio U., 1945; U. of Minnesota, 1944-68. Published a literary magazine, *Manuscript*, 1933-36. **Member:** Artists Equity (President, 1959-63). **Commissions:** Minneapolis Public Library; Wellesley College; St. Marks Cathedral, Minneapolis; Hamline U. **One-man Exhibitions:** (first) Passedoit Gallery, NYC, 1937, also 1940-45; Colgate U., 1941; Durand-Ruel Gallery, NYC, 1944; Newark Museum, 1944; Minneapolis/Institute, 1945; U. of Minnesota, 1945, 46; Ward Eggleston Gallery, NYC, 1946, 47 (paintings); A.A.A. Gallery, Chicago, 1949; Galleria del Fiori, Milan, 1956; L'Obelisco, Rome, 1956; Weintraub Gallery, 1969. **Retrospective:** U. of Minnesota, 1974. **Group:** WMAA; U. of Minnesota; Walker; Corcoran; Cranbrook. **Collections:** Andover/Phillips; Corcoran; Cranbrook; Minneapolis/Institute; U. of Minnesota; Ohio U.; Walker. **Bibliography:** Brumme; **Rood;** Seuphor 3.

ROSATI, JAMES. b. 1912, Washington, Pa. Violinist with the Pittsburgh Symphony for two years. **Taught:** Cooper Union; Pratt Institute; Yale U., 1960-64, 1968- ; Dartmouth College, 1963. **Federal A.P.:** Sculptor. **Commissions:** St. John's Abbey, Collegeville, Md. (sculpture). **Awards:** Brandeis U., Creative Arts Award, 1960; Chicago/AI, The Mr. & Mrs. Frank G. Logan Medal and Prize, 1962; Carborundum Major Abrasive Marketing Award, 1963; Guggenheim Foundation Fellowship, 1964; National Council on the Arts Grant, 1968. **Address:** 252 West 14 Street, NYC 10011. **Dealer:** Marlborough Gallery Inc., NYC. **One-man Exhibitions:** (first) The Peridot Gallery, 1954; Otto Gerson Gallery, NYC, 1959, 62; Dartmouth College, 1963; Colgate U., 1968; Brandeis U., 1969; Buffalo/Albright, 1970; Yale U., 1970; Marlborough Gallery Inc., NYC, 1970. **Group:** Ninth Street Exhibition, NYC, 1951; WMAA Annuals, 1952, 53, 54, 60, 62, 66; Carnegie, 1958, 61, 64; Claude Bernard, Paris, 1960; A.F.A., Contemporary Sculpture, 1960; International Outdoor Sculpture Exhibitions, Otterlo, Holland, 1961; Chicago/AI, 1961, 62; Seattle World's Fair, 1962; WMAA, First Five Years, 1962; Festival of Two Worlds, Spoleto, 1962; Battersea Park, London, International Sculpture Exhibition, 1963; New York World's Fair, 1964-65; Flint/Institute, I Flint Invitational, 1966; Colby College, 1967; Museum of Contemporary Crafts, circ., 1967-68. **Collections:** Buffalo/Albright; Brandeis U.; Carnegie; Ciba-Geigy Corp.; Colby College; Dartmouth College; Hirshhorn; NYU; Newark Museum; Rockefeller University; WMAA; Yale U. **Bibliography:** *Monumenta*; Read 3; Selz, J.; Seuphor 3.

ROSENBORG, RALPH M. b. June 9, 1913, Brooklyn, N.Y. **Taught:** Brooklyn Museum School, 1936-38; Ox-Bow Summer School, Saugatuck, Mich., 1949; U. of Wyoming; U. of North Carolina. **Awards:** AAAL, 1960.

Address: 4 Park Avenue, NYC 10016. **One-man Exhibitions:** Karl Nierendorf Gallery, NYC; Artists' Gallery, NYC, 1939; The Willard Gallery, 1941; The Pinacotheca, NYC, 1945; Chinese Gallery, NYC, 1946, 47; J. Seligmann and Co., 1948, 50; Davis Gallery, NYC, 1954; Barone Gallery, NYC; Passedoit Gallery, NYC, 1959; Albert Landry, NYC, 1960; International Gallery, Baltimore, 1964. **Group:** Corcoran; WMAA; U. of Illinois; MOMA; Phillips; Chicago/ AI; VMFA; Brooklyn Museum; Seattle/AM; Detroit/Institute. **Collections:** Brandeis U.; Colby College; Cornell U.; U. of Georgia; MMA; MOMA; Montclair/AM; Newark Museum; U. of Oregon; Phillips; SRGM; St. Louis/City; Smith College; Yale U. **Bibliography:** American Artists Congress, Inc., Janis, S.; Motherwell and Reinhardt, eds.

ROSENQUIST, JAMES. b. November 29, 1933, Grand Forks, N.D. **Studied:** U. of Minnesota, with Cameron Booth; ASL. **Awards:** Torcuato di Tella, Buenos Aires, International Prize, 1965. **Address:** 1724 East 7 Avenue, Ybor City, Tampa, Fla. 33605. **Dealer:** Leo Castelli Inc. **One-man Exhibitions:** (first) Green Gallery, NYC, 1962, also 1964; Dwan Gallery, 1964; Ileana Sonnabend Gallery, Paris, 1964, 65, 68; Galleria d'Arte Contemporaneo, Turin, 1965; Leo Castelli Inc., 1965, 66, 69, 70, 73; Stockholm/National, 1966; Amsterdam/Stedelijk, 1966, 73; Berne, 1966; Humlebaek/Louisiana, 1966; Staatliche Kunsthalle, Baden-Baden, 1966; Ottawa/National, 1968; Galleria Sperone, Turin, 1968; MMA, 1968; Galerie Rolf Ricke, 1970; Cologne, 1972; Margo Leavin Gallery, 1972; Chicago/Contemporary, 1972; Courtney Sales Gallery, Dallas, 1973; Jack Glenn Gallery, Corona del Mar, 1973; Portland (Ore.) Center for the Visual Arts, 1973; Max Protetch Gallery, Washington, D.C., 1974; Jared Sable Gallery, Toronto, 1974; Galerie Michael Pabst, Vienna, 1974. **Group:** Hartford/Wadsworth, 1962; Dallas/MFA, 1962; WGMA, The

Popular Image, 1962; Chicago/AI, 1962, 66; SRGM, Six Painters and The Object, 1963; Buffalo/Albright, Mixed Media and Pop Art, 1963; ICA, U. of Pennsylvania, The Atmosphere of '64, 1964; Salon Du Mai, Paris, 1964; Tate, Dunn International, 1964; Amsterdam/Stedelijk, American Pop Art, 1964; New York State Pavilion, New York World's Fair, 1964-65; Worcester/AM, 1965; Palais des Beaux-Arts, Brussels, 1965; Torcuato di Tella, Beunos Aires, 1965; Hamburger Kunstkabinett, 1965; MOMA, Around the Automobile, 1965; Kansas City/Nelson, Sound, Light, Silence, 1966; Flint/Institute, I Flint Invitational, 1966; Expo '67, Montreal, 1967; IX Sao Paulo Biennial, 1967; MOMA, The 1960's, 1967; Eindhoven, 1967; Palazzo Grassi, Venice, 1967; WMAA Annual, 1967; Documenta IV, Kassel, 1968; Vancouver, 1969; U. of California, Irvine, New York: The Second Breakthrough 1959-1964, 1969; Hayward Gallery, London, Pop Art, 1969; MMA, Prints by Four New York Painters, 1969, New York Painting and Sculpture: 1940-1970, 1969-70; VMFA, American Painting, 1970; Foundation Maeght, 1970; Indiana U., American Scene: 1900-1970, 1970; Buffalo/Albright, Kid Stuff, 1971; Los Angeles/County MA, Art & Technology, 1971; Musee Galliera, Paris, Festival d'Automne, 1973; Yale U., American Drawing: 1970-1973, 1973; Seattle/AM, American Art—Third Quarter Century, 1973; WMAA, American Pop Art, 1974; MOMA, Works from Change, 1974. **Collections:** Brandeis U. **Bibliography:** Alloway 1; Becker and Vostell; Bihalji-Merin; Calas, N. and E.; *Contemporanea*; Davis, D.; Dienst 1; Hulten; Hunter, ed.; Kozloff 3; Lippard 2; *Metro; Report*; Rose, B. 1; Rublowsky; Russell and Gablik: Tomkins and Time-Life Books; Weller.

ROSENTHAL, BERNARD. b. August 9, 1914, Highland Park, Ill. **Studied:** U. of Michigan, 1936, BA; Chicago Art Institute School; Cranbrook Academy of Art, with Carl Milles.

Corps of Army Engineers, 1942-46. Traveled Mexico, Europe, USA. **Taught:** California School of Art, 1947-48; UCLA, 1953. **Federal A.P.:** U.S. Post Office, Nakomis, Ill. (relief). **Commissions:** Elgin Watch Building, New York World's Fair, 1939; Museum of Science and Industry, Chicago, 1941; General Petroleum Building, Los Angeles, 1949; 260 Beverly Drive, Beverly Hills, 1950 (bronze reliefs, 3 storeys high); Bullock's Westwood, Los Angeles, 1951; RKO Studios, Hollywood, 1952; UCLA Elementary School, 1952; J.W. Robinson Department Store, Beverly Hills, 1952; Capri Theatre, San Diego, 1954; 1000 Lake Shore Drive, Chicago, 1954 (30-ft. relief); Beverly Hilton Hotel, Beverly Hills, 1955; Temple Emanuel, Beverly Hills, 1955; Century City (Alcoa Development), 1963; U. of Michigan, 1968; CSCS, Fullerton, 1969. **Awards:** SFMA Sculpture Award, 1950; Los Angeles/County MA, **P.P.**, 1950; Los Angeles All-City Show, Sculpture Prize, 1951; Audubon Artists, Sculpture Award, 1953; PAFA, Hon. Men., 1954; Los Angeles/County MA, Sculpture Award, 1957; American Institute of Architects, Southern California Chapter, Honor Award, 1959; Ford Foundation, **P.P.**, 1963; Tamarind Fellowship, 1964; U. of Michigan, Outstanding Achievement Award, 1967; Carborundum Major Abrasive Marketing Award, 1969. **Address:** 124 East 40 Street, NYC 10016. **Dealer:** Knoedler Contemporary Art. **One-man Exhibitions:** (first) Pat Wall Gallery, Monterey, 1947; A.A.A. Gallery, Chicago, 1947; Scripps College, 1948; SFMA, 1950; A.A.A. Gallery, NYC, 1950; Santa Barbara/MA, 1952; Long Beach/MA, 1952; Catherine Viviano Gallery, 1954, 58, 59; Carnegie, 1959; The Kootz Gallery, NYC, 1961, 63, 66; M. Knoedler & Co., 1968; Gertrude Kasle Gallery, 1973. **Group:** MMA; MOMA; Sao Paulo Biennial; Brussels World's Fair, 1958; Chicago/AI; PAFA; Sculptors Guild; Audubon Artists; Walker; ICA, Boston; Yale U.; WMAA, 1964, 66, 68; Buffalo/Albright, 1965; Boston/MFA, 1966; Sculpture in Environment, New York

City Wide Exhibition, 1967; HemisFair '68, San Antonio, Tex., 1968; Grand Rapids, 1969. **Collections:** Arizona State College; Astor Place, NYC; Baltimore/MA; Buffalo/Albright; Carborundum Company; U. of Illinois; Indianapolis/Herron; Lincoln, Mass./De Cordova; Long Beach/MA; Los Angeles/County MA; Lytton Savings and Loan Association; MOMA; U. of Michigan; Milwaukee; NCFA; NYU; Newark Museum; Santa Barbara/MA; South Mall, Albany; Springfield, Ill./State; UCLA; WMAA; Xerox Corp. **Bibliography:** Hunter 8; *Monumenta*; Read 3; Rodman 2; Trier 1. Archives.

ROSS, CHARLES. b. December 17, 1937, Philadelphia, Pa. **Studied:** U. of California, AB, 1960, MA, 1962. **Taught:** U. of California, 1962, 65; Cornell U., 1964; U. of Kentucky, Artist-in-Residence, 1965; School of Visual Arts, NYC, 1967, 70-71; Herbert H. Lehman College, Bronx, N.Y., 1968; U. of Utah, 1972-74. Co-director and collaborator, Dancers Workshop Company, San Francisco, 1964-66. Films: "Sunlight Dispersion," 16mm, 1972; "Arisaig, July 10, 1972," 16mm, 1972. **Awards:** U. of California, James D. Phelan Traveling Scholarship, 1962; National Endowment for the Arts. **Address:** 383 West Broadway, NYC 10012. **Dealer:** John Weber Gallery. **One-man Exhibitions:** (first) Dilexi Gallery, San Francisco, 1961, also 1965, 66, 68; RAC, 1962; Cornell U., 1964; U. of Kentucky, 1965; Dwan Gallery, 1968, 69, 71; Dayton's Gallery 12, Minneapolis, 1968; John Weber Gallery, 1972; The Clocktower, NYC, 1974. **Group:** Musee Cantonal des Beaux-Arts, Lausanne, II Salon International de Galeries Pilotes, 1966; Paris Biennial; Architectural League of New York, 1967; A.F.A., 1967; Finch College, 1967; Ridgefield/Aldrich, 1967; Kansas City/Nelson, The Magic Theatre, 1968; Newark Museum, 1968; Milwaukee, Directions I: Options, circ., 1968; Prospect '68, Dusseldorf, 1968; ICA, U. of Pennsylvania, WMAA Sculpture Annual, 1969; Toronto, New Alchemy Ele-

ments • Systems • Forces, 1969;
Dusseldorf/Kunsthalle, Prospect '69,
'71, 1969, 71; Finch College, NYC,
Projected Art, 1971; U. of Wisconsin,
Earth, Air, Fire, Water, 1974; Indianapo-
lis, 1974. Dance Theater; Judson Dance
Theater, NYC, A Collaborative Event
(with the Judson Dancers), 1963. **Col-
lections:** U. of California, Berkeley;
Indianapolis; Kansas City/Nelson;
WMAA. **Bibliography:** Atkinson.

ROSZAK, THEODORE. b. May 1,
1907, Poznan, Poland. **Studied:** Co-
lumbia U., 1925-26; Chicago Art
Institute School, 1922-29, with John W.
Norton, Boris Anisfeld; NAD, 1925-26,
with C.W. Hawthorne. Traveled Latin
America, Europe extensively. **Taught:**
Chicago Art Institute School, 1927-29;
Design Laboratory, NYC, 1938-40;
Sarah Lawrence College, 1940-56; Co-
lumbia U., 1970-72; lectured at many
museums and universities. Began ab-
stract constructions 1936, free-form
sculpture 1946. **Member:** Commission
of Fine Arts, Washington, D.C. (ap-
pointed for 1963-67); Advisory Com-
mittee on the Arts, US State Depart-
ment (appointed for 1963-67); National
Council on Art and Government. **Feder-
al A.P.:** Easel painting. **Member:** New
York City Art Commission, 1969-75;
NIAL. **Commissions:** Yale & Towne
Inc.; MIT (spire and bell tower); Rey-
nolds Metals Co. (aluminum sculpture
memorial); American Embassy, London;
Maremont Building, Chicago; New
York World's Fair, 1964-65; New Public
Health Laboratory, NYC (outdoor
sculpture), 1968; Lafayette Square,
Washington, D.C.; Court of Claims,
NYC. **Awards:** World's Fair, Poland,
1929, Silver Medal; Chicago/AI, Joseph
N. Eisendrath Prize, 1934; Chicago/AI,
The Mr. & Mrs. Frank G. Logan Medal,
1947, 51; I Sao Paulo Biennial, 1951;
ICA, London/Tate, International Un-
known Political Prisoner Competition,
1953; PAFA, George D. Widener Me-
morial Gold Medal, 1958; Chicago/AI,
Campana Prize, 1961; Ball State Teachers
College, Griner Award, 1962; elected to
the NIAL; Century Association, Medal

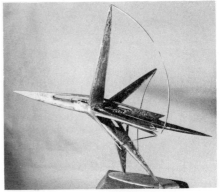

Theodore Roszak *Flight* 1970-71

for Sculpture. **Address:** One St. Luke's
Place, NYC 10014. **Dealer:** Pierre Ma-
tisse Gallery. **One-man Exhibitions:**
(first) Allerton Galleries, Chicago, 1928;
Nicholas Roerich Museum, 1935; Al-
bany/Institute, 1936; Artists' Gallery,
NYC, 1941; Julien Levy Galleries, NYC,
1941; Pierre Matisse Gallery, 1957, 62,
74; ICA, Boston, circ., 1959; XXX Venice
Biennial, 1960; Century Association,
1971; Harold Ernst Gallery, 1973.
Retrospective: WMAA, circ., 1956.
Group: Chicago/AI Annuals, 1931, 32,
35, 37, 38, 41; WMAA Annuals, 1932-
38, 1941, 57, 58, 59, 62, 1964-68; A
Century of Progress, Chicago, 1933-34;
MOMA, Fourteen Americans, circ.,
1946; PAFA, 1946, 64; A.F.A., Tradition
and Experiment in Modern Sculpture,
circ., 1950-51; Documenta I & II, Kassel,
1955, 59; Brussels World's Fair, 1958;
Carnegie, 1958; NIAL, 1958, 59; Tate,
1959; American Painting and Sculpture,
Moscow, 1959; Seattle World's Fair,
1962; Silvermine Guild, 1962; Museum
des 20. Jahrhunderts, 1962; MOMA,
1963; Cleveland/MA, 1964; MOMA,
The New American Painting and Sculp-
ture, 1969. **Collections:** U. of Arizona;
Baltimore/MA; Chicago/AI; Cleveland/
MA; U. of Colorado; Hirshhorn; U. of
Illinois; Industrial Museum, Barcelona;
MOMA; U. of Michigan; U. of North
Carolina; PAFA; SRGM; St. Joseph/Al-
brecht; Sao Paulo; Smithsonian; Tate;
WMAA; Walker; West Palm Beach/

Norton; U. of Wisconsin; Worcester/ AM; Yale U. **Bibliography:** Arnason 5; Baur 7; Blesh 1; Brumme; Chipp; Craven, W.; Gertz; Giedion-Welcker 1; Goodrich and Baur 1; Hunter 6; Kepes 2; Kuh 1, 3; Langui; Licht, F.; McCurdy, ed.; Mendelowitz; *Metro*; Miller, ed. 2; Myers 2; Neumeyer; Read 3; Ritchie 1, 3; Rodman 3; Seuphor 3; Seymour; Trier 1; Weller. Archives.

ROTH, FRANK. b. February 22, 1936, Boston, Mass. **Studied:** Cooper Union, 1954; Hofmann School, 1955. Traveled Europe, Mexico. **Taught:** School of Visual Arts, NYC, 1963-75; State U. of Iowa, 1964; U. of California, Berkeley, 1968, Irvine, 1971-73. **Awards:** Chaloner Prize Foundation Award, 1961; Guggenheim Foundation Fellowship, 1964; Ford Foundation Artist-in-Residence, 1966; IV International Young Artists Exhibit, America-Japan, Tokyo, Minister of Foreign Affairs Award, 1967. **Address:** 135 Wooster Street, NYC 10012; 120 Acabonac Road, East Hampton, N.Y. 11973. **One-man Exhibitions:** (first) Artists' Gallery, NYC, 1958; Grace Borgenicht Gallery Inc., 1960, 1962-65; The American Gallery, NYC, 1962; Galerie Anderson-Mayer, Paris, 1964; American Embassy, London, 1965; Hamilton Galleries, London, 1965, 67; U. of Utah, 1967; Martha Jackson Gallery, 1967, 68, 70, 71; Molly Barnes Gallery, Los Angeles, 1968; Galerie Paul Facchetti, 1968; Obelisk Gallery, 1969; Gimpel & Weitzenhoffer Ltd., 1974. **Group:** Buffalo/Albright, 1958; WMAA Annuals, 1958, 60; Carnegie, 1959; Chicago/AI, 1959; WMAA, Young America, 1960; Walker, 60 American Painters, 1960; Corcoran, 1962; Flint/Institute, 1963; Tate, 1965; U. of Illinois, 1965; M. Knoedler & Co., Art Across America, circ., 1965-67; IV International Young Artists Exhibit, America-Japan, Tokyo, 1967; RISD, 1967; Kent State U., 1968; A.F.A., 1968; Moore College of Art, Science, and Industry, 1969; Philadelphia Art Alliance, 1969; VMFA, American Painting, 1970; Foundation Maeght,

1970; Indianapolis, 1970; Amherst College, Color Painting, 1972; Lehigh U., Contemporary American Painting, 1972. **Collections:** American Republic Insurance Co.; Baltimore/MA; Bellevue Hospital; Buffalo/Albright; Chase Manhattan Bank; Colonial Bank & Trust Co.; Cornell U.; Des Moines; Hirshhorn; Leicester Education Committee; MOMA; Manufacturers Hanover Trust Co.; McDonald & Company; Mead Corporation; Michigan State U.; NYU; U. of Oklahoma; Pasadena/AM; Prudential Insurance Co. of America; RISD; Ringling; Santa Barbara/MA; Schiedam/Stedelijk; Tate; U. of Utah; WMAA; Walker. **Bibliography:** Gerdts.

ROTHKO, MARK. b. September 25, 1903, Dvinska, Russia; **d.** February 25, 1970, NYC. To USA 1913. **Studied:** Yale U., 1921-23; ASL, 1925, with Max Weber. Traveled Europe, USA. **Taught:** Center Academy, Brooklyn, N.Y., 1929-52; California School of Fine Arts, summers, 1947, 49; Brooklyn College, 1951-54; U. of Colorado, 1955; Tulane U., 1956. A co-founder of the Expressionist group The Ten, 1935. Co-founder of a school, "Subject of the Artist," with William Baziotes, Robert Motherwell, and Barnett Newman, NYC, 1948. **Federal A.P.:** 1936-37. **Awards:** Yale U., Hon. DFA, 1969. **One-man Exhibitions:** (first) Contemporary Arts Gallery, NYC, 1933; Portland, Ore./AM, 1933; Art of This Century, NYC, 1945; Santa Barbara/MA, 1946; Betty Parsons Gallery, 1946-51; RISD, 1954; Chicago/AI, 1954; Sidney Janis Gallery, 1955, 58; Houston/MFA, 1957; XXIX Venice Biennial, 1958; Phillips, 1960; MOMA, 1961; Whitechapel Art Gallery, London, 1961; Amsterdam/ Stedelijk, 1961; Palais des Beaux-Arts, Brussels, 1962; Kunsthalle, Basel, 1962; Paris/Moderne, 1962, 72; Marlborough Fine Art Ltd., London, 1964, 70; Marlborough Gallery Inc., NYC, 1970, Zurich, 1971; Berlin/National, 1971; Newport Harbor, 1974. **Group:** PAFA, 1940; WMAA, 1945-50; XXIV Venice Biennial, 1948; MOMA, Abstract Paint-

ing and Sculpture in America, 1951; MOMA, Fifteen Americans, circ., 1952; 10th Inter-American Conference, Caracas, 1954; 3rd International Contemporary Art Exhibition, New Delhi, 1957; Carnegie, 1958, 61; MOMA, The New American Painting, circ. Europe, 1958-59; Documenta II, Kassel, 1959; Federation of Modern Painters and Sculptors Annuals; Walker, 60 American Painters, 1960; Cleveland/MA, 1966; MOMA, The New American Painting and Sculpture, 1969; MMA, New York Painting and Sculpture: 1940-1970, 1969-70; Venice Biennial, 1974. **Collections:** U. of Arizona; Baltimore/MA; Brooklyn Museum; Buffalo/Albright; Chicago/AI; Dusseldorf/KN-W; Kansas City/Nelson; MOMA; Paris/Moderne; Phillips; Rio de Janeiro; SFMA; Tate; Utica; Vassar College; WMAA. **Bibliography:** Ashton 3, 5; Barker 1; Barr 3; Battcock, ed.; Baur 7; Bihalji-Merin; Blesh 1; Calas, N. and E.; Chipp; Eliot; Elsen 2; Goodrich and Baur 1; Goossen 1; *The Great Decade*; Greenberg 1; Haftman; Henning; Hess, T.B. 1; Hunter 1, 6; Hunter, ed.; Janis and Blesh 1; Janis, S.; Kozloff 3; Lynton; McChesney; McCoubrey 1; McCurdy, ed.; *Metro*; Motherwell, ed.; Ponente; Read 2; Restany 2; Richardson, E.P.; Rickey; Ritchie 1; Rodman 1, 2; Rose, B. 1, 4; Rosenblum 2; Rubin 1; Sandler; Seitz 1; **Selz, P. 4;** Seuphor 1; Soby 5; Tuchman, ed.; Weller. Archives.

RUBEN, RICHARDS. b. November 29, 1925, Los Angeles, Calif. **Studied:** Chouinard Art Institute, 1944-46; Bradley U., BFA, 1951. US Army, 1942-44. **Taught:** Arts and Crafts Center, Pittsburgh, 1949; Chouinard Art Institute, 1954-61; Pomona College, 1958-59; Pasadena Museum School; UCLA, 1958-62; Cooper Union, 1962-64; Otis Art Institute. **Awards:** International Arts Festival, Newport, R.I., First Prize, 1951; Bradley U., **P.P.**, 1952; Brooklyn Museum, First Prize, 1953, 54; SFMA, Anne Bremer Memorial Prize, 1954; L.C. Tiffany Grant, 1954. **Address:** 85 Mercer Street, NYC 10012. **Dealer:**

Poindexter Gallery. **One-man Exhibitions:** Felix Landau Gallery, 1952, 54; Pasadena/AM, 1954, 55, 61; Oakland/AM, 1957; Paul Kantor Gallery, Beverly Hills, Calif., 1958; Grand Central Moderns, NYC, 1958; Ferus Gallery, Los Angeles, 1960, 61, 63; California Palace, 1961; Poindexter Gallery, 1962, 64, 69; SFMA, 1970. **Group:** Los Angeles/County MA, 1948, 53, 55, 57; Bradley U., 1952, 53; U. of Illinois, 1952, 56; Dallas/MFA, 1953; Corcoran, 1953; PAFA, 1954; SRGM, Younger American Painters, 1954; Sao Paulo, 1955; Carnegie, 1955; Santa Barbara/MA, 1955, 58; Brooklyn Museum, 1957, 59; I Paris Biennial, 1959; WMAA, Fifty California Artists, 1962-63; El Retiro Parquet, Madrid, Arte de America y España, 1963; WMAA, 1964. **Collections:** Boston/MFA; Bradley U.; Brooklyn Museum; Los Angeles/County MA; Oakland/AM; Pasadena/AM; Raleigh/NCMA; W. & J. Sloane, Inc; U. of Southern California; Stanford U.

RUDA, EDWIN. b. May 15, 1922, NYC. **Studied:** ASL, 1940-41; Cornell U., 1947, BS; New School for Social Research, 1948; Columbia U., 1949, MA; School of Painting and Sculpture, Mexico City, 1949-51; U. of Illinois, 1956, MFA. Traveled Mexico, Europe, Southwest Pacific, Australia. US Naval Reserve. **Taught:** School of Visual Arts, NYC; Pratt Insitute; U. of Texas. **Address:** 44 Walker Street, NYC 10013. **Dealer:** Paula Cooper Gallery. **One-man Exhibitions:** (first) Globe Gallery, NYC, 1961; Feiner Gallery, NYC, 1963; Park Place Gallery, NYC, 1966-67; Paula Cooper Gallery, 1969, 71, 73, 75; Gallery A, Sydney, 1973; Tyler School of Art, Philadelphia, 1974. **Group:** New York World's Fair, 1965; SRGM, Systemic Painting, 1966; U. of Illinois, 1967, 74; ICA, U. of Pennsylvania, Art in the City, 1967; Newark Museum, Cool Art, 1968; Fort Worth Art Museum, Drawings, 1969; WMAA Annuals, 1969, 73; Indianapolis, 1970, 72; Chicago/AI, 1970; ICA, U. of Pennsylvania, Two Generations of Color Painting, 1970; U.

of Texas, Color Forum, 1972; Cincinnati/Contemporary, Options, 73/30, 1973. **Collections:** Allentown/AM; Canberra/National; Chase Manhattan Bank; U. of Connecticut; Great Southwest Industrial Park; Greenville; Indianapolis; U. of North Carolina; South Mall, Albany.

RUSCHA, EDWARD. b. December 16, 1937, Omaha, Neb. **Studied:** Chouinard Art Institute (with Richards Rubin). Traveled Europe. **Taught:** U. of Arizona; U. of North Dakota; UCLA; Vancouver (B.C.) School of Art; SFAI. Film: "Premium," 16mm, 1970; "Miracle," 16mm, 1974. **Awards:** National Council on the Arts, 1967; Guggenheim Foundation Fellowship, 1971. **Address:** 1024-¾ N. Western Avenue, Hollywood, Calif. 90029. **Dealer:** Leo Castelli Inc., NYC. **One-man Exhibitions:** (first) Ferus Gallery, Los Angeles, 1963, also 1964, 65; Alexandre Iolas Gallery, NYC, 1967, 70; Irving Blum Gallery, Los Angeles, 1968, 69; Galerie Rudolf Zwirner, 1968; Pavilion Art Gallery, Newport Beach, Calif. (two-man), 1968; Galerie Heiner Friedrich, Munich, 1970; Nigel Greenwood Inc. Ltd., London, 1970; Contract Graphics Associates, Houston, 1971; Janie C. Lee Gallery, Dallas, 1972; Corcoran and Corcoran, Coral Gables, 1972; Minneapolis/Institute, 1972; D.M. Gallery, London, 1972; Leo Castelli Inc., NYC, 1973, 74; John Berggruen Gallery, 1973; Projections: Ursula Wevers Gallery, Cologne, 1973; Ronald Greenberg Gallery, St. Louis, 1973; ACE Gallery, Los Angeles, 1973; Colgate U., 1973; Yvon Lambert, 1973; Françoise Lambert, Milan, 1973; The Texas Gallery, 1974; Galerie Rolf Ricke, 1975; Jared Sable Gallery, Toronto, 1975; U. of North Dakota, Grand Forks, 1975. **Group:** Oklahoma, 1960; Pasadena/AM, New Paintings of Common Objects, 1962; Oakland/AM, Pop Art USA, 1963; SRGM, American Drawings, 1964; M. Knoedler & Co., Art Across America, circ., 1965-67; SRGM, 1965; Seattle/AM, 1966; IX Sao Paulo Biennial, 1967; V Paris Biennial, 1967;

WMAA Annual, 1967; Hayward Gallery, London, Pop Art, 1969; XXXV Venice Biennial, 1970; Hayward Gallery, London, Eleven Los Angeles Artists, 1971; Akron/AI, Four Artists, 1972; Amerika Haus, Berlin, 1973; Yale U., American Drawing: 1970-1973, 1973; Oakland/AM, Cirrus Editions, 1974; WMAA, American Pop Art, 1974; VMFA, Works on Paper, 1974. **Collections:** Los Angeles/County MA; MOMA; Pasadena/AM. **Bibliography:** Alloway 1; *Contemporanea*; Finch; Lippard 5; Lippard, ed.; Meyer; *The State of California Painting; USA West Coast.*

RUSSELL, MORGAN. b. January 25, 1886, NYC; **d.** 1953, Broomall, Pa. **Studied:** Privately with Robert Henri; ASL (with James E. Fraser). Traveled Europe, resided Paris 1906-46. Developed Synchromism, with Stanton Macdonald-Wright in Paris, 1912. **One-man Exhibitions:** Galerie Bernheim-Jeune, Paris, 1913; Neue Kunstsalon, Munich, 1913; Carrol Gallery, NYC, 1914; Galerie la Licorne, Paris, 1923; Rose Fried Gallery, 1953; Walker, 1954. **Group:** Salon d'Automne, Paris, 1910; Salon des Artistes Independants, Paris, 1913; The Armory Show, 1913; Anderson Galleries, NYC, Forum Exhibition, 1916; Dallas/Contemporary, 1960; WMAA, 1963; M. Knoedler & Co., 1965; Marlborough-Gerson Gallery Inc., 1967; U. of New Mexico, Cubism: its impact in the USA, 1967. **Collections:** Evansville; Los Angeles/County MA; MOMA; NYU; Utica; WMAA. **Bibliography:** *Avant-Garde Painting and Sculpture*; Baur 7; Blesh 1; Brown; Canaday; Haftman; Hunter 6; Richardson, E.P.; Rickey; Rose, B. 1; Seuphor 1; Wright 2. Archives.

RUVOLO, FELIX. b. April 28, 1912, NYC. Throughout his youth, family resided in Italy, where he first attended art school (Catania). **Studied:** Chicago Art Institute School. Traveled Europe, Mexico, Canada, USA. **Taught:** Chicago Art Institute School, 1945-47; Mills College, summer, 1948; U. of

California, Berkeley, 1950- ; U. of Southern California, 1963. **Federal A.P.:** Easel painting. **Commissions:** Merchandise Mart, Chicago (murals). **Awards:** SFMA, Anne Bremer Memorial Prize, 1942; Chicago/AI, **P.P.**, 1942, 46, 47; California Palace, Gold Medal, 1946; Milwaukee, Kearney Memorial Prize, 1946; Pepsi-Cola, 1947, 48; Hallmark International Competition, 1949; U. of Illinois, **P.P.**, 1949; SFMA, **P.P.**, 1950; U. of California Institute for Creative Work in the Arts, Travel Fellowship, 1964; and some two dozen others. **Address:** 78 Strathmoor Drive, Berkeley, Calif. 94705. **One-man Exhibitions:** (first) Durand-Ruel Gallery, NYC, 1946; Mills College, 1947; de Young, 1947, 58; Grand Central Moderns, NYC, 1948; Catherine Viviano Gallery, 1949, 50, 52, 54; Poindexter Gallery, 1957, 58; U. of Southern California, 1963; Galleria Van der Voort, 1970; Jason Avers Gallery, San Francisco, 1971. **Group:** U. of Illinois, 1947, 61; MOMA, Abstract Painting and Sculpture in America, 1951; Buffalo/Albright, Expressionism in American Painting, 1952; Walker, 60 American Painters, 1960; Chicago/AI Annuals; MMA; Corcoran; PAFA; WMAA. **Collections:** Auckland; U. of California; Chicago/AI; Denison U.; Denver/AM; Des Moines; U. of Illinois; Mills College; SFMA; U. of Southern California; Tulsa/Philbrook; Walker. **Bibliography:** Genauer; Pousette-Dart, ed.; Ritchie 1.

RYMAN, ROBERT. b. May 30, 1930, Nashville, Tenn. **Studied:** Tennessee Polytechnic Institute, 1948-49; George Peabody College, 1949-50. US Army, 1950-52. **Member:** American Abstract Artists. **Awards:** Guggenheim Foundation Grant, 1973. **Address:** 637 Greenwich Street, NYC 10014. **Dealers:** John Weber Gallery; Lisson Gallery; Konrad Fischer Gallery, Dusseldorf;

Yvon Lambert. **One-man Exhibitions:** Paul Bianchini Gallery, NYC, 1967; Konrad Fischer Gallery, Dusseldorf, 1968, 69, 73; Galerie Heiner Friedrich, Munich, 1968, 69, 73; Fischbach Gallery, 1969, 70, 71; Françoise Lambert, Milan, 1969; Yvon Lambert, 1969; ACE Gallery, Los Angeles, 1969; Current Editions, Seattle, 1971, 72; Dwan Gallery, NYC, 1971; Galerie Heiner Friedrich, Cologne, 1971, 72; John Weber Gallery, 1972, 73, 74; 75; Galerie Annemarie Verna, Zurich, 1972; Galleria del Cortile, Rome, 1972; Lisson Gallery, 1972; Galleria San Fedele, Milan, 1973; Art & Project, Amsterdam, 1973; Brussels/Beaux-Arts, 1975. **Retrospective:** SRGM, 1972. **Group:** New York World's Fair, 1964-65; American Abstract Artists, 1965; SRGM, Systemic Painting, 1966; A.F.A., Rejective Art, 1967; ICA, U. of Pennsylvania, A Romantic Minimalism, 1967; A.F.A., The Square in Painting, 1968; Washington U., Here and Now, 1969; Berne, When Attitudes Become Form, 1969; WMAA, Anti-Illusion: Procedures/Materials, 1969; Seattle/AM, 557, 087, 1969; Dusseldorf/Kunsthalle, Prospect '69, 1969; Fort Worth Art Museum, Drawings, 1969; Amsterdam/Stedelijk, Op Losse Schroeven, 1969; Buffalo/Albright, Modular Painting, 1970; Cincinnati/Contemporary, Monumental Art, 1970; New Delhi, Second World Triennial, 1971; SRGM, Guggenheim International, 1971; Chicago/Contemporary, White on White, 1971-72; Chicago/AI, 1972; Documenta V, Kassel, 1972; Seattle/AM, American Art: Third Quarter Century, 1973; MOMA, Some Recent American Art, circ., 1973; U. of California, Santa Barbara, 1975. **Collections:** Amsterdam/Stedelijk; Dayton/AI; Hartford/Wadsworth; MOMA; Milwaukee; Minneapolis/Institute; WMAA. **Bibliography:** *Contemporanea;* Lippard, ed.; Murdock 1; *Robert Ryman; When Attitudes Become Form.* Archives.

SAGE, KAY. b. June 25, 1898, Albany, N.Y.; **d.** January 7, 1963, Woodbury, Conn. Self-taught. Resided Italy, 1900-14, 1919-37, Paris, 1937-39. **m.** Yves Tanguy. **One-man Exhibitions:** (first) Galleria Il Milione, Milan, 1936; Pierre Matisse Gallery, 1940; SFMA, 1941; Julien Levy Galleries, NYC, 1944, 47; Catherine Viviano Gallery, 1950, 52, 56, 58; L'Obelisco, Rome, 1953; Galerie Nina Dausset, Paris, 1953; Hartford/Wadsworth, 1954 (two-man); Mattatuck Historical Society Museum, Waterbury, Conn., 1965. **Retrospective:** Catherine Viviano Gallery, 1960. **Group:** Salon des Surindependants, Paris, 1938; International Surrealist Exhibition, NYC, 1942; Chicago/AI, 1945, 47, 51; Carnegie, 1946-50; WMAA, 1946-55; Toledo/MA, 1947, 49; California Palace, 1949, 50; U. of Illinois, 1949, 51; Brussels World's Fair, 1958. **Collections:** California Palace; Chicago/AI; MMA; MOMA; SFMA; WMAA; Wesleyan U. **Bibliography:** Breton 3; Goodrich and Baur 1; Pearson 2; Seitz 3; Tomkins and Time-Life Books; Waldberg 3. Archives.

SALEMME, ATTILIO. b. October 18, 1911, Boston, Mass.; **d.** January 24, 1955, NYC. Self-taught. US Marine Corps, 1927-28. Traveled USA. **Commissions** (murals): Moore-McCormack Lines Inc., 1949; 200 East 66 Street, NYC, 1950. **Awards:** Chicago/AI, Flora Mayer Witkowsky Prize, 1949; MMA, **P.P.**, 1950; William and Noma Copley Foundation Grant, 1954. **One-man Exhibitions:** (first) "67" Gallery, NYC, 1945; Carlebach Gallery, NYC, 1947; Passedoit Gallery, NYC, 1948; Saidenberg Gallery, 1950; Grace Borgenicht Gallery Inc., 1953; Duveen-Graham Gallery, NYC, 1955; ICA, Boston, 1958; Walker, 1958; Catherine Viviano Gallery, 1960; Staempfli Gallery, 1963; Terry Dintenfass, Inc., 1974. **Retrospectives:** WMAA, 1960. **Group:** Carnegie; WMAA Annuals; Chicago/AI Annuals; U. of Illinois, 1955. **Collections:** Brooklyn Museum; MMA; MOMA; WMAA. **Bibliography:** Goodrich and Baur 1; Kent, N.; McCurdy, ed.; Newmeyer; Pousette-Dart, ed. Archives.

SAMARAS, LUCAS. b. September 14, 1936, Kastoria, Macedonia, Greece. To USA 1948; citizen 1955. **Studied:** Rutgers U., 1955-59, BA; Columbia U. Graduate School, 1959-62. **Taught:** Yale U., 1969; Brooklyn College, 1971-72. **Awards:** Woodrow Wilson Fellow, Columbia U. **Address:** 52 West 71 Street, NYC, 10023. **Dealer:** The Pace Gallery, NYC. **One-man Exhibitions:** Rutgers U., 1955, 58; Reuben Gallery, NYC, 1959; Green Gallery, NYC, 1961, 64; Dwan Gallery, Los Angeles, 1964; The Pace Gallery, NYC, 1966, 68, 70, 71, 72, 74; Galerie der Spiegel, Cologne, 1969; Hannover/Kunstverein, 1970; MOMA, 1975. **Retrospectives:** Chicago/Contemporary, 1971; WMAA, 1972. **Group:** Martha Jackson Gallery, New Media—New Forms, II, 1961; MOMA, The Art of Assemblage, circ., 1961; MOMA, Lettering by Hand, 1962; Corcoran, 1963; Brandeis U., Recent American Drawings, 1964; WMAA Annuals, 1964, 68, 70, Young America, 1965; SRGM, 1965; RISD, 1965, Recent Still Life, 1966; WMAA, Contemporary American Sculpture, Selection I, 1966; MOMA, 1966; Walker, 1966; Los Angeles/County MA, American Sculpture of

Lucas Samaras *Large Word Drawing #32* 1975

the Sixties, 1967; Chicago/AI, 1967, 74; ICA, London, The Obsessive Image, 1968; MOMA, Dada, Surrealism and Their Heritage, 1968; Documenta IV & V, Kassel, 1968, 72. **Collections:** Buffalo/Albright; Chicago/AI; Fort Worth; Hartford/Wadsworth; Los Angeles/County MA; MMA; MOMA; Ridgefield/Aldrich; SRGM; St. Louis/City; U of St. Thomas (Tex.); WMAA; Walker **Bibliography:** Alloway 2; Battcock, ed.; Finch; Friedman and van der Marck; Hansen; *Happening & Fluxus*; Hunter, ed.; Kozloff 3; Lippard 5; Monumenta; Rickey; **Samaras**; Seitz 3; Tuchman 1. Archives.

SANDBACK, FRED. b. 1943, Bronxville, N.Y. **Studied:** Williston Academy, 1957-61; Theodor Heuss Gymnasium, Heilbronn, 1961-62; Yale U., 1962-66; Yale School of Art and Architecture, 1966-69. **Awards:** CAPS Grant, 1972. **Address:** 49 Crosby Street, NYC 10012. **Dealer:** John Weber Gallery. **One-man Exhibitions:** (first) Konrad Fischer Gallery, Dusseldorf, 1968; Galerie Heiner Friedrich, Munich, 1968, 70, 72, 73, 74; Dwan Gallery,

NYC, 1969, 70; ACE Gallery, Los Angeles, 1969; Françoise Lambert, Milan, 1970; Yvon Lambert, 1970; Galerie Reckermann, Cologne, 1970, 72; Galerie Annemarie Verna, Zurich, 1971, 72; John Weber Gallery, 1972, 74; Galerie Diogenes, Berlin, 1972; Galerie Nachst St. Stephen, Vienna, 1973; Galerie im Taxispalais, Innsbruck, 1973; Berne, 1973; Galleria Martano Due Torino, 1974; Galeria Milano, Milan, 1974; Galeria Piano Primo, Rome, 1974; Leverkusen, 1974; Galerie Heiner Friedrich, Cologne, 1974; Essen, 1974; Kunstraum, Munich, 1975; Darmstadt/Hessisches, 1975; Galerie d & c Mueller-Roth, Stuttgart, 1975. **Group:** WMAA, 1968; Dusseldorf/Kunsthalle, Prospect '68, 1968; MOMA, New Media: New Methods, circ., 1969; Berne, When Attitudes Become Form, 1969; ICA, U. of Pennsylvania, Between Object and Environment, 1969; Arnhem, Sonsbeek '71, 1971; Neuer Berliner Kunstverein, Berlin, Multiples, 1974. **Collections:** Krefeld/Kaiser Wilhelm; MOMA; RISD; WMAA.

SANDER, LUDWIG. b. July 18, 1906, NYC; **d.** July 31, 1975, NYC. **Studied:** NYU, BA; Hofmann School, Munich, two semesters. Traveled Europe, 1927, 1931-32. US Army, World War II. **Taught:** Colorado College, summers, 1951, 52, 53; Bard College, 1956-58. **Member:** NIAL. **Awards:** Hallmark International Competition; Longview Foundation Grant; National Council on the Arts; Guggenheim Foundation Fellowship, 1968; AAAL, Childe Hassam Fund Purchase, 1973. **One-man Exhibitions:** (first) Morton Gallery, NYC, 1930; Hacker Gallery, NYC, 1952; Leo Castelli Inc., 1959, 61; The Kootz Gallery, NYC, 1962, 64, 65; A.M. Sachs Gallery, 1967, 69; Lawrence Rubin Gallery, NYC, 1970, 72, 73; Waddington Galleries, London, 1972; Knoedler Contemporary Art, 1974. **Group:** Ninth Street Exhibition, NYC, 1951; SRGM, Abstract Expressionists and Imagists, 1961; Chicago/AI Annuals, 1961, 62; MOMA, Recent American Painting and

Ludwig Sander
Adirondack II 1971

Sculpture, circ. USA and Canada, 1961-62; WMAA, Geometric Abstraction in America, circ., 1962; Seattle World's Fair, 1962; Los Angeles/County MA, Post Painterly Abstraction, 1964; XXXII Venice Biennial, 1964; Toledo/MA, Form of Color, 1970; WMAA, 1973; SRGM, American Painters through Two Decades, 1973; U. of Miami, Less is More: The Influence of The Bauhaus on American Art, 1974. **Collections:** American Republic Insurance Co.; Baltimore/MA; Brandeis U.; Buffalo/Albright; Chase Manhattan Bank; Chicago/AI; Ciba-Geigy Corp.; Columbia Broadcasting System; Corcoran; Fort Worth; International Minerals & Chemicals Corp.; MIT; MMA; Ridgefield/Aldrich; SFMA; SRGM; U. of Texas; Union Carbide Corp.; Uris Buildings Corp.; WMAA; Walker. **Bibliography:** MacAgy 2; Weller. Archives.

SANDOL, MAYNARD. b. 1930, Newark, N.J. **Studied:** Newark State Teachers College, 1952. Traveled Europe. **Taught:** Hackettstown (N.J.) High School, 1964- ; Fairleigh Dickinson U., 1965-68. **Address:** Bunn Street, Lebanon Township, Califon, N.J. 07830. **Dealer:** Washburn Gallery Inc. **One-man Exhibitions:** Suttman-Riley Gallery, NYC, 1958; Artists' Gallery, NYC, 1959; Castellane, NYC, 1960, 63; Castellane, Provincetown, 1962, 63; Athena Gallery, New Haven, 1963; Chapman

Kelly Gallery, 1964; The Peridot Gallery, 1967, 68; Washburn Gallery Inc., 1971. **Group:** Newark Museum; Hartford/Wadsworth; MOMA; Corcoran; New York World's Fair, 1964-65; Trenton/State. **Collections:** Brandeis U.; Hartford/Wadsworth; Hirshhorn; Newark Museum; Princeton U. **Bibliography:** Gerdts.

SARET, ALAN. b. December 25, 1944, NYC. **Studied:** Cornell U., 1961-66, B. Arch.; Hunter College, 1967-68. Traveled Europe, Mexico, North Africa; resided in India 1971-73. **Award:** Guggenheim Fellowship, 1969. **Address:** 54 Leonard Street, NYC 10013. **One-man Exhibitions:** Bykert Gallery, 1968, 70; The Clocktower, NYC, 1973. **Group:** WMAA, 1968; Oberlin College, 1968; U. of North Carolina, 1969; Amsterdam/Stedelijk, Op Losse Schroeven, 1969; Berne, When Attitudes Become Form, 1969; MOMA, New Media: New Methods, circ., 1969; New Delhi, Second World Triennial, 1971. **Collections:** Detroit/Institute; Los Angeles/County MA; MOMA; Toronto; WMAA. **Bibliography:** *When Attitudes Become Form.*

SATO, TADASHI. b. February 6, 1923, Maui, Hawaii. **Studied:** Honolulu Academy School; Brooklyn Museum School; Pratt Institute, with Stuart Davis, John Ferren, Ralston Crawford.

Traveled USA, Japan, and around the world. **Member:** Hawaii Painters and Sculptors League; Lahaina Art Society (Hawaii); Honolulu Academy; Hui Noeau Association (Hawaii). **Awards:** Brooklyn Museum School, Scholarship, 1948; Dallas/MFA, Hon. Men., 1953; John Hay Whitney Fellowship, 1954; Honolulu Community Foundation Scholarship, 1955; Albert Kapp Award, 1958. **Address:** 1600 Kuuipo Street, Lahaina, Maui, Hawaii 96761. **One-man Exhibitions:** Gima's Art Gallery, Honolulu, 1950; Library of Hawaii, Honolulu, 1950; 442nd Infantry Memorial Hall, Honolulu, 1950, 52; Gallery 75, NYC, 1955; The Gallery, Honolulu, 1956; The Willard Gallery, 1958, 59, 61; McRoberts & Tunnard Gallery, London, 1961. **Retrospective:** The Willard Gallery, 1969. **Group:** U. of Nebraska, 1954; SRGM, 1954; SFMA, 1957; Silvermine Guild, 1958. **Collections:** U. of Arizona; Ball State U.; Buffalo/Albright; Fort Worth; Honolulu Academy; Omaha/Joslyn; SRGM; WMAA. **Bibliography:** Read 4.

SAUL, PETER. b. August 16, 1934, San Francisco, Calif. **Studied:** Stanford U.; California School of Fine Arts, 1950-52; Washington U., with Fred Conway, 1952-56, BFA. Traveled Europe; resided Holland, 1956-58, Paris, 1958-62, Rome, 1962-64. **Awards:** *Art In America* (Magazine), New Talent, 1962; William and Noma Copley Foundation Grant, 1962. **Address:** c/o Dealer. **Dealer:** Allan Frumkin Gallery, NYC and Chicago. **One-man Exhibitions:** Allan Frumkin Gallery, Chicago, 1961, 63, 64, 66, 69, 72, NYC, 1962-64, 66, 68, 69, 71, 73, 75; Galerie Breteau, Paris, 1962, 63, 64, 67; La Tartaruga, Rome, 1963; Rolf Nelson Gallery, Los Angeles, 1963; Notizie Gallery, Turin, 1964; Galerie Anne Abels, Cologne, 1965; Contemporary Gallery, Kansas City, 1967; Palos Verdes Estates, Calif., 1967; Wanamaker Gallery, Philadelphia, 1967; San Francisco Art Institute, 1968; Reed College, 1968; California College of Arts and Crafts, 1968; Darthea Speyer

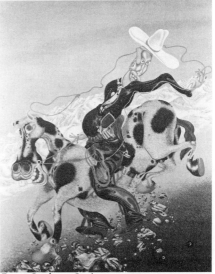

Peter Saul *Cowboy* 1974

Gallery, 1969, 72; Musee d'Art et d'Industrie, Paris, 1971; California State U., Sacramento, 1973. **Group:** Salon des Jeunes Peintres, Paris, 1959, 60; Dayton/AI, International Selection, 1961; U. of Colorado, 1962; Chicago/AI, 1962, 63, 64; SFMA, Directions—Painting U.S.A., 1963; U. of Michigan, 1963, 65; Musee Cantonal des Beaux-Arts, Lausanne, I Salon International de Galeries Pilotes, 1963; Abbey Saint-Pierre, Ghent, Forum, 1963; Brandeis U., Recent American Drawings, 1964; The Hague, New Realism, 1964; Des Moines, 1965; Indianapolis/Herron, 1966; U. of Kentucky, 1966; Carnegie, 1967; MOMA, circ., 1968; U. of Oklahoma, 1968; U. of Illinois, 1969; WMAA, Human Concern/Personal Torment, 1969; Corcoran, 1971; Chicago/AI, 1972. **Collections:** U. of California, Berkeley; Chicago/AI; U. of Illinois; MOMA; U. of Massachusetts; Oberlin College; WMAA.

SAUNDERS, RAYMOND. b. October 28, 1934, Homestead, Pa. **Studied:** U. of Pennsylvania, 1954-57; Barnes Foundation, 1953-55; PAFA, 1953-57;

Carnegie Institute of Technology, 1959-60, BFA; California College of Arts and Crafts, 1960-61, MFA. Traveled Mexico, Europe, USA. **Taught:** RISD; California State U., Hayward, 1968- . **Awards:** PAFA, Cresson Fellowship, 1956; AAAL Grant, 1963; Eakins Prize; Ford Foundation, **P.P.**, 1964; Prix de Rome, 1964, 65. **Address:** 6007 Rock Ridge Boulevard, Oakland, Calif. 94618. **Dealer:** Terry Dintenfass, Inc. **One-man Exhibitions:** (first) Pittsburgh Playhouse Gallery, 1953, also 1955; Terry Dintenfass, Inc., 1962, 64, 66-69, 71, 73, 75; Dartmouth College, 1969; Simpson College, Indianola, Iowa, 1969; Lehigh U., 1970; Miami-Dade, 1971; Spelman College, 1972; RISD, 1972; Carleton College, 1974; Peale House, Philadelphia (two-man), 1974. **Group:** PAFA Annuals, 1962-67; SFMA Annuals; New School for Social Research; WMAA, 1971, Annuals, 72, 73; NAD; UCLA, The Negro in American Art, 1966; A.F.A., 1966, 67; Dartmouth College, 1968; 30 Contemporary Black Artists, circ., 1968-69; Westmoreland County/MA, 1969; Boston/MFA, Black Artists: New York and Boston, 1970; Oakland/AM, Oakland Artists, 1974; VMFA, 1974. **Collections:** Allentown/AM; Andover/Phillips; California College of Arts and Crafts; U. of California, Berkeley; Howard U.; MOMA; NIAL; Oakland/AM; PAFA; U. of Texas; WMAA.

SAVELLI, ANGELO. b. October 30, 1911, Pizzo Catanzaro, Italy. **Studied:** Liceo Artistico, Rome, 1930-32; Academy of Fine Arts, Rome, with Ferruccio Ferrazzi, Diploma di Decorazione, 1932-36. To USA 1954. Traveled Europe, USA. A co-founder of The Art Club, Rome, with Gino Severini, Enrico Pramolini, Fazzini and others, 1944. **Taught:** Collegio Nazionale, Rome, 1939-40; Liceo Artistico, Rome, 1940-43, 1948-54; Scarsdale Art Workshop, 1957-61; New School for Social Research, 1959-64; Positano (Italy) Art Workshop, 1960-62; U. of Pennsylvania, 1960-69; Columbia U., 1966; Hunter College, 1968; U. of Minnesota, 1974; Cornell U., 1974; PAFA, 1975; U. of Arkansas, 1975. **Commissions:** Sora, Italy (church façade, fresco); F.A.U., Rome (mural); Italian Line (paintings for *SS Leonardo da Vinci* and *SS Michelangelo*); Lincoln Plaza, Syracuse, N.Y.; Audobon Art Center, New Haven, Conn. **Awards:** Fellowship from the Italian Ministry of Education, 1948; Bergamo, First Prize, 1941, 42; Battistoni, First Prize, 1958; XXXII Venice Biennial, 1964, Grand Prize for Graphics; Potsdam/SUNY, **P.P.**, 1965; Vancouver, **P.P.**, 1968. **Address:** 123 Fulton Street, NYC 10038. **Dealer:** Henri Gallery. **One-man Exhibitions:** (first) Galleria Roma, Rome, 1941; La Spiga, Milan, 1942; Galleria Ritrove, Rome, 1943; Galleria San Marco, Rome, 1944, 51; Galleria Cronache, Bologna, Italy, 1946; Oblo Capri, 1946; Galleria d'Arte del Naviglio, Milan, 1947, 54, 61; Galleria Sandri, Venice, 1947; Centra d'Art Italien, Paris, 1952; Numero Galleria d'Arte, Florence, Italy, 1953; The Contemporaries, NYC, 1955; D'Amecourt Gallery, Washington, D.C., 1956; Leo Castelli Inc., 1958; Galleria del Cavallino, Venice, 1958; Galleria Selecta, Rome, 1959; U. of Minnesota, 1960, 74; Peter H. Deitsch Gallery, 1962; D'Arcy Gallery, NYC, 1963; Philadelphia Art Alliance, 1963; XXXII Venice Biennial, 1964; Eastern Illinois U., 1964; Wellfleet Art Gallery, 1964; Contemporary Prints and Drawings, Chicago, 1966; Henri Gallery, 1969; Peale House, Philadelphia, 1969; Syracuse/Everson, 1972; Stout State U., Menomonie, Wisc., 1973. **Retrospective:** Catanzaro, Italy, 1954. **Group:** Rome National Art Quadrennial, 1943- ; Venice Biennial, 1948- ; Rose Fried Gallery, International Collage Exhibition, 1956; Hartford/Wadsworth, Graphics, 1956; A.F.A., Collage in America, circ., 1957-58; Library of Congress, 1959; Brooklyn Museum, 1962, 63; Gallery of Modern Art, Ljubljana, Yugoslavia; A.F.A., Moods of Light, circ., 1963-64; Sidney Janis Gallery, 1964; WMAA Annuals, 1966, 67; PAFA Annual, 1968; Brooklyn

Museum, 1968; Corcoran Biennial, 1969; Salon du Mai, Paris, 1969; Madred/Nacional, II Biennial, 1969; Corcoran, 1969; Chicago/Contemporary, White on White, 1971-72. **Collections:** Brooklyn Museum; Cincinnati/AM; Corcoran; Eilat; Helsinki; Library of Congress; MOMA; U. of Minnesota; NCFA; NYPL; Norfolk/Chrysler; PMA; U. of Pennsylvania; Phoenix; Rome/Nazionale; Syracuse/Everson; Turin/Civico; Vancouver; Victoria and Albert Museum.

SCARPITTA, SALVATORE. b. 1919, NYC. To Italy to study, 1936; returned to NYC, 1959. Traveled Italy, Switzerland. **Taught:** Maryland Institute, 1965- . **Address:** 307 East 84 Street, NYC 10028. **Dealer:** Leo Castelli

Inc. **One-man Exhibitions:** Gaetano Chiurazzi, Rome, 1949; Galleria Il Pincio, Rome, 1951; La Tartaruga, Rome, 1955, 57, 58; Galleria d'Arte del Naviglio, Milan, 1956, 58; Leo Castelli Inc., 1959, 60, 63, 65, 75, Leo Castelli Warehouse, 1969; Dwan Gallery, NYC, 1961; Galerie Schmela, 1963; Galleria dell'Ariete, 1963; Brussels/Royaux, 1964; Galleria Notizie, Turin, 1972; Galerie Jacques Benador, Geneva, 1973; L'Uomo & l'Arte, Milan, 1974. **Group:** Galleria Roma, Rome, 1944; Rome National Art Quadrennial, 1948; XXVI, XXVIII, and XXIX Venice Biennials, 1952, 56, 58; Columbus, 1960; Martha Jackson Gallery, New Media—New Forms, I & II, 1960, 61; Houston/MFA, Ways and Means, 1961; Corcoran, 1963; Musee Cantonal des Beaux-Arts, Lau-

Salvatore Scarpitta *Settlement and Pouch Sled* 1974

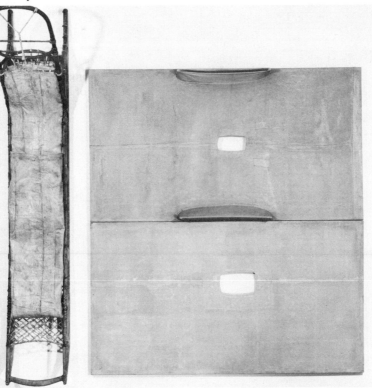

sanne, I Salon International de Galeries Pilotes, 1963; Maryland Institute, 1964; Chicago/AI, 1964; U. of Illinois, 1965; ICA, U. of Pennsylvania, Highway, 1970; Hofstra U., Art around the Automobile, 1971; Rome, III Quadriennial, 1972. **Collections:** Amsterdam/Stedelijk; Buffalo/Albright; Los Angeles/County MA; MOMA; Tel Aviv. **Bibliography:** Janis and Blesh 1; *Metro;* Weller. Archives.

SCHANKER, LOUIS. b. July 20, 1903, NYC; **Studied:** Educational Alliance, NYC; Cooper Union; ASL. Traveled Europe, Africa, USA. **Taught:** New School for Social Research, 1940-60; Bard College, 1949-64; U. of Colorado, 1953; U. of Minnesota, 1959. **Federal A.P.:** 1940-41. **Member:** Sculptors Guild; Federation of Modern Painters and Sculptors. **Address:** Box 359, Stamford, Conn. 06902. **Dealer:** The New Bertha Schaefer Gallery; Weyhe Gallery; A.A.A. Gallery. **One-man Exhibitions:** (first) Contemporary Arts Gallery, NYC, 1933; Kleemann Gallery, NYC; New School for Social Research, 1938; Artists' Gallery, NYC, 1939; Brooklyn Museum, 1943; The Willard Gallery, 1944, 45, 46, 48, 50; Mortimer Brandt, NYC, 1945; Hacker Gallery, NYC, 1950; Grace Borgenicht Gallery Inc., 1952, 55; Dorsky Gallery; The New Bertha Schaefer Gallery, 1973. **Retrospective:** Walker, 1959. **Group:** WMAA; Brooklyn Museum; MMA; Utica; Chicago/AI; U. of Michigan. **Collections:** Brooklyn Museum; Chicago/AI; Hirshhorn; MMA; U. of Michigan; NYPL; Newark Museum; PMA; Phillips; Toledo/MA; Utica, Wesleyan U. **Bibliography:** American Artists Congress, Inc.; Baur 7; Cheney; Hayter 1; Pousette-Dart, ed. Archives.

SCHAPIRO, MIRIAM. b. 1923, Toronto, Canada. **Studied:** State U. of Iowa, 1944-49, BA, MA, MFA. **Taught:** State U. of Iowa, 1946-49; Scarsdale School of Art, 1965-66; Connecticut College for Women, 1966; Parsons School of Design, NYC, 1966-67; U. of California, 1967-69; California Institute of the

Arts, Valencia, 1971- ; Nova Scotia College of Art and Design, Halifax, 1974. **Member:** Board of Directors, College Art Association and Los Angeles Institute of Contemporary Art. **Awards:** Tamarind Fellowship, 1963. **m.** Paul Brach. **Address:** 393 W. Broadway, NYC 10013; Montauk Highway, East Hampton, N.Y. 11037. **Dealers:** Cynthia Comsky Gallery; Andre Emmerich Gallery, NYC. **One-man Exhibitions:** U. of Missouri, 1950; Illinois Wesleyan U., 1951; Andre Emmerich Gallery, NYC, 1958, 61, 63, 67, 69, 71, 73; Skidmore College, 1964; Franklin Siden Gallery, Detroit, 1965; Vassar College, 1973; Cynthia Comsky Gallery, 1974, 75; Douglass College Library, 1975; Benson Gallery, 1975. **Retrospectives:** New London, 1966; Newport Harbor and La Jolla, Paul Brach and Miriam Schapiro, 1969; U. of California, San Diego, 1975. **Group:** MOMA, New talent; U. of Nottingham (England), Abstract Impressionists, 1958; International Biennial Exhibition of Paintings, Tokyo; Carnegie, 1959; WMAA, 1959; MOMA, Abstract American Drawings and Watercolors, circ. Latin America, 1961-63; Jewish Museum, Toward a New Abstraction, 1963; SFMA, Directions—Painting U.S.A., 1963; Walker; Denver/AM; Brooklyn Museum; Chicago/AI; Brandeis U., New Directions in American Painting, 1963; PAFA, 1963, 64; Dayton/AI, 1967; Fort Worth Art Museum, Drawings, 1969; Jewish Museum, Superlimited: Books, Boxes, and Things, 1969; Long Beach/MA, Invisible/Visible Twenty-one Artists, 1972; Scripps College, California Women Artists, 1972; Womanhouse, Los Angeles, 1972; U. of North Dakota, 14 Women, 1973; Womanspace, Los Angeles, Female Sexuality/Female Identity, 1973; PMA/Museum of the Philadelphia Civic Center, Focus, 1974; Newport Harbor, The Audacious Years, 1974; Cerritos College Art Gallery, Norwalk, Calif., 16 Los Angeles Women Artists, 1974. **Collections:** Albion College; Amstar Corp.; Avco Corp.; Bank of America; U. of California; Hirshhorn; Illinois Wesleyan U.; La Jolla; Levin

Townsend Computer Corp.; MOMA; NYU; Newport Harbor; St. Louis/City; Security Pacific Bank; Stanford U.; Stephens College; Tougaloo College; United Nations; WMAA; Worcester/ AM. **Bibliography:** Art: *A Woman's Sensibility*; **Miriam Schapiro.**

SCHLEMOWITZ, ABRAM. b. July 19, 1911, NYC. **Studied:** Beaux-Arts Institute of Design, NYC, 1928-33; ASL, 1934; NAD, 1935-39. **Taught:** Contemporary Art Center, YMHA, NYC, 1936-39; Pratt Institute, 1962-63; U. of California, Berkeley, 1963-64. Organizing chairman of the New Sculpture Group, 1957-58. **Awards:** Guggenheim Foundation Fellowship, 1963. **Address:** 139 West 22 Street, NYC 10011. **One-man Exhibitions:** The Howard Wise Gallery, NYC, 1961, 62, 67. **Group:** Betty Parsons Gallery, American Abstract Artists, 1959; Claude Bernard, Paris, 1960; The Stable Gallery, Sculpture Annuals, 1960, 61; Museum of Contemporary Crafts, Collaboration: Artist and Architect, 1962; Riverside Museum, 12 New York Sculptors, 1962; New School for Social Research, Humanists of The 60's, 1963; MOMA, Art in Embassies, circ. internationally, 1963-64. **Collections:** U. of California, Berkeley; Norfolk/Chrysler.

SCHMIDT, JULIUS. b. 1923, Stamford, Conn. **Studied:** Oklahoma A. and M. College, 1950-51; Cranbrook Academy of Art, 1952, BFA, 1955, MFA; Zadkine School of Sculpture, Paris, 1953; Academy of Fine Arts, Florence, Italy. Traveled Europe, USA, Mexico, Mediterranean. **Taught:** Silvermine Guild School of Art, summers, 1953, 54; Cleveland Institute of Art, 1957; Kansas City /AI, 1954-59; RISD, 1959-60; U. of California, Berkeley, 1961-62; Cranbrook, 1962-69; U. of Iowa, 1969- . **Awards:** Mid-American Biennial, First Prize and **P.P.**; Guggenheim Foundation Fellowship, 1963. **Address:** U. of Iowa, Art Department, Iowa City, Iowa 52242. **One-man Exhibitions:** Silvermine Guild, 1953; Kansas City/AI, 1956,

1965-66; Santa Barbara/MA, 1961; Otto Gerson Gallery, NYC, 1961, 63; Franklin Siden Gallery, Detroit, 1964; Gertrude Kasle Gallery, 1965, 67, 72, 74; U. of Arkansas, 1966; Talladega College, 1966; Marlborough-Gerson Gallery Inc., 1966, 71; Rockford (Ill.) College Museum of Art, 1974. **Retrospective:** U. of Iowa, 1974. **Group:** Detroit/Institute, 1958; PAFA, 1958, Annual, 1964; MOMA, Sixteen Americans, circ., 1959; Claude Bernard, Paris, Aspects of American Sculpture, 1960; Chicago/AI, 1960; WMAA Annuals, 1960-63; Carnegie, 1961; Dayton/AI, 1961; Boston Arts Festival, 1961; MOMA, American Painting and Sculpture, circ., 1961; New School for Social Research, Mechanism and Organism, 1961, also 1966; SFMA, 1962; SRGM, The Joseph H. Hirshhorn Collection, 1962; Battersea Park, London, International Sculpture Exhibition, 1963; Sao Paulo, 1963; Walker, Ten American Sculptors, 1964; Flint/Institute, 1965; WMAA, Contemporary American Sculpture, Selection I, 1966; U. of Illinois, 1967; PMA, American Sculpture of the Sixties, 1967; U. of California, 1968; U. of Wisconsin, 1975. **Collections:** American Republic Insurance Co.; Brenton Bank; Buffalo/Albright; Buffalo/SUNY; Chase Manhattan Bank; Chicago/AI; Cranbrook; Davenport/Municipal; Detroit/Institute; U. of Illinois; U. of Iowa; Kalamazoo/Institute; Kansas City/Nelson; MOMA; U. of Massachusetts; U. of Michigan; U. of Nebraska; Oswego/ SUNY; Princeton U.; Santa Barbara/ MA; WMAA; Walker; Washington U. **Bibliography:** Read 3.

SCHNAKENBERG, HENRY. b. September 14, 1892, New Brighton (Staten Island), N.Y.; **d.** October 15, 1970, Newton, Conn. **Studied:** ASL, 1914, with Kenneth Hayes Miller. US Army, 1917-19. Traveled Mexico, Europe. **Taught:** ASL. **Commissions** (murals): US Post Offices, West New York, N.J., and Amsterdam, N.Y. **Awards:** U. of Vermont, Hon. DFA; elected to the NIAL, 1952. **One-man Exhibitions:** (first) Whitney Studio Club, NYC, 1921;

Alfredo Valente Gallery, NYC, 1926; Hartford/Wadsworth (two-man), 1955; Kraushaar Galleries, 1929, 35, 37, 40, 41, 42, 46, 48, 50, 54, 56, 60, 63, 69. **Group:** MMA; WMAA; U. of Nebraska; Chicago/AI; Brooklyn Museum; Newark Museum. **Collections:** ASL; Andover/Phillips; Brooklyn Museum; California Palace; Chicago/AI; Dallas/MFA; Dartmouth College; Hartford (Conn.) State Library; Hartford/Wadsworth; MMA; Minneapolis/Institute; Montclair/AM; U. of Nebraska; Newark Museum; New Britain; PAFA; Princeton U.; SFMA; Scripps College; Springfield, Mass./MFA; US Military Academy; U. of Vermont; WMAA; Wichita/AM; Yale U. **Bibliography:** Baur 7; Cheney; **Goodrich 6;** Goodrich and Baur 1; Hall; *Index of 20th Century Artists;* Kent, N.; Mellquist; Pearson 1; Richardson, E.P. Archives.

SCHRAG, KARL. b. December 7, 1912, Karlsruhe, Germany. **Studied:** Humanistisches Gymnasium, Karlsruhe, 1930; Ecole des Beaux-Arts, Geneva, 1931; Atelier Lucien Simon, Paris; Academie Ranson, Paris, with Roger Bissiere; Academie de la Grande Chaumiere, 1931-35; ASL, with Harry Sternberg; Atelier 17, NYC, with S.W. Hayter. To USA 1938; citizen 1944. Traveled Europe, Mexico. **Taught:** Brooklyn College, 1953; Columbia U., 1958; Cooper Union, 1954-68; Director of Atelier 17, NYC, 1950. **Member:** Artists Equity; SAGA; ASL. **Awards:** Brooklyn Museum Biennials, **P.P.**, 1947, 50; SAGA, **P.P.**, 1954; The Print Club, Philadelphia, Charles M. Lea Prize, 1954; American Color Print Society, 1958, Florence Tonner Prize, 1960; Sonia Wather Award, 1964; Ford Foundation Fellowship for work at Tamarind Lithography Workshop; Syracuse State Fair, Nelson Rockefeller Award, 1963; AAAL, 1966; Albion College, **P.P.**, 1968; AAAL, Childe Hassam Fund Purchase, 1969, 73; Davidson College, **P.P.**, 1974. **Address:** 127 East 95 Street, NYC 10028. **Dealer:** Kraushaar Galleries; A.A.A. Gallery. **One-man Exhibitions:** (first) Galerie Arenberg, Brussels, 1938;

Smithsonian, 1945; Kraushaar Galleries, 1947, 50, 52, 56, 59, 62, 64, 66, 68, 71; 75; U. of Alabama, 1949; Philadelphia Art Alliance, 1952; U. of Maine, 1953; State U. of New York, Oneonta, 1958; Gesellschaft der Freunde Junger Kunst, Baden-Baden, Germany, 1958; Storm King Art Center, 1967; NCFA, 1972. **Retrospectives:** A.F.A./Ford Foundation, circ., 1960-62; A.A.A. Gallery, 1972. **Group:** SAGA; PAFA; The Print Club, Philadelphia; Brooklyn Museum; Graphische Sammlung Albertina; SFMA, 1941, 45, 46; WMAA, 1943, 55, 57; Carnegie, 1944, 47; Musee du Petit Palais, Paris, 1949; Chicago/AI; Instituto Nacional de Bellas Artes, Mexico City, 1958; U. of Nebraska, 1973; MOMA, 1975. **Collections:** Achenbach Foundation; U. of Alabama; Atlanta U.; Bibliotheque Nationale; Boston/MFA; Bradley U.; Brandeis U.; Brooklyn Museum; Chicago/AI; Cleveland/MA; Commerce Trust Co., Kansas City, Mo.; Dartmouth College; Detroit/Institute; Hartford/Wadsworth; U. of Illinois; Karlsruhe; Lehigh U.; Library of Congress; Lincoln Life Insurance Co.; Los Angeles/County MA; MMA; MOMA; U. of Maine; NYPL; National Gallery; Newark Museum; Oakland/AM; Omaha/Joslyn; PMA; The Pennsylvania State U.; RISD; Smithsonian; Springfield, Mass./MFA; Storm King Art Center; Syracuse U.; U.S. Rubber Co.; Utica; WMAA; Yale U.; Youngstown/Butler. **Bibliography: Gordon 3;** Hayter 1, 2; Reese. Archives.

SCHUCKER, CHARLES. b. January 9, 1908, Gap, Pa. **Studied:** Maryland Institute, 1928-34. **Taught:** NYU, 1947-54; Pratt Institute, 1956- ; City College. **Member:** Yaddo Board of Directors. **Federal A.P.:** Easel painting in Chicago, 1938-42. **Awards:** Henry Walters Traveling Fellowship; Guggenheim Foundation Fellowship, 1953; Audubon Artists, Prize for Oil Painting. **Address:** 33 Middagh Street, Brooklyn, N.Y. 11201. **Dealer:** Max Hutchinson Gallery. **One-man Exhibitions:** (first) Renaissance Society, Chicago; Albert Roullier Gallery, Chicago; Chicago/AI; The Chicago

Artists Room; Macbeth Gallery, NYC, 1946, 49, 53; Passedoit Gallery, NYC, 1955, 58; Katonah (N.Y.) Art Gallery, 1955; The Howard Wise Gallery, NYC, 1963; Lincoln Center, 1968; WMAA, 1971; Max Hutchinson Gallery, 1972, 74, 75. **Group:** MOMA, Painting and Sculpture from 16 American Cities, 1933; Carnegie, 1949; Walker, Contemporary American Painting, 1950; MMA, American Paintings Today, 1950; PAFA, 1951, 52, 53; California Palace Annual, 1952; WMAA Annuals, 1952-57, 1960, 61, 63; Chicago/AI, 1954; SFMA, Art in the Twentieth Century, 1955; WMAA, Nature in Abstraction, 1958; Corcoran; Brooklyn Museum; Riverside Museum, NYC; Amherst College, Color Painting, 1972; Cincinnati/Contemporary, Options, 73/30, 1973; WMAA, 1973; Katonah (N.Y.) Art Gallery, 1973. **Collections:** AAAL; Brooklyn Museum; Harcourt Brace Jovanovich Inc.; Newark Museum; New Britain; WMAA. **Bibliography:** Baur 5; Goodrich and Baur 1. Archives.

SCHUELER, JON. b. September 12, 1916, Milwaukee, Wisc. **Studied:** U. of Wisconsin, 1934-38, BA (Economics), 1939-40, MA (English Literature); Bread Loaf School of English, Middlebury, Vt., 1941; California School of Fine Arts, 1948-51, with David Park, Elmer Bischoff, Richard Diebenkorn, Hassel Smith, Clyfford Still, Clay Spohn. US Air Force, 1941-43. Traveled Europe, Great Britain, USA extensively. **Taught:** U. of San Francisco, 1947-49 (English Literature); Yale U., 1960-62, and summer school, 1960, 61; Maryland Institute, 1963. **Commissions:** New York Hilton Hotel, 1962 (lithograph). **Address:** Mallaig, Scotland. **Dealer:** Ben Heller Inc. **One-man Exhibitions:** (first) Metart Gallery, San Francisco, 1950; The Stable Gallery, NYC, 1954, 62, 64; Leo Castelli Inc., 1957, 59; B.C. Holland Gallery, 1960; Hirschl & Adler Galleries, Inc., NYC, 1960; Cornell U., 1962; Columbia U. School of Architecture, 1962; Maryland Institute, 1962, 64; Richard Demarco Gallery, Edinburgh, 1973; Edinburgh College of Art, 1973;

WMAA, 1975. **Group:** Walker, 1955; WMAA Annuals, 1956, 59, 61, 63; Corcoran, 1958, 62; A.F.A., School of New York—Some Younger American Painters, 1960; Walker, 60 American Painters, 1960; WMAA, 50 Years of American Art, 1964. **Collections:** New York Hilton Hotel; Union Carbide Corp.; WMAA. **Bibliography:** Baur 5; Friedman, ed.; Goodrich and Baur 1; McChesney.

SCHWABACHER, ETHEL. b. May 20, 1903, NYC. **Studied:** ASL, 1927-28, with Robert Laurent, Max Weber; and privately with Arshile Gorky, 1934-36. Resided Europe, 1928-34. **Address:** 1192 Park Avenue, NYC 10028. **One-man Exhibitions:** (first) Passedoit Gallery, NYC, 1935, also 1947; Betty Parsons Gallery, 1953, 56, 57, 60, 62, 64; Greenross Gallery, NYC, 1964; Buffalo/SUNY, 1972. **Group:** WMAA Annuals, 1947, 49, 51, 52, 54, 56, 57, 59, 61, 63; A.F.A., 1953; Brooklyn Museum, 1956, 60; Corcoran, 1958; WMAA, Nature in Abstraction, 1958; Walker, 1960; Mexico City/Nacional, 1960; Carnegie, 1961; Buffalo/Albright, 1962, Abstract Expressionism: First and Second Generations, 1972. **Collections:** Buffalo/Albright; Rockefeller Institute; WMAA. **Bibliography:** Baur 5; Goodrich and Baur 1; **Schwabacher.** Archives.

SCHWARTZ, MANFRED. b. November 11, 1909, Lodz, Poland; **d.** November 7, 1970, NYC. **Studied:** ASL, with George Bridgeman, John Sloan. Traveled Europe, Algeria. **Taught:** NYU; Skowhegan School; Brooklyn Museum School; Pratt Institute; New School for Social Research, 1964-70. **Member:** Federation of Modern Painters and Sculptors. **Awards:** Silvermine Guild, Silvermine Prize ($500), 1965, Silvermine Marine Award, 1967; PAFA, Jennie Sesnan Gold Medal, 1968. **One-man Exhibitions:** (first) Lilienfeld Gallery, NYC, 1940; Durand-Ruel Gallery, NYC, 1947, 48, 49; Otto Gerson Gallery, NYC, 1955, 57; Albert Landry, NYC, 1962, 63; Brooklyn Museum, Drawings and Pastels, 1959; New

School for Social Research, 1967; WMAA, 1971; RISD, 1974; Knoedler Contemporary Art, 1974. **Retrospective:** Brooklyn Museum, Manfred Schwartz: 20-Year Retrospective, 1961. **Group:** Cincinnati/AM; Brooklyn Museum; WMAA. **Collections:** Brooklyn Museum; MMA; MOMA; U. of Minnesota; Newark Museum; New School for Social Research; PMA; U. of Rochester; SRGM; WMAA. **Bibliography:** Genauer. Archives.

SEGAL, GEORGE. b. November 26, 1924, NYC. **Studied:** NYU, 1950, BS; Rutgers U., 1963, MFA. **Taught:** New Jersey high schools, 1957-63. **Awards:** Walter K. Gutman Foundation Grant, 1962; Chicago/AI, First Prize, 1966. **Address:** RFD #4, Box 323, North Brunswick, N.J. 08902. **One-man Exhibitions:** (first) Hansa Gallery, NYC, 1956, also 1957, 58, 59; Rutgers U., 1958; Green Gallery, NYC, 1960, 62, 64; Ileana Sonnabend Gallery, Paris, 1963; Galerie Schmela, 1963; Sidney Janis Gallery, 1965, 67, 68, 70, 71, 73, 74; Toronto (three-man, with Jim Dine, Claes Oldenburg); Chicago/Contemporary, 1968; Darthea Speyer Gallery, 1969, 71; Galerie der Spiegel, Cologne, 1970; Galerie Onnasch, Cologne, 1971; Zurich, circ., 1971, 73; Trenton/State (two-man), 1971; U. of Wisconsin, Milwaukee, 1973; Andre Emmerich Gallery, Zurich, 1975. **Group:** Boston Arts Festival, 1956; Jewish Museum, The New York School, Second Generation, 1957, Recent American Sculpture, 1964, also 1966; WMAA Annuals, 1960, 64, 68; A.F.A., The Figure, circ., 1960, also 1968; Sidney Janis Gallery, The New Realists, 1962; VII & IX Sao Paulo Biennials, 1963, 67; Stockholm/National, American Pop Art, 1964; Corcoran Biennial, 1965; Cordier & Ekstrom, Inc., 1965; Palais des Beaux-Arts, Brussels, 1965; WMAA, A decade of American Drawings, 1965; SRGM, 1965, 67; RISD, Recent Still Life, 1966; Chicago/AI, 1966, 74; Walker, 1966; Los Angeles/County MA, American Sculpture of

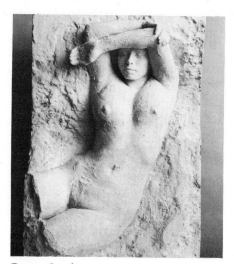

George Segal
Bas-Relief: Girl with Hands above Her Head 1973

the Sixties, 1967; MOMA, The 1960's, 1967; Carnegie, 1967; II Internationale der Zeichnung, Darmstadt, 1967; Trenton/State, Focus on Light, 1967; Gelsenkirchen, 1967; Documenta IV, Kassel, 1968; St. Paul Gallery, 1968; ICA, London, The Obsessive Image, 1968; Fort Worth Art Museum, Drawings, 1969; Grand Rapids, Sculpture of the 60s, 1969; Boston U., American Artists of the Nineteen Sixties, 1970; Expo '70, Osaka, 1970; Indianapolis, 1970; Carnegie, 1970; WMAA, 1970; Walker, Figures/Environments, circ., 1970-71; Chicago/AI, Contemporary, Drawings, 1971; Chicago/Contemporary, White on White, 1971-72; Utica, 1972. **Collections:** Akron/AI; Amsterdam/Stedelijk; Buffalo/Albright; CNAC; Charlotte/Mint; Chicago/AI; Des Moines; Detroit/Institute; Hartford/Wadsworth; Helsinki; Indiana U.; Krefeld/Kaiser Wilhelm; MOMA; Milwaukee; Munich/SG; Newark Museum; U. of North Carolina; Omaha/Joslyn; Ottawa/National; PAFA; SFMA; St. Louis/City; Schwebber Electronics; Stockholm/National; Stuttgart; Toronto; Trenton/State; Vancouver; WMAA; Walker; Zurich. **Bibliography:** Battcock, ed.; Becker and Vostell; Bihalji-Merin; Ca-

las, N. and E.; *Contemporanea*; Craven, W.; Dienst 1; Figures/Environments; Finch; Friedman and van der Marck; Gerdts; Hansen; Hunter, ed.; Kaprow; Kozloff 3; *Kunst um 1970*; Licht, F.; Lippard 5; *Recent Figure Sculpture*; Trier 1; Tuchman 1; Weller. Archives.

SELEY, JASON. b. May 20, 1919, Newark, N.J. **Studied:** Cornell U., 1936-40, BA; ASL, with Ossip Zadkine, 1943-45; Academie des Beaux-Arts, Paris, 1950. Traveled Europe. **Taught:** Le Centre d'Art, Port-au-Prince, Haiti, 1946-49; Hofstra U., 1953-65; NYU, 1963-67; Dartmouth College, 1968; Cornell U., 1968- ; Deutscher Akademischer Austauchdienst, Berlin, 1970-71. **Commissions:** Haitian Government, 1949; Episcopal Cathedral, Port-au-Prince, Haiti, 1952. **Awards:** US State Department Grant, 1947-49; Fulbright Fellowship (France), 1949; Silvermine Guild, First Prize for Sculpture, 1962. **Address:** 209 Hudson Street, Ithaca, N.Y. 14850. **Dealer:** Louis K. Meisel Gallery. **One-man Exhibitions:** (first) Le Centre d'Art, Port-au-Prince, Haiti, 1946, also 1947, 48, 49; American-British Art Center, NYC, 1947, 48; A.A.A. Gallery, NYC, 1955; Hofstra College, 1957; Barone Gallery, NYC, 1960; The Kornblee Gallery, 1962, 64, 67, 69; Dartmouth College, 1968; U. of Vermont, 1968; Dunkelman Gallery, Toronto, 1968; Wesleyan U. (Conn.), 1969; Amerika Haus, Berlin, 1971; Colgate U., 1974; Louis K. Meisel Gallery, 1974. **Retrospective:** Cornell U., 1965. **Group:** WMAA Sculpture Annuals, 1952, 53, 62, 64, 66, 68-69; Newark Museum, 1958, 61, 64; MOMA, Recent Sculpture USA, 1959; MOMA, The Art of Assemblage, circ., 1961; SRGM, The Joseph H. Hirshhorn Collection, 1962; Festival of Two Worlds, Spoleto, 1962; Battersea Park, London, International Sculpture Exhibition, 1963; MOMA, Americans 1963, circ., 1963-64; Documenta III, Kassel, 1964; MOMA, Around the Automobile, 1965; WMAA, Contemporary American Sculpture, Selection I,

1966; MOMA, The 1960's, 1967; WMAA, 1967; Toronto International Sculpture Symposium, 1967. **Collections:** U. of California; Chase Manhattan Bank; Cornell U.; Dartmouth College; Fredonia/SUNY; MOMA; Newark Museum; Ottawa/National; Ridgefield/Aldrich; St. Lawrence U.; South Mall, Albany; Syracuse/Everson; Toronto; WMAA. **Bibliography:** Craven, W.; Read 3; Seitz 3.

SELIGER, CHARLES. b. June 3, 1926, NYC. Self-taught in art. Traveled Switzerland, France. **Taught:** Mt. Vernon (N.Y.) Art Center, 1950-51. **Address:** 10 Lenox Avenue, Mount Vernon, N.Y. 10552. **Dealer:** Andrew Crispo Gallery. **One-man Exhibitions:** (first) Art of This Century, NYC, 1945, also 1946; Carlebach Gallery, NYC, 1948, 49; de Young, 1949; Art Center School, Los Angeles, 1949; The Willard Gallery, 1951, 53, 55, 57, 59, 61, 63, 65, 68; Otto Seligman Gallery, 1955, 63, 65, 67; Haydon Calhoun Gallery, Dallas, 1963; Nassau Community College, Garden City, N.Y.; Andrew Crispo Gallery, 1974. **Retrospective:** Wooster Community Art Center, Danbury, Conn., 1969. **Group:** VMFA, 1946; Chicago/AI, Abstract and Surrealist Art, 1948; XXIV Venice Biennial, 1948, Guggenheim Collection; Brooklyn Museum, 1949; Cornell U., Young Painters, 1951; MOMA, Abstract Painting and Sculpture in America, 1951; Chicago/AI, 1952; WMAA, 1952, 55, 56; USIA, American Painting, circ. Europe, 1956; Utica, 1957; Rome-New York Foundation, Rome, 1960; Norfolk; St. Paul Gallery, 1966; AAAL, 1966, 68; The Willard Gallery, 1967; Smithsonian, The Art of Organic Forms, 1968. **Collections:** Andover/Phillips; Baltimore/MA; Brandeis U.; Chicago/AI; The Hague; Iowa State U.; MOMA; Newark Museum; Seattle/AM; Southern Illinois U.; Tel Aviv; US State Department; Utica; Vancouver; Vassar College; WMAA. **Bibliography:** Baur 7; Read 2, 4; Richardson, E.P.; Ritchie 1. Archives.

SELIGMANN, KURT. b. July 20, 1900, Basel, Switzerland; **d.** January 2, 1962, NYC. **Studied:** Ecole des Beaux-Arts, Geneva, 1920; Academy of Fine Arts, Florence, Italy, 1927. To USA 1939; became a citizen. **Taught:** Brooklyn Museum School. Designed sets for modern dance and ballet groups. Authority on magic. **One-man Exhibitions:** Jeanne Bucher, Paris, 1932, 35; Zwemmer Gallery, London, 1933; Mitzowko-Shi, Tokyo, 1935; Wakefield Gallery, NYC; Karl Nierendorf Gallery, NYC, 1939, 41; New School for Social Research, 1940; Mexico City/Nacional, 1943; Durlacher Brothers, NYC, 1944, 46, 48, 50, 53; Arts Club of Chicago, 1946; Alexander Iolas Gallery, 1953; Walker, 1958; Fine Arts Associates, NYC, 1960; Ruth White Gallery, 1960, 61, 68; D'Arcy Gallery, NYC, 1964; Berne, 1967; Galerie Jacques Benador, Geneva, 1974; John Bernard Myers Gallery, NYC, 1974. **Retrospective:** La Boetie, NYC, 1973. **Group:** WMAA; MOMA; Chicago/AI; Detroit/Institute; U. of Illinois; MMA; NYPL; PAFA; Buffalo/Albright, Drawings and Watercolors, 1968. **Collections:** Aubusson; Bibliotheque Nationale; Brooklyn Museum; Buffalo/Albright; Chicago/AI; College des Musees Nationaux de France; U. of Illinois; Kunstkredit; Lodz; MMA; MOMA; Mexico City/Nacional; NYPL; PAFA; Smith College; WMAA. **Bibliography:** Blesh 1; Breton 2; Dorner; Flanagan; Frost; Goodrich and Baur 1; Huyghe; Jakovski; Janis and Blesh 1; Janis, S.; Kuh 1; Pearson 2; Pousette-Dart, ed.; Richardson, E. P.; Rubin 1; Sachs; **Seligmann**; Tomkins and Time-Life Books; Waldberg , 4. Archives.

SENNHAUSER, JOHN. b. December 10, 1907, Rorschach, Switzerland. **Studied:** Technical Institute, Treviso, Italy; Academy of Fine Arts, Venice; Cooper Union. Traveled Europe, USA. **Taught:** Leonardo da Vinci Art School, NYC, 1936-39; Contemporary School of Art, NYC, 1939-42. **Member:** American Abstract Artists; Federation of Modern Painters and Sculptors; International Institute of Arts and Letters. **Commissions:** Murals for banks and private buildings in NYC and other cities. **Awards:** WMAA, **P.P.**, 1951; Tulsa/Philbrook, **P.P.**, 1951. **Address:** 255 West 84 Street, NYC. **One-man Exhibitions:** (first) Leonardo da Vinci Art School Gallery, NYC, 1936; Contemporary Arts Gallery, NYC, 1939; Theodore A. Kohn Gallery, NYC, 1942; Artists' Gallery, NYC, 1947, 50, 52; Brown U., 1954; U. of Maine, 1955; Black Mountain College, 1956; The Zabriskie Gallery, 1956, 57; Knapik Gallery, NYC, 1961; The Salpeter Gallery, NYC, 1964; Meierhans Art Galleries, Perkasie, Pa., 1963, 68. **Group:** Brunswick U.; Bennington College; Worcester/AM; Walker; Dallas/MFA; NAD; PAFA; Chicago/AI; Museum of Non-Objective Art, NYC; Corcoran; U. of Illinois; Brooklyn Museum; Baltimore/MA; Salon des Realites Nouvelles, Paris. **Collections:** American Museum of Immigration; Calcutta; SRGM; Tulsa/Philbrook; Utica; WMAA. **Bibliography:** Pousette-Dart, ed. Archives.

SERISAWA, SUEO. b. April 10, 1910, Yokohama, Japan. **Studied:** Otis Art Institute, Los Angeles, 1932-33, with George Barker; Chicago Art Institute School, 1943. Traveled Europe, Mexico, Far East, Japan. **Taught:** Kann Art Institute, West Hollywood, 1948-50; Scripps College, 1950-51; Claremont Graduate School, 1950-51; U. of Southern California, summer, 1974-75; and privately. **Member:** President, California Watercolor Society, 1950. **Awards:** California State Fair, 1940, 49; PAFA, Medal, 1947; Pepsi-Cola, 1948. **Address:** 10552 Santa Monica Boulevard, Los Angeles, Calif. 90025. **Dealer:** Serisawa Gallery. **One-man Exhibitions:** Tone-Price Gallery, West Hollywood, 1940; Los Angeles/County MA, 1941; Dayton/AI, 1945; Dalzell Hatfield Gallery, 1948; Pasadena/AM, 1951; Occidental College, 1952; Felix Landau Gallery, 1959, 62. **Retrospective:** Occidental College; Laguna Beach (Calif.)

Art Gallery. **Group:** MMA, 1950; Los Angeles/County MA; California Palace; SFMA; U. of Illinois; Chicago/AI; San Diego; Santa Barbara/MA, I & II Pacific Coast Biennials, 1955, 57; PAFA; WMAA Annuals; Corcoran; Sao Paulo Biennial; International Biennial Exhibitions of Paintings, Tokyo; U. of Nebraska; Carnegie; Walker. **Collections:** Arizona State College; California State Fair; Eilat; Los Angeles/County MA; Lytton Savings and Loan Association; MMA; MOMA; Pasadena/AM; San Diego; Santa Barbara.

SERRA, RICHARD. b. November 2, 1938, San Francisco, Calif. **Studied:** U. of California, BA; Yale U., BA, MFA; Traveled Italy. **Award:** Skowhegan School Medal, 1975. **Address:** 319 Greenwich Street, NYC 10013. **One-man Exhibitions:** Galleria la Salita, Rome, 1966; Galerie Rolf Ricke, 1968, 73; Galerie Lambert, Milan, 1969; Leo Casteli Inc., NYC, 1970, 72, 74; ACE Gallery, Los Angeles, 1970, 72, 74; U. of California, San Diego, 1970; Pasadena/AM, 1970; School of Visual Arts, NYC, 1974. **Group:** Yale U., Drawings, 1966; Ithaca College, Drawings 1967, 1967; A.F.A., Soft Sculpture, 1968; WMAA, 1968, 70, 73; MOMA, New Media: New Methods, circ., 1969; Seattle/AM, 557,087, 1969; Trenton/State, Soft Art, 1969; Berne, When Attitudes Become Form, 1969; WMAA, Anti-Illusion: Procedures/Materials, 1969; SRGM, Nine Young Artists, 1969; Chicago/Contemporary, Art by Telephone, 1969; U. of California, Irvine, Five Sculptors, 1969; Hannover/Kunstverein, Identifications, 1970; SRGM, Guggenheim International, 1971; Dusseldorf/Kunsthalle, Prospect '71, 1971; Los Angeles County/MA, Art & Technology, 1971; Arnhem, Sonsbeek '71, 1971; Documenta V, Kassel, 1972; Rijksmuseum Kroller-Muller, Diagrams and Drawings, 1972; Festival of Two Worlds, Spoleto, 1972; New York Cultural Center, 3D into 2D, 1973; Yale U., Options and Alternatives, 1973;

Detroit/Institute, Art in Space, 1973; Yale U., American Drawings: 1970-1973, 1973; Parcheggio di Villa Borghese, Rome, Contemporanea, 1974; Princeton U., Line as Language, 1974; MIT, Interventions in Landscapes, 1974; CNAC, Art/Voir, 1974. **Collections:** Amsterdam/Stedelijk; Melbourne/National; Oberlin College; Pasadena/AM; Ridgefield/Aldrich; Rijksmuseum Kroller-Muller; SRGM; Stockholm/National; WMAA. **Bibliography:** *Art Now 74;* Celant; *Contemporanea; Kunst um 1970;* Lippard, ed.; Muller; *Options and Alternatives; Report; When Attitudes Become Form.*

SHAHN, BEN. b. September 12, 1898, Kovno, Lithuania; **d.** May 14, 1969, NYC. To USA 1906. **Studied:** NYU; City College of New York, 1919-22 (Biology); NAD, 1922; ASL. Traveled Europe, Japan, North Africa, USA. Photographer and designer for Farm Security Administration, 1935-38. Designed posters for Office of War Information, 1942, and for CIO, 1944-46. Designed sets for "Ballets: USA" and for the Festival of Two Worlds, Spoleto, 1958. **Commissions:** Community Building, Roosevelt, N.J., 1938-39; US Post Offices, Bronx, N.Y. 1938-39 (with Bernarda Bryson), and Jamaica, N.Y., 1939; Social Security Building, Washington, D.C., 1940-42; William E. Grady Vocational High School, Brooklyn, N.Y., 1957 (mosaic). **Awards:** PAFA, Pennell Memorial Medal, 1939, 53, Alice McFadden Eyre Medal, 1952, Joseph E. Temple Gold Medal, 1956; *Look* Magazine poll of "Ten Best Painters," 1948; II Sao Paulo Biennial, 1953; XXVII Venice Biennial, 1954; Harvard U., Medal, 1956; American Institute of Graphic Art, Medal, 1958; North Shore, Long Island, N.Y. Art Festival Annual Award, 1959. **One-man Exhibitions:** The Downtown Gallery, 1930, 32, 33, 44, 49, 51, 52, 55, 57, 59, 61; Julien Levy Galleries, NYC, 1940; MOMA, 1947; Arts Council of Great Britain, circ., 1947; Albright Art School, 1950; Perls Galleries, 1950; Arts Club of Chicago, 1951; Santa Barbara/

MA, circ., 1952, also 1967; Houston/ MFA, 1954; Detroit/Institute (three-man), 1954; Chicago/AI, 1954; XXVII Venice Biennial, 1954; Southern Illinois U., 1954; American Institute of Graphic Art, 1957; St. Mary's College (Ind.), 1958; Bucknell U., 1958; Katonah (N.Y.) Art Gallery, 1959; Leicester Gallery, London, 1959, 64; U. of Louisville, 1960; U. of Utah, 1960; Library of the New Haven (Conn.) Jewish Community Center, 1961; Institute of Modern Art, Boston, Documentary, 1957; Amsterdam/Stedelijk, 1961; Rome/Nazionale, 1962; MOMA, Ben Shahn, circ. Europe, 1962; Randolph-Macon Woman's College, 1966; PMA, 1967; Orlando, 1968; Kennedy Gallery, 1968-69, 1970, 71, 73; Nantenshi Gallery, Tokyo, 1970. **Retrospectives:** MOMA, 1947; ICA, Boston, 1948; Osaka Municipal, 1970; National Museum of Western Art, Tokyo, 1970. **Group:** Corcoran; Carnegie; WMAA; Chicago/AI; U. of Nebraska; Brooklyn Museum; MOMA; Buffalo/Albright. **Collections:** Abbott Laboratories; Andover/Phillips; Arizona State College; U. of Arizona; Auburn U.; Baltimore/MA; Brandeis U.; Brooklyn Museum; Buffalo/Albright; California Palace; Carnegie; Chicago/AI; Container Corp. of America; Cranbrook; Dartmouth College; Des Moines; Detroit/Institute; Fort Wayne/AM; U. of Georgia; Grand Rapids; Hartford/Wadsworth; Harvard U.; U. of Illinois; Indiana U.; Inland Steel Co.; Jewish Museum; MMA; MOMA; Mary Washington College; U. of Michigan; Museum of the City of New York; U. of Nebraska; Newark Museum; U. of Oklahoma; Omaha/Joslyn; PAFA; Phillips; Sara Roby Foundation; St. Louis/City; Santa Barbara/MA; Smith College; Springfield, Mo./AM; Syracuse U.; Terry Art Institute; VMFA; WMAA; Walker; Wellesley College; Wesleyan U.; Wichita/AM; Youngstown/Butler. **Bibliography:** Baigell 1; Barr 3; Baur 7; Bazin; Biddle 4; Bihalji-Merin; Blesh 1; **Bush 1;** Canaday; Christensen; Eliot; Finkelstein; Flanagan; Flexner; Gaunt; Gerdts; Goodrich and Baur 1; Greengood; Haftman; Hunter 6; Kepes 2; Kuh

1, 2; Langui; Lee and Burchwood; McCurdy, ed.; Mendelowitz; *Metro*; **Morse**; Munsterberg; Newmeyer; Newton 1; Nordness, ed.; Pearson 1, 2; Pousette-Dart, ed.; Read 2; Richardson, E.P.; Rodman 1, 2, 3; Sachs; **Shahn 1, 2; Shahan, B.B.;** Shapiro; **Soby 2, 3, 4, 5;** Sutton; Weller; Wight 2. Archives.

SHAW, CHARLES. b. May 1, 1892, NYC; **d.** April 2, 1974, NYC. **Studied:** Yale U., Ph.D.; Columbia U. School of Architecture; ASL, with Thomas Hart Benton; and privately with George Luks. US Army, World War I. Traveled Europe extensively, Scandinavia, West Indies. Author of children's books, poetry, and articles for *Vanity Fair, The Bookman, Smart Set,* and other magazines. **Member:** American Abstract Artists; Federation of Modern Painters and Sculptors; Fellow of the International Institute of Arts and Letters. **Commissions:** *Vanity Fair* (Magazine) (covers); Shell-Mex Ltd. (poster). **Awards:** Nantucket, First and Second Prizes; Century Association, Hon. Men., 1964. **One-man Exhibitions:** (first) Curt Valentine

Charles Shaw *Sketch for Shaped Canvas* 1936

Gallery, NYC, 1934, also 1938; Museum of Living Art, NYC, 1935; SRGM, 1940; Passedoit Gallery, NYC, 1945, 46, 50, 51, 54, 1956-59; Nantucket, 1954-68; Albert Landry, NYC, 1960, 61; Art Association of Newport (R.I.), 1960, 62; U. of Louisville, 1963; Southampton East Gallery, Southampton, N.Y., 1963, 64; The Bertha Schaefer Gallery, 1963, 64, 66, 68, 71; Faure Gallery, La Jolla, 1964; Century Association, 1967, 75. **Group:** WMAA Annuals: Chicago/AI; Carnegie; Walker; SFMA; U. of Illinois; Corcoran; American Abstract Artists, annually, 1936-68; Federation of Modern Painters and Sculptors, annually, 1940-68; PMA, "8 x 8," 1945; MOMA, Abstract Painting and Sculpture in America, 1951; International Association of Plastic Arts, Contemporary American Paintings, circ. Europe, 1956-57; WMAA, Geometric Abstraction in America, circ., 1962; PAFA, 1966; U. of Colorado, 1966. **Collections:** Atlanta U.; Baltimore/MA; Boston/MFA; Brandeis U.; Brooklyn Museum; California Palace; Chase Manhattan Bank; Chicago/AI; Cincinnati/AM; Cleveland/MA; Corcoran; Dayton/AI; Denver/MA; Detroit/Institute; Fort Worth; U. of Georgia; Hartford/Wadsworth; Los Angeles/County MA; U. of Louisville; MMA; MOMA; NYU; Nantucket; Newark Museum; Norfolk/Chrysler; U. of North Carolina; PMA; Paris/Moderne; Phillips; Pittsfield/Berkshire; RISD; Raleigh/NCMA; Rockefeller Institute; SFMA; SRGM; WMAA; Walker; Wichita/AM; Williams College; Yale U. **Bibliography:** Baur 7; Cheney; Kootz 2; Pousette-Dart, ed.; Ritchie 1. Archives.

SHEELER, CHARLES. b. July 16, 1883, Philadelphia, Pa.; **d.** May 7, 1965, Dobbs Ferry, N.Y. **Studied:** Pennsylvania School of Industrial Art, Philadelphia, 1900-03; PAFA, 1903-06, with William M. Chase. Traveled Europe, USA. **Taught:** Phillips Academy, 1946; Currier Gallery School, 1948. Collaborated with Paul Strand on the film, "Mannhattana." **Commissions:** Ford Motor Co., photographed the Ford Plant, 1927.

Awards: Chicago/AI, Norman Wait Harris Medal, 1945; PAFA, Alumni Award, 1957; Hallmark International Competition, 1958 ($1,000); AAAL, Award of Merit Medal, 1962. **One-man Exhibitions:** (first) Modern Gallery, NYC, 1918 (photographs); DeZayas Gallery, NYC, 1920 (paintings); The Daniel Gallery, NYC, 1922; Whitney Studio Club, NYC, 1924; J.B. Neumann Gallery, NYC (two-man), 1926; Art Center, NYC, 1926; The Downtown Gallery, 1931, 38, 40, 41, 43, 46, 49, 51, 56, 58, 65, 66; Arts Club of Chicago, 1932; Harvard U. (three-man), 1934; Society of Arts and Crafts, Detroit, 1935; Cincinnati/AM (four-man), 1941; Dayton/AI, 1944; Andover/Phillips, 1946; Currier, 1948; Houston/MFA (two-man), 1951; Walker, 1952; Detroit/Institute (three-man), 1954; Katonah (N.Y.) Art Gallery, 1960; State U. of Iowa, 1963; NCFA, 1968; Terry Dintenfass, Inc., 1974. **Retrospective:** MOMA, 1939; UCLA, circ., 1954; MIT, 1959; Allentown/AM, 1961; Cedar Rapids/AA, 1967; NCFA, 1968. **Group:** NAD, 1906; PAFA, 1907, 1908-10; The Armory Show, 1913; Anderson Galleries, NYC, Forum Exhibition, 1916; Society of Independent Artists, NYC, 1917; Brooklyn Museum, 1923, 25; Cincinnati/AM, 1924, 1927-31, 34, 35, 39; Whitney Studio Club Annuals, NYC, 1925, 27, 30; Cleveland/MA, 1926, 1927-29, 31, 32, 34; Royal Academy, London, 1930; St. Louis/City, 1931-34, 41, 42, 44, 45; Carnegie, 1931, 33, 35, 37, 40, 41, 43, 45, 48, 52; WMAA, 1932, 34, 36, 42; XVII & XXVIII Venice Biennails, 1934, 56; Chicago/AI, 1935, 37, 38, 41, 46, 48, 49, 51, 54. **Collections:** Albany/Institute; Andover/Phillips; Arizona State College; Boston/MFA; Britannica; Brooklyn Museum; Buffalo/Albright; California Palace; Chicago/AI; Cleveland/MA; Colonial Williamsburg; Columbus; Currier; Detroit/Institute; General Motors Corp.; Harvard U.; Kansas City/Nelson; MMA; MOMA; The Miller Co.; Mount Holyoke College; U. of Nebraska; Newark Museum; New Britain; PAFA; PMA; Phillips;

RISD; Sara Roby Foundation; Santa Barbara/MA; Smith College; Springfield, Mass./MFA; Tel Aviv; Toledo/MA; Utica; VMFA; WMAA; Walker; Wesleyan U.; West Palm Beach/Norton; Wichita/AM; Williams College; Worcester/AM; Yale U.; Youngstown/Butler. **Bibliography:** *Avant-Garde Painting and Sculpture*; Barker 1; Barr 3; Baur 7; Bazin; Beam; Biddle 4; Blesh 1; Born; Boswell 1; Brown; Bulliet 1; Cahill and Barr, eds.; **Charles Sheeler**; Cheney; Christensen; **Dochterman**; Dorner; Eliot; Flanagan; Flexner; *Forerunners*; Frank, ed.; Frost; Goldwater and Treves, eds.; Goodrich and Baur 1; Haftman; Hall; Halpert; **Hirsch**; Hunter 6; Huyghe; *Index of 20th Century Artists*; Janis and Blesh 1; Janis, S.; Jewell 2; Kootz 1, 2; Kouvenhoven; Kuh 1; Mather 1; McCoubrey 1; McCurdy, ed.; Mellquist; Mendelowitz; Nauhaus; Newmeyer; Nordness, ed.; Pagano; Phillips 1, 2; Poore; Pousette-Dart, ed.; Ringel, ed.; Rose, B. 1, 4; Rosenblum 1; **Rourke**; Sachs; Sager; Soby 5; Tashjian; Wight 2; **Williams, W.C.** Archives.

SHEETS, MILLARD. b. June, 1907, Pomona, Calif. **Studied:** Chouinard Art Institute, Los Angeles, 1925-29, with F.T. Chamberlain, Clarence Hinkle. Traveled Europe, Central America, Mexico, USA, Pacific, the Orient. **Taught:** Chouinard Art Institute, 1928-35; Scripps College, 1932-54, 1955-72; Director, Los Angeles County Art Institute, 1953-60. **Member:** California Water Color Society; NAD; American Watercolor Society; Society of Motion Picture Art Directors; Bohemian Club. President, Millard Sheets Designs, Inc.; Architectural designer. **Commissions** (murals): Pomona (Calif.) First Federal Savings and Loan Association; Our Lady of the Assumption Church, Ventura, Calif. (interior and exterior). **Awards:** Witte, Edgar B. Davis Prize; California Watercolor Society, 1927; Arizona State Fair, 1928, 29, 30; California State Fair, 1930, 32 (first Prize), 33, 38; Los Angeles/County MA, First Prize, 1932, and 1945; Chicago/AI, 1938. **Address:** Barking Rocks, Gualala,

Calif. 95445. **Dealer:** Dalzell Hatfield Gallery. **One-man Exhibitions:** (first) Los Angeles, Calif. 1929; Corcoran; Los Angeles/County MA; California Palace; San Diego; Fort Worth, 1931, 34; Milwaukee; Baltimore/MA; Buffalo/Albright; Albany/Institute; Witte, 1931, 34; New Orleans/Delgado; Memphis/Brooks; Springfield, Mass./MFA; U. of Oklahoma; U. of Rochester; A. Tooth & Sons, London, 1964. **Group:** Chicago/AI, 1931-35; NAD Annuals, 1932-35; A Century of Progress, Chicago, 1933-34; Denver/AM, 1935; Sao Paulo, 1955; WMAA; Carnegie; Oakland/AM; Buffalo/Albright; Kansas City/Nelson; U. of Nebraska. **Collections:** Albany/Institute; Britannica; Brooklyn Museum; Carnegie; Cleveland/MA; Chicago/AI; Dayton/AI; de Young; Fort Worth; High Museum; Houston/MFA; Los Angeles/County MA; Los Angeles Public Library; MMA; MOMA; Montclair/AM; Montpelier; Muskegon/Hackley; U. of Oklahoma; RISD; SFMA; San Diego; Seattle/AM; WMAA; Witte. **Bibliography:** Cheney; Hall; **Miller** 2; Pagano. Archives.

SHIELDS, ALAN. b. 1944, Harrington, Kan. **Studied:** Kansas State U.; U. of Maine. **Award:** Guggenheim Foundation Fellowship, 1973. **Address:** 83 Leonard Street, NYC 10013. **Dealer:** Paula Cooper Gallery. **One-man Exhibitions:** Paula Cooper Gallery, 1969, 70, 72, 74; Janie C. Lee Gallery, Dallas, 1970, 71; New Gallery, Cleveland, 1971; Ileana Sonnabend Gallery, Paris, 1971; Galleria dell'Ariete, 1972; Hansen-Fuller Gallery, 1973; U. of Rhode Island, 1973; Madison Art Center, 1973; Galerie Aronowitsch, Stockholm, 1973; Richard Gray Gallery, 1974; Phoenix Gallery, San Francisco, 1974; Barbara Okun Gallery, St. Louis, 1974; The Texas Gallery, 1974; U. of Kansas, 1975; E.G. Gallery, Kansas City, 1975. **Retrospectives:** Chicago/Contemporary, 1973; Houston/Contemporary, 1973. **Group:** Trenton/State, Soft Art, 1969; WMAA, 1969, 72; Indianapolis, 1970; Chicago/AI, 1970, 72, 73; ICA, U. of

Pennsylvania, Two Generations of Color Painting, 1970; U. of North Carolina, 1970; Corcoran, Depth and Presence, 1971; U. of Rochester, Aspects of Current Painting, 1971; SRGM, Contemporary Prints and Drawings, 1971; ICA, U. of Pennsylvania, Grids, 1972; U. of California, Berkeley, Eight New York Painters, 1972; Documenta V, Kassel, 1972; Detroit/Institute, 12 Statements, 1972; New York Cultural Center, Soft as Art, 1973; Seattle/AM, American Art: Third Quarter Century, 1973; VIII Paris Biennial, 1973; Indianapolis, 1974; MOMA, Printed, Folded, Cut and Torn, 1974. **Collections:** Akron/AI; Chase Manhattan Bank; Chicago/AI; Hirshhorn; MOMA; McCrory Corporation; Oberlin College: PMA; Ridgefield/Aldrich; SRGM; WMAA. **Bibliography:** Art Now 74.

SHINN, EVERETT. b. November 6, 1876, Woodstown, N.J.; **d.** January 2, 1953, NYC. **Studied:** PAFA. Wrote and produced a number of melodramas in NYC. **Member:** The Eight. **Commissions** (murals): Trenton (N.J.) City Hall; Spring Garden Institute, Philadelphia. **Awards:** Chicago/AI, Watson F. Blair Prize, 1939; elected to the NIAL, 1951. **One-man Exhibitions:** M. Knoedler & Co., 1903, 69; 56th Street Gallery, NYC, 1930; Metropolitan Gallery, NYC, 1931; Morton Gallery, NYC, 1935; One-Ten Gallery, NYC, 1939; Ferargil Galleries, NYC, 1943; James Vigeveno Gallery, Los Angeles, 1945, 47, 48; American-British Art Center, NYC, 1945, 46, 49; The Graham Gallery, 1952, 58, 65; Davis Gallery, 1959; U. of Pennsylvania, 1959; Trenton/State, 1971. **Group:** Macbeth Gallery, NYC, The Eight, 1908; The Armory Show, 1913; Brooklyn Museum, The Eight, 1943; PMA, 1945; Syracuse/Everson, The Eight, 1958; U. of Pittsburgh, 1959. **Collections:** Boston/MFA; Brooklyn Museum; Buffalo/Albright; Chicago/AI; Detroit/Institute; MMA; New Britain; Phillips; WMAA. **Bibliography:** Baur 7, Biddle 4, Blesh 1; Brown; Canaday; Cheney;

Eliot; Flanagan; Flexner; Gallatin 8; Gerdts; Glackens; Goodrich and Baur 1; Hartmann; Hunter 6; Kent, N.; McCoubrey 1; McCurdy, ed.; Mellquist; Mendelowitz; Neuhaus; Pagano; Perlman; Richardson, E.P.; Rose, B. 1; Sutton. Archives.

SIMON, SIDNEY. b. June 21, 1917, Pittsburgh, Pa. **Studied:** Carnegie Institute of Technology; PAFA; U. of Pennsylvania, with George Harding, BFA; Barnes Foundation. US Army artist, 1943-46. Traveled Austria, Italy, Morocco. **Taught:** Skowhegan School, 1946-58 (Vice President and Director), 1975; Cooper Union, 1947-48; Brooklyn Museum School, 1950-52, 1954-56; Parsons School of Design, 1962-63; Salzburg Center for American Studies, 1971; ASL, 1973-75; Castle Hill Art Center, 1973-74. **Member:** Artists Equity (National Director, Treasurer, Vice President, 1946-60); Century Association; Architectural League of New York; Vice President, Sculptors Guild; New York City Art Commission, 1975-79. **Federal A.P.:** U.S. Post Office, Flemingsburgh, Ky. (mural). **Commissions:** Fort Belvoir, Va., 1942 (3 murals); Temple Beth Abraham, Tarrytown, N.Y.; Walt Whitman Junior High School, Yonkers, N.Y.; stage set for NYC production of Ulysses in Nighttown, by James Joyce, 1959; Federation of Jewish Philanthropies; "The Family," sculpture group for the film "David" and "Lisa," 1962 (with Robert Cook and Dorothey Greenbaum); Protestant Council of New York (Family of Man Medal, presented to President John F. Kennedy, 1963); "The Circus," sculpture for Woodland House, Hartford, Conn., 1963; Our Lady of the Angels Seminary, Glenmont, N.Y., 1965; Downstate Medical Center, Brooklyn, N.Y. 1967; Prospect Park Playground, 1968; 747 Third Avenue Building, NYC, 1973. **Awards:** PAFA, Cresson Fellowship; Edwin Austin Abbey Fellowship, 1940; Prix de Rome, Hon. Men., 1940; Chicago/AI, Posner Painting Prize; PAFA, Fellowship, 1960; Chautauqua Institute, Babcock Memo-

rial Award, 1963; Century Association, Gold Medal for Sculpture, 1969. **Address:** 95 Bedford Street, NYC 10014. **One-man Exhibitions:** (first) PAFA, 1946; Niveau Gallery, NYC, 1949; Grand Central Moderns, NYC, 1951, 53; Rockland Foundation, 1955; Motel of the Mountain, 1959; Market Fair, Nyack, N.Y., 1960; Grippi Gallery, NYC, 1963 and others; Pittsburgh Plan for Art; Yale U., 1966; Wellfleet Art Gallery, 1966-67, 69, 71, 73; New School for Social Research, 1969; The Graham Gallery, 1970. **Retrospective:** Sarah Lawrence College, 1971. **Group:** NAD Annuals, 1944-60; PAFA, 1948-53, 1962; MMA, American Painters Under 35, 1950; WMAA, 1950, 52-55, 59, 62, 63; International Biennial Exhibition of Paintings, Tokyo; Brooklyn Museum, 1953; U. of Nebraska Annuals, 1954, 55; Corcoran, 1955; MOMA, The Art of Assemblage, circ., 1961; A.F.A., Educational Alliance Retrospective, 1963. **Collections:** ASL; Century Association; Chautauqua Institute; Colby College; Cornell U.; MMA; U. of North Carolina; The Pentagon; Sports Museum; US State Department. **Bibliography:** Seitz 3. Archives.

SIMPSON, DAVID. b. January 20, 1928, Pasadena, Calif. **Studied:** California School of Fine Arts, with Leonard Edmondson, Clyfford Still, 1956, BFA; San Francisco State College, 1958, MA. US Navy, 1945-46. Traveled Mexico, 1953, Western Europe, 1969. **Taught:** American River Junior College, 1959-61; Contra Costa College, 1961-65; U. of California, Berkeley, 1965- . **Address:** P.O. Box 248, Richmond, Calif. 94807. **Dealer:** Hank Baum Gallery, San Francisco. **One-man Exhibitions:** (first) David Cole Gallery, Sausalito, Calif., 1959; Santa Barbara/MA, 1960; Esther Robles Gallery, 1960; de Young, 1961; Joachim Gallery, Chicago, 1961; Robert Elkon Gallery, 1961, 63, 64; David Stuart Gallery, 1963, 64, 66, 68; Henri Gallery, 1968; Galeria Van der Voort, 1969; Hank Baum Gallery, San Francisco, 1972, 73, Los Angeles, 1972.

Retrospective: SFMA, 1967. **Group:** Carnegie, 1961, 62, 67; Portland (Ore.)/AM, 1968; U. of Illinois, 1963, 69; Los Angeles/County MA, Post Painterly Abstraction, 1964; Chicago/AI; Walker; PAFA, 1967; Spokane World's Fair, 1974. **Collections:** Baltimore/MA; Central Research Corp.; Columbia Broadcasting System; Crown Zellerbach Foundation; First National Bank of Seattle; Golden Gateway Center; La Jolla; MOMA; NCFA; Oakland/AM; PMA; Phoenix; SFMA; Seattle/AM; Stanford U.; Storm King Art Center.

SINTON, NELL. b. June 4, 1910, San Francisco, Calif. **Studied:** California School of Fine Arts, with Maurice Sterne, Spencer Macky, Ralph Stackpole. Traveled Europe, India, The Orient, Africa, South America, Middle East, USA, Mexico. **Taught:** SFAI, 1970, 71; San Francisco Student League, 1973; Institute for Creative and Artistic Development, Oakland, 1974, 75. **Member:** San Francisco City Art Commission; Artists Committee, San Francisco Art Institute (Trustee). **Address:** 1020 Francisco Street, San Francisco, Calif. 94109. **Dealer:** Quay Gallery. **One-man Exhibitions:** (first) California Palace, 1949; Santa Barbara/MA, 1950; SFMA (two-man), 1957; Bolles Gallery, San Francisco and New York, 1962; SFMA (four-man), 1962; Quay Gallery, 1969, 71, 74; SFMA, 1970; Jacqueline Anhalt Gallery, 1972. **Group:** MMA, 1952; ART:USA:58, NYC, 1958; Vancouver, 1958; Denver/AM, 1958, 60; SFMA; de Young; California Palace; Oakland/AM, Scripps College, 1961; Los Angeles-/County MA, 1961; A.F.A.; Stanford U.; U. of Nevada, 1969; Claremont College, 1973; SFAI, 1974. **Collections:** AT &T; U. of California, Berkeley; Chase Manhattan Bank; Lytton Savings and Loan Association; Oakland/AM; SFMA. Archives.

SIPORIN, MITCHELL. b. May 5, 1910, NYC. **Studied:** Crane Junior College; Chicago Art Institute School; privately with Todros Geller; American

Academy, Rome, 1949-50. US Army, 1942-45. Traveled Mexico, Latin America, Africa, Europe. **Taught:** Boston Museum School, 1949; Columbia U., 1951; Brandeis U., 1951- ; American Academy, Rome, Artist-in-Residence, 1966-67. **Member:** Brandeis U. Creative Arts Award Commission; Fellow, American Academy, Rome. **Federal A.P.:** Mural painting. **Commissions:** Bloom Township High School, Chicago, 1938 (mural); US Post Offices, Decatur, Ill., 1940, and St. Louis, Mo. (with Edward Millman), 1940-42 (mural); Berlin Chapel, Brandeis U. (ark curtain). **Awards:** Chicago/AI, Bertha Aberle Florsheim Prize, 1942; Guggenheim Foundation Fellowship, 1945, 46; PAFA, Pennell Memorial Medal, 1946; Chicago/AI, The Mr. & Mrs. Frank G. Logan Medal, 1947; State U. of Iowa, First **P.P.**, 1947; Prix de Rome, 1949; Hallmark International Competition, Second Prize, 1949; Boston Arts Festival, Second Prize, 1954, and Third Prize, 1955; AAAL, 1955; Youngstown/Butler, First Prize for Watercolors, 1961; Fulbright Fellowship (Italy), 1966-67. **Address:** 300 Franklin Street, Newton, Mass. 02158. **One-man Exhibitions:** The Downtown Gallery, 1940, 42, 46, 47, 57; Springfield, Mass./MFA; Chicago/AI, 1947; Philadelphia Art Alliance, 1949; Boris Mirski Gallery, Boston, 1952; Jewish Community Center, Cleveland, 1953; The Alan Gallery, NYC, 1954; Lincoln, Mass./De Cordova, 1955; U. of Vermont, 1956; Park Gallery, Detroit, 1960; Lee Nordness Gallery, NYC, 1960. **Retrospective:** Lincoln, Mass./De Cordova, 1954. **Group:** A Century of Progress, 1933-34; MOMA, New Horizons in American Art, 1936; New York World's Fair, 1939; Golden Gate International Exposition, San Francisco, 1939; MOMA/USIA, Pintura Contemporanea Norteamericana, circ. Latin America, 1941; MOMA, Americans 1942, circ., 1942; Chicago/AI, 1942-46; WMAA, 1942-57; Carnegie, 1944-49; Paris/Moderne, 1946; ICA, Boston, American Painting in Our Century, circ., 1949; Contemporary American

Drawings, circ. France, 1956; Art:USA: Now, circ., 1962-67. **Collections:** Andover/Phillips; U. of Arizona; Auburn U.; Brandeis U.; Britannica; Chicago/AI; Cranbrook; U. of Georgia; Harvard U.; U. of Illinois; State U. of Iowa; MMA; MOMA; NCFA; NYPL; U. of Nebraska; Newark Museum; U. of New Mexico; PMA; Smith College; WMAA; Wichita/AM; Worcester/AM; Youngstown/Butler. **Bibliography:** Baur 7; Goodrich and Baur 1; Halpert; Miller, ed. 1; Nordness, ed.; Pagano; Pousette-Dart, ed.; Wight 2. Archives.

SLOAN, JOHN. b. August 2, 1871, Loch Haven, Pa.; **d.** September 7, 1951, Hanover, N.H. **Studied:** Spring Garden Institute, Philadelphia; PAFA, 1892, with Thomas Anshutz. **Taught:** ASL, 1914-26, 1935-37; Archipenko School of Art, 1932-33; George Luks School, 1934. Art Editor of *The Masses* (Magazine), 1912-16. Organized a group called The Eight. **Member:** Society of Independent Artists, NYC (President, 1918-42); NIAL. **Awards:** Carnegie, Hon. Men., 1905; Panama-Pacific Exposition, San Francisco, 1915, Medal; Philadelphia Sesquicentennial, 1926, Medal; PAFA, Carol H. Beck Gold Medal, 1931; MMA, 1942 ($500); NIAL, Gold Medal, 1950. **One-man Exhibitions:** (first) Whitney Studio Club, NYC, 1916; Hudson Guild, NYC, 1916; Kraushaar Galleries, 1917, 26, 27, 30, 37, 39, 43, 48, 52, 60, 66; Corcoran, 1933; Montross Gallery, NYC, 1934; WMAA, 1936, 52; Carnegie, 1939; Currier, 1940; The U. of Chicago, 1942; PMA, 1948; Santa Fe, N.M., 1951; Wilmington, 1961; Bowdoin College, 1962; Kennedy Gallery, 1964 (two-man); U. of Connecticut, 1971; Harbor Gallery, Cold Spring, N.Y., 1972. **Retrospectives:** Wanamaker Gallery, Philadelphia, 1940; Dartmouth College, 1946; Andover/Phillips, 1946; National Gallery, 1971. **Group:** Macbeth Gallery, NYC, The Eight, 1908; The Armory Show, 1913; MMA; Brooklyn Museum, The Eight, 1943; PMA; Syracuse/Everson, The Eight, 1958; Chicago/AI; Detroit/Institute;

PAFA; Carnegie; Corcoran; WMAA, The 1930's, 1968, and others. **Collections:** Barnes Foundation; Boston/MFA; Brooklyn Museum; Carnegie; Chicago/AI; Cincinnati/AM; Cleveland/MA; Corcoran; Detroit/Institute; Hartford/Wadsworth; IBM; MMA; NYPL; Newark Public Library; PMA; The Pennsylvania State U.; Phillips; U. of Rochester; San Diego; Santa Fe, N.M.; WMAA; Walker. **Bibliography:** Baur 7; Bazin; Beam; Blesh 1; Boswell 1; **Brooks;** Brown; Bryant, L.; Cahill and Barr, eds.; Canaday; Cheney; Coke 2; Craven, T. 1, 2; Du Bois 4; Eliot; Ely; Finkelstein; Flanagan; Flexner; **Gallatin 2, 5;** Gerdts; Glackens; **Goodrich 7;** Goodrich and Baur 1; Greengood; Haftman; Hall; Hartmann; Hunter 6; Huyghe; *Index of 20th Century Artists;* Jackman; Jewell 2; Kent, N.; Kouvenhoven; Mather 1; McCoubrey 1; McCurdy, ed.; Mendelowitz; Newmeyer; Pach 1, 3; Pagano; Pearson 1; Perlman; Phillips 2; Poore; Pousette-Dart, ed.; Reese; Richardson, E.P.; Ringel, ed.; Rose, B. 1, 4; Sachs; **St. John; St. John, ed.; Sloan, H.F.; Sloan, ed.; Sloan, J. 1, 2, 3, 4, 5;** Smith, S.C.K.; Sutton; Wight 2. Archives.

SMITH, DAVID. b. 1906, Decatur, Ind.; **d.** May 24, 1965, Bennington, Vt. **Studied:** Ohio U., 1924; ASL, 1926-30, with John Sloan, Jan Matulka. Traveled Europe, USSR, 1935; resided Voltri and Spoleto, Italy, 1962. **Taught:** Sarah Lawrence College, 1948; U. of Arkansas, 1953; Indiana U., 1954; U. of Mississippi, 1955. Created a series of 15 bronze "Medals of Dishonor," 1937-40. **Awards:** Guggenheim Foundation Fellowship, 1950, 51; Brandeis U., Creative Arts Award, 1964. **One-man Exhibitions:** East River Gallery, NYC, 1938; Skidmore College, 1939, 43, 46; Neumann-Willard Gallery, NYC, 1940; The Willard Gallery, 1940, 43, 46, 47, 50, 51, 54, 55, 56; Kalamazoo/Institute, 1941; Walker, 1942, 43, 52; Buchholz Gallery, NYC, 1946; Cooling Gallery, London, 1946; Utica, 1947; Kleemann Gallery, NYC, 1952; Tulsa/Philbrook, 1953; The Kootz Gallery, NYC, 1953;

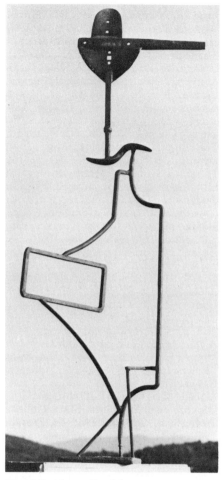

David Smith *Untitled* 1953

Cincinnati/AM, 1954; MOMA, 1957; Fine Arts Associates, NYC, 1957; Otto Gerson Gallery, NYC, 1957, 61; French & Co. Inc., NYC, 1959, 60; MOMA, circ. only, 1960; Everett Ellin Gallery, Los Angeles, 1960; ICA, U. of Pennsylvania, 1964; Marlborough-Gerson Gallery Inc., 1964, 67, 68; Harvard U., 1966; Storm King Art Center, 1971; Knoedler Contemporary Art, 1974. **Retrospective:** Tate, 1966; SRGM, 1968. **Group:** XXIX Venice Biennial, 1958; Sao Paulo, 1959; Documenta II & III, Kassel, 1959, 64; WMAA; Chicago/AI; Carnegie;

MOMA, The New American Painting and Sculpture, 1969, and others. **Collections:** Baltimore/MA; Brandeis U.; Carnegie; Cincinnati/AM; Chicago/AI; Detroit/Institute; MMA; MOMA; U. of Michigan; U. of Minnesota; SFMA; St. Louis/City; Utica; WMAA; Walker. **Bibliography:** Battcock, ed.; Baur 5, 7; Blesh 1; Brumme; Calas, N. and E.; Chipp; **Cone 1**; Craven, W.; Davis, D.; **Fry**; Gertz; Giedion-Welcker 1; Goodrich and Baur 1; Goossen 1; *The Great Decade*; Greenberg 1; Henning; Hunter 6; Hunter, ed.; Janis and Blesh 1; Kozloff 3; **Kramer 1**; Kuh 1, 2, 3; Licht, F.; Lynton; **McCoy**; McCurdy, ed.; Mendelowitz; *Metro; Monumenta;* Motherwell, ed.; Motherwell and Reinhardt, eds.; Myers 2; **O'Hara** 1, 2; Passloff; Read 3; Rickey; Ritchie 1, 3; Rodman 1, 3; Rose, B. 1, 4; Rubin 1; Seitz 3; Selz, J.; Seuphor 3; Seymour; **Smith, D.**; Trier 1; Tuchman 1. Archives.

SMITH, HASSEL W., Jr. b. April 24, 1915, Sturgis, Mich. **Studied:** Northwestern U., BS; California School of Fine Arts, with Maurice Sterne. Traveled Europe, USA, Mexico. **Taught:** California School of Fine Arts, 1945, 47, 48, 52; San Francisco State College, 1946; U. of Oregon, 1947-48; Presidio Hill School, San Francisco, 1952-55; U. of California, Berkeley, 1963-65; UCLA, 1965-66; Bristol (Eng.) Polytechnic, 1966- . **Awards:** Abraham Rosenberg Foundation Fellowship, 1941. **Address:** 19 Ashgrove Road, Bristol 6, England. **Dealer:** David Stuart Gallery. **One-man Exhibitions:** (first) California Palace, 1947, also 1952; California School of Fine Arts, 1956; New Arts Gallery, Houston, 1960, 62; Ferus Gallery, Los Angeles, 1960; Gimpel Fils Ltd., 1961; Pasadena/AM, 1961; Andre Emmerich Gallery, NYC, 1961, 62, 63; Dilexi Gallery, San Francisco, 1962; U. of Minnesota, 1962; Galleria dell'Ariete, 1962; David Stuart Gallery, 1963, 68, 73; U. of California, Berkeley, 1964; Santa Barbara/MA, 1969; Suzanne Saxe Gallery, San Francisco, 1970, 73; City Art Gallery, Bristol, 1972. **Retrospective:** San Francisco State College, 1964. **Group:** California Palace; Pasadena/AM; WMAA Annuals; Los Angeles/County MA; Oakland/AM; SFMA; U. of California, Berkeley; Oakland/AM, A Period of Exploration, 1973. **Collections:** Buffalo/Albright; Corcoran; Dallas/MFA; Hirshhorn; Houston/MFA; Los Angeles/County MA; New Paltz/SUNY; Oakland/AM; Pasadena/AM; Phillips; SFMA; St. Louis/City; Tate; WMAA; Washington U. **Bibliography:** McChesney.

SMITH, LEON POLK. b. May 20, 1906, Chickasha, Okla. **Studied:** East Central State College, AB; Columbia U., MA. Traveled Mexico, Europe, Canada, USA, Venezuela. **Taught:** Oklahoma public schools, 1933-39; Georgia University System, Teachers Colleges, 1939-41; State Supervisor, Delaware, 1941-43; Rollins College, 1949-51; Mills College of Education, 1951-58; Artist-in-Residence, Brandeis U., 1968, and U. of California, Davis, 1972. **Awards:** Guggenheim Foundation Fellowship, 1944; Longview Foundation Grant, 1959; National Council on the Arts; Tamarind Fellowship. **Address:** Box 386, Shoreham, N.Y. 11786. **Dealers:** Galerie Denise Rene/Hans Mayer, Dusseldorf; Galerie Denise Rene, NYC and Paris. **One-man Exhibitions:** (first) Uptown Gallery, NYC, 1940; Savannah/Telfair, 1941; Rose Fried Gallery, 1942, 46, 49; Santa Fe, N.M., 1943; Charles Egan Gallery, 1945; Betty Parsons Gallery, 1957, 59; The Stable Gallery, 1960, 62; Caracas, 1962; Galerie Muller, 1964; Galerie Chalette, 1967, 68, 69 70; Brandeis U., 1968; SFMA, 1968; Fort Worth Art Museum, 1968; Galerie Denise Rene, Paris, 1973, 75. **Group:** WMAA, 1959; Helmhaus Gallery, Zurich, Konkrete Kunst, 1960; SRGM, Abstract Expressionists and Imagists, 1961; WMAA Annual, 1962; WMAA, Geometric Abstraction in America, circ., 1962; Chicago/AI, 1962; DALLAS/MFA, "1961," 1962; Corcoran, 1963; Brandeis U., New Directions in American Painting, 1963; MOMA,

American Collages, 1965; MOMA, The Responsive Eye, 1965; WMAA, A Decade of American Drawings, 1955-1965, 1965; SFMA, Colorists 1950-1965, 1965; SRGM, Systemic Painting, 1966; Carnegie, 1967, 70; Buffalo/Albright, Plus by Minus, 1968; Chicago/Contemporary, Post-Mondrian Abstraction in America, 1973; Carnegie, Celebration, 1974-75. **Collections:** Aachen; Carnegie; Cleveland/MA; Fort Worth; Indianapolis; Los Angeles/County MA; MMA; MOMA; Oklahoma State Art Collection; SRGM; Springfield, Mass./MFA; U. of Sydney. **Bibliography:** Alloway 3; American Artists Group Inc. 2; Battcock, ed.; Calas, N. and E.; *Kunst um 1970*; MacAgy 2; Rickey; Seuphor 1.

SMITH, TONY. b. 1912, South Orange, N.J. **Studied:** ASL, 1933-36; New Bauhaus, Chicago, 1937-38. Worked on new buildings designed by Frank Lloyd Wright, 1938-39. **Taught:** NYU, 1946-50; Cooper Union, 1950-53; Pratt Institute, 1950-53, 1957-58; Bennington College, 1958-61; Hunter College, 1962-74. **Awards:** Longview Foundation Grant, 1966; National Council on the Arts, 1966; Guggenheim Foundation Fellowship, 1968; College Art Association, Distinguished Teaching of Art Award, 1974; Brandeis U., Creative Arts Award for Sculpture, 1974. **Address:** 647 Berkeley Road, Orange, N.J. 07050. **Dealer:** Fourcade, Droll Inc. **One-man Exhibitions:** Hartford/Wadsworth, 1966; ICA, U. of Pennsylvania, 1966; Walker, 1967; Galerie Muller, Stuttgart, 1967; Bryant Park, NYC, 1967; Galerie Rene Ziegler, 1968; Yvon Lambert, 1968; Donald Morris Gallery, Detroit, 1968; MOMA, circ., 1968; U. of Hawaii, 1969; Newark Museum, 1970; Montclair/AM, 1970; Princeton U., 1970; Trenton/State, 1970; Knoedler Contemporary Art, 1970; MOMA, 1970; U. of Maryland, 1974. **Group:** Hartford/Wadsworth, Black, White, and Grey, 1964; Jewish Museum, Primary Structure Sculptures, 1966; WMAA, 1966, 71, 73; Detroit/Institute, Color,

Image and Form, 1967; Chicago/AI, A Generation of Innovation, 1967; Los Angeles/County MA, American Sculpture of the Sixties, circ., 1967; Carnegie, 1967; Corcoran, Scale as Content, 1967; SRGM, Guggenheim International, 1967; A.F.A., Rejective Art, 1967; Finch College, NYC, Schemata 7, 1967; Documenta IV, Kassel, 1968; Buffalo/Albright, Plus by Minus, 1968; MOMA, The Art of the Real, 1968; HemisFair '68, San Antonio, Tex., 1968; MMA, New York Painting and Sculpture: 1940-1970, 1969-70; Akademie der Kunst, Berlin, Minimal Art, 1969; Expo '70, Osaka, 1970; Cincinnati/Contemporary, Monumental Art, 1970; U. of Nebraska, American Sculpture, 1970; Los Angeles/County MA, Art & Technology, 1971; Foundation Maeght, 1971; Arnhem, Sonsbeek '71, 1971; Indianapolis, 1974. **Collections:** Corcoran; Detroit/Institute; Hartford/Wadsworth; MOMA; Mutual Life Insurance Building, Chicago; U. of Pennsylvania; Princeton U.; Rice U.; Rijksmuseum Kroller-Muller; Trenton/State; Walker. **Bibliography:** Calas, N. and E.; *Monumenta; Report; Tony Smith.*

SMITHSON, ROBERT. b. January 2, 1938, Passaic, N.J.; **d.** July 20, 1973, Tecovas Lake, Tex. **Studied:** ASL, 1953, with John Groth; Brooklyn Museum School, 1956. US Army Reserve Forces, Special Services. Traveled USA, Mexico, London, Rome. **One-man Exhibitions:** (first) Artists' Gallery, NYC, 1959; Galleria George Lester, Rome, 1961; Dwan Gallery, NYC, 1966-69, 70; Konrad Fischer Gallery, Dusseldorf, 1968-69; Galleria l'Attico, Rome, 1969; ACE Gallery, Los Angeles and Vancouver, 1970; New York Cultural Center, circ., 1974; Kunstmuseum, Lucerne, circ., 1975. **Group:** ICA, U. of Pennsylvania, Current Art, 1965; Jewish Museum, Primary Structure Sculptures, 1966; Finch College, NYC, 1966, 67; WMAA, 1966, 69, 70, Annual, 1969; Los Angeles/County MA, American Sculpture of the Sixties, 1967; Trenton/

State, Focus on Light, 1967; The Hague, Minimal Art, 1968; MOMA, The Art of the Real, 1968; Buffalo/Albright, Plus by Minus, 1968; Dusseldorf/Kunsthalle, Prospect '68, '69, 1968, 69; Mikwaukee, Directions 1: Options, circ., 1968; Amsterdam/Stedelijk, Op Losse Schroeven, 1969; Berne, When Attitudes Become Form, 1969; ICA, U. of Pennsylvania, Between Object and Environment, 1969; Chicago/Contemporary, Art by Telephone, 1969; Seattle/AM, 557, 087, 1969; ICA, U. of Pennsylvania, Against Order: Chance and Art, 1970; Chicago/AI, 69th and 70th American Exhibitions, 1969, 72; MOMA, Information, 1971; Documenta V, Kassel, 1972; Rijksmuseum Kroller-Muller, Diagrams and Drawings, 1972; New York Cultural Center, 3D into 2D, 1973; MIT, Interventions in Landscape, 1974; Neuer Berliner Kunstverein, Berlin, Multiples, 1974; Rutgers U., Response to the Environment, 1975. **Collections:** Kingsborough Community College; MOMA; Milwaukee; WMAA. **Bibliography:** Atkinson; Battcock, ed.; Calas, N. and E.; Celant; De Vries, ed.; Goossen 1; *Kunst um 1970*; Lippard 4; Lippard, ed.; MacAgy 2; Muller; *Report*; Tuchman 1; *When Attitudes Become Form*. Archives.

SNELGROVE, WALTER. b. March 22, 1924, Seattle, Wash. **Studied:** U. of Washington; U. of California, Berkeley, with James McCray, M. O'Hagan, BA, MA; California School of Fine Arts, with Hassel Smith, Antonio Sotamayor, James Weeks. US Navy, 1943-47. Traveled Europe; resided Florence, Italy. **Taught:** U. of California, 1951-53. **Awards:** U. of California, James D. Phelan Traveling Scholarship, 1951; SFMA, M. Grumbacher Award, 1959; Oakland/AM, First Prize, 1962. **Address:** c/o Dealer. **Dealer:** Gump's Gallery. **One-man Exhibitions:** (first) Oakland/AM, 1959; California Palace; Santa Barbara/MA; Gump's Gallery; Colorado Springs/FA. **Retrospective:** Foothill College, 1967. **Group:** de Young; SFMA; RAC; Oakland/AM, Contemporary Bay Area Figurative Painting, 1957; Los Angeles/County MA; WMAA, Fifty California Artists, 1962-63; VMFA; U. of Illinois, 1963; Carnegie, 1964; Denver/AM, 1964; U. of Washington; Des Moines. **Collections:** A.F.A.; California Palace; Colorado Springs/FA; Oakland/AM; Stanford U.; WMAA.

SNELSON, KENNETH. b. June 29, 1927, Pendleton, Ore. **Studied:** U. of Oregon (with Jack Wilkinson); Black Mountain College (with Josef Albers, Buckminster Fuller, Willem de Kooning); Academie Montmartre, Paris (with Fernand Leger); US Naval Reserve, 1945-46. Traveled Europe, Near East, Far East. **Taught:** Cooper Union; Pratt Institute; School of Visual Arts, NYC; Southern Illinois U.; Yale U. **Commission:** Reynolds Metals Co., Sculpture Award, 1974. **Awards:** Milan Triennial, Silver Medal, 1964; New York City Council on the Arts Award, 1971; DAAD Fellowship, Berlin, 1975; National Endowment for the Arts, 1975. **Address:** 140 Sullivan Street, NYC 10012. **One-man Exhibitions:** (first) Pratt Institute, 1963; New York World's Fair, 1964-65; Dwan Gallery, NYC, 1966, 68; Dwan Gallery, Los Angeles, 1967; Bryant Park, NYC, 1968; Fort Worth, 1969; Rijksmuseum Kroller-Muller, 1969; Stadtische Kunsthalle, Dusseldorf, 1969; Hannover/Kunstverein, 1971; John Weber Gallery, 1972; Galeria van der Voort, Ibiza, 1972; Waterside Place, NYC, 1974; Galerie Buchholz, Munich, 1975. **Group:** MOMA, 1959, 62; Milan Triennial, 1964; WMAA Sculpture Annual, 1966-69; Los Angeles/County MA, American Sculpture of the Sixties, 1967; CSCS, Los Angeles, 1967; Chicago/AI, 1967; Buffalo/Albright, Plus by Minus, 1968; Dusseldorf/Kunsthalle, Prospect '68, 1968; PMA, 1968; Grant Park, Chicago, Sculpture in the Park, 1974. **Collections:** Amsterdam/Stedelijk; Chattanooga/Hunter; City of Hamburg; City of Hannover; Hirshhorn; MOMA; Rijksmuseum Kroller-Muller; WMAA. **Bibliography:** MacAgy 2; Tuchman 1.

SOLOMON, HYDE. b. May 3, 1911, NYC. **Studied:** Columbia U., with Meyer Schapiro; American Artists School, NYC, 1938; Pratt Institute; ASL, 1943, with Ossip Zadkine. Traveled Europe. **Taught:** Princeton U., 1959-62; Goddard College, summers, 1954, 55. **Member:** American Abstract Artists. **Awards:** MacDowell Colony Fellowship, 1949, 50, 51, 52; Yaddo Fellowship, 1951, 56, 57, 58, 59, 62, 63, 64; AAAL, **P.P.**, 1971; Mark Rothko Foundation, 1973. **Address:** c/o General Delivery, Taos, N.M. 87571. **Dealers:** Poindexter Gallery; Hunter-Meek Gallery. **One-man Exhibitions:** (first) Vendome Galleries NYC, 1941; Jane Street Gallery, NYC, 1945, 48; The Peridot Gallery, 1954, 55, 56; Poindexter Gallery, 1956, 58, 60, 63, 65, 67, 69, 70, 71, 73; Princeton U., 1959; Rutgers U., 1961; Skidmore College, 1962. **Group:** MOMA; Walker; Brooklyn Museum; Newark Museum; Yale U.; Hartford/Wadsworth; PMA; The Kootz Gallery, NYC, New Talent, 1950; WMAA, Nature in Abstraction, 1958, Annual, 1965, and others; Carnegie, 1964, 67; VMFA, American Painting, 1966; New School for Social Research, Humanist Tradition, 1968; Allentown/AM, Monhegan Island Painters, 1974. **Collections:** Brandeis U.; U. of California, Berkeley; Chase Manhattan Bank; Ciba-Geigy Corp.; Ford Foundation; Hartford/Wadsworth; Mitsui Bank of Japan; Newark Museum; *Readers Digest*; Utica; WMAA; Walker; Westinghouse. Archives.

SOLOMON, SYD. b. July 12, 1917, Uniontown, Pa. **Studied:** Chicago Art Institute School, 1934; Academie des Beaux-Arts, Paris, 1945. **Taught:** Art Institute of Pittsburgh, 1947; Ringling School of Art, 1948-50; Famous Artists Schools, Inc., 1954-67; Sarasota School of Art, 1950, 55; Fine Arts Institute of New College, Sarasota, Fla., 1964-65, 1967-69. US Corps of Engineers, World War II. **Commissions** (murals): St. Petersburg *Times* Building; Far Horizons Hotel, St. Petersburg, Fla. **Awards:** Hallmark International

Competition, 1952; Youngstown/Butler, First **P.P.**, 1957; Audubon Artists, Gold Medal of Honor, 1957; American Institute of Architects, Medal of Honor, 1959; Ringling, First Prize, 1962; Silvermine Guild, 1962; Ford Foundation, **P.P.**, 1964; Florida State Fair, First Prize. **Address:** 9210 Blind Pass Road, Sarasota, Fla.; summer: P.O. Box 115, Ocean Avenue, East Hampton, N.Y. 11937. **Dealers:** Saidenberg Gallery; The Berenson Gallery. **One-man Exhibitions:** Farnham Castle, England; Clearwater (Fla.) Museum of Art, 1951; U. of Miami, 1953; U. of Floriada, 1954; A.A.A. Gallery, NYC, 1955; Clearwater/Gulf Coast, 1956; Saidenberg Gallery, 1959-62, 1964, 67, 70; Safrai Gallery, Jerusalem, 1960; Tel Aviv, 1960; U. of Tennessee, 1961; Sarasota (Fla.) Art Association, 1961; James David Gallery, Ltd., Miami Beach, 1963, 64; Jacksonville U., 1968; The Berenson Gallery, 1969, 71, 74; Midtown Gallery, Atlanta, 1971; Contemporary Gallery, St. Petersburg, 1971; Trend House Gallery, Tampa, 1972, 74; Hokin Gallery, Palm Beach, 1973; Ridge Art Association, Winter Haven, Fla., 1973; Brevard College, Cocoa, Fla., 1974. **Retrospective:** Ringling, 1974. **Group:** New Orleans/Delgado, 1951, 57; MMA, 1952; Hallmark Art Award, 1952; U. of Florida, 1953; Dallas/MFA, 1954; Youngstown/Butler, 1954, 56-57; NAD, 1955, 57, 59; Houston/MFA, 1955; Ringling, Fifty Florida Painters, 1955; Carnegie, 1956; Corcoran, 1959; WMAA Annual, 1959; AAAL, 1959; Art:USA:59, NYC, 1959; Corcoran, 1959; Chicago/AI, 1961; U. of Illinois, 1965; Colorado Springs/FA, 1966; SRGM, 1966; Pan American Union, Washington, D.C., Florida Seventeen, 1968. **Collections:** Adelphi U.; Atlanta/AA; Baltimore/MA; Birmingham, Ala./MA; Brandeis U.; Cincinnati/AM; Clearwater/Gulf Coast; First National Bank, Tampa; Florida Southern College; Friends of Art; Georgia Institute of Technology; Gulf Life Insurance Co.; Hartford/Wadsworth; High Museum; Hirshhorn; International Minerals & Chemicals Corp.; Jacksonville U.; Louisiana State

U.; Mead Corporation; U. of Miami; New Orleans/Delgado; New Orleans Museum; Norfolk/Chrysler; PMA; Ringling; SRGM; U. of South Florida; Tupperware Museum; WMAA; West Palm Beach/Norton; Witte; Youngstown/Butler. **Bibliography:** Pousette-Dart, ed.; *Syd Solomon.*

SONENBERG, JACK. b. December 28, 1925, Toronto, Canada. **Studied:** Washington U., with Fred Becker, Paul Burlin, BA. Traveled USA, Great Britain. **Taught:** School of Visual Arts, NYC; Pratt Institute; Queens College. **Commissions:** International Graphic Arts Society; New York Hilton Hotel. **Awards:** L.C. Tiffany Grant (printmaking), 1962; Silvermine Guild, First Prize, 1962; St. Paul Gallery, Drawing USA, **P.P.**; Bradley U., Print Annual, **P.P.**; Ford Foundation/A.F.A., Artist-in-residence, 1966; Guggenheim Foundation Fellowship, 1973; CAPS, New York State Council of the Arts, 1973. **Address:** 217 East 23 Street, NYC 10010. **Dealer:** Fischbach Gallery. **One-man Exhibitions:** (first) Washington Irving Gallery, NYC, 1958; Carl Siembab Gallery, Boston, 1959; Roko Gallery, NYC, 1961; Feingarten Gallery, Los Angeles, 1962, NYC, 1963; Des Moines, 1964; The Byron Gallery, 1965, 68; Hampton Institute, 1966; Grand Rapids, 1968; U. of Iowa, 1969; Flint/Institute, 1973; Fischbach Gallery, 1973. **Group:** Brooklyn Museum, Print Biennials; Chicago/AI; Silvermine Guild; SRGM; Des Moines; WMAA, American Prints Today, 1959, Annual, 1968; Youngstown/Butler, 1961; U. of Illinois, 1963; New York World's Fair, 1964-65; Finch College, 1965; PAFA, 1969; WMAA, 1973; MOMA, Printed, Folded, Cut and Torn, 1974. **Collections:** Bradley U.; Brandeis U.; Grand Rapids; Hampton Institute; MMA; MOMA; Minnesota/MA; NYPL; PMA; SRGM; Syracuse U.; WMAA; Washington U.

SONNIER, KEITH. b. 1941, Mamou, La. **Studied:** U. of Southwestern Louisana, 1959-63, BA; Rutgers U., 1965-66, MFA. Resided France, 1963-

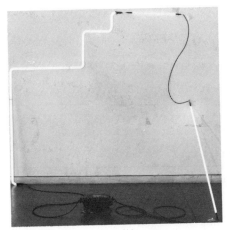

Keith Sonnier *Untitled* 1971

64. **Awards:** Tokyo Print Biennial, First Prize, 1974; Guggenheim Foundation Fellowship, 1974. **Address:** c/o Dealer. **Dealer:** Leo Castelli Inc., NYC. **One-man Exhibitions:** Douglass College, New Brunswick, N.J., 1966; Galerie Rolf Ricke, 1968, 71, 72; Leo Castelli Inc., NYC, 1970, 72, 74, 75; ACE Gallery, Los Angeles, 1970, 75; Eindhoven, 1970; MOMA, 1971; Seder/Creigh Gallery, Coronado, 1974. **Group:** A.F.A., Soft Sculpture, 1968; American Abstract Artists, 1968; Trenton/State, Soft Art, 1969; Washington U., Here and Now, 1969; Berne, When Attitudes Become Form, 1969; WMAA, Anti-Illusion: Procedures/Materials, 1969; Chicago/AI, 1970; ICA, U. of Pennsylvania, Against Order: Chance and Art, 1970; WMAA, 1970; MOMA, Information, 1971; Dusseldorf/Kunsthalle, Prospect '71, 1971; New Delhi, Second World Triennial, 1971; Humlebaek/Louisiana, American Art, 1950-1970, 1971; Venice Biennial, 1972; Festival of Two Worlds, Spoleto, 1972; Yale U., Options and Alternatives, 1973; New York Cultural Center, 3D into 2D, 1973; Parcheggio di Villa Borghese, Rome, Contemporanea, 1974; WMAA, 1973; Seattle/AM, American Art—Third Quarter Century, 1973; CNAC, Art/Voir, 1974. **Collections:** Canberra/National; Cologne; Harvard U.; U. of North Carolina;

Stockholm/National; WMAA. **Bibliography:** *Art Now 74;* Celant; *Contemporanea;* Davis, D.; *Kunst um 1970;* Lippard, ed.; Muller; *Options and Alternatives; When Attitudes Become Form.* Archives.

SOYER, MOSES. b. December 25, 1899, Tombov, Russia; **d.** September 2, 1974, NYC. To USA 1913; citizen 1925. **Studied:** Cooper Union; NAD; Educational Alliance, NYC; Ferrer School, San Francisco, with Robert Henri, George Bellows. Traveled Europe, Russia. **Taught:** Contemporary School of Art, NYC; New School for Social Research; Educational Alliance, NYC; and elsewhere. **Member:** NAD; Artists Equity; Audubon Artists; NIAL. **Federal A.P.:** US Post Office, Philadelphia, Pa.; Greenpoint Hospital, Brooklyn, N.Y. (mural, with James Penney); 10 portable murals for libraries. **Awards:** AAAL, Childe Hassam Award (2); NAD, Annual, Andrew Carnegie Prize. **One-man Exhibitions:** (first) J.B. Neumann's New Art Circle, NYC, 1928; Kleeman Gallery, NYC, 1935; Macbeth Gallery, NYC, 1940; 41, 43; Boyer Gallery, NYC; ACA Gallery, 1944, 47, 70, 72; Guild Hall, 1972. **Retrospective:** U. of North Carolina, 1972. **Group:** MMA; WMAA; Brooklyn Museum; Detroit/Institute; Youngstown/Butler; NAD. **Collections:** AAAL; Birmingham, Ala./MA; Brooklyn Museum; Detroit/Institute; Hartford/Wadsworth; U. of Kansas; Library of Congress; MMA; MOMA; NAD; Newark Museum; PMA; Phillips; Toledo/MA; WMAA; Youngstown/Butler. **Bibliography:** Brown; Cheney; Finkelstein; Mendelowitz; **Smith, B.;** **Soyer, M.;** Soyer, R. 1; Wheeler; **Willard.** Archives.

SOYER, RAPHAEL. b. December 25, 1899, Tombov, Russia. To USA 1912. **Studied:** Cooper Union; NAD, 1919-21; ASL, with Guy Du Bois. **Taught:** ASL; American Art School, NYC; New School for Social Research; NAD, 1965-67. **Member:** NIAL; NAD. **Federal A.P.:** Easel painting. **Commissions:** US Post Office, Kingsessing

Carnegie, Hon. Men. (3); Chicago/AI, The M.V. Kohnstamm Prize, 1932; Chicago/AI, Norman Wait Harris Gold Medal, 1932; PAFA, Carol H. Beck Gold Medal, 1934; Chicago/AI, Norman Wait Harris Bronze Medal, 1940; PAFA, Joseph E. Temple Gold Medal, 1943; PAFA, Walter Lippincott Prize, 1946; Corcoran, William A. Black Prize and Corcoran Gold Medal, 1951; ART: USA:59, NYC, $1,000 Prize, 1959. **Address:** 88 Central Park West, NYC 10023. **Dealer:** The Forum Gallery. **One-man Exhibitions:** The Daniel Gallery, NYC, 1929; L'Elan Gallery, NYC, 1932; Curt Valentine Gallery, NYC, 1933, 34, 35, 37, 38; Frank K.M. Rehn Gallery, NYC, 1939; Treasury Section, Fine Arts Division, 1939; A.A.A. Gallery, NYC, 1940, 41, 48, 53, 55; Weyhe Gallery, 1944; Philadelphia Art Alliance, 1949; ACA Gallery, 1960; Alfredo Valente Gallery, NYC, 1961; Bernard Crystal Gallery, NYC, 1962; The Forum Gallery, 1964, 66, 67, 72; The Margo Feiden Galleries, NYC, 1972. **Retrospective:** WMAA, circ., 1967. **Group:** Salons of America, NYC, 1926; WMAA Annuals, 1932- ; PAFA, 1934, 43, 46; Corcoran, 1937, 51; VMFA, 1938; Chicago/AI, 1940; Brooklyn Museum, 1941; Carnegie, 1944; Phillips, 1944; Dallas/MFA, 1945; California Palace, 1945; MOMA, 1946; NAD, 1951, 52; A.F.A., 1967. **Collections:** Andover/Phillips; U. of Arizona; Boston/MFA; Brooklyn Museum; Buffalo/Albright; Columbus; Corcoran; Detroit/Institute; Hartford/Wadsworth; MMA; MOMA; Montclair/AM; U. of Nebraska; Newark Museum; Norfolk/Chrysler; Oslo/National; Phillips; WMAA. **Bibliography:** American Artists Congress, Inc.; American Artists Group Inc. 3; Bazin; Biddle 4; Boswell 1; Brown; Cheney; Finkelstein; **Foster; Goodrich** 10; Goodrich and Baur 1; **Gutman;** Hall; Kent, N.; Mellquist; Mendelowitz; Nordness, ed.; Pagano; Reese; **Soyer, R.** 1, 2, 3; Wheeler; Zigrosser 1. Archives.

SPEICHER, EUGENE. b. April 5, 1883, Buffalo, N.Y.; **d.** 1962. **Studied:** Buffalo Fine Arts Academy, 1902-06; ASL,

1907-08, with Frank V. DuMond, William M. Chase; Robert Henri School, 1909, with Robert Henri. Traveled Europe extensively. **Member:** NIAL; NAD; National Arts Club. **Awards:** ASL, Kelley Prize, 1907; NAD, Thomas R. Proctor Prize, 1911; Salmagundi Club, Jose S. Isadora Prize, 1913; NAD, Hallgarten Prize, 1914, 15; Panama-Pacific Exposition, San Francisco, 1915, Silver Medal; PAFA, Carol H. Beck Gold Medal, 1920; Carnegie, Third Prize, 1921, Second Prize, 1923; Chicago/AI, Potter Palmer Gold Medal, 1926; Corcoran, Second William A. Clark Prize, 1928; Corcoran, First Prize; VMFA, **P.P.**; Hon. DFA, Syracuse U., 1945. **One-man Exhibitions:** Montross Gallery, NYC, 1918; M. Knoedler & Co., 1920; Carnegie, 1924; Boston Arts Club, 1925; Rehn Galleries, 1925, 29, 34, 41, 43; Des Moines, 1926; Denver/AM, 1948; Wildenstein & Co., NYC, 1954; AAAL, Memorial Exhibition, 1963; ACA Gallery, 1965. **Retrospective:** Buffalo/Albright, 1950. **Group:** WMAA; PAFA; Carnegie; Century Association, Robert Henri and Five Pupils, 1946; MOMA; Chicago/AI. **Collections:** ASL; Andover/Phillips; Boston/MFA; Britannica; Brooklyn Museum; Buffalo/Albright; Cincinnati/AM; Cleveland/MA; Corcoran; Decatur; Des Moines; Detroit/Institute; Galveston; Harvard U.; IBM; Indianapolis/Herron; Kansas City/Nelson; Los Angeles/County MA; MMA; MOMA; Minneapolis/Institute; Phillips; RISD; St. Louis/City; Toledo/MA; VMFA; WMAA; West Palm Beach/Norton; Worcester/AM; Yale U. **Bibliography:** Baur 7; Bazin; Biddle 4; Blesh 1; Boswell 1; Brown; Bryant, L.; Burchfield 3; Cahill and Barr, eds.; Cheney; Eliot; Goodrich and Baur 1; Hall; *Index of 20th Century Artists*; Jackman; Jewell 2; Kent, N.; **Mather 1, 2**; McCurdy, ed.; Mellquist; Mendelowitz; Narodny; Neuhaus; Pagano; Phillips 2; Poore; Richardson, E.P.; Sachs; Smith, S.C.K.; **Speicher**; Watson, E.W. 1; Zaidenberg, ed. Archives.

SPENCER, NILES. b. May 16, 1893, Pawtucket, R.I.; **d.** May 15, 1952, Dingman's Ferry, Pa. **Studied:** RISD, 1913-15; Ferrer School, NYC (with Robert Henri, George Bellows), 1915; ASL (with Kenneth Hayes Miller), 1915. Traveled Europe, 1921-22, 1928-29. **Taught:** RISD, 1915. **Awards:** Carnegie, Hon. Mention, 1930; MMA, **P.P.**, 1942. **One-man Exhibitions:** (first) The Daniel Gallery, NYC, 1925, also 1928; The Downtown Gallery, 1947, 52; Washburn Gallery Inc., 1972. **Retrospective:** Downtown Gallery, 1947, 52; MOMA, 1954; U. of Kentucky, 1965. **Group:** Whitney Studio Club, NYC, from 1923; MOMA, Paintings by 19 Living Americans, 1929; Cincinnati/AM, A New Realism, 1941; Providence (R.I.) Art Club; Carnegie; MMA, Artists for Victory, 1942; Walker, The Precisionist View, 1960; WMAA, 1966; U. of New Mexico, Cubism: its impact in the USA, 1967. **Collections:** Andover/Phillips; Arizona State College; U. of Arizona; Buffalo/Albright; Columbus; Cornell U.; Illinois Wesleyan U.; MMA; MOMA; U. of Michigan; U. of Nebraska; Newark Museum; Phillips; RISD; SFMA; San Francisco Art Institute; Santa Barbara/MA; WMAA; Walker; Wichita/AM; Youngstown/Butler. **Bibliography:** Baur 7; Hunter 6; *Index of 20th Century Artists*; Kootz 1, 2; Pousette-Dart, ed. Archives.

SPOHN, CLAY E. b. November 24, 1898, San Francisco, Calif. **Studied:** California College of Arts and Crafts, 1910-12, 1916, 20; Augusta Military Academy (Va.), 1917-18; U. of California, Berkeley, 1919-22; privately with Armin Hansen, 1921; San Francisco Art Institute, 1921, 27; ASL, 1922-24, with Guy Du Bois, George Luks, Boardman Robinson, Kenneth Hayes Miller, Kimon Nicolaides; Academie Moderne, Paris, 1926, with Othon Friesz. Traveled Europe, USA, Mexico, Canada. **Taught:** San Francisco Art Institute, 1945-50; Mount Holyoke College, 1958; School of Visual Arts, NYC, 1964-69; and privately. **Federal A.P.** (murals, 1935-41): Shriner Hospital, San Francisco; Volunteer Fire Department, Carmel, Calif.; Contra Costa County

(Calif.)CommunityCenter.**Address:**245 Grand Street, NYC 10002. **One-man Exhibitions:** (first) Art League Gallery, San Francisco, 1929, also 1931; SFMA, 1942; Rotunda Gallery, San Francisco, 1946; Stables Gallery, Taos, N.M., 1957. **Retrospective:** Oakland/AM, 1974. **Group:** San Francisco Art Association, intermittently 1929-38; de Young, *ca.* 1937-38; SFMA, Art of Our Time, 1945; California Palace, 1945, 48, 50; American Abstract Artists Annual, 1949; Denver/AM, 1952; U. of Illinois, 1953. **Collections:** SFMA. **Bibliography:** McChesney. Archives.

SPRINCHORN, CARL. b. May 13, 1887, Broby, Sweden. **d.** September , 1971. To USA 1903. **Studied:** New York School of Art, 1903-10, with William M. Chase, Robert Henri; Academie Colarossi, Paris, 1914-15. Traveled France, Scandinavia, Carribbean, USA. **Taught:** Art League of Los Angeles, 1912-14. Manager, Robert Henri School, 1907-10. Director, The New Gallery, NYC, 1922-25. **One-man Exhibitions:** (first) George S. Hallman Gallery, NYC, 1916; M. Knoedler & Co., NYC, 1917; Marie Sterner Gallery, NYC, 1922-32; Frank K.M. Rehn Gallery, NYC, 1927; Ainslie Gallery, NYC, Philadelphia, Detroit, 1930; Mrs. Cornelius J. Sullivan Gallery, NYC, 1933-37; Macbeth Gallery, NYC, 1941-53; American Swedish Historical Museum; Worcester/AM; Arts Club of Chicago. **Group:** The Armory Show, 1913; Independent Artists, NYC; PAFA; Corcoran; Brooklyn Museum; Phillips; PMA; WMAA, 1963; Colby College. **Collections:** American Swedish Historical Museum; Atlanta/AA; Boston/ MFA; Brooklyn Museum; Dayton/AI; Harvard U.; MMA; U. of Maine; Museum of the City of New York; New Britain; PMA; Phillips; RISD; Virginia State College. **Bibliography:** Blesh 1; *Carl Sprinchorn*; Rose, B. 1.

SPRUANCE, BENTON, b. June 25, 1904, Philadelphia, Pa.; **d.** December 6, 1967, Philadelphia, Pa. **Studied:** U. of Pennsylvania, 1924; PAFA, 1925-29.

Taught: Beaver College, 1933-67; Philadelphia College of Art, Director, Department of Printmaking, 1934-65. **Member:** NAD; SAGA; The Print Club, Philadelphia; Philadelphia Art Alliance. **Commissions:** Municipal Court Building, Philadelphia (mural). **Awards:** PAFA, Cresson Fellowship, 1928, Pennell Memorial Medal, 1937, 66, Alice McFadden Eyre Medal, 1944, First Prize, 1948; Audubon Artists, First Prize, 1948; National Color Print Society, First Prize, 1948; Library of Congress, First Pennell **P.P.**, 1948; Guggenheim Foundation Fellowship, 1951; Hon. Member, American Institute of Architects, 1967. **One-man Exhibitions:** Rehn Galleries, 1949; Carnegie, 1949; Philadelphia Art Alliance, 1951; Mount Holyoke College, 1951; Beaver College, 1964; Muhlenberg College, 1964; The Print Club, Philadelphia, 1964. **Retrospective:** Philadelphia College of Art, 1967; PAFA, 1968. **Group:** PAFA; Library of Congress; NYPL; PMA; WMAA; Carnegie. **Collections:** Carnegie; Library of Congress; NYPL; National Gallery; PAFA; PMA. **Bibliography:** American Artists Group Inc. 3; Bethers; Cheney; Hall; Reese; Zigrosser 1.

SPRUCE, EVERETT. b. December 25, 1908, Conway, Ark. **Studied:** Dallas Art Institute, 1925-29, with O.H. Travis, T.M. Stell, Jr. **Taught:** Dallas Museum School, 1936-40 (Assistant Director and Instructor); U. of Texas, 1940- . **Awards:** Scholarship, Dallas Art Institute; Dallas/MFA, First Prize, 1935, 55; Pepsi-Cola, 1946; Houston/MFA, First Prize, 1946; Carnegie, Hon. Men., 1946; La Tausca Competition, 1947; PAFA, J. Henry Schiedt Memorial Prize, 1947; Corcoran, Hon. Men., 1949; Texas State Fair, D.D. Feldman Award, 1955. **Address:** 15 Peak Road, Austin, Tex. 78746. **One-man Exhibitions:** Dallas/MFA, 1932, 58; Joseph Sartor Gallery, Dallas, 1934; Delphic Studios, NYC, 1936; Hudson D. Walker Gallery, NYC, 1938; Witte, 1943; Mortimer Brandt, NYC, 1943; Santa Barbara/MA, 1945; Mortimer Levitt Gallery, NYC,

1945, 46, 48, 50, 51; Arts Club, Washington, D.C., 1948; San Antonio/McNay, 1959. **Retrospective:** A.F.A., 1959. **Group:** Dallas/MFA, 1932, 35, 38, 40; Corcoran, 1939, 41, 43, 45, 51; MOMA, 1942; Denver/AM, 1946; Pepsi-Cola, 1946; Carnegie, 1948, 49, 51; U. of Illinois, 1948, 50, 51, 52; Bordighera, 1955. **Collections:** U. of Alabama; Austin; Baltimore/MA; California Palace; Colorado Springs/FA; Dallas/MFA; Des Moines; de Young; Illinois Wesleyan U.; Kansas City/Nelson; MMA; MOMA; NYPL; U. of Nebraska; Newark Museum; New Orleans/Delgado; North Texas State U.; Ohio Wesleyan U.; PAFA; Phillips; Rio de Janeiro; Southern Methodist U.; Tulane U.; WMAA; Walker; Wichita/AM; Witte. **Bibliography:** Baur 7; Goodrich and Baur 1; Hall; Miller, ed. 1; Pearson 1; Pousette-Dart, ed.

SQUIER, JACK. b. February 27, 1927, Dixon, Ill. **Studied:** Oberlin College; Indiana U., with Robert Laurent, Leo Steppat, 1950, BS; Cornell U., with John Hartell, 1952, MFA. Traveled Central and South America, Europe, Middle East, the Orient. **Taught:** Cornell U., 1958- . **Address:** 221 Berkshire Road, Ithaca, N.Y. 14850. **Dealer:** Mitzi Landau Gallery. **One-man Exhibitions:** (first) The Alan Gallery, NYC, 1956, also 1959, 62, 64, 66, 68; Cornell U., 1959, 64, 68; Lima, Peru, 1963. **Group:** WMAA; MOMA; Houston/MFA; Andover/Phillips; Boston/MFA; Brussels World's Fair, 1958; U. of Illinois; Chicago/AI; Boston Arts Festival; Carnegie; Claude Bernard, Paris; Buffalo/Albright. **Collections:** Cornell U.; Ithaca College; Lima, Peru; MOMA; Stanford U.; Syracuse/Everson; WMAA. **Bibliography:** Weller.

STAMOS, THEODOROS. b. December 31, 1922, NYC. **Studied:** American Artists School, NYC, with Simon Kennedy, Joseph Konzal. Traveled Europe, Near East, Greece. **Taught:** Black Mountain College; Cummington School of Fine Arts; ASL, 1958-75;

Brandeis U. **Commissions:** Moore-McCormack Lines Inc., *SS Argentina* (mural). **Awards:** L.C. Tiffany Grant, 1951; NIAL, 1956; Brandeis U., Creative Arts Award, 1959; National Arts Foundation, 1967. **Address:** Plateia Hrwon, Paralia 6, Lefkada, Greece; 37 West 83 Street, NYC. **Dealers:** Marlborough Gallery Inc., NYC. **One-man Exhibitions:** (first) Wakefield Gallery, NYC, 1940; Mortimer Brandt, NYC, 1945; Betty Parsons Gallery, 1947, 56; Phillips, 1950, 54; Philadelphia Art Alliance, 1957; Andre Emmerich Gallery, NYC, 1958, 59, 60, 63, 66, 68; San Antonio/McNay, 1960; Gimpel Fils Ltd., 1960; Galleria d'Arte del Naviglio, Milan, 1961; Brandeis U., 1967; Waddington Fine Arts Ltd., Montreal, 1968; Marlborough Gallery Inc., NYC, 1970; Omaha/Joslyn, 1973; Athens Gallery, 1974. **Retrospective:** Corcoran, 1959. **Group:** Carnegie, 1955, 58, 61, 64; International Biennial Exhibition of Paintings, Tokyo; MOMA, The New American Painting, circ. Europe, 1958-59; WMAA, Nature in Abstraction, 1958, Annual, 1963; Venice Biennial; Documenta II, Kassel, 1959; SRGM, Abstract Expressionists and Imagists, 1961; MMA, 1965; WMAA, Art of the U.S. 1670-1966, 1966; Corcoran Biennial, 1967; MOMA, Dada, Surrealism and Their Heritage, 1968; MOMA, The New American Painting and Sculpture, 1969. **Collections:** Andover/Phillips; U. of Arizona; Baltimore/MA; Brandeis U.; Buffalo/Albright; California Palace; Case Institute; Chase Manhattan Bank; Chicago/AI; Ciba-Geigy Corp.; Colorado Springs/FA; Corcoran; Cornell U.; Des Moines; Detroit/Institute; Hartford/Wadsworth; Hirshhorn; U. of Illinois; State U. of Iowa; La Jolla; MIT; MMA; MOMA; Memphis/Brooks; Michigan State U.; U. of Michigan; NYU; U. of Nebraska; U. of North Carolina; Phillips; Phoenix; Rio de Janeiro; SFMA; San Antonio/McNay; Smith College; Tel Aviv; Toronto; Trenton/State; Utica; Vassar College; WGMA; WMAA; Walker; Wellesley College; Yale U.; Youngstown/Butler. **Bibliography:**

Barker 1; Baur 5, 7; Biddle 4; Blesh 1; Eliot; Goodrich and Baur 1; Haftman; Janis and Blesh 1; McCurdy, ed.; Mendelowitz; Nordness, ed.; **Pomeroy**; Pousette-Dart, ed.; Read 2. Richardson, E.P.; Ritchie 1; Rubin 1; Sandler; Seuphor 1; Soby 5. Archives.

STANCZAK, JULIAN. b. November 5, 1928, Borownica, Poland. To USA 1950; citizen 1956. **Studied:** Borough Polytechnic, London, 1949-50; Cleveland Institute of Art, BFA, 1950-54; Yale U. (with Josef Albers, Conrad Marca-Relli), MFA, 1954-56. Traveled Poland, Russia, Persia, India, East Africa, England, Western Europe. **Taught:** Art Academy of Cincinnati, 1957-64; Cleveland Institute of Art, 1964- ; Dartmouth College, Artist-in-Residence, 1968. **Member:** American Abstract Artists. **Commissions:** National City Bank, Dayton, Ohio, 1973; Ohio Building Authority, Columbus, 1974; Rotweil, West Germany (flag design), 1974. **Awards:** Ohio State Council on the Arts Award, 1972. **Address:** 6229 Cabrini Lane, Seven Hills, Ohio 44131. **Dealer:** Martha Jackson Gallery. **One-man Exhibitions:** (first) Dayton/AI, 1964; Martha Jackson Gallery, 1964, 65, 68, 71, 72, 73, 75; Miami U., 1965; U. of Wisconsin, 1965; Feingarten Gallery, 1966; Kent State U., 1968; Dartmouth College, 1968; Makler Gallery, Philadelphia, 1969; London Arts, Detroit, 1969, 72, London, 1971; Akron/AI, 1970; Women's City Club, Cleveland, 1970; The Packard Gallery, Akron, 1970; Images Gallery, Toledo, 1971, 72; Carl Solway Gallery, Cincinnati, 1972; Corcoran, 1972; Cincinnati/AM, 1972; New Gallery, Cleveland, 1972; Haslem Fine Arts Inc., 1972; Phoenix Gallery, San Francisco, 1974; Canton Art Institute, 1974; Pollock Gallery, Toronto, 1975. **Retrospective:** Cleveland Institute of Art, 1971; Lakeland College, Sheboygan, Wisc., 1975. **Group:** MOMA, The Responsive Eye, 1965; Buffalo/Albright, 1965, Plus by Minus, 1968; Riverside Museum; Detroit/Institute; U. of Illi-

nois, 1965, 69; WMAA Annual, 1967; Carnegie, 1967; Indianapolis/Herron, 1969; U. of Illinois, 1969, 74; Flint/Institute International, 1969; Carnegie, 1970; NCFA, Black and White, 1970-72; Amherst College, Color Painting, 1972; Mansfield Art Center, Stanczak—Anuszkiewicz, 1973; Minnesota/MA, Drawings USA, 1973; U. of Miami, Less is More: The Influence of the Bauhaus on American Art, 1974. **Collections:** Akron/AI; American Republic Insurance Co.; Baltimore/MA; Buffalo/Albright; Canton Art Institute; Cincinnati/AM; Cleveland/MA; Corcoran; Dartmouth College; Dayton/AI; Indianapolis/Herron; U. of Miami; Miami-Dade; Milwaukee; National Gallery; Oklahoma; PAFA; Ridgefield/Aldrich; Trade Bank and Trust Company, NYC; Youngstown/Butler. **Bibliography:** MacAgy 2; Weller.

STANKIEWICZ, RICHARD P. b. October 18, 1922, Philadelphia, Pa. **Studied:** Hofmann School, 1948-49, with Hans Hofmann; Atelier Fernand Leger, Paris, 1950-51; Zadkine School of Sculpture, Paris, 1950-51. Traveled Europe, Australia, USA. An organizer of Hansa Gallery, NYC, 1952. **Taught:** Albany/SUNY, 1967. **Member:** International Institute of Arts and Letters; NIAL; Century Association. **Awards:** Brandeis U.; National Academy of Arts and Sciences; Ford Foundation Grant. **Address:** Star Route, Huntington, Mass. 01050. **Dealers:** The Zabriskie Gallery; Frank Watters Gallery. **One-man Exhibitions:** (first) Hansa Gallery, NYC, 1953, also 1954-58; Allan Frumkin Gallery, Chicago, 1958; The Stable Gallery, 1959-63; Galerie Neufville, Paris, 1960; The Pace Gallery, Boston, 1961; Walker, 1963 (two-man, with Robert Indiana); Daniel Cordier, Paris, 1964; Tampa/AI, 1965; Frank Watters Gallery, 1969; Melbourne/National, 1969; The Zabriskie Gallery, 1972, 73, 75. **Group:** PAFA, 1954; WMAA, 1956, 60, 62, Young America, 1957; Hous-

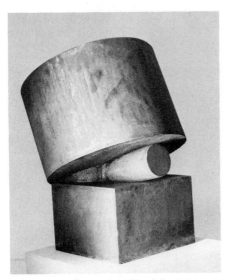

Richard Stankiewicz *Untitled* 1974

ton/MFA, Irons in the Fire, 1957; XXIX Venice Biennial, 1958; Carnegie, 1958, 61; A.F.A., Recent Sculpture, USA, 1959; MOMA, Sixteen Americans, circ., 1959; Claude Bernard, Paris, Aspects of American Sculpture, 1960; Amsterdam/Stedelijk, 1961; Chicago/AI, 1961, 62; VI Sao Paulo Biennial, 1961; MOMA, The Art of Assemblage, circ., 1961; Stockholm/National, 4 Americans, circ., 1962; Seattle World's Fair, 1962; SRGM, The Joseph H. Hirshhorn Collection, 1962; WMAA, Forty Artists under Forty, circ., 1962; Amsterdam/Stedelijk, Four Americans, 1962; MOMA, Hans Hofmann and His Students, circ., 1963-64; Battersea Park, London, International Sculpture Exhibition, 1963; Jewish Museum, Recent American Sculptors, 1964; MOMA, The Machine, 1968. **Collections:** Buffalo/Albright; Chicago/AI; Dayton/AI; Hirshhorn; MOMA; SRGM; Stockholm/National; Tel Aviv; WMAA; Walker. **Bibliography:** Blesh 1; Chipp; Craven, W.; Friedman, ed.; Goodrich and Baur 1; Hulten; Hunter, ed.; Janis and Blesh 1; Kuh 3; Licht, F.; Lowry; *Metro*; Read 3; Seitz 3; Seuphor 3; Weller. Archives.

STANLEY, ROBERT. b. January 3, 1932, Yonkers, N.Y. **Studied:** Oglethorpe U. (with Marion O'Donnell, Wendell Brown), BA, 1953; ASL, 1953; Brooklyn Museum School (with Yonia Fain, William King), 1954-56. Traveled USA, Holland, Germany, Caribbean. **Taught:** School of Visual Arts, NYC, 1970-72. **Awards:** Cassandra Foundation, 1969. **Address:** 3 Crosby Street, NYC 10013. **Dealer:** Galerie Paul Bianchini. **One-man Exhibitions:** (first) The Bianchini Gallery, NYC, 1965, also 1966; Orez International Gallery, The Hague, 1966; Cincinnati/Contemporary, 1966; Galerie Rolf Ricke, Kassel, 1966, 67; Galerie Kuckels, Bochum, Germany, 1967; Kleine Galerie, Frankfurt, 1968; Gegenverkehr, Aachen, 1969; On First, NYC, 1969; Warren Benedek Gallery, NYC, 1972; New York Cultural Center, 1974. **Group:** Van Bovenkamp Gallery, NYC, 1965; Chicago/AI, 1965, 69; Indianapolis/Herron, 1967; WMAA Annual, 1967; Documenta IV, Kassel, 1968; ICA, London, The Obsessive Image, 1968; Milwaukee, Aspects of a New Realism, 1969; David Stuart Gallery, 1969; Chicago/AI, 1969; Cincinnati/Contemporary, Monumental Art, 1970; WMAA, 1972, 73; Eindhoven, Relativerend Realisme, 1972; U. of North Carolina, 1973; New York Cultural Center, Three Centuries of the American Nude, 1975. **Collections:** American Republic Insurance Co.; Cincinnati/Contemporary; Cologne; Donaldson, Lufkin, & Jenrette, Inc.; Harvard U.; Housatonic Community College; MMA; McCrory Corporation; Milwaukee; Norfolk/Chrysler; Time Inc.; WMAA; Washington U. (St. Louis); Westport Art Education Society. **Bibliography:** Lippard 5.

STASIK, ANDREW. b. March 16, 1932, New Brunswick, N.J. **Studied:** NYU; Columbia U., BA; State U. of Iowa; Ohio U., MFA. **Taught:** New School for Social Research; Ohio U.; Ball State Teachers College; Pratt Graphic Art Center; Pratt Institute; Yale U.; U.

of Calgary. Editorial Staff, *Artist's Proof* Magazine. Director, Pratt Graphics Center, NYC. **Awards:** Cleveland/MA, First Prize in Lithography, 1958; Bay Printmakers Society, Oakland, **P.P.**, 1958; Cleveland/MA, First Prize in Serigraphy, 1958; Pasadena/AM, **P.P.**, 1958; Gallery of Modern Art, Ljubljana, Yugoslavia, III International Exhibition of Prints, 1959, Le Prix Internationale de 100,000 dn.; Achenbach Foundation, Open Award for All Media, 1961; The Print Club, Philadelphia, Collins Prize; L.C. Tiffany Grant, 1966; Audubon Artists Medal, 1969; Silvermine Guild, **P.P.**, 1974; Texas Tech U., **P.P.**, Color-print USA, 1974. **Address:** 831 Broadway, NYC 10003. **One-man Exhibitions:** Ohio U., 1956; Avant Garde, NYC, 1958; Ball State Teachers College, 1959; Ross Widen Gallery, Cleveland, 1960; Miami/Modern, 1960; Samuel S. Fleisher Art Memorial, Philadelphia, 1961; Yoseido Gallery, Tokyo, 1961; Castagno Gallery, NYC, 1966; Gallery of Graphic Arts, NYC, 1967; Pollock Gallery, Toronto, 1968; Museu de Arte, Rio Grande do Sul, Brazil, 1968; Union of Plastic Artists, Bucharest, 1968; Pryzmat Gallery, Krakow, 1968; Centar Gallery, Zagreb, 1968; Galeria Colibri, San Juan, Puerto Rico, 1968; U. of Calgary, 1969; Mala Gallery, Ljubljana, Yugoslavia, 1969; Bader Gallery, Washington, D.C. (two-man), 1969; Secession Gallery, Vienna, 1970; Spectrum Gallery, NYC, 1971; A.A.A. Gallery, 1971; Graphics Gallery, 1971; Molloy College, Rockville Centre, N.Y., 1971; Jacques Baruch Gallery, 1973; Montclair State College (two-man), 1974. **Group:** Cincinnati/AM Biennials, 1956, 58, 60, 62, 68; PCA, American Prints Today, circ., 1959-62; Gallery of Modern Art, Ljubljana, Yugoslavia, III, IV, VI, VII, & VIII International Exhibition of Prints, 1959, 61, 65, 67, 69; A.F.A., Prints of the World, 1962; The Print Club, Philadelphia, 1962; Library of Congress; MOMA, Prize-Winning American Prints, circ. Canada; Krakow Print Biennials, 1966, 68, 70, 72; Brooklyn Museum Print Biennials, 1968, 70, 72;

U. of Washington, 1969; International Print Biennials, Ljubljana, Yugoslavia, 1969, 71, 73; U. of Washington, Prints/Multiples, 1970; IV American Biennial, Santiago, 1970. **Collections:** Amsterdam/Stedelijk; Ball State U.; Budapest/National; California Palace; Cincinnati/AM; Cleveland/MA; Library of Congress; MMA; MOMA; NCFA; NYPL; NYU; National Gallery; U. of Nebraska; Oakland/AM; PMA; Pasadena/AM; Rockefeller Brothers Fund; Warsaw/National.

STEFANELLI, JOSEPH. b. March 20, 1921, Philadelphia, Pa. **Studied:** Philadelphia Museum School, 1938-40; PAFA, 1941-42; ASL, 1946-48; Hofmann School, 1948-49. Traveled Europe, Middle East. **Taught:** U. of California, Berkeley, 1960, 63; Princeton U., 1963-66; Columbia U., 1966- ; New School for Social Research, 1966- . Artist for *Yank* Magazine, 1942-46 (field drawings made during World War II are in the permanent collection of the War Archives Building, Washington, D.C.). **Awards:** Fulbright Fellowship (Rome), 1958-59; New York State Council on the Arts Grant, 1971. **Address:** 463 West Street, NYC 10014. **Dealer:** The New Bertha Schaefer Gallery. **One-man Exhibitions:** Artists' Gallery, NYC, 1950, 54; The New Gallery, NYC, 1952; Hendler Gallery, Philadelphia, 1953; Ganymede Gallery, NYC, 1956; Poindexter Gallery, 1957, 58, 60; Hacker Gallery, NYC, 1962; Thibaut Gallery, NYC, 1963; Princeton U., 1964; U. of Arkansas, 1965; Westbeth Gallery, NYC, 1971; New School for Social Research, 1972; The New Bertha Schaefer Gallery, 1973, 74. **Group:** Ninth Street Exhibition, NYC, 1951; PAFA; WMAA; Corcoran; Carnegie; U. of Illinois; Buffalo/Albright; Walker; Chicago/AI; MOMA. **Collections:** Baltimore/MA; U. of California, Berkeley; Chase Manhattan Bank; Chicago/AI; Cornell U.; U. of Massachusetts; U. of Montana; NYU; Norfolk; Norfolk/Chrysler; Sarah Lawrence College; Union Carbide Corp.; WMAA; Walker.

STEG, J.L. b. February 6, 1922, Alexandria, Va. **Studied:** Rochester Institute of Technology; State U. of Iowa, BFA, MFA. Traveled Europe, Mexico, Spain. **Taught:** Cornell U., 1949-51; Tulane U., 1951- . **Member:** SAGA. **Awards:** Carnegie Exchange Fellowship (Italy); VIII Lugano Drawing and Print Show, 1,000-Franc Award; Brooklyn Museum, **P.P.;** Seattle/AM, **P.P.;** Dallas/MFA, **P.P.;** Birmingham, Ala./MA, **P.P.;** U. of Minnesota, **P.P.;** Syracuse State Fair, **P.P.;** Library of Congress, Pennell **P.P.;** New Orleans/Delgado, **P.P.;** The Print Club, Philadelphia, **P.P. Address:** 7919 Spruce Street, New Orleans, La. **Dealer:** A.A.A. Gallery, NYC; Gallery 1640. **One-man Exhibitions:** (first) Weyhe Gallery, 1945; Utica, 1951; Philadelphia Art Alliance, 1957; Davenport/Municipal, 1958; Dallas/MFA; Orleans Gallery, New Orleans; A.A.A. Gallery, NYC; U. of South Florida; Baton Rouge; Studio-Craft Gallery, Miami; Bienville Gallery, 1970; The Ohio State U., 1971; Tulane U., 1972, 74; USIS, Ankara, 1975. **Group:** ART:USA, NYC; New York World's Fair, 1964-65; Oakland/AM; USIA; Philadelphia Art Alliance, 50th Anniversary, 1968; U. of Pittsburgh; Oneonta/SUNY, 1969. **Collections:** Albion College; Bezalel Museum; Bowling Green State U.; Brooklyn Museum; Carnegie; Cleveland/MA; Colgate U.; Dallas/MFA; U. of Delaware; George Washington U.; Georgia State U.; Harvard U.; IBM; Library of Congress; MOMA; Malmo; U. of Minnesota; NYPL; U. of Nebraska; New Orleans/Delgado; The Ohio State U.; Oklahoma; Oslo/National; PMA; Princeton Print Club; The Print Club, Philadelphia; Print Club of Rochester; Randolph-Macon College; Remington-Rand Corp.; Roanoke; Sao Paulo; San Antonio/McNay; Seattle/AM; Smithsonian; Southern Illinois U.; USIA; US State Department; Utica; Worcester/AM.

STEIN, RONALD. b. September 15, 1930, NYC. **Studied:** Cooper Union, with Will Barnet; Yale U., with Josef Albers, BFA; Rutgers U., MFA. Traveled Europe, North Africa. **Taught:** Worcester Museum School, 1959-60; Rutgers U., 1960-61. **Commissions:** Uris Buildings Corp. (80-ft. mosaic mural for No. 2 Broadway, NYC). **Awards:** Yale U. Traveling Fellowship. **Address:** 76 East 79 Street, NYC. **Dealer:** Marlborough Gallery Inc., NYC. **One-man Exhibitions:** (first) Boris Mirski Gallery, Boston, 1956; Gallery Mayer, NYC, 1960, 61; Irving Galleries, Inc., Milwaukee, 1961; Cheekwood, 1961; Tibor de Nagy Gallery, 1964; Eleanor Rigelhaupt Gallery, Boston, 1966; Marlborough Fine Art Ltd., 1967. **Group:** Chicago/AI, 1956, 57; Lincoln, Mass./De Cordova, 1958; Carnegie, 1959; Corcoran, 1961; Pan-Pacific Exhibition, circ. Japan, 1961; MOMA; ICA, Boston, 1961; New York World's Fair, 1964-65. **Collections:** A.F.A.; Buffalo/Albright; Carnegie; Cheekwood; Guild Hall; Guild Plastics Co.; Hartford/Wadsworth; Loch Haven Art Center; New York Hilton Hotel; North Shore State Bank; Ringling; SRGM; Uris Buildings Corp.; Wellesley College.

STEINBERG, SAUL. b. June 15, 1914, Ramnicul-Sarat, Rumania. **Studied:** U. of Milan, 1932-40. To USA 1942; citizen 1943. US Navy, 1943-46. **Commissions:** Terrace Plaza Hotel, Cincinnati, 1948 (mural). **Address:** Amagansett, N.Y. 11930. **Dealer:** Sidney Janis Gallery. **One-man Exhibitions:** Betty Parsons Gallery, 1940 (two-man, with Constantino Nivola), 1966, 69, 73; Wakefield Gallery, NYC, 1943; Sao Paulo, 1952; Frank Perls Gallery, 1952; Galerie Blanche, Stockholm, 1953; Amsterdam/Stedelijk, 1953; Arts Club of Chicago, 1953; A.F.A., circ., 1953-55; Galerie Maeght, 1953, 66, 73, Zurich, 1971; Hannover/K-G., 1954; Basel, 1954; ICA, London, 1957; Sidney Janis Gallery, 1966, 69, 73; Rotterdam, 1967; Obelisk Gallery, 1967; Irving Galleries, Inc., Milwaukee, 1968; J. L. Hudson Art Gallery, Detroit, 1969; Kiko Gallery,

Saul Steinberg *Villa Maria* 1972

Houston, 1970; Felix Landau Gallery, 1971. **Retrospective:** Cologne/Kunstverein, circ., 1974-75. **Group:** MOMA, Fourteen Americans, circ., 1946; Chicago/AI, 1949; L'Obelisco, Rome, 1951; ICA, London, 1952; Brussels World's Fair, 1958; Salon du Mai, Paris, 1966; Carnegie, 1970; Foundation Maeght, L'Art Vivant, 1970. **Collections:** Buffalo/Albright; Detroit/Institute; Harvard U.; MMA; MOMA; Utica; Victoria and Albert Museum. **Bibliography:** Baudson; Baur 7; Biddle 4; Kepes 2; *Metro*; Miller, ed. 2; Richardson, E.P., Rodman 1; Sachs; Schneider; **Steinberg, S. 1, 2, 3.**

STEINER, MICHAEL. b. 1945, NYC. **Studied:** ASL, with Stephen Green. **Awards:** Guggenheim Foundation Fellowship, 1971. **Address:** 704 Broadway, NYC 10003. **Dealer:** Andre Emmerich Gallery, NYC. **One-man Exhibitions:**

(first) Fischbach Gallery, 1964; Dwan Gallery, NYC, 1966, 68; U. of Saskatchewan, Regina, 1970; Marlborough Gallery Inc., NYC, 1970, 72, 74; Makler Gallery, 1970; David Mirvish Gallery, 1970; U. of Toronto, 1971; Noah Goldowsky/Richard Bellamy, NYC, 1972; Boston/MFA, 1974; Andre Emmerich Gallery, NYC, 1975. **Group:** Ridgefield/Aldrich, 1968; The Hague, 1968; Wellesley College, 1970; Toledo/MA, The Form of Color, 1970; WMAA, 1970, 72; Akron/AI, 20th Century Sculpture, 1971; Edmonton Art Gallery, Alberta, Masters of the Sixties, 1972; Montreal/Contemporain, 11 Artistes Americains, 1973; NIAL, 1975.

STELLA, FRANK. b. May, 1936, Malden, Mass. **Studied:** Phillips Academy, with Patrick Morgan; Princeton U., with William Seitz, Stephen Greene. **Awards:** International Biennial Exhibi-

tion of Paintings, Tokyo, First Prize, 1967. **Address:** c/o Dealer. **Dealers:** Leo Castelli Inc.; Knoedler Contemporary Art. **One-man Exhibitions:** Leo Castelli Inc., 1960, 62, 64, 66, 67, 69, 70, 73, and two-man, 1962; Galerie Lawrence, Paris, 1961, 64; Ferus Gallery, Los Angeles, 1963, 65; Kasmin Ltd., 1964, 66, 68, 71; Harvard U., Three American Painters (three-man, with Kenneth Noland, Jules Olitski), circ. Pasadena, 1965; Pasadena/AM, 1966, 71; David Mirvish Gallery, 1966, 68, 71; Seattle/AM, 1967; Galerie Bischofberger, Zurich, 1967; Douglas Gallery, Vancouver, 1967; WGMA, 1968; Irving Blum Gallery, Los Angeles, 1968, 69, 70, 72; Bennington College, 1968; U. of Puerto Rico, 1969; Brandeis U., 1969; MOMA, 1970; Lawrence Rubin Gallery, NYC, 1970, 71; Galerie Rene Ziegler, 1970; Hayward Gallery, London, 1970; Amsterdam/Stedelijk, 1970; Joseph Helman Gallery, St. Louis, 1970; Toronto, 1971; Hansen-Fuller Gallery, 1971; John Berggruen Gallery, 1971; Knoedler Contemporary Art, 1973; Portland (Ore.) Center for the Visual Arts, 1974; U. of Washington, Seattle, 1974; ACE Gallery, Vancouver, 1974. **Group:** Oberlin College, 3 Young Painters, 1959; MOMA, Sixteen Americans, circ., 1959; SRGM, Abstract Expressionists and Imagists, 1961; Houston/MFA, Ways and Means, 1961; A.F.A., Explorers of Space, circ., 1961-62; Seattle World's Fair, 1962; WMAA, Geometric Abstraction in America, circ., 1962; Chicago/AI, 1963, 65; Corcoran, 1963, Biennial, 1967; WGMA, The Formalists, 1963; Jewish Museum, Toward a New Abstraction, 1963; Musee Cantonal des Beaux-Arts, Lausanne, I Salon International de Galeries Pilotes, 1963; Brandeis U., New Directions in American Painting, 1963; Jewish Museum, Black and White, 1963; Hartford/Wadsworth, Black, White, and Gray, 1964; Los Angeles/County MA, Post Painterly Abstraction, 1964; XXXII Venice Biennial, 1964; WMAA Annuals, 1964, 67; MOMA, The Responsive Eye, 1965; VIII Sao Paulo Biennial, 1965; SRGM, Sys-temic Painting, 1966; Kansas City/Nelson, Sound, Light, Silence, 1966; Amsterdam/Stedelijk, New Shapes of Color, 1966; Expo '67, Montreal, 1967; International Biennial Exhibition of Paintings, Tokyo, 1967; Carnegie, 1967; Eindhoven, 1967; Documenta IV, Kassel, 1968; MOMA, The Art of the Real, 1968; PMA, 1968; Vancouver, 1969; U. of California, Irvine, New York: The Second Breakthrough 1959-1964, 1969; Worcester/AM, The Direct Image, 1969; Denver/AM, Report on the Sixties, 1969; WMAA, 1969; MMA, New York Painting and Sculpture: 1940-1970, 1969-70; Chicago/Contemporary (four-man), 1970; Cincinnati/Contemporary, Monumental Art, 1970; Carnegie, 1971; WMAA, The Structure of Color, 1971; Dublin/Municipal, International Quadriennial (ROSC), 1971; High Museum, The Modern Image, 1972; Kansas City/Nelson, Color Field Painting to Post Color Field Abstraction, 1972; Houston/MFA, The Great Decade of American Abstraction: Modernist Art 1960-1970, 1974; U. of Miami, Less is More: The Influence of the Bauhaus on American Art, 1974; VMFA, Twelve American Painters, 1974. **Collections:** Buffalo/Albright; MOMA; Pasadena/AM; WMAA. **Bibliography:** Alloway 3; Battcock, ed.; Bihalji-Merin; Calas, N. and E.; *Contemporanea*; Coplans 2; De Vries, ed.; Goossen 3; *The Great Decade*; Hunter, ed.; Kozloff 3; Lippard 5; MacAgy 2; Rickey; Rose, B. 1, 4; **Rubin 2**; *7 Decades*; Tomkins.

STELLA, JOSEPH. b. June 13, 1877, Muro Lucano, Italy; **d.** November 5, 1946, NYC. To USA 1896; citizen 1923. **Studied** medicine and pharmacology, 1896; ASL, 1897; New York School of Art, 1898-1900, with William M. Chase. Traveled Europe, USA. **Member:** Societe Anonyme. **Awards:** One-year scholarship to New York School of Art, 1899. **One-man Exhibitions:** (first) Carnegie, 1910; Italian National Club, NYC, 1913; Bourgeois Gallery, NYC, 1920; Societe Anonyme, NYC; Duden-

sing Gallery, NYC, 1924; The New Gallery, NYC, 1926; Des Moines Art Association, 1926; Curt Valentine Gallery, NYC, 1926, 28, 31, 35; Angiporto Galleria, Naples, 1929; Galerie Sloden, Paris, 1930; Washington Place, Paris, 1932; Cooperative Gallery, Newark, 1937; A.A.A. Gallery, NYC, 1941; M. Knoedler & Co., NYC, 1942; ACA Gallery, 1943; The Zabriskie Gallery, 1958, 59, 60, 61; MOMA, circ., 1960 (drawings); Robert Schoelkopf Gallery, NYC, 1963, 64, 66, 70; U. of Maryland, 1968; Rutgers U., 1970. **Retrospective:** Newark Museum, 1939; WMAA, 1963. **Collections:** Indiana State College; Iowa State Education Association; MMA; MOMA; U. of Nebraska; Newark Museum; WMAA; Walker, Yale U. **Bibliography:** *Arthur Dove: The Years of Collage; Avant-Garde Painting and Sculpture;* **Baur** 3, 5, 7; Bethers; Biddle 4; Blanchard; Blesh 1; Brown; Cahill and Barr, eds.; Christensen; Dreier 2; Eliot; Elsen 2; Flanagan; *Forerunners;* Frost; Gerdts; Goodrich and Baur 1; Haftman; Hess, T.B. 1; Hulten; Hunter 6; Janis and Blesh 1; Janis, S.; Kozloff 3; Kuh 1; McCoubrey 1; McCurdy, ed.; Mellquist; Mendelowitz; Poore; Richardson, E.P.; Ritchie 1; Rose, B. 1, 4; Rosenblum 1; Rubin 1; Seitz 3; Soby 5; Tashjian; Tomkins and Time-Life Books. Archives.

STERN, GERD. b. October 12, 1928, Saarbrucken, Germany. **Studied:** Black Mountain College, with M.C. Richards. Traveled USA, Latin America, Venezuela, Brazil, England. **Taught:** Harvard U., 1967-68; U. of California, Santa Cruz, 1971-72. President, Intermedia Systems Corp. **Commissions:** Immaculate Heart College; Associated Coin Amusement Company, Los Angeles (flashing mural); WMAA. **Awards:** New York State Council on the Arts; National Council on the Arts; Massachusetts State Council on the Arts Grant. **Address:** Intermedia Systems Corp., 711 Massachusetts Avenue, Cambridge, Mass.02139. **One-man Exhibitions:** (first) SFMA, 1963; U. of

British Columbia, 1964. **Group:** Dwan Gallery, Boxes, 1964; SFMA; U. of Rochester; Los Angeles/County MA; International Arts Festival, Newport, R.I.; Jewish Museum; MOMA; Brooklyn Museum; WMAA; Eindhoven; Walker.**Collections:** Associated Coin Amusement Company; Immaculate Heart College; SFMA. **Bibliography:** Davis, D.

STERNBERG, HARRY. b. July 19, 1904, NYC. **Studied:** ASL; and privately with Harry Wickey. Traveled Mexico, Canada. **Taught:** ASL, 1933-68; New School for Social Research, 1942-45; 1950-51; Brigham Young U., 1958; U. of Southern California, 1959-69; Palomar College, 1974. Directed and produced a film, "The Many Worlds of Art," 1960. **Federal A.P.** (murals): US Post Offices, Sellersville, Pa., and Chester, Pa. (1935-37); advisor on Graphic project. **Awards:** Fifty Prints of the Year, 1930; Fine Prints of the Year, 1932, 33, 34; Guggenheim Foundation Fellowship, 1936; 100 Prints of the Year, 1938; The Print Club, Philadelphia, 1942; Audubon Artists, 1955; AAAL, **P.P.**, 1972. **Address:** 1606 Conway Drive, Escondido, Calif. 92027. **Dealer:** ACA Gallery. **One-man Exhibitions:** Keppel & Co., NYC, 1937; Weyhe Gallery, 1941; ACA Gallery, 1947, 50, 56, 58, 60, 62, 64, 66, 68, 70, 72, 74; U. of Minnesota, 1957; Garelick's Gallery, Detroit, 1958; Brigham Young U., 1958; Idyllwild Art School, 1958; Gallery Eight, Santa Barbara, 1961; Salt Lake Art Center, Salt Lake City, 1961. **Group:** WMAA; Chicago/AI; Walker; U. of Minnesota; de Young; Brooklyn Museum; MOMA. **Collections:** Andover/Phillips; Auckland; Bibliotheque Nationale; Brooklyn Museum; Cleveland/MA; de Young; Harvard U.; Library of Congress; MMA; MOMA; U. of Minnesota; NYPL; Phillips; U. of Southern California; Syracuse U.; Tel Aviv; Victoria and Albert Museum; WMAA; Walker. **Bibliography:** American Artists Congress, Inc.; American Artists Group Inc. 3; Hayter 1; *Index of 20th Century Artists;* Mellquist; Reese; **Smith,**

A.; **Sternberg, 1, 2;** Zigrosser 1. Archives.

STERNE, HEDDA. b. August 4, 1916, Bucharest, Rumania. **Studied:** U. of Bucharest; Kunsthistorisches Institut der Universitat, Vienna; and at academies in Paris. To USA 1941. Traveled Europe extensively, Mexico, Latin America. **Awards:** Chicago/AI, Second Prize, 1957; Fulbright Fellowship, 1963. **Address:** c/o Dealer. **Dealer:** Betty Parsons Gallery. **One-man Exhibitions:** (first) Wakefield Gallery, NYC, 1943; Mortimer Brandt, NYC, 1945; Betty Parsons Gallery, 1947, 48, 50, 53, 54, 57, 58, 61, 63, 68, 70, 74; Sao Paulo, 1953; L'Obelisco, Rome, 1953, 61; Arts Club of Chicago, 1955; Vassar College, 1956; Saidenberg Gallery, 1956; Rizzoli Gallery, NYC, 1968; U. of Rochester, 1973; Upstairs Gallery, East Hampton, 1973; Lee Ault & Co., 1975. **Group:** Art of This Century, NYC, 1943, 44; WMAA, The New Decade, 1954-55; Chicago/AI, 1954, 55, 57, 60; MOMA, 1955; RISD, 1955; Stanford U., 1955, 56; U. of Illinois, 1955, 60; Corcoran, 1955, 56, 58, 63; Carnegie, 1955, 58, 61, 64; XXVIII Venice Biennial, 1956; Smithsonian, 1956; VMFA, American Painting, 1958; PAFA, 1958 and Annuals; State U. of Iowa, 1958, 59; Rome-New York Foundation, Rome, 1959, 61; II Inter-American Paintings and Prints Biennial, Mexico City, 1960; WMAA Annuals; U. of Colorado, 1960; Finch College, NYC, Artists at Work, 1971; Minnesota/MA, Drawings USA, 1971. **Collections:** Buffalo/Albright; Carnegie; Chase Manhattan Bank; Chicago/AI; Detroit/Institute; U. of Illinois; Inland Steel Co.; MMA; MOMA; Minnesota/MA; U. of Nebraska; PAFA; Rockefeller Institute; St. Joseph/Albrecht; Toledo/MA; US State Department; United Nations; VMFA; WMAA. **Bibliography:** Motherwell and Reinhardt, eds.; Pousette-Dart, ed.; Read 4. Archives.

STERNE, MAURICE. b. 1878, Libau, on the Baltic; **d.** 1957, NYC. To USA 1889. **Studied:** Cooper Union, 1892; NAD, 1894-99, with Thomas Eakins. Traveled Europe, India, Burma, Java, Egypt. **Member:** National Fine Arts Commission, 1945-51. **Commissions:** Justice Department, Washington, D.C. (mural); Fairmount Park, Philadelphia (monument); Rogers-Kennedy Memorial, Worcester, Mass., 1926. **Awards:** Mooney Traveling Scholarship, 1904; Chicago/AI, The Mr. & Mrs. Frank G. Logan Prize, 1928; Corcoran, William A. Clark Prize and Corcoran Gold Medal, 1930; Carnegie, Hon. Men., 1930; Golden Gate International Exposition, San Francisco, 1939; NAD Annual, Andrew Carnegie Prize, 1957. **One-man Exhibitions:** Paul Cassirer Gallery, Berlin, 1910; Berlin Photograph Co., NYC, 1910, 15; Chicago/AI, 1917; Bourgeois Gallery, NYC, 1917, 22; Boston Arts Club, 1919; Scott and Fowles Gallery, NYC, 1926; Reinhardt Galleries, NYC, 1928, 30; SFMA, 1936, 38; Honolulu Academy, 1939; The Milch Gallery, 1962. **Retrospective:** MOMA, 1933; Phillips, 1952; Hirschl & Adler Galleries, Inc., NYC, 1962. **Group:** Rome National Art Quadrennial, 1925; Chicago/AI; Corcoran; WMAA; SFMA; Brooklyn Museum; Newark Museum. **Collections:** Carnegie; Chicago/AI; Cleveland/MA; Cologne; Corcoran; Detroit/Institute; MMA; Phillips; RISD; San Diego; Yale U. **Bibliography:** Baur 7; Biddle 4; Birnbaum; Blesh 1; Brown; Cahill and Barr, eds.; Cheney; Coke 2; Eliot; Genauer; Goodrich and Baur 1; Hall; *Index of 20th Century Artists;* Jackman; Jewell 2; **Kallem;** Kent, N.; Kootz 1; Mather 1; Mayerson, ed.; McCurdy, ed.; Mendelowitz; Neuhaus; Parkes; Phillips 2; Richardson, E.P.; Ringel, ed.; Rose, B. 1; Sachs. Archives.

STEVENSON, HAROLD. b. March 11, 1929, Idabel, Okla. **Studied:** U. of Oklahoma; U. of Mexico; ASL. Traveled Europe, Mexico, USA; resided Paris ten years. Subject of the Andy Warhol film "Harold," 1964. **Taught:** Austin College, Artist-in-Residence. **Address:** 302 Southeast Adams, Idabel, Okla. 74745. **Dealers:** Iris Clert Gallery; Alexandre

Iolas Gallery, NYC. **One-man Exhibitions:** (first) Alexandre Iolas Gallery, NYC, 1956, also 1958, 65, 72, 73; Galerie la Cour d'Ingres, Paris, 1960; Iris Clert Gallery, 1962, 63, 68; Robert Fraser Gallery, 1962; Richard Feigen Gallery, Chicago, Los Angeles, and NYC, 1964; Galerie Svensk-Franska, Stockholm, 1965; American Embassy, Paris, 1969; Knoedler & Co., Paris, 1970; Galeria Blu, Milan, 1971; La Medusa Gallery, Rome, 1970, 73; Alexandre Iolas Gallery, Paris, 1973; Galerie Zoumbulakis, Athens, 1973. **Group:** Salon du Mai, Paris, 1962; WMAA Annual, 1964; Musee de la Haye, Amsterdam, 1964; Palais des Beaux-Arts, Brussels, 1965; Galerie Svensk-Franska, Stockholm, 1965; ICA, London, The Obsessive Image, 1968; Prospect '68, Dusseldorf, 1968; ICA, London, The Obsessive Image, 1968; Dusseldorf/Kunsthalle, Prospect '68, 1968; HemisFair '68, San Antonio, Tex., 1968; Musee du Louvre, Paris, Comparaisons, 1969; CNAC, L'Image en Question, 1971; Paris, Salon d'Automne, 1971. **Bibliography:** Lippard 5. Archives.

STILL, CLYFFORD. b. November 30, 1904, Grandin, N.D. **Studied:** Spokane U., 1933, BA; Washington State College, MA. **Taught:** Yaddo, 1934, 35; Washington State College, 1935-45; College of William and Mary, 1944; California School of Fine Arts, 1946-50; "Subject of the Artist," NYC, 1947-48; Hunter College, 1952; Brooklyn Museum School, 1952; U. of Pennsylvania, 1963. Encouraged California students to form a group which became the Metart Gallery. **Awards:** Skowhegan School, Medal for Painting, 1975. **Address:** P.O. Box 337, Windsor, Md. 21776. **Dealer:** Marlborough Gallery Inc, NYC. **One-man Exhibitions:** (first) SFMA, 1943; Art of This Century, NYC, 1946; Metart Gallery, San Francisco, 1950; ICA, U. of Pennsylvania, 1964; Marlborough-Gerson Gallery Inc., 1969, 71. **Retrospective:** Buffalo/Albright, 1959. **Group:** MOMA,

Fifteen Americans, circ., 1952; MOMA, The New American Painting, circ. Europe, 1958-59; Documenta II, Kassel, 1959; MOMA, The New American Painting and Sculpture, 1969. **Collections:** Baltimore/MA; Buffalo/Albright; MOMA; Phillips; WMAA. **Bibliography:** Ashton 5; Battcock, ed.; Blesh 1; Chipp; *Clyfford Still*; Finkelstein; Flanagan; Gaunt; Goossen 1; *The Great Decade*; Greenberg 1; Haftman; Hess, T.B. 1; Hunter 1, 6; Hunter, ed.; McChesney; McCurdy, ed.; *Metro*; Ponente; Read 2; Richardson, E.P.; Rickey; Rose, B. 1; Rosenblum 2; Rubin 1; Sandler; Seuphor 1; Tuchman, ed.

STONE, SYLVIA. b. June, 1928, Toronto, Canada. **Studied:** ASL, 1950-52, with Vaclav Vytlacil and Morris Kantor. Traveled Europe, Central America, Morocco. **Taught:** Brooklyn College. **Awards:** CAPS, 1971; National Endowment for the Arts Grant. **Address:** 435 W. Broadway, NYC 10012. **Dealer:** Andre Emmerich Gallery, NYC. **One-man Exhibitions:** Brata Gallery, NYC (two-man), 1959; Tibor de Nagy, NYC, 1967, 68, 69; Andre Emmerich Gallery, NYC, 1972, 75. **Group:** Newark Museum, Cool Art, 1968; Walker, 14 Sculptors: The Industrial Edge, 1969; WMAA, 1969, 71, 73; ICA, U. of Pennsylvania, Plastics and New Art, 1969; Milwaukee, A Plastic Presence, circ., 1969. **Collections:** Buffalo/Albright; Hartford/Wadsworth; Ridgefield/Aldrich; WMAA. **Bibliography:** Friedman, M.2.

STOUT, MYRON ʖ. b. December 5, 1908, Denton, Tex. **Studied:** North Texas State U., 1930, BS; Columbia U., with C. J. Martin, MA; Academia San Carlos, Mexico City, 1933; Hofmann School. US Army and Air Force, 1943-45. Traveled France, Italy, Mexico, Greece, Turkey. **Taught:** Fine Arts Work Center, Provincetown, Mass., Artist-in-Residence, 1968. **Awards:** National Council on the Arts, 1966; J. S. Guggenheim Fellowship, 1969. **Address:** 4 Brewster Street, Provincetown,

Mass. **One-man Exhibitions:** (first) The Stable Gallery, NYC, 1954, Hansa Gallery, NYC, 1957, 58 (three-man). **Group:** WMAA Annual, 1958; Carnegie, 1959; ICA, Boston, 100 Works on Paper, circ. Europe, 1959; ICA, Boston, Paintings, USA, 1959; A.F.A., New Talent, circ., 1960; WMAA, Geometric Abstraction in America, circ., 1962; Jewish Museum, 1964; SRGM, American Drawings, 1964; Corcoran Biennial; Buffalo/Albright, Plus by Minus, 1968; WMAA, American Drawings: 1963-1973, 1973. **Collections:** Brooklyn Museum; Carnegie; MOMA; SRGM; WMAA; Woodward Foundation. **Bibliography:** MacAgy 2.

STROUD, PETER ANTHONY. b. May 23, 1921, London, England. **Studied:** London University; Central School of Arts and Crafts, London, 1950, BFA, 1952, BA.Ed., 1953, MFA. British Army, 1939-45. Traveled Europe, Near East. **Taught:** Maidstone College of Art, 1962-63; Bennington College, 1963-64; 1966-68; Hunter College, 1965-66; Maryland Institute, 1968; Rutgers U., 1968- . **Commissions:** Royal Festival Hall, London, "Groupe Espace" Project, 1958; International Union of Architects, London (mural), 1961; State School, Leverkusen, Germany (mural), 1963; Manufacturers Hanover Trust Co., NYC (mural), 1969; Watertown (N.Y.) State Office Building, 1970. **Address:** 311 Church Street, NYC 10013. **Dealer:** Max Hutchinson Gallery. **One-man Exhibitions:** ICA, London, 1961; Bennington College, 1964; U. of Vermont, 1966; Marlborough-Gerson Gallery Inc., 1966; Nicholas Wilder Gallery, 1967; Axiom Gallery, London, 1968; Galerie Muller, 1969; Gertrude Kasle Gallery, 1969; Rutgers U., 1969; Max Hutchinson Gallery, 1970, 72; 73; Bernard Jacobson Gallery, London, 1971; Hoya Gallery, London, 1974. **Group:** Groupe Espace, London and Paris, 1957; New Vision Centre, London, Form and Experiment, 1957; Drian Gallery, London, Construction Great Britain: 1950-60, 1960; Carnegie, 1961,

64; Leverkusen, Constructivism 1962, 1962; Kunsthalle, Basel, Seven Young British Painters, 1963; MOMA, The Responsive Eye, 1965; Jewish Museum, European Painters Today, 1968; Museum of Modern Art, Oxford, Painters of the Sixties, 1969; Melbourne/National, Form and Structure, 1970; U. of California, Santa Barbara, Constructivist Tendencies, circ., 1970; Ulster Museum, From Sickert to Conceptual Art, 1971; Finch College, NYC, The Constructivist Tradition, 1972. **Collections:** Detroit/Institute; Leverkusen; Los Angeles/County MA; Newark Museum; Pasadena/AM; SRGM; San Diego; Tate; Trenton/State; U. of Vermont; Whitworth.

STUEMPFIG, WALTER. b. 1914, Germantown, Pa.; **d.** November 30, 1970, Ocean City, N.J. **Studied:** PAFA, 1931-35. **Taught:** PAFA, 1946-70. **Member:** NIAL. **Awards:** PAFA, Cresson Fellowship, 1933. **One-man Exhibitions:** Philadelphia Art Alliance, 1942; Durlacher Brothers, NYC, 1943-62; de Young, 1946; Artists' Gallery, Philadelphia, 1947; Woodmere Art Gallery, Philadelphia, 1953; U. of Miami, 1960; MIT, 1960; Art Association of Newport (R.I.), 1961; Maynard Walker Gallery, NYC, 1962; Richard Larcada Gallery, 1965, 70; PAFA, 1970. **Group:** PAFA; PMA. **Collections:** Chicago/AI; Corcoran; Harvard U.; MMA; MOMA; PMA; WMAA. **Bibliography:** Bazin; Eliot; Hunter 6; Mendelowitz; Nordness, ed.; Soby 5; Wight 2.

SUGARMAN, GEORGE. b. May 11, 1912, NYC. **Studied:** Zadkine School of Sculpture, Paris, 1955-56. Traveled Mexico, USA, Europe; resided Paris, 1951-55. **Taught:** Hunter College, 1960- ; Yale U., 1967-68. **Commissions:** Geigy Chemical Corp. (wall sculpture); Xerox Data Systems, El Segundo, Calif.; First National Bank of St. Paul, Minn.; Albert M. Greenfield School, Philadelphia; City of Leverkusen, West Germany; South Mall, Albany; Brussels World Trade Center; Garmatz

George Sugarman *Kite Castle* 1974

Federal Building, Baltimore. **Awards:** Longview Foundation Grant, 1960, 61, 63; Carnegie, Second Prize, 1961; Ford Foundation, 1965; National Council on the Arts, 1966. **Address:** 21 Bond Street, NYC 10012. **Dealer:** The Zabriskie Gallery. **One-man Exhibitions:** Union Dime Savings, NYC, 1958; Widdifield Gallery, NYC, 1960; Stephen Radich Gallery, 1961, 64, 65, 66; Philadelphia Art Alliance, 1965; Dayton's Gallery 12, Minneapolis, 1966; Fischbach Gallery, 1966-69; Galerie Schmela, 1967; Ziegler Gallery, 1967; Kunsthalle, Basel, 1969; Krefeld/Kaiser Wilhelm, 1969; One Hundred and Eighteen: An Art Gallery, Minneapolis, 1971; Dag Hammarskjold Plaza, NYC, 1974; The Zabriskie Gallery, 1974. **Retrospective:** Kunsthalle, Basel, circ. Amsterdam, West Germany, 1969. **Group:** A.F.A., Sculpture in Wood, circ., 1941-42; Salon de la Jeune Sculpture, Paris, 1952, 54; Salon des Realites Nouvelles, Paris, 1954; Silvermine Guild, 1958; Claude Bernard, Paris, 1960; Carnegie, 1961; Seattle World's Fair, 1962; Hartford/

Wadsworth, 1962; A.F.A., Sculpture for the Home, circ., 1962; Chicago/AI, 1962, 66; VII Sao Paulo Biennial, 1963; Walker, Ten American Sculptors, 1964; Jewish Museum, Recent American Sculpture, 1964; ICA, U. of Pennsylvania, 1964; New York World's Fair, 1964-65; NYU, 1965; Flint/Institute, 1965; WMAA, Art of the U.S. 1670-1966, 1966; Los Angeles/County MA, American Sculpture of the Sixties, 1967; WMAA, Sculpture Annuals, 1967, 69; Foundation Maeght, l'Art Vivant, circ. French museums, 1968; XXXIV Venice Biennial, 1968; MOMA, 1969; Foundation Maeght, L'Art Vivant, 1970; U. of Nebraska, American Sculpture, 1970; WMAA, 1970, 73; Cincinnati/Contemporary, Monumental Art, 1970; Middelheim Park, Antwerp, XI Sculpture Biennial, 1971; MIT, Outdoor Sculpture, 1972; WMAA, American Drawings: 1963-1973, 1973; Newport, R.I., Monumenta, 1974. **Collections:** Basel; Chicago/AI; Ciba-Geigy Corp.; Kalamazoo/Institute; Krefeld/Haus Lange; MIT; MOMA; Museum Schloss Marberg; NCFA; NYU; St. Louis/City; The Singer Company Inc.; Torrington Mfg. Corp.; Walker; Wuppertal. **Bibliography:** Battcock, ed.; Calas, N. and E.; Janis and Blesh 1; *Monumenta*; Rickey; Tuchman 1. Archives.

SUMMERS, CAROL. b. December 26, 1925, Kingston, N.Y. **Studied:** Bard College, with Stefan Hirsch, Louis Schanker, 1951, BA. US Marine Corps, 1944-48. Traveled the Orient, Italy, France, Czechoslovakia, Central America, India. **Taught:** Hunter College, 1963-64; Brooklyn Museum School; School of Visual Arts, NYC; Pratt Graphics Center, NYC; Columbia U.; Haystack Mountain School of Crafts; U. of Pennsylvania; SFAI, 1973. **Awards:** Italian Government Travel Grant, 1955; L.C. Tiffany Grant, 1955, 61; J.S. Guggenheim Fellowship, 1959; Fulbright Fellowship (Italy), 1961. **Address:** 133 Prospect Court, Santa Cruz, Calif. 95065. **Dealers:** A.A.A. Gallery, NYC; Fendrick Gallery; Graphics I &

Graphics II. **One-man Exhibitions:** (first) The Contemporaries, NYC, 1954, also 1961; MOMA, circ., 1964-66; A.A.A. Gallery, NYC, 1967; Bard College, 1968. **Retrospective:** SFMA, 1967. **Group:** Major national print exhibitions. **Collections:** Baltimore/MA; Bibliotheque Nationale; Boston/MFA; Bradley U.; Brooklyn Museum; Chicago/AI; Cincinnati/AM; Cornell U.; Free Library of Philadelphia; U. of Kentucky; Library of Congress; Los Angeles/ County MA; Lugano; MMA; MOMA; Milwaukee-Downer College; U. of Minnesota; NYPL; National Gallery; U. of Nebraska; New Britain; Ohio U.; PMA; Seattle/AM; U. of Tennessee; U. of Utah; Victoria and Albert Museum; Walker. **Bibliography:** *Carol Summers. Woodcuts 1950-1967.* Archives.

SUTTMAN, PAUL. b. July 16, 1933, Enid, Okla. **Studied:** Adelphi College, with Robert Cronbach; U. of New Mexico, with Adja Yunkers, Robert Mallory, 1956, BFA; Cranbrook, with Tex Schwetz, Maija Groten, 1958, MFA; with Giacomo Manzu, 1960. Traveled Europe, Latin America; resided Mexico, Italy. **Taught:** U. of Michigan, 1958-62; Dartmouth College, 1973. **Commissions:** Roswell (N.M.) Museum and Art Center (bronze relief for façade); National Educational Television, 1961 ("The Bronze Man," a film illustrating casting techniques); Hughes, Hatcher & Suffrin Building, Detroit, 1964; U. of Michigan, 1967. **Awards:** Cranbrook, Horace H. Rackham Research Grant (Florence, Italy), 1960; Fulbright Fellowship (Paris), 1963; Prix de Rome, 1965, 66, 67; Ingram Merrill Foundation Grant, 1972. **Address:** via delle Mantellate 15a,

Paul Suttman *Fruit Table I* 1967

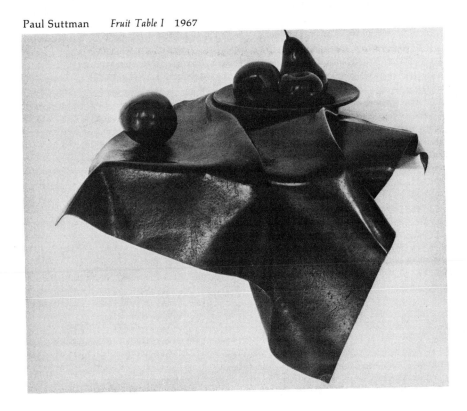

Rome, Italy. **Dealers:** Terry Dintenfass, Inc.; Richard Gray Gallery; Felix Landau Gallery; Donald Morris Gallery. **One-man Exhibitions:** Roswell, 1959; Park Gallery, Detroit, 1959, 62; Donald Morris Gallery, 1959, 62, 65, 67, 69; U. of Michigan, 1962; Terry Dintenfass, Inc., 1962, 64, 65, 67, 69, 71, 73; Felix Landau Gallery, 1970; Robinson Galleries, 1971; Galleria Nuovo Carpine, Sardinia, 1972; Dartmouth College, 1973. **Group:** Youngstown/Butler; Detroit/Institute; U. of Michigan; Santa Barbara/MA; de Young; U. of New Mexico; American Academy, Rome, 1966-68; Musee Rodin, Paris, International Sculpture, 1968; Indianapolis/Herron, 1969; PAFA Annual, 1969; USIS, Rome, 1969, 70, 72. **Collections:** Detroit/Institute; First National Bank of Chicago; Kalamazoo/Institute; Layton School of Art; MOMA; Macomb County Community College; U. of Michigan; Roswell. **Bibliography:** Walker. Archives

SUZUKI, JAMES HIROSHI. b. September 19, 1933, Yokohama, Japan. **Studied:** Privately with Yoshio Markino; Portland (Me.) School of Fine and Applied Art, 1952; The Corcoran School of Art, 1953-54. To USA 1952. Traveled USA, Japan. **Taught:** U. of California, Berkeley, 1962-63; U. of Kentucky, 1966-68. **Awards:** Corcoran, Eugene Weiss Scholarship, 1954; John Hay Whitney Fellowship, 1958; Silvermine Guild, Larry Aldrich Prize, 1959. **Address:** 2003 MacArthur Boulevard, Oakland, Calif. **Dealer:** Quay Gallery. **One-man Exhibitions:** (first) The Graham Gallery, 1957, also 1958, 59, 61, 62; U. of California, Berkeley, 1963; Nihonbashi Gallery, Tokyo, 1963; Seido (Gallery), Kyoto, 1963; Comara Gallery, 1970; Palos Verdes, 1970; Quay Gallery, 1973. **Group:** Corcoran, 1956, 58, 60; WMAA; Baltimore/MA; ICA, Boston, Contemporary Painters of Japanese Origin in America; Cincinnati/AM; Des Moines; A.F.A., Cross-Currents, circ., 1957-58; Syracuse/Everson, 1958; Silvermine Guild, 1959; Hartford/Wadsworth, 1959; Houston/MFA, Waning Moon and Rising Sun, 1959; U. of Nebraska, 1960; SFMA, 1963, 64; Tokyo/Modern, 1964. **Collections:** Corcoran; Hartford/Wadsworth; Kamakura; McDonnell & Co. Inc.; Rockefeller Institute; Tokyo/Modern; Toledo/Ma.

TAKAI, TEIJI. b. February 5, 1911, Osaka, Japan. **Studied:** Shinano Bashi Art School, Osaka, 1929. Traveled north and central China, Europe. **Taught:** Kodo Art School, Tokyo; Winthrop College, Rock Hill, S.C., 1972-74. **Member:** "Nika" (Japanese Modern Art Group), 1939 (accepted for exhibition 1931); Kodo Art Group, 1947. To USA 1954. **Awards:** Niki Prize, 1938; Okada Prize, 1941; Japanese Government Prize, 1943; Fukushima Prize, 1963. **Address:** 235 West 103 Street, NYC 10025. **Dealer:** Poindexter Gallery. **One-man Exhibitions:** Takashimaya Gallery, Tokyo; Diamaru, Osaka; 1949-54; Collectors Gallery, NYC, 1956; Poindexter Gallery, 1959, 61, 63, 65, 68, 72. **Retrospective:** Takashimaya Gallery, Tokyo, 1967. **Group:** ICA, Boston, 1958; WMAA Annuals, 1960, 62; Corcoran, 1960, 62; Carnegie, 1961, 64; Columbia, S.C./MA, 1963; IV, V, & VI International Biennial Exhibitions of Prints, Tokyo, 1964, 66, 68. **Collections:** Columbia, S.C./MA; Corcoran; Friends of Art; Tokyo/Modern; WMAA.

TAKAL, PETER. b. December 8, 1905, Bucharest, Rumania. **Studied:** Paris, Berlin. To USA 1939; citizen 1944. Traveled Europe, Africa, North and South America. **Taught:** Beloit College, 1965; Central College, Iowa,

1968. **Member:** Artists Equity; Color Print Society; SAGA. **Commissions** (graphic art): International Graphic Arts Society, 1956, 59, 63; Print Club of Cleveland, 1956, 57; The Contemporaries, NYC, 1957; A.A.A. Gallery, NYC, 1958. **Awards:** The Print Club, Philadelphia, Max Katzman Award, 1957; Silvermine Guild, Nancy A. Fuller Award, 1959; Yaddo Fellowship, 1961; Pasadena/AM Annual, **P.P.**, 1962; Tamarind Fellowship, 1963-64; Ford Foundation/A.F.A., Artist-in-Residence, 1965. **Address:** Saylorsburg, Pa. 18353; 116 East 68 Street, NYC 10021; 40 rue du Mole, CH 1201, Geneva, Switzerland. **Dealers:** Weyhe Gallery; A.A.A. Gallery, NYC; Van Straaten Gallery. **One-man Exhibitions:** (first) Gallery Gurlitt, Berlin, 1932; Galerie Zak, Paris, 1933; Galerie Jeanne Castel, Paris, 1935, 37; Galerie Derche, Casablanca, 1937; Katharine Kuh Gallery, Chicago, 1937, 39, 41; Galerie Charpentier, Paris, 1939; Chauvin Gallery, Algiers, 1939; Carstairs Gallery, NYC, 1940; Santa Barbara/MA, 1941, 57; de Young, 1942; Karl Nierendorf Gallery, NYC, 1942; Artists' Gallery, NYC, 1954; Duveen-Graham Gallery, NYC, 1955, 58, 1957-58 (circ. American museums and colleges); Wittenborn Gallery, NYC, 1956; Pasadena/AM, 1956; Minneapolis/Institute, 1957; Los Angeles/County MA, 1957; Dallas/MFA, 1957; La Jolla, 1957; Carnegie College of Art, 1957; Mills College, 1957; The Print Club of Philadelphia, 1958; Kansas City/Nelson, 1958; Cleveland/MA, 1959; Memphis/Brooks, 1959; Smithsonian, 1959; Galeria de Arte Mexicano, Mexico City, 1959; Smithsonian, circ. USA, 1959-60; Cushing Galleries, Dallas, 1959-60, 1966; The Contemporaries, NYC, 1959, 60, 62, 66; Palazzo Strozzi, Florence, Italy, 1960; Sabersky Gallery, Los Angeles, 1961; Kestner-Museum, circ. Germany, 1961-62; Philadelphia Art Alliance, 1962; Mary Harriman Gallery Inc., Boston, 1964; Weyhe Gallery, 1964, 65, 68, 72; Beloit College, 1965; Scranton/Everhart, 1967; Central College, 1968; Carnegie/Mellon U., 1969;

Hunt Botanical Library, Pittsburgh, 1969. **Retrospective:** Galerie du Grand-Mezel, Geneva, 1970. **Group:** Salon d'Automne, Paris, 1933-35; A.F.A.; PAFA, 1953, 59, 60, 63, 65, 67, 69; Brooklyn Museum, Print Biennials, 1955-64; WMAA Annuals, 1955-60, 1962-64; Library of Congress Print Annuals, 1955, 58, 59, 60, 62; MOMA, Recent Drawings USA, 1956; The Print Club, Philadelphia, 1956-58, 1961-63; Boston Printmakers, 1956-59, 1962, 63, 64; ICA, Boston, 100 Works on Paper, circ. Europe, 1959; PCA, American Prints Today, circ., 1959-62; Gallery of Modern Art, Ljubljana, Yugoslavia, IV International Exhibition of Prints, 1961; MOMA, circ. Europe and Far East, 1961 (drawings); St. Paul Gallery, Drawings, USA, 1963; SAGA Annual, 1963, 65; Minnesota/MA, 1963, 1966-68, 1971-73; The Japan Print Association, Tokyo, 1967; WMAA, 1968, 69; MOMA, Tamarind: Homage to Lithography, 1969. **Collections:** Achenbach Foundation; Albion College; Andover/Phillips; Baltimore/MA; Beloit College; Berlin/National; Bibliotheque Nationale; Brandeis U.; Bremen; Brooklyn Museum; U. of California, Berkeley; Carnegie; Chicago/AI; Cincinnati/AM; Cleveland/MA; Copenhagen; Dallas/MFA; Darmstadt/Hessisches; de Young; Exeter; Fort Worth; Graphische Sammlung der E.T.H.; Grenoble; Hamburg; Indianapolis/Herron; Karlsruhe; Kassel; Kestner-Museum; Kupferstichkabinett; La Jolla; Library of Congress; Lincoln, Mass./De Cordova; Los Angeles/County MA; MMA; MOMA; U. of Maine; Mills College; U. of Minnesota; Minnesota/MA; Montreal/MFA; NYPL; NYU; National Gallery; Omaha/Joslyn; Oran; PAFA; PMA; Paris/Moderne; Paris/Outre-Mer; Pasadena/MA; RISD; Recklinghausen; Saarlandmuseum; Stockholm/National; Stuttgart; Stuttgart/WK; U. of Texas; Topeka Public Library; UCLA; USIA; US State Department; Uffizi Gallery; Victoria and Albert Museum; WMAA; Walker; U. of Wisconsin; Wuppertal; Yale U. **Bibliography:** Kent, N.

TALBOT, WILLIAM H.M. b. January 10, 1918, Boston, Mass. **Studied:** PAFA, 1936-38, 1940-41, with Walker Hancock; privately with George Demitrios, Boston, 1938-39; Academie des Beaux-Arts, Paris, 1945-46, with Marcel Gaumont. US Army, 1941-46. Traveled USA extensively, Mexico, Canada, Europe (esp. Greece), Egypt, Sudan. **Taught:** Birch Wathen School, 1947-48; Visiting Lecturer, U. of Michigan, 1949. **Member:** President, Sculptors Guild, 1965-68; Federation of Modern Painters and Sculptors; Architectural League of New York; Century Association. **Commissions:** Bryn Mawr College, 1948; Fitchburg (Mass.) Youth Library, 1950; National Council of State Garden Clubs, St. Louis, Mo., 1957-59; Johnson Rehabilitation Center, Barnes Hospital, St. Louis, Mo., 1964. **Awards:** PAFA, Cresson Fellowship, 1941; Prix de Rome, 1941; Connecticut Academy of Fine Arts, Howard Penrose Prize, 1950; NIAL, 1975. **Address:** Washington, Conn. 06793. **Dealers:** Rehn Galleries; Martin Schweig Gallery. **One-man Exhibitions:** (first) Carroll-Knight Gallery, St. Louis, 1949; Andrew-Morris Gallery, NYC, 1963; Earlham College, 1964; Martin Schweig Gallery, 1965, 69; St. Lawrence U., 1966; Hartford (Conn.) Jewish Community Center, 1967; Mattatuck Historical Society Museum, Waterbury, Conn., 1967; Rehn Galleries, 1968, 71; Arts Club of Chicago, 1972. **Group:** Federation of Modern Painters and Sculptors Annuals; Fairmount Park Association, Philadelphia, Sculpture International; Boston Arts Festival; WMAA; PMA; St. Louis/City; Dallas/MFA; Lincoln, Mass./De Cordova; Andover/Phillips; U. of Michigan, 1949; New York World's Fair, 1964-65; PAFA, 1966, and Annuals; Hartford/Wadsworth, 1966; Stamford (Conn.) Museum and Nature Center, 1968; Sculptors Guild, 1968, 69, and Annuals; NIAL, 1975. **Collections:** Bryn Mawr College; The Cambridge School; Earlham College; Rumsey Hall School; St. Lawrence U.; WMAA; Washington U.

TAM, REUBEN. b. January 17, 1916, Kapaa, Hawaii. **Studied:** U. of Hawaii, 1937, B.Ed.; New School for Social Research; Columbia U.; California School of Fine Arts.**Taught:** Brooklyn Museum School, 1948- ; Oregon State U., 1966; Queens College, 1973. **Awards:** Guggenheim Foundation Fellowship, 1948; Golden Gate International, Exposition, San Francisco, 1939, First Prize; U. of Illinois, **P.P.**; Honolulu Academy, First Prize, 1939, 40; Brooklyn Museum, First Prize, 1952, 58; NAD, Landscape Prize, 1974. **Address:** 549 West 123 Street, NYC 10027; summer: Monhegan Island, Me. **Dealer:** Coe Kerr Gallery: **One-man Exhibitions:** (first) California Palace, 1940; Sacramento/Crocker, 1941; Honolulu Academy, 1941, 67; The Downtown Gallery, 1945, 46, 49, 52; U. of Illinois, 1949, 51, 53, 55, 59; Philadelphia Art Alliance, 1954; The Alan Gallery, NYC, 1955, 57, 59, 61, 64; Portland, Ore./AM, 1966; Oregon State U., 1966; The Landau-Alan Gallery, NYC, 1967; Coe Kerr Gallery, 1971; Wichita Art Association, 1971; Molloy College, Rockville Centre, N.Y. **Group:** Carnegie; Brooklyn Museum, Watercolor Biennials; PAFA; Corcoran; Chicago/AI Annuals; VMFA; Walker; WMAA Annuals; WMAA, Artists of Maine; MMA, American Painters Under 35, 1950; MMA, American Paintings Today, 1950; MMA, American Painting, 1953; MOMA, Recent Drawings USA, 1956; U. of Illinois, 1961, 65, 69; Smithsonian, 1969; Omaha/Joslyn, A Sense of Place, 1973; AAAL, 1973; U. of Iowa, 1974; NAD, 1974, 75. **Collections:** AAAL; Berea College; Bowdoin College; Britannica; Brooklyn Museum; Buffalo/Albright; Colby College; Corcoran; Dallas/MFA; Des Moines; Fort Worth; U. of Georgia; Hawaii State Foundation; Hirshhorn; Honolulu Academy; IBM; U. of Illinois; MMA; MOMA; Massillon Museum; U. of Michigan; NCFA;˙NYPL; U. of Nebraska; Newark Museum; North Carolina/State; The Pennsylvania State U.; Reading/Public; Rockland/Farnsworth; Tel Aviv; Temple U.; Utica; WMAA; Wichita/AM; Youngstown/ Butler. **Bibliography:** Bethers; Nordness, ed.; Pousette-Dart, ed. Archives.

TANGUY, YVES. b. January 5, 1900, Paris, France; **d.** January 15, 1955, Woodbury, Conn. French Army, 1920-22. Traveled Africa, USA. To USA 1939; citizen 1948. **m.** Kay Sage. **One-man Exhibitions:** (first) Galerie Surrealiste, Paris, 1928; Galerie des Cahiers d'Art, Paris, 1935, 47; Stanley Rose Gallery, Hollywood, 1935; Julien Levy Galleries, NYC, 1936; Howard Putzell Gallery, Hollywood, 1936; Palais des Beaux-Arts, Brussels (three-man), 1937; Bucher-Myrbor Galerie, Paris, 1938; Guggenheim Jeune Gallery, London, 1938; Hartford/Wadsworth, 1939; Pierre Matisse Gallery, 1939, 42, 43, 45, 46, 50, 63; Arts Club of Chicago, 1940; "G" Place Gallery, Washington, D.C., 1943; SFMA, 1946; Musee du Luxembourg, Paris, 1947; Galerie Maeght, 1947; Copley Gallery, Hollywood, 1948; Galerie Nina Dausset, Paris, 1949; ICA, Washington, D.C., 1952; Kunsthalle, Basel, 1952; L'Obelisco, Rome, 1953; Hartford/Wadsworth, 1954 (two-man); MIT (two-man); Bodley Gallery, NYC, 1960; Petit Galerie, Paris, 1961; Galatea Galleria d'Arte, Turin, 1971; Acquavella Gallery, NYC, 1974. **Retrospective:** MOMA, 1955. **Group:** Chicago/AI; Hartford/Wadsworth; WMAA; MOMA, Fantastic Art, DADA, Surrealism, 1936; Palais des Beaux-Arts, Brussels, 6 Surrealist Painters, 1967. **Collections:** Buffalo/Albright; Chicago/AI; Hartford/Wadsworth; U. of Illinois; MMA; MOMA; PMA; WMAA; Washington U. **Bibliography:** Battcock, ed.; Baur 7; Blanchard; Blesh 1; **Breton** 1, 2, 3, **4**; Canaday; Christensen; Flanagan; Ford; Gascoyne; Genauer; Goodrich and Baur 1; Guggenheim, ed.; Haftman; Hunter 6; Hunter, ed,; Janis, S.; Kozloff 3; Kuh 1; Langui; McCurdy, ed.; Mendelowitz; Pearson 2; Pousette-Dart, ed.; Ramsden 1; Raynal 3; Read 5; Richardson, E.P.; Rosenblum 2; Rubin 1; Sachs; Seitz 3; **Soby** 1, **8**; **Tanguy**; Tomkins and Time-Life Books; Waldberg 3, 4; Zervos.

TANIA (Schreiber). b. January 11, 1924, Warsaw, Poland. **Studied:** McGill U., 1941-42; Columbia U., 1942-44, MA; ASL, 1948-51, with Yasuo Kuniyoski, Morris Kantor, Vaclav Vytlacil, Harry Sternberg. Traveled Europe extensively, Canada, USA, Caribbean. **Taught:** NYU, 1963- . **Address:** 362 West Broadway, NYC 10013. **One-man Exhibitions:** (first) Albert Landry, NYC, 1959, also 1961, 62; The Bertha Schaefer Gallery, 1963, 64. **Group:** NYU, 3 Artists; U. of Illinois; U. of Virginia, Color and Space; WGMA, The Formalists, 1963; Oakland/AM; World House Galleries, NYC, International, 1964. **Collections:** Brandeis U.; Morgan State College; NYU.

TAUBES, FREDERIC. b. April 15, 1900, Lwow, Poland. **Studied:** Academy of Fine Arts, Munich, 1918-20, with Franz von Stuck, Max Doerner; Bauhaus, Weimar, 1920-21, with Josef Itten; and in Berlin and Italy. Traveled Europe extensively, USA, Africa, Near East, Far East. To USA 1930. **Taught:** Mills College, 1938; U. of Hawaii, 1939; U. of Illinois, 1940-41; Cooper Union, 1943; U. of Wisconsin, 1943; U. of Oklahoma; London U.; Oxford; Royal College of Art; and In Canada. Contributing editor, *American Artist* Magazine, 1943-62; columnist and American editor, *Artist* Magazine. **Member:** Fellow, Royal Society of Arts. **Address:** The Studio, Haverstraw, N.Y. 10927. **One-man Exhibitions:** (first) Vienna/Stadt, 1921; The Midtown Galleries; San Diego; Los Angeles/County MA; SFMA; Sacramento/Crocker; Honolulu Academy; U. of Nebraska; Kansas City/Nelson; Mills College; Seattle/AM. **Group:** PAFA, 1935-44; Chicago/AI, 1935-46; Carnegie, 1936-46; Corcoran, 1936-46; VMFA, 1938-46; Memphis/Brooks. **Collections:** American Locomotive Co.; Atlanta/AA; Britannica; de Young; IBM; Indiana U.; Kansas City/Nelson; MMA; Mills College; SFMA; San Diego; Santa Barbara/MA; Standard Oil Co.; Stony Brook/SUNY. **Bibliography:** Allen, C.C., ed.; Boswell 1; **Boswell, ed.;** Kent,

N.; Pagano; **Taubes 1, 2, 3, 4, 5, 6, 7, 8, 9, 10, 11, 12, 13**; Watson, E.W. 2.

TCHELITCHEW, PAVEL. b. September 21, 1898, District of Kaluga, near Moscow, Russia; **d.** July 31, 1957, Grotta Ferrata, Italy. **Studied:** U. of Moscow; Kiev Academy, 1918-20. Traveled Europe, USA, North Africa, USSR. To USA 1934; citizen 1952. Designed sets and costumes for ballets by Balanchine, Massine, and others. **One-man Exhibitions:** (first) Claridge Gallery, London, 1928; A. Tooth & Sons, London, 1933, 35, 38; Julien Levy Galleries, NYC, 1934, 37, 38; Arts Club of Chicago, 1935, 38; Durlacher Brothers, NYC, 1942, 45, 51; Hanover Gallery, 1949; Institute of Modern Art, Buenos Aires, 1949; Detroit/Institute, 1952; Galerie Rive Gauche, Paris, 1954, 56; Galleria d'Arte del Naviglio, Milan, 1955; Catherine Viviano Gallery, 1964, 67; Galerie Lucie Weile, Paris, 1966; MOMA, 1972; Alpine Club, London, 1972, 74. **Retrospective:** Durlacher Brothers, NYC, 1948; Gallery of Modern Art, NYC, 1964. **Group:** Many national and international exhibitions. **Collections:** Hartford/Wadsworth; Kansas City/Nelson; MMA; MOMA; U. of Michigan; Santa Barbara/MA; Tretyakov Art Gallery, Yale U. **Bibliography:** Bazin; Canaday; Flanagan; Ford; Frost; Holme 1; Huyghe; **Kirstein 3; Kirstein, ed.;** Kuh 1; McCurdy, ed.; Mendelowitz; Pousette-Dart, ed.; Richardson, E.P.; **Soby 1, 7; Tyler, P. 1;** Wight 2.

THEK, PAUL. b. November 2, 1933, Brooklyn, N.Y. **Studied:** Cooper Union, ASL, Pratt Institute, 1951-54. Traveled Europe; resided Rome, 1967-75. **Commissions:** Nederlands Dans Theater, sets and costumes for the ballet "Arena," by Glen Tetley, 1969. **Awards:** Fulbright Fellowship, 1967. **Address:** 58 East Third Street, NYC, 10003. **Dealer:** Alexandre Iolas Gallery, Paris and NYC. **One-man Exhibitions:** Mirell Gallery, Miami, Fla., 1957; Galleria 88, Rome, 1963; The Pace Gallery, NYC, 1966; The Stable Gallery, 1964,

67, 69; Thelan Gallery, Essen, 1968; Loernerscuit Gallery, Amsterdam, 1968, 69; Amsterdam/Stedelijk, 1969; Stockholm/National, 1969; Galerie 20, Amsterdam (two-man), 1969; Alexandre Iolas Gallery, NYC, 1975. **Group:** Carnegie, 1967; ICA, London, The Obsessive Image, 1968; Documenta IV, Kassel, 1968; Walker, 1968; Cologne, 1969. **Collections:** CNAC; Cologne. **Bibliography:** *Figures/Environments.*

THIEBAUD, WAYNE. b. November 15, 1920, Mesa, Ariz. **Studied:** San Jose State College; Sacramento State College, BA, MA. US Army Air Force, 1942-45. Traveled Europe, Mexico, USA. **Taught:** Sacramento City College, 1951-60; Sacramento State College, 1954-55; California School of Fine Arts, 1958; U. of California, Davis, 1960- ; Cornell U., summer, 1967. Produced 11 educational motion pictures. **Commissions:** California State Fair, 1950, 52, 55; Sacramento (Calif.) Municipal Utility Building, 1959 (mosaic mural). **Awards:** California State Fair, Art Film Festival, First Prize, 1956; Film Council of America, Golden Reel Award, 1956 (American Film Festival, Chicago); Columbia Records Award, 1959 ($6,000); Scholastic Art Awards for the films "Space" and "Design," 1961; Creative Research Foundation, $1,000 Grant, 1961. **Address:** c/o Department of Art, U. of California, Davis, Calif. 95616. **Dealer:** Allan Stone Gallery. **One-man Exhibitions:** (first) Sacramento/Crocker, 1951, 69; Artists Co-op Gallery, Sacramento, 1957, 58; SFMA, 1961; de Young, 1962; Allan Stone Gallery, 1962-67; Galleria Schwarz; Stanford U., 1965; Albright Museum, Kansas City, Mo., 1966; Pasadena/AM, 1967; WMAA, 1971. **Group:** SFMA Annual; Chicago/AI Annual; WMAA Annual; Los Angeles/County MA; California Palace; Denver/AM; ICA, London; Pasadena/AM, New Paintings of Common Objects, 1962; Houston/Contemporary, Pop Goes the Easel, 1963; IX Sao Paulo Biennial, 1967; Documenta V, Kassel, 1972; and print exhibitions abroad. **Collections:** Achenbach Foundation; American Broadcasting Co.; Brandeis U.; Bryn Mawr College; Buffalo/Albright; California State Library; Chicago/AI; Corcoran; Dallas/MFA; Hartford/Wadsworth; Harvard U.; Houston/MFA; Immaculate Heart College; Kansas City/Nelson; Library of Congress; MMA; MOMA; U. of Miami; Milwaukee; U. of Nebraska; Newark Museum; Oakland/AM; PMA; RISD; SFMA; Sacramento/Crocker; Sacramento State College; San Jose State College; Shasta College; Southern Illinois U.; Stanford U.; Time Inc.; Utah; WGMA; WMAA. **Bibliography:** Hunter, ed.; Lippard 5; Sager; *The State of California Painting;* Weller.

THOMAS, ROBERT C. b. April 19, 1924, Wichita, Kans. **Studied:** Zadkine School of Sculpture, Paris, 1948-49; U. of California, Santa Barbara, 1950, BA; California College of Arts and Crafts, 1952, MFA; and privately with David Green, Pasadena, 1946-47. US Air Force, 1943-46. Traveled Spain, France, Italy; resided Paris, 1960-61, Florence, Italy, 1972-73. **Taught:** U. of California, Santa Barbara, 1954- . **Commissions:** I. Magnin, Century City, Calif.; U. of California, Santa Barbara. **Awards:** Los Angeles Art Festival, Bronze Medal, 1949; Walnut Creek (Calif.) Pageant, Third Prize for Sculpture, 1951; San Francisco Art Association Annual, Bank of America Award, 1952; RAC, First Prize, 1952; San Francisco Art Association, American Trust Co. Award, 1953; RAC, First Prize, Sculpture, 1953; California State Fair, Second Prize and Silver Medal, 1954; Santa Barbara/MA, III Pacific Coast Biennial, **P.P.**, 1959; U. of California Institute for Work in the Creative Arts, 1967-68; and others. **Address:** 38 San Mateo Avenue, Goleta, Calif. 93017. **Dealer:** Adele Bednarz Gallery. **One-man Exhibitions:** (first) U. of California, Santa Barbara, 1949; Coit Lane Gallery, Santa Barbara, 1950; Paul Desch Gallery, Santa Barbara, 1952; Santa Barbara/MA, 1955, 1959 (two-

man), 1963 (three-man); Esther Robles Gallery, 1959, 60, 61, 63, 66; La Jolla, 1960; Esther Bear Gallery, 1961; Adele Bednarz Gallery, 1970, 71, 72, 74. **Retrospective:** U. of California, Santa Barbara, 1966. **Group:** Salon des Artistes Independants, Paris, 1949; Salon du Mai, Paris, 1949; City of Los Angeles Annual, 1949; Los Angeles/County MA, 1950, 55, 56; RAC, 1951, 53; SFMA, 1952, 53, 56, 57; California State Fair, 1954, 57, 58, 59, 60, 62; Oakland/AM, 1954, 55, 56, 58; Denver/AM, 1959, 62; La Jolla, 1962; Ball State Teachers College, 1962, 63. **Collections:** Hirshhorn; Santa Barbara/MA.

THOMPSON, BOB. b. June 26, 1937, Louisville, Ky.; **d.** May 30, 1966, Rome, Italy. **Studied:** Boston Museum School, 1955; U. of Louisville, 1955-58. Traveled Europe, North Africa; resided Paris, Ibiza, NYC, Rome. **Awards:** Walter K. Gutman Foundation Grant, 1961; John Hay Whitney Fellowship, 1962-63. **One-man Exhibitions:** Delancey Street Museum, NYC, 1960; Superior Street Gallery, Chicago, 1961; Martha Jackson Gallery, 1963, 65, 68; El Cosario Gallery, Ibiza, Spain, 1963; The Drawing Shop, NYC, 1963-64; Richard Gray Gallery, 1964, 65; Paula Johnson Gallery, NYC, 1964; Donald Morris Gallery, 1965, 70; East End Gallery, Provincetown, 1965; Louisville/Speed, 1971; U. of Massachusetts, 1974. **Retrospective:** New School for Social Research, 1969. **Group:** Martha Jackson Gallery, 1964; Dayton/AI, International Selection, 1964; Yale U., 1964; New School for Social Research, 1965; Gallery 12 St. Marks, NYC, 1967; Star Turtle Gallery, NYC, The Tenants of Sam Wapnowitz, 1969; Brooklyn Museum, Eight Afro-American Artists, 1971. **Collections:** A.F.A.; American Republic Insurance Co.; Buffalo/Albright; Charlotte/Mint; Dayton/AI; Jay Dorf, Inc.; Miles College.

TOBEY, MARK. b. December 11, 1890, Centerville, Wisc.; **d.** April 24, 1976, Basel, Switzerland. **Studied:** Chicago Art Institute School, 1908, with Frank Zimmerer, Prof. Reynolds. Traveled Europe, Mexico, USA, the Orient extensively. **Taught:** Cornish School, Seattle, intermittently 1923-29; Dartington Hall, Devonshire, England, 1931-38. **Federal A.P.:** Easel painting, 1938. **Awards:** Seattle/AM, Katherine Baker Memorial Award, 1940; MMA, Artists for Victory, $500 Prize, 1942; Portrait of America, Fourth Prize, 1945; NIAL, 1956; Guggenheim International, $1,000 Award, 1956; American Institute of Architects, Fine Arts Medal, 1957; XXIX Venice Biennial, 1958, First Prize of the Commune of Venice; *Art In America* Magazine, 1958 ($1,000); elected to American Academy of Arts and Sciences, 1960 (fails to accept election); Skowhegan School, Painting Award, 1971. **One-man Exhibitions:** (first) M. Knoedler & Co., NYC, 1917; Arts Club of Chicago, 1928, 40; Romany Marie's Cafe Gallery, NYC, 1929; Cornish School, Seattle, 1930; Contemporary Arts Gallery, NYC, 1931; Paul Elder Gallery, San Francisco, 1934; Beaux Arts Gallery, London, 1934; Stanley Rose Gallery, Hollywood, 1935; Seattle/AM, 1942; The Willard Gallery, 1944, 45, 47, 49, 50, 51, 53, 54, 57, 71, 74; Margaret Brown Gallery, Boston, 1949, 54, 56; Portland, Ore./AM, 1950 (three-man); California Palace, circ., 1951; The U. of Chicago, 1952; Zoé Dusanne Gallery, Seattle, 1952; Otto Seligman Gallery, 1954, 57, 62; Chicago/AI, 1955; Gump's Gallery, 1955; Jeanne Bucher, Paris, 1955, 59, 68; Paul Kantor Gallery, Beverly Hills, Calif., 1955; ICA, London, 1955; Victoria (B.C.), 1957; Galerie Stadler, Paris, 1958; St. Albans School, Washington, D.C., 1959; Frederic Hobbs Fine Art Center, San Francisco, 1960; Mannheim, 1960; Galerie Beyeler, Basel, 1961, 70, 71; Royal Marks Gallery, 1961; Seattle World's Fair, 1962; Phillips, 1962; Hanover Gallery, 1968; Bon Marche, Seattle, 1969; PAFA, 1969; Baukunst Galerie, Cologne, 1971; WMAA, 1971; Galleria dell'Ariete, 1971; Tacoma, 1972; Cincinnati/AM, 1972; Galerie Biedermann, Munich,

1973; NCFA, 1974; Krefeld/Haus Lange, 1975. **Retrospective:** Seattle/AM, circ., 1959, 70; Musee des Arts Decoratifs, 1961; MOMA, 1962; Kunstverein, Dusseldorf, 1966; Berne, 1966; Hannover/K-G., 1966; Amsterdam/Stedelijk, 1966; Dallas/MFA, 1968. **Group:** MOMA, Paintings by 19 Living Americans, 1929; New York World's Fair, 1939; Chicago/AI, 1940, 45, 47, 48, 51; MMA, 1942, 44, 45; MOMA, Romantic Painting in America, 1943; Brooklyn Museum, 1945, 51; Seattle/AM, 1945, 50, 51, 52, 53, 55, 56, 58; WMAA, 1945, 46, 47, 49, 62; Tate, 1946; MOMA, Fourteen Americans, circ., 1946; Utica, circ., 1947; XXIV, XXVIII, & XXIX Venice Biennials, 1948, 56, 58; U. of Illinois, 1949, 50, 51, 55, 59; SFMA, 1949; Walker, Contemporary American Painting, 1950; MMA, American Paintings Today, 1950; MOMA, Abstract Painting and Sculpture in America, 1951; Ueno Art Gallery, Tokyo, 1951; U. of Minnesota, 40 American Painters, 1940-50, 1951; I & III Sao Paulo Biennials, 1951, 55; Carnegie, 1952, 55, 58, 61; International Biennial Exhibition of Paintings, Tokyo; Pavillion Vendome, Aix-en-Provence, 1954; France/National, 50 Ans d'Art aux Etats-Unis, circ. Europe, 1955; Darmstadt/Kunsthalle, circ., 1956; III International Contemporary Art Exhibition, New Delhi, 1957; USIA, Eight American Artists, circ. Europe and Asia, 1957-58; WMAA, Nature in Abstraction, 1958; Brussels World's Fair, 1958; American Painting and Sculpture, Moscow, 1959; Documenta II, Kassel, 1959; Walker, 60 American Painters, 1960; Seattle World's Fair, 1962; National Gallery, American Art at Mid-Century, 1973; NCFA, Art of the Pacific Northwest, 1974. **Collections:** Andover/Phillips; Baltimore/MA; Boston/MFA; Brooklyn Museum; Buffalo/Albright; Carnegie; Chicago/AI; Detroit/Institute; Hartford/Wadsworth; MMA; MOMA; Milwaukee; Phillips; Portland, Ore/AM; SFMA; St. Louis/City; Seattle/AM; Utica; WMAA; West Palm Beach/Norton. **Bibliography:** Alvard; Ashton 5;

Baur 5, 7; Beekman; Biddle 4; Bihalji-Merin; Blesh 1; Eliot; Gaunt; Goodrich and Baur 1; Haftman; Henning; Hess, T. B. 1; Hulten; Hunter 1, 6; Hunter, ed.; Janis, S.; Kuh 2, 3; Langui; Leepa; Lynton; *Mark Tobey*; McCurdy, ed.; Mendelowitz; *Metro*; Miller, ed. 2; Neumeyer; Nordness, ed.; Ponente; Pousette-Dart, ed.; Ragon 1, 2; Read 2; Restany 2; Richardson, E. P.; Rickey, Ritchie 1; **Roberts**; Rodman 1, 3; Rose, B. 1; **Seitz** 1, **5**; Seuphor 1; Soby 5; Tapie 1; **Thomas; Tobey**; Weller. Archives.

TODD, MICHAEL. b. June 20, 1935, Omaha, Neb. **Studied:** U. of Notre Dame, 1957, BFA, magna cum laude; UCLA, 1959, MA. **Taught:** UCLA, 1959-61, San Diego, 1968- ; Bennington College, 1966-68. **Awards:** Woodrow Wilson Fellowship, 1957-59; Fulbright Fellowship (Paris), 1961-63; National Endowment for the Arts, 1974. **Address:** 172 Neptune Street, Encinitas, Calif. 92024. **Dealer:** The Zabriskie Gallery. **One-man Exhibitions:** Hanover Gallery, 1964; The Pace Gallery, NYC, 1964; Henri Gallery, 1965, 68; Gertrude Kasle Gallery, 1968; Salk Institute, La Jolla, 1969; Reese Palley Gallery, NYC, 1971; California State U., Fullerton, 1972; U. of Notre Dame, 1972; Palo Alto Square, 1973, 74; The Zabriskie Gallery, 1974. **Group:** American Cultural Center, Paris, 1962; WMAA, 1965, 67, 68, 70; WMAA, Young America, 1965; Jewish Museum, Primary Structure Sculptures, 1966; Los Angeles/County MA, American Sculpture of the Sixties, circ., 1967; Corcoran, 1968; Maeght Foundation, 1970; San Diego, 1974. **Collections:** California State U.; Hirshhorn; Los Angeles/County MA; U. of Notre Dame; Oakland/AM; Pasadena/AM; WMAA.

TOMLIN, BRADLEY WALKER. b. August 19, 1899, Syracuse, N.Y.; **d.** May 11, 1953, NYC. **Studied:** Studio of Hugo Gari Wagner, 1913; Syracuse U., 1917-21; Academie Colarossi, Paris, and Academie de la Grande Chaumiere,

Michael Todd *Lasso* 1973

1923. Traveled Europe. **Taught:** Buckley School, 1932-33; Sarah Lawrence College, 1932-41; Dalton Schools, NYC, 1933-34. **Member:** Federation of Modern Painters and Sculptors; Whitney Studio Club, NYC; Woodstock Artists Association. **Awards:** Scholarship to Wagner Studio, 1913; Syracuse U., Hiram Gee Fellowship; Schlorship to L.C. Tiffany Foundation, Oyster Bay, N.Y.; Carnegie, Hon. Men., 1946; U. of Illinois, **P.P.**, 1949. **One-man Exhibitions:** Skaneateles and Cazenovia, N.Y., 1922; Anderson Galleries, NYC, 1923; Montross Gallery, NYC, 1926, 27; Frank K.M. Rehn Gallery, NYC, 1931, 44; Betty Parsons Gallery, 1950, 53; Phillips, 1955. **Retrospective:** WMAA, circ., 1957; Hofstra U., 1975. **Group:** U. of Illinois, 1949, 51; MOMA, Abstract Painting and Sculpture in America, 1951; U. of Minnesota, 1951; MOMA, Fifteen Americans, circ., 1952; MMA, 1953; WMAA, The New Decade, 1954-55; France/National, 1955; MOMA, The New American Painting and Sculpture,

1969. **Collections:** Andover/Phillips; Cranbrook; U. of Illinois; MMA; Phillips; Utica; WMAA. **Bibliography:** Baur 7; Blesh 1; Flanagan; Goodrich and Baur 1; Haftman; Hess, T.B. 1; Hunter 1, 6; Hunter, ed.; McCoubrey 1; McCurdy, ed.; Mendelowitz; Motherwell and Reinhardt, eds.; Pagano; Ponente; Pousette-Dart, ed.; Read 2; Ritchie 1; Rose, B. 1; Sandler; Seuphor 1; Tuchman, ed.; Weller. Archives.

TOOKER, GEORGE. b. August 5, 1920, NYC. **Studied:** Phillips Academy, 1936-38; Harvard U., AB, 1942; ASL, with Reginald Marsh, Paul Cadmus, Kenneth Hayes Miller, Harry Sternberg. US Marine Corps, 1942-43. Traveled France, Italy, Great Britain. **Taught:** ASL, 1965-68. **Member:** NAD. **Awards:** NIAL Grant, 1960. **Address:** Hartland, Vt. **Dealer:** Rehn Galleries. **One-man Exhibitions:** (first) Hewitt Gallery, NYC, 1951, also 1955; Robert Isaacson Gallery, NYC, 1960, 62; Durlacher Brothers, NYC, 1964, 67; Dart-

mouth College, 1967. **Retrospective:** WMAA, 1974. **Group:** WMAA; MOMA; MMA, 1950, 52; Chicago/AI, 1951; Corcoran, 1951; ICA, London; PAFA, 1952; XXVIII Venice Biennial, 1956; Carnegie, 1958; Festival of Two Worlds, Spoleto, 1958. **Collections:** Dartmouth College; MMA; MOMA; NCFA; Sara Roby Foundation; WMAA; Walker. **Bibliography:** Garver; Goodrich and Baur 1; Mendelowitz; Newmeyer; Nordness, ed.; Pousette-Dart, ed.; Rodman 1; Weller. Archives.

TOVISH, HAROLD. b. July 31, 1921, NYC. **Studied:** WPA Art Project, with Andrew Berger; Columbia U., 1940-43, with Oronzio Maldarelli; Zadkine School of Sculpture, Paris, 1949-50; Academie de la Grande Chaumiere, 1950-51. Traveled France, Italy, Japan, Indonesia, Nepal, Iran, Turkey. **Taught:** New York State College of Ceramics, 1947-49; U. of Minnesota, 1951-54; Boston Museum School, 1957-66; U. of Hawaii, 1969-70; Boston U., 1971- . **Member:** Artists Equity; Boston Visual Artists Union. **Awards:** Minneapolis/Institute, First Prize, Sculpture, 1954; Boston Arts Festival, First Prize for Drawing, 1958, First Prize for Sculpture, 1959; NIAL Grant, 1971. **m.** Marianna Pineda. **Address:** 164 Rawson Road, Brookline, Mass. 02146. **One-man Exhibitions:** (first) Walker, 1953; The Swetzoff Gallery, Boston, 1957, 60, 65; Fairweather-Hardin Gallery, 1960; Terry Dintenfass, Inc., 1965, 73; Andover/Phillips, 1965; Alpha Gallery, 1968, 73. **Retrospective:** Wheaton College, 1967; SRGM, 1968. **Group:** MMA, Artists for Victory, 1942; Toledo/MA, Sculpture Today, 1947; Walker, 1951; SFMA, 1952; Minneapolis/Institute, 1952, 54; WMAA, 1952, 54, 57, 60, 64, 67; Denver/AM, 1955; Carnegie, 1958; Chicago/AI, 1959; MOMA, Recent Sculpture USA, 1959; Venice Biennial; SRGM, The Joseph H. Hirshhorn Collection, 1962; Lincoln, Mass./De Cordova, 1964; U. of Illinois, 1964, 67, 68, 69; PAFA Annual, 1967; HemisFair '68, San Antonio, Tex., 1968. **Collec-**

tions: Andover/Phillips; Boston/MFA; Boston Public Library; Chicago/AI; MOMA; Minneapolis/Institute; U. of Minnesota; PMA; SRGM; WMAA; Walker; Worcester/AM. **Bibliography:** Weller.

TOWNLEY, HUGH. b. February 6, 1923, West Lafayette, Ind. **Studied:** U. of Wisconsin, 1946-48; privately with Ossip Zadkine, Paris, 1948-49; Central School of Arts and Crafts, London, 1949-50, with Victor Passmore. Traveled France, Great Britain, Holland, Brazil, Peru. **Taught:** Layton School of Art, 1951-56; Beloit College, 1956-57; Boston U., 1957-61; U. of California, Berkeley, 1961, Santa Barbara, 1968; Harvard U., 1967; Brown U., 1961- . **Member:** Artists Equity, Boston, 1961. **Commissions:** YMCA, Milwaukee, 1956; Sobin Chemical Co., Boston, 1963. **Awards:** SFMA Annual, 1952; Chicago/AI, Exhibition Momentum, 1952, 53; MIT, Summer Fellowship, 1956; ICA, Boston, View, 1960; ICA, Boston, Selections, 1961; Berkshire Art Association Annual, 1961, 63; Brown U., Hon. MFA, 1962; Rhode Island Arts Festival, 1962, 63; Silvermine Guild, 1963; Yaddo Fellowship, 1964; Kalamazoo Art Center, Lithographic Workshop, Fellowship, 1964; NIAL, 1967; Tamarind Fellowship, 1969; Rhode Island, Governor's Arts Award, 1972. **Address:** 6 Walley Street, Bristol, R.I., 02809. **One-man Exhibitions:** Studio 40, The Hague, 1950 (two-man); Gallerie Apollinaire, London, 1951; U. of Wisconsin, 1955, 68; Beloit College, 1956 (two-man); Milwaukee, 1957; Arts Council of Winston-Salem (N.C.), 1958; The Swetzoff Gallery, Boston, 1958, 59; Connecticut College, 1960; The Pace Gallery, Boston, 1960, 64, NYC, 1964; U. of Connecticut, 1964; Valparaiso U. (Ind.), 1965; Mitchem Gallery, Milwaukee, 1965; U. of New Hampshire, 1965; Temple U., 1966; Eleanor Rigelhaupt Gallery, Boston, 1966; Exeter, 1966; Yale U., 1966; Bristol (R.I.) Museum of Art, 1968 (two-man, with Robert S.

Neuman); Michael Walls Gallery, 1968 (two-man); Lincoln, Mass./De Cordova, 1969; Graphics Gallery, 1969; Bradley Galleries, Milwaukee, 1970; Brockton/Fuller (two-man), 1971; Brown U., 1972. **Group:** USIA, Americans in Paris, circ. Europe, 1949; SFMA Annual, 1952; MOMA, New Talent; Chicago/AI, Exhibition Momentum, 1952, 53, 56, 57, also 1964; Walker, 1956; WMAA, Young America, 1957, Annual, 1962; Carnegie, 1958; Boston Arts Festival, 1958, 61, 64; Silvermine Guild, 1959, 60, 62, 63, 64, 66; ICA, Boston, View, 1960, Selections, 1961; U. of Illinois, 1961, 63; Hartford/Wadsworth, Eleven New England Sculptors, 1963; Lincoln, Mass./De Cordova, 1964; M. Knoedler & Co., Art Across America, circ., 1965-67; Andover/Phillips, 1966; Birmingham, Mich., Art Museum, 1966; U. of North Carolina, 1966; Flint/Institute, I Flint Invitational, 1966; NIAL, 1967; Oakland/AM, 1969; Utica, 1970; Newport, R.I., Monumenta, 1974. **Collections:** Andover/Phillips; Boston/MFA; Brandeis U.; Brown U.; First National Bank of Boston; Harvard U.; Kalamazoo/Institute; Lincoln, Mass./De Cordova; MOMA; Mead Corporation; Milwaukee; Princeton U.; RISD; SFMA; Utica; WMAA; Williams College; Wrexham Foundation. **Bibliography:** *Monumenta.*

TREIMAN, JOYCE. b. May 29, 1922, Evanston, Ill. **Studied:** Stephens College, 1941, AA; State U. of Iowa, with Philip Guston, Lester Longman, 1943, BFA. Traveled Europe, Mediterranean, Middle East. **Taught:** U. of Illinois, 1958-60; San Fernando Valley State College, 1968; UCLA, 1969-70; Art Center School, Los Angeles, 1968. **Awards:** Graduate Fellowship to State U. of Iowa, 1943; L.C. Tiffany Grant, 1947; Denver/AM, **P.P.**, 1948; Springfield, Ill./State; Chicago/AI, Mr. & Mrs. Frank H. Armstrong Prize, 1949; Chicago/AI, The Mr. & Mrs. Frank G. Logan Prize, 1951; Chicago/AI, Pauline Palmer Prize, 1953; Tupperware Art Fund, 1955; Chicago/AI, Martin B. Cahn Award, 1949, 60; Ford Founda-

tion, **P.P.**, 1960; Pasadena/AM, 1962; La Jolla, 1962; Tamarind Fellowship, 1962; Ford Foundation/A.F.A. Artist-in-Residence, 1963; Los Angeles, All-City Show, **P.P.**, 1964, Sculpture Prize, 1966; Los Angeles *Times*, Woman of the Year for Art, 1965. **Address:** 712 Amalfi Drive, Pacific Palisades, Calif. 90272. **Dealers:** The Forum Gallery; Adele Bednarz Gallery; Fairweather-Hardin Gallery. **One-man Exhibitions:** (first) Paul Theobald Gallery, Chicago, 1942; John Snowden Gallery, Chicago, 1945; Chicago/AI: The Chicago Artists Room, 1947; Fairweather-Garnett Gallery, Evanston, Ill., 1950; Hewitt Gallery, NYC, 1950; Palmer House Galleries, Chicago, 1952; Elizabeth Nelson Gallery, Chicago, 1953; Feingarten Gallery, Chicago, 1955; Cliff Dwellers Club, Chicago, 1955; Fairweather-Hardin Gallery, 1955, 58, 62, 64, 73; The Willard Gallery, 1960; Felix Landau Gallery, 1961, 64; The Forum Gallery, 1963, 66, 71, 75; Adele Bednarz Gallery, 1969, 71, 74. **Retrospective:** La Jolla, 1972. **Group:** Denver/AM, 1943, 48, 55, 58, 60, 64; Chicago/AI Annuals, 1945-59, Directions in American Painting, 1946, 51, 54, 56, 59, 60, also 1964, 68; MMA, American Painters Under 35, 1950; U. of Illinois, 1950, 51, 52, 56, 61, 63; WMAA Annuals, 1951, 52, 53, 58, Young America, 1957; Library of Congress, 1954; Carnegie, 1955, 57; Corcoran, 1957; U. of Nebraska, 1957; PAFA, 1958; MOMA, Recent Painting USA: The Figure, circ., 1962-63; WMAA, Fifty California Artists, 1962-63; Ravinia Festival, Highland Park, Ill.; U. of Illinois, 1965, 67, 69, 71, 74; NAD, 1972, 73; AAAL, 1974. **Collections:** Abbott Laboratories; Ball State U.; U. of California, Santa Cruz; Chicago/AI; Denver/AM; International Minerals & Chemicals Corp.; State U. of Iowa; Long Beach/MA; Los Angeles/County MA; Oberlin College; U. of Oregon; Orlando; Pasadena/AM; San Fernando Valley State U.; Springfield, Ill./State; Tupperware Museum; UCLA; Utah State U.; WMAA. **Bibliography:** Pousette-Art, ed.

TROVA, ERNEST. b. February 19, 1927, St. Louis, Mo. Self-taught in art. **Address:** 6 Layton Terrace, St. Louis, Mo. 63124. **Dealer:** The Pace Gallery. **One-man Exhibitions:** Image Gallery, St. Louis, 1959, 61; H. Balaban Carp Gallery, St. Louis, 1963; The Pace Gallery, Boston, 1963, NYC, 1963, 65, 67, 69, 70, 71, 73, 75; Hanover Gallery, 1964, 66, 68, 70; Famous-Barr Co., St. Louis Bicentennial, 1964; MIT; Container Corp. of America, Chicago and NYC, 1965; The Pace Gallery, Columbus, 1966, 70, 75; J.L. Hudson Art Gallery, Detroit, 1967; Harcus-Krakow Gallery, 1968; Dunkelman Gallery, Toronto, 1969; Gimpel & Hanover, 1970; Galerie der Spiegel, Cologne, 1970; Rene Block Gallery Ltd., 1970; Galerie Dieter Brusberg, Hanover, 1970; Fundacion Eugenio Mendoza, Caracas, 1971; Jerusalem/National, 1971; Makler Gallery, 1972; Galerie Charles Kriwin, Brussels, 1972; Elizabeth Stein Gallery, St. Louis, 1973; Phoenix, 1974; Hokin Gallery, Palm Beach, 1975. **Group:** Oakland/AM, Pop Art USA, 1963; Chicago/AI Annual, 1964, 67; SRGM, American Drawings, 1964; Dallas/MFA, 1965; SRGM, 1965-66; Walker, 1966; SFMA, 1966; WMAA, Art of the U.S. 1670-1966, 1966; WMAA Sculpture Annual, 1966, 68; VMFA, American Painting, 1966; U. of Illinois, 1967; SRGM, Sculpture International, 1967; MOMA, Dada, Surrealism and Their Heritage, 1968; Documenta IV, Kassel, 1968; WMAA, Human Concern/Personal Torment, 1969; ICA, U. of Pennsylvania, Highway, 1970; Cincinnati/Contemporary, Monumental Art, 1970; Museo de Arte Contemporaneo, Cali, Colombia, S.A., Bienal Graficas, 1973; V International Poster Biennial, Warsaw, 1974; Hirshhorn, Inaugural Exhibition, 1974. **Collections:** Brandeis U.; Des Moines; Hirshhorn; Kansas City/Nelson; MOMA; Phoenix; Ridgefield/Aldrich; SRGM; St. Louis/City; Syracuse/Everson; Tate; WMAA; Walker; Wichita State U.; Worcester/AM. **Bibliography:** Finch; Friedman and van der Marck; Lippard 5; Rubin 1; Trier 1; Tuchman 1; Weller.

TRUITT, ANNE. b. March 16, 1921, Baltimore, Md. **Studied:** Bryn Mawr College, 1943, BA; ICA, Washington, D.C., 1948-49; Dallas/MFA, 1950. **Awards:** Guggenheim Foundation Fellowship, 1971; National Endowment for the Arts, 1972. **Address:** c/o Dealer. **Dealers:** Andre Emmerich Gallery, NYC; Pyramid Art Galleries Ltd. **One-man Exhibitions:** Andre Emmerich Gallery, NYC, 1963, 65, 69, 75; Minami Gallery, 1964, 67; Baltimore/MA, 1969, 74; Pyramid Art Galleries Ltd, 1971, 73, 75; WMAA, 1973; Corcoran, 1974. **Group:** Pan American Union, Washington, D.C., Artists of the United States in Latin America, 1955; Hartford/Wadsworth, Black, White, and Grey, 1964; ICA, U. of Pennsylvania, 7 Sculptors, 1965; Jewish Museum, Primary Structure Sculptures, 1966; Los Angeles/County MA, American Sculpture of the Sixties, circ., 1967; HemisFair '68, San Antonio, Tex., 1968; WMAA, 1968, 70, 72; Chicago/Contemporary, Five Artists: A Logic of Vision, 1974; Corcoran Biennial, 1975. **Collections:** Institute for Policy Studies, Washington, D.C.; MOMA; NCFA; WMAA.

TSUTAKAWA, GEORGE. b. February 22, 1910, Seattle, Wash. **Studied:** U. of Washington, 1937, BA, MFA. US Army, 1942-46. Traveled Europe, Japan, Southeast Asia, Near East. **Taught:** U. of Washington, 1946- . **Commissions:** Seattle Public Library; Renton Center, Renton, Wash.; Lloyd Center, Portland, Ore.; St. Marks Cathedral, Seattle; Century 21, Seattle World's Fair, 1962 (US Commemorative Medal); Northgate Shopping Center, Seattle; J.W. Robinson Department Store, Anaheim, Calif.; Pacific First Federal Savings and Loan Association, Tacoma, Wash.; Bon Marche Dept. Store, Tacoma, Wash.; Fresno (Calif.) Civic Mall; Commerce Tower, Kansas City, Mo. (sunken garden); University YMCA, Seattle; Lake City Library, Seattle; U. of Wash-

ington (Phi Mu fountain); Washington Cathedral, Washington, D.C.; UCLA School of Public Health; Jefferson Plaza, Indianapolis, 1971; Safeco Plaza, Seattle, 1973; The Pennsylvania State U., 1974; Expo'74, Spokane, US Commemorative Medal, 1974. **Awards:** Washington State, Governor's Award of Commendation, 1967. **Address:** 3116 South Irving Street, Seattle, Wash. 98144. **One-man Exhibitions:** (first) Studio Gallery, Seattle, 1947; U. of Washington, 1950, 54; Press Club, Spokane, Wash., 1953; Zoé Dusanne Gallery, Seattle, 1953, 58; U. of Puget Sound, 1955, 64; Tacoma; Seattle/AM, 1957. **Group:** Seattle/AM Annuals, 1933- ; Oakland/AM, 1951; Spokane Art Center of Washington State U., 1954-57; III Sao Paulo Biennial, 1955; Vancouver, 1955, 57; SFMA, 1955, 58, 60; Portland, Ore./AM, 1955, 60; Yoseido Gallery, Tokyo, 1956; Santa Barbara/MA, 1959, 60, 61; San Diego, 1960; Los Angeles/County MA, 1960; Denver/AM, 1960, 64; Amerika Haus, East Berlin, International Arts Festival, 1965, 66; Expo '70, Osaka, 1970; NCFA, Art of the Pacific Northwest, 1974. **Collections:** Bellevue, Wash.; Denver/MA; Santa Barbara/MA; Seattle/AM; U. of Washington.

TUM SUDEN, RICHARD. b. 1936, Shanghai. **Studied:** Cooper Union, 1956-57; Wagner College, 1958, BA cum laude; NYU, 1961; Hunter College, 1962, MFA; Haystack Mountain School of Crafts, 1963; Brooklyn Museum School, 1965. **Taught:** Cornell U., 1964; Hunter College, 1964, 72; Hull College of Art, England, 1964; New York Institute of Technology, 1967; U. of California, Davis, 1968; C.W. Post College, 1970-72; New School for Social Research, 1972, 73; ASL, 1973; U. of Minnesota, 1974. **Awards:** Brooklyn Museum Sculpture Prize, 1959; Yaddo Fellowship, 1964. **Address:** 40 Great Jones Street, NYC 10012. **Dealer:** Nancy Hoffman Gallery. **One-man Exhibitions:** Hilda Carmel Gallery,

NYC, 1961; Tibor de Nagy Gallery, NYC, 1963, 64, 67, 68; Cornell U., 1964; French & Co. Inc., NYC, 1971; Nancy Hoffman Gallery, 1973, 74. **Group:** Chicago/AI, 1965. **Collections:** Chase Manhattan Bank; MOMA; NYU; Rybak.

TUTTLE, RICHARD. b. 1941, Rahway, N.J. **Studied:** Trinity College, Hartford, Conn., 1963; Cooper Union. **Address:** 151 West 87 Street, NYC 10024. **Dealer:** Betty Parsons Gallery. **One-man Exhibitions:** Betty Parsons Gallery, 1965, 67, 68, 70, 72; Galeria Schmela, 1968; Nicholas Wilder Gallery, 1969; Buffalo/Albright, 1970; Galerie Rudolf Zwirner, 1970, 72; Dallas/MFA, 1971; Galerie Lambert, Paris, 1972; Galerie Schlesa, Dusseldorf, 1972; MOMA, 1972; Konrad Fischer Gallery, Dusseldorf, 1973; Kunstraum, Munich, 1973; Weinberg Gallery, San Francisco, 1973. **Retrospective:** WMAA, 1975. **Group:** American Abstract Artists, 1968; Des Moines, Painting, Out from the Wall, 1968; Detroit/Institute, Other Ideas, 1969; Berne, When Attitudes Become Form, 1969; WMAA, Anti-Illusion: Procedures/Materials, 1969; Corcoran, 1969; Bennington College, Paintings without Supports, 1971; Utica, 1972; Documenta V, Kassel, 1972; Stockholm/National, Young American Artists, 1973. **Collections:** Co-

Richard Tuttle *Rust-Colored Triangle with Parallelogram Added an Apex* 1967

logne; Corcoran; Krefeld/Kaiser Wilhelm; Ottawa/National; St. Louis/City. **Bibliography:** *Art Now 74; Contemporanea; Options and Alternatives; When Attitudes Become Form.*

TWARDOWICZ, STANLEY. b. July 8, 1917, Detroit, Mich. **Studied:** Skowhegan School, 1946-47, with Henry Poor. Traveled Mexico, Europe, Canada. **Taught:** The Ohio State U., 1946-51; Hofstra U., 1964- . **Awards:** Guggenheim Foundation Fellowship, 1956. **Address:** 57 Main Street, Northport, N.Y. 11768; 133 Crooked Hill Road, Huntington, N.Y. 11743. **One-man Exhibitions:** (first) Contemporary Arts Gallery, NYC, 1949, also 1951, 53, 56; The Peridot Gallery, 1958-61, 1963-65, 67, 68, 70; Dwan Gallery, 1959, 61; Columbus, 1963. **Retrospective:** Huntington, N.Y./Heckscher, 1974. **Group:** PAFA, 1950; SRGM, 1954; Chicago/AI, 1954, 55; WMAA, 1954, 55, 57, 64; Carnegie, 1955; Sao Paulo, 1960; U. of Nebraska, 1960; MOMA, the New American Painting and Sculpture, 1969. **Collections:** Columbus; Fisk U.; Harvard U.; Hirshhorn; Huntington, N.Y./Heckscher; Los Angeles/County MA; MOMA; U. of Massachusetts; Milwaukee; NYU; Newark Museum; St. Joseph/Albrecht; Vassar College; Youngstown/Butler.

TWOMBLY, CY. b. 1929, Lexington, Va. **Studied:** Boston Museum School; ASL; Black Mountain College, with Franz Kline, Robert Motherwell. Resided Rome, 1957- . **Address:** c/o Dealer. **Dealer:** Leo Castelli Inc. **One-man Exhibitions:** The Kootz Gallery, NYC, 1951; The Stable Gallery, 1953, 55, 57; Galleria del Cavallino, Venice, 1958; Gallerie d'Arte del Naviglio, Milan, 1958, 60; La Tartaruga, Rome, 1958, 60, 63; Galerie 22, Dusseldorf, 1960; Leo Castelli Inc., 1960, 64, 66, 67, 68, 72, 74; Galerie J, Paris, 1961; Galerie Rudolf Zwirner, Essen, 1961, Cologne, 1963, 69; Notizie Gallery, Turin, 1962; Galleria del Leone, Venice, 1962; Brussels/Royaux, 1962, 65; Galerie Anne Abels, Cologne, 1963; Galerie Jacques Benador, Geneva, 1963, 75; Galerie Bonnier, Lausanne, 1963; Galerie Handschin, Basel, 1964; Galerie Friedrich & Dahlem, Munich, 1964; Amsterdam/Stedelijk, 1966; Milwaukee, 1968; Nicholas Wilder Gallery, 1969; Galerie Hans R. Neuendorf, Cologne, 1970; Stockholm/SFK, 1970; Galerie Bonnier, Geneva, 1970; Gian Enzo Sperone, Turin, 1971, 73; Yvon Lambert, 1971; Galleria dell'Ariete, 1971; Galerie Mollenhoff, Cologne, 1971; Dunkelman Gallery, Toronto, 1972; Janie C. Lee Gallery, Houston, 1972; F.H. Mayor Gallery, London, 1973; Berne, 1973; Galerie Oppenheim, Brussels, 1973, 74; Galerie Heiner Friedrich, Munich, 1974; Modern Art Agency, Naples, 1975; Galerie Art in Progress, Munich, 1975; ICA, U. of Pennsylvania, 1975; SFMA, 1975. **Group:** Gutai 9, Osaka, 1958; Festival of Two Worlds, Spoleto, 1961; Premio Lissone, 1961; Premio Marzotto, 1962; Amsterdam/Stedelijk, Art and Writing, 1963; Salon du Mai, Paris, 1963; L'Aquila, Aspetti dell'Arte Contemporanea, 1963; SRGM, 1964; MOMA, 1966; NYU, 1967; WMAA Annual, 1967; Indianapolis/Herron, 1969. **Collections:** Cologne; First City National Bank, Houston; MOMA; Milwaukee; RISD; WMAA. **Bibliography:** Calas, N. and E.; *Contemporanea;* **Huber;** *Kunst um 1970; Metro;* Restany 2.

TWORKOV, JACK. b. August 15, 1900, Biala, Poland. To USA 1913; citizen 1928. **Studied:** Columbia U., 1920-23; NAD, 1923-25, with Ivan Olinsky, C.W. Hawthorne; privately with Ross Moffett, 1924-25; ASL, 1925-26, with Guy Du Bois, Boardman Robinson. **Taught:** Fieldston School, NYC, 1931; Queens College, 1948-55; American U., 1948-51; Black Mountain College, summer, 1952; Pratt Institute, 1955-58; Yale U., 1963- ; American Academy, Rome, 1972; Dartmouth College, 1973; Columbia U., 1973; Royal College of Art, London, 1974. **Federal A.P.:** Easel painting, 1935-41. **Awards:** Corcoran,

William A. Clark Prize and Corcoran Gold Medal, 1963; Guggenheim Foundation Fellowship, 1970; Maryland Institute, Hon. DFA, 1971; Columbia U., Honorary Doctor of Humane Letters, 1972; Skowhegan School Painting Award, 1973. **Address:** 161 West 22 Street, NYC 10011; 30 Commercial Street, Provincetown, Mass. 02657. **Dealer:** Nancy Hoffman Gallery. **One-man Exhibitions:** (first) ACA Gallery, 1940; Charles Egan Gallery, 1947, 49, 52, 54; Baltimore/MA, 1948; U. of Mississippi, 1954; Walker, 1957; The Stable Gallery, 1957, 58, 59; B.C. Holland Gallery, 1960, 63; Leo Castelli Inc., 1961, 63; Tulane U., 1961; Yale U.,

Jack Tworkov
Knight Series OC #3, Q3-75#4 1975

1963; Gertrude Kasle Gallery, 1966, 67, 69, 71, 73; WMAA, 1971; Toledo/MA, 1971; Dartmouth College, 1973; Portland (Ore.) Center for the Visual Arts, 1974; Reed College, 1974; Denver/AM, 1974; Jack Glenn Gallery, Corona del Mar, 1974; Harcus Krakow Rosen Sonnabend, 1974; Nancy Hoffman Gallery, 1974. **Retrospective:** WMAA, 1964. **Group:** PAFA, 1929; MOMA, The New American Painting, circ. Europe, 1958-59; Documenta II, Kassel, 1959; Walker, 60 American Painters, 1960; Carnegie, 1961; SRGM, Abstract Expressionists and Imagists, 1961; U. of Illinois, 1961; SRGM/USIA, American Vanguard, circ., Europe, 1961-62; MOMA, Abstract American Drawings and Watercolors, circ. Latin America, 1961-63; Seattle World's Fair, 1962; Art:USA:Now, circ., 1962-67; WMAA Annual, 1963; Corcoran, 1963; MOMA, The New American Painting and Sculpture, 1969; VMFA, 12 American Painters, 1974; Santa Barbara/MA, Five Americans, 1974. **Collections:** Allentown/AM; American U.; Baltimore/MA; Buffalo/Albright; Cleveland/MA; Dartmouth College; Hartford/Wadsworth; MMA; MOMA; NCFA; Newark Museum; New Paltz/SUNY; Rockefeller Institute; SRGM; Santa Barbara/MA; Union Carbide Corp.; WGMA; WMAA; Walker; U. of Wisconsin. **Bibliography:** Goodrich and Baur 1; Hess, T.B. 1; Hunter 1, 6; Hunter, ed.; *Metro*; Nordness, ed.; Plous; Pousette-Dart, ed.; Read 2; Rodman 3; Rose, B. 1; Tomkins. Archives.

URRY, STEVEN. b. September 5, 1939, Chicago, Ill. **Studied:** U. of Chicago, 1957-59; Chicago/AI, 1957-59; California College of Arts and Crafts, 1960-61; SFAI, 1962-63. **Commission:** Loyola U., 1969. **Awards:** U. of Illinois, **P.P.,** 1966; National Endowment for the Arts Award, 1966; Chicago/AI, Linde Prize, 1967; Chicago/AI, Emilie L. Wild Prize, 1967. **Address:** 64 Wooster Street, NYC 10012. **Dealer:** The Zabriskie Gallery. **One-man Exhibitions:** Kendall College, Evanston, Ill., 1966; Dell Gallery, Chicago, 1966; The U. of Chicago, 1967, 68; Royal Marks Gallery,

Steve Urry *Mini Blat II* 1971

1967; De Paul U., Chicago, 1968; Chicago/AI, 1969; The Zabriskie Gallery, 1969, 72; Phyllis Kind Gallery, Chicago, 1971. **Group:** SFAI, 1962; Illinois Institute of Technology, Chicago, 1965; U. of Illinois, 1966, 74; Chicago/AI, 1967, 70; U. of Nebraska, 1970. **Collections:** Chicago/AI.

VAN BUREN, RICHARD. b. 1937, Syracuse, N.Y. **Studied:** San Francisco State College; U. of Mexico; Mexico City College. **Taught:** NYU; School of Visual Arts, NYC. **Address:** 137 West Broadway, NYC 10006. **Dealer:** Paula Cooper Gallery. **One-man Exhibitions:** New Mission Gallery, San Francisco, 1961; SFMA, 1962; Dilexi Gallery, San Francisco, 1964; Bykert Gallery, 1967, 68, 69; Bennington College, 1970; Ithaca College (three-man), 1970; Janie C. Lee Gallery, Dallas (two-man), 1971; Paula Cooper Gallery, 1972, 75; 112 Greene Street, NYC, 1973; The Texas Gallery, 1974; Rice U., 1974; City U. of New York, 1975. **Group:** SFMA, Bay Area Artists, 1964; Jewish Museum, Primary Structure Sculptures, 1966; ICA, U. of Pennsylvania, A Romantic Minimalism, 1967; U. of Illinois, 1967; Ridgefield/Aldrich, Cool Art: 1967, 1968; WMAA, 1968, 70; Milwaukee, A Plastic Presence, circ., 1969; Finch College, NYC, Art in Process, 1969; Chicago/AI, 1969, 72; Foundation Maeght, 1970; Akron/AI, Watercolors and Drawings by Young Americans, 1970; Walker, Works for New Spaces, 1971; Milwaukee, Directions 3: Eight Artists, 1971; Buffalo/Albright, Kid Stuff, 1971; Harvard U., New American Graphic Art, 1973; Cincinnati/Contemporary, Options 73/70, 1973; Indianapolis, 1974; VMFA, Works on Paper, 1974. **Collections:** MOMA; Walker. **Bibliography:** *Art Now* 74.

VANDER SLUIS, GEORGE. b. December 18, 1915, Cleveland, Ohio. **Studied:** Cleveland Institute of Art, 1934-39; Colorado Springs Fine Arts Center, 1939-40, with Boardman Rob-

inson. US Army, 1942-45. Traveled Europe, USA. **Taught:** Colorado Springs Fine Arts Center, 1940-42, 1945-47; Syracuse U., 1947. **Federal A.P.:** Mural painting, 1939. **Commissions:** US Post Offices, Rifle, Colo., 1941, and Riverton, Wyo., 1942; Syracuse U., 1955; J.C. Georg Company, Syracuse, N.Y., 1957; designed 11¢ and 9¢ airmail stamps. **Awards:** Fulbright Fellowship (Italy), 1951-52; New York State Council on the Arts, 1966. **Address:** 4132 Onondaga Boulevard, Camillus, N.Y. 13031. **One-man Exhibitions:** (first) Salt Lake Art Center, Salt Lake City, Utah, 1942; Columbia U., 1943; Colorado Springs/FA, 1945; Southern Methodist U., 1946; U. of Nebraska, 1947; Hood College, 1948; Galleria d'Arte Contemporanea, Florence, Italy, 1952; Syracuse U., 1955, 74; Syracuse-/Everson, 1956, 61, 71; Alfred U., 1957; Colgate U., 1957; U. of Rochester, 1959, 69; J. Seligmann & Co., 1959; Cleveland Institute of Art, 1962; Royal Marks Gallery, 1962, 63, 64; Utica, 1963; The Krasner Gallery, 1968, 69, 71. **Group:** Cleveland/MA, The May Show, 1937, 38, 40, 41; Smithsonian, American Watercolors, 1941; Chicago/AI Annuals, 1941; San Francisco Art Association Annuals, 1941, 42; MMA, Artists for Victory, 1942; Pepsi-Cola Co., Paintings of the Year, 1946, 47; Corcoran, 1947, 57; Utica Annuals, 1948-70; PAFA, 1953; WMAA, 1954; WMAA, Fulbright Artists, 1958; U. of Illinois, 1961; The White House, Washington, D.C., 1966-69; Museum of Contemporary Crafts, The Door, 1968; New York State Fair, Enviro-Vision, circ., 1972. **Collections:** Arnot; Brookings Institute; Cleveland/MA; Colgate U.; Colorado Springs/FA; General Electric Corp.; Hamline U.; Kalamazoo/Institute; Kansas City/Nelson; New Britain; U. of Rochester; St. Lawrence U.; Southern Methodist U.; Syracuse/Everson; Syracuse U.; Utica.

VASILIEFF, NICHOLAS, b. November 3, 1892, Moscow, Russia; **d.** October 13, 1970, Lanesboro, Mass. **Studied:** Academy of Fine Arts, Moscow, with Leonid Pasternack. Traveled Turkey, France, Germany. **Taught:** Academy of Fine Arts, Moscow, 1918-19; and privately. To USA 1921. **Commissions** (murals): a nightclub in Constantinople, Turkey, 1921; Club Troika, Washington, D.C., 1932; a nightclub in Baltimore, Md., 1934. **Awards:** Academy of Fine Arts, Moscow, Gold Medal; La Tausca Competition, 1948 ($3,000); U. of Illinois, **P.P.**, 1954. **One-man Exhibitions:** (first) Artists' Gallery, NYC, 1938; John Heller Gallery, NYC; The Bertha Schaefer Gallery; The Amel Gallery, NYC. **Group:** PAFA; Yale U.; Corcoran; WMAA; Buffalo/Albright; Carnegie; NIAL; Brooklyn Museum, 1926; Bordighera, 1955; Art:USA:Now, circ., 1962-67; U. of Illinois, 1963. **Collections:** Albany/Institute; Ball State U.; Brooklyn Museum; Colby College; Corcoran; U. of Florida; Hartford/Wadsworth; U. of Illinois; Kansas City/Nelson; U. of Minnesota, Duluth; Mount Holyoke College; NYU; U. of Nebraska; New Orleans/Delgado; PAFA; PMA; Phoenix; Pittsfield/Berkshire; Rutgers U.; Santa Barbara/MA; Tel Aviv; WMAA; Yale U.; Youngstown/Butler. **Bibliography:** Nordness, ed.

VASS, GENE. b. July 28, 1922, Buffalo, N.Y. **Studied:** U. of Buffalo, 1952, BFA; Yale U. Traveled Spain, France, Holland; resided Rome, 1958-59. **Taught:** U. of Buffalo, 1956-58. **Address:** 159 Mercer Street, NYC, 10012. **One-man Exhibitions:** (first) a gallery in Buffalo, N.Y., 1957; Appunto Gallery, Rome, 1959; Grace Borgenicht Gallery Inc., 1960, 61; The Bertha Schaefer Gallery, 1967, 69. **Group:** Buffalo/Albright, 1956-59; PAFA, 1957; Norfolk, Drawing Annual, 1957; Carnegie, 1958, 64; Corcoran, 1959; U. of Illinois, 1961; U. of Nebraska, 1961; Chicago/AI, 1961; MOMA, Recent American Painting and Sculpture, circ. USA and Canada, 1961-62; WMAA Annuals, 1962, 65. **Collections:** Baltimore/MA; Buffalo/Albright; Chase Manhattan Bank; Chicago/AI; Des Moines; MOMA; Minnesota/MA; U. of Nebraska; SRGM; WMAA.

VICENTE, ESTEBAN. b. January 20, 1904, Segovia, Spain. **Studied:** Real Academia de Bellas Artes de San Fernando, Madrid, BA. Resided Paris, 1927-32. To USA 1936. **Taught:** U. of California, Los Angeles and Berkeley, 1954-55; Queens College; Black Mountain College; High Field School, Falmouth, Mass.; NYU; Yale U.; and in Puerto Rico; Princeton U., Artist-in-Residence, 1965, 69, 70, 71; New York Studio School, Paris, 1965-75; Honolulu Academy, 1969; American U., 1973; Columbia U., 1974. **Awards:** Ford Foundation, 1961, 62; Tamarind Fellowship, 1962; AAAL, 1971. **Address:** Main Street, Bridgehampton, N.Y. 11932; 1 West 67 Street, NYC 10023. **Dealer:** Andre Emmerich Gallery, NYC. **One-man Exhibitions:** Kleemann Gallery, NYC, 1937; The Peridot Gallery, 1950, 51; Allan Frumkin Gallery, Chicago, 1953; Charles Egan Gallery, 1955; Rose Fried Gallery, 1957, 58; Leo Castelli Inc., 1958; U. of Minnesota, 1959; Holland-Goldowsky Gallery, Chicago, 1960; Andre Emmerich Gallery, NYC, 1960, 62, 64, 65, 69, 72, 75; Primus-Stuart Gallery, Los Angeles, 1961; New Arts Gallery, Houston, 1962; B.C. Holland Gallery, 1963; Dayton/AI, 1963; St. John's Gallery, Annapolis, Md., 1963; Des Moines, 1967; Princeton U., 1967, 71; Cranbrook, 1968; Honolulu Academy, 1969; Benson Gallery, 1969, 72; Guild Hall, 1970; J.L. Hudson Art Gallery, Detroit, 1972. **Group:** International Biennial Exhibition of Paintings, Tokyo; Corcoran; The Kootz Gallery, NYC, New Talent, 1950; Ninth Street Exhibition, NYC, 1951; Carnegie, 1958, 59, 61; WMAA Annuals, 1958, 59, 61, 62, 65, 67, 70; ICA, Boston, 100 Works on Paper, circ. Europe, 1959; Columbus, Contemporary American Painting, 1960; Walker, 60 American Painters, 1960; Chicago/AI, 1960, 66; MOMA, The Art of Assemblage, circ., 1961; SRGM, Abstract Expressionists and Imagists, 1961; SRGM/USIA, American Vanguard, circ. Europe, 1961-62; Seattle World's Fair, 1962; Hartford/Wadsworth, Continuity and Change, 1962; Sao Paulo, 1963; New York World's Fair, 1964-65; Black Mountain College, 1966; MOMA, The New American Painting and Sculpture, 1969. **Collections:** Baltimore/MA; Brandeis U.; U. of California, Berkeley; Chase Manhattan Bank; Chicago/AI; Ciba-Geigy Corp.; Dallas/MFA; Dartmouth College; Hartford/Wadsworth; Honolulu Academy; Iowa State U.; Kansas City/Nelson; Los Angeles/County MA; MMA; MOMA; NCFA; NYU; Newark Museum; U. of North Carolina; Princeton U.; Reynolds Metals Co.; U. of Rochester; SFMA; Shuttleworth Carton Co.; The Singer Company Inc.; Tate; Trenton/State; Union Carbide Corp.; Vanderbilt U.; WGMA; WMAA; Worcester/AM; Yale U. **Bibliography:** Hess, T.B. 1; Hunter 6; Janis and Blesh 1; Seitz 3. Archives.

VOLLMER, RUTH. b. Munich, Germany. To USA 1935; citizen 1943. Traveled Europe, Middle East, Mediterranean. **Taught:** Fieldston School, NYC, 1956-61. **Member:** American Abstract Artists; Sculptors Guild. **Commissions:** Uris Buildings Corp. (mural for 575

Ruth Vollmer *Archimedean Screw* 1973

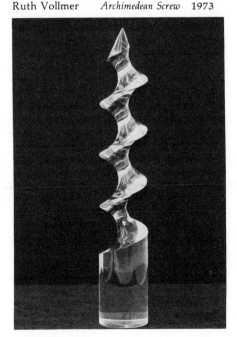

Madison Avenue, NYC); MOMA exhibits; Committee for Economic Development (anniversary award sculpture), 1967. **Address:** 25 Central Park West, NYC 10023. **Dealer:** Betty Parsons Gallery. **One-man Exhibitions:** Betty Parsons Gallery, 1960, 63, 66, 68, 70, 73; Drew U. (two-man), 1966; Syracuse/Everson, 1974. **Retrospective:** Purchase/SUNY, 1975. **Group:** Brussels World's Fair, 1958; PAFA; U. of Colorado, 1961; American Abstract Artists Annuals, 1963-68; Sculptors Guild, 1964-68; Musee Cantonal des Beaux-Arts, Lausanne, II Salon International de Galeries Pilotes, 1966; U. of Connecticut, Sculpture in the Spring, 1970; Skidmore College, Contemporary Women Artists, 1970; USIA, New American Sculpture, circ., 1971; Williams College, Women Artists, 1973. **Collections:** Brandeis U.; MOMA; NCFA; NYU; Syracuse/Everson; WGMA; WMAA. Archives.

VON SCHLEGELL, DAVID, b. May 25, 1920, St. Louis, Mo. **Studied:** U. of Michigan, 1940-42; ASL, with William Von Schlegell (his father) and Yasuo Kuniyoshi, 1945-48. US Air Force, 1943-44. **Taught:** Privately, 1950-55; U. of California, 1968; School of Visual Arts, NYC, 1969-70; Yale U., 1971- . **Awards:** Rhode Island Arts Festival, First Prize, 1962; Carnegie, **P.P.,** 1967; National Council on the Arts, $5,000 Award, 1968; Guggenheim Foundation Fellowship, 1974. **Address:** 190 Dromara Road, Guilford, Conn. 06437. **Dealer:** The Pace Gallery, NYC. **One-man Exhibitions:** (first) The Swetzoff Gallery, Boston, 1955, also 1961; Poindexte Gallery, 1960; Stanhope Gallery, Boston, 1964; U. of New Hampshire, 1964; NYU (three-man), 1966; Ogunquit, 1965; Royal Marks Gallery, 1966-67; Ward-Nasse Gallery, Boston, 1968; Obelisk Gallery, 1968; Reese Palley Gallery, NYC, 1970, 71; The Pace Gallery, NYC, 1974. **Retrospective:** Brandeis U., 1968. **Group:** WMAA Annuals, 1960-68; ICA, Boston, 1963; Hartford/Wadsworth, 1963; WMAA, Contemporary American Sculpture, Selection I, 1966; Jewish Museum, Primary Structures, 1966; Chicago/AI;

David Von Schlegell *Model for Gate* 1974

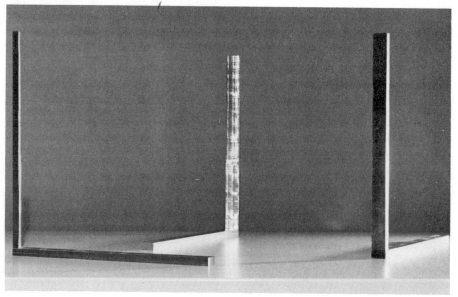

Los Angeles/County MA, American Sculpture of the Sixties, 1967; Carnegie, 1967; Walker, Works on New Space, 1971; Middelheim Park, Antwerp, XI Sculpture Biennial, 1971; U. of Washington, 1971. **Collections:** Andover/Phillips; Carnegie; Cornell U.; Hirshhorn; Lannan Foundation; MIT; U. of Massachusetts; Ogunquit; Ridgefield/Aldrich; South Mall, Albany; Storm King Art Center; WMAA. **Bibliography:** Calas, N. and E.; Tuchman 1.

VON WEIGAND, CHARMION. b. March 4, 1900, Chicago, Ill. **Studied:** Barnard College; Columbia U.; NYU; self-taught in art. Traveled Europe, Mexico. **Member:** American Abstract Artists (President, 1952-53). **Awards:** Cranbrook, Religious Art Exhibition, First Prize, 1969. **Address:** 333 East 34 Street, NYC 10016. **One-man Exhibitions:** Rose Fried Gallery, 1942, 48, 56; Saidenberg Gallery, 1952; John Heller Gallery, NYC, 1956; Zoé Dusanne Gallery, Seattle, 1958; La Cittadella d'Arte Internazionale e d'Avanguardia, Ascona, Switzerland, 1959; The Howard Wise Gallery, NYC, 1961; U. of Texas, 1969; Birmingham, Ala./MA, 1970; Galleria Fiamma Vigo, Rome and Venice, 1973; Annely Juda Fine Art, London, 1974; Noah Goldowsky, 1975; Andre Zarre Gallery, NYC, 1975. **Group:** Art of This Century, NYC, The Women, 1945; American Abstract Artists Annuals; Helmhaus Gallery, Zurich, Konkrete Kunst, 1950; MMA, 1951; Walker, The Classic Tradition, 1953; WMAA, 1955, 57; Houston/MFA, The Sphere of Mondrian, 1957; Galerie Chalette, Construction and Geometry in Painting, circ., 1960; WMAA, Geometric Abstraction in America, circ., 1962; Amsterdam/Stedelijk, Art and Writing, 1963. **Collections:** Carnegie; Ciba-Geigy Corp.; Cincinnati/AM; Cleveland/MA; Container Corp. of America; Cornell U.; Hirshhorn; MOMA; McCrory Corporation; NYU; Newark Museum; New York Hospital; U. of Notre Dame; Seattle/AM; Spring-field, Mass./MFA; U. of Texas; WMAA. **Bibliography:** Janis and Blesh 1; MacAgy 2; Rickey; Seitz 3; Seuphor 1. Archives.

VON WICHT, JOHN. b. February 3, 1888, Holstein, Germany; **d.** January 22, 1970, Brooklyn, N.Y. **Studied:** Private art school of the Grand Duke of Hesse, 1909-10, BA; School of Fine and Applied Arts, Berlin, 1912. Traveled Europe. To USA 1923; citizen 1936. **Taught:** ASL, 1951-52; John Herron Art Institute, 1953. **Member:** American Abstract Artists; Audubon Artists; Federation of Modern Painters and Sculptors; International Institute of Arts and Letters; SAGA. **Federal A.P.:** Mural painting. **Commissions:** Pan American Airways Terminal, Miami, Fla.; McGill U.; New York World's Fair, 1939; Pennsylvania Railroad Station, Trenton, N.J. **Awards:** Brooklyn Museum, First Prize, 1948, 49, **P.P.**, 1951, 64; SAGA, Mrs. A.W. Erickson Prize, 1953; The Print Club, Philadelphia, William H. Walker Memorial Prize, 1957; Audubon Artists, Gold Medal of Honor, 1958; Ford Foundation, **P.P.**, 1960; SAGA, **P.P.**, 1967-68. **One-man Exhibitions:** (first in USA) Architects Building, NYC, 1936; 608 Fifth Avenue, NYC, 1939; Artists' Gallery, NYC, 1944; Kleemann Gallery, NYC, 1946, 47; UCLA, 1947; Passedoit Gallery, NYC, 1950, 51, 52, 54, 56, 57, 58; Indianapolis/Herron, 1953; Esther Robles Gallery, 1959; Pasadena/AM, 1959; Liege, 1959; The Bertha Schaefer Gallery, 1960, 61, 62, 64, 66; Galerie Neufville, Paris, 1962; Grippi Gallery, 1966. **Retrospective:** Santa Barbara/MA, 1959. **Group:** California Palace, 1964; Brooklyn Museum; Audubon Artists; MMA; WMAA Annuals; Federation of Modern Painters and Sculptors; Corcoran; PAFA; SRGM; Carnegie; NAD; Chicago/AI. **Collections:** Baltimore/MA; Boston/MFA; Brandeis U.; Brooklyn Museum; Chase Manhattan Bank; Cincinnati/AM; Jewish Museum; S.C. Johnson & Son, Inc.; Library of Congress; Liege; Lincoln, Mass./De Cordova; MMA; MOMA; Madrid/Nacional; NCFA; PMA; Paris/Moderne;

Norfolk/Chrysler; Stockholm/National; Union Carbide Corp.; WMAA; Yale U. **Bibliography:** Baur 7; Nordness, ed.; Pousette-Dart, ed. Archives.

VOULKOS, PETER. b. January 29, 1924, Bozeman, Mont. **Studied:** Montana State College, BS; California College of Arts and Crafts, MFA. Traveled Italy, 1967. **Taught:** Archie Bray Foundation, Helena, Mont.; Black Mountain College; Los Angeles County Art Institute; Montana State U.; U. of California, Berkeley, 1959- ; Greenwich House Pottery, NYC; Teachers College, Columbia U. "Voulkos and Company," 16mm film produced by Clyde Smith, 1972. **Awards:** RAC, First Prize; National Decorative Art Show, Wichita, Kans., First Prize; Portland, Ore./AM, Northwest Craft Show, First Prize; Pacific Coast Ceramic Show, First Prize; Denver/AM, **P.P.**; Cranbrook, **P.P.**; Smithsonian, **P.P.**; Los Angeles/ County Fair, **P.P.**; Pasadena/AM, **P.P.**; Ford Foundation, **P.P.**; International Ceramic Exhibition, Ostend, Belgium, Silver Medal, 1959; International Ceramic Exhibition, Cannes, France, Gold Medal; I Paris Biennial, 1959, Rodin Museum Prize in Sculpture; SFMA, Ford Foundation **P.P.**; Montana State U., L.H.D. (Hon.), 1968. **Address:** 1306 Third Street, Berkeley, Calif. 94710. **Dealer:** David Stuart Gallery. **One-man Exhibitions:** Gump's Gallery; U. of Florida; Historical Society of Montana; Felix Landau Gallery; Chicago/AI; Bonniers, Inc., NYC; Fresno State Collete; Scripps College; U. of Southern California; Pasadena/AM; David Stuart Gallery, 1967; Los Angeles/County MA; Hansen Gallery, San Francisco; Quay Gallery, 1968, 74; SFMA, 1972. **Group:** MMA; Scripps College; Syracuse/Everson, National Ceramic Exhibition; U. of Tennessee; Brussels World's Fair, 1958; de Young; Seattle World's Fair, 1962; Stanford U.; Denver/AM; Smithsonian; Los Angeles/County MA; Battersea Park, London, International Sculpture Exhibition, 1963; Los Angeles State College, 1964; U. of California, Irvine, 1966; WMAA, 1970. **Collections:** Balti-more/MA; Archie Bray Foundation; City of Fresno; Cranbrook; Denver/ AM; U. of Florida; Fresno State College; U. of Illinois; State U. of Iowa; Iowa State Teachers College; Japanese Craft Museum; La Jolla; Los Angeles County Fair Association; Los Angeles/County MA; MOMA; Montana State College; Museum of Contemporary Crafts; Oakland/AM; Pasadena/AM; Portland, Ore./AM; SFMA; Santa Barbara/MA; Smithsonian; Syracuse/Everson; Tokyo Folk Art Museum; WMAA; Wichita/ AM; U. of Wisconsin. **Bibliography:** Read 3; *Report*; Selz, P. 2; Trier 1; Tuchman 1.

VYTLACIL, VACLAV. b. November 1, 1892, NYC. **Studied:** Chicago Art Institute School, 1908-12; ASL, 1912-14; Hofmann School, Munich, 1922-26. Traveled extensively; resided Europe 16 years. **Taught:** Minneapolis Institute School, 1918-22; U. of California, Berkeley, summers, 1927, 28; ASL, 1928-69; California College of Arts and Crafts, summers, 1936, 37; Colorado Springs Fine Arts Center, summers, 1947, 48, 49; Chicago Art Institute School, 1954; U. of Georgia, 1968. **Member:** Federation of Modern Painters and Sculptors; American Abstract Artists. **Federal A.P.:** Organized an art school in Harlem, NYC. **Awards:** Chicago/AI, William R. French Memorial Gold Medal. **Address:** Sparkill, N.Y. **One-man Exhibitions:** (first) Feigl Gallery, NYC, 1942; Phillips; U. of Rochester; Baltimore/MA; Minneapolis Institute School; The Krasner Gallery; Southern Vermont Art Center, Manchester; U. of Notre Dame, 1975. **Retrospective:** Montclair/AM, 1975. **Group:** American Abstract Artists Annuals; Federation of Modern Painters and Sculptors Annuals; Chicago/ AI; Carnegie; PAFA; WMAA; Corcoran; MMA. **Collections:** ASL; Colorado Springs/FA; Dalton School; U. of Georgia; Hartford/Wadsworth; MMA; Montclair/AM; PAFA; Phillips; U. of Rochester; WMAA. **Bibliography:** Baur 7; Blesh 1; Cheney; Janis, S.; Pousette-Dart, ed. Archives.

WALD, SYLVIA. b. October 30, 1914, Philadelphia, Pa. **Studied:** Moore Institute of Art, Science and Industry, Philadelphia, 1931-35. Traveled Europe, Central America, Greece, Spain. **Federal A.P.:** Teacher. **Awards:** MOMA, **P.P.**, 1941; Library of Congress, Pennell **P.P.**, 1944; National Serigraph Society, NYC, First Prize, 1948; Brooklyn Museum, **P.P.**, 1951, 54; Pratt Institute, International Miniature Competition, 1967; The Print Club, Philadelphia, 1969. **Address:** 37 East 4 Street, NYC 10003. **One-man Exhibitions:** (first) ACA Gallery, 1939; Kent State College, 1945; U. of Louisville, 1945, 49; National Serigraph Society, NYC, 1946; Grand Central Moderns, NYC, 1957; Devorah Sherman Gallery, 1960; Briarcliff (N.Y.) Public Library, 1966; New School for Social Research, 1967; Book Gallery, White Plains, N.Y., 1968. **Group:** WMAA; National Sculpture Society, 1940; City of Philadelphia, Sculpture International, 1940; Chicago/AI, Directions in American Painting, 1941; Brooklyn Museum, Print Biennials; MOMA, 1941, 53, 56; Library of Congress, 1943, 52, 58; WMAA Annuals, 1948, 55; PAFA Annuals, 1950, 53, 54, 57; International Print Exhibition, Salzburg and Vienna, 1952; II Sao Paulo Biennial, 1953; Smithsonian, Curators Choice—1942-52, circ. USA, 1954;

MOMA, 50 Years of American Art, circ. Europe, 1955; Brooklyn Museum, 10 Years of American Prints—1947-56, 1956; Bordighera, 1957; PCA, American Prints Today, circ., 1959-62; New York Cultural Center, Women Choose Women, 1973; MOMA, American Prints: 1913-1963, 1974-75. **Collections:** Aetna Oil Co.; American Association of University Women; Ball State U.; Bibliotheque Nationale; Brandeis U.; Brooklyn Museum; Howard U.; State U. of Iowa; Library of Congress; Louisville/Speed; U. of Louisville; MOMA; NYPL; National Gallery; U. of Nebraska; Ohio U.; U. of Oklahoma; PMA; Princeton U.; Raleigh/NCMA; Toronto; Utica; Victoria and Albert Museum; WMAA; Walker; Worcester/AM. **Bibliography:** Peterdi.

WALDMAN, PAUL. b. August 1, 1936, Erie, Pa. **Studied:** Brooklyn Museum School; Pratt Institute. **Taught:** New York Community College, 1963-64; Brooklyn Museum School, 1963-67; The Ohio State U., 1966; U. of California, Davis, 1966; School of Visual Arts, NYC, 1966- . **Awards:** Ford Foundation, Artist-in-Residence, 1965. **Address:** 10 Waterside, NYC 10010. **Dealer:** Leo Castelli Inc., NYC. **One-man Exhibitions:** (first) Allan Stone Gallery, 1963, 65; St. Joseph/Albrecht, 1966; Leo Castelli Inc., NYC, 1973, 75. **Group:** Barnard College, Young Americans, 1962; Louis Alexander Gallery, NYC, Recent American Drawings, 1962; WGMA, 1963, 64; Brandeis U., Recent American Drawings, 1964; Hartford/Wadsworth, Figures, 1964; U. of Colorado, Survey of World Painting and Sculpture, 1964; Brooklyn Museum, Print Biennials; Finch College, 1966, 67 (circ.), 68; Smithsonian, circ. Germany, 1967; WMAA Annual, 1967; Finch College, NYC, The Dominant Female, 1968; Hirshhorn, Inaugural Exhibition, 1974. **Collections:** Achenbach Foundation; Brandeis U.; Brooklyn Museum; U. of California; Colby College; Colgate U.; Cornell U.; Des Moines; Fairleigh Dickinson U.; Harvard U.; Hirshhorn; Johns Hopkins U.; J. Turner Jones, Inc.;

Kansas City/Nelson; Los Angeles/ County MA; MIT; MOMA; U. of Massachusetts; Mount Holyoke College; NYU; Newark Museum; Pasadena/ AM; RISD; U. of Rochester; Russell Sage College; Rutgers U.; The Singer Company Inc.; Smithsonian; Stony Brook/SUNY; Storm King Art Center; Washington U.

WALKOWITZ, ABRAHAM. b. March 28, 1878, Tyumen, Russia; **d.** January 26, 1965. **Studied:** NAD; Academie Julian, Paris, with Jean Paul Laurens. Traveled Europe extensively. **Taught:** Educational Alliance, NYC. **Awards:** AAAL, Marjorie Peabody Waite Award, 1962. **One-man Exhibitions:** "291," NYC, 1912; The Downtown Gallery, 1930; Park Gallery, NYC, 1937; Brooklyn Museum, 1939; Newark Museum, 1941; NYPL, 1942; Schacht Gallery, NYC, 1944; Chinese Gallery, NYC, 1946; Charles Egan Gallery, 1947; Jewish Museum, 1949; Hartford/Wadsworth, 1950; ACA Gallery, 1955; The Zabriskie Gallery, 1959, 64, 66, 68, 69, 73; Danenberg Gallery, 1971. **Retrospective:** Utah, 1974. **Group:** NAD, 1904; WMAA; The Armory Show, 1913; Anderson Galleries, NYC, Forum Exhibition, 1916. **Collections:** Andover/Phillips; Boston/MFA; Brooklyn

Museum; Columbus; Kalamazoo/Institute; Library of Congress; MMA; MOMA; Newark Museum; Phillips; WMAA. **Bibliography:** *Avant-Garde Painting and Sculpture;* Baur 7; Biddle 4; Blesh 1; Brown; Cahill and Barr, eds.; Cheney; Frank, ed.; Goodrich and Baur 1; Haftman; Hartmann; Hunter 5; Janis, S.; McCoubrey 1; McCurdy, ed.; Mellquist; Richardson, E.P.; Rose, B. 4; **Walkowitz 1, 2;** Wright 1. Archives.

WARHOL, ANDY. b. 1928, Pittsburgh, Pa. **Studied:** Carnegie. **Address:** c/o Dealer. **Dealer:** Leo Castelli Inc. **One-man Exhibitions:** Ferus Gallery, Los Angeles, 1962, 63; The Stable Gallery, 1962, 64; Ileana Sonnabend Gallery, Paris, 1964, 65, 67; Leo Castelli Inc., 1964, 66; Morris International Gallery, Toronto, 1965; Galleria Sperone, Turin, 1965; Galleria Rubbers, Buenos Aires, 1965; ICA, U. of Pennsylvania, 1965; Eva de Buren Gallery, Stockholm, 1965; ICA, Boston, 1966; Galerie Hans R. Neuendorf, Hamburg, 1966; Galerie Rudolf Zwirner, 1967; Stockholm/National, 1968; Rowan Gallery, London, 1968; Leo Castelli Inc./ David Whitney Gallery, 1969; Chicago/Contemporary, 1970; Eindhoven, 1970; Paris/Moderne, 1970; Tate, 1971; WMAA, 1971; Gotham Book Mart,

Andy Warhol *Portrait of Dorothy* 1974

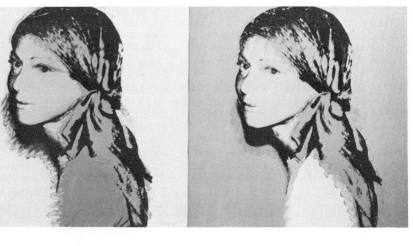

NYC, 1971; Modern Art Agency, Naples, 1972; Walker, 1972; New Gallery, Cleveland, 1973; Musee Galliera, Paris, 1973; Ileana Sonnabend Gallery, Paris, 1974; Jared Sable Gallery, Toronto, 1974; F.H. Mayor Gallery, London, 1974; Margo Leavin Gallery, 1975. **Group:** SRGM, Six Painters and The Object, circ., 1963; WGMA, The Popular Image, 1963; Kansas City/Nelson, 1963; Oakland/AM, Pop Art USA, 1963; ICA, London, The Popular Image, 1963; Stockholm/National, American Pop Art, 1964; Salon du Mai, Paris, 1964; U. of Rochester, 1964; Worcester/AM, 1965; Palais des Beaux-Arts, Brussels, 1965; Hamburger Kunstkabinett, 1965; SRGM, 1966; RISD, Recent Still Life, 1966; Flint/Institute, I Flint Invitational, 1966; Expo '67, Montreal, 1967; Detroit/Institute, Color, Image and Form, 1967; IX Sao Paulo Biennial, 1967; MOMA, The 1960's, 1967; Carnegie, 1967; Eindhoven, 1967; Palazzo Grassi, Venice, 1967; WMAA Annual, 1968; Jewish Museum, 1968; Documenta IV, Kassel, 1968; Milwaukee, Directions I: Options, circ., 1968; Finch College, NYC, 1968; Jewish Museum, Superlimited: Books, Boxes, and Things, 1969; Ars 69, Helsinki, 1969; Indianapolis, 1969; U. of California, Irvine, New York: The Second Breakthrough, 1959-1964, 1969; Hayward Gallery, London, Pop Art, 1969; MMA, New York Painting and Sculpture: 1940-1970, 1969; Denver/AM, Report on the Sixties, 1969; Pasadena/AM, Painting in New York: 1944-1969, 1969; WMAA, 1969, 73; Expo '70, Osaka, 1970; Indianapolis, 1970; Kunsthalle, Nurnberg, The Thing as Object, 1970; Cincinnati/Contemporary, Monumental Art, 1970; Buffalo/Albright, Kid Stuff, 1971; Dusseldorf/Kunsthalle, Prospect '71, 1971; ICA, U. of Pennsylvania, Grids, 1972; High Museum, The Modern Image, 1972; Detroit/Institute, Art in Space, 1973; Parcheggio di Villa Borghese, Rome, Contemporanea, 1974; Seattle/AM, American Art—Third Quarter Century, 1974; Chicago/AI, Idea and Image in Recent Art, 1974, WMAA, American Pop Art, 1974.

Collections: Brandeis U.; Buffalo/Albright; Detroit/Institute; Kansas City/Nelson; Los Angeles/County MA; MOMA; Toronto; WGMA; WMAA; Walker. **Bibliography:** Alloway 1; *Art Now 74;* Battcock, ed.; Becker and Vostell; Calas, N. and E.; *Contemporanea;* Coplans 3; **Coplans, Mekas, and Tomkins; Crone;** Davis, D.; Dienst 1; Finch; **Green;** Hunter, ed.; **Koch, S.,** Kosloff 3, *Kunst um 1970;* Lippard 5; *Report;* Rose, B. 1; Rublowsky; Russell and Gablik; Sager; Tomkins and Time-Life Books; **Warhol; Warhol** *et al,* **eds.;** Weller.

WARSHAW, HOWARD. b. August 14, 1920, NYC. **Studied:** ASL, 1938-42, with Homer Boss, Howard Trafton. Traveled Europe, Japan. **Taught:** Jepson Art Institute, Los Angeles, 1948-52; State U. of Iowa, 1950-51; U. of California, Santa Barbara, 1955- . **Commissions** (murals): Wyle Laboratory, El Segundo, Calif., 1955; Santa Barbara (Calif.) Public Library, 1958 (with Channing Peake); U. of California, Santa Barbara, Dining Commons, 1960; Bowdoin College; U. of California, Los Angeles, San Diego, Riverside, Santa Barbara. **Address:** 250 Toro Canyon Road, Carpinteria, Calif. 93013. **Dealer:** J. Seligmann and Co. **One-man Exhibitions:** The Little Gallery, Beverly Hills, 1944; Gallery of International Art, Los Angeles, 1945; Julien Levy Galleries, NYC, 1946, 1948 (two-man, with Arshile Gorky); Frank Perls Gallery, 1949, 52, 54; Santa Barbara/MA (three-man, with Rico Lebrun and Channing Peake), 1956; J. Seligmann and Co., 1957 (two-man, with Channing Peake), 1958; Felix Landau Gallery, 1957, 59; Pasadena/AM; de Young; Los Angeles/County MA; Richard Larcada Gallery. **Group:** U. of Illinois, 1951, 58; U. of Nebraska, 1958; Carnegie; WMAA; Sao Paulo; Paris/Moderne; MMA; PAFA. **Collections:** Carnegie; City of Oakland; Los Angeles/County MA; PAFA; Santa Barbara/MA; U. of Southern California; UCLA.

WASHINGTON, JAMES W., JR. b. November 10, 1909, Gloster, Miss.

Studied painting privately with Mark Tobey in Seattle. Changed from painting to sculpture in 1956. Traveled Mexico, Europe, Middle East. **Federal A.P.:** Teacher (Vicksburg, Miss.). **Member:** Sculptors Institute. **Commissions:** Island Park School, Mercer Island, Seattle Wash. (sculpture); First National Bank of Seattle, 1968; World Trade Center, Seattle. **Awards:** SFMA, **P.P.**, 1956; Oakland/AM, **P.P.**, 1957; Seattle World's Fair, 1962, Second Prize; Graduate Theological Union, Hon. DFA, 1975. **Address:** 1816 26th Avenue, Seattle, Wash. 98122. **Dealer:** Foster-White Gallery. **One-man Exhibitions:** Feingarten Gallery, Los Angeles, 1958; Haydon Calhoun Gallery, Dallas, 1960, 61; Nordness Galleries, 1962; Gordon Woodside Gallery, 1963, 64, 65; Richard White Gallery, Seattle, 1968; St. Mary's College (Ind.), 1969; Foster-White Gallery, 1972, 74. **Group:** Santa Barbara/MA, 1959; Otis Art Institute, 1963; Seattle World's Fair, 1962; Expo '70, Osaka, 1970. **Collections:** Oakland/AM; SFMA; Seattle/AM. **Bibliography:** Dover.

WATKINS, FRANKLIN C. b. December 30, 1894, NYC; **d.** December 3, 1972, Italy. **Studied:** U. of Virginia, 1911-12; U. of Pennsylvania, 1912-13; PAFA, 1913-14, 1916-17, 1918. US Navy, 1917-18. Traveled Europe, North Africa. **Taught:** Stella Elkins Tyler School of Fine Arts, Temple U., 1935; PAFA, 1935-72; American Academy, Rome, 1953-54. Designed sets and costumes for a ballet, "Transcendence," 1934. **Awards:** PAFA, Cresson Fellowship, 1917, 18; Art Club of Philadelphia, 1925; Carnegie, First Prize, 1931; Paris World's Fair, 1937, Bronze Medal; Chicago/AI, 1938; Golden Gate International Exposition, San Francisco, 1939; Corcoran, Gold Medal, 1939; PAFA, Carol H. Beck Gold Medal, 1941, Gold Medal, 1949; Franklin and Marshall College, Hon. DFA, 1954; Philadelphia Art Alliance, Medal of Achievement, 1957. **One-man Exhibitions:** (first) Rehn Galleries, 1934, also 1937, 42, 48;

Smith College, 1940; PMA (two-man), 1946; Detroit/Institute, 1954; PAFA, 1972. **Retrospectives:** MOMA, 1950; PMA, 1964. **Group:** Corcoran; PAFA; Carnegie; Chicago/AI; WMAA. **Collections:** Baltimore/MA; The Budd Co.; Buffalo/Albright; Corcoran; Courtauld Institute; Detroit/Institute; Harvard U.; Kansas City/Nelson; MMA; MOMA; Marquette U.; Newark Museum; PMA; U. of Pennsylvania; Phillips; Randolph-Macon Woman's College; Santa Barbara/MA; Smith College; WMAA; Wichita/AM. **Bibliography:** Baur 7; Cahill and Barr, eds.; **Clifford**; Flexner; Goodrich and Baur 1; Pousette-Dart, ed.; Richardson, E.P.; Wheeler; Wight 2. Archives.

WATTS, ROBERT M. b. June 14, 1923, Burlington, Iowa. **Studied:** U. of Louisville, 1944, B.Mech.Eng.; Columbia U., 1951, AM; ASL, with Bernard Klonis, John McPherson, Ethel Katz, Morris Kantor, William Zorach. US Naval Reserve, 1941-46. Traveled Mexico, Europe, Caribbean. **Taught:** Institute of Applied Arts and Sciences, Brooklyn, 1951-52; Rutgers U., 1952-53; Douglass College, 1953- . Changed from painting to sculpture, 1956; changed to light-sound-motion sculpture, 1957; first Events and Happenings, 1958. Designed costumes for James Waring Dance Co. **Films:** "Cascade," 1962; "G.W. & Sons," 1963; "89 Movies," 1965; "Alice," 1968. **Awards:** Rutgers U. Research Fund Grant, 1961, 62, 63; Carnegie Corporation Grant, 1965. **Address:** 80 Wooster Street, NYC 10012. **Dealers:** Galerie Baecker; Multipla; Rene Block Gallery Ltd. **One-man Exhibitions:** Douglass College Art Gallery, 1953, 57; U. of Alabama, 1957; Delacorte Gallery, NYC, 1958 (welded sculpture); Grand Central Moderns, NYC, 1960, 61; Smolin Gallery, NYC, 1960 (Magic Kazoo), 1963; The Kornblee Gallery, 1963; Galerie Rolf Ricke, 1966, 67; Galleria Christian Stein, Turin, 1967; SFAI, 1969; Apple Gallery, NYC, 1971; Galleria Bertesca, Milan, 1973; Galerie Baecker, 1973; Multipla, 1974, 75. **Group Exhibitions, Events, Happen-**

ings: Newark Museum, New Jersey Artists, 1955; Montclair/AM, New Jersey State Annual, 1955, 56; American Abstract Artists, 1957; Martha Jackson Gallery, New Media—New Forms, II, 1961; Amsterdam/Stedelijk, Art in Motion, circ. Europe, 1961-62; MOMA, The Art of Assemblage, circ., 1961; Fluxus International Festival, NYC, 1962-63; WGMA, The Popular Image, 1963; Smolin Gallery, NYC, Yam Festival, A Series of Events, 1963; III Paris Biennial, Two Inches (event), 1963; Buffalo/Albright, Mixed Media and Pop Art, 1963; Dwan Gallery, Boxes, 1964; Douglass College, 1964; MOMA, The Machine, 1968; MOMA, Photography into Sculpture, 1970; Cologne/Kunstverein, Happening & Fluxus, 1970; MOMA, Information, 1971; Documenta V, Kassel, 1972. **Bibliography:** Atkinson; *Contemporanea*; Gerdts; *Happening & Fluxus*; Hulten; Kozloff 3; *Kunst um 1970*; Lippard 5; *Report*; Seitz 3.

WAYNE, JUNE. b. March 7, 1918, Chicago, Ill. Self-taught in art. Traveled Europe extensively. **Federal A.P.:** Easel painting. **Member:** Artists Equity; Society of Washington Printmakers; The Print Club, Philadelphia; SAGA. Founder and director of Tamarind Lithography Workshop, Inc. (1959-75), funded by the Program in Humanities and the Arts of the Ford Foundation. Visiting Committee of the School of Visual and Environmental Studies, Harvard U., 1972-76. **Awards:** Los Angeles County Fair, **P.P.**, 1950; Los Angeles/County MA, **P.P.**, 1951; Library of Congress, Pennell **P.P.**, 1953; The Print Club, Philadelphia, **P.P.**, 1958; Pasadena/AM, **P.P.**, 1958, 59; SAGA, Edna Pennypacker Stauffer Memorial Prize, 1963; and others. **Address:** 1108 North Tamarind Avenue, Los Angeles, Calif. **Dealers:** La Demeure; Prints on Prince Street; Peter Plone Associates; Van Doren Gallery. **One-man Exhibitions:** (first) Boulevard Gallery, Chicago, 1935; Mexico City/Nacional, 1936; SFMA, 1950; Santa Barbara/MA, 1950, 53, 58; Pasadena/AM, 1952; Chicago/AI,

1952; The Contemporaries, NYC, 1953; de Young, 1956; California Palace; Achenbach Foundation, 1958; Los Angeles/County MA, 1959; Long Beach/MA, 1959; Philadelphia Art Alliance, 1959; U. of New Mexico, 1968; U. of Iowa, 1970; Grunwald Graphic Arts Foundation, Los Angeles, 1971; Gimpel & Weitzenhoffer, 1972; Los Angeles Municipal Art, 1973; Van Doren Gallery, 1974; Muckenthaler Cultural Center, Fullerton, Calif., 1974; La Demeure, 1975. **Retrospectives:** FAR Gallery, 1969; Cincinnati/AM, 1969. **Group:** Library of Congress; Brooklyn Museum; Seattle/AM; PAFA; U. of Illinois; Los Angeles/County MA; MMA; SAGA Annuals; MOMA, circ. (graphics); MOMA, Young American Printmakers, 1953; California State Fair; San Diego; Denver/AM; WMAA Annuals; Sao Paulo, 1955; Smithsonian; Achenbach Foundation; PCA, American Prints Today, circ., 1959-62; Paris/Moderne; The Japan Print Association, Tokyo, 1961; Smithsonian, 1964; CSCS, Fullerton, 1964; San Francisco Art Institute, 1965; Cincinnati/AM, 1968; and many others. **Collections:** Achenbach Foundation; Bibliotheque Nationale; Bibliotheque Royale de Belgique; UCLA; U. of California, Santa Barbara; Chicago/AI; Cincinnati/AM; Columbia, S.C./MA; De Pauw U.; Fort Worth; Grunwald Foundation; Iowa State U.; La Jolla; Lehigh U.; Library of Congress; Long Beach/MA; Los Angeles/County MA; MOMA; U. of Minnesota; NYPL; National Gallery; Newberry Library; U. of New Mexico; Northwestern U.; Oberlin College; PMA; Pasadena/AM; The Print Club, Philadelphia; San Diego; San Jose State College; Santa Barbara/MA; Smithsonian; Walker. **Bibliography:** *Art: A Woman's Sensibility*; Rodman 1, 3. Archives.

WEBER, HUGO. b. May 4, 1918, Basel, Switzerland; **d.** 1971. **Studied:** U. of Basel, 1942-46; Kunstgewerbeschule, Basel; Atelier Suter, Basel; Atelier Gimond, Paris, 1939; and with Aristede Maillol, Jean Arp, Alberto Giacometti,

1939-45. Swiss Army, 1939-41. Traveled USA, Canada, Europe; resided Paris. **Taught:** Institute of Design, Chicago, 1946-55; Oslo, Norway, 1955; The Pennsylvania State U.; NYU, 1963-70. Produced two films, "Vision in Flux," 1951, and "Process Documentation by the Painter," 1954. **Member:** Abstract and Concrete Artists Alliance, 1947-53. **Commissions:** Container Corp. of America (bronze bust of Lincoln). **One-man Exhibitions:** (first) Colorado Springs/FA, 1951; Chicago/AI, 1951; Galerie 16, Zurich, 1952; Institute of Design, Chicago, 1952; Galerie Parnass, Wuppertal, 1952; Allan Frumkin Gallery, Chicago, 1953, 55; Betty Parsons Gallery, 1953, 55, 59; American U., Beirut, Lebanon, 1954; B.C. Holland Gallery, 1961; Gres Gallery, Chicago, 1962; The Howard Wise Gallery, NYC, 1962-63; Galerie Hutter, Basel, 1963; Finch College, NYC, 1974; Landmark Gallery Inc., NYC, 1974. **Group:** Kunsthalle, Basel, 1945, 56; Toledo/MA, Sculpture Today, 1947; Chicago/AI Annuals, 1947, 49; Salon des Realites Nouvelles, Paris, 1948, 58, 59; Chicago/AI, Directions in American Painting, 1951; SRGM, Younger American Painters, 1954; Salon des Comparaisons, Paris, 1956; Galerie Creuze, Paris, 50 Years of Abstract Painting, 1957; Galerie Arnaud, L'Art Moral, 1957; Palais des Beaux-Arts, Charleroi, Belgium, L'Arte de XXIeme Siecle, 1958; Zurich, 16 Basel Maler, 1960; Salon du Mai, Paris, 1961; Dayton/AI, International Selection, 1963. **Collections:** Chicago/AI; Cincinnati/AM. **Bibliography:** *Avant-Garde Painting and Sculpture.* Archives.

WEBER, MAX. b. April 18, 1881, Byalestok, Russia; **d.** October, 1961, Great Neck, N.Y. To USA 1891. **Studied:** Pratt Institute, 1898-1900, with Arthur Dow; Academie Julian, Paris, 1905-06, with Jean Paul Laurens; Academie de la Grande Chaumiere; Academie Colarossi, Paris, 1906-07. Traveled Europe extensively. **Taught:** Lynchburg, Va., public schools, 1901-03; U. of Virginia (summer); State Normal School, Duluth, Minn., 1903-05; helped organize a class under Henri Matisse, Paris, 1907-08; White School of Photography, NYC, 1914-18; ASL, 1920-21, 1925-27; U. of Minnesota, 1931. **Member:** Society of Independent Artists, NYC (Director, 1918-19); American Artists Congress (National Chairman, 1937, Hon. National Chairman, 1938-40). **Awards:** Chicago/AI, Potter Palmer Gold Medal, 1928; PAFA, Joseph E. Temple Gold Medal, 1941; Corcoran, Third William A. Clark Prize, 1941; Chicago/AI, Ada S. Garrett Prize, 1941; Pepsi-Cola, Second Prize, 1945, 1946 ($500), 1947 ($750); Carnegie, Fourth Prize, 1946; La Tausca Competition, First Prize, 1946. **One-man Exhibitions:** (first) Haas Gallery, NYC, 1909; Photo-Secession, NYC, 1911; Murrary Hill Gallery, NYC, 1912; Ehrich Galleries, NYC, 1915; Jones Gallery, Baltimore, 1915; Montross Gallery, NYC, 1915, 23; J.B. Neumann Gallery, NYC, 1924, 25, 27, 30, 35, 37; The Downtown Galllery, 1928, 57, 58; Dayton/AI, 1938; A.A.A. Gallery, NYC, 1941, 70; Baltimore/MA, 1942; P. Rosenberg and Co., 1942, 43, 45, 46, 47; Carnegie, 1943; Santa Barbara/MA, 1947; WMAA, 1949; Walker, 1949; California Palace, 1949; Jewish Museum, 1956; Weyhe Gallery, 1956; Brandeis U., 1957; Pomona College, Stieglitz Circle, 1958; Pratt Institute, 1959; B'nai B'rith Gallery, Washington, D.C., 1961; U. of California, Santa Barbara, 1968; Danenberg Gallery, 1969, 70, 71, 72; Graham Gallery, 1970; Pratt Manhattan Center, NYC, 1971; Long Beach/MA, 1971; Alpha Gallery, 1974; Medici II Gallery, Bay Harbor Island, Fla., 1974; The Forum Gallery, 1975. **Retrospective:** 1968; Danenberg Gallery, 1969; Newark Museum, 1913, 59; Galerie Bernheim-Jeune, Paris, 1924; MOMA, 1930; P. Rosenberg and Co., 1944; A.F.A., circ., 1953; AAAL, Memorial, 1962. **Group:** MOMA, Paintings by 19 Living Americans, 1929; Corcoran; Chicago/AI; MOMA; WMAA. **Collec-**

tions: Andover/Phillips; Arizona State College; Baltimore/MA; Bezalel Museum; Brandeis U.; Britannica; Brooklyn Museum; Buffalo/Albright; California Palace; Carnegie; Chicago/AI; Cleveland/MA; Columbus; Cranbrook; Dartmouth College; Des Moines; Detroit/Institute; Fort Worth; Hartford/Wadsworth; Harvard U.; Howard U.; State U. of Iowa; Jewish Theological Seminary; Kansas City/Nelson; LaJolla; Los Angeles/County MA; MMA; MOMA; U. of Nebraska; Newark Museum; U. of North Carolina; PMA; Phillips; Sara Roby Foundation; San Antonio/McNay; San Diego; Santa Barbara/MA; Seattle/AM; Tel Aviv; Utica; Vassar College; WMAA; Walker; West Palm Beach/Norton; Wichita/AM; Youngstown/Butler. **Bibliography:** American Artists Congress, Inc.; *Arthur Dove: The Years of Collage*; Ashton 5; Barker 1; Baur 7; Bazin; Biddle 4; Blesh; Brown; Bulliet 1; **Cahill**; Cahill and Barr, ed.; Cassou; Cheney; Christensen; Eliot; Flanagan; Flexner; Frost; Genauer; **Goodrich 9**; Goodrich and Baur 1; Haftman; Hartmann; Hess, T.B. 1; Hunter 6; *Index of 20th Century Artists*; Janis, S.; Kootz 1, 2; Lee and Burchwood; McCoubrey 1; McCurdy, ed.; Mellquist; Mendelowitz; Munsterberg; Newmeyer; Pagano; Pearson 1, 2; Phillips 1, 2; Poore; Pousette-Dart, ed.; Read 2; Richardson, E.P.; Ringel, ed.; Ritchie 1; Rose, B. 1; Rosenblum 1; Sachs; Smith, S.C.K.; Soby 5; **Story**; Sutton; **Weber 1, 2**; Wight 2. Archives.

WEEKS, JAMES. b. December 1, 1922, Oakland, Calif. **Studied:** San Francisco Art Institute, 1940-42, with David Park; Nebraska State Teachers College, 1943; Hartwell School of Design, 1946-47; Escuela de Pintura y Escultura, Mexico City, 1951. US Army Air Force, 1942-45. **Taught:** San Francisco Art Institute, 1947-50, 1958, 64; Hartwell School of Design, 1948-50; California College of Arts and Crafts, 1958-59; UCLA, 1967-70; Tanglewood Summer Art Program, 1970-72; Bran-

deis U., 1973; Boston U., 1970-75. **Commission:** US Department of the Interior, Bicentenntial Program, 1975. **Awards:** Abraham Rosenberg Foundation Fellowship, 1952; Howard U., 1961; California Palace, 1961, 62. **Address:** 11 Notre Dame Road, Bedford, Mass. 01730. **Dealers:** Poindexter Gallery; Sunne Savage Gallery. **One-man Exhibitions:** (first) Lucien Labaudt Gallery, San Francisco, 1951; California Palace, 1953; Gallery 6, San Francisco, 1955; The East-West Gallery, San Francisco, 1958; Poindexter Gallery, 1960, 61, 63, 74; Felix Landau Gallery, 1963, 65, 66, 67, 70. **Retrospective:** SFMA, 1965; Boston U., 1971. **Group:** Los Angeles/County MA, 1957; Birmingham, Ala./MA, Figure Painting, 1961; Corcoran Biennial, 1961; California Palace, 1961, 62; Houston/MFA, 1961, 62; Yale U., 1962; St. Louis Artists' Guild, 1962; State U. of Iowa, Five Decades of The Figure, 1962; Chicago/AI, 1963; La Jolla, 1963; Skowhegan School, 1969; Carnegie, 1966; U. of Illinois, 1968; Scripps College, Figurative Painting, 1968; Expo '70, Osaka, 1970; Oakland/AM, A Period of Exploration, 1973. **Collections:** A.F.A.; Corcoran; First National Bank of Seattle; Howard U.; Lytton Savings and Loan Association; SFMA; US Department of the Interior. **Bibliography:** McChesney.

WEINBERG, ELBERT. b. May 27, 1928, Hartford, Conn. **Studied:** Hartford Art School; RISD, 1951, BFA; Yale U., with Waldemar Raemisch, 1955, MFA. **Taught:** RISD; Yale U.; Cooper Union. **Commissions:** Atlanta, Ga. (copper eagle for a façade); Alavath Achim Synagogue, Atlanta, Ga.; 405 Park Avenue, NYC (terra cotta mural); Jewish Museum, 1959 (sculpture for the garden); Brandeis U.; Colgate U.; Jewish Community Center, White Plains, N.Y.; Washington (D.C.) Hebrew Congregation; Jewish Theological Seminary. **Awards:** Prix de Rome, 1951-53; ICA, London/Tate, International Unknown Political Prisoner Competition, Hon.

Men., 1953; *Progressive Architecture* Magazine, 1954; Yale U., Silver Medal for Schievement in the Arts, 1959; Guggenheim Foundation Fellowship, 1960. **Address:** c/o Dealer. **Dealer:** Grace Borgenicht Gallery Inc. **One-man Exhibitions:** Providence (R.I.) Art Club, 1951, 54; Grace Borgenicht Gallery Inc., 1957-66, 1969, 70. **Group:** WMAA, 1935, 36, 57, Annuals, 1957, 58, 60, 64, 65; Andover/Phillips, 1954; Silvermine Guild, 1954; Jewish Museum, 1954; ICA, Boston, 1957; Hartford/Wadsworth, Connecticut Artists, 1957; AAAL, 1958; A.F.A./USIA, Religious Art, circ. Europe, 1958-59; U. of Nebraska, 1958, 59, 61; Carnegie, 1958, 61; MOMA, Recent Sculpture USA, 1959; Chicago/AI, 1959, 61; Utica, 1960; Boston Arts Festival, 1961; PAFA, 1961; Smithsonian, 1961. **Collections:** Andover/Phillips; Brandeis U.; Colgate U.; 405 Park Avenue, NYC; Hartford/Wadsworth; Jewish Museum; MOMA; RISD; WMAA; Yale U. **Bibliography:** Chaet; Rodman 3.

WEINRIB, DAVID. b. 1924, Brooklyn, N.Y. **Studied:** Brooklyn College; Alfred/SUNY. **Taught:** School of Visual Arts, NYC. **Awards:** J.S. Guggenheim Fellowship, 1968. **Address:** c/o Dealer. **Dealer:** Royal Marks Gallery. **One-man Exhibitions:** The Howard Wise Gallery, 1963; Royal Marks Gallery, 1966, 71. **Group:** WMAA Annual, 1964-65, 66-67; VIII Sao Paulo Biennial, 1965; NYU, 1965; Los Angeles/County MA, American Sculpture of the Sixties, 1967; Southern Illinois U., 1967; U. of Illinois, 1969. **Collections:** Los Angeles/County MA; WMAA; Walker. **Bibliography:** Battcock, ed.; Friedman, M. 2; Tuchman 1.

WELLIVER, NEIL. b. July 22, 1929, Millville, Pa. **Studied:** Philadelphia Museum School, 1948-52, BFA; Yale U., with Josef Albers, James Brooks, Burgoyne Diller, Conrad Marca-Relli, 1953-54, MFA. Traveled Southeast Asia, Europe. **Taught:** Cooper Union, 1953-57; Yale U., 1955-65; Swarthmore College, 1966; U. of Pennsylvania, 1966-69. **Commissions:** Painted murals for the architect Paul Rudolph. **Awards:** NAD, Samuel F.B. Morse Fellowship, 1962. **Address:** R.D. 2, Lumberville, Me. 04849. **Dealer:** Fischbach Gallery. **One-man Exhibitions:** (first) Alexandra Grotto, Philadelphia, 1954; Boris Mirski Gallery, Boston, 1959; The Stable Gallery, 1962-65; Swarthmore College, 1966; Tibor de Nagy Gallery, NYC, 1968-69, 1970; McLeaf Gallery, Philadelphia, 1969; John Bernard Myers Gallery, NYC, 1970, 71; Parker Street 470 Gallery, Boston, 1970; U. of Rhode Island, 1974; Fischbach Gallery, 1974. **Group:** PAFA Annual, 1962; A.F.A., Wit and Whimsey in 20th Century Art, circ., 1962-63; Baltimore/MA, 1963; Swarthmore College, Two Generations of American Art, 1964; WMAA Annuals; U. of Illinois, 1964; Vassar College, 1968; PAFA, 1968; A.F.A., Painterly Realism, 1970; NIAL, 1971; Boston U., The American Landscape, 1972; U. of North Carolina, Works On Paper, 1972; WMAA Annuals, 1972, 73; U. of Nebraska, 1973; Queens Museum, New Images, 1974; Oklahoma, Contemporary American Landscape Painting, 1974. **Collections:** Bank of New York; Boston/MFA; Brandeis U.; Chase Manhattan Bank; Colby College; NYU; U. of North Carolina; Utah; Vassar College; WMAA.

WESLEY, JOHN. b. November 25, 1928, Los Angeles, Calif. Traveled USA, Europe. **Taught:** School of Visual Arts, NYC, 1970-73. **Address:** 52 Barrow Street, NYC 10014. **Dealer:** Robert Elkon Gallery. **One-man Exhibitions:** Robert Elkon Gallery, 1963, 64, 65, 67, 69, 71, 72, 73, 74; Galerie Rudolf Zwirner, 1973; Carl Solway Gallery, Cincinnati, 1974; U. of Rochester, 1974. **Group:** Washington (D.C.) Gallery of Modern Art, Popular Image, 1965; Brussels/Beaux-Arts, Nouveau Realisme, 1967; A.F.A., The Figure International, 1967-68; WMAA, 1968, 69; Indianapolis, 1969; Documenta V, Kassel, 1972. **Collections:** Brandeis U.;

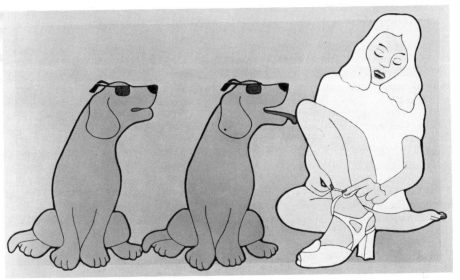

John Wesley *Pet* 1972

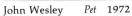

Tom Wesselmann *1970 Nude* 1975

Buffalo/Albright; Hirshhorn; MOMA; U. of Rochester; U. of Texas.

WESSELMANN, TOM. b. February 23, 1931, Cincinnati, Ohio. **Studied:** Hiram College; U. of Cincinnati, BA (psychology); Art Academy of Cincinnati; Cooper Union, with Nicholas Marsicano. **Address:** 115 East 9 Street, NYC 10002. **Dealer:** Sidney Janis Gallery. **One-man Exhibitions:** (first) Tanager Gallery, NYC, 1961; Green Gallery, NYC, 1962, 64, 65; Ileana Sonnabend Gallery, Paris, 1966; Sidney Janis Gallery, 1966, 68, 70, 72, 74; Galleria Sperone, Turin, 1967; Dayton's Gallery 12, Minneapolis, circ., 1968; Newport Harbor, circ., 1970; Jack Glenn Gallery, Corona del Mar, 1971; Rosa Esman Gallery, 1972; Galerie Aronowitsch, Stockholm, 1972; Multiples Inc., Los Angeles, 1973; California State U., Long Beach, circ., 1974; Galerie des 4 Mouvements, Paris, 1974. **Group:** Sidney Janis Gallery, The New Realists, 1962; MOMA, Recent Painting USA: The Figure, circ., 1962-63; Dwan Gallery, 1962, 64; Ileana Sonnabend Gallery, Paris, 1963; Buffalo/Albright, Mixed Media and Pop Art, 1963; WGMA and ICA, London, The Popular Image, 1963; Amsterdam/Stedelijk, American Pop Art, 1964; Stockholm/National, 1964; Chicago/AI, 1964; Carnegie, 1964, 67; Milwaukee, 1965; Palais des Beaux-Arts, Brussels, 1965; WMAA, Young America, 1965; WMAA Annuals, 1965, 68, 72, 73; MOMA, Art in the Mirror, 1966; Toronto, 1966; WMAA, Art of the U.S. 1670-1966, 1966; RISD, Recent Still Life, 1966; IX Sao Paulo Biennial, 1967; Expo '67, Montreal, 1967; Trenton/State, Focus on Light, 1967; Documenta IV, Kassel, 1968; WMAA, Artists Under 40, 1968; Vancouver, circ., 1969; Cincinnati/Contemporary, Monumental Art, 1970; Mathildenhohe, Darmstadt, III Internationale der Zeichnung, 1970; ICA, U. of Pennsylvania, Highway, 1970; Roko Gallery, Homage to Tanager: 1952-62, 1971; Dublin/Municipal, International Quadriennial (ROSC), 1971; Hofstra U., Art around the Automobile, 1971; Chicago/AI, 1972, 74; WMAA, American Drawings, 1963-1973, 1973; Turin/Civico, La Fotografia e l'Arte, 1973; New School for Social Research, Erotic Art, 1973; Yale U., American Drawing: 1970-1973, 1973; WMAA, American Pop Art, 1974. **Collections:** Brandeis U.; Buffalo/Albright; Cincinnati/AM; Cologne; U. of Kansas; MOMA; Minneapolis/Institute; U. of Nebraska; PMA; Princeton U.; Rice U.; U. of Texas; Washington U. **Bibliography:** Alloway 1; Battcock, ed.; Bihalji-Merin; Calas, N. and E.; *Celebrate Ohio*; Davis, D.; Dienst 1; Hunter, ed.; *Kunst um 1970*; Lippard 5; Rose, B. 1; Rublowsky; Russell and Gablik; Sager; Weller.

WESTERMANN, H.C. b. December 11, 1922, Los Angeles, Calif. **Studied:** Chicago Art Institute School, 1947-54, with Paul Wieghardt. US Marine Corps, World War II. Traveled the Orient. **Awards:** Chicago/AI, Campana Prize, 1964; National Council on the Arts, 1967; Tamarind Fellowship, 1968; Sao Paulo Biennial Prize, 1973; Chicago/AI, The Mr. & Mrs. Frank G. Logan Medal, 1974. **Address:** Box 28, Brookfield Center, Conn. 06805. **Dealer:** Allan Frumkin Gallery, NYC. **One-man Exhi-**

H. C. Westermann *A New Piece of Land* 1973

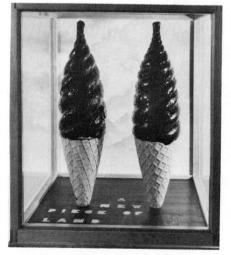

bitions: (first) Allan Frumkin Gallery, Chicago, 1957, also 1962, 67, 71, NYC, 1961, 63, 65, 67, 68, 70, 71, 73, 74; Dilexi Gallery, Los Angeles, 1962, San Francisco, 1963; Kansas City/Nelson, 1966; U. of California, Berkeley, 1971; Moore College of Art, Philadelphia, 1972; Galerie Rudolf Zwirner, 1972; Galerie Hans R. Neuendorf, Hamburg, 1973; Galerie Thomas Borgmann, Cologne, 1973; James Corcoran Galleries, Los Angeles, 1974. **Retrospectives:** Los Angeles/County MA, 1968; Chicago/Contemporary, 1969. **Group:** Houston/MFA; Hartford/Wadsworth; A.F.A.; MOMA, New Images of Man, 1959; MOMA, The Art of Assemblage, circ., 1961; U. of Illinois, 1961; Tate, Gulbenkian International, 1964; The Hague, New Realism, 1964; Chicago/AI, 1964, 67, and Exhibition Momentum; WMAA, 1964, 68; Worcester/AM, 1965; RISD, 1965; Walker, 1966; The Ohio State U., 1966; Los Angeles/County MA, American Sculpture of the Sixties, 1967; Carnegie, 1967; Documenta IV, Kassel, 1968; ICA, U. of Pennsylvania, The Spirit of the Comics, 1969; WMAA, Human Concern/Personal Torment, 1969; La Jolla, Continuing Art, 1971; SRGM, 10 Independents, 1972; Chicago/Contemporary, Chicago Imagist Art, 1972; New York Cultural Center, 3D into 2D, 1973; WMAA, American Drawings: 1963-1973, 1973; Sao Paulo Biennial, 1973; Chicago/AI, 1974. **Collections:** Ackland; Chicago/AI; Hartford/Wadsworth; Los Angeles/County MA; Pasadena/AM; WMAA; Walker; Wichita/AM. **Bibliography:** Atkinson; Friedman and van der Marck; Janis and Blesh 1; **Kozloff 1**; Lippard 5; Read 3; Rose, B. 1; Schulze; Seitz 3; Tuchman 1; Weller.

WHITMAN, ROBERT. b. 1935, NYC. **Studied:** Rutgers U., 1957; Columbia U. **Address:** c/o Dealer. **Dealer:** Bykert Gallery. **One-man Exhibitions:** (first) Hansa Gallery, NYC, 1959; Reuben Gallery, NYC, 1959; The Pace Gallery, 1967; Chicago/Contemporary, 1968; Jewish Museum, 1968; MOMA, 1973; Bykert Gallery, 1974; Galleria l'Attico, Rome, 1974. **Happenings:** Since 1960, more than 15 theatre pieces, incl. Prune Flat, The American Moon, The Night Time Sky. **Cinema Pieces:** Cinema, Shower, and others. **Group:** Reuben Gallery, NYC, 1959; Martha Jackson Gallery, New Media—New Forms, I & II, 1960, 61, also 1962; Nine Great Jones Street, NYC (two-man, with Walter De Maria), 1963; SRGM, 1965; Finch College, 1967; Walker, 1968; Newark College of Engineering, 1968; Walker, 6 Artists—6 Exhibitions, 1968; Newark College of Engineering, Light as Art, 1968; Kansas City/Nelson, Magic Theater, 1968; Expo '70, Osaka, 1970; Los Angeles/County MA, Art & Technology, 1971; MOMA, Projects: Robert Whitman, 1973. **Collections:** Chicago/Contemporary; Jewish Museum. **Bibliography:** *Art Now 74*; Becker and Vostell; *Contemporanea*; Davis, D.; *Figures/Environments*; Hansen; *Happening & Fluxus*; Hunter, ed.; Kaprow; Kirby; Lippard 5; *Report*; Sontag.

WIEGHARDT, PAUL. b. August 26, 1897, Germany; **d.** December 9, 1969, Evanston, Ill. **Studied:** School of Fine Arts, Cologne; Bauhaus, Weimar, with Paul Klee; Academy of Fine Arts, Dresden. **Taught:** Chicago Art Institute School, 1946-68; Illinois Institute of Technology, 1950-68. **One-Man Exhibitions:** Pittsfield/Berkshire, 1941; Harvard U.; St. Paul Gallery; Phillips; M. Knoedler & Co., NYC; Springfield, Mass./MFA; Chicago/AI; Illinois Institute of Technology; Syracuse U.; Milwaukee; Hagen; U. of Arizona; 1920 Art Center, Chicago. **Group:** Salon d' Automne, Paris; Salon des Tuileries, Paris; Salon des Artistes Independants, Paris; Exposition Nationale, Paris; Chicago/AI; PAFA; Library of Congress; Stanford U.; U. of Illinois. **Collections:** Barnes Foundation; Buffalo/Albright; Phillips; Pittsfield/Berkshire; Smith College.

WILDE, JOHN. b. December 12, 1919, Milwaukee, Wisc. **Studied:** U. of Wis-

consin, 1947, MA. **Taught:** U. of Wisconsin, 1948- , Alfred Sessler Distinguished Professor of Art. **Address:** RFD #1, Evansville, Wisc. 53536. **Dealers:** Veldman Galleries; Frank Oehlschlaeger Gallery, Chicago. **One-man Exhibitions:** (first) U. of Wisconsin, 1942; David Porter Gallery, Washington, D.C., 1944; Kalamazoo/Institute, 1945; Layton School of Art, 1947; Milwaukee, 1948, 59; Pennsylvania College for Women, 1949; Hewitt Gallery, NYC, 1950, 53, 55; Bresler Galleries Inc., Milwaukee, 1949, 51, 53, 55, 58, 61, 63; Newman Brown, Chicago, 1953; Robert Isaacson Gallery, NYC, 1959, 61; Columbia, S.C./MA, 1960; Lane Gallery, Los Angeles, 1960; U. of Wisconsin, Milwaukee, 1960; Durlacher Brothers, NYC, 1963; The Banfer Gallery, 1968; Northern Illinois U., 1969; Veldman Galleries, 1971, 73; Nordness Galleries, 1971; Frank Oehlschlaeger Gallery, Chicago, 1974. **Retrospective:** Milwaukee, 1967. **Group:** Chicago/AI, 1940, 41, 42, 51, 52, 54, Abstract and Surrealist Art, 1948; PAFA, 1941, 46, 50, 52, 53, 58, 59, 60, 62; Walker, 1947, 49, 51, 62, Reality and Fantasy, 1954; U. of Illinois, 1948, 52, 55, 57, 58, 61, 63; A.F.A., American Watercolors, 1949; MMA, 1950, 52 Americans Under 35, 1954; WMAA, 1950, 52, 53, 55, 56, 58, 60, 62, 70; Corcoran, 1953; Youngstown/Butler, 1953, 55, 57, 69; Denver/AM, 1955, 56; Hallmark Art Award, 1955, 58; MOMA, Recent Drawings USA, 1956; Carnegie, 1958; Detroit/Institute, 1959; ART:USA:Now, circ., 1962-67; NAD, 1968; St. Joseph/Albrecht, Drawing—America: 1973, 1973. **Collections:** Carnegie; Chicago/AI; De Beers Collection; Detroit/Institute; Hartford/Wadsworth; Kalamazoo/Institute; Marquette U.; Milwaukee; Milwaukee *Journal*; Minnesota/MA; NCFA; U. of Nebraska; Neenah/Bergstrom; PAFA; Sara Roby Foundation; St. Joseph/Albrecht; Santa Barbara/MA; WMAA; Walker; Washington Federal Bank, Miami; U. of Wisconsin; Worcester/AM; Youngstown/Butler. **Bibliography:** Nordness, ed.

WILEY, WILLIAM T. b. October, 1937, Bedford, Ind. **Studied:** California School of Fine Arts, 1956-60, BFA. **Taught:** U. of California, Davis, 1962-*ca.*1968. **Awards:** CSFA, Painting Award, 1959, Fletcher Award, 1960; SFMA, First Prize, 1960; Oakland/AM, cash award, 1961; Chicago/AI, First Prize and Guest of Honor Award, 1961. **Address:** Box 654, Woodacre, Calif. 94973. **Dealer:** Allan Frumkin Gallery, NYC. **One-man Exhibitions:** RAC, 1960; Staempfli Gallery, 1960, 62, 64; The Lanyon Gallery, 1965; Allan Frumkin Gallery, NYC, 1968, 70, 73, Chicago, 1969; Hansen-Fuller Gallery, 1969, 71, 72; SFAI, 1969; Eugenia Butler, 1969; Studio Marconi, Milan, 1971; James Manolides Gallery, Seattle, 1972; Margo Leavin Gallery, 1972; Eindhoven, 1973. **Retrospective:** U. of California, Berkeley, 1971. **Group:** SFMA, 1959, 60; RAC, 1959, 60; San Francisco Art Festival, 1960; WMAA, Young America, 1960; Chicago/AI, 1961; U. of Illinois, 1961; U. of Nebraska, 1961; California Palace, 1961; WMAA, Fifty California Artists, 1962; Los Angeles/County MA, American Sculpture of the Sixties, 1967; U. of California, Berkeley, Funk, 1967; WMAA Annual, 1967; Moore College of Art, Philadelphia, Beyond Literalism, 1968; Tampa Bay Art Center, Forty California Sculptors, 1968; Chicago/Contemporary, Violence in Recent American Art, 1968; Indianapolis, 1969; Berne, When Attitudes Become Form, 1969; MOMA, New Media: New Methods, circ., 1969; Eindhoven, Kompas IV, 1969-70; Foundation Maeght, 1970; Omaha/Joslyn, Looking West, 1970; SFAI, Centennial Exhibition I, 1970; Sacramento/Crocker, SacramentoSampler I, 1972; Documenta V, Kassel, 1972; Venice Biennial, 1972; Ringling, After Surrealism, 1972; WMAA, 1973. **Collections:** U. of California, Berkeley; Chicago/AI; Des Moines; Eindhoven; Fort Worth; Illinois Bell Telephone Company; U. of Kansas; Los Angeles/County MA; MOMA; Minneapolis/Institute; Oakland/AM; SFMA; WMAA. **Bibliography:** *Art Now 74*; Lippard, ed.;

Report; **Richardson, B. 2**; Selz, P. 2; *The State of California Painting;* Tuchman 1; *When Attitudes Become Form.* Archives.

WILFRED, THOMAS (Richard Edgar Løvstrøm). b. June 18, 1889, Naestved, Denmark; **d.** August 15, 1968, West Nyack, N.Y. **Studied:** Sorbonne. Traveled Europe, USA. **Awards:** Philadelphia College of Art, Hon. Ph.D., 1968. **Group:** MOMA, Fifteen Americans, circ., 1952; Stockholm/National, Art in Motion, 1961; Eindhoven, Kunst-Licht-Kunst, 1966; Walker and Milwaukee, Light Motion Space, 1967; Trenton/State, Focus on Light, 1967; The Howard Wise Gallery, Lights in Orbit, 1967, and Festival of Lights, 1968; Worcester/AM, Light and Motion, 1968. **Collections:** Clairol Inc.; Cleveland/MA; Honolulu Academy; MMA; MOMA; Omaha/Joslyn. **Bibliography:** Davis, D.; Rickey; Rubin 1.

WILKE, ULFERT S. b. July 14, 1907, Bad Toelz, Germany. **Studied:** Arts and Crafts School, Brunswick, 1924-25; privately with Willy Jaeckel, 1923; Academie de la Grande Chaumiere, 1927-28; Academie Ranson, Paris, 1927-28; Harvard U. Graduate School, 1940-41; State U. of Iowa, 1946-47, MA. Traveled Europe extensively, Japan. US citizen 1943. US Army, 1942-45. **Taught:** Kalamazoo College, 1940-42; Springfield (Ill.) Art Association, 1946-47; State U. of Iowa, 1947-48; U. of Louisville, 1948-55, 1958-59, 1961-62; U. of Georgia, 1955, 56; Rutgers U., 1962-67. Director, Museum of Art, State U. of Iowa, 1968- . **Awards:** Albrecht Durer Prize, 1928; New Orleans/Delgado, First Prize, 1928; US Army Arts Contest, Gold Medal, 1945; Lousiville Art Center Annual Exhibition, First Prize, Painting, 1951; Georgia Museum of Art, **P.P.**, 1956; Guggenheim Foundation Fellowship, 1959, 60. **Address:** R.R. #3, Solon, Iowa 52333. **Dealers:** Kraushaar Galleries; David Stuart Gallery. **One-man Exhibitions:** (first) a gallery in Germany, 1927; Brunswick Castle, 1929; Anton Ullrich Museum, Brunswick, 1933; Westermann Gallery, NYC, 1939; Harvard U., 1940; Denver/AM, 1943; Springfield (Ill.) Art Association, 1946; Decatur, 1947; Kalamazoo/Institute, 1947; Muhlenberg College, 1947; Memphis Academy of Arts, 1948; U. of Louisville, 1948; Santa Barbara/MA, 1949; Sweet Briar College, 1949; U. of Nebraska, 1949; The Little Gallery, Louisville, 1950, 53; Kunstverein Hannover, 1952; Kraushaar Galleries, 1958, 60; Tulane U., 1958; Yamada Gallery, Kyoto, 1958; de Young, 1959; Dallas/MFA, 1960; American Academy, Rome, 1960; Primus-Stuart Gallery, Los Angeles, 1961; Rutgers U., 1963; Kalamazoo/Institute, 1964 (two-man, with George Rickey); The Howard Wise Gallery, 1965 (three-man); Design Center of Berea, Cleveland, 1970; Des Moines, 1970; SFMA, 1971; Omaha/Joslyn, 1971; Columbus, 1971; Percival Galleries, Des Moines, 1972; Jodi Scully Gallery, 1972; Poindexter Gallery, 1973; Waterloo, 1974; MacNider Museum, 1974. **Group:** Academy of Fine Arts, Berlin, 1929, 31; *Life* Magazine, War Art, circ. USA, 1942; Chicago/AI, 1943-47; MMA, 1952; SRGM, Younger American Painters, 1954; Brooklyn Museum, 1955, 56, 57, 58, 61; Smithsonian, Italy Rediscovered, circ. USA, 1955-56; MOMA, Lettering by Hand, 1962; M. Knoedler & Co., Art Across America, circ., 1965-67; International Biennial Exhibition of Paintings, Tokyo. **Collections:** Aetna Oil Co.; Brandeis U.; Brunswick; Buffalo/Albright; Carnegie, Chase Manhattan Bank; Citizens Fidelity Bank, Louisville; Columbia U.; Cooper Union: Dayton/AI; Decatur; U. of Georgia; Hartford/Wadsworth; Honolulu Academy; U. of Illinois; State U. of Iowa; Kultusministerium; Louisiana State U.; Mills College; Minneapolis/Institute; NYU; U. of Notre Dame; Nurnberg; Omaha/Joslyn; PMA; Phoenix; Pratt Institute; SFMA; Seagram Collection; Stanford U. **Bibliography:** Seldis and Wilke; Wilke. Archives.

WILLENBECHER, JOHN. b. May 5,

John Willenbecher *The Table (I)* 1975

1936, Macungie, Pa. **Studied:** Brown U. (with William Jordy, George Downing), BA, 1958; NYU (with Craig Hugh Smyth), 1958-61. Traveled Europe. **Taught:** Philadelphia College of Art, 1972-73. **Awards:** MacDowell Colony Grant, 1974. **Address:** 145 West Broadway, NYC, 10013. **Dealer:** A.M. Sachs Gallery. **One-man Exhibitions:** (first) Feigen-Herbert Gallery, NYC, 1963; Feigen-Palmer Gallery, Los Angeles, 1964; Richard Feigen Gallery, Chicago, 1964, 68, NYC, 1965, 67; A.M. Sachs Gallery, 1973, 75; Syracuse/Everson, 1975; Brown U., 1975; Arts Club of Chicago, 1976. **Group:** Buffalo/Albright, Mixed Media and Pop Art, 1963; ICA, U. of Pennsylvania, Current Art, 1965; RISD, 1965; WMAA, Young America, 1965; Eindhoven, Kunst-Licht-Kunst, 1966; U. of Illinois, 1967; WMAA Annual, 1968; Brooklyn Museum Print Exhibition, 1970; Indianapolis, 1970; Finch College, NYC, Projected Art, 1971; Rice U., Gray is the Color, 1974; U. of North Carolina, Works on Paper, 1974; AAAL, 1974. **Collections:** Boise-Cascade Corp.; Buffalo/Albright; Chase Manhattan Bank; MMA; PMA; U. of Pennsylvania; RISD; Ridgefield/Aldrich; SRGM; U. of Texas; 3M Company; WMAA.

WILLIAMS, HIRAM. b. February 11, 1917, Indianapolis, Ind. **Studied:** ASL, 1939, with Jean Charlot, Robert Brackman; The Pennsylvania State U., with Hobson Pittman, Victor Lowenfeld, 1949-50, BS, 1951, MA.Ed. US Army, 1941-45. Traveled Europe. **Taught:** Harrington (Del.) public schools, 1949-51; U. of Southern California, 1952-53; U. of Texas, 1954-60; U. of South Carolina, summer, 1957; UCLA, summer, 1959; U. of Florida, 1960- . **Awards:** Texas State Fair, D.D. Feldman Award, 1956, 58, 59; U. of Texas Research Grant, 1958; Guggenheim Foundation Fellowship, 1963; Longview (Tex.) Art Museum, **P.P.,** 1966. **Address:** 2804 N.W. 30 Terrace, Gainesville, Fla. 32605. **Dealer:** Nordness Galleries. **One-man Exhibitions:** (first) Muncy (Pa.) Library, 1940; Witte,

1957; Nye Gallery, Dallas, 1958, 61, 64; Laguna Gloria Gallery, Austin, Tex., 1959; Texas Fine Arts Association, 1959; Felix Landau Gallery, 1959; Cushman Gallery, Houston, 1960; Lee Nordness Gallery, 1961, 63, 68; Chapman Kelly Gallery, 1965 (two-man, with Hobson Pittman); Longview (Tex.) Art Museum, 1966 (two-man); U. of Wisconsin, 1966; Kovler Gallery, 1966; Florida State U., 1967; U. of Florida, 1967; U. of Missouri, 1967; U. of Colorado, 1967; Northern Illinois U., 1967; U. of Wichita, 1967; Troy State College, 1967; Palm Beach (Fla.) Junior College, 1969. **Group:** PMA, 1951; Austin, 1955, 57; MOMA, 1960, Recent Painting USA: The Figure, circ., 1962-63; PAFA, 1960, 63; WMAA Annual, 1960, also 1965, 66; Houston/MFA, The Emerging Figure, 1961; Corcoran, 1961, Biennial, 1965; SFMA, 1963; Carnegie, 1964; U. of Illinois; M. Knoedler & Co., Art Across America, circ., 1965-67; Florida State U., 1966; NIAL, 1966; Huntington, N.Y./Heckscher, 1969. **Collections:** Ball State U.; Corcoran; Dallas/MFA; MOMA; Milwaukee; NCFA; PAFA; The Pennsylvania State U.; Ringling; U. of Texas; WMAA; Wilmington. **Bibliography:** Nordness, ed.; **Williams, H.**

WILLIAMS, NEIL. b. August 19, 1934, Bluff, Utah. **Studied:** California School of Fine Arts, 1959, BFA. Traveled Europe, Southwest USA. **Taught:** School of Visual Arts, NYC. **Awards:** National Council on the Arts Award, 1966; Guggenheim Foundation Fellowship, 1968. **Address:** Box 234, Sagaponack, N.Y. 11962. **Dealer:** Andre Emmerich Gallery. **One-man Exhibitions:** City Lights Book Store, San Francisco, 1959; Green Gallery, NYC, 1964; Dwan Gallery, Los Angeles, 1966; LoGiudice Gallery, NYC, 1971; Walter Kelly Gallery, 1973. **Group:** San Francisco Art Association, 1958; RAC, 1959; SRGM, 1964, also Systemic Painting, 1966; WMAA, Young America, 1965; Oberlin College, 1965; Amsterdam/Stedelijk, New Shapes of Color, 1966; Southern

Illinois U., 1967; Southern Illinois U., Decade Seven, 1967; Carnegie, 1967; WMAA, 1967, 72; Des Moines, Painting, Out from the Wall, 1968; Vassar College, Current Minimal Paintings, 1969. **Collections:** MIT; RAC; WMAA. **Bibliography:** Alloway 3.

WILMARTH, CHRISTOPHER. b. June 11, 1943, Sonoma, Calif. **Studied:** Cooper Union, 1960-62, 1964, 65, BFA. Traveled Europe. **Taught:** Cooper Union, 1969- ; Yale U., 1971-72. **Awards:** National Endowment for the Arts, 1968; Guggenheim Foundation Fellowship, 1970; Chicago/AI, Norman Wait Harris Award, 1972; Brown U., Howard Foundation Fellowship, 1972. **Address:** P.O. Box 203, Canal Street Station, NYC 10013. **One-man Exhibitions:** (first) The Graham Gallery; Paula Cooper Gallery, 1971, 72; Galleria dell' Ariete, 1973; Janie C. Lee Gallery, Dallas and Houston, 1974; Weinberg Gallery, San Francisco, 1974; Rosa Esman Gallery, 1974; Hartford/Wadsworth, 1974; St. Louis/City, 1975; Galerie Aronowitsch, Stockholm, 1975. **Group:** WMAA, 1966, 68, 70, 73; Park Place Gallery, NYC, 1966; Foundation Maeght, 1970; Chicago/AI, 1972; MOMA, 1972, 74; MMA, 1974; Hayward Gallery, London, 1975. **Collections:** Chicago/AI; Dallas/MFA; Des Moines; Harvard U.; MMA; MOMA; PMA; RISD; Woodward Foundation.

WILSON, JANE. b. April 29, 1924, Seymour, Iowa. **Studied:** State U. of Iowa, with Stuart Edie, James Lechay, Mauricio Lasansky, 1945, BA, PBK, 1947, MA (Painting). Traveled Mexico, USA extensively. **Taught:** State U. of Iowa, 1947-49; Pratt Institute, 1967-69; and privately. **Awards:** Ingram Merrill Foundation Grant, 1963; L.C. Tiffany Grant, 1967. **Address:** c/o Dealer. **Dealer:** The Graham Gallery. **One-man Exhibitions:** St. John's College, Annapolis, Md., 1951; Hansa Gallery, NYC, 1953, 55, 57; Esther Stuttman Gallery, NYC, 1958, 59; Tibor de Nagy Gallery, 1960-66; Gump's Gallery, 1963; Esther

Baer Gallery, 1963, 64; The Graham Gallery, 1968, 69, 71, 73. **Group:** Chicago/AI, 1946; The Stable Gallery Annuals, 1951, 52; MOMA, New Talent, circ., 1957-59; WMAA Annual, 1962; A.F.A., circ., 1963; MIT; Corcoran; New York World's Fair, 1964-65. **Collections:** Chase Manhattan Bank; Cincinnati/AM; Corcoran; Hartford/Wadsworth; Indianapolis/Herron; MOMA; NYU; Rockefeller Institute; The Singer Company Inc.; Uris Buildings Corp.; WMAA.

WINES, JAMES. b. June 27, 1932, Oak Park, Ill. **Studied:** Syracuse U., with Ivan Mestrovic, 1950-55, BA. Traveled Europe, USA; resided Rome, 1956-62. **Taught:** School of Visual Arts, NYC, 1965-71; NYU, 1965- ; Cornell U., 1969; Buffalo/SUNY, 1970. President, SITE, Inc., 1969- . **Commissions:** Hoffmann-La Roche Pharmaceutical Co. (3 large sculptures for New Jersey offices). **Awards:** Pulitzer Fellowship, 1953; Prix de Rome, 1956; Guggenheim Foundation Fellowship, 1962; Ford Foundation Grant, 1964. **Address:** 60 Greene Street, NYC 10012. **One-man Exhibitions:** National Academy of Istanbul, Turkey, 1956; Baltimore/MA, 1958; Silvan Simone Gallery, 1958, 59, 61; Alphonse Chave, Vence, France, 1960; Galleria Trastevere di Topazia Alliata, Rome, 1960, 61; Otto Gerson Gallery, NYC, 1960, 62; Syracuse U., 1962; Walker, 1964; Colgate U., 1966. **Group:** Syracuse/Everson, 1951-54, 1963; Baltimore/MA, 1952, 53, 54; Uffizi Loggia, Florence, Italy, 1957; Los Angeles/County MA, 1958; Sacramento Arts Festival, 1958; WMAA Annuals, 1958, 60, 62; MOMA, Recent Sculpture USA, 1959; Chicago/AI, 1959, 63; U. of Illinois, 1959, 63, 65, 69; Museum des 20. Jahrhunderts; Amsterdam/Stedelijk; Carnegie, 1961; VII Sao Paulo Biennial, 1963; Flint/Institute, I Flint Invitational, 1966. **Collections:** Amsterdam/Stedelijk; Buffalo/Albright; Chicago/AI; Cleveland/MA; Colgate U.; Columbia Broadcasting System; Currier; Hoffmann-La Roche Inc.; Indianapo-

lis/Herron; Kansas City/Nelson; Los Angeles/County MA; U. of Massachusetts; Museum des 20. Jahrhunderts; NYU; South Mall, Albany; Syracuse/Everson; Tate; Towson State College; Treadwell Corp.; Utica; WMAA; Walker; U. of Wisconsin. **Bibliography:** Goodrich and Baur 1; Read 3. Archives.

WOELFFER, EMERSON. b. July 27, 1914, Chicago, Ill. **Studied:** Chicago/AI School, with Francis Chapin, Boris Anisfeld, 1935-37, BA. US Air Force, 1939-42. Traveled USA, Mexico and Europe extensively. **Taught:** New Bauhaus, Chicago, 1941-49; Black Mountain College, 1949; Chouinard Art Institute, 1959; Colorado Springs Fine Arts Center; Southern Illinois U., 1962; California Institute of the Arts, Valencia, 1969-73; Honolulu Academy, 1970; Otis Art Institute, 1974- . **Federal A.P.:** Easel painting and project assistant, **Awards:** SFMA, Hon. Men., 1948; Chicago/AI, Pauline Palmer Prize, 1948; Tamarind Fellowship, 1961, 70; US State Department Grant (Turkey), 1965; Guggenheim Foundation Fellowship, 1967-68; PAFA, Raymond A. Speiser Memorial Prize, 1968; Los Angeles All-City Show, **P.P.**, 1968. **Address:** 475 Dustin Drive, Los Angeles, Calif. 90065. **Dealers:** Poindexter Gallery; Jodi Scully Gallery. **One-man Exhibitions:** Bennington College, 1938; 740 Gallery, Chicago, 1946; Black Mountain College, 1949; Chicago/AI, 1951; Margaret Brown Gallery, Boston, 1951; Artists' Gallery, NYC, 1951, 54; Paul Kantor Gallery, Beverly Hills, Calif., 1956, 60; Poindexter Gallery, 1959, 61, 75; Primus-Stuart Gallery, Los Angeles, 1961; La Jolla, 1962; Quay Gallery, 1968; David Stuart Gallery, 1969; Jodi Scully Gallery, 1972, 73; Phillips, 1974. **Retrospective:** Pasadena/AM, 1962. **Group:** WMAA, 1947, 49, Six American Painters; Salon des Realites Nouvelles, Paris, 1948; ICA, Boston, 1950; MIT, Four Americans, 1952; Corcoran, 1952; Carnegie, 1952, 54, 55, 58; Houston/MFA, 1957; SRGM, 1962; WMAA, Fifty California Artists, 1962-

63; Los Angeles/County MA, Post Painterly Abstraction, 1964; PAFA, 1968. **Collections:** Avco Corp.; Atlantic Richfield Co.; California State U., Los Angeles; U. of California, Berkeley; Amon Carter Museum; Chicago/AI; Colorado Springs/FA; Dresdener Bank; Fort Worth; Honolulu Academy; U. of Illinois; U. of Iowa; La Jolla; Los Angeles/County MA; MOMA; New Orleans/Delgado; Pasadena/AM; Raleigh/NCMA; UCLA; WGMA; WMAA.

WOFFORD, PHILIP. b. August 14, 1935, Van Buren, Ark. **Studied:** U. of Arkansas, 1957, BA; U. of California, 1958. **Taught:** NYU, 1964-68; Bennington College. **Address:** c/o Dealer. **Dealer:** Andre Emmerich Gallery, NYC. **One-man Exhibitions:** Green Gallery, NYC, 1962; Allan Stone Gallery, 1964; David Whitney Gallery, NYC, 1970, 71; Andre Emmerich Gallery, NYC, 1972, 74; Little Rock/MFA, 1973. **Group:** SFMA, 1958; Oakland/AM, 1958; Yale U., Young New York Painters, 1964; WMAA, 1969, 72, 73; WMAA, Lyrical Abstraction, 1971; Corcoran, The Way of Color, 1973.

WOLFF, ROBERT JAY. b. July 27, 1905, Chicago, Ill. **Studied:** Yale U., 1923-26; Academie des Beaux-Arts, Paris, with Henri Bouchard; and privately with Georges Mouveau in Paris. US Army and Air Force, 1942-45; US Naval Reserve. Traveled Europe extensively, 1921-31; resided Paris, 1929-31. **Taught:** A founding collaborator, with Lazlo Moholy-Nagy and Gyorgy Kepes, of the Institute of Design, Chicago, 1938-42; Brooklyn College, 1946-71; U. of Wisconsin, 1955; MIT, 1961; Harvard U., 1961. **Member:** American Abstract Artists, 1937-50. **Federal A.P.:** Illinois State Supervisor of Painting, 1937. **Awards:** Chicago/AI, Robert Jenkins Prize, 1933. **Address:** Garland Road, New Preston, Conn. **One-man Exhibitions:** Chicago/AI, 1934 (first sculpture shown); Reinhardt Galleries, NYC, 1935 (sculpture); Quest Gallery, Chicago, 1936 (first paintings shown); Karl Nierendorf Gallery, NYC, 1937; Katharine Kuh Gallery, Chicago, 1938, 39; SFMA, 1940; MOMA, Elements of Design, circ., 1947; Kleemann Gallery, NYC, 1947, 48; SRGM, 1952; Saidenberg Gallery, 1953, 54; Grace Borgenicht Gallery Inc., 1956, 58. **Group:** American Abstract Artists Annuals, 1937-50; Corcoran; WMAA; PAFA; U. of Illinois; U. of Nebraska; SFMA; MIT. **Collections:** Brooklyn College; Brooklyn Museum; Chicago/AI; Hartford/Wadsworth; Kenyon College; RISD; SRGM; Tate. **Bibliography:** Baur 7; Cheney; Janis, S. Archives.

WOLFSON, SIDNEY. b. June 18, 1914, Brooklyn, N.Y.; **d.** March 9, 1973. **Studied:** Pratt Institute, with George Bridgeman, Denman W. Ross, Oronzio Maldarelli, Ogden Pleissner. US Air Force, four years. Traveled Caribbean, Latin America, Far East. **Taught:** Creative Arts Academy, NYC, Artist-in-Residence, summer, 1968; Dutchess Community College, Poughkeepsie, N.Y., 1971. **One-man-Exhibitions:** (first) Three Arts Gallery, Poughkeepsie, 1952, also 1965; Salisbury (Conn.) Public Library; Pittsfield/Berkshire; Betty Parsons Section Eleven (Gallery), NYC, 1959, 61; World House Galleries, NYC, 1964; Bennett College, 1966; The Contemporaries, NYC, 1967. **Retrospective:** Bennington College, 1962; Vassar College, 1972. **Group:** ART: USA:NYC; Helmhaus Gallery, Zurich, Konkrete Kunst, 1960; A. Tooth & Sons, London, Six American Painters, 1961; WMAA, Geometric Abstraction in America, circ., 1962; Carnegie; U. of St. Thomas (Tex.), Art Has Many Facets; Syracuse U., Modern Classicism. **Collections:** Colgate U.; Columbia U.; Hartford/Wadsworth; Stony Brook/SUNY; Vassar College; WMAA.

WONNER, PAUL JOHN. b. April 24, 1920, Tucson, Ariz. **Studied:** California College of Arts and Crafts, 1937-41, BA; ASL, 1947; U. of California, Berkeley, 1950-53, MA, 1955, MLS. US Army, 1941-45. Traveled Europe.

Taught: U. of California, Berkeley, 1952-53, Los Angeles, 1962-63; Otis Art Institute, 1965-68. **Address:** 1151 Keeler, Berkeley, Calif. 94708. **Dealer:** Felix Landau Gallery. **One-man Exhibitions:** (first) de Young, 1955; San Francisco Art Association, 1956; Felix Landau Gallery, 1959, 60, 62, 63, 64, 68, 71; Santa Barbara/MA, 1960; California Palace, 1961; Poindexter Gallery, 1962, 64, 71; Esther Baer Gallery, 1964 (two-man, with William T. Brown); San Antonio/McNay, 1965; Waddington Gallery, London, 1965; The Landau-Alan Gallery, NYC, 1967; Charles Campbell Gallery, 1972; Jodi Scully Gallery, 1973. **Group:** SRGM, Younger American Painters, 1954; III Sao Paulo Biennial, 1955; Walker, Vanguard, 1955; Oakland/AM, Contemporary Bay Area Figure Painting, 1957; Festival of Two Worlds, Spoleto, 1958; Carnegie, 1958, 64; ART:USA:59; NYC, 1959; WMAA Annuals, 1959, 67; U. of Illinois, 1961, 63; Chicago/AI Annuals, 1961, 64; VMFA, American Painting, 1962; MOMA, Recent Painting USA: The Figure, circ., 1962-63; Denver/AM, 1964. **Collections:** Lytton Savings and Loan Association; NCFA; U. of Nebraska; U. of North Carolina; Oakland/AM; *Readers Digest*; SFMA; SRGM. **Bibliography:** Nordness, ed.; *The State of California Painting.*

WOOD, GRANT. b. February 13, 1891, Anamosa, Iowa; **d.** February 12, 1942, Iowa City, Iowa. **Studied:** State U. of Iowa; Minneapolis School of Design; Academie Julian, Paris. US Army, 1918-19. Traveled Germany, France. **Taught:** Rosedale, Iowa, 1911-12; Jackson, Iowa, 1919-23; Chicago Art Institute School, 1916; State U. of Iowa, 1934-42. **Member:** NAD; National Society of Mural Painters. **Federal A.P.:** Director, Iowa Division, 1934. **Commissions:** Cedar Rapids (Iowa) Memorial Building, 1926-28 (stained glass window). **Awards:** Iowa State Fair, First Prize, 1929, 30, 31, 32; Carnegie, 1934; Hon. Ph.D., U. of Wisconsin; Hon. MA, Wesleyan U.; Hon. DFA, Lawrence College; Hon.

DFA, Northwestern U. **One-man Exhibitions:** Ferargil Galleries, NYC, 1935; Lakeside Press Gallery, Chicago, 1935; Hudson D. Walker Gallery, NYC, 1936. **Retrospective:** U. of Kansas, 1959; Davenport/Municipal, 1966; Cedar Rapids/AA, 1969. **Group:** Chicago/AI, 1930; Carnegie, 1934; Iowa State Fair; WMAA. **Collections:** Abbott Laboratories; Cedar Rapids/AA; Chicago/AI; Dubuque/AA; MMA; U. of Nebraska; Omaha/Joslyn; Terre Haute/Swope; WMAA. **Bibliography:** Baigell 1; Barr 3; Baur 7; Bazin; Beam; Benton 1; Biddle 4; Blanchard; Blesh 1; Boswell 1; Brown; Canaday; Cheney; Christensen; Craven, T. 2; Eliot; Finkelstein; Flanagan; **Garwood**; Gaunt; Goodrich and Baur 1; Haftman; Hall; Hunter 6; *Index of 20th Century Artists*; Kent, R., ed.; Kootz 2; Kouvenhoven; Lee and Burchwood; McCurdy, ed.; Mellquist; Mendelowitz; Newmeyer; Pagano; Pearson 1; Reese; Richardson, E.P.; **Rinard and Pyle**; Rose, B. 1; Wight 2. Archives.

WYETH, ANDREW. b. July 21, 1917, Chadds Ford, Pa. **Studied** with N.C. Wyeth. **Member:** NAD; Audubon Artists; NIAL; AAAL. **Awards:** AAAL, Medal of Merit, 1947; Hon. DFA, Harvard U., 1955; Hon. DFA, Colby College, 1955; Hon. DFA, Dickinson College, 1958; Hon. DFA, Swarthmore College, 1958; Freedom Medal, 1963; Hon. DFA, Princeton U.; Hon. DFA, Tufts U.; Hon. DFA, Franklin and Marshall College; Hon. DFA, Northeastern U.; Hon. DFA, Amherst College; Hon. DFA, Bowdoin College; Hon. DFA, U. of Pennsylvania; Hon. DFA, U. of Delaware; Hon. DFA, La Salle U. **Address:** Chadds Ford, Pa. 19317; Cushing, Me. **Dealer:** Coe Kerr Gallery. **One-man Exhibitions:** Currier, 1951; Doll and Richards, Boston, 1938, 40, 42, 44, 46; Macbeth Gallery, NYC, 1938, 39, 48; Rockland/Farnsworth, 1951, 63; de Young, 1956, 73; Santa Barbara/MA, 1956; Wilmington, 1957; M. Knoedler & Co., NYC, 1958; MIT, 1960; Buffalo/Albright, 1962; Pierpont Morgan Library, 1963; Corcoran, 1963;

Harvard U., 1963; Southampton/Parrish, 1966; PAFA, 1966; WMAA, 1966; Chicago/AI, 1966; Baltimore/MA, 1966; Brandywine Museum, Chadds Ford, Pa., 1971. **Retrospective:** Tokyo/Modern, circ., 1974. **Group:** Houston/MFA; MOMA; PMA; Wilmington; PAFA, 1938, 39, 41-45, 49-52, 58, 63; WMAA, 1946, 48, 51, 52, 53, 56, 57, 59, 63, 64; Carnegie, 1947-50, 52, 55, 58, 61, 64; U. of Illinois, 1948, 49, 63, 65, 69; A.F.A., 1954; Brussels World's Fair, 1958; Tate, 1963. **Collections:** Andover/Phillips; Boston/MFA; California Palace; Chicago/AI; Colby College; Currier; Dallas/ MFA; Hartford/Wadsworth; Houston/ MFA; MOMA; McDonnell & Co., Inc.; Montclair/AM; National Gallery; U. of Nebraska; New London; Omaha/Joslyn; Oslo/National; PMA; Rockland/Farnsworth; Utica; Wilmington; Winston-Salem Public Library. **Bibliography:** *Andrew Wyeth* (two titles); Barker 1; Baur 7; Canaday; *8 American Masters of Watercolor;* Eliot; Flanagan; Gaunt; Hunter 6; McCurdy, ed.; Mendelowitz; Nordness, ed.; **Pitz;** Pousette-Dart, ed.; Richardson, E.P.; Rodman 1, 3; Rose, B. 1; Sachs; Watson, E.W. 1.

XCERON, JEAN. b. February 24, 1890, Isari, Greece; **d.** March 29, 1967, NYC. to USA 1904. **Studied:** The Corcoran School of Art, 1910-16, with George Lohr, Abraham Rattner. Resided Paris, 1927-37. Art reviewer for American newspapers from Paris, 1930-34. **Member:** American Abstract Artists; Federation of Modern Painters and Sculptors. **Federal A.P.:** Christian Science Chapel, Rikers Island, NYC, 1941-42 (murals). **Commissions:** U. of Georgia, 1947. **Awards:** U. of Illinois, **P.P.**, 1951. **One-man Exhibitions:** (first) Galerie de France, Paris, 1931 (sponsored by *Cahiers d'Art*); Galerie Percier, Paris, 1933; Galerie Pierre, Paris, 1934; Garland Gallery, NYC, 1935; Karl Nierendorf Gallery, NYC, 1938; Bennington College, 1944; Sidney Janis Gallery, 1950; Rose Fried Gallery, 1955, 57, 60, 61, 62, 63, 64; The Peridot Gallery, NYC, 1971; Andre Zarre Gallery, NYC, 1975. **Retrospectives:** Jean Xceron, circ. seven museums in the Southwest and West Coast, 1948-49; SRGM, 1952. **Group:** Independent Artists, NYC, 1921-24; Salon des Surindependants, Paris, 1931-35; New York World's Fair, 1939; Golden Gate International Exposition, San Francisco, 1939; SRGM, 1939-52, 1954, 55, 56, 58, 62; American Abstract Artists, 1941-44, 1951-57; Carnegie, 1942, 43, 44, 46, 47, 48, 49, 50; Federation of Modern Painters and Sculptors, 1945, 46, 48, 49, 50, 51, 53, 54, 55, 56; California Palace; WMAA Annuals, 1946, 49, 52, 56; Salon des Realites Nouvelles, Paris, annually, 1947-52; U. of Illinois, 1948, 49, 50, 52, 55, 57; Houston/MFA, The Sphere of Mondrian, 1957; MOMA, circ. Latin America, 1963-64. **Collections:** Andover/Phillips; Brandeis U.; Carnegie; U. of Georgia; U. of Illinois; Karlsruhe; MOMA; NYU; U. of New Mexico; Phillips; Pittsfield/Berkshire; SRGM; Smith College; WMAA; Washington U.; Wellesley College. **Bibliography:** Bethers; Blanchard; Hess, T.B. 1; Hunter, ed.; Janis and Blesh 1; Kootz 2; Pousette-Dart, ed.; Rickey; Rose B. 1. Archives.

YEKTAI, MANOUCHER. b. December 22, 1922, Teheran, Iran. **Studied** with Amédée Ozenfant and Robert Hale, 1945; Academie des Beaux-Arts, Paris, 1946, with Andre Lhote. **Address:** 225 West 86 Street, NYC 10024. **Dealers:** Poindexter Gallery; Gertrude

Jean Xceron *No. 239A* 1937

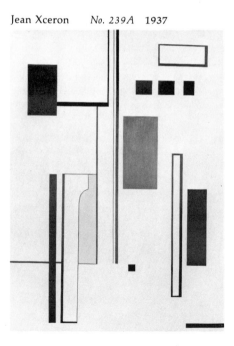

Kasle Gallery. **One-man Exhibitions:** Grace Borgenicht Gallery Inc., 1952-54; A.A.A. Gallery, NYC, 1956; Poindexter Gallery, 1957, 59, 60, 62; Galerie Anderson-Mayer, Paris, 1963; Galerie Semiha Huber, Zurich, 1963; Piccadilly Gallery, 1963, 66, 72, 73; Felix Landau Gallery, 1963; Gertrude Kasle Gallery, 1965, 66, 67, 68, 70; Feingarten Gallery, Chicago; Robert Elkon Gallery; Gump's Gallery; Benson Gallery. **Group:** Salon des Comparaisons, Paris; Walker, 60 American Painters, 1960; Carnegie, 1961; USIA, Paris, 1961; MOMA, Recent Painting USA: The Figure, circ., 1962-63; Chicago/AI, Directions in American Painting, 1963; Paris/Moderne, 1963. **Collections:** Baltimore/ MA; Charleston/Carolina; MOMA; Syracuse/Everson; Union Carbide Corp.

YOUNGERMAN, JACK. b. March 25, 1926, Webster Groves, Mo. **Studied:** U. of North Carolina (US Navy Training Program), 1944-46; U. of Missouri, 1947, BA; Academie des Beaux-Arts, Paris, 1947-48. Traveled Europe, Near East; resided Europe, 1947-54. Designed stage sets for *Histoire de Vasco*, produced by Jean-Louis Barrault, Paris, 1956, and *Deathwatch*, by Jean Genet, NYC, 1958. **Awards:** *Art In America* Magazine, New Talent, 1959. **Address:** c/o Dealer. **Dealer:** The Pace Gallery. **One-man Exhibitions:** Galerie Arnaud, 1951; Gres Gallery, Washington, D.C., 1957 (two-man); Betty Parsons Gallery, 1957, 60, 61, 64, 65, 67, 68; Galleria dell'Ariete, 1962; Galerie Lawrence, Paris, 1962, 65; Everett Ellin Gallery, Los Angeles, 1963; Worcester/ AM, 1965; MIT, 1966; Galerie Maeght, 1966; Phillips, 1968; The Pace Gallery, 1971, 72, 73; J.L. Hudson Art Gallery, Detroit, 1971; The Berenson Gallery, 1972; Portland (Ore.) Center for the Visual Arts, 1972; Seattle/AM, 1972; Arts Club of Chicago, 1973; Galerie Denise Rene, Paris, 1973; Fendrick Gallery, 1974; Kingpitcher Gallery, Pittsburgh, 1974. **Group:** Galerie Maeght, Les Mains Eblories, 1950; Galerie Denise Rene, Paris, 1952;

Jack Youngerman *Centaurus* 1975

Carnegie, 1958, 61, 67, 71; MOMA, Sixteen Americans, circ., 1959; Corcoran, 1959, 62; Kimura Gallery, Tokyo, American Painters, 1960; SRGM, Abstract Expressionists and Imagists, 1961; Chicago/AI, 1961, 62; MOMA, Recent American Painting and Sculpture, circ. USA and Canada, 1961-62; Seattle World's Fair, 1962; International Biennial Exhibition of Paintings, Tokyo; SRGM, American Drawings, 1964; WMAA, A Decade of American Drawings, 1965; SRGM, Systemic Painting, 1966; Rotterdam, 1966; WMAA Annual, 1967; Utica, American Prints Today, 1968; Indianapolis, 1969; Jewish Museum, Superlimited: Books, Boxes, and Things, 1969; Foundation Maeght, L'Art Vivant, 1970. **Collections:** Buffalo/Albright; U. of California, Berkeley; Carnegie; Chase Manhattan Bank; Chicago/AI; Corcoran; Equitable Life Assurance Society; Hartford/Wadsworth; Hirshhorn; MOMA; NCFA; Phillips; Reynolds Metals Co.; VMFA; WMAA; Wichita/AM; Worcester/AM; Yale U. **Bibliography:** Alloway 3; Battcock, ed.; Nordness, ed.; Rickey; Rose, B. 1; Weller. Archives.

YRISARRY, MARIO. b. March 29, 1933, Manila, Philippines. **Studied:** Queens College, 1955, BA, with Robert Goldwater, John Ferren; Cooper Union, 1955-58, with Charles Cajori. Traveled around the world, 1951; USA, Mexico, Canada. **Taught:** School of Visual Arts, NYC; California Institute of the Arts, Valencia; Herbert H. Lehman College, Bronx, N.Y. **Awards:** Tamarind Fellowship, 1973. **Address:** 297 Third Avenue, NYC 10010. **Dealers:** David McKee Gallery; Harcus Krakow Rosen Sonnabend; Luz Gallery. **One-man Exhibitions:** Udinotti Gallery, Tempe, Ariz., 1960; Thompson Gallery, Provincetown, Mass., 1961; The Graham Gallery, 1964, 65, 67; Galerie Gunar, Dusseldorf, 1967; Obelisk Gallery, 1969; Deson-Zaks Gallery, Chicago, 1970; OK Harris Works of Art, 1969, 70, 72; Jerrold Morris Gallery, Toronto (two-man), 1970. **Group:** ICA, Boston, Painting without a Brush, 1965; Bennington College, 5 Painters and a Sculptor, 1967; U. of Illinois, 1967; WMAA Annuals, 1969, 70; Indianapolis, 1970; WMAA, The Structure of Color, 1971; ICA, U. of Pennsylvania, Grids, 1972; Youngstown/Butler, 1973; U. of Miami, The International Style in America, 1974. **Collections:** Baltimore/MA; Brandeis U.; Connecticut Community College; Hotel Corp. of America; Hirshhorn; Indianapolis; Jones & Laughlin Steel Corp.; MIT; Ridgefield/Aldrich; Storm King Art Center; WMAA; Worcester/AM.

YUNKERS, ADJA. b. July 15, 1900, Riga, Latvia. **Studied** art in Leningrad, Berlin, Paris, and London. Traveled the world extensively; resided Paris 14 years, Stockholm during World War II. Edited and published art magazines *ARS* and *Creation* in Sweden, 1942-45. To USA 1947; became a citizen. **Taught:** New School for Social Research, 1947-54; U. of New Mexico, summers, 1948, 49; Cooper Union, 1956-67; Honolulu Academy, 1964; U. of California, Berkeley, 1966; U. of Colorado, 1967; Columbia U., 1974. **Commissions:** Syracuse

U., 1966; Stony Brook/SUNY, 1967. **Awards:** Guggenheim Foundation Fellowship, 1949-50, renewed 1954-55; Ford Foundation, 1959; Chicago/AI, Norman Wait Harris Medal, 1961; Tamarind Fellowship, 1961. **Address:** 217 East 11 Street, NYC 10003. **Dealers:** The Zabriskie Gallery; Smith Andersen Gallery; Palo Alto. **One-man Exhibitions:** (first) Maria Kunde Gallery, Hamburg, 1921 or 1922; Galerie Per, Oslo; Tokanten (Gallery), Copenhagen, 1947-54; Kleemann Gallery, NYC; Corcoran; Smithsonian; Chicago/AI; Pasadena/AM; Colorado Springs/FA; Grace Borgenicht Gallery Inc., 1954, 55; Galerie Paul Facchetti; Galleria Schneider, Rome; Salon des Realites Nouvelles, Paris, 1955; Zwemmer Gallery, London, 1957-59; Los Angeles/County MA; Rose Fried Gallery; The Howard Wise Gallery, Cleveland; Andre Emmerich Gallery, NYC; Honolulu Academy, 1964-65; The Zabriskie Gallery, 1974, 75. **Retrospectives:** Baltimore/MA; U. of Utah; Mexico City/Nacional, 1975. **Group:** MOMA, The New American Painting and Sculpture, 1969. **Collections:** Arts Council of Great Britain; Atlanta/AA; Baltimore/MA; Basel; Bibliotheque Nationale; Bibliotheque Royale de Belgique; Boston/MFA; Brandeis U.; Brooklyn Museum; UCLA; Carnegie; Cleveland/MA; Colorado Springs/FA; Corcoran; Florence (Italy)/Modern; Hamburg; Harvard U.; Johannesburg/Municipal; Library of Congress; Lima, Peru; Louisville/Speed; MMA; MOMA; Memphis/Brooks; Minneapolis/Institute; Minnesota/MA; NCFA; NYPL; National Gallery; Oslo/National; PMA; The Print Club, Philadelphia; Rijksmuseum Amsterdam; SRGM; Sao Paulo; Springfield, Mass./MFA; Stockholm/National; Trenton/State; U. of Utah; Victoria and Albert Museum; WMAA; Walker; Wellesley College; Worcester/AM. **Bibliography:** Goodrich and Baur 1; Nordness, ed.; Read 2. Archives.

ZACHARIAS, ATHOS. b. June 17, 1927, Marlborough, Mass. **Stud-**

ied: RISD, 1952, BFA; ASL, with Yasuo Kuniyoshi, summer, 1952; Cranbrook Academy of Art, with Zoltan Sepeshy, 1953, MFA. Traveled Europe, eastern USA. **Taught:** Brown U., 1953-55; Parsons School of Design, 1963-65; Long Island U., summer, 1967; Wagner College, 1968-75. **Commissions:** Fram Corporation, 1963 (painting of explorer ship *Fram*). **Awards:** Scholarship to RISD, 1950; Longview Foundation Grant, 1962; Guild Hall, First and Second Prizes; Long Island U., **P.P.**, 1968; MacDowell Colony Fellowship, 1969. **Address:** 463 West Street, NYC 10014. **One-man Exhibitions:** (first) Brown U., 1954; Great Jones Gallery, NYC, 1960; Joachim Gallery, Chicago, 1961; Gallery Mayer, NYC, 1961; Bob Keene, Southampton, N.Y., 1961-64; Louis Alexander Gallery, NYC, 1962, 63; Guild Hall, 1965; Benson Gallery, 1967; Westbeth Gallery, NYC, 1970, 71; Landmark Gallery Inc., NYC, 1973. **Group:** Boston Arts Festival, 1954; ART:USA:59, NYC, 1959; Raleigh/NCMA, 1959; Pan-Pacific Exhibition, circ. Japan, 1961. **Collections:** ICA, Boston; Kalamazoo/Institute; U. of North Carolina; Phoenix; RISD; Westinghouse.

ZAJAC, JACK. b. December 13, 1929, Youngstown, Ohio. **Studied:** Scripps College, 1949-53, with Millard Sheets, Henry McFee, Sueo Serisawa. Traveled the world extensively. Changed from painting to sculpture, 1955. **Taught:** Pomona College, 1959; Dartmouth College, 1970. **Commissions:** Reynolds Metals Co., 1968. **Awards:** California State Scholarship, 1950; Youngstown/Butler, Second Prize, 1950; Pasadena/AM, **P.P.**, 1951; Los Angeles/County MA, **P.P.**, 1953, 58; Prix de Rome, 1954, 56, 57; AAAL, 1958; Guggenheim Foundation Fellowship, 1959; Limited Editions Club, $2,500 Prize for Etching, 1959; Sarasota Art Association, Prize for Sculpture, 1959; Grace Cathedral, San Francisco, Art in Religion, First Prize, 1960; National Religious Art Exhibition, Birmingham, Mich., 1962. **Address:** c/o

Dealer. **Dealer:** The Forum Gallery. **One-man Exhibitions:** (first) Pasadena/AM, 1951; Felix Landau Gallery, 1951, 53, 54, 56, 58, 60, 62, 63, 66, 68, 70; Santa Barbara/MA, 1953; Scripps College, 1955; Galleria Schneider, Rome, 1955; John Young Gallery, Honolulu, 1956; Il Segno, Rome, 1957; The Downtown Gallery, 1960; Devorah Sherman Gallery, 1960; Roland, Browse and Delbanco, London, 1960; Gallery Marcus, Laguna Beach, Calif., 1961; The Landau-Alan, NYC, 1966, 68; Alpha Gallery, 1969; Fairweather-Hardin Gallery, 1970; The Forum Gallery, 1971, 74; La Margherita Gallery, Rome, 1972; Galleria d'Arte l'Obelisco, 1973; Jodi Scully Gallery, 1973. **Retrospectives:** Newport Harbor, 1965; California Institute of Technology, Pasadena, 1969; Temple U., Rome, 1969; Dartmouth College, 1970. **Group:** Santa Barbara/MA, 1959; WMAA Annual, 1959; Chicago/AI Annual, 1959; MOMA, Recent Sculpture USA, 1959; Los Angeles/County MA, 1959, 60; Claude Bernard, Paris, Aspects of American Sculpture, 1960; Smithsonian, Drawings by Sculptors, circ. USA, 1961-63; SRGM, The Joseph H. Hirshhorn Collection, 1962; WMAA, American Painters Today, circ., 1962; VMFA, American Painting, 1962; WMAA, Fifty California Artists, 1962-63; MOMA, Recent Painting USA: The Figure, circ., 1962-63. **Collections:** California Federal Savings and Loan Association; Gibraltar Savings & Loan Association; Hirshhorn; Home Savings and Loan Association; Kansas City/Nelson; Los Angeles/County MA; Lytton Savings and Loan Association; MOMA; Milwaukee; U. of Nebraska; PAFA; Pasadena/AM; Santa Barbara/MA; State of California; Syracuse U.; Utica; Walker. **Bibliography:** Seldis and Wilke; Weller.

ZAMMITT, NORMAN. b. February 3, 1931, Toronto, Canada. US Air Force, 1951-56. US citizen, 1956. **Studied:** Pasadena City College, AA, 1950-51, 1956-57; Otis Art Institute, MFA, 1957-61. **Taught:** School of Fine Arts, Los Angeles, 1962-63; Occidental Col-

lege, 1963; U. of New Mexico, 1963-64; CSCS, Fullerton, 1964-66; California Institute of the Arts, Los Angeles, 1967; U. of Southern California, 1968-69; UCLA, 1971-72. **Awards:** Pasadena City College, Ruth Estes Bissiri Memorial Scholarship, 1957; Otis Art Institute, four-year scholarship, 1957-61, 50th Anniversary Sculpture Exhibition, **P.P.**, 1968; Tamarind Fellowship; Guggenheim Foundation Fellowship, 1968; Long Beach/MA. **Address:** 3574 Tacoma Avenue, Los Angeles, Calif. 90065. **Dealer:** Felix Landau Gallery. **One-man Exhibitions:** Felix Landau Gallery, 1962, 63, 69; Robert Schoelkopf Gallery, 1963; The Landau-Alan Gallery, NYC, 1967, 68; Santa Barbara/MA, 1968. **Group:** Los Angeles/County MA, 1961, 64; American Sculpture of the Sixties, 1967; Pasadena/AM, 1962; U. of St. Thomas (Tex.), 1965; MOMA, 1965; U. of Illinois, 1967; Hansen Gallery, San Francisco, 1967; Lytton Art Center, Los Angeles, 1967. **Collections:** Library of Congress; MOMA; Ridgefield/Aldrich. **Bibliography:** Davis, D.; Tuchman 1.

ZERBE, KARL. b. September 16, 1903, Berlin, Germany; **d.** November 28, 1972, Tallahassee, Fla. **Studied:** Technische Hochschule, Friedberg, 1920; Debschitz School, Munich, with Josef Eberz, 1921-23, DFA. Traveled Europe, USA, Mexico, Canada. To USA 1934; citizen 1939. **Taught:** Fine Arts Guild, Cambridge, Mass., 1935-37; Boston Museum School, 1937-55; Florida State U., 1954-72. **Member:** Artists Equity (President, 1957-59). **Federal A.P.:** Easel painting. **Awards:** VMFA, John Barton Payne Medal, 1942; ICA, Boston, First Prize, 1943; Chicago/AI, Watson F. Blair Prize, 1944; Chicago/AI, Norman Wait Harris Silver Medal and Prize, 1946; Carnegie, Third Prize, 1948; PAFA, J. Henry Schiedt Memorial Prize, 1949; Boston Arts Festival, First Prize, 1953; U. of Illinois, **P.P.**, 1955. **One-man Exhibitions:** (first) Gallery Gurlitt, Berlin, 1922; Marie Sterner Gallery, NYC, 1934, 35, 36, 37; Grace Horne Galleries, Boston, 1936, 38, 39, 40; Vose Gallery, Boston, 1941; Buchholz Gallery, NYC, 1941; Mount Holyoke College, 1943; Pittsfield/Berkshire, 1943, 47; The Downtown Gallery, 1943, 46, 48, 51, 52; Chicago/AI, 1945, 46; Detroit/Institute, 1946; Philadelphia Art Alliance, 1948, 49; Boris Mirski Gallery, Boston, 1948, 55, 66; Utica, 1950; The Alan Gallery, NYC, 1954; Ringling, 1958; Nordness Galleries, 1958, 59, 60, 64, 70; WMAA, 1962 (two-man); Florida State U., 1962; St. Armands Gallery, Florida, 1963; James David Gallery, Miami, 1963; Mickelson's Gallery, Washington, D.C., 1963; Glassboro State College, 1964; U. of Tampa, 1965; Kovler Gallery, 1966. **Retrospective:** ICA, Boston, circ., 1951-52; A.F.A., circ., 1961-62. **Group:** ICA, Boston; Chicago/AI; Carnegie; PAFA; U. of Illinois; WMAA. **Collections:** Andover/Phillips; Auburn U.; Baltimore/MA; Boston/MFA; Birtannica; Brooklyn Museum; Buffalo/Albright; Chicago/AI; Colby College; Cranbrook; Detroit/Institute; Fort Worth; Frankfurt am Main; U. of Georgia; Harvard U.; IBM; Illinois Wesleyan U.; U. of Illinois; Indianapolis/Herron; State U. of Iowa; Kestner-Museum; Los Angeles/County MA; MIT; MMA; MOMA; Milwaukee; U. of Minnesota; NIAL; U. of Nebraska; Newark Museum; New Britain; Oberlin College; U. of Oklahoma; PMA; Phillips; RAC; RISD; Rio de Janeiro; U. of Rochester; St. Louis/City; San Diego; Sarah Lawrence College; Smith College; Staatliche Graphische Sammlung Munchen; Syracuse U.; Tel Aviv; Utica; WMAA; Walker; Washington U.; U. of Washington; Wichita/AM; Youngstown/Butler. **Bibliography:** Baur 7; Bethers; Chaet; Genauer; Goodrich and Baur 1; Halpert; Nordness, ed.; Pearson 2; Pousette-Dart, ed.; Richardson, E.P.; Wight 2. Archives.

ZOGBAUM, WILFRID. b. September 10, 1915, Newport, R.I.; **d.** January 7, 1965, NYC. **Studied:** Yale U., 1933-34; with John Sloan, NYC, 1934-35; Hofmann School, NYC and Provincetown, 1935-37 (class monitor). US Army 1941-

46. Traveled Europe, the Orient, West Indies, USA. Began sculpture, 1954. **Taught:** U. of California, Berkeley, 1957, 1961-63; U. of Minnesota, 1958; Pratt Institute, 1960-61; Southern Illinois U., 1961. **Member:** American Welding Society; Sculptors Guild. **Awards:** S.R. Guggenheim Fellowship for Painting, 1937; U. of California Institute for Creative Work in the Arts, 1963. **One-man Exhibitions:** (first) Alexander Iolas Gallery, 1952 (paintings); The Stable Gallery, 1954, 58; Walker, 1958; Staempfli Gallery, 1960; Obelisk Gallery, Washington, D.C., 1962; Dilexi Gallery, San Francisco, 1962; U. of California, Berkeley, 1962; Grace Borgenicht Gallery Inc., 1963. **Group:** American Abstract Artists, 1935-41; Oakland/AM, 1957; U. of Nebraska, 1961; Baltimore/MA, 1961; MOMA, Modern American Drawings, circ. Europe, 1961-62; Seattle World's Fair, 1962; WMAA Annuals; Chicago/AI, 1962; Carnegie, 1962; Turin/Civico, 1962. **Collections:** U. of California; International Institute for Aesthetic Research; New School for Social Research; SFMA; WMAA. **Bibliography:** Hunter, ed.; Tuchman 1. Archives.

ZORACH, MARGUERITE. b. September 25, 1887, Santa Rosa, Calif.; **d.** June 27, 1968, Brooklyn, N.Y. **Studied** in Paris, 1906-10. Traveled Europe, Mexico, Central America, and around the world, 1911-12. **Taught:** Provincetown, 1913-18; Columbia U., intermittently during the 1940's. **Commissions** (murals): US Post Offices, Peterborough, N.H., and Ripley, Tenn. **Awards:** Chicago/AI, The Mr. & Mrs. Frank G. Logan Medal, 1920; Golden Gate International Exposition, San Francisco, 1939, Silver Medal; Bates College, Hon. Ph.D. **m.** William Zorach. **One-man Exhibitions:** (first) The Daniel Gallery, NYC, 1915, also 1917; Montross Gallery, NYC, 1921; Joseph Brummer Gallery, NYC, 1930; The Downtown Gallery, 1935, 38; M. Knoedler & Co., NYC, 1944; Kraushaar Galleries, 1953,

57, 62, 68, 74. **Retrospective:** NCFA, 1973. **Group:** Salon d'Automne, Paris, 1910; The Armory Show, 1913; WMAA; MOMA. **Collections:** Colby College; Louisville/Speed; MMA; MOMA; Massillon Museum; Newark Museum; WMAA. **Bibliography:** *Avant-Garde Painting and Sculpture*; Biddle 4; Cheney; Goodrich and Baur 1; Hunter 6; Richardson, E. P.; Ringel, ed.; **Tarbell**; Wright 1.

ZORACH, WILLIAM. b. February 28, 1887, Eurburg, Lithuania; **d.** November 15, 1966, Bath, Me. To USA 1891. **Studied:** Cleveland Institute of Art, 1902-05; NAD, 1908-10; and in Paris, 1910-11. **Taught:** ASL, 1929-66; The Des Moines Art Center, 1954. **Member:** NIAL (Vice President, 1955-57); Sculptors Guild. **Commissions:** Radio City Music Hall, NYC, 1932; US Post Office, Benjamin Franklin Station, Washington, D.C., 1937; New York World's Fair, 1939; Mayo Clinic, Rochester, Minn., 1954; Municipal Court Building, NYC, 1958; R.S. Reynolds Memorial Award, 1960 (a sculpture). **Awards:** Chicago/AI, The Mr. & Mrs. Frank G. Logan Medal, 1931, 32; Architectural League of New York, Hon. Men., 1939; Bates College, Citation, 1958; Bowdoin College, Hon. MA, 1958; NIAL, Gold Medal for Sculpture, 1961; PAFA, George D. Widener Memorial Gold Medal, 1962. **m.** Marguerite Zorach. **One-man Exhibitions:** Taylor Galleries, Cleveland, 1912; The Daniel Gallery, NYC, 1915, 16, 18; O'Brien's Gallery, Chicago, 1916; Dayton/AI, 1922; U. of Rochester, 1924; Kraushaar Galleries, 1924, 26, 48; Arts and Crafts Club, New Orleans, 1927; Eastman-Bolton Co., NYC, 1929; The Downtown Gallery, 1931, 32, 33, 36, 43, 44, 47, 51, 55, 67; Passedoit Gallery, NYC, 1937; Ansel Adams Gallery, San Francisco, 1941; Boston Museum School, 1941; Dallas/MFA, 1945; California Palace, 1946; San Diego, 1946; Pasadena/AM, 1946; Ten Thirty Gallery, Cleveland, 1948; Coleman Gallery, NYC, 1949; New Paltz/SUNY, 1950;

Clearwater/Gulf Coast, 1952; Des Moines, 1954; San Antonio/McNay, 1956; Bowdoin College, 1958; Philadelphia Art Alliance, 1961; Coe College, 1961; Queens College, 1961; Brooklyn Museum, 1968; Danenberg Gallery, 1970; The Zabriskie Gallery, 1974. **Retrospectives:** ASL, 1950, 69; WMAA, circ., 1959. **Group:** Salon d'Automne, Paris, 1910; The Armory Show, 1913; Society of Independent Artists, NYC, 1914-16; Anderson Galleries, NYC, Forum Exhibition, 1916; PAFA, New Tendencies, 1918; A Century of Progress, Chicago, 1933-34; American Painting and Sculpture, Moscow, 1959; PAFA; MOMA; WMAA; Corcoran; Chicago/AI. **Collections:** AAAL; Andover/Phillips; Arizona State College; Baltimore/MA; Bezalel Museum; Boston/MFA; Bowdoin College; Brandeis U.; Brooklyn Museum; Buffalo/Albright; Chicago/AI; Cleveland/MA; Colby College; Columbia U.; Columbus; Corcoran; Dallas/MFA; Des Moines; Dubuque/AA; Fairleigh Dickinson U.; Fort Worth; IBM; Los Angeles/County MA; MMA; MOMA; U. of Nebraska; Newark Museum; New Britain; Oberlin College; Ogunquit; PMA; The Pennsylvania State U.; Phillips Pittsfield/Berkshire; Sara Roby Foundation; Shelburne; Syracuse U.; Tel Aviv; Terre Haute/Swope; Utica; VMFA; WMAA; West Palm Beach/Norton; Wichita/AM; Wilmington. **Bibliography:** *Avant-Garde Painting and Sculpture*; Baur 7; Beam; Biddle 4; Blesh 1; Brown; Brumme; Bryant, L.; Cahill and Barr, eds.; Cheney; Craven, W.; Flanagan; Gertz; Goodrich and Baur 1; Hall; Halpert; **Hoopes**; Hunter 6; *Index of 20th Century Artists*; Jewell 2; Lee and Burchwood; McCurdy, ed.; Mellquist; Mendelowitz; Myers 2; Neuhaus; Parkes; Pearson 2; Phillips 2; Richardson, E.P.; Ringel, ed.; Ritchie 3; Rose, B. 1; Seuphor 3; Weller; Wheeler; **Wingert**; Wright 1; **Zorach 1, 2**. Archives.

ZOX, LARRY. b. May 31, 1936, Des Moines, Iowa. **Studied:** U. of Oklahoma, with Amelio Amero, Eugene Bavinger; Drake U., with Karl Mattern; The Des Moines Art Center, with George Grosz, Louis Bouché, Will Barnet. Traveled USA, Mexico, and Canada extensively. **Taught:** Cornell U., Artist-in-Residence, 1961; U. of North Carolina, Artist-in-Residence, 1967; School of Visual Arts, NYC, 1967-68, 1969-70; Juniata College, Artist-in-Residence, 1968; Dartmouth College, Artist-in-Residence, 1969; Yale U., 1972; Kent State U., 1974. **Awards:** Guggenheim Foundation Fellowship, 1967; National Council on the Arts Award, 1969. **Address:** 238 Park Avenue South, NYC 10003. **Dealer:** Andre Emmerich Gallery, NYC. **One-man Exhibitions:** (first) The American Gallery, NYC, 1962; The Kornblee Gallery, 1964, 66, 68, 69, 70, 71; J.L. Hudson Art Gallery, Detroit, 1967; Galerie Rolf Ricke, 1968; Colgate U., 1968; Dartmouth College, 1969; Janie C. Lee Gallery, Dallas, 1970, 74, Houston, 1974; Akron/AI, 1971; Des Moines, 1971, 74; WMAA, 1973; Andre Emmerich Gallery, NYC, 1973, 75. **Group:** Des Moines, 1955, 56; Gallery of Modern Art, NYC, 1965; WMAA, Young America, 1965, Annuals, 1965-66, 1967-68, 1969, 70, 73; Chicago/AI, 1965; Boston/MFA, 1966; SRGM, Systemic Painting, 1966; Expo '67, Montreal, 1967; New Delhi, First World Triennial, 1968; Kent State U., 1968; Worcester/AM, The Direct Image, 1969. **Collections:** American Republic Insurance Co.; Columbia Broadcasting System; Cornell U.; Dallas/MFA; Dartmouth College; Des Moines; Des Moines *Register & Tribune*; Hirshhorn; Houston/MFA; Indianapolis; MOMA; National Bank of Des Moines; Oberlin College; South Mall, Albany; Tate; WMAA. **Bibliography:** Alloway 3; Battcock, ed.; Hunter, ed.; **Monte**; Rose, B. 1.

Bibliography

I. = Illustrated; B. = Bibliography; D. = Diagrams;
G. = Glossary; P. = Plans; C. = Chronologies;
A. = Appendices. In cases of more than one entry for the same author,
the numeral immediately following the author's name is keyed to the
Bibliography section of the Artists' entries. A supplemental list of Books
of General Interest follows the main bibliography.

ADAMS, PHILIP RHYS, 1. *Painter of Vision: Walt Kuhn*. Tucson: University of Arizona Art Gallery, 1966. Foreword by William B. Steadman. I. *Major retrospective catalogue*.
_____, 2. *Walt Kuhn*. Cincinnati: The Cincinnati Art Museum, 1960. I. *Monograph*.

ADRIANI, GOETZ; KOEPPLIN, DIETER; and ROSE, BARBARA. *Zeichnungen von Claes Oldenburg*. Tubingen: Kinsthalle Tubingen, 1975. I.B.C. (German text.) *A major exhibition and study of the drawings*.

AGEE, WILLIAM C. *Marca-Relli*. New York: The Whitney Museum of American Art, 1967. I.B. *Retrospective catalogue*.

ALBERS, JOSEF, 1. *Day and Night*. Los Angeles: Tamarind Lithography Workshop, Inc., 1964. *Boxed folio of 10 lithographs (ed. 20)*.
_____, 2. *Despite Straight Lines*. New Haven, Conn.: Yale University Press, 1961. I.B. *Captions by Albers; analysis of his graphic constructions, by François Bucher*. (German edition, *Trotz der Geraden*, Berne: Benteli, 1961).
_____, 3. *Homage to the Square. Ten Works by Josef Albers*. New Haven, Conn.: Ives-Sillman, 1962. Preface by Richard Lippold. *Ten color silkscreens in folio*.
_____, 4. *Interaction of Color*. New Haven, Conn., and London: Yale University Press, 1963. I. *More than 200 color studies, with commentaries*.
_____, 5. *Poems and Drawings*. New Haven, Conn.: Readymade Press. 1958. I. (German and English text.)
_____, 6. *Poems and Drawings* (2nd ed., rev. and enlarged). New York: George Wittenborn, Inc., 1961. I. (Bilingual text.)
_____, 7. *Zeichnungen—Drawings*. New York: George Wittenborn, Inc.; Berne: Spiral Press, 1956. (Text by Max Bill in German and English.) *Twelve b/w plates loose in folio*.

Albert Bloch: 1882-1961. Utica, N.Y.: Munson-William-Proctor Institute,

1974. I. *Exhibition catalogue.*

Alexander Archipenko, A Memorial Exhibition. Los Angeles: University of California, 1967. Foreword by Katharine Kuh. Archipenko Collection: Frances Archipenko. Alexander Archipenko, Life and Work: Frederick S. Wight. The Drawings and Prints: Donald H. Karshan. I.B. *Well documented retrospective catalogue.*

Alexander Calder. Berlin: Akademie der Kunste, 1967. Preface by William Sandberg. I.B. (German text.) *Retrospective catalogue.*

Alexander Calder. New York: A Studio Book/Viking Press, 1971. Introduction by H. Harvard Arnason. Photographs and design by Ugo Mulas. I.B. *Photo survey of Calder, his works, and his milieu.*

Alexander Liberman: Painting and Sculpture 1950-1970. Washington, D.C.: Corcoran Gallery of Art, 1970. Introduction by James Pilgrim. I.B.C. *Retrospective catalogue.*

ALFIERI, BRUNO. *Gyorgy Kepes.* Ivrey, Italy: Centro Culturale Olivetti, 1958. I.B. *Monograph.*

Alfred Jensen. Bern: Kunsthalle Bern, 1973. I.B. (German and English text.) *Retrospective catalogue.*

Al Held. San Francisco: San Francisco Museum of Art, 1968. I.B. *One-man exhibition catalogue.*

ALLEN, CLARENCE CANNING, ed. *Are Young Fed Up with Modern Art?* Tulsa, Okla.: The Rainbow Press, 1957. I. *Popular reaction against the new art.*

ALLEN, VIRGINIA. *Jim Dine Designs for "A Midsummer Night's Dream."* New York: The Museum of Modern Art, 1967. I. *Costume designs for the play.*

ALLOWAY, LAWRENCE, 1. *American Pop Art.* New York: Collier Books, 1974. I.B. *Exhibition survey of pop art.*

——, 2. *Samaras: Selected Works 1960-1966.* New York: The Pace Gallery, 1966. I.B. *Includes a statement by the artist.*

——, 3. *Systemic Painting.* New York: The Solomon R. Guggenheim Museum, 1966. I.B. *Catalogue including artists' statements.*

——, 4. *William Baziotes.* New York: The

Solomon R. Guggenheim Museum, 1965. I.B. *Retrospective catalogue.*

ALVARD, J. *Mark Tobey.* Paris: Musee des Arts Decoratifs, Palais du Louvre, 1961. I.B. (French and English text.) *Retrospective catalogue.*

AMERICAN ABSTRACT ARTISTS, ed. *American Abstract Artists.* New York: American Abstract Artists, 1946. I. *Documents members and activities.*

AMERICAN ARTISTS CONGRESS, INC. *America Today, a Book of 100 Prints.* New York: Equinox Cooperative Press, 1936. I.

AMERICAN ARTISTS GROUP INC., 1. *Handbook of the American Artists Group.* New York: American Artists Group Inc., 1935. I.B. *Members and organizational information.*

——, 2. *Missouri, Heart of the Nation.* New York: American Artists Group Inc., 1947. I.B. *Midwest art of the 1930's and 1940's.*

——, 3. *Original Etchings, Lithographs and Woodcuts by American Artists.* New York: American Artists Group Inc., 1936. I.

Amerikanischer Fotorealismus. Stuttgart: Wurttembergischer Kunstverein, 1972. Introduction by Uwe M. Schneede. I.C. (German text.) *Survey exhibition, including artists' statements.*

Andrew Wyeth. Buffalo: Buffalo Fine Arts Academy. Albright-Knox Art Gallery, 1963. I. *Exhibition catalogue.*

Andrew Wyeth. New York: Abercrombie & Fitch Co., 1966. Preface by E.P. Richardson. I. *Retrospective catalogue.*

ARCHIPENKO, ALEXANDER, 1. *Archipenko, 50 Creative Years.* New York: Tekhne, 1960. I.B. *Autobiography.*

——, 2. *Archipentura.* New York: Anderson Galleries, 1928. B. *Exhibition catalogue.*

Arman: Selected Works 1958-1974. La Jolla: La Jolla Museum of Contemporary Art, 1974. Introduction by Jan van der Marck. I.B. *Retrospective catalogue.*

ARMITAGE, MERLE. *Rockwell Kent.* New York: Alfred A. Knopf, 1932. I.B. *Monograph.*

ARNASON, H. HARVARD, 1. *Marca-Relli.* New York: Harry N. Abrams Inc., 1962. I. *Monograph.*

____, 2. *Philip Guston*. New York: The Solomon R. Guggenheim Museum, 1962. I.B. *Exhibition catalogue.*

____, 3. *Stuart Davis*. Minneapolis: The Walker Art Center, 1957. I. *Exhibition catalogue.*

____, 4. *Stuart Davis, Memorial Exhibition.* Washington, D.C.: National Collection of Fine Arts, 1965. I.B. *Major retrospective catalogue.*

____, 5. *Theodore Roszak*. Minneapolis: The Walker Art Center, 1956. I.B. *Exhibition catalogue.*

ARP, HANS. *Onze Peintres*. Zurich: Editions Girsberger, 1949. (French and German text.) I.

Arthur Dove: The Years of Collage. College Park, Md.: University of Maryland Art Gallery, 1967. I.B. *Major study of the collages of Dove.*

Art as a Muscular Principle. South Hadley, Mass.: Mount Holyoke College, 1975. I.B. *A study of ten artists and San Francisco, 1950-1965.*

Art Now 74: A Celebration of the American Arts. Washington, D.C.: Artrend Foundation, 1974. Foreword by Jocelyn Kress. Introduction by Henry T. Hopkins and Maurice Tuchman. I. *Catalogue of performances and exhibition of objects; includes artists' statements.*

Art: A Woman's Sensibility. Valencia: California Institute of the Arts, 1975. Introduction by Deena Metzger. I. *Exhibition catalogue including artists' statements.*

ASHTON, DORE, 1. *The Mosaics of Jeanne Reynal*. New York: George Wittenborn, Inc., 1964. I. *Monograph.*

____, 2. *Philip Guston*. New York: Grove Press Inc., 1960. I.B. *Monograph.*

____, 3. *A Reading of Modern Art*. Cleveland and London: The Press of Case Western Reserve University, 1969. I. *Criticisms of recent modern art and literature.*

____, 4. *Richard Lindner*. New York: Harry N. Abrams Inc., 1970. I. *Monograph.*

____, 5. *The Unknown Shore*. Boston: Little, Brown and Co., 1962. I. *Collected essays mostly reprinted from* Art and Architecture *Magazine.*

ASHTON, DORE, ed. *A Joseph Cornell Album*. New York: Viking Press, 1974.

I. *Collected writings by and about Cornell.*

ATKINSON, TRACY. *Directions I: Options 1968*. Milwaukee: Milwaukee Art Center, 1968. Preface by Lawrence Alloway. I. *Catalogue of "people involved art" with statements by artists.*

Avant-Garde Painting and Sculpture in America: 1910-1925. Wilmington: Delaware Art Museum, 1975. Preface and acknowledgments by William Innes Homer. Foreword by Charles T. Wyrick, Jr. I.B.C. *An in-depth survey catalogue.*

BAER, DONALD. *Russell Cowles*. Los Angeles: Dalzell Hatfield Gallery, 1946. I. *Monograph.*

BAIGELL, MATTHEW, 1. *The American Scene: American Paintings*. New York: Praeger Publishers (American Art and Artists of the 1930s), 1974. I.B. *Superficial survey.*

____, 2. *Thomas Hart Benton*. New York: Harry N. Abrams Inc., 1974. I.B.C. *Heavily illustrated monograph.*

BALDES, ALTON PARKER. *Six Maryland Artists*. Baltimore: Balboa Publishers, 1955. I.

BALDINGER, WALLACE S., in collaboration with Harry B. Green. *The Visual Arts*. New York: Holt, Rinehart and Winston, Inc., 1960. I.B. *Includes chapters on the visual arts.*

BALLO, FERDINANDO, ed. *Grosz*. Milan: Rosa e Balio Editori, 1956. I. (German and Italian text.) *Critical essays.*

BARKER, VIRGIL, 1. *From Realism to Reality in Recent American Painting*. Lincoln: University of Nebraska Press, 1959. I. *Essays on the rise of abstract and nonfigurative painting.*

____, 2. *Henry Lee McFee*. New York: The Whitney Museum of American Art (American Artists Series), 1931. I. *Monograph.*

BARNES, ALBERT C. *The Art in Painting*. Merion, Pa.: The Barnes Foundation Press, 1925. I. *Dr. Barnes' theories.*

BARO, GENE. *Paul Feeley*. New York: The Solomon R. Guggenheim Museum, 1968. I.B. *Retrospective catalogue.*

BARR, ALFRED H., Jr., 1. *Cubism and Abstract Art*. New York: The Museum

of Modern Art, 1936. I.B. *Essays on Cubism and its evolution.*

———, 2. *Edward Hopper.* New York: The Museum of Modern Art, 1933. I.B. *Exhibition catalogue.*

———, 3. *What Is Modern Painting?* New York: The Museum of Modern Art, 1956. I. *Popular introduction to modern art.*

BASKIN, LEONARD. *Leonard Baskin.* Brunswick, Me.: Bowdoin College, 1962. I.B. *Exhibition catalogue.*

BATES, KENNETH. *Brackman, His Art and Teaching.* Noank, Conn.: Noank Publishing Studio, 1951. I. *Monograph.*

BATTCOCK, GREGORY, ed. *Minimal Art: A Critical Anthology.* New York: E.P. Dutton, 1968. I. *Critical essays reprinted from periodicals and exhibition catalogues.*

BAUDSON, PIERRE. *Steinberg: Zeichnungen und collagen.* Hamburg: Hamburger Kunsthalle, 1968. Foreword by Helmut R. Leppien. I.B. (German text.) *Retrospective catalogue including an interview with the artist.*

BAUR, JOHN I.H., 1. *Charles Burchfield.* New York: The Whitney Museum of American Art, 1956. I.B. *Retrospective catalogue.*

———, 2. *George Grosz.* New York: The Whitney Museum of American Art, 1954. I.B. *Retrospective catalogue.*

———, 3. *Joseph Stella.* New York: The Whitney Museum of American Art, 1963. I.B. *Retrospective catalogue.*

———, 4. *Loren MacIver—Rice Pereira.* New York: The Whitney Museum of American Art, 1953. I.B. *Exhibition catalogue.*

———, 5. *Nature in Abstraction.* New York: The Macmillan Company, for The Whitney Museum of American Art, 1958. I.B. *Nature considered as catalyst for abstraction.*

———, 6. *Philip Evergood.* New York: Frederick A. Praeger, for The Whitney Museum of American Art, 1960. I.B. *Monograph.*

———, 7. *Revolution and Tradition in Modern American Art.* Cambridge, Mass.: Harvard University Press, 1959. I. *Important essays on conservative and advance guard art.*

BAYER, HERBERT, 1. *Book of Drawings.* Chicago: Paul Theobald and Co., 1961. I.B.

———, 2. *Herbert Bayer: Painter, Designer, Architect.* New York: Reinhold Publishing Co., 1967. I.B.D.P. *Autoiographical monograph.*

BAZALGETTE, LEON. *George Grosz.* Paris: Les Ecrivains Reunis, 1927. I.B. (French text.) *Monograph.*

BAZIN, GERMAIN. *History of Modern Painting.* New York: Hyperion Press, Harper and Brothers, 1951. I.B. *Includes recent American artists of international reputation.*

BEAM, PHILIP C. *The Language of Art.* New York: The Ronald Press, 1958. I.B. *Essays on interpretation.*

BECKER, JURGEN and VOSTELL, WOLF. *Happenings, Fluxus, Pop, Nouveau Realism.* Reinbek bei Hamburg: Rowohlt Verlag GMBH, 1965. I. *International survey.*

BEEKMAN, AARON. *The Functional Line in Painting.* New York: Thomas Yoseloff Inc., 1957. I.

BEEREN, WIM. *Roy Lichtenstein.* Amsterdam: Stedelijk Museum, 1967. I.B. (Dutch and English text.) *Major retrospective catalogue includes interview of the artist by John Coplans.*

BEGGS, THOMAS M. *Paul Manship.* Washington, D.C.: Smithsonian Institution, 1958. I. *Exhibition catalogue.*

BENSON, E.M. *John Marin, The Man and His Work.* Washington, D.C.: American Federation of Arts, 1935. *Monograph.*

BENTON, THOMAS HART, 1. *An American in Art.* Lawrence: University of Kansas, 1969. I. *Autobiography.*

———, 2. *An Artist in America.* New York: Robert M. McBride and Co., 1937. I. *Autobiography.*

———, 3. *Thomas Hart Benton.* New York: American Artists Group Inc., 1945. I. *Autobiographical monograph.*

———, 4. **THOMAS HART BENTON.** Lawrence: University of Kansas, 1958. I. Exhibition catalogue.

BERMAN, EUGENE. *Imaginary Promenades in Italy.* New York: Pantheon Books, 1956. I. *Illustrated essays.*

Bernard Reder. Tel Aviv: The Tel Aviv Museum of Art, 1963. I.B. *Retrospective catalogue including statements by the artist.*

BETHERS, RAY. *How Paintings Happen.* New York: W.W. Norton and Co., 1951. I. *Artists at work.*

BIDDLE, GEORGE, 1. *An American Artist's Story.* Boston: Little, Brown and Co., 1939. I. *Autobiography.*

_____, 2. *Ninety Three Drawings.* Colorado Springs: Colorado Springs Fine Arts Center, 1937. I. *Essays on Boardman Robinson's drawings.*

_____, 3. *Tahitian Journal.* St. Paul: University of Minnesota, 1968. I. *Travel book.*

_____, 4. *The Yes and No of Contemporary Art.* Cambridge, Mass.: Harvard University Press, 1957. I. *An artist comments on the contemporary scene.*

BIEDERMAN, CHARLES, 1. *Art as the Evolution of Visual Knowledge.* Red Wing, Minn.: Privately published, 1948. I.B. *History, aesthetics, and theory.*

_____, 2. *Letters on the New Art.* Red Wing, Minn.: Privately published, 1951. *Essays.*

_____, 3. *The New Cezanne.* Red Wing, Minn.: Art History, 1955. I.B. *Homage to Cezanne and theories of subsequent developments.*

BIHALJI-MERIN, OTO. *Adventures of Modern Art.* New York: Harry N. Abrams Inc., 1966. I.B. *Sets postwar Americans in the world art scene.*

BIRCHMAN, WILLIS. *Faces and Facts.* New York: Privately published, 1937. I. *Short biographies with photographs.*

BIRD, PAUL. *Fifty Paintings by Walt Kuhn.* New York: Studio Publications, 1940. I. *Monograph.*

BIRNBAUM, MARTIN. *Introductions.* New York: Frederic Fairchild Sherman, 1919. *New talent in 1919.*

BITTNER, HUBERT. *George Grosz.* New York: A Golden Griffin Book, Arts, Inc., 1959. I. *Monograph.*

BLANCH, ARNOLD, 1. *Arnold Blanch.* New York: American Artists Group Inc., 1945. I. *Autobiographical monograph.*

_____, 2. *Methods and Techniques for Gouache Painting.* New York: American Artists Group Inc., 1946. I.

_____, 3. *Painting for Enjoyment.* New York: Tudor Publishing Co., 1947. I.

BLANCHARD, FRANCES BRADSHAW. *Retreat from Likeness in the Theory of Painting.* New York: Columbia University Press, 1949. I.B. *From art as illustration to the object as art.*

BLESH, RUDI, 1. *Modern Art, USA. Men—Rebellion—Conquest 1900-1956.* New York: Alfred A. Knopf, 1956. I. *Popular study of American art from 1900 to 1956.*

_____, 2. *Stuart Davis.* New York: Grove Press Inc., 1960. I. *Monograph.*

BORN, WOLFGANG. *American Landscape Painting, an Interpretation.* New Haven, Conn.: Yale University Press, 1948. I.

BOSWELL, PEYTON, Jr., 1. *Modern American Painting.* New York: Dodd, Mead and Co., 1939. I. *Painting in the first 40 years of the twentieth century.*

_____, 2. **VARNUM POOR.** New York: Hyperion Press, Harper and Brothers, 1941. I.B. *Monograph.*

BOSWELL, PEYTON, Jr., ed. *An Appreciation of the Work of Frederic Taubes.* New York: Art Design Monographs, 1939. I. *Monograph.*

BOURDON, DAVID. *Christo.* New York: Harry N. Abrams Inc., 1971. I.B.C. *Considerable biographical data included in this critical study.*

BOURGEADE, PIERRE. *Bonsoir, Man Ray.* Paris: Pierre Belfond, 1972. *An interview, in French.*

BREEKSIN, A.D., 1. *Franz Kline.* Washington, D.C.: Washington Gallery of Modern Art, 1962. I. *Retrospective catalogue.*

_____, 2. *Ilya Bolotowsky.* New York: The Solomon R. Guggenheim Museum, 1974. I.B. *Retrospective catalogue; includes aritst's statements.*

BRETON, ANDRE, 1. *Le Surrealisme et la peinture.* Paris: N.R.F., Gallimard, 1928. I. *The Surrealist movement in art.*

_____, 2. *Le Surrealisme et la peinture.* New York: Brentano's, 1945. I. *Revised and expanded edition of the above entry.*

_____, 3. *Le Surrealisme in 1947.* Paris: Editions Maeght, 1947.

_____, 4. *Yves Tanguy.* New York: Pierre Matisse Editions, 1946. I. (French and

English text.) *Monograph.*

BRION, MARCEL, l. *Art abstrait.* Paris: Editions Albin Michel, 1956. I. (French text.) *Development of abstract art in the twentieth century.*

———, 2. *Modern Painting: From Impressionism to Abstract Art.* London: Thames and Hudson, 1958. I.

BROOK, ALEXANDER. *Alexander Brook.* New York: American Artists Group Inc., 1945. I. *Autobiographical monograph.*

BROOKS, VAN WYCK. *John Sloan, a Painter's Life.* New York: E.P. Dutton, 1955. I. *Biography.*

BROWN, MILTON W. *American Painting: From The Armory Show to the Depression.* Princeton, N.J.: Princeton University Press, 1955. I.B.

Bruce Conner Drawings: 1955-1972. San Francisco: San Francisco Museum of Art, 1974. Preface by Ian McKibbin White. Introduction by Thomas H. Garver. I. *Retrospective catalogue of drawings.*

BRUCE, EDWARD and WATSON, FORBES. *Art in Federal Buildings.* Washington, D.C.: Art in Federal Buildings, Inc., 1936. I.P.

BRUMME, C. LUDWIG. *Contemporary American Sculpture.* New York: Crown Publishers Inc., 1948. I.B.

BRYANT, EDWARD. *Nell Blaine.* Southampton, N.Y.: Parrish Art Museum, 1974. I.B.C. *Retrospective exhibition catalogue.*

BRYANT, LORINDA M. *American Pictures and Their Painters.* New York: John Lane Co., 1917. I.

BULLIET, C.J., 1. *Apples and Madonnas.* Chicago: Pascal Covici, Inc., 1927. I. *Cirtical essays on American artists.*

———, 2. *The Significant Moderns and Their Pictures.* New York: Covici-Friede, Publishers. 1936. I.

BUNCE, LOUIS. *Louis Bunce.* Portland, Ore.: Portland Art Museum, 1955. I. *Exhibition catalogue.*

BURCHFIELD, CHARLES, 1. *Charles Burchfield.* Buffalo: Buffalo Fine Arts Academy, Albright Art Gallery, 1944. I. *Exhibition catalogue.*

———, 2. *Charles Burchfield.* New York: American Artists Group Inc. 1945.

I. *Autobiographical monograph.*

———, 3. *Eugene Speicher.* Buffalo: Albright Art Gallery, 1950. I. *Exhibition catalogue.*

BURROUGHS, ALAN. *Kenneth Hayes Miller.* New York: The Whitney Museum of American Art (American Artists Series), 1931. I.B. *Exhibition catalogue.*

BUSH, MARTIN H., 1. *Ben Shahn: The Passion of Sacco and Vanzetti.* Syracuse: Syracuse University, 1968. I.B. *A history of the development of the mural.*

———, 2. *Doris Caesar.* Syracuse, N.Y.: Syracuse University, 1970. Introduction by Marya Zaturenska. I.B. *Appreciation with some biographical data.*

BUSH, MARTIN H. and MOFFETT, KENWORTH. *Goodnough.* Wichita: Wichita Art Museum, 1973. I.B.C. *Retrospective catalogue.*

BYWATERS, JERRY, 1. *Andrew Dasburg.* Dallas: Dallas Museum of Fine Arts, 1957. I. *Exhibition catalogue.*

———, 2. *Andrew Dasburg.* New York: American Federation of Arts, 1959. I. *Retrospective catalogue.*

CABANNE, PIERRE. *Dialogues with Marcel Duchamp.* Translated by Ron Padgett. New York: Viking Press (The Documents of 20th-Century Art), 1971. Preface by Salvador Dali. Introduction by Robert Motherwell. Appreciation by Jasper Johns. I.B.C. *Talking with Marcel with an eye on history.*

CAGE, JOHN. *The Drawings of Morris Graves, with Comments by the Artist.* Boston: For the Drawing Society, Inc., by the New York Graphic Society Ltd., 1974. Preface by David Daniels. I.C. *Survey of drawings.*

CAHILL, HOLGER. *Max Weber.* New York: The Downtown Gallery, 1930. I. *Monograph.*

CAHILL, HOLGER and BARR, ALFRED H., Jr., eds. *Art in America, a Complete Survey.* New York: Reynal and Hitchcock, 1935. I.B. *Considers architecture, fine arts, folk art, etc.*

CALAS, NICOLAS. *Bloodflames, 1947.* New York: Hugo Galleries, 1947. I. *Essays on the advance guard in New York in the 1940's.*

CALAS, NICOLAS and ELENA. *Icons*

and *Images of the Sixties.* New York: E.P. Dutton, 1971. I. *Collected essays.*

CALDER, ALEXANDER, 1. *Calder: An autobiography with pictures.* New York: Pantheon Books, 1966. Foreword by Robert Osborn. I. *Folksy presentation of Calder's life.*

_____, 2. *Three Young Rats.* New York: The Museum of Modern Art, 1946, 2nd ed. I. *A children's story.*

CALDER, ALEXANDER and LIEDL, CHARLES. *Animal Sketching.* Pelham, N.Y.: Bridgeman Publishers, Inc., 1941, 6th ed. I.

CAMPOS, JULES. *Jose de Creeft.* New York: Erich S. Herrmann, Publisher, 1945. I. *Monograph.*

CANADAY, JOHN. *Mainstreams of Modern Art.* New York: Simon and Schuster, 1959. I. *Popular history of art.*

Carl Andre Sculpture: 1958-1974. Bern: Kunsthalle Bern, 1975. Foreword by Johannes Gachnang. Introduction by Carl Andre. I.B.C.

Carl Holty Memorial Exhibition. New York: Andrew Crispo Gallery, 1974. Introduction by Andrew J. Crispo. I.B.C. *Catalogue includes encomiums by friends.*

Carl Sprinchorn: A Memorial Exhibition. Orono, Me.: University of Maine, 1972. Foreword by Richard S. Sprague. I.C. *Exhibition catalogue.*

Carol Summers. Woodcuts 1950-1967. San Francisco: San Francisco Museum of Art, 1967. Preface by Anneliese Hoyer. I. *Retrospective catalogue; includes statements by the artist.*

CASSOU, JEAN. *Gateway to the 20th Century.* New York: McGraw-Hill Book Co., Inc., 1962. I. *Development of nineteenth-century art and indications of its twentieth-century ramifications.*

CELANT, GERMANO. *Art Povera.* New York: Praeger Publishers, 1969. I. *Catalogues artists' statements and illustrations of their works: earthworks, actual art, concept art.*

Celebrate Ohio. Akron: Akron Art Institute, 1971. Foreword by Orrel Thompson. Introduction by Alfred Radloff. I.C. *Exhibition catalogue.*

CHAET, BERNARD. *Artists at Work.* Cambridge, Mass.: Webb Books Inc.,

1960. I. *Interviews with artists.*

Charles Biederman: The Structurist Relief 1935-1964. Minneapolis: The Walker Art Center, 1965. Introduction by Jan van der Marck. I.B.G.C. *Retrospective catalogue.*

Charles Demuth: The Mechanical Encrusted on the Living. Santa Barbara: University of California Press, 1971. Introduction by Phyllis Plous. I.B.C. *A bad centennial retrospective catalogue.*

Charles Sheeler. Washington, D.C.: National Collection of Fine Arts, 1968. I.B. *Essays by Martin Friedman, Bartlett Hayes, Charles Millard; major retrospective catalogue.*

CHENEY, MARTHA CHANDLER. *Modern Art in America.* New York: Whittlesey House, McGraw-Hill Book Co., Inc., 1939. I.

CHIPP, HERSCHEL B. *Theories of Modern Art.* Berkeley and Los Angeles: University of California Press, 1968. I.B. *Artists' statements.*

CHRISTENSEN, ERWIN O. *The History of Western Art.* New York: New American Library, 1959. I.

CHRIST-JANER, ALBERT. *Boardman Robinson.* Chicago: The University of Chicago Press, 1946. I.B. *Monograph.*

CLIFFORD, HENRY. *Franklin Watkins.* Philadelphia: The Philadelphia Museum of Art, 1964. I. *Exhibition catalogue.*

Clyfford Still. Foreword by Katharine Kuh. Buffalo: The Buffalo Fine Arts Academy, 1966. I. *Exhibition catalogue; includes statements by the artist.*

COATES, ROBERT M. *Walter Quirt.* New York: American Federation of Arts, 1959. I. *Retrospective catalogue.*

COKE, VAN DEREN, 1. *Nordfeldt, the Painter.* Albuquerque: The University of New Mexico Press, 1972. Foreword by Sheldon Cheney. I.B.C. *Exhibition catalogue.*

_____, 2. *Taos and Santa Fe. The Artistic Environment. 1882-1942.* Albuquerque: University of New Mexico Press, 1963. I.

CONE, JANE HARRISON, 1. *David Smith.* Cambridge, Mass.: Fogg Art Museum, 1966. I.B. *Exhibition catalogue*

includes statements by the artist.

———, 2. *Walter Darby Bannard.* Baltimore: The Baltimore Musem of Art, 1972. Foreword by Tom Le Freudenheim. I.B. *Retrospective catalogue, includes artist's statements.*

Contemporanea. Rome: Incontri Internazionali d'Arte, 1973. Introduction by Graziella Lonardi. I.B. (Italian and English text.) *Comprehensive international avant-garde exhibition: art, cinema, theatre, photography, books, visual poetry, etc.*

COPLANS, JOHN, 1. *Ellsworth Kelly.* New York: Harry N. Abrams Inc., 1973. I.B.C. *Picturebook monograph.*

———, 2. *Roy Lichtenstein.* Pasadena: The Pasadena Art Museum, 1967. I.B. *Includes an interview with the artist.*

———, 3. *Serial Imagery.* Pasadena: The Pasadena Art Museum, 1968. I.B. *Includes statements by some artists.*

COPLANS, JOHN, ed. *Roy Lichtenstein.* New York: Praeger Publishers (Documentary Monographs in Modern Art), 1972. I.B. *Collected essays about the artist; monograph; biographical notes.*

COPLANS, JOHN, with contributions by JONAS MEKAS and CALVIN TOMKINS. *Andy Warhol.* Greenwich, Conn.: New York Graphic Society Ltd., 1970. I.B. *Monographic study; filmography.*

CORTISSOZ, ROYAL, 1. *American Artists.* New York: Charles Scribner's Sons, 1923. *Essays on noted artists of the late nineteenth and early twentieth century.*

———, 2. *Guy Pene Du Bois.* New York: The Whitney Museum of American Art (American Artists Series), 1931. I.B. *Monograph.*

CRAVEN, THOMAS, 1. *Modern Art, The Men, The Movements, The Meaning.* New York: Simon and Schuster, 1934. I. *Essays on twentieth-century American figurative artists.*

———, 2. *The Story of Painting: From Cave Pictures to Modern Art.* New York: Simon and Schuster, 1943. I. *Popular history of art.*

———, 3. *Thomas Hart Benton.* New York: Associated American Artists, 1939. I. *Monograph.*

CRAVEN, WAYNE. *Sculpture in America.*

New York: Thomas Y. Crowell Co., 1968. I.B. *Historical survey of traditional sculpture.*

CRESPELLE, J.-P. *Montparnasse vivant.* Paris, Hachette, 1962. I. *The panorama of Montparnasse life.*

CRONE, RAINER. *Andy Warhol.* New York: Praeger Publishers, 1970. I.B. *Critical essays and catalogue of works; filmography.*

CURRY, JOHN STEUART, 1. *John Steuart Curry.* New York: American Artists Group Inc., 1945. I. *Autobiographical monograph.*

———, 2. *John Steuart Curry.* Syracuse, N.Y.: Joe and Emily Lowe Art Center, Syracuse University, 1956. I. *Exhibition catalogue.*

———, 3. *John Steuart Curry.* Lawrence: University of Kansas, 1957. I. *Exhibition catalogue.*

Dan Flavin. Cologne: Kunsthalle Koln, 1973. I.B. (German and English text.) *Artist's statement.*

DAUBLER, THEODOR and GOLL, IWAN. *Archipenko-Album.* Potsdam: Gustav Kiepenheuen Verlag, 1921. I. (German text.) *Monograph.*

DAVEY, RANDALL. *Randall Davey.* Santa Fe: Museum of New Mexico, 1957. I. *Exhibition catalogue.*

David Simpson 1957-1967. San Francisco: San Francisco Museum of Art, 1967. Preface by John Humphrey. I.B. *Retrospective catalogue; includes statements by the artist.*

DAVIDSON, MORRIS, 1. *An Approach to Modern Painting.* New York: Coward-McCann, Inc., 1948. I. *Appreciation of modern art.*

———, 2. *Understanding Modern Art.* New York: Coward-McCann, Inc., 1931. I. *Appreciation and understanding of modern concepts in art.*

DAVIS, DOUGLAS. *Art and the Future.* New York: Praeger Publishers, 1973. I.B.D.G. *An effusion of the collaboration of art and science.*

DAVIS, STUART. *Stuart Davis.* New York: American Artists Group Inc., 1945. I. *Autobiographical monograph.*

DAWSON, FIELDING. *An Emotional Memoir of Franz Kline.* New York:

Pantheon Books, 1967. I. *A personal memoir.*

DE CREEFT, JOSE. *Jose de Creeft.* Athens: University of Georgia Press (American Sculptors Series), 1950. I. *Autobiographical monograph.*

DEHN, ADOLF. *Watercolor Painting.* New York: Studio Publications, 1945. I.

DE KOONING, WILLEM. *De Kooning: Drawings.* New York: Walker & Co., 1967. I. *Two dozen charcoal drawings with a statement by the artist.*

DEVREE, CHARLOTTE. *Jose de Creeft.* New York: American Federation of Arts and The Ford Foundation, 1960. I. *Retrospective catalogue.*

DE VRIES, GERD, ed. *Uber Kunst/On Art.* Cologne: Verlag M. DuMont Schauberg, 1974. I.B. (German and English text.) *Artists writings on art after 1965; exhibition lists.*

D'HARNONCOURT, ANNE and MC SHINE, KYNASTON, eds. *Marcel Duchamp.* New York: The Museum of Modern Art and the Philadelphia Museum of Art, 1973. Preface by Richard E. Oldenburg and Evan H. Turner. Introduction by Anne d'Harnoncourt. I.C.B. *Retrospective exhibition catalogue.*

DIENST, ROLF GUNTER, 1. *Pop-Art.* Wiesbaden: Limes Verlag, 1965. I.B. (German text.) *Pop art in Europe and USA.*

_____, 2. *Richard Lindner.* New York: Harry N. Abrams Inc., 1970. I. *Critical study of the oeuvre.*

DOCHTERMAN, LILLIAN. *The Quest of Charles Sheeler.* Iowa City: State University of Iowa, 1963. I. *Biography.*

DORIVAL, BERNARD. *Twentieth Century Painters.* New York: Universe Books, Inc.; Paris: Editions Pierre Tisne, 1958. I.B. *Painting in Europe and America.*

DORNER, ALEXANDER. *The Way Beyond Art.* New York: New York University Press, 1958. I. *Development of art and its influence in the museums.*

DOVER, CEDRIC. *American Negro Art.* Greenwich, Conn.: New York Graphic Society, 1965. I.B. *Illustrated history.*

The Drawings of Charles E. Burchfield.

Cleveland:Print Club of Cleveland and The Cleveland Museum of Art, 1953. I. *Exhibition catalogue. (See also Jones, ed.)*

DREIER, KATHERINE S., 1. *Burliuk.* New York: The Societe Anonyme, Inc., 1944. I. *Monograph.*

_____, 2. *Western Art and the New Era, an Introduction to Modern Art.* New York: Brentano's, 1923. I. *Early polemic on abstract and non-figurative art.*

DU BOIS, GUY PENE, 1. *Artists Say the Silliest Things.* New York: American Artists Group Inc., 1940. I. *Autobiography.*

_____, 2. *Edward Hopper.* New York: The Whitney Museum of American Art (American Artists Series), 1931. I.B. *Monograph.*

_____, 3. *Ernest Lawson.* New York: The Whitney Museum of American Art (American Artists Series), 1932. I.B. *Monograph.*

_____, 4. *John Sloan.* New York: The Whitney Museum of American Art (American Artists Series), 1931. I.B. *Monograph.*

_____, 5. *William Glackens.* New York: The Whitney Museum of American Art (American Artists Series), 1931. I.B. *Monograph.*

_____, 6. *William Glackens.* New York: The Whitney Museum of American Art, 1939. *Exhibition catalogue.*

DUCHAMP, MARCEL, 1. *Marcel Duchamp.* Pasadena: The Pasadena Art Museum, 1963. I.B. *Exhibition catalogue.*

_____, 2. *Marchand du Sel.* Paris: Le Terrain Vague, 1958. I.B. *Essays.*

EBERSOLE, BARBARA. *Fletcher Martin.* Gainesville: University of Florida Press, 1954. I. *Exhibition catalogue.*

Edward Kienholz. Dusseldorf: Stadtische Kunsthalle Dusseldorf, 1970. Introduction by Jurgen Harten. I.B.C. *Retrospective catalogue.*

Edward Kienholz: 11 + 11 Tableaux. Stockholm: Modern Museet, 1971. Introduction by K.G.P. Hulten. I.B. *Exhibition catalogue.*

8 American Masters of Watercolor. Los Angeles: County Museum of Art, 1968. Preface by Larry Curry. I.B.

Documented survey.

ELIOT, ALEXANDER. *Three Hundred Years of American Painting.* New York: Time Inc., 1957. I.B. *Popular history of American art.*

ELLIOTT, JAMES. "Stuart Davis." *Bulletin of the Los Angeles County Museum of Art,* Vol. XIV, No. 3, 1962. I. *Entire issue devoted to this essay.*

ELSEN, ALBERT, 1. *Paul Jenkins.* New York: Harry N. Abrams Inc., 1973. I.B.C. *A major monograph.*

———, 2. *Purposes of Art.* New York: Holt, Rinehart and Winston, Inc., 1962. I.B. *Elucidation of the art process.*

———, 3. *Seymour Lipton.* New York: Harry N. Abrams Inc., 1969. I. *Monograph.*

ELY, CATHARINE BEACH. *The Modern Tendency in American Painting.* New York: Frederic Fairchild Sherman, 1925. I.

ETTING, EMLEN. *Drawing the Ballet.* New York: Studio Publications, 1944. I.

Eva Hesse: A Memorial Exhibition. New York: The Solomon R. Guggenheim Museum, 1972. I.B.C. *Retrospective exhibition catalogue; includes essays by Robert Pincus-Witten, Eva Hesse, Linda Shearer.*

EVANS, MYFANWY, ed. *The Painter's Object.* London: Gerald Howe Ltd., 1937. I. *Critical essays.*

FARNHAM, EMILY. *Charles Demuth: Behind a Laughing Mask.* Norman, Okla.: University of Oklahoma Press, 1971. I.B.C. *A poor book that fails profoundly.*

FARRELL, JAMES T. *The Paintings of Will Barnet.* New York: Press Eight, 1950. I. *Monograph.*

FAITH, CREEKMORE, ed. *The Lithographs of Thomas Hart Benton.* Austin and London: University of Texas Press, 1969. I. *Catalogue of the prints; includes comments by the artist.*

FEININGER, T. LUX. *Lyonel Feininger: At the Edge of the World.* New York: Frederick A. Praeger, 1968. I. *Essay on the development of imagery and ideas.*

FERN, ALAN. *Leonard Baskin.* Annotated by Leonard Baskin. Washington, D.C.: Smithsonian Institution Press, 1971. I.B.C. *Exhibition catalogue; filmography.*

FIERENS, PAUL. *Sculpteurs d'aujourd'hui.* Paris: Editions de Chroniques de Jour, 1933. I. (French text.)

Figures/Environments. Minneapolis: The Walker Art Center, 1970. Introduction by Martin Friedman. I.C. *Exhibition catalogue.*

FINCH, CHRISTOPHER. *Pop Art: object and image.* New York: Studio Vista/Dutton Pictureback, 1968. I. *Well illustrated popular assessment of international pop art.*

FINKELSTEIN, SIDNEY. *Realism in Art.* New York: International Publishers, 1954.

FLANAGAN, GEORGE A. *Understanding and Enjoying Modern Art.* New York: Thomas Y. Crowell Co., 1962. I.B.

FLEXNER, JAMES THOMAS. *A Short History of American Painting.* Boston: Houghton Mifflin Co., 1950. I.B. *Authoritative history of American painting.*

FLOCKHART, LOLITA L.W. *Art and Artists in New Jersey.* Somerville, N.J.: C.P. Hoagland Co., 1938. I.

FORD, CHARLES HENRI. *Poems for Painters.* New York: View Editions, 1945. I. *Poems illustrated by surrealist artists.*

Forerunners of American Abstraction. Pittsburgh: Musem of Art, Carnegie Institute, 1971. Foreword by Leon Anthony Arkus. Introduction by Herdis Bull Teilman. I.B. *Survey exhibition with biographical sketches.*

FOSTER, JOSEPH K. *Raphael Soyer, Drawings and Watercolors.* New York: Crown Publishers Inc., 1968. I. *A selection of 52 watercolors and 72 drawings.*

FRANK, WALDO, ed. *America and Alfred Stieglitz.* Garden City, N.Y.: Doubleday, Doran and Co., Inc., 1934. I. *A history of Alfred Stieglitz and his influence.*

FRASCONI, ANTONIO. *Against the Grain: The Woodcuts of Antonio Frasconi.* New York: Macmillan Publishing Co. Inc., 1974. Introduction by Nat Hentoff. Appreciation by Charles Parkhurst. I.D. *Thirty-five years of his woodcuts reviewed; includes section on his methods.*

Frederick Kiesler Architekt: 1890-1965. Vienna: Galerie Nachst St. Stephan,

1975. Introduction by Friedrich St. Florian. I.D.P. *Retrospective catalogue; includes artist's statements.*

FREUNDLICH, AUGUST L. *William Gropper: Retrospective.* Los Angeles: Ward Ritchie Press, 1968. I.B. *Retrospective catalogue including statements by the artist.*

FRIED, MICHAEL., 1. *Morris Louis.* Boston: Museum of Fine Arts, 1967. I.B. *Major retrospective catalogue including essay by Clement Greenberg.*

———, 2. *Morris Louis.* New York: Harry N. Abrams Inc., 1970. I. *Monograph.*

FRIEDMAN, B.H., 1. *Alfonso Ossorio.* New York: Harry N. Abrams Inc., 1971. I.B.C. *Picturebook monograph.*

———, 2. *Jackson Pollock: Energy Made Visible.* New York: McGraw-Hill Book Co., 1972. I.B. *A biographical study of the painter.*

FRIEDMAN, B.H., ed. *School of New York: Some Younger Artists.* New York: Grove Press Inc., 1959. I. *Younger artists of promise in the 1950's.*

FRIEDMAN, MARTIN, 1. *Adolph Gottlieb.* Minneapplis: The Walker Art Center, 1963. I.B. *Exhibition catalogue.*

———, 2. *14 Sculptors: The Industrial Edge.* Minneapolis: The Walker Art Center, 1969. I.B. *Exhibition catalogue with essays by Barbara Rose, Christopher Finch, and Martin Friedman.*

———, 3. *Nevelson Wood Sculptures.* New York: E.P. Dutton, n.d. I.B.C. *Exhibition catalogue.*

FRIEDMAN, MARTIN and VAN DER MARCK, JAN. *Eight Sculptors: The Ambiguous Image.* Minneapolis: The Walker Art Center, 1966. I.B.C. *Exhibition catalogue.*

Fritz Glarner. Bern: Kunsthalle Bern, 1972. Foreword by Max Bill. I.B. *Retrospective catalogue.*

FROST, ROSAMOND. *Contemporary Art: The March of Art from Cezanne Until Now.* New York: Crown Publishers Inc., 1942. I.B.

FRY, EDWARD. *David Smith.* New York: The Solomon R. Guggenheim Museum, 1969. I.B. *Retrospective catalogue.*

GABO, NAUM. *Of Divers Arts.* London: Faber and Faber, Ltd., 1962. I. *Critical*

essays.

GALLATIN, A.E., 1. *American Watercolourists.* New York: E.P. Dutton, 1922. I.

———, 2. *Certain Contemporaries: A Set of Notes in Art Criticism.* New York: John Lane Co., 1916.

———, 3. *Gallatin Iconography.* n.p.: Privately published, 1934. I. *Genealogy through portraits.*

———, 4. *Gaston Lachaise.* New York: E.P. Dutton, 1924. I. *Critical essay.*

———, 5. *John Sloan.* New York: E.P. Dutton, 1925. I. *Critical essay.*

———, 6. *Paintings by Gallatin.* New York: Wittenborn, Schultz, Inc., 1948. I.B.

———, 7. *Paul Manship.* New York: John Lane Co., 1917. I.B. *Cirtical essay.*

———, 8. *Whistler, Notes and Footnotes.* New York: The Collector and Art Critic Co., 1907. I. *Critical essays.*

GARVER, THOMAS H. *George Tooker.* San Francisco: California Palace of the Legion of Honor, 1974. I.B.C. *Retrospective catalogue.*

GARWOOD, DARRELL. *Artist in Iowa.* New York: W.W. Norton and Co., 1944. *Biography.*

GASCOYNE, DAVID. *A Short Survey of Surrealism.* London: Cobden-Sanderson, 1935. I. *Essays and documentation.*

GAUNT, WILLIAM. *The Observer's Book of Modern Art from Impressionism to the Present Day.* London: Frederick Warne and Co. Ltd., 1964. I.G.

GENAUER, EMILY. *Best of Art.* Garden City, N.Y.: Doubleday and Co. Inc., 1948. I. *Painting during the 1940's.*

Gene Davis. San Francisco: San Francisco Museum of Art, 1968. Preface by Gerald Nordland. I.B. *One-man exhibition.*

George Grosz: Dessins et Aquarelles. Paris: Galerie Claude Bernard, 1966. Preface by Edouard Roditi. I. *Exhibition catalogue.*

George Rickey. Los Angeles: University of California, Los Angeles, 1971. An interview by Frederick S. Wight. I.B.D.C. *Exhibition catalogue.*

GEORGE, WALDEMAR, 1. *Les Artistes juifs et l'ecole de Paris.* Algiers: Editions

du Congres Juif Mondial, 1959. I. (French text.)

———, 2. *John D. Graham.* Paris: Editions Le Triangle, n.d. I. *Critical essay.*

GERDTS, WILLIAM H., Jr. *Painting and Sculpture in New Jersey.* Princeton, N.J.: D. Van Nostrand, 1964. Foreword by Richard J. Hughes. I.B.D. *The first art history of New Jersey.*

GERSTNER, KARL. *Kalte Kunst.* Switzerland: Verlag Arthur Niggli, 1957. I. (German text.) *Hard edge painting and sculpture.*

GERTZ, ULRICH. *Contemporary Plastic Art.* Berlin: Rembrandt-Verlag, GMBH, 1955. I. (German and English text.) *Post-war painting in Europe, including American influence.*

GETLEIN, FRANK, 1. *Chaim Gross.* New York: Harry N. Abrams Inc., 1974. I.B.C. *Illustrated mongraph.*

———, 2. *Jack Levine.* New York: Harry N. Abrams Inc., n.d. I. *Monograph.*

———, 3. *Peter Blume.* New York: Kennedy Galleries, 1968. I. *Exhibition catalogue.*

GETLEIN, FRANK and DOROTHY. *Christianity in Art.* Milwaukee: The Bruce Publishing Co., 1959. I.B.

GIEDION-WELCKER, CAROLA, 1. *Contemporary Sculpture: An Evolution in Volume and Space.* Documents of Modern Art, Vol. 12. New York: George Wittenborn, Inc., 1955. I.B.

———, 2. *Modern Plastic Art: Elements of Reality, Volume and Disintegration.* Zurich: Dr. H. Girsberger, 1937. I.B. *Twentieth-century sculpture.*

GLACKENS, IRA. *William Glackens and the Ashcan Group: The Emergence of Realism in American Art.* New York: Crown Publishers Inc., 1957. I.

Glimcher, Arnold B. *Louise Nevelson.* New York: Praeger Publishers, 1972. I.C. *Monograph.*

GOLDWATER, ROBERT and TREVES, MARCO, eds. *Artists on Art. From the XIV to the XX Century.* New York: Pantheon Books, 1945. I.

GOMRINGER, EUGEN. *Josef Albers.* New York: George Wittenborn, Inc., 1968. I.B. *Essays on all the aspects of Albers' work, with comments by the artist.*

GOODRICH, LLOYD, 1. *American Watercolors and Winslow Homer.* New

York: The Walker Art Center, for American Artists Group Inc., 1945. I.

———, 2. *The Drawings of Edwin Dickinson.* New Haven, Conn.: Yale University Press, 1963. I.

———, 3. *Edward Hopper.* New York: Penguin Books, 1949. I. *Monograph.*

———, 4. *Edward Hopper.* New York: The Whitney Museum of American Art, 1956. I.B. *Exhibition catalogue.*

———, 5. *Edwin Dickinson.* New York: The Whitney Museum of American Art, 1965. I.B. *Retrospective catalogue.*

———, 6. *H.E. Schnakenberg.* New York: The Whitney Museum of American Art (American Artists Series), 1931. I.B. *Monograph.*

———, 7. *John Sloan.* New York: The Whitney Museum of American Art, 1952. I.B. *Exhibition catalogue.*

———, 8. *Kuniyoshi.* New York: The Whitney Museum of American Art, 1948. I. *Exhibition catalogue.*

———, 9. *Max Weber.* New York: The Whitney Museum of American Art, 1949. I. *Exhibition catalogue.*

———, 10. *Raphael Soyer.* New York: The Whitney Museum of American Art, 1967. I.B. *Retrospective catalogue.*

———, 11. *Reginald Marsh.* New York: The Whitney Museum of American Art, 1955. I. *Exhibition catalogue.*

GOODRICH, LLOYD and BAUR, JOHN I.H., 1. *American Art of Our Century.* New York: The Whitney Museum of American Art, 1961. I. *Development of American art illustrated through the collection of the WMAA.*

———, 2. *Four American Expressionists.* New York: The Whitney Museum of American Art, 1949. I. *Exhibition catalogue: Doris Caesar, Chaim Gross, Karl Knaths, Abraham Rattner.*

GOODRICH, LLOYD and IMGIZUMI, ATSUO. *Kuniyoshi.* Tokyo: National Museum of Modern Art, 1954. I. (Japanese and English text.) *Retrospective catalogue.*

GOODRICH, LLOYD and MANDEL, PATRICIA FITZG. *John Heliker.* New York: The Whitney Museum of American Art, 1968. I.B. *Retrospective catalogue.*

GOOSSEN, E.C., 1. *The Art of the Real*

USA 1948-1968. New York: The Museum of Modern Art, 1968. I.B. *A proposal that some art is more "real" than other art.*

_____, 2. *Ellsworth Kelly.* New York: The Museum of Modern Art, 1973. I.B.A. *Retrospective monograph.*

_____, 3. *Helen Frankenthaler.* New York: The Whitney Museum of American Art, 1969. I.B. *Retrospective catalogue.*

_____, 4. *Stuart Davis.* New York: George Braziller, Inc., 1959. I.B. *Monograph.*

_____, 5. *Three American Sculptors.* New York: Grove Press Inc., 1959. I. *Monograph: Herbert Ferber, David Hare, Ibram Lassaw.*

GORDON, JOHN, 1. *Franz Kline.* New York: The Whitney Museum of American Art, 1968. I.B. Chronology. *Retrospective catalogue.*

_____, 2. *Isamu Noguchi.* New York: The Whitney Museum of American Art, 1968. I.B. Chronology. *Retrospective catalogue.*

_____, 3. *Karl Schrag.* New York: American Federation of Arts and The Ford Foundation, 1960. I. *Retrospective catalogue.*

_____, 4. *Louise Nevelson.* New York: The Whitney Museum of American Art, 1967. I.B. *Retrospective catalogue.*

GRAHAM, JOHN D. *System and Dialectics of Art.* New York: Delphic Studios, 1937. *Critical essays.*

The Great Decade of American Abstraction: Modernist Art 1960 to 1970. Houston: The Museum of Fine Arts, 1974. Foreword by R.A. Carmean, Jr. Introduction by Philippe de Montebello. I.B. *Exhibition catalogue; reprints, critical essays, and essays on the conservation of color-field paintings.*

GREEN, SAMUEL ADAMS. *Andy Warhol.* Philadelphia: Institute of Contemporary Art, 1965. I. *Exhibition catalogue.*

GREENBERG, CLEMENT, 1. *Art and Culture.* Boston: Beacon Press, 1961. *Critical essays.*

_____, 2. *Hofmann.* Paris: The Pocket Museum, Editions George Fall, 1961. I. *Monograph.*

GREENGOOD, LILLIAN. *Great Artists of America.* New York: Thomas Y. Crowell Co., 1963. I.B. *Popular biographical essays.*

GROSS, CHAIM. *Fantasy Drawings.* New York: Beechhurst Press (A Bittner Art Book), 1956. I. *Drawings.*

GROSSER, MAURICE, 1. *The Painter's Eye.* New York: Rinehart and Co., Inc., 1951. I. *Essays on divers topics.*

_____, 2. *Painting in Public.* New York: Alfred A. Knopf, 1948. *Autobiographical.*

GROSZ, GEORGE, 1. *George Grosz.* Berlin: Akademie der Kunste, 1962. I. *Retrospective catalogue.*

_____, 2. *George Grosz Drawings.* New York: H. Bittner and Co., 1944. I. *Drawings.*

_____, 3. *Die Gezeichneten.* Berlin: Malik Verlag, 1930. I. (German text.) *Drawings.*

_____, 4. *A Little Yes and a Big No. The Autobiography of George Grosz.* New York: The Dial Press, 1946. I.

_____, 5. *Der Spiesser-Spiegel.* Dresden: Carl Reisser Verlag, 1925. I. (German text.) *Drawings.*

GUEST, BARBARA and FRIEDMAN, B.H. *Goodnough.* Paris: The Pocket Museum, Editions George Fall, 1962. I. *Monograph.*

GUGGENHEIM, PEGGY, ed. *Art of This Century.* New York: Art of This Century, 1942. I. *Documents her New York gallery.*

GUTMAN, WALTER K. *Raphael Soyer, Paintings and Drawings.* New York: Shorewood Publishing Co., Inc., 1960. I. *Monograph.*

HAAS, IRVIN. *A Treasury of Great Prints.* New York: Thomas Yoseloff Inc., 1959. I.

HAFTMAN, WERNER. *Paintings in the Twentieth Century.* New York: Frederick A. Praeger, 1960, 2 vols. I. *A major history of twentieth-century art.*

HAHN, OTTO. *Arman.* Paris: Fernand Hazan Editeur, 1972. I.B. (French text.) *Appreciation with biographical information.*

HALE, ROBERT BEVERLY. *Waldo Peirce.* New York: American Artists Group Inc., 1945. I. *Monograph.*

HALL, W.S. *Eyes on America.* New York: Studio Publications, 1939. I. *Figurative painting in America.*

HALPERT, EDITH GREGOR. *The Downtown Gallery.* New York: The Downtown Gallery, 1943. I. *Documents members of the gallery.*

HAMILTON, GEORGE H. *Josef Albers.* New Haven, Conn.: Yale University Art Gallery, 1956. I. *Exhibition catalogue.*

HAMILTON, RICHARD. *The Bride Stripped Bare by her Bachelors, Even.* New York: George Wittenborn, Inc., 1960. *Documentary essay on Marcel Duchamp.*

HANSEN, AL. *A Primer of Happenings and Time/Space Art.* New York: Something Else Press Inc., 1965. I. *People places events and Hansen in happenings and time-/space.*

Happening & Fluxus. Cologne: Kolnischer Kunstverein, 1970. Foreword by Harald Szeeman. I.B.D.P.C. *The major documentary resource on happening, fluxus, events, non-art, 1959-1970.*

HARTLEY, MARSDEN. *Adventures in the Arts.* New York: Boni and Liveright, Inc., 1921. *Autobiography.*

HARTMANN, SADIKICHI. *A History of American Art.* Boston: L.C. Page and Co., 1932, rev. ed., 2 vols. I. *Important history of American Art.*

HASKELL, BARBARA, 1. *Arthur Dove.* San Francisco: San Francisco Museum of Art, 1974. I.B.C. *Retrospective catalogue.*

———, 2. *Claes Oldenburg: Object into Monument.* Pasadena: The Pasadena Art Museum, 1971. I.B.C. *Exhibition catalogue with comments on individual pieces by the artist.*

HAYTER, S.W., 1. *About Prints.* London: Oxford University Press, 1962. I.B. *Print appreciation and techniques.*

———, 2. *New Ways of Gravure.* New York: Pantheon Books, 1949. I.D. *Printmaking techniques.*

HELD, JULIUS S. *Joseph Floch.* New York: Thomas Yoseloff Inc., 1968. Foreword by Jean Cassou. I. *Monograph.*

HELM, MAC KINLEY. *John Marin.* New York: Pellegrini and Cudahy, 1948. I. *Monograph.*

HELM, MAC KINLEY and WIGHT, FREDERICK S. *John Marin.* Boston: Institute of Modern Art, 1947. I. *Exhibition catalogue.*

HENNING, EDWARD B. *Paths of Ab-* stract *Art.* Celveland: The Cleveland Museum of Art, 1960. I. *Twentieth-century development of abstract art.*

HESS, HANS. *Lyonel Feininger.* London: Thames and Hudson, 1961. I.B. *Catalogue raisonné.*

HESS, THOMAS B., 1. *Abstract Painting: Background and American Phase.* New York: Viking Press, 1951. I. *Important documentation of abstract painting in America.*

———, 2. *Barnett Newman.* New York: Walker & Co., 1969. I.B. *Monograph.*

———, 3. *Barnett Newman.* New York: The Museum of Modern Art, 1971. I.B. *Retrospective monograph.*

———, 4. *Willem de Kooning.* New York: The Museum of Modern Art, 1968. I.B. *Retrospective monograph; includes statements by the artist.*

———, 5. *Willem de Koonig: Drawings.* Greenwich, Conn.: New York Graphic Society Ltd., 1972. I.B.C. *Essays on his drawings.*

HILDEBRANDT, HANS. *Alexander Archipenko.* Berlin: Ukrainske Slowo Publishers Ltd., 1923. I. *(Ukrainian and English text.) Monograph.*

HILL, ANTHONY. ed. *D.A.T.A.— Directions in Art, Theory and Aesthetics.* London: Faber and Faber, Ltd., 1968. I.B. *Collected statements by neo-plastic and kinetic artists, including Charles Biederman.*

HIRSCH, RICHARD. *Charles Sheeler.* Allentown, Pa.: Allentown Art Museum, 1961. I. *Exhibition catalogue.*

HOFMANN, HANS. *Search for the Real.* Andover, Mass.: Addison Gallery of American Art, 1948. I. *Hofmann's theory of painting.*

HOLME, BRYAN, 1. *Master Drawing in Line.* New York: Studio Publications, 1948. I.

———, 2. *Master Drawings.* New York: Studio Publications, 1943. I.

HONIG, EDWIN. *Mauricio Lasansky— The Nazi Drawings.* Iowa City: Mauricio Lasansky Foundation, 1966. I. *Exhibition catalogue.*

HONNEF, KLAUS. *Concept Art.* Cologne: Phaidon Verlag, 1971. I.B.D.C. *(German text.) Critical essay including artists' statements and documentation.*

HOOPES, DONELSON F. *William*

Zorach. New York: Brooklyn Museum, 1968. I. *Retrospective of the paintings, drawings, and watercolors.*

HOPE, HENRY R. *The Sculpture of Jacques Lipchitz.* New York: The Museum of Modern Art, 1954. I.B. *Exhibition catalogue.*

HOPPER, EDWARD. *Edward Hopper.* New York: American Artists Group Inc., 1945. I. *Autobiographical monograph.*

HOPPS, WALTER. *Frank Lobdell.* Pasadena: The Pasadena Art Museum, 1966. I. *Retrospective catalogue.*

HOWARD, CHARLES. *Charles Howard.* San Francisco: California Palace of The Legion of Honor, 1946. I.B. *Exhibition catalogue.*

Howard Kanovitz. Duisburg: Wilhelm-Lehmbruck-Museum, 1974, I.B.C. (German and English text.) *Ten-year retrospective including artist's statements.*

HUBER, CARLO. *Cy Twombly. Bilder 1953-1972.* Bern: Kunsthalle Bern, 1973. Foreword by Carlo Huber and Michael Pelzet. I.C. (German text.) *Exhibition catalogue.*

HULTEN, K.G. PONTUS. *The Machine.* New York: The Museum of Modern Art, 1968. I.B. *Art and the mechanical age.*

HUMPHREY, JOHN. *Roy De Forest: Retrospective.* San Francisco: San Francisco Museum of Art, 1974. I.B.C. *Catalogue including artist's statements.*

HUNTER, SAM, 1. *Art Since 1945.* New York: Harry N. Abrams Inc., 1958. I.B. *Comprehensive study of world art since 1945.*

——, 2. *Hans Hofmann.* New York: Harry N. Abrams Inc., 1962. I.B. *Monograph.*

——, 3. *James Brooks.* New York: The Whitney Museum of American Art, 1963. I.B. *Retrospective catalogue.*

——, 4. *James Metcalf.* Chicago: William and Noma Copley Foundation, n.d. I. *Monograph.*

——, 5. *Larry Rivers.* New York: Harry N. Abrams Inc., 1970. I. *Monograph.*

——, 6. *Modern American Painting and Sculpture.* New York: Dell Publishing Co., 1959. I. *Concise history of American art since 1900; includes biographies.*

——, 7. *Philip Guston.* New York: Jewish Museum, 1966. I.B. *Major retrospective catalogue, including a dialogue with Harold Rosenberg.*

——, 8. *Rosenthal: Sculpture.* New York: M. Knoedler & Co., n.d. I. *Exhibition catalogue, including dialogue with the artist.*

HUNTER, SAM, ed. *New Art Around the World: Painting and Sculpture.* New York: Harry N. Abrams Inc., 1966. I. *16 essays on the most modern art since 1945, updated to 1966.*

HUYGHE, RENE. *Histoire de l'art contemporain. La Peinture.* Paris: Librairie Felix Alcan, 1936. I.B. (French text.)

IGNATOFF, DAVID. *Kopman.* New York: E. Weyhe, 1930. I. *Monograph.*

Index of 20th Century Artists. New York: The College Art Association, 1933-37, 4 vols. B. *Comprehensive reference on American artists of the 1920's and 1930's.*

Isabel Bishop. Tucson: University of Arizona Museum of Art, 1974. Foreword by Sheldon Reich. Introduction by Martin H. Bush. B. *Retrospective catalogue.*

Isamu Noguchi. Tokyo: Minami Gallery, 1973. I.D.C. (English and Japanese text.) *Exhibition catalogue; includes artist's statements.*

JACKMAN, RILLA EVELYN. *American Arts.* Chicago: Rand McNally and Co., 1928. I.B. *Popular essays on the arts.*

JACOBSON, J.Z., ed. *Art of Today: Chicago 1933.* Chicago: L.M. Stein, 1932. I.

JAKOVSKI, ANATOLE. *Arp, Calder, Helion, Miro, Pevsner, Seligmann.* Paris: Chez J. Povolozky, 1933. I. (French text.)

JANIS, HARRIET and BLESH, RUDI, 1. *Collage. Personalities—Concepts—Techniques.* Philadelphia and New York: Chilton Co., 1962. I.G. *Documents development of collage in the world.*

——, 2. *de Kooning.* New York: Grove Press Inc., 1960. I. *Monograph.*

JANIS, SIDNEY. *Abstract and Surrealist Art in America.* New York: Reynal and Hitchcock, 1944. I. *Essays on the two schools of art in the 1940's.*

JENKINS, PAUL and ESTHER, eds. *Observations of Michael Tapie.* New York: George Wittenborn, Inc., 1956. I. *A collection of the critic's commentaries.*

Jeremy Anderson. San Francisco: San Francisco Museum of Art, 1966.

Preface by Gerald Nordland. I.B. *Retrospective catalogue.*

JEWELL, EDWARD ALDEN, 1. *Alexander Brook.* New York: The Whitney Museum of American Art (American Artists Series), 1931. I.B. *Monograph.*

——, 2. . . . *America.* New York: Alfred A. Knopf, 1930. I. *Critical essays.*

——, 3. *Have We an American Art?* New York and Toronto: Longmans, Green and Co., 1939. *Critical essays.*

Joan Mitchell: My Five Years in the Country. Syracuse: Everson Museum of Art, 1972. Introduction by James Harithas. I.B.C. *Exhibition catalogue.*

John Altoon. San Francisco: San Francisco Museum of Art, 1967. Preface by Gerld Nordland. I.B. *Retrospective catalogue.*

John McLaughlin. La Jolla: La Jolla Museum of Contemporary Art, 1973. Foreword by Jay Belloli. Introduction by John McLaughlin. I.B.C. *Retrospective catalogue.*

JOHNSON, UNA E., 1. *Gabor Peterdi.* New York: Brooklyn Museum, 1959. I. *Exhibition catalogue.*

——, 2. *Isabel Bishop.* New York: Brooklyn Museum, 1964. I.B. *The prints and drawings of Miss Bishop with two essays by the artist.*

——, 3. *Paul Cadmus.* New York: Brooklyn Museum, 1968. I.B. *Catalogue of an exhibition of prints and drawings.*

JONES, DAN BURNE. *The Prints of Rockwell Kent.* Chicago: The University of Chicago Press, 1975. Foreword by Carl Zigrosser. I.B. *Catalogue raisonné.*

JONES, EDITH H., ed. *The Drawings of Charles Burchfield.* New York: Frederick A. Praeger, 1968. I. *A pictorial survey. (See also under* "Drawings . . ." *for Cleveland volume.)*

Jose De Rivera: Retrospective Exhibition 1930-1971. La Jolla: La Jolla Museum of Contemporary Art, 1972. Introduction by Thomas B. Tibbs. I.C. *Includes catalogue raisonné of 191 works.*

Joseph Goto. Providence: Rhode Island School of Design, 1971. Foreword by Stephen E. Ostrow. Introduction by William H. Jordy. I.C. *Exhibition catalogue.*

Joseph Hirsch. Athens, Ga.: Georgia Museum of Art, 1970. Foreword by William D. Paul, Jr. Introduction by Frank Getlein. I.C.B. *Exhibition catalogue.*

JOYNER, BROOKS. *The Drawings of Arshile Gorky.* College Park, Md.: University of Maryland, 1969. Preface by George Levitine. Foreword by William H. Gerdts. I.B. *Major essay on the drawings.*

JUIN, HUBERT. *Seize peintres de la jeune ecole de Paris.* Paris: Le Musee de Poche, 1956. I.

KALLEM, H.M. *Maurice Sterne.* New York: The Museum of Modern Art, 1933. I.B. *Exhibition catalogue.*

KAPROW, ALLAN. *Assemblage, Environments and Happenings.* New York: Harry N. Abrams Inc., 1965. I. *Scripts. A major illustrated and documented book.*

KARFIOL, BERNARD. *Bernard Karfiol.* New York: American Artists Group Inc., 1945. I. *Autobiographical monograph.*

KARSHAN, DONALD. *Archipenko: The Sculpture and Graphic Art.* Tubingen: Ernst Wasmuth Verlag, 1974. I.B.C. *Catalogue raisonné.*

KATZ, LESLIE. *William Glackens in Retrospect.* St. Louis: The City Art Museum, 1966. I.B. *Major retrospective catalogue.*

KECKEMET, DUSKO. *Ivan Mestrovic.* Zagreb: Spektan Cpg Delo, 1970. I.B. *Poorly translated, but a major resource.*

KELDER, DIANE, ed. *Stuart Davis.* Documentary Monographs in Modern Art. New York: Praeger Publishers, 1971. I.B.C. *Collected writing of and about the artist. Monograph.*

KENT, NORMAN. *Drawings by American Artists.* New York: Watson-Guptill Publishing Co. Inc., 1947. I.

KENT, ROCKWELL, 1. *It's Me O Lord.* New York: Dodd, Mead and Co., 1955. I. *Autobiography.*

——, 2. *Rockwell Kent.* New York: American Artists Group Inc., 1945. I. *Autobiographical monograph.*

——, 3. *Rockwelkentiana.* New York: Harcourt, Brace and Co., 1945. I. *Autobiographical monograph.*

KENT, ROCKWELL, ed. *World Famous*

Paintings. New York: Wise and Co., 1939. I. *Paintings of all ages.*

KEPES, GYORGY, 1. *Language of Vision.* Chicago: Paul Theobald and Co., 1944. I. *An aesthetic of seeing.*

———, 2. *The New Landscape in Art and Science.* Chicago: Paul Theobald and Co., 1956. I. *Convolutions of science and art.*

KEPES, GYORGY, ed. *The Visual Arts Today.* Middletown, Conn.: Wesleyan University Press, 1960. I.B. *Essays on architecture, fine arts, graphics, typography, etc.*

KIRBY, MICHAEL. *Happenings.* New York: E.P. Dutton, 1965. I *A history with scripts of the happenings.*

KIRSTEIN, LINCOLN, 1. *Elie Nadelman.* New York: The Eakins Press, 1973. I.B. *Catalogue raisonné; monograph including artist's statements and writings.*

———, 2. *Elie Nadelman Drawings.* New York: H. Bittner and Co., 1949. I. *Drawings.*

———, 3. *Pavel Tchelitchew.* New York: Gallery of Modern Art, 1964. I.B. *Retrospective catalogue.*

———, 4. *The Sculpture of Elie Nadelman.* New York: The Museum of Modern Art, 1948. I. *Retrospective catalogue.*

KIRSTEIN, LINCOLN, ed. *Paval Tchelitchew Drawings.* New York: H. Bittner and Co., 1947. I. *Drawings.*

KLIGMAN, RUTH. *Love Affair: A Memoir of Jackson Pollock.* New York: William Morrow & Co. Inc., 1974.

KOCH, JOHN. *John Koch in New York.* New York: Museum of the City of New York, 1963. I.B. *Retrospective catalogue.*

KOCH, STEPHEN. *Stargazer: Andy Warhol's World and His Films.* New York: Praeger Publishers, 1973. I. *Filmography.*

KOOTZ, SAMUEL M., 1. *Modern American Painters.* n.p.: Brewer and Warren Inc., 1930. I. *Survey of painting in the 1930's.*

———, 2. *New Frontiers in American Painting.* New York: Hastings House, 1943. I. *Surveys the advance guard in painting.*

KOSTELANETZ, RICHARD, ed. *Moholy-Nagy.* Documentary Monographs in Modern Art. New York: Praeger Publishers, 1970. I.B.D.C. *Edited essays by and about the artist. Monograph.*

KOUVENHOVEN, JOHN A. *Made in America: The Arts in Modern Civilization.* Garden City, N.Y.: Doubleday and Co. Inc., 1948. I.B. *Critical essays on American culture.*

KOZLOFF, MAX, 1. *H.C. Westermann.* Los Angeles: County Museum of Art, 1968. I.B. *Retrospective catalogue.*

———, 2. *Jasper Johns.* New York: Harry N. Abrams Inc., 1967. I.B. *Well illustrated monograph.*

———, 3. *Renderings.* New York: Simon and Schuster, 1968. I. *Collected critical essays on modern art.*

KRAMER, HILTON, 1. *David Smith.* Los Angeles: County Museum of Art, 1965. I.B. *Includes statements by the artist.*

———, 2. *Milton Avery: Paintings, 1930-1960.* New York: Thomas Yoseloff Inc., 1962. I. *Monograph.*

———, 3. *The Sculpture of Gaston Lachaise.* New York: The Eakins Press, 1967. I.B. *Well illustrated monograph.*

KRAUSS, ROSALIND. *Jules Olitski—Recent Painting.* Philadelphia: Institute of Contemporary Art, 1968. I.B. *Exhibition catalogue.*

KROLL, LEON, 1. *Leon Kroll.* Cleveland: Print Club of Cleveland and The Cleveland Museum of Art, 1945. I. *Exhibition catalogue.*

———, 2. *Leon Kroll.* New York: American Artists Group Inc., 1946. I. *Autobiographical monograph.*

KUH, KATHARINE, 1. *Art Has Many Faces—The Nature of Art Presented Visually.* New York: Harper and Brothers, 1951. I.

———, 2. *The Artist's Voice, Talks with Seventeen Artists.* New York: Harper and Row, 1962. I.

———, 3. *Break-up: The Core of Modern Art.* Greenwich, Conn.: New York Graphic Society, 1965. I.

KUHN, WALT, 1. *The Story of The Armory Show.* n.p.: Privately published, 1938.

———, 2. *Walt Kuhn.* Cincinnati: The Cincinnati Art Museum, 1960. I. *Exhibition catalogue.*

KUNIYOSHI, YASUO. *Yasuo Kuniyoshi.*

New York: American Artists Group Inc., 1945. I. *Autobiographical monograph.*

Kunst um 1970: Art Around 1970. Aachen: Neue Galerie der Stadt Aachen, 1972. Foreword by Wolfgang Becker. I.B. (German and English text.) *Mostly American art from the Peter Ludwig collection.*

KYROU, ADO. *Le Surrealisme au Cinema.* Paris: Le Terrain Vague, 1963. I.

LANDON, EDWARD. *Picture Framing.* New York: American Artists Group Inc., 1945. I.

LANE, JAMES W. *Masters in Modern Art.* Boston: Chapman and Grimes, 1936. I

LANGSNER, JULES. *Man Ray.* Los Angeles: County Museum of Art, 1966. I.B. *Major exhibition catalogue including essays by the artist.*

LANGUI, EMILE. *Fifty Years of Modern Art.* New York: Frederick A. Praeger, 1959. I. *Critical historical survey.*

LARSON, PHILIP. *Burgoyne Diller.* Minneapolis: The Walker Art Center, 1971. I.B. *Retrospective exhibition.*

LARSON, PHILIP and SCHJELDAHL, PETER. *De Kooning: Drawings/Sculptures.* New York: E.P. Dutton, 1974. Acknowledgments by Martin Friedman. I.B.C. *Exhibition catalogue.*

LEACH, FREDERICK D. *Paul Howard Manship: An Intimate View.* St. Paul: Minnesota Museum of Art, 1973. Prologue by Malcolm E. Lein. I.B. *Major retrospective catalogue; quotes from the artist.*

LEBEL, ROBERT. *Marcel Duchamp.* New York: Grove Press Inc., 1959. I.B. *Monograph.*

LEE, KATHRYN DEAN and BURCHWOOD, KATHARINE TYLER. *Art Then and Now.* York: Appleton-Century-Crofts, Inc., 1949. I. *A popular history.*

LEEPA, ALLEN. *The Challenge of Modern Art.* New York: Thomas Yoseloff Inc., 1957. I *Problems presented by abstract and non-figurative art.*

LEVY, JULIEN, 1. *Arshile Gorky.* New York: Harry N. Abrams Inc., 1966. I.B. *Well illustrated monograph.*

————, 2. *Eugene Berman.* New York: American Studio Books, 1947. I. *Monograph.*

LICHT, FRED. *Sculpture, 19th and 20th Centuries.* Greenwich, Conn.: New York Graphic Society, 1967. I. *Well illustrated introduction to modern sculpture.*

LICHT, JENNIFER. *Eight Contemporary Artists.* New York: The Museum of Modern Art, 1974. I.B.D.C. *Small exhibition catalogue including artists' statements.*

LIPCHITZ, JACQUES, with ARNASON, H.H. *My Life in Sculpture.* New York: Viking Press (Documents of Twentieth Century Art), 1972. I. *Biography.*

LIPPARD, LUCY R., 1. *Ad Reinhardt.* New York: Jewish Museum, 1967. Preface by Sam Hunter. I.B.D. *Major retrospective catalogue.*

————, 2. *Changing: Essays in Art Criticism.* New York: E.P. Dutton, 1971. Foreword by Gregory Battcock. I. *Collected essays, written mostly in the mid-1960s.*

————, 3. *The Graphic Work of Philip Evergood.* Selected drawings and complete prints. New York: Crown Publishers Inc., 1966. Foreword by Abram Lerner. Poem by James Michener. I. *Catalogue raisonné of prints augmented with selected drawings.*

————, 4. *Minimal Art.* The Hague: Haags Gemeentemuseum, 1968. Preface by E. Develing. I.B. (Dutch and English text.) *Important early minimal exhibition catalogue with artists' statements.*

————, 5. *Pop Art.* New York: Frederick A. Praeger, 1966. I. *Early international survey of Pop, with contributions by Lawrence Alloway, Nancy Marmer, Nicolas Calas.*

LIPPARD, LUCY R., ed. *Six Years: The Dematerialization of the Art Object from 1966 to 1972: a cross-reference book of information on some esthetic boundaries: consisting of a bibliography into which are inserted a fragmented text, art works, documents, interviews, and symposia, arranged chronologically and focused on so-called conceptual or information or idea art with mentions of such vaguely designated areas as minimal, anti-form, systems, earth or process art, occurring now in the Americas, Europe, England, Australia and Asia (with occasional political overtones).*

New York: Praeger Publishers, 1973.
Annotated by Lucy R. Lippard. I.B. *See
title for description.*
**LIVINGSTON, JANE and TUCKER,
MARCIA.** *Bruce Nauman: Work from
1965-1972.* Los Angeles: Los Angeles
County Museum of Art, 1972. I.B.C.
Exhibition catalogue with critical essays.
LOMBARDO, JOSEF VINCENT.
Chaim Gross. New York: Dalton House
Inc., 1949. I.B. *Monograph.*
LORAN, ERLE, 1. *Cezanne's Composition.*
Berkeley: University of California
Press, 1947. I.
_____, 2. *Recent Gifts and Loans of Paintings by
Hans Hofmann.* Berkeley: University of
California Press, 1964. I.
LOWRY, BATES. *The Visual Experience:
An Introduction to Art.* Englewood Cliffs,
N.J.: Prentice-Hall Inc.; New York:
Harry N. Abrams Inc., 1961. I. *Methods
for extending the visual experience.*
LUNDE, KARL. *Isabel Bishop.* New York:
Harry N. Abrams Inc., 1975. I.B.C.
Well-illustrated monograph.
LYNTON, NORBERT. *The Modern
World.* New York: McGraw-Hill Book
Co., Inc., 1965. I.B.G. *Introduction to
modernism in the arts.*
MAC AGY, DOUGLAS, 1. *James Boynton.*
New York: Barone Gallery, Inc., 1959.
I. *Monograph.*
_____, 2. *Plus by Minus: Today's Half-
Century.* Buffalo: Albright-Knox Art
Gallery, 1968. I.D.P. *Major survey of the
development of "cool" art.*
MAN RAY, 1. *Alphabet for Adults.* Beverly
Hills, Calif.: Copley Gallery, 1948. I.
_____, 2. *Man Ray.* Pasadena, Calif.:
Pasadena Art Institute, 1944. I. *Exhibi-
tion catalogue.*
_____, 3. *Ogetti d'Affezione.* Turin: Giulio
Einavdi, 1970. I. (Italian text.) *Catal-
ogue of work.*
_____, 4. *Self Portrait.* Boston: Little,
Brown and Co., 1963. I. *Autobiography.*
Man Ray. Rome: Galleria Il Collezionista
d'Arte Contemporanea, 1973. Intro-
duction by Murizo Fagiolo. I.C. (Itali-
an text.) *Retrospective catalogue.*
Mark Tobey. Basel: Editions Beyeler,
1971. Introduction by John Russell.
I.C. *Exhibition catalogue, including essays by*

*John Cage, Naum Gabo, Lyonel Feininger,
and artists' statements.*
MARSH, REGINALD. *Anatomy for Art-
ists.* New York: American Artists
Group Inc., 1945. I.
MARTIN, HENRY. *Arman or Four and
Twenty Blackbirds Baked in a Pie or Why
Settle for Less When You Can Settle for More.*
New York: Harry N. Abrams Inc.,
1969. I.B. *A critical study of his art.*
**MARTIN, J.L., NICHOLSON, B. and
GABO, N., eds.** *Circle.* London: Faber
and Faber Ltd., 1937. I.B. *Essays on
purist art.*
MATHER, FRANK JEWETT, Jr., 1. *The
American Spirit in Art.* New Haven,
Conn.: Yale University Press, 1927. I.
Historical survey with commentary.
_____, 2. *Eugene Speicher.* New York: The
Whitney Museum of American Art
(American Artists Series), 1931. I.B.
Monograph.
**MAYERSON, CHARLOTTE LEON,
ed.** *Shadow and Light.* New York:
Harcourt, Brace & World, Inc., 1964.
I. *Biography of Maurice Sterne, edited from
the artist's own writings.*
McBRIDE, HENRY. *John Marin.* New
York: The Museum of Modern Art,
1936. I.B. *Exhibition catalogue.*
McCAUSLAND, ELIZABETH. *Marsden
Hartley.* Minneapolis: University of
Minnesota Press, 1952. I. *Biography.*
McCHESNEY, MARY FULLER. *A Period
of Exploration: San Francisco 1945-1950.*
Oakland: The Oakland Museum,
1973. Introduction by Terry N. St.
John. I.A. *An excellent study and survey of
five years' activity surrounding the California
School of Fine Arts, San Francisco; biogra-
phies.*
McCOUBREY, JOHN W., 1. *American
Tradition in Painting.* New York: George
Braziller, Inc., 1963. I.B. *Postulates an
American tradition.*
_____, 2. *Robert Indiana.* Philadelphia:
Institute of Contemporary Art, Uni-
versity of Pennsylvania, 1968. I.B.
*Retrospective catalogue including artist's
statements.*
McCOY, GARNETT, ed. *David Smith.*
Documentary Monographs in Mod-
ern Art. New York: Praeger Publish-

ers, 1973. I.B.C. *Collected writing of the artist. Monograph.*

McCURDY, CHARLES, ed. *Modern Art . . . A Pictorial Anthology.* New York: The Macmillan Company, 1958. I.B.

MEDFORD, RICHARD C. *Guy Pene Du Bois.* Hagerstown, Md.: Washington County Museum of Fine Arts, 1940. I. *Exhibition catalogue.*

MEDINA, JOSE RAMON. *Marisol.* Caracas: Ediciones Armitano, 1968. I. (Spanish text.) *Picture book of the sculpture.*

MEHRING, WALTER. *George Grosz, Thrifty Drawings and Watercolors.* New York: Erich S. Herrmann, 1944. I. *Monograph.*

MELLQUIST, JEROME. *The Emergence of an American Art.* New York: Charles Scribner's Sons, 1942.

MENDELOWITZ, DANIEL M. *A History of American Art.* New York: Holt, Rinehart and Winston, Inc., 1961. I.

MESSER, THOMAS M. *Jan Muller.* New York: The Solomon R. Guggenheim Museum, 1962. I. *Retrospective catalogue.*

METRO International Directory of Contemporary Art. Milan: Metro, 1964. I.B. (English and Italian text.)

MEYER, URSULA. *Conceptual Art.* New York: E.P. Dutton, 1972. *Collected exegesis of concept art.*

MILLER, DOROTHY C., ed., 1. *Americans 1942. 18 Artists from 9 States.* New York: The Museum of Modern Art, 1942. I. *Documented exhibitions catalogue.*

———, 2. *14 Americans.* New York: The Museum of Modern Art, 1946. I.B. *Documented exhibition catalogue.*

———, 3. *The Sculpture of John B. Flannagan.* New York: The Museum of Modern Art, 1942. I. *Retrospective catalogue.*

MILLER, KENNETH HAYES. *Kenneth Hayes Miller.* New York: Art Students League, 1953. I. *Exhibition catalogue.*

MILLIER, ARTHUR, 1. *Henry Lee McFee.* Claremont, Calif.: Scripps College, 1950. I. *Exhibition catalogue.*

———, 2. *Millard Sheets.* Los Angeles: Dalzell Hatfield Gallery, 1935. I. *Monograph.*

Miriam Schapiro: The Shrine, The Computer, and The Dollhouse. La Jolla: Mandeville

Art Gallery, 1975. Introduction by Linda Nochlin. I.B. *Documentary exhibition catalogue including interview and essays.*

MOAK, PETER. *The Robert Laurent Memorial Exhibition.* Durham: University of New Hampshire, 1972. Foreword by Melvin J. Zabarsky. Essay by Henry Hope. I.B. *Retrospective exhibition catalogue.*

MOCSANYI, PAUL. *Karl Knaths.* Washington, D.C.: The Phillips Gallery, 1957. I.B. *Exhibition catalogue.*

MOFFETT, KENWORTH. *Jules Olitski.* Boston: Museum of Fine Arts, 1973. I.B. *Retrospective catalogue.*

MOHOLY-NAGY, LAZLO, 1. *A New Vision and Abstract of an Artist.* 4th rev. ed. New York: George Wittenborn, Inc., 1947. Preface by Walter Gropius. I.B. *A primer of modern design.*

———, 2. *Painting, Photography, Film.* Cambridge, Mass.: MIT Press, 1969. I. *English-language reprint of this famous book.*

MOHOLY-NAGY, SIBYL, 1. *Experiment in Totality.* New York: Harper and Brothers, 1950. I. *Biography: Lazlo Moholy-Nagy.*

———, 2. *Lazlo Moholy-Nagy.* Chicago: Museum of Contemporary Art, 1969. I.B. *Retrospective catalogue.*

MONTE, JAMES. *Larry Zox.* New York: The Whitney Museum of American Art, 1973. I.B.C. *Exhibition catalogue.*

MONTE, JAMES and TUCKER, MARCIA. *Anti-Illusion: Procedures/Materials.* New York: The Whitney Museum of American Art, 1969. I.B. *Survey of the anti-illusion expression.*

Monumenta. Newport, R.I.: Monumenta Newport Inc., 1974. Introduction by Sam Hunter. I. *Catalogue of an outdoor exhibition, including interviews and statements by the artists.*

MORRIS, G.L.K. *American Abstract Artists.* New York: Ram Press, 1946. I.B. *Documentation of members.*

MORSE, JOHN D., ed. *Ben Shahn.* Documentary Monographs in Modern Art. New York: Praeger Publishers, 1972. I.B.C. *Collected writings of the artist. Monograph.*

MOTHERWELL, ROBERT, 1. *The Dada Painters and Poets.* New York: Witten-

born, Schultz, Inc., 1951. Documents of Modern Art, Vol. 8. I.B. *A documented history of this group.*

———, 2. *Robert Motherwell.* Northampton, Mass.: Smith College, 1962. I. *Exhibition catalogue.*

MOTHERWELL, ROBERT, ed. *Possibilities, No. 1.* New York: Wittenborn, Schultz, Inc., 1947. I. *An occasional review concerned with all the arts.*

MOTHERWELL, ROBERT and REINHARDT, AD, eds. *Modern Artists in America.* New York: Wittenborn, Schultz, Inc., 1951. I.B. *The European and American advance guard in the 1940's.*

MULAS, UGO and ARNASON, H.H. *Calder.* New York: A Studio Book/Viking Press, 1971. I.B. *Picture book with comments by Calder.*

MULLER, GREGOIRE. *The New Avantgarde.* New York: Praeger Publishers, 1972. I.D. *Photographs by Gianfranco Gorgoni documenting artists and works.*

MUNSTERBERG, HUGO. *Twentieth Century Painting.* New York: Philosophical Library, 1951. I. *Critical essays.*

MURDOCK, ROBERT M., 1. *Modular Paintings.* Buffalo: Albright-Knox Art Gallery, 1970. Foreword by Gordon M. Smith. I.C. *Exhibition catalogue.*

———, 2. *Nassos Daphnis.* Buffalo: Albright-Knox Art Gallery, 1969. Foreword by Gordon M. Smith. I.B.C. *Retrospective catalogue.*

MURRELL, WILLIAM, 1. *Charles Demuth.* New York: The Whitney Museum of American Art (American Artists Series), 1931. I. *Monograph.*

———, 2. *Elie Nadelman.* Woodstock, N.Y.: William M. Fischer, 1923. I. *Monograph.*

MURTHA, EDWIN. *Paul Manship.* New York: The Macmillan Company, 1957. I. *Monograph.*

MYERS, BERNARD, 1. *Fifty Great Artists.* New York: Bantam Books, 1953. I.B. *Historical essays.*

———, 2. *Understanding the Arts.* New York: Henry Holt and Co., 1958. I. *Art appreciation.*

Nancy Graves. La Jolla: La Jolla Museum of Contemporary Art, 1973. Introduction by Jay Belloli. I.B.C. *Exhibition catalogue including artist's statements.*

Nancy Graves: Sculpture/Drawings/Films 1969-1971. Aachen: Neue Galerie im Alten Kurhaus, 1971. Introduction by Phyllis Tuchman. I.C. *Exhibition catalogue.*

NARODNY, IVAN. *American Artists.* New York: Roerich Museum Press, 1930. B. *Figurative painting before 1930.*

NELSON, JUNE KOMPASS. *Harry Bertoia, Sculptor.* Detroit: Wayne State University Press, 1970. I.B.C. *Exhibition catalogue; the essay contains some biographical data.*

NEMSER, CINDY. *Art Talk.* New York: Charles Scribner's Sons, 1975. I.B.C. *Conversations with 12 women artists.*

NESS, JUNE L., ed. *Lyonel Feininger.* New York: Praeger Publishers (Documentary Monographs in Modern Art), 1974. I.B.C. *Collected writings of and about the artist. Monograph.*

NEUHAUS, EUGENE. *The History and Ideals of American Art.* Stanford, Calif.: Stanford University Press, 1931. I.B. *Critical essays.*

NEUMEYER, ALFRED. *The Search for Meaning in Modern Art.* Englewood Cliffs, N.J.: Prentice-Hall Inc., 1964. I. *Essays on the understanding of art.*

NEWMEYER, SARAH. *Enjoying Modern Art.* New York: Reinhold Publishing Co., 1955. I. *Popular essays on art appreciation.*

NEWTON, ERIC, 1. *The Arts of Man.* Greenwich, Conn.: New York Graphic Society, 1960. I. *Critical essays.*

———, 2. *In My View.* London: Longmans, Green and Co., 1950. *Critical essays.*

NOCHLIN, LINDA. *Philip Pearlstein.* Athens, Ga.: Georgia Museum of Art. Preface by William D. Paul, Jr. I.B.C. *Exhibition catalogue.*

NOGUCHI, ISAMU. *A Sculptor's World.* New York: Harper and Row, 1968. Preface by R. Buckminster Fuller. I. *Autobiography.*

NORDLAND, GERALD, 1. *Gaston Lachaise.* Los Angeles: County Museum of Art, 1963. I.B. *Retrospective catalogue.*

———, 2. *Gaston Lachaise: The Man and His Work.* New York: George Braziller, Inc., 1974. I.B. *Monograph including*

artist's writings.

———, 3. *Jeremy Anderson.* San Francisco: San Francisco Museum of Art, 1966. I.B. *Retrospective catalogue.*

———, 4. *Paul Jenkins: Retrospective.* Houston: Museum of Fine Arts, 1971. I.B.C. *Essay is brief sketch of the artist's life.*

NORDMARK, OLLE. *Fresco Painting.* New York: American Artists Group Inc., 1947. I.

NORDNESS, LEE, ed. *Art:USA:Now.* Lucerne: C.J. Bucher, 1962, 2 vols. I.B. *A collection catalogue with biographies and critical essays.*

NORMAN, DOROTHY, ed. *The Selected Writings of John Marin.* New York: Pellegrini and Cudahy, 1949. I. *Letters.*

O'HARA, FRANK, 1. *Art Chronicles: 1954-1966.* New York: George Braziller, Inc., 1975. I.B. *Collected essays.*

———, 2. *David Smith.* London: Tate Gallery, 1966. I.B. *Retrospective catalogue.*

———, 3. *Franz Kline.* London: Whitechapel Art Gallery, 1964. I. *Exhibition catalogue.*

———, 4. *Jackson Pollock.* New York: George Braziller, Inc., 1959. I.B. *Monograph.*

———, 5. *Nakian.* New York: The Museum of Modern Art, 1966. I.B. *Retrospective catalogue.*

OLDENBURG, CLAES, 1. *Notes in Hand.* New York: E.P. Dutton, 1971. I.B. *Miniature version of his sketchbooks.*

———, 2. *Proposals for Monuments and Buildings.* Chicago: Follett Publishing Co., 1969. I. *New concepts for decorating the landscape.*

———, 3. *Raw Notes.* Halifax: Nova Scotia College of Art and Design, 1973. I. *Documents and scripts for* Stars, Moveyhouse, Massage, The Typewriter; *annotated.*

Oldenburg: Six Themes. Minneapolis: The Walker Art Center, 1975. Introduction by Martin Friedman. I.B.C. *Exhibition catalogue, including statements by the artist.*

OLSON, RUTH and CHANIN, ABRAHAM. *Gabo-Pevsner.* New York: The Museum of Modern Art, 1948. I.B. *Exhibition catalogue.*

O'NEAL, BARBARA. *E. Lawson.* Ottawa:

National Gallery of Canada, 1967. I.B. (French and English text.) *Retrospective catalogue.*

ONSLOW-FORD, GORDON. *Towards a New Subject in Painting.* San Francisco: San Francisco Museum of Art, 1948. I. *The artist's theory of painting.*

Options and Alternatives: Some Directions in Recent Art. New Haven: Yale University Art Gallery, 1973. Preface by Alan Shestack. Toward a Definition by Anne Coffin Hanson. Notes on the Anatomy of an Exhibition by Klaus Kertess. Intellectual Cinema; A Reconsideration by Annette Michelson. I.B.D. *Survey of new media and materials.*

Oscar Bluemner: American Colorist. Cambridge, Mass.: Fogg Art Museum, 1967. I.B. *Retrospective catalogue.*

PPALEN, WOLFGANG. *Form and Sense. Problems of Contemporary Art No. 1.* New York: Wittenborn and Co., 1945. I. *Essays in aesthetics.*

PACH, WALTER, 1. *Ananias or the False Artist.* New York: Harper and Brothers, 1928. I. *Critical essays.*

———, 2. *The Masters of Modern Art.* New York: B.W. Huebsch, Inc., 1926. I.B. *American and European art before 1926.*

———, 3. *Queer Thing, Painting.* New York: Harper and Brothers, 1938. I. *Autobiography.*

PAGANO, GRACE. *Contemporary American Painting. The Encyclopaedia Britannica Collection.* New York: Duell, Sloan and Pearce, 1945. I.

PALMER, WILLIAM C. *William C. Palmer.* Utica, N.Y.: Munson-Williams-Proctor Institute, 1956. I. *Exhibition catalogue.*

PARKES, KINETON. *The Art of Carved Sculpture.* New York: Charles Scribner's Sons, 1931, 2 vols. I.B.

PASSLOFF, PATRICIA. *The 30's. Painting in New York.* New York: Poindexter Gallery, 1963. I.

PEARSON, RALPH M., 1. *Experiencing American Pictures.* New York: Harper and Brothers, 1943. I. *Appreciation of modern art.*

———, 2. *The Modern Renaissance in American Art.* New York: Harper and Brothers, 1954. I. *Development of modern art in*

America.

PEIRCE, WALDO. *Waldo Peirce.* New York: American Artists Group Inc., 1945. I. *Autobiographical monograph.*

PENROSE, ROLAND. *Man Ray.* Boston: New York Graphic Society Ltd., 1975. I.B. *Appreciation and biographical sketch.*

PERLMAN, BENNARD B. *The Immortal Eight.* New York: Exposition Press, 1962.

PETERDI, GABOR. *Printmaking: Methods Old and New.* New York: The Macmillan Company, 1959. I.

PHILLIPS, DUNCAN, 1. *The Artist Sees Differently.* New York: E. Weyhe, 1931. I. *Critical essays.*

———, 2. *A Collection in the Making.* New York: E. Weyhe, 1926. I. *Development of the Phillips collection in Washington, D.C.*

PITTMAN, HOBSON. *Hobson Pittman.* Raleigh: North Carolina Museum of Art, 1963. I.B. *Retrospective catalogue.*

PITZ, HENRY C. *The Brandywine Tradition.* Boston: Houghton Mifflin Co., 1969. I.B. *Popular biographies of many recent painters, including Andrew Wyeth.*

PLOUS, PHYLLIS. *5 American Painters: Recent Work.* Santa Barbara: The Art Gallery, University of California, Santa Barbara, 1974. I.B. *Exhibition catalogue.*

POMEROY, RALPH. *Stamos.* New York: Harry N. Abrams Inc., 1974. I.B.C. *Monograph.*

PONENTE, NELLO. *Modern Painting: Contemporary Trends.* Geneva: Skira, 1960. I.B.

POOR, HENRY VARNUM, 1. *An Artist Sees Alaska.* New York: Viking Press, 1945. I.

———, 2. *A Book of Pottery, from Mud into Immortality.* Englewood Cliffs, N.J.: Prentice-Hall Inc., 1958. I.B. *Autobiographical.*

POORE, HENRY R. *Modern Art: Why, What and How?* New York: G.P. Putnam's, 1931. I. *Investigation into the reasons for modern art.*

PORTER, FAIRCHILD. *Thomas Eakins.* New York: George Braziller, Inc., 1959. I.B. *Monograph.*

POUSETTE-DART, NATHANIEL.

Paintings, Watercolors, Lithographs. New York: Clayton Spicer Press, 1946. I.B. *Monograph.*

POUSETTE-DART, NATHANIEL, ed. *American Painting Today.* New York: Hastings House, 1956. I. *Pictorial documentation of American painting in the mid-1950's.*

PRINT CLUB OF CLEVELAND. *The Work of Rudy Pozzatti.* Cleveland: The Cleveland Museum of Art, 1955. I. *Exhibition catalogue.*

PRINT COUNCIL OF AMERICA. *Prints.* New York: Holt, Rinehart and Winston, Inc., 1962. I.

RAGON, MICHEL, 1. *L'Aventure de l'art abstrait.* Paris: Robert Laffont, 1956. I.B. (French text.) *Development of abstract art.*

———, 2. *Expression et non-figuration.* Paris: Editions de la Revue Neuf, 1951. I. (French text.) *Expressionism and the development of non-figurative art.*

RAMSDEN, E.H., 1. *An Introduction to Modern Art.* London: Oxford University Press, 1940. I.

———, 2. *Sculpture: Theme and Variations Toward a Contemporary Aesthetic.* London: Lund Humphries, 1953. I.B.

Raymond Duchamp-Villon/Marcel Duchamp. Paris: Musee National d'Art Moderne, 1967. I.B. (French text.) *Major exhibition of the brothers.*

RAYNAL, MAURICE, 1. *A. Archipenko.* Rome: Valori Plastici, 1923. I. (French text.) *Monograph.*

———, 2. *Jacques Lipchitz.* Paris: Edition Jeanne Bucher, 1947. I. (French text.) *Monograph.*

———, 3. *Modern Painting.* Geneva: Skira, 1953. I.B. *Survey of modern painting.*

———, 4. *Peinture moderne.* Geneva: Skira, 1953. I.B. (French text.)

READ, HERBERT, 1. *The Art of Sculpture.* Bollingen Series XXV, No. 3. New York: Pantheon Books, 1956. I. *Documented critical essays on connoisseurship of sculpture.*

———, 2. *A Concise History of Modern Painting.* New York: Frederick A. Praeger, 1959. I.B.

———, 3. *A Concise History of Modern Sculpture.* New York: Frederick A.

Praeger, 1964. I.B. *Essay source book.*

——, 4. *The Quest and the Quarry.* Rome: Rome-New York Art Foundation Inc., 1961. I. *Critical essays.*

——, 5. *Surrealism.* New York: Harcourt, Brace and Co., 1939. I. *Essays on Surrealism.*

——, 6. *The Tenth Muse.* London: Routledge and Kegan Paul, 1957. I. *Critical essays.*

READ, HERBERT and MARTIN, LESLIE. *Gabo.* London: Lund Humphries, 1957. I.B. *Monograph.*

Recent Figure Sculpture. Cambridge, Mass.: Fogg Art Museum and Harvard University, 1972. Preface by Daniel Robbins. Introduction by Jeanne L. Wasserman. I.B. *Small survey exhibition.*

REESE, ALBERT. *American Prize Prints of the 20th Century.* New York: American Artists Group Inc., 1949. I.

A Report on the Art and Technology Program of the Los Angeles County Museum: 1967-1971. Los Angeles: Los Angeles County Museum of Art, 1971. Introduction by Maurice Tuchman. Essay: Thoughts on Art and Technology, by Jane Livingston. I.D.P. *Documents an amalgam of art, science, and business.*

RESTANY, PIERRE, 1. *J.F. Koenig.* Paris: Galerie Arnaud, 1960. I. (French and English text.) *Monograph.*

——, 2. *Lyrisme et abstraction.* Milan: Edizioni Apollinairi, 1960. I. (French text.) *Exposition of a lyrical theory in painting leading toward abstraction.*

RIBEMONT-DESSAIGNES, G. *Man Ray.* Paris: Librairie Gallimard, 1924. I. *Monograph.*

RICHARDSON, BRENDA, 1. *Joan Brown.* Berkeley: University of California, Berkeley, 1974. I.B. *Retrospective catalogue.*

——, 2. *William T. Wiley.* Berkeley: University of California, Berkeley, 1971. I.B. *Retrospective catalogue.*

RICH, DANIEL CATTON, 1. *Georgia O'Keeffe.* Chicago: The Art Institute of Chicago, 1943. I. *Retrospective catalogue.*

——, 2. *Georgia O'Keeffe.* Worcester, Mass.: The Worcester Art Museum, 1960. *Retrospective catalogue.*

RICHARDSON, E.P. *Painting in America,* the Story of 450 Years. New York: Thomas Y. Crowell Co., 1956. I.B. *Important history of American painting.*

RICHTER, HANS. *Dada Profile.* Zurich: Verlag Die Arche, 1961. I. (German text.) *Snapshot introductory essays on the Dadaists.*

RICKEY, GEORGE. *Constructivism: Origins and Evolution.* New York: George Braziller, Inc., 1967. I.B.D. *Biographies. History of this movement.*

RINARD, PARK and PYLE, ARNOLD. *Grant Wood.* Chicago: Lakeside Press Galleries, 1935. I. *Exhibition catalogue.*

RINGEL, FRED J., ed. *America as Americans See It.* New York: The Literary Guild, 1932. I. *Anthology of the writings of various Americans on American culture.*

RITCHIE, ANDREW CARNDUFF, 1. *Abstract Painting and Sculpture in America.* New York: The Museum of Modern Art, 1951. I.B. *Documented exhibition catalogue.*

——, 2. *Charles Demuth.* New York: The Museum of Modern Art, 1950. I.B. *Retrospective catalogue.*

——, 3. *Sculpture of the Twentieth Century.* New York: The Museum of Modern Art, 1952. I.B.

ROBBINS, DANIEL. *Walter Murch.* Providence: Rhode Island School of Design, 1966. I.B. *Retrospective catalogue.*

Robert Ryman. Amsterdam: Stedelijk Museum, 1974. I.B.C. *Retrospective catalogue.*

ROBERTS, COLETTE. *Mark Tobey.* New York: Grove Press Inc., 1959. I. *Monograph.*

ROBERTSON, BRYAN, 1. *Charles Howard.* London: Whitechapel Art Gallery, 1956. I. *Retrospective catalogue.*

——, 2. *Jackson Pollock.* New York: Harry N. Abrams Inc., 1960. I.B. *Monograph.*

RODMAN, SELDEN, 1. *Conversations with Artists.* New York: Capricorn Books, 1961. I.

——, 2. *The Eye of Man.* New York: Devin-Adair, 1955. I. *Polemic devised toward figuration.*

——, 3. *The Insiders.* Baton Rouge: Louisiana State University Press, 1960. I. *A thesis for figurative artists.*

ROGALSKI, WALTER R. *Prints and*

Drawings by Walter R. Rogalski. Cleveland: Print Club of Cleveland and The Cleveland Museum of Art, 1954. I. *Exhibition catalogue.*

ROOD, JOHN. *Sculpture in Wood.* Minneapolis: University of Minnesota Press, 1950. I. *Technique.*

ROSE, BARBARA, 1. *American Art Since 1900, a critical history.* New York: Frederick A. Praeger, 1967. I.B.

_____, 2. *Claes Oldenburg.* New York: The Museum of Modern Art, 1969. I.B. *Retrospective catalogue.*

_____, 3. *Frankenthaler.* New York: Harry N. Abrams Inc., 1971. I.B. *Monograph.*

_____, 4. *Readings in American Art Since 1900.* New York: Frederick A. Praeger, 1968. I.B. *Collected essays by and about artists and their work.*

ROSE, BERNICE. *Jackson Pollock: Works on Paper.* New York: The Museum of Modern Art, 1969. I. *A study of the drawings.*

ROSENBERG, HAROLD, 1. *Arshile Gorky, The Man, The Time, The Idea.* New York: Horizon Press, Inc., 1962. I.B. *Monograph.*

_____, 2. *De Kooning.* New York: Harry N. Abrams Inc., 1974. I.B.C. *Monograph.*

ROSENBLUM, ROBERT, 1. *Cubism and Twentieth Century Art.* New York: Harry N. Abrams Inc., 1961. I.B. *Chronicles Cubism and its influence.*

_____, 2. *Modern Painting and the Northern Romantic Tradition: Friedrich to Rothko.* New York: Harper and Row Publishers Inc., 1975. I.B. *Essays on the dark side of romantic painting.*

ROTERS, EBERHARD. *Painters of the Bauhaus.* New York: Frederick A. Praeger, 1969. I.B. *A history of the master teachers.*

ROTHSCHILD, LEON. *Style in Art.* New York: Thomas Yoseloff Inc., 1960. I. *Critical essays.*

ROTHSCHILD, LINCOLN. *To Keep Art Alive: The Effort of Kenneth Hays Miller, American Painter.* Philadelphia: The Art Alliance Press, 1974. I.B. *Monograph.*

ROURKE, CONSTANCE. *Charles Sheeler, Artist in the American Tradition.* New York: Harcourt, Brace and Co., 1938. I. *Biography.*

RUBIN, WILLIAM S., 1. *Dada, Surrealism, and Their Heritage.* New York: The Museum of Modern Art, 1968. I.B. *Chronology. Catalogue of controversial MOMA exhibition.*

_____, 2. *Frank Stella.* New York: The Museum of Modern Art, 1970. I.B.C. *A major retrospective catalogue.*

RUBLOWSKY, JOHN. *Pop Art.* New York: Basic Books, 1965. I. *Pop art, its artists, dealers, collectors, and activities.*

RUSSELL, JOHN and GABLIK, SUZI. *Pop Art Redefined.* New York: Frederick A. Praeger, 1969. I. *Includes statements by other critics.*

SACHS, PAUL J. *Modern Prints and Drawings.* New York: Alfred A. Knopf, 1954. I.B.

SAGER, PETER. *Neue Formen des Realismus.* Cologne: Verlag M. DuMont Schauberg, 1973. I.B.C. (German text.) *First international survey of various forms of new realist painting and sculpture; list of international group exhibitions; artists' statements.*

ST. JOHN, BRUCE *John Sloan.* American Art and Artists. New York: Praeger Publishers, 1971. I.B.C. *Appreciation and life of the artist.*

ST. JOHN, BRUCE, ed. *John Sloan's New York Scene.* With an Introduction by Helen Farr Sloan. New York: Harper and Row, 1964. I. *Edited from diaries, notes, and correspondence of the artist dating from 1906 to 1913.*

SALVINI, ROBERTO. *Guida all'arte moderna.* Florence: L'arco, 1949. I.B. (Italian text.)

SAMARAS, LUCAS. *Samaras Album. Autointerview Autobiography Autopolaroid.* New York: The Whitney Museum of American Art and Pace Editions Inc., 1971. I. *The complete autoexpose of Samaras.*

Sam Francis. Paintings 1947-1972. Buffalo: Albright-Knox Art Gallery, 1972. I.B.C. *A major retrospective catalogue; contains essays by Franz Meyer; Wieland Schmied, Robert T. Buck, Jr.*

SANDLER, IRVING. *The Triumph of American Painting: A History of Abstract Expressionism.* New York: Praeger Publishers, 1970. I.B.C. *A history of the mid-20th-century period.*

SASOWSKY, NORMAN. *Reginald Marsh. Etchings, Engravings, Lithographs.* New York: Frederick A. Praeger, 1956. I. Catalogue raisonné .

SAWYER, KENNETH. *The Paintings of Paul Jenkins.* Paris: Editions Two Cities, 1961. I. *Monograph.*

SCHEYER, ERNST. *Lyonel Feininger, Caricature and Fantasy.* Detroit: Wayne State University Press, 1964. I.B. *Documentary monograph drawn from letters and notes of the artist showing development from cartoonist to painter.*

SCHMECKEBIER, LAURENCE E., 1. *Boris Margo.* Syracuse: School of Art, Syracuse University, 1968. I.B. *Exhibition catalogue, including a catalogue raisonné of the artist's prints.*

——, 2. *John Steuart Curry's Pageant of America.* New York: American Artists Group Inc., 1943. I. *Biography.*

SCHNEIDER, PIERRE. *Louvre Dialogues.* Translated from the French by Patricia Southgate. New York: Atheneum, 1971. I. *Interviews made while walking through the Louvre.*

SCHULZE, FRANZ. *Fantastic Images: Chicago Art Since 1945.* Chicago: Follett Publishing Co., 1972 I. *Eccentric figurative art from 1945 to 1972.*

SCHWABACHER, ETHEL K. *Arshile Gorky.* New York: The Whitney Museum of American Art, 1957. I.B. *Biography.*

SCHWARZ, ARTURO, 1. *The Complete Works of Marcel Duchamp.* New York: Harry N. Abrams Inc., 1969. I.B. *Biographical, critical catalogue raisonné : the major source book.*

——, 2. *Marcel Duchamp: Notes and Projects for the Large Glass.* New York: Harry N. Abrams Inc., 1969. I. *Facsimile reproduction of the notes for this work.*

SCOTT, DAVID W. *The Art of Stanton Macdonald-Wright.* Washington, D.C.: National Collection of Fine Arts, 1967. I.B. *Includes "A Treatise on Color" and selected writings of the artist. Retrospective catalogue.*

Sculpture and Drawings by Michael Lekakis. Dayton: Dayton Art Institute, 1968. Introduction by Priscilla Colt. I.C. *Appreciation.*

Sculpture of the Western Hemisphere. New York: International Business Machines Corp., 1942. I. *Catalogue of IBM sculpture collection.*

SEITZ, WILLIAM C., 1. *Abstract Expressionist Painting in America: An Interpretation Based on the Work and Thought of Six Key Figures.* Ph.D. thesis, Princeton University, 1955. Not published; available on microfilm.

——, 2. *Arshile Gorky.* New York: The Museum of Modern Art, 1962. Foreword by Julien Levy. I.B. *Retrospective catalogue.*

——, 3. *The Art of Assemblage.* New York: The Museum of Modern Art, 1961. I.B. *Documented exhibition catalogue.*

——, 4. *Hans Hofmann.* New York: The Museum of Modern Art, 1963. I.B. *Exhibition catalogue.*

——, 5. *Mark Tobey.* New York: The Museum of Modern Art, 1962. I.B. *Retrospective catalogue.*

SELDIS, HENRY J. *Rico Lebrun.* Los Angeles: County Museum of Art, 1967. I.B. *Retrospective catalogue with major documentation: notes on "Genesis" by Peter Selz.*

SELDIS, HENRY J. and WILKE, ULFERT. *The Sculpture of Jack Zajac.* Los Angeles: Gallard Press, 1960. I.B. *Monograph.*

SELIGMANN, HERBERT J., ed. *Letters of John Marin.* New York: An American Place, 1931.

SELIGMANN, KURT. *The Mirror of Magic.* New York: Pantheon Books, 1948. I. *This artist was an authority on magic: his art reflects its influence.*

SELZ, JEAN. *Modern Sculpture.* New York: George Braziller, Inc., 1963. I.B. *Origins of modern sculpture from 1850 to 1920.*

SELZ, PETER, 1. *Directions in Kinetic Sculpture.* Berkeley: University of California, 1966. Preface by George Rickey. I. B. *International survey exhibition catalogue including artists' statements.*

——, 2. *Funk.* Berkeley: University of California, 1967. I.G. *Includes statements by artists.*

——, 3. *German Expressionist Painting.* Berkeley: University of California

Press, 1957. I.B. *Major work documenting the development of German Expressionism and its influence.*

_____, 4. *Mark Rothko.* New York: The Museum of Modern Art, 1961. I.B.*Retrospective catalogue.*

SEUPHOR, MICHEL, 1. *Abstract Painting. 50 Years of Accomplishment, from Kandinsky to the Present.* New York: Dell Publishing Co., 1964. I.

_____, 2. *L'Art abstrait.* Paris: Editions Maeght, 1949. I.B. (French text.)

_____, 3. *The Sculpture of This Century, Dictionary of Modern Sculpture.* London: A. Zwemmer Ltd., 1959. I.B.

7 *Decades.* Andover, Mass.: Addison Gallery of American Art, Phillips Academy, 1969. Foreword by Bartlett H. Hayes, Jr. I.C. *Exhibition catalogue including artists' statements.*

SEYMOUR, CHARLES, Jr. *Tradition and Experiment in Modern Sculpture.* Washington, D.C.: The American University Press, 1949. I.

SHAHN, BEN, 1. *The Biography of Painting.* New York: Paragraphic Books, 1966. I. *A testament of the artist.*

_____, 2. *The Shape of Content.* Cambridge, Mass.: Harvard University Press, 1957. I. *Critical essay.*

SHAHN, BERNARDA BRYSON. *Ben Shahn.* New York: Harry N. Abrams Inc., 1972. I.B.C. *Picture catalogue of works and biographical sketch.*

SHAPIRO, DAVID, ed. *Social Realism: Art as a Weapon.* New York: Frederick Ungar Publishing Co., 1973. I.B. *A study of the social implications of figurative art in the 1930s and 1940s.*

SHEARER, LINDA. *Brice Marden.* New York: The Solomon R. Guggenheim Museum, 1975. I.B. *A ten-year survey.*

SIEGFRIED, JOAN C. *Bruce Conner.* Philadelphia: Institute of Contemporary Art, 1967. Preface by Stephen S. Prokopoff. I. *Retrospective catalogue.*

SLOAN, HELEN FARR. *The Life and Times of John Sloan.* Wilmington, Del.: Wilmington Society of the Fine Arts, 1961. I.

SLOAN, HELEN FARR, ed. *American Art Nouveau: The Poster Period of John Sloan.* Lock Haven, Pa.: Privately published

by Hammermill Paper Co., n.d. I. *New material on an unknown period of the artist's work.*

SLOAN, JOHN, 1. *The Art of John Sloan.* Brunswick, Me.: Walker Art Museum, Bowdoin College, 1962. *Exhibition catalogue.*

_____, 2. *The Gist of Art.* New York: American Artists Group Inc., 1939. I. *The aritst's theory of painting.*

_____, 3. *John Sloan.* Andover, Mass.: Addison Gallery of American Art, Phillips Academy, 1938. I.B. *Exhibition catalogue.*

_____, 4. *John Sloan.* New York: American Artists Group Inc., 1945. I. *Autobiographical monograph.*

_____, 5. *John Sloan, Paintings and Prints.* Hanover, N.H.: Dartmouth College, 1946. I. *Exhibition catalogue.*

SLUSSER, JEAN PAUL. *Bernard Karfiol.* New York: The Whitney Museum of American Art (American Artists Series), 1931. I.B. *Monograph.*

SMITH, ANDRE. *Concerning the Education of a Print Collector.* New York: Harlow, Keppel and Co., 1941. I.

SMITH, BERNARD. *Moses Soyer.* New York: ACA Gallery, 1944. I. *Monograph.*

SMITH, BRYDEN. *Donald Judd.* Ottawa: National Gallery of Canada, 1975. I.B.C. *Retrospective catalogue and catalogue raisonné, 1960-1974.*

SMITH, DAVID. *David Smith.* New York: Holt, Rinehart and Winston, Inc., 1968. I. *Writings and photographs.*

SMITH, S.C. Kaines. *An Outline of Modern Painting.* London: The Medici Society, 1932. I. *Early documentation of twentieth-century art.*

SOBY, JAMES THRALL, 1. *After Picasso.* Hartford, Conn.: Edwin Valentine Mitchell; New York: Dodd, Mead and Co., 1935. I. *Critical essays.*

_____, 2. *Ben Shahn.* New York: The Museum of Modern Art; West Drayton, England: Penguin Books, 1947. I. *Monograph.*

_____, 3. *Ben Shahn.* New York: George Braziller, Inc., 1963. I.B. *Monograph.*

_____, 4. *Ben Shahn, His Graphic Work.* New York: George Braziller, Inc., 1957. I.B.

Monograph.

———, 5. *Contemporary Painters.* New York: The Museum of Modern Art, 1948. I. *Documented exhibition catalogue.*

———, 6. *Modern Art and the New Past.* Norman: University of Oklahoma Press, 1957. *Critical essays and documentation.*

———, 7. *Tchelitchew.* New York: The Museum of Modern Art, 1942. I.B. *Exhibition catalogue.*

———, 8. *Yves Tanguy.* New York: The Museum of Modern Art, 1955. I.B. *Exhibition catalogue.*

SONTAG, SUSAN. *Against Interpretation.* New York: Dell Publishing Co., 1966. *Assorted collected essays.*

SOYER, MOSES. *Painting the Human Figure.* New York: Watson-Guptill Publishing Co. Inc., 1964. I. *How-to-paint book.*

SOYER, RAPHAEL, 1. *Homage to Thomas Eakins, etc.* Rebecca L. Soyer, ed. South Brunswick, N.J.: Thomas Yoseloff Inc., 1965. I. *Travelogue and art world personalities.*

———, 2. *A Painter's Pilgrimage.* New York: Crown Publishers Inc., 1962. I. *A European travelogue.*

———, 3. *Raphael Soyer.* New York: American Artists Group Inc., 1946. I. *Autobiographical monograph.*

SPEICHER, EUGENE. *Eugene Speicher.* New York: American Artists Group Inc., 1945. I. *Autobiographical monograph.*

The State of California Painting. New Plymouth, N.Z.: Govett-Brewster Art Gallery, 1972. Foreword by Robert H. Ballard. Introduction by Michael Walls. I.C. *Exhibition catalogue.*

STEINBERG, LEO. *Jasper Johns.* New York: George Wittenborn, Inc., 1964. I.B. *Monograph.*

STEINBERG, SAUL, 1. *The Art of Living.* New York: Harper and Brothers, 1945. I. *Cartoons.*

———, 2. *The Passport.* New York: Harper and Brothers, 1945. I. *Cartoons.*

———, 3. *Steinberg Dessins.* Paris: N.R.F., Gallimard, 1955. I. *Cartoons.*

STERNBERG, HARRY, 1. *Modern Methods and Materials of Etching.* New York: McGraw-Hill Book Co., Inc., 1949. I.

———, 2. *Silk Screen Color Printing.* New York: McGraw-Hill Book Co., Inc., 1942. I.

STORY, ALA. *First comprehensive retrospective exhibition in the West of Max Weber.* Santa Barbara: University of California, 1968. I.B. *Major Retrospective catalogue.*

SUTTON, DENYS. *American Painting.* London: Avalon Press, 1948. I. *Mid-twentieth-century painting.*

SWEENEY, JAMES JOHNSON, 1. *Alexander Calder.* New York: The Museum of Modern Art, 1951. I.B. *Exhibition catalogue.*

———, 2. *Jacques Villon, Raymond Duchamp-Villon, Marcel Duchamp.* New York: The Solomon R. Guggenheim Museum, 1957. I.B. *Exhibition catalogue.*

———, 3. *Sam Francis.* Houston: Museum of Fine Arts of Houston, 1967. I. *Exhibition catalogue.*

———, 4. *Stuart Davis.* New York: The Museum of Modern Art, 1945. I.B. *Exhibition catalogue.*

SWEET, FREDERICK A. *Ivan Albright.* Chicago: The Art Institute of Chicago, 1964. I. *Retrospective catalogue.*

Syd Solomon. Sarasota, Fla.: John and Mable Ringling Museum of Art, 1974. Acknowledgments by Richard S. Carroll. Conversation with Solomon by Kurt Vonnegut, Jr. Introduction by Leslie Judd Ahlander. I.B. *Retrospective catalogue.*

TAFT, LORADO. *Modern Tendencies in Sculpture.* Chicago: The University of Chicago Press, 1921. I.

TAKIGUCHI, SHUZO. *Noguchi.* Tokyo: Bijutsu Shippan-Sha, 1953. I. *Monograph.*

TANGUY, YVES. *Un Recueil de Ses Oeuvres/A Summary of His Work.* New York: Pierre Matisse, 1943. I.B. (French and English text.) *Catalogue raisonné.*

TAPIE, MICHEL, 1. *Un Arte autre.* Paris: Gabriel-Giraud et Fils, 1952. I. (French text.) *Polemic thesis for advance guard painting.*

———, 2. *Ossorio.* Turin: Edizioni d'Arte Fratelli Pozzo, 1961. I. (English and French text.) *Monograph.*

TARBELL, ROBERTA K. *Marguerite Zorach: The Early Years, 1908-1920.* Washington, D.C.: National Collection of Fine Arts, 1973. Foreword by Joshua C. Taylor. I.B.C. *Exhibition catalogue and detailed study of the artist's early life.*

TASHJIAN, DICKRAN. *Skyscraper Primitives.* Middletown, Conn.: Wesleyan University Press, 1975. I.B. *Observations on dadamerica.*

TAUBES, FREDERIC, 1. *Anatomy of Genius.* New York: Dodd, Mead and Co., 1948. I. *Critical essay.*

____, 2. *The Art and Techniques of Portrait Painting.* New York: Dodd, Mead and Co., 1957. I.

____, 3. *Better Frames for Your Pictures.* New York: Studio Publications, 1952. I.

____, 4. *Frederic Taubes.* New York: American Artists Group Inc., 1946. I.B. *Autobiographical monograph.*

____, 5. *The Mastery of Oil Painting.* New York: Studio Publications, 1953. I. *Technique.*

____, 6. *Modern Art, Sweet or Sour?* New York: Watson-Guptill Publishing Co. Inc., 1958. I. *Critical essays.*

____, 7. *The Painter's Question and Answer Book.* New York: Watson-Guptill Publishing Co. Inc., 1948. I. *Technique.*

____, 8. *Paintings and Essays on Art.* New York: Dodd, Mead and Co., 1950. I.

____, 9. *Pen and Ink Drawing, Art and Technique.* New York: Watson-Guptill Publishing Co. Inc., 1956. I.

____, 10. *Pictorial Composition and the Art of Drawing.* New York: Dodd, Mead and Co., 1949. I.

____, 11. *Studio Secrets.* New York: Watson-Guptill Publishing Co Inc., 1943. I. *Technique.*

____, 12. *The Technique of Oil Painting.* New York: Dodd, Mead and Co., 1941. I.

____, 13. *You Don't Know What You Like.* New York: Dodd, Mead and Co., 1947. I. *Critical essays.*

TAVOLATO, ITALO. *George Grosz.* Rome: Valori Plastici, 1924. I. (French text.) *Monograph.*

THOMAS, EDWARD B. *Mark Tobey.* Seattle: Seattle Art Museum, 1959. I.

Exhibition catalogue.

Three Realists: Close, Estes, Raffael. Worcester, Mass.: The Worcester Art Museum, 1974. Foreward by Leon Shulman. I.B. *Exhibition catalogue.*

TILLIM, SIDNEY. *Richrd Lindner.* Chicago: William and Norma Copley Foundation, n.d. I. *Monograph.*

TOBEY, MARK. *Mark Tobey.* New York: The Whitney Museum of American Art, 1951. I. *Exhibition catalogue.*

TOMKINS, CALVIN. *The Bride and the Bachelors.* New York: Viking Press, 1965. I. *Essays on the avant-garde.*

TOMKINS, CALVIN and the Editors of TIME-LIFE BOOKS. *The World of Marcel Duchamp.* New York: Time Inc., 1966. I.B.

Tony Smith: Painting and Sculpture. Baltimore: University of Maryland Art Gallery, 1974. Foreword by Eleanor Green. I. *Exhibition catalogue.*

Transparency, Reflection, Light, Space: Four Artists. Los Angeles: UCLA Art Galleries, 1971. Foreword by Frederick S. Wight. I.B.C. *Exhibition catalogue; interviews and artists' statements.*

TRIER, EDUARD, 1. *Form and Space: Sculpture in the 20th Century.* New York: Frederick A. Praeger, 1968. I.B. *Survey by concept.*

____, 2. *Moderne Plastik von August Rodin bis Marino Marini.* Frankfurt am Main: Buchergilde Gutenberg, 1955. I.B. (German text.) *Short illustrated history of twentieth-century sculpture.*

TUCHMAN, MAURICE, 1. *American Sculpture of the Sixties.* Los Angeles: County Museum of Art, 1967. I.B.G. *Major survey exhibition catalogue includes essays by 10 critics and statements by the artists.*

____, 2. *Edward Kienholz.* Los Angeles: County Museum of Art, 1966. I.B. *Retrospective catalogue.*

TUCHMAN, MAURICE, ed. *New York School, The First Generation: Paintings of the 1940s and 1950s.* Los Angeles: County Museum of Art, 1965. I.B. *Major exhibition catalogue with statements by artists and critics.*

TUCKER, MARCIA. *Al Held.* New York: The Whitney Museum of

American Art, 1974. I.B.C. *Retrospective catalogue.*

TYLER, KENNETH E. *Josef Albers: White Line Squares.* Los Angeles: Gemini G.E.L., 1966. I.B. *Graphics exhibition catalogue includes artist's statements.*

TYLER, PARKER, 1. *The Divine Comedy of Pavel Tchelitchew.* New York: Fleet Publishing Co., 1967. I.B. *Biography.*

———, 2. *Marca-Relli.* Paris: The Pocket Museum, Editions George Fall, 1960. I. *Monograph.*

USA West Coast. Hamburg: Kunstverein in Hamburg, 1972. Foreword by Helmut Heissenbuttel. Essay by Helene Winer. I.C. (German and English text.) *Exhibition catalogue.*

VALENTINE, W.R., 1. *Letters of John B. Flannagan.* New York: Curt Valentine, 1942.

———, 2. *Origins of Modern Sculpture.* New York: Wittenborn and Co., 1946. I.

VAN BORK, BERT. *Jacques Lipchitz: The Artist at Work.* With a critical evaluation by Dr. Alfred Werner. New York: Crown Publishers Inc., 1966. I. *Well illustrated popular essay about the artist at work.*

VARGA, MARGIT. *Waldo Peirce.* New York: Hyperion Press, Harper and Brothers, 1941. I. *Monograph.*

VERKAUF, WILLY, ed. *Dada: Monograph of a movement.* New York: Wittenborn and Co., 1957. I.B. *Documented monograph.*

VITRY, PAUL. *Paul Manship.* Paris: Editions de la Gazette des Beaux Arts, 1927. I. *Monograph.*

WALDBERG, PATRICK, 1. *Bernard Pfriem.* Chicago: William and Noma Copley Foundation, 1961. I. (French and English text.) *Monograph.*

———, 2. *Main et marveilles.* Paris: Mercure de France, 1961. I. *Essays on Surrealism.*

———, 3. *Surrealism.* Geneva: Skira, 1962. I.B. *Documentation and essays on Surrealism.*

———, 4. *Surrealism.* New York: McGraw-Hill Book Co., Inc., 1965. I.B. *Chronology. A short history of Surrealism.*

WALDMAN, DIANE, 1. *Carl Andre.* New York: The Solomon R. Guggenheim Museum, 1970. I.B. *A ten-year survey of Andre's work.*

———, 2. *Chryssa: Selected Works 1955-1967.* New York: The Pace Gallery, 1968. I.B. *Well illustrated exhibition catalogue.*

———, 3. *Joseph Cornell.* New York: The Solomon R. Guggenheim Museum, 1967. I.B. *Retrospective catalogue.*

———, 4. *Robert Mangold.* New York: The Solomon R. Guggenheim Museum, 1971. I.B. *Exhibition catalogue.*

WALKOWITZ, ABRAHAM, 1. *A Demonstration of Objective, Abstract, and Non-Objective Art.* Giraud, Kans.: Haldeman: Julius Press, 1945. I. *The artist's theories, illustrated.*

———, 2. *100 Drawings.* New York: B.W. Huebsch, Inc., 1925. I.

WARHOL, ANDY. *The Philosophy of Andy Warhol.* New York: Harcourt Brace Jovanovich, 1975. *Artist's statements.*

WARHOL, ANDY; KONIG, KASPER; HULTEN, PONTUS and GRANTH, OLLE, eds. *Andy Warhol.* Stockholm: Moderna Museet, 1968. I. *Pictorial history of the development of the artist, his work, and friends, including comments by the artist.*

WATSON, ERNEST W., 1. *Color and Method in Painting.* New York: Watson-Guptill Publishing Co. Inc., 1942. I. *Studies of various artists' use of color.*

———, 2. *Twenty Painters and How They Work.* New York: Watson-Guptill Publishing Co. Inc., 1950 I.

WATSON, FORBES. *William Glackens.* New York: Duffield and Co., 1923. I. *Monograph.*

WEBER, MAX, 1. *Essays on Art.* n.p.: Privately published, 1916.

———, 2. *Max Weber.* New York: American Artists Group Inc., 1945. I. *Autobiographical monograph.*

WEITEMEIER, HANNAH. *Moholy-Nagy.* Eindhoven, Holland: Stedelijk van Abbe-Museum, 1967. I. (Dutch and English text.) *Retrospective catalogue including statements by the artist.*

WELL, HENRY W., ed. *Selected Poems by Marsden Hartley.* New York: Viking Press, 1945. I.

WELLER, ALLEN S. *The Joys and Sorrows of Recent American Art.* Urbana: University of Illinois Press, 1968. I.

"What Abstract Art Means to Me." *Bulletin* of The Museum of Modern

Art, Vol. XVIII, No. 3, Spring 1951. I. *Statements by leading artists.*

WHEELER, MONROE. *Painters and Sculptors of Modern America.* New York: Thomas Y. Crowell Co., 1942. I.

When Attitudes Become Form: Works/Concepts/Processes/Situations/Information. Bern: Kunsthalle Bern, 1969. Foreword by Harald Szeemann. Introduction by John A. Murphy. I.B.C. (English, French, and German text.) *Major international exhibition of above-mentioned tendencies.*

WIGHT, FREDERICK S., 1. *Hans Hofmann.* New York: The Whitney Museum of American Art, 1957. I. *Exhibition catalogue.*

———, 2. *Milestones of American Painting in Our Century.* New York: Chanticleer Press, 1949. I. *Historical view of American painting.*

———, 3. *Milton Avery.* Baltimore: Baltimore Museum of Art, 1952. I. *Exhibition catalogue.*

———, 4. *Nathan Oliveira.* Los Angeles: University of California, 1963. I. *Monograph.*

WIGHT, FREDERICK S., BAUR, JOHN I.H. and PHILLIPS, DUNCAN. *Morris Graves.* Berkeley: University of California Press, 1956. I.B. *Exhibition catalogue.*

WIGHT, FREDERICK S. and GOODRICH, LLOYD. *Hyman Bloom.* Boston: Institute of Contemporary Art, 1944. I. *Exhibition catalogue.*

WILENSKI, R.H. *The Modern Movement in Art.* London: Faber and Faber, Ltd., 1955. I. *European and American development of modern art.*

WILKE, ULFERT. *Music to Be Seen.* Louisville, Ky.: Erewhon Press, n.d. I. (English, French, and German text.) *A collection of drawings.*

WILLARD, CHARLOTTE. *Moses Soyer.* Cleveland: World Publishing Co., 1962. I. *Monograph.*

WILLIAMS, HIRAM. *Notes for a Young Painter.* Englewood Cliffs, N.J.: Prentice-Hall Inc., 1963. I.

WILLIAMS, WILLIAM CARLOS. *Charles Sheeler.* New York: The Museum of Modern Art, 1939. I.B. *Exhibition catalogue.*

WINGERT, PAUL S. *The Sculpture of William Zorach.* New York: Pitman Publishing Co., 1938. I.B. *Monograph.*

WINGLER, HANS M., ed. *Graphic Work from the Bauhaus.* Greenwich, Conn.: New York Graphic Society, 1968. I.B.

WOELFFER, EMERSON. *Emerson Woelffer.* Pasadena: The Pasadena Art Museum, 1962. I. *Exhibition catalogue.*

WOOD, JAMES N. *Six Painters.* Buffalo: Albright-Knox Art Gallery, 1971. Foreword by Gordon M. Smith. I.B.C. *Exhibition catalogue.*

WRIGHT, WILLARD HUNTINGTON, 1. *The Forum Exhibition of Modern American Painters.* New York: Anderson Galleries, 1916. I.B.

———, 2. *Modern Painting.* New York: Dodd, Mead and Co., 1927. I. *Essays on modern art.*

ZAIDENBERG, ARTHUR, ed. *The Art of the Artists.* New York: Crown Publishers Inc., 1951. I. *Pictorial documentation of various artists.*

ZERVOS, CHRISTIAN. *Histoire de l'art contemporain.* Paris: Editions Cahiers d'Art, 1938. I.B. *Documented history of contemporary art.*

ZERVOS, CHRISTIAN and ADAMS, PHILIP R. *Mary Callery.* New York: Wittenborn and Co., 1961. I.B. *Monograph and catalogue raisonné.*

ZIGROSSER, CARL, 1. *The Artist in America.* New York: Alfred A. Knopf, 1942. I. *Critical essays and biographies.*

———, 2. *Mauricio Lasansky.* New York: American Federation of Arts, 1960. I. *Retrospective catalogue.*

ZORACH, WILLIAM, 1. *William Zorach.* New York: American Artists Group Inc., 1945. I. *Autobiographical monograph.*

———, 2. *Zorach Explains Sculpture, What It Is and How It Is Made.* New York: American Artists Group Inc., 1947. I.

BOOKS OF GENERAL INTEREST

AGEE, WILLIAM C. *The 1930's: Painting and Sculpture in America.* New York: Frederick A. Praeger, 1968. I.B. *Based on a Whitney Museum exhibition.*

AMERICAN ABSTRACT ARTISTS, ed. *The World of Abstract Art.* New York:

George Wittenborn and Co., 1957. I. *Documentation of the group and its members.*

ARNASON, H. HARVARD. *American Abstract Expressionists and Imagists.* New York: The Solomon R. Guggenheim Museum, 1961. B. *Documented exhibition catalogue.*

———. *History of Modern Art.* New York: Harry N. Abrams Inc., 1968. I.B. *The world of modern art, up to date.*

ARONSON, CHIL. *Artistes Americains Modernes de Paris.* Paris: Editions Le Triangle, 1932. I. (French text.)

ASHTON, DORE. *Modern American Sculpture.* New York: Harry N. Abrams Inc., 1968. I. *Well illustrated survey book.*

———. *The New York School: A cultural Reckoning.* New York: Viking Press, 1973. I.B. *Sociophilosophic observations on mid-20th-century New York art and culture.*

BARR, ALFRED H., Jr., ed. *Masters of Modern Art.* New York: The Museum of Modern Art, 1955. I.B. *Major anthology of modern art.*

BATTCOCK, GREGORY, ed. *Idea Art.* New York: E.P. Dutton, 1973. I. *Reprints magazine pieces on concept art.*

———. *The New Art, a critical anthology.* New York: E.P. Dutton, 1966. I. *Reprints of selected vital essays from periodicals and museum catalogues, with a Preface by the editor.*

———, *Super Realism.* New York: E.P. Dutton, 1975. I. *The initial critical anthology.*

BAZIN, GERMAIN. *The History of World Sculpture.* Greenwich, Conn.: New York Graphic Society, 1968.

BELMONT, I.J. *The Modern Dilemma in Art.* New York: Harbinger House, 1944. I. *Critical evaluation of increasing abstractionsim.*

BETHERS, RAY. *Art Always Changes.* New York: Hastings House, 1958. I. *Critical essays.*

BROWN, MILTON W. *The Story of the Armory Show.* New York: The Joseph H. Hirshhorn Foundation, 1963. I.B. *Documented history of the famous exhibition.*

BURNHAM, JACK. *Beyond Modern Sculpture.* New York: George Braziller, Inc., 1968. I.B. *Survey of recent modern sculpture.*

CAHILL, HOLGER. *New Horizons in American Art.* New York: The Museum of Modern Art, 1936. I. *Exhibition catalogue related to Federal Art Project.*

CALAS, NICOLAS. *Art in the Age of Risk and Other Essays.* New York: E.P. Dutton, 1968. Introduction by Gregory Battcock. I. *A collection of essays from periodicals.*

CANADAY, JOHN. *Culture Gulch: Notes on Art and Its Public in the 1960s.* New York: Farrar, Straus and Giroux, 1969. I. *Essays garnered from The New York Times.*

CHENEY, SHELDON. *A Primer of Modern Art.* New York: Boni and Liveright, 1924. I.

———. *Sculpture of the World.* New York: Viking Press, 1968. I.B. *Valuable survey of the sculpture of all time.*

———. *The Story of Modern Art.* New York: Viking Press, 1958. I. *Popular history of modern art.*

CIRLOT, JUAN-EDUARDO. *Del Expresionismo a la Abstraccion.* Barcelona: Editorial Seix Barral, S.A., 1955. I. (Spanish text.) *Development of nonfigurative art.*

CRANE, AIMEE, ed. *Portrait of America.* New York: Hyperion Press, Harper and Brothers, 1945. I. *Critical essays.*

DAVIDSON, MARSHALL B. *Life in America.* Boston: Houghton Mifflin Co., 1951, 2 vols. *Critical essays and documentation.*

DUFFUS, R.L. *The American Renaissance.* New York: Alfred A. Knopf, 1928. *Critical discussion of American culture.*

FAULKNER, RAY; ZIEGFELD, EDWIN; and HILL, GEROLD. *Art Today. An Introduction to the Fine and Functional Arts.* New York: Henry Holt and Co., 1941.

FELDMAN, EDMUND BURKE. *Art as Image and Idea.* Englewood Cliffs, N.J.: Prentice-Hall Inc., 1967. I.B. *The great themes of all time in art.*

GARDNER, ALBERT TEN EYCK. *History of Water Color Painting in America.* New York: Reinhold Publishing Co., 1966. I. *Popular survey of watercolor painting from the late eighteenth century to the present time.*

GELDZAHLER, HENRY. *American Pain-*

ting in the 20th Century. New York: The Metropolitan Museum of Art, 1965. I.B. *A survey based mainly on the Museum's collection.*

GOODALL, DONALD B. *Partial Bibliography of American Abstract-Expressive Painting, 1943-58.* Los Angeles: University of Southern California, Department of Fine Arts, 1958. *Periodicals and a few books.*

GOODRICH, LLOYD. *Three Centuries of American Art.* New York: Frederick A. Praeger, 1966. I. *Survey book based on a Whitney Museum exhibition.*

_____. *The Whitney Studio Club and American Art: 1900-1932.* New York: The Whitney Museum of American Art, 1975. I. *Reviews the Club's history and the founding of the Museum.*

GOWANS, ALAN. *The Restless Art; A History of Painters and Painting, 1760-1960.* Philadelphia: J.B. Lippincott, 1966. I.B. *History developed by major artists and major works.*

GREGG, FREDERICK JAMES. *For and Against.* New York: Association of American Painters and Sculptors Inc., 1913. *Anthology of commentary on The Armory Show of 1913.*

GRUSKIN, ALAN D. *Painting in the USA.* Garden City, N.Y.: Doubleday and Co., 1946. I. *Survey of American painting in the 1940s.*

GUGGENHEIMER, RICHARD. *Sight and Insight, a Prediction of New Perceptions in Art.* New York: Harper and Brothers, 1945. *Critical discussion.*

HARSHE, ROBERT B. *A Reader's Guide to Modern Art.* San Francisco: The Wahlgreen Co., 1914. *Bibliography.*

HENNING, EDWARD B. *50 Years of Modern Art 1916-1966.* Cleveland: The Cleveland Museum of Art, 1966. I.B. *Extensive survey exhibition.*

HENRI, ADRIAN. *Total Art: Environments, Happenings, and Performance.* New York: Praeger Publishers, 1974. I.B.C.A. *International survey.*

HUNTER, SAM. *American Art of the 20th Century.* New York: Harry N. Abrams Inc., 1972 (?) I.B. *An up-to-date survey.*

KEAVENEY, SYDNEY STAN. *American Painting: A Guide to Information Sources.*

Detroit: Gale Research Co., 1974.

KEPPEL, FREDERICK P. and DUFFUS, R.L. *The Arts in American Life.* New York: McGraw-Hill Book Co., Inc., 1933. *Survey of the arts and their development in America.*

KRAMER, HILTON. *The Age of the Avant-Garde: An Art Chronicle of 1956-1972.* New York: Farrar, Straus and Giroux, 1973. I. *Collected essays.*

KULTERMANN, UDO. *Art and Life.* Translated by John William Gabriel. New York: Praeger Publishers, 1971. I. *Investigations into happenings, events, environments; underground film, television, theatre; intermedia, concept art.*

_____. *The New Painting.* New York: Frederick A. Praeger Publishers, 1969. I.B.C. *International critical survey of art of the 1960s.*

LIPPARD, LUCY. *955,000.* Vancouver, Canada: Vancouver Art Gallery, 1970. I.D.P. *An informative deck of 4- x 6-inch cards in a brown paper envelope.*

LOZOWICK, LOUIS. *100 Contemporary American Jewish Painters and Sculptors.* New York: YKUF Art Section, 1947. I. *Includes statements by the artists.*

LUCAS, E. LOUISE. *Art Books, a basic bibliography on the fine arts.* Greenwich, Conn.: New York Graphic Society, 1968. B.

McDARRAH, FRED W. *The Artist's World in Pictures.* New York: E.P. Dutton, 1961. Introduction by Thomas B. Hess. I. *Major pictorial documentation of the art scene in the 1950s.*

McMAHON, A. PHILIP. *The Meaning of Art.* New York: W.W. Norton and Co., 1930. B.

_____. *Preface to an American Philosophy of Art.* Chicago: The University of Chicago Press, 1945. B.

MORRIS, LLYOD R. *Incredible New York: 1850-1950.* New York: Random House, 1951. I. *Social history.*

MYERS, BERNARD S. *Modern Art in the Making.* New York: McGraw-Hill Book Co., Inc., 1959. I.B. *Historical development of modern art.*

MYERS, BERNARD S., ed. *Encyclopaedia of Painting. Painters and Painting of the World from Prehistoric Times to the Present*

Day. New York: Crown Publishers Inc., 1955. I.

NAYLOR, GILLIAN. *The Bauhaus.* New York: Studio Vista/Dutton Picture-backs, 1968. I. *Popular introduction to the Bauhaus program.*

NEUHAUS, EUGENE. *The Appreciation of Art.* Boston: Ginn and Co., 1924. I.

——. *Painters, Pictures, and the People.* San Francisco: Philopolis Press, 1918. I.

NORMAN, DOROTHY. *Alfred Stieglitz. Introduction to an American Seer.* New York: Duell, Sloan and Pearce, 1960. I. *Appreciation, with his famous photographs.*

O'DOHERTY, BRIAN. *Object and Idea: An Art Critic's Journal 1961-1967.* New York: Simon and Schuster, 1967. *Collection of published essays.*

OERI, GEORGINE. *Man and His Images.* New York: Viking Press, 1968. I. *A way of seeing art.*

One Hundred Prints by 100 Artists of the Art Students League of New York: 1875-1975. New York: The Art Students League, 1975. Foreword by Judith Goldman. I. *Centennial print exhibition catalogue; biographies.*

One Hundreth Anniversary Exhibition of Paintings and Sculpture by 100 Artists Associated with the Art Students League of New York. New York: The Art Students League, 1975. Foreword by Lawrence Campbell. I. *Exhibition catalogue including short history of the League; biographies and appreciations.*

PACH, WALTER. *Modern Art in America.* New York: C.W. Kraushaar Art Galleries, 1928. I. *Concise discussion of modern art and its development.*

PARK, ESTHER AILLEEN. *Mural Painters in America: A biographical Index.* Pittsburg: Kansas State Teachers College, 1949.

PARKER, R.A. *First Papers of Surrealism.* New York: Coordinating Council of French Relief Societies Inc., 1942. *Documented exhibition catalogue.*

PLAGENS, PETER. *Sunshine Muse: Contemporary Art on the West Coast.* New York: Praeger Publishers, 1974. I.B. *Survey of 20th-century West Coast art, mostly post-World War II.*

PUMA, FERNANDO. *Modern Art Looks Ahead.* New York: The Beechhurst Press, 1947. I. *Popular essays on art.*

REID, B.L. *The Man From New York: John Quinn and His Friends.* New York: Oxford University Press, 1968. I.B. *Biography of the master patron of the early twentieth century.*

RICHARDSON, E.P. *A Short History of Painting in America, the Story of 450 Years.* New York: Thomas Y. Crowell Co., 1963. I. *A basic history of American painting.*

——. *Twentieth Century Painting.* Detroit: Detroit Institute of Arts, 1947, 4th ed. I.B. *Concise essays.*

RICHMAN, ROBERT, ed. *The Arts at Mid-Century.* New York: Horizon Press, Inc., 1954.

RITTERBUSH, PHILLIP C. *The Art of Organic Forms.* Washington, D.C.: Smithsonian Institution Press, 1969. I.B. *A science, art and nature concept.*

ROBBINS, DANIEL. *The Neuberger Collection.* Preface by Roy R. Neuberger. Providence: Rhode Island School of Design, 1968. I. *Documented catalogue of a major modern collection.*

ROSENBERG, HAROLD. *Artworks and Packages.* New York: Horizon Press, Inc., 1969. I. *Essays some of which first appeared in the* New Yorker.

——. *The De-definition of Art: Action Art to Pop to Earthworks.* New York: Horizon Press, 1972. I. *Collected essays mostly from the* New Yorker.

——. *Discovering the Present.* Chicago: The University of Chicago Press, 1973. *Collected essays on art, culture, and politics.*

SAYLOR, OLIVER M. *Revolution in the Arts.* New York: Brentano's, 1930. *Critical essays.*

SCHNIER, JACQUES. *Sculpture in Modern America.* Berkeley: University of California Press, 1948. I.B.

SEWCALL, JOHN IVES. *A History of Western Art.* New York: Holt, Rinehart and Winston, Inc., 1961. I.

SMITH, RALPH C. *A Biographical Index of American Artists.* Baltimore: The Williams and Wilkins Co., 1930. B.

SWEENEY, JAMES JOHNSON. *Vision and Image.* New York: Simon and Schuster, 1968. B. *Concise commentary on*

our present-day culture.

WATSON, FORBES. *American Painting Today.* Washington, D.C.: American Federation of Arts, 1939. I. *Concerned with the period before World War II.*

WESCHER, HERTA. *Die Collage.* Cologne: M. Dumont, 1968. I.B. (German text.) *The major history of collage.*

WESTON, NEVILLE. *Kaleidoscope of Modern Art.* London: Geo. C. Harrap & Co. Ltd., 1968. I.B. *Popular introduction to international modern art.*

WICKES, GEORGE. *Americans in Paris: 1903-1939.* Paris Review Editions. Garden City, New York: Doubleday & Co., Inc., 1969. I.B. *A history of Americans in the art world abroad.*

WILMERDING, JOHN. *A History of American Marine Painting.* Salem, Mass.: The Peabody Museum, 1968. I.B. *The major work on American marine painting.*

YOUNG, A.R., ed. *Art Bibliography.* New York: Teachers College of Columbia University, 1941. *A bibliography for the educator.*